$\begin{array}{c} \text{The Art and Architecture of} \\ \textbf{LONDON} \end{array}$

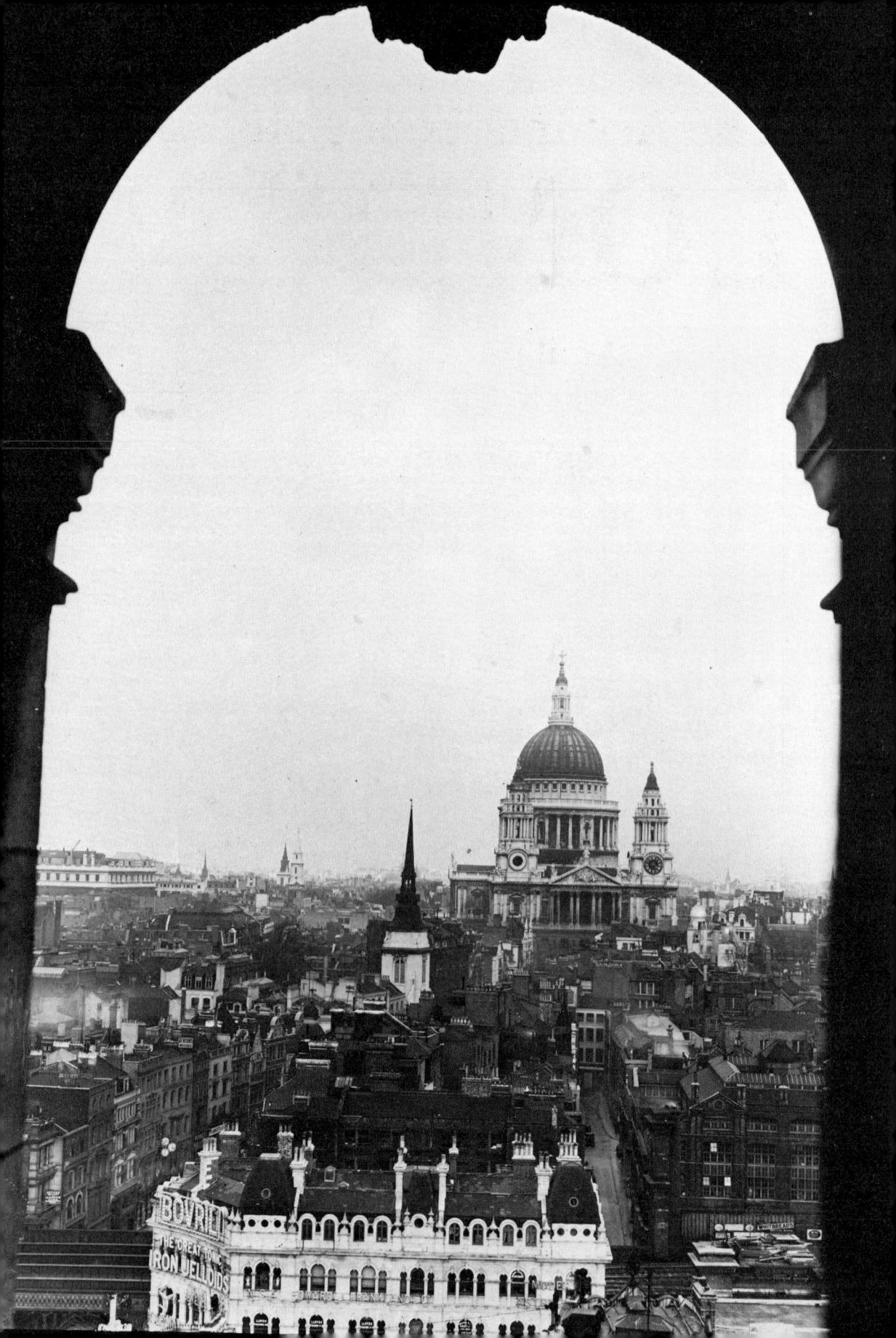

The Art and Architecture of LONDON

An illustrated guide

SECOND EDITION

Ann Saunders

Old houses were scaffolding once and workmen whistling. T. E. HULME

Phaidon · Oxford

The publishers are very grateful to the National Monuments Record for providing the majority of the illustrations in this book, and would like to acknowledge in particular the work of Gordon Barnes among their photographers. They also wish to thank the following photographers and copyright owners for supplying and giving permission to reproduce the remaining photographs. (Numbers refer to page numbers.)

Dagenham Public Libraries, 199; Paul Barkshire, 17, 26, 50, 87, 123, 132, 133, 136, 137, 146, 172, 189, 226, 227 (right), 244, 284, 294, 307, 319, 350, 375, 376; Bexley Public Library, 340; by Courtesy of the Trustees of the British Museum, London, 215; Central Electricity Generating Board, 430; by kind permission of Country Life, 49, 164; Courtauld Institute of Art (Conway Library), 43, 85, 143, 383; Messrs. Coutts, 125; Crown copyright – reproduced with permission of the Controller of Her Majesty's Stationery Office, 116, 126; Croydon Natural History and

Scientific Society, 356; Festival of Britain, 324; Ford of Bri-

tain Photographers, 267; Ford Motor Company, 198; Hel-

Aerofilms Ltd, 430; the Air Ministry, 142; Barking and

and Civic Design, 65, 162, 240, 348, 419, 431; Guildhall Library, 55, 56, 66; Horniman Museum, 388; Douglas Jobson, 204 (bottom); Kentish Independent, 345; A. F. Kersting, 13, 18, 55, 77, 109, 110, 141, 179, 211, 231, 232, 236 (left), 268 (right), 275, 316, 337; D. King, 380; Horst Kolo, 321; Denys Lasdun and Partners, 14; Owen Laurence Photography, 204 (top); K. D. Lilley, 247; The Mansell Collection, 41; Marylebone Public Libraries, 188; J. W. Mellish, 336; Mercers' Hall, 58; Merton Library Service, 393, 394; Ministry of Agriculture, Fisheries and Food, 414; Ministry of Public Building and Works, 363; Newham Library Service, 311 (bottom); D. H. Norman, 322; P. & O., 78; S. Pollikett, 29 (right), 45, 91; Derek Rowe (photos) Ltd, 71; Royal Artillery, London, 370; Ruislip Public Library, 279; St. Mark's, Biggin Hill, 353; Walter Scott, Bradford, 103; S. Seifert and Partners, 204 (top), 360; O. Smith, 224; Surrey County Council, 401; Sutton Public Library, 421; Thames Water, 319; Vintners' Company, 51; London Borough of Waltham Forest, 335; Warburg Institute, 104, 113,

365; P. Wester, 340; City of Westminster Public Library,

192, 194; R. H. Windsor, 366

mut Gernsheim, 2, 93; GLC Department of Architecture

Phaidon Press Limited, Littlegate House, St. Ebbe's Street, Oxford OX1 1SQ

First published 1984 Second edition (paperback) 1988 © 1984, 1988 by Ann Saunders

All rights reserved. No part of this publication may be reproduced, stored in a retrieval system, or transmitted in any form or by any means, without the prior permission of the author.

British Library Cataloguing in Publication Data

Saunders, Ann

The art and architecture of London

1. London (England) – Description – 1981 – Guide-books

I. Title

919.21′0458 DA679

ISBN 0-7148-2523-9 p/b 0-7148-2533-6 h/b

Designed by Sarah Tyzack

Printed and bound in England at The Bath Press, Avon

Frontispiece: St. Paul's Cathedral, seen from St. Bride's, about 1939

Contents —

Foreword by
H.R.H. The Duke of Edinburgh 7
Preface 9
Introduction 11

The City of London

Fleet Street and the Temple 25
St. Paul's Cathedral 32
North from Ludgate Hill
Newgate to Smithfield 39
Blackfriars Bridge
to Southwark Bridge 47

The Guildhall and its Neighbourhood 53

North from London Wall

The Barbican, Aldersgate to Bishopsgate 6

Around the Bank 67

Bishopsgate to Aldgate 75

Bishopsgate to Aldgate 75

Regent Street and Soho 161

Hyde Park and Kensington Gardens 167

London Bridge and Riverside 84

The City of Westminster

Westminster Abbey 95
Westminster 107
Whitehall and Trafalgar Square 114
The Strand 122
Covent Garden 130
The Embankment 135

St. James's 139

Belgravia, Pimlico, and Victoria
St. Marylebone 182
Paddington 190

Piccadilly 148

Mayfair 154

— North of the River —

Barking and Dagenham 197 Harrow 260
Barnet 200 Havering 266
Brent 206 Hillingdon 271
Camden 210 Hounslow 281
Ealing 229 Islington 292

Enfield 234 Kensington and Chelsea 298

Hackney 239 Newham 310
Hammersmith and Fulham 243 Redbridge 314

Hampton Court and Hampton 249 Tower Hamlets 317

Haringey 256 Tower of London 326

Waltham Forest 332

South of the River —

Bexley 339

Bromley 346

Croydon 355

Croydon 355

Greenwich 362

Kingston upon Thames 373

Lewisham 386

Merton 391

Richmond upon Thames 397

Southwark 410

Sutton 420

Lambeth 378

Wandsworth 427

DETAILS OF INSTITUTIONS OPEN TO THE PUBLIC 433

Indexes 439
1 Places of Worship 440
2 Funeral monuments 443
3 Artists and craftsmen 447
4 General 456

Foreword

By H.R.H. the Duke of Edinburgh

BUCKINGHAM PALACE.

Big cities are both the best and the worst of man's creations. Their very success as centers of culture and prosperity has always acted as a magnet to both the ambitious and enterprising as well as to the poor and frustrated from miles around. For those who do not succeed, the pressures of high density living in slum conditions have inevitably encouraged crime and political volatility. Yet in spite of this, big cities have always been vital and vigorous organisms, each with its own distinctive and unique character and atmosphere.

Among the world's big cities, London must surely have a very special place and I think this splendid book explains just how this great patchwork of a city has developed through good times and bad.

Preface

I began work on this book over a decade ago, in 1970. My intention was to observe and record anything within the Greater London area that might interest an intelligent person with a preference for the arts, living in or visiting this section of the Thames valley. I have attempted to include landscape and natural features, buildings of every kind, with the contents of some of them, and as many historical and literary associations as possible. I have not written room-by-room guides to the major museums, since each of them provides its own handbook and several of them are undergoing major refurbishing, though I have given comparatively detailed descriptions of less well-known institutions, hoping that some readers may be moved to visit them.

Everywhere that I went, no matter whether I revisited those parts of London I already knew well, or whether I explored an enclave or suburb with which I was less familiar, I found something of beauty, interest, or excitement. Four things in particular impressed me. First, although London is often described nowadays as a tourist city, which implies that its pageantry and old buildings are preserved simply to entertain visitors, the attentive observer soon realizes that the so-called tourist attractions are still, in fact, functioning vitally. Secondly, in spite of its size, in spite of London's proverbial role as a magnet drawing all other parts of the countryside to it, there is a strong sense of local identity, which can be sensed as keenly in Marylebone High Street as in outlying Middlesex villages such as Harmondsworth. Thirdly, in spite of all one reads and hears about the ugliness of modern urban living, I was exhilarated by the beauty of the buildings, ranging from the eleventh century to the present day, varying from the tiny, perfect, Norman church dedicated to St. Helen and St. Giles at Rainham, through the delights of Pinner High Street, with shops and inns dating from the fifteenth to the eighteenth centuries, or the happy juxtaposition of Wren's St. Margaret Lothbury with G. Somers Clarke's Victorian Moorish General Credit and Discount Company offices of 1868 beside it, to the achievements of the present generation, such as Robert Matthew's New Zealand House in the Haymarket, which cherishes Nash's Royal Opera House Arcade of 1816–18 within its ample structure, or the delicate Music Schools built beside the lake in the grounds of Bromley Palace.

I was repeatedly astonished at the treasures sheltered in our parish churches. There is wonderful stained glass, such as that in St. Margaret's Westminster, which can boast of the finest pre-Reformation window in London, as well as modern aisle windows designed by John Piper. There are magnificent brasses, such as those to Joyce, wife of Sir John Tiptoft, at Enfield, or to Lord and Lady L'Estrange at Hillingdon. There is exquisite woodwork in most of the City churches, particularly the screens in St. Margaret Lothbury and St. Peter Cornhill, the font cover in All Hallows by the Tower, the altar surround in St. Mary Abchurch, the door-cases in St. Martin Ludgate, and the pulpit and door-cases of All Hallows Lombard Street, which have been moved to Twickenham. In particular, there is the sculpture of the funeral monuments. Apart from the treasurehouse of Westminster Abbey, there are masterpieces such as the mid-seventeenth-century Draper family at Crayford, all of them garbed with such puritanical severity that it seems unlikely that they could have been worldly enough to have had their likenesses recorded in stone, or Lady Elizabeth Berkeley at Cranford whose effigy, carved by Nicholas Stone, seems to float out of the marble as if half-submerged in an imprisoning element, or the eloquent figures of James Cooper (d.1743) and his wife at West Ham, still smiling companionably at each other more than two centuries after the living couple have become dust.

Fourthly, I revelled in seeing how much of London remains green, even today. There are broad, open expanses - Hampstead Heath, Wimbledon Common, Hounslow Heath, Richmond Park, Epping Forest - all of which deserve their names. There are the well-kempt royal parks providing breathingspace for Inner London, and carefully tended municipal parks everywhere, ranging from the mathematical flower-beds of the newly made Jubilee Gardens at Lambeth, to the long-established and rare trees of Stephen's Park near Church End, Finchley, or of High Elms Park near Farnborough in Bromley. And there are the Londoners' own gardens, the very special ones opened occasionally to the public in association with the National Gardens Scheme, the rose-filled plots on the Becontree Housing Estate near Dagenham, or just the geranium pots on the window-sills of those who have no gardens, for whom Sir Sidney Waterlow opened his park at Highgate.

10 PREFACE

I am grateful for all that I have seen and learned during these years of exploration and recording. I hope that I may be able to communicate some of the excitement and deep satisfaction I have found on my London travels. With Edward Hasted, the historian of Kent, who wrote in 1778, I claim that 'I have no superior abilities or learning to boast of; I can only affirm that my industry has been indefatigable; and that I have penned the whole to the utmost of my power, with integrity, and a sacred regard to truth and impartiality.'

In a work of this size, there will, almost inevitably, be omissions and inaccuracies. For these, I ask my readers' pardon and trust that their corrections will show me where to amend, should a second edition

give me the opportunity to do so.

H.R.H. The Duke of Edinburgh has graciously consented to write a foreword to this book. I am very conscious of the honour, and thank him for his kindness.

Finally, it remains my very pleasant duty to thank all those who have helped me in my labours. I began this work at the suggestion of Professor Michael Port, who has never ceased to encourage me. To the librarians of London I owe an especial debt, and I remember in particular the staffs of the London Library and of the Library of the Society of Antiquaries; James Howgego and Ralph Hyde of the Guildhall; Margaret Swarbrick and Loraine Williams of Westminster City Libraries; the late Mr. Stonebridge, Richard Bowden, and Anne James of St. Marylebone (now part of Westminster); the late Mr. Macdonald of Paddington; Rita Ensing, Brian Curl, and Tim Egan of Kensington; Christina Gee and Marguerite Van Reenan of Keats Hampstead; Mary Pearce of Uxbridge; Alan Ball and Robert Thomson of Harrow; James Howson of Barking; Yvette Williams and Penelope Hatfield of the Minet Library, Lambeth; Mr. Tofts White and

Anthea Cameron of Hounslow Reference Library: June Broughton of Sutton; Mary Boast of Southwark. My friends, Dr. Helen Wallis of the Map Room, British Library, and Sir Roy Strong of the Victoria and Albert Museum, gave much good advice, and so did Philippa Glanville, Victoria Moger, Rosemary Weinstein, and Chris Elmers of the Museum of London, Alison Reeve of the Greater London Council Record Office, Veronica Stokes of Coutts Bank, Dr. Alan Braham of the National Gallery, and Peter Bezodis of the Survey of London. Averil Lansdell of Kingston and Neil Rhind of Blackheath drove me over their territories and showed me what I might otherwise have missed: Mrs. Alexander, Mrs. China, and Mrs. Walker cheered me with hospitality in the further reaches of the London area; Hana Sambrook gave regular encouragement. I should also like to thank all those rectors and vicars whom I have disturbed with requests to see inside their churches, and who have borne my inquiries patiently.

My editors, Jean-Claude Peissel and Bernard Dod of Phaidon, have shown great courage in supporting such a long-drawn-out undertaking. Liz Roberts has been a stalwart editorial assistant, and Sarah Tyzack a most sympathetic designer. I am grateful to Tessa St. John Perry, whose dextrous fingers transformed my scrawls into typescript, and to Patricia White who produced the final version. Gideon Woolf dealt resolutely with the final stages of the index. To my children, Matthew and Katherine, who have grown up with this book and who have sustained me through its vicissitudes, I owe much, and I dedicate the finished work to my husband, Bruce, without whose steadfast support it would never have been

completed.

Ann Saunders London, 20 March 1983

POSTSCRIPT

For this paperback edition, I have taken the opportunity to correct some minor inaccuracies, to replace out-of-date photographs, and to write short notes on two new museums and the Thames Barrier. More extensive revisions will have to await a full-scale second edition. In the mean time, I am particularly grateful to Ylva French for help with changes of times of opening and admission charges, and to all those who have written to me with encouragement, corrections and suggestions; such advice is always welcome.

Ann Saunders Summer 1987

Introduction

People, and the places in which they live, are the raw materials of history. A great city, its inhabitants, and its development through the centuries, are proper subjects for our contemplation, for it is through such studies that we may arrive at a fuller and more sympathetic comprehension of the present. London may well be the most remarkable achievement of the English nation. It is not the oldest British city -Winchester and Colchester were established centres before London had begun - but since Roman times it has, for the most part, been the capital. It is an incomparable artefact. It has grown for nearly two thousand years, always changing, sometimes almost artlessly as if of its own accord, at other times developing elegantly under the careful attention of architects and planners. And London is still evolving, still altering and striving to improve itself, sometimes with triumphant, sometimes with unfortunate, results. The city's roots are old, but they go deep and have sufficient life to nourish new generations.

The key to London is the Thames. Without the river, the city might not have existed and would certainly not have flourished. It provides a readymade, two-way communication system, flowing eastwards to the sea and so opening the route to the European mainland, while providing westwards an inland means of communication. There are traces of pre-Roman habitation along the Thames valley - a Stone Age camp on Hampstead Heath, an Iron Age workshop that manufactured flint tools in Acton. There was a substantial Iron Age settlement in Brentford, while the runways at Heathrow Airport cross the site of a temple of the same period. The massive ramparts of pre-Roman forts can still be seen near Haves in Bromley and at Wheathampstead in Hertfordshire. The lynchets or earth banks marking out Celtic field boundaries are still visible on Farthing Down near Coulsdon, while the sinuously decorated shield of some Celtic warrior, dredged from the Thames at Battersea, is now in the British Museum, in company with a bronze horned helmet found near Waterloo Bridge. The name of London is probably of Celtic derivation, though its meaning is disputed, coming either from 'Llyn-din', a watery fort, or else incorporating a personal name. So far, however, no firm archaeological evidence has been found to prove the existence of a Celtic settlement here. It was the Romans who created London.

Caesar's two tentative expeditions of 55 and 54 BC, though claimed as triumphant victories in his despatches, had scarcely achieved as much as he implied. The real invasion came in AD 43 under Aulus Plautius, Landing at Richborough in Kent, he crossed the Medway after a hard-fought battle where Rochester stands today, and pushed on to the Thames, where he paused, sending back word to Rome that the Emperor should encourage the army with his august presence. While waiting for Claudius to arrive, he must have constructed a temporary bridge so that this next natural obstacle might be crossed. Plautius was an experienced soldier commanding well-trained troops, with plenty of timber at hand, so that, at least, a floating bridge of rafts could have been undertaken. The main problem was to find a site on which firm ground would give sure foundations and easy embarkation. On the north bank of the Thames, there were several excellent patches of gravel, but on the south there was just one spit of sand among the marshes, where Southwark stands today. The Roman bridge lay a little downstream from the present structure, spanning the river at the highest navigable and lowest bridgeable point.

Settlements grew up at both bridgeheads, that on the north bank taking advantage of the low twin hills on either side of a small tributary stream, the Walbrook. A substantial trading port had developed by AD 61, when Queen Boudicca (Boadicea) descended, with her fierce East Anglian tribesmen, the Iceni, and wiped it out; the ashes of the razing are still sometimes visible when deep excavations are dug for new buildings. After the Queen's defeat and death, London was rebuilt, and by the end of the century became the capital of the Roman province, in preference to the pre-Roman tribal centre at Colchester. A great basilica, the largest north of the Alps, was laid out, and the governor of the province occupied a noble palace where Cannon Street station stands today.

There are few visible remains of the Roman capital; London is not a ghost city but throughout its history has been a thriving, bustling, mercantile centre so that each fresh generation has hastened to impose itself upon the remains of the past. Close to the Tower and to the north of the City, however, the footings of the Roman wall may be seen – the upper parts are chiefly medieval – and the west gate of the

Roman fort, which once occupied London's northwestern corner, may be visited at lunch-time in the underground car-park near Wood Street. There are Roman fragments in the crypts of All Hallows by the Tower and St. Bride's in Fleet Street, and a reconstruction of the temple of Mithras lies close to its original site in Queen Victoria Street, while the wealth of London's excavations can best be studied in the excellent displays in the Museum of London. What remains of the Roman occupation is the outline of the square mile of the city, which is roughly the shape of the area fortified by the second century and which still holds good today as an administrative unit, and London Bridge; the successor to Aulus Plautius's line of advance is still in daily use.

The legions came and the legions went. They marched away by AD 410, leaving their walls, their temples, and their dead - the Goldsmiths' Company treasures an altar to Diana, and the touching inscriptions on the gravestones in the British Museum and the Museum of London bear mute witness to the generations who lived out their lives in this chilly, off-shore island on the north-western boundary of the Empire. What happened to London between their going and AD 604, when Saint Augustine ordained his companion Mellitus as its first bishop, is uncertain. The Roman street pattern vanished, more or less completely, but the walls and the alignment of the main roads leading to and from the capital remained. Substantial Saxon cemeteries have been excavated at Mitcham, Ewell, and Hanwell; information about London is less finite. Presumably life went on, possibly in a ramshackle, sub-colonial manner but continuing after a fashion till, at the beginning of the eighth century, the Venerable Bede was able to write of London as 'the mart of many nations resorting to it by sea and land' and in 886 the fortifications were repaired by Alfred the Great. Plenty of good Anglo-Saxon place names are still current - Londoners still tramp daily along Queenhithe, Billingsgate, Ludgate, and Cheapside. Was there once a palace near the Guildhall? Was St. Alban's church, dedicated to the British proto-martyr, its chapel? We can only guess; all that we know for certain is that London was still there, and, as we shall see, a force to be reckoned with in 1066.

Meanwhile, by 1052, something of immense importance was happening round a bend in the river upstream, where the monarch, Edward the Confessor, was building a palace and a great abbey church, his minster in the west, which gave a name, Westminster, to the whole area. The significance of this development can scarcely be over-stressed; London has twin centres – Westminster and the City, the one representing court and political power, the other mercantile and commercial strength. The relationship between the two was frequently critical.

Edward died childless on a winter's night in January 1066, a bare ten days after the consecration of his abbey, dedicated to Saint Peter. As his heir, he named

William of Normandy, but his nobles elected one of their number, Harold Godwinson, as king. It is uncertain whether Harold was crowned in the new abbey or in St. Paul's Cathedral in the City; we only know that when William invaded England in the autumn of 1066, he was very careful neither to harm nor offend the men of London, though their levy had fought hard beside Harold at the Battle of Hastings. On Christmas Day, William was crowned in the Abbey and he then made his own peace with the Londoners, granting them a charter confirming all their rights and privileges. This guarantee was set out, in Anglo-Saxon, in a writ to the bishop of London, to Gosfrith the portreeve, and to the burgesses of the City, and is still preserved in the Guildhall.

William did, however, immediately order an earthwork to be thrown up against the eastern angle of the Roman city wall, to overawe 'the vast and fierce populace' of London and to protect his capital from attack up-river by marauding Vikings, such as those who had pulled down London Bridge in 1015. A more permanent building was begun about 1078 under the direction of Gundulf, Bishop of Rochester. It was of stone specially imported from Caen in Normandy, and, since it was later whitewashed, it became known as the White Tower; with walls 90 feet high and 15 feet thick at the base, it remained the inmost citadel of the Tower of London and is one of the few hall-keeps, both fortress and palace, left in Europe. Its chapel, dedicated to St. John, is London's most perfect example of early Norman ecclesiastical architecture. William built other fortresses in a wide arc about his capital, the most important of them being Windsor Castle, which was to become the chief royal residence and stronghold.

The Conqueror ensconced himself in Edward's palace at Westminster.1 His son, William Rufus, began to enlarge it, erecting a magnificent Great Hall which, he boasted, was 'nothing but a bedchamber' compared with what he intended to build, though death cut short his ambitions. His subjects, too, were busy, rebuilding with stone the wooden Saxon churches that they had found; their work can be seen in the crypt of St. Mary-le-Bow in Cheapside and, outside London, in the little churches dedicated to St. Helen and St. Giles at Rainham, to Our Lady at East Ham, and to St. Peter and St. Paul at Cudham, and in the superbly carved doorways, ornamented with dog-tooth mouldings and cats' masks, at Harmondsworth and Harlington. Square Norman fonts, which have been used to baptize generations of infants, are still in use at Hendon, at Stepney, at Beddington, and at another dozen churches besides. Remains such as these have great simplicity and great dignity, typified by the serene curve of the chancel arch still in

position at East Bedfont or the massive strength of

¹ It is significant that, as far as we can tell, no defensive keep was ever built at Westminster. The Jewel Tower is merely a towered strong-room for the monarch's personal valuables.

the rounded arcades of St. Bartholomew's church in Smithfield or of Waltham Abbey.

Within the comparative safety of its walls, the city prospered. Whenever the king quarrelled with his barons, the merchants of London extracted charters and privileges from him, in return for money and support. In 1132, Henry I granted the citizens the right to elect a sheriff for Middlesex – a demonstration of the closeness of the link between London and its countryside; in 1191, when Richard I was away on crusade, Prince John granted the townspeople the right to form a commune, and in the following year the first Mayor, Henry FitzAilwyn, was elected, a privilege which John, as King, was forced to confirm in 1215; Henry III, Edward I, Edward II, and Edward III all gave charters confirming the rights of London.

Around the middle of the thirteenth century, there was a great upsurge of building and of architectural experiment in England. The pointed, Gothic arch had already reached the capital by the mid-twelfth century, when it was used for the crossing in St Bartholomew's. It was used again for the circular arcade of the Templars' round church in 1185, though the interlaced blind arcading decorating the walls still kept the old Norman semicircular curve. About 1245, out of his great devotion to Edward the Confessor, Henry III decided to rebuild completely

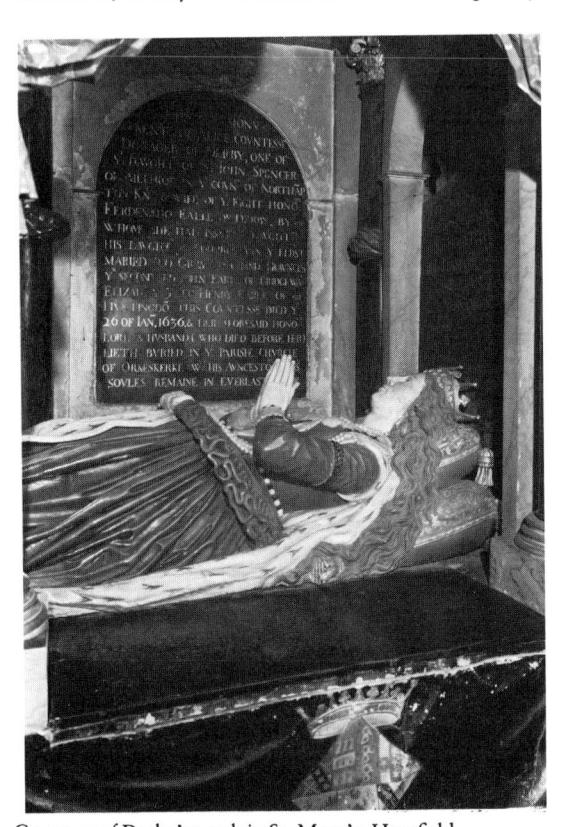

Countess of Derby's tomb in St. Mary's, Harefield

his saintly predecessor's abbey; of the original eleventh-century building, nothing save a morsel of the undercroft, the Chapel of the Pyx, remains. First the choir, then the north-east cloister, were rebuilt, and the glorious Chapter House was added, while during the later years of the King's reign, until 1269, the eastern part of the nave was rebuilt. This plain, unadorned style is known as Early English; among the finest remaining examples in London are the choir and retro-choir or Lady Chapel of Southwark Cathedral. Meanwhile, the Tower of London was given new defences by Henry's soldier son, the future Edward I (1272–1307).

Before the last years of the thirteenth century had passed, a new delight in greater intricacy of form made itself felt. The best London examples which remain are to be found in the church of St. Etheldreda in Ely Palace, Holborn, with its magnificent west window, and in the elaborate fourteenth-century tombs which are among the glories of Westminster Abbey - Henry III, Edward I's Queen, Eleanor of Castile, the Earl of Lancaster and his wife, Aveline, Edward III, Richard II, and Anne of Bohemia. St. Stephen's crypt, one of the few surviving morsels of the Palace of Westminster, remains embedded in Barry's Houses of Parliament; in spite of Victorian restoration and redecoration, the elaboration of its lines and curves still makes itself felt. The City churches built at this period vanished in the Great Fire of 1666; the chapel of St. Helen's Bishopsgate and of Chelsea Old Church remind us of what has gone, while, further afield, there are the Lady chapels of St. Alban's Abbey and Waltham Abbey to visit. One tantalizing fragment, an exquisite rose window, all that is left of the Bishop of Winchester's palace, remains behind Southwark Cathedral.

Gradually, a more robust style, known as Perpendicular, began to supersede the intricate cusps and ogee curves that were the hallmark of the first three-quarters of the fourteenth century. This, the third phase of Gothic architecture in England, was to endure as the prevailing mode all through the terrible vicissitudes of that bloody civil strife known picturesquely as the Wars of the Roses. In Tudor times and even later it was still current - St. Lawrence's church at Morden, rebuilt in 1636, either chose to save a Perpendicular window from an older building and to reinsert it in the east end or to construct a seventeenth-century copy. The greatest undertaking of the period, the western part of the nave of Westminster Abbey, cannot be considered as characteristic; the fourteenth-century architects deliberately, with complete selflessness and total architectural integrity, subjugated the style of their own day to that of an earlier generation, modelling their work to match what had already been executed; there are differences in detail, but the visitor needs to look hard at the shafts of the columns of the fourth and fifth bays of the nave to see where the thirteenthcentury builders ended their work and the four14 INTRODUCTION

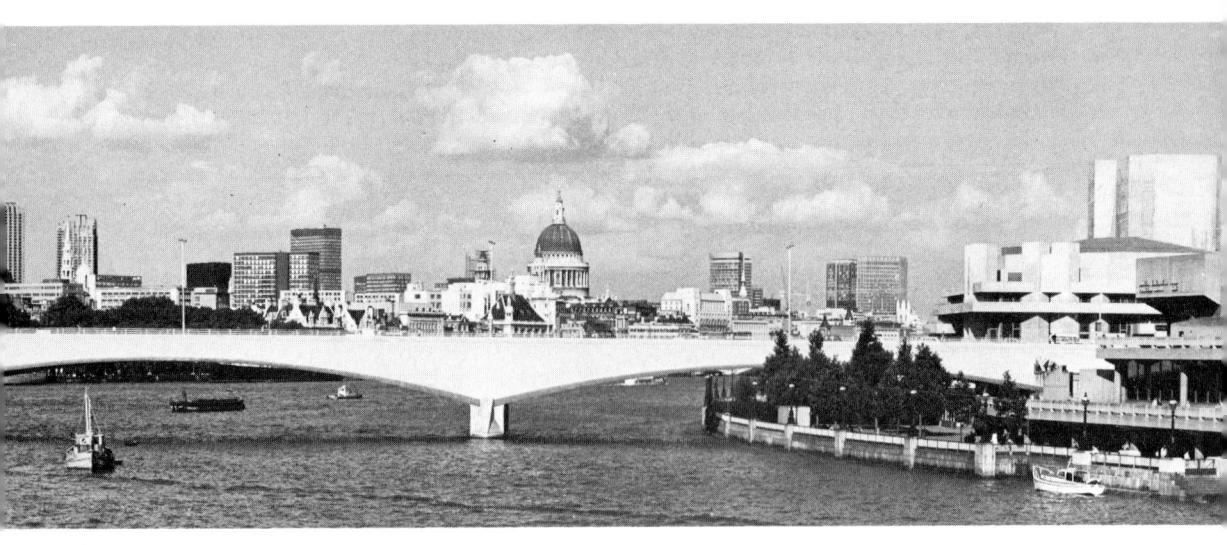

Waterloo Bridge, the National Theatre, and the City behind

teenth-century craftsmen took up the great task, which was not to be completed till the end of the succeeding century.

For good examples of Perpendicular churches, we need look no further than the north-eastern edge of the City, that sliver of London which a merciful change of wind delivered from the Great Fire of 1666. Here we shall find four: St. Helen, St. Olave, St. Ethelburga, and St. Andrew Undershaft, all built or extended in the fifteenth century, which survived more or less intact, and to these we may add St. Giles' Cripplegate, which retains its original lines despite bomb damage and restoration, the spare majesty of St. Dunstan's Stepney, and, in Westminster beside the Abbey, the near perfection of St. Margaret's church. Further afield, there is St. Margaret's at Barking, and others dedicated to Our Lady at Hendon, at Harrow, and at Harefield which date, substantially, from the fifteenth century.

A wealth of secular architecture remains too. Noblest of all is the superb hammerbeam roof with which Richard II graced the Norman Hall at Westminster; in 1399, he was forced to surrender his crown to his cousin, the future Henry IV, before his carpenters and masons had completed their labours. A generation later, the City, determined not to be outdone even by the King's majesty, began to build its new Guildhall, the stone walls of which have withstood the conflagrations of 1666 and of 1940, though the roof is the fourth to span the chamber within. A modest royal residence can still be visited at Eltham Palace, and in Crosby Hall, now rebuilt at Chelsea, we can see that a fifteenth-century merchant prince could build a mansion very little inferior to that enjoyed by a monarch. The hall built by the Carew family at Beddington was even more handsome, and further examples of fifteenth-century

work may be seen in the gateway of Lambeth Palace (Archbishop Morton c.1490), the Archbishop's Palace at Croydon, and the Hall and Chapel at Lincoln's Inn. Time and succeeding generations have swept away the homes of humbler folk, though the ample kitchens beneath the Merchant Taylors' Hall have been in use since 1388.

The culmination, the last full flowering of the Perpendicular style, is to be found in three chapels, Eton College Chapel, St. George's Windsor, and the Henry VII Chapel at Westminster. In the recently rediscovered and restored murals of the first, and in the aery refinement of the vaulting of the others, the style reached its zenith, its apogee; decline, or change, was inevitable.

Perhaps we should pause for a moment to contemplate London as it must have been about 1530. This decade, and not the year 1485, highlighted arbitrarily by Henry VII's victory over Richard III at Bosworth Field, is the true end of the Middle Ages. In 1530, London still lay, more or less, within the shelter of the City walls. Its chief landmark, Old St. Paul's, the largest church in the kingdom, crowned the western hill, with the grey metal roof of Leadenhall, formerly the City granary, on the easternmost, and the proud mass of the Guildhall lying between, a little to the north, close to the City wall. 108 churches were crowded within the square mile, and the great monastic orders - the Franciscans (Greyfriars), the Carmelites (Whitefriars), the Dominicans (Blackfriars) - had their houses within, or close to, the walls. On them the poor depended for relief; the buildings which remain from the Charterhouse still give some idea of how substantial these communities were. The merchants' houses, built for the most part from lath and timber with thatched roofs, lined the streets; two miraculous survivals, the

facade of Staples Inn in High Holborn and the carved front of Sir Paul Pindar's House from Bishopsgate, now in the Victoria and Albert Museum, though dating from the end of the sixteenth century, give us some idea of how prosperous Londoners lived. On the further side of London Bridge, a considerable suburb had grown up in Southwark, its focal point the tower of St. Mary Overie (now Southwark Cathedral) with the Bishop of Winchester's London residence close beside it. The Thames provided London with its main thoroughfare. Along the Strand, which then was, indeed, the river's margin, were numerous mansions, residences for the prelates and nobility; the road linked the City with Westminster, where the Abbey, the King's palace, and the palace of the Archbishop of York were the main buildings. The countryside around London was green and, in places, still thickly forested; Marylebone and Islington were little more than hamlets, Hampstead, Highgate, and Harrow still hilltop villages.

The great changes, in the capital as elsewhere, came with the Reformation and the Dissolution of the Monasteries. However strong a case may be made out for Henry VIII, the poor and needy, throughout the country, were suddenly deprived of the charity and support which the religious houses had once dispensed; their charge fell upon the parishes, which lacked resources to provide what was required. The monastic churches were closed and, only too often, torn down for their building materials. Sir Miles Partridge won St. Paul's bells when playing dice with the King; he soon sold them to be melted down, while the shrine of St. Erkenwald in the Cathedral was stripped of its adornments. Cardinal Wolsey's palace in York Place became the King's palace of Whitehall. Here and there, parishioners fought to save what they could; the choir, crossings, and transepts of St. Bartholomew's were purchased to become the parish church, though the nave was destroyed by the new owner, Sir Richard Rich. The Mercers' Company acquired the Hospital of St. Thomas Acon and preserved the chapel; the bombs of the Second World War brought to light a superb life-sized figure of the dead Christ which had been concealed, reverently, four centuries earlier to protect it from desecration. Only the recently completed Henry VII's Chapel in Westminster Abbey retained intact its goodly army of carved saints and martyrs; the King might want a Reformation, but he did not intend to worship in a desecrated building.

London's problems were worsened by an extraordinary increase in population during the second half of the sixteenth century; reasons for this expansion are still being debated but a likely estimate would set the figure at 50,000 in 1530, with a jump to close on 225,000 souls by the end of the century. At first, the deserted and half-derelict monastic buildings provided tenements for the homeless; St. Martin's-le-Grand and Whitefriars, soon to be known as Alsatia, became the haunt of thieves and criminals instead of being the habitations of holy men. Then the building began to push out beyond London's walls; John Stow (1525–1605), tailor and antiquary, recorded that the 'fair hedgerows of elm trees, with bridges and easy stiles to pass over into the pleasant fields' to the east of the city, had vanished during his lifetime, to be replaced with 'a continual building throughout, of garden-houses and small cottages, with . . . timberyards, bowling alleys and such like'.

In 1580, Queen Elizabeth passed the first royal edict forbidding any expansion of the capital, and followed it in 1593 with an act prohibiting further growth – an act which her Stuart successors turned to profitable advantage. But these commands were in vain; London began, first to nudge, and then, uncontrollably, to burst its boundaries. That growth has continued for four centuries.

These social problems were only one facet of the sixteenth-century capital. About 1558, an anonymous cartographer produced the first proper map of London; the name of a surveyor, Ralph Agas, who lived a generation later, has become inexplicably but inextricably attached to the wood-cut copy of it. Now, a city which wishes to survey, to contemplate, and to explore itself is a city that is both self-conscious and self-confident. It knows itself and it knows its own worth; London was, rightly, proud of its own identity and was ready to proclaim its importance to the world.

Meanwhile, the activities of the court, centred at Westminster, served as a means of linking the whole area which is today Greater London. Near to the capital, Henry VIII had residences near Chelsea. Kew, Richmond, Hanworth, Kennington, and Eltham; further away, there were establishments at Dartford, Hunsdon, Hatfield, Oatlands, Horsley, Woking, and Chobham, as well as the great palaces at Greenwich, Nonsuch, Hampton Court, and Windsor. He, and his tireless daughter Elizabeth, visited them all regularly on their progresses; the sight of the royal train making its ponderous advance across the Home Counties must have been a familiar one. The cornfields of Heston supplied fine wheat for the Queen's own bread; horsemen posted between Westminster and the Archbishop of Canterbury's residences at Lambeth and Croydon; a curious relic, Oueen Elizabeth's Hunting Lodge, still stands, in excellent repair, at Chingford on the borders of Epping Forest.

With such exceptions as Henry VII's Chapel in Westminster Abbey, St. James's Palace, the Inns of Court, 17 Fleet Street, Canonbury Tower, and, deep below a ministry building in Whitehall, Henry VIII's wine-cellar, we must look outside London for the architectural legacy of the sixteenth and early seventeenth centuries. Palaces – a royal one at Hampton Court, a pair for prelates at Croydon and Fulham, others for noblemen at Hatfield, at Knole, at Audley End – ring London about; manor-houses, such as

Charlton, Boston, and Eastbury, show that the gentry lived quite as comfortably if less magnificently. Church building virtually ceased for a while after the Reformation, as if no one was quite certain how an Anglican church should look, or how it should be planned, but a new emphasis on the importance of the individual gave a fresh impetus to the craft of the statuary. Throughout the Middle Ages, only kings, prelates, and the highest nobility would have been commemorated by life-sized effigies; during the sixteenth century, the minor aristocracy, prosperous merchants, and well-beloved clerics began to be recorded in sculpture, where before they would have aspired to nothing more than an engraved brass. Particularly rich collections of funeral monuments can be found in St. Andrew's Undershaft, St. Helen's Bishopsgate, St. Bartholomew the Great, and St. Mary's church at Harefield in Middlesex, where the Countess of Derby (d.1636) lies, eternally youthful, under a domed and curtained canopy. The quality of these monuments varies greatly, from the wonderful figures which the Italian, Torrigiani, wrought for Henry VII, for his Queen, Elizabeth of York, and for his mother, Lady Margaret Beaufort, in Westminster Abbey, to more homely effigies by forgotten craftsmen, to be found in scores of parish churches, such as that to Alexander Kinge and his spouse in St. Mary's at Finchley, or to Alderman Humble and his two wives in Southwark Cathedral, the first lady plainly clad, the second, who erected the memorial, resplendent in the latest fashion.

Through all these figures there breathes the new humanism of the Renaissance. Out of Italy, there came this double influence, at once emphasizing the vitality of classical literature, architecture, and ornament, and conferring on the individual a new importance. It was three generations before the lessons of classical harmony and proportions were fully felt in British architecture, but on ornament and on decoration they had an early effect. The *putti* around Henry VII's tomb are purely Italian; the timid classical decorations on the capitals to the pillars of More's Chapel in All Saints, Chelsea, bear the date 1528; the strapwork ornamenting the hall screen at Gray's Inn is wholly Renaissance. England was ready to receive and welcome the freshening influence of antiquity.

London's first truly classical building was the Queen's House at Greenwich, begun in 1616 for James I's consort, Anne of Denmark, left unfinished on her death in 1619, and completed at last between 1630 and 1635 for Charles I's bride, Henrietta Maria. Its architect was Inigo Jones (1573–1652), a genius of obscure and humble origins, who had travelled in Italy both under his own auspices and as the protégé and mentor of the second Earl of Arundel. He found favour at the English court, first as a designer of scenery for the masques in which Anne of Denmark delighted, and later as Surveyor of the King's Works. In January 1619, the banqueting hall of Whitehall Palace was burnt down and Jones was

commanded to build a replacement; completed by 1622, it was central London's first Palladian classical building, its white stone standing among the surrounding Tudor brickwork as a lily in an armful of red roses.

From 1631, Inigo Jones was able to apply the same principles of order and proportion to the planning of the Earl of Bedford's estate in Covent Garden. Though James I strove to enforce Elizabeth's edict against new building around London, Charles I was willing - at a price - to grant a licence for a development likely to become an ornament to his capital. Drawing his inspiration from the church and Piazza at Leghorn, and modelling his houses on those around the Place des Vosges in Paris, Jones gave London its first precisely regulated square, and set the pattern for the capital's architectural layout for the next two centuries and beyond. The church on the west side of the piazza was an early attempt at providing an Anglican place of worship; the regularity of the houses was almost immediately imitated on the west side of Lincoln's Inn Fields. Lindsay House (now numbers 59 and 60) still stands there: we cannot be certain that it is Jones's own work, but it was certainly designed under his influence, while in nearby Great Queen Street, the 'first regular street in London', the same Italian manner was observed, albeit in a more rustic, homespun fashion.

The work on the Earl's estate was scarcely complete before England was torn by Civil War. The prologue played itself out at Westminster; Charles I, unable to tolerate Parliament's criticism of his policies, in defiance of all tradition, entered the House of Commons and demanded the arrest of five particularly obstreperous members. His rash action was in vain - the men had already been hurried out of the building and rowed away to safety. Charles left London to raise his standard at York; when he re-entered his capital it was as a prisoner. He was tried, by a court the authority of which he refused to recognize, on charges of 'high treason and high misdemeanour', was condemned to death, and was executed, in the twilight of a cold late January afternoon in 1649, outside the Banqueting House, which Inigo Jones had designed for his father, and where he himself had often danced in the court masques. Immediately after the King's death, Cromwell, finding that his pockets were as empty as his royal predecessor's had been, ordered the sale of all crown estates. The Civil War had left London unscathed, save for trenches and fortification around the western approaches, guarding against an assault from the King's headquarters at Oxford, but this sudden transfer of ownership effected great change. The main royal palaces, such as Whitehall, Hampton Court, and Windsor, were exempted and reserved for the use of the Lord Protector, but the royal hunting

17

park at Marylebone was bought up by a syndicate and, since no man knew how long his tenure might last should Cromwell die and the King come into his own again, all the trees were felled to be sold as timber, their roots were grubbed up, the land ploughed and let out as small farmsteads. Similar upheavals occurred throughout the country, and then, when Charles II was restored to his father's throne in 1660, there was a second turmoil when the crown repossessed itself of its estates.

Scarcely was the King settled on his throne, when London suffered two of the most appalling calamities in all its history. Disease had always been present in the narrow streets and crowded tenements, but the plague which struck in the long, dry summer of 1665 was of a virulence previously unknown. We cannot be certain how many perished; it was perhaps in the order of 100,000. Another hot summer followed, drying out the thatched roofs and timber walls which made up the greater part of the City, so that when, in the early morning of 2 September 1666, a strong easterly wind fanned the flames from a fire in a baker's shop in Pudding Lane, close to the north end of London Bridge, the holocaust spread irresistibly, engulfing four-fifths of the City of London. For four days it raged, unchecked, till a change of wind and the determined action of the citizens, led by the King himself and his brother, the Duke of York, in blowing up buildings to create firebreaks so wide that the flames could not overleap the gaps, made it possible to control and quench the onslaught. St. Paul's was in ruins, the Guildhall an empty shell, 89 churches had vanished, and 400 streets with 13,200 houses and all the public buildings in them were utterly consumed. The bare quarter-century between the outbreak of the Civil War in 1642 and the Great Fire in 1666 was perhaps the most distressing and dislocated period in the whole history of London.

The citizens, camping under the September stars in Moorfields, were at first stunned by the magnitude of the disaster, but, rallied by their monarch, before long City and Court - and indeed all England determined to rebuild a capital more beautiful than it had ever been before. A Fire Court was set up to settle disputes about boundaries, and stringent new building regulations were decreed, with houses to be of brick and stone with tiled roofs. The haphazard. mingled charm and squalor of medieval and Tudor London vanished in the flames; from 1666 onwards, there was some attempt to control what was being built. Designs were drawn up and put forward, proposing that London should be laid out afresh in a more orderly and dignified manner, but, such was the urgency of rebuilding, the medieval street plan was retained with few changes and has endured, more or less intact, to the present day. A young mathematician, almost unknown outside academic circles, was appointed as one of the commissioners for the work; his name was Christopher Wren and he gave to posterity St. Paul's Cathedral and 51 City churches besides. No other English architect has ever been given a harder problem; perhaps no one else could have resolved it confidently, half a hundred times over, with greater originality, versatility, and sheer ability to make the most of some very awkward sites. Of those churches a bare half remain to us, with the towers of seven more; later fires, wartime calamities, shifting of population, and redevelopment have robbed us of the rest.

Inevitably, in the destruction of the City and the confusion of rebuilding, London continued to spread, especially westwards. Before the end of the seventeenth century, St. James's Square, Piccadilly, and Mayfair had been built up. Fires in 1691 and 1698 damaged Whitehall Palace, thereby increasing the importance of St. James's Palace, while William III's preference for Kensington and Hampton Court as royal residences near London encouraged the movement away from the centre, so that Whitehall was left to the civil servants. Speculative entrepreneurs busied themselves with developments, such as those undertaken by Nicholas Barbon in Red Lion

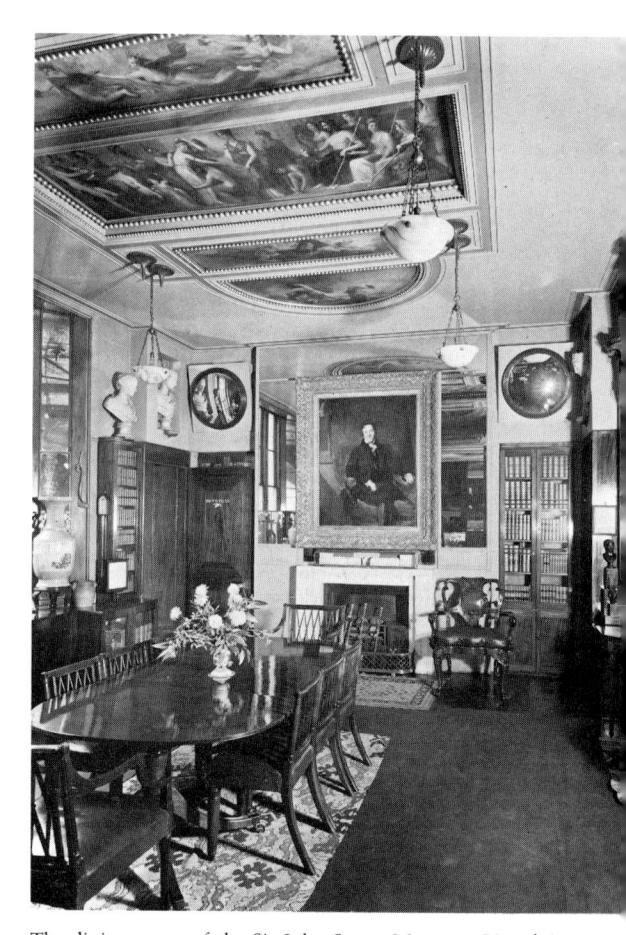

The dining room of the Sir John Soane Museum, Lincoln's Inn Fields

Square and along Bedford Row. The charitable impulses of Charles II and his niece, Queen Mary, resulting in the erection of the Royal Hospital at Chelsea, and of Greenwich Hospital, extended development still further from the centre. The Grosvenor Estate was built up as far as Oxford Street, Bloomsbury was developed by the Bedfords, and the Duke and Duchess of Portland began to lay out their estate in Marylebone with streets and squares of orderly, flat-fronted, well-built houses.

Development of another, less elegant but equally important kind was going on to the east of London; assent to the construction of the Howland West Dock in Limehouse Reach was granted in 1696. London's population increased inexorably, swelled by the craftsmen who arrived from all over the country to help with the rebuilding, and by the arrival of refugees from Europe, such as 30,000 Huguenots from France, who escaped from religious persecution after the Revocation of the Edict of Nantes in 1685. Settling in Spitalfields and in Soho, they brought new skills to their adopted country, in particular that of silk-weaving; the broad windows which lighted their attic work-rooms can still be seen in a few old houses in Fournier Street, and the lustrous products of their looms may be admired in Bethnal Green Museum.

This influx of population meant that more churches were needed to serve the spiritual needs of the newcomers, and in 1711 an act was passed authorizing the building of 50 new places of worship. As it fell out, only a dozen were built, half of them by Nicholas Hawksmoor, the lonely introverted genius who was Wren's assistant. He gave us six Baroque masterpieces – St. Alphege in Greenwich, St. Anne's in Limehouse, St. George-in-the-East in Stepney, St. George's in Bloomsbury, St. Mary Woolnoth in the City, and, strangest building of all, Christchurch in Spitalfields. Happily, in spite of war damage to St. George-in-the-East, all these churches are still with us.

About the first quarter of the eighteenth century, a new influence began to be felt in English architecture. A group of scholarly noblemen, turning away from the Baroque majesty of Hawksmoor's steeples, began to study anew the work of Inigo Jones and the writings and buildings of Andrea Palladio, from whose example Jones had drawn much of his inspiration. In 1725, Lord Burlington began to build a little retreat in the grounds of his family mansion in Chiswick to house his library and art collection; the poised charm of this villa was to influence English architecture for more than a century. He had already, with the help of William Kent, his friend and protégé,

built Burlington House in Piccadilly; despite much alteration and the addition of an extra storey, it is still possible to assess the contrast between this ordered stone façade and the ruddy brick from which much of the new West End was being constructed.

Once introduced, the influence of Palladio was soon felt elsewhere. About 1721, Giacomo Leoni designed Oueensberry House, now the Bank of Scotland, in Burlington Gardens. He emphasized the main façade with applied giant pilasters, running from the first through to the second storey, thus indicating that the rooms were now on the upper level. This device, which had been introduced a century earlier on the façade of Lindsay House in Lincoln's Inn Fields, was for the next hundred years one of the standard features of superior town development, both in London and in the provinces. Such a façade gave unity, cohesion, and monumentality to a terrace of individual houses. The idea was taken up, almost at once (c.1725-35), by the Grosvenor Estate; though the whole of Grosvenor Square has by now been rebuilt, the original east side was planned as a symmetrical unit, while several houses to the north were grouped together behind a shared first-floor portico. For the triumphant fulfilment of these experiments, we must look, not at London, but at Bath, where the ingenuity of the younger John Wood evolved the arrangement of houses in a crescent. This became a standard ingredient in urban layout, used again and again until well into the nineteenth century; in London, Park Crescent is a particularly fine, and Stockwell Crescent an especially neat, example.

The last half of the eighteenth century, and the first quarter of the nineteenth, were perhaps the period of London's most handsome expansion. Though Roman London, in the context of its own times, may have been more magnificent, although nothing surpassed the interiors of Westminster Abbey and Westminster Hall for grandeur, and though the city of spires, which Wren created, may well have been in its day the loveliest in Europe, yet Georgian London has an unsurpassed dignity and self-confidence. We are fortunate that, even today, so much remains.

The key to understanding the London of this period is to remember that the streets and squares and crescents were all planned, sometimes by ground landlords, sometimes by speculative builders with the headlease. The leasehold system had one great advantage; the freeholder was anxious to see well built properties on his estate. Even today, the care and consideration behind the layout of Marylebone, of Islington, or of that part of Paddington around Marble Arch, are still obvious; equally striking examples are to be found south of the Thames where new bridges (Westminster, 1750; Blackfriars, 1760; Battersea, 1773) and broad thoroughfares carried increasing coaching traffic through Southwark and Camberwell towards the coast, the Channel, and the Continent. It was this century that saw the founda-

¹ The other churches were: St. Mary-le-Strand and the steeple of St. Clement Danes by James Gibbs; St. George's Hanover Square, probably St. Luke's, Old Street, and possibly St. John's, Horsleydown, by John James; St. John's Smith Square and St. Paul's, Deptford by Thomas Archer. England's other great Baroque architect, Sir John Vanbrugh, has left little mark on London.

tion of the British Museum (1757) and gave us so many of London's most famous buildings - the Lord Mayor's Mansion House in the City (George Dance the Elder, 1739-53), the Horse Guards (designed by William Kent, executed by John Vardy, 1751-80) in Whitehall, Somerset House (Sir William Chambers, 1776) along the Strand. When Samuel Johnson declared: 'Sir, when a man is tired of London, he is tired of life, for there is in London all that life can afford', he was probably expressing the sentiments of most of his fellow citizens. Interiors salvaged - the Music Room from Brettingham's Norfolk House, formerly in St. James's Square, or Adam's Glass Drawing Room from Northumberland House, which stood where Northumberland Avenue runs today, both now resurrected in the Victoria and Albert Museum – give a darkened reflection of the brilliance and colour which must once have existed.

From the third quarter of the eighteenth century onwards, the influence of Robert Adam and his brothers began to be felt. Though there is little left, besides the name, of their most adventurous metropolitan enterprise, the Adelphi, yet their remodelling and rebuildings of earlier mansions -Kenwood, Syon, and Osterley among them – survive unspoilt, to delight all those who visit them. Graceful Neo-classicism had a charm and lightness not to be found in the work of earlier architects. At the same time, Horace Walpole's antiquarian passion for Gothic architecture soon began to have an effect out of all proportion to the apparent importance of his little country retreat at Strawberry Hill, and these combined influences gave late eighteenth- and early nineteenth-century English architecture an elegance previously unknown.

The long wars with revolutionary and Napoleonic France slowed, though they did not stop, London's expansion. The most significant development was to the north-west. Marylebone Park, where the Tudors had hunted, had been disparked under the Commonwealth and leased out as farm land. The leases were due to fall in in 1811; the forethought, genius and perseverance of three very different men gave London the beauty and grace of Regent's Park. They were a civil servant, John Fordyce, an architect, John Nash, and the Prince who became King George IV. Fordyce preserved the park from encroachment, reserving its development for the crown alone; Nash provided a remarkable plan for the estate, creating a rus in urbe, a city in Arcadia, faced with gleaming stucco like some gigantic wedding cake, which both epitomized the town planning of the previous century and pointed the way to the garden cities of the future; the Prince Regent, though the world judged him to be frivolous and volatile, supported his protégé's scheme through a decade and a half when it was beset with every kind of mischance. The Park is rightly named after him. This development was coupled with the cutting through of Regent Street, linking the Park with Westminster and providing the

future monarch with a via triumphalis through his capital.

The achievement of George IV's regency and reign encouraged metropolitan improvements, accomplished during Victoria's tenure of the throne. Trafalgar Square was laid out and a number of important new thoroughfares, Charing Cross Road, New Oxford Street, and Shaftesbury Avenue among them, were driven through the seamier parts of the capital. Disastrous fires at the Old Palace of Westminster (1834) and at the Royal Exchange in the City (1839) gave fresh opportunities to the architects; Sir Edward Tite built a seemly if uninspired Exchange, while Sir Charles Barry, aided by Augustus Pugin and encouraged by the Prince Consort, achieved the imposing Victorian Gothic Houses of Parliament which we have today. Thomas Cubitt, the most notable of London's nineteenth-century speculative builders, laid out Belgravia for the aristocracy, Pimlico and much of Bloomsbury for the professional and middle classes, and Cubitt's Town in the Isle of Dogs for the dock-workers. A more florid building style replaced the delicacy of Regency architecture.

The Great Exhibition, held in Hyde Park in 1851.

brought visitors from all over England and all over

the world to London. This influx gave an impetus to

the West End, to Oxford Street, and to Knightsbridge as fashionable shopping areas, and left the organizers with such a profit that they were able to buy up those acres in Kensington on which a number of London's great museums - the Victoria and Albert, Natural History, Science, and Geological - stand today. And throughout the century, London grew and grew. When the first full census was taken in 1811, there were roughly 9,000,000 people in Britain, with less than a million in London; by 1900, the population of the capital had increased to 4,500,000, and there were 6,500,000 in the Greater London area. This increase was due chiefly to immigration, both from the provinces - London's first mainline railway terminus had opened at Euston in 1838 - and from abroad; the birth-rate of Londoners did not exceed the death-rate till after 1870. Squalid slums, into which these myriads were herded, bred disease; appalling outbreaks of cholera in the 1830s and 1840s, killing rich and poor alike, emphasized the need for proper public health measures. In 1859, the Metropolitan Board of Works took over the duties of the Metropolitan Buildings Office and the Metropolitan Commission of Sewers; under the direction of the Board's able and determined engineer, Joseph

Bazalgette, one of London's insufficiently sung

heroes, five lines of main intercepting sewers were

built and the Victoria, Albert, and Chelsea Embank-

ments were laid out in place of oozing acres of

foul-smelling Thames mud. The London School

Board, established in 1870, began to wrestle with the

problem of educating London's untaught multitudes:

in 1889, the Metropolitan Board of Works was

replaced by the London County Council, which, in

its turn, became the Greater London Council in 1965. When the Queen-Empress Victoria died in 1901, London was perhaps at its zenith, the hub of an empire, the largest financial and commercial centre in the world; at her accession, the docks had handled £33,000,000-worth of goods, but, before 1900, £252,000,000-worth were passing through annually.

Throughout the centuries, those who could afford to do so moved out of London, at first, as Stow recorded, to the green fields on the perimeter and then out to the suburbs. In his old age, Pepys settled at Clapham, in the house of his friend and former secretary, Will Hewer; in 1762 Sir Robert Taylor completed an exquisite villa, Danson Park, for Alderman Boyd at Bexley Heath, while, at much the same time, Robert Adam was enlarging an older house at Kenwood, near Hampstead, for the Earl of Mansfield; Charles Darwin made his home from 1842 till his death forty years later at Down House beyond Bromley. In 1860, William Morris commissioned his friend, Philip Webb, to design the Red

House for him at Bexley Heath: in 1890, Sir William Schwenk Gilbert moved out to Stanmore to live in Grimsdyke, a house built 20 years earlier by Norman Shaw. Wonderful churches were built, such as the three by I. L. Pearson, St. Michael and All Angels (1871, Croydon), St. John the Evangelist (Norwood), and St. Augustine (Kilburn), All Hallows (1889) at Gospel Oak by James Brooke, or Christchurch (1872–7) at Bexley Heath by William Knight, or St. Mary Magdalene (1868), gloriously eccentric, by Buckton Lamb at Croydon, or St. Mary the Virgin (1904) at Great Warley by Harrison Townsend, and St. Peter's (1893) at Ealing by J. D. Sedding, both fascinatingly Art Nouveau. Students of nineteenthcentury English architecture must be prepared to explore the outskirts of London.

London has changed, more and faster, during the first three-quarters of the twentieth century than it had done during the previous nineteen centuries. By 1900, the square mile of the City had become 117 square miles of the County of London; in 1965, the new Greater London Council began to administer

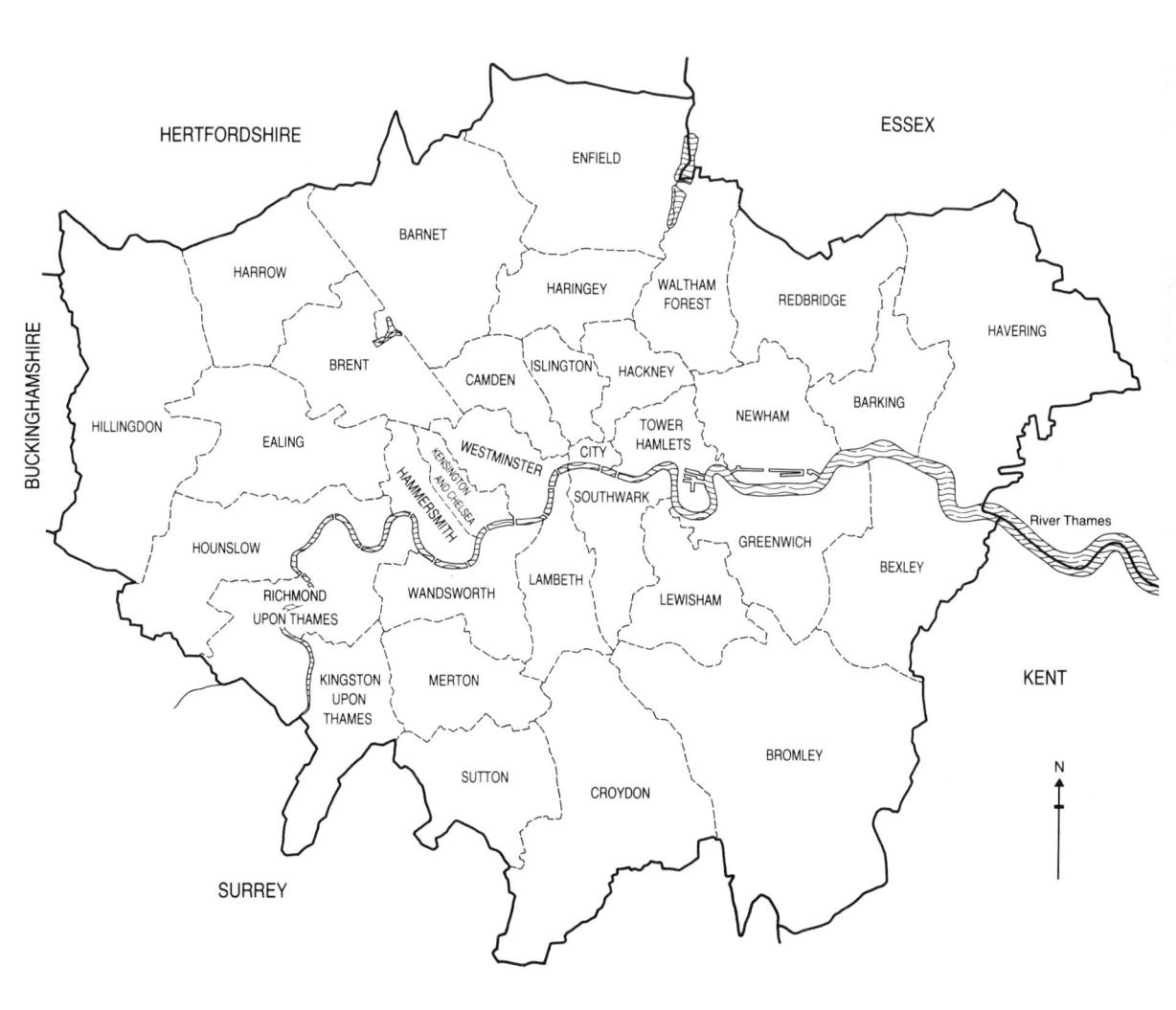

some 616 square miles; Middlesex, a sixth of Essex, and parts of Kent, Surrey, Hertfordshire, and Buckinghamshire had all been rolled into Greater London, an area with a population of over 8,000,000 people. At the beginning of the century, the railways carried millions to and from work; during the 1920s and 1930s, arterial roads began to be built across London's countryside to accommodate the newcomer. the motor-car. New suburbs sprang up, engulfing older village centres; some, like South Harrow, were developed in straight rows of houses, each with a small back garden, while others, like Hampstead Garden Suburb, were laid out more spaciously, with winding roads well planted with flowering trees. Only the London County Council's determination to establish a belt of green country around London, reinforced by the slump of the 1930s, imposed some restriction on this expansion.

The First World War did little to change the face of London, though social life in the capital altered sharply after 1918. Perhaps the most noticeable practical change was the general employment of women in offices; residential servants became harder to find and to retain; flats began to replace houses. In the Second World War, London faced its first effective assault since the Danes came up the Thames in 1015. The Blitz of 1940 and the flying bombs of later years devastated huge areas of the City, the docklands, and the suburbs, making possible some slum clearance and necessitating much rebuilding. Even during the War, plans were being prepared for a new city; in 1943, Abercrombie and Forshaw published their plan for the County of London, a year later, Abercrombie's Greater London Region appeared, and in 1946 Holden and Holford produced the City of London Plan. New towns -Stevenage, Basildon, Milton Keynes - were created to deal with the mass of population. Slowly and painfully, its progress dogged by labour problems, the area north of London Wall began to develop into the extraordinary but fascinating urban landscape of the Barbican; the Guildhall received a magnificent stone vault, roofed outside with golden Collyweston tiles, as well as an exciting new extension to accommodate offices, the library, and the archive,

print, and map collections. London acquired its own museum, set high on London Wall. Tower blocks began to sprout in the City, dwarfing St. Paul's and making nonsense of what was left of Wren's skyline. The use of the London docks declined. Mayfair began to turn into an area of expensive offices and flats, accommodating an aristocracy of money every whit as exclusive as the old aristocracy of birth and breeding. L.C.C. and municipal housing developments concentrated on the building of tower blocks till the collapse of one of them, Ronan Point in 1968. brought home the dangers of the method, and more humane developments, such as Lillington Gardens (Darbourne and Darke, 1972) off the Vauxhall Bridge Road, became the rule. Expensive town houses, such as those in the smaller streets off the Bayswater Road near Marble Arch, and the smarter suburban developments like those executed at Ham and at Wevbridge by the Span group of architects, returned to having their drawing-rooms on the first floor, a good part of the ground floor now being occupied by the garage. Churches, such as St. Mark's at Biggin Hill planned by the Reverend Vivian Symonds, were built, as reverently and with as much beauty as in the Middle Ages or Wren's day. Vociferous public outcry prevented the redevelopment of Piccadilly and Covent Garden; it remains to be seen whether renovation will produce the desired results but so far. at Covent Garden at least, the signs are hopeful. The closure of London's docks offers a remarkable opportunity for humane and imaginative redevelopments.

As always, the future is dark. We do not know how London will look a generation hence, as we enter the twenty-first century, still less what sort of city it will be in four generations' time, as we reach the year 2100. But a city which has grown for 2,000 years, and has renewed itself after each crisis – after the destruction meted out by Boadicea's tribesmen, after the Roman withdrawal, after the vicissitudes of the Middle Ages, after the disaster of the Plague of 1665 and the holocaust of the Great Fire a year later, after the fiery hail of the 1940s Blitz – is capable of withstanding another couple of millennia. London is still a proud city.

THE CITY OF LONDON

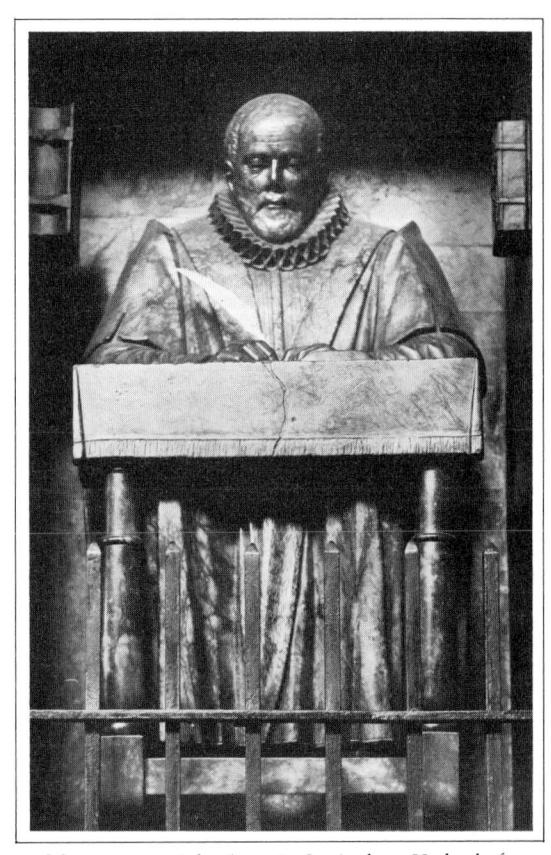

Monument to John Stow in St. Andrew Undershaft

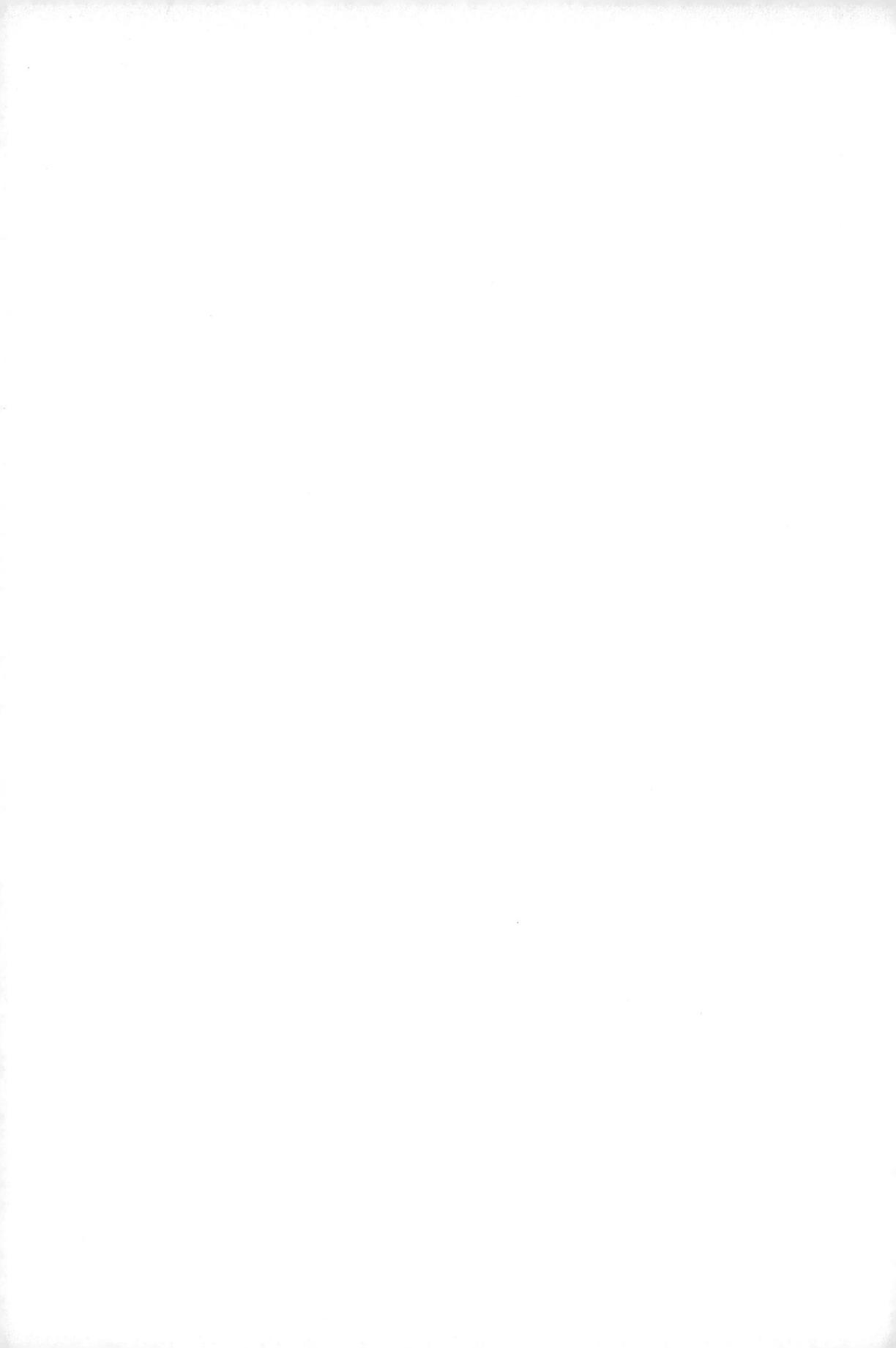

Fleet Street and the Temple

From earliest times, Fleet Street has been London's main approach road from the west, and it is from here that our exploration of the square mile of the City should begin. Despite the passage of time, despite fire, bombing, and redevelopment, the City of London has retained its medieval street pattern, a pattern that was probably laid down in the centuries before the Norman Conquest, superimposing itself upon the plan of the earlier Roman city and virtually obliterating it. This medieval street pattern is, only now, beginning to be eroded by the construction of the riverside main road and underpass.

One can walk across the City from north to south or from west to east in less than 30 minutes, but to know it thoroughly needs a lifetime of patient and loving observation. Into its square mile are packed buildings of historical, artistic, or architectural importance, crammed so closely that a street-by-street exploration and examination become necessary. The City is the oldest, the longest-inhabited part of London; memories and information about our past and ourselves are more thickly concentrated here than in any other part of the whole Greater London area save, possibly, the enclave around Westminster Abbey and Palace.

In order to render manageable an exploration of this enthralling but intractable city, it has been divided almost, but not quite, arbitrarily into nine sections, with a chapter devoted to each. One chapter, the second, centres upon St. Paul's cathedral, concentrating on one building and its immediate surroundings; the others take groups of streets that may conveniently be explored in a long morning's or afternoon's walk.

FLEET STREET runs from Temple Bar to Ludgate Circus. The roadway is narrow – absurdly so for the tide of traffic which surges along it today – and the buildings on either side are high. The river Fleet, which lends its name to the street, flows out of sight

beneath New Bridge Street, joining the Thames by Blackfriars Bridge. In spite of the buildings, the steep incline of the banks is still apparent – it can best be appreciated from Holborn Viaduct; from these slopes, the neighbourhood to the north took its name of Holborn, the bourne in the hollow.

The City boundary is marked by a curious square pillar; designed by Sir Horace Jones, it supports figures of Queen Victoria and the Prince Consort (by Sir Edward Boehm) and is surmounted by the City's dragon (by C. B. Birch). It was set up after Wren's post-Fire Temple Bar was dismantled in 1878 to be re-erected at Theobald's Park in Hertfordshire. It is here that the sovereign, about to enter the City, pauses and waits to be received and admitted by the Lord Mayor who, within the boundaries of the City, takes precedence over all others save the monarch alone. On ceremonial occasions, the Lord Mayor presents the City Sword, point downwards, to the Queen and, receiving it back, causes it to be borne in procession before her. The sword is that of Sir James Yerwood, purchased by the City in 1520 and used

Just beyond Temple Bar, on the north side of Fleet Street, stands St. Dunstan's church. Probably of pre-Conquest foundation, the medieval church, where William Tyndale, translator of the Bible, had served as lecturer, escaped the Fire through the efforts of the boys of Westminster School, but by the early nineteenth century it had become dilapidated and was demolished in 1829. A new church, set back in the former churchyard to permit road widening, was erected in 1831-3 to the designs of the elder John Shaw, the work being completed after his death by his son. The church has a square tower to the south, surmounted by an octagonal lantern with tall thin Perpendicular windows - presumably inspired by the tower of All Saints' Pavement in York. A clock projects on a bracket from beside the tower; it was made in 1671 by Thomas Harris at a cost of £35, and was the first in London to have a minute hand; in an alcove behind it two figures strike the hour with hammers. When the church was demolished, the clock and figures were purchased by the Marquis of Hertford, who set them up in the garden of his villa in Regent's Park; they were restored to the church in 1934 by Lord Rothermere. Below the clock is a memorial designed by Lutyens, with a bust by Lady 26 THE CITY

Hilton Young, to Lord Rothermere's brother, Lord Northcliffe. Over the vestry porch, in a recess, stands a figure of Queen Elizabeth I, made about 1586 by William Kirwan, which used to stand on Ludgate. When the gate was demolished in 1760, the figure of the Queen, in company with statues of King Lud and his two sons, were brought to the church, where they have remained ever since, the king and his offspring standing in the vestry porch.

St. Dunstan's is entered through a porch under the tower: inside, dramatic vaulting emphasizes the octagonal shape. The south porch is matched on each of the other seven sides by recesses, roofed over alternately with tunnel and rib-vaulting; above each recess is a clerestory window. The altar is placed directly opposite the entrance on the north side and has a fine surround of sixteenth-century Flemish woodwork. The north-eastern alcove is filled with an early nineteenth-century icon screen, which was brought from the monastery at Antim near Bucharest in 1966 by the Patriarch of Romania for the use of the Romanian Orthodox Congregation in London. Most of the monuments came from the old church. The earliest is a brass with figures of Henry Dacres and his wife Elizabeth; he had been 'a Cetezen and Marchant Taylor and sumtyme Alderman of London' and she died in 1530. Gerard Legh (d.1563) and his wife, Cuthbert Fetherstone, King James's doorkeeper (d.1615), Elizabeth North (d.1612), and William Morecroft (d.1657) all have small figures or busts, Elizabeth North's effigy being surrounded with very pretty decorations and having three small children kneeling beneath. The two Sir Richard Hoares,

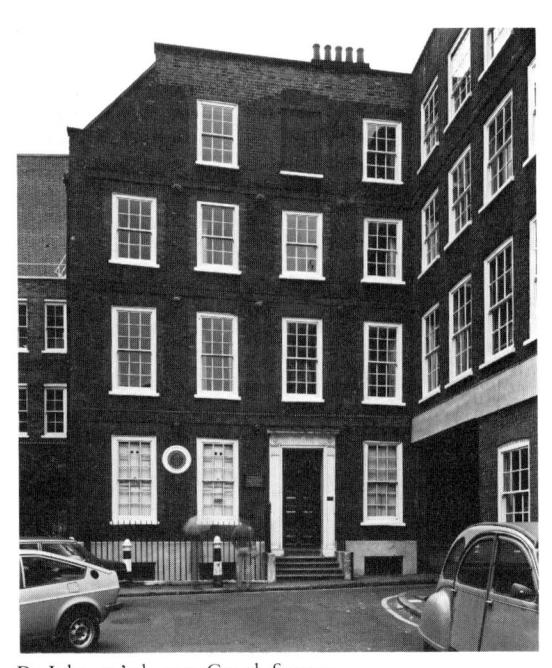

Dr Johnson's house, Gough Square

both Lord Mayors (d.1718 and 1754), have grander monuments, a tablet with *putti* by Thomas Steyner for the older man and a sarcophagus with a cherub and a portrait bust for the younger. Two plain tablets commemorate men of different professions; that to the swordsman, Alexander Layton (d.1679), has the couplet:

His Thrusts like Lightning flew, more Skilful Death

Parr'd 'em all, and beat him out of breath, and another to an 'Honest Solicitor' ends:

Go Reader and imitate Hobson Judkin.

The worthy Mr. Judkin died in 1812. In the southeast alcove lies a bust of a youth, Edward James Auriol, who was drowned in the Rhône in 1847; his father was rector here. A stained-glass window, inserted in 1895 by the Angling Society, commemorates Izaak Walton, who held the offices of 'Scavenger, Quitsman and Sidesman' at St. Dunstan's from 1629 till 1644. Since 1962, St. Dunstan's has been a guild church, serving the needs of week-day office workers; it is also the headquarters of the Guild of All Souls, founded in 1873 to pray for the dying and the repose of the souls of the dead.

Just behind the church stood Clifford's Inn, established in 1345. Unscathed in 1666, the Fire Judges met there to settle boundary claims. The Hall was rebuilt in the late eighteenth century, but everything, save for one modern gateway, was demolished in 1935. The panelling from number 3 was acquired by the Victoria and Albert Museum; flats and offices now stand on the site.

The alleyways and courtyards with names more poetical than their present-day appearance — Hen and Chicken Court, Fleur-de-Lys Court, Crane Court, Three Kings Court, and Wine Office Court — all recall former hostelries. Number 145 Fleet Street is Ye Olde Cheshire Cheese, built about 1677 and still much frequented. The walls are lined with dark panelling and it is claimed, though Boswell does not confirm the suggestion, that Dr. Johnson often came here. That he may have done seems most reasonable for, barely 100 yards northwards, lies 17 Gough Square, where Dr. Johnson lived from 1748 to 1759, while he wrote the *Dictionary* which made his name. From here, he also issued *The Rambler* from March 1750 till 1752, and wrote *Irene*, a tragedy which

¹ After the Second World War, it was realized that the contrast between the huge daytime population of the City and the shrunken resident population required special measures to meet religious needs. The City of London (Guild Churches) Act became law in 1952 and was put into operation two years later. Some churches remained parochial, others became 'guild' churches, usually closed at weekends but very active during the week, especially with lunch-time congregations; most guild churches accepted special responsibilities. In the pages that follow, each church is described as 'parish' or 'guild' without further explanation; where relevant, special activities and duties are noted.

FLEET STREET AND THE TEMPLE Holborn Holborn Circus St. Andrew* Temple Flore Henry 8 Room Temple Holborn Temple Flore Henry 8 Room Temple Holl The Temple Noticona Embanisment Noticona E

David Garrick, Johnson's former pupil, produced with conspicuous lack of success at Drury Lane. The house, some four bays wide, was peculiarly apt for Johnson's purpose, for across its width ran an attic where he installed the five or six amanuenses whom he employed. Here his wife died in March 1752 and here he was visited by Boswell, Garrick, Goldsmith, Dr. Burnley, Sir Joshua Reynolds, many other friends, and a swarm of aspiring writers. The house became a shabby hotel till in 1911 Lord Harmsworth bought, renovated, and presented it to the nation, as a museum. Restored again after bomb damage in 1940, 1941, and 1944, 17 Gough Square is open on weekdays. The rooms are carefully furnished and the atmosphere remains that of a private house.

Returning to the north side of Fleet Street, the façades of the offices of the Daily Telegraph (Elcock and Sutcliffe with Thomas Tait, 1928) and the Daily Express (Ellis and Clarke with Sir Owen Williams, 1931) provide a contrast. When new, both were considered stylistically advanced; neither seems particularly attractive today. This is the heart of the newspaper world and it is sometimes possible to visit the offices of one or other of the national papers. Such a visit is usually made in the evening, since the deadline for the daily press is about 10.00 p.m. As the time approaches, tension begins to mount

throughout the building, lest some late news should come in, requiring a readjustment of the headlines. By midnight, it is possible to sit in one of the cafes – they keep late hours in Fleet Street – and read the next day's news, a slightly uncanny experience.

Crossing to the south side of Fleet Street, the easternmost building is St. Bride's church. It is the eighth church to stand here. Wren's exquisite creation having been reduced to a smoking shell on the terrible night of 29 December 1940. But the destruction gave an opportunity to London's archaeologists. who, led by Professor Grimes, uncovered the remains of an unspecified Roman building, perhaps the only one to be built between the City and Westminster, and of a sixth-century church, the earliest certain Christian place of worship to be found in London. The medieval church, in which the printer Wynkyn de Worde and the poet Richard Lovelace were buried and in which Samuel Pepys was baptized, disappeared in the flames of 1666: in its place Wren built another, giving it the tallest and loveliest of all his steeples. Rising from a square tower, it soars up through four open, airy, octagonal stages to end in a delicate spirelet. The story is told of a parishioner, a confectioner called Rich, who, inspired by the steeple, created wedding cakes in tiers of diminishing size, and made his fortune thereby. The tale is probably apocryphal, but his wife's best gown is still on view in the crypt and it is a stylish dress for a confectioner's spouse.

Wren built his church five bays long with galleries, round clerestory windows, and rich furnishings - it cost £11,430.5s.11d, the dearest of any save for St. Laurence Jewry and Christ Church, Newgate Street. In it Samuel Richardson, the novelist, who lived nearby in Salisbury Square, was buried, as were the wife and children of John Nichols, the antiquary. After the bombing which left standing only the outer walls, the tower, and the steeple, the restoration was undertaken by Godfrey Allen, Wren's successor as Surveyor to the Fabric of St. Paul's, and the press from all over the world contributed generously, for St. Bride's is the parish church of Fleet Street and of newspapermen everywhere. Wren's arrangement of a tunnel-vaulted nave with groined aisles was retained, but the galleries were not rebuilt. The aisles have been left open but, between the giant Corinthian columns which carry the vault, two open screens of square, fluted Corinthian pillars have been placed, separating the nave from the aisles, and the seating has been arranged in collegiate fashion, facing inwards. At the west end, two more screens serve to make the nave chapel - for that is what the space amounts to - still more intimate; each is surmounted with a statue by David McFall, St. Bridget to the south and St. Paul to the north. Beyond them is a minstrels' gallery with a splendid modern royal coat of arms and behind the west wall, out of sight from the body of the church, is the organ presented by Lord Astor of Hever and made by Compton's. At the

28 THE CITY

east end, a superbly carved oaken, segmental-headed reredos with coupled Corinthian pillars, modelled quite consciously on those designed by Wren, stands in front of the shallow recess which used to serve as chancel. Between the capitals is an ellipse of stained glass depicting Christ in Majesty; it is the work of Glyn Jones, who also painted the Crucifixion hanging above the altar, as well as the figures of Moses and Aaron on the walls behind the reredos and the celestial choir above: here, he has achieved a remarkable trompe l'oeil effect for, though the wall is flat, it appears to be a curved apse. The plain font has a cover modelled on one of Wren's alternative but unexecuted designs for St. Bride's steeple; beside it stand two Charity Children from the former nearby school, and on the wall is a tablet recording that the parents of Virginia Dare, the first English child to be born in America, were married here. St. Bride's has another American association for Edward Winslow. one of the leaders of the Pilgrim Fathers and three times Governor of Plymouth, Massachusetts, was a parishioner and his parents were married here too.

In the crypt the archaeological remains of the earlier churches and of the Roman building can be seen, surrounded by an impressive exhibition, arranged by John Lansdell, telling the history of the area. The modern fountains in the churchyard were given as a war memorial by the Fleet Street branch of the British Legion. Behind the church stands St. Bride's Institute, in the library of which there is an excellent collection of material on early and fine print-

Daily Express building, Fleet Street

ing. The institute also possesses a handsome collection of old printing presses.

Southwards, facing the river, is Sion College with its splendid theological library, founded in 1632 under the will of Dr. Thomas White, once vicar of St. Dunstan's. It had its first premises on London Wall on the site of Elsing Spital, and moved on 1886 to the present red-brick building designed by Sir Arthur Blomfield on the Embankment. Beside it stand the City of London School for Boys and Unilever House. The latter was built in 1930–1 by J. Lomax-Simpson to an unusual plan, for the main façade follows the curve of the Embankment where it joins New Bridge Street. The ground floor is heavily rusticated, there are huge columns above, and several large pieces of sculpture by Sir William Reid Dick. Unilever House stands on part of the site of Bridewell Palace, built for Henry VIII around three courtvards and given by his son, Edward, to the City of London to serve as a house of correction.

Westwards, beside the river and behind the façade of shops and offices in Fleet Street, shielded from the hubbub of traffic, is the peaceful enclave of the TEMPLE. The Order of the Knights Templars was founded in 1118, its members pledged to the defence of travellers to the Holy Land. A provincial headquarters was set up in England off Chancery Lane, but in about 1180 the Templars moved to the present site, where they built a church, consecrated in 1185, circular in shape like the Church of the Holy Sepulchre in Jerusalem,1 and beside it a Great Hall and living accommodation. The Order was dissolved in 1312; their buildings were handed over to the Knights of St. John who, during the fourteenth century, leased some of the ground to the lawyers, who have remained here ever since. The Reformation did not disturb them and in 1608 James I granted the land in perpetuity to the benchers of the Inner and Middle Temple.

Though the two institutions are quite distinct, the precinct must be considered as a single entity. The buildings range from the twelfth to the twentieth centuries, yet all are in harmony with each other. It is like an Oxford or Cambridge college though much larger, and must be explored at leisure and on foot. One may enter through the Gateways of the Inner or the Middle Temple, the latter probably designed by Roger North, a talented gentleman, a lawyer, a writer, and an administrator, as well as an amateur of architecture. It was built in 1684, of brick with huge Ionic pilasters and a pediment. The Inner Temple Gateway is even more interesting. Built of timber, plaster, and some brick, it has over it the apartment known as Prince Henry's Room. There was an inn here, the Hand, in the sixteenth century, but in 1610 its publican applied for permission to

¹ There are other round churches in England, at Cambridge, Northampton, Ludlow Castle, and Little Maplestead, and the Hospitallers built one at their House of St. John in Clerkenwell; see p. 292.

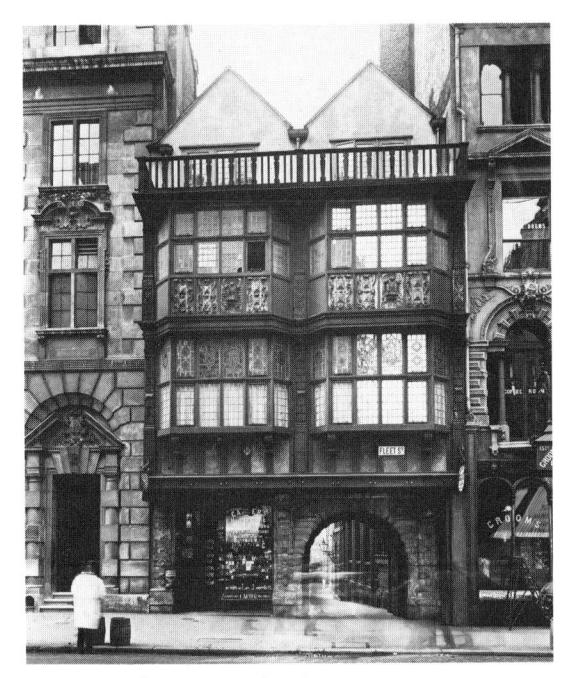

Inner Temple gateway, Fleet Street

extend his premises. When the work had been carried out, the tavern was renamed the Prince's Arms, in deference to James I's eldest son, Prince Henry. It has long been claimed that the council of the Duchy of Cornwall met here but there is no documentary evidence to support the legend; the Prince of Wales is also Duke of Cornwall. The room over the gateway is, however, very fine, with panelled walls and a superb plasterwork ceiling adorned with flowers and the Prince of Wales's feathers, comparable with those at Forty Hall, Enfield, or Boston Manor near Osterley (see p. 287). The house was renumbered 17 Fleet Street; from 1795 till 1816 it housed Mrs. Salmon's waxworks exhibition, which inspired Charles Dickens in The Old Curiosity Shop, but by the end of the century, it had grown so dilapidated that it seemed due for demolition. In 1898 the recently established London County Council acquired the building, restored it, and now the first-floor room is open to the public each afternoon. A grating in the window bay enables a watcher to see into the street without being seen himself.

Once within the Temple, the church should be visited. The Round Church was consecrated in 1185. Its west doorway is under a magnificent deeply recessed, round-headed arch, but inside, the inner circle of six pillars, supporting the clerestory, has pointed arches. Each pillar has four shafts, two stout and two slender, and is of Purbeck marble, this being the first time that this stone was used extensively for a building in London. In the building, Norman or Romanesque architecture exists side by side with Gothic; there is no antipathy between the round and

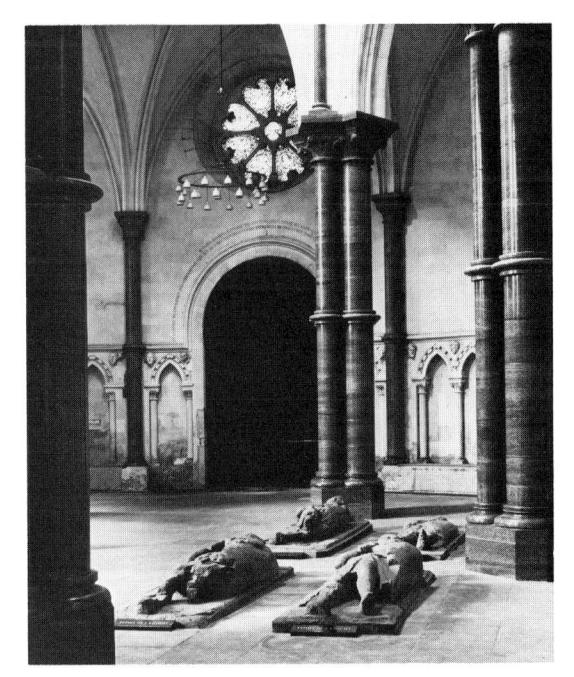

Round nave of the Temple church, Fleet Street

the pointed arch. About the walls is a blank arcading, and the roof of the ambulatory around the circular inner space has rib vaulting. Above the central pillars is the triforium and then the clerestory; the triforium is decorated with a blind arcading of intersecting arches with Purbeck colonnettes. On the floor in the centre lie the effigies of eight knights in armour, memorials to great benefactors of the order. On 10 May 1941, in the last raid of the Blitz, the Temple church was reduced to a ruin and the effigies were greatly damaged, but they have been repaired skilfully. William Marshall, Earl of Pembroke (d.1219), and his sons, William and Gilbert, lie on the south side, and Geoffrey de Mandeville (d.1144) on the north. In the south ambulatory, another figure, that of Robert de Ros (d.1227) escaped with little damage. The font dates from 1842 and is a copy of a transitional Norman one at Alphington near Exeter, while most of the small carved heads around the aisle arcade are of the same date.

The Round Church probably had, originally, a shallow chancel, but between 1220 and 1240 an oblong eastern choir was added and was consecrated on Ascension Day 1240 in the presence of Henry III and his court. Beautifully proportioned, with elegant Purbeck pillars (four attached shafts around a central column), it was designed on the hall principle, that is, the aisles are of the same height as the nave. The height to the vault is 36 feet 3 inches and to the capitals of the pillars 20 feet 10 inches, that is, roughly, a ratio of 3:2, a most satisfying balance. The vaulting has thin, delicate ribs and there are lancet windows in sets of three, the central light being taller

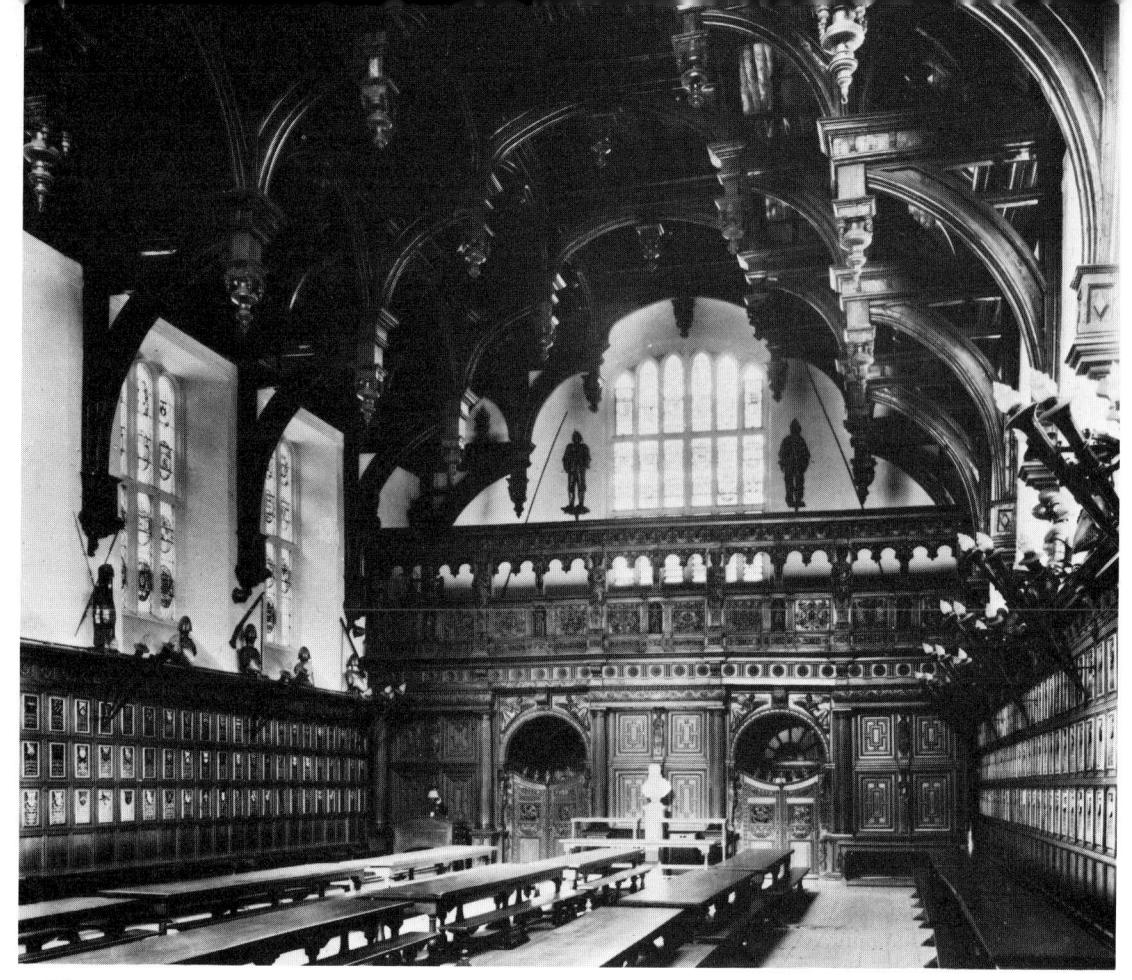

Middle Temple Hall, Fleet Street

than those on either side. The bomb damage was felicitously restored by Walter H. Godfrey. The whole church, though it had escaped the Fire, had been refurbished by Wren, who had designed a handsome reredos which, in the middle of the last century, was banished as being inappropriate. It was the work of that excellent carver, William Emmett, and he was paid £45 for his labours. Fortunately, the reredos found its way to Bowes Castle Museum, from whence it was returned to the Temple in 1953. The reredos is broad, with the Creed, Ten Commandments, and Lord's Prayer inscribed upon it. Fluted pilasters with Corinthian capitals separate the texts and between them hang garlands of flowers; two cherubs' heads nestle beneath a segmental pediment. Bombing also destroyed the Victorian window-glass but it has been replaced triumphantly by Carl Edwards, whose achievement recalls the medieval work at Canterbury in the richness and vividness of its colouring.

A double marble piscina is set in the southern corner at the east end; a staircase with slit windows, at the northern junction of the Round Church with the Choir, leads up to the Pentitential Cell in which

erring Templars were allegedly incarcerated. Despite the flames of 1941, three important monuments were saved. The earliest, in the south aisle of the choir, is a full-length Purbeck marble figure of a bishop wearing his robes. It is uncertain whether he is Sylvester de Everdon, Bishop of Carlisle, who was killed by a fall from his horse in London in 1255, or the Patriarch Heraclius of Jerusalem, who consecrated the church in 1240. When the tomb was opened in 1810, the skeleton of a child was found in the coffin beside the remains of the bishop; it seems probable that the infant was William Plantagenet, Henry III's baby son, who died in 1256. Two lawyers have fine tombs. Edmund Plowden (d.1584) has an alabaster effigy under a most elaborate canopy. Treasurer to the Middle Temple and one of the most learned men ever to have practised jurisprudence in England, it was he who first made detailed reports of cases, which provided other lawyers with permanent sources of reference. His adherence to the Catholic church prevented him from reaching the highest offices, but this abstinence from public service gave him more time to devote to the affairs of the Middle Temple: the Great Hall was built during his treasurership. He

was buried in a Protestant church at his own request, for he wanted to lie among the buildings and institutions he had served and loved. Richard Martin, Recorder to the City of London (d.1618), kneels near him, a jovial Latin epitaph on his tomb ending in a prayer for endless time for lawsuits. Near the south door, a glass plate covers a black stone slab marking the resting place of the great jurist, John Selden. The Temple Church is, like Westminster Abbey, a royal peculiar, which means that its clergy are not under the control of the Bishop of London but are answerable only to the Queen and to the Archbishop of Canterbury.

The rest of the Templars' buildings were gradually replaced by others more suited to later occupants. Two Halls were built, one for the Inner, the other for the Middle Temple. The Inner Temple Hall, rebuilt in the nineteenth century, was bombed during the Second World War. A handsome new Hall, its walls decorated with the coats of arms of those who have been treasurers here, was built to plans by Sir H. Worthington and T. S. Sutcliffe, with Sir Edward Maufe as consultant. Lit by modern silver candelabra, in the musicians' gallery hang some of the 22 portraits of those judges who sat in the Fire Court to settle boundary claims after the Great Fire of 1666; they were commissioned by the City Corporation from Michael John Wright. There is also a fine collection of silver. The weather-vane of the Hall is a winged horse, the Inner Temple's own badge; this sign was originally a horse bestridden by two Templars, symbolizing community of property between the brethren, but later generations misinterpreted the sign and a Pegasus developed. The terrace outside the Hall looks across a well tended lawn to the river, and it was in these gardens that the chroniclers place the fatal quarrel between Richard Plantagenet and the Earl of Somerset which began the Wars of the Roses (see Shakespeare, Henry VI, part I, act II, scene 4), the red and white blossoms being plucked from the lawyers' bushes.

All around the Hall are a variety of buildings of differing ages, accommodating for the most part lawyers' offices and chambers. One range, King's Bench Walk, is of particular interest, for the northern half, numbers 1–6, was designed by Sir Christopher Wren. Number 1 has been rebuilt save for the doorway. The southern half of the range is later – number 7 c.1685, number 8 dated 1782, numbers 9–11 of 1814 by Sir Robert Smirke – but still very dignified. This is a magical place in which to walk of an evening when the gas-lamps are lit, whether in summer or in winter. Charles Lamb was born nearby, in Crown Office Row; he loved the Temple all his life and in old age wrote of it proudly: 'A man would give something to have been born in such places.'

The westernmost third of the precinct is the Middle Temple – the Outer Temple, granted to the Bishop of Exeter in the fourteenth century, was long ago built over. The badge of the Middle Temple is a

lamb and its glory is its Hall, begun in 1562 during Plowden's treasurership and completed in 1570. Though bomb-shattered in November 1940, by skill and with determination it has been wonderfully restored. 101 feet 3 inches long, 40 feet 9 inches wide and 57 feet 6 inches at its loftiest point, the Hall has the finest double hammerbeam roof in England and a magnificent screen at its lower end. This is in five sections, carved all over with Renaissance exuberance, the second and fourth being round-headed doorways, and above is a gallery with a frieze of figures along it. A bust of Edmund Plowden, carved in 1868 by Morton Edwards, very properly stands in front of it; along the walls are coats of arms of those who have been readers here since 1597 and there is heraldic glass in the windows. Helmets and cuirasses enliven the window-ledges, though no one is certain how they came to be here, and at the west end of the Hall hang portraits of Queen Elizabeth, Charles I (studio of Van Dyck), Charles II, James II (attributed to John Riley), William III, Queen Anne (both by Thomas Murray) and George I (by Enoch Seeman). The three tables in the Hall should be noticed. At the west end, on a dais, is the Benchers' table for the senior members of the Inn. It consists of three planks, each running its full length, and is 29 feet 4 inches long and 3 feet 2 inches wide. Made from a single oak tree grown in Windsor Forest, it was given by Queen Elizabeth I, who delighted to dine here. In this Hall, she watched Twelfth Night, newly written by Shakespeare for the occasion, on 2 January 1601. Below the Benchers' table stands another, the Cupboard, made from the timbers of the Golden Hind, in which Sir Francis Drake circumnavigated the globe. He dined in Hall here, on 4 August 1586, a few days after his glorious return. It is on this table that newly qualified barristers sign their names in the volume which contains the Middle Temple's roll of members. On the floor of the Hall is a third table, the Ancients' table, reserved for the use of the eight senior barristers in Hall who are not Benchers. Provided application is made well beforehand to the Treasurer, it is usually possible to visit the Hall.

The Middle Temple's library was established with the collection bequeathed by Robert Ashley in 1641. In addition to the books, there is a remarkable pair of globes, celestial and terrestial, made by Emery Molyneux about 1600. In addition to its holdings on English law, the library specializes in American law and the law of the European Community. The interest in American law is due, in part, to the long connection between the Middle Temple and the New World, for Sir Walter Raleigh, who organized the first attempt to colonize Virginia, was a member, as were five of the men who signed the Declaration of Independence in 1776. The Declaration itself was drafted by a Middle Templer, John Dickinson, the 'Penman of the Revolution', and yet another, John Rutledge, drafted the Constitution on which the government of the United States still depends.

St. Paul's Cathedral

During the night of Sunday, 2 September 1666, a fire broke out in a baker's shop near London Bridge (see also p. 89); by morning it had spread through the neighbouring streets, and it was not until Wednesday that the flames were brought under control. By then, four-fifths of London had been destroyed. The Guildhall, 89 churches, 13,200 houses, 44 City company halls, and London's pride, St. Paul's Cathedral, were all in ruins. The resolution and inventiveness shown by the King, the City Fathers, Sir Christopher Wren, the masons and joiners, and the ordinary people of London throughout the rebuilding that followed make up one of the most astonishing episodes in London's history.

Before describing the rebuilding of the cathedral, a brief account of its earlier history may be useful. In AD 604, St. Augustine consecrated Mellitus, who had accompanied him from Rome, as Bishop of the East Saxons, and it was he who built the first wooden church on the summit of one of London's twin hills. Before the end of the century, it had been built again in stone by Erkenwald, Bishop of London; after his death, he was canonized and his tomb became a shrine and a place of pilgrimage. His body was saved from two later disastrous fires, which necessitated further rebuildings of St. Paul's in 962 and 1087. By the later date, Maurice, William the Conqueror's chaplain, was Bishop; the cathedral, which he planned and which subsequent generations completed, was of a size almost without parallel in Europe. The choir was in use by 1148, and the nave was completed before the end of the twelfth century. The spire was built between 1220 and 1240, and then in 1258 it was decided to rebuild the choir in the airy Perpendicular style in which Henry III was refashioning Westminster Abbey. A chapter-house was added in the precincts by William of Ramsay in 1332. When the great building was at last completed, it was 585 feet long and 290 feet wide across the transepts. The spire reached 489 feet into the air and was one of the wonders of Europe. Of all the churches in England, only that of the great abbey of Glastonbury approached it; of cathedrals in Europe, only Seville and Milan excelled it.

The maintenance of so large a fabric was a serious responsibility, especially since the citizens of London were inclined to treat their cathedral as a general meeting-place, in the way a main piazza might be

used in a sunnier climate. Although Queen Elizabeth rode in triumph to St. Paul's to give thanks for the defeat of the Armada in 1588, yet the great church was already beginning to decay, as can be seen in the Society of Antiquaries' diptych of the building, and in 1620 James I set up a royal commission to inquire what could be done to remedy the trouble. Eventually, Inigo Jones, the King's Surveyor, was put in charge and he, at a cost of £100,000, encased the nave in Portland stone, masking the original shape of the windows to give, from the outside, a classical appearance: at the west end he set up a great portico with Corinthian columns, increasing the length of the building to 625 feet. The work was scarcely completed when the Civil War between King and Parliament broke out in 1642.

One man acted with foresight. The antiquarian, William Dugdale, went to St. Paul's and to Westminster Abbey, taking with him the artist, William Sedgwick. He took measurements and copied down the inscriptions while Sedgwick drew the buildings. Having fought for the King, Dugdale spent the Commonwealth period writing his *History of St. Paul's*. Sedgwick's drawings were engraved by Wenceslaus Hollar, and a magnificent volume was published in 1659; from it we can reconstruct what an extraordinary building the medieval cathedral must have been.

Though the reformers, a century earlier, had left the building comparatively unscathed save for stripping the gold and jewels from St. Erkenwald's tomb, the zeal of the Puritans soon tarnished its beauty. Although the choir was still used as a preachinghouse, the nave was made to serve as a cavalry barracks, the men sharing their quarters with the horses. The woodwork was torn up and smashed for firewood, shops and booths were set up against the new portico, and the scaffolding around the south transept fell down. When the Restoration came, the cathedral was described as 'a loathsome Golgotha', and Charles II, as his grandfather had done before him, set up a royal commission to determine a remedy. The commissioners invited Dr. Christopher Wren to make suggestions for restoring St. Paul's to its old magnificence. By 1 May 1666, Christopher Wren, who at this time was known, not as an architect, but as a brilliant mathematician and astronomer, produced a report, and on 27 August the commissioners, among them William Sancroft, the Dean, and the diarist, John Evelyn, met in St. Paul's to consider his plans, which included the demolition of the unstable steeple and its replacement with 'a noble cupola, a form of church-building not as yet known in England, but of wonderful grace' (John Evelyn, *Diary*). The idea of a dome was already firmly in Wren's mind. After considerable argument, the commissioners accepted the suggestion in principle: less than a week later, the Fire broke out.

In the confusion after the Fire, the cathedral authorities, uncertain of what official support they might expect to receive, at first planned to shore up the ruins, but falls of masonry soon made obvious the impracticality of such a course. Wren was instructed to 'frame a Design, handsome and noble, and suitable to all the Ends of it, and to the Reputation of the city, and the Nation, and to take it for granted, that Money will be had to accomplish it'. Wren, already busy with the reconstruction of the City churches, his natural genius reinforced by the authority of the Surveyorship-General which was conferred on him by the King's own wish in 1669, produced his first model in 1670. The King approved it and work began on the demolition of the old building. As it proceeded, it became obvious that this first plan was too modest in relation to the fine churches and handsome company halls that were rising in the new city. Wren, therefore, at a cost of £600, had prepared a superb model - the Great Model, as it is called - of the cathedral he longed to build (see also p. 37). Shaped like a Greek cross, so that chancel, nave, and transepts were of equal length, a huge portico at the west entrance, the whole building is concentrated on a domed central space, supported on eight piers and ringed about by eight smaller domed or vaulted

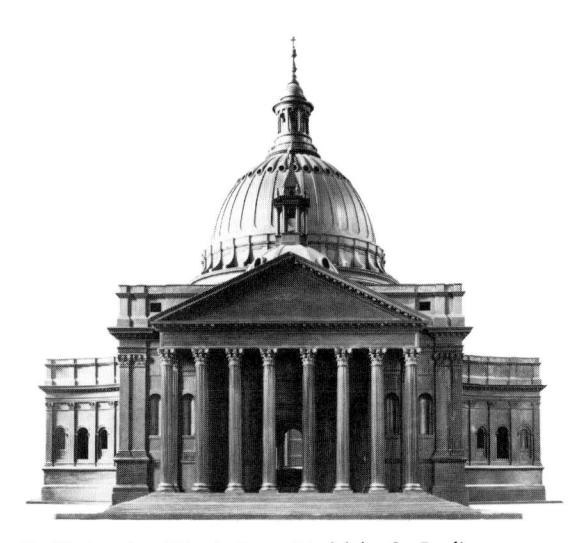

Sir Christopher Wren's Great Model for St. Paul's Cathedral

compartments, designed to serve as chancel and choir, chapels or vestibule. These compartments opened into the central space and into each other, so forming both an ambulatory and one vast auditorium. The perfect unity of this design delighted the connoisseurs and critics, but was too unconventional for the clergy, who knew a congregation must be persuaded to direct its attention towards the service or the preacher. Wren's patience was boundless. He produced a third design, a curious hybrid, shaped like a Latin cross with a pinched, spindly dome surmounted by a steeple reaching heavenwards in seven diminishing stages, like a meaner version of that which adorns St. Bride's church. To that design, Charles affixed his warrant on 14 May 1675, but he also authorized his architect to make such alterations to the plan as might become necessary during its realization. The King understood the situation, and the cathedral that Wren built was far nearer to the Great Model than to the Warrant Design.

St. Paul's rose slowly, for Wren laid out the whole foundation at the beginning. He was taking no chances. Had he begun with only the chancel and choir, financial stringency or the whim of a committee might have curtailed or altered his noble concept. Ignoring the Warrant Design, he dismissed the incongruous steeple, and realigned the nave so that it was of equal length with the choir, redistributing the remaining space in the longer western arm, so as to form a great vestibule between the entrance and the main body of the church. Such a space is most useful in the national church, for the formation of processions. His final plans for the dome evolved slowly, though he never wavered from his original vision.

Around him gathered a team of masons, sculptors, carpenters, joiners, plasterers, and smiths; the experience gained in the rebuilding of London produced the generation of craftsmen who built the country houses of the eighteenth century. The fiery holocaust necessitated the relaxation of the guild laws that forbade the employment of craftsmen from other parts of the country. Of those who worked on the cathedral, the two most important families were the Strongs from Taynton in Oxfordshire, and the Kempster brothers, Christopher and William, from Burford, both places where stone had been quarried since the Middle Ages. As they, and the teams of craftsmen under them, laboured, each foot and yard of masonry or joinery which they wrought was meticulously measured and as carefully recompensed, the money coming from a tax especially levied on coal brought into the port of London. Wren's own income was scrutinized too; when, in 1697, Parliament felt that the cathedral rose too slowly, they cut his salary from £200 to £100 a year, and it was not till January 1711, when the work was complete, that he received the arrears. But this politically inspired niggardliness – for the men who served William of Orange had little in common with those who had advised Charles II - did not perturb 34 THE CITY

Wren, who worked on unruffled, and their action should not blind us to the fact that, whereas it had taken 120 years and the efforts of 13 successive architects to build St. Peter's in Rome, St. Paul's in London was completed in half a lifetime under the direction of a single man.

ST. PAUL'S CATHEDRAL is best approached from the west, by way of Fleet Street and Ludgate Hill. It is entered up a double flight of steps and through a two-storeyed portico formed from coupled Corinthian columns, six pairs below and four above. The pediment is adorned with a relief of the conversion of St. Paul, carved by Francis Bird, and is surmounted with statues by the same sculptor. Two towers flank the portico, their lower stages garlanded with stone flowers. In the southern one is a clock, and, above that stage, each tower has a steeple, the lower part of which is formed from intricately arranged pairs of columns, which project on the diagonals. The stonework above recedes upwards to ogee-shaped lead cappings.

On entering the cathedral, it is best to stand first in the centre of the vestibule, where a crib is usually placed at Christmas-time, and to look down the whole vista of the nave and crossing and choir towards the High Altar; off the North Aisle is the Chapel of All Souls, in which stands a Pietà carved by Sir William Reid Dick and a memorial to Lord Kitchener, with a recumbent effigy by the same sculptor, and then St. Dunstan's chapel, reserved for private prayer and entered through a carved wooden screen, the work of Ionathan Maine, who was paid £231.1s.1d. for it. Back in the nave are monuments to Lord Leighton (d.1896), by Sir Thomas Brock, to General Gordon (d.1885), by Sir Edgar Boehm, to William and Frederick, Viscounts Melbourne (d.1848 and 1853), by Baron Marochetti, and to the Duke of Wellington. This last was the work of Alfred Stevens; he began it in 1857 but it was not completed till 1912, when John Tweedie finished it after Stevens's death. It is a remarkable work. A lofty canopy shelters a sarcophagus on which rests the Duke's effigy; the canopy is adorned with bronze figures of Valour and Cowardice, Truth and Falsehood, modelled with extraordinary vigour and drama, and above them a final storey supports an equestrian statue of the Duke.

In the North Transept stands the font, carved by Francis Bird in 1727 for a fee of £250. Around the walls are a number of monuments to the heroes of the Napoleonic Wars, among them a sinister relief by Chantrey to General Hoghton who fell at the terrible battle of Albuera in 1811. Later works to two musicians, Sir Arthur Sullivan (d.1900), by Goscombe John and Sir John Stainer (d.1903), by H. Pegram, are worth noticing. At the end of the North Choir Aisle is an unadorned altar, marking the Chapel of Modern Martyrs, where the names of all

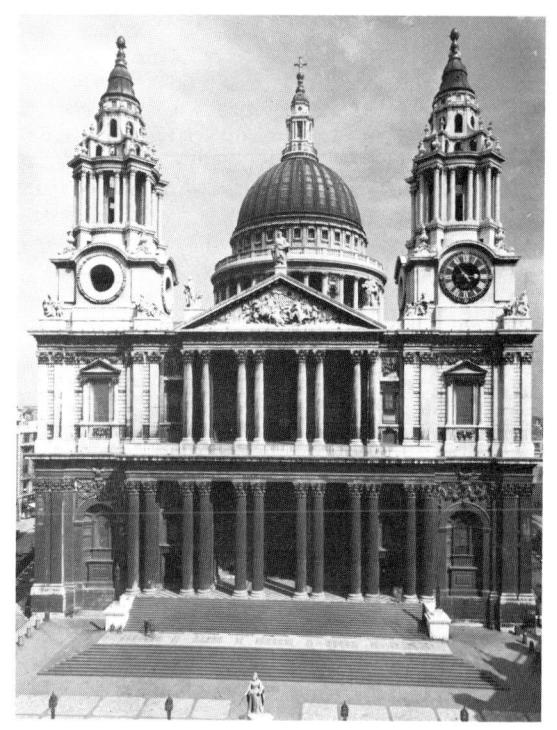

West front of St. Paul's Cathedral

those known to have died for the Anglican faith since 1851 are recorded in a marble casket.

This is on a level with the High Altar. The sanctuary is separated from the aisles by two wonderful wrought-iron screens, the work of the French craftsman Jean Tijou. Behind the altar is the American Memorial Chapel, set up in the curve of the apse and dedicated in 1958 in gratitude to the 28,000 Americans who served in Britain and gave their lives in the Second World War. The architects were S. E. Dykes Bower and Godfrey Allen, the three stained-glass windows, of which the central one is the main east window of the building, were designed by Brian Thomas and made by the Whitefriars Stained Glass Studios, and the panelling is adorned with eight limewood festoons, carved delicately with American birds and flowers by Rattee and Kett of Cambridge. The altar rails, by Wainwright and Waring, contain specific reference to the many Jewish servicemen who gave their lives, for they are adorned, symbolically, with the burning bush and the Tables of the Law inscribed in Hebrew, Beyond the apse is the south choir aisle with the Lady Chapel at its east end. Here Wren's original High Altar stands, a marble statue of the Virgin and Child upon it, which once formed part of the reredos of the Victorian High Altar. Nearby is an imposing statue of the Virgin and Child by Josephena de Vasconcellos. On the choir wall, just beyond the chapel, is the sole monument to survive intact from the Fire of 1666,
that of Dr. John Donne, the poet who became Dean of St. Paul's and one of the greatest preachers of all time. It is the work of Nicholas Stone and shows the Dean wrapped in his shroud, standing upright upon an urn. It was fashioned from a painting made in Donne's lifetime, for which he sat wrapped in his grave clothes.

Returning to the crossing and looking upwards into the dome, we may remember the lantern above the crossing in Ely cathedral, where Wren's uncle had been bishop. The dome is supported on eight huge arches, their keystones elaborately carved, for the sum of £280, by Caius Gabriel Cibber, a Danish sculptor who worked in England and whose son became a successful dramatist. The spandrels were filled with mosaics during the nineteenth century, the four major prophets by Alfred Stevens and the evangelists by Watts (St. John and St. Matthew) and A. Brittan (St. Mark and St. Luke). The dome itself is painted in grisaille with scenes from the life of St. Paul by Sir James Thornhill, sergeant-painter to Queen Anne and to George I, between 1716 and 1719. Effective though the work is, Wren would have preferred mosaics. Thornhill's painted ceiling is not the dome visible from outside but a shallower, inner rotundity, proportionate to the scale of the interior. Wren must have seen Mansart's church of Val-de-Grâce and Lemercier's Sorbonne Chapel on his visit to Paris in 1665, and, through his friendship with Robert Hooke, who collected architectural engravings, he was able to study, at second hand, the Italian achievements of the previous century and especially the domes which Sangallo and Bramante proposed for St. Peter's and that which Michelangelo finally built for the great church. He knew that the external dome must rise high in order to produce a silhouette to dominate London's skyline and the spires around it, but that a cupola so pitched would seem ungainly from within. The engineering of the structural relationship between the two domes was a problem, but he resolved it by building the inner, painted dome of brick and setting above it, quite invisible, a brick

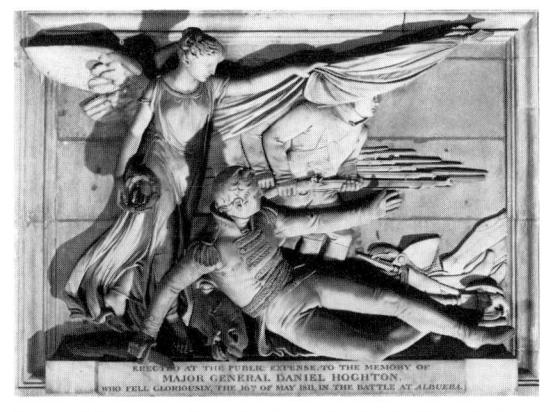

Memorial to Maj. Gen. Hoghton, St. Paul's Cathedral

cone which carries the lantern and the familiar ball and cross. From the outside, the cone is concealed by the external dome which is comparatively light, being made of timber covered with a lead skin.

The High Altar is not as Wren designed it. His work was replaced between 1883 and 1888 by a more elaborate altar and marble reredos designed by G. F. Bodley, but they were shattered in October 1940 by one of the few bombs that struck St. Paul's. A new altar made of Sicilian marble, designed by S. E. Dykes Bower and Godfrey Allen, was consecrated on 7 May 1958 in memory of 335,451 men and women of the Commonwealth, who gave their lives during the two World Wars. Above it is a splendid gilded oaken baldacchino, not unlike that designed for Westminster Cathedral three-quarters of a century earlier (see p. 180). The roof of the choir beyond was decorated by Sir William Richmond. The seventeenth-century choir stalls and the organ case were the work of a young Flemish carver, Grinling Gibbons, who laboured on them with a team of craftsmen for two entire years. Cherubs carol above the stalls while angels sound trumpets from the organ case. The original organ, designed in 1695 by 'Father' Schmidt, served to divide the choir from the nave, but in 1870 the instrument was rebuilt by Henry Willis and was divided to stand on either side of the choir, so permitting an uninterrupted view of the altar. A further rebuilding was begun in 1973. Just below the chancel steps stands the pulpit, designed by Lord Mottistone, Surveyor to the Fabric from 1957 to 1963; the workmanship bears comparison with Gibbons.

No memorials were permitted in St. Paul's till 1790, when overcrowding in Westminster Abbey had become serious, and then four were erected, Sir Joshua Reynolds by John Flaxman, while the elder John Bacon was responsible for Dr. Johnson, John Howard the prison reformer, and Sir William Jones, the Indian administrator and jurist. All four main figures were clad in classical drapery. Scarcely were they set up than the long struggle broke out with France and with Napoleon. Parliament decided to express the nation's gratitude to the heroes of these wars through a series of elaborate and costly marble monuments. The heroes are variously attired, appearing sometimes in their proper uniforms, sometimes in classical garb, and occasionally, as with Thomas Banks's stalwart figure of Captain Burgess, very nearly naked. Changes of fashion should not, however, prevent us from recognizing such felicities as Flaxman's portraval of Nelson, the strength and grace of the younger John Bacon's mourners who lower Sir John Moore into his grave, the drama of Westmacott's group to Sir Ralph Abercrombie, as he falls from his horse into the arms of a kilted Highlander, or the troops, carved in low relief, who file away in the background of Hopper's otherwise not very happy memorial to Major-General Andrew Hay. Sebastian Gahagan, Nollekens's poorly paid

assistant, produced a fine group in memory of Sir Thomas Picton, who bears an uncanny resemblance to Themistocles, and the monument by William Thead and Edward Hodges Baily to Sir William Ponsonby, who was killed at Waterloo when his horse stumbled, is worth searching out in the crypt, for it is one of the earliest English sculptures to show, in the treatment of the draperies and of the fallen horse, the influence of the Elgin marbles, which had first been exhibited in London in 1806.

Holman Hunt's painting, *The Light of the World*, hangs on one of the pillars in the south aisle; the original is in the chapel of Keble College, Oxford, but this copy was painted by the artist himself, some fifty years later in 1900. Beyond, at the western end of the aisle, is the Chapel of the Order of St. Michael and St. George, with woodwork by Jonathan Maine. The Order is conferred on those who have given distinguished service to the Commonwealth in Britain or overseas. At the end of the aisle, closed to the public, is the Geometrical Staircase, a larger version of Inigo Jones's spiral in the Queen's House at Greenwich (see p. 365). Here the staircase is by William Kempster and the balustrade by Jean Tijou.

At the entrance to the crypt, there is a small plaque with a well executed relief to Captain Scott and the companions who died with him on their return from the South Pole. The crypt itself extends beneath the

North-west tower of St. Paul's Cathedral

whole area of the cathedral and is said to be the largest in Europe; it has recently undergone a considerable rearrangement. Here Sir Christopher Wren lies, beneath a justly proud epitaph composed by his son; the final phrase reads:

Lector, si monumentum requiris, Circumspice.

(Reader, if you seek a monument, look about you.)

Many artists lie near him, even as Van Dyck was buried in Old St. Paul's. Reynolds, Turner, Lawrence, Millais, George Cruikshank, Holman Hunt, and Randolph Caldecott lie here, and on the walls are memorials to William Blake, Sir George Frampton, Sir William Orchardson, and Sir Edwin Landseer, who has a dog to mourn him. Alfred Gilbert has a plaque with a relief figure of his Eros (see p. 148) and John Singer Sargent is represented by one of his own paintings, a large, idiosyncratic Crucifixion. which his sister presented in his memory. There are recent tablets to John Constable and to Philip Wilson Steer, as well as to Sir Albert Richardson, Muirhead Bone, Sir Alfred Munnings, Sir Gerald Kelly, Sir Edwin Lutyens, Sir William Reid Dick, Hamo Thornycroft, and W. G. Holford, who did so much to replan London after the destruction of the Second World War. Although the ashes of one great poet, Walter de la Mare, rest here - he was a choir boy at St. Paul's - the crypt of London's cathedral should be considered as the artistic and architectural counterpart of Poets' Corner in Westminster Abbey. The artists are kept company by the composer, Arthur Sullivan, the composer, librettist, and actor, Ivor Novello, and the economist, Sir Stafford Cripps, whose bust is by Epstein. There is a fine bust of George Washington too, and another by Rodin of the Victorian critic and poet, W. E. Henley. Admiral Lord Nelson and the Duke of Wellington lie here, Nelson in a black marble sarcophagus which Benedetto da Rovezzana carved for Cardinal Wolsey; Henry VIII confiscated it, and it lay untenanted at Windsor for more than two and a half centuries till it was thought to be a fitting resting-place for Nelson's body. The Duke¹ lies in a sacrophagus of Cornish porphyry, his imposing tomb ringed about with memorials to the field marshals - Alanbrooke, Alexander, Auchinleck, Dill, Gort, Ironside, Montgomery, Slim, Wavell, and Wilson - of the Second World War and to all who served with them.

At the eastern end of the crypt is St. Faith's Chapel, named in memory of a medieval parish church, which disappeared in the fourteenth century when the choir of St. Paul's was enlarged; it was redesigned by Lord Mottistone in 1960 to serve as the Chapel of the Order of the British Empire. The engraved glass in the panels of the entrance screen contains portraits

¹ His funeral car, designed by Gottfried Semper, formerly on view in the crypt, is now at Stratfield Saye, the home of the Duke of Wellington.

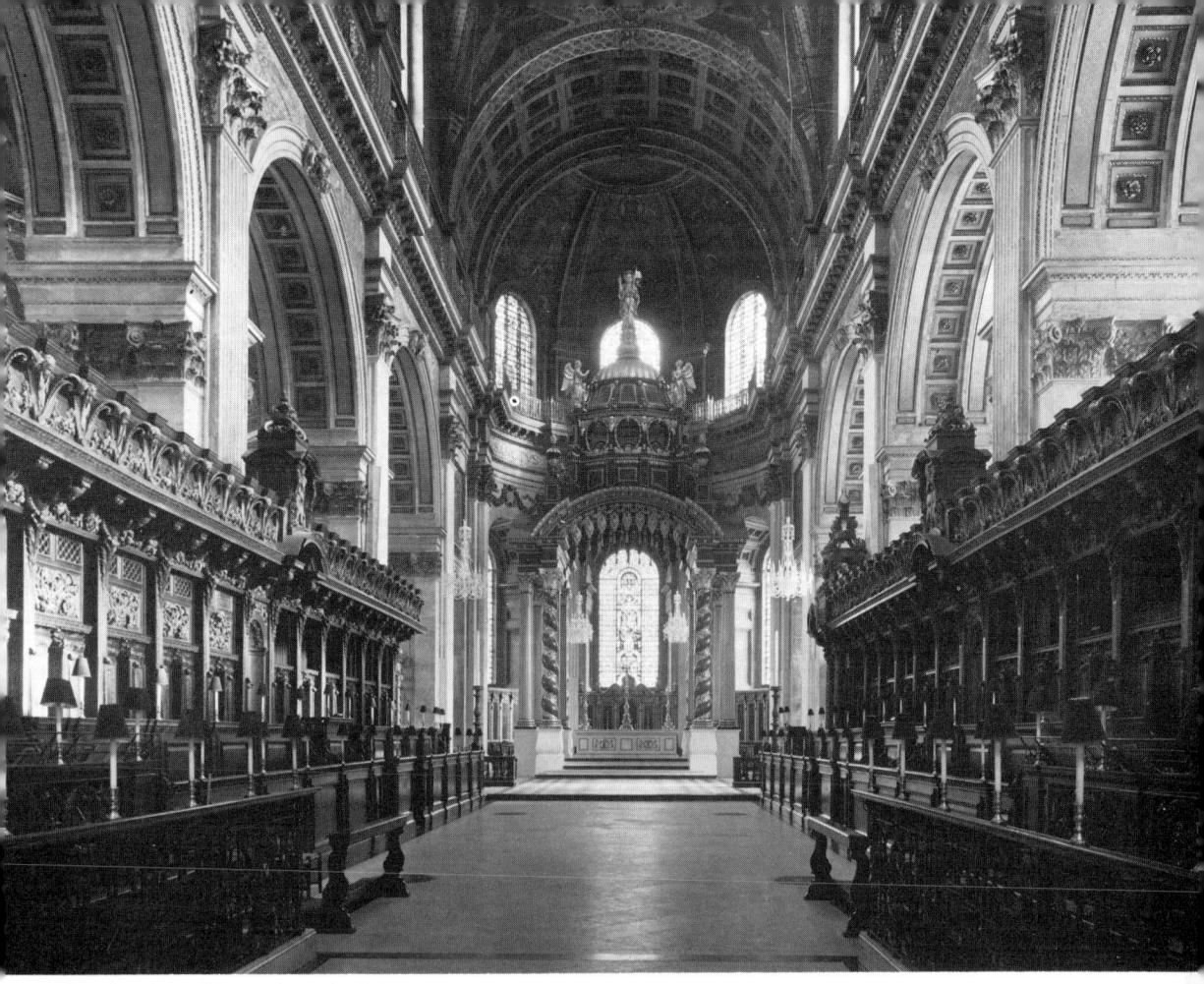

Interior view of St. Paul's Cathedral

of the present Queen and of her grandfather, George V, the founder of the Order. At the western end, Wren's Great Model has recently been set up, displayed in all its glory (see p. 33); near it are a number of charred and damaged monuments from Old St. Paul's. In 1981, the crypt acquired a new interest – the cathedral authorities decided to open a Treasury in which to display the cathedral's superb collection of church plate, as well as the records, which include Wren's accounts, drawings, and plans for the building, and liturgical embroideries. Beryl Dean's cope, first worn by the Bishop of London at the present Queen's jubilee service in 1977, and decorated with representations of the spires of all the city's churches, is breath-taking.

The ascent of the dome should not be attempted except by those sound in wind and limb. The first stage, to the Whispering Gallery, is easy enough, for the stairs are broad and shallow. From the Whispering Gallery, Thornhill's painting of the dome can be seen, as well as details of ironwork and carving which cannot be distinguished from below. A verger will demonstrate the extraordinary accoustic prop-

erties of the Gallery, for a sentence whispered into the wall at any point can be heard clearly on the other side. The climb to the Stone Gallery is harder. for the stairs are steep and narrow; as one clambers. it is possible to see the brick cone which supports the Lantern. The Stone Gallery runs directly above the main drum of the dome, which consists of a perfectly plain base ringed about with Corinthian columns, every fourth space between them being filled in so as to conceal a structural wall, and ornamented with a round-headed niche. Above is the balustrade of the Gallery, matching that running around the top of the main building; Wren had wanted a parapet and when over-ruled said, with rare asperity, 'Ladies think nothing well without an edging.' From this vantage point, the City and river spread out below. From the western side of the dome, the view down towards the two towers gives the whole structure of the building a different significance, for it can be seen that the upper parts of the outer walls are blind and that behind them lies, not the expected second storey. but simply open space. Seen in section, St. Paul's consists of a high nave flanked by single-storey aisles;

contemplated from the pavement outside it appears to be a two-storey building, but, from the Gallery, it is made clear that the side walls were raised for structural and aesthetic reasons only and do not serve to provide additional accommodation or lofty aisles. They are there to conceal the flying buttresses which the dome needs for support but which, being essentially Gothic, would accord unhappily with the main design of the exterior. The weight of the walls also serves to counterbalance the thrust of the main structure – the dome, with a diameter of 112 feet, weighs some 64,000 tons. These walls have been called a sham and Wren has been criticized for raising them, but they are in fact an essential part of the engineering of the cathedral.

Above the Stone Gallery, the drum contracts. At this level, it is ringed about with windows, a fluted pilaster set between each pair, and, from above them, the glorious grey hemisphere curves upwards to the Golden Gallery and the lantern with the familiar ball and cross, 365 feet above ground level. A peep-hole reveals the interior of the whole great cathedral spread out below. Wren's starting-point for this final design was the little Tempietto at S. Pietro in Montorio, a bare 15 feet in diameter, which Bramante had erected between 1502 and 1510 on the spot where St. Peter was martyred, but what he built was all his own, a dome expressive of the serenity and confidence from which his own nature was compounded, and so steadfastly engineered that even the bombing of the Second World War could not shake it. The final ascent is hard work, but it is worth the effort.

Open spaces surround the cathedral. In the forecourt, is a statue of Queen Anne, in whose reign it was completed. The original figure was the work of Francis Bird, but it weathered so badly that in 1885 a replacement had to be made, and the old one was

removed to stand in the grounds of a house in St. Leonard's-on-Sea. The figures around the base represent England, France, Ireland, and North America. The old churchvard lay to the north: offices now fill the spaces which, before the bombing, were lined with shops. The Chapter House, much modernized behind the old façade, is here, and beyond are a series of arcaded piazzas designed by Sir William Holford, with a sculpture by Elizabeth Frink, Paternoster, a shepherd walking behind his flock, set up in 1975 in one of them. The layout of the area is uncompromisingly modern, and yet wholly in sympathy with the great church, of which the archways and courtvards afford unexpected glimpses and vistas. To the east stands the Choir School, completed in 1967. Designed by Leo de Syllas of the Architects' Co-operative, it is built behind the steeple of St. Augustine's, the church having been destroyed by bombing. Beside it is a garden, laid out by the Company of Gardeners, with a large basin of water and a statue, The Young Lovers, by George Erlich, and to the south, on the far side of Cannon Street, the site of Old Change Court has been laid out as a piazza. In it. surrounded by bushes of an astonishing range of shades of greens, stands a bronze statue by Michael Ayrton, Icarus, set up in 1973, and from here, the south side of St. Paul's is revealed. The elegant, semicircular porch to the doorway of the south transept, the restrained but always adequate use of carving as adornment, the incisive quality of that stone carving, and the treatment of the facade as a two-storeyed building are all remarkable. The north and south facades owe a great deal to Inigo Iones's Banqueting House in Whitehall, especially the triangular pedimented windows of the upper storey, the pilasters between them, and the garlands which link their capitals. And above it all rides the dome. silhouetted against the changing clouds.

North from Ludgate Hill

Newgate to Smithfield

The eastern end of Fleet Street dips sharply, descending the western bank of the river Fleet which now lies concealed beneath Farringdon Street and New Bridge Street; the road junction is marked by Ludgate Circus, and on the further bank Ludgate Hill rises steeply, leading to St. Paul's Cathedral. Northwards lies a variety of close-packed buildings, including a Norman church, London's oldest established hospital, and the forbidding Old Bailey, the Central Criminal Court.

Standing at Ludgate Circus and looking eastwards towards Wren's magnificent temple, the viewer may think bitterly that only in England could the metropolitan cathedral, the national place of worship, have such cramped and shrouded surroundings as St. Paul's has. The view of the cathedral is obscured by an exceptionally ugly iron railway bridge, criticized as soon as it was erected, something over a century ago. The line of Ludgate Hill, called after that legendary British monarch, King Lud, is virtually unchanged since Wren's day, though today's higher buildings render the cathedral half invisible. Yet, though St. Paul's might have gained in dignity by being set in a great place approached by stately avenues, it would have lost the immediacy of surprise, the shock of delight always experienced as the dome swings into sight and the majesty of the cathedral is suddenly revealed.

Wren thought much about St. Paul's setting and its relationship with the buildings nearby. St. Martin's church stands on the north side of Ludgate Hill, the twelfth-century building having vanished in the Fire. The west front, towards the road, is stone-faced and plain, with three doorways and three segmentheaded windows. The square tower projects slightly, is connected with the façade by scrolly volutes, and topped by an elaborate lead steeple. This steeple commences with a bell-shaped dome supporting a balcony, from which trumpeters sound a fanfare on May Day, and terminates in a spire of needle sharpness more Scandinavian than English and a perfect foil to the rotundity of the cathedral's dome, which, from a certain point halfway up Fleet Street, it bisects neatly - it is worth risking the traffic to observe the harmony between the two.

The entrance, through the central doorway, leads into a narthex or vestibule, for in the seventeenth century carts rumbled noisily up Ludgate Hill; the device is sufficient to muffle even today's traffic. Although the site runs north to south, Wren turned the interior to obtain a correct ritual orientation. The church is a lofty rectangle, 57 feet long, 66 feet broad, and 59 feet high. The crossing is marked by four Composite pillars, panelled around the base, and supporting plasterwork entablatures which mark out the corners of the groin-vaulted roof. From the centre hangs a huge brass chandelier, which came from the cathedral on the island of St. Vincent in the West Indies. St. Martin's chief glory is its woodwork; the joiners here were Grey, Athey, and Poulden, and the carver William Emmett. Above the narthex is a gallery, in the substructure of which are three superb door-cases. The western gallery, its corners adorned with flaming urns, supports an organ, installed in 1684 by Bernard Schmidt. Beneath, a pelican feeds its young with blood from its own breast, and the font, presented by Thomas Morley in 1673, has around its base the Greek palindrome - NIΨON ANOMHMA MH MONAN OΨIN - 'Cleanse my transgression, not my outward part only' (See also pp. 75, 418). The reredos, with the Lord's Prayer, Ten Commandments, and Creed, is flanked by paintings, a large Transfiguration by R. Browne, painted in 1720 for the now demolished church of St. Mary Magdalen Fish Street, and a triptych with St. Martin dividing his cloak with the beggar, Mary Magdalen and St. Gregory beside him. The woodwork - altar table, rails, and pulpit - is all of Wren's day; the double chair, made of wood and cane in 1690 for the churchwardens, is probably unique. The Vestry walls contain stones from old London Wall, which visitors may see on request, as well as a silver model of Old Ludgate, which straddled the road at the foot of the hill and served as a debtors' prison till its demolition in 1760.

Stationers' Hall lies behind the church. The guild existed from the early fifteenth century, receiving its first charter in 1557. From then until 1710, all books legally published had to be registered with the Company, and it is to these registers that we owe much of our knowledge of English literature. In 1606, the Company bought their present site from Lord Abergavenny, but a new Hall was needed after the Fire. It

was built, with panelling by Stephen Colledge at a cost of £300 - Colledge was later hanged at Oxford in 1681 for extreme religious views - and a splendid oak screen by an unknown carver. Later, a Court Room was added and the building was refronted in 1800 by Robert Mylne. During the Second World War, the Hall escaped with comparatively slight damage but the Court Room had to be rebuilt, though the fireplace was saved. Samuel Richardson, the novelist, was Master of the Company in 1754; Joseph Highmore painted his portrait. Cutlers' Hall lies to the north in Warwick Lane. This company received a charter in 1416, though it had existed long before. The Hall, built in 1887 to designs by T. Tayler Smith, is the Company's fifth; it stands on the site formerly occupied by the College of Physicians. The Company's crest is an elephant and it possesses an interesting poor box made in the shape of that animal, as well as a collection of spoons made between 1679 and 1742.

A little westwards of St. Martin's, slightly lower down the hill, runs a street called Old Bailey which gives its name to the Central Criminal Court, constituted in 1834 and built in 1902-7 to the designs of Edward Mountford. Faced with Portland stone, the building is grimly suited to the dispensation of justice. It centres around a dome surmounted by a 12-foot-high gilded figure of Justice, her eyes unbandaged, her outstretched arms holding the sword and scales. She is the work of Frederick William Pomeroy, RA, who also sculpted the figures of Truth, Justice, and the Recording Angel which sit above the massive segmental pediment of the main entrance. Inside, under the dome and at the head of a marble staircase, is a central hall. The lunettes of the dome were painted by Professor Gerald Moira and his assistants with murals symbolizing the meting out of Justice, the Mosaic Law, and English Law, with the figure of King Alfred; the sculpture in the pendentives is by F. W. Pomerov. In the hall stands a remarkable collection of sculpture – three figures by John Bushnell from the second Royal Exchange of 1671, representing Charles I, Charles II, and Thomas Gresham, and eight Victorian statues, Elizabeth Fry by Alfred Drury, Mary II (Alexander Munro, 1863), James I and Charles I (T. Thorneycroft, 1867), George IV and William IV (W. Theed. 1867), William III (Thomas Woolner, 1868), and Charles II (H. Weekes, 1870). An extension to the Central Criminal Court was completed in 1972 to the designs of Messrs. McMorran and Whitby; firmly modern in style, it stands well beside the older building. Admittance to the Courts may be obtained by queuing at the public entrance at 10.00 a.m.

The Old Bailey occupies the site of Newgate Prison. The medieval city gateway had been put to this grim use at least by the beginning of the twelfth century and it served to house the most violent felons, as well as a number of political prisoners. Other buildings were added to it, including a Ses-

sions House built in 1539; here were tried the regicides who had condemned Charles I, William, Lord Russell, Jonathan Wild, Jack Sheppard, Bellingham, who murdered the Prime Minister Spencer Perceval, Thistlewood and his fellow conspirators, and poor Oscar Wilde. The conditions in the gaol were appalling, so bad that during the May Sessions in 1750 the Lord Mayor, two judges, an alderman, an under-sheriff, and some fifty other persons died of fever. The posies which the judges carry on two days in each month between May and September are a relic of the precautions taken to ward off infection. In 1767, the younger George Dance submitted plans for a rebuilt Newgate which was completed by 1778, only to be much damaged two years later during the anti-Catholic Gordon riots. Dance repaired it, with improvements, and it continued in use till 1902. The building was Dance's most famous achievement, its façade sombre and powerful, its rustication echoed, faintly, by its successor, Mountford's Old Bailey. It was outside this building that public executions took place from 1783 till 1868, and it was here that Elizabeth Fry made her first momentous prison visit in 1813. Dickens has left us a frightening description of Newgate in Letters by Boz, number XXIV, and in chapter LII of Oliver Twist he tells us of Fagin's

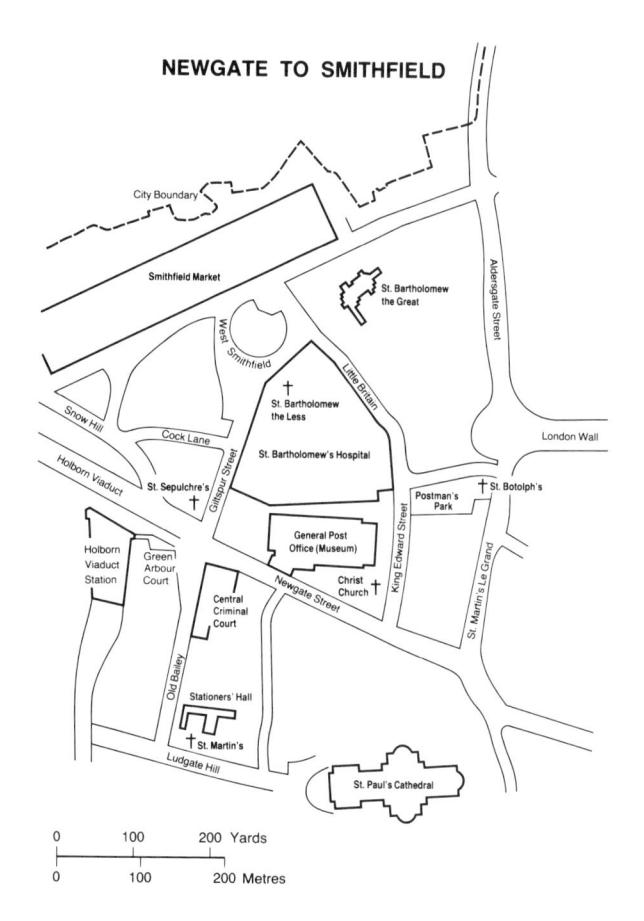

execution in the street outside, between the gaol and the public house, the Magpie and Stump, where business is still continued, though in rebuilt premises.

An impressive section of the City wall of which Old Newgate was a part, remains in a basement below the Post Office van marshalling-yard in Giltspur Street; it may be visited on written application to the Postmaster-General. The extensive Post Office buildings above cover the site of the church of St. Martin's-le-Grand, founded in the eighth century, rebuilt in 1056, and demolished in 1538. The church had special rights of sanctuary and even after its destruction these privileges were claimed for the surrounding area so that, coupled with its proximity to Newgate, St. Martin's became an unsavoury haunt for the underworld till 1821, when the whole site was cleared to make way for a magnificent new General Post Office headquarters to the east of the old church. This was built to the designs of Sir Robert Smirke and remained in use till 1913, when it made way for the present, less splendid, buildings. The National Postal Museum is here, founded as a result of a suggestion made in 1965 by the philatelist, Reginald M. Phillips, who most generously gave his own collection of nineteenth-century postage stamps to the nation. The arrangement and display are ingenious, and the museum is open daily; children are made especially welcome.

The Post Office buildings also cover the site of Christ's Hospital, the famous Bluecoat school, which flourished here from 1552 till 1902 when it moved to Horsham. Among its pupils were Edmund Campion, who died a martyr for the Roman Catholic church, the antiquarian William Camden, and the writers Charles Lamb, Samuel Taylor Coleridge, and Leigh Hunt. The school originally used part of the Franciscan friars' (Greyfriars') buildings, though after the Fire a new school had to be built; an annual school service is still held in St. Sepulchre's church. The Franciscan church, Christ Church, acquired by the parish at the dissolution of the monasteries, was replaced by one of Wren's happiest designs in 1677-87, but heavy bombing in the Second World War reduced the nave to a shell and in 1974 the building was demolished, save for the tower and part of the walls which stand today beside the much-widened Newgate Street.

Beyond the Post Office buildings, at the point where St. Martin's-le-Grand turns into Aldersgate Street, stands a little church dedicated to St. Botolph (for dedication, see p. 64). Being on the edge of the City, it escaped the Fire but, becoming ruinous, it had to be rebuilt in 1788–91 in brick with a little west tower and a bell-cote to the designs of Nathaniel Evans. Some 40 years later it was made more elegant, possibly under the direction of J. W. Griffith, by stuccoing the east end and inserting a Venetian window between coupled Ionic columns. In spite of this, the exterior is not particularly exciting, so that the interior is all the more of a fascinating surprise,

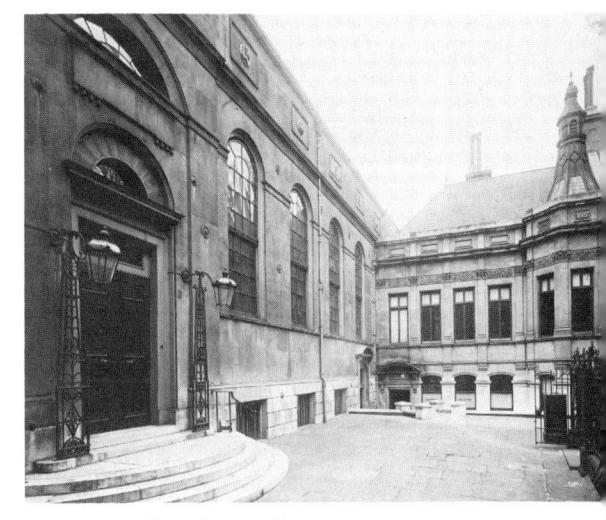

Stationers' Hall, Ludgate Hill

for it has changed hardly at all since the end of the eighteenth century. At both the east and west ends, invisible from outside, are two coffered apses, reminiscent of the one in All Hallows, London Wall, which George Dance had rebuilt some 25 years earlier. Over the altar is a transparency painted by John Pearson in 1788 of the Agony in the Garden. It is the only eighteenth-century transparency in the City, and appears to hang between curtains, but these are in fact moulded in plaster and painted. Above the north and south aisles run galleries supported on square pillars with Corinthian capitals, rising from the gallery level to the clerestory, which is lit by semicircular windows with delicate leading. The ceiling is coved, with huge plaster rosettes of leaves and flowers with hanging stamens set in fanciful circles. A third gallery runs above the west end, supporting an organ, its case made by Samuel Green in 1778. An excellent plasterwork frieze with classical motifs runs right round the church, level with the base of the galleries.

In the north aisle is some good late Victorian glass by Ward and Hughes, and in the south aisle are four modern windows showing events connected with the church and its neighbourhood, including John Wesley preaching in the fields close to the church (his conversion on 24 May 1738 was in a house which used to stand beside St. Botolph's). There is a sword-rest and the late eighteenth-century pulpit rests on a carved palm tree. The funeral monuments are an interesting collection, several having come from the earlier building. The oldest is a brass to Dame Anne Packington (d.1563), a benefactress to the church and widow of Sir John, 'late chirographer to the Court of Common Pleas'. There is a bust of Lady Richardson, who died in 1639 at the early age of 32, and two memorials to seventeenth-century physicians, Sir John Micklethwaite who tended

Charles II, and Dr. Francis Bernard. Of greater artistic importance is Roubiliac's bust of 15-year-old Elizabeth Smith, who died in 1750, far away from her parents who were in America; there is also a tablet to Daniel Wray, who died in 1783 at the advanced age of 82, having for 37 years been a Deputy-Teller of the Exchequer, as well as one of the original trustees of the British Museum, part-author of *Athenian Letters*, and friend to the poets Dyer and Akenside. St. Botolph's has one of the most unexpected and rewarding interiors in the City and deserves to be better known.

The churchyard is laid out as a garden and along its southern boundary runs the line of the City wall. In the centre stands a statue of the minotaur by Michael Ayrton, set up in 1974; it is a characteristic work but has little apparent relevance to its setting. In a corner is an arbour erected by George Frederick Watts, the wall behind it lined with tiles, each one inscribed with a brief account of a deed of self-sacrifice on the part of some otherwise unrecorded person. Because of its proximity to the Post Office, the garden is known as Postmen's Park, and postmen can usually be seen here, resting between duties.

St. Sepulchre's church stands at the eastern or City end of Holborn viaduct. A church stood here by the beginning of the twelfth century and was originally dedicated to St. Edmund, the martyr-king of East Anglia, but at the time of the Crusades the second dedication was added and it is now properly known as the Church of the Holy Sepulchre, London, Rebuilt in the mid-fifteenth century, largely through the munificence of Sir John Popham, Chancellor of Normandy and Treasurer to Henry VI's Household, it was much renewed after the Fire, and was altered at intervals during the nineteenth century. Of the medieval building, the tower and the porch remain, the latter particularly notable for its fine vaulting and 17 carved bosses. The tower was much restored in 1878 by W. P. Griffiths and was then given oversize pinnacles. The same architect refaced the porch and a year later A. Billing re-Gothicized the aisle windows, which had been altered in the eighteenth century. The post-Fire church followed the ground plan of the medieval edifice so that St. Sepulchre's is the largest parish church in the City.

The entrance is through the south porch into a room under the tower, the arches of which are original though much restored. A peal of ten bells hangs here – 'the Bells of Old Bailey' of the nursery rhyme – and it was the Great Bell here which was tolled during executions outside Newgate Prison. A font cover rests on a pedestal; it came from Christ Church and was saved when that church was bombed. A glass screen separates the tower room from the church proper; the interior is large and rectangular with one chapel to the north. The church is seven bays long, with a flat, coffered nave-ceiling installed in 1834, and groined vaulting to the aisles. The arches are carried on Tuscan columns, and the

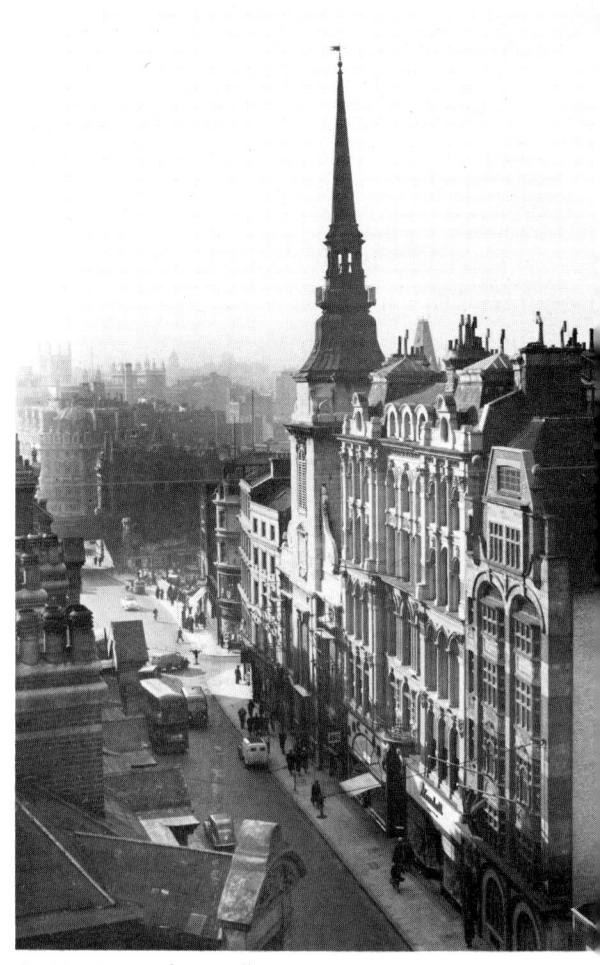

St. Martin's, Ludgate Hill

chancel is not divided from the nave. The interior is less impressive than it should be, largely because the organ, a noble instrument originally installed in 1670 by Renatus Harris, though frequently altered since then, has been moved from its proper position when the west gallery was taken away c.1880, and since 1931 has been positioned at the east end of the north aisle, which diminishes the light in the body of the church and prevents the organ-case - one of the prettiest in the City, with gilded cherubs – from being seen to its best advantage. St. Sepulchre's is particularly renowned for the quality of its music and a festival is held here annually on St. Cecilia's Day (22 November) when the choirs from St. Paul's Cathedral, Westminster Abbey, Canterbury Cathedral, and the Chapel Royal sing together. In the north chapel is a window dedicated to the memory of Sir Henry Wood, the founder of the promenade concerts, who became assistant organist here at the age of fourteen. Two other modern windows, designed by Brian Thomas, commemorate the composer John Ireland

and the singer Dame Nellie Melba. The kneelers are embroidered with designs referring to great musicians and with musical motifs.

Returning to the main church, the plain reredos, the marble font with an exceptionally pretty cover, and the pulpit, all date from about 1670; the latter was originally a double-decker but has been cut down. The south aisle serves as the Regimental Chapel of the Royal Fusiliers, City of London Regiment, whose colours hang here. Attached to a pillar in the nave is a fragment of stone from the Church of the Holy Sepulchre in Jerusalem, presented by a visiting Archimandrite in 1964, and beside another is the bell rung at midnight outside the condemned cell in Newgate to remind those within of their fate the next morning. Robert Dowe (see p. 81) left a bequest of £50 in 1605 to provide this macabre service. Three men are particularly associated with this church - Roger Ascham, tutor to Lady Jane Grey and to Queen Elizabeth, is buried here, John Rogers, the first Protestant to be burnt during the Marian persecution, was vicar here, and Captain John Smith, who led the expedition to Virginia in 1606-7, was buried here. There is a modern stained-glass window to his memory.

A small bust of Charles Lamb, a Christ's Hospital schoolboy, is set in the outside east wall of St. Sepulchre's facing Giltspur Street; a little to the north, the meeting of Cock Lane with Giltspur Street is known as Pye Corner, where a small gilt figure of a boy marks the furthest extent of the Great Fire of 1666. 33 Cock Lane stands on the site of a house alleged to be haunted in 1762, though an investigating committee, of which Dr. Johnson was a member, proved it a fraud. Giltspur Street leads into the open space of Smithfield, where tournaments were held in the fourteenth century and where, in 1381, the boyking Richard II confronted the rebellious peasantry under Wat Tyler, who was struck down and killed by the Lord Mayor, Sir William Walworth. From 1400, when Sir William Chatris was burnt for his beliefs, Smithfield was the regular place of execution for those found guilty of heresy. The place has more cheerful associations in St. Bartholomew's Fair, which was held here annually from Henry II's day till 1855. It was one of the great cloth fairs of England and the street name, Cloth Fair, is a witness to it. In it stand two pre-Fire houses, numbers 41-42, built of red brick with two-storey window-bays projecting over the pavement. They are among the oldest in London. A live cattle market grew up beside the cloth fair and continued until 1855, when it was moved to Islington, but Smithfield continued to be London's main market for slaughtered meat and a covered market was built by Sir Horace Jones in 1866-7. It was said to have had the largest clear span dome in Europe when first constructed. Various additions have been made since, the latest by T. P. Bennett and Son in 1962–3, and it is worth going down early in the morning to see the meat-porters or bummarees as they are called, slinging ox carcasses around as if they weighed no more than the Sunday joint. Their work done, they rest in the small round park in the centre of Smithfield, ocupied at other times only by pigeons and late Victorian statuary.

To the east of Smithfield stand the hospital and the two churches dedicated to St. Bartholomew. A hospital and priory was founded in 1123 by Rahere, said to have been a jongleur at the court of Henry I, who was inspired by a vision when on pilgrimage; he became the first prior. The hospital is the only one of London's medieval foundations to continue on its original site to the present day. So much was it valued by the citizens of London that, after the Reformation, they urged Henry VIII to re-found the Hospital, which he did by Royal Charter, a bare fortnight before his death. By the beginning of the eighteenth century, it became necessary to modernize the building. First, in 1702, the Henry VIII gateway was rebuilt by Edward Strong, nephew of Wren's mason, with a statue of the monarch by Francis Bird (rebuilt 1834, most carefully, by Philip Hardwick).

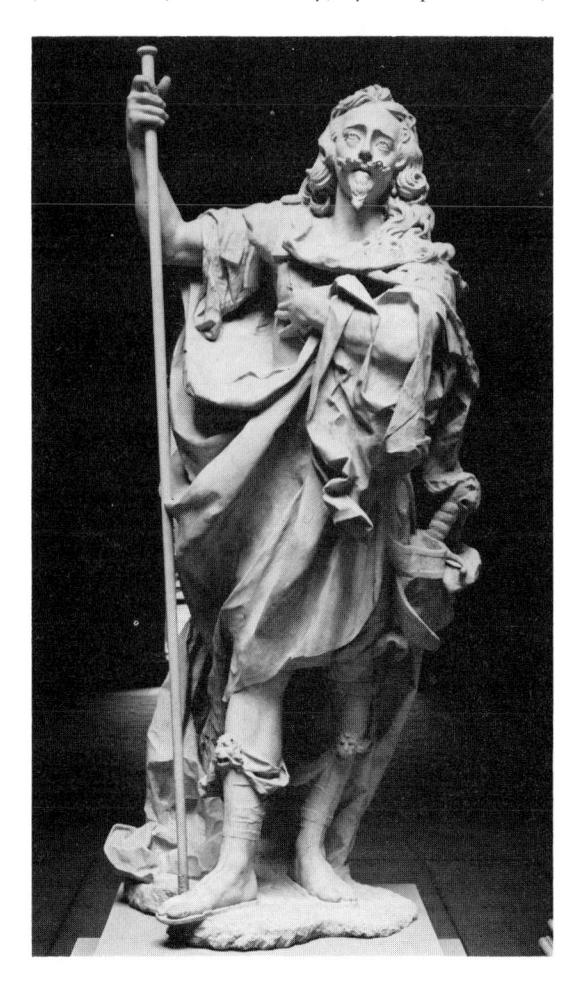

Statue of Charles I in the Old Bailey

Four new wards were added, but the accommodation still proved insufficient for the growing population of the City, so James Gibbs, the architect, was elected a governor and by 1729 had prepared new plans, giving his services and advice without fee. He replanned the Hospital in four large blocks round a central courtvard; three of them are still in use, and the Great Hall and its staircase remain. The new buildings were faced with Bath stone, provided on advantageous terms by Ralph Allen, who was anxious to introduce the material to the capital, but it proved unsuited to London's atmosphere and had to be recased in Portland stone by Philip Hardwick in 1850. The Great Hall is a nobly proportioned room, well lit by two tiers of windows on either side, one of them with stained glass of about 1664 (restored by Price in 1743) showing Henry VIII granting the Hospital's charter. The lacy plasterwork ceiling was the work of Jean-Baptiste St. Michèle. Lists of benefactors panel the walls, against which are portraits of governors and of staff. A copy of Holbein's fulllength portrait of Henry VIII, given in 1738, was 'fixed with decent and respectful ornaments' above the fireplace under Gibbs's supervision, while Hogarth, also a governor, painted, free of charge (1734–7), two murals for the staircase, representing The Pool of Bethesda and The Good Samaritan (cf. his work for the Foundling Hospital, p. 220). The Hall and staircase may be visited on written application to the Archivist. St. Bartholomew's also possesses a remarkable archive for, from the twelfth century onwards, bequests of land were made to it.

The church of St. Bartholomew-the-Less stands in the hospital grounds but is usually open. It occupies the site of one of the medieval chapels of the Hospital, probably, though so far unproven, that of the brethren of the Hospital. The tower and west wall are fifteenth-century, but George Dance the younger, the Hospital's surveyor, rebuilt the interior in 1789 as a timber octagonal church within the old walls; most of the monuments were destroyed. The timber, however, warped and rotted so that in 1825 the whole church, save the tower, was demolished and rebuilt by Philip Hardwick, who followed Dance's octagonal plan in stone. The windows were lost during the Second World War but in 1951 Lord Mottistone undertook the restoration and new windows were made by Hugh Easton. In the vestibule under the tower is a brass to William (d.1439) and Alice Markesby; he had been a tenant of the Hospital. Robert Balthrope (d.1591), surgeon to Queen Elizabeth, has a small monument; and Lady Anne Bodley was buried here in 1611, for her husband, Sir Thomas, founder of the Bodleian Library in Oxford, also lived within the Hospital Close. An anonymous fifteenth-century canopied tomb now supports a tablet to Elizabeth and John Freke, who were buried in the Poors' Chapel at the back of the church. A modern memorial worth noting is the Art Nouveau wall-plaque with mother-of-pearl mosaic to Sir

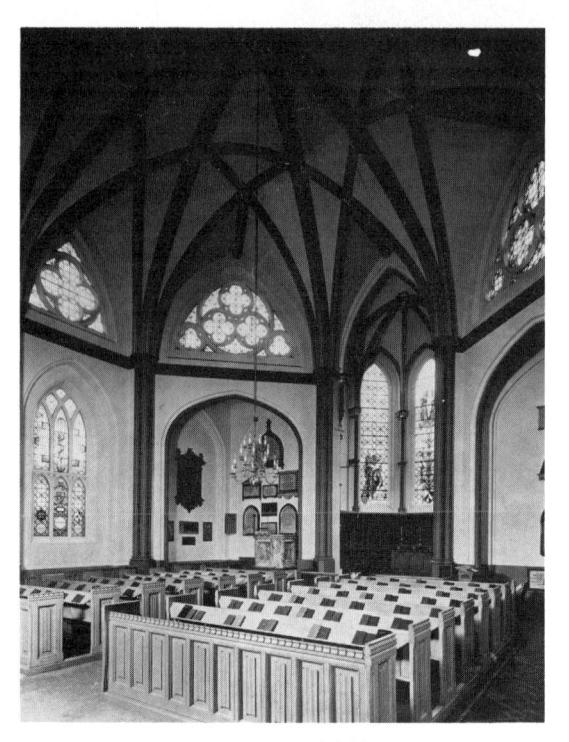

St. Bartholomew-the-Less, Smithfield
St. Bartholomew-the-Great, Smithfield

James Paget (d.1899), Principal Surgeon at St. Bartholomew's, and Serjeant-Surgeon to Queen Victoria.

St. Bartholomew-the-Great, the oldest parish church in London, stands to the north. This was the main church of the priory, begun in 1123 immediately upon its foundation. The north transept was used for parish services. At the Reformation, the whole church was sold to Sir Richard Rich, who demolished the nave, but the parish retained the chancel, the Lady Chapel, the crossing and the transepts. In later centuries, the building was much abused, the cloisters being turned into stables and the Lady Chapel being used first as a printer's workshop (Benjamin Franklin worked here in 1725 as an apprentice) and later as a fringe-making factory. In 1887, the rector, the Rev. Borrodail Savory, Bart., and the architect, Sir Aston Webb, set about restoring the church and though purists may disapprove of some of their measures, without them there might well have been no St. Bartholomew's today. Work on the cloisters is, even now, continuing.

Entrance is through the south porch, added in 1893 by Sir Aston Webb. Behind it a stout, squat, battlemented brick tower rises, added in 1628 as a west tower to the curtailed parish church. It houses a peal of five bells, all made by Thomas Bullisdon, a

¹ The only other church in England which possesses a peal of more than four pre-Reformation bells is St. Lawrence, Ipswich.

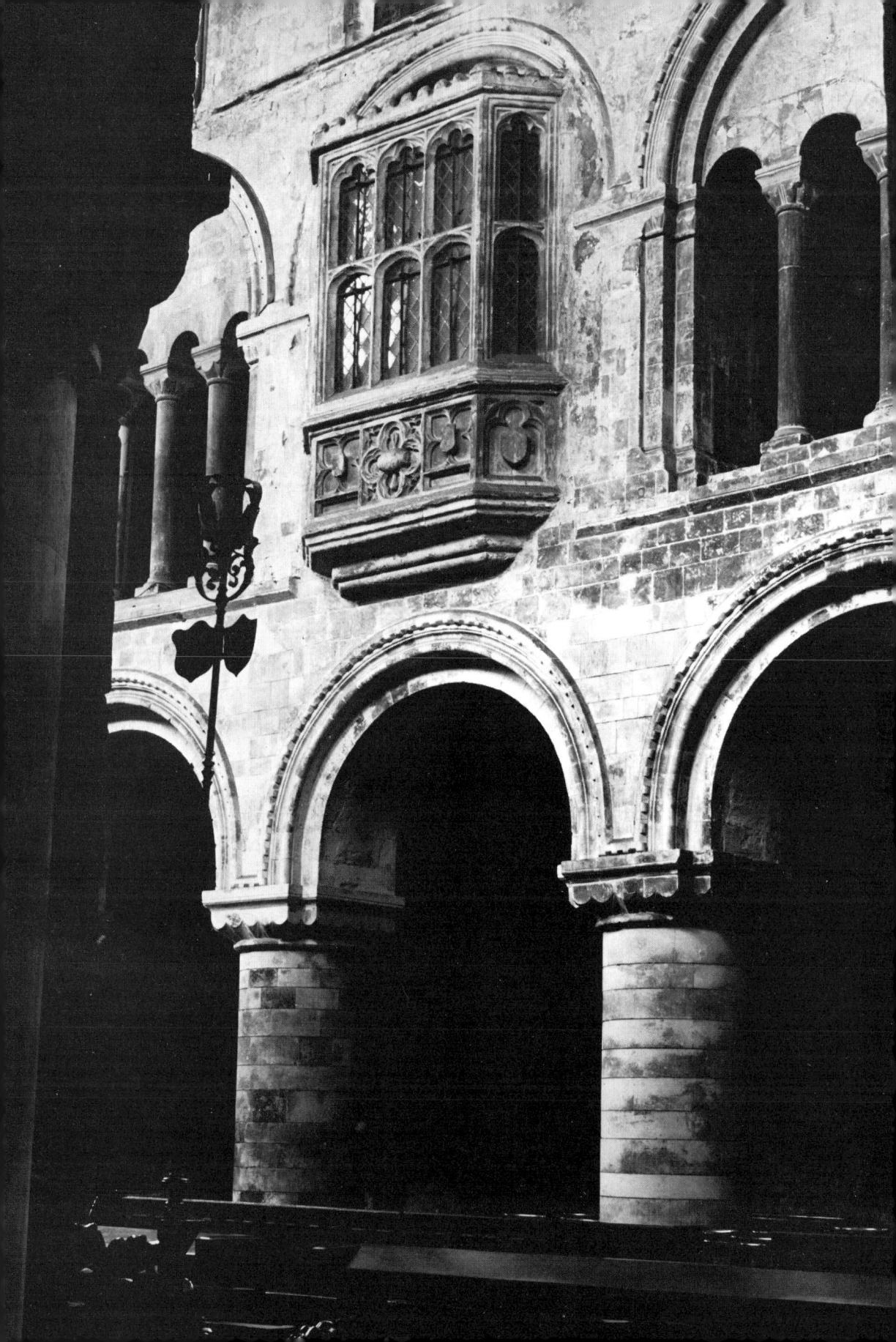

bell-founder in Aldgate who was working between 1500 and 1520; these bells are rung each Sunday for thirty minutes before evensong. The chancel was begun in Rahere's own time and was completed, with the crossing, before the death of his successor, Thomas of St. Osyth, in 1174. Stout pillars with round-headed, unmoulded arches and decorated capitals divide the ambulatory and aisles from the body of the chancel, in which the seating is arranged collegiate fashion, facing inwards. Above the ambulatory is a clerestory added in the late fourteenth century with pointed twin-light Perpendicular windows, and an oriel window on the south side inserted in the sixteenth century by one of the last, great priors of the original foundation, William Bolton. His rebus, a visual pun on his name, can be seen below the window - a tun of wine transfixed by the bolt from a cross-bow. In the curve of the apse stands the altar, a splendid kneeler lying before it, designed by Denise Williams and embroidered by the congregation, working at a long frame set up in the cloisters. The work represents the animals mentioned in the Benedictus. On the north side of the altar stands Rahere's tomb. The founder's body lies here, though the effigy was made long after his death (probably in the early sixteenth century), and cannot be considered a likeness.

The Lady Chapel lies east of the chancel and ambulatory. It is entered through a wrought-iron screen made by Starkie Gardner to the designs of Sir Aston Webb. Much restoration was needed here, but the old walls (c.1330) were saved whenever possible. This large chapel is now especially dedicated to the 600 City of London Squadron Royal Auxiliary Air Force: they hold an annual service here and their winged symbol decorates the altar cloth. A modern door cut in the south wall leads to the crypt, constructed in the fourteenth century with a tunnel vault with transverse ribs, and formerly used as a charnel house. Services are occasionally held here.

To many it seems that St. Bartholomew's has a deeper calm and comfort, an atmosphere more conducive to prayer, than any other City church. Wren built churches in which services might be celebrated in a decent and seemly fashion, clearly in the sight of the whole congregation, and in which sermons might be expounded to listening ears in a reasonable manner. St. Bartholomew's has a different, indefinable quality which is still none the less real.

The monuments should be noted too. Sir Walter Mildmay (d.1589), founder of Emmanuel College, Cambridge, who served Henry VIII, Edward VI, Queen Mary, and Queen Elizabeth, becoming at last Chancellor of the Exchequer and a Privy Councillor, has a large wall monument with the stoical inscription: 'Death is gain to us.' On the north wall, a smaller work commemorates Sir Robert Chamberlayne, who travelled much and perished between Tripoli and Cyprus in 1615 at the age of 35; angels hold a canopy over his kneeling figure. Percival and Agnes Smalpace (d.1558 and 1588) are shown both in life and in death. Margaret and John Whiting (d.1680 and 1681) have a much-quoted but still touching epitaph:

> She first deceased, Hee for a little Tryd To live without her, lik'd it not and dyd.

There is also, in the north aisle, a modern sculpture by Josephina de Vasconcellos of the risen Christ. On the south wall, a bust of James Rivers (d.1641), may have been carved by Hubert le Sueur, and Edward Cooke (d.1652, aged 32) has a memorial carved of the soft marble known as 'weeping marble', though the installation of central heating has dried its tears. Captain John Millet, a mariner (d.1660) has a tablet with a splendid epitaph which begins:

> Many a storm and tempest past Here hee hath quiet anchor cast.

In the south transept is an elegantly dressed little figure of Elizabeth Freshwater, who died in 1617. She is sheltered by an arch, and this is probably the earliest example of this decorative device, which was much in fashion by the middle of the century. Beneath her stands the plain, solid, squat font. Wrought in the early fifteenth century, it is the only pre-Reformation font in the City; in it, Hogarth and his sisters, who were all born nearby, were baptized. In the sacristry is a tablet to Thomas Roycroft, the printer, who worked in Bartholomew Close and who died in 1677. The base is carved in the form of six books and this past Master of the Stationers' Company deserved such a memorial, for it was he who printed the great Polyglot Bible, which gives the text in nine different languages - Hebrew, Latin, Greek, Chaldean, Arabic, Samaritan, Syriac, Persian, and Ethiopian. The east side of the cloister has recently been restored and reopened for use as a parish room.

The gateway which leads back into Smithfield, though much altered, was originally the thirteenthcentury doorway into the nave; it was restored as a memorial to Sir Aston Webb and to F. L. Dove who both worked to renew the church, and in a niche is a wooden figure of the patron saint, carved from an old church beam, which was set up in memory of Philip Webb, Sir Aston's son, who was killed in action in September 1916.

Blackfriars Bridge to Southwark Bridge

The strip of land running south from Ludgate Hill to the River Thames, and stretching from Blackfriars Bridge to Southwark Bridge, contains four Wren churches and the tower of a fifth, two of the three City livery company halls which remained undamaged throughout the Second World War, the College of Arms, and the Mermaid Theatre. In spite of Faraday Building, the main telephone exchange, which squats balefully where, among other buildings, the courtyards of Doctors' Commons once spread out (see p. 49), and in spite of the widening of Upper Thames Street into a new bypass, which is slicing away the whole riverside area while archaeologists work frantically to record what is revealed of earlier waterside communities before the evidence is gone forever, much remains that is worth seeking out.

Blackfriars Lane leads from Ludgate Hill to Queen Victoria Street, skirting what was once the site of a great Dominican monastery. The Order, having come to London in 1221, was given the site of Baynard's Castle in 1278 and began to build beside the Thames, reusing stone from the castle and from the City wall. Their church was large, some 220 feet by 95 feet; the division between chancel and nave is marked to this day by the line of a narrow passage called Church Entry. The Dominicans were usually treated with exceptional royal favour, one of their number often holding the post of confessor to the king. It was in this priory that Wyclif was censured for his opinions in 1382, that Parliament was held in 1450, 1523, and 1529, and that the Legatine Court assembled to try the divorce between Henry VIII and Katharine of Aragon. The priory was dissolved in 1538, the Great Hall and prior's lodging going to Sir Francis Bryan, the church and other buildings to Sir Thomas Carwarden. He promptly pulled down the church1 and the parochial chapel dedicated to St. Anne, though he was forced to provide the parishioners with a temporary church in a house till a new one was built in 1597 close to the premises used as the Blackfriars theatre. Here was buried the miniaturist Isaac Oliver (d.1617) and Van Dyck's daughter Justinia was baptized here on the day of her father's death; the artist had spent the last years of his life nearby and was buried in St. Paul's Cathedral. St. Anne's was not rebuilt after 1666, but burials continued in the churchyard, including that of the engraver, William Faithorne, in 1691. Two morsels of grass, set about with tombstones, mark it out to this day, and the narrow alleyways and passages here are as evocative of London's past as any that can be found.

The Worshipful Society of Apothecaries have their hall on the site of the guest house of the priory. Having received their charter in 1617 from James I. they purchased the old buildings in 1632 but had to rebuild after the Great Fire, the main hall and rooms, designed by Thomas Locke, being completed by 1671. The entry from Blackfriars Lane is, however, through an additional range of buildings completed in 1786. An archway leads into a courtyard; a lamp stands in the centre and beside it are two iron plates covering a well, which was in use by 1278. The seventeenth-century buildings enclose the other three sides of the courtyard, a pediment having been added above the eastern side in 1786. To the north is a Tuscan colonnade which would originally have been open. From the entrance hall a magnificent staircase leads up to the main rooms on the first floor. The balusters are unusual in design, their lower half being in the shape of an urn with a barley-sugar stick for the upper half; they date from 1671. At the foot of the staircase and further up it hang two unusual paintings, one showing Queen Elizabeth watching the Battle of the Armada which, in fact, she never saw, the other with William of Orange on the road to Exeter after landing in England in 1689.

At the top of the staircase are the Great Hall, the Court Room, the Parlour, and the Library. The Great Hall was panelled in 1671 by Robert Burges and Roger Davies at a cost of £117.12s.0d., and a fine screen was set up at the same time for an additional £75. At the north end is a musicians' gallery. The ceiling, in the Adam style, was inserted in 1786 and from it hangs a 24-branch chandelier presented by Sir Benjamin Rawling, Master of the Apothecaries in 1736. Around the walls hang full-length portraits of

¹ Substantial fragments of carved stone from the priory have been recovered from the site; a whole arcade was set up at Selsdon Park in Surrey and a pillar with its base and capital has been resurrected in St. Dominic's church, Haverstock Hill.

benefactors, including James I and Charles I. The panelling of the Court Room is a year later than that of the Great Hall; in it hang portraits of former masters, besides a panel painting of James I, a portrait by Reynolds of the great anatomist, John Hunter, and an early seventeenth-century bust of Gideon Delaune. The Company possesses a remarkable collection of pharmaceutical porcelain and stone-ware jars and pill slabs.

The southern walls of the Apothecaries' buildings lie along Playhouse Yard, which marks the site of the Blackfriars theatre. Plays were performed here by various boys' companies from 1577 till 1584, and then in 1596 James Burbage obtained a lease of a large apartment known as the Parliament Chamber, which he converted into a theatre, leasing it to the Children of the Queen's Revels. When they fell into disfavour in 1608, Richard Burbage, James's son, ran it as a playhouse in a syndicate with six other shareholders, among whom was William Shakespeare; it was probably their winter house, performances being given at the Globe (see pp. 239, 413) in summer. Many of Shakespeare's plays were acted here. The title page of the 1622 quarto edition of Othello gives Blackfriars as its place of performance, and the playwright bought a house in nearby Ireland Yard as an investment. The theatre was closed in 1642 and pulled down in 1655.

At the southern end of Blackfriars Lane is **Printing House Square** which takes its name from the office of the King's Printer. *The Universal Daily Register* was first issued here on 1 January 1785; three years later,

it changed its name to *The Times* and continued to be published here till 1974 when it moved to new premises in Gray's Inn Road.

On the eastern side of these substantial buildings is the church of St. Andrew-by-the-Wardrobe. The first written reference to the church is in a document dating from 1244 among muniments of St. Paul's Cathedral, but the foundation may well be earlier. The church derives its curious name from its proximity to the medieval Royal Wardrobe. After the death of Sir John Beauchamp in 1359, Edward III purchased his mansion from his executors and moved the Royal Wardrobe there from the Tower. James I sold off most of the contents and the building disappeared in the Great Fire, but the name remained attached to St. Andrew's. Wren rebuilt the church between 1685 and 1692 in red brick with stone quoins. He gave it a square tower with a simple parapet, and a nave and aisles five bays long with tunnel-vaulting to the nave and groin-vaulting to the aisles; in the side walls are two rows of round-headed windows. On the night of 29-30 December 1941 the church was gutted by bombs and fire and most of the fittings and monuments were lost; it was restored by Marshall Sisson and reconsecrated on 14 July 1961. Wren's original designs have been adhered to for the most part, though the aisles have been boxed in with solid panelling, the north aisle serving as offices for the British and Foreign Bible Society and the south aisle as a chapel dedicated to St. Ann and used for weekday services.

The furnishings are an interesting collection from a

Apothecaries' Hall, Blackfriars Lane

variety of sources. A sword-rest, two beadles' staves, the plate, and two monuments, including Samuel Manning's memorial to the Rev. Isaac Saunders, were all that remained of St. Andrew's own, but a fine pulpit and a font with its cover, all carved originally by Edward Pierce for St. Matthew, Friday Street, were purchased in 1965. The royal arms in the south gallery come from St. Olave, Old Jewry, and in the sanctuary stands a wooden figure of St. Andrew carved about 1600. Two good early eighteenthcentury chandeliers hang in the body of the church. The stained glass in the west window, representing the conversion of St. Paul, was made in the mideighteenth century for Bulstrode Park House in Buckinghamshire, the organ was originally built in 1769 by John Snetzler for Toddesley Hall in Staffordshire. Outside, the weather-vane comes from St. Michael Bassishaw, the Crucifix was designed by Walter Tapper, and the iron gates across the entrance to Queen Victoria Street were erected in memory of Professor Banister Fletcher, architect and historian.

Away from the river up St. Andrew's Hill is the Rectory, a fine eighteenth-century house, with others nearby. Where the hill joins Carter Lane is **Dean's Court** with St. Paul's Deanery, brick-built in 1670 by Sir Christopher Wren, a simple and restrained piece of domestic architecture save for the fine doorcase. There is another half-hidden surprise in a turning on the south side of Carter Lane. The entrance to **Wardrobe Place** is tucked away under an arch, and numbers 3–5 in this tiny square were built in the first years of the eighteenth century. The enclave occupies

the site of the medieval mansion which housed the King's Wardrobe. The name is also perpetuated in Wardrobe Terrace, an unexpected footpath which leads past a block of flats back to the riverside and St. Andrew's church. On its other side is Bible House, the offices of the British and Foreign Bible Society, which houses an ever-growing library consisting at present of some 24,000 copies of the Bible, or portions of the text, in over 1,500 different languages.

Addle Hill also leads back to Queen Victoria Street; its west side is filled with Faraday Building, the headquarters of the telephone exchange. Built in 1932, it was immediately execrated for the harm it does to St. Paul's skyline; its bulk covers the site of Thomas Linacre's house, where he founded the College of Physicians in 1518, and it has also obliterated Bell Yard, where a tavern once stood from which a certain Richard Qyney wrote a letter in 1598 addressed to 'My loving good friend and countryman, Mr. Wm. Shakespeare'. This too was the site of Doctors' Commons, a college first mentioned in 1532 for doctors of civil law.

Eastwards, beyond Goodliman Street, the past remains, triumphantly incorporated in the bricks and mortar of the College of Arms. The heralds of the kings of England had been part of the royal household since early times, but were not given a charter till 1484. Since it was bestowed by Richard III, who perished a year later on Bosworth Field, Henry VII took away both the charter and the accommodation which the last Plantagenet had given. Henry's granddaughter Mary Tudor granted another charter and gave the heralds a house, Derby Place, by Paul's Wharf. It was destroyed in 1666, but the library with its charters, rolls, and records was saved, presumably by way of the river. The College was soon rebuilt to the designs of Morris Emmett, Master Bricklayer to the Office of Works. He took particular pains with the staircases, panelling, and carved wood of the building, which stood around a courtyard, the fourth side of which was lost when Queen Victoria Street was driven through in the nineteenth century. Though St. Andrew's church was burnt to the westward, and St. Nicholas Cole Abbey to the east, a near-miraculous change of wind saved the College, which survived the War intact save for its gates and railings which went as scrap-metal. In 1956, Mr. Blevins Davis of the United States presented gates from Goodrich Court in Herefordshire; the magnificence of the courtyard proclaims his generosity. The College is not open to the public but organizes changing displays of heraldic material in the Tower of London.

To the east is another Wren church, St. Nicholas Cole Abbey. Of the medieval building, established by 1144, only one small carved stone head remains,

 $^{1\,}$ Now Cole Abbey church for the London Presbyterian congregation.

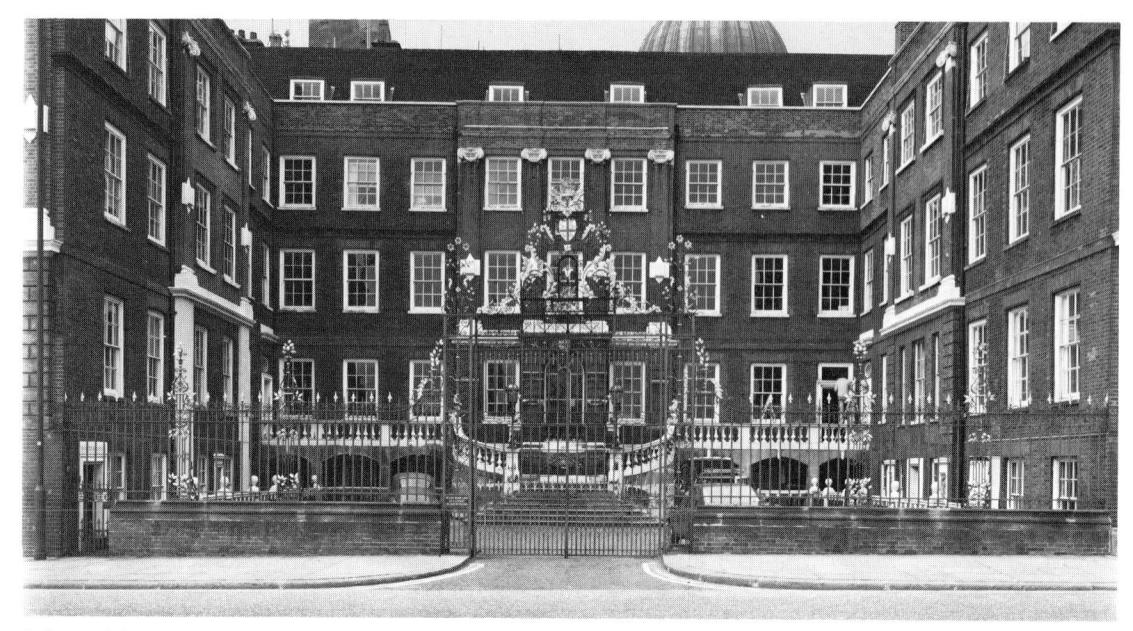

College of Arms, Queen Victoria Street

let into the stone-work near the south-west door of the present church. The reason for the curious name is uncertain – was there a benefactor called Colby, or is it a corruption of Cold Harbour? In those early times, the main fish market was at St. Paul's Wharf and not Billingsgate, and thus many of the leading fishmongers were buried in St. Nicholas, while the pungently named Old Fish Street Hill, which runs beside the church, is a reminder of their association. This was the first post-Fire church to be completed to Wren's designs, the work being finished in 1677 at a cost of £5,042.6s.11d. Of brick with stone facing on the southern front towards the river, St. Nicholas has a square tower with four urns and a curious octagonal steeple shaped like an inverted trumpet. Two elliptical windows, one large and one small, are let into each of its sides, and above them is a balcony from which rises a spire surmounted by a gilded ship, the weather-vane from the steeple of St. Michael Queenhithe. The church was burnt out in a daylight raid on 11 May 1941, the last heavy attack on London during the Blitz, but devoted fire-watchers managed to carry much of the seventeenth-century woodwork to safety; restored by Arthur Bailey in 1962, it was possible to reinstate the fine pulpit, font, communion rails, royal arms, sword rest, and chandelier. A new flat plaster ceiling was erected and three east windows were filled with glass by Keith New, with rivers representing the gospel message flowing world-wide through the Anglican communion. St. Nicholas is essentially a riverside church, its interior almost dazzling from the clear light flooding in through the plain glass of the six windows facing the Thames.

Queen Victoria Street turns northwards to cross Cannon Street. South-east of the junction, filling the whole area between Trinity Lane and Garlick Hill, is Beaver House, the London office of the Hudson Bay Company, founded on 2 May 1670 by Prince Rupert and a group of courtiers and merchants. The head-quarters of the London fur trade is here; Beaver House auctions at least 50 different species, and a visit to its storerooms, where mink, opossum, wolf, bear, and sable skins all hang together, offers a remarkable sight.

Painters' Hall occupies the western side of Little Trinity Lane; the Company is mentioned as joining in an affray in 1327. In 1532, Sir John Browne, serjeant-painter to Henry VIII, died, leaving his property on this site to the Company. That Hall disappeared in the Great Fire and the seventeenth-century building had to be replaced in 1914–16 by another, designed by H. D. Searles-Wood, which in its turn was much damaged by bombs in 1941. The restoration work by D. E. Harrington was completed in 1961; the Company has good collections of portraits and of silver.

On the eastern side of Beaver House, in Skinner Lane at the foot of Garlick Hill, stands the church of St. James Garlickhythe, in existence by the eleventh century but newly set about with railings fashioned like entwined vines, the gift of the Vintners' Company. Its parish registers date from 1535 and are possibly the earliest in England. The medieval church having vanished in 1666, it was rebuilt by Wren at a cost of £5,257 and was completed in 1682. The tower, faced with Portland stone, rises square through three storeys to an elegant parapet with fat

urns at each corner. The steeple is in three stages as well, all of them square, the first two having pairs of small columns set diagonally across each corner. At the very top is a minute dome and a weather-vane. The tower must be viewed in conjunction with that of St. Michael Paternoster Royal on the eastern side of Queen Street, where the steeple follows the same theme with an octagon in place of a square; the subtle differences between the two are remarkable.

The entrance leads into a vestibule with a double staircase; the woodwork is plentifully adorned with cockle-shells, the emblem of St. James of Compostella, to whom the church is dedicated; the woodwork and carving throughout are exceptionally good, the joiners having been Fuller and Cleer and the carver William Newman. The interior is rectangular, 75 feet long by 45 feet broad, with a lofty ceiling, some 40 feet high. The nave is five bays long, divided by slender pillars into a central space with two narrow aisles. A deep recess serves as chancel, an unusual arrangement for Wren, who more often set the altar table flat against the east wall. Here, a painting by Andrew Geddes of the Ascension, presented in 1815, hangs above the reredos, and the communion table (from St. Michael Queenhithe) is a fine solid one. with doves nestling on the bars which join the feet; the well-carved pulpit with a wig-peg on the back panel came from the same demolished church. The

Staircase of Vintners' Hall, Upper Thames Street

font has a plain ogee-shaped cover, and there are two sword-rests with pairs of lions and unicorns as supporters, carved with great vivacity. In the west gallery is an organ, possibly set up in 1697 by Father Schmidt but much altered in 1719 by Knopple. St. James's is still a parish church and indeed now serves seven former City parishes, its own, All Hallows the Less and St. Martin Vintry (not rebuilt, 1666), Holy Trinity the Less (became Lutheran after 1666 and since destroyed), St. Michael Queenhithe (demolished 1875), All Hallows the Great (demolished 1893), and St. Michael Paternoster Royal, which became a guild church after the Second World War.

Eastwards is Queen Street, one of the few major post-Fire reorganizations of the streets of London, it and King Street being cut through to give direct access to the Guildhall from the river. Numbers 27–28 Queen Street are among the few remaining eighteenth-century houses in the City. The street leads on to Southwark Bridge, first built between 1815 and 1819 to designs by Sir John Rennie and then rebuilt in 1921 to plans by Sir Ernest George.

Beside the bridge is Vintners' Hall, which remained, miraculously, almost unscathed throughout the Second World War. The Vintners have had a hall on this site since 1446 but they were in existence as a guild by 1364; the previous year, a wealthy vintner, Henry Picard, had entertained five kings, the monarchs of England, Scotland, France, Denmark, and Cyprus, to a sumptuous banquet. The medieval hall was destroyed in 1666, but the company managed to evacuate its records, presumably by water. They built a new hall at once in consultation with Roger Jarman the carpenter, Mr. Lem the bricklaver. and Mr. Woodroffe the carver; part of the building was in use by 1671 and the whole was finished in 1676, so the Company can claim that their Court Room is the oldest inhabited chamber in the whole City. Alterations were carried out in the 1870s and early 1900s, and the premises were generally renovated after the Second World War.

The main apartments are the Court Room, the Hall, and the staircase with its lobby. The Court Room is panelled with fluted pilasters and elaborate decorations of carved fruit and flowers. Around the cornice are 14 shields with coats of arms of early masters of the Company, and the floor is covered with a magnificent Persian carpet, a Meshed. There are portraits of William III and of Queen Mary, and a School of Van Dyck painting of St. Martin dividing his cloak with the beggar; since St. Martin is the patron saint of the Company, the Vintners possess several representations of him. The Hall, completed by 1671, was enlarged in 1822, though the screen at the west end was retained; when a new ceiling was needed in 1932, the architect, Alex Gale, based his design on one at Winchester College, which was repainted in 1969 in most unusual and subtle colourings. In the hall is a wooden sword-rest made to accommodate the City Sword in 1705, when Sir

Thomas Rawlinson, the Lord Mayor, dined with the Company (see also p. 77). The staircase is the loveliest of all. Carved by Mr. Woodroffe in 1673, each baluster has a garland of leaves and flowers and on each newel post is a basket of fruit. The hand-rail has an elegant string-course. The Drawing Room upstairs also dates from the 1671 building and in it is kept the company's collection of wine glasses and drinking appurtenances, the acquisition of which was begun as recently as 1933. The Vintners have a good collection of silver, including a sixteenthcentury coconut cup, an early salt, and numerous wine labels, and they also own a fifteenth-century tapestry and a sixteenth-century embroidered funeral pall. Outside Vintners' Hall, a little Coade Stone figure of a boy from the Vintry Ward Charity School was put in the wall of Anchor Allev in 1949.

Extensive road widening to convert the eastern half of Upper Thames Street into an underpass has obliterated much of the past but, in doing so, has made possible the discovery and excavation of the Roman river defences, hitherto unknown. The tower of St. Mary Somerset still stands, its main building having been demolished in 1871, and just west of it is a tiny church, dedicated to St. Benet. The earliest mention of the dedication, given as St. Benedict, is in 1111. Elias Ashmole, the antiquary, was married here in 1638, and Inigo Jones was buried here in 1652, leaving £100 in his will that a monument might be erected to him, which his pupil, John Webb, duly saw executed, but tomb and memorial were lost in the Fire. Now a wall-tablet, erected at the end of the last century by the great architect's descendant, Lieutenant-Colonel Inigo Jones, is the only reminder that the builder of the Banqueting House in Whitehall and the Queen's House in Greenwich lies here. Wren rebuilt the church in dark red and blue chequer-worked bricks, with three round-headed windows to the north and south and two to the east and west. He gave it stone quoins and stone swags over the windows, a hipped roof, and a tower to the north-west, which rises through three storeys to terminate in a small lead dome with elliptical windows, on which perches a tiny open lantern and a still smaller spire. The ground rises steeply behind the

church to Queen Victoria Street, giving the building a picturesque setting. Seen from the Stone Gallery round the dome of St. Paul's, St. Benet's stands out by virtue of the warmth of the colour of the brick, and looks like a Dutch doll's house.

The interior is almost square $-51\frac{1}{4}$ feet by $41\frac{1}{4}$ feet - with little galleries supported by Corinthian columns on the west and on the north. The aisle under the western gallery is now shut off to form a vestry and offices, since the church ceased to be parochial in 1879 and became the London church of the Welsh Episcopalian congregation; services are held here in Welsh each Sunday. In former times, the north gallery accommodated the pews for members of Doctors' Commons and of the College of Arms nearby. The walls of the church are panelled to shoulder height, there is a large oaken reredos with a segmental pediment supporting four urns, and an exceptionally fine communion table with carved angels as legs and a little figure of Charity seated on the stretcher. The pulpit is plain and there is an octagonal font with four cherubs' heads. There is an iron sword-rest and a lectern attached to the pews. which are made from the wood of the original box-pews. The modern electric light fittings are unexpected but inoffensive. It was here that Henry Fielding, the magistrate and novelist, was married for the second time.

At the end of Upper Thames Street, beside Puddle Dock, stands the Mermaid Theatre, the first theatre to open in the City since the Puritans drove out the players in 1642. It is the creation of the actor and producer Bernard Miles (now Lord Miles of Blackfriars), who first established a company in his house in St. John's Wood in 1951. The theatre opened on 28 May 1959, having been erected upon the foundations and within the shell of a Victorian warehouse. The site was leased at a peppercorn rent by the City Corporation, and the architect was Elidir Davies. The new underpass meant a temporary closure and redevelopment as part of an office block but the Mermaid opened triumphantly for a second time in 1982

 $^{1\,}$ Though the City Theatre, Grub Street (Milton Street), struggled to survive from 1829 to 1835.

The Guildhall and its Neighbourhood-

Even as the Bank of England sits at the commercial centre of the City, so the Guildhall provides the civic nexus. In the small area bounded by Moorgate, London Wall, St. Martin's-le-Grand, and Cheapside, together with the triangle of land south to Queen Victoria Street, there are crammed the Guildhall itself, the Guildhall Library, five Wren churches and the sites of eight others of varying antiquity, nine company halls, and an important section of the Roman Wall. Like so much of the rest of the City, this quarter is an extraordinary mixture of the very old and the very new.

The Guildhall is the headquarters of City administration. Here the Lord Mayor and Sheriffs are elected, the Lord Mayor holds his annual banquet, the Freedom of the City is presented to those deemed worthy to receive it, and the meetings of Common Council and of Common Hall are held. The City has had a Guildhall at least since the middle of the twelfth century and all the early documentary evidence points to its having occupied but the one site, a part of that which it now covers. The present buildings consist of the Guildhall itself, begun in 1411 and completed during the next 20 years, which stands above two crypts, the eastern contemporary with the main building, the western at least a century earlier. A cloister to the west now joins the Guildhall to the new administrative offices completed in the autumn of 1974. The Guildhall is one of the few medieval buildings left in central London.

The medieval Guildhall, begun in 1411, was built to the designs of John Croxtone. The Great Hall was the second largest in England, surpassed only by the King's own hall at Westminster; it is 52 feet long and 49½ feet wide, and may be compared with Westminster Hall or with smaller, domestic apartments, such as Crosby Hall (see p. 308). The building probably had a magnificent stone screen running its entire length, but of this nothing remains. Controversy still continues over whether the roof was originally of wood, or whether it was vaulted in stone. Most probably, the City Fathers planned a stone vault; the piers from which it would have sprung are still there

and in use, but it seems likely that money and enthusiasm at last ran short and the work was completed in wood. In this hall, Anne Askew was tried for heresy in 1546 and the poet Earl of Surrey for treason in 1547. Lady Jane Grey and her husband, Lord Guildford Dudley, were condemned here in 1553, and so was Father Garnett, the Jesuit, for his part in the Gunpowder Plot.

The Fire of 1666 left only the walls standing; onto them Sir Christopher Wren put a new roof so that the building was soon in use again. The east crypt was intact but the roof of the west had fallen in; the damage was shored up with bricks and the chamber was used as a lumber-room for almost three centuries.

In 1788–9, the Guildhall was refronted by George Dance the younger. The new façade was nine windows wide, divided into three groups of three by tall buttresses crowned with pinnacles, which project above the roof with an oriental air; Dance may have been inspired by William Daniell's Select Views of *India*, published two years before he began his work. The medieval porch, with its two bays of vaulting, one of them with a boss bearing the arms of Edward the Confessor, remained but was stripped of the six statues which adorned it; four were female figures, representing Discipline, Fortitude, Justice, and Temperance, and two male, representing Law and Learning. Alderman Boydell, that patron of the arts who lived in Cheapside (see p. 145), begged for the statues and presented them to Thomas Banks the sculptor. At his death, they were sold to Henry Bankes, MP, and were discovered in 1973 in the possession of his descendant, H. W. Bankes, in Flintshire. Somewhat battered but still dignified, they are now on display in the Museum of London.

Wren's ceiling was replaced by another with open hammer-beams in 1862–3, the work of the City Architect, Horace Jones. This was destroyed on 29 December 1940, when a gale fanned the flames of the incendiary bombs which rained down on London that night. The roof crashed down, but the walls and east crypt still stood firm. A temporary roof was erected and the work of the City was carried on under it till a new roof was built after the War, between Lord Mayor's Day 1953 and 1954; the designs were by Sir Giles Gilbert Scott and this time the arches were of stone, with hidden steel trusses to

GUILDHALL AND ITS NEIGHBOURHOOD

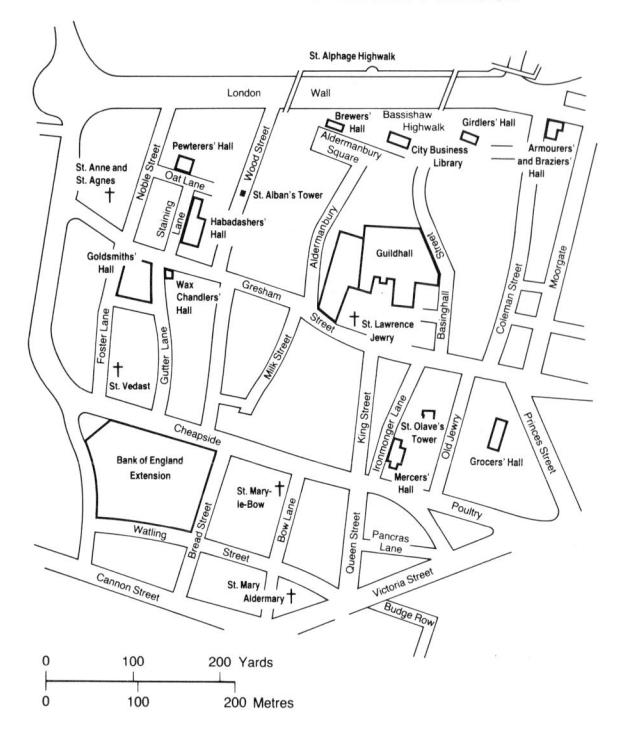

support the weight. Between each rib, shields painted with the arms of the livery companies are displayed. The design was inspired by the stone vaulting of the Archbishop's Palace at Mayfield in Sussex. The roof above it is of golden Collyweston stone tiles, and from it rises a teak flèche with a lead crocketted spire. Seen from a distance, the roof glows like willow trees in spring or beech leaves in autumn.

Within the Hall are several interesting statues. High on the balcony at the west end stand two giants, Gog and Magog, carved in wood by David Evans, each 9 feet 3 inches high. Traditional pageant figures since at least the fifteenth century, they replace an eighteenth-century pair destroyed in 1940. Five monuments stand around the walls, one of them dedicated to William Beckford, father of the author of Vathek, who, as Lord Mayor in 1769, dared to remonstrate with George III over the Middlesex elections. The Corporation so applauded their Mayor's temerity that they commemorated it in stone; the statue was carved by Francis J. Moore. Lord Chatham is commemorated by a florid but successful group by the elder John Bacon; the younger Pitt was celebrated by J. G. Bubb, Nelson by James Smith, and Wellington by John Bell. In 1955 a bronze seated figure of Sir Winston Churchill, by Oscar Nemon, was added.

Beneath the Guildhall, the east crypt dates from the first quarter of the fifteenth century. Delicate Purbeck marble pillars divide it into a nave and side aisles and uphold the tierceron vaults. The earlier west crypt, constructed probably between 1270 and 1290, is a more primitive, rugged chamber, with stocky octagonal piers and simple rib vaulting; a full restoration was completed in 1973. The crypts are usually open to the public.

The new additions to the Guildhall include provision for the Library and the collections of manuscripts, maps, prints, and drawings. The Library. established in 1828 and opened to the public in 1873, has an unparalleled collection on London, its history, people, topography, commerce. architecture; the helpfulness of its staff equals the excellence of the collection. In addition to the books. there are 28,000 maps (including one of the three existing copies of the Elizabethan map of London ascribed to Ralph Agas), 30,000 topographical prints and drawings (including a spectacular Rowlandson and much work by the Shepherd family, by Robert Blemmel Schnebbelie, and by William Capon). 14,000 portraits, 17,000 photographs, architects' perspectives, theatre programmes, trade cards, watch papers, and much material on the Lord Mayors' banquets. The oil paintings of the old Guildhall Art Gallery collection, which include works by Samuel Scott and William Marlow, are less accessible, though any work can be made available to the serious student. The clock collection of the Worshipful Company of Clock-makers is housed here too. Comprising about 700 items, it is the largest and most comprehensive such collection in the world.

Immediately to the south-west of the Guildhall stands St. Lawrence Jewry, the Corporation's own church, taking its name from the inhabitants of that quarter before Edward I's foolish expulsion of the Iews in 1290. William Grocyn, the great teacher of Greek, of whom Erasmus wrote 'he is the patron and preceptor of us all', became vicar in 1496 and St. Thomas More, who was born nearby, lectured here. Sir Geoffrey Bullen, Anne Boleyn's great-grandfather, was buried here, and so was Sir Richard Gresham, father of Sir Thomas (see p. 68). The medieval church vanished in the flames of 1666, to be replaced, between 1671 and 1687, by Sir Christopher Wren's costliest creation; the bill came to £11,870. The church is rectangular, with a western tower topped with a parapet and obelisk pinnacles at the corners. A square open belfry is surmounted by a sturdy lead spire from which flies a weather-vane shaped like the grid iron on which St. Lawrence was roasted alive. Its shaft is fashioned in the form of an incendiary bomb, in memory of the holocaust in which church and Guildhall suffered. The exterior is faced with Portland stone, and emphasis is laid on the south front, to Gresham Street, and on the east end, nearest to the Guildhall. To the south front Wren gave a cased door at either end, a circular

window over each, and five round-headed windows between them. The east end he divided into five bays with Corinthian columns supporting a pediment.

The original hall-type interior was wiped out by bombs: restoration was undertaken by Cecil King between 1954 and 1957. The space under the former north gallery has become an aisle, separated from the body of the church by a screen of square, fluted, Corinthian pillars. At its east end is the Commonwealth Chapel. The plasterwork of Wren's ceiling has been copied and a new, tall reredos, in Wren's manner with Corinthian pillars and an elaborate pediment, has been set behind the altar. On it hangs a painting by Cecil Brown of the martyrdom of St. Lawrence. The pulpit and the lectern were the gift of the Mercers' Company, the pews came from Holy Trinity, Marylebone, and the font, made about 1620, from Holy Trinity in the Minories. A fine new organ has been set up at the west end. The glass throughout is by Christopher Webb; the small window in the vestibule shows Wren with his master-mason and master-carver, and has tiny pictures of the modern rebuilding underneath. St. Lawrence's church is again magnificent, fit for civic occasions, though the architect has chosen a harsh, dark brown stain for the woodwork.

St. Lawrence's is of particular significance to members of the Anglican communion, for it possesses the earliest post-Reformation cup and cover known in the country – it dates from 1548 and must have been made within a few months of the authorization of communion in both kinds for the congregation. Four great Anglican divines are associated with the church, three of them as rectors and the fourth as lecturer. The three were Edward Reynolds (rector 1631), the author of the General Thanksgiving, later Bishop of Norwich, Seth Ward (rector 1660-2), the celebrated mathematician and astronomer who became Bishop of Exeter and then of Salisbury, and John Wilkins (rector 1662), who married Oliver Cromwell's sister Robina, helped to found the Royal Society, and became Bishop of Chester. He lies in the church, and so does John Tillotson, who was lecturer here for 30 years and who became Archbishop of Canterbury in 1691.

East of the Guildhall, the site of the former Wool Exchange is now occupied by Woolgate House, designed by C. Lovett Gill and Partners, with a

The Guildhall with new extension

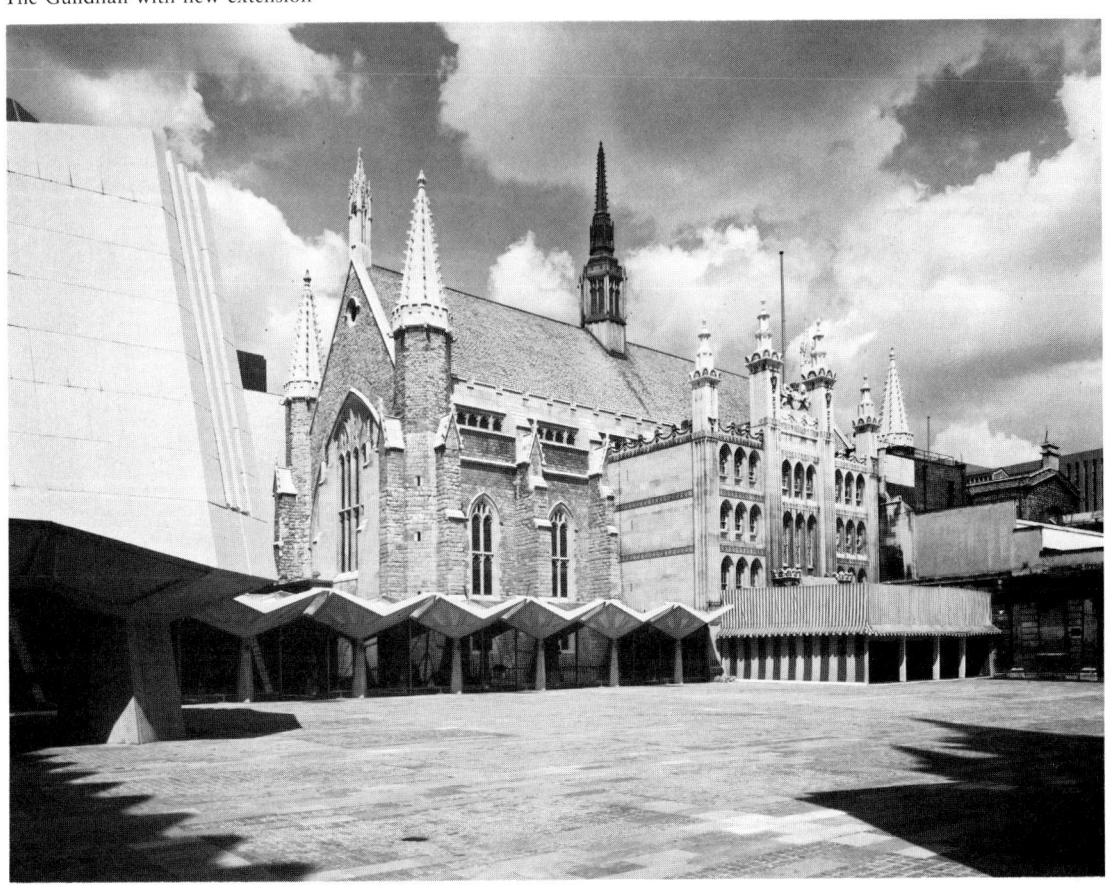

public courtyard laid out with curving seats around a fountain. In it stands a sculpture, *Ritual*, by Antanas Brazdys. The enclave won the Miller Trophy in 1969, awarded annually for the most attractive improvement made to the City. Nearby, at 55 Basinghall Street, is the City Business Library, which supplies businessmen with reference material and newspapers. This southern side of London Wall was planned for the City authorities by Sir Leslie Martin in collaboration with Sir Hubert Bennett for the LCC. Two statues have been installed, *Beyond Tomorrow*, a pair of seated adolescent figures, and *The Gardener*, both by Karin Jonzen, and a magnificent fountain of greenish glass and metal by Allen David stands in Aldermanbury.

From Bassishaw Highwalk, as it strides over the thoroughfare of London Wall, the Halls of three livery companies, the Brewers (Aldermanbury Square), the Girdlers (off Basinghall Avenue), and the Armourers and Brasiers (Coleman Street), can be seen. Due to bombing, the first two are modern: the Brewers' Hall was rebuilt in 1958-60 by Sir Hubert Worthington, and the Girdlers' in 1960-61 by Waterhouse and Ripley; both Halls are traditional in style and both companies possesss some good plate. The Armourers' and Brasiers' Hall was built in 1840 by J. H. Good and fortunately escaped severe damage during the air raids. The stuccoed facade has a splendid coat of arms with militant supporters perched at roof level. Inside, there is an important collection of plate, including the mid-sixteenthcentury Richmond and Bisby Cups, and 72 seal-top spoons, dating from 1552 to 1627, as well as a remarkable collection of armour.

Just below the Highwalk, to the west, is Aldermanbury Square, much bombed and now rebuilt. Near it is an open space in which stones mark out the foundations of the church of St. Mary Aldermanbury, in existence on the site since 1181 at least but heavily bombed. The medieval church had been the burial place of Henry Condell and John Heminge, Shakespeare's contemporaries and editors of the 1623 folio edition of the dramatist's works. Here too Milton married his second wife, Katherine Woodcocke. Edmund Calamy, the distinguished Nonconformist divine, was minister here during the Commonwealth period; he died of grief and shock when the church disappeared in the flames of 1666. Wren built a new church with a large and noble east window, flanked by robust, curly volutes, where cruel Judge Jefferies was buried in 1693. After the bombs of 1940-41, St. Mary's ruins stood undisturbed for quarter of a century until 1966, when they were transported to Westminster College, Fulton, Missouri, in the United States, and re-erected there as a memorial to Sir Winston Churchill.

Nearby, at 20 Aldermanbury, stands the Chartered Insurance Institute, occupying the site of the medieval inn, the Axe (the sign still hangs in the basement) and housing a collection of fire-insurance

marks, dating back to the post-Fire period, when the idea of insurance was first introduced, and of fire-fighting equipment.

To the west lies Wood Street, following the line of the central road of the Roman fort, which stood in this north-western corner of London (see pp. 61–2). In it stands the tower of St. Alban's church, of ancient, possibly pre-Conquest foundation, and allegedly the chapel of a Saxon royal palace which is believed to have existed in this corner of the City. The medieval church, in which Sir John Cheke, the Greek scholar and tutor to Edward VI, was buried, was replaced with another by Wren, but this in turn was almost completely destroyed by bombs, so that now only the tower remains, standing alone, four stages high crowned with a parapet and eight pinnacles, a landmark and a memorial.

The company halls cluster all around this area. Pewterers' Hall (1959–61 by D. E. Nye and Partners) stands in Oat Lane and houses a fine collection of pewter plates and tankards; near to it, in Staining Lane, is Haberdashers' Hall. The Company has had a Hall on this site since 1478, but the present building dates only from 1956; the Company possesses some excellent clocks and furniture, as well as paintings by Reynolds and Kneller. The south end of the Hall abuts on to Gresham Street, where a small, sunken garden marks the site of St. John Zachary, destroyed in 1666 and not rebuilt. The parish was united with that of St. Anne and St. Agnes. The garden has been most imaginatively planned and is well maintained. with a fine Catalpa bignonioides flourishing in it. A stone's throw away, in another tiny garden in Noble Street, the footings of an angle of Roman wall can still be seen. This was the corner turret of the fort, the existence of which remained unknown till the bombings of the Second World War revealed it. The fort accounted for the curious re-entrant angle of the main line of the city wall, which had puzzled generations of archaeologists.

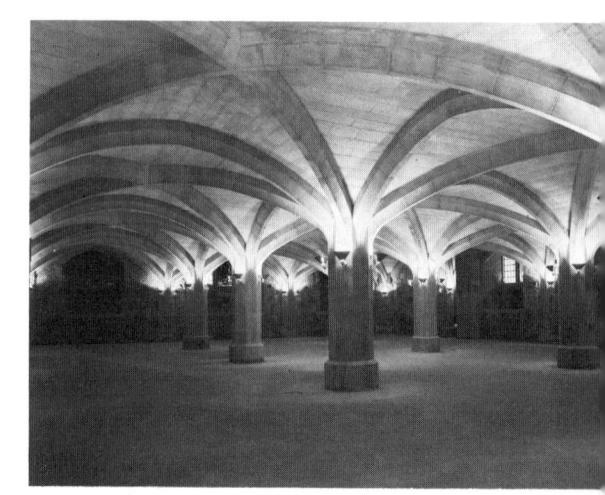

The Guildhall crypt

At the corner of Noble Street and Gresham Street stands the church of St. Anne and St. Agnes. Founded by 1200, the medieval building vanished in 1666 and was replaced with another of Wren's design, completed in 1680. The original brick was stuccoed over in 1820. The plan of the church is a Greek cross, with a groin-vaulted central square on four pillars. Heavily damaged in 1940, the church remained open largely through the passionate determination of its verger, and was restored in 1966 by Braddock and Martin Smith, who wisely removed the stucco to reveal Wren's warm and homely brickwork. Used by the Latvian congregation of London on Sundays, the church is celebrated for its lunch-hour recitals.

To the south, down Foster Lane, is Goldsmiths' Hall. The Company has occupied this site since 1339, the longest tenure of any in the City though the Merchant Taylors followed only six years later. Four halls have stood here: two medieval, a third built in 1634-5 by Nicholas Stone, with the advice of Inigo Jones, which, though damaged by the Fire in 1666, was capable of restoration afterwards under the supervision of Edward Jarman, and the fourth, the present hall. This was built in 1830-5 with Philip Hardwick as architect: the entrance hall and staircase were altered in the 1870s and it was heavily bombed in the Second World War, but it has now been restored and redecorated. The façade to Foster Lane is nine bays wide, with six huge Corinthian columns marking the centre and Corinthian pilasters at the corners. The carved decorations are by S. Nixon. A statue of St. Dunstan, the patron saint of goldsmiths, stands on the staircase; it came from the Company's barge and was carved about 1700.

The main apartments are the magnificent Livery Hall, the Court Room and the Drawing Room. The Livery Hall is lit by chandeliers, which were shown at the Great Exhibition of 1851; they are still lit by real candles and the quality of light given by the living flame is incomparable. In the Court Room is a fireplace, believed to be by Roubiliac, from Canons (see p. 264), and in the ante-room of the Library is seventeenth-century panelling from East Acton Manor House, brought here in 1912. The Company possesses a superb collection of silver, its earliest piece being the Cressener Cup of 1503. It also has the Royal Tudor Clock Salt, probably given to Henry VIII by François I, and one of only three objects known to have survived from the 1,605 items listed in the 1574 English Royal Treasury Inventory. It is the Company's policy to collect fine examples of modern silver. This is the most accessible of all the livery halls, for exhibitions, usually of modern goldwork and jewellery and open to the public, are frequently held here. Finally, the Goldsmiths have a Roman altar, dedicated to Diana, with a carving of the divine huntress upon it, discovered when the foundations were dug for the 1830 rebuilding. This has always been the goldsmiths' quarter of London and it was near to the Hall that the Cheapside Hoard

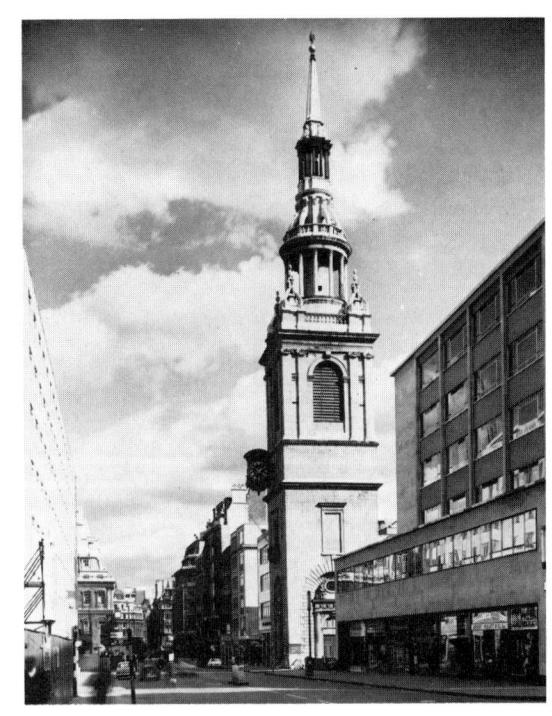

St. Mary-le-Bow, Cheapside

was found in 1912. This was the delectable stock of an Elizabethan jeweller's shop, hidden we know not why, and now to be seen in the Museum of London.

At the southern end of Foster Lane is St. Vedast's church. The dedication is rare, only one other, at Tathwell, Lincolnshire, being known in England. He was a sixth-century Bishop of Arras, who worked many miracles. The church was 'lately new built' in Stow's day and was rebuilt by Wren. Though damaged in the Second World War, all its woodwork and fittings being destroyed, it was restored by S. E. Dykes Bower and rededicated in 1966. The interior is plain enough, with nave and chancel virtually in one, the pews arranged in collegiate fashion to face each other, and only a south aisle, in which several small memorials of varying date have been installed. The reredos and communion rails come from St. Christopher-le-Stocks: the carved pulpit is from the former All Hallows, Bread Street, and the font cover from St. Anne and St. Agnes. The organ from St. Bartholomew-by-the-Exchange is exceptional, for the case, made in 1731, is noble and the organ itself, by Renatus Harris, is largely original. The modern windows, with scenes from the life of St. Vedast, were designed by Brian Thomas and made by the Whitefriars Glassworks. The pride of the church is its tower and steeple. The tower is square and the steeple rises up in three stages, the first with pilasters at the corners and concave walls between, the next recessed with convex sides, and then the obelisk spire and a weather-vane. The concave and convex sides

have wide openings but the pilasters on the corners are massed so that, from some angles, the steeple looks solid and from others hollow. Its simplicity is in direct contrast with the delightful fantasy of the steeple of St. Mary-le-Bow and it is a pity that modern buildings make it almost impossible to see the two at the same time. The poet Robert Herrick was baptized in St. Vedast's on 24 August 1591, having been born in Cheapside, where his father, Nicholas Herrick, was a goldsmith.

St. Vedast's stands almost at the western corner of Cheapside. Off the northern side of that thoroughfare, a number of streets lead back towards the Guildhall and London Wall. In Gutter Lane stand the post-war Halls of the Wax-Chandlers' and Saddlers' Companies, the latter possessing a funeral pall embroidered for the use of its deceased members in 1520. Wood Street comes next; where it runs out of Cheapside there stand two tiny, much-altered shops, the only survivors of those rebuilt immediately after the Fire. Just behind them is an open space, with a plane tree marking the site of the now-vanished medieval church of St. Peter-le-Cheap and in a window looking on to it there once hung a caged bird whose song inspired Wordsworth to write The Reverie of Poor Susan. The next narrow street to the east is Milk Street where Sir Thomas More was born on 7 February 1478, and then comes King Street which, with Queen Street to the south, was one of the few new thoroughfares deliberately created after the Fire; it affords a view up to the Guildhall.

Ironmonger Lane, in which the Mercers' Hall stands proudly, is next. The Mercers are the foremost of the twelve great companies; Henry FitzAylwyn, London's first Mayor, Richard Whittington, and Sir Thomas Gresham were all Mercers. In 1540, the Company bought the site of the Hospital of St. Thomas of Acon, an order founded by the sister of St. Thomas à Becket in the saint's birthplace; to this day, the Mercers are the only City Company to have their own chapel. On the site, they built a Hall which was destroyed in 1666, as was its successor in 1940; a new Hall has now been built to designs by E. N. Clifton of Gunton and Gunton. When the bombed site was being cleared in 1954, a remarkable early sixteenth-century statue of the dead Christ was discovered under the rubble, hidden, presumably, at the Reformation. Christ lies on a bier covered with an imperial mantle, looking as if life had only just left Him, His face drawn, the jaw slightly sunken. The figure now lies in the Ambulatory at the entrance of the Chapel. Opposite is a full-length effigy of Richard Fishborne, an important Mercer who died in 1625. The Company possesses a superlative collection of plate, including a spoon given by Richard Whittington, Lord Mayor of London in 1395, 1401, and 1408, and the Leigh Cup made in 1499.

Behind the Mercers' Hall, in St. Olave's Court, is the tower of another Wren church dedicated to St. Olave, now converted into offices since the demolition of the body of the church in 1888. Alderman John Boydell was buried there, and a bust set up to his memory by his niece Mary, wife of George Nichol, George III's bookseller, has since been removed to St. Margaret Lothbury. Just to the east of it, hidden away in an alleyway beyond Old Jewry, stands Grocers' Hall. The Company's older Hall was bombed and suffered a later fire, though a wroughtiron screen made by Thomas Collins in 1682–3 survived the damage; the new building (completed 1970) is the work of Bear, Bennett and Wilkins.

On the south side of Cheapside stands the most famous of all City churches, St. Mary-le-Bow. Probably of pre-Conquest foundation, a stone Norman church was built before the end of the eleventh century above a crypt with stone arches or bows, the first to be constructed in London. The capitals were adorned with spearhead decoration, possibly the earliest example of such elaboration. It was here that an ecclesiastical court of discipline met, and from the crypt it took its name: the Court of Arches. The Crypt and its pillars are still in Cheapside, having withstood the Great Fire, the Blitz, and nearly nine centuries of usage. The medieval church had a distinctive steeple and, when it vanished in 1666, Wren replaced it with one of his most imaginative creations. The church itself was conventional enough, being nearly square - 65 feet 6 inches long and 63 feet wide - with a central nave separated from the north and south aisles by columns. The tower projects into Cheapside, for there Wren found the gravelling of a Roman road and used it to support the foundations. The base is square and the whole edifice is a precise lesson in the architectural orders, for the pillars on either side of the handsome doorway have Tuscan capitals supporting the arch, while outside them a pair of Doric columns bears the entablature. The second storey of the tower, where the bells hang, has four arched apertures, and flanking pilasters with Ionic capitals, and a parapet with

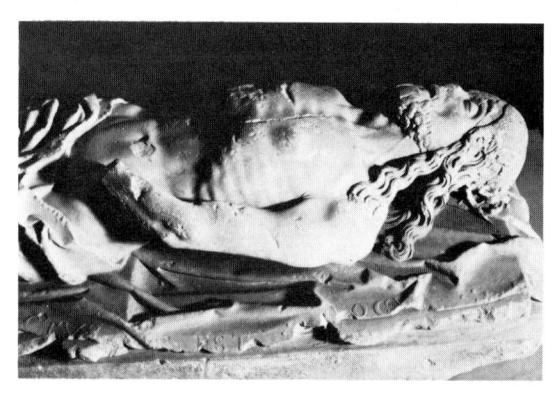

Statue of Christ in the Mercers' Chapel, Cheapside

¹ The others being Grocers, Drapers, Fishmongers, Goldsmiths, Skinners and Merchants Taylors (who alternate sixth and seventh), Haberdashers, Salters, Ironmongers, Vintners, and Clothworkers.

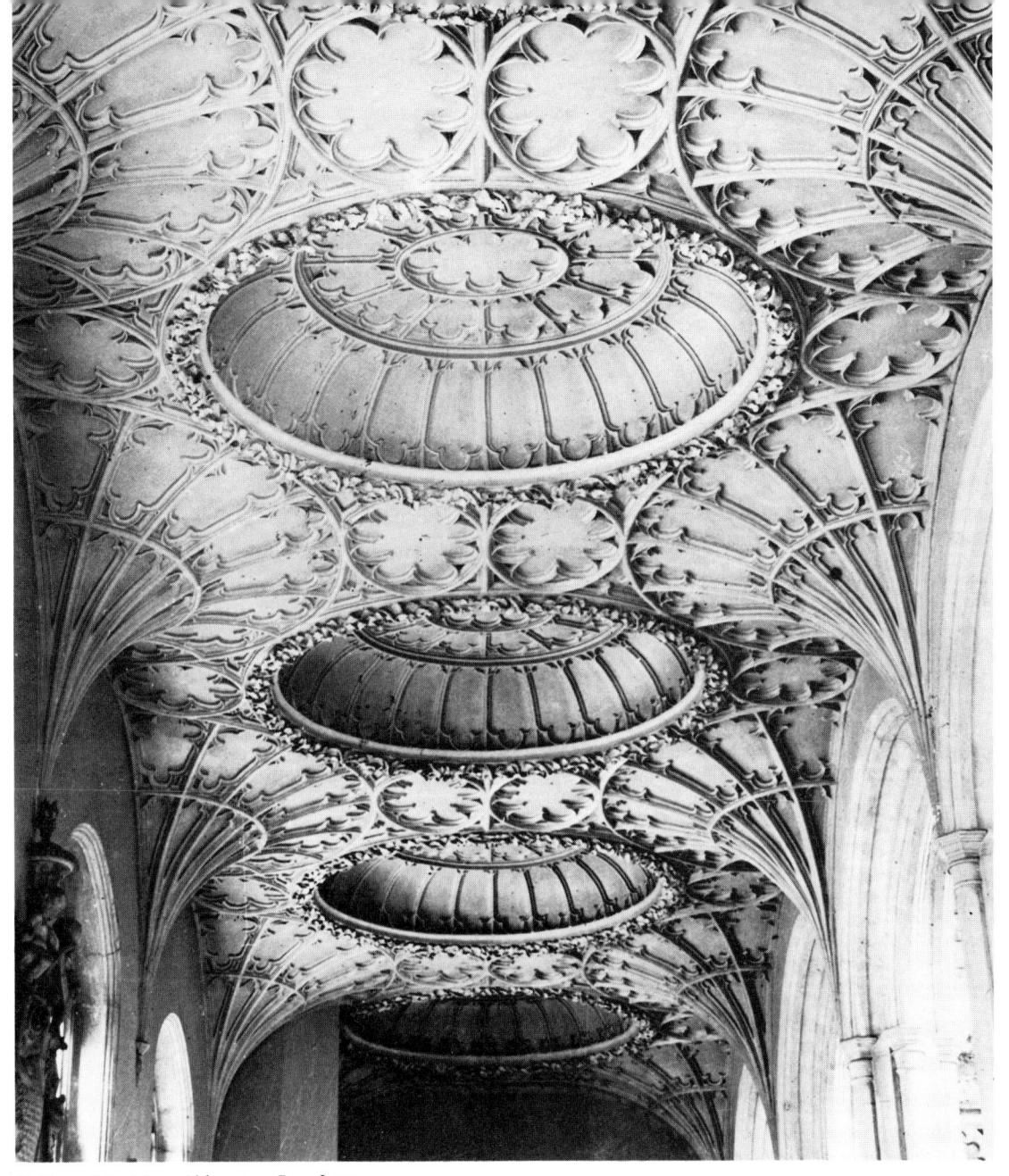

Ceiling of St. Mary Aldermary, Bow Lane

urns supported on volutes at the corners. Then the steeple begins with a drum or temple of twelve columns, their capitals of the Composite order, topped by an entablature and a parapet. Above the columns, twelve little flying buttresses spring upwards to support a final storey, with twelve tiny columns arranged in a Greek cross and crowned with Corinthian capitals. Then comes the spire, an obelisk with a weather-vane in the form of a dragon. It is of copper, very large, being 8 feet 10 inches long; it was cast by Richard Bird from a wooden model by

Edward Pierce. The steeple was not completed till 1680, though the main body of the church had been finished in 1673.

The last raid of the Blitz, on 10 May 1941, wrecked St. Mary-le-Bow. The tower acted as a funnel for the flames and the famous peal of bells crashed down and were shattered. Bow Bells had always been celebrated. Legend claims that it was their sound which recalled Dick Whittington to the apprenticeship from which he rose to be Lord Mayor of London, and to be a true Cockney or Londoner,

one must have been born within earshot of them. It was 20 years before they were to ring again, when a new peal was recast from the metal of the old by Mears and Stainbank of Whitechapel and were set ringing on 20 December 1961 by the Duke of Edinburgh. The restoration of the church was not completed until 1964 and was carried out to the design of Laurence King. The exterior, the tower, and the steeple were restored according to Wren's plans, but significant changes were made to the interior. This became one great hall with a freestanding altar, behind which is a throne for the Bishop of London when he visits the church. There is no cross on the altar lest it obscure his vision, but a great rood hangs from the roof, and figures of Mary Magdalen and the Centurion keep vigil beside Our Lady and St. John. Two pulpits stand on either side of the altar for dialogues, the black and white floor is bare of pews, chairs being brought in as they are needed, so that there is never an empty seat. The organ over the west door is by Rushworth and Draper. The stained glass is by John Hayward; in the north-east window Our Lady cradles St. Marv-le-Bow in her arms, with the other bombed churches of London all around her. The same artist designed the rood and executed the engraved glass of the screen across the entrance to the crypt, used today as a chapel for private prayer and as a parish room. The contractors were Dove Brothers; the head of their managing director, Lieutenant-Colonel W. W. Dove. is carved on one of the stone corbels, with likenesses of others concerned with the rebuilding.

Outside, the churchyard has been repaved and laid out with flower-beds around a statue of Captain John Smith (see also p. 43), a present from the Jamestown Foundation of America in 1960. A tablet on the west wall of the church celebrates the birth of the poet John Milton in nearby Bread Street.

An alleyway behind the churchvard turns into Bow Lane, which leads to the church of St. Mary Aldermary, so called because it is believed to be the earliest dedication to Our Lady in London, and probably of pre-Conquest foundation. The medieval church, rebuilt in 1511 but incomplete till 1629, was swept away by the Fire a generation later, save for the tower, which Wren retained and restored (1702-4) when he had completed the new body of the church in 1682. At its corners he set heavy stone pinnacles. to which the eighteenth century added slender stone finials; in 1962, these were replaced with copies in gilded fibreglass. The interior is most unusual for Wren, being his only interpretation of Gothic architecture. The story is that he needed to comply with a bequest in the will of Henry Rogers, but the evidence does not seem to bear out the legend. The central nave is divided from north and south aisles by slender arcades which support the clerestory. The roofs are flat with cherubically fat central rosettes of plaster set between fan-vaulting on either side. Could Wren have been imitating a plaster vault of the early seventeenth century rather than a medieval vault? Hall Staircase at Christ Church, Oxford, has similarities. Or was he simply giving rein to his imagination? Whatever the source, the result is enchanting. The pulpit is carved with cherubs' heads, the font was installed in 1682, and a fine door-case came from the church of St. Antholin, which was demolished in 1875. There is a rich oaken sword-rest of 1682, carved with flowers and fruit, and a poor box with a twisted stem. There is some attractive modern heraldic glass and two agreeable small monuments, one by the younger John Bacon to Margaret Bearsley (d.1802) and another, unsigned work, with cherubs. Time, and Death, to John Seale, who died in 1714. It was in St. Mary Aldermary that Milton married his third wife, Elizabeth Minshall, in 1663.

North from London Wall

The Barbican, Aldersgate to Bishopsgate

The first bomb to hit the City of London during the Second World War fell at the western end of Fore Street, just north of London Wall, on 25 August 1940; before the end of 1941, some 63 acres, northwards to the City boundary, were almost completely devastated. As early as 1955, a plan was put forward by the architects. Chamberlin, Powell and Bon, and then, in 1956, Lord Sandys, Minister for Housing, appealed to the City authorities not to devote this area solely to office buildings but to make it 'a genuine residential neighbourhood, incorporating schools, shops, open spaces and amenities, even if this means forgoing a more remunerative return on the land'. The City Council adopted this suggestion and took advantage of the challenging opportunity of so much land being laid bare in a great capital city, on which to attempt to build an ideal city for the future. The southern section nearest to London Wall was planned jointly by the City authorities and the London County Council; the land in the centre and to the north, under the control of the City, was laid out according to the revised plans of Chamberlin, Powell and Bon and was called the Barbican, a barbican being a projecting watch-tower over the gate of a fortified city.

The southern section takes the now much-widened street, London Wall, as its axis; beside and across it, overhead walk-ways thread to and fro – the first time an English city had provided such accommodation on such a scale – and along it, at an oblique angle, are ranged six huge tower blocks of offices, four to the north and two to the south. Though each is by a different architect, the overall design was the responsibility of the City Planning Officer, H. A. Mealand, and of Sir Leslie Martin and Sir Hubert Bennett for the London County Council; they determined the basic ground-plan and decreed some uniformity in the façades, so that the office blocks stand like stalwart glass sentinels along London Wall.

The dramatic new building of the Museum of London is housed on the triangular podium below the westernmost block on the north side. Established

by Act of Parliament in 1965 and designed by Powell and Moya, the foundation stone was laid in 1973 and the Museum opened in 1976. It was created by the union of two much older institutions, the Guildhall Museum and the London Museum. The Guildhall Museum, established in 1825, collected 'such antiquities as relate to the City and suburbs' and paid particular attention to the City Corporation and its ceremonial and to the City Companies; from 1876 till the Second World War it was housed beneath the Guildhall Library and, after bombing, in temporary accommodation. The London Museum, opened in 1911, aimed at portraying the life of the capital in its widest sense; it had earlier homes in Lancaster House and Kensington Palace. The public exhibition, on the walk-way level of the podium, tells the story of London, beginning with a remarkable display on the geological and prehistoric site and continuing through historical periods from the Romans to the present day. The most popular exhibits are probably the objects discovered in the Mithraium (see p. 74), the working model of the Great Fire, beloved of generations of school children, and the Lord Mayor's Coach, constructed in 1757 with painted panels said to be the work of Cipriani, which is pulled out each year to take its part in the ceremonial installation of the City's chief officer. The Museum has a well equipped lecture hall, where a varied programme of lunch-time and evening lectures is given, and runs an excellent service to schools; it aims to be 'the obvious and irresistible starting-point for all visitors to London'. Behind the scenes are research departments, a library, a collection of maps, paintings, prints, and drawings, a superb costume collection, and conservation laboratories. The Department of Urban Archaeology, established in 1973 to take responsibility for excavation in the London area, has its headquarters here. The Museum is open daily save on Mondays, free of charge.

At street level, every effort has been made to preserve and restore as much of the Roman and medieval walls of London as time and bombing have spared; a good stretch lies just by Fore Street. The existence of a Roman fort, to which the north-west corner of the wall owes its curious re-entrant angle, was revealed by war-time destruction. The underground car-park beneath the street of London Wall shelters the remains of the fort's western gateway;

pedestrians may view it freely between 12.30 and 2.00 on weekdays. Wood Street marks the northsouth axis of the fort. In it stands the tower of St. Alban's church, completed by Wren in 1685, but the foundation of the church was much older, as the dedication to Britain's first martyr indicates. It is claimed that there was a Saxon palace within the city walls and that this was the site of its chapel, which may have been so, though the centuries between the departure of the Romans and the coming of the Normans are the most indistinct in London's history. Sir John Cheke, the eminent Greek scholar and tutor to Edward VI, was buried in the medieval church. Wren's church was much altered by later generations so, when bombs damaged it, it was not rebuilt; only the fine square tower of four storeys, topped by a parapet and pinnacles, was retained as a landmark.

Halfway along the opposite, eastern end of London Wall, another relic, the ruin of St. Alphege's church, nestles beside the modern thoroughfare. The tower was that of Elsing Spital, which became a parish church at the Reformation. Escaping the Fire, it was extensively repaired in 1777 and again early in the present century. Heavy bombing destroyed the eighteenth-century building, but the medieval remains were incorporated into the new landscape. A good portion of the wall is visible here and a blue plaque marks the site of Cripplegate, a former entrance to the City demolished in 1760; its name means a 'covered way' and refers to London's defences.

From here the Barbican may be entered by way of Monkwell Square, the architecture of which, with

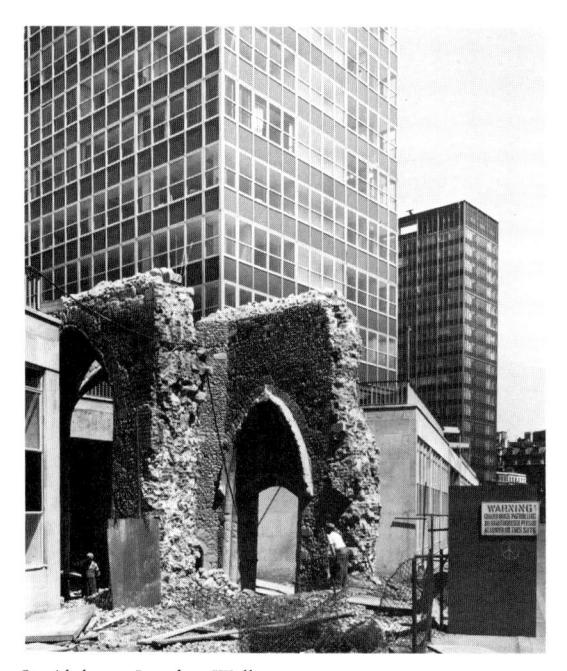

St. Alphege, London Wall

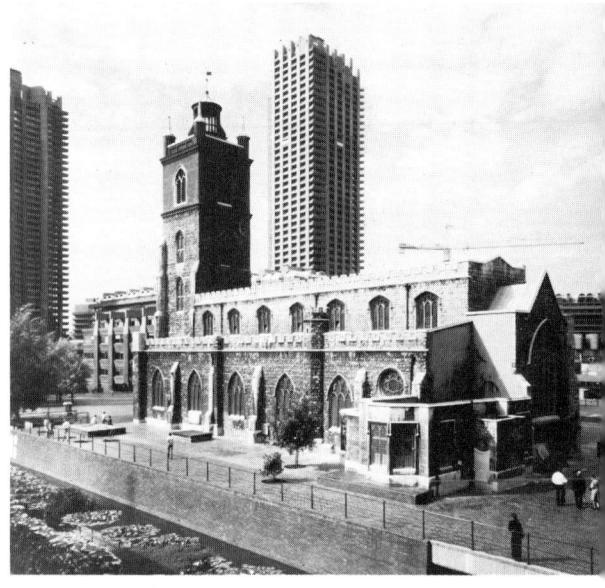

St. Giles, Cripplegate

excellent brickwork and detailing, is reminiscent of a medieval walled city. In the square is the hall of the Barber Surgeons' Company, with that of the Ironmongers nearby. The Barber Surgeons possess a superb gilt mazer, presented by Henry VIII when the Company was formed in 1540, and Holbein painted them a group showing the monarch surrounded by his doctors (see also p. 214). The Ironmongers have a pleasant Tudor-style hall (Sidney Tachell, 1920), and own much fine silver and an embroidered funeral pall, presented to them in 1515 by the widow of John Gyva. Beyond lies the main residential area of the Barbican. Three massive blocks, Shakespeare, Cromwell, and Lauderdale Towers – at the time of building, the tallest residential accommodation in Britain at over 400 feet - houses and maisonettes around Monkwell Square, and lower-rise flats, each called after a great man associated with this part of London, provide some 2,100 dwellings for about 6,500 people. Some have small private gardens and all have access to green artificial islands jutting out into pools and lagoons, which the architects have made a feature of their scheme. Among so much modernity, the corner bastion of the Roman fort has been preserved, and the restored church of St. Giles apart from the Wall, the only old building to have survived in the area – has been made the centrepiece, ringed about and illuminated by a horse-shoe of old gas-lamps, with tombstones from the churchyard laid between them.

A church has stood here since 1090 at least, when it is said to have been built by one Alfune who, in his old age, helped Rahere to build St. Bartholomew's. There may even have been an earlier shrine, for the body of the royal martyr Edmund, killed by the

Danes in 869, entered the City at Cripplegate, where his presence wrought miracles; there may have been a chantry where the body lay for a while. A new church was built in 1390 and rebuilt after fire damage in 1545, though it escaped the holocaust of 1666; it is this church, much restored, which stands today in the most modern part of the City. A new brick top was added to the old tower in 1682–4 by John Bridges; from this rises a white wooden turret and weather-vane. The tower stands 134 feet 9 inches high and contains a peal of 12 bells, a clock, and a chiming mechanism.

The interior, gutted by fire on 29 December 1940, was restored by Godfrey Allen with a large, airy nave, seven bays long, the chancel slightly recessed. The delicate fifteenth-century arcades have pillars so slender that they scarcely create a division between nave and aisles; above them is a clerestory with plain glass to admit more light. A new east window with brilliant stained glass by A. K. Nicholson Studios was dedicated in 1967; it represents the Crucifixion, St. George, St. Alphege, St. Anselm, Bishop Lancelot Andrewes (who was vicar here from 1588 to 1605) and St. Bartholomew in the lower lights. A new west window, by John Lawson of Faithcraft Studios, was inserted in 1968. Beneath St. Giles, and the arms of the sees of Canterbury and London and of the City, the armorial bearings of five men associated with this church fill the lower lights. They are Robert Glover, Somerset Herald of Arms 1544-88, John Milton who, with his father, is buried near the chancel, John Egerton, Earl of Bridgewater, whose house stood on the north side of the Barbican and for whose children Milton wrote his masques Arcades and Comus,

Oliver Cromwell, who married Elizabeth Bouchier here on 22 August 1620, and Sir Martin Frobisher, the Elizabethan explorer who is buried here. Among those buried in St. Giles were John Foxe, the martyrologist (d.1587), John Speed, the cartographer (1552-1629), and William Bulle, physician to Edward VI, Mary I, and Elizabeth I. Among the parishioners were Sir Thomas More, Sir Humphrey Gilbert, who discovered Newfoundland, the musician Thomas Morley, and Ben Jonson the dramatist. Shakespeare may have come here for his nephew's christening in 1604 and Edward Alleyn, whose Fortune theatre stood nearby between Whitecross Street and Golden Lane, certainly worshipped here. John Bunyan and Daniel Defoe were buried close by in Bunhill Fields (see p. 295), and Dr. Samuel Annesley, the father of Charles Wesley's strong-minded mother, was vicar here from 1658 to 1662. Sir Ebenezer Howard, the Victorian town-planner and creator of the ideal of the garden suburb, also worshipped here. Many of the names are recalled by those of the streets and blocks of flats nearby.

The great pride of the church is its organ. There was one here by 1627; its replacement, installed in 1704 by Renatus Harris, was destroyed in 1940. Today, a Jordan and Bridge instrument of 1733 from St. Luke's, Old Street, housed in the casework of a Renatus Harris organ of 1684 from St. Andrew's Holborn, has been restored by Noel Mander and now fills St. Giles with sound of such a quality that broadcasts are often made here. There are frequent public recitals. Around the church stand busts, two of Milton (one carved by the elder John Bacon in 1793), and others of Cromwell, Speed, Bunyan, and

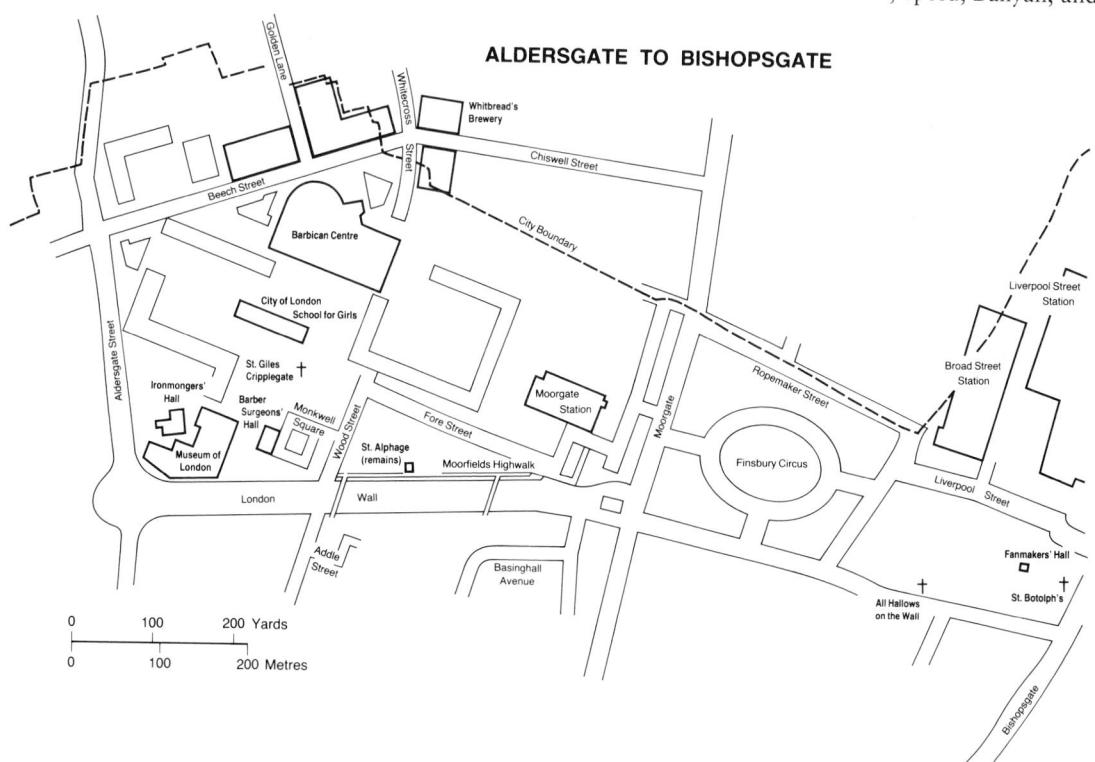

Defoe. There is a fine sword-rest and a marble font from St. Luke's, Old Street.

North of St. Giles is the Barbican Centre. From the beginning of the post-war replanning, it had been the intention to provide premises for the Guildhall School of Music and Drama. By 1959, there were proposals for an arts centre and in 1964 it was decided to include accommodation for the Royal Shakespeare Company and the London Symphony Orchestra, to provide a library and an art gallery, and to create facilities for conferences. After a troubled gestatory period, the Guildhall School of Music and Drama was installed by 1977 and the horseshoe-shaped, multi-level Barbican Centre for Arts and Conferences was opened by Her Majesty the Queen on 3 March 1982; the approved cost stood at £153 million pounds and the work had taken 27 years.

Technically, the facilities provided are excellent. The acoustics of the Concert and Conference Halls are impressive, the Barbican Theatre, the home of the Royal Shakespeare Company, seats 1,116, has its own rehearsal rooms and a high fly-tower to accommodate quantities of scenery, there are three cinemas of various sizes, which double as conference rooms, the Library is well-stocked, the Art Gallery and Sculpture Court are spacious, and there are imaginative touches such as the Conservatory, an amazing attempt at an indoor garden, which can be booked for private functions. But, all the time, the visitor is aware of the 120,000 cubic yards of rough-tooled concrete used to build the Barbican; in spite of the soothing watery surroundings and unusual sculptures such as Michael J. Sanfry's Sculpture for Lighting in the fover, the explorer seems to wander in an arid maze, struggling against a severe lack of sign-posting. We can only await improvements. In the meantime, it is fascinating to observe the brave new world of the 1950s down, so to speak. the wrong end of a 1984 telescope.

Just north of the Barbican, with the City boundary passing through its premises, stands Whitbread's Brewery fronting on to Chiswell Street. It has been here since 1749, though beer is no longer brewed on site, but the dray-horses each November pull the Lord Mayor's Coach from the Guildhall to the Law Courts in the Strand, when the new Lord Mayor goes to be sworn into office (see also p. 295).

Returning to the more familiar City, the area between Moorgate and Bishopsgate is left. Moorgate led onto open heathland where women spread their washing, apprentices skated in winter, and the citizens of London slept under the night sky, clutching such belongings as they had managed to save, in the September nights after the Fire. Finsbury Square and Circus were laid out here in the early nineteenth century, though only the Circus lies within the City boundaries; elegant, with tall Georgian houses around a precise oval, it was built in 1815 by William Montague following George Dance's plans.

The private houses have been rebuilt as offices but the oval remains around a garden, a bowling green, and a drinking fountain in a miniature temple.

A narrow, older stretch of the street of London Wall runs eastwards, with the church of All Hallows on the Wall pressed against it. Ancient masonry can be seen in the churchyard and the line of a Roman bastion determines the curve of the apse. The medieval church, famous for its fifteenth-century anchorite, escaped the Fire but became so ruinous that the parishioners commissioned a 24-year-old architect, the younger George Dance, to rebuild it: the work was carried out between 1765 and 1767. Working on a cramped site and a limited budget -All Hallows cost under £3,000 - Dance created one of the most successful of London church interiors. The exterior is of brick, very modest, with a square stone tower at the west end, rising through three stages and topped by a small cupola. Inside, a vestibule leads to the church, which consists only of a nave and apse, the narrowness of the site prohibiting aisles. Lit by three wide, high, clear, semicircular windows - the proximity of the city walls makes any other arrangement impossible on the north side – the roof is tunnel-vaulted and coffered, with delicate motifs picked out in white and gold. There is no cornice – a startling omission for the period – but the fluted Ionic columns which carry the vault lead up to a frieze just below the windows, and the apse is coffered in blue and gold. The pulpit can be entered only through the vestry and the west gallery supports a small organ. There is one monument, other than simple tablets, to the architect Joseph Patience (d.1797); it was designed by his son, Thomas. A large copy, made by Sir Nathaniel Dance-Holland. George Dance's brother, of Pietro da Cortona's Ananias Restoring Sight to Saul's Eyes serves as reredos. All Hallows, after severe bombing, was restored by David Nye and rededicated in 1962. It is a guild church and the headquarters of the Council for the Care of Churches.

Just behind the church is Liverpool Street Station, designed by E. Wilson and opened in 1874 though the line had been begun as early as 1839. It stands on the original site of Bethlehem Hospital, now moved to Beckenham in Kent, the Bedlam where so many deranged people were confined until 1675; Hogarth depicted the later building in the last stage of his Rake's Progress (see p. 214). To the east is Bishopsgate with St. Botolph's church on its western side. St. Botolph (d.c.680) was an Anglo-Saxon abbot who established a monastery, probably in Boston in Lincolnshire ('Botolph's town'). He was believed to take particular care of travellers - an Anglo-Saxon St. Christopher – and so there were churches dedicated to him at five of London's main gateways. Those at Cripplegate and Billingsgate vanished but those at Aldgate, Aldersgate, and Bishopsgate survive. St.

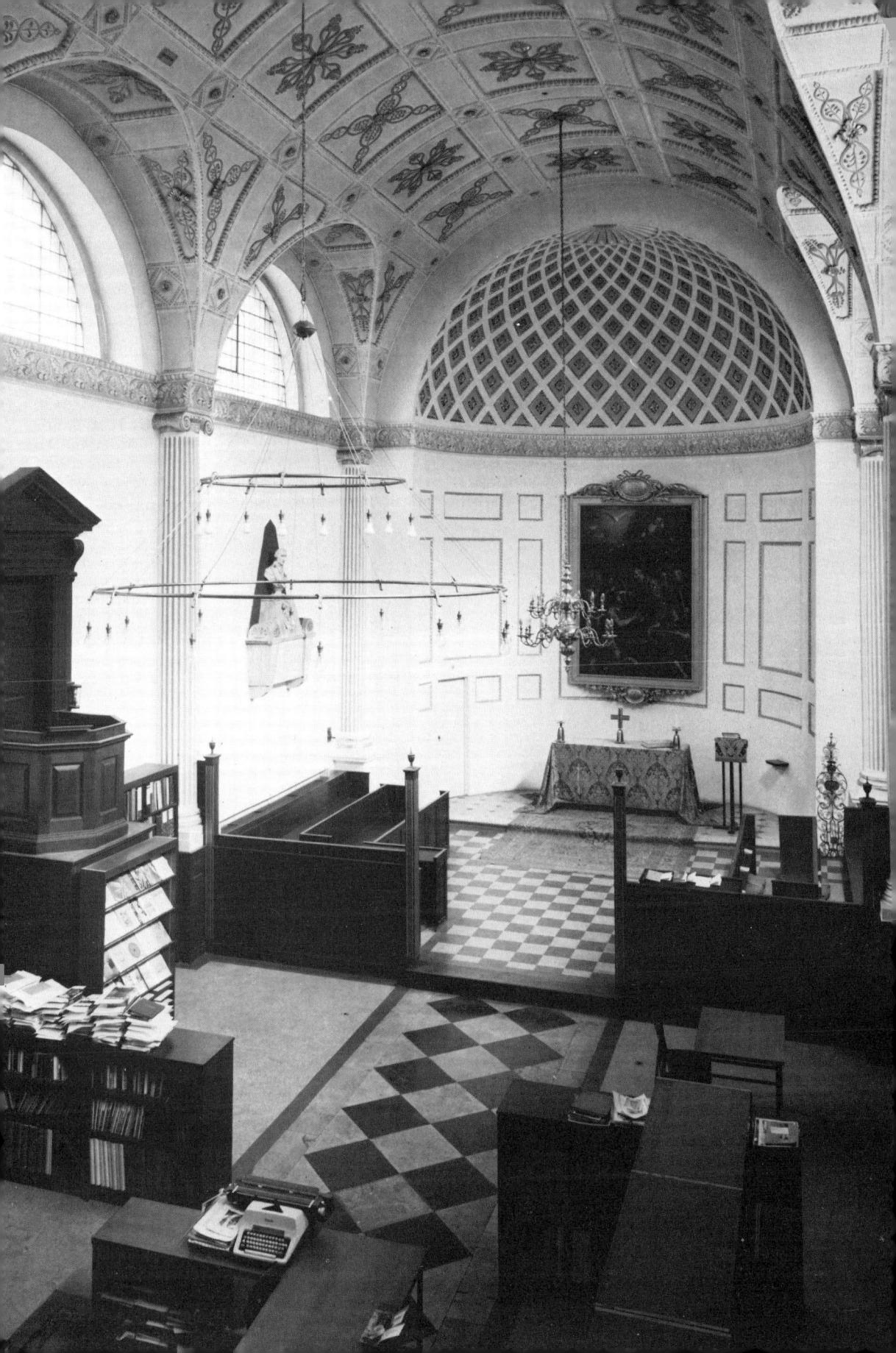

Botolph's Bishopsgate is first mentioned in 1213; the medieval church, where Ben Jonson's infant son was buried and where Edward Alleyn, the future actormanager, was christened, survived the Fire but later became ruinous. It was rebuilt in 1727-9 by James Gould and his son-in-law, the elder George Dance. It is a large brick church, with stone quoins and a stone-faced west front and tower. The latter presents itself imposingly to Bishopsgate, rising in three square stages topped by a circular balustrade, a lantern, a cupola, and an urn; the doorway stands between coupled Doric pilasters supporting a pediment. The entrance today, however, is from the north side, formerly the churchyard. The rectangular interior is rather dark, despite the lantern, which Michael Meredith inserted into the nave roof in 1821. The chancel was remodelled in 1878. Above each aisle is a gallery, carried on huge Corinthian columns which also support the coved ceiling. John Keats, who was born at the Swan and Hoop public house in Finsbury Pavement, where his grandfather was innkeeper and his father chief ostler, was christened here, and there is an eighteenth-century monument to a seventeenth-century parishioner, Sir Paul Pinder, a merchant prince who lived in a magnificent house in Bishopsgate, the façade of which is still to be seen today in the Victoria and Albert Museum.

St. Botolph's large churchyard provides a welcome green resting-place for City workers, with a fountain and a tennis court. Just behind the church stands a little hall built to serve as a church school in 1861, in a style following that of the church with eighteenth-century Coade Stone figures of a school-boy and girl set in niches by the door; it is today used as the headquarters of the Fanmakers' Company.

Northwards, on the eastern side of the road, stands the Bishopsgate Institute designed in 1894 by Harrison Townsend. An unexpected, original, Arts and Crafts Movement building, with a big arched entrance, mullioned windows, polygonal corner turrets, and much carved decoration, it houses public examination halls, a reference library, and a considerable collection of prints and drawings recording the appearance of a London now vanished.

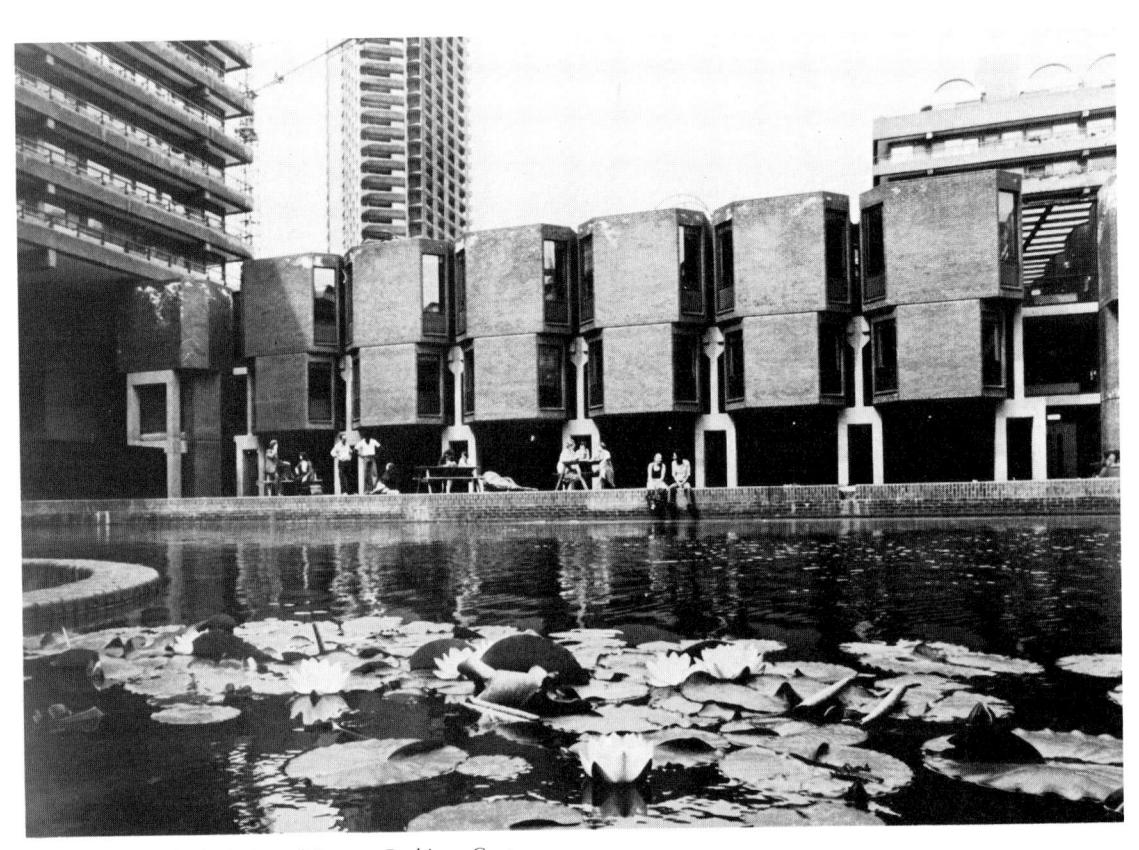

Guildhall School of Music and Drama, Barbican Centre

Around the Bank

The road junction outside the Bank of England and the Mansion House, from which eight streets -Threadneedle Street, Cornhill, Lombard Street, King William Street, Queen Victoria Street, Poultry leading to Cheapside, Princes Street, and Mansion House Place radiate out like irregularly placed spokes on a wheel, may fairly claim to be the hub, the true centre, of the City of London. The buildings, of the eighteenth century to the present day, throng together, one period jostling another; they turn the streets into tall, narrow canyons, and along them, as it were, flow streams, of commerce, of finance, and of power.

The Bank of England, projected by a Scot, William Paterson, was established in 1694 and confirmed by royal charter. Nationalized in 1946, it is the central bank of the United Kingdom, acting for both the Government and the other principal clearing banks, and is responsible for the issue of banknotes. Its buildings cover an irregularly shaped area of between three and four acres fronting on to Threadneedle Street, which probably took its name from the arms of the Needlemakers' Company or from an inn or shop sign with the device of three needles; in its turn, it provided the Bank with its own personification, the Old Lady of Threadneedle Street, first characterized by Sheridan and soon after realized by the cartoonist, James Gillray. The Bank first operated from the Chapel of the Mercers' Company and then from Grocers' Hall till 1734, when premises were built for it, to designs by George Sampson, on part of the present site. Wings were added by Sir Robert Taylor, Wren's church of St. Christopher-le-Stocks being demolished to give the Bank more room. When these buildings proved inadequate, a new single-storey one, surrounded by a blind wall for security, was designed by Sir John Soane, the Bank's surveyor from 1798 till 1833; he retained Taylor's Court Room where the directors still meet. Soane's dignified and sober building was rebuilt in 1924, to plans by Sir Herbert Baker; the curtain walls remain but the Bank within is grandiose rather than noble. During construction, two Roman pavements were found and are now laid down inside the building, one at the foot of the main staircase; the centre portion of another Roman pavement, found here in 1805, is now in the British Museum. The large sculptures adorning the Threadneedle Street façade are by Sir Charles Wheeler. The Bank has a small museum of its own; admission is by written application only.

Beside the Bank, along Old Broad Street, is the Stock Exchange, newly built to designs by Llewelyn Davies, Weeks, Forestier-Walker and Partners and Fitzroy Robinson and Partners and opened in 1972 by Her Majesty the Queen. The tower is 330 feet high and both it and the lower part of the building are covered with precast concrete panels with emphatic mullions round the windows. The Stock Exchange has occupied this site since 1802.

Exchange has occupied this site since 1802.

Behind the Bank, fronting on to Lothbury, is St.

Margaret's church, rebuilt by Wren and completed in 1690. The church was here by 1200 but was rebuilt in 1440, chiefly at the expense of Robert Large, mercer, Lord Mayor of London, and master to William Caxton, the future printer. Wren's church, of white Portland stone, is roughly oblong in plan (66 feet by 54 feet) with a square, four-stage tower at the south-west corner, topped by a delicate, tapering lead spire, rising to 140 feet. Three round-headed windows look on to Lothbury. Inside, the church has a nave, chancel, and south aisle with a flat ceiling. It is remarkable for the splendour of its fittings, many of them coming from the demolished churches of All Hallows the Great and St. Olave Jewry. The especial glory is the screen (from All Hallows) - only two Wren screens to survive (see p. 69) - running right across the church, with four divisions on either side of the main aperture, which is topped by a segmental pediment and an eagle with outspread wings. The pulpit is carved with flowers and fruit, the sounding board above it (from All Hallows) with lively cherubs and birds. The font-cover, reredos, and church plate come from St. Olave Jewry. The font (St. Margaret's own) has a baluster stem and round bowl carved with cherubs' heads, Adam and Eve, Noah's Ark, and the baptisms of Christ and of the Eunuch; the tripartite reredos is of dark wood with Corinthian columns. The former east windows are now covered by paintings of Moses and Aaron (executed c.1700) from St. Christopher-le-Stocks. Among the monuments are busts of Mrs. Simpson (d. 1795) carved by Nollekens, of Alderman Boydell (d.1820),

68

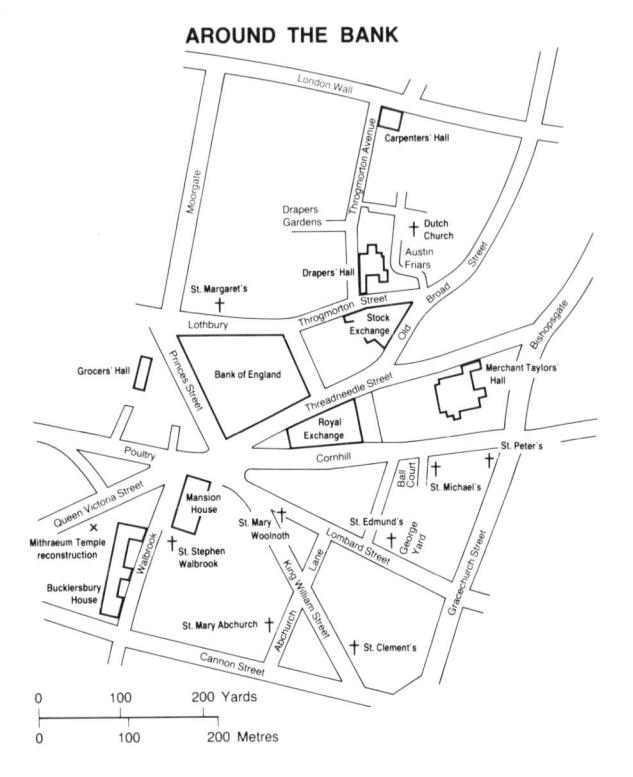

the originator of the Shakespeare Gallery (see p. 145), designed by Thomas Banks and carved by F. W. Smith, from St. Olave's, and of Sir Peter Le Maire (d.1631), possibly by Le Sueur, from St. Christopher-le-Stocks.

Lothbury runs into Throgmorton Street with Throgmorton Avenue and Drapers' Hall beyond. The Company, in existence by 1180, provided London with its first mayor, William FitzAlwyn; it acquired the house of Thomas Cromwell, Earl of Essex, after his execution in 1540, and subsequent Halls have been built on the site. The present structure preserves seventeenth-century brickwork in the Clerk's Room and Court Dining Room, though the rest was remodelled in 1868-9 by Herbert Williams, with a marble staircase added thirty years later by Sir T. G. Jackson, who also designed the bearded supporters on either side of the entrance. The Company possesses an impressive series of royal portraits, includings works by Kneller and Lawrence, and a fine collection of silver; it has done much to support galleries and museums, in particular the Whitechapel Art Gallery. The greater part of the once famous Drapers' Garden, in which Macaulay walked, is now covered by a huge convex-sided tower block, rising to 326 feet, designed by Richard Seifert and Partners in 1962-5.

At the far end of Throgmorton Avenue is Carpenters' Company Hall. Unscathed by the Great Fire, they gave hospitality to the Drapers, who reciprocated the kindness in 1941 when Carpenters' Hall

was bombed; the present building was remodelled in 1955 by Whinney, Son and Austen Hall on the late nineteenth-century building designed by W. W. Pocock. The Company possesses some good seventeenth-century silver and three sixteenth-century painted panels, formerly part of a mural.

Eastwards, in a maze of alleyways, is Austin Friars. The Augustinians built a monastery here in 1253; their buildings were granted for the use of Protestant refugees by Edward VI and eventually came to be used solely by the Dutch whose church it still is today. The old church escaped the Great Fire, but was completely destroyed in an air raid on the night of 15–16 October 1941; a new church, designed by Arthur Bailey, was rededicated in 1954. It is a plain, compact building with a delicate flèche; the interior is remarkable for the glass, with an east window designed by Max Nauta. Beneath the communion table is the altar stone of the monks' church. The new organ, built by W. van Leeuwen of Leiderdorp in

Holland, is superb. In the angle made by Threadneedle Street and Cornhill stands the Royal Exchange, the third to be built since Sir Thomas Gresham opened his exchange in 1570; Queen Elizabeth I visited it in January 1571 and declared that it should henceforth be called Royal. The original building, which disappeared in the Fire, stood round an open piazza and was used as a meeting-place for merchants; it had provision for some hundred shops. The second Exchange, designed by Edward Jarman, was also burnt in 1838; the third, by Sir Edward Tite (1841-4), still retains the original pavement of Turkey stone. The entrance is under an imposing, eight-column portico, surmounted by an elaborate pediment with sculpture by the younger Richard Westmacott, representing Commerce holding the charter of the Exchange and attended by the Lord Mayor and merchants of all nations. The courtyard walls were adorned with large historical paintings during the late nineteenth and early twentieth centuries; Lord Leighton, Frank Salisbury, Sigismund Goetze, and Frank Brangwyn were among the artists commissioned, but their works are obscured now since the Exchange is filled with temporary offices erected for the London International Financial Futures Exchange. The authorities are, however, most co-operative in giving access to the paintings; a public gallery permits inspection of the apparently frantic dealings on the floor below. Before the Exchange stands an equestrian statue of Wellington by Chantrey and a war memorial by Sir Aston Webb, with bronze figures by Alfred Drury; behind it, where St. Benet Fink used to be, is a courtyard with a statue of George Peabody, the philanthropist, by Story and a small fountain by Jules Dalou (1879) with figures of a mother and two children (see also p. 323).

Further along Threadneedle Street stands the Merchant Taylors' Hall, which has occupied this site since 1347; there is probably more medieval mason-

ry here than in any other livery hall in the City. The crypt of a late fourteenth-century chapel survives and so does the Great Kitchen, certainly in use since 1427 and possibly since 1388. Added to and altered over the centuries, the Hall was sympathetically restored by Sir Albert Richardson after bombing; the walls of the Drawing Room are covered with hand-painted, early nineteenth-century Chinese wallpaper. The Company possesses a youthful portrait of Henry VIII by an unknown artist, much fine sixteenth- to twentieth-century silver, and two fine pre-Reformation embroidered funeral palls — only six others remain in the City.

Next comes Cornhill, bearing one of the oldest names in the City; in it stand two churches, St. Michael's and St. Peter's, and on its south side lies a maze of alleyways, including Ball Court with Simpson's, a still-flourishing eighteenth-century eating-house, Castle Court, with the George and Vulture, and Bengal Court. George Yard, which runs through to Lombard Street, was laid out at the expense of Barclays Bank, with a fountain and sculpture by Sir Charles Wheeler; the result is admirable.

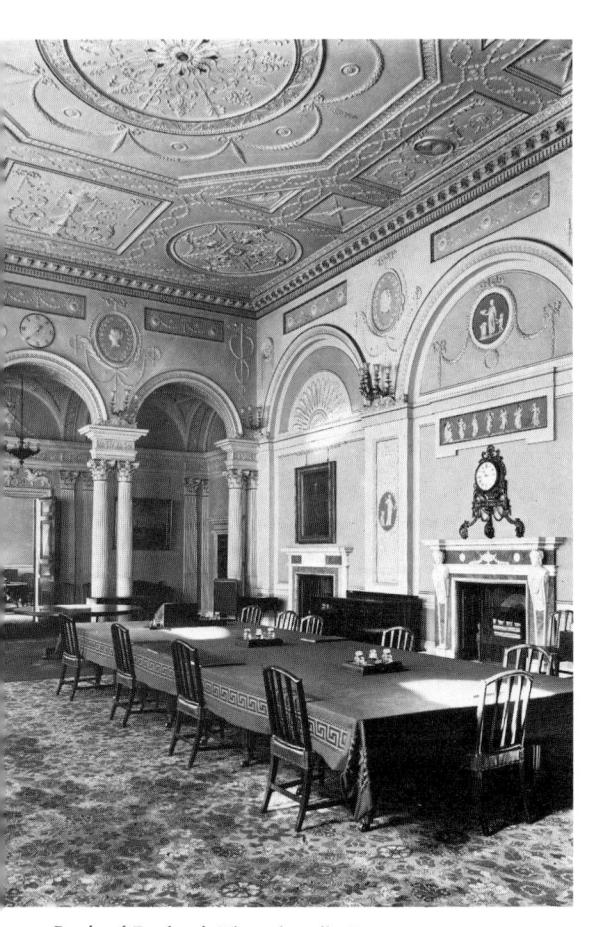

Bank of England, Threadneedle Street

St. Michael's, of pre-Conquest foundation, was the burial place of Robert Fabyan, the City's chronicler, and of John Stow's parents, grandparents, and godparents (see p. 79). The present church was rebuilt by Wren (1670–7) though the old tower remained till 1715, when it was replaced by a grand one with pinnacles and sculptured heads three-quarters of the way up, the work being completed in 1722, when Wren was 90; the design was probably by Nicholas Hawksmoor. The church is oblong, measuring 87 feet by 60 feet, but much altered by Sir Gilbert Scott (1858-60) who added an elaborate. recessed Gothic porch to the north-west on to Cornhill, and gave the windows Venetian tracery. Most of the old furnishings were cast out, the interior was repainted, bright glass by Clayton and Bell was inserted, a new reredos was installed, incorporating seventeenth-century paintings of Moses and Aaron by Robert Streater, and W. Gibbs Rogers carved pulpit, lectern, and pew-ends. The old font, given by James Paul in 1672, was retained, with a new baluster to support it, and so was a large pelican, designed by George Paterson in 1775 as part of the altar-piece. In the 1960s the church was redecorated and Scott's garish colouring toned down to chaste blue, gold, and white. St. Michael's is distinguished for its organ and its bells. The organ was originally built by Renatus Harris in 1684; it has been remodelled since but is still one of the best in England; William Boyce, the composer, was organist here for 32 years, and Dr. Harold Darke held the post for 50 years till he retired in 1966. Five bells were installed in 1421 and a sixth, the tenor, given by William Rus and called after him, about ten years later. A new peal of 12 was hung in the 1720s, which was recast or sand-blasted and quarter-turned in the 1960s; they are rung regularly. St. Michael's is still a parish church; it has one of the oldest sets of churchwardens' accounts in the City, now deposited with its registers in the Guildhall Library.

St. Peter's claims to be the oldest church in London, for it is said that it was founded by Lucius, the first Christian king of Britain, in AD 179, some 400 years before the coming of St. Augustine. The legend cannot be proved, but the foundation is certainly ancient. The present church, built by Wren and completed in 1681, can best be seen, not from Cornhill, but from the churchyard, where two great plane trees stand. The exposed brickwork of the tower supports a small cupola, from which rises a slender steeple with a weather-vane in the shape of St. Peter's key. Inside, the church is oblong, measuring 80 feet by 47 feet, and is divided into a nave and aisles by two five-bay arcades of columns with attached Corinthian colonnettes, panelled around their square bases; the walls are panelled to the same height. On the west wall are four fine carved doorcases. The roof is tunnel-vaulted and the aisles transverse tunnel-vaulted. The particular feature of St. Peter's is the screen, which divides the chancel and

chapels from the nave. Less elaborate than that in St. Margaret's Lothbury (see p. 67) it is still very fine, its entrance arch surmounted by the royal arms with the lion and unicorn. The pulpit is finely carved with an elaborate tester; an octagonal font, installed in 1681, has a cover said to have been saved from the flames of 1666. On the reredos is carved a lamb's skin representing Christ, with the name of God inscribed on it in Hebrew - a seventeenth-century religious visual aid! The gallery and organ-case retain their original woodwork; the organ, installed by Father Schmidt, has retained its unique flute stops through all subsequent rebuildings. Along the east wall are five windows with rather dark glass by C. A. Gibbs, 1872; in the north aisle are new windows by Hugh Easton to the Royal Tank Regiment, with three others on the south side to the Bedfordshire and Hertfordshire Regiments and to the Fifth Army. A memorial records that the seven Woodmason children were burnt to death while their parents were at a ball at St. James's Palace in 1782; this pathetic tribute with its seven cherubs' heads is said to have been designed by Bartolozzi and carved by Ryley. In the vestry are a brass tablet, reengraved after the Fire, telling of the church's ancient foundation by King Lucius, and the old organ console, on which Mendelssohn played on 30 September 1840.

Lombard Street takes its name from the Italian bankers who were already here by 1318. In it stands St. Edmund's church, called after the monarch martyred by the Danes in AD 870. Founded by the twelfth century, the medieval church, where John Shute, author of an early English treatise on architecture, was buried, disappeared in the Fire; Wren completed the present building in 1679, though the tower was not finished till 1708. The church, which occupies an awkward site and is necessarily orientated north and south, is of Portland stone, oblong in plan, measuring 59 feet by 40 feet, with a square tower, adorned with urns and supporting an octagonal lantern with a concave-sided, octagonal, lead spire. The interior, which was restored by Mr. Rodney Tachell in 1957, is without divisions, save for the slight apse which contains the altar. It was much altered in 1864 and in 1880; the box pews were chopped up to make choir stalls. The reredos is plain, with a segmental pediment and two paintings of Moses and Aaron, unusually enough by William Etty, so much more famous for painting nudes. The pulpit is good, the communion rails have unusually shaped balusters, the organ is in two halves, on the south and west walls, and the marble font has acanthus decoration and a wooden cover with gilded figures of the apostles. There is a sword-rest and a poor monument by the elder John Bacon to Dr. Jeremiah Milles (d.1784) who supported Thomas Chatterton, publishing at his own expense a fine edition of the boy's poems in 1782. St. Edmund's has another literary association, for here Addison married the Dowager Countess of Warwick in 1716.

Of pre-Conquest foundation, St. Mary Woolnoth's strange name possibly derives from a Saxon noble called Wulfnoth; it was one of the 128 churches rebuilt in stone by William the Conqueror. The medieval church, though damaged by the Fire, was patched up by Wren, but the stones began to crumble and a complete rebuilding was needed, which Hawksmoor, Wren's most original disciple, undertook between 1716 and 1727. The site was a difficult one, blind and cramped on the south side, till King William Street was cut through in 1830. Hawksmoor's monumental front is now isolated at the sharp angle made by Lombard Street and King William Street and is thereby even more dramatic than when first built. The centre projects, with an arched doorway surrounded by heavy rustication. Two Doric rusticated pillars emphasize the façade's separation from the recessed bays on either side, each pierced by two windows, one above the other. The west tower rises up, a curious broad-fronted oblong. much restricted in depth. Its front is portioned out among three pairs of Corinthian pillars. They support an entablature and from it rise twin square turrets with parapets. The north, south, and east walls are blind, though the north, facing Lombard Street, has three large round-headed frames surrounding blank niches and flanked by columns. It was towards this church that T. S. Eliot's crowds

Flowed up the hill and down King William Street, To where Saint Mary Woolnoth kept the hours With a dead sound on the final stroke of nine.

THE WASTE LAND, I, 66–68

Within, the baroque majesty of the exterior is maintained. The interior is a square enclosing a smaller central square marked out by twelve Corinthian pillars, three at each corner, supporting an entablature from which rises a clerestory with large semicircular windows, filled with clear glass, in each wall. The flat ceiling is painted blue and powdered with gold stars; from it hangs a fine chandelier, installed as a memorial to Colonel Buxton, churchwarden, banker, and friend to Lawrence of Arabia. St. Mary's was the only City church to come through the Second World War unscathed; its furnishings have great dignity. An elaborately carved baldacchino shelters the altar: the communion rails are of wrought iron and the pulpit swells out into the church under a tester with carved supports. Sir Martin Bowes, a sixteenth-century goldsmith, left bequests to the church, along with his helm, gauntlets, and banners, which are still displayed. There are memorials to John Newton, a slave-trader who became a minister and whose preaching here encouraged William Wilberforce and Hannah More in their philanthropic work; to Edward Lloyd, the coffeehouse-keeper on whose premises marine insurance began to organize itself formally; and to Henry Fourdrinier, inventor of the continuous paper-mak-
ing machine and grandfather of John Henry, Cardinal Newman. The woodwork of the organ-case is largely original, the first instrument having been installed there by Father Schmidt in 1681. St. Mary Woolnoth's, being a guild church (see p. 26), is active during the week; on Sundays the Germanspeaking Swiss church in London holds services here. The carved figures around the church and embroidered footstools in the sanctuary are gifts from artists all over Europe. The 'Spital Sermon' is preached here annually in Easter week, attended by the Lord Mayor and Aldermen in full state.

Two other churches stand nearby. St. Clement's church is on the corner of Clement's Lane, a plain little stucco building, designed by Wren between 1683 and 1687, with a south-west tower of exposed brick. The oblong interior is equally simple, the walls panelled and whitened above, and its very plainness sets off the magnificence of the pulpit with its elaborate sounding-board. The woodwork throughout is good and receipts for payments to Jonathan Maine, who also worked on St. Paul's, are extant. The interior was much altered by Butterfield in 1870–89, though his changes have been modified,

Aerial view of the City, with Angel Court, Throgmorton Street, in the foreground

but in 1933 the reredos was embellished by Sir Ninian Comper, who painted it in blue and gold, so that it no longer accords with the rest of the fittings. The organ in the west gallery was installed by Renatus Harris in the late seventeenth century; Henry Purcell and Jonathan Battishill were both organists here. The octagonal marble font has a pretty cover with a dove, identical with that of St. Peter Cornhill. There is a carved bread-cupboard in the tapering south aisle and a gilded sword-rest. St. Clement's was served by two great divines. Thomas Fuller, the historian, was lecturer here, and John Pearson dedicated his Exposition of the Creed to the parishioners, while Bryan Walton, compiler of a great Polyglot Bible, was rector at St. Martin, Ongar, a parish now united with St. Clement. It is sometimes claimed that this church is the St. Clement's of the nursery rhyme 'Oranges and Lemons' and not St. Clement Danes (see p 128).

St. Mary Abchurch lies to the south of King William Street in Abchurch Lane. It is a homely little brick church with stone dressings and a square tower in the north-west corner, from which rises an ogee-shaped lead dome, an airy lantern, and a little lead spire. The setting of St. Mary Abchurch is peculiarly attractive; the entrance is in Abchurch Yard to the south, once the churchyard, but now paved with a fascinating pattern of circles.

Founded during the twelfth century, war-time bombing revealed a fourteenth-century crypt. After the modesty of St. Mary's facade, the spaciousness and dignity of the interior is unexpected. Almost square – 63 feet long and 60 feet broad – the space is undivided under a great central dome, which rests on eight arches springing from pairs of groins and terminating in pendentives in each corner. The dome, lit by oval lunettes, was painted by William Snow between 1708 and 1714. The base is ornamented with architectural motifs, above are the Virtues, and in the centre is the name of God in Hebrew, surrounded by angels. The altar is superb and is undoubtedly by Grinling Gibbons, for requests for payment for the 'olter pees' have been found. This carving was blown into some two thousand pieces by the bombs in 1940, but was mended between 1948 and 1953. The pulpit and tester are handsome too; they were carved in 1685 by William Grey. William Kempster made the marble font a year later and William Emmett carved the statuettes of the evangelists for its cover. The door-cases are richly carved too and above one sits a pelican feeding its young with its own blood; the work of Robert Bud, it was till 1764 the vane on the spire. The pious pelican is the badge of Corpus Christi College, Oxford, which is patron of St. Mary's church. At the west end is a gallery with an organ; the case, made in 1717, came from All Hallows, Bread Street. The original pews stand around the north, south, and west walls. A successful post-War restoration was carried out by the architect, Godfrey Allen. On the east wall, beneath

St. Mary Woolnoth, Lombard Street

the south window, is a monument to Sir Patience Ward (d.1696) with *putti* and an allegorical figure standing between urns; Sir Patience, a zealous Whig, served as Lord Mayor in 1680 and was Member of Parliament for the City of London in 1688–9.

Returning to the central knot of streets, we reach the Mansion House, the official residence of the Lord Mayor, its portico elevated above the bustle by a double flight of steps. Until the eighteenth century the Lord Mayor had no official residence, but in 1728 a committee was set up to find a site and to raise the money. The site chosen was that of the Old Stocks Market, called after the instrument of punishment which stood there. A competition was held and Giacomo Leoni, John James, James Gibbs, Isaac Ware, and Batty Langley all submitted plans, but the winner was George Dance the Elder, who made the most of an exceptionally difficult site. Though today the entrance is from Walbrook, it is meant to be up the steps and under the portico of six huge Corinthian columns, topped by a pediment filled with sculpture by Robert Taylor, representing the opulence and dignity of the City of London. The building is of Portland stone; though the foundations were laid in 1739, it was not till 1752 that Sir Crisp Gascoyne, then Lord Mayor, was able to take up residence, for the site offered unexpected difficulties, being so marshy that it had to be piled at great expense. The principal rooms, at first-floor level, are state rooms and a Justice Room, for the Lord Mayor is the Chief Justice within the City. The Long Parlour, North and South Drawing Rooms, and Venetian Parlour are of an almost unbelievable

magnificence, with fireplaces by Christopher Horsnaile, wood-carving by John Gilbert, and plasterwork by George Fewkes and Humphry Willmott; the coving of the ceiling of the Long Parlour is astonishingly deep. Behind the main building, behind what was originally an open courtyard though it has now been roofed in, lies the Egyptian Hall. This apartment is based on Vitruvius's description of what he presumed an Egyptian hall would be, though the result would have been unfamiliar to the Pharoahs. Huge columns reaching from floor to roof run round it on all four sides, with an ambulatory between them and the walls. The walls themselves are lined with niches, which are filled with a remarkable collection of Victorian statuary, representing subjects taken from English literature from Chaucer to Byron; there are, for example, Egeria and Caractacus by Foley, Comus by Lough, Griselda by Marshall, Britomart by Wyon, Sardanapalus by Weekes, and a Welsh bard by Theed. The figures were commissioned in 1853, 1856, and 1861. In 1796, the flat ceiling was replaced by a tunnel vault, designed by the younger George Dance. The stained glass is by Alexander Gibbs (1868). The whole building and and its contents are the epitome of civic opulence, dignity, and self-confidence.

There is also the collection of gold and silver plate, to which each successive Lord Mayor has added since the seventeenth century; the result is perhaps more impressive for its commercial than its aesthetic value. Of far greater interest are the items of the Lord Mayor's insignia of office: the Crystal Sceptre, the Chain of Office, the Swords, and the Great Mace. The Sceptre is 18 inches long and is of crystal mounted in gold, with a gold and jewelled head. The shaft is of great antiquity and authorities believe it to be of Saxon workmanship; the head is fifteenthcentury work and the gold is of a different colour from that of the shaft; little is known of its history save that it has always belonged to the City. It is seldom used save at a Coronation. The provenance of the Chain of Office is well attested, having been bequeathed by Sir John Allen, Lord Mayor in 1535. It is of gold SS-shaped links alternating with enamelled Tudor roses and knots, and from it hangs the badge of office, an onyx cameo set in gold and diamonds and carved with the arms, crest, and supporters of the City. The badge was adopted in 1799 and replaced a gold and jewelled cross given by Sir Martin Bowes in 1558. Then there is the Pearl Sword, said to have been given by Queen Elizabeth in 1571, but more probably purchased in 1554. The blade was made at Solingen in Germany and it is the finest sixteenth-century sword in England; it is this sword which is presented to the Queen by the Lord Mayor at Temple Bar when she enters the City in state. The Sword of State was made at Ferrara in Charles II's reign. The Great Mace, which is unusually large - 5 feet high - and very heavy, was made by John White in 1735.

To the west of the Mansion House runs the Street known as Walbrook; it marks the east bank of the stream which divided Roman London into two halves. Immediately behind the Mansion House is the church of St. Stephen Walbrook, built by Wren in 1672-9. First mentioned about 1100, nothing remains of the medieval building. The exterior is plain enough, with a ragstone west tower and Portland stone steeple, not completed till 1717, but inside it is the most dramatic of all Wren's churches, save for St. Paul's, and it was in St. Stephen's that he tried out his plans for the cathedral. The interior is rectangular, 82 feet 6 inches by 59 feet 6 inches, and is divided by four rows of columns, 16 in all, into five aisles, the broadest in the centre. The pillars are so grouped that, by the omission of the central shaft of the two inner rows, a bulwark is formed in each corner to support an irregular entablature, from which spring the eight arches needed to support the dome, which is visible only from within the church. Light is admitted through a lantern at the summit and the interior of the dome is coffered, the coffering interrupted with a band of wreaths. Windows at the east end and in the clerestory also help to illuminate the church. The

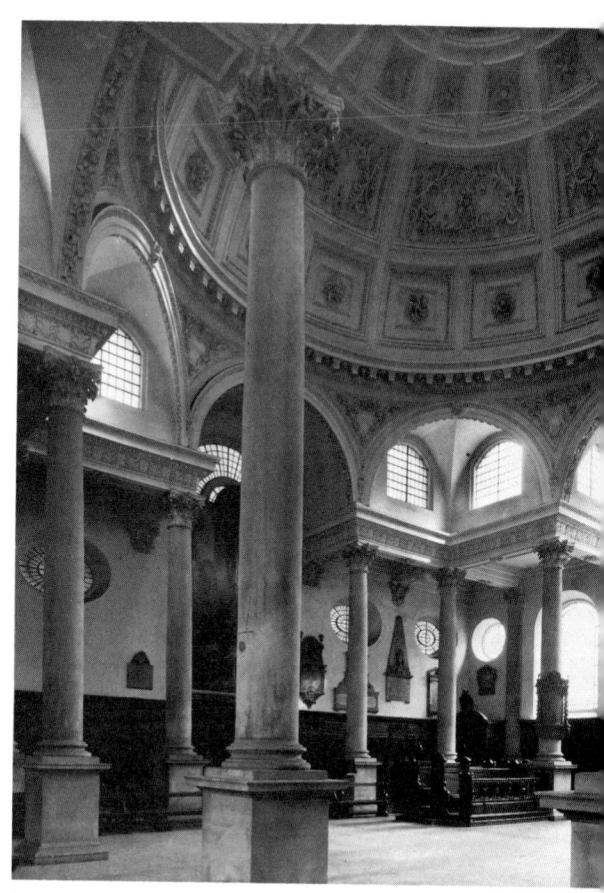

St. Stephen Walbrook, Walbrook

whole interior is an extraordinary achievement and the vestrymen of St. Stephen's must have been an adventurous body with great faith in their architect. The total area is small, yet the sweep of the dome seems vast; the interplay of light and shadow, enclosure and space, is almost uncanny. The furnishings are of a high standard; the pulpit with cherubs dancing on the tester, the altar, its rails, the font and its cover, are as Wren left them. There is a fine west gallery, in which an organ was installed in 1765. The church was bombed but was restored immediately after the War by Godfrey Allen, when glass by Keith New was inserted into the east windows; a second restoration was needed in 1981-2. John Dunstable, the musician, was buried in the old church in 1453; Nathaniel Hodges, a physician who behaved heroically during the Plague Year of 1665, was interred in the present St. Stephen's in 1688, as was Sir John Vanbrugh (d.1726), architect, dramatist, and Clarenceux King of Arms.

In 1954 another, much older, place of worship was discovered on the west bank of the Walbrook – a

temple dedicated to the god Mithras. A group of sculptures, buried perhaps to save them from Christian iconoclasts, was also found; they included heads of Mithras, Minerva, and Serapis, the god of the underworld - this last a superb piece of work - with statuettes of Mercury and of Dionysus and his companions, and a silver box and strainer, decorated with mysterious ritual scenes. The site was to have been buried beneath the foundations of Bucklersbury House, but the discovery so caught the imagination of the public that it was decided to reconstruct the remains of the Mithraium above ground near to its original position, in front of Bucklersbury House on Queen Victoria Street. The reconstruction is not completely reliable, for the modern crazy paving of the floor is inaccurate and the windswept location gives no impression of the secret underground place that the original temple would have been, but it was a generous and imaginative decision. A reconstruction of the Mithraium as it would have been, and the sculptures and other objects found during the excavations, are on display in the Museum of London.

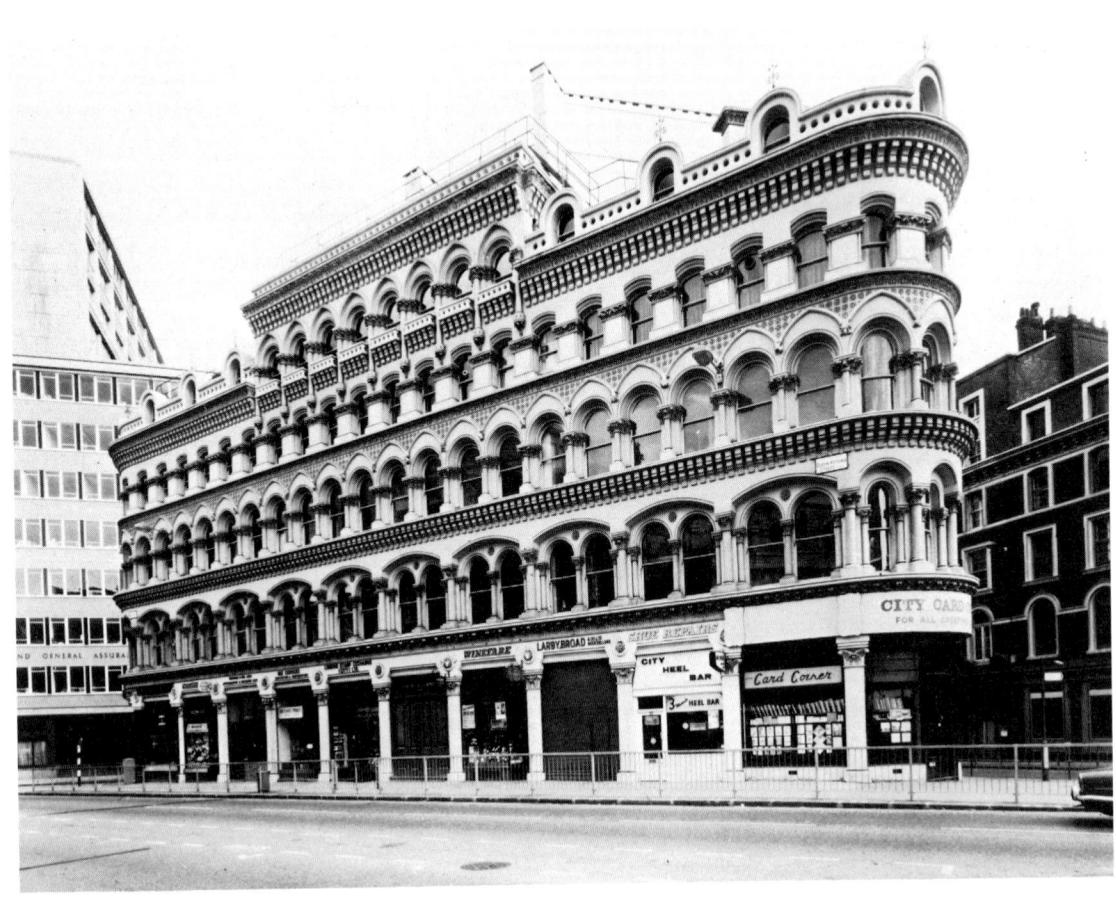

Nineteenth-century office building, Queen Victoria Street

Bishopsgate to Aldgate

To the north-east of the City lies an area which, owing to the prevailing westerly direction of the wind in the first week of September 1666, escaped more or less unscathed from the ravages of the Great Fire. Despite subsequent bombing and redevelopment, this segment still contains the majority of the remains of medieval London, and can boast of five pre-Fire churches. Its narrow thoroughfares are bounded by Gracechurch Street and Bishopsgate on the east, by the City boundary on the north and west, and by a line a little north of Eastcheap on the south.

In BISHOPSGATE, which probably owes its name to St. Erkenwald, who became Bishop of London in 675, is the fourteenth-century church of St. Ethelburga. She was St. Erkenwald's sister and for her he founded a nunnery at Barking in Essex. Though the church may be presumed to be of ancient foundation, there is no written record of it before 1250. St. Ethelburga's is tiny, the interior measuring less than 60 feet by 30 feet, with walls built of rubble and ragstone. Squeezed in between taller buildings, all that is visible is the stout west wall with a fourteenthcentury doorway and a fifteenth-century three-light window above. The small square tower is topped by a bell-turret, probably erected in 1775, though the weather-vane dates from 1671. Until 1932 even less could be seen, for two small shops were built right across the façade. The church was entered through a porchway over which was written the dedication, as if the saint too kept shop there; only the turret and weather-vane stretched up to announce its existence. The rectangular, panelled, fourteenth-century interior consists of a nave and chancel, with a south aisle divided from the body of the church by three four-shaft pillars with arches above them. A clerestory helps to give light. The fitments have been altered frequently, possibly in the hope of squeezing in more parishioners as the congregation grew. In 1912 Sir Ninian Comper erected a little gallery at the west end, like one in a country church, and an organ by Harrison and Harrison was installed there. He also separated the chancel from the nave by a nicely detailed five-bay wooden screen. The east wall is now

adorned with a stark mural by Hans Feibusch (1962) showing the Crucifixion, flanked by St. Luke with a patient and St. Ethelburga with a group of children. By the entrance stands a seventeenth-century chest with an elaborate lock, in which the parish records used to be kept, and a font, probably eighteenthcentury, with the symbols of the Passion carved on its sides and around the bowl the same Greek palindrome as that in St. Martin's Ludgate (see p. 39); the fine seventeenth-century font-cover comes from the bombed church of St. Swithin London Stone, A modern tablet records that Richard Larke, friend of Sir Thomas More, was rector here from 1504 till 1542. More obtained this living and that of Chelsea for him, and Larke followed his friend and patron to the scaffold in 1544. Nearby hangs a painting, given to the church in 1931, by the sixteenth-century Flemish artist Peter Koeke van Aelst, of Christ healing the blind beggar; it is thought to be the only work by this artist to be found in England. Three stained-glass windows in the south aisle, all executed by Leonard Walker between 1928 and 1930, record incidents in the life of Henry Hudson, who, with his crew, received communion in St. Ethelburga's on 19 April 1607, before setting out to seek the north-west passage to China. They reached the mouth of the Canadian river which today bears his name, but there the crew mutinied and set Hudson, his young son, and a few companions adrift in a small boat, so that they perished. At the east end of the south aisle is a small altar to St. George and beyond is a doorway leading to the former churchyard, now a garden. St. Ethelburga's is now a guild church with weekday services only; appropriately, its particular responsibility is the ministry of healing - the Saint was remembered for her courage in time of plague.

Nearby but set back from the road is Great St. Helen's, the finest medieval parish church left in the City and still most active in its ministry. It is dedicated to the mother of the Emperor Constantine, who was miraculously guided to find the True Cross on which Christ died, and who in past times was believed to have been a British princess. The foundation is certainly early though there is no written record before 1150, when the church is mentioned as being in the jurisdiction of St. Paul's Cathedral. Some time shortly before 1216, the dean and chapter gave William, son of William the Goldsmith, permission

to establish a Benedictine nunnery beside the parish church and a new building was added to the north, so that there is now a double nave, the nuns' portion on the left and that of the parish on the right from the west door. In medieval times, they would have been divided by a screen. At the Reformation, the parish acquired the nuns' church and the Leathersellers' Company the convent buildings; they used the dormitory as their common hall till 1799, when it was demolished, but their present hall is still just by the church. In 1631-33 extensive alterations were undertaken; an endearing wooden bell-turret was perched between the western doorways; and a fine classical doorway was cut in the south wall; the work shows the new Italian influences introduced by Inigo Jones. In 1874, the church of St. Martin Outwich was demolished and its parish combined with that of St. Helen's, some eighteen monuments being moved into the latter church.

The entrance to St. Helen's is through the fourteenth-century parish doorway at the west end. The two fifteenth-century windows are filled with stained glass, the parish window by John Hayward being modern, while the nuns' window is of 1899 and shows famous men connected with the church. Between them stands the font, paid for in 1632. From here there is a clear view of the long double nave,

BISHOPSGATE TO ALDGATE

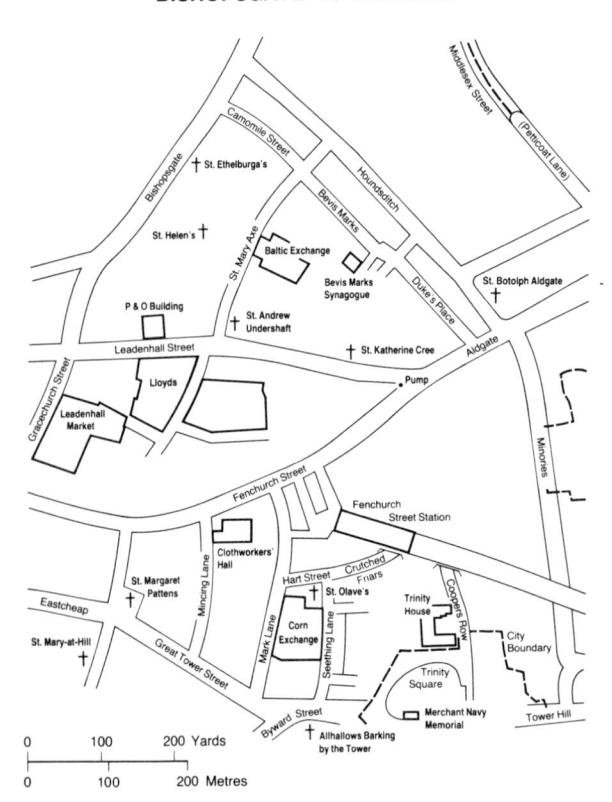

divided centrally by four magnificent arches built soon after 1475, possibly with the help of a legacy left by Sir John Crosby. Both naves are 122 feet long: the nuns' nave is 26 feet 6 inches wide and the parish 24 feet. The church is famous for its number of imposing tombs and monuments; so many of the most influential City merchants chose to be buried here that St. Helen's has been called the Westminster Abbey of the City. On the thirteenth-century north wall, Alderman John Robinson (d.1588) kneels, facing his wife, their numerous sons and daughters behind them. A canopied tomb chest to Alderman Hugh Pemberton (d.1500) has a brass showing him with at least ten sons; his wife and daughters have disappeared. Next there is a memorial to Francis Bancroft (d.1727), the founder of Bancroft's School, now at Woodford in Essex, and then another, standing in the nave, to the master mason William Kirwin, his wife Magdalen, and their five children. The Latin inscription may be translated:

To me who has adorned London with noble buildings the fates have afforded this narrow house. By me royal palaces were built for others. By me this tomb is erected for my bones.

Beside the alabaster war memorial, set up in 1921, can be seen the night staircase leading to the nuns' dormitory, giving them direct access to the church for the night-time services. Beyond are two wall monuments to a father and his son, Captain Martin Bond (d.1643), who commanded the City Trained Bands at Tilbury in 1588, the year of the Spanish Armada: he is shown in his tent with sentries outside and a groom ready with his horse. His father, Alderman William (d.1576), can be seen with his wife, six sons and one daughter, and his epitaph tells us that he was 'moste famous in his age for his great adventures by land and sea'. On the wall nearby is a squint or hagioscope through which a nun, too sick to attend service, might peep and see the Elevation of the Host. Above the squint is an Easter sepulchre wherein the Crucifix was laid from Maundy Thursday till Easter Sunday; it was constructed in 1525 as a memorial to Johane Alfrey. The chancel of the nuns' church is divided from that of the parish by two arches opened up at different periods, the western in the fourteenth century, the eastern c.1475. In the chancel stand two table tombs, those of Sir Thomas Gresham (d.1579), founder of the Royal Exchange, and Sir Julius Caesar Adelmare (d.1636). Sir Thomas has a plain black marble-topped sarcophagus, with fluted sides adorned with restrained classical mouldings and his coat of arms and grasshopper badge; a helmet, carried at this funeral, is set on a wall-bracket. Sir Julius Caesar, the son of Queen Mary's Italian physician, became Master of the Rolls and a Privy Councillor to James I; his third wife was Sir Francis Bacon's niece and he was present at the philosopher's death-bed at Highgate in 1626. His tomb is adorned only with a deed, carved so that it

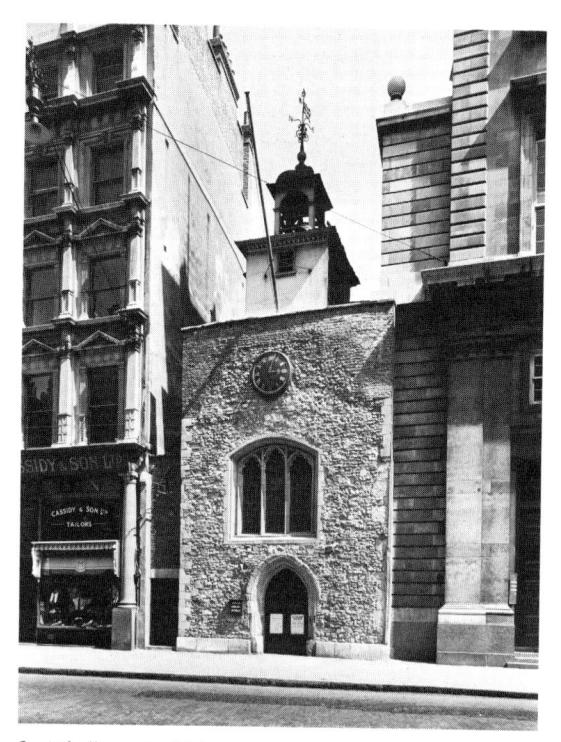

St. Ethelburga's, Bishopsgate

seems to be parchment, not marble, till touched. The inscription declares that Sir Julius was ready to pay to God the debt of nature whenever it might please Him; the execution of this rare and imaginative conceit is ascribed to Nicholas Stone. On the floor beside it is a brass to John Leventhorp, who died in 1510, having been one of the four Ushers of the Chamber to Henry VIII, and on the wall is a memorial to Sir Andrew Judd (d.1558), a Lord Mayor who founded Tonbridge School.

Turning westwards, the line and elegance of the central arcade can be appreciated. A huge canopied table tomb with recumbent figures separates the nuns' chancel from that of the parish; it is to Sir William Pickering, Queen Elizabeth's ambassador to Spain. The back rows of the choir stalls, made in the fifteenth century with grotesque arm-rests, were for the nuns' choir; those in the front date from the mid-seventeenth century. In the chancel stands a wooden sword-rest, that of Sir John Lawrence, who was a courageous and devoted Lord Mayor in 1665, the year of the Great Plague; iron sword-rests are usual, but this and another in the possession of the Vintners' Company, are the only known wooden ones.

Beyond the chancel is the south transept, added in the middle of the thirteenth century and now halffilled with the organ, its case carved with musical instruments, which was installed in the west gallery in 1744 by Thomas Griffin and moved in 1868. The

eastern half of the transept contains two small chapels, dedicated to the Holy Ghost and to Our Lady, and built soon after 1354. The Lady Chapel has two piscinas and a small figure of a woman, said to have been carved about 1600 by Maximilian Colt. In the Chapel of the Holy Ghost is a window with fifteenth-century heraldic glass, and two table tombs, those of Sir John Crosby (d.1475) and of John de Oteswich. Sir John and his wife, Agnes, were great benefactors to St. Helen's; they lived in Crosby Hall (see p. 308), just south of the church. John de Oteswich lies beside his wife too; their tomb, which came from St. Martin Outwich, is the oldest in the church, dating from the fifteenth century. John had been so great a benefactor to St. Martin's that a corruption of his name was added to its dedication in gratitude. In the floor are six brasses, usually covered with carpets for protection; they show two late fifteenth-century priests (from St. Martin Outwich), an unknown citizen and his wife (c.1465), Thomas Wylliams (d.1495) and his wife, Robert Rochester (d.1514) who was Sergeant of the Pantry to Henry VIII, and a lady in a heraldic mantle. There are inscriptions to Robert Cotesbrook (d.1393), and to Thomas Wright (d.1633, from St. Martin Outwich). In the south-west corner of the transept are a large tomb to Alderman Walter Bernard (d.1746) and a wall tablet to Gervase Reresby (d.1704).

Back in the nave, behind the richly carved pulpit (c.1615) is a blocked-up mid-thirteenth-century lancet window. Against the south wall are two more magnificent tombs, those of Alderman Richard Staper (d.1608) and Sir John Spencer (d.1609). The Alderman is shown with his wife, five sons and four daughters; a galleon, symbolizing the trade which brought him his prosperity, plunges above their heads, and the inscription tells us that he was 'the chiefest actor in discovere of the trades of Turkey and East India, a man humble in prosperity'. Sir John was a cloth-worker who became very rich. He was Lord Mayor in 1594-5 and his daughter and heiress married Lord Compton. The canopied monument has recently been restored and repainted. Back at the west door stands the poor-box, resting on the shoulders of a wooden seventeenth-century figure of a beggar holding out his hat, and a small tablet in memory of Dame Abigail Lawrence (d.1682), wife to the Plague Year Lord Mayor Sir John, 'an exemplary matron of this Cittie' who reared nine daughters to maturity but whose only son died a baby.

Southward lies Leadenhall Street with a large open pedestrian precinct between it and the church. There, in a paved piazza, stand the headquarters of the Peninsular and Oriental Line of shipping, and of the Commercial Union Insurance Company, the latter rising through 28 storeys to a height of 387 feet, the P. & O. with a two-storey podium and a ten-storey block above. The design is by Gollins, Melvin and Ward; it won the 1970 Civic Award for the best development in the City. It is not easy to assess

comparatively new buildings but these two blocks, surrounded by so much open space, seem to have been planned on a human scale that relates to the nearby churches of St. Helen's and St. Andrew Undershaft, which are now more fully revealed than they have been for centuries. The P. & O. building has a giant statue of Navigation by P. G. Bentham standing in the courtyard and a brightly-painted Maypole along the stairway leading to the podium.

Leadenhall Street bisects this area from east to west. It takes its name from a lead-roofed hall built for Sir Hugh Neville and given to the City for use as a granary in 1445 by Sir Simon Eyre, a linen-draper who became Lord Mayor. Meanwhile a market had grown up around it, for the stone walls and fine roof must have made it a landmark among so many buildings of wood, wattle, and daub. The rights of that market were acquired for the City by Richard Whittington in 1411 and the City still controls Leadenhall Market which continues to purvey meat, game, fish, groceries, and plants. The present market buildings were erected in 1881 to the designs of Sir Horace Jones; they stand on the site of something far older, the Roman basilica, built in the first century AD, and the largest in the Roman empire north of the Alps. The eastern end lies under the market and the western on the far side of Gracechurch Street, beneath the church of St. Peter Cornhill; the great building must have been more than 450 feet long and at least 130 feet wide. To the south of it lay the forum, with shops and work-shops around it, and in the area were many important houses. Some 15 tessellated pavements have been found in this area, one of the best showing a happily inebriated Bacchus riding on a tiger; it is now in the British Museum.

On the southern side of Leadenhall Street there stood, till 1862, East India House, the headquarters of the East India Company, incorporated in 1600. In it, for 33 years, worked the essayist Charles Lamb, whose writings tell so much about early nineteenthcentury London. Its site is today occupied by Lloyd's buildings. The history of that company began in 1686, when Edward Lloyd opened a coffee-house in Tower Street, which soon became a regular meetingplace for ship owners, sea captains, merchants, and underwriters, all anxious to transact business and to insure ships and their cargoes. A newspaper, Lloyd's News, was started in 1696 but was suppressed by the government for printing Parliamentary news. Lloyd moved to Lombard Street and when he died was buried in St. Mary Woolnoth. His son-in-law carried on the coffee-house. The newspaper was revived in 1734 and a first Register of Shipping was published in 1760. A more formal organization for the classification and the insurance of ships was set up in 1771 and still continues, though the Register and the insurance work are now separated. The present massive Lloyd's building was erected in 1925-28 to designs by Sir Edwin Cooper and in 1950-57 an extension to it was built in Lime Street under the

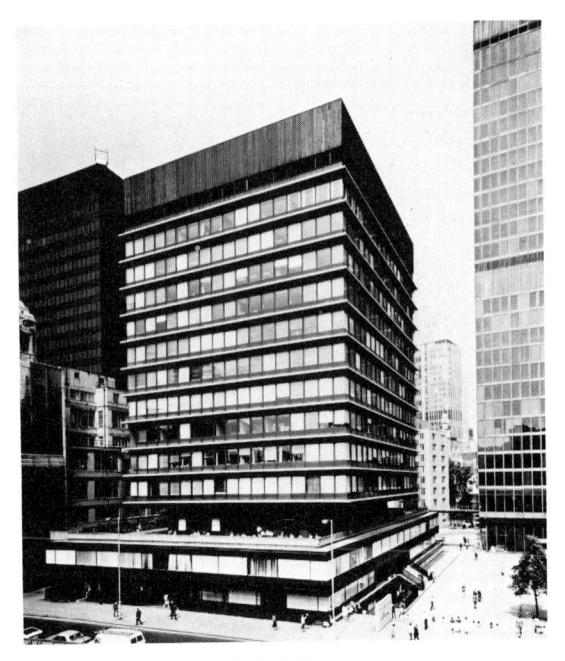

P. & O. Building, Leadenhall Street

direction of Terence Haysham. 'The Room', where the underwriters meet to do business, is in the extension, where hangs the bell of the French bullion ship *Lutine*, which sank in 1799 off Terschelling in Holland. Salvage operations were carried on between 1851 and 1861, regaining about a quarter of the cargo and the ship's bell is rung nowadays when an important announcement is to be made.

Opposite Lloyd's, on the north side of Leadenhall Street, stands St. Andrew Undershaft, another medieval church and one especially dear to all Londoners since in it lies the body of London's earliest and perhaps best historian and topographer, John Stow. First mentioned in 1147, the church was rebuilt in the fourteenth century. When that building decayed, a third was erected (1520-32) which has survived the Great Fire and two World Wars. The church takes its curious name from the tall Maypole which used to overshadow the steeple but which ceased to be raised after the riots of Evil May Day in 1517, when the apprentices attacked foreigners living within the City. Henry VIII hanged several for their violent conduct and the Maypole was laid aside till his son's reign, when the curate of St. Katharine Christ Church (today St. Katharine Cree) preached against it, saying that by incorporating its name in that of the church it was made an object of worship. His zealous listeners took the poor idol and chopped it up; the gaily painted Maypole on the stairway of the P. & O. building is in memory of its Tudor predecessor.

St. Andrew's is not an impressive church from the

outside. The rough grey stone walls seem grimy and the tower, the base of which remains from the fifteenth-century church, was unharmoniously retopped in brick in 1883 by Chatfeild Clarke. The Renaissance doorway, however, is impressive, with a fine knocker, and the interior has something of the grandeur of those churches built in Norfolk and Suffolk during their period of great prosperity in the late fourteenth and fifteenth centuries. St. Andrew's is rectangular, with a nave and aisles six bays long, and a slightly recessed chancel. The arcades have four-shaft columns with depressed arches; there are large four-light windows to the aisles and smaller three-light openings in the clerestory. The original flat wooden aisle-roofs remain, though the nave-roof was restored in 1950 and has not yet had time to mellow. The roof bosses deserve study with binoculars, for many of them show the coupled emblems of Henry VIII and of Katherine of Aragon, a Tudor rose and a ripe pomegranate, a fertility symbol - a pathetic device for, of several children, only Mary Tudor grew to maturity. Over the generations, the parishioners have spent lavishly on St. Andrew's. In 1632, they commissioned a marble font from Nicholas Stone, paying him £16 for the work. Soon afterwards they installed a pulpit carved with fruit, flowers, and ears of wheat, and in 1696 they ordered a fine organ from Renatus Harris, originally set up in the west gallery though now in the south aisle. In 1704, Jean Tijou provided splendid altar rails, and in 1726 Henry Tombes paid for Robert Browne to paint scriptural scenes in the spandrels between the arches, though these are now much faded. Glass, with portraits of Edward VI, Elizabeth, James I, and Charles I and II, had been given for the east window by Sir Christopher Clitherow in the seventeenth century. In the north-east corner stands St. Andrew's chief monument, to John Stow (d. 1605), the tailor who spent his time and money and 'many a cold winter night's study' in recording London as he knew it, together with such details as he could find from older men's memories and from documents. In old age, he had to petition James I for a licence to beg. This cold charity the niggardly King granted and Stow died two years later in great want. Afterwards, money was raised to set him up a fine monument sculpted by Nicholas Johnson. A stiff half-length figure sits at a desk in an alcove, to the inner walls of which are attached marble books, while the outer pillars are decorated with ribbon-work, lions' heads, and more columns. The arms of the Merchant Taylors' Company surmount it, and there is a motto: Aut scribenda agere, aut legenda scribere (Either do something worth writing about, or write something worth reading). In the figure's stone hand is a real quill pen which the Lord Mayor of London renews annually, at a service held as close as possible to the date of the historian's death in the spring. Without Stow's Survey of London we should know very little of the pre-Fire capital and much less than we do of the pre-Reformation churches, monasteries, and church life.

Nearby, on the north wall, Sir Christopher Clitherow and his wife share a canopied table tomb and above a small door is a large monument to Sir Hugh Hammersley (d.1636) and his wife. They are represented almost life-sized, kneeling facing each other, flanked on either side by soldiers standing with arms reversed in attitudes of grief, for Sir Hugh was President of the Artillery Gardens, from which place of assembly the Honourable Artillery Company sprang. An arched recess shelters a delightful little effigy of Alice Byng (d.1616) who had three husbands, 'all batchellors and stationers'; beside her is a brass, on which she herself appears, which she raised to the memory of her father, Simon Burton (d.1593), Master of the Company of Wax Chandlers. On the east wall is another brass, the oldest in the church. executed with exceptional skill. It shows Nicholas Leveson (d. 1539) with his wife Dionysia, a daughter of Sir Thomas Bodley, with all their 18 children. All the figures are clearly defined and it is a remarkable piece of compact craftsmanship. In the chancel wall, beside the altar, are five tiny figures, Sir Thomas and Lady Offley and their three sons, two of whom died in childhood, while one lived to become a bearded man. It is the work of Cornelius Cure, Master Mason to Queen Elizabeth and to James I, who carved Marv Queen of Scots' monument in Westminster Abbey. A nineteenth-century brass in the south aisle records that Hans Holbein was a resident in the parish.

St. Andrew Undershaft is a parish church so the

Roof boss in St. Andrew Undershaft, Leadenhall Street

bells are still rung for services on Sundays; they are a fine peal, four of the six having been made by Robert Mot, who was in charge of the Whitechapel Bell Foundry from 1570. Three of them were cast in 1597, a fourth in 1600, and the remaining two were made by Bryans Eldridge in 1650 and Anthony Bartlett in 1669. Fairbane Stedman, the author of *Change Ringing*, was buried here, and so was Peter Anthony Motteux, a merchant who spent his spare time translating *Don Quixote* and Rabelais into English.

Beside St. Andrew's, running at right angles to Leadenhall Street, is a thoroughfare with a wonderful name, St. Mary Axe. A church dedicated to Our Lady stood here beside a house, possibly a tavern, outside which hung an axe as a sign. The church was demolished in 1561 and its parish united with St. Andrew's, but the name remains and in the road stands the Baltic Exchange, which, like Lloyd's, had its beginnings in the coffee-houses of London. Captains with an empty ship and merchants with cargoes to convey met at the Virginia and Maryland Coffee House which in 1744 was renamed the Virginia and Baltic. By 1823 a formal organization, the Baltic Club, had been established and required ever more capacious premises. In 1891 St. Mary Axe was burnt out by a severe fire; in 1903 the present building was erected there to the designs of T. H. Smith and W. Wimble. It is solidly Victorian in character, faced with pink granite on the lower walls and huge granite pillars running through the upper storeys. An extension, built by Kenneth Lindy and Partners, was opened in 1956. Freight from all over the world finds its means of transport here and there is an increasing market in air freight and passenger charter flights.

Towards the eastern end of Leadenhall Street is the church of St. Katharine Cree. This church is of particular interest, for it is one of the very few built during Charles I's reign. Originally constructed in the early fourteenth century in the grounds of the Priory of Holy Trinity Christ Church, Aldgate, it became ruinous, so the nave was rebuilt. Archbishop Laud reconsecrated it on 16 January 1631, with such elaborate ceremonies and genuflections that his bearing was made a charge against him at his trial 14 years later. The entrance is under the sixteenthcentury tower at the western end. St. Katharine's was much damaged during the War, but has been restored by Marshall Sisson. Inside, the church is a plain rectangle with a nave and two aisles. Both aisles and clerestory have unusual three-light, flat-headed windows, which can be seen clearly from Leadenhall Street. The aisles are separated from the nave by arcades of six bays, with Corinthian columns and round-headed arches, a manner which must have seemed outlandish at a time when the Perpendicular style was the accepted one. The roof is rib-vaulted, with big bosses ornamented with the arms of City companies. The east window is a beautiful rose within a square in memory of St. Katharine, who

was tortured on a wheel for her beliefs. The early eighteenth-century pulpit and altar table were the gift of a parishioner, John Dyke.

St. Katharine's has its original plate, the altar vessels bearing hallmarks showing them to have been made in 1629-31, so that they were probably those used by Laud at the consecration, while the alms dishes were the gift of Charles I himself. The alabaster font is of the early seventeenth century and, since it bears the arms of the Gayer family, may have been the gift of Sir John Gaver, who is buried in the chancel. He was Lord Mayor in 1646 and left £200 to the church that a sermon might be preached annually on 16 October, as it is to this day, in memory of his deliverance from a lion, when he was a voung merchant travelling in Turkey. The organ was installed in 1686 at a cost of £250; it was the work of 'Father' Schmidt. There are few monuments in the church, the finest being that to the merchant Sir Nicholas Throckmorton, Elizabeth's ambassador to Spain and to Scotland: his armed alabaster figure reclines beneath a canopy ornamented with strapwork. There is a monument to Bartholomew Elmore (d.1636) and a tablet by the elder John Bacon to Samuel Thorpe (d.1791). A window by C. Farrer Bell, Christ Walking on the Water, was installed in the south aisle in 1964, and there is a small modern carved figure of Charles I, representing him as a martyr. St. Katharine's is no longer a parish church but the headquarters of the Industrial Christian Fellowship. Their excellent work is carried on in unattractive offices partitioned off from the aisles.

ALDGATE is the easternmost entrance to the City; over it, as a blue plaque on a nearby wall records, the poet Geoffrey Chaucer had rooms, as part of his perquisites as Controller of Customs to the Port of London. The parish pump still stands here, though it no longer gives water, and in Aldgate is the George public house, established in 1717 and rebuilt in 1899 with plaster Art Nouveau vines entwined all over the façade. Just outside the gate, at the junction of Houndsditch and Aldgate High Street, stands the church of St. Botolph Aldgate.

The church is very possibly of pre-Conquest foundation, though there is no written record of its existence till 1115, when the burgesses gave it into the keeping of the priory of Holy Trinity Aldgate, then newly founded by Queen Matilda. Stow records that the medieval church had been rebuilt just before the Reformation and this edifice, in which Daniel Defoe was married in 1683, remained in use till 1741, when it needed to be replaced by another to the designs of the elder George Dance (completed 1744). The church is orientated roughly north and south, presumably to take best advantage of the site. It is of brick with stone quoins and window dressings, and has a square tower terminating in an obelisk spire over the entrance of the southern (ritually western) end. The interior has been much altered since Dance's day, for it was redecorated by I.

F. Bentley, the architect of Westminster Abbey, was severely bombed at intervals during the Second World War and then, after its restoration by Rodney Tatchell, was much damaged by an inexplicable outbreak of fire in 1965, so that a further restoration had to be carried out. St. Botolph's was rehallowed on 8 November 1966 by the Bishop of London, in the presence of the Queen Mother and the Lord Mayor, who attended in state.

The church entrance is under the tower through a doorway surmounted by a pediment and flanked by pillars. Within is an octagonal vestibule used today as a baptistery and separated from the church proper. In three of the shorter walls are alcoves sheltering monuments, the oldest of them a small alabaster tablet with a draped emaciated figure; it is to the memory of Lord Darcy of the North and Sir Nicholas Carew, beheaded on Tower Hill for opposition to Henry VIII's changes in religion. The others are busts of benefactors, Robert Dowe (d.1612), who left money for the ringing of St. Sepulchre's bell before executions (see p. 43), and Sir John Cass (d.1718), whose bequests founded a school in his own day, and the Sir John Cass Institute nearer our own. His bust was copied by Eric Winter from Roubiliac's fulllength figure in the Institute.

Since the church is on an island site, its interior is unusually light. The nave is open, with galleries around three sides and a Renatus Harris organ, installed at the western end in 1676. St. Botolph's is remarkable for Bentley's ceiling and furnishings. In the deep coving above the galleries stand rows of exulting angels, epitomizing the spirit of the Arts and Crafts movement and quite unlike anything else in any City church. There are several small memorials in the galleries and one tablet in the nave to the memory of William Symington, who built the Charlotte Dundas, the first steam-boat. St. Botolph's great treasure is a wooden late seventeenth-century panel of King David playing his harp. The sculptor is unknown but it came from St. Mary Whitechapel. St. Botolph's is one of the busiest of City churches, standing as it does on the edge of the East End. It is a parish church and the crypt is used as a canteen and club by London's tramps and as a youth club. The tramps can get baths and hair-cuts, as well as human sympathy given without criticism. Serving as it does an area with a predominantly Jewish population, it is the headquarters of the Diocesan Council for Christian-Jewish Understanding. The church is shut on

Just beyond St. Botolph's, the City boundary runs northwards along Middlesex Street, better known by its older name of Petticoat Lane, where a vigorous general market flourishes each Sunday morning. At the northern end of Petticoat Lane, in Widegate Street and Artillery Lane, there are still some elegant eighteenth-century shop fronts. The line of the former City wall is marked by Houndsditch, which takes its gruesome name from the carrion flung into

it. Parallel to it, run Bevis Marks and Camomile Street, the former drawing its strange name from land held there by the Abbots of Bury. In it stands the Spanish and Portuguese synagogue built for the Sephardic Jewish community in 1700–1 by Joseph Avis, a Quaker who so respected the congregation that he would take no payment for his work. The wood for one of the main beams was given by Queen Anne. The building is roughly rectangular with seats facing inwards and galleries on three sides; at the eastern end is the Echal or Ark, looking very like a tripartite reredos, and in the centre is a raised dais or Tebah. The synagogue is splendidly appointed, with seven magnificent brass chandeliers which came from Amsterdam.

South from Aldgate along the Minories, an increasingly fine view of the Tower opens up. The Minories take their name from the Little Sisters of St. Clare, the Sorores Minores, for whom a convent was established here in 1293 by Blanche of Navarre, wife of Edmund, Duke of Lancaster. Their church, handed over to the parish at the Reformation, was rebuilt in 1708; damaged by bombs, it was demolished in 1956-8. During demolition, a painted female figure was found, lacking the head and arms but with robes still retaining areas of paint, Indian red with gold fleur-de-lys on the outer robe, vermilion with golden marguerites on the inner. The figure probably represents the Synagogue or the Old Law and would have been companioned by a sister effigy representing the Church or the New Law. It was probably made about 1335 and is now in the Museum of London.

To the west lies Fenchurch Street Station, built about 1840 with a scalloped canopy over the entrance, very much like those of the countryside stations in the Eastern Region which it serves. The station backs on to Crutched Friars, which takes its strange name from an order of Friars established in England in 1244, who wore a blue habit with a red cross; they had only seven houses in the whole country. At the junction of Crutched Friars, Hart Street, and Seething Lane is the church of St. Olave, its churchyard fronting on to Seething Lane and entered through a gateway surmounded with skulls, crossbones, and spikes with the motto 'Mors mihi lucrum' - 'Death is a light to me'. Dickens described it in The Uncommercial Traveller, speaking of it as 'his best beloved churchyard, the Churchyard of St. Ghastly Grim'.

St. Olave's, Hart Street, is the only survivor of five churches in the City and Southwark dedicated to the Norwegian warrior prince whose later conversion to Christianity so provoked his subjects that they rebelled; Olave fell at the Battle of Stiklestad on 29 June 1030, to be canonized a year later. He became a most popular saint in England and the dedication argues for an early foundation, though there is no written record of the church before 1109. If a Saxon church stood here, it would have been of wood and any traces have vanished. The stone Norman replace-

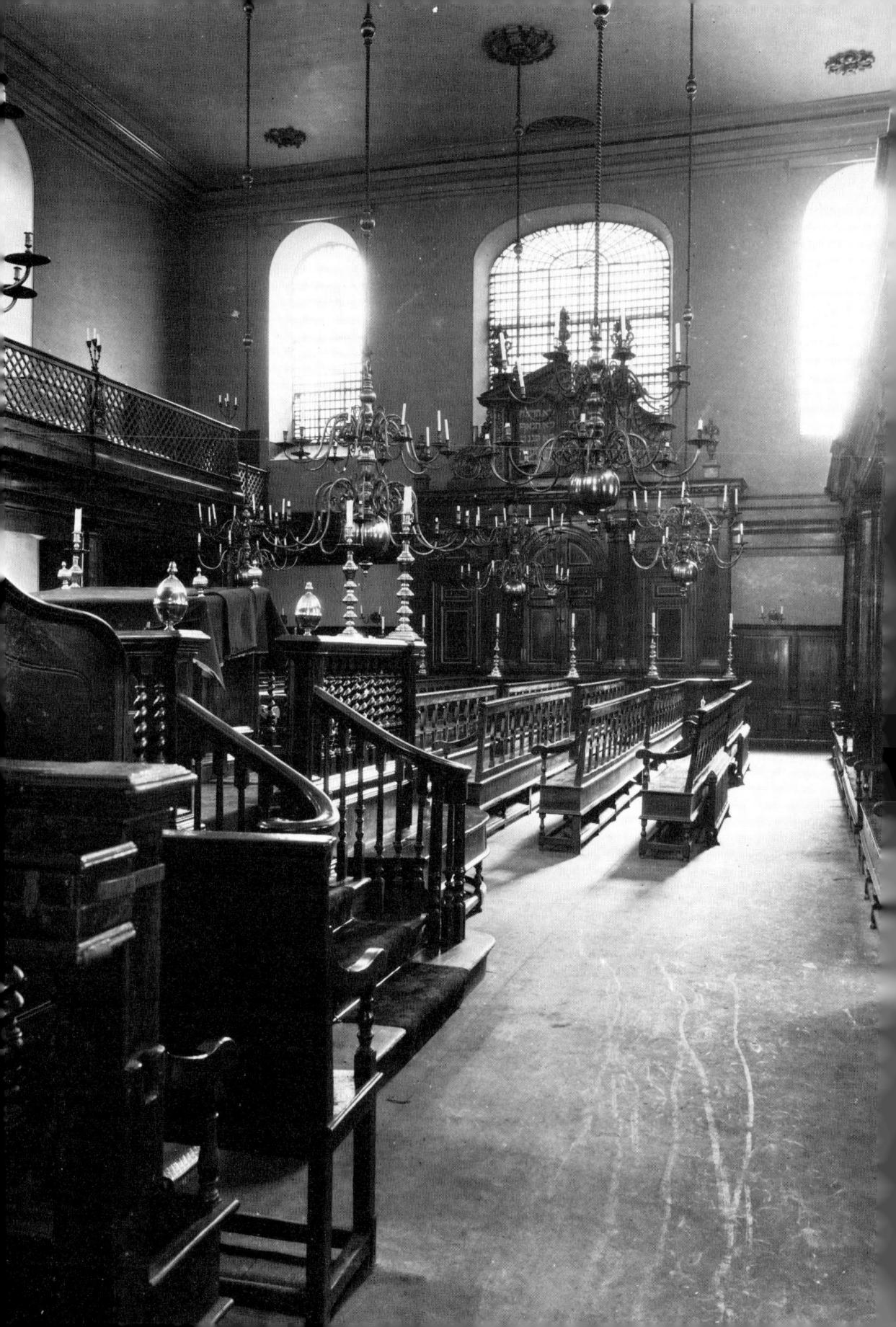

ment gave way in its turn to another, built about the middle of the fifteenth century at the expense, so it is said, of two brothers, Richard and Robert Cely, who were fell-mongers. A thirteenth-century crypt built over a well was incorporated into the new church. The building was gutted by bombs in 1941, but the outer walls stood firm so it would be more accurate to say that St. Olave's has been restored rather than rebuilt. King Haakon VII of Norway laid the restoration stone on 15 June 1951. The work was carried out under the patient and devoted direction of E. R. Glanfield, the only new addition being a south porch. The church is of stone with a tower partly rebuilt in brick in 1732 by John Widdows; it is now surmounted by a small modern cupola and weathervane. Fifteenth-century arcades, with four-shaft, clustered columns and broad arches, separate the nave from the aisles. Pale oak pews and an oaken font were given by the congregation of St. Olave's Toronto. The new wooden roof is flat, with a gilded cross over the sanctuary and bosses with arms and emblems of City companies and trades. Fortunately, some of the fittings and monuments were saved from the old church and have now been reinstalled. The richly carved seventeenth-century pulpit came from St. Benet's Gracechurch Street (demolished 1867), and the altar table and rails from St. Catherine Colechurch, when its parish was united with St. Olave's in 1921. Four sword-rests stand around the walls, two of them St. Olave's own and two from All Hallows Staining. The peal of eight bells, six of them made in the seventeenth century by Anthony and James Bartlett of the Whitechapel Bell Foundry, all melted in the fire of 1941, but they have been recast and are still rung. There has been an organ here since 1552, but the war destroyed the eighteenth-century instrument in use at the time of the bombing and the present one is by the John Compton Organ Company. Fortunately, the Vestry remained unharmed. Added in 1662, it is entered through an oaken door some six centuries old. There is a fine plaster ceiling, with an angel in relief in the centre and a chiaroscuro painting, attributed to De Witte, of three unidentified figures, which has recently been restored by the National Gallery.

St. Olave's most famous parishioner was Samuel Pepys. He worked in the Navy Office in Seething Lane and came to live there on 17 July 1660; he had been keeping his diary for a bare six months at that time. He and his wife Elizabeth regularly attended services at St. Olave's, 'our own church' as he wrote,

and they were proud to sit in the Navy Office pew; the pew was burnt in 1941, though its entrance is still outlined on the churchyard wall. When Elizabeth died in 1669, 34 years before her husband, she was buried here beside Pepys's brother. She was 29 at the time of her death; she and Pepys had wed when she was barely 15. Pepys commissioned a bust of her from John Bushnell and when he died in 1703 was laid to rest by her side. He remained without a monument till 1884, when one by Sir Arthur Blomfield was raised to him.

There are several brasses, among them two, to Sir Richard Haddon (d.1524) and to Thomas Morley (d.1566), particularly worthy of notice. Sir John and Lady Radclif (d.1568 and 1585) have small kneeling effigies; the aldermen and brothers, Andrew and Paul Bayning (d.1610 and 1616) are shown at prayer, and there is a figure of an Italian gentleman, Peter Cappone, who died in London in 1582. Sir James Deane's monument tells us that he died childless, though he was married three times, but the figures of three tiny babies, 'swathed in their chrysomes', demonstrate the incidence of infant mortality. There is a tablet to Dr. William Turner (d.1568), who had a house in Crutched Friars and was Dean of Wells and the author of the first English herbal, and another to John and Elleyne Orgene (d.1584) with this inscription:

> As I was, so be ye, As I am, you shall be. What I gave, that I have, What I spent, that I had; Thus I count all my cost, What I left, that I lost.

Clothworkers' Hall stands nearby in Mincing Lane. The street takes its name from the Anglo-Saxon word 'mynechene', a nun. The building is modern, designed by H. Austen Hall in 1955–8 in a neo-Georgian manner, though the Company was formed in 1527/28 by the amalgamation of two early cloth guilds, the Fullers and the Shearmen. It possesses a superb collection of plate, among it the Pepys Cup and Cover, perhaps the finest cup in the whole City. The diarist proudly presented it in 1677 when he was Master of the Company, though the maker is unknown. Pepys also gave a dish and ewer, while, the year before, the Company had received a scroll salt from Sir James Williamson, the Secretary of State, who was then serving as Master.

London Bridge and Riverside

In all probability, London owes its very existence to the Romans' choice of site for a bridge across the Thames. A traders' town, which eventually grew into a provincial capital, was established around the northern bridgehead, which recent excavations have shown to have lain about 100 feet east of the present structure. The shore strips on either side of it have preserved to this day a faintly maritime character, while in the alleyways north of the Custom House nestles St. Mary-at-Hill, the least changed of all Wren's churches.

The Roman bridge must have continued its existence into later centuries. Our first written reference to the crossing is in the Anglo-Saxon Chronicle for the late tenth century; a woman was found guilty of causing a man's death by witchcraft, so 'they took that woman and drowned her at London Bridge'. It may also be that the nursery rhyme, 'London Bridge is Falling Down', refers to an attack on the Bridge led in 1015 by King Olaf of Norway, in support of Ethelred II of England, the Unready.

In 1176, a cleric, Peter of Colechurch, was entrusted with the construction of a stone bridge, the first to be built in Europe since Roman times, for it antedated the Pont d'Avignon by a year. It was not completed till 1209, four years after Peter's death; his body was laid to rest in the undercroft of the chapel built over the eleventh pier from the northern bank and dedicated to St. Thomas à Becket. The bridge was 910 feet 10 inches long and stood on 19 stone piers of irregular spacing with arches of various widths, since, in order to sink them at all without the knowledge of coffer-dam construction, the best advantage had to be taken of every inch of firm ground in the river bed. In spite of its length, the bridge was only 20 feet wide and the roadway along it a mere 12 feet, so that two carts could only just pass each other and there was a constant hubbub and traffic jam along it. Shops were built across it almost at once; a rental of 1358 records that there were

This bridge remained the sole means of crossing the river, save by boat, till the completion of Westminster Bridge in 1749. Its appearance was well recorded, by Wyngaerde in the mid-sixteenth cen-

already 139.

tury, and later by Hollar, and by the Buck brothers. The Guildhall Collection contains a version of Samuel Scott's well-known painting.

Despite widening and the removal of the shops in 1758, by the end of the century it was clear that the old bridge could no longer bear the volume of traffic, on foot or by horse and cart, which tramped across it. A new bridge, designed by John Rennie, was built under his son's supervision; it involved much alteration of the street pattern near the north bridgehead. Begun in 1823, it was opened on 1 August 1831 by William IV; on 22 November the demolition of the medieval bridge began.

The new bridge was 1005 feet long and 56 feet wide, with a roadway of 32 feet, resting on five broad arches and built from 120,000 tons of stone. One of its most attractive features was the steps leading to the water from either corner of each end. By 1924, however, a settlement was reported in the east side of the South Pier and by 1962 cracks were beginning to show. Work was begun in November 1967 and a new bridge was opened by Her Majesty the Queen on 16 March 1973. The design was by Harold Knox King, the City Engineer, and the building contractors were John Mowlem and Co., whose tender for the work was £4,067,000. It is a post-tensioned concrete structure, faced with granite and spanning the river in three broad arches, thus leaving a wider channel for navigation. Rennie's bridge was sold to the McCulloch Oil Corporation of California and has been re-erected at Lake Havasu in Arizona, the facing stones having been carefully numbered so that each would find its proper place again. The price paid for it was £1,025,000.

On either side of the bridge stands a single large building, an office block, Adelaide House, to the east and Fishmongers' Hall to the west. A Hall has stood here since 1434 but the post-Fire building had to be demolished to accommodate Rennie's bridge; the twentieth-century structure has made amends by providing the Hall with a more open, dignified setting than it had hitherto. The Hall was built between 1831 and 1834 to designs by Henry Roberts, in whose office George Gilbert Scott was chief assistant at the time. The result, as Sir John Summerson says, is that Roberts was never again so grand nor Scott so pure in achievement. The Hall presents an eleven-bay front to the Bridge and a

seven-bay front to the river with giant attached Ionic columns and a five-bay pediment. Around the top runs an elegant balustrade. It is significant that a site so important and commanding should be filled, not by a public building, but by a company hall. Fishmongers' Hall looks like a small palace; great power resides in the City companies. Despite necessary restoration in 1929 by Goodhart-Rendel and again in 1951 by Austen Hall, both the exterior and interior are remarkably pure neo-Grecian. There is a grand staircase on which stands a statue, some eight feet tall, of Sir William Walworth, the Lord Mayor who killed Wat Tyler; carved about 1685, it was the work of Edward Pierce. The Company also possesses the fatal dagger. It has besides a number of less sinister treasures, a fine late-fiteenth-century embroidered funeral pall, the Rushout Salt of c.1654, as well as much magnificent post-Fire and eighteenthcentury silver, and some good modern work besides. The Company has collected Dutch paintings of fish; in the 1960s it commissioned paintings from Pietro Annigoni of the Queen and of Prince Philip. It still has a noble figure of St. Peter, a fisherman himself, carved from its eighteenth-century state barge, and a curious chair with its seat made from the foundation stone of Old London Bridge and its back, carved to represent several of the Thames bridges, from one of the piles. West of the Bridge, in Pountney Hill

Statue of Sir William Walworth, Fishmongers' Hall, Upper Thames Street

running beside the churchyard of St. Lawrence Poultney, which disappeared in the Great Fire, are several merchants' houses constructed in the early eighteenth century; Sir Nikolaus Pevsner considers that numbers 1 and 2, built in 1703, are the finest dwellings of their date still standing in the City, if not in the whole of London. They can only be compared with the houses in Queen Anne's Gate.

Cannon Street Station (designed by Edward Barry, opened 1866, recently largely rebuilt with an office block above it) and the railway lines behind it, running southwards across the river, form a solid wedge between Cannon Street and the Thames. Owing to the fall of the ground towards the river, a massive brick viaduct, its walls 60 feet high, was built to carry the platforms across Upper Thames Street; its walls, which needed 27,000,000 bricks, and its lead-capped, ogee-shaped towers fronting the river, are all that remain of the original building. The station stands on an important Roman site. Remains of a great hall were found after the Fire and William Maitland, writing in 1796, guessed that the building must have belonged to the governor of the province. Excavations for the modern station proved him right. It was, of course, impossible to uncover the whole palace - the great difficulty in uncovering London's early history is that the site has never been untenanted since Roman times - but it was clear that there were state reception rooms and audience chambers, private apartments with painted walls, and a huge courtyard, with an ornamental lake stretching for more than 100 feet to the east of the station and for an unknown distance beneath it. Archaeological evidence indicates that the building was erected between AD 80 and 100, about the time when it was decided to transfer the capital from Colchester, the British centre, to the new city of London, founded, in all probability, a bare half-century before and already destroyed once by Boadicea's angry tribesmen. The natural advantages of London's site, its communication by river and sea with the hinterland and with the Continent, and its central position for the network of roads which were to spread across the province, all made it a more suitable choice than Colchester, remote in its East Anglian countryside. The magnificence of the Governor's palace and the noble proportions of the basilica and forum (see p. 78) show that London became the capital as a matter of conscious and deliberate policy.

From the Middle Ages till the end of the sixteenth century its site was that of the steel-yard of the Hanseatic merchants (they and their heirs remained its legal possessors till 1853), but through all the changes, one relict of Roman rule remained and still exists today — London Stone. A rough, irregular block of stone, it stood on the south side of Cannon Street. Recent excavations have demonstrated that its original position would have been about the middle of the main gateway of the palace. Camden judged it to have been the central Roman milestone from

which all distances were measured. By 1747 it had worn down to a stump and was removed to the north side of the street till 1798, when it was set in a niche in the wall of St. Swithin's church. When that was bombed, the Stone was saved and now nestles in the wall of the Bank of China, which has replaced the church, though the churchyard remains as a small

and welcoming garden.

In Dowgate Hill stand three City companies' halls, those of the Tallow Chandlers, the Skinners, and the Dyers. The Tallow Chandlers' Hall was rebuilt in 1670-72, possibly by Captain J. Caine, though a payment is also recorded to Edward Jarman. Though altered, agreeably, down the centuries, it still has the original Court Room, with the seating undisturbed; a side door in Cloak Lane has a large, beautifully carved shell hood. The Skinners' Hall is set unobtrusively back from the road; the street façade, erected by W. Jupp about 1790, is adorned with a Coade stone pediment designed by John Bacon. The Skinners are one of the twelve great companies and alternate annually sixth and seventh with the Merchant Taylors in order of civic precedence, as laid down by the Lord Mayor, Sir Roger Billesdon, in 1484.1 The Hall itself, though somewhat altered, is the post-Fire building and the Court Room still has its seventeenth-century woodwork. Over the chimney-piece is a carving of the Stuart royal arms, which the Company set up when they entertained General Monck in April 1660 – that is, a full month before Charles II was restored to his throne. The Company possesses a good collection of silver, including several pre-Fire pieces, such as the five Cockayne Cups presented in 1605 by William Cockayne, each vessel made in the shape of a cockerel, and the Peacock Cup, presented in 1642 by Mary, the wife of James Peacock, and fashioned like a peahen with three chicks. The Company has recently acquired a superb Russian chandelier, made in one of the glass factories established by Potemkin, minister to Catherine the Great, and originally brought to this country about 1784 by Sir James Harris, who was British Ambassador to St. Petersburg. The Dyers' Hall, at number 10 Dowgate Hill, was built in 1839-40, to designs by Charles Dyer. The entrance is through a long corridor with a glass vault, the walls painted with birds by Peter Scott, and round the Committee Room is an astonishing Art Nouveau wallpaper. At the foot of Dowgate Hill in College Street is the Innholders' Hall; its frontage is of 1886 but the Court Room was built just after the Fire and has a ceiling in a still earlier manner, that of Inigo Jones and his pupil and nephew-in-law, John Webb.

Just to the west of this complex of halls, on the corner of College Lane and College Hill, stands St. Michael Paternoster Royal, a garden separating it from Upper Thames Street. The church takes its name from the old names of the nearby streets – Paternoster Lane and La Riole, so called from its former inhabitants, wine-merchants from La Riole near Bordeaux. Founded by the middle of the thirteenth century, the medieval church was rebuilt by Richard Whittington, who lived in College Lane and who was thrice Lord Mayor of London, in 1396–97,

City wall, Coopers Row, showing Roman work in the lower courses

¹ The 1484 judgement was necessitated by the squabbles of the Skinners and Merchant Taylors – hence 'to be at sixes and sevens'.

1406, and 1419; the work was not completed until after his death in 1423, when he was laid in a marble tomb in St. Michael's. The poet, John Cleveland, was also buried here. The church disappeared in the flames of 1666. It was the last of Wren's churches to be completed and much of the work was under the supervision of his master mason, Edward Strong, the body of the church being finished in 1694 and the steeple in 1713. In 1941 the edifice was shattered by bombs, though fortunately the fittings had been removed to safety; it was restored through the determination of the City authorities. Today, St. Michael's is a guild church, its west end used as offices for the Mission to Seamen.

Outwardly much as Wren left it, the body of the church is of brick, the tower and south side stone-faced. This tower is the most important feature, rising in three stages and topped with a lacy parapet. From it, again in three stages, rises the steeple, three diminishing octagonal lanterns, the light showing between the columns, the roofs of each stage fretting in and out, with urns set above each little pillar, the whole capped with a tiny spire and cross. This steeple should be viewed from the south, in relationship with St. James Garlickhythe, which repeats the same

pattern but with square instead of octagonal stages: the harmony between the two is remarkable. Inside. the church is a plain rectangle with a nave and two aisles. The pulpit, reredos, and lectern with a figure of Charity as the base are the original fittings. The magnificent brass chandelier and statues of Moses and Aaron on either side of the altar came from All Hallows the Great; the statues are unexpected – it is more usual to have paintings of the patriarchs. There are few monuments, though one to Sir Samuel Pennant, the judge who died from gaol fever in the deadly sessions of 1750 at the Old Bailey, is worth notice. Four new windows have glass by John Havward, St. Michael vanquishing Satan above the altar, flanked by the Virgin and Child to the north, and by the Archangel Gabriel with Adam and Eve to the south; in the south aisle window, a young Dick Whittington, accompanied by his cat, steps out on the golden pavements of the city in which he found his good fortune. A blue plaque on number 19-20 College Hill marks the site of the house of this most famous of all Lord Mayors; numbers 21 and 22a nearby have spectacular late seventeenth-century gateways, adorned with fruit and flowers and veget-

Custom House, Lower Thames Street

Queen Street, running parallel with College Hill, was cut through after the Great Fire to give the Guildhall a prospect towards the river; numbers 27 and 28 are good stalwart eighteenth-century houses. It opens on to Southwark Bridge, constructed in 1815–19 to designs by John Rennie, spanning the river with three cast-iron arches. The contractors were Messrs. Joliffe and Banks; Sir Edward Banks's epitaph at Chipstead in Surrey tells us that he was responsible for the 'three noblest bridges in the world – London, Southwark and Waterloo'. In 1919, Southwark Bridge was rebuilt to a less interesting design by Sir Ernest George.

Returning to London Bridge and walking eastward, the first building is Adelaide House, significant because it was the earliest office building to break away from the hitherto accepted classical appearance and to substitute an Egyptian style and facade. It was the work of Sir John Burnet and Tait in 1924-5; whether the firm's originality was profit or loss architecturally is debatable. The eye is then drawn to the Monument, rearing up at the junction of Monument Street and Fish Street. A pillar of Portland stone, 202 feet high, surmounted by a gilded flaming urn, the design was probably the combined effort of Wren and the City Surveyor, Robert Hooke. It was built as a reminder of the dreadful fire which broke out on 2 September 1666 and within a space of four days consumed four-fifths of the City; 89 churches, 400 streets with 13,200 houses, and all the public buildings vanished in the flames. The Monument stands on the site of St. Margaret's Fish Street, its height measuring the exact distance eastwards from its base to the spot where the conflagration began in a baker's shop in Pudding Lane. On the west side, a bas-relief by Caius Gabriel Cibber shows a personification of the City of London sitting, despairing and dishevelled. Time raises her up while Peace and Prosperity hover in the clouds, casting down blessings. Behind her, houses still blaze, but at her feet is a beehive, symbolizing the industry of her citizens, ready to begin repairs. On the right, Charles II, in Roman armour, comes to London's aid, assisted by Science, Liberty, and Architecture who carries a plan, a set-square, and a compass in a most practical manner. Behind the King stands his brother, James Duke of York, later James II, carrying a garland with which to crown poor London and a sword to defend her. Justice and Fortitude attend the royal couple, and behind them labourers can be seen rebuilding houses. On the ground Envy sits gnawing a heart and breathing out poison, and, above the relief, at each corner of the base of the column, crawls a dragon, all four sculpted by Edward Pierce. Inside the Monument, 345 black marble steps lead to a public viewing gallery enclosed with railings. The ascent is hard and steep but the view, including as it does the dome of St. Paul's, is magnificent, even in the twentieth century, and is well worth the effort involved.

Between the Monument and the river, in Lower

Thames Street, stands the church of St. Magnus the Martyr. Henry Yevele, Richard II's master mason who was also bridgemaster of London Bridge, was buried here, and Miles Coverdale, the translator of the Bible into English, held the living from 1564 till 1566; his ashes were removed to St. Magnus's church when his burial place, St. Bartholomew-bythe-Exchange, was demolished in 1840. Wren built one of his most magnificent edifices here (completed 1671–6, steeple 1705). Since Old London Bridge was a little downstream from later bridges, the spire of St. Magnus's and the Monument were the focal point for any one approaching from the Southwark side. The western tower rises in three stages, its lowest a porch through which ran the right of way to the bridge. From the second storey projects a large gilt clock, presented in 1709 by Sir Charles Duncombe, who was Lord Mayor that year, with a belfry above supporting an octagonal lantern crowned with a lead cupola and an obelisk spire. In the churchyard stand blocks of masonry from Old London Bridge and a pile from a Roman wharf, or possibly from the Roman bridge itself. The church is oblong with beswagged round windows in the north wall.1 The interior is magnificent; T. S. Eliot wrote of its 'inexplicable splendour of Ionian white and gold', and later alterations have enhanced rather than diminished it. The nave is tunnel-vaulted, separated from the aisles by fluted Ionic pillars. The reredos is original, with paintings of Moses and Aaron, but above it Martin Travers, in 1924-5, set a noble Crucifixion; two superb door-cases – some of Wren's best carpenters, Cleer, Gray, and Massey, worked here - were then adapted as side-altars. There is a plain octagonal font of 1683, an elaborately carved pulpit and tester, and a magnificent west gallery, reached by two staircases with twisted balusters. In it sits the organ, presented, like the clock, by Sir Charles Duncombe, and made by Abraham Jordan, who claimed that one of the four sets of kevs was 'adapted to the art of emitting sounds by swelling the notes, which never was in any organ before'. The altar rails probably date from 1705 and there is an iron sword-rest of 1708.

Outside the church lies Billingsgate Fish Market, closed in 1982 and removed to new premises in the former West India Docks, Isle of Dogs, but built in 1875, to designs by Sir Horace Jones, of brick with arcades of cast-iron pillars within and flourishing Victorian lettering over the purveyors' stalls. Recent excavation of a nearby site has revealed much about the Roman and medieval waterfront, while beneath the Victorian Coal Exchange, wantonly torn down in 1968, a Roman bath-house was found in remarkably intact condition; it is hoped that one day it may be made accessible to the public. Eastwards again is the Custom House, built in 1815–17 by D. Laing, with

¹ Of these windows, only that above the blocked doorway is original, the rest having been altered to this shape by J. Tricker in 1782.

the centre of the river front being rebuilt by Sir Robert Smirke in 1825. This is the fifth Customs House to stand here, four others, the earliest dating from 1382, having all been destroyed by fire, though the nineteenth-century building was scarcely damaged in the Second World War.

Beyond the Custom House, close to the Tower of London (see p. 326), is the church of All Hallows by-the-Tower, founded in the seventh century, bombed to an empty shell in 1940, and now restored to a new beauty. Its former name of All Hallows Barking tells us that the church belonged to the convent at Barking, in Essex, which St. Erkenwald founded for his sister, St. Ethelburga, about 660; recent archaeological discoveries prove that it must have been built soon after the foundation of the mother house. All Hallows stands on the site of a Roman house, for remains of two tessellated pavements are in the crypt, while bombing laid bare a Saxon arch made from Roman bricks and tiles and brought down fragments of two Saxon crosses from the arcading into which they had been built. Save for some of the remains in the crypt of St. Bride's, these are the oldest architectural fragments left from any church in London. The proximity of All Hallows to the Tower of London meant that the mutilated bodies of John Fisher, Bishop of Winchester, of Henry Howard, the poet Earl of Surrey, of Sir Thomas Grey, Lady Jane Grey's uncle, and of Archbishop Laud, all rested here for a while after their executions.

The church tower was much damaged in 1649 by an explosion in a nearby ship's chandler's shop, where gunpowder was stored, and had to be rebuilt some ten years later to the designs of Samuel Twin, a bricklayer. This was the only church building to have been undertaken in the City during the Commonwealth period, when the edifices of the established church were not always treated with great respect. All Hallows escaped serious damage in 1666 through the prompt action of Admiral Sir William Penn, who instructed sailors to blow up the houses around the church, thus creating a fire-break; Samuel Pepys ascended that tower on the Wednesday morning and gazed on 'the great Fires, oyle-cellars and brimstone and other things burning' till he 'became afeard to stay there long and came down again as fast as I could'. It was the son of that Sir William Penn, another William, baptized in All Hallows on 23 October 1644, who became the founder of Pennsylvania in America; John Quincy Adams, the sixth President of the United States, was married there to Louise Catherine Johnson on 26 July 1797.

In 1922, the Reverend P. B. Clayton became Vicar of All Hallows. It was he who had, during the First World War, established at Talbot House, in Poperinghe near Ypres, a centre for rest and prayer for troops temporarily withdrawn from battle. The initials T. H. were rendered 'Toc H' in signallers' parlance, and this gave a name to the movement of

Christian brotherhood which began there, survived the war, and still flourishes. All Hallows became the Toc H church.

A high-explosive bomb on the night of 8 December 1940 and a hail of incendiaries three weeks later left only the crypt and undercroft, the shell of the tower, and the splintered north and south walls. Rebuilding, begun in 1948, was completed in 1957. The architect was Lord Mottistone of Seely and Paget, to whose scholarship, industry, and imagination London owes the restoration of many shattered churches and historic buildings; All Hallows is perhaps his most personal re-creation. He retained the old north and south aisle walls, though the east end was, of necessity, rebuilt in brick, with a gable reminiscent of the Great Hall at Hampton Court; below the gable and above the great east window is a carving of the Toc H lamp. Lord Mottistone added a copper spire, the first to be erected on a City church for 200 years. It rises, needle-sharp, from four shoulders which, in their turn, sit on a circular base with a parapet, giving the riverside of London a new and lovely landmark.

The interior of the church is a free interpretation of the Perpendicular or late medieval style. The nave is 103 feet long and rises 44 feet to a flattened tunnelvault of reinforced concrete. The arcades to the north and south aisles are of Painswick stone from Gloucestershire; they have clustered shafts to their columns, broad arches, and rise to a clerestory. The east window, of clear glass, admits a cold river light, giving the interior an unusual radiance in almost all weathers. Below it stands the altar, a copy of the Jacobean table which the bombs destroyed, with two candlesticks upon it of unusual and elegant design, from Lord Mottistone's drawings. There is no Cross lest it conceal the face of Christ in the painting of the Last Supper, which forms the reredos; Brian Thomas, the artist, deliberately dressed his principal figures in a timeless garb, in order to symbolize that the breaking of the bread belongs to the brotherhood of all ages. The brass altar rails incorporate some eighteenth-century work saved from the bombing. In the nave stands the pulpit from St. Swithin's London Stone, which is in the Grinling Gibbons manner, with cherubs' heads and garlands of flowers. The lectern, with wrought-iron work made in Sussex about 1613, was skilfully restored after the war. On the litany desk is a panel of wood, the only morsel saved from All Hallows' original pulpit.

The north aisle is the Toc H chapel. At the east end is an altar tomb, that of Alderman John Croke (d.1477) with a brass showing him and his wife, with their eight sons and five daughters; the two eldest young ladies have very sprightly dresses. On the tomb stands a casket, made by the Bromsgrove Guild of Art to contain the Toc H lamp of maintenance; the casket was given in 1922 by the future Edward VIII. Nearby is a war memorial, a tomb-chest with a recumbent figure, sculpted by Cecil Thomas, of the

Hon. Alfred Forster, who died from wounds. On the wall is a small kneeling figure of Hieronymus Benalius, an Italian who died in London in 1583.

The south aisle is the Mariners' Chapel; a number of model ships have been placed here as votive offerings. At the west end is the organ, a new instrument by Harrison of Durham, installed in memory of Queen Mary. Below it is a screened-off section, the Mary Rushworth Book Centre, where those visiting the church may read quietly and into which the Saxon arch has been incorporated. Near it is the font promised to All Hallows in 1943, when Dr. Clayton visited the garrison of Gibraltar. Men of the 172 Tunnelling Company, Royal Engineers, cut out a block of hard, pale, crystalline Gibraltar limestone, and a Sicilian prisoner of war named Tulipani carved this into a plain, shallow, circular basin on a baluster stem. The font cover, given to the church by J. Foyle in 1681, is as elaborate as the font is unadorned and, almost certainly, the work of Grinling Gibbons himself; a pair of cherubs romp round a mound of flowers, fruits, hops, ears of corn, and fir-cones, on top of which a dove perches.

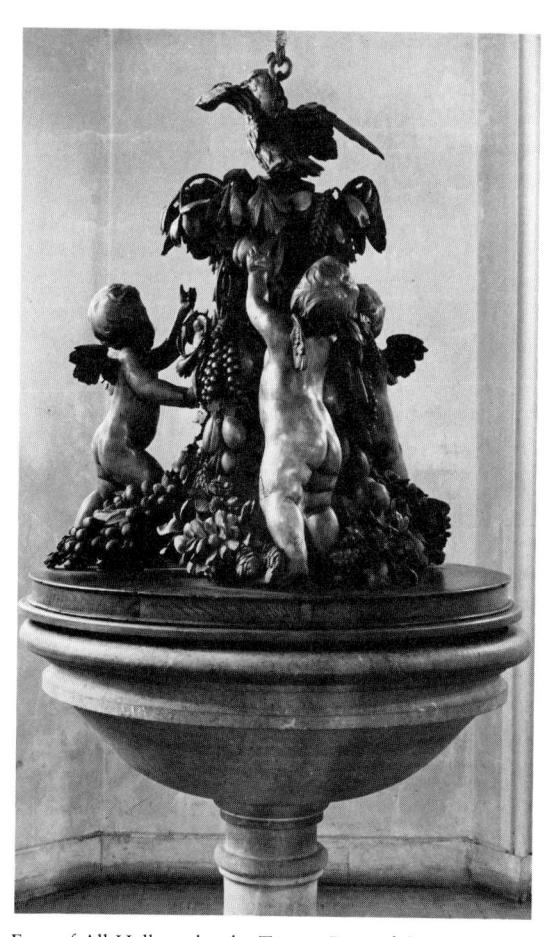

Font of All Hallows-by-the-Tower, Byward Street

Just beyond the baptistery, steps lead down to the undercroft, which was created in 1925, when some underpinning was needed, and to the crypt, where Roman paving and other remains are displayed. A seventeenth-century vault has become the Chapel of St. Clare, and the fourteenth-century crypt chapel, now dedicated to St. Francis, has been set aside for private prayer.

All Hallows possesses the finest collection of brasses of any City church. The majority of the 17, ranging from 1389 to 1651, are inlaid in the chancel and kept covered for protection, though the carpet will be removed on request. William Tonge's, with a circular inscription round a coat of arms with a single fleur-de-lys, is the earliest, and John and Joan Bacon (1437), John Rusche (1498), Christopher Rawson and his wives (1518), and Roger James (1591), all have full-length figures. There is a Resurrection brass, possibly made for the tomb of Sir Robert Tate, and an exceptionally good Flemish brass1 to Andrew Evyngar (1530), a salter, and Ellen, his wife, who stand beside each other, their seven children around them, while, above their heads, the Virgin cradles the dead body of Christ in her arms. There is a palimpsest brass to William Thynne and his wife (1546) on the back of which are two unidentified, incomplete figures. Thynne was the uncle of Sir George Thynne of Longleat, an ancestor of the Marquess of Bath, and it was he who edited the first edition of Chaucer's works.

Great Tower Street and Eastcheap lead back to London Bridge; between them and the river is a maze of alleyways made more picturesque by the steepness of the river-banks, among which hide two more Wren churches, while a third stands in Eastcheap. Of the first church, St. Dunstan's, nothing remains save the tower and the walls, for it was burnt out in 1941. Probably of Saxon foundation, the medieval church held a monument, raised by his fellow-parishioners, to the Elizabethan sea-captain and explorer, Sir John Hawkins, whose body was buried at sea. That vanished with the church in 1666, but Wren rebuilt it with an airy Gothic steeple, reminiscent of St. Nicholas, Newcastle, or St. Giles, Edinburgh. A stalwart tower rises in four stages, each corner marked by a large pinnacle, from which spring four ribs to support the lantern and the tall, thin spire. The body of the church, becoming ruinous, was rebuilt in 1821 by David Laing, the architect of the Custom House close by; in it was placed a memorial to Colonel John Finnis of the XI Regiment of Bengal Native Infantry, who was killed at Meerut on 10 May 1857, the first Englishman to die in the Indian Mutiny. After the Second World War, only the tower was restored, though the walls were left standing. The ground within them was turned into a garden, so that now clematis scrambles through the window tracery.

¹ Equalled only by that in the church of St. Mary at Quay in lpswich.

St. Margaret Pattens, Eastcheap

The complete church, St. Mary-at-Hill, is tucked away down a narrow passageway under a clock; it can be reached from the street of St. Mary-at-Hill, or from Lovat Lane, or from Botolph Alley. First mentioned in 1177, it was damaged but not destroyed in the Fire; Wren rebuilt the interior, leaving the tower and the side walls. The tower was rebuilt in 1787-8 in somewhat incongruous vellow brick by George Gwilt; the side walls were renewed in 1826 by James Savage, who also redecorated the ceiling. The interior is the least spoilt of all Wren's churches and, alone in the City, has retained the original box-pews. Cruciform in plan, like St. Anne and St. Agnes, St. Mary's has, over the crossing, a shallow dome which rests on four free-standing pillars. Much of the woodwork was renewed in the mid-nineteenth century, but the carving by W. Gibbs Rogers can scarcely be distinguished from that of Wren's craftsmen. The reredos and pulpit are original, though the backboard is signed by Rogers and the tester is probably his too; there is a fine lectern and a glorious west gallery with an organ. The font is octagonal and there are six elaborate sword-rests, the best collection in any single church. In the vestibule is a relief of the general resurrection, formerly in Billingsgate Ward School, on which small figures leap nimbly from their tombs and coffins. St. Mary's was restored by Seeley and Paget in 1967; a new organ by William Hill of London was installed in 1971 and recitals are frequently given. The poet Edward Young, author of Night Thoughts, was married here on 27 May 1731 to Lady Elizabeth Lee, and among the rectors of St. Mary-at-Hill have been John Brand, the author of Popular Antiquities, one of the earliest serious studies of English folklore, and William Carlisle, founder of that philanthropic institution, the Church Army

From the street of St. Mary-at-Hill, the tower and spire of St. Margaret Pattens are visible on the north side of Eastcheap. The square tower at the northwest corner of the church terminates in a parapet and four sharp pinnacles at the corners. From it rises a tall, lead-covered steeple, looking as if it had been drawn by Arthur Rackham to illustrate a fairy-tale. It is the third highest of Wren's steeples, surpassed only by those of St. Bride's and St. Mary-le-Bow. It is unknown whether the church, of medieval foundation, takes its name from the pattens made and sold in the area or from a benefactor called Patyns. The entrance from the southwest corner leads into a spacious vestibule. St. Margaret's is now a guild church, used as a clergy and conference centre. Wren completed the church in 1687, though the steeple was not finished till 1702. The building is rectangular, measuring 66 feet by 52 feet, with a nave, chancel, and north aisle and gallery resting on freestanding pillars, which support an entablature continued round the church on attached pilasters. Unfortunately, there is some insipid modern stained glass in the east window. The woodwork is good throughout – W. Cleer was the joiner employed here. The fine reredos now supports a small painting of Christ in Gethsemane by Carlo Maratti (1625-1713). The pulpit is plain and sturdy, the octagonal font is adorned with cherubs, and in the north aisle a small side-altar has been created from a door-case. The organ installed in 1750 in the west gallery has a splendid case; below it are the royal arms of Charles II and two canopied church-wardens' pews. There are monuments to Sir Peter Vandeput (d. 1686), to Sir Peter Delme (d.1728) by Rysbrack, and to Susannah Batson (d.1728), and two pretty embroidered pictures hang in the south aisle. In the eighteenth century, St. Margaret's had scholarly rectors, for Thomas Birch, historian and editor of Spenser, Raleigh, Bacon, and Milton's prose works, was here for nearly 19 years till his death in 1766, and then Peter Whalley, formerly headmaster of Christ's Hospital and editor of Ben Jonson's works, held the living till his death in 1791.

THE CITY OF WESTMINSTER

Dean Wilcocks's Memorial in Westminster Abbey (see p. 97)

Westminster Abbey

Legend asserts that the abbey church of St. Peter at Westminster was founded at the beginning of the seventh century during the reign of King Sebert, that it was miraculously consecrated by its own patron saint, and that its royal founder was buried within its walls when he died in AD 616. These stories are incapable of proof, but we know that there was a small monastery on Thorney Island towards the end of the tenth century, when St. Dunstan was Archbishop of Canterbury, which Edward the Confessor decided to refound in redemption of a vow to make a pilgrimage to St. Peter's in Rome. The Benedictine establishment was enlarged till there were 70 monks, and for them the king built the great church which was consecrated on 28 December 1065, only ten days before his own death. It is possible that his rightful successor, Harold, was crowned here; it is certain that William the Conqueror celebrated his own coronation in the great abbey church on Christmas Day 1066, for he had based his claim to the throne on Edward's promise of it to him, and he wanted to emphasize their relationship by assuming the crown in the Confessor's own church. Since that time, Westminster Abbey has been the coronation place of all our sovereigns, save only Edward V and Edward VIII, neither of whom was ever crowned, and, from Henry III's death till that of George II, this has been their customary place of sepulchre. 39 monarchs have been crowned here and here 16 have been buried. These associations combine to make the Abbey the most important historical building in England. They also served to protect its supreme architectural beauty from mutilation and iconoclasm at the Reformation.

The Confessor's church, of which nothing now remains above ground, was said to have derived its plan from that of Jumièges. The monarch was canonized in 1163 and the church was rebuilt by Henry III, whose devotion to the Saxon saint was such that he called his eldest son after him, was buried beside him, and judged the Confessor's own edifice to be too humble a resting-place for his sacred body. In 1245, he began to pull down the old structure and to rebuild it in the magnificent style of Rheims Cathedral, which had just been completed.

The work carried out under his aegis during the next 25 years must be considered as the most significant display of artistic patronage ever undertaken

by an English monarch. Henry's piety and reverence for his predecessor were such that the work was carried out at his own expense; a conservative estimate¹ suggests that he laid out well over £40,000. His first consideration was the building, and here we should remember that the queens of France and of England were sisters, daughters of Raymond Berengar, the poet Count of Provence; the cultural relationships between the two courts were close and fruitful. Specifically French architectural features will be pointed out later, but the royal connection should be noted. From 1245 till about 1253, the king's master mason was Henry of Reynes, who may have been a Frenchman or who may have come from Raynes in Essex, but who had certainly worked in France. He had already been responsible for new buildings at Windsor. His assistant and successor was John of Gloucester, who directed the work till 1261; after that date, Robert of Beverley was in control.

As the building progressed, so Henry furnished it, for he believed that the adornments were of equal importance with the main structure. The walls and the woodwork were painted, the floors inlaid with precious marbles, sculpture was commissioned and installed, metal work was wrought, and Mabel of Bury St. Edmunds embroidered altar frontals and copes. The very account entries suggest the King's enthusiam for the work and the respect in which he held his craftsmen; Master Walter of Durham is described as 'dilectissimus pictor' and Mabel is allowed to keep the surplus silks and gold thread for her own use. It is important to realize that what we have today is only a flicker of the brilliance and colour that must once have filled the building.

The work continued till 1269, by which time the east end, the transepts, and the first four bays of the nave were completed, the saint's body had been placed in a new, magnificent shrine, and the chapter house was finished. There the building stayed, the lofty eastern portion awkwardly joined to the nave of the older, less stately, church. A century later, two efficient abbots, Simon Langham and Nicholas de Litlyngton, re-organized the abbey's finances and, with the generous support of Richard II, continued

¹ Brown, R. A., Colvin, H. M. and Taylor, A. J., History of the King's Works, 1963. volume I, p. 157.

the work. Their master mason was Henry Yevele, whose humility and sensibility were so great that he planned it, not in the style of his own day, but in that first chosen by Henry of Reynes, so that the whole church could almost be the work of one generation. After Richard's deposition in 1399, the work languished till Abbot Islip completed the vaulting in 1503-6. At the same time, the Lady Chapel, constructed about 1220 from the Abbey's own funds, which stood to the east of the main building, was pulled down and a new one was begun by the express desire of Henry VII. The king and his mother, the Lady Margaret Beaufort, spent some £14,000 on the chapel which was to be 'painted, garnished and adorned as such work requireth and as to a King's work apperteyneth'. The western end remained unfinished till 1734 when Hawksmoor, disciplining his ingenuity as Yevele had done before him, designed two square pinnacled towers with a gable between them. He died in 1736 but John James completed the work in 1745. The labours of five centuries were at last complete and the Abbey a perfect and harmonious whole.

WESTMINSTER ABBEY is shaped like a Latin cross, measuring 511 feet 6 inches from the west door to the eastern extremity of Henry VII's Chapel, and 203 feet 2 inches from the north door, across the Choir, to the south door. The western towers soar 225 feet 4 inches into the air, and the nave rises up through 101 feet 8 inches. It was built of stone quarried in Caen and shipped across the Channel with difficulty and at great expense, but by the end of the seventeenth century, the exterior was in need of repair and the work of refacing was begun in 1698 under the careful supervision of Sir Christopher Wren. The whole of Henry VII's Chapel was refaced, less sympathetically, by Wyatt between 1807 and 1822, and in the middle of that century J. T. Micklethwaite renewed the rose window in the south transept, while Sir Gilbert Scott began, and J. L. Pearson continued, the remodelling of the North Porch. In spite of these renewals, the form of the Abbey remains clear and we should notice especially the windows, the buttresses, and the North Porch. The tall windows are divided into two lights by bar tracery, while above them and below the window arch is a sexfoiled circle, all of open work. Such tracery had been devised in Rheims, between 1210 and 1220, and it is generally accepted that this delicate technique was first introduced into England when it was employed for the Abbey. The windows are divided by buttresses which rise above the aisle

roofs to terminate in pinnacles, while from them flying buttresses stretch out to brace themselves between the windows of the clerestory. To Henry III's fabric, the main entrance was not from the west, but by the north, the royal porch. This entrance was the nearest and most convenient to the palace of Westminster.

When visiting the Abbey today, it is best to enter by the west porch. The plan of the interior repeats the basic simplicity of the cross formed by the outer walls, and there are two especially French features in the design, namely the height of the nave and the chevet arrangement at the east end, where an ambulatory surrounds the apse of the choir and chancel, and is itself encircled by a chain of small polygonal chapels, dedicated to different saints. The nave is the highest in England, exceeding the choir at Lincoln by more than 27 feet, though dwarfed in its turn by Amiens and Rheims. It is 35 feet wide, giving a ratio of three to one, proportions more usually found in France than in England. It consists of 12 bays, but the ritual choir projects into it and occupies the four easternmost. A screen is set across the central aisle at this point, with the nave altar before it. The pillars of the main arcade should be examined carefully; they are of Purbeck marble and, uncharacteristically enough, have always been polished and never painted. At the fourth bay, their form changes slightly and they have eight shafts instead of four; this distinction marks the end of Henry III's work and the beginning of Yevele's fabric. Above the main arcade are the windows of the triforium and clerestory; a gallery runs around the church at triforium level - an arrangement more characteristically English than French. The vaulting is studded with great, golden bosses and from the sides hang 16 glorious Waterford glass chandeliers, given by the Guinness family in celebration of the nine-hundredth anniversary of the Abbey's consecration.

At eye and pavement level, our contemplation of the nave may be jarred by the extraordinary number of monuments, many of white marble, which throng the walls, the aisles, and the chapels. Besides the kings, many of the great, and a fair number of the comparatively humble dead lie in the Abbey or have their monuments here. The Abbey can claim to shelter a neat anthology of English sculpture from the thirteenth century to the present day. Details of each monument are set out in the official guide. Of pre-Reformation work, more can be seen in the Abbey than in any other church in the country, so thoroughly was the destruction of religious sculpture elsewhere carried out under Henry VIII and Edward VI.

Above the entrance in the west porch is a carving of Our Lord, flanked by St. Peter and Edward the Confessor. The work, by Michael Clark, is made of teak and was set up in 1967. At the west end of the nave, a black slab with a long inscription covers the body of the Unknown Soldier, laid here on 11

¹ Unless, as Sir Nikolaus Pevsner reminds us, the great, glorious, blinded, bricked-up west window of Binham Priory in Norfolk was indeed completed, as Matthew Paris asserts in his *Chronica Maior*, before 1244, in which case this remote corner of North Norfolk has the honour of having brought such tracery to this island.

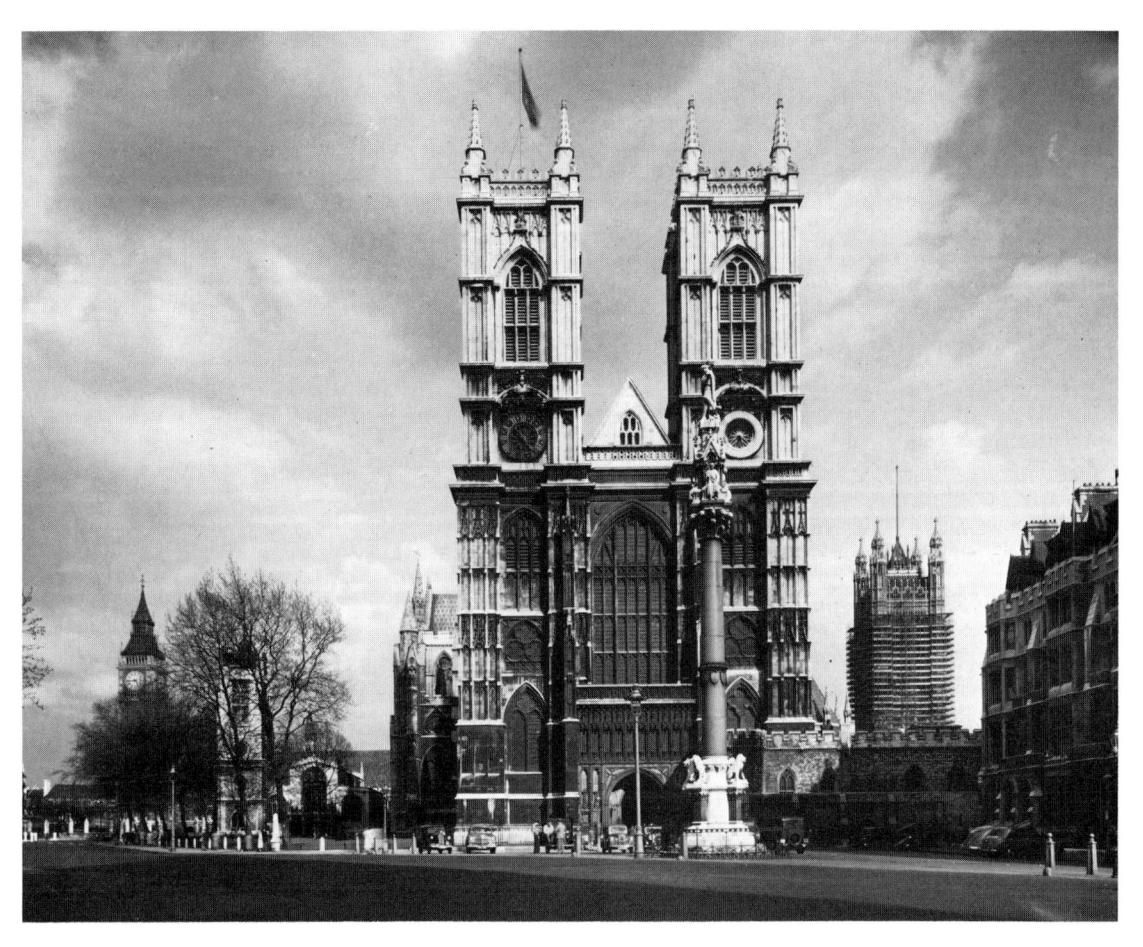

West front of Westminster Abbey

November 1920. Wreaths and posies of scarlet poppies always ring it round. Nearby, another, plainer slab commemorates Winston Churchill, who lies with his family at Bladon, Outside St. George's Chapel hangs a portrait of Richard II, probably the work of André Beaunève de Valenciennes, painter to Charles V, who visited England about 1398. The pose is stiff and hieratic, majesty enshrined rather than enthroned, but the face is clearly a portrait, the earliest convincing one that we have of an English king, and should be compared with the effigy on Richard's tomb and with the younger man shown in the Wilton Diptych in the National Gallery (see p. 119). The great west window is part of the fifteenthcentury work, but the glass dates from the 1730s, when the figures were designed by Sir James Thornhill and executed by Joshua Price. Among the many large monuments - the younger Pitt and Charles James Fox, political rivals throughout their lives, lie near each other and are both commemorated by Westmacott – is one small one under the south-west tower. It is by Cheere to Joseph Wilcocks, Dean of Westminster for 25 years, during which time the western towers were completed. So proud was he of those towers that the sculptor showed them on his memorial. On English monuments, the most interesting and skilful work is often to be found, not in the main figures, but in the details or the bas-reliefs of the pedestals. Two particularly memorable examples in the Abbey are the monuments to Lieutenant-Colonel the Hon. Roger Townsend and to Thomas Thynne. The former was killed in 1759 when reconnoitring the French lines at Ticonderoga: the basrelief, designed by Robert Adam and Jean-François Breton and carved by John Eckstein and T. Carter, shows the fort with French and English troops, garbed as Roman soldiers, skirmishing. The latter's monument, carved by A. Quellin, shows the murder of Thynne in 1682 by three ruffians in the pay of Count Konigsmarck, as he drove in his coach along Whitehall.

The Choir Screen, which was set up in 1834, was designed by Edward Blore, though much of the inner stonework dates from the thirteenth century. Against it, facing into the nave, are placed two monuments, both designed by William Kent and executed by

Rysbrack; they are to James, 1st Earl Stanhope, and to Isaac Newton. Near to Newton lie other great scientists – Kelvin, Herschel, Darwin, Thomson, and Rutherford – while plaques commemorate Faraday and Clerk-Maxwell. A single grave close by encases the bodies of two great clock-makers, Thomas Tompion (d.1713) and his friend and apprentice, George Graham (d.1751).

Behind the Screen lies the Choir, its black and white pavement given by Dr. Richard Busby, Headmaster of Westminster School. The medieval stalls were destroyed by the Abbey surveyor in 1775 and the present ones date only from 1847 but, with painted and gilded woodwork behind them, they make a brave showing. The Organ has grown from an instrument built by Christopher Shrider in 1730, and still incorporates two stops from the 'Father' Schmidt organ of 1694, namely the 8-foot Stopped Diapason and the 4-foot Stopped Nason on the Choir Organ. Among the Abbey organists have been Orlando and Christopher Gibbons, John Blow and his pupil Henry Purcell, Samuel Arnold, and Thomas Greatorex. Purcell and Blow lie in the north aisle of the choir, underneath the organ, and near them are the graves and monuments of many British composers. In this part of the Abbey, the carvings on the spandrels of the north and south wall-arcades should be noticed. They are a series of sculptured coats of arms, traditionally representing those who assisted Henry III in the rebuilding. The arms of the Holy Roman Emperor are there, with those of the King of France and the Count of Provence, Henry III's father-in-law; among the English nobles, Roger Bigod, Earl of Norfolk, and Simon de Montfort, Earl of Leicester, are represented. In 1264, within a year of the shields being set up, de Montfort was in open rebellion against the King, determined to force the rule of Parliament upon him.

We now stand in the crossing under the Lantern and can look towards the transepts. The North Transept is known as the Statesmen's Aisle, so many of our greatest politicians are commemorated there. The fashion was set by the elder John Bacon's monument to the elder Pitt, which stands 33 feet high in white marble and cost £6,000. Castlereagh, Grattan, Peel, Palmerston, Disraeli, Gladstone, and Asquith have graves or memorials here. Gibson refused to undertake the statue for Peel (d.1850) unless he might garb the statesman in classical attire, so Peel is represented in a toga, but Boehm's figure of Disraeli has something of the character and panache which its subject must have had in life. The north transept has three distinct aisles, the eastern one being divided into three small chapels dedicated to St. Michael, St. Andrew, and St. John the Evangelist. In St. John's Chapel lie two soldier brothers, Sir Francis and Horace Vere, 1st Baron Vere of Tilbury (d.1609 and 1635). Francis Vere's widow set up a monument to them, a copy of the tomb of the Count of Nassau at Breda. It consists of two slabs of black marble, on the

lower of which lies Sir Francis's body, wrapped in his cloak. Four kneeling knights support the upper slab on their shoulders and on it is laid his armour like an empty carapace, to show that he died in his bed and not upon the field of battle. Adjacent, in St. Michael's Chapel, is Roubiliac's famous monument to Lady Elizabeth Nightingale. The poor lady died from a miscarriage, having been frightened during a thunder-storm. She sinks down, lifeless, in her husband's arms, while he tries in vain to ward off Death's spear, directed by a ghastly skeleton which emerges from the base of the monument. Charles I's supporter, the Duke of Newcastle, has a fine tomb with effigies upon it of himself and his learned wife, Margaret Lucas; she is shown holding a book, an inkhorn, and a pen. They share their vault with their son-in-law, Edward Harley, 2nd Earl of Oxford, who died in 1741; his wonderful library of manuscripts is now the Harleian Collection in the British Museum. An exceptionally graceful figure of an Oriental maiden, carved by Scheemakers, adorns Rear-Admiral Charles Watson's monument (d.1757), and there are numerous morsels of thirteenth-century sculpture on the arches and spandrels of the walls and aisles. St. Margaret and her dragon keep each other company outside St. Andrew's chapel. Opposite, the slightly narrower, aisleless South Transept is the most popular corner of the whole great church. Chaucer was buried here in 1400, probably because, in his old age, he lived in a house close to the Abbey. The place was unmarked, but in 1555 another poet, Nicholas Brigham, gave a grey marble tomb as a memorial, and was himself buried nearby. When Edmund Spenser (d.1599) was laid here, all his contemporaries, in all probability Shakespeare among them, gathered here and threw their elegies and the pens with which they had written them, into the grave. From that time onwards, the bodies or the memorials of England's poets have been gathered together in the South Transept. A dandified figure of Shakespeare, designed by Kent and carved by Scheemakers, is here, and there are tributes to Dryden, Drayton, Beaumont, Milton, Addison, Gay, Sheridan, Prior, Burns, Southey, Coleridge, Wordsworth, Byron, Tennyson, Browning, Dickens, Kipling, T. S. Eliot, Dylan Thomas, Henry James, and W. H. Auden. The great actor, Garrick, is represented by a figure carved by H. Webber, and there is a fine statue of the composer, Handel, by Roubiliac; the face was worked from a death mask. William Camden, antiquary and Headmaster of Westminster School, who wrote the first guide-book to the Abbey in 1600, lies in the South Transept. His pupil, the poet Ben Ionson, who lies in the Nave, wrote of him with affectionate reverence, and near to Camden's grave lies William Heather, his friend and executor, who was a composer and founded the music professorship at Oxford

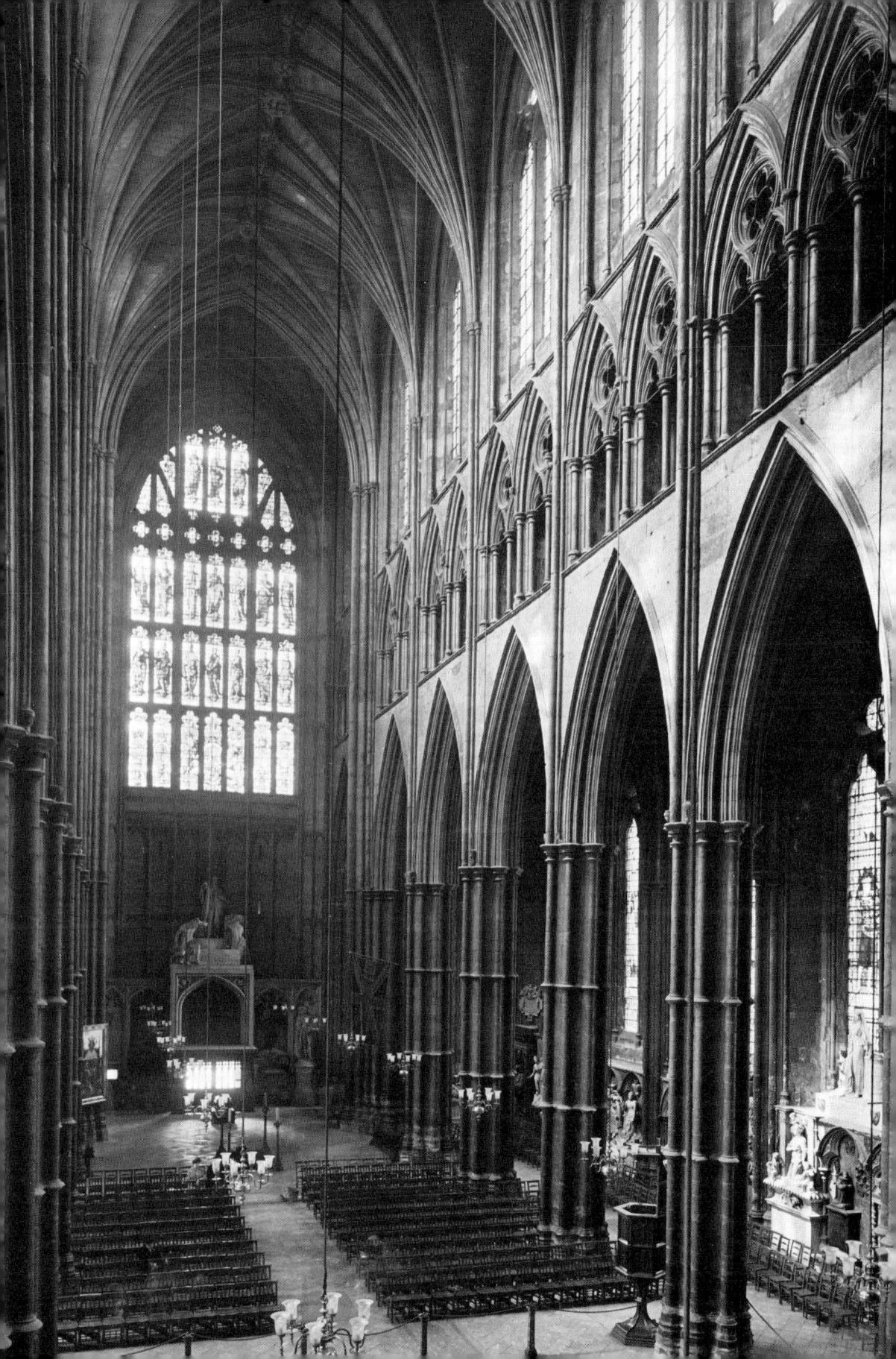

which is called after him. Among so many literary men is one monument to a statesman, John Campbell, 2nd Duke of Argyll (1680–1743), who was largely responsible for the union of England and Scotland and whose body lies in Henry VII's chapel. A memorial group was carved by Roubiliac; History inscribes the Duke's titles, Eloquence proclaims his fame, and Minerva contemplates his deeds. In the midst of these three ladies, the Duke sits, attired in classical armour, looking a little apprehensive of their vehemence. The whole work has a fair claim to being considered as Roubiliac's masterpiece, the tense attitude and flowing draperies of Eloquence being an especially remarkable achievement.

In the South Transept, special attention should be paid to the remains of the thirteenth-century adornments. High up at the south end, on a level with the triforium, are four figures, two of them winged angels, joyously swinging censers, another seated holding a staff, and a fourth, now headless, standing patiently. The angels are often held to be the finest sculpture of their period surviving in England, but binoculars are needed to appreciate them. They were wrought with such careful attention that even the backs of the wings are meticulously carved with feathers. Below them at eye level, partially obscured by the memorials, are two huge wall-paintings representing St. Christopher and the Incredulity of St. Thomas. A door in the wall beside the paintings leads into St. Faith's Chapel which is reserved for private prayer and meditation. Above the altar is a life-sized wall-painting of the saint, her visage beautiful but most uncompromising, with a book and a gridiron – the instrument of her martyrdom. Below is a crucifixion, with two curiously shaped devices on either side. Their outline is that of an eight-pointed star but the small scenes that once filled them have faded away. To the left is a small half-figure of a Benedictine monk, a scroll issuing from his lips with two lines of Latin enclosed in it - they are a prayer to the Virgin. Professor Tristram suggests that a monk, either Master William of Westminster or Master Walter of Durham, was responsible for these masterpieces.

The Sanctuary, St. Edward's Shrine, and the Royal Tombs lie to the east. The floor of the Sanctuary or Presbytery is raised about 30 inches above the level of the nave and it is here, before the high altar, that the ceremony of coronation takes place. The present altar was set up in 1867 to designs by Sir Gilbert Scott; it stands against a retable with a mosaic of the Last Supper which was designed by J. R. Clayton of Clayton and Bell and was executed by Salviati. The mosaic is flanked by wooden figures of St. Peter, St. Paul, Moses, and David, carved by H. H. Armstead. Before the altar, carefully covered by carpeting, is a pavement of Cosmati work. It was laid down about 1268, Abbot Ware having brought back from Rome a skilled craftsman called Odericus. It is made of Purbeck marble with panels of porphyry and serpentine and mosaics of marble and glass, all arranged in inter-woven circles and squares, the pattern showing the plan and the duration of the universe and the elements of which it is composed. Strangely enough, the pavement is shown in the foreground of Holbein's painting, The Ambassadors, which is in the National Gallery. On the north side of the Sanctuary are three magnificent tombs, those of Edmund Crouchback (d.1296), Earl of Lancaster youngest son of Henry III, of Aveline, the beautiful heiress who became his wife (d.1274), and of Aymer de Valence, Earl of Pembroke (d.1324). All three are altar tombs with elaborate canopies above them, and around the bases are little figures of men and women called 'weepers'. The tombs of Edmund and Aveline are very similar and may be by Master Alexander of Abingdon or by Master Michael of Canterbury, while Master Richard of Reading may have fashioned that for Aymer de Valence, who is shown both in effigy and again in a roundel on the top of the pediment, where he wears full armour and is charging on horseback. On the south side, opposite the tombs, are the sedilia or seats for the senior clergy. They were set up in Edward I's day, in the time of Abbot Wenlock. Behind them are four panels and, on two of them, painted, life-sized figures of kings are clearly visible. They are probably meant to represent Henry III and Edward I. Originally, the figures were ornamented with glass mosaic, though this has now nearly all disappeared. Other figures are visible on the backs of the panels and can be seen from the South Ambulatory; they are probably part of an Annunciation, and Edward the Confessor giving a ring to a pilgrim, who proved to be St. John. They should be compared with the figures in the South Transept. In the south corner of the Sanctuary lies that sensible lady, Anne of Cleves. Nearly fifty years after her death, a marble slab was set above her tomb; the decoration, a skull and cross-bones, is said to be the first of its kind in England.

Behind the High Altar is the Shrine of St. Edward the Confessor. The Saint lies in a marble tomb covered with mosaic decoration, the work of Peter, 'civis Romanus', possibly the son of that Odericus who laid the pavement in the Sanctuary. Around the tomb are trefoil-headed recesses, in which pilgrims would crouch hoping for miraculous cures. Above is a curious wooden feretory or superstructure, added by Abbot Feckenham in 1557 during the reign of Mary Tudor. Carvings of events from the Confessor's life and of miracles wrought by him run along the frieze of the screen, which divides the Shrine from the Sanctuary, which was completed in 1441. Burial near to the Saint was a privilege reserved only for those of the blood royal or of particular importance. The Lady Edith, his wife, and his sensible great-niece, Maud, who married Henry I and so united the Saxon and Norman lines, lie in unmarked graves, but some of the other royal persons have remarkable tombs. At the north-west corner, Edward I lies in a plain altar

tomb of Purbeck marble; it was said that adornment was avoided so that the king's body could easily be taken out to be carried before his troops should they march north to Scotland. His father's, Henry III's, tomb comes next, and is as magnificent as Edward's is plain. It is another Purbeck marble altar-tomb, but it is adorned with entwined circles and squares in mosaic work by Peter the Roman, and on it rests a gilt-bronze effigy, showing the king crowned and in coronation robes. The figure is the work of the sculptor, William Torel, citizen and goldsmith of London, who was also responsible for the gilt effigy of Eleanor of Castile, Edward's beloved queen, to whose memory he raised the Eleanor Crosses from Lincoln to Charing Cross (see p. 122). The tomb was made by Richard of Crundale and had originally a wooden canopy above it, made by Thomas de Hokyntone and painted by Master Walter of Durham, though this was destroyed, probably to make way for Henry V's Chantry, and has been replaced by a plainer structure. Queen Eleanor wears a simple coronet, beneath which her hair falls loosely; she looks young and lovely, and her hands are long and elegant. Around the effigy is an intricate iron grille made by Master Thomas of Leighton Buzzard. Opposite her, on the south side of the Shrine, lies Philippa of Hainault, Queen to Edward III; her effigy is of white marble, carved by the famous French sculptor, Hennequin de Liège; her face is kindly and sensible, she wears a stiffly formal head-dress, and some 70 little bronze figures, made by John Orchard, used to adorn the tomb, though most of them have now vanished. Edward III comes next, his tomb designed by Henry Yevele. The gilt-bronze effigy upon it, showing the king in coronation robes, is by John Orchard and the elaborate wooden canopy above is the work of Hugh Herland. Around the base of the tomb stood little bronze weepers, representing twelve of the fourteen children of Edward and Philippa; of these, six only, on the south side, now remain. They were clearly intended as portraits and it was always said that the venerable face of the King's effigy was modelled from a death mask. The westernmost bay on the south side is occupied by the double tomb of Richard II and his first queen, Anne of Bohemia. The Queen died in 1394 at the Palace of Sheen (now known as Richmond, in Surrey); so bitter was her husband's grief, that he caused part of the building to be torn down. He entrusted the tomb to his master masons, Henry Yevele and Stephen Lote, and the coppersmiths, Nicholas Broker and Godfrey Prest, and bade them fashion two effigies, holding hands. The work was completed by 1397, having cost £670. Richard was murdered in 1400, but some thirteen years later, Henry V, the son of the man who had supplanted Richard, had the poor body disinterred and buried honourably at Westminster. Richard and his queen lie together, but the effigies have been damaged and the linked hands are missing.

At the western end of the Shrine stands the Coronation Chair. This was made soon after 1297 when Edward I seized the Stone of Scone and brought it to the Abbey from Scotland. Tradition identifies the stone with the one on which Jacob rested his head at Bethel, and various interesting legends account for its transfer to Scotland. Edward had a magnificent oaken chair made with a compartment to hold it, and Master Walter of Durham painted it all over with birds and foliage and animals on a gilt ground. Lions were added for feet, probably in Tudor times. The Chair has never left the Abbey, save when it was carried across to Westminster Hall for the installation of Oliver Cromwell as Lord Protector, and during the Second World War when it was removed to Gloucester cathedral; the stone was buried in the Islip Chapel.

Just to the east of the Confessor's Shrine is the chantry chapel raised to hold the remains of Henry V (d.1422). It was designed by John of Thirske, who was in charge of the fabric of the Abbey at that time, and was completed some time after 1441. It consists of a platform, some 5 feet 9 inches high, on which rests a panelled Purbeck marble tomb-chest. On it lies an oaken effigy of the King, which originally had a silver head, but this disappeared in 1546, and it was not till 1971 that a new one was supplied, of humbler material but good workmanship. Above the tomb is a Chantry Chapel raised on a bridge, the piers and the sides of which are covered with carv-

ings of saints and of scenes from the monarch's life.

Henry's queen, Catherine of Valois, lies here, but the upper structure is not open to the public.

Around the Sanctuary and the Shrine runs an Ambulatory, and off it there are four large and three small chapels, four to the north and three to the south. At the western end of the north Ambulatory is the Islip Chapel. Abbot Islip lies here; it was he who completed the building of the nave, helped to plan and to build Henry VII's Chapel, and added the Jerusalem Chamber to the Abbot's House; his rebus (an eye within a slip or branch of a tree) appears in the carvings. The chapel is today dedicated to the use of members of the nursing profession. Beside it is the tiny chapel of Our Lady of the Pew, the walls of which still bear traces of the elaborate blue brocade pattern, adorned with white fleur-de-lys, with which they were once painted. Beyond are the larger Chapels of St. John the Baptist and St. Paul, which contain some remarkably fine tombs, of which the most impressive are perhaps those of Sir John and Lady Puckering, Sir Thomas Bromley, Giles, Baron Daubeny, and Frances Sidney, Countess of Sussex, who founded Sidney Sussex College. The dress of her effigy is painted vermilion and its feet rest on the quills of a porcupine, her family crest. Off the south Ambulatory lie the Chapels of St. Nicholas, St. Edmund, and St. Benedict, all of them thronged with monuments, each of which has its own particular interest. In St. Nicholas's Chapel, we should notice

especially the 24-foot high, painted, multicoloured marble monument to Mildred Cecil, Lord Burghley's second wife, and to Anne, Countess of Oxford, their daughter. Both ladies were learned, benevolent, and strong-minded; children and grand-children cluster about the effigies, and Lord Burghley himself wrote the Latin inscription which speaks of his grief for the loss of those who 'were dear to him beyond the whole race of womankind'. The centre of the chapel is occupied by the altar-tomb of Sir George Villiers and his wife, Mary, the parents of the Duke of Buckingham. The exceptionally fine white marble recumbent figures were the work of Nicholas Stone and cost £560. Next door, in St. Edmund's Chapel, Eleanor, Duchess of Gloucester (d.1399), lies under the finest brass in the Abbey. At the entrance to the Chapel is the tomb of John of Eltham, second son of Edward II, who died at the age of 19, but not before he had been regent of England three times over. His effigy is of alabaster, his shield bears the lions of England surrounded by the fleur-de-lys of France, and around the sides of the tomb there once stood 24 little weepers. Three of them are missing and several of the rest are mutilated, but those at the west end are intact; their appearance is far from dolorous, for their faces are jocund and their attitudes positively jaunty. Beside John of Eltham is a tiny tomb-chest containing the dust of his nephew and niece, William of Windsor and Blanche of the Tower, children of Edward III. The diminutive alabaster figures by John Orchard are of especial interest for they show what children wore in 1340. On the right-hand side of the entrance to the chapel is the tomb of William de Valence (d.1296). The tomb and the effigy are of exceptional interest for they were originally covered with Limoges champlevé enamelwork, of which substantial traces remain, the only example of this technique of adornment in England. Next door is St. Benedict's Chapel, where rest Gabriel Goodman (1529-1601), Dean of Westminster for forty years under Queen Elizabeth and friend of William Camden, whose expenses he defrayed in 'some of his journeys after antiquity', and Simon de Langham (d.1376) who rose from being Abbot of Westminster to being Lord Chancellor of England and Archbishop of Canterbury. So able was he that Pope Urban V made him a cardinal and summoned him to Rome, but he chose the Abbey as his resting-place and left his whole fortune towards the rebuilding of the nave. Under the arch between this chapel and that of St. Edmund is a small altar-tomb which holds the remains of Katherine, Henry III's five-year-old dumb daughter who died in 1257, four of his other children, and four small children of Edward I. Katherine was an exceptionally attractive child, and to express and assuage their grief her parents ordered an exquisite tomb, inlaid with marbles and mosaics and adorned with two figures, now lost, a brass one by Master Simon of Wells, and one of silver by William of Gloucester.

Turning eastwards up the south ambulatory to Henry VII's Chapel, we pass the tomb in which King Sebert's body is said to rest (see p. 95), and above it the thirteenth-century paintings on the backs of the sedilia. A little further on, attached to the back of Queen Philippa's tomb, is the Westminster Panel or Retable, part of Henry III's original altar furnishings, which, though worn and battered, is still worth careful study. It is a long panel (3 feet high by 11 feet long) divided into five compartments. That in the centre and those on the sides were painted with figures - we can still distinguish St. Peter with his key and Christ accompanied by the Virgin and St. John while the second and fourth compartments hold four representations of miracles, each little scene set in a curious distinctive frame shaped like an eightpointed star or a lozenge enclosed in a square, and similar to the blank panels on the plasterwork in St. Faith's chapel. We can distinguish the Raising of Jairus' Daughter, the Healing of the Blind Man, and the Feeding of the Five Thousand, but the other divisions are now blind. The backgrounds of the gesso panels were inlaid with glass and adorned with goldwork. Comparison with manuscript illuminations of the third quarter of the century (in particular Douce MS 180 in the Bodleian Library, Oxford), and a careful study of the serpentine lines of the draperies, the gentle melancholy of those faces which are still visible, and the extraordinarily long, thin, sinuous hands, suggest an English rather than a French origin for this masterpiece.

Henry VII's Chapel was begun on 23 January, 1502-3. The Chapel consists of a chancel and apse, around which radiate five small chapels, and two aisles, almost completely invisible from the chancel. It seems probable that the architect responsible was Robert Vertue, one of the King's three master masons, whose brother William vaulted St. George's Chapel at Windsor about 1505. Wonderful bronze gates, probably made by Thomas Ducheman, separate the Chapel from the main Abbey. They are divided into compartments, each of which is filled with badges relating to the royal house. Beyond, the incomparable vaulting draws its inspiration from the roof of the Divinity School at Oxford, which was completed about 1480. The aisles and the chapels are fan-vaulted, but the chancel has a groined vault from which are suspended huge fan-shaped pendants which in fact act as braces to the arches. Half-way up the walls, reaching up to where the ribs of the vault poise themselves for their airy leap, are the stalls, some of them still the original furnishings, others added in 1725 when the Chapel was first used for the installation of the Knights of the Bath, whose banners hang brightly above them, contrasting with the grey of the stonework. The stalls retain their misericords which are carved with scenes of robust humour. Above them, on a level with the triforium, runs a series of carvings of saints, the most perfect of its kind surviving in England, for 95 of the original 107 figures remain, almost all of them intact. Even the most ardent of Reformation iconoclasts did not dare to damage the Abbey church which, to this day, is a royal peculiar. Besides all the more popularly represented saints, there are a number of specifically English ones – St. Edward, St. Edmund, St. Thomas of Canterbury, St. Kenelm, St. Dunstan, St. Cuthbert, and St. Hugh of Lincoln, as well as some Breton worthies, St. Armagilus and St. Roche, who remind us that Henry VII spent much of his boyhood in that windswept countryside.

In the burial vault beneath the chancel lie Edward VI, at whose funeral the burial service of the Church of England was used for the first time for a monarch, and George II, the last sovereign to be entombed in the Abbey. The altar itself is modern, designed by Sir Walter Tapper in 1933-4, though it incorporates two pillars and a part of a frieze from the original altar by Torrigiani, and upon it hangs a painting of the Virgin and Child by Vivarini. Behind the altar stands the tomb of Henry VII and Elizabeth of York, his queen. He died in 1509 leaving instructions that he should be buried in a manner somewhat to our dignitie Roial, eviteng alwaies dampnable pompe and outeragious superfluities'. He had intended his tomb to be designed by Guido Mazzoni, known as Pagenino, who had worked for the King of France, but nothing came of the suggestion and Pietro Torrigiani was charged with the commission, which he completed about 1518 at a cost of £1,500. He had been a pupil of Ghirlandaio at the same time as Michelangelo and is perhaps best remembered for the brawl in which he broke his fellow-pupil's nose. The king's tomb is of black and white marble, with gilt-bronze effigies, angels, and enrichments, and is the harbinger of the arrival of Renaissance sculpture in England. The scheme - two effigies recumbent upon their tomb - is traditional enough, but the skill with which they are modelled, the lifelikeness of the rounded forms beneath their mantles, the delicacy of the hands and features, was of an excellence not seen before in England. The emphasis is essentially on the humanity, rather than on the sovereignty, of the couple who lie here, whose union brought peace to England after a generation spent in bitter civil war. The ornaments of the sarcophagus were of a new fashion, too: putti had replaced prim angels, enwreathed medallions showing pairs of saints decorated the sides in place of niches filled with weepers, while graceful, Italian spirits with grave faces, clad in floating golden draperies, perch on each corner. In contrast, the screen - almost as great an achievement within its own field - which encloses the wonderful tomb, is utterly English and wholly Perpendicular. Two tiers of elaborate openwork tracery are sustained by stalwart buttresses at the corners and provide, at intervals, niches for the saints. It was the work of Thomas Ducheman.

In the chapels around the apse there are several monuments of great interest. Beginning on the north

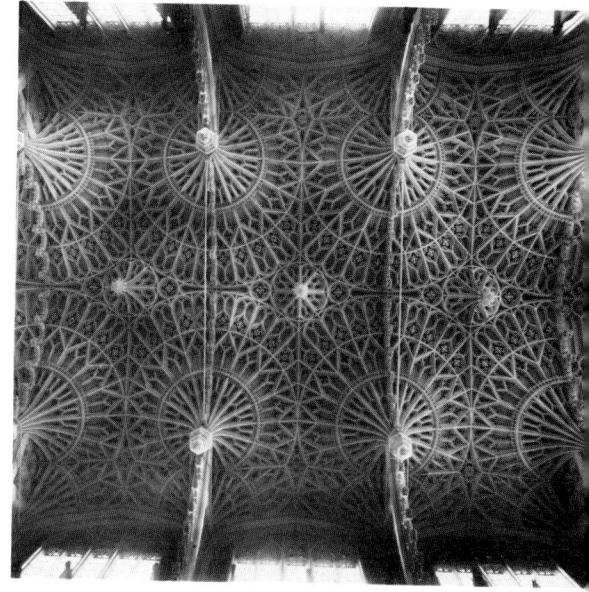

Ceiling of Henry VII's Chapel, Westminster Abbey

side, the first chapel is filled with the tomb of George Villiers, Duke of Buckingham, friend and favourite of James I and Charles I, who was murdered in 1628. The main figures and the mourners at each corner were by Le Sueur, the little figures of their children, of whom only one lived to become a man, were by Nicholas Stone. The Mars and Neptune who sorrow at the Duke's feet are especially good. In the northeastern chapel is the monument of John Sheffield, 1st Duke of Buckinghamshire (1648-1721), who married Catherine Sedley, the illegitimate but very regal daughter of James II, who built Buckingham House on the site where the Palace stands today in St. James's Park. The life-sized figure of the Duke is shown in Roman armour, the Duchess wears contemporary dress; these figures are by Scheemakers, the allegories around them are by Delvaux.

The easternmost chapel was the burial place of Oliver Cromwell, his family and some of his supporters but their bodies were disinterred at the Restoration and reburied in a common pit in St. Margaret's churchyard (see p. 113). In 1947 the chapel was dedicated to the memory of the men of the Royal Air Force who died in the Battle of Britain, and Viscount Trenchard, 'Father' of the R.A.F., and Lord Dowding, who controlled Fighter Command during the battle, are buried here. The glass of the east window was designed by Hugh Easton, the altar by Sir Albert Richardson, and the cross, candlesticks, and candelabra by J. Seymour Lindsay. The figures of St. George and King Arthur were carved by A. F. Hardiman, RA. In the south-eastern chapel lie Dean Stanley, author of Memorials of Westminster Abbey, and his wife, Lady Augusta, Queen Victoria's friend; Sir Edgar Boehm sculpted their memorial. In the

southernmost chapel is the tomb of Ludovic Stuart, Duke of Richmond and Lennox and cousin to James I (d.1624), who lies in the company of other members of his family. The huge monument almost fills and quite overwhelms the chapel; it was designed by Hubert Le Sueur and consists of a black and gilt sarcophagus with recumbent gilt effigies, shaded by a canopy borne by four larger than life-sized caryatids representing Faith, Hope, Charity, and Prudence. The canopy supports a gilt openwork dome on top of which is perched a figure of Fame, equipped with two trumpets. Such tombs were more common in France or the Netherlands than in this country.

In the north aisle of the Chapel, Henry VIII's two daughters, Mary and Elizabeth, share a tomb, though only Elizabeth has an effigy, which Maximilian Colt carved from white marble, giving to the stone the life and character of the queen's gaunt, aquiline profile. The memorial - a tomb-chest on which the effigy lies, shaded by a canopy supported by six black pillars - was finished by 1606 and cost a mere £765, far more economical than the resting places of some of her subjects, and considerably less than James I spent on his mother's memorial in the south aisle. At the end of the north aisle is 'Innocents' Corner' as Dean Stanley called it, where James I's daughters lie. Princess Sophia died in 1606 when she was only three days old; Maximilian Colt made an alabaster cradle from which a small chubby face peeps over the coverlet; he was paid £170. Her two-year-old sister Mary (d.1607) is shown, halfreclining, on a small tomb-chest, and against the wall beside them stands an urn, carved by Joshua Marshall, Charles II's master mason, about 1678 when the bodies of two children were found, buried under a staircase, in the Tower of London and, in all probability correctly, were held to be the murdered remains of Edward V and his younger brother.

The south aisle contains what is perhaps the most important piece of sculpture in the whole Abbey, Torrigiani's tomb for the Lady Margaret Beaufort, Countess of Richmond and Derby, Henry VII's mother, from whom he derived his claim to the throne. She died in 1509 and Torrigiani undertook to have the work finished by 1513, so this truly Renaissance sculpture probably antedates the king's own memorial. The design for the black tomb-chest with its gilded effigy is similar to the king's, the effigy is remarkably lifelike with refined features and tiny, wrinkled hands, the face expressing clearly the intellect, the asceticism, and the determination from which her character was compounded. The grille around the tomb was made by Cornelius Symondson in 1529; he was paid £25 for it by St. John's College, Cambridge, which the Lady Margaret had founded. It disappeared during the nineteenth century but was discovered and recognized in 1915 and, through the generosity of the National Art Collections Fund, was restored to its proper place. Near to the Lady Margaret lie Mary, Queen of Scots, and Margaret Douglas, Countess of Lennox. The Scottish Queen has a magnificent memorial designed and carved by William and Cornelius Cure between 1607 and 1612. The white marble effigy is dressed with extreme elegance, a crowned Scottish lion crouches at her feet, and the coffered vaulting of the canopy above her is studded with Scottish thistles. The Countess of Lennox was a lady of extraordinary beauty. She was the daughter of Margaret Tudor. Henry VIII's sister, by her second marriage with the Earl of Angus. She married Matthew Stuart, Earl of Lennox, in 1544 and became the mother of four sons and four daughters, who are shown kneeling on the sides of her tomb. The eldest was Henry, Lord Darnley, who became Mary Queen of Scots' second husband, so the Countess was mother-in-law to the Queen of Scotland and grandmother to James I and VI. The little figure of Lord Darnley has a crown above his head.

Re-entering the main body of the church, a door leads into the cloisters, which were built during the thirteenth and fourteenth centuries, the work beginning in the north-east corner about 1244. The vaulting overhead is simple and unadorned, the great windows, opening into the garth or central green, are of three and four lights with elaborate tracery. In the East and South Cloisters are long benches of stone on which the old men and children who were entitled to Maundy money sat to have their feet washed on the

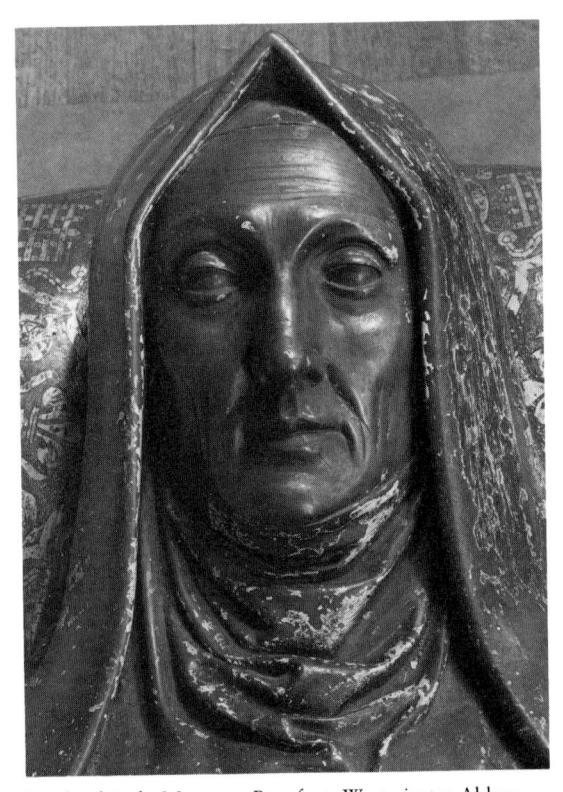

Tomb of Lady Margaret Beaufort, Westminster Abbey

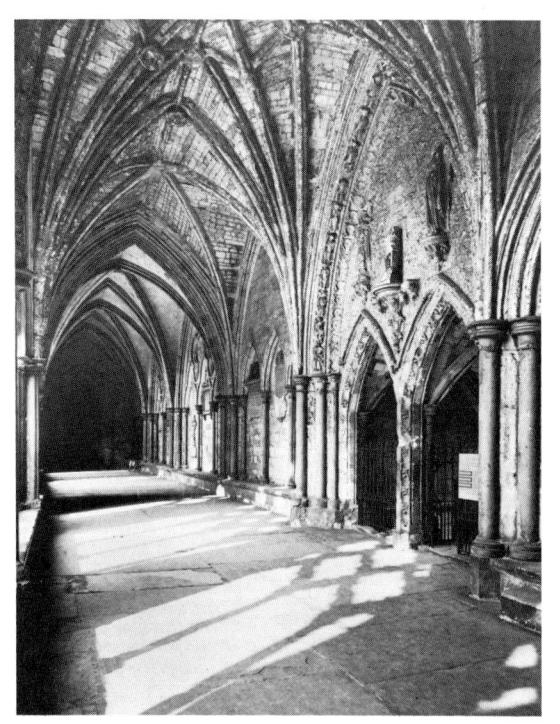

East Cloister, Westminster Abbey

Thursday in Holy Week, while the North Walk was used as the library and scriptorium, and the novices were taught in the West Walk. Around the walls are a great number of memorials, the most touching of them all being that to 'Jane Lister, deare child', who died in 1688; she was the daughter of Dr. Martin Lister, an eminent physician and zoologist.

From the East Cloister open the Chapter House, the staircase which leads up to the Library and Muniment Room, the Chapel of the Pyx, and the steps down to the Norman Undercroft which houses the Museum. All these are worth visiting, the Chapter House being of especial importance. It was built between 1245 and 1255, octagonal in shape with a central pillar and a diameter of 60 feet, probably by Master Alberic working under Henry of Reynes. There had been circular chapter-houses at Worcester, built rather earlier, about 1160, and at Beverley, and a polygonal one at Lincoln, and there were to be others, at Lichfield, at Wells, and at Salisbury, but the chapter-house at Westminster was, as Matthew Paris wrote, 'incomparable'. Its shape stressed the equality of the Abbey brethren in 'the work-shop of the Holy Spirit', as Abbot Ware wrote, but its great size was to enable it to be used for secular meetings. The Great Council assembled here in March 1257, and until 1547 it was used regularly for the meetings of the House of Commons. After the Reformation, when the Commons forsook it for St. Stephen's Chapel, it was used as a depository for state papers, and the

roof, which became ruinous, had to be rebuilt in 1740, but Sir Gilbert Scott restored it as carefully as he could in 1865, with considerable success. A double entry under a tall, blind arch around which run the generations of the Tree of Jesse, leads into it off the Cloister. The Purbeck marble shafts are adorned with carved sprays of foliage. The vestibule had, necessarily, to be low and dark since the monks' dormitory lay above it, but the dark passage only served to emphasize the lightness and spaciousness of the chapter-house itself. Huge four-light windows fill six of its sides; they are 39 feet high and each light is four-and-a-half feet broad, so the great chamber always seems radiant, even on a dull day. In the nineteenth century, the windows were filled with stained glass but this was shattered by bombing, and modern glass, designed by Joan Howson, now preserves their brilliance. Heraldic panels of those most closely associated with the building of the Abbey, have been inserted at intervals. On entering the Chapter House, it is necessary to don felt overshoes to protect the patterned tiles which cover the floor, the finest of its kind still left in England. They are decorated with shields, including one of the earliest surviving representations of the royal arms of England as well as an archer, a horseman, a king, a queen, a pilgrim, a bishop, and a rose window, and were clearly the work of an able artist who may have been Master William, a monk at Winchester, who was described as 'the King's beloved painter'. In the south-east corner, Henry III placed a triumphant inscription which can in part still just be discerned: 'Ut rosa flos florum, sic est domus ista domorum.' ('As the rose is the flower of flowers, so is this House the house of houses'.)

Around the walls of the Chapter House are a number of paintings which can be divided into four distinct groups, a Last Judgement on the east, scenes from the Apocalypse on the west, an Angel Choir winging its way above the heads of the arches, and animals and birds which occupy the spaces below the Apocalypse scenes. John of Northampton, a monk at Westminster from 1372 till 1404, gave the first two. and they were probably executed about 1400. The Last Judgement fills the whole eastern wall below the window and extends into the two bays on either side. while 85 scenes, probably based on the paintings in a manuscript now in the library of Trinity College, Cambridge (Ms. B 10, 2), can be distinguished in the Apocalyptic series. These works and the angel heads, which were probably executed at the same time, are sadly worn and were probably, even in their heyday, of a quality which should be described as forceful rather than exceptionally accomplished. The birds and the beasts were added towards the end of the century. They bear titles in English and one can distinguish an Ostrych, the Reynder, the Ro, the Wild Asse and the Tame Asse, the Dromedary, the Kamel, the Lyon, the Cokedryll (crocodile) and the Greyhound. Between each pair of beasts is a tree, 106 WESTMINSTER

with birds, which include a proud farmyard cock, perched among the branches. On the entrance wall of the Chapter House is a roundel with a *Christ in Majesty* commissioned by Sir Gilbert Scott, which is flanked by thirteenth-century figures of the Virgin and Archangel Gabriel. Two sculptors, Master John of St. Albans and William Yxewerth, are mentioned in the accounts of the period but we cannot be certain that they were responsible for the carvings. The figures are tall – over six feet high – and of an arresting beauty. Their elongated, graceful forms seem to sway backwards and in the spandrels of the arch are two smaller (3 feet 6 inches) angels who joyously swing censers.

Beyond the Chapter House is the entrance to the Library and Muniment Room, which lies above the South Transept. There are several finely carved

bosses in the vaulting here.

The Chapel of the Pyx was built soon after the Conquest as part of the early monastic buildings, and was used in the fourteenth century as the monastic treasury and to house the pyx or box containing the standard pieces of gold and silver which were tested once a year, as they still are in the Mint. Next door to it is the Undercroft, of a similar antiquity, which since 1908 has housed the Abbey Museum, where are displayed the wax effigies carried on top of the hearse at the funerals of royalty or the greater nobility. The earliest is that of Edward III, a fulllength wooden figure, the face probably carved from a death mask, since it shows a slight droop at the corner of the mouth which suggests the stroke from which he died. There is a complete figure for Catherine of Valois, Henry V's Queen, but only the heads of Anne of Bohemia, Henry VII, and Elizabeth of York, his Queen. They are certainly portraits - one has only to compare Anne's unmistakable long face with that of the effigy on her tomb. There are life-sized figures of Charles II dressed in his Garter robes, of William III, Queen Mary, and Queen Anne, of Catherine, Duchess of Buckingham, and Frances, Duchess of Richmond, of William Pitt, Earl of Chatham, which was made by an American lady, Mrs. Patience Wright, and is extraordinarily lifelike, and of Admiral Nelson. There is also one of Queen Elizabeth, remade in 1760 to replace an earlier figure which had decayed. The effigies are of particular importance to the student of costume.

Behind the Abbey, around Dean's Yard, lie the medieval monastic buildings which are still in use as **Westminster School**. There was of course a school for novices, and Henry VIII provided for two masters and 40 boys at the Reformation, but Queen

Elizabeth is regarded as the founder of the school as it is today.

The School Hall is out of sight, but was part of the monastic dormitory built between 1090 and 1100; the old walls have served generations of schoolboys very well. The Prior's Lodging was built in the fourteenth century and then, in the third quarter of the seventeenth, was refaced and much altered, probably by John Webb, Inigo Jones's assistant, and is now called Ashburnham House. The woodwork and plasterwork are sumptuous, and the well-hall and staircase with a lantern above are among the most satisfying interiors in London. Plans for the school dormitory, which can hardly be seen from the Yard since it looks onto the garden, were prepared by a famous pupil, Sir Christopher Wren, though the designs executed, in 1722–30, were by Lord Burlington.

The Abbey garden, usually open to the public on Thursdays, is probably the oldest continually cultivated garden in England. Occasionally, it is possible to see the Jerusalem Chamber, which was built in the late fourteenth century. Henry IV, who was stricken down as he prayed at St. Edward's Shrine on the eve of his departure on an expedition to the Holy Land in 1413, was carried into this chamber for his greater comfort; when he became conscious again, he asked where he was and on being told the name of the chamber, knew that he would die there for it had been prophesied that he would end his days in Jerusalem. The Chamber has been used by those engaged upon the Authorized Version of the Bible, in 1611, on the Revised Version of 1885, and on the New English Bible in 1961. There is some thirteenthcentury glass in the windows and around its walls hang five portions from two large tapestries designed by Bernard van Orley and executed at Brussels by W. Pannemaker in about 1540-50. The carved cedarwood overmantel was installed by the Dean when he entertained the French Ambassador at a banquet to celebrate the betrothal of the Prince of Wales, later Charles I, to Princess Henrietta Maria in 1624.

During recent years, the atmosphere of the Abbey has altered greatly. Cost of maintenance has risen, and troops of tourists in their thousands wander to and fro around the barriers set up to channel their explorations. For a good part of the day, the emphatic patter of the guides, shepherding small groups from one monument to another, has replaced the sound of prayer, and it is more important than ever for the serious student to attend a religious service, for then the great building, which can fairly claim to be the most important and to have the loveliest interior in all England, comes into its own.
Westminster

The City of Westminster covers an area of 5,334 acres and houses a population of 191,000. Since 1965, Marylebone and Paddington have been joined to it, so that Westminster now stretches from Hampstead in the north to the Thames in the south, and from Kensington in the west to the City of London in the east. But the name Westminster immediately suggests that small enclave, 'within the sound of the division bell', that centres around the Houses of Parliament and the Abbey, and which is filled with large government offices and small houses, many of them dating from the eighteenth century, and all much sought after by Members of Parliament.

On the night of 16 October 1834, a fire almost completely destroyed the ancient Palace of Westminster. Edward the Confessor had moved his court there from the City in the middle of the eleventh century, thereby creating a most significant and far-reaching separation of the royal power from that of the mercantile community. To the Confessor's palace, William Rufus added the noblest Great Hall in Europe, while Magna Carta fixed Westminster as the permanent seat of the Court of Common Pleas. Later, Henry III unwillingly welcomed to that same Hall the Great Parliament of 1265. Henry VIII abandoned the old palace for Whitehall (see p. 114) and thereafter Westminster was used more and more by the civil service, while the Commons, who had no fixed meeting-place, took over St. Stephen's Chapel for their assemblies. In the space of that single October night, almost the whole building vanished, along with Sir John Soane's scarcely completed, magnificent Scala Regia. All that remained of the palace was the Great Hall, the thirteenth-century undercroft of the chapel with the sixteenth-century cloister adjoining it, and the Jewel Tower, which stood detached from the main building.

Grief at the magnitude of the disaster was matched by excitement at the incomparable opportunity given to the architects of the day. A competition was announced, specifying that the new building must be in the Gothic or the Elizabethan style; 97 entries were received and (Sir) Charles Barry was declared the winner. Although he had already built four churches outside London in the Gothic manner, Barry had a preference for the Italian style in which he had, most successfully, designed the Travellers' Club in Pall Mall and the Royal Institution of Fine Arts in Manchester (now the City Art Gallery). He planned his Houses of Parliament with a late Perpendicular or Early Tudor façade and supported his designs with a set of detailed drawings executed by Augustus Welby Northmore Pugin, son of Augustus Charles Pugin, the draughtsman, teacher, and international authority on Gothic ornament. The resulting building, which was not completed until 1860, by which time Pugin was dead and Barry was dying, was the outcome of the exceptionally happy collaboration of two most dissimilar talents. Although their sons bickered in public about where the credit should lie, each of the architects acknowledged the other's abilities. Pugin could never have produced Barry's orderly, controlled plan, its regularity spiced by the unexpectedness of the Victoria Tower and of the Clock Tower which houses Big Ben, nor could he have endured the wearisome committees, the frequent alterations, and the almost constant criticisms which Barry faced with robust good humour. The older man admitted that he lacked Pugin's constant flow of inventive originality and he called his young assistant his 'comet'.

Before the foundation stone was laid in 1840, Queen Victoria had come to the throne and had married Prince Albert. The Prince wanted to see the walls of the new building covered with paintings depicting the nobler moments in British history and literature, as an inspiration to the members working among such scenes. His admiration for the Middle Ages persuaded him that fresco was the most desirable technique, and Peter von Cornelius, the leading German exponent of the method, came to England to give advice. Competitions were held, entries exhibited, and prizes won; Daniel Maclise, George Frederic Watts, Charles West Cope, H. H. Horsley, Edward Armitage, and William Dyce proceeded to execute their designs upon the walls of the new palace.

Barry and Pugin were well served by the artists, craftsmen, and contractors whom they recruited. Particular emphasis was laid upon sculpture. Lifesized figures adorned the façade and were dispersed

108 WESTMINSTER

throughout the interior, besides carved coats of arms and other decorations. John Thomas, who had already worked for three years with Barry, executing the wood and stone carvings for Birmingham Grammar School, was in charge. Individual works were carved by a team of sculptors, including Henry Hugh Armstead, John Lawlor, John Birnie Phillip, Alexander Ritchies, Robert Jackson, and Alexander Munro, but the supervision and much of the work were Thomas's. Most of the metalwork and much of the stained glass came from John Hardman of Birmingham. The main contractors for the building were Messrs. Grissell and Peto; after Peto's death, Grissell carried on the work alone. A visit reveals the clearcut discipline of Barry's design, with the principal apartments disposed along a north-south spine, leading easily and naturally into each other.

The public enters from Old Palace Yard, up the Royal Staircase which leads to the Norman Porch, every inch of its surface, walls, vaults, and pillars, densely decorated or carved from Pugin's designs. Beyond is the Queen's Robing Room, on its walls five frescoes by William Dyce, illustrating stories from the Arthurian legends chosen to symbolize the virtues of hospitality, mercy, religion, generosity, and courtesy. The fireplace is one of Pugin's more elaborate designs, and there is a chair of state with a fine embroidered backcloth worked in 1856.

Beyond the Robing Room is the Royal Gallery, designed to provide a processional way for the monarch at state openings. Not an inch of the whole surface of the 110-feet-long room is left undecorated - the panelling is carved, the stonework around the windows painted, patterned, encaustic tiles make a maze of the floor, the main roof-beams are carved, while bosses and other decorations fill the compartments between them, and statues by J. B. Philip stand sentinel beside the doors. The centres of the long walls are filled by two huge waterglass frescoes by Daniel Maclise, representing The Death of Nelson and The Meeting of Wellington and Blücher.1 The technique by which they are painted - water-colour on a dry wall composed of mortar, sand, and lime, sprayed after completion with liquid silica – gives the frescoes a pale, pearly, slightly unearthly quality. The compositions are clear and there is plenty of narrative detail. At the far end of the Gallery is a small room, the Prince's Chamber, which contains portraits of Henry VIII and his six wives by Frederick Crace. Below them are bronze bas-reliefs representing important events in Tudor history. The fireplace, ornamented all over and bedizened with coats of arms, is by Pugin, and there is a charming marble statue by John Gibson of the young Victoria.

Beyond is the House of Lords, on which Pugin lavished his utmost ingenuity. The metalwork of the throne, with its canopy, the railings, and the candelabra give a dazzling effect; they are all of brass, wrought by the men operating the machines in John Hardman's factory, and so ornamented that every inch of the surface refracts the light filtering in through the stained-glass windows. The crimson upholstery of the Woolsack and other seating gives a warmth and vibrance to Pugin's usually sombre, predominantly brown, colour-scheme. On the end walls are six large frescoes by Dyce, Cope, Horsley. and Maclise, representing scenes from British history. Around the upper walls are 18 bronze statues of the barons who forced King John to sign Magna Carta. The coffered roof over all has intricate patterns in each compartment.

WESTMINSTER AND WHITEHALL

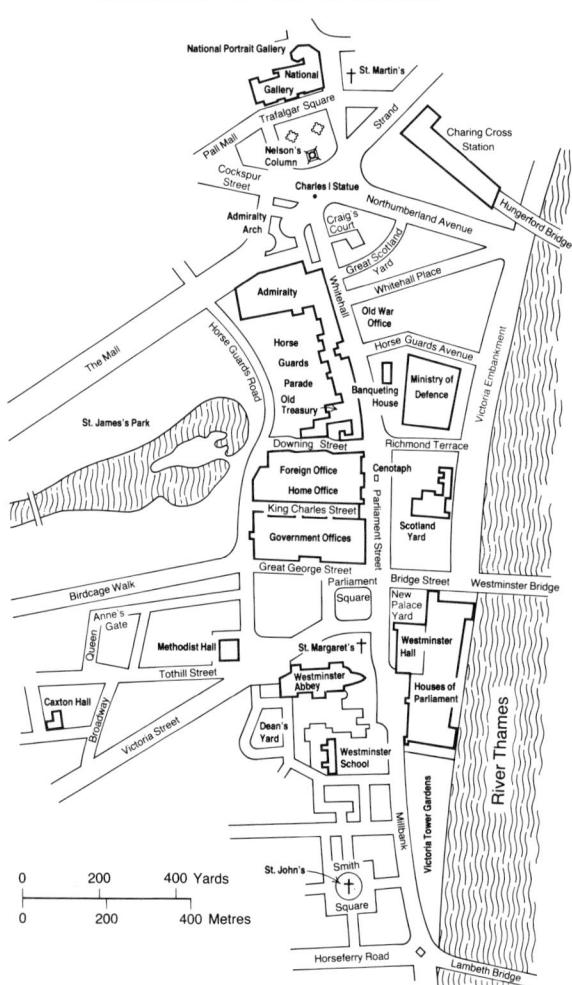

¹ In 1924, it was suggested that the gaps in the walls should be filled with five paintings by (Sir) Frank Brangwyn, representing the products of the British Empire. The completed works were, unfortunately, rejected and are now in the Guildhall at Swansea; their strong colours and massed forms would have looked well beside Maclise's works.

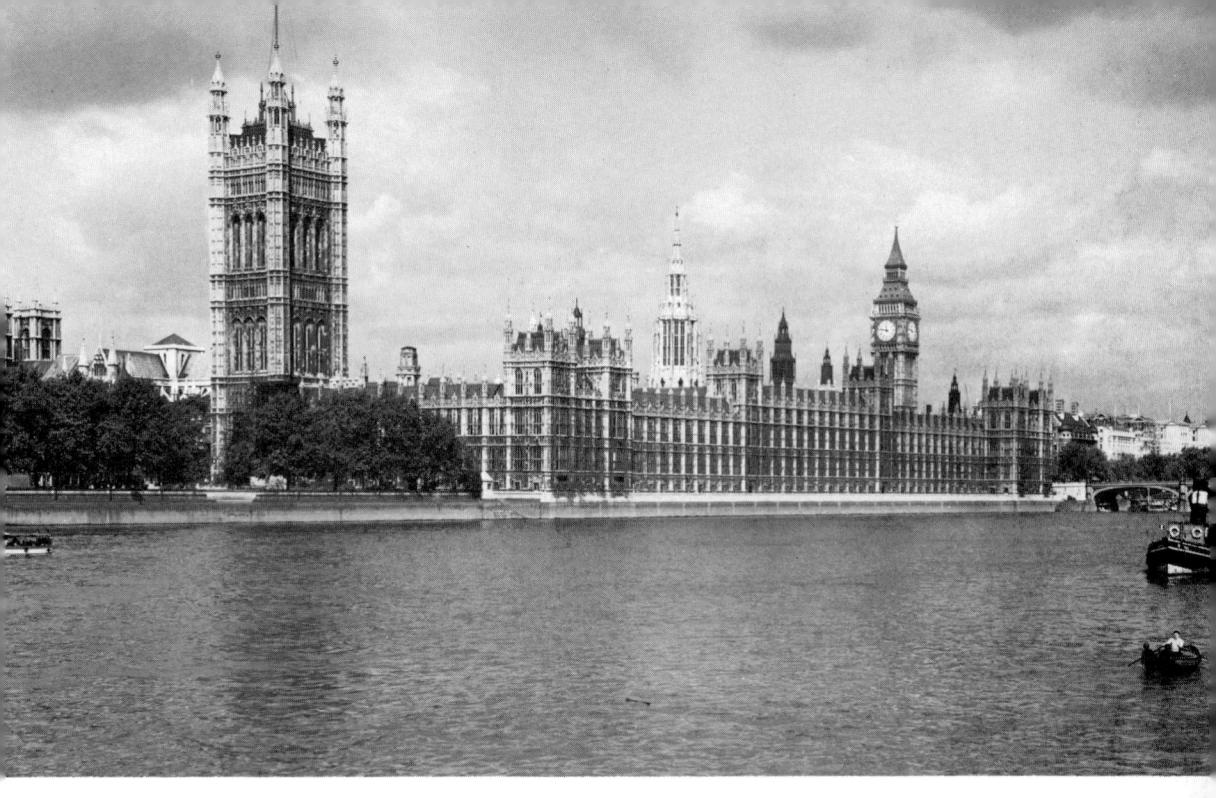

Houses of Parliament, Westminster

Beyond the Chamber is the Peers' Lobby, its floor patterned with Minton tiles and its doors of solid brass, with the Peers' Corridor beyond, its walls covered with good, straightforward, narrative paintings by Cope, reproductions of which have enlivened many school-rooms. This leads to the octagonal Central Lobby, where the public may await their Members of Parliament. In each wall is a door or window; above them are mosaics, by Anning Bell and Poynter, of the patron saints of England, Scotland, Wales, and Ireland. The roof rises high, Tudor roses filling the compartments of the lierne vaulting; invisible from within, the central flèche soars up above the vault towards the sky. The archway into the House of Commons was rebuilt after the war with stones damaged when the Commons' Chamber was bombed. It is today known as the Churchill Arch and beside it stands a statue by Oscar Nemon of Sir Winston. On the other side of the doorway is another of Lloyd George by Uli Nimptsch.

On the far side of the Lobby, the same logical sequence of rooms prevails as did on the Peers' side. The Corridor, with frescoes by E. M. Ward, leads to the Lobby and this opens into the House of Commons. The Lobby and the Chamber were destroyed by bombs on 10 May 1941 and were rebuilt, more or less to Barry's plans, by Sir Giles Gilbert Scott. The Chamber reopened on 26 October 1950. Unfortunately, 'no attempt [was] made to follow the design of the old woodwork and stonework.' The smooth, rebuilt Chamber instantly emphasizes the import-

ance and achievement of Pugin's restless intensity of decoration. The effect of the House of Lords *is* overwhelming, but it can be returned to again and again and some fresh detail found to be admired; by comparison the House of Commons looks pinched, starved, and lifeless. The loss and the antiseptic rebuilding bring home to the spectator what Barry and Pugin accomplished.

To the west of the Central Lobby is St. Stephen's Hall. Here Barry deliberately reconstructed, as far as he was able, the chapel which had stood on the site since 1348 and which had served as the chamber of the House of Commons since 1550. It was here that Charles I attempted to arrest the Five Members, that Cromwell dismissed the Rump Parliament, and that Pitt, Burke, and Fox made their orations. In spite of the retention of the original proportion and in spite of the vaulting, the Hall refuses to seem medieval and remains Victorian. This is due largely to the tiling of the floor and to the statues, provided by Thomas's team of sculptors, which crowd the door jambs. Around the walls are a number of free-standing marble figures of great politicians, commissioned during the latter part of the century. The walls are covered with frescoes, painted from 1927 onwards, with The Building of Britain as their theme. Eight artists - V. Forbes, A. K. Lawrence, Sir William Rothenstein, Sir Thomas Monnington, Sir George Clausen, C. Sims, G. Philpot, and C. Gill - worked on them with delicate, almost pastel, palettes.

From the Hall, through St. Stephen's Porch, is

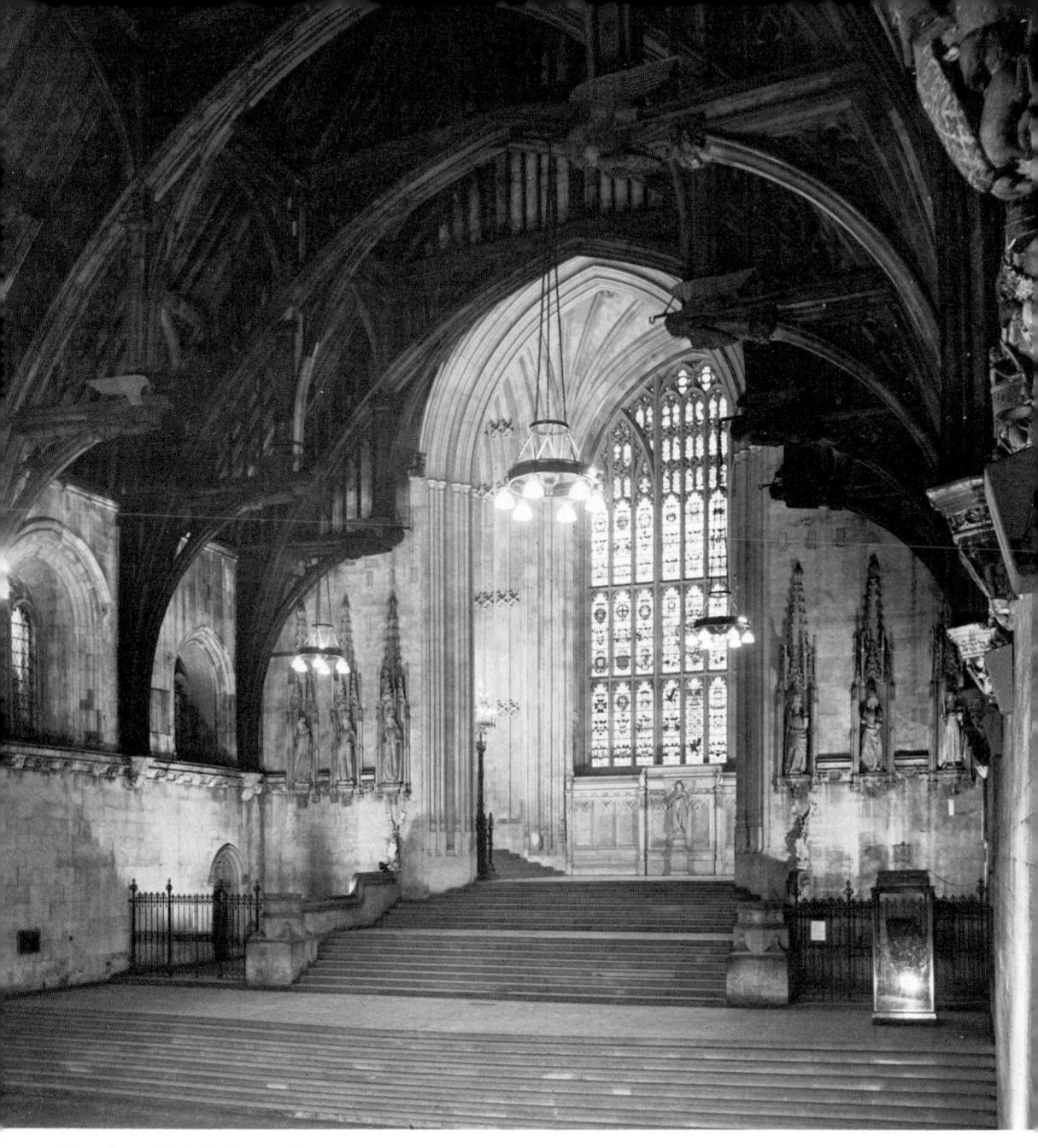

Westminster Hall, Parliament Street

Westminster Hall. All the noise of the present day is hushed and the centuries seem to slide backwards. This was the Great Hall of the Kings of England. 240 feet long, it was probably the largest in Europe. The Conqueror's son, William Rufus, built it, between 1097 and 1099, boasting that it should be but as a bed-chamber compared with what he would add to it: the arrow in the New Forest annulled his plans. The misalignment of the stone piers suggests that the Hall may have been built around an even earlier Saxon timber hall, the existence of which would have

made accurate measurements difficult. To the hall, almost three centuries later, Richard II gave a new roof. Originally, the roof rested on two lines of supporting pillars, giving the effect of a nave and side aisles. The new work was undertaken between 1394 and 1401 by Henry Yevele, the king's master mason, and Hugh Herland, his master carpenter. The walls were raised and a hammerbeam roof, covering the whole 68 feet in a single span, was built. The roof weighs 660 tons; the stone buttresses needed to contain the thrust are visible on the west side.

The work was still incomplete when Richard was forced to surrender his crown to his cousin, Bolingbroke, afterwards Henry IV. It was in this hall that the royal courts of justice met, their furniture being dismantled for such occasions as a coronation banquet or a state trial. Here were tried, and condemned, Sir William Wallace, the Scottish patriot, on 23 August 1305, Sir Thomas More and John Fisher. Bishop of Rochester, in 1535, Guy Fawkes in 1606, King Charles I himself in 1649, and the Scottish lords who supported that unfortunate monarch's grandson and great-grandson in 1715 and 1745. Warren Hastings, who had been accused of oppression and corruption in his governance in India, was tried here and acquitted, but the proceedings had lasted from 1788 to 1795 and the strain of them broke his health.

The fire of 1834 left the hall virtually unscathed. Barry set back the great south window and inserted a dramatic dais, approached by three flights of eight broad, shallow steps apiece. Along the wall containing the dais are set six larger than life-sized statues of kings of England, and five more larger figures stand between the windows. They were part of a set of 15 statues commissioned in 1385, representing the kings of England from Edward the Confessor to Richard II - the first and the last sovereigns were probably represented twice over. Another of the set stands in Trinity Square, Southwark, and two more have recently been found in Bayon's Manor in Lincolnshire. Coming from English workshops, they are fine productions, though native skills lay far behind those of French craftsmen at that time. Air-raid damage in 1941 and a fire-bomb in 1974 caused damage to the roof, but it has been repaired. Today, the vast, shadowy, empty hall is used for such sombre occasions as the lying-in-state of members of the royal family or others deserving special honour.

From the Great Hall, it is possible to descend to the crypt of St. Stephen's Chapel, known as St. Mary Undercroft. This was completed soon after 1300 and has what is almost certainly the earliest lierne vault ever to be built. Unfortunately, it was all so thoroughly redecorated in the nineteenth century that its antiquity is disguised almost beyond recognition. Beyond it are the Cloisters, built between 1526 and 1529, but these are not open to the public.

The calm majesty of the river front, its emphasis on the horizontal, repeating the line of the water below, must be viewed from the South Bank, since the Terrace is open only to Members and their guests. From the far side of the river, it is possible to appreciate the asymmetrical emphasis to the north and south of the Victoria Tower and the Clock Tower, both square and heavy, so that the central flèche seems delicate as lace by comparison.

On the north bank, the tracery, which covers the whole façade, may be seen. Barry, influenced by economic considerations, had planned a far plainer façade, but Pugin, inspired by the exterior of Henry VII's chapel on the far side of Old Palace Yard,

Old Palace Yard, Westminster

proposed otherwise. It is the constant interplay of window and buttress, topped with crocketted pinnacles, the whole surface given vivacity by the tracery which covers it, which holds the eye and the imagination of the spectator. 77 statues of kings and queens, from the Heptarchy to the Conquest, came from John Thomas's workshops to adorn the north and south fronts. In front of Westminster Hall stands an impressive bronze figure of Oliver Cromwell by Hamo Thornycroft, unveiled in 1899, while in Old Palace Yard is a bronze equestrian statue of Richard I by Carlo Marochetti, who came from Piedmont at the time of the 1848 troubles, was befriended by the Prince Consort, and became an Academician. Opinions vary as to its quality, but it is a London landmark.

To many people, the most important feature of the House of Parliament is the clock tower, familiarly known as Big Ben. Properly speaking, that name should be applied only to the bell hanging within the tower, though whether the name was given in compliment to Sir Benjamin Hall, the first Commissioner of Works, or to Benjamin Caunt, the boxer, who in 1857 at the age of 42 lasted 60 rounds in a drawn fight against Nathaniel Langham, is uncertain. The clock was designed by E. B. Denison, later Baron Grimthorpe, and E. J. Dent. The great 16-ton bell, cast originally at Norton, near Stockton-on-Tees, and then recast by George Mears of the Whitechapel Bell Foundry, was winched into position in October 1858 and has hung there ever since. There are four other bells beside Big Ben and their chime is said to be based on a phrase from the aria I know that my Redeemer Liveth in Handel's Messiah; Vaughan Williams, in his London Symphony, and Eric Coates, in his London Suite, both echo their chimes. The Victoria Tower, at the opposite end of the building to Big Ben, houses the records of Parliament.

The Houses of Parliament are among the most important administrative buildings in London; they can also claim to be among the most significant 112 WESTMINSTER

architecturally. Barry's uncluttered, logical planning looks backward to the eighteenth century, the restless intensity of Pugin's decoration looks forward to the developments of the later nineteenth and earlier twentieth centuries. The architects, artists, and sculptors of that generation were given a unique opportunity and fulfilled it heroically. The principal English institution was given a purpose-built palace, so adorned by native artists that the decorations added up to a 'monumental history of England'.

Across Abingdon St. stands the Jewel Tower, built between 1365 and 1366 to house Edward III's personal valuables and his magnificent wardrobe. The architect was almost certainly Henry Yevele; the three-storey tower is built of Kentish ragstone with a large and a small room on each floor. The ceilings are vaulted with well carved roof-bosses in the main room on the ground floor. Around the little building runs a moat, which served originally both as a defence and as a fish-pond. From 1621 till 1864, the tower was used to store Parliamentary records and when these were moved to the Victoria Tower, it accommodated the Weights and Measures Office till 1938, so the old building gave active service for five and three-quarters centuries. Since the Second World War, during which it was partly damaged, it has been opened daily to the public as an historic monument.

Near it stands Sir William Reid Dick's lifeless stone memorial statue of George V, the folds of his mantle so sylized that from some angles the work has an abstract quality. Nearby is Henry Moore's work, Knife Edge, and opposite, in the gardens beyond the Victoria Tower, are A. G. Walker's statue of the indomitable Mrs. Pankhurst and a bronze replica of Rodin's famous group, The Burghers of Calais. In Parliament Square, laid out by Barry on the site of more humble properties in order to give the new Houses of Parliament a worthier environment, are a number of nineteenth-century statues of statesmen, including Lord Palmerston (1878 by T. Woolner); Lord Derby (1874 by Matthew Noble); Disraeli (1883 by Nicolas Raggi), and Peel (1876 by Noble). To them, the twentieth century has added Epstein's restless figure of Field-Marshal Smuts and Ivor Roberts-Jones' truculent statue of Churchill. On the perimeter of the square stand Canning (1832, Westmacott) and Abraham Lincoln, the statue copied from that by St. Gauden in Chicago. The square was one of the first to be used as a traffic roundabout.

The church particularly associated with the Commons is St. Margaret's, Westminster. The relationship began on Palm Sunday, 17 April 1614, when the Commons attended Holy Communion there instead of in the Abbey for 'fears of copes and wafer-cakes, and others such important reasons'. The foundation of the church probably dates from the early twelfth century, though the present building was begun in the late fifteenth to plans by the Abbey's own master-mason, Robert Stowell. The chancel and tower were added early in the sixteenth

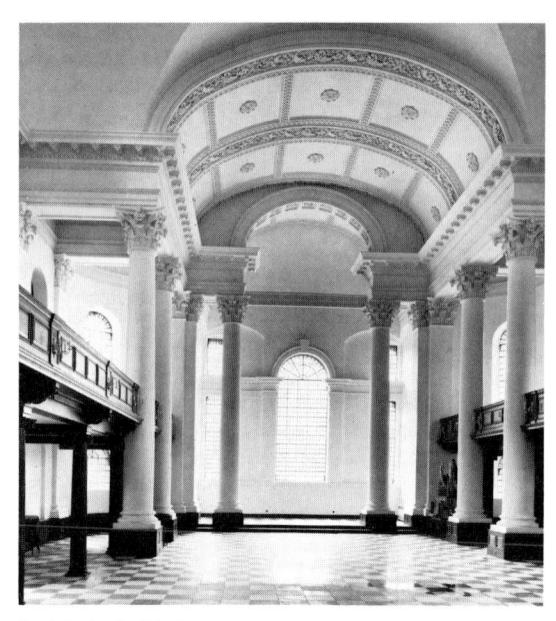

St. John's, Smith Square

by John Islip, the last great abbot of Westminster, with Thomas and Henry Redman as his architects, though the upper parts of the tower were rebuilt between 1735 and 1737 by John James, and a porch was added by J. Loughborough Pearson in the late nineteenth century. Dwarfed but not overwhelmed by its neighbours, the Abbey and the Palace of Westminster, St. Margaret's sits secure in its own right, a small, neat, Perpendicular, house of worship, essentially still a parish church.

St. Margaret's special significance lies in the glass of its east window and in the variety and quality of its funeral monuments. The window was made in Flanders to celebrate the marriage of Prince Arthur, Henry VII's eldest son, to Princess Katharine of Aragon. Before the end of five months, the young bridegroom was dead; his bride remained in England, to become Henry VIII's first queen. The window, which may have been intended for Westminster Abbey, arrived too late; it was sent to Waltham Abbey and, after the Reformation, passed through various private hands till, in 1758, it was purchased by the House of Commons for 400 guineas and was installed in St. Margaret's. The three centre lights are filled with an elaborate scene of the Crucifixion, the three crosses rising starkly against a wonderfully blue sky above the throng which jostles below. In the two outer lights, Arthur and Katharine, forever young and serene, kneel below St. George and St. Katharine - a memorial to a might-have-been of English history. In the tiny compartments between the tracery, a heavenly orchestra rejoices. Below the window is a remarkable reredos, carved in limewood in 1753 by Siffrin Alken. The centrepiece is based on Titian's

painting, *The Supper at Emmaus*, and it is flanked on either side with panels containing small figures of saints.

William Caxton, the printer, was buried here in 1491, though there is no sign now of his tomb. Sir Walter Raleigh's headless body was interred beneath the high altar after his execution in Old Palace Yard; his portrait is enshrined in the nineteenth-century west window. A quantity of small memorials line the walls, the two most fascinating to people who served at the Tudor court in practical hard-working capacities. Cornelius Van Dun, an 'honest and vertuous' Dutchman who held the posts of 'yeaman of the gard and user to K. Henry, K. Edward, Q. Mary and Q. Elizabeth', died in 1577 aged 94, having built two almshouses for poor widows. On the west wall kneels a small effigy of Blanche Parry, her hands clasped, her resolute, rugged old face upturned in prayer. She had served Elizabeth since the Queen's childhood, first as personal maid and later as keeper of the royal jewels - no mean responsibility when one considers the Queen's love of personal adornment. Another of Elizabeth's attendants to lie in this church was Lady Dorothy Stafford, who served the Queen for forty years, dying soon after her mistress in 1605; she is shown kneeling on her monument with her three sons and her three daughters. Lady

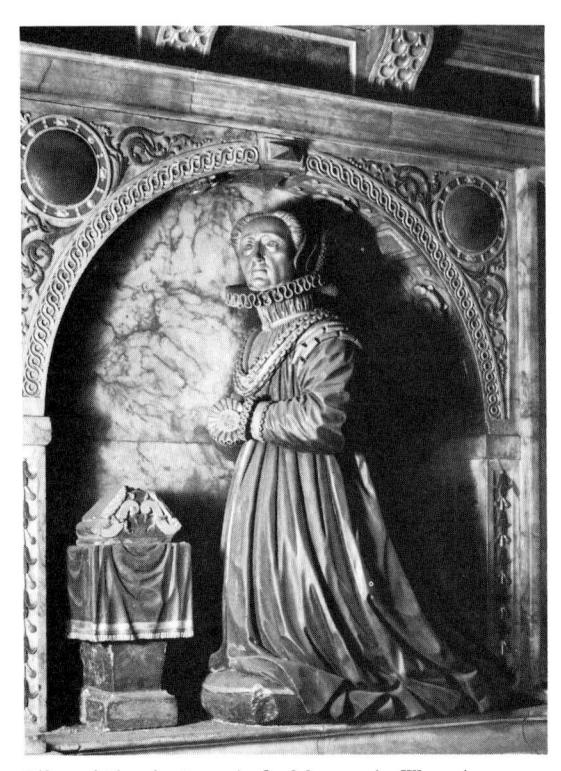

Effigy of Blanche Parry in St. Margaret's, Westminster

Mary Dudley, sister to Lord Howard of Effingham, who commanded the British fleet against the Armada, has a fine, full-length effigy, and beside the altar steps kneels a figure of one of her husbands, Richard Montpesson. A brass plate shows Thomas Cole, who died in 1597, kneeling with all his family; the inscription is too long to be quoted. Robert Stewart, who died in 1714, has a monument designed by James Gibbs, and Sir Peter Parker (d.1814) has an allegory sculpted by C. Prosperi.

In the churchyard lie the bodies of Admiral Robert Blake, John Pym, Cromwell's mother and daughter, and 19 others who had held office during the Commonwealth period. When the Restoration came, they were haled from their tombs in the Abbev and were flung into a pit in St Margaret's churchyard. It was in this church that the banns were called for Milton's second marriage to Katherine Woodcock, and it was here, a bare 15 months later, that first she and then their six-week-old daughter were interred. During the last century, a stained-glass window was set up to the poet's memory. Another poet, Alexander Pope, wrote an excellent epitaph for a parishioner, Elizabeth Corbett, who died in 1724. The modern stained-glass in the south windows was designed in 1967 by John Piper, who was responsible for the glass in Coventry Cathedral; here he has used soft tones of grey and green with a wonderfully tranquil effect.

South of the church, on Millbank, is the headquarters of Imperial Chemical Industries. The stonefaced building was designed by Sir F. Baines in 1928 and was given astonishing metal doors with panels in high relief, representing man and his relationship with science and industry. They were the work of W. B. Fagan, and, at the same time of their making, were held to rival Ghiberti's work on the Baptistery doors in Florence. Behind the main thoroughfare lie a number of streets of small, neat, early eighteenthcentury houses, well maintained and much prized by Members of Parliament because of their proximity to the House of Commons. They centre around Smith Square (Sir James Smith was the landowner and developer) in which stands St. John's church, designed by Thomas Archer, and built between 1713 and 1728. Pevsner describes it as 'the boldest manifestation of an English Baroque in Inner London', though Charles Dickens had considered it to be 'a very hideous church' (Our Mutual Friend, book II, chapter I). It stands four-square, each corner marked by a tower with a lantern, enormous Tuscan columns flanking the entrances; the interior is laid out as a Greek cross. The church was burnt out during the war but, between 1964 and 1969, after innumerable plans for its use had been proposed and then discarded, it was restored by Marshall Sisson and is today used as a music centre; its acoustics are such that sounds produced within its walls have an exceptional purity.

Whitehall and Trafalgar Square

The gentle curve of Whitehall and its continuation, Parliament Street, links Westminster Abbey and the Houses of Parliament with Trafalgar Square¹. The thoroughfare is broad and on either side stand a medley of administrative buildings and government offices, providing an epitome of official architecture from the sixteenth to the twentieth centuries.

The greater part of the area was originally church land, belonging first to Westminster Abbey and then, from 1240, to the see of York. Here the archbishop built his London residence, York Place. When Wolsey became primate in 1514, he began to rebuild magnificently, but when he lost the King's favour in 1529, Henry VIII confiscated the palace and moved into it himself, abandoning the medieval buildings at Westminster to Parliament, the lawyers, and his civil service. York Place was renamed Whitehall and served as the chief royal residence in the capital until it was almost completely destroyed by fire in 1698, when a laundry maid set clothes to dry around an open hearth and herself perished in the flames along with the Tudor buildings.

It was in this palace that Henry VIII died, Mary I received the submission of her subjects after Wyatt's rebellion, and Elizabeth I held her court. Of it, five relics still exist as a reminder. Two of them are immediately accessible, the first a large stretch of Tudor wall, uncovered in 1960–4 and now incorporated into the south side of the Treasury building (see p. 116) where it is easily visible from Downing Street, and the second a terrace with landing-steps, designed for Mary II by Sir Christopher Wren. It now lies on the river side of the Ministry of Defence buildings and shows how much the embankment has narrowed the Thames.

Under the Ministry of Defence building, Henry VIII's wine-cellar lies intact. It survived the fire of 1698 and remained in Whitehall till a new Ministry of Defence was built in 1946. Then it was found that the brick vaulted chamber, 70 feet long and 30 feet broad, impeded the site, but for once expediency was ignored and, with imagination and engineering skill, at a cost of £100,000, the cellar was encased in

concrete, shifted onto a platform of girders, and winched, a quarter of an inch at a time, till it was clear of its original position. Then its own site was excavated to a depth of 20 feet, the cellar was winched back again into the chasm, and the Ministry was built on top of it. The platforms for the wine barrels are still in position and the vaulting springs from four octagonal piers down the centre of the chamber.

A fourth relic of the Tudor palace is to be found in the National Portrait Gallery - the life-sized cartoon drawing by Hans Holbein of Henry VIII. It was a preliminary study for a huge fresco which adorned the walls of the Privy Chamber and was painted by Holbein, the King's Painter, during 1537. The fresco was burnt with the rest of the palace, but the whole design is known from two copies painted by Remigius van Leemput on the orders of Charles II. and now at Hampton Court. The completed work showed Henry VIII with Queen Jane Seymour, the mother of his son Edward VI, and Henry VII with his Queen, Elizabeth of York, standing behind them. It was the marriage of Henry VIII's parents that had united the warring houses of Lancaster and York and had brought an end to the civil strife which had wracked England for 30 years between 1455 and 1485. The cartoon, for the left-hand half of the painting, shows us Henry VII wearing a long furred robe, his expression at once wistful and shrewd, while to his right in the foreground, the figure of Henry VIII rears up, broad-shouldered, feet apart, opulently dressed, superbly proud, knowing himself to be King of England, ruler of both church and state. The frieze of mermen and maids, supporting cartouches on which the initials H and J, for Henry and Jane, are entwined, and the shell decoration of the alcove, all indicate the extent to which the influence of the Renaissance had suddenly reached Britain.

It was not until 80 years later, when a new Banqueting House was built in Whitehall, that the capital received its first classical building (see also under Greenwich, p. 362). The architect was Inigo Jones, the son of a London cloth-worker, born in St. Benet's parish on 15 July 1573. After early travels and studies in Italy, he designed in 1605 his first setting for one of Ben Jonson's court masques; by 1615 he was Surveyor of the Royal Works, and in June 1619 he began work on the Banqueting House.

The hall was a landmark in the history of English architecture; its story sums up the whole history of the Stuart dynasty. It is our final relic of Whitehall Palace.

Externally, the building consists of an undercroft with two storeys, seven bays wide, above. Originally, it was encased in Oxford and Northamptonshire stone, with a Portland stone balustrade round the roof, and it must have risen like a gold and silver temple among the red brick and timber of the Tudor palace. The windows on the first floor have alternate segmental and triangular pediments and are separated by attached Ionic columns. The windows above are square-headed and are separated by Corinthian columns, which support a frieze of garlands and carved heads. The recessed staircase bay to the north was added in 1798 by S. Wyatt, and in 1829 the crumbling exterior was encased, under Sir John Soane's supervision, Portland stone being used throughout.

Inside, the basement is devoted to kitchens and other offices; above, the hall rises through the whole height of the building, being 110 feet long and 55 feet broad and high, thus forming a double cube. The pattern of the façade is followed internally; Ionic pillars support a gallery which runs the entire way round the room between the two rows of windows, and from the gallery square, fluted, attached Corinthian columns run upwards to the roof. The ceiling is divided into nine compartments. Peter Paul Rubens,

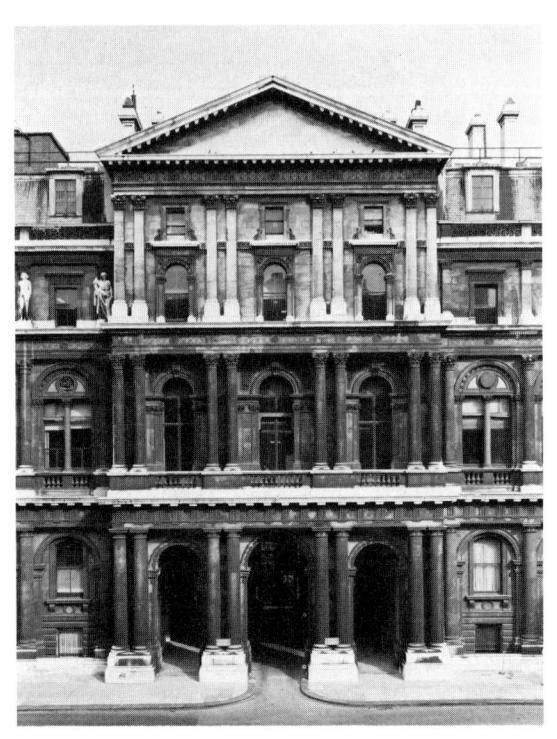

Foreign Office, Whitehall

a diplomat as well as a painter, was sent in 1629 to improve relations between England and Spain. During his visit. Charles I commissioned him to produce paintings to fill the great ceiling compartments, choosing as the theme the union of England and Scotland under the benevolent rule of his father James I, who had died in 1625. The work was completed in 1634, and Rubens, whom Charles had already knighted, was paid £3,000. The central panel shows the apotheosis of James I, in which the venerable monarch is rapt up to Heaven by Justice; in the compartments on either side, jubilant cherubs, symbolizing prosperity, rollick in procession. At the centre of the south end, the benefits of government under James I are depicted; Peace and Plenty embrace each other while Wisdom, adorned with Minerva's attributes, casts out the King's enemies, and Mercury points the way down to Hades. Two ovals, showing Abundance subduing Avarice and Reason bridling Discord, flank this. At the north end, a seated figure of the King smiles in welcome and stretches out his sceptre towards a naked child who, supported by England and Scotland, represents the newly founded union between his southern and northern kingdoms. Britannia holds two coupled crowns over the child's head and cherubs bear aloft the joint arms of the principalities. In the flanking ovals, Hercules (Heroic Virtue) clubs down Envy or Rebellion and Minerva (Wisdom) spears Ignorance. Although much of the work must have been executed by his assistants, Rubens claimed that the main figures were by his own hand and there is no reason to doubt this; the portrait of James I at the northern end is especially good.

These splendid works, which belong to the mainstream of European painting, clearly set out Charles I's views on the divine nature of kingship, and his opinions were given living expression in the symbolism of the masques presented in the hall, in which the king himself acted. Within seven years, the Banqueting House stood silent, for the king had ridden north to raise his standard and subdue his rebellious subjects, and seven years later still, he walked across the hall, beneath the canvases which glorified his father, and stepped through a window onto the scaffold erected in Whitehall, where the block and the headsman's axe awaited him.

It was in the Banqueting House on 13 February 1689 that the crown was offered jointly to Mary II and William of Orange, when James II was driven from his throne. After the fire at the palace nine years later, the hall was converted by Wren to serve as a Chapel Royal; in 1890 Queen Victoria permitted the Royal United Services Institution to use it as a museum, the Father Schmidt organ, installed in 1699, being removed to the Chapel of St. Peter ad Vincula in the Tower. During the 1960s, the museum was rehoused and the Banqueting House restored. It is today used for official receptions and, when not needed by the Government, is open daily to the

public. A bronze bust of James II by Le Sueur stands on the staircase.

So much recapitulation of history is necessary to understand the development of Whitehall from Tudor times to the present day. A perambulation of the street may most conveniently begin at the northern end, traversing first the eastern and then the western side. At the head of the street is a bronze equestrian statue of Charles I, cast by Hubert Le Sueur in 1633 for the Roehampton garden of the Earl of Portland, at a cost of £600. During the Civil War, the statue was concealed by one John Rivet, a brazier of Holborn, and was brought out again triumphantly at the Restoration to be set up where it stands today. on the site of the original Eleanor Cross (see p. 122) in the place where those who had signed the King's death warrant were executed. The oval pedestal, possibly designed by Wren, was the work of Joshua Marshall, master mason to the crown.

To the south is an alleyway, Craig's Court, in which stands Harrington House, elegantly built in 1702 of brick with stone quoins, and now used as part of a telephone exchange. The next turning is Scotland Yard, so called because the kings of Scotland had their London residence here when they came to do homage for their English fiefs. After the union of the crowns, the buildings were used as offices, and then in August 1829 the Commissioner of Police set up his office at number 4 Whitehall Place. The rear entrance was onto Scotland Yard and the picturesque name so caught the attention of the press and the public that, even when the police headquarters were moved in 1891 and then again in 1967 (see pp. 135, 178), the designation was retained.

The first official building in Whitehall, occupied by the Commissioners of Crown Lands and the Ministry of Agriculture and Fisheries, was built in 1909 to the designs of J. W. Murray. Next to it is the old War Office building, designed in 1898 by William Young and completed after his death by his son. Across Horse Guards' Avenue, we come to the Banqueting House behind which, set back from Whitehall, is the new Ministry of Defence, designed in 1936 by E. Vincent Harris but not built until the 1960s.

On the south side of the Banqueting House is Gwydyr House, built in 1772, possibly to the designs of John Marquand. It is of brick, five bays wide, with a good Venetian window and a fine lamp holder with a snuffer, so that the link-boys could extinguish their torches. Today it is used as the office of the Department of Welsh Affairs. On the green beyond it stands a bronze statue of Sir Walter Raleigh, the work of W. McMillan.

Richmond Terrace was built in 1822 by George Harrison at right angles to Whitehall, and beyond it, in the centre of the road, stands the Cenotaph, a plain, stark stele designed by Sir Edwin Lutyens, raised as a memorial to the dead, originally of the First, and then of the Second World War too. Whitehall then becomes Parliament Street.

Returning along the western side, the first three blocks give an excellent conspectus of late, high, and early Victorian architecture. It is worth comparing the solidity of I. M. Brydon's Government Offices (1898–1913), the vivacity of Sir George Gilbert Scott's Home Office and Foreign and Commonwealth Office (1868-73), and the dignity of Sir Charles Barry's façade to the old Treasury (completed 1845). Scott's building is an Italian palazzo, with Corinthian columns in pairs, statues in niches, and a multiplicity of balconies. The architect wanted to build in the Gothic style, but Palmerston insisted on the Italian manner and at last Scott complied. The Treasury building stands on the site of the Cockpit of the Tudor palace, and into it has been built the wall of the early sixteenth-century Close Tennis Court which exists almost to its full height, with an empty doorway high up on the western side which once led into a turret. Remains of a brick oven can be seen about the middle of the wall. About 1604, the Tennis Court was converted into offices and Dorset House was built on an adjacent site. Then, in 1733-6, William Kent designed a new Treasury to face north onto Horse Guards' Parade, from which it can still be seen. The building is seven bays wide with a four-column Ionic portico supporting a pediment high up on the second floor. It looks tall and thin but Kent had intended to give it an extra four bays on each side. Inside there are several fine rooms and the Board Room has a magnificent chimney-piece. Beneath Kent's building runs Cockpit Passage, a mysterious public tunnel leading to Horse Guards' Parade.

In 1824 Sir John Soane built a new office for the Privy Council and the Board of Trade, standing at right angles to Kent's building and facing onto

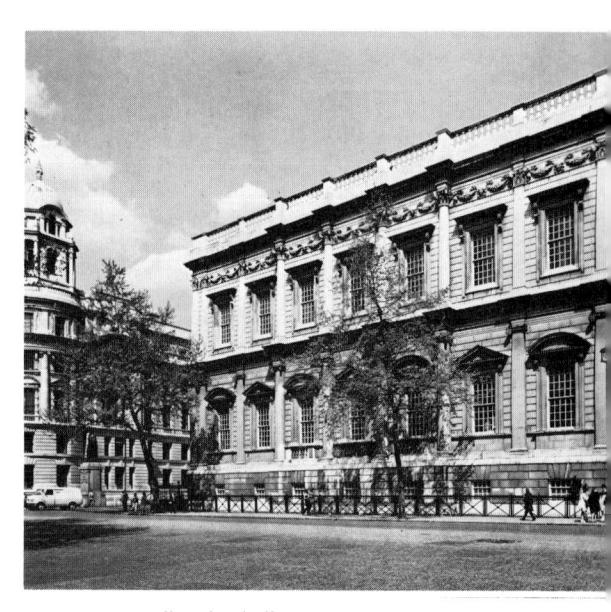

Banqueting Hall, Whitehall

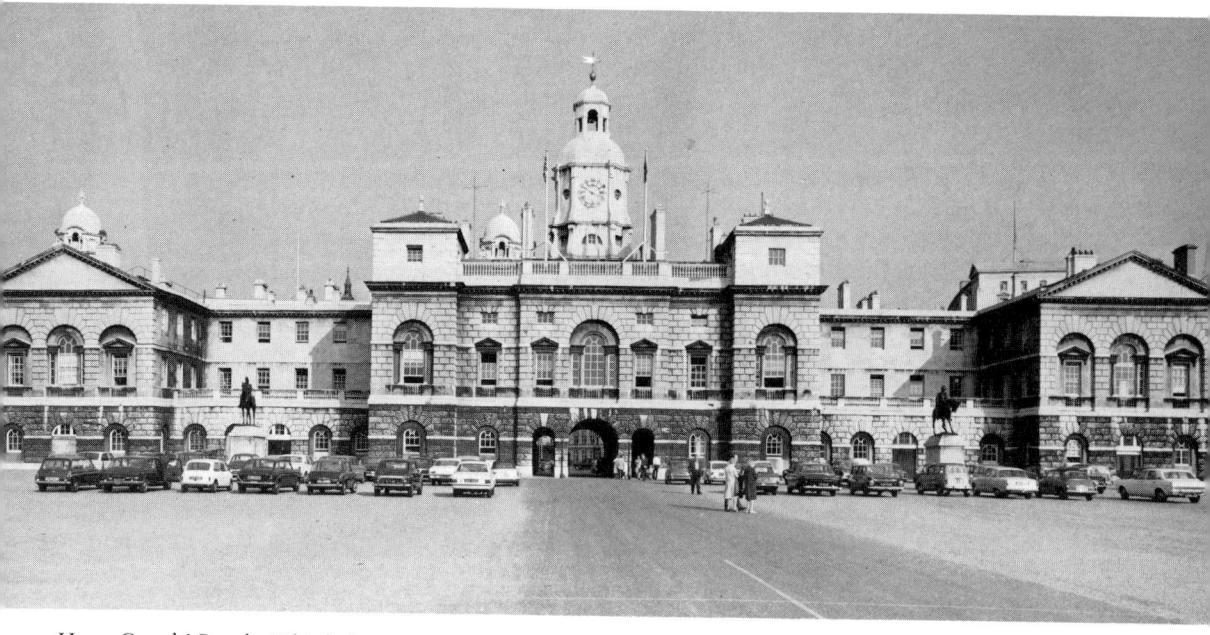

Horse Guards' Parade, Whitehall

Whitehall but it, like so many of Soane's other public works, was unlucky, for by 1844 it had proved too small. It was dismantled by Sir Charles Barry, who retained some of the interiors and the giant columns and frieze which had adorned the façade. These he reused and the front towards Whitehall is a serene expanse of 23 bays, each separated from the next by a giant Corinthian column running upwards through three beautifully proportioned storeys.

Downing Street runs between Scott's and Barry's buildings, taking its name from Sir George Downing, a treacherous man who began his career as chaplain to the Parliamentarian army but changed his allegiance when he saw the Restoration of Charles II was certain. He bought land in Whitehall and built houses there. In 1731 George II offered number 10 to Sir Robert Walpole as a personal gift, but Sir Robert declined, and it became the official residence of the Prime Minister. Numbers 11 and 12 have now been made to connect with number 10, but the fine interiors in numbers 10 and 11, by Sir John Soane, have been retained.

Back in Whitehall, on the northern side of Barry's façade, is Dover House, built in 1755–8 by James Paine as a private house for Sir Matthew Featherstonehaugh and used today as the Scottish Office. The house is hardly visible from the road, for in 1787 it was bought by the Duke of York who commissioned Henry Holland to build a high wall to screen his dwelling, but the elegance and simplicity of the original building can be appreciated from Horse Guards' Parade. The Guards' quarters were designed by William Kent in about 1745–8 and were built after his death by John Vardy between 1750 and

1760. The buildings lie around three sides of a courtyard and are extraordinarily restless; the sevenbay centre is broken into five separate parts with projections and recessions, and the same angularity is continued in the five-bay wings, which lie far back, and in the three-bay corner pavilions, which project forwards again. Guardsmen sit, immobile, astride their horses in the sentry boxes, and the Guard is changed ceremonially at 11 a.m. and is inspected at 4 p.m. At the centre of the main range, an archway leads through into Horse Guards' Parade, a gravelled expanse where the Queen takes the Salute each year on her official birthday in June. The Parade is worth exploring carefully, partly because of the backs of buildings which can be seen from it and partly because of the guns and statues upon it. The statues -Lord Kitchener (John Tweed, 1926), Lord Roberts (H. Bates, 1923), and Sir Garnett Wolseley (Sir W. Goscombe John, 1917) – are not especially exciting, but the guns are superb, one of them, brought to Europe in 1801, having been made in Turkey in 1524 by Murad, son of Abdullah, and the other, a mortar, having been made to celebrate the raising of the siege of Cadiz after the Battle of Salamanca on the 22 July 1812. The carriage on which it rests is adorned with three scaly sea-monsters and the Prince of Wales's plumes, since it was presented to the Prince Regent. In the north-west corner of the parade ground is an extraordinary building, the Citadel, constructed during the Second World War as a stronghold for vital Government communications. It looks like a solid rock, and is covered with a Virginia creeper.

The next building to the north of Horse Guards' is the Paymaster-General's Office, which was built in

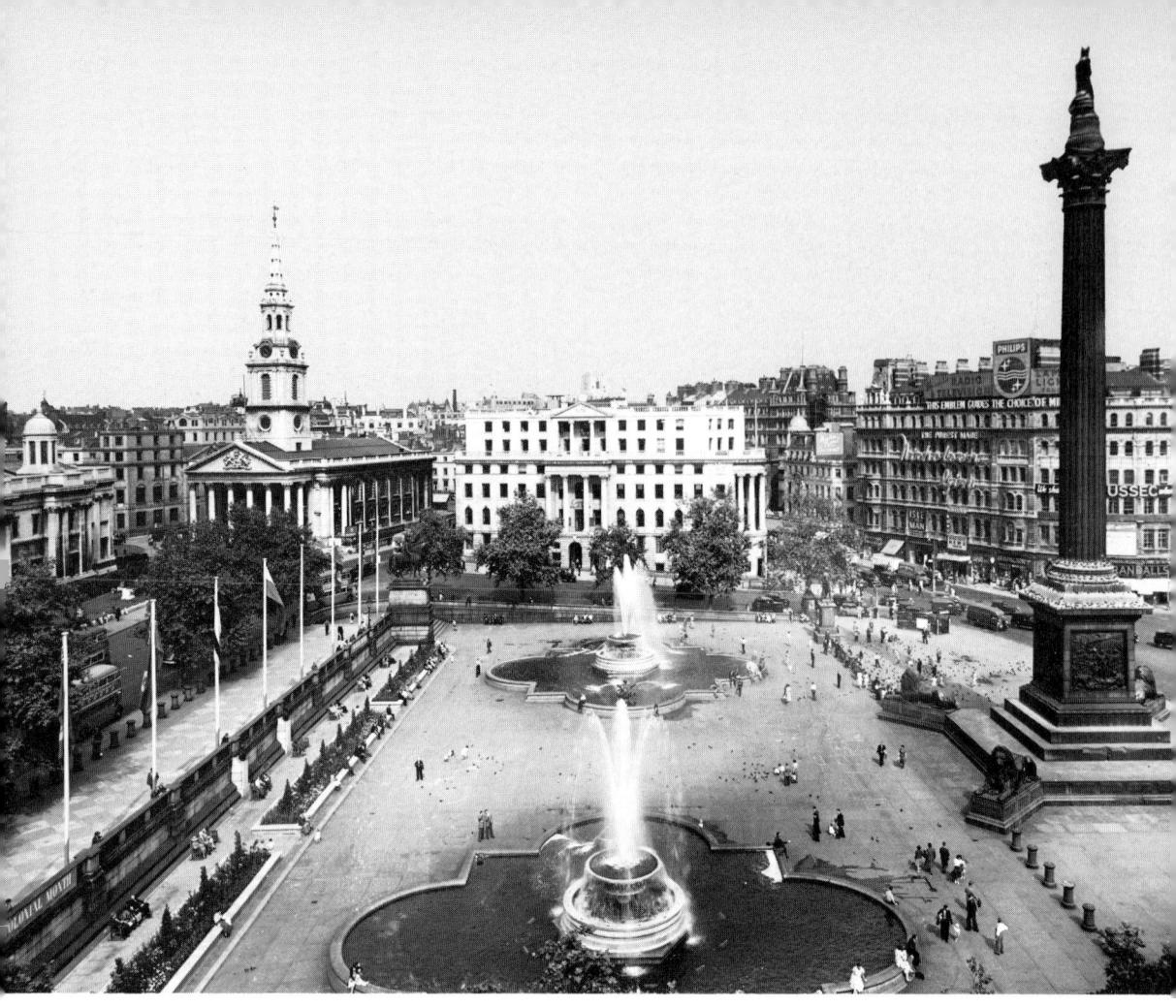

Trafalgar Square, the National Gallery, and St. Martin-in-the-Fields

1732 by John Lane. It is of plain brick, five bays wide, with a small pediment in which is set a lunette window, and appears to be more in keeping with Norwich or Newmarket than Whitehall. But its back is very grand, for it was added in 1910, having been brought from 37 Great George Street. The stone facing and Venetian windows can easily be seen from the Parade. The next building is Admiralty House, designed in 1786-8 by S. P. Cockerell, and beside it is the Admiralty, which was built in 1722-6 by Thomas Ripley. The screen topped by sea-horses, which obscures it from the road, was constructed in 1759-61 by Robert Adam. The rooms within are stately; the fireplace in the Board Room is decorated with superb wood-carvings in which nautical instruments, several of them now obsolete, are entwined among the more usual fruit and flowers.

North of the Admiralty are the Whitehall Theatre (1930, E. A. Stone) and **Trafalgar Square**, occupying the site of the royal mews and stables, and laid out in the 1830s and 1840s. This is the capital's only big

public square, where people congregate on the evening of general election days, for political meetings, and on New Year's Eve. The idea of the square came from John Nash, though its construction, together with the widening of the Strand and the cutting through of Charing Cross Road, was not completed till long after his death. The Square is important both for the buildings around it and because it is so characteristic of London; it was laid out by Sir Charles Barry.

The ground slopes quite steeply to the north, so a terrace was created below the National Gallery. Into the foot of it are set the imperial measures of the inch, the foot, and the yard. In the centre of the Square is Nelson's Column, begun in 1840 and completed three years later, though the lions at the base of the column, designed by Sir Edwin Landseer and cast by Baron Marochetti, were not installed until 1868. The column, made of Devonshire granite, rises 172 feet 2 inches into the air, the capital which surmounts it being made of bronze from the guns of

the Royal George. It was designed by William Railton, while Nelson's figure was the work of Edward Hodges Baily. The statue stands 17 feet high and was made in three pieces, the heaviest weighing 30 tons. Around the base of the column are four reliefs cast from captured cannon and representing the battles of St. Vincent, the Nile, and Copenhagen (by M. L. Watson, W. F. Woodington and J. Ternouth respectively), and the death of Nelson (by J. E. Carew). Against the terrace walls are the busts of three other admirals to keep Nelson company; they are Jellicoe, Cunningham, and Beatty and are the work of W. McMillan, Franta Belsky, and Sir Charles Wheeler respectively.

At the corners of the square are four plinths. That to the north-west is empty, but to the north-east is a stirrupless equestrian statue of George IV by Chantrey; to the south-west and south-east are Sir Charles Napier and Sir Henry Havelock. Beside Havelock's statue is a stone pedestal for a lamp, which conceals a tiny police box. The fountains were part of the original design but were remodelled by Sir Edwin Lutyens in 1939, and after the Second World War were adorned with mermen by Sir Charles Wheeler and William McMillan. To the west is Canada House, built in 1824-7 by Sir Robert Smirke, originally for the Union Club and the Royal College of Physicians; to the east is South Africa House by Sir Herbert Baker, its façade enlivened by carvings of South African animals.

The north side is filled by the National Gallery, built in 1832 to the plans of William Wilkins, who reused in its portico the columns from Carlton House. The design, though not especially imposing, and later much enlarged at the back, makes the most of a long, narrow, awkward site and provides an interior with a convenient and welcoming layout of rooms. The collection is one of the finest in the world and unusual among major European galleries in that it is not based on a former royal or aristocratic collection, whether donated or confiscated at some time in the past. Its nucleus was the 38 paintings purchased in 1824 from the estate of John Julius Angerstein, the banker (see p. 367), and his own collection given by Sir George Beaumont. For more than a century and a half, the collection has grown steadily and now numbers over 2,000 paintings, built up systematically to represent the best in all European schools. This all-round strength is the Gallery's supreme quality, though the Italian Renaissance and the Dutch seventeenth century are particularly well represented. For the full excellence of the English school, for modern European, and for American art, a visit to the Tate Gallery is of course necessary (see p. 181).

Among the earliest paintings in the National Gallery are works by Duccio, and in Room I is a Pentecost attributed to Giotto. Masaccio, Piero della Francesca, and Mantegna are all represented in later rooms, and a panel from Uccello's Rout of San

Romano is here. It once hung in Lorenzo de' Medici's bedroom, and it turns the lances of the pursuing Florentines and the figures of the fleeing Sienese into a grim pattern of struggle. Leonardo da Vinci's cartoon drawing of The Virgin and Child with St. Anne and St. John the Baptist was purchased from the Royal Academy in 1962, and the Gallery also possesses a variant of the mysterious Madonna of the Rocks (the original is in the Louvre). Michelangelo is represented by his unfinished Entombment, with the disciples bracing themselves to lower Christ's weight. The Titians include Bacchus and Ariadne, The Death of Actaeon, and the strange Allegory of Prudence, in which the old man's face may well be a self-portrait. Then there are Botticelli's wide-eyed Venus with Mars asleep beside her, and the calm dignity of Bellini's portrait of Leonardo Loredan, the Doge of Venice, his face severe but still humane; both painter and sitter were about 70.

The Gallery owns two magnificent works by Holbein, The Ambassadors, a double portrait of Jean de Dinteville and Georges de Selve, Bishop of Lavaur, and the full-length portrait of Christina of Denmark, Duchess of Milan, painted when the sixteen-year-old widow was being considered as a possible bride for Henry VIII; her hands, which were famous for their beauty, stand out against her dark dress. Another portrait with royal associations, though of an earlier period, is the Wilton Diptych, exquisitely painted by an unknown artist, who may have been French or English. It shows Richard II being presented by his patron saints to the Virgin and Child. Even the angels wear the young king's badge and around their necks are collars of broom-pods, the emblem of Richard's second wife, Isabella of France.

From the Netherlands comes Jan van Eyck's representaion of the Betrothal of Giovanni Arnolfini and Giovanna Cenami; every detail in the room is recorded with such intensity of vision that the spectator seems to be a witness, along with the artist, at that solemn moment in 1434. The Rembrandts range from the radiant portrait of his young wife, Saskia, to three summings-up of the loneliness and indomitability of old age, the portraits of Jacob and Margaretha Trip, and the self-portrait accomplished in the last year of the artist's life. Then there is Pieter de Hooch's Courtyard of a House in Delft, two of Vermeer's pearly interiors with ladies seated or standing at virginals, Carel Fabritius's Young Man in a Fur Cap, which may well be a self-portrait, and Egbert van der Poel's record of the ruins of Delft, after a powder-magazine had blown up in 1654 and had killed, among many others, Fabritius himself. One of the best-loved pictures in the entire collection is Hobbema's The Avenue, Middelharnis, which winds away into the distance, its trees wind-blown. Rubens's Peace and War, which he gave to Charles I is here, and so is his Rape of the Sabines, keeping company with the portrait of his delectable sister-inlaw, known as Chapeau de Paille, and with the

120

enchanted landscape, Autumn: the Chateau de Steen. Van Dyck's equestrian portrait of Charles I sets the king alongside the heroes of legend.

Native English painters are triumphantly represented. The six scenes of Hogarth's Marriage à la Mode provide a record of the eighteenth-century capital. Reynolds's Countess of Albemarle sits contentedly tatting, while Gainsborough's newly-wed Mr. and Mrs. Hallett take their morning walk in spring sunshine, the ribbons and laces of her dress and the young leaves on the trees all quivering with life. Constable's peaceful Cornfield and his Hay Wain are here, with Turner's Rain, Steam, and Speed and The Fighting Téméraire in contrast near them.

The Spanish paintings are all together in Rooms 41 and 42; Velázquez's Rokeby Venus (so called because it was formerly at Rokeby in Yorkshire) and his full-length portrait of Philip IV, dressed in brown and silver, Zurbaran's prim St. Margaret controlling a docile dragon, Goya's portraits of the flamboyant Dona Isbel de Porcel and the haunted Duke of Wellington, who hated the human cost of his victories, and El Greco's breath-taking Agony in the Garden and Christ Driving the Traders from the

Temple.

Of the French School of the seventeenth century, Claude and Poussin, so eagerly sought by English collectors, are richly represented, in particular Claude's Embarkation of the Queen of Sheba and Poussin's Worship of the Golden Calf, and there is Philippe de Champagne's triple portrait of Cardinal Richelieu, which may have served Bernini as the model for his marble bust of the prelate. For the

Detail from the door of St. Martin-in-the-Fields

eighteenth century, though the Gallery possesses Watteau's La Gamme d'Amour and Chardin's little boy concentrating on his card house with grave intensity, much more can be found in the Wallace Collection (see p. 184), but for the nineteenth and early twentieth centuries there is Ingres's sumptuous portrait of Madame Moitessier and Delacroix's representation of Baron Schwiter, as well as Boudin's beach scenes at Trouville, full of clear seashore light. Manet is well represented by his La Servante des Bocks, La Musique aux Tuileries, and studies for the Execution of the Emperor Maximilian, and there are three great works by Cézanne, Les Grandes Baigneuses, and portraits of the artist's father and of La Vielle au Chapelet. Then there are two of Monet's studies of water-lilies, Renoir's child making her Première Sortie, and the rhythm of the open umbrellas in his Les Parapluies, and finally the intense stab

of gold from Van Gogh's Sunflowers.

The National Gallery is unusual in that the entire study collection is on view downstairs in the Lower Floor Galleries. An extension at the back has been added and another is to be built at the side. Small special exhibitions are arranged to concentrate the visitor's attention on one particular painting and public lectures are given four times a week. At the head of the main inner staircase are mosaics by Boris Anrep, installed, at intervals, between 1927 and 1952, almost in defiance of the twentieth century. The west and east vestibules, completed 1928 and 1929, represent the Labours and Pleasures of Life, the half-way landing displays the Awakening of the Muses, with Sir Osbert Sitwell as Music, Virginia Woolf as History, and Greta Garbo as Tragedy, while on the floor of the larger north vestibule are set out the Modern Virtues - the Russian poet Anna Akhmatova represents Compassion, Sir Winston Churchill appears as Defiance, Dame Margot Fonteyn poses as Delectation, T. S. Eliot relaxes himself as Leisure, Bernard Russell conveys Lucidity, and Dame Edith Sitwell symbolizes the Sixth Sense as she glides across a monster-infested chasm supported only on a twig, a book of poetry in her hands, on which her eyes are fixed. Outside the Gallery are two bronze statues, James II by Grinling Gibbons and a replica of Jean Houdin's figure of George Washington.

Just round the corner in St. Martin's Place is the National Portrait Gallery. Founded in 1856, its purpose is to record the faces of English history rather than to assemble a collection of superb portraits, but in fact both aims have been achieved. The collection of nearly 10,000 paintings and sculptures, to which, since 1968, photographs have been added, is arranged in chronological order; it is best to start on the top floor (a lift is available) and work downwards to the basement. The earliest true portrait from the life is Michel Sittow's painting of Henry VII, dated 1505; we have already mentioned Holbein's life-sized study of the king's son, Henry

VIII, and Gheeraerts's triumphant portrait of the last Tudor monarch, Elizabeth I, is here too, a glittering icon, painted soon after the defeat of the Spanish Armada. The only contemporary portrait of Shakespeare is here, as are Reynolds's double portrait of David Garrick and his wife, and Patrick Branwell Brontë's moving study of his three sisters, the poets and novelists Charlotte, Emily, and Anne. Among more modern works, William Strang's brooding portrait of Thomas Hardy, the young Winston Churchill by Walter Sickert, and self-portraits by Gwen John, Laura Knight, Gaudier-Brzeska. and Graham Sutherland are particularly memorable. Special exhibitions of real importance are arranged from time to time, and the miniatures, Sir Walter Raleigh and Sir Francis Drake among them, are a delight. The photographic collection has recently expanded into fresh premises at 15 Carlton House Terrace (see p. 145).

Behind the Gallery, in St. Martin's Street, is Westminster Art Reference Library. Though smaller than the libraries at the Victoria and Albert Museum or the Courtauld Institute, the collection has the advantages of a central location and of being open to all comers.

Outside the Gallery stands the memorial to Edith Cavell (1865–1915) by Sir George Frampton, and on the further side of the road is the church of St. Martin in-the-Fields. A church is mentioned on the site as early as 1222, when it indeed stood in the fields, and the parish was enlarged by Henry VIII to stop funerals passing through his palace at Whitehall on their way to a burial at St. Margaret's (see p. 112). Francis Bacon (d.1626) and Nell Gwynne (d.1687)

were both buried here. The church was rebuilt in 1544 and again in 1722–6 to the designs of James Gibbs. When Gibbs drew up his plans, the site was hemmed in by mean buildings; it was not until Trafalgar Square was laid out, more than a century later, and the streets around were widened, that the grandeur of his church could be properly seen and appreciated. St. Martin's has a magnificent portico of six giant Corinthian columns with a pediment above. The tower and the elaborate steeple rise from the west end of the church, immediately behind the portico. Despite the cramped position when he built, Gibbs gave monumental treatment to the sides and east end of the church, two rows of windows and huge pilasters, and a fine Venetian window.

The interior has five bays with a tunnel vault, giant Corinthian columns, and galleries on three sides. The chancel is narrower than the nave and at the junction are two boxes, that to the north for the use of the royal family should they attend services here, for St. James's and Buckingham Palaces lie within St. Martin's parish. The original organ was given by George I in lieu of performing his duties as churchwarden: it is now at St. Mary's, Wotton-under-Edge, Gloucestershire, and a newer, larger one has been installed in St. Martin's. The plasterwork is by Artari and Bagutti, and the church possesses a marble bust of Gibbs by Rysbrack. The church plate is exceptionally fine and so is kept in safety at the Victoria and Albert Museum. St Martin's has always been renowned for its ministry to London's destitute and outcasts; the brick-vaulted crypt is used nightly as a soup-kitchen and meeting-place where those who are desolate can find comfort and companionship.

The Strand, running from Charing Cross to Temple Bar, is today a medley of nineteenth-and twentieth-century buildings — shops, offices, banks, hotels and theatres. It takes its name from its proximity to the Thames and provides a riverside link between the City and Westminster, along which, throughout the Middle Ages, the Tudor, and the Stuart periods, first the prelates and then the nobility built their houses. The distance between the Strand and the Embankment shows how much broader the river used to be.

King Charles's statue (see p. 116), at the north end of Whitehall, stands on the site of the original Charing Cross, erected in memory of Eleanor, Edward I's queen, who died on 28 November 1290 at Harby, near Lincoln, when following her husband on campaign to Scotland. Her body was carried back to London for burial in Westminster Abbey and at each place where the funeral cortège paused for the night, a cross was erected.1 Charing Cross, marking the last stage of the journey, survived the iconoclasm of the Reformation but was finally destroyed in 1647, on Parliament's orders, as a godless image. At the Restoration, its site was chosen for the execution of the eight regicides, the men who had signed Charles I's death warrant, and in 1675, Charles's statue was set up on that spot. Queen Eleanor was forgotten for two centuries till Victorian enthusiasm for the Middle Ages inspired a new cross, designed by E. M. Barry, which was erected in the forecourt of Charing Cross Station. Set around the tall, slim, octagonal obelisk are eight statues of Eleanor, the work of Thomas Earp.

Between the statue of Charles I and the station runs Northumberland Avenue, driven through in 1874, across the site of Northumberland House (see p. 137). In the Avenue stands the Royal Commonwealth Society and in nearby Northumberland Street is the Sherlock Holmes public house, adorned with souvenirs of the great detective. Beyond it is Craven Street, where the German poet, Heinrich Heine,

lodged, cold and miserable, in the spring of 1827, and where Henry Flitcroft, the architect, lived at number 33 from 1731 to 1741. Mark Akenside, the poet, came to live in the same house in 1759. Charing Cross Station was designed by John Hawkshaw and was opened in 1864. It covers the site of Hungerford market close to Hungerford Stairs, where the blacking factory stood in which Charles Dickens worked as a small boy when his father was imprisoned for debt. The future novelist never forgot the experience and describes the loathsome, rat-infested place in the eleventh chapter of *David Copperfield*.

The architecture in the Strand itself is uninspired, though Sir Denys Lasdun's building, now New South Wales House, erected in 1957-9 and Coutts's new bank (see p. 129), are exceptions; the streets down to the river provide more interesting matter. In the section immediately east of the station their very names tell a fascinating story. Mary Tudor gave land here to the Archbishop of York, in compensation for Whitehall Palace (see p. 114). Later Sir Nicholas Bacon, Keeper of the Great Seal, lived in a part of York House and Francis Bacon was born there on 22 January 1561; when he in his turn became Lord Keeper, he returned to his birthplace and lived there till he was disgraced for bribery four years later. Then George Villiers, Duke of Buckingham, was granted the property, which eventually passed to his son. But the old house was too expensive and inconvenient to maintain, so he sold it, and in 1674 streets of smaller houses began to cover the site. A condition of the sale was that Buckingham's names and title should be commemorated in those streets and so we have George Street (now York Buildings), Villiers Street, Duke Street, Of Alley (now York Place), and Buckingham Street. Of the great house, one relic is left, standing in Victoria Embankment Gardens. It is the Watergate, the landing stage for the duke's barge. It was built in 1626 by Nicholas Stone, though the credit for the design is variously given to him, to Balthasar Gerbier, and to Inigo Jones. Now under the protection of the Greater London Council. it is of three bays with fat pillars and rusticated stonework on the river side; Buckingham's coat of arms is displayed towards the river.

Buckingham Street and, to a lesser extent, Villiers Street, have an especial fascination in respect of their past residents. John Evelyn, the diarist, took lodgings

¹ Of the twelve originally erected, three survive, at Geddington, Northampton, and Waltham.

THE STRAND 123

in Villiers Street during the winter of 1653/4 – we do not know at which number - and Rudvard Kipling wrote The Light that Failed when he had rooms in number 43 (formerly number 19). In Buckingham Street, several of the doorways and windows are elegant enough to be worth noticing - numbers 13 and 18 are especially attractive. Leonard Knyff lived here from 1683 till 1698, while he was making the topographical drawings on which so much of our knowledge of the seventeenth-century city depends. The two philosophers, David Hume and Jean-Jacques Rousseau, lodged and quarrelled in number 10 in 1766; Samuel Pepys spent more than 20 years here, living first at number 12 from 1679 till 1687 and then at number 14 till 1700. Robert Harley, Earl of Oxford, took over the house and it was from here, in 1705, that he made his first considerable purchase of books. Today, the Harleian Manuscripts are one of the great treasures of the British Library collection. From 1732 till 1788, the house was used as the Salt Office, and when the tax on salt was at last repealed, it was let out in chambers. Sir Humphry Davy rented the basement for experiments but, because the house faced the river and enjoyed excellent light, it was more often occupied by artists. William Etty had the top floor from 1826 to 1849, and Clarkson Stanfield had other rooms from 1826 to 1831. Across the street at number 15 William Burges, the architect, occupied rooms on the second floor from 1857 to 1881.

Goodwin's Court, Strand (see p. 134)

The land immediately to the east of Buckingham's estate was the property of the Bishop of Durham in the Middle Ages. After the Reformation, it passed into various hands, including those of Sir Walter Raleigh, who lived there for nearly 20 years from 1584, till he fell from favour when James I came to the throne. In 1768, this became the site of one of London's most adventurous architectural enterprises when the Adam brothers, Robert and James, the architects, and William, the financier, decided to transform what had become a slum into a fashionable quarter. They named their venture the Adelphi, from the Greek word meaning brothers, for they wanted to express their strong feeling of brotherly unity. The land sloped steeply towards the river, so they built up the ground on a series of arches and on top of them they constructed Adelphi or Royal Terrace, Robert Street, and Adam Street to the west and east, and John (now John Adam) Street to the north. Before they were finished, money ran short, but they set up a lottery with tickets at £50 apiece and all was well in the end. The main terrace consisted of two groups of 11 houses each, back to back, with a single house at either end. The dwellings were the usual tall, thin, town houses of the period. but adorned with such elegance and taste as London had not seen before. The brick fronts were lightened with pilasters with honevsuckle mouldings, and the fireplaces and plasterwork of the interiors were exquisite, though Horace Walpole said it looked like 'a trull in a soldier's old coat'. David Garrick the actor took number 5, living there from 1772 till his death 9 years later. Here he was visited by Dr. Johnson, Boswell, Sir Joshua Reynolds, the learned Mrs. Montagu, Dr. Charles Burney and his daughter Fanny, the novelist, while Hannah More rented the attic and sometimes came down to join the company. Garrick's French wife lived on in the house after his death until her own, some 43 years later in 1822. The façade was ruined in the 1870s and the whole central terrace was torn out for commercial development in 1936. It was replaced by a large heavy building designed by Collcutt and Hamp. Number 7 Adam Street, the offices of The Lancet, gives some idea of what the original houses were like, and the drawingroom of Garrick's house survives and has been reconstructed in the Victoria and Albert Museum. Something of the vaults on which the terrace rested can be seen from Lower Robert or Lower Adam Streets.

One part of the brothers' scheme survives intact, still fulfilling its original purpose – the Royal Society of Arts at number 8 John Adam Street. It was founded in 1754 under the title of the Society for the Encouragement of the Arts, Manufactures and Commerce, and its aim was to improve the standard of all three by arranging competitions for those employed in them. For example, John Bacon, the sculptor, won eleven premiums and a gold medal during his apprenticeship and young manhood; the financial

and psychological encouragement he received did much to help him to develop his talents to the full. Between 1772 and 1774, the Adams built for the Society a house with a fine entrance hall, a lecture room, a library, and accommodation for the secretary. The entrance is handsome, with three steps and a small, square porch; a Venetian window is above the door and from the first to the second storey run attached Ionic pilasters which support a frieze and pediment. On the frieze are the words Arts and Commerce Promoted, and this the Society still continues to do. Inside, the Lecture Room is adorned with six large paintings by the enthusiastic but unlucky James Barry, who refused all payment for his work. Executed between 1777 and 1783, the paintings 'illustrate this great maxim . . . Happiness, as well individual as public, depends on cultivating the human faculties.' Several of the figures are portraits of Barry's contemporaries: Barry himself, Dr. Burney the musicologist, Dr. Johnson, Edmund Burke, Dr. John Hunter, Bishop Hurd of Worcester, and numerous members of the Royal Society of Arts are all recognizable.

Beyond the Adelphi is the bulk of Shell-Mex House, and then the Savoy Chapel, Theatre, and Hotel. A great house was built here by Peter of Savoy, uncle to Eleanor of Provence, Henry III's queen; he was granted the land in 1246 and the rent he paid was three barbed arrows a year. After his death the property passed to the Earls, later the Dukes, of Lancaster. The first Duke spent £35,000 on rebuilding; so fine was the house that King John of France was lodged there after he was taken prisoner at the Battle of Poitiers in 1357. Later, it passed to his daughter, Blanche, wife to John of Gaunt, at whose death Chaucer composed his Boke of the Duchesse. The mansion remained the property of the widower and so was thoroughly sacked and the great hall blown up when Wat Tyler and his men marched on London in 1381, for Gaunt was one of the more unpopular nobles. Thereafter, the remaining buildings were patched up and put to various uses – a hospital, a barracks, a prison, and shops – till at last the site was cleared in 1817 when the construction of Waterloo Bridge began.

All that remains today is the Chapel, which was built in the sixteenth century. It was much damaged by fire in 1843 and 1864, being restored first by Sir Robert Smirke and then by his brother Sidney. Little remains of the original building, though the flat wooden roof was copied. In 1937 it became the Chapel of the Royal Victorian Order and it is used as such today. No parish is attached to the Chapel but regular Sunday services are held, save in the months

THE STRAND AND THE EMBANKMENT

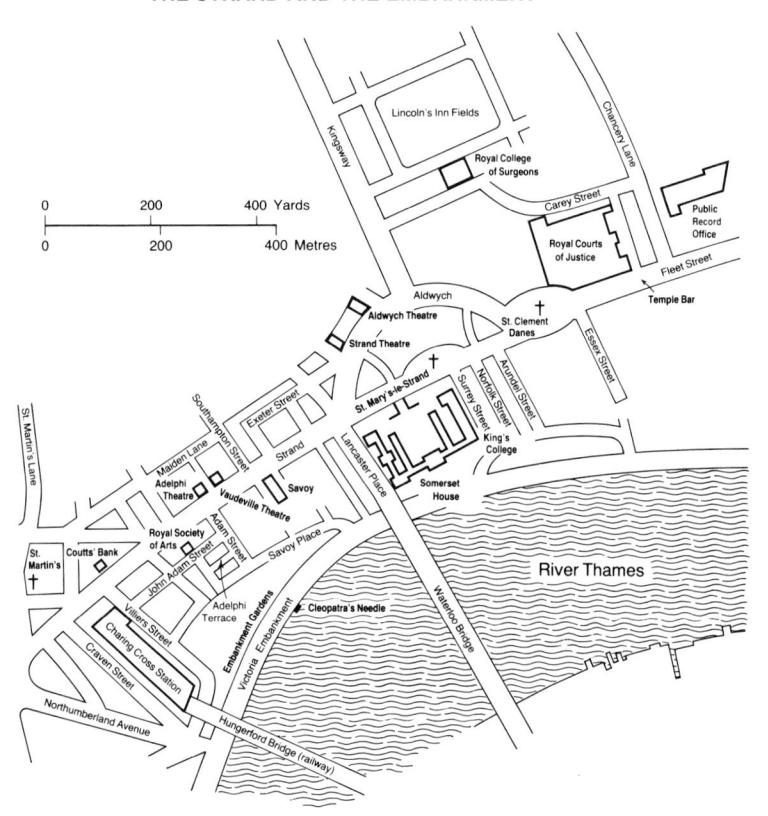

125

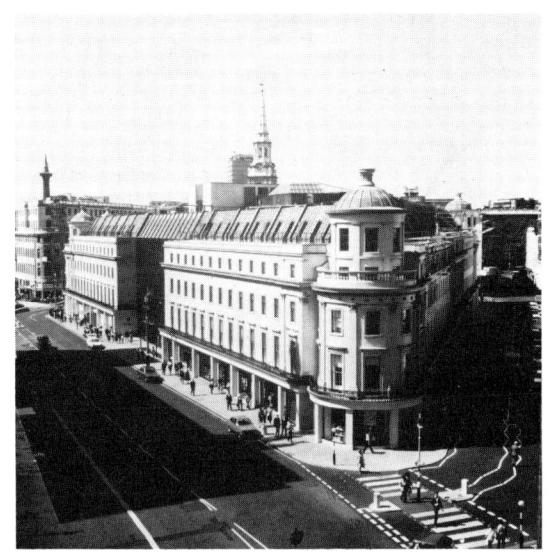

Nash's development of the West Strand, rebuilt to incorporate Coutts's Bank

of August and September, with music of a high standard. The walls are panelled; much of the modern glass is by Joan Howson, with one window to the memory of Richard and Rupert D'Oyly Carte. The church possesses a fourteenth-century Florentine painting by an unknown artist, and an early seventeenth-century English embroidery of the Garden of Eden. Brasses commemorate Thomas Halsey, Bishop of Leighlin in Ireland, and Gavin Douglas, the Scottish poet who was also Bishop of St. Andrews: they both died in London. Two small figures in the chancel, representing Alicia Steward (d.1573) and Nicola Murray (d.1612), are all that the fire of 1864 left of the monuments. The embroideries of the priest's chair and of the altar kneelers, with unusual combinations of stitches, are by Sir Norman Warwick. Archibald Cameron of Lochiel was buried here in 1753 after execution for his part in Charles Edward Stuart's rising of 1745, and in the churchyard, without memorials, lie a Tudor composer, John Floyd (d.1523), and two Restoration poets, Anne Killigrew (d.1685), and George Wither (d.1677).

In 1881, a part of the site of the old palace was acquired by Richard D'Oyly Carte and on it he built the Savoy Theatre to designs by C. J. Phipps. It was the first theatre in London to be lit by electric light and on 10 October 1881, *Patience*, by W. S. Gilbert and Arthur Sullivan, was presented to an audience which included the Prince and Princess of Wales. Almost around the theatre, the Savoy Hotel was built in 1903–4, with a bathroom and lavatory to each room; such provision was considered to be extraordinary. The Strand front of the Savoy was designed by T. E. Collcutt, and the later block towards the river by A. H. Mackmurdo.

Beyond Waterloo Bridge (see p. 138) stands Somerset House. Before the Reformation, the site was occupied by the residences of the Bishops of Worcester and Chester, but the Protector Somerset had their inns demolished in Edward VI's reign and in their place his steward, Sir John Thynne, began to build for him a mansion with gardens stretching down to the river. Extra stone was filched from St. Paul's Cathedral. and the Duke's men attempted to pillage other building materials from St. Margaret's Westminster, but they were driven off by the outraged parishioners. The entrance gate from the Strand, carved by Nicholas Cave, Henry VIII's master mason at Nonsuch, was a veritable triumphal arch, but the palace was not finished when Somerset knelt to the executioner's axe in 1552. The house was sequestered to the Crown and was put to various uses, providing in particular a residence for two queen consorts, Henrietta Maria and Catherine of Braganza; Inigo Jones built a chapel there for the former lady. But it was too old-fashioned for Queen Charlotte, on whom Buckingham House (see p. 147) was settled, and so was demolished.

On the site, a great building, designed to accommodate government offices and learned societies, was constructed, following the designs of Sir William Chambers, who had been drawing-master to George III. The building is set around a huge courtyard, measuring 350 feet by 310 feet, and faced with Portland stone throughout. The facade to the river was planned in dignified Palladian rivalry to the Adam brothers' more spirited Adelphi river frontage, begun some eight years earlier. It is 800 feet long and rests on huge rusticated arches, which would originally have stood directly on the river bank. These arches are sombre and dramatic, inspired by Piranesi. Above them is a terrace from which the facade proper rises, 45 bays long. The centre is marked by a portico, surmounted by a recessed pediment (sculpture by R. Rathbone) and a still more recessed small dome. This centre is too insignificant, too unemphatic, to dominate such an expanse of stonework, but in the centre of each side, a huge arch and an open colonnade provide more successful punctuation. On either side of Chambers's river front is an extension, that to the west towards Waterloo Bridge by Sir James Pennethorne, that to the east, for King's College, by Sir Robert Smirke. Seen from the river, this is one of the most impressive façades along the waterfront.

In the centre of the courtyard stands a huge statue of George III and the River Thames by John Bacon, and a war memorial by Lutyens to the Civil Service Rifles. The north, Strand, frontage is nine bays wide with arches at pavement level. The central keystone represents the Ocean with the rivers Severn, Tyne, Tweed, and Medway to the left and the Thames, Humber, Mersey, and Dee to the right; they were carved by Joseph Wilton, or his assistant Nathaniel Smith, and by Agostino Carlini.

126 WESTMINSTER

This north range was designed to accommodate the Royal Society, the Society of Antiquaries, and the Royal Academy; it fulfilled this use till the Societies and Academy moved to Burlington House in the 1850s, and was then occupied by the Registrar-General. In 1973 restoration work began on the rooms within. Three of them, an Ante-Room, the Antique Academy, and the Council Chamber, had been for the use of the Royal Academy; the dignified plasterwork of the ceilings, by Thomas Collins, can best be seen in the Council Chamber. It now seems probable that the Courtauld Institute and its gallery (see pp. 185, 227) will be reunited in Somerset House before the end of the present decade.

The eastern quarter of the Somerset House site was used for the building of King's College in 1829–35, to designs by Sir Robert Smirke. The style matched that of the parent building but the cramped site and narrow entrance made it easy for Pugin to represent it meanly in his Contrasts, when he compared it with the main gateway of Christ Church Oxford. Additional property has been acquired and a new front, which accords uncomfortably with the old, was added in 1966–71 by Troup and Steele, with E. D. Jefferiss Mathews as consultant. Down Surrey Steps off Strand Lane beside the College is the so-called Roman Bath, the property of the National Trust. A natural spring oozes up the small building,

but the brickwork is more likely to be seventeenthcentury than Roman. The history of the place is uncertain, but Dickens makes David Copperfield have 'many a cold plunge' in it and it is open to the public.

Opposite the entrance to King's College, standing on an island in the middle of the road, is the church of St. Mary-le-Strand. A church has stood near here since 1147 at least, but the present building was set up between 1714 and 1717 to the designs of James Gibbs. The architect made the most of the island site. The north and south sides are seven bays long with two rows of windows, the pediments of which are alternatively triangular and segmental. The lower tier of windows is blind. Urns decorate the balustrade which tops the building. The west entrance, through a semicircular porch, leads to an interior consisting of a simple rectangle, save for the eastern apse, inspired by Fontana's Holy Apostles, and Cortona's St. Luke and St. Martin, in Rome. The round-headed upper windows are flanked by Corinthian columns, and the ceiling is an intricate pattern of squares and lozenges. Coupled columns at the east and west ends frame the apse and support a balcony, and there is a bulbous, tulip-shaped pulpit with rich decorations. A service is held here annually at the end of January in memory of Charles I, in his persona as Charles, King and Martyr.

Somerset House, Strand

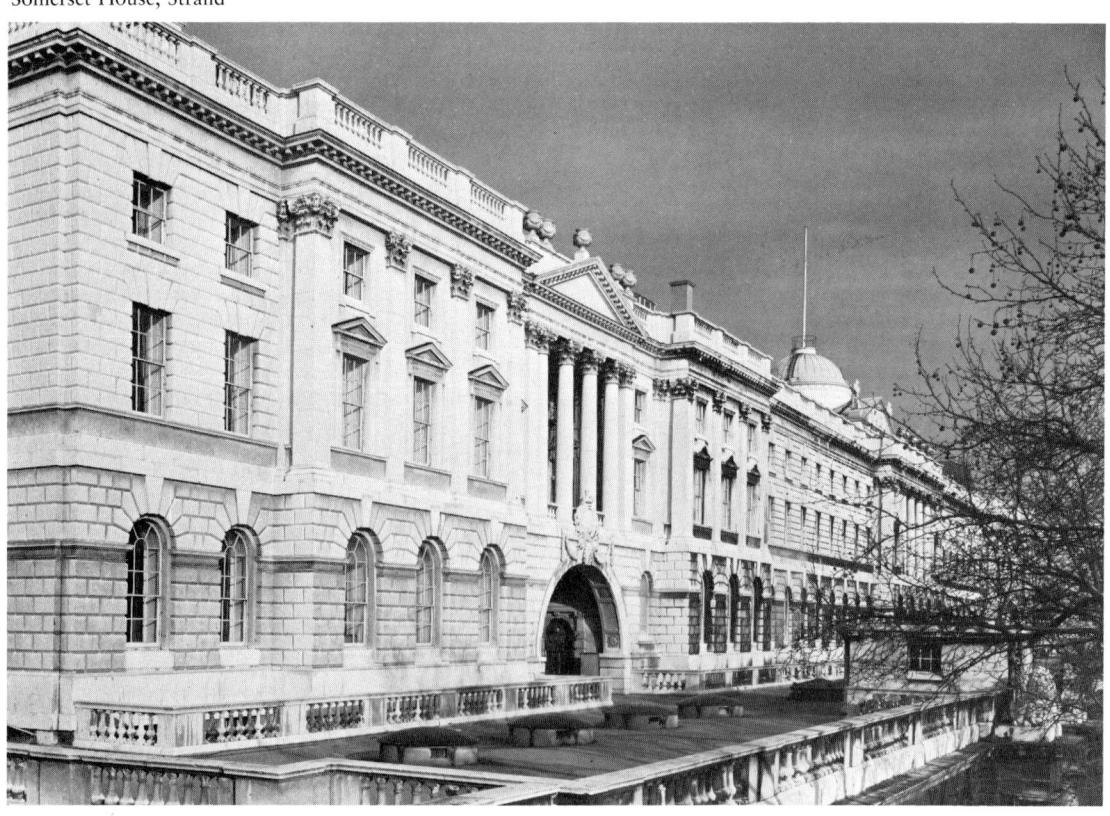

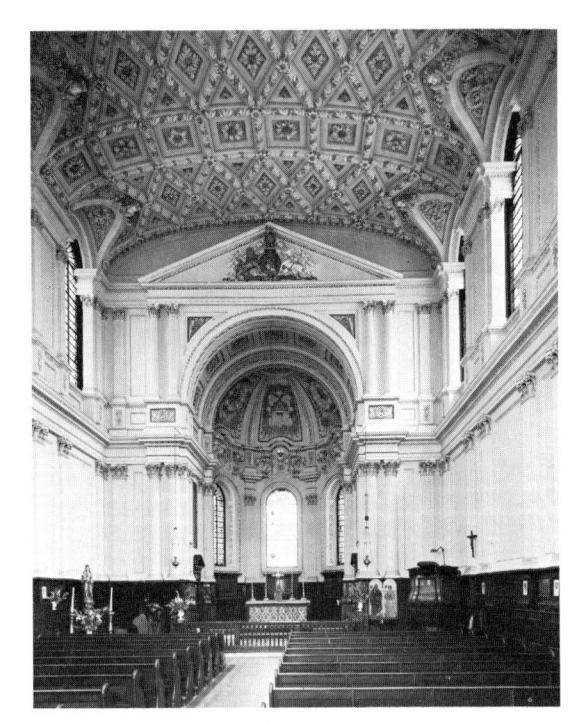

St. Mary-le-Strand, Strand

It was outside St. Mary's that a maypole, 134 feet high, was set up to celebrate the Restoration of Charles II; somewhat shortened, it remained in position till 1717 when, having decayed, it was taken down and, at Sir Isaac Newton's request, was sent to Wanstead to support a telescope. The loss remained in the popular mind and in 1731 James Bramston published his much-quoted couplet:

What's not destroyed by Time's devouring Hand? Where's Troy and where's the Maypole in the Strand?

Gibbs had planned originally to have a plain square tower and a statue of Queen Anne set a little distance away on a column. But the Queen died and the tower was raised through three open oblong stages above the belfry and was topped by a little spire, to form a landmark the length of the Strand and a foil to the steeple of St. Clement Danes.

Essex Street runs across the site once filled by the mansion of Robert Devereux, Earl of Essex, Queen Elizabeth's last favourite, whom she regretfully beheaded for rebellion in 1601. The land was built over by Nicholas Barbon (see p. 210) in the early 1680s. In Devereux Street is a public house with a bust of the Earl, possibly set up in 1676, high on the wall. On the corner of the street is Twining's tea and coffee warehouse, founded in 1710 by Thomas Twining, who purveyed his goods to Queen Anne. Twining's is the oldest ratepayer in the City of Westminster and is

possibly the oldest business still continuing on its original site, for its original purpose, and owned by the original family.

Opposite are the Law Courts, built between 1866 and 1882 to designs by George Edmund Street, who wore himself out over the work and died a year before the great building was completed. The facade, in a thirteenth-century Gothic manner, presents an irregular rhythm to the Strand with three main points of emphasis - the eastern clock tower, 160 feet high, the courtvard entrance, and the entrance to the main hall. This hall, 250 feet long, 82 feet high, is fit for a palace or cathedral; it is here that lawyers meet and consult with their clients. In it is a fine statue of Street by Henry Armstead; the architect is shown seated, studying one of the thousands of drawings which he made for the building, while around the base is a frieze of masons, carpenters, and smiths, all executing his plans. There are also statues of Sir William Blackstone by Paul Bartlett and of Lord Russell by Bruce Joy, as well as paintings, including two by John Michael Wright of the judges of the Fire Court who served, unpaid, to settle disputes after the Great Fire. The ironwork throughout is particularly worth attention: Street was deeply interested in the crafts and designed much of it himself with some help from his son, A. E. Street, and from Arthur Blomfield; the designs were carried out by James Leaver and Thomas Potter and Sons.

On an island site in the Strand is St. Clement Danes, which probably owes its name to a Danish settlement established in King Alfred's day on the west side of London. The great cathedral of Aarhus is dedicated to St. Clement, the patron saint of sailors. The medieval church escaped the Fire but, becoming ruinous, was rebuilt in 1680-2 by Wren, who retained the fifteenth-century tower, encasing it in new masonry and giving it an entrance hall with a domed lobby on either side, the doorways of which have segmental heads. The outer walls with two tiers of windows are stone-faced, the south is more elaborately decorated than the north, since in Wren's day there was a roadway on that side alone. The octagonal, open, triple-staged steeple was added in 1719 by James Gibbs; it is said that when he showed his designs to the ageing architect, Wren enthusiastically approved of the work. Inside, the nave was tunnelvaulted with groin-vaults in the side aisles; the ambulatory was carried on around the east end, a feature unique in Wren's work and possibly a retention of the plan of the medieval church.

St. Clement's was gutted by fire-bombs in 1941; when the rubble was cleared, a medieval crypt was found. The church was restored in 1955–8 by Anthony Lloyd, and it is now the Royal Air Force church. The black oak of the pews, the panelling, and the screen at the west end, contrast sharply with the white, pale grey, and gold of the upper walls, roof, and floor. The central aisle is unusually wide; in it and in the side aisles have been set more than 700

128

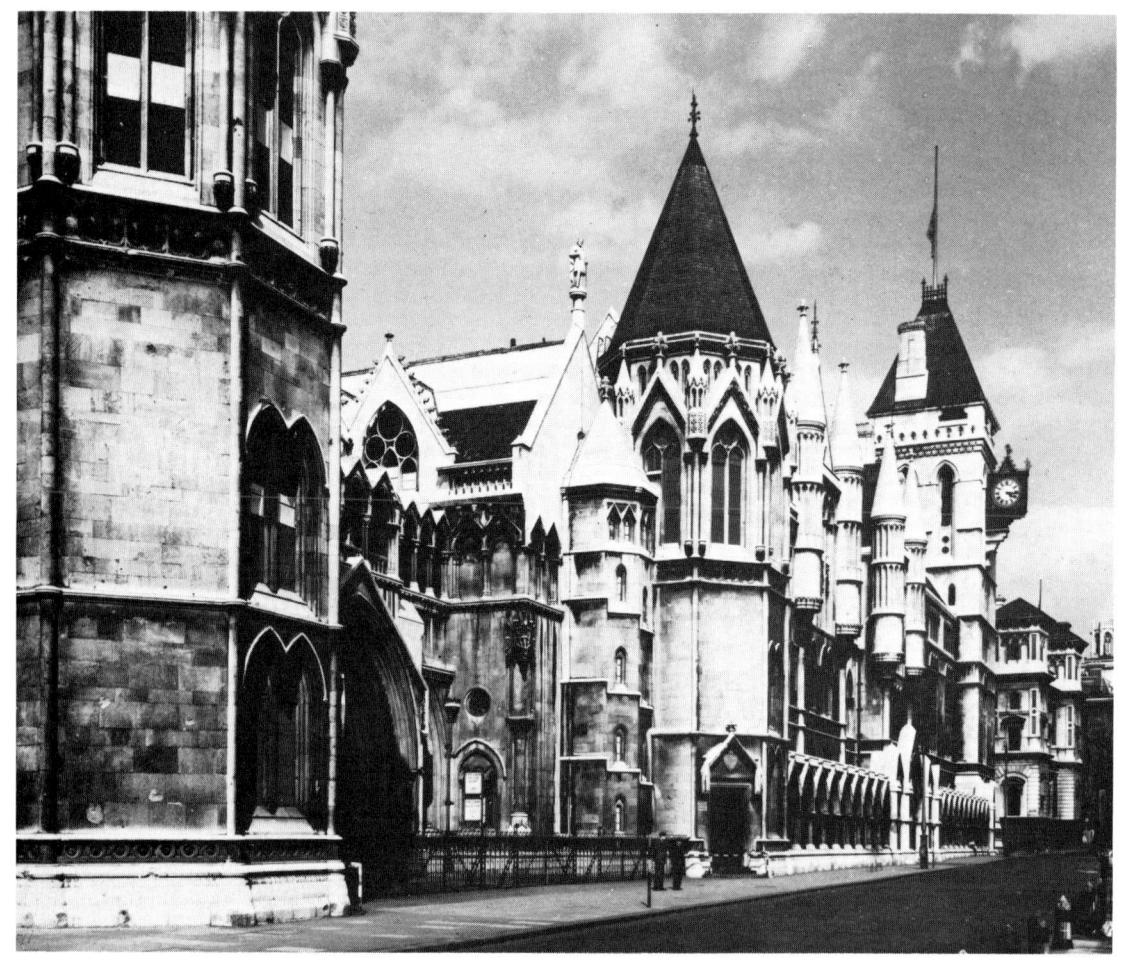

Royal Courts of Justice, Strand

squadron and unit badges, carved from Welsh slate, many of them the work of Madge Whiteman. Memorial shrines, encasing books with the names of those who have died, stand beneath the windows. Square, fluted, oaken pillars carry the galleries, and above them circular, white columns with golden Corinthian capitals rise to the moulded vaulting. The altar painting by William Kent was destroyed but a new one, of the Annunciation, has been painted on gold by Ruskin Spear. The glass of the three east windows round the apse is by Carl Edwards. The pulpit was made for Wren's church; it survived the war. In the chancel stand two thrones into which fifteenthcentury Italian embroideries have been set. On the stairway to the vestry hangs a six-panel 'Victory' tapestry worked by Janet Barrow. A new organ by Ralph Downes is in the west gallery, and in the crypt is a superb black polished granite font, the gift of the Norwegian Air Force.

Into the walls are set old coffin-plates, and a chain used to secure a fresh coffin, so that body-snatchers

should not rifle the contents, is still in position. Of the peal of ten bells, only 'Sanctus', cast in 1588, survived the bombing; it was repaired and the others were recast from old metal by the Whitechapel Bell Foundry. A carillon in the steeple plays the *Old Hundredth*, the Air Force march, and *Oranges and Lemons*. A service is held here every year in Lent; each child attending it is given an orange and a lemon to take home. John Donne became rector here in 1617; his wife, Anne, was buried here in the same year, her memorial being carved by Nicholas Stone, who had 'fifteen pieces' for his labours. Samuel Johnson attended services here regularly; his statue, the work of Percy Fitzgerald (erected in 1910), stands at the eastern tip of St. Clement's island.

Before the west door stands a statue to Mr. Gladstone; it is the work of Thomas Thornycroft. Beyond it, the roads separate, the Strand running straight and Aldwych sweeping round in an arc to rejoin the Strand opposite Waterloo Bridge. A crescent-shaped island lies locked between the two

thoroughfares. In the early 1900s, a maze of dilapidated but picturesque streets and alleyways was swept away, the street, Aldwych (possibly taking its name from the former Danish settlement) was driven through, and four huge buildings, Australia House (1912-18, architect Marshall Mackenzie, entrance sculpture by Harold Parker), Bush House, holding the overseas service of the British Broadcasting Corporation (1925-35, Helmle and Corbett), India House (1928-30, Sir Herbert Baker and A. T. Scott, with carvings of Indian deities and wall paintings by Indian artists) and the former offices of the English Electric Company, now a bank (1957, Adams Holden and Pearson; Sir Charles Wheeler's statues have been removed), occupied the island in company with some smaller offices. The English Electric building filled the site once occupied by the Gaiety Theatre; a plague on the wall of Bush House records that from an earlier building Marconi's Station, 2 LO, broadcast from May to November 1922, and that the BBC's first programmes were transmitted from there.

On the north side of the Aldwych are the Aldwych and Strand Theatres, both designed by C. J. Phipps, and between them the Waldorf Hotel, designed by A. Marshall Mackenzie and built in 1907–8. Returning along the north side of the Strand, there is less of importance than on the south side. It is however, worth noticing the Lyceum Theatre, the remodelled shell of Sir Henry Irving's triumphs, now used only as a dance hall, and the Vaudeville and Adelphi Theatres (C. J. Phipps, 1889; Ernest Schaufelberg, 1930). At number 391 in the Strand is the firm of Stanley Gibbons, stamp-dealers. It was founded in Plymouth in 1856, moved to its London premises in 1891, became a royal warrant holder in 1914, and still exists today. A little nearer to Trafalgar Square, on the corner with Agar Street, is Rhodesia (now Zimbabwe) House. The premises were originally built by Charles Holden for the British Medical Association, and, on the second floor, the windows were flanked by Epstein's male and female figures, now much mutilated. At the time, they raised an outcry; this was Epstein's first major work in England.

The triangular site formed by the Strand, Adelaide Street, and William IV Street was part of John Nash's designs for the West Strand and was completed by the builder William Herbert in 1831. Nash had placed pepper-pot towers at the corners, one each at the north-west and south-east, and two at the southwest. The Lowther Arcade, which ran diagonally from the Strand to Adelaide Street, had originally very superior shops but by 1870 most had become toy shops, a mecca for children. In 1902 Coutts & Co., bankers, having obtained a building lease for the Arcade's site, completely demolished it and built their new premises designed by MacVicar Anderson; they moved in to '440' in 1904. By the 1960s Coutts & Co. had outgrown '440' and eventually commissioned Sir Frederick Gibberd and Partners to design the present head office bulding, with modifications advocated by conservationists. It was opened by Her Majesty the Oueen on 14 December 1978. The Nash facades and the pepper-pot towers were retained, and the central parts facing Adelaide Street and William IV Street were restored according to the original Nash designs. Facing the Strand there is a large glass screen, affording a view of the first-floor Garden Court and the Banking Hall, with three floors of galleries round the central space, for the head office divisions and the Strand branches. The Garden Court is approached by escalators and has a glass roof. The old party walls were retained to a depth of nine feet to tie the old façades to the new work. At street level the ground floor is let out in shops, as in 1831.

Covent Garden

Covent Garden takes its name from the original use of these acres, which were once the garden of Westminster Abbey or convent; today, it has undergone a resurrection little short of miraculous and has become London's newest and most exciting shopping centre, the emphasis being on the arts and crafts, health foods and ethnic goods, on publishers' offices, bookshops, and small art galleries.

At the Reformation, the land was acquired by the first Earl of Bedford: later Bedford House was built on a part of it, and then, in 1630, Francis Russell, the fourth earl, decided to develop the rest of the estate. It was London's first planned layout; three talented, most dissimilar men, Charles I, the Earl, and Inigo Iones, the King's architect, were responsible for it. At his accession in 1625, Charles had set up a Commission of Building to enforce the regulations, passed at intervals since 1580, aimed at preventing the haphazard expansion of London. The Earl was a practical man, of strong Puritanical inclinations and shrewd financial sense. With the advice of Dutch engineers, he had drained that part of the Fens which is still known today as the Bedford Level. He applied to the King for a development licence and was granted one for £2,000, provided that it should be a distinguished, well-planned extension to the capital. Though the documentary evidence is scanty, it seems certain that the Earl was compelled to accept Inigo Jones's designs for both the layout of the estate and the façades of the buildings.

The model for Covent Garden was the work carried out in Leghorn under the aegis of Ferdinand Medici, who became Duke of Tuscany in 1587. Within a life-span, the small town became an international sea-port, with a great piazza and a cathedral. Jones would have seen the work in progress on his first visit to Italy around the turn of the century. He would also have seen the fine buildings going up in Paris around the Place des Vosges, when he went to Europe a second time in 1613–14. So, when he came to plan the Earl's estate, he included in the design a piazza and a church with a setting worthy, in miniature, of a cathedral. The piazza, measuring 420 feet from west to east and 316 feet from north to south, lay to the north of Bedford House and so was

left open on the south side, where the Earl's gardens were, but around the north and east sides were houses and along their ground floors ran an open arcade, providing a vaulted walk on two sides of the rectangle. The uniformity, elegance, and grace of the façades aroused the admiration of the capital and became a point of topical comment in plays of the period.

The west side was occupied by St. Paul's church. No mention had been made of it in the original licence to build, but the Earl was shrewd enough to realize that if his new development was to become a distinct and distinguished social unit, it had to have its own place of worship. For Jones, the church was the pivot of the whole scheme. The west side commanded the piazza, and Russell Street, which bisects the east, gave a vista along the whole main axis. The focal point was the eastern façade of the church, to which Jones gave a portico of four rugged Tuscan pillars with deeply projecting eaves above it, the roof rafters being left unmasked. Horace Walpole tells the story:

When the Earl of Bedford sent for Inigo, he told him he wanted a chapel for the parishioners of Covent Garden, but added he would not go to any considerable expense; 'In short', said he, 'I would not have it much better than a barn.' 'Well! then,' said Jones, 'You shall have the handsomest barn in England.'

At first sight, the story seems merely to contrast the investor's economy with the architect's largesse, yet the resulting building must have reconciled the two, for Bedford's puritanical spirit must have approved of the simplicity and masculine strength of the building, while Jones had an especial affection for the fundamental, almost rural, naturalness of the Tuscan order. In short, he had built a handsome barn, and the Earl wrote in his commonplace book 'London the Ring Couengarden the iewell of that ring'. The final cost was not cheap: £4,886.5s.8d.

St. Paul's was as important liturgically as it was architecturally, for it was the first completely new Anglican edifice to be planned since the Reformation, St. Katharine Cree having been rebuilt on an old foundation (see p. 80). Jones wanted the main entrance to be from the piazza, by the great door at the east end, with the altar transferred to the west, but,

understandably enough, Archbishop Laud and the body of the clergy refused to allow this, so a more conventional arrangement was adopted and the door behind the portico is only a sham.

Of the original building, comparatively little is left, for St. Paul's was gutted by fire in 1795, though it was carefully rebuilt to Iones's designs by Thomas Hardwick. The entrance is through the churchvard. the western facade being identical with the eastern. with the omission of the portico. There is the same broad doorway with a round window above it and on either side a tall, thin, roundheaded window. The same deep eaves mark the roof. Inside is a vestibule. from which stairs lead up to offices. The interior of the church is a plain rectangle, twice as long as it is broad. Hardwick altered the original plan, inserting galleries on the north, south, and west; all, save the last, were later removed. Six of their pillars now form an open two-bay screen on either side of the altar; Hardwick's refined altar rail and the architectural framework of his reredos have been retained. The latter consists of four flat Corinthian pilasters supporting a pediment, in the tympanum of which a sunburst masks the round east window. The west gallery houses the organ. The richly carved hexagonal pulpit, set on a baluster leg, was made in the early nineteenth century. In 1965 a limewood wreath carved by Grinling Gibbons, who was buried here in 1721, was presented by the Dean and Chapter of St. Paul's; it is one of the finest specimens of the great sculptor's work.

St. Paul's Covent Garden is the actors' church. Ellen Terry was buried here, and simple wooden tablets, grouped together at the west end, record the well known names of many whose ashes lie here or who worshipped in the church. Thomas Arne, the composer, who was born at 31 King Street, has the opening notes of his best-known composition, *Rule Britannia*, carved on his memorial. Ivor Novello,

COVENT GARDEN

1 200 400 Yards

1 200 400 Metres

1 2 200 Metres

C. B. Cochrane, Leslie Henson, the comedian, the designer Sophie Fedorovitch, Marie Lloyd, Leo Quartermaine, Vivien Leigh, and the playwright Clemence Dane, all have memorials here.

As the 1631 licence put it, the fourth Earl's intention was to provide houses and buildings fitt for the habitacons of Gentlemen and men of ability' and the dwellings which Iones designed and which were built under the supervision of his associates. Isaac de Caux and Edward Carter, attracted just those categories of resident. On the east side, one of the original lessees was Sir Edmund Verney, Charles I's critical but loyal standard-bearer, who fell at Edgehill; he had Sir Francis Kynaston as a neighbour in the days before the Civil War. Sir Edmund's house later became the home of Sir Godfrey Kneller, who lived there from 1682 till 1702. On the north side, Sir Peter Lely lived, from 1651 till his death in 1680, at what became numbers 10-11, and his executor, Roger North, the diarist and lawver, lived there after him. Sir James Thornhill had his academy at number 12 from 1722 till 1734; his daughter became Hogarth's wife, much to her father's disapproval.

31 King Street, Arne's birthplace, was also the home of the painter and engraver, John Raphael Smith, from 1787 till 1805. In Henrietta Street, Samuel Cooper, the miniature painter, had accommodation from c.1650 till 1672; he painted both Cromwell and Pepvs's wife, Elizabeth, receiving £30 for the latter commission. Samuel Scott, the marine painter, lived in Henrietta Street from 1747 till 1758. In Russell Street, Charles and Mary Lamb had rooms at number 20 for six years from 1817 and it was at number 8, the house of Thomas Davies the bookseller, that James Boswell met Samuel Johnson on the evening of 16 May 1763. In Tavistock Row, Richard Wilson and Nathaniel Dance lived and worked, and David Garrick took the lease of 27 Southampton Street from 1749 till 1772. It cost him five hundred guineas; 'Dirt and all, 'tis reckoned a very good Bargain', wrote his wife. In Maiden Lane, in a house on the site where number 28 stands today, the great Dutch engineer, Cornelius Vermuyden, had lodgings when he came to England in 1647 to advise the Earl on the draining of the Fens. Andrew Marvell, the poet, had lodgings here in 1775, on the site where number 21 now stands. In Bow Street lived Grinling Gibbons, William Wycherley, the dramatist, and Marcellus Laroon the painter, but the most important associations of this street are with the work carried out in Bow Street Magistrates' Court under Henry Fielding, who is better known as a novelist, and under his half-brother, Sir John Fielding, the 'Blind Beak'.1

It was, however, less than a century before the 'Uniformitie and Decency' of Jones's design was

¹ Those who wish to pursue further the fascinating history of this area should read E. Beresford Chancellor, *Annals of Covent Garden* (1930), and the *Survey of London*, volume XXXVI (1970). Clemence Dane's *London hath a Garden* can also be recommended.

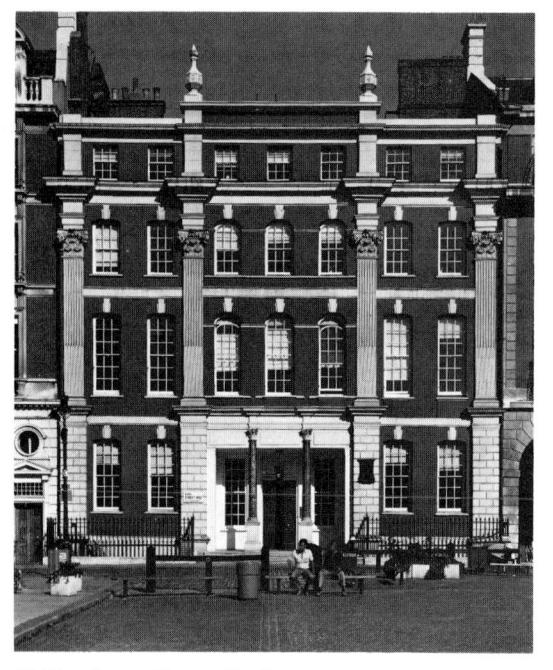

43 King Street, Covent Garden

disturbed. The first alteration to rupture the harmony of his arcades was at 43 King Street, in the north-west corner of the piazza by the church, which Admiral Edward Russell, with Thomas Archer as his architect, rebuilt in 1716 as an astonishing Baroque mansion with huge Corinthian capitals running between the first and second storeys. After that, bit by bit, the original plan was whittled away till not an arch of it remained. The ninth Duke, a man of great sensibility, insisted, even against his own financial interests, that the eight-bay range west of James Street, which was rebuilt in 1877-9 as Bedford Chambers, should have a façade approximating to Jones's design, but it proved impossible for these good intentions to be extended. The architect of Bedford Chambers was Henry Clutton, who so sympathetically restored St. Paul's church.

Developments in the centre of the piazza had disturbed the aristocratic design even before the lessees tampered with the buildings. By 1654, unofficial traders were beginning to congregate in the square, and in 1670 the fifth Earl obtained a licence for a daily fruit and vegetable market to be held there. From then onwards the market spread till the very name of Covent Garden became synonymous with the purveyance of garden produce. In 1700, the Russells moved to Bloomsbury; soon afterwards Southampton Street replaced Bedford House, so ending Covent Garden's comparative isolation from the Strand. By the end of the eighteenth century, it

had become the greatest market in all England for herbs, fruit, flowers, and vegetables; it should be remembered that within ten miles of London there were some 15,000 acres of market-gardening land. The responsibility for controlling the traffic and trading conditions remained with the Bedford Estate. In 1828, it was decided that there must be new. permanent market buildings and these were designed by Charles Fowler, who planned three ranges of shops with space for stalls between them and a colonnade surrounding the whole, thus obliterating Jones's noble square. In 1874-5 and in 1888-9, the buildings were roofed in by Cubitt, using glass and iron in an elegant design. By 1862, a new flower market had to be added and, for the first time, market buildings were allowed to trespass outside the original limits of the central piazza. The congestion continued to worsen and in 1891 Sidney Webb published The Scandal of London's Markets, attacking the Duke of Bedford for the conditions at Covent Garden and for the income which he received from market dues. The Duke might justifiably have replied that most of the income went on the upkeep and regulation of the market, but it had become clear that only a public authority could hope to regulate and control the situation. The London County Council. to which the duke offered to sell the market, was unable to accept the responsibility.

In 1918, the Duke sold his interests to a public company headed by the Beecham family, and it was not till 1962 that it was possible to establish the Covent Garden Market Authority. Soon afterwards it was decided to close the market and remove it to Nine Elms (see p. 429); trading ceased in November 1974. Already, in 1968, a consortium consisting of the Greater London Council in partnership with Westminster and Camden Councils, had announced their intentions in a publication, Covent Garden's Moving. Demolition and wide-scale redevelopment were proposed, but public outcry was so vehement and persistent that a public enquiry was held in 1971 and the planners were told to think again. The following account relates to Covent Garden as it was at Easter 1983.

St. Paul's church remains the key building. Its western portico still confronts the elegantly renovated Central Market building, now filled with a variety of small, speciality shops and restaurants, the aisles between them let out daily to stall-holders who seem, for the most part, to sell craftwork. It remains to be seen whether the Market will become a vital part of Londoners' London or whether it exists only as an up-market tourist attraction. Admiral Russell's grand house, 43 King Street, has been rescued from the indignity of a ground floor gutted to provide warehousing for vegetables, and is now restored as dignified office accommodation.

The London Transport Museum now occupies half the Flower Market; the display is an impoverished selection of the buses, trams, and trains that

¹ Grandson of the fourth, nephew and son-in-law of the fifth earl, he defeated the French at La Hogue and became First Lord of the Admiralty and Earl of Orford.

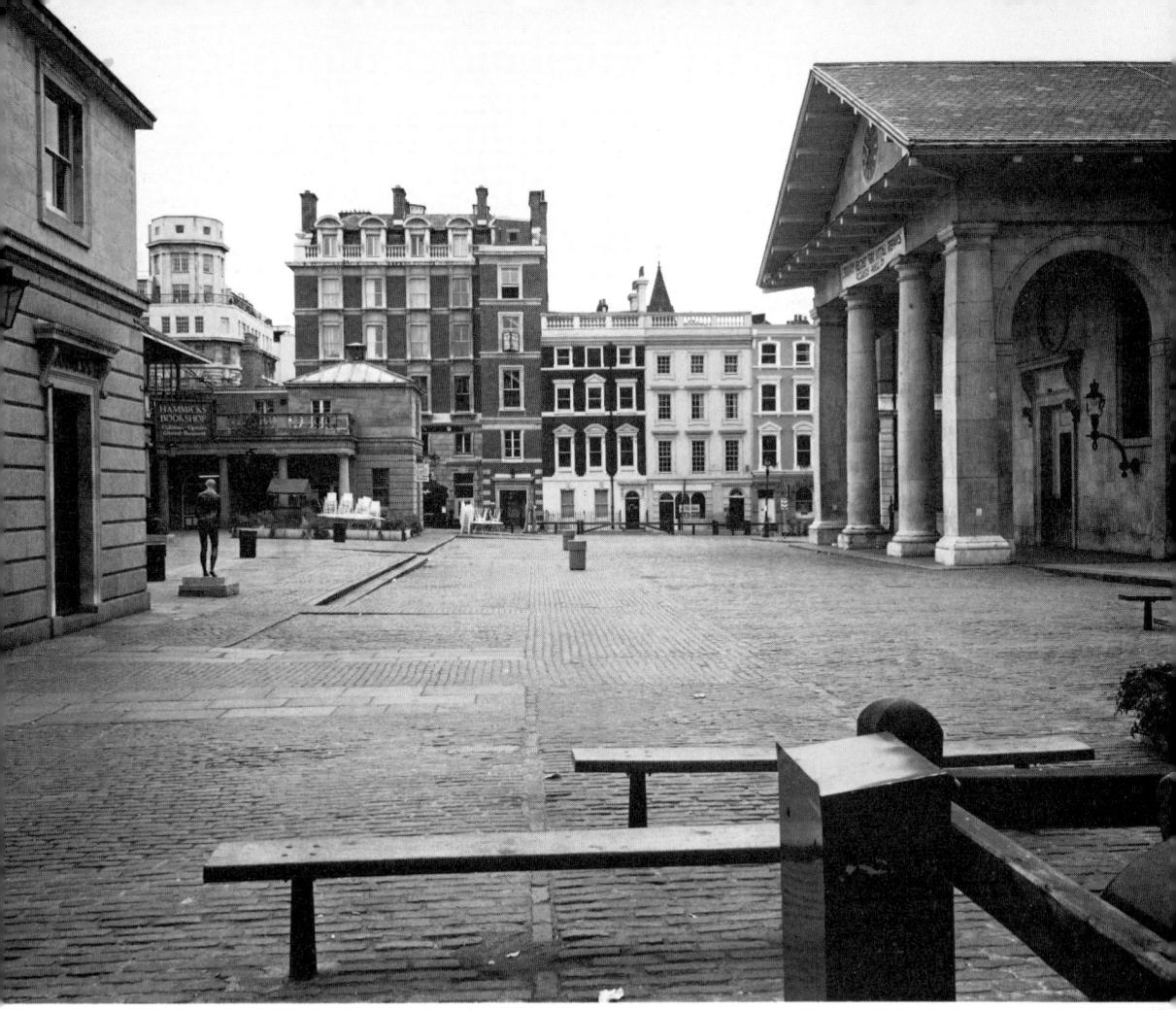

Covent Garden

used to crowd the old premises in Clapham Bus Garage. Additional vehicles are stored at Broughton near Swindon and we must hope that one day a fuller showing will be possible; in the meantime there is an excellent selection of publications for sale. The other half of the building now provides premises for the National Theatre Museum, which opened in 1987. The Museum is at present housed in the Victoria and Albert Museum; its holdings have been built up around three main collections - that of the British Theatre Museum, which is based on the Henry Irving archive, the Gabrielle Enthoven collection of playbills and theatre programmes given as early as 1924, and the Richard Buckle Museum of Performing Arts. Besides programmes and playbills, there are paintings, scripts, stage designs, costumes, prompt copies, photographs, and ephemera. The Museum's opening is awaited eagerly.

To the south-east and the north of the Market stand the Theatre Royal, Drury Lane, and the Royal Opera House, both inextricably part of Covent Garden's history. A first theatre was built on the Catherine Street corner of the Drury Lane site in 1663; here Nell Gwynne appeared in Dryden's Indian Queen. That building was burnt down in 1672 and was replaced by another, probably designed by Wren, at which David Garrick appeared with such success from 1747 till his retirement in 1775, when Richard Brinsley Sheridan took over and commissioned Henry Holland to rebuilt the theatre in 1794. Holland's creation was acclaimed as the loveliest theatre in Europe, but it too perished in flames on the night of 24 February 1809, Sheridan watching the destruction with philosophical composure from a coffee-house nearby. The fourth building, completed by 1812, was designed by Benjamin Wyatt, with a Doric vestibule and a domed entrance hall from which staircases, to left and right, lead up to the domed fover on the first floor - no other theatre has quite such elegance and style. In 1820, James Spiller added the porch with its coupled square Doric pillars, and in 1831 Samuel Beazley gave it a

long colonnade of Ionic pillars on the eastern frontage towards Russell Street. Drury Lane is famous for its spectacular musicals; its longest run was *My Fair Lady* which ran for 2281 performances from 30 April 1958.

Drury Lane's rival and companion theatre was built in 1732 by the manager John Rich, who became wealthy in fact as well as in name after a long series of successes culminating in the production of John Gay's Beggar's Opera in 1728. That theatre was burnt down in 1808 and its successor, designed by Sir Robert Smirke, was similarly destroyed in 1856. The present theatre was built by E. M. Barry, the six giant Corinthian pillars of its portico being a welcome and familiar sight to all opera-lovers. In niches on either side stand figures of Melpomene and Thalia by C. Rossi, and inside the portico runs a frieze by John Flaxman showing Tragedy and Comedy; these have been preserved from the earlier building. The Royal Opera and the Royal Ballet have their home here; before long, an extension with rehearsal rooms is to be built towards James Street.

Long Acre, its name a memory of the field which once lay here, marks the northern boundary of the Bedford Estate; it was planned as a continuation of Great Queen Street, which linked it to Lincoln's Inn Fields (see p. 210). Among its residents have been Oliver Cromwell (1637-43), Nicholas Stone, the sculptor (1615-45), John Dryden, the poet (1668-86), and Adrian Vandiest the painter (1698–1704). Some unusual office and residential development is in progress along its northern side. At the western end of Long Acre is Garrick Street, driven through in 1860 as part of a great slum clearance. In this street stands the Garrick Club, designed by F. Marrable, possessing an excellent theatrical library and a remarkable collection of paintings and sculpture connected with the stage. Northward lies Seven Dials, laid out in 1693 by Sir Thomas Neale. The curious name comes from the pillar which used to stand in the centre of the radiating star of streets, a sundial on each face turned towards a street opening. The column is now on Weybridge Green where, surmounted by a ducal coronet, it serves as a memorial for the Duchess of Northumberland; the original top rests in Weybridge Museum. Seven Dials was to become one of the worst criminal areas of London, its horrors portrayed in Hogarth's engraving Gin Lane, and described in chapters XVI and XLVI of Dickens's novel Bleak House, where it features as Tom-all-Alone's. Today, it is being renovated into something far more pleasant; the British Crafts Centre in Earlham Street is worth visiting, and people

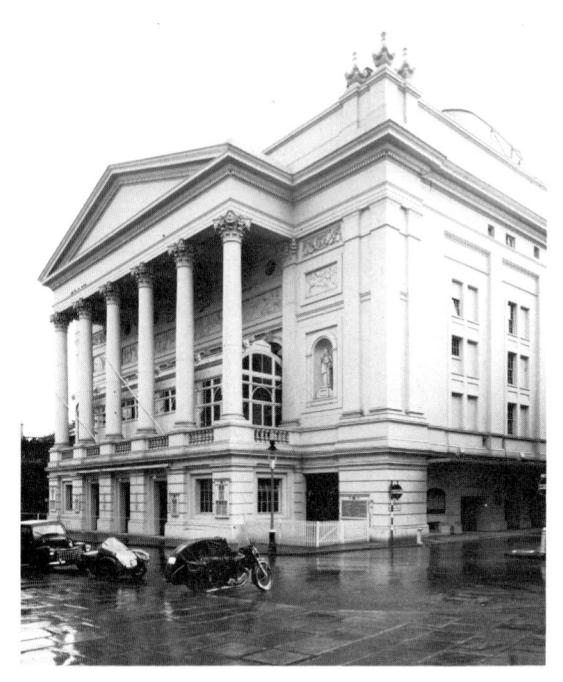

Royal Opera House, Covent Garden

travel for miles to make purchases at the bread and health food shops in Neal Street and Neal's Yard. Nearby, in Great Newport Street, is the Photographers' Gallery, where excellent displays are regularly held.

To the south again, by way of St. Martin's Lane, are three theatres, the Albery (formerly the New, built 1903 by W. G. R. Sprague), the Duke of York's (1892 by Walter Emden), and the gloriously flamboyant Coliseum topped with its globe (1904, Frank Matcham; now the home of the English National Opera), as well as a fine late Victorian public house, the Salisbury, which glitters with cut and frosted glass. Opposite is a narrow alleyway, hard to discover, called Goodwin's Court, in which numbers 1-8 have remained unaltered since the late eighteenth century. In St. Martin's Lane lived Abraham Vanderdoort, resident from 1630 to 1639, who was keeper of Charles I's collection of paintings, as well as Sir Theodore Mayerne, the king's physician, Sir John Suckling, the poet, and Carew Raleigh, Sir Walter's son. In the next century, the two Thomas Chippendales, father and son, had their premises from 1753 till 1813 at numbers 60-61, where they designed and made fine furniture.

The Embankment

The embanking of the River Thames was a landmark in sanitary reform and a major achievement of Victorian engineering. The undertaking was first proposed by Wren, and was recommended again in the early nineteenth century by Sir Frederick Trench and by the painter, John Martin, who suggested that such an embankment should enclose the main drainage. Nothing was done till after the summer of 1858, when the stench in the Houses of Parliament made only too obvious the absence of a low-line main sewer. The work was carried out in three stages by the Metropolitan Board of Works, whose engineer was that remarkable man, Sir Joseph Bazalgette. The Victoria Embankment on the north side (one and a quarter miles long, cost £1,156, 981) was completed between 1864 and 1870;1 the Albert Embankment on the south (nearly a mile long, £1,014,525) was built between 1866 and 1869, and the Chelsea Embankment (nearly threequarters of a mile, £269,591) was constructed between 1871 and 1874.

The imagination plays with what other European capitals - Paris, Vienna, Budapest - would have made of such an opportunity. In London, we have a plain, solid embankment with a broad roadway, which lays bare London's spine, the reason for its existence, the hard-working River Thames. On the northern side of the road along the Victoria Embankment, four narrow strips of prim gardens have provided the nation with places in which to display a mixed collection of memorials to a medley of famous and worthy people. When considering this interesting random selection of late nineteenth- and early twentieth-century sculpture, one must remember that they were all, save Thornycroft's Boadicea, commissioned as memorials, with the limitations that a specific commission implies. Far greater freedom, both of imagination and of execution, may be observed in the dolphins which twine and sport about the lamp-posts, and in the benign camels and genteel sphinxes which crouch to support the seats lining the riverside.

A walk from Westminster Bridge to Blackfriars Bridge, though it can hardly claim to be beautiful, does reveal a different, less public, aspect of London. The walker may turn his attention from the nearby buildings and statues to observe the purposeful waters of the Thames as they ebb and flow, and to look across at the varying panorama of the South Bank which begins with County Hall beside Westminster Bridge, continues with the Royal Festival Hall and the National Theatre after Hungerford Bridge, and beyond Blackfriars Bridge begins to reveal the new buildings which compose the redeveloped riverscape of today's London.

By Westminster Bridge stands Thomas Thornycroft's statue of Boadicea and her daughters. The queen stands stiffly upright, spear in hand, her daughters crouch besides her in their scythed chariot, which is drawn, apparently without harness, by rearing horses. The sculptor began work in the 1850s and laboured for 15 years, at first with the encouragement of Prince Albert, who wished to place the group on top of the arch at Hyde Park Corner. but the Prince died before Thornvcroft had finished and it was not till after the sculptor's own death that his son presented the work, in plaster, to the nation in 1895. Mr. W. J. Bull, the Chairman of the London County Council, raised a subscription to have it cast in bronze and it was at last set in its present position in 1902.

Opposite the statue are the steps to Westminster Pier, from which, during the summer months, it is possible to travel by water down stream to Greenwich or westwards to Kew, Richmond, and Hampton Court – the pleasantest and least hackneyed way of seeing London.

Behind Boadicea's statue is the mass of New Scotland Yard, erected to Norman Shaw's designs between 1888 and 1890, with an annexe to the south added in 1906. The building, Shaw's only important public work, is stern and authoritative, as befitted a police headquarters. It is six storeys high, granite for the ground floor and brick with stone bandings above, with circular tourelles at the angles hinting at a medieval castle; a bust of the architect, carved by Sir Hamo Thornycroft and cradled in a roundel, is set high on the wall. Today the building provides

136 WESTMINSTER

accommodation for Members of Parliament. On the far side of Richmond Terrace stands the Ministry of Defence (designed in 1898 by William Young and completed after his death by his son), with the terrace designed for Mary II by Wren, its two flights of landing steps showing clearly how much land had to be reclaimed from the river to form the Embankment. Here is the first stretch of garden, in which stand statues to Lord Trenchard (1961, by William McMillan) and to General Gordon (1888, first placed in Trafalgar Square, but removed to the gardens in 1953). Opposite the gardens, on the river side of the road, is the memorial to the Royal Air

Force, designed by Sir Reginald Blomfield. A great golden eagle, executed by W. Reid Dick, perches on top of a stone stele.

Beyond Horse Guards Avenue is a second stretch of garden lying between the river and Whitehall Court (Archer and Green, 1884), of which the extraordinary roofline, turreted like a French château, provides a fantastic termination to one of London's most romantic vistas, looking north-eastwards across Horse Guards' Parade from St. James's Park. The National Liberal Club is attached to the northern end of Whitehall Court; solemnly Gothic, it was designed in 1884 by Alfred Waterhouse. A new

Hungerford Lane, Charing Cross

marble staircase, running unsupported through three storeys, was inserted during 1951 by Clyde Young and Engel. In the garden on the river side stand three large bronze statues, William Tyndale by Sir Edgar Boehm (unveiled 1884), Sir Bartle Frere by Sir Thomas Brock (1888), and General Sir James Outram by Matthew Noble (1871).

At this point, Northumberland Avenue cuts down from Charing Cross to the river-bank. It was driven through in 1874 and necessitated the demolition of Northumberland House. The original mansion had been built by Bernard Jansen and Gerard Christmas between 1605 and 1609 for Henry Howard, Earl of Northampton. Successive generations made additions and alterations to it, its title changing whenever the property passed to the distaff side. Algernon Seymour, 6th Duke of Somerset, added a new west wing in 1749, in which his daughter, Elizabeth, wife of Sir Hugh Smithson, later the first Duke of Northumberland, commissioned Robert Adam to create a Glass Drawing Room, its walls lined with red and green spangled glass and elaborate gilt metalwork, and hung with eight great tripartite gilded mirrors, ordered from Picardy in France at a cost of £1,465, on top of which the Duke had to pay 75% duty. Paintings above the doors and in ovals on the walls were executed by Cipriani. The divisions of the painted ceiling matched the arrangement of the mirrors on the walls, and the effect at night when the great central chandelier was lit must have been an endless, glittering vista in which the brilliance of the mirrors, the bold colours of the walls, and the finery of the company were reflected back and forth. It was perhaps the most sophisticated interior Adam ever created. Deliberately theatrical, he used the same colour scheme again for his redecoration of Drury Lane Theatre in 1775, the year in which the work at Northumberland House was completed. Unfortunately, the Duchess died a year later, having hardly had time to enjoy her gaudy Drawing Room. Adam did not repeat the design - few patrons had the courage or the money to surround themselves with such a setting. At the time of the Great Exhibition, Northumberland House was opened to the public at the express request of Prince Albert, but by then, Adam's style was judged to be 'quaint ... too intricate and discordant', rather than magnificently dramatic.

When in 1873 the 6th Duke reluctantly agreed to sell the house to the Metropolitan Board of Works so that it might be demolished to give easier access to the new embankment, the panels and ceiling from the Drawing Room were crated up and the great Percy lion, made of Coade stone, was removed from above the gateway to be installed in a similar position at Syon House. After the Second World War, the Drawing Room was sold to an antique dealer, who hired the wall-panels out as decor for debutante balls, till at last in 1955 the remains were purchased for the Victoria and Albert Museum, where they

Victoria Embankment gardens

were restored and have now been reassembled and put on display in the Department of Woodwork, a travesty of what the room once was but still a fine reminder of Adam's panache and of the first Duchess's brilliant entertaining.

Beyond Northumberland Avenue is Charing Cross Station, built in 1863 on the site of Hungerford Market which had opened in 1682. The railway lines are carried across to the south bank by a bridge of iron girders, replacing a suspension bridge installed in 1845 by Brunel. That graceful structure can still be seen over the Avon Gorge at Clifton near Bristol. The present railway bridge accommodates a footbridge which provides remarkable views down the river towards the City.

On the further side of the station is another stretch of garden, in which stand six statues, two other memorials of a more architectural nature, and one of London's most unusual relics, the Water Gate of York House (see p. 122). The statues include three conventional bronze figures – Robert Burns by Sir John Steell (erected 1884), Sir Wilfred Lawson, the temperance reformer, by David McGill (1909), and Robert Raikes, the founder of Sunday schools, by Sir Thomas Brock (1880); this last is the most successful of the three. A bronze bust of the composer, Sir Arthur Sullivan, is set on a stone pedestal; it is the work of W. Goscombe John (1903), and the sculptor added, at his own expense, a graceful bronze figure of Music, who clings, mourning and dishevelled, to

the stone. Near it, above a granite basin designed by Basil Champneys, is a bronze medallion, the work of Mary Grant, to the blind Postmaster-General, Henry Fawcett (1886), and close by is a small memorial to the Imperial Camel Corps, by Cecil Brown (1921), with a bronze trooper mounted on a most life-like camel. At the far end of the garden is a lily-pond, in memory of Lord Cheylesmore, and beside the road is a long, curved wall designed by Sir Reginald Blomfield, which provides a background for a more than life-size bronze group of a woman, a boy, and a girl carrying wreaths and flowers. The work of Victor Rousseau, they were given 'to the British Nation from the grateful people of Belgium', many of whom took refuge here during the 1914–1918 War. It was unveiled in 1920.

Waterloo Bridge, London's first concrete bridge, spans the Thames in five effortless arches, the downstream side giving an uninterrupted view of the riverside façade of Somerset House (see p. 125). Built to the designs of Sir Giles Gilbert Scott, it was completed in 1944 under great difficulties, due to the Second World War. It replaced an earlier bridge, designed by John Rennie and built 1811–17, which the sculptor Canova declared was the most beautiful in the world. It had nine semi-elliptical arches and each pier was adorned with a pair of Doric columns, which supported an entablature running the whole length of the bridge.

Beyond Somerset House is a last snippet of garden in which stand three statues, all life-sized and in bronze, and the pedestal for a fourth. There is an uninspired figure of that splendid engineer, Isambard Kingdom Brunel, by Carlo Marochetti (erected 1890), a more satisfactory statue of the statesman, William Edward Forster, who carried through the bill introducing elementary education, by H. Richard Pinker (unveiled 1890), and a third of John Stuart Mill by Thomas Woolner (erected 1878). The empty pedestal once supported a memorial to the temperance advocate, Lady Henry Somerset. It took the form of a bronze statue of a little girl holding a jug of water and was unveiled in 1897, but, some years ago, it was wrenched from its stand and has disappeared.

Two silver and scarlet dragons by the roadway and a stone tablet with Queen Victoria's head, by C. H. Mabey, attached to the railings of Temple Garden, mark the boundary of the City. Near Blackfriars Bridge stands a statue of Queen Victoria in middle age, nine feet high in bronze, made by C. H. Birch and unveiled in 1896. The present Blackfriars Bridge, built to the designs of James Cubitt, was completed in 1869. Adorned with four stout columns of pink Aberdeen granite, their capitals wreathed with carved foliage, it was widened in 1907–9 from 80 to 110 feet in order to provide space for a tramway.

Returning towards Westminster by the riverside, there is first a massive water-gate with the inscription that this section of the Thames was named the King's

Reach in 1935, in commemoration of George V's Silver Jubilee. Just beyond it is an oblong bronze plaque by F. Brook Hatch and A. H. Ryan Tenison, a memorial to the submarines and men lost in the First and Second World Wars; the relief shows the interior of a submarine with her crew, while around the hull outside sinister figures with nets drag her down to destruction. Two panels give the numbers of the fifty craft lost in the First World War and two more have been added with the names of those lost in the Second.

On the Embankment wall near to Waterloo Bridge are two plaques, both by Sir George Frampton, to the journalist, W. T. Stead, who was lost with the Titanic in 1912, and to the writer, Sir Walter Besant, who founded the Society of Authors. Beyond the bridge stands Cleopatra's Needle, an Egyptian stele which has no historical connection with the fascinating queen. The pink granite obelisk, $68\frac{1}{2}$ feet high, was in fact erected about 1500 BC by Thothmes III near Heliopolis and was later removed to Alexandria. It was presented in 1819 to the British Nation by Mehemet Ali and was at last brought to London, with great difficulty, 'through the patriotic zeal of Erasmus Wilson, F.R.S.', in 1878. The two bronze sphinxes at the base were designed by G. Vulliamy and were modelled by C. H. Mabey. The obelisk was slightly damaged by a bomb, one of the first to hit London, dropped on 4 September 1917; the marks are still visible on the base and on a nearby tree.

Opposite Embankment Station are two more plaques, the first, by Frampton, to William Schwenk Gilbert (unveiled 1913), and the second, by George Simonds, to Sir Joseph Bazalgette, the engineer of the Embankment. Gilbert's bronze bas-relief incorporates figures of Tragedy and Comedy; the latter toys with a dangling string of puppets representing characters, including the Mikado, from the Savoy operas.

At this point, Westminster Bridge is in sight again. The present structure was designed by Thomas Page and was opened in 1862. Spanning the river in seven arches which rest on granite piers, it replaces an earlier bridge of exceptional interest. That structure was the work of a Swiss engineer, Charles Labelye; its 15 arches were built between 1739 and 1747. Till its construction, London Bridge was the sole means of crossing the Thames, other than by boat, and the protests of the City Corporation, of the inhabitants of Southwark, of the Watermen's Company, and of the shop-keepers on London Bridge, were vociferous when the new bridge was proposed. The work was, however, carried out through the resolution of the backers who included the Archbishop of Canterbury and the Earl of Pembroke, and the staunch determination of the engineer who had to overcome many unforeseen problems. It was from the top of the Dover coach, crossing Labelye's bridge, that the young William Wordsworth caught the view of London which inspired the sonnet he composed during the rest of the journey.

South from Piccadilly lies the aristocratic hinterland of St. James's, stretching across the Mall and through St. James's Park to Birdcage Walk, Even today, save along Pall Mall, it is secluded from the worst concourse of traffic. It is an area of royal residences, grand houses, exclusive clubs, dignified shops, and sheltered arcades in which a gentleman may saunter and pass the time on a wet afternoon before going to his club for tea. For this is a man's enclave; Bond Street, north of Piccadilly, is for the ladies, but the shops in Jermyn Street cater for gentlemen, with made-to-measure shirts and hand-made ties and fine leather goods and first editions and vintage port. Even today, here, masculine taste reigns supreme.

The main lines of its development run from east to west; entering from the north, one must choose a byway or descend the slope of St. James's Street, where the elegant and self-assured architecture of the clubs on either side - Brooks's (1777-8, Henry Holland), the Carlton Club (1826–7, Thomas Hopper) and No. 74, the building formerly occupied by the Conservative Club (1843-5, Sydney Smirke and George Basevi), on the west, White's (1787–8, James Wyatt, altered 1852) and Boodle's, with its graceful Venetian window (1775, John Crunden, with subsequent alterations) on the east - remain to be admired.

At the southern end of the street, the gateway of St. James's Palace, built in the 1530s by Henry VIII, closes the vista. A lazar house, dedicated to St. James, had stood here since the thirteeth century; the King purchased the land in 1532, settled annuities upon the inmates, razed the old buildings, and erected a new, small, royal residence. In it, Mary Tudor died and Charles I slept peacefully on the night before his execution. Charles II, understandably, disliked Whitehall, since it was there that his father had suffered, and so made St. James's his principal residence, building a new pall mall alley in which he displayed his skill at the sport. He improved the grounds too, laying them out, probably on the advice of Louis XIV's gardener, Le Nôtre, with a long straight canal down the centre, and then he opened the park to the public, so that he might see and be seen by his subjects. When Whitehall Palace was burnt down, William III asked Wren to create new state rooms at St. James's and life at the eighteenthcentury court is intimately described in the diaries of Fanny Burney, the novelist, and of Mrs. Papendiek, both of whom served at the court of George III. The Palace eventually ceased to be used as a royal residence when Buckingham Palace became the

monarch's London dwelling.

Today, the Palace houses the Lord Chamberlain's Office and is not open to the public, but since it stands directly on the roadway and since three of the four courtvards may be entered freely, it is possible to study the red Tudor brickwork with its blue diapering, and to admire Wren's embattled additions on the south side of the Engine Court. The most important architectural details of the interior are the staircase, the State Rooms, the Banqueting Hall, the Armoury and the Tapestry Room. The staircase is probably an early Georgian development of one inserted by Wren; two flights converge on each other, meeting at the landing, and then proceed straight upwards on their separate ways. In the Throne Room, on either side of the fireplace, hang two superb garlands of fruit and flowers carved by Grinling Gibbons. The Armoury and Tapestry Room both still have their Tudor fireplaces, but were redecorated in 1866-7 by William Morris, which indicates that somebody about the Court at that period had very advanced tastes. The tapestries were woven for Charles II though they were not hung till 1795. One chamber in the palace is, however, accessible, for the Chapel is open for divine service on certain Sundays throughout the year; The Times should be consulted on a Saturday for details of services throughout London. The Chapel is part of Henry VIII's palace, though it was redecorated in the 1830s. The painted roof, traditionally said to be Holbein's work, remained undisturbed. Here were contracted the marriages of Princess Mary to the Prince of Orange, later William III, of George III to Princess Charlotte, of Queen Victoria to Prince Albert, and of the Duke of York, afterwards George V, to Princess Mary of Teck, and it was here that Wren married his second wife, Jane Fitzwilliam.

The south-west end of the State Rooms is joined to Clarence House, built by Nash in 1825-7 for the Duke of Clarence, who became William IV. To the west of the Palace stands Lancaster House and to the east are the Queen's Chapel and Marlborough House. Lancaster House was built in 1827 by Benjamin Wyatt for the Duke of York - 'the grand old Duke of York' of the nursery rhyme - who was George IV's younger brother and heir presumptive to the throne, but he died before the work was finished and the mansion was sold to the Marquess of Stafford, the proceeds being used to purchase and lay out land for Victoria Park in Bethnal Green, thus giving East London an open breathing-space. The Marquess, later Duke, of Sutherland had the house enlarged by Robert Smirke, and Charles Barry was called in to advise on the sumptuous decorations. The second Duke was married to one of Queen Victoria's closest friends, Harriet, daughter of the Earl of Carlisle and Mistress of the Robes from 1837 to 1861. The young Duke and Duchess were liberal in their views and ardent in their support of social reform - here Shaftesbury advocated the cause of factory children and Garrison, the American abolitionist, the cause of the slave, while in 1864 Garibaldi, the Italian patriot and revolutionary, was the guest of the third Duke and people stopped in the streets to cheer him as he passed by. A generation later, the fourth Duchess made her house the London headquarters of the aristocratic intellectual group known as 'The Souls'; its members, among whom was Arthur Balfour, concerned themselves with serious social problems which they discussed at meetings on Friday afternoons. The house was, for nearly a century, of great importance in London's cultural life; a part of the Orleans Collection of paintings hung in the Great Gallery and in 1848 Queen Victoria came here with Prince Albert to listen to Chopin playing the piano.

In 1912, the Sutherlands decided to give up the house. It was bought by Viscount Leverhulme as a gift to the nation for official entertaining and to house the London Museum. In 1941, the museum was transferred to Kensington Palace;1 the decorations were restored after bomb damage and the house is once again a centre of government hospitality. When official engagements permit, the public is admitted. The exterior of the house is very plain, save for the two-storyed Corinthian portico which marks the entrance. All the grandeur is within, so that Queen Victoria used to say to her friend, 'Now I have come from my house to your palace', and indeed the scale is such that the visitor is reminded of Versailles. The entrance hall with its Grand Staircase is among the most magnificent in England; lit from a clerestory, it rises to the full height of the building and leads to a series of State Apartments of which the most important is the Grand Gallery, with a painting by Guercino, taken from the church of St. Grisogonus at Trastevere in Rome, let into the ceiling, and

four great decorated mirrors, two of which reflect the vistas through the suite of State Rooms. It was here on 5 June 1953 that Sir Winston Churchill gave a coronation banquet to his new sovereign, Elizabeth II.

Marlborough House has a longer history than Lancaster House. It was built in 1709-11 by Sarah, Duchess of Marlborough, friend of Queen Anne and wife of the victorious general. Sir Christopher Wren, when designing it for her, followed her instructions to make it 'strong, plain and convenient' and in complete contrast with the elaborate palace at Blenheim, which Sir John Vanbrugh had designed and a grateful nation had given to her husband, but which she had never liked. It is said that the small, bright red bricks from which the house is made were shipped to England as ballast in Marlborough's empty, returning troop-ships. Before the house was finished, the Duchess took the direction of it into her own hands; she felt that Sir Christopher, 'the poor old man' as she called him, was being cheated by the contractors. One touch of grandeur and of wifely pride the Duchess permitted herself; she called in Louis Laguerre, Louis XIV's god-son, who had settled in England in 1684, and bade him paint, around the walls and the staircases and the central hall, her husband's victories, which were, of course, the defeats of his godfather's generals. Sarah died here in 1744, irascible, indomitable, and fascinating to the last; her descendants asked Sir William Chambers to enlarge the trim, compact building in 1770-2, and

Green

Park

Constitution Hill

Buckingham

Palace

ST. JAMES'S AND PICCADILLY

Albany

St. James's Park

Constitution Hill

Co

¹ It is now the Museum of London in the City (see p. 61).

they continued in occupation until their lease ran out in 1817. The house then reverted to the crown and, until Queen Mary's death in 1953, housed members of the royal family. Since then, it has been used for government and Commonwealth entertainment; the public is admitted on guided tours when possible.

The main feature of the much altered interior is still Sarah's one triumphant gesture, the frescoes depicting her husband's victories. Blenheim, his first and greatest success, which saved Vienna from falling into French hands in 1704, is represented around the Saloon, the hall of the original house: in the main scene opposite the entrance, the French commanderin-chief, Marshal Tallard, surrenders to the Duke. Ramillies (1706), perhaps Marlborough's most brilliant action, rages up and down the main west staircase, and Malplaquet (1709) is grimly fought out on the lesser east stair. Apart from the artist's considerable skill, these paintings, executed within a few years of the actions they commemorate, are an important contemporary record of military techniques, and are unusually interesting in that they portray the participants in the uniforms they would have worn, at a time when Thornhill, at Greenwich, was representing William III arriving in England in Roman attire. The ceiling above the Blenheim mural is of great importance, for it is the one originally painted by Gentileschi for the hall of the Queen's House at Greenwich, hacked from its original setting and squeezed into the ceiling compartments at Marlborough House. The circular central panel depicts the nine Muses and the Fine and Liberal Arts:

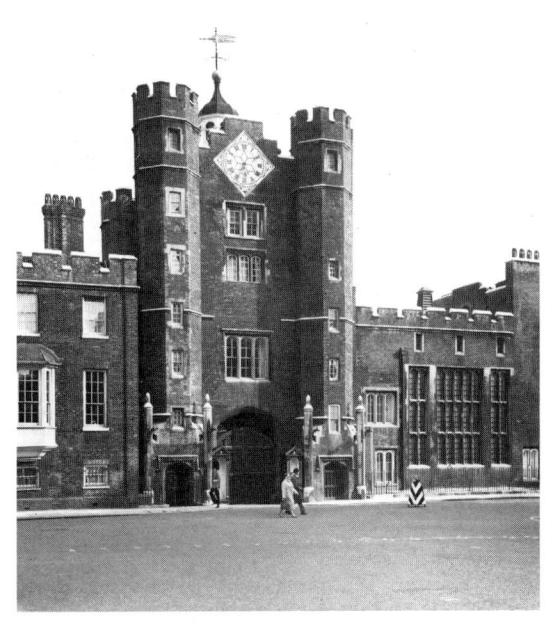

St. James's Palace, St. James's Street

Painting, Music, Geometry, and Sculpture fill the corner roundels, and the mutilated rectangles show Comedy and Tragedy. The nine panels were originally designed to repeat the geometrical pattern on the marble floor of the Oueen's House.

The visitor to Marlborough House is also admitted to the Queen's Chapel, built by Inigo Jones for Charles I's French bride, Henrietta Maria. It was originally attached to St. James's Palace, but the cutting through of Marlborough Road isolated it from the rest of the palace buildings. A double cube, 110 feet long and 55 feet wide, it has an elaborately coffered, carved, wooden roof and a western gallery for the royal pew. It is claimed that the soft olive green and white of the walls has changed little since the seventeenth century. During the early summer months, anyone may attend morning prayer here.

North-east from the Palace is the rectangle of streets bounded by Pall Mall, the Haymarket, Piccadilly, and St. James's Street, to which the name of St. James's most properly belongs. The heart of the area is St. James's Square and the land on which it stands was first leased in 1661, and was later granted freehold, to Henry Jermyn, Earl of St. Albans, who had faithfully served Charles II throughout his long exile. Iermyn had intended the Square to be surrounded by noblemen's palaces; the mansions as built were less magnificent, but they still formed a distinct and handsome court suburb. His own house. at the south-east corner, was probably designed by Sir John Denham and the façade, red brick with stone facings, three storeys high, was copied with a fair degree of regularity around the square, thus producing a development nearly as elegant as Inigo Iones's at Covent Garden. The tight-knit unity of the square was emphasized by the limited access to it: three comparatively narrow streets led into it from the centres of the north, east, and west sides (Duke, now Duke of York Street, Charles II Street, and King Street), and two alleyways on the south side were all the entries. Within a century, the houses began to be rebuilt so that nothing of the original development remains today, but a few words about the dwellings. past and present, in St. James's Square, may be of interest.

In the southern half of the east side stood Norfolk House, built on the site of Jermyn's own house between 1748 and 1752 to the designs of the elder Matthew Brettingham. The house was long and low, nine bays wide and built of brick; the interior was magnificent. When it was completed, a great reception was held and Horace Walpole reported:

All the earth was there ... You would have thought there had been a comet, everyone was gaping in the air and treading on one another's toes ... The lightness and novelty of the ornaments, and the ceilings are delightful.

The house was demolished in 1938, and the block of flats which replaced it provided General Eisenhower

142 WESTMINSTER

with a headquarters for the First Allied Army during the Second World War. One single apartment, the Music Room, was spared and has been resurrected at the Victoria and Albert Museum. Brettingham designed a large room, 30 feet by 20 feet, with a ceiling divided into compartments, on the pattern of that in the Banqueting Hall in Whitehall. This solid Palladian framework was overlaid with rococo decorations, in direct contrast with the rooms that Burlington had designed for himself in Piccadilly (see pp. 150, 151). The Duchess of Norfolk, a forceful lady, was Roman Catholic, and looked to the prevailing style on the Continent for an example. An Italian, Giovanni Baptista Borra, was called in to provide designs for the adornment of the house. Into the staid compartments of the ceiling, he inserted fantastic trophies - a martial one in the centre flanked by Painting and Sculpture, with Music, Science, and Astronomy on the west and Literature, Architecture, and Geometry on the east.

A careful examination of Architecture reveals that it includes a plan for Norfolk House. Borra also designed the gilded woodwork and trophies composed of musical instruments which adorn the mirrors and the fire-places; the former were carved by John Ceunot and the latter sculpted by James Lovell. The whole room was painted in white and gold and even today, torn from its proper surroundings and imprisoned in a museum, it is breath-taking. The Victoria and Albert Museum also possesses one of the 'monkey' doors from the Green Drawing Room, in which animals swarm over the ogee-shaped pediment above the lintel.

Walking anti-clockwise about the Square, we pass number 33. The original house on the site was demolished in 1770 and a new one was built for the Hon. George Hobart, later Earl of Buckinghamshire, by Robert Adam; the designs are in the Soane Museum. Additions were made by Sir John Soane between 1817 and 1823, and from 1824 till 1840 it was the home of John Julius Angerstein, whose collection of paintings formed the nucleus of the National Gallery. The house is today used by the National Provincial Bank and is kept in a state of good repair. On the far side of Charles II Street, numbers 1–3 have been rebuilt, but number 4 is of

Red Lion Inn, Duke of York Street

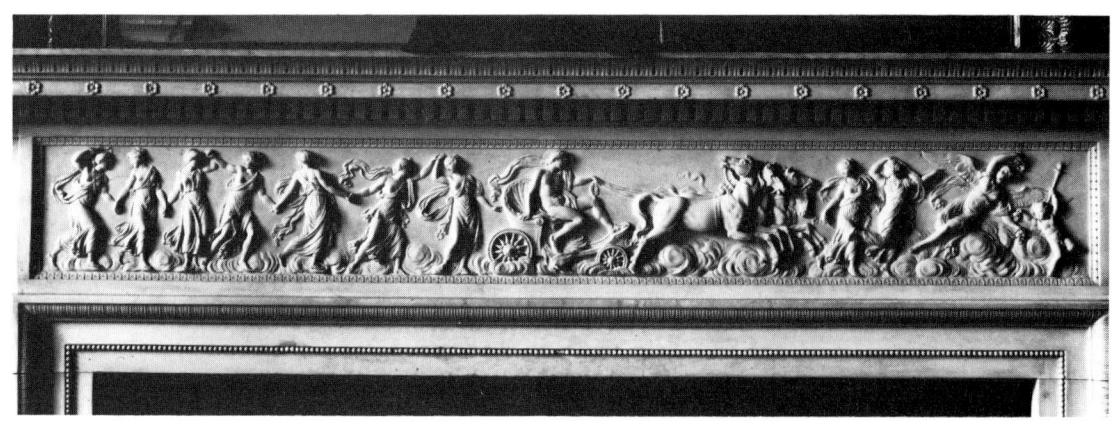

Detail of interior decoration, 20 St. James's Square

exceptional interest. The original house was burnt down in 1725 and a new house was built in its place by the Duke of Kent, who was seriously interested in architecture. We do not know whom he employed – claims can be made for Nicholas Hawksmoor, Giacomo Leoni, or Edward Shepherd - but the results were magnificent, with a splendid first-floor drawing-room approached by a broad staircase on one wall; in that niche stands a statue of Inigo Iones, said to be a studio copy of Rysbrack's figure at Chiswick House. From 1834 till 1859, number 4 was the home of the Earl de Grey, the first President of the Royal Institute of British Architects, who gave 'large and charming soirées', and from 1948 till 1968 it was the headquarters of the Arts Council. Today it serves as government offices and is no longer easy of access.

Number 5 was built in 1748-9 by the elder Matthew Brettingham for the second Earl of Strafford, though it was refaced with stone in 1854 by Messrs. Cubitt. Numbers 9, 10, and 11 were all built on the site of the great mansion, known at successive periods at St. Alban's, then Ormonde, then Chandos House. In 1733 the Duke of Chandos found himself in financial difficulties and sold the house to a builder called Benjamin Timbrell, who pulled it down and built three smaller dwellings on the site with Henry Flitcroft as his architect. Number 9 has housed three prime ministers – the elder Pitt from 1751 to 1761, Edward Stanley, Earl of Derby, from 1837 to 1854, and Mr. Gladstone during the parliamentary session of 1890. In 1923 it was bought to accommodate the Royal Institute of International Affairs and its neighbour, number 10, was purchased for the same body in 1943; the premises were made to communicate and are now called Chatham House. Some of the original rooms remain, more or less intact. Number 14, the narrowest house in the square with a hotchpotch of a façade, houses the London Library, beloved of scholars and serious readers, which was founded by Thomas Carlyle in 1841; the present building was erected in 1896-8 by J. Osborne Smith.

The original number 15 was the home of Frances Stewart, Duchess of Richmond, who adorned the court of Charles II and whose image as Britannia used to adorn our coinage. The house was rebuilt in 1765 by James 'Athenian' Stuart for Thomas Anson. It is three bays wide with a rusticated ground floor in which the door and the two windows have segmental heads. The windows to the first floor have triangular pediments, and giant fluted Ionic columns run between them, extending from the first to the second storey. Above the pillars is a triangular pediment of brickwork with simple mouldings. Inside, the fine plasterwork of the ceilings is particularly remarkable. The house was considerably altered in 1791-4 by Samuel Wyatt, working for Thomas Anson's great-nephew, another Thomas. In 1856, it was sold to the General Medical Society (today the Clerical, Medical and General Life Assurance Society) who still own and maintain the house.

Next door, occupying the sites of numbers 16 and 17, is the East India, Devonshire, Sports Club built for the East India United Service Club in 1865 by Charles Lee. The uniform, seven-bay-wide, stuccoed front has before it a range of flambeaux which are ignited for royal weddings and other suitable occasions, giving a wonderful atmosphere of excitement and sparkle to the square. The original house on the site of number 16 had been rebuilt in 1790 for Edward Boehm; his widow continued to reside there and it was at her house that the Prince Regent was dining on the night of 21 June 1815, when Henry Percy drove up in a carriage, defeated French eagles and battle standards sticking out of the windows, to deliver Wellington's despatch with the news of the victory at Waterloo.

On the far side of King Street, at number 20, now owned by the Distillers' Company, is the prettiest eighteenth-century survival in St. James's Square. The house was built between 1771 and 1775 by Robert Adam for Sir Watkin Williams Wynne, and

May Day 1775 was celebrated with a musical breakfast and country dancing below stairs. Of the façade, Adam wrote:

It is not in a space of forty six feet, which is the whole extent of the elevation, that an architect can make a great display of talents. Where variety and grandeur in composition cannot be obtained, we must be satisfied with a justness of proportion and elegance of style.

He achieved the finest facade in the square, not unlike Stuart's at number 15, but with Ionic pilasters, and a frieze and parapet instead of a pediment, the whole just that much more unified and elegant a composition than the earlier work, while the interior was probably the best ever designed for a comparatively small town house. The plasterwork of the ceilings was particularly delicate and throughout Adam used his favourite green and pink. From 1906 to 1920, it was the home of Lady Elizabeth Bowes-Lyon, the future consort of George VI. Though damaged by oil-bombs during the Second World War, the house has been well restored and is proudly maintained by the present owners. The Distillers' Company purchased number 21 next door and, while remodelling the interior, had the façade built to match Adam's work by Messrs. Mewès and Davis. A visit to number 20 is occasionally possible; application is by letter only.

In the garden of St. James's Square stands a statue of William III, clad in classical draperies, his proud horse about to tread the molehill which caused its rider's fatal fall. The statue was among the last works designed by John Bacon and was executed by his son, the younger John Bacon. West of the square, in King Street, is the Golden Lion, which has certainly held a licence since 1732, and opposite are the premises of Christie's, the auctioneers. The firm was founded in 1766 by James Christie, who opened his rooms in Pall Mall. Dying in 1803, he was buried in St. James's, Piccadilly. Twenty years later, the firm moved to King Street and has remained there since, though the original building had to be reconstructed after bomb damage. Sales, which are open to the public, are held five days a week, from early October till the end of July. Christie's will freely give a valuation and expert opinion on any article brought in to them. The nearby streets, especially Duke Street, house a concentration of art dealers.

King Street runs into St. James's Street where, in addition to the club architecture (see p. 139), the airy and dignified *Economist* group of buildings consisting of three towers of unequal height, sited so as to take advantage of the slight slope of the land, designed in 1962–4 by Alison and Peter Smithson, is worth attention. At the southern end of the street, on the east side, is a courtyard of four houses built in 1732, Pickering Place, and three shops, Messrs. Berry Brothers and Rudd, Messrs. Lobb, and Messrs. Lock. The first of these was a grocery established by

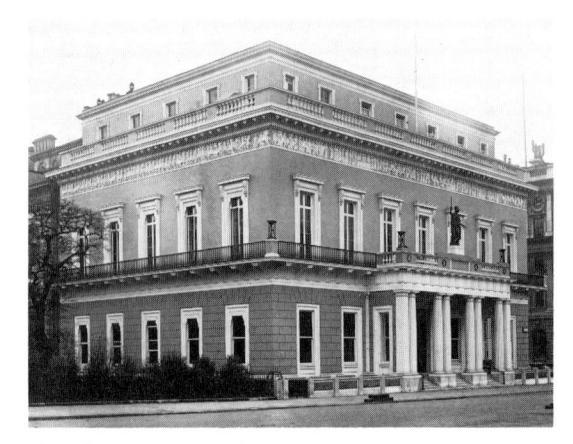

The Athenaeum, Waterloo Place

Widow Bourne in or about 1699 and later taken over by William Pickering, who also built the houses in the courtyard. In the late nineteenth century, the grocery trade was abandoned and the firm continued as wine merchants. The arcaded timber shop-front was built in the second half of the eighteeth century, though much restoration work had to be undertaken in 1931. Lock's the hatters have been at number 6 St. James's Street since 1765, though the business was founded in 1726 on the opposite side of the street by Charles Davis. The façade dates from the mideighteenth century, though the carcass may well be late seventeenth. The two corner blocks of offices, at the junction with Pall Mall, were both built by Norman Shaw for the Allied Assurance Company, the eastern corner in 1882, the western in 1903; they provide an interesting and convenient comparison between the middle and late stages of the great architect's development.

Little or nothing remains in Jermyn Street of the original seventeenth-century development, but Messrs. Paxton and Whitfield, the cheese merchants, have a nice mid-Victorian facade at number 93. In the Haymarket, which takes its name from the horse fodder sold there till 1830, are two theatres and a modern building, New Zealand House. The first Haymarket Theatre was built in 1720 and was replaced by a second building designed by John Nash in 1821. The white façade with its portico and pediment is one of the most magical theatre entrances in London; the interior was remodelled. successfully, in 1904. Her Majesty's, the fourth theatre to occupy the site, stands opposite. The first had been designed by Sir John Vanbrugh and opened in 1705; the architect's own comedy. The Confederacy, was produced here. The present building was designed by C. J. Phipps and S. L. Florence in 1895-8. Beside it, on the corner with Pall Mall, stands New Zealand House, designed by Robert Matthew, Johnson-Marshall and Partners in 1957-63. There is a four-storey podium from which rises a

ST. JAMES'S

15-storey tower, seemingly made of glass. On either side of the entrance from the Haymarket are glass panels engraved by John Hutton. Through the western side of the building runs Royal Opera House Arcade, the prettiest of all London's arcades, designed by John Nash and G. S. Repton in 1816–18. Along its western side runs a row of bow-fronted shops and above it is a groin-vaulted glass-domed roof

Pall Mall, like St. James's, is famous for its clubs. At the Haymarket end, on the southern side, is the former United Service Club, founded in 1817. The present building was designed by John Nash in 1827 and remodelled by Decimus Burton in 1842. The Pall Mall front has a Roman Doric porch, with a Corinthian portico and a pediment above it. Beyond it is Waterloo Place, created by John Nash as the southern end of his grand approach to Carlton House, which was demolished in 1829, almost as soon as the Via Triumphalis had been completed (see p. 161). By 1834, a column designed by Benjamin Wyatt had been set up in the centre to support a bronze statue by Westmacott of the Duke of York. The column and statue, which rise to the height of 137 feet 9 inches. are better proportioned than Nelson's, Around Waterloo Place stand six bronze statues, the best of them by Lady Scott to her husband, Captain Scott. To the north at the foot of Lower Regent Street, is the Guards' Crimean Memorial, designed by John Bell in 1859, with subsidiary figures of Florence Nightingale by A. Walker (added 1915) and Sidney Herbert by J. H. Foley (added 1867). On the western side of Waterloo Place stands the Athenaeum, designed by Decimus Burton in 1828-30 - a building of Grecian beauty, elegantly stuccoed, with a welcoming Doric porch surmounted by a large gilt figure of Pallas Athene by Baily. Above the main windows runs a Hellenic frieze by John Henning, painted in blue and white.

Returning to Pall Mall, the first club is the Travellers', designed by Barry in 1829–32 in the style of the Italian Renaissance, a plain, dignified building, two storeys high and five bays wide, with a handsome cornice and the front door set to one side. Barry also built the next club in Pall Mall, the Reform, completing it in 1841. Once again, he chose a Renaissance style, but this time built a grander, more regular, palazzo, faced in stone instead of stucco, nine bays wide and three storeys high. Continuing along Pall Mall, the Royal Automobile Club (Mewès and Davis, 1908-11) precedes Schomberg House. This was built in 1698 for the third Duke of Schomberg, whose father, William III's friend and supporter, fell at the Battle of the Boyne. The interior was completely rebuilt in 1956-8, but the old façade was retained; there is not much of this period still standing in London. The mansion was considerably grander than the average town house; it is of brick with stone dressings, four storeys high and nine bays wide, with three central bays, the end ones projecting. A

pediment at roof level crowns the centre and the main entrance is through a porch supported on Coade stone caryatids, which date from about 1791. In 1769 the mansion had been divided into three houses and it was in one of them that Gainsborough died in 1788, reconciled to Sir Joshua Reynolds, with whom he had quarrelled, and murmuring to the great portrait painter: 'We are all going to Heaven and Van Dyck is of the company.'

145

Almost opposite Schomberg House, on the site of 52 Pall Mall, stood Alderman John Boydell's Shakespeare Gallery. Boydell had made a fortune as an engraver and print-seller and in 1787 he engaged the younger George Dance to build for him a gallery. in which works by leading British artists should illustrate scenes from Shakespeare. He commissioned works by Reynolds, Romney, Fuseli, West, Angelica Kauffman, and John Opie and he paid handsomely for them. The gallery opened in June 1789 but the wars with France ruined the Continental market for prints and the good Alderman found himself in difficulties. He died in December 1804 and his estate was sold off by lottery in the following year, a Mr. William Tassie winning the Gallery and its contents, which were auctioned. The Gallery was pulled down in 1868-9.

Marlborough Road leads to the greenery of St. James's Park, passing on the way Alfred Gilbert's memorial to Queen Alexandria, with figures of Faith, Hope, and Love, representing the Queen's amiable qualities, clad in swirling Art Nouveau draperies, though the sculpture was not unveiled till 1932. Away to the east is Carlton House Terrace, white and stately, built in the early 1830s by John Nash on the site of Carlton House. The latter had been begun in 1787 by Henry Holland and had been enlarged and redecorated at enormous expense for the occupancy of the Prince Regent. The layout of Regent Street and Waterloo Place was planned to provide a triumphal approach to the Prince's abode, but the work was scarcely complete when the Prince, on becoming King, decided to enlarge Buckingham Palace and Carlton House was pulled down. The pillars from its façade were used for the portico of the newly built National Gallery and the two blocks of the terrace, each 31 bays wide, were constructed in its place. Built as grand private houses, they now accommodate institutions such as the Royal Society (number 6), the Institute of Contemporary Arts, and the Photographic Department and Archives of the National Portrait Gallery. During the Second World War, the corner building, 4 Carlton Gardens, served as General de Gaulle's headquarters.

The Mall, laid out on its present lines after the Restoration, provides a formal approach to Buckingham Palace. It is the most un-English thoroughfare to find in London, being far closer in spirit to the dignified composure of the Champs Elysées. Its character can be savoured most intently on a misty day in November. The park which it crosses provides a

friendlier landscape. Charles II's long canal was converted into an informal lake by Nash; the birds which the monarch introduced are still here: there have been pelicans in St. James's Park since Evelyn noted their presence in 1664. From the centre of the park, looking westwards towards Whitehall, is a magical roofline, across the top of Horse Guards' Parade to the domes and near minarets of Whitehall Court along the Victoria Embankment. Beyond Birdcage Walk, the southern boundary of the Park, is a fine row of early eighteenth-century houses, Queen Anne's Gate, with the National Trust at present at number 42, while against number 15 stands a statue of Queen Anne, already in the street by 1708. Beyond are the Royal Military Chapel and Wellington Barracks, built in 1833 by the engineer Sir Francis Smith, in consultation with Philip Hardwick. The Chapel was shattered during the Second World War, when a bomb hit it directly during morning service in June 1944 and 121 people were killed. It was rebuilt in 1961-3 by Bruce George; in the apse are the splendid mosaics designed for the first building in 1875-9 by J. R. Clayton and executed by Burke and Salviati, which escaped the force of the bomb.

The first building on the site of Buckingham Palace, was erected by Lord Goring in 1640 and the house, after the Restoration, became the property of Lord Arlington. At the end of the century it was sold to the Duke of Buckingham, who declared it looked out on 'the pleasantest park in the world'. In 1762, George III bought it as a dower house for Queen Charlotte and it became the royal couple's favourite London residence. On his accession to the throne, George IV demolished the old house, and indulged in an architectural orgy which resulted in the unwilling but still loyal John Nash being called before two parliamentary committees to answer for his master's debts. Nash was dismissed in 1830 and the work was completed by Edward Blore. In 1913, Sir Aston Webb gave it a new, chilly, eastern façade towards the park and set in front of the Palace a huge circular monument to Queen Victoria - George V knighted him kneeling in front of his creation. The palace is not open to the public but Nash's long western front, built of warm Bath stone, and very much that of a large country house, can be seen across the gardens from the top of any bus passing down Grosvenor Place in winter, when the trees are bare of leaves. The Guard is changed daily outside the palace at 11.30 a.m., and this, like the similar ceremony at Horse Guards' Parade, is one of the sights of London that should not be missed.

Two sections of the Palace are easily accessible to the public. They are the Queen's Gallery (closed on Mondays) which opened in 1962 and in which changing exhibitions selected from the royal collection are displayed, and the Royal Mews, which are open on Wednesday and Thursday afternoons. The stables, with their imposing entrance from Buckingham Palace Road, were part of Nash's original design. The horses are immaculately kept and groomed, and the visitor can also see the state coaches. They include the Golden State Coach, painted by Cipriani, the Irish State Coach, prettiest of all with delicate metal work round the top, and the Glass Coach, used especially for royal weddings. If one wants to appreciate the applied arts in England, the Royal Mews is the place to visit.

North from Buckingham Palace, across Constitution Hill, lies **Green Park**. Quietest and most private of the London parks, the visitor seems to float in its leafiness.

> ... annihilating all that's made To a green thought in a green shade.

Along the eastern boundary, passing the side wall of Lancaster House, runs Queen's Walk, called after Caroline, George II's consort, who had her own private library in a small pavilion there. Two mansions, Bridgewater House and Spencer House, respectively in Cleveland Row and St. James's Place, have their main façades towards the park and so can be admired from Queen's Walk. Bridgewater House was built for Lord Ellesmere by Sir Charles Barry between 1845 and 1854, though the Art Gallery was open in time to display the Bridgewater Collection of paintings to the public during the Great Exhibition. The building is very like Barry's Reform Club in Pall Mall but even grander. Inside, the main feature was the Saloon, an arcaded marble hall which rose through two storeys, with decorations painted about 1857 by J. Gotzenberger. The mansion has been well converted into offices. John Vardy was the architect of Spencer House, which he built with advice from General George Gray between 1752 and 1754. The basement and ground floor are rusticated and the seven windows of the first floor have pediments, alternately triangular and segmental, with Tuscan columns between them rising to a five-bay pediment in the centre of which is set an elliptical window. Inside, the three main rooms in the western range were all painted throughout by James Stuart from 1759 onwards, in the Pompeian manner, with small panels set in elaborate overall designs of foliage, garlands, and arabesques.

South of Spencer House, at 26 Cleveland Row, is a block of split-level flats built in 1959–60 by Sir Denys Lasdun. By comparison, they are stark and functional, not gracious and harmonious to the eye, but the design is strong, on a human scale, and able to hold its own beside Vardy and Barry without being either dismissed or condemned.

Piccadilly

Ask a foreigner to name the first place in London which comes into his mind and, as often as not, he will fix on Piccadilly. The irregularly shaped place around Gilbert's statute of Eros exerts an extraordinary magnetism. But Piccadilly is more than a space and a statue. It is also a long street, 1 stretching as far as the edge of the eighteenth-century metropolis; even today, the western half of the southern side of Piccadilly gives onto the open space of Green Park. Save for two survivors, the grand houses that once bordered its northern side have now been replaced by hotels, offices, motor showrooms, and airline parlours, but Apsley House and Burlington House remain, not only as reminders of the past but, respectively, as a busy museum and as the nexus of a group of learned societies.

Piccadilly Circus has an extraordinary place in the architectural and artistic history of the capital. It was originally laid out by John Nash in 1819-20 as part of his scheme for Regent Street. As planned, it was a quiet, dignified *place*, entered only at the four points of the compass, from which one could admire the arcade adorning the Quadrant, as the southern curve of Regent Street is known to this day, or look due south towards the façade of Carlton House, the Prince Regent's residence. Carlton House was demolished in 1827, the arcade, which must have been as pleasant as that in the Rue de Rivoli, was pulled down in 1848, and Shaftesbury Avenue was driven through the north-east quadrant in 1886, thereby ruining the symmetry of the Circus. At the beginning of the twentieth century, Norman Shaw attempted to replan the area, producing a series of designs astonishing in their vivacity for a man already in his seventies, but the greed of the developers, the thriftiness of the Crown Estate Commissioners, and the determination of the Regent Street shopkeepers to have nothing but large plate-glass windows, defeated him. The only part of his plan to be executed was the Piccadilly Hotel.

The centre of the Circus was chosen as the site for

a memorial to be erected to the philanthropist, Lord Shaftesbury. The sculptor chosen was Alfred Gilbert, then an idealistic young man. He decided that Shaftesbury's great-heartedness and generosity would be better conveyed by a symbolic figure of the winged god of love than by a solemn stone effigy of an elderly gentleman in the conventional clothing of his day, so he designed a bronze fountain, around which children and fishes disport themselves and from which jets of water were intended to flow, to quench the thirst of passers-by. He topped the base with an aluminium figure - the first time that the metal had been used for a statue – poised on one toe, its wings outspread, holding a bow from which the shaft has just sped. The unveiling ceremony was on 23 June 1893, but Gilbert was not present. The memorial committee was determined that the water from the fountain should be drinkable and the London County Council was equally insistent that the jets should not wet the road surface. Gilbert had intended his airy figure to be seen through a veil of water. On 3 September Edmund Gosse, writing in The Times, declared that the new statue was 'dingy and decayed ... as dry as autumn dust can make it'. The unfortunate sculptor found that, although he was paid £3,000 for his work, he had used such excellent materials that his debts amounted to some £7,000. Unable to free himself from his financial anxieties, tormented by the reception of his creation, he left England in 1901 and settled in Bruges for the next 25 years. Gilbert had hoped that 'some sort of imitation of foreign joyousness might find place in our cheerless London'; now, he wanted the statute to be pulled down and sold as scrap and the money so raised to be spent on providing 'shelters for the poor creatures who, year in and year out, congregate on the Embankment nightly'. The public, however, did not agree with the journalists and critics who condemned Eros, as the figure came to be known. They took it to their hearts, so that it became a rendezvous and a symbol not only of Shaftesbury's noble qualities but of London itself.

An unhurried walk on a fine spring morning down the broad street of **Piccadilly** is one of the great pleasures of London life. The curious name is derived from the profession of one of the first residents, Robert Baker, a tailor or draper, who sold pickadils or frilling for collars. His house stood to the north of PICCADILLY 149

the Circus, where Windmill Street runs today. When he died in 1623, Piccadilly was no more than a country lane running across the fields; ten years after his death, John Gerard the herbalist noted that 'the small wild buglosse grows upon the drie ditch bankes about Piccadilla'. But the country lane became a main route from London to the West. Within a generation of Gerard making his observations, the nobility began to build their mansions along Piccadilly and tradespeople built their shops in order to supply the great houses. When the aristocracy moved away, flats and offices filled their places.

On the south side of Piccadilly is Simpson's store, built by Joseph Emberton in 1935-6, and as excellent a design today as it was then. Just beyond it is St. James's church, built by Sir Christopher Wren between 1676 and 1684. The new church was a part of the Earl of St. Albans's development of St. James's Square (see p. 141), but it must be described as a part of Piccadilly. It is built of brick with stone quoins and dressings, and a tower at the western end with a spire designed by Jonathan Wilcox and erected by his son, Edward. The vestry had charged the older man to invent 'some pretty thing which will be an ornament to the west end of the town'. Lobbies, wholly in sympathy with Wren's design, were added in 1856 at either side of the tower. There is a large Venetian east window and two rows of windows in the north and south walls, the lower tier segment-headed, those above round-headed. In the building of this church

Statue of Eros, Piccadilly Circus

Wren had, in contrast to so many of his commissions in the City, an unrestricted site, and the edifice he raised gave him a particular satisfaction. He wrote:

In our reformed Religion ... [the churches] are to be fitted for Auditories. I can hardly think it practicable to make a single Room so capacious, with Pews and Galleries, as to hold above 2,000 Persons, and all to hear the Service, and both to hear distinctly, and to see the Preacher. I endeavoured to effect this, in building the Parish Church of St. James's ... I think it may be found beautiful and convenient, and as such, the cheapest of any Form I could invent.

The interior is spacious, five bays long, with north and south galleries supported on square piers, while from the balconies Corinthian pillars spring up to the roof. The nave is tunnel-vaulted and the aisles each have five transverse tunnel vaults, which penetrate into the nave. The especial beauty of the furnishings is the work of Grinling Gibbons. He carved a pelican in its piety, which sits above the altar; on either side of the bird are great festoons and garlands of flowers and fruits carved from limewood. In his diary for 16 December 1684, John Evelyn noted: 'There was no altar anywhere in England, nor has there been any abroad, more handsomely adorned.' Gibbons also carved the font, one of his rare works in marble; the shaft is fashioned as a Tree of Knowledge, the serpent coiled about its trunk, while Adam and Eve stand on either side. Around the bowl are carved the baptisms of Our Lord, and of the treasurer of Candace by St. Philip, and the return of the dove to the ark with an olive branch in its beak. At this font were baptized William Pitt, later the Earl of Chatham, the Earl of Chesterfield, and William Blake, poet and artist. Gibbons also carved the six figures, four of them cherubs and two angels with trumpets, which adorn the organ-case. The original organ came from James II's Roman Catholic chapel at Whitehall, for which it had been made by Renatus Harris in 1685. Dr. Tenison begged it from Queen Mary and it was installed in St. James's by 'Father' Schmidt, so the two greatest English organ-builders of the seventeenth century had a hand in the instrument.

On 14 October 1940, the church was severely damaged by bombs and by fire, but though the fabric suffered, the reredos, the font, and the organ-case were preserved. After the war, the shattered roof and the interior were restored under the supervision of Sir Albert Richardson, the mouldings being recast in fibrous plaster by Messrs. Eaton from salvaged fragments. Wilcox's 70-ton spire had to be replaced with London's first spire of glass reinforced with plastic, a mere nine tons in weight. Though the organ-case was saved, the organ had to be rebuilt. Plain glass was used throughout for the windows save at the east end, for which six new lights were designed by Christopher Webb. The pulpit of 1862, with three panels carved in high relief of Moses, John the

Baptist, and St. Paul, was safe and the altar was given a new dorsal of eighteenth-century Florentine needlework. The royal arms, those of William and

Mary, were set up in the vestibule.

The majority of the monuments were removed to the galleries, where the finest, to the Earl of Romney (d.1704) by W. Woodman, is on the north side. In the vestibule is a small memorial by John Flaxman to James Dodsley, bookseller and brother of Robert Dodsley, who supported and encouraged Dr. Johnson. The south aisle has become a chapel with a Pietà on the wall by Ernest Jackson RA, and many other Academicians are buried here, for this is the parish church of the Royal Academy. Earlier artists who lie here are the two William van der Veldes, father and son, Dutch marine painters (d.1693 and 1701). James Huysmans, the Flemish portrait painter (d.1696), Michael Dahl, the Swedish portrait painter (d.1743), James Gillray, the cartoonist (d.1815), and G. H. Harlow (d.1819). James Christie, the auctioneer, was also buried here. Four of the past rectors - Tenison, Wake, Secker, and William Temple - have become archbishops of Canterbury. The church plate, the work of Ralph Leeke, hallmarked 1683, was given by Sir Robert Gayre and is exceptionally fine; the large alms dish is still used each Sunday.

The churchyard lies on the north side, laid out as a garden by the generosity of Lord Southwood, in commemoration of the fortitude of Londoners during the Second World War. The wrought-iron gates, designed by Sir Reginald Blomfield to open into Piccadilly, were set up for the coronation of George VI. A coffee-shop and restaurant has opened on the Jermyn Street side. The Rectory stands to the east of the garden and to the west, in harmony with the seventeenth-century church, is a branch of the Midland Bank, designed by Lutyens in his happiest 'Wrenaissance' manner.

Beyond the church are shops, among them Hatchard's the booksellers, established in Piccadilly in 1797 and occupying this site since 1801, and Fortnum and Mason, a business which has flourished since the early eighteenth century and where the display of groceries reaches the level of fine art. Beyond Duke Street is the Piccadilly Arcade, built in 1909/10 to designs by G. Thrale Jell, on the site of the Egyptian Hall, in which Benjamin Robert Haydon exhibited his last paintings in 1846. The public disregarded his works and preferred to spend their money gaping at a dwarf, General Tom Thumb, who was only 31 inches high. Only three months later, the ruined Haydon cut his own throat.

Arlington Street follows, in which number 21 was built in 1769 by Sir William Chambers and number 22, Wimborne House, by William Kent. Kent's designs were carried out between 1740 and 1755 for Henry Pelham, but were masked by a forecourt erected later. At number 16 (entered from Park Place) is the Royal Over-Seas League, which occupies

a mansion built in 1736 by James Gibbs for Lord North. On the corner with Piccadilly is the Ritz Hotel, built in 1906 to designs by Mewès and Davis. The material used is Norwegian granite, the style elegantly Parisian, with an arcade to the ground floor like that of the Rue de Rivoli, and with wide, open views across Green Park from the western windows.

On the north side and west of Piccadilly Circus, is Albany, which was originally built between 1771 and 1775 by Sir William Chambers for Sir Peniston Lamb, the father of Queen Victoria's first prime minister, Lord Melbourne. Sir Peniston approved of his architect's work and wrote to him:

I am sure in this you will Shew, as you have done in all other parts of my works, more taste, and in every respect give me more satisfaction, than all other Architects put together could possibly have done.

However, in 1791, the Lambs exchanged houses with Frederick, Duke of York and Albany, George III's favourite son. The Lambs went to live in Whitehall and the residence in Piccadilly was thereafter known by the Duke's second title, Albany. He remained there till 1800 and then decided to sell the house which was, in 1802, converted into apartments by Alexander Copland, and has continued in that use ever since. Lord Byron, 'Monk' Lewis, Bulwer Lytton, Gladstone, and Macaulay all had chambers here, and the literary tradition has continued into the twentieth century with the publisher

John Lane and with J. B. Priestley.

Burlington House comes next. It was begun about 1664, in a field off Piccadilly called Stone Conduit Close, by Sir John Denman, poet and architect, who held the post of Surveyor-General to Charles II. He sold it, unfinished, to Richard Boyle, the first Earl of Burlington, for whom it was probably completed by Hugh May. It was a plain building, two storeys high, seven bays wide, with shallow, one-bay wings, and a hipped roof, set well back from the road behind a wall and a deep courtyard. The second Earl died young, leaving a ten-year-old son, another Richard, who was to become a most learned and enthusiastic connoisseur of Palladian architecture. He spent a year in Italy between 1714 and 1715 and came home determined to transform Burlington House into 'the only town residence really fit for a British nobleman'. His architect was probably Colen Campbell, his artistic adviser William Kent, then known only for his paintings, whom the Earl had met in Italy. The basic structure of the house was not much changed but it was given a gracious new Italianate façade, with a rusticated ground floor, while above, the windows received alternately a triangular or a segmental pediment.1 Between each pair of windows was inserted an Ionic pilaster and a balustrade was

¹ For a full architectural history of the house, see Survey of London, volume XXXII, pp. 390–430.

PICCADILLY 151

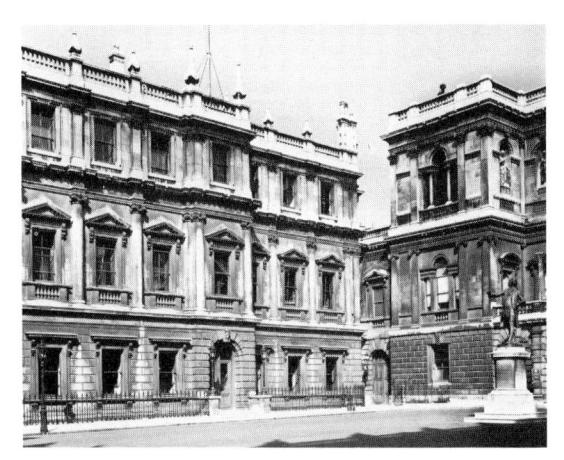

Society of Antiquaries, Burlington House, Piccadilly

added around the roof. The neat pairs of groundfloor windows in the wings were replaced with single openings, and, for those at first-floor level, grand Venetian windows were substituted, set between coupled Ionic pilasters. Inside, walls and ceilings were adorned by Sebastiano Ricci, Giovanni Antonio Pellegrini, and William Kent himself. The stable blocks on either side of the courtyard were enlarged, probably by James Gibbs, and were linked to the street wall by two curving Doric colonnades which Horace Walpole described as 'one of those edifices in fairy-tales that are raised by genii in a night's time'. A new and grand entrance gate was designed by Campbell, who drew his inspiration from York House Water Gate (see p. 122). It is worth noticing how often the eighteenth century followed Palladio through Inigo Iones's interpretation; the ground floor of Burlington House is like that of the Queen's House at Greenwich, and the first floor is similar to the ground floor of the Banqueting House in Whitehall, which Campbell considered 'without Dispute, the first Structure in the World'.

On the third Earl's death in 1753, the house passed to his only child, Charlotte, who married the Duke of Devonshire. It remained with that family and in 1815 was purchased by the sixth Duke's uncle, Lord George Cavendish. For him, substantial internal alterations were made, the most important being the insertion of a new great staircase in the centre of the house. The work was undertaken skilfully by Samuel Ware. In 1854, the house was purchased by the Government, becoming in 1869 the home of the Royal Academy. The stabling blocks, Gibbs's magical colonnade, and Campbell's triumphant gateway were torn down and were replaced with large imposing ranges designed by Robert Richardson Banks and Charles Barry to accommodate the Royal Society, the Society of Antiquaries, the Linnean, the Chemical, the Astronomical, and the Geological Societies. After lying for years in Battersea Park, the colonnade was pulverized for hardcore.

The Royal Academy had been founded in 1768 by George III, with Sir Joshua Reynolds as its first President. It first had temporary accommodation in Pall Mall, then rooms in Somerset House (see p. 125). Next it shared premises with the National Gallery in Trafalgar Square, and finally moved to Burlington House. Under the direction of Sidney Smirke, a range of exhibition galleries, three rooms deep, was built over the gardens, and an extra storey was added to the old house. It contains the Diploma Gallery, which is windowless, being lit from the roof. Above each of the seven windows is a niche with a statue, kept company by two other statues on the inner wall in each of the wings; the figures represent Phidias and William of Wykeham by Joseph Durham, Michelangelo and Titian by W. Calder Marshall, Leonardo da Vinci, Reynolds, and Wren by Edward Stephens, and Flaxman and Raphael by Henry Weekes. Corinthian pilasters separated the niches and a second pair of Venetian windows was set above those in the first-floor wings. On the ground floor, the space between the wings was filled in with an arcaded porte-cochère. The additions destroyed the elegant proportions of Lord Burlington's house and the high ranges on the other three sides of the courtyard turned it into a comparatively cheerless place. The interior of the old house remained more or less undisturbed and provided an excellent setting for the meetings of the Academy. Occasionally, these rooms are opened to the public and are worth visiting. In them, some part of the Academy's own distinguished collection can be seen. In addition to the European works acquired over the years, each Academician upon election is required to present his Diploma work – his own choice from among his own achievements - to the Academy, and it therefore provides a very personal conspectus of English art since the mid-eighteenth century.

In the ceiling of the entrance hall are set panels brought from Somerset House, five by Benjamin West and four by Angelica Kauffman. Ricci's paintings of The Triumph of Galatea and Diana and Her Attendants are on either side of Ware's grand staircase. On the first floor, the Saloon has ceilings by Kent representing The Wedding Feast of Eros and Psyche, with panelling on the walls and a superb doorcase, the main entrance with Corinthian columns and a triangular pediment, and the two smaller doorcases with reclining putti. The south-east doorway leads into the Council Room, which has a ceiling by Ricci representing the gods on Olympus, and a chimney-piece carved by Joseph Wilton and brought from Somerset House. This leads into the Reynolds Room, a magnificent triple cube designed by Ware to serve as a ballroom, at the end of which a special small chamber has been made in which the Carrara marble relief, The Madonna and Child with the Infant St. John, by Michelangelo is displayed. The tondo was carved in 1504-5 and belonged to a Florentine patron called Taddeo Taddei. Sir George

152

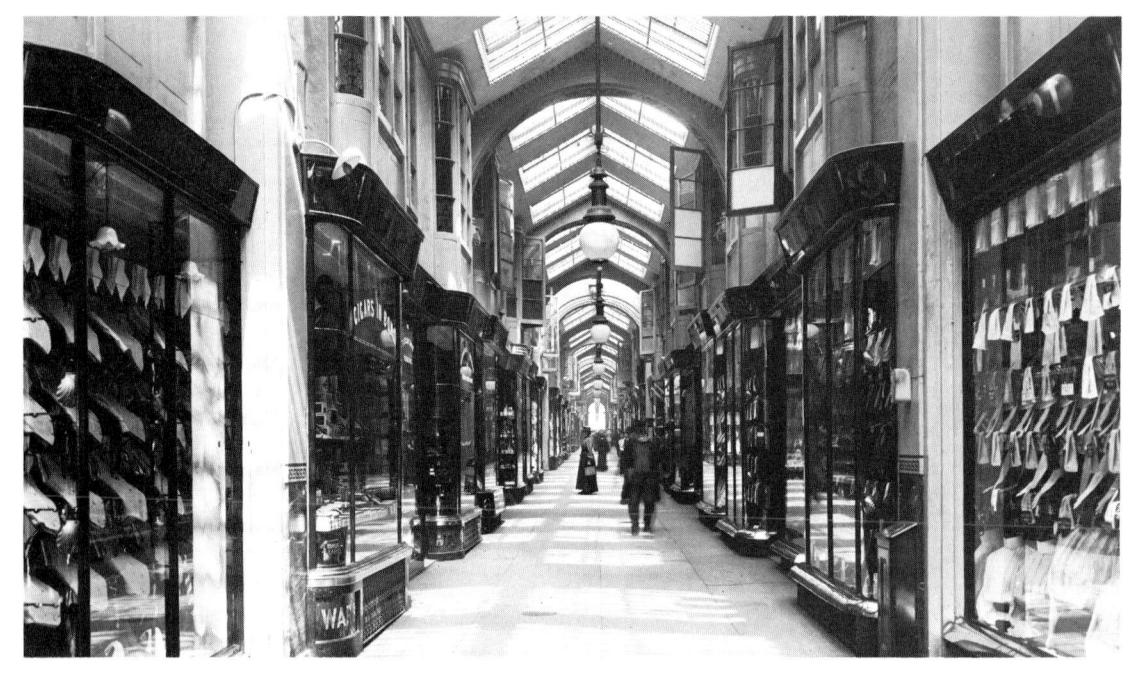

Burlington Arcade

Beaumont bought it from his descendants and bequeathed it to the Academy in 1827. It is one of only four major sculptures by Michelangelo to be seen outside Italy. In the carving, St. John offers a goldfinch, the symbol of the Passion, to the infant Christ, who shrinks away from the fluttering bird and what it portends, clinging to the shelter of his Mother's arm.

To the west of the Saloon are the Secretary's Room and the Assembly Room, the former with a wooden ceiling still at its original height of 14 feet 7 inches, undisturbed since Burlington's day. It is divided into compartments by intersecting ribs, beautifully decorated with bands of flowered guilloche; in the centre is a painting by Kent of Jupiter consenting to the Nuptials of Eros and Psyche and at each of the corners a bunch of flowers. The Assembly Room was designed by Ware to serve as a state dining-room; Ricci's painting of Bacchus and Ariadne, which originally adorned the staircase, has been set in the ceiling, and the central entrance to the room, set in a round-arched recess, was designed by Norman Shaw. Each year, the Academy holds its summer exhibition, to which any artist may offer works. A panel of Academicians makes a selection from the entries; the public flocks to inspect the official condition of English art. During the winter, exhibitions of international standard are arranged on various aspects and schools of art.

Among the learned societies around the courtyard, the Society of Antiquaries of London deserves special mention. A College of Antiquaries had been founded in 1572 by Archbishop Parker, with William Camden

among its original members, but it had been dissolved by James I. The idea was raised again in 1707, meetings resumed regularly in 1717, George II granted a Royal Charter of Incorporation, and in 1781 George III provided the Society with rooms in the new Somerset House. The most important society for archaeologists and historians, its membership is by election. The magnificent and resourceful library, handsomely housed, is open to members and sometimes, by special arrangement, to other scholars. The Society possesses, among many other antiquities and works of art, a large diptych painted in 1616 by John Gipkyn, of Old St Paul's cathedral, showing the lofty tower and the Preaching Cross, and a handsome bust of George III by John Bacon.

Beyond Burlington House lies the Burlington Arcade. This was built in 1815–19 by Samuel Ware, but was unfortunately given a new south entrance from Piccadilly in 1929–31 by Beresford Pite. The arcades — Burlington, Piccadilly, Royal Opera House, Halkin, and several others — are among the great joys of London shopping; sheltered and warm, the glass-fronted treasure-houses are there to study at leisure, and the eye is so delighted that whether or not one has the money to buy is immaterial.

West of Bond Street stood two great houses, the Earl of Clarendon's, designed for him just after the Restoration by Sir Roger Pratt, and Berkeley House, built by Hugh May for Lord Berkeley of Stratton. Clarendon House, which Evelyn called 'the best contrived, most useful, graceful and magnificent house in England', was demolished in 1683 after its owner's disgrace and exile, and Berkeley House was

burnt down in 1733. By that time it had become the property of the Duke of Devonshire and a new Devonshire House was built, with William Kent as architect. It remained in Piccadilly, one of the great centres of English society, till 1924, when it was pulled down and its place taken by motor car show-rooms, offices, and flats. One relic remains, the great blue and gold wrought-iron gates, made originally for Lord Heathfield's house in Turnham Green, moved thence to Chiswick House, and installed in Piccadilly in the 1890s. When Devonshire House was demolished, they were taken across the road and set up on the edge of Green Park. A single great house remains, used today by the Naval and Military Club and known familiarly as the In and Out, according to the traffic directions on its gate-posts. It was built for Lord Egremont by Matthew Brettingham between 1756 and 1760; later, it became the home of Lord Palmerston, the prime minister.

At the western end of Piccadilly, backing on to Hyde Park, is Apsley House, familiarly known as 'Number 1, London', and originally built by Robert Adam for Henry Bathurst, Baron Apsley, in the early 1770s. Lord Wellesley, Wellington's elder brother, purchased the house in 1805, and sold it to the Duke in 1817. Extensive alterations and enlargements were carried out in 1828-29, so that only two of the apartments, the Piccadilly Drawing Room and the Portico Room, retain anything of their original Adam decoration. Otherwise, the house was redecorated throughout and was refaced in Bath stone. The Waterloo Gallery, 90 feet long, was added and was hung with yellow satin, much to the disgust of Mrs. Arbuthnot, the Duke's friend; it 'is just the very worst colour he can have for the pictures and will kill the affect of the gilding. However, he will have it', she wrote. The Gallery was used for the Waterloo banquets which the Duke held annually on 18 June from 1830 till 1852, the year of his death. The table was decorated with the Portuguese service, a tableservice of silver-gilt consisting of some 1,000 pieces, made by D. A. de Sequiera and presented by the future King John VI of Portugal. The window shutters were lined with looking-glass so that when they were closed, the mirrors reflected back the candles on the long tables and made the room blaze with light. Wyatt designed the decorations and furniture in a 'Louis Quatorze' style with sumptuous results. The estimate had been for £14,000, the final bill was £42,000; understandably, the Duke was furious. When one thinks of the Spartan campaign bed at Walmer Castle on which he slept throughout his life and in which he died, one suspects that, in spite of the determination to have yellow satin, the Duke really preferred a less elaborate setting.

The house and contents were given to the nation by the seventh Duke of Wellington in 1947 and were opened the public in 1952. A collection of personal relics and items connected with Wellington's career is on view. Among the gifts given to him were several magnificent sets of Meissen and Sèvres porcelain and the Wellington shield of silver-gilt, presented by the bankers and merchants of the City of London. Then there is a giant marble statue of Napoleon, carved by Canova and purchased by the Prince Regent for the victor of Waterloo; Napoleon had taken a dislike to the heroic nude figure, for the tiny figure of Victory, which the statue holds in its hand, has its back turned and appears to be flying away. Around the Dining Room hang portraits of the allied monarchs, including one by Sir David Wilkie of George IV wearing Highland dress. Everywhere, there are busts and portraits of the Duke, the three most interesting being the head and shoulders painted by Sir Thomas Lawrence in 1814, a copy, also made by Lawrence, of a cloaked full-length painting by Spiridione Gambardella, and a huge equestrian painting by Goya.

The most astonishing thing about the house is the Duke's collection of paintings. After the Battle of Vitoria (1813), Joseph Bonaparte, Napoleon's brother, whom he had made King of Spain, fled from the battlefield. His carriage was captured and in it were found 165 paintings cut, not only from their frames but from their stretchers, and stolen from the Spanish royal collection. The Duke, who was the soul of honesty, had them restored and offered them back to the King of Spain, but that monarch wished him to keep them. 'His Majesty', wrote Count Fernan Nunez, 'touched by your delicacy, does not wish to deprive you of that which has come into your possession by means as just as they are honourable.' So works by Jan Brueghel the Elder, Jan Vermeer of Haarlem, Adam Elsheimer, Rubens, David Teniers the Younger, Juan de Flandes, Ribera, Murillo, and Correggio hang in Apsley House. Among the prizes, perhaps the most important of all were three paintings by Velázquez, Portrait of a Gentleman, Two Young Men eating at a Humble Table, in which an orange is perched over the mouth of a water or wine jar to serve as a stopper, and The Water Seller of Seville, one of the best loved of all the painter's works. To these riches, the Duke added his own purchases. He was a man of great artistic sensibility when a young officer, he burned his violin in order to curb his love of music and so focus all his attention on his military career – and he chose such works as Pieter de Hooch's Musical Party, in which the setting afternoon sun strikes in through a single window to illumine the company in a room otherwise made mysteriously dark by closed red curtains, and two by followers of Caravaggio, The Gamblers and The Conjuror, which are both alive with drama. Apsley House, though popular, is seldom crowded and the paintings can be examined at leisure, exhibited in the setting of a private room rather than a public gallery. In 1982, a complete redecoration was accomplished, and the house now looks, as nearly as possible, as in did in the Duke's day.

Mayfair

Mayfair, built originally as an aristocratic quarter in close relationship to the court area around St. James's Palace and still an enclave of distinction, its buildings ranging from plain eighteenth-century through terracotta Victorian monumental and Arts and Crafts visionary to advanced twentieth-century institutional, takes its lovely name from the cattle market authorized by James II in 1686 and held during the first two weeks in May. It flourished, drawing to it every huckster and side-show in or near the metropolis, till the 1730s when it was suppressed because of the superior development that had grown up around it. The laying-out of the streets and building of the houses was undertaken by six landowners or groups of speculators, the first to venture being a consortium of three builders, John Hynde, Cadogan Thomas, and Richard Frith, from whom Sir Thomas Bond, Lord Dover, and Margaret Stafford leased a number of sites and gave their names to the streets. Their example was followed by the widowed Lady Berkeley of Stratton, by Richard Lumley, Earl of Scarborough, by Lord Burlington, by Sir Nathaniel Curzon, and later by Lord Grosvenor so that the development was more or less completed by the third quarter of the eighteenth century. Today,1 for the most part, the original aristocratic occupants have relinquished their houses to embassies, offices, and the headquarters of international airlines, but, possibly because of its tight boundaries along Piccadilly, Park Lane, Oxford Street, and Regent Street, Mayfair still retains its homogeneous layout and its distinctive character.

Mayfair should be enjoyed as an example of civilized urban planning, each estate attending courteously on its neighbour so that a vista, such as that afforded from Park Lane to Regent Street along the line of Brook Street, Grosvenor Square, Hanover Square, and Hanover Street, was obtained across the extent of Lord Grosvenor's and the Earl of Scarborough's lands. Though Piccadilly has been ruined and the protuberances of the Hilton and the other hotels crowding round it have desecrated Hyde Park yet, on the whole, the developers have been kind to the hinterland of Mayfair; heights have been curbed and new façades, inserted between eighteenth-century buildings, are often in sympathy with their neighbours.

The great delight which Mayfair has to offer to the visitor is the excellence of its shops. The individual is still given proper and personal attention, and if an article has beauty, or excellence, or fine workmanship, then it is to be found here, though the price may be high. To the philosophically minded, the pleasures of window shopping, and the ideas to be gleaned therefrom, may well be as keen as the joys of actual purchase, and are certainly less expensive.

Bond Street is an architectural medley with eccentric numbering; going northwards from Piccadilly, the numbers run from 1 to 24 on the eastern side of Old Bond Street till, breaking off at Burlington Gardens, they turn back on the western side, running from 25 to 50. The same principle is observed in New Bond Street, 1 to 86 on the eastern side and back again with 87 to 180 on the western. This thoroughfare and the streets around it are the Mecca of the art dealer and of the art lover. Here the galleries cluster, scholarly Colnaghi's (14 Old Bond Street), the forceful and enterprising Marlborough Gallery (number 39) and Agnew's (number 43), founded in Manchester in 1817. Their London Gallery, on the site of the house in which Laurence Sterne died in 1768, was built in 1875 and runs right through to Albemarle Street. The walls are hung with crimson damask, which Sickert claimed set off a painting better than any other colour, and upstairs, approached by a friendly oaken staircase, is a long gallery. Galleries such as these are dignified and may even seem forbidding, but once inside the atmosphere changes and becomes friendly. Beyond Agnew's is the Royal Arcade, so called because Queen Victoria used to patronize Brettle's, who had their premises therein, for underwear.

On the western side of Bond Street are the superb plate-glass windows of Asprey's, founded in 1781

¹ Those interested in the fascinating if intricate topographical history of the area should read B. H. Johnson's *Berkeley Square to Bond Street* (1952), and volumes XXIX and XXXII of the *Survey of London*. Reginald Colby's *Mayfair* (1966) is an excellent, more general book.

MAYFAIR 155

and still flourishing under family direction. The first William Asprey used to make fitted dressing-cases; these the firm still supplies, as well as other luxury goods of every possible sort and of the finest quality. Northwards on the same side is the Time/Life building at 153 New Bond Street; designed by Michael Rosenauer, it has a frieze sculpted by Henry Moore, unfortunately sited so high that it can scarcely be examined from the pavement. On the further side of Bruton Street is the Fine Arts Society, founded in 1876 and specializing in British paintings - Scottish, Irish, and Welsh artists are recognized here. Opposite are Sotheby's, the art auctioneers, established in 1744 and originally particularly famous for rare book sales; nowadays, Sotheby's deals in paintings and in other works of art as well. The excellently prepared and printed catalogues indicate, like those of Christie's, in their own shorthand, the likelihood of an attribution – a work described as being by 'Sir Joshua Reynolds, P.R.A.' has a far greater chance of being by the artist than one curtly attributed to 'Reynolds' or even 'Sir J. Reynolds'. Viewing days and auctions are normally open to the public and are worth visiting, to see both the objects offered for sale and the physiognomies of those buying. Items are sold at the rate of about two lots each minute and, on a day when hundreds of thousands of pounds are changing hands, the atmosphere becomes tense.

Northwards, on the west side of Bond Street, is

Brook Street, where Handel lived at number 25 for nearly 40 years; in that street today, Colefax and Fowler have their colourful shop specializing in chintzes and Claridge's has maintained its impeccable hotel standards for a century and a half. To the east, Hanover Square was laid out on land belonging to Richard Lumley, 1st Earl of Scarborough, between 1717 and 1719. The earl was a staunch Whig. He had fought for William III at the Battle of the Boyne and had welcomed George I to the throne of England. He called his new square after the monarch's hereditary principality and dedicated its church to the king's canonized namesake. The Earl's architect remains unknown but, whoever he was, he had style and imagination. The houses around the square were, for the most part, built to uniform elevations, three storeys high, of red and grey brick, the segmental-headed windows laced together by vertical strips of rusticated stone, in a style consciously intended to look German. A few remain in the south-west corner and others on the west side of Saint George Street, a curious, funnel-shaped entrance to the south side of the square. The reason for the unexpected line of the street remains unknown. The effect is baroque and won contemporary approval, for James Ralph in his Critical Review of the Public Buildings in and about London, published in 1734, described the view across the square and down the street as being 'one of the most entertaining in this whole city'.

Avery Row, off Brook Street

20 Hanover Square

156 WESTMINSTER

St. George's church was built between 1720 and 1724 to the designs of John James as one of Queen Anne's fifty new churches (see p. 19). Of stone, with a short, square tower with coupled columns at the corners, it has a huge portico of six Corinthian columns, which projects out into the street. Almost simultaneously, similar porticoes were being built by James Gibbs for St. Martin-in-the-Fields and by Hawksmoor, whose idea it probably was, for St. George's, Bloomsbury. The columns support a pediment on which the architect planned to perch an equestrian statue of George I; perhaps fortunately, this scheme was unfulfilled. The ceiling of the portico is beautifully coffered and shelters two iron dogs, reputed to be by Landseer, who gaze out dreamily, as if waiting patiently for some eternal matins to end. Inside, there is a tunnel-vaulted nave, aisles with transverse tunnel vaults, and galleries supported on square columns which rise to Corinthian capitals. The church retains its original reredos, a Last Supper probably painted by William Kent, with carved side panels of fruit and flowers. Above it, the east window contains glass made in the sixteenth century for the church of the Grands Carmes in Antwerp, and there are two small angels in a side chapel, carved about

1500 for a German altar. The carved pulpit stands on six columns and has an elegant iron stairway. There is a magnificent royal arms and a good case for the organ, installed originally by Schmidt and restored to a fresh glory of sound in 1972. St. George's has always been famous for its fashionable weddings; here Disraeli married Mary Anne Lewis, and the novelist George Eliot, who in real life was Mary Ann Evans, was wedded to John Walter Cross, Theodore Roosevelt married Edith Carow here in 1886 – they spent their honeymoon afterwards at Brown's Hotel in Dover Street - and, most celebrated of all, Herbert Asquith married Margot Tennant, with four prime ministers - Gladstone, Lord Rosebery, Balfour, and the bridegroom himself - to sign the register and a fifth, Campbell-Bannerman, in the congregation.

Conduit Street lies to the south, its name a reminder of the conduit which, from the early Middle Ages, carried fresh water from the Tyburn to the City of London, and beyond is the land which, lying behind his own mansion, the third Earl of Burlington developed as his 'little town'. The work began soon after 1717. The Earl himself designed a house for General Wade in Old Burlington Street and his protégés, Colen Campbell and William Kent, had

St. George's, Hanover Square

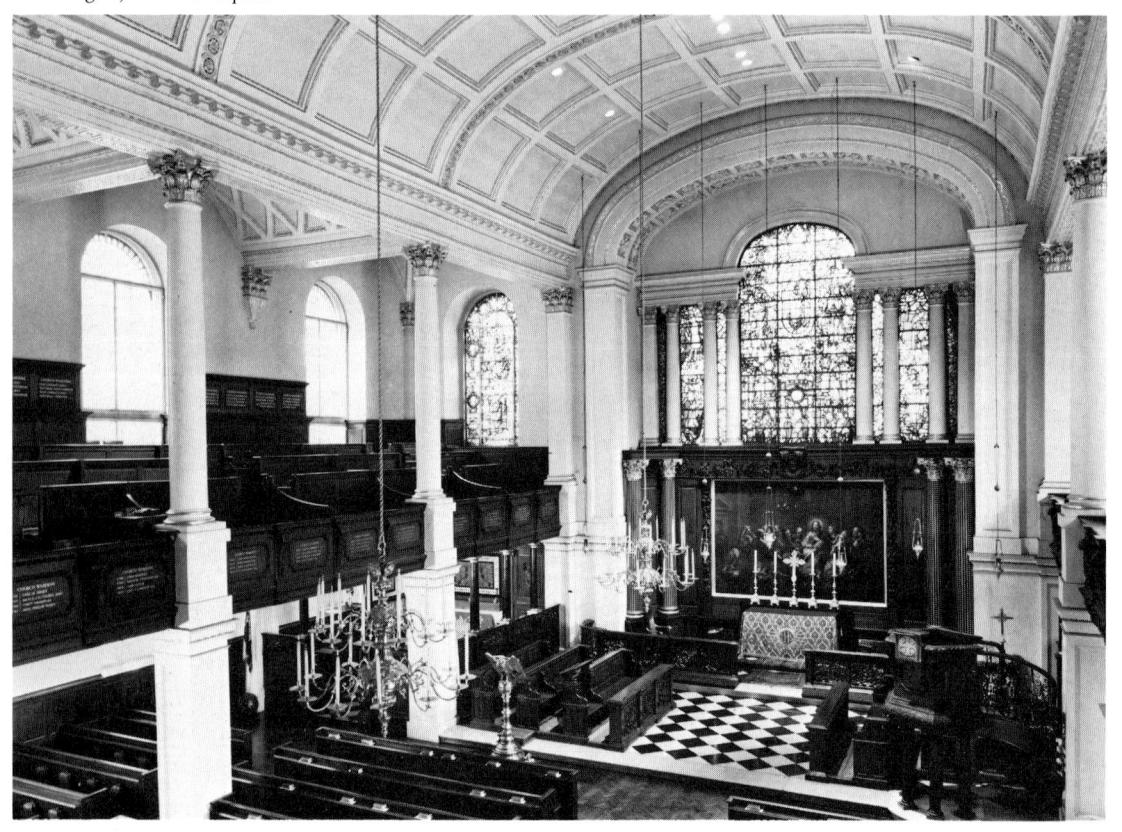

MAYFAIR 157

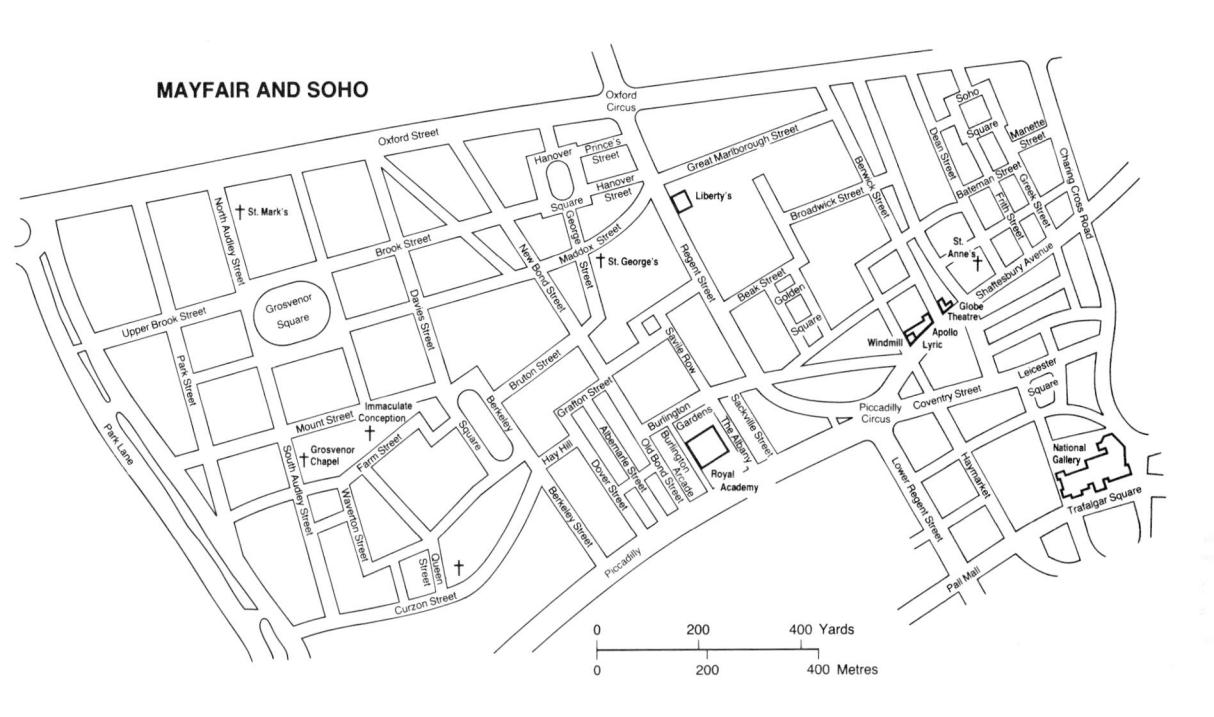

houses in that street and in Savile Row. Of that development, little more remains than the street plan, though at the southern end of Savile Row several fine houses survive from the terrace built there about 1733.

On the corner with Vigo Street is the London headquarters of the Bank of Scotland, occupying what was once Uxbridge House. It was built for the third Earl of Queensberry by the bricklayer, John Witt, to the designs of Giacomo Leoni between 1721 and 1723. The Earl of Uxbridge acquired it in 1785 and had it enlarged by the younger John Vardy and Joseph Bonomi.

The gardens behind Burlington House were built over by Sir James Pennethorne in 1866–9 for a headquarters for the University of London. In time, the building came to house the Civil Service Commission and now accommodates the Museum of Mankind, the Ethnographical Department of the British Museum. The lofty rooms have been adapted as galleries and such treasures as the Mayan crystal skull and turquoise masks, and the gold pectoral star from Ashanti in Ghana are on permanent display, supported by a series of temporary exhibitions.

To the west of Bond Street, turning northwards again, is the Royal Institution in Albemarle Street. Founded in 1799 'for the promotion of science and the diffusion and extension of useful knowledge', it has been served by a succession of great scientists, and in particular by Sir Humphry Davy and by

Michael Faraday, whose laboratory, still with its contemporary equipment, is maintained in the basement and can be visited on Tuesday afternoons. The original building was designed by Thomas Webster in consultation with George Saunders, being developed from houses already existing on the site; the Albemarle Street façade, with its screen of giant Corinthian columns, was added by Lewis Vulliamy in 1838. The Friday evening lectures, given throughout the winter, are exciting and important events. Nearby, 50 Albemarle Street accommodates the publishers, John Murray. Founded in 1768, the firm moved here in 1812. The second John Murray was the publisher of Byron, Jane Austen, George Crabbe, and George Borrow. It was in his drawing-room that Byron's autobiography was burnt after his death, since Murray and the dead man's other friends judged it too scandalous for publication.

The streets here form a sort of maze. At the end of Albemarle Street is Grafton Street, in which stands the Medici Gallery, established in 1908 for the sale of reproductions of works of art; nearby in **Dover Street** a mid-eighteenth-century house, number 4, bears a blue plaque recording that Lord Brougham lived there. Number 37 was built in 1772 by Sir Robert Taylor as a London residence for the Bishops of Ely. The impeccable Palladian façade, three bays wide with heavy rustication to the ground floor, has one touch of discreet flamboyance; above the first-floor windows, with their neat balustrades and triangular

158

pediments supported on Corinthian columns, are set three medallions, the centre one carved with a bishop's mitre. A later generation added another endearing detail to the exterior; at some time after 1852, the torch extinguishers on the railings were replaced by casts of the dignified seated lion which Alfred Stevens designed originally for the vanished guard-rails of the British Museum. The interior was much altered in 1909, when A. Dunbar Smith and Cecil Brewer, leading members of the Art Workers' Guild, enlarged it to provide premises for the Albemarle Club. They extended Taylor's vestibule to form a main, marble-paved corridor, created a new double staircase between the first and second floors. raised Taylor's elliptical stairway by a storey, and designed a third, horseshoe-shaped stair to link the eighteenth-century mansion with the new club premises, which extended as far as Berkeley Street. In all this work, with the additional complication of differing street levels, a remarkable harmony was maintained between Taylor's formal classicism and the controlled Art Nouveau style, robust yet delicate, of Smith and Brewer.

Hav Hill runs westwards out of Dover Street and at its foot Berkeley Square, of which Max Beerbohm rightly declared that it 'had no squareness', lies to the north. It is a long, thin quadrilateral, its north and south sides far from parallel to each other. The east side was built first, houses being occupied by 1739; the west side followed immediately, and still contains what Pevsner calls 'the finest terrace house in London'. The present century has torn down the east side, replacing number 11, which Horace Walpole made his home from 1779 till his death there in 1797, with motor-car showrooms, and has filled the south side which, till 1930, was the garden of Lansdowne House, with a shapeless, sunless office block which usurps both name and land. Something of the old dignity remains, however, and the square is worth careful attention. Walpole's house has gone, but the plane trees, planted by his neighbour, Mr. Bouverie, about 1789, still spread their branches in the centre of the square. Among them stands a little pump-house with a Chinese roof, which provides water for the fountain near to the south railing. This fountain takes the form of an elegiac nymph with a pitcher; she was the work of Alexander Munro, an early adherent to the principles of the Pre-Raphaelite group, and was installed by 1867.

In the south-west corner, facing Fitzmaurice Place, is a building known today as the Lansdowne Club. Built in 1762–8 by Robert Adam for the Earl of Shelburne, later Marquis of Lansdowne, it stood in comparative isolation, a country mansion strayed into a London square. From 1772 till 1780, Lord Lansdowne's librarian was Joseph Priestley, the scientist who isolated oxygen without realizing what he had accomplished. After his wife's death in 1771, the Marquis travelled abroad, collecting manuscripts, paintings, and sculpture. At his death in

1805, his son sold the manuscripts to the British Museum and dispersed the paintings, but the sculpture was retained and displayed in a special gallery, designed by the younger George Dance and completed by Sir Robert Smirke, till it too was sold at Christie's in 1930. When Devonshire House was demolished and the gardens of both mansions were built over, the facade of Lansdowne House was set back by some 40 feet, Adam's dining-room and drawing-room being ripped out and removed, the former to the Metropolitan Museum of Art in New York and the latter to the Pennsylvania Museum of Art in Philadelphia. One fine fireplace is now in the Prevost Room of the London Library, St. James's Square. The facade was reconstructed from the old stones, but the side pavilions were demolished and the upper floors were raised so that the original proportions were lost. The Sculpture Gallery is now used as a ballroom.

In the centre of the west side is number 44, built for Lady Isabella Finch by William Kent in 1742–4. The house seems ordinary enough from the outside. Three bays wide, of brick with elaborate rustication round the front door, there is little to give a hint of the grandeur inside. Into the square core of the house, Kent fitted, with extraordinary ingenuity, a spectacular staircase which rises in a single flight to an apse which forms a landing, and then returns in two curving arms to the first floor. The ornate ironwork was by Benjamin Holmes. A screen of Ionic columns conceals the stairway up to the second floor. Horace Walpole appreciated the staircase; '[it is] as beautiful a piece of scenery and, considering the

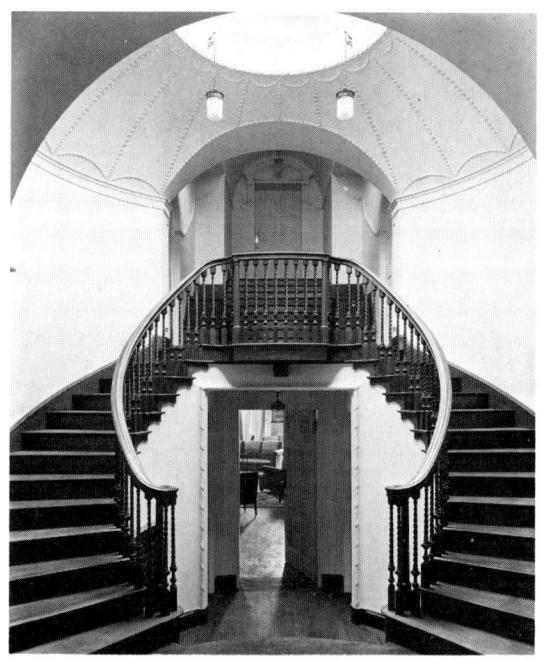

Interior of 37 Dover Street

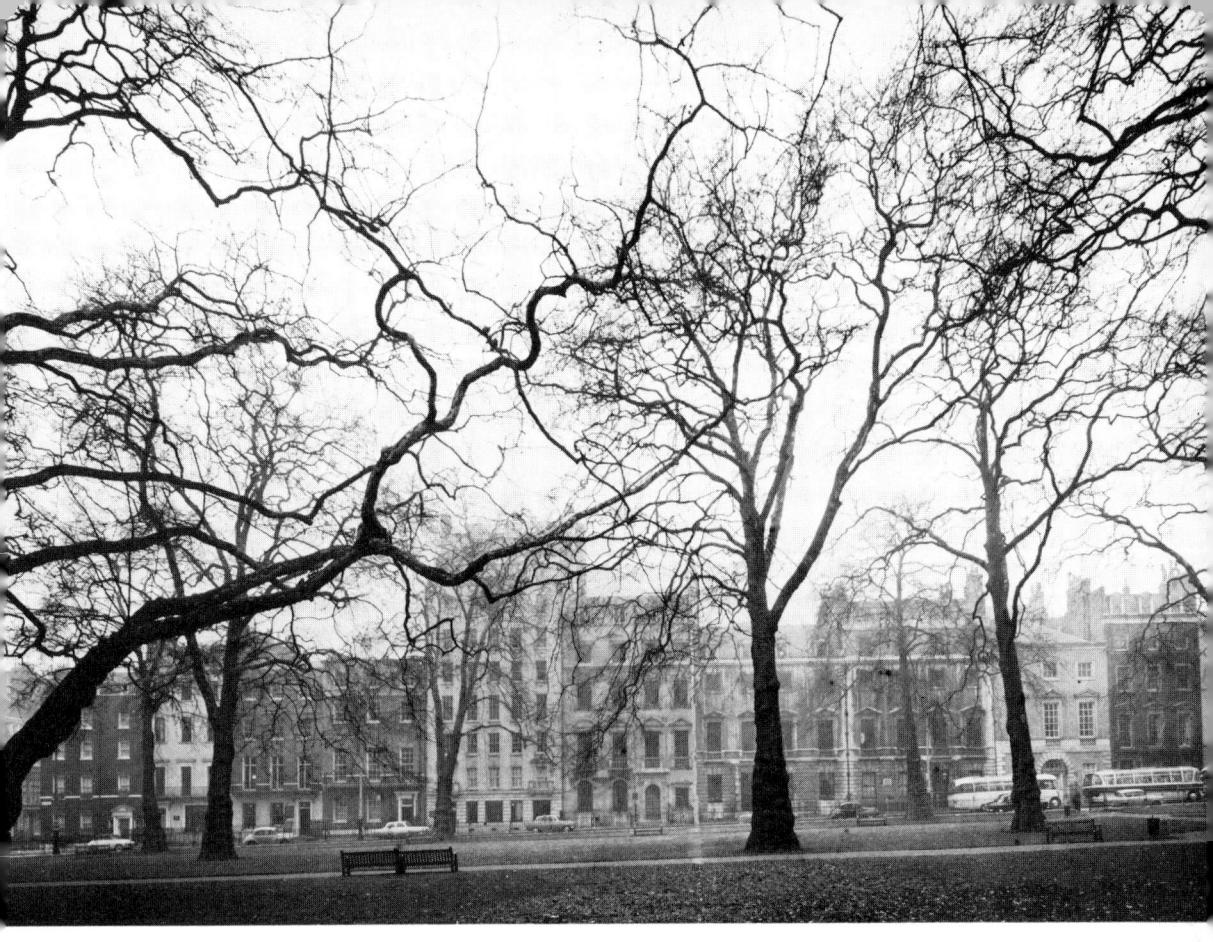

Berkeley Square

space, of art as can be imagined', he wrote. The first-floor salon is as magnificent, rising through one and a half storeys, the half-storey blind, to a coved tunnel-vaulted ceiling, coffered and gilded, with small inset paintings, probably by Kent himself, of the loves of the gods and goddesses. Rich, dark colours have been used throughout; the plasterwork was by Robert Dawson. The house is now the property of the Clermont Club and was restored and redecorated in 1963 by John Fowler, so that it is still as spectacular as it was when first built.

Mount Street, with its startling shops and houses built of terracotta brick and ornamental tiles at the end of the last century, leads to **Grosvenor Square** by way of Carlos Place or South Audley Street. Sir Richard Grosvenor wished to emulate the Earl of Scarborough's success in Hanover Square and the work was begun in the 1720s, though it was not completed for some 30 years. Either Sir Richard or his agent, Robert Andrews, had great ambitions for the square and Colen Campbell was asked to prepare a design for a strictly architectural layout for the east side. Nothing came of it, but all sites on that side were taken up by a builder called John Simmons, who attempted to weld the façades into a symmet-

rical block with taller houses at the ends and in the centre – probably the first time such a composition had been attempted in London. Of the original buildings of the square, nothing is left. The west side is occupied by Eero Saarinen's new American Embassy, a spacious, resolute building with a fine eagle perched aloft. The other sides are filled by other embassies, by expensive flats, and by offices, and the garden in the centre of the square, said to have been first planned by William Kent, has been laid out anew, rather stiffly, in memory of Franklin D. Roosevelt. A statue of him by Sir William Reid Dick was unveiled by Mrs. Roosevelt in 1948.

The last eighteenth-century house, number 44, was demolished in 1968. Twice over, that house was important in British history. It was there, on the evening of 21 June 1815, that the cabinet received Wellington's despatch telling of his victory at Waterloo, and less than five years later, on 23 February 1820, Arthur Thistlewood and his fellow conspirators planned, unsuccessfully, to murder the entire cabinet in that house. The house had been built by Thomas Richmond and the first occupant was Oliver St. John, Member of Parliament for Dungannon in Ireland. The most impressive feature of the house

was its hall and staircase. The walls were painted in trompe l'oeil to show groups of fashionably dressed people leaning over a balustrade. A few years earlier, William Kent had executed a similar decoration for the King's Staircase at Kensington Palace. It has been suggested that the Grosvenor Square mural and another, now lost, which once decorated the staircase at 75 Dean Street, Soho, may have been the work of John Laguerre, son of the Louis Laguerre who executed the murals at Blenheim and in the Saloon at Marlborough House (see p. 140). When number 44 was demolished, the mural was removed to the Victoria and Albert Museum, where it is displayed on a staircase leading from the Raphael Cartoons to the English Primary Galleries.

In North Audley Street, which joins the square to Oxford Street, stands St. Mark's church, built in 1828 by J. Gandy-Deering but at present closed. It was the burial place of Sir Hudson Lowe, who had the thankless task of guarding Napoleon on St. Helena.

On the opposite side of the square, in South Audley Street, are two shops, Purdey's famous for guns and Thomas Goode's for fine china, and the Grosvenor Chapel, built about 1730 by Benjamin Timbrell, who may also have designed it. Sir Richard Grosvenor presented the organ in 1732. The little church has a small tower and a four-column Tuscan porch. The galleried interior is painted white, save for the deep blue of the roof of the tiny Lady Chapel, which lies behind the elaborate altar, installed in 1913 to designs by Sir Ninian Comper.

Behind the church is a tranquil open space, Mount Street Gardens, and on the far side of these, in Farm Street, is the Roman Catholic church of the Immaculate Conception, built by J. J. Scoles between 1844

and 1849 in a manner entirely medieval but unattached to any one period. Pugin designed the high altar and the candelabra, and Evie Hone made the modern glass for the west window.

South Audley Street ends in Curzon Street, where Sir Nathaniel Curzon leased land to Lord Chesterfield, and to two builders, Nicholas Blick and Edward Shepherd. Isaac Ware built a fine house, now demolished, for Lord Chesterfield, who wrote of the boudoir and library that the 'former is the gavest and most cheerful room in England, the latter the best'. Shepherd built a 'white garden house' for himself which, after much alteration and enlargement, became the Marquess of Crewe's London residence and which is still in use. Another venture by the same builder has been equally long-lived; on the site where the May Fair was held, Shepherd built a small market to serve the needs of the great houses nearby. By some miracle, the gridiron of little streets has tenaciously survived, to remind us how sensibly the eighteenth-century developers planned.

Much attractive eighteenth-century building remains around Curzon Street, the houses and balconies in Queen Street being especially pretty. In Charles Street is the English-Speaking Union, housed in Lord Revelstoke's grand house, which W. Alwright created for him in 1890 from three older ones. Elaborate, rococo ironwork covers the front but one room at the back on the first floor still has panelling which may well date from 1740. Nearby, on the corner of Waverton Street, is a weather-boarded house, said to have been built by John Phillips, a carpenter who worked on the original development of the area. Mayfair has always been, and still is, a smart area, and sometimes the past is closer than one

might expect.

Regent Street and Soho

Regent Street is a busy thoroughfare. 1 It can claim to be one of London's grander shopping streets; crowds eddy along it by day, appraising the goods that lie behind the plate-glass windows of the stores, or drift through it on winter evenings, marvelling at the illuminated Christmas decorations. These throngs are made up, at random, of Londoners and of visitors from the provinces and from abroad; the street itself is English enough, presenting to the public the bland, slightly portentous face of turn-of-thecentury official commercial architecture. Soho, its eastward hinterland, is quite different. It is not, has never been, an English area. From its late seventeenth-century beginnings, it has been a place apart, a stranger's place, in which wave after wave of newcomers - French, Italian, Indian, Middle European, Chinese - have settled, perhaps uneasily at first but later more confidently, and tried to earn a living by doing the thing they knew best, which was usually cooking and running a restaurant, though even today, such specialist skills as book-binding. gilding, music printing, picture framing, and instrument making, to name only a few, can be found here. Soho is in, but not of, London. Today, it has a sleazy and a raffish side, but the visitor should also look for the real character of the area, which resides in its buildings and its long-term inhabitants.

Regent Street, broad, consciously planned, and lined with shops, was intended to provide a direct communication between Westminster and the newly laid-out Crown Estate in Regent's Park. Its southern end was aligned at right angles to Carlton House, the Prince of Wales's residence, thus creating for him a triumphal way through London's newest quarter. It is one of the rare examples in London of the Crown using its power and influence to accomplish an urban transformation; to clear a way for the new street, some 120 feet wide, more than 700 properties were demolished. For the northern section, Nash took

advantage of the noble width of Portland Place, which he called the finest street in London; he then turned his new thoroughfare through an angle at Langham Place and made an asset of the deviation by adorning it with the curious but enchantingly spired temple of All Souls' church. Then, turning southwards, he followed the line of Swallow Street, minimizing the crossings at Oxford Street and Piccadilly by means of circuses surrounded by buildings of extreme elegance. The length of the street, and its considerable distance from Westminster, he attempted to disguise by the variety of buildings erected therein. All the façades were under his supervision, though he would hardly have corrected Sir John Soane's designs for numbers 154-170. The culmination of Nash's plan was the graceful curve of the Quadrant, as the southern end of the main stretch of street is still called, running from Vigo Street and Brewer Street to Piccadilly Circus. The building of this he financed himself, determined that no single jarring façade should blemish the harmony of his masterpiece. In front of the buildings and across the pavement, he set an arcade, so that shoppers might continue their agreeable occupation under shelter even when the weather was inclement. London had secured her only boulevard.

Demolition and building preparations for the new street had begun in 1816; the work was virtually completed by 1824. Less than a generation passed before Nash's concept was marred. In 1848, the arcade was pulled down. The shop-keepers complained that it darkened their premises and encouraged vice; The Builder mourned the destruction in vain. In the 1920s, on the termination of the original leases, a general rebuilding was carried out. Today, some attempt would, perhaps, be made to retain and renovate the structures, but the stucco of Nash's new street disappeared, to be replaced by stone-fronted buildings. All that remains is the purpose-built elegance of its line and the sweep of the Quadrant; we may, mournfully, compare Nash's work with later rationalizations of London's street scheme, such as Shaftesbury Avenue, Charing Cross Road, Aldwych, or Kingsway.

One shop deserves particular attention – Liberty's. The firm was founded in 1875 by Arthur Lazenby Liberty, who opened a small emporium at 218a Regent Street. He dealt in oriental furniture and

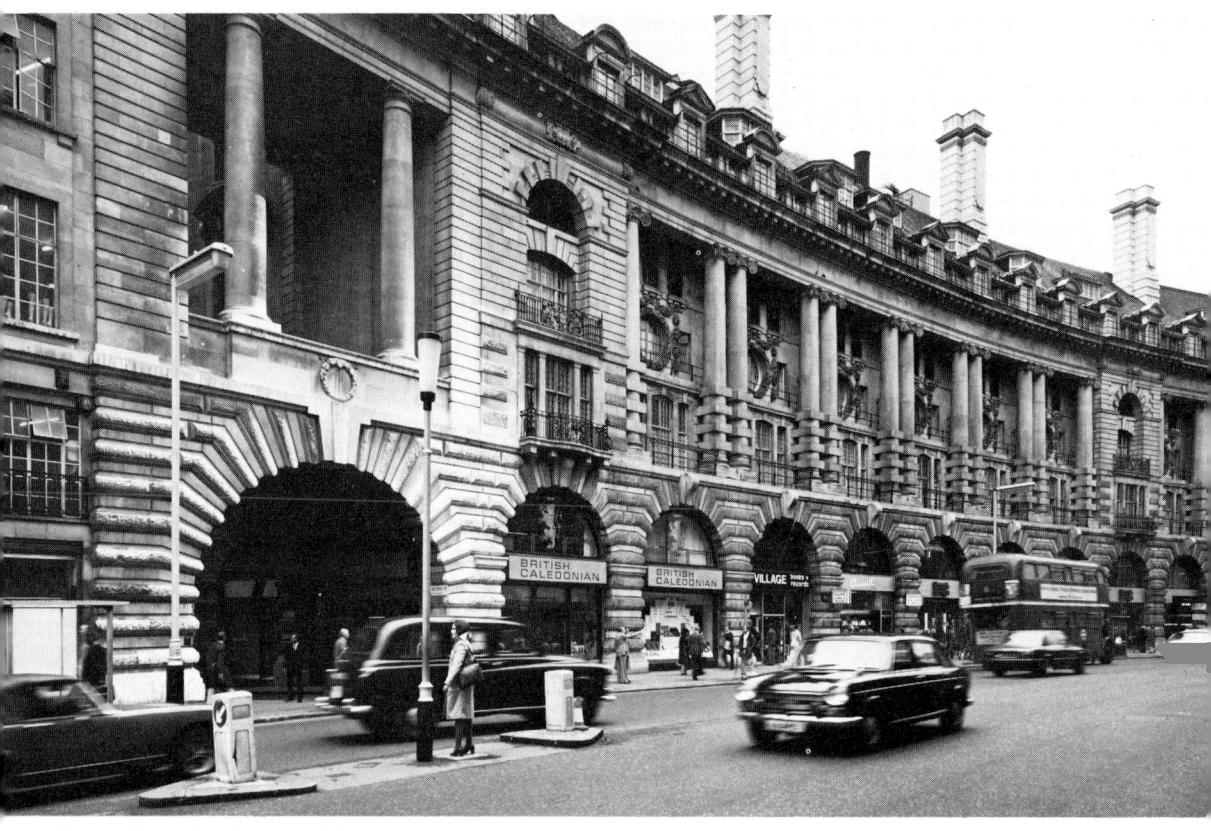

Regent Street façade designed by Reginald Blomfield, 1923

china, for which he felt a great enthusiasm. Whistler, Rossetti, and Burne-Jones all patronized him, setting a fashion followed by other, wealthier clients. The new furniture needed new furnishing materials so, since oriental fabrics were expensive, Liberty commissioned designs specially and set up his own mill. Soon, there was a demand for the new patterns in dress-weight materials, and the Liberty style, which is still flourishing, was created. Since the new materials were supple, unlike other fabrics in fashionable wear, a dress-making department was needed with E. W. Godwin, the theatrical designer, to provide sketches. The aesthetic movement, so delightfully ridiculed in the Savoy opera *Patience*, had found its own uniform. When the shop premises had to be rebuilt in 1925, Captain Stewart Liberty was as much of an individualist as his uncle had been. He commissioned a building from E. T. and E. S. Hall, with large windows for displaying goods and a slightly concave curve to the upper floors of the Portland stone façade to Regent Street. Giant Ionic pillars ran from the first to the third floors with an elaborate cornice above them, surmounted in its turn by a frieze of figures, carved by Charles Doman and Thomas Clapperton, which seem to wave and gesticulate to any passer-by below who chances to look

upwards. The Great Marlborough Street facade was another matter, for this was modelled on black and white Tudor half-timbering, and it was a drawing of this aspect which used to ornament Liberty's bags and wrappers. The building is divided into two halves by Kingly Street and on an arch over the alleyway is a clock, across the face of which St. George and the Dragon engage in combat on the hour. The interior of Liberty's was constructed from the timbers of two of the last old wooden ships of the Navy, HMS Hindustan, launched in 1824 when Regent Street was almost completed, and HMS Impregnable, launched in 1865 and then the largest wooden ship afloat. The floors of the main building are constructed as wooden galleries around the deep well of the central hall. The building materials throughout were hand-worked, the Portland stone being chiselled, not carved, and the timbers mortised. tenoned, and pegged together. However eccentric Captain Liberty may have seemed to his contemporaries, he gave his building an unusual integrity and his firm now begins its second century, as unquestioningly individualistic as ever.

On leaving Liberty's timeless style, one may turn up Foubert's Place to Carnaby Street where the style is, feverishly, of today or, preferably, of the day after tomorrow. This pedestrian precinct, created in 1963 by popular demand, sells garments and adornments in the style of the moment, whatever that style may be.

In constructing Regent Street, it was Nash's avowed intention to use it to separate the aristocratic development of Mayfair from the meaner houses in Soho. Although in its early years the quartier had many well-connected inhabitants and visitors - Old Compton Street takes its name from Sir Francis Compton, brother of Bishop Compton who consecrated St. Anne's church, Dean Street probably refers to the latter being Dean of the Chapel Royal – it was always associated with foreigners and those who came to London as a place of refuge. A church was built in the 1670s where St. Martin's School of Art stands in Charing Cross Road, and was used first by the Greek Christian community in London and then, from 1681 onwards, by the French Protestants, who had first been welcomed to England more than a century earlier by the young king, Edward VI. The French congregation increased enormously after 1685 when Louis XIV revoked the Edict of Nantes, which had granted the Huguenots freedom of worship. Charles II declared that they should have free letters of denization and the right to trade in England and between 40,000 and 50,000 crossed the Channel, about a third settling in London, many of them in Soho. Many of them prospered, as can be seen from the smart appearance of the congregation shown in Hogarth's engraving Noon, which was issued in 1738. The little church appears in the background. To this community, many of them skilled in specialized crafts and trades, there were added immigrants from virtually every nation in Europe, and, by the middle of the last century. Soho became known for the quality, variety, and comparative inexpensiveness of its restaurants, a reputation which it still holds today.

The curious name of Soho first appears in the rate books of St. Martin's parish for 1636, and seems to have derived from the hunting cry used when a hare was roused. About 1682, the Duke of Monmouth built himself a fine house here, and used the shout as his watchword and battle-cry at Sedgemoor three years later. His mansion stood on the south side of Soho Square, which was originally known as King Square, though whether it owed its name to the monarch or to the genealogist, Gregory King, who claimed to have designed the layout, is uncertain. A statue of Charles II stands in the centre. It was the work of Caius Gabriel Cibber, the Danish artist who became 'sculptor in ordinary' to William III. Originally, statues representing the principal rivers of England - Thames, Severn, Tyne, and Humber stood around the central figure, but by 1876 they had been lost and the king was so dilapidated that he was dismissed from the square and banished to the garden of the painter Frederick Goodall at Harrow Weald, where he remained till 1938 when he was

reinstated, though not to the centre of the square, his features battered but his mien still majestic. The original site of the statue is now occupied by a timbered structure, part arbour, part tool-shed, erected in 1876 to the designs of S. J. Thatcher.

Of the buildings around the square, little remains of the original houses, though seventeenth-century carcases survive, heavily disguised, at numbers 10 and 15. Until the end of the eighteenth century, the residents were aristocratic and distinguished; thereafter humbler persons occupied it, and many premises were used for trade. Richard Payne Knight, the connoisseur, lived at number 3 from 1808 till 1821; his collections of coins, jewels, and bronzes, which now belong to the British Museum, were first housed there. By coincidence, numbers 8 and 9 gave way in 1891-3 to a new French Protestant church designed by Sir Aston Webb. It is built of red brick, in his Gothic manner. In 1950, a sculpture was inserted into the tympanum above the main entrance, showing the French community first seeking refuge in England and being granted it by Edward VI. The French church has for company St. Patrick's Roman Catholic church, also built in 1891-3. It was designed by John Kelly in an Italianate style with a tall and impressive campanile. Number 22, the site of which is now covered by a block of offices and showrooms, was once the home of Alderman William Beckford, Lord Mayor of London in 1762 and 1769. He lived here from 1751 till his death in 1770 and his son, the younger William Beckford, author of Vathek, for whom Wvatt built the fantastic Fonthill Abbey, was born here in 1759. Five houses away, on the corner of the square and Greek Street, lived Richard Beckford, East Indian merchant, brother of the elder William and uncle of the younger.

The original houses on this site were demolished about 1743 and a new, much larger, mansion was built by Joseph Pearce, who later went bankrupt. In 1754, the house was leased to Beckford and it was probably he who commissioned the magnificent plasterwork and woodwork which adorn the interior, making the house perhaps the most dramatic example in London of mid-eighteenth-century Rococo decoration. No documentary evidence remains to tell who were the artists and craftsmen responsible for the work but, though they are anonymous, their skill was consummate. The exterior is very plain, basement, three storeys, and a garret in height, five bays wide to Greek Street, four to Soho Square. There is a stone doorcase with a heavy lintel and two blunt obelisks on either side in front to mark it. The importance of the house lies in the adornment of the interior. The stone-flagged hall rises through two storeys and around it runs a cantilevered stone staircase with a metal balustrade of lyre-scrolls supported on pairs of C-scrolls. Its walls and ceiling are covered with a profusion of rich plasterwork – swags of fruit and flowers, lions' heads, busts in roundels, and shell shapes are all mingled together. The de164 WESTMINSTER

coration of the principal room on the first floor is equally rich, with writhing dragons on the chimney-piece – an allusion to Beckford's City connections? – and four stout *putti* dancing on the ceiling, bearing the symbols of the elements. The other two first-floor rooms and the lobby are as magnificent as the first.

Beckford's fine decorations - if indeed he was responsible for commissioning them – were hardly completed when he died, abroad, in France. The house passed through a succession of owners who, happily, altered little and then in 1861 was sold to the House of St. Barnabas-in-Soho, a house of charity established in 1846 for the relief of the destitute and homeless poor of London. W. E. Gladstone and Frederick Denison Maurice were associated with it. A chapel designed by Joseph Clarke was added behind the house. It has a narrow, lofty nave with a rounded apse and much polychrome marble decoration. The original glass was destroyed during the Second World War and was replaced with new by John Hayward in 1957-8. The charity continues its good work and opens its remarkable building freely on Wednesday afternoons and Thursday mornings. Those visiting the house may like to know that it is mentioned in Dickens's A Tale of Two Cities and that in chapter VI there is a reference to the plane tree which still shades the internal courtyard.

On leaving the House of St. Barnabas (Barnabas was the 'son of consolation'), diagonally across Soho

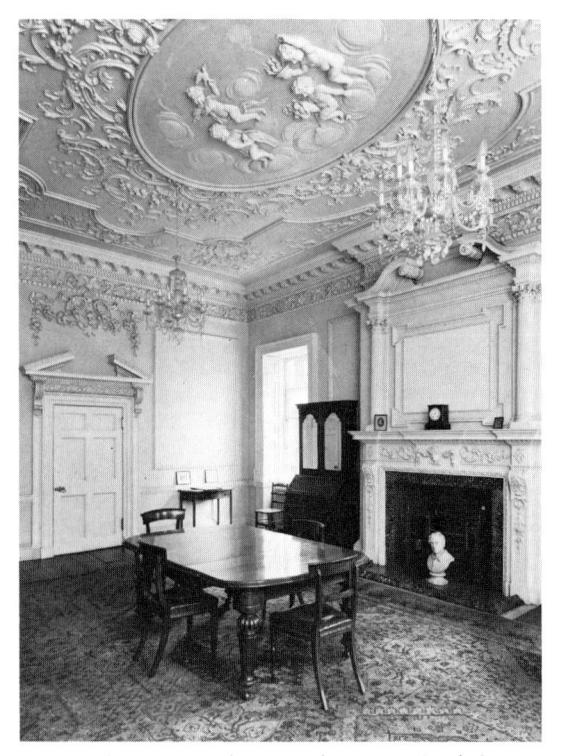

Interior of the House of St. Barnabas, no. 1 Greek Street

Square can be seen the façade of number 37. The original house on the site was rebuilt about 1766 and in the early nineteenth century was given a fine shop-front with four attached Greek Doric columns and an entablature. Today, the building houses a music publisher.

From the Square run the three most important streets in Soho – Greek Street, Frith Street, and Dean Street, leading to Oxford Street or Shaftesbury Avenue. In Greek Street, next to the house of St. Barnabas, stands a public house, the Pillars of Hercules, in which the poet, Francis Thompson, used to drink. At number 1, the essayist De Quincy took shelter when he was destitute and starving, while number 60 was Sir Thomas Lawrence's property from 1790 till 1814, William Etty working here as his pupil from 1807. The seventeenth century carcase of number 17 has recently been much renovated but a fine shop-front, added in the early nineteenth century, has been retained. There are two things to remember when walking in Soho. First, here as in Covent Garden, the eyes must be cast upwards to the first and second storeys. The ground-floor façade has too often been modernized at some time or another, but frequently the original work survives above the level of a casual glance. Secondly, there are two Sohos, the domestic scene of the morning which gives place to the more hectic crowds shifting to and fro in the narrow streets as evening begins.

Frith Street takes its name from its builder, Richard Frith, who was so busy in late seventeenthcentury London. The critic and essayist, William Hazlitt, whose life had been spent in argument, died at number 6, murmuring as his breath ebbed away, 'Well, I've had a happy life.' During the autumn of 1764, the eight-year-old Mozart stayed at number 20, having amazed George III and all London society with his wonderful talent, and at number 22 James Logie Baird first made a picture appear on his experimental television screen. Number 15 should be observed for the architectural interest of its shopfront. The building dates from 1733-4 but about 1816 a Gothick ground-floor façade, of three unequal bays separated by slender cast-iron shafts, was inserted. The tops of the two window bays are filled with elaborate cast-iron tracery.

There is another fine shop-front at number 88 Dean Street, which was built about 1791. Narrow pilaster strips divide the ground-floor façade into four compartments, two for doors to house and shop, two for windows. Above them, a curved fascia is ornamented with panels set in Rococo frames, as if Robert Adam had left the drawing-rooms of the aristocracy and had applied his imagination to the adornment of a humble shop. Out of Dean Street runs a passageway, Meard Street; it is a street of tiny houses built about 1732 by John Meard, carpenter of Soho, who rose to become a justice of the peace and a freeman of the City of London. The south side remains intact with pretty doorcases and simple

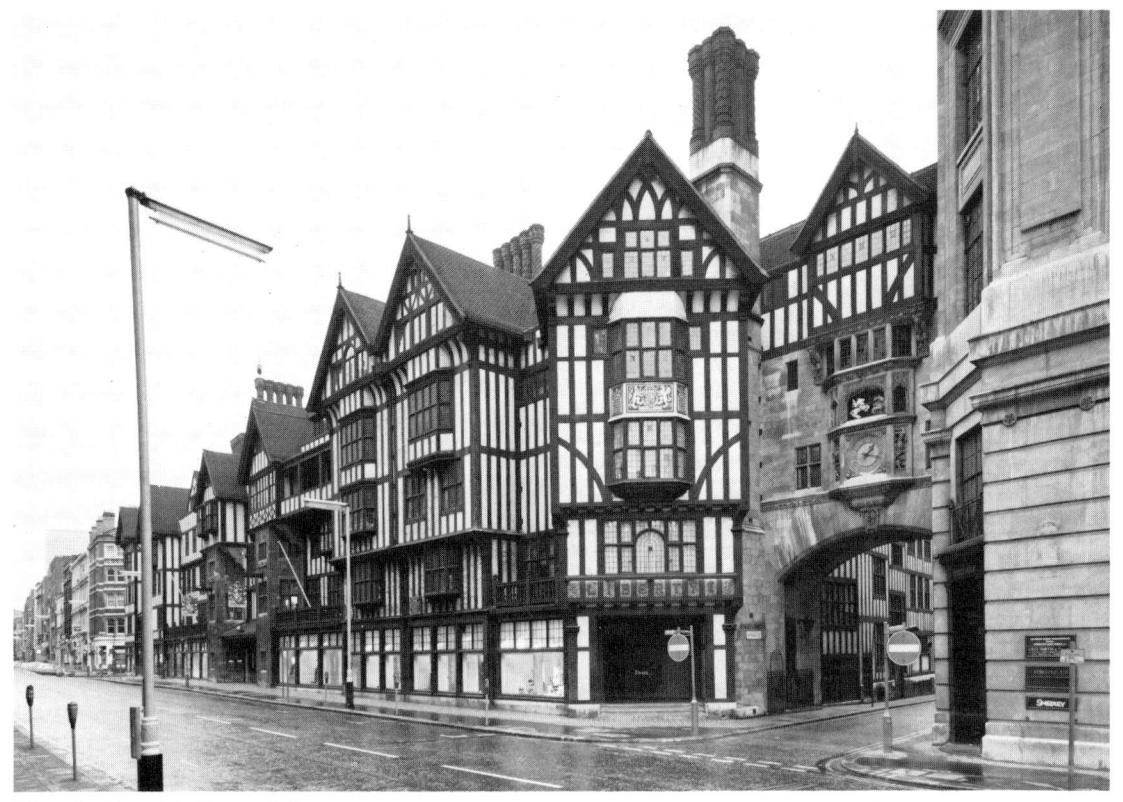

Liberty's, Great Marlborough Street

panelling to the first-floor rooms. The modern counterpart is **Wedgwood Mews**, recently opened off Greek Street and lined with studios of graphic artists.

At the southern end of Dean Street stands the tower of St. Anne's church. Begun in 1677 and consecrated in 1686, it was designed by William Talman, who probably consulted Sir Christopher Wren. It was a plain, red-brick basilica, five bays long with an eastern apse and double rows of windows in the north and south walls. The square tower had at each corner a large urn and was topped with an octagonal, bell-shaped dome with a small dormer window in each diagonal face. Above the dome was an open arched lantern, on which was set a short, bulbous spire terminating in a ball and weather vane. The tower and the spire were rebuilt by S. P. Cockerell in 1801 with a sphere set with four clock faces; the result was certainly unusual but was also heavy and ugly. In 1940, the church was destroved by bombs though the steeple was left standing. Today, the ruins have been cleared away and the tower stands alone, its octagonal Vestry room used by the local amenity society. Dorothy Sayers was a churchwarden here for many years. Outside in the churchyard, the gravestones remain, among them one to Theodore, known as the king of Corsica, whose epitaph Horace Walpole composed.

The western side of the churchvard leads into Wardour Street, lined with offices of film companies, their windows displaying enlarged photographs of the celluloid dreams they purvey. At numbers 152-160 stands a remarkable building, apparently modelled on the German Renaissance Rathaus at Bremen. and designed in 1906 by Frank Loughborough Pearson for Messrs. Novello, the music publishers. Their name can be seen, entwined in foliage, along the entablature, though in 1965 the firm moved elsewhere. There is still a reassuring number of musical instrument makers in and around Wardour Street. Inside, in an ante-room at the head of the staircase which was inspired by the stairway of Ashburnham House, Westminster School, was a niche in which stood a statue of Handel, executed in marble by Roubiliac; it is now in the Victoria and Albert Museum. Thomas Sheraton, the furniture designer, lived at number 163 from 1751 to 1803.

Parallel with Wardour Street is Berwick Street which, running southwards, becomes Rupert Street; an excellent vegetable market, which has flourished for 200 years, is held here. At this point, the street pattern becomes complicated but Beak Street, where Canaletto lodged at number 41, leads back to Regent Street. A slight detour southwards, by way of Upper John or Upper James Streets, brings us into Golden

Square, in which stands an affably democratic figure of George II, fashioned by John van Nost about 1720, possibly for the Duke of Chandos's gardens at Canons in Middlesex (see p. 264). After the sale, it found its way in 1753 to Soho, where the King remains, clad in Roman attire, extending his arm in a benevolent gesture as if he wished to shake hands with all comers, for the plinth on which he stands is only a few inches high. Angelica Kauffmann lived at 16 Golden Square from 1767 till 1781, but the house has long since been demolished.

At this point, stand still and remember what you have seen, for the developers are moving in on Soho and no one can be certain how much longer this intriguing enclave will be with us. Already a tower block has reared up in Marshall Street, a plaque reminding us that the poet and artist, William Blake, was born here in 1757; one doubts whether Blake himself would have rejoiced in the commemoration. If Soho goes, the loss will be irreparable, for the survival of such an area, built between the late seventeenth and the early nineteenth centuries and still with its original street pattern almost intact, is unique. Grander areas survive in St. James's, Mayfair, and Marylebone, but nowhere else in London is there quite the domestic simplicity, the humble but contented dignity, of these houses and shops, built on a modest, human scale, and still, for the most part, keeping to usages not so very far removed from their original purposes.

Today, Shaftesbury Avenue, with its throng of theatres, marks the southern extent of Soho, but till the avenue was created between 1877 and 1887 by widening King Street, the area was considered to stretch to Leicester House, which stood on the northern side of what is now Leicester Square. The Earl of Leicester built his town house in 1631; several generations of his family used it and then in the ensuing century it was let, first from 1718 to 1727 to the future George II when he was Prince of Wales, and later to his son, Frederick, who died there in 1751. The house was pulled down in 1791 and the Empire Cinema covers most of its site. The ground on which the house had stood was originally Lammas land, that is, land on which all the parish might graze their cattle after harvest time. In compensation for this loss of rights, the Earl had paid £3 to the parish and had laid out the rest of the fields as pleasant public walks at his own expense. The irregular shape of the square marks this former grazing ground. The southern, eastern, and western sides were built up by the end of the seventeenth century and have been rebuilt ever since at intervals. The landscaping of the square was undertaken in 1874 by Baron Grant, a speculator who ended in the bankruptcy courts but was, earlier, sufficiently public-spirited to spend a part of his wealth on such an improvement as this. In the centre of the garden is a very poor statue of Shakespeare by James Knowles, and in each corner is a bust of a distinguished local resident - Sir Joshua Reynolds by H. Weekes, William Hogarth by J. Durham, Dr. John Hunter by T. Woolner, and Sir Isaac Newton by W. Calder Marshall. Reynolds lived at 47 Leicester Square from 1760 till his death in 1792, with Hunter as a neighbour at number 28 from 1783 till 1793, while Hogarth had lived at number 30 from 1733 till 1764, and Sir Isaac Newton had dwelt nearby at number 35 St. Martin's Street from 1711 till 1727. Revnolds's house stood on the west side of the Square; its site is today covered by Fanum House. Its grounds extended as far as Whitcomb Street, and on them Reynolds built a gallery and a 'large and commodious' octagonal painting room. Here he was visted by all his distinguished sitters and his friends, Dr. Johnson, Boswell, Fanny Burney, Goldsmith, Garrick, and Burke among them.

The square today is comparatively undistinguished; it lies empty in the morning but is packed with cinema crowds in the evening. Just off its north side, in Leicester Place, and still preserving the near-circular polygon of Robert Barker's Panorama, which stood here from 1793 till 1864, is the Roman Catholic church of Notre Dame de France. The Panorama building had been converted to this use within a year of the display's closure, but heavy bombing in 1940 necessitated a new building. This was carried out between 1953 and 1955 to designs by Professor H. O. Corfiato of Corfiato, Stewart Lloyd Thomason and Partners and is an impressive building. The Survey of London describes the façade as Beaux Arts Modern, the circular interior is lofty and light, and the fittings are of especial interest. Above the main entrance is a large triangular relief of the Mater Misericordiae by Professor Saupique, and the panels on the rounded piers between the three doorways, with scenes of the life of the Virgin, are by students of the Beaux Arts de Paris. Inside is a huge tapestry of Our Lady, Queen of Creation, designed by Dom Robert, OSB, and made at Aubusson. Jean Cocteau decorated the walls of the Lady Chapel, and the statue of the Virgin was copied by students at L'Ecole Boule in Paris from a fourteenth-century figure.

Soho's eastern boundary is the Charing Cross Road, still lined in parts on either side with bookshops, for both new and secondhand treasures. Of them, Foyle's is the largest and the most famous but other, smaller establishments, such as Zwemmer's at number 78, who specialize in works on art and architecture, have much to offer. Among the bookshops is the St. Martin's School of Art, founded by 1854 and possibly the oldest in the country. It moved to Charing Cross Road in 1913; the present building, with much carved stone decoration, is by E. P. Wheeler.

Hyde Park and Kensington Gardens-

Across the West End of London stretches a line of royal parks, St. James's bordering on Green Park, which in turn has Hyde Park for a neighbour, while the 360 acres of that open space merge into the 275 acres of Kensington Gardens, so that it is possible to walk literally for miles across grass and beneath trees. At the Reformation, Henry VIII possessed himself of church lands which today form St. James's Park, Kensington Gardens, and Hyde Park: he stocked them with deer and his son and daughters enjoyed the sport within them. James I opened Hyde Park to the public and his grandson. Charles II. extended the same courtesy with regard to St. James's. William III and his sister-in-law, Oueen Anne, who had little in common save their love of gardening, enclosed modest portions of the western side of Hyde Park to form a garden around the new royal residence at Kensington, while Caroline, George II's consort, laid out a more substantial area, damming the Westbourne and linking a series of marshy ponds to form the Long Water and the Serbentine.

The most immediate advantage of the royal parks is the sheer animal delight which the town dweller must feel at the sight of so much open space. To this, the explorer can add more intellectual pleasures, for spangled all over Hyde Park and Kensington Gardens are sculptures, belonging to a variety of periods and styles, summer-houses designed by Wren and Hawksmoor, associations and memories of all kinds, and – final objective to a morning's or afternoon's walk – the State Apartments at Kensington Palace, opened to the public by Queen Victoria in 1899.

An exploration may begin at the north-eastern corner of Hyde Park, near the Marble Arch, designed by John Nash in 1827 to stand as an elaborate flourish in front of George IV's newly built Buckingham Palace, its white marble contrasting oddly with the honey-coloured Bath stone of the building: the

design was probably inspired by the Arch of Constantine. It was removed to its present situation in 1851. The reliefs on the north side are by Westmacott, those on the south by Baily, while Chantrey cast a bronze equestrian statue of the King to stand on the top, which was, however, eventually placed in Trafalgar Square. Close to the Arch, a bronze triangle in the roadway marks the site of Tyburn gallows, a place of public execution from 1196 till 1783 (see p. 190). Inside the Park, especially at weekends, there is an atmosphere of attentive, sometime argumentative discussion and debate, for this is Speakers' Corner where public meetings have been held since 1855. while ever since 1872 any member of the public has had the right to stand up and address all who care to listen on any subject that may occupy or trouble his mind. Speakers' Corner is best visited on a fine Sunday.

Westwards across the Park lies the Bird Sanctuary, created in 1925 in memory of W. H. Hudson, the naturalist (d.1922). In it stands a stone screen, five feet high and ten feet wide, with a relief by Epstein representing Rima, half-human, half forest-spirit, a character in Hudson's book *Green Mansions*. The stolid rigidity of the central figure and the formalized birds which flank it were not appreciated by contemporaries and the sculpture was several times daubed with green paint. Time has passed and passions have died down, so that it would today be admitted that Epstein's work at least expresses the power and ferocity of nature.

Further west, near to Victoria Gate, is the Dogs' Cemetery, wherein pet animals were buried from 1880 till the First World War. At this point, the Carriage Drive turns south and is called the Ring; just beyond it, at the head of the Long Water, stands Queen Anne's Alcove. This small temple, intended to be used as a summer-house, was probably designed by Wren and was moved to its present position from Kensington Gardens. Beside it is a paved courtyard with four fountains and an Italianate summer-house which used to shelter a pumping station. Nearby is a seated bronze statue of Dr. Jenner, who introduced vaccination against smallpox to this country. Sculpted by W. Calder Marshall, it was erected in Trafalgar Square in 1858 and moved to its present site in 1862; neat Aesculapian symbols decorate the chair.

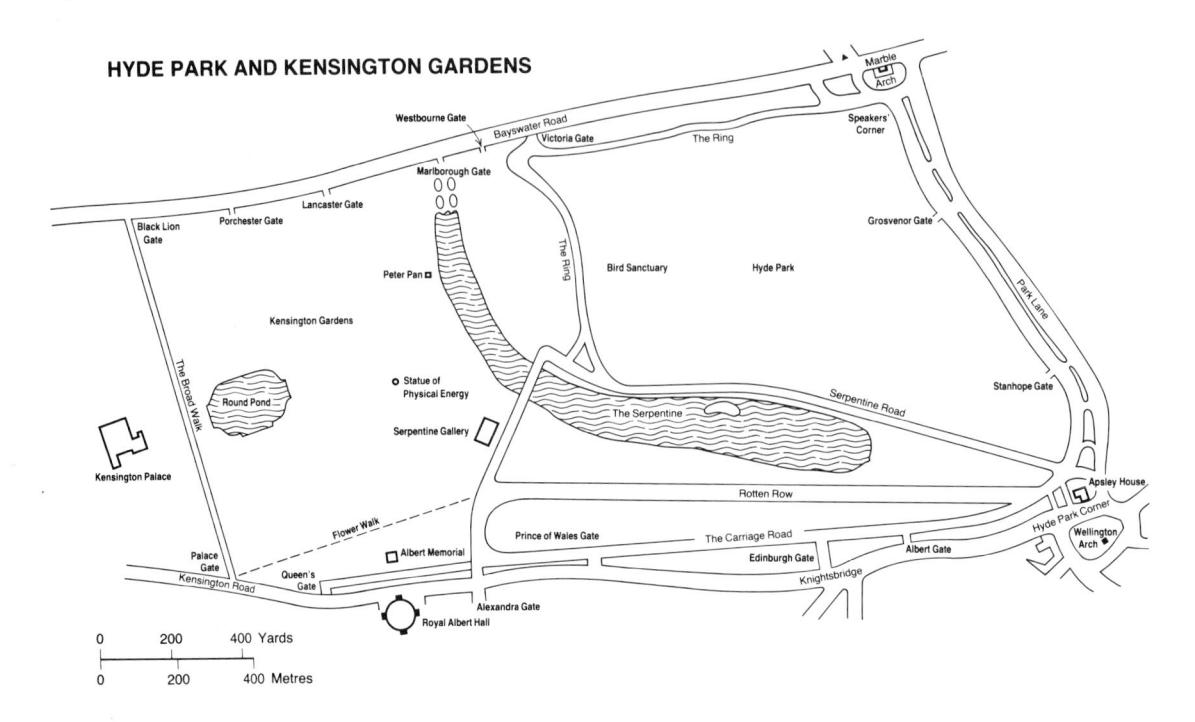

The road leads past the Serpentine Gallery, opened in 1970 to display the work of young artists, to the bridge designed by the brothers, Sir John and George Rennie, in 1826, which divides the Long Water from the Serpentine and Hyde Park from Kensington Gardens, in which stand two important statues and an obelisk. G. F. Watts's vigorous bronze, Physical Energy, represents a man seated, easily and confidently, on a horse which stamps its left fore-hoof, anxious to be off. The original statue forms the central portion of the Cecil Rhodes memorial on Table Mountain near Cape Town in South Africa; the copy was set up in Kensington Gardens in 1904. Just north of it is an obelisk, erected in 1866 to J. H. Speke, the discoverer of the Nile, and in a small glade, near the Long Water, is Sir George Frampton's bronze figure of Peter Pan, the boy who never grew up, hero of Sir James Barrie's book and play, erected in 1912 through the generosity of an anonymous donor; a figure of a child holding a small cast of Peter Pan is on the sculptor's tomb in St. Paul's. Whimsy may be out of fashion today, but in all fairness it should be said that the main figure, for which the actress Nina Boucicault modelled, is graceful and that the base, fashioned like a gnarled tree bole from which fairies, children, rabbits, mice, squirrels, and birds emerge, has great imagination and power.

Returning to Speakers' Corner and travelling southwards along the eastern border of the Park, it becomes apparent that Park Lane and the East Carriage Drive form one enormous traffic roundabout, three-quarters of a mile long. The older houses in Park Lane still look out across a green sea

of tree-tops. The great mansions which once stood here - Grosvenor House, Dorchester House, Londonderry House - have gone and their places have been taken by hotels. Grosvenor House was built in the late eighteenth century and became the home of the Marquess of Westminster in 1822. A picture gallery was added in 1843 to Thomas Cundy's designs, and here hung the family's collection, which included Gainsborough's Blue Boy (now in the Huntington Collection in America) and Reynolds's Mrs. Siddons as the Tragic Muse (now in the National Gallery). Dorchester House was built for the millionaire R. S. Holford by Lewis Vulliamy between 1851 and 1857, with a façade modelled on that of Peruzzi's Villa Farnese in Rome. The diningroom was decorated by Alfred Stevens, his magnificent designs taking more than 15 years to complete and costing some £8,000, which dismayed even the wealthy Holford. When the house was demolished in 1929, many of the fittings went to the Walker Art Gallery in Liverpool, and the dining-room fireplace, with caryatids reminiscent of Michaelangelo's sculpture, is now in the Gamble Room at the Victoria and Albert Museum. Londonderry House, where Lord Londonderry's collection of sculpture, including several works by Canova, was displayed in its own gallery, was demolished in 1964, the statues having been sold at Sotheby's two years earlier, and the Hilton Hotel, designed by Lewis Solomon, Kaye and Partners and built in 1963, with a tower rising some 328 feet into the air above the Park, ends the chain.

On the verdant side of Park Lane is a fountain adorned with leaping figures by T. B. Huxley Jones,

known as The Iov of Life, and Hyde Park Corner itself is an open-air gallery of English sculpture. Just north of Apsley House is a colossal bronze statue of Achilles by Richard Westmacott, erected in 1822 as a memorial to the Duke of Wellington from the women of England, at a cost of £10,000, the metal being supplied by 12 French 24-pounder guns. The pose is modelled on that of one of the two horse tamers on the Quirinal at Rome; the unabashed nudity of the figure shocked contemporary opinion. On the other side of the Carriage Drive, inaccessible among the swirl of traffic, sits a bedraggled figure of Byron, his dog beside him, the work of Richard Best. The figure was unveiled in 1880, £3,500 having been subscribed by the public and 57 tons of marble for the pedestal having been supplied by the Greek government. Both the poet and the public deserve a braver, more handsome, memorial than this pinched, melancholy figure.

Across the entrance to the Park is Decimus Burton's Screen, erected in 1825 and originally intended to provide Buckingham Palace with a noble approach to Hyde Park. Groups of Ionic columns separate the three arches of the Screen and a frieze, based on that of the Parthenon by the younger John Henning, runs along the top. Beyond the Screen, we are at Hyde Park Corner. On an island in the middle of the traffic is the Wellington Arch surmounted by Adrian Jones's huge bronze group, The Quadriga. The Arch was designed by Burton in 1828 and was originally crowned by M. C. Wyatt's gigantic equestrian statue of the Iron Duke, mercifully removed to Aldershot in 1883. Jones's group replaced it in 1912. It represents Peace descending from Heaven into the chariot of War, causing the horses which draw the fell vehicle to rear up to a standstill. The dramatic proportions of the figures are shown to particular advantage in their lofty situation. Sharing the island with the Arch are C. Sergeant Jagger's Royal Artillery Memorial, Derwent Wood's Machine Gun Corps Memorial, and the Duke of Wellington's monument by Edgar Boehm. The bronze figure of the Duke is mounted on Copenhagen, the horse that carried him at Waterloo; the effigy gazes directly into the courtyard of his former home, Apsley House, a telescope in hand. The Machine Gun Corps Memorial is a graceful naked bronze figure, representing David. He leans on Goliath's sword; on the pedestal is the grisly text (I Samuel, xviii, 7): 'Saul hath slain his thousands, but David his ten thousands.' The Artillery Memorial is a work of extraordinary power and intensity; it consists of an enormous block of Portland stone surmounted by a stone representation of a 9.2-inch howitzer. Around the base, in low relief, are carved scenes of the Artillery in action, and at each side is a large bronze figure, a subaltern, an ammunition carrier, a cloaked driver, and, lying prostrate, a dead gunner, his body covered with a

Kensington lies westwards and is reached by Rot-

ten Row, its name a corruption of the route du roi, which leads to Kensington Palace. The avenue is still a riding track. At the eastern end of the Row is the Dell, in which stands a monolith of Cornish granite weighing seven tons, originally part of a now-dismantled fountain. A stone nearby records that the monks of Westminster once drew their water from a conduit here. The Serpentine curves stiffly away on our right, its rigidity of line making it hard to realize that Queen Caroline's insistence on such a shape was an extraordinary break with the formal tradition of royal gardens. Beside the Edinburgh Gate is Epstein's bronze group, set up in 1961, of Pan, piping a family on to run wild in the freedom of the Park. their dog barking and capering beside them. Beyond are the newly rebuilt Horse Guards barracks (1970, Sir Basil Spence); the pediment of an earlier barracks, designed by T. H. Wyatt in 1879, has been retained above the entrance, where it perches uncertainly, ill-at-ease among so much modernity. Just beyond, opposite Prince of Wales Gate, is the site on which the Crystal Palace stood, to house the Great Exhibition of 1851.

This Exhibition, and its consequences, had a great influence on the history of British art and on the development of London. The idea of an international exhibition at which artistic and manufacturing achievements from all over the world might be displayed originated with Henry, later Sir Henry, Cole, a promising young civil servant; it was taken up, enthusiastically, by Prince Albert, and to it he gave indomitable support. The novel scope of the undertaking was matched by the originality of the building erected to house it; a committee of architects and engineers was only able to produce a compromise design, a huge, brick-built construction with a glass dome larger than that of St. Peter's, both slow and costly to erect, but Joseph Paxton, head gardener to the Duke of Devonshire, produced a design based on his experience in building glasshouses which *Punch* promptly dubbed 'The Crystal Palace'. It fulfilled the triple needs of the Exhibition committee - it admitted the maximum amount of light, it was comparatively economical to construct and, since the whole building, 1,848 feet long by 408 feet wide, was made from standardized, prefabricated parts of glass and metal, a venture never undertaken before on such a scale, it could be set up in less than a year, which was all the time available. The sentiments aroused by the Exhibition, in the hearts of the Queen and her Consort down to the six million ordinary people who came from all over England and from other parts of the world, were deeply religious, feelings of awe that the Almighty could inspire mankind to such achievements, and of joyous optimism that the nations of the world, having cooperated so well over one task, might learn to live together in peace and unity. The Queen visited the Exhibition 29 times, the Duke of Wellington walked over daily from Apsley House. In the prevail170

ing mood of reverent but exuberant confidence, it was believed that the arts would flourish and, allying themselves with manufacture, would fill every home, even the humblest, with articles of daily usefulness that would also be so beautiful that their employment would be a joy and inspiration. The dream faded, but it was not unworthy, and its reflections can still be seen today in such places as the furnishing department of Liberty's.

The Exhibition closed on 15 October; the Crystal Palace, to most people's sorrow, was dismantled to be re-erected at Sydenham; Hyde Park returned to normal. Paxton, very properly, was knighted, the Corporation of London was so delighted with the sculpture that they had seen that they decided to spend £10,000 on statuary for the Egyptian Hall of the Mansion House, and the controlling committee was left with a profit of £186,437, with which they bought 87 acres in South Kensington, where they built a centre for the encouragement of the arts and sciences (see p. 301).

Alexandra Gate leads into Kensington Gardens, in which stands the Albert Memorial. The Prince Consort died on 14 December 1861, to be mourned throughout the rest of her long life by Queen Victoria. The spontaneous grief of the nation at this unexpected loss demanded an impressive monument. The Memorial, designed by Sir George Gilbert Scott, took ten years to complete and cost £120,000. A square, pinnacled spire, rising 175 feet into the air, was hollowed out to form a shrine for a huge bronze statue of the Prince. The spire rises from a tall pedestal around which runs a frieze. It is in turn raised on a platform approached by four flights of granite steps. Four bronze groups, representing Engineering (J. Lawlor), Agriculture (W. Calder Marshall), Manufacture (H. Weekes), and Commerce (T. Thornycroft), stand at the corners of the pedestal, and four huge marble compositions, personifying the continents, mark the corners of the platform. The whole Memorial seems like a gigantic medieval reliquary, each detail of it expressing some facet of the Prince's broad interests.

Each component part is of interest, either technically or artistically. The spire is covered with lead and inlaid with 'agate, onyx, jasper, cornelian, crystal, marble, granite and other richly coloured hard substances'; it was the work of Messrs. Skidmore of Coventry. The central statue of the Prince, who is shown studying a volume of the Great Exhibition catalogue, established J. H. Foley as the leading sculptor of his day and is both expressive and workmanlike, though not inspired. The four bronze groups around him are comparatively stiff and lifeless and of the marble groups below, only Africa (W. Theed) and America (J. Bell) have any sort of line or spirit, Asia (J. H. Foley) and in particular Europe (P. McDowell) being flaccid and uninteresting. The great attraction of the Memorial is the frieze around the pediment.

This frieze is composed of 178 portrait figures, cut in such high relief that some of them are almost free-standing, depicting practitioners of all the arts since the days of ancient Egypt. The architects and sculptors on the north and west sides were the work of J. B. Philip, the poets, musicians, and painters on the south and east that of H. H. Armstead. Homer, Raphael, Michelangelo, and Giotto each occupy the centre of a side, the two latter being portrayed a second time elsewhere. Wherever possible, a true likeness was aimed at, and appropriate attributes given - Pythagoras has geometrical instruments, Hogarth his dog as well as his brushes - and some of the groupings are delightful; Cimabue and Giotto work out a problem together, Gibbons, Bird, and Bushnell are in conference, Ghiberti and Luca della Robbia are frankly gossiping, while William of Sens is deep in meditation, and Sir Christopher Wren contemplates his companions with good-humoured detachment. Unfortunately, no woman seems to have qualified for inclusion.

From the Memorial, the Flower Walk runs westwards. This triumphant herbaceous border, on a par with those beside the Broad Walk in Regent's Park or in the gardens at Hampton Court, must be considered as an artistic achievement in its own right. It leads to the Broad Walk, Kensington Palace, and the Round Pond, completed in 1728 to the designs of Charles Bridgman. Near the Palace are the Sunken Garden and the Orangery, the former opened in May

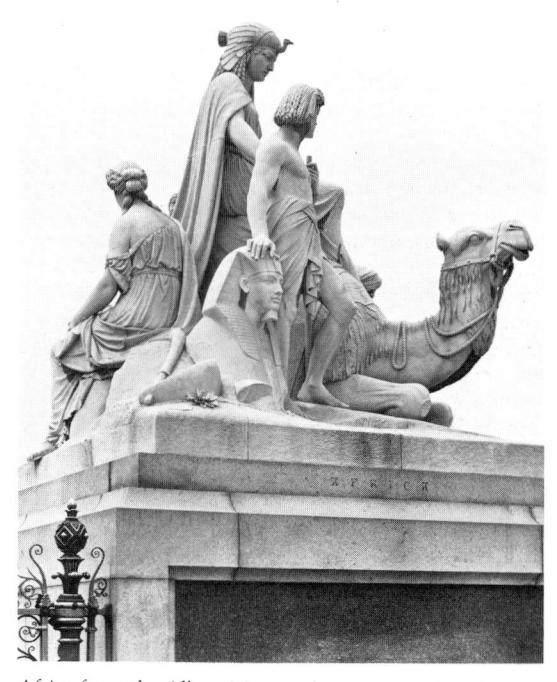

Africa from the Albert Memorial, Kensington Gardens

1909 in imitation of the formal gardens which delighted William and Anne, and surrounded by a pleached lime-alley. The Orangery lies further north; its perfectly proportioned, dignified façade was designed by Hawksmoor with modifications by Vanbrugh in 1704, and Queen Anne used it as a 'Summer Supper House'.

Kensington Palace has had a fragmented and varied development. A house was built on the site about 1605 by Sir George Coppin, which later became the property of the Earl of Nottingham. He sold it in June 1689 to William III and Queen Mary for £18,000. Neither of these monarchs liked the palace at Whitehall; he suffered from asthma and the damp and smoke made him worse, while she felt trapped in a place where she could 'see nothing but wall or water'. Wren was instructed to enlarge the Jacobean mansion into a royal residence and over the next seven years he gave it a new main portico, a clock tower, ranges containing the King's, the Queen's, and the Stone Galleries, as well as domestic offices and stables, but the scale remained essentially private. Around it, the 'old court suburb' of Kensington began to grow up.

Mary died there in December 1694 and William came to spend more and more of his time at Kensington, lavishing attention on the formal gardens, for which his designers were George London and Henry Wise. In 1702, having been injured by a fall from his horse at Hampton Court, he begged to be carried to Kensington and there he too died, to be succeeded by his sister-in-law, Anne. She spent much time there, contentedly, delighting in it as a country retreat and giving her attention to the gardens. George I had different ideas; he decided to transform Kensington into a proper palace and he employed three architects, William Benson, who replaced Wren as Surveyor in 1718, William Kent, Lord Burlington's protégé, and Colen Campbell, the Deputy Surveyor. The core of the old house, in the north-eastern corner, was torn out and replaced by three state rooms, arcaded courtyards took the place of old outbuildings, and new kitchens were installed. Henry Joynes was the resident Clerk of Works. George II, succeeding in 1727, made Kensington Palace his principal residence; little was done in the way of building, but his Queen, Caroline, lavished her efficient attention and, unknown to the King, much public money on the gardens. Her gardeners were Henry Wise and Charles Bridgman and to them we owe the Round Pond and the three avenues which radiate from it eastwards to the Serpentine and Long Water. It is to Queen Caroline that we also owe the Holbein drawings in the royal collection, which she discovered, tucked away in a bureau in Kensington Palace, and recognized for their true worth.

George II was the last reigning monarch to reside at Kensington, but the old palace has continued to be used by members of the royal family. The lower floors were remodelled by James Wyatt for the Duke

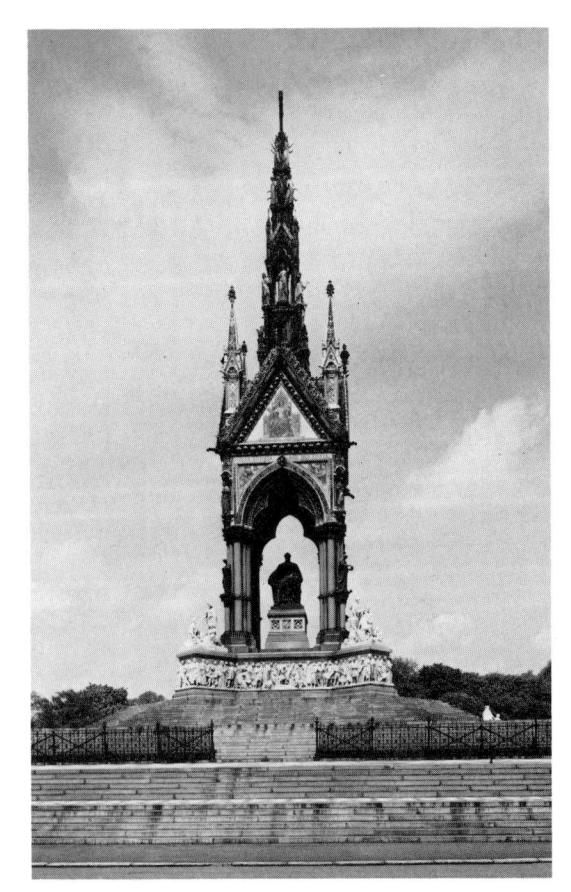

Albert Memorial, Kensington Gardens

of Kent, Queen Victoria's father, and the future queen was herself born there on 24 May 1819. It was also at Kensington that she learnt that she was Queen, and that she held her first council on 20 June 1837. She moved to Buckingham Palace, but her mother remained at Kensington until her death. Towards the end of her reign, on 24 May 1899, Victoria opened the State Apartments, which had been carefully restored, to the public; with the exception of prolonged wartime closures, they have remained accessible ever since, and in 1933, under the direction of Queen Mary, three more rooms associated with Queen Victoria were opened. From 1912 to 1914 and from 1950 to 1975, the London Museum was housed in part of the palace.

The State Apartments are normally open daily. The entrance is from the garden, not by any grand or formal portal, but through one of two doorways, one with a segmental pediment carved in 1690–1 by Thomas Hill, a master mason whom Wren had employed on St. Paul's, with entwined initials of William and Mary, and the other with a neat early Georgian porch which affords shelter from the rain. The shallow risers of the stairs lead up to the Queen's

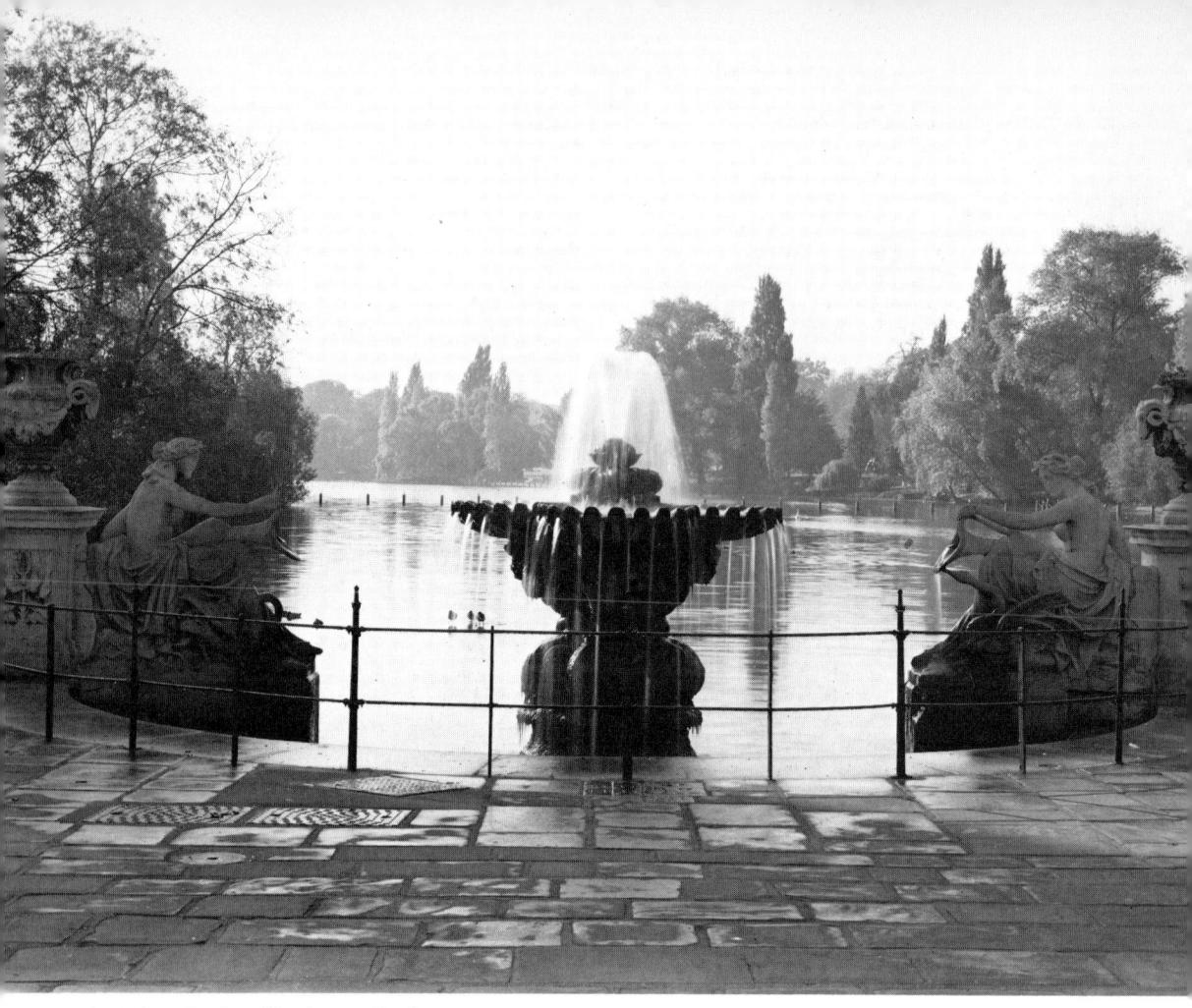

The Italian Gardens, Kensington Gardens

Gallery, a fine panelled apartment 84 feet long. There are two grey marble fireplaces, one original, made by Thomas Hill, and the other a modern copy, but both retain their gilt mirrors which serve as overmantels, and have surrounds carved with festoons of flowers by Grinling Gibbons, Royal portraits – William and Mary and their visitor, Peter the Great of Russia, by Kneller, and George II and Queen Caroline by Enoch Seeman - hang here, and the gallery leads into a series of smaller rooms, which were used as private apartments by Queen Mary, Queen Anne, and Queen Caroline. It was in the Closet that Sarah, Duchess of Marlborough, had her last, diastrous interview with her royal friend, Queen Anne, whom she had addressed as 'Mrs. Morley' for so many vears.

The suite of State Apartments were designed by Campbell and decorated by Kent for George I. The Privy Chamber comes first, its ceiling painted by Kent with Mars, wearing the Order of the Garter, and Minerva, as a compliment to the King and his consort, followed by the Cupola Room, high and

square, with heavy marble door-cases and giant Ionic pilasters running from the floor to the ceiling, which is deeply coved and painted with blue and gold octagonal coffers, with the Garter Star in an octagonal panel in the centre. Between the pillars are marble niches with gilded figures of Roman gods and goddesses, and above them, against flat panels, are bronze busts of Greek philosophers and poets, which came from Italy and had been in Charles I's collection. Over the fireplace is a particularly fine relief by Michael Rysbrack, representing a Roman marriage. The intention was to lend to the Hanoverian dynasty the virtues and dignity of ancient Rome. In these apartments stands a wonderful clock made for Augusta, Princess of Wales, George III's mother. It was begun about 1730 by Charles Clay and was completed by John Pyke. On the sides are scenes recalling the four great monarchies prophesied by Daniel -Chaldea, Persia, Macedonia, and Rome – with silver bas-reliefs by Rysbrack and backgrounds painted by Jacopo Amigoni. Delicate bronze allegorical figures by Louis François Roubiliac adorn the case.

Beyond is the King's Drawing Room, with an oval central panel to the ceiling, containing a painting by Kent of Jupiter appearing to Semele, and a fine marble fireplace by James Richards. The vista from the windows is now, unfortunately, marred by highrise buildings in the distance. It looks across the Round Pond and down Bridgeman's central avenue to Watts's Physical Energy. To the north of this room is the Council Chamber, now filled chiefly with furniture, paintings, and other objects relating to Queen Victoria, which includes copies of Wilkie's painting of the young Queen's accession council and of Winterhalter's The First of May 1851, in which the 82-year-old Duke of Wellington presents a casket to his infant godson, Prince Arthur, who is ensconced in his mother's arms, while Prince Albert stands behind them, proudly holding the plans of the Crystal Palace, which had opened that morning and which can be seen in the background.

To the south of the Drawing Room lie Queen Victoria's Bedroom and Nursery and behind, in the older part of the palace, is the Presence Chamber, which still retains the cornice Wren designed for it, and a richly carved over-mantel by Grinling Gibbons, though this was probably originally intended for the King's Gallery. The room was much altered for George I, Kent painting the ceiling, for which he was paid in 1724. He decorated it in what came to be known as the Pompeian manner, which was later popularized by the Adam brothers (see Osterley, p. 288); bright, hard, dark reds and blues stand out against a white background, and in the central roundel Apollo urges on his sun-chariot.

The King's Gallery runs almost the length of the southern side of the State Apartments. It is 96 feet long, and still has the elaborately carved cornice which Wren gave it. William III kept the best of his collection of paintings here; Mary adorned her Gallery with her collection of Oriental porcelain. Above the fireplace is a wind-dial connected to a vane on the roof; behind it is a map of north-western Europe, painted by Robert Norden in 1694. William was a soldier and his interests lay across the sea. The mechanism was possibly devised by Thomas Tompion. The ceiling was decorated in 1725–6 with seven paintings by Kent, representing the adventures of Ulysses. Around these scenes are small grisaille

cartouches, figures, and arabesques against an imitation mosaic background; they were the work of a talented Spanish assistant, Fransciscus de Valentia, of whom nothing else is known. The walls are hung with a selection of paintings, varied from time to time, from the royal collection.

At the far end of the Gallery is the King's Staircase, part of Wren's design, with a scrolled, wrought-iron balustrade by Tijou. This is closed to public use, but it is possible to stand at the top and to admire the walls and ceiling painted by Kent, though from this vantage point the perspective may seem strange, for it is intended to be viewed when ascending the stairs. The lower walls are painted in a mottled grey and are adorned with trophies, sea-horses, and medallions bearing Britannia's head. Around the upper part, Kent painted a gallery crowded with people who seem to hang over the balustrade as if about to address anyone mounting the staircase. The most celebrated example of this style of decoration was Le Brun's Escalier des Ambassadeurs at Versailles, but Kent had probably also seen Laguerre's work in the Saloon at Blenheim, which had been completed five years earlier. Many of the figures on the balcony can be identified as portraits of George I's courtiers - the two Turkish servants who tended him when he was wounded at the siege of Vienna in 1685 are there, as well as Peter the Wild Boy, who was found living like an animal in the woods near Hanover but who settled down to court life in England, while Lady Suffolk's page has scrambled precariously to the wrong side of the balustrade. From the ceiling above, Kent himself, his mistress, Elizabeth Butler, two of his assistants, and some musicians peer down.

On leaving the Palace, it is worth walking to the northern extremity of the Broad Walk to look at the Elfin Oak. In 1930, the sculptor Ivor Innes was allowed to carve the natural knots and protuberances of this tree into the shapes suggested by his imagination and the taste of the times, so that the whole trunk is alive with elves, witches, frogs, foxes, rabbits, fairies, and mysterious doorways. The Elfin Oak may not be great art, but it can provide an uncommonly good objective on an otherwise empty afternoon and may be compared with the Peter Pan statue. These two artefacts tell us a great deal about one sort of childhood a generation ago.

Belgravia, Pimlico, and Victoria

A rough triangle of land encompasses Belgravia and Pimlico, bounded to the north and west by Horseferry Road, Victoria Street, Grosvenor Place and Sloane Street, cradled to the east and south along Grosvenor Road and Millbank by the bight of the Thames. Though too large to be explored in a day, these two areas must be described in a single chapter for they are the

opposite sides of a coin.

Most of the land here belongs to the Grosvenor Estate, the property of the Duke of Westminster, and most of the development was carried out under the supervision of one man. Thomas Cubitt. Born in Norfolk in 1788, he learned his trade as a ship's carpenter and in India, and set up on his own in Holborn in 1811. Within four years, he had become a speculative builder and was laying out the Calthorpe estate off the Gray's Inn Road. By 1825, he had been joined by his brothers, William and Lewis, and was a sufficiently successful entrepreneur to negotiate with Lord Grosvenor and with the Lowndes family for the development of their estates. Save for Wren or Nash, Thomas Cubitt did more to change the face of London than any other single man. He was not an architect, though his brother Lewis became a good one, nor was he an innovator, but he had a talent for planning an estate to take the uttermost advantage of the lie of the land. He was also a good organizer – one of the first builders ever to retain on a permanent basis all kinds of skilled craftsmen - had a sound financial sense, and acted with absolute integrity towards both his men and his patrons. When his yard at Pimlico caught fire in August 1854 and some £100,000 worth of damage was done, Cubitt simply said, 'Tell the men they shall be at work within a week and that I will subscribe £600 towards buying them new tools.' When he died a year later, Queen Victoria wrote in her diary that 'a better, kinderhearted or more simple, unassuming man never breathed.'

BELGRAVIA, which takes its name from the Grosvenor estate at Belgrave in Cheshire, was developed when Nash rebuilt Buckingham Palace for George IV. Cubitt laid it out with trim white terraces; even today, their stucco gleams for they are immaculately maintained. Till then, the Five Fields, as they were called, lay open. Hay-making was carried on there, as Dean Swift noted, and there were isolated groups of houses; in one of them, now 180 Ebury Street, the eight-year-old Mozart composed his first symphony in 1764 or 1765. The Lock Hospital for Women had been built in 1746, where Grosvenor Place runs today, and near to Hyde Park Corner were the sale rooms and stables of Richard Tattersall, the distinguished horse-dealer, but otherwise, the fields were clear.

Cubitt's design for the no

Cubitt's design for the new estate was spacious. More intricate than the straightforward gridiron development of Marylebone, he based his plan on four squares – Belgrave, Eaton, Chester, and Lowndes – linking them with broad connecting roads and crescents. He employed the same component parts as Nash, blocks of stuccoed terrace houses, punctuated by isolated villas, though Cubitt's façades are heavier, more ornate and florid, and the whole setting is more urban – Belgrave Square may cover nearly ten acres but it is very small compared with Regent's or St. James's Parks, and there are no vistas such as Nash delighted to compose. Belgravia has, however, great style and a calm self-confidence.

At Hyde Park Corner is the white expanse of the former St. George's Hospital. Established in 1733 in Lanesborough House, Westminster, it was rebuilt to designs by William Wilkins in 1829. Above the entrance on the Knightsbridge side was a bust of John Hunter, the surgeon, who died suddenly from a heart attack after an acrimonious governors' meeting at the old hospital in 1793. It is the work of Alfred Gilbert, who took the likeness from Reynolds's portrait of the great practitioner; the right hand points to a copy of a small anatomical figure, said to have been by Michaelangelo, which he holds in his left. The figure was commissioned on the centenary of Hunter's death. The future of the building is at present uncertain.

Behind Wilton Crescent, in Wilton Row, is the Grenadier, a neat public house; a maze of mews,

many of them on different levels and only accessible on foot, lies behind the eastern curve of the Crescent. St. Paul's church is worth visiting too. Designed by the younger Thomas Cundy and consecrated in 1843, it has an open timber roof, a magnificent screen and rood by G. F. Bodley, which were installed in 1892, and around the walls are set pictures of Biblical scenes painted on tiles.

It is impossible today to appreciate the magnificence of Cubitt's design in Belgrave Square, since the trees in the central garden have grown up enough to obscure the view. The boscage does, however, give a mystery without which the massive façades might seem arid. At each corner, a pair of roads leads into the square, so that the four sides are each occupied by an unbroken terrace. These terraces were designed and planned by George Basevi, Soane's most brilliant pupil, who worked on them from 1825 till 1840. He was employed by George and William Haldimand and by William Prevost, three bankers of Swiss extraction who took over the financial responsibility for the square from Cubitt, who was a prudent man. Each terrace has eleven houses, save for that on the south side, which has twelve. The central house and the end houses in each terrace are given especially grand treatment, with pilasters running between the first and second floors; the north and east sides, which were built first, are plainer than the south and west, which were undertaken when the success of the venture was certain. Basevi signed his name on the portico of number 37, where George Haldimand lived, with his brother, William, across the square at number 18. The architect died tragically young in 1845, when he fell while inspecting the bell-tower of Ely Cathedral. How great the loss was to English architecture may be gauged by walking slowly round the square and considering the delicacy and ingenuity with which Basevi varied the details of the façades; the subtle differences which distinguish the centres of each of the four sides are, perhaps, the most obvious example.

The regularity of Belgrave Square is tempered by the insertion of large mansions placed diagonally across three of the four corners. The approach to the fourth, north-east, corner was deliberately broadened to provide a dignified entrance from Grosvenor Crescent, and a particularly large house, now the Caledonian Club, was built between the square and Halkin Street; it was designed in Cubitt's own office and was for a while the home of Sidney

BELGRAVIA

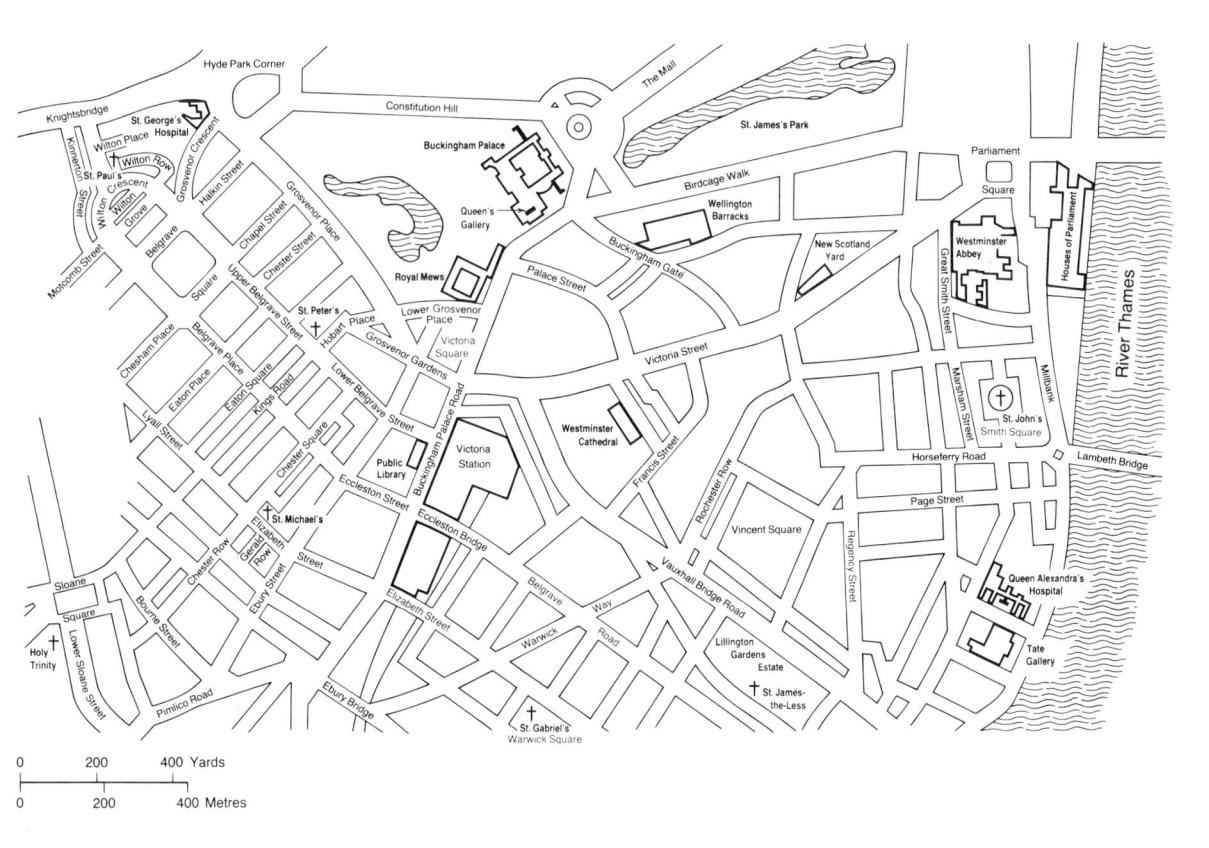

176 WESTMINSTER

Herbert, the friend and supporter of Florence Nightingale.¹ The houses on the north-west and south-west corners were built, respectively, by Sir Robert Smirke and H. E. Kendall; they are both on a smaller scale than the terraces, and lower, with neo-Greek porches. The house on the south-east corner is enormous, a palazzo designed by Philip Hardwick for Lord Sefton, and used today as the Imperial Defence College.

The square was, from the first, a desirable purlieu for the aristocracy. In 1840, Queen Victoria gave it the final accolade when she took number 36 at a rental of £2,000 as a residence for her mother, the Duchess of Kent, while grander apartments were being prepared for the lady at Kensington Palace. By 1860, three dukes had their London homes there, with thirteen other peers and the same number of MPs as neighbours. Today, numerous embassies are set about the square, and other houses are used, entirely or in part, by a medley of institutions and commercial bodies. Few private families can maintain such mansions today; they have migrated to the mews cottages which lie behind the main terraces.

The smaller streets, alleyways, and closes in which these cottages stand are worth exploring in their own right. Groom Place, with the Horse and Groom public house, is most attractive, and so are the tiny mews, eight of them, off Kinnerton Street. In West Halkin Street stands the Belfry, built in 1830 as a Presbyterian church and still looking just like one, though it has been a private house and is now a club and restaurant. The newly established Halkin Arcade links West Halkin Street to Motcomb Street: the shops it shelters display goods both luxurious and elegant. In Motcomb Street stands the Pantechnicon, designed by Joseph Jopling, built in 1830 by W. H. Seth-Smith as a storage warehouse, burnt down in 1870 and rebuilt to the original designs. It is an enormous building with a screen of gigantic Greek Doric columns in front.

There are many good, small, modern, developments in this area, providing an opportunity to compare the nineteenth century with the modern shop windows, which line in neighbourly fashion both West Halkin Street and Lowndes Street.

In the hinterland of Belgravia lies Eaton Square. It is square only in name, being 1,637 feet long and 371 feet broad, and seems still longer and narrower, for its main axis is bisected by the King's Road. Most of the 104 houses which make up its six terraces are large and imposing; work was begun on them about 1827 but was not completed till 1855, the year of Cubitt's death. Each terrace looks onto its own communal garden. The first building to be completed was St. Peter's church, designed by Henry Hakewill in 1824 and consecrated three years later. It stands at the east end of the square, aligned with the northern

South of Eaton Square is another long narrow rectangle, Chester Square, awkwardly chopped into two unequal parts by Eccleston Street. The houses around this enclave are smaller than those in the other Belgravian squares, and are therefore the more manageable and desirable. Matthew Arnold lived at number 2 from 1859 till 1866, and Mary Shelley died at number 24 on 21 February 1851. At the western end stands St. Michael's church, designed in 1846 by the younger Thomas Cundy. It is built of grev ragstone rubble, an unusual building material in this setting, has a tower and spire 150 feet high, and many restless gables, five of them facing onto the square. There is a striking reredos of Italian alabaster with near free-standing figures, and a War Memorial Chapel added in 1921 by Sir Giles Gilbert Scott, with tall lancet windows filled with stained glass, showing the arms of those who were allies in the First World War, Japan and Italy among them. On the wall hangs a painting of St. Martin dividing his cloak with the beggar, said to be from the studio of Van Dyck, and near the font is another, a Virgin and Child after Murillo.

Nearby, in Buckingham Palace Road, is the City of Westminster Public Library. It is close to Victoria Station, from which trains shuttle to and fro between London and the Channel ports. The buildings near to the station, in Grosvenor Gardens, are very French; the Grosvenor Hotel in Buckingham Palace Road, built in 1860-61 by J. T. Knowles, was one of the first in London to have a French pavilion roof. In the public garden nearby stands a statue of Marshal Foch, a cast of one by G. Malissard set up at Cassel, and two lodges or summer-houses, decorated with shells. The station itself was begun in 1860 for the London, Chatham, and Dover Railway. There was strong opposition to its opening from the aristocratic residents of Belgravia, who feared the almost certain increase in dirt and noise. The bill authorizing the new station passed through Parliament, but only with an amendment that the tracks from the Thames to the station itself were to be enclosed in a vast glass and steel tunnel. The cost of this meant that there was no money available to build an elaborate facade. but this was remedied in 1902-8 when, under the direction of the railway company's Chief Engineer, Sir Charles Morgan, a whole new station, covering some 16 acres, was built, with a long Baroque frontage whereon two huge mermaids support a broken pediment. Along the frieze, the magic words are carved - 'The Gateway to the Continent'. A new

gardens so no vista can be obtained of the façade, with its portico of six huge Ionic columns. The interior was remodelled in 1872–5 by Sir Arthur Blomfield; later, in 1895, he set an iron screen between the nave and chancel, with a pulpit projecting from it so that the preacher seems like a bird in a wire cage. The glass in the nave is by Clayton and Bell, the modern windows in the chancel by John Hayward.

¹ The Caledonian club extension at 9 Halkin Street in an interesting dark brick building of 1912 by Deitman Blow and Fernand Billerey.

Victoria Square

building is at present in progress along Buckingham Palace Road.

North of the station is Victoria Square, built in 1838–9 to designs by Matthew Wyatt, where Leonard Woolf came to live at number 24 in 1952. The land which lies southwards and eastwards, between Victoria Station and the river, may most conveniently be divided into two congruent triangles, Vauxhall Bridge Road being their common side, Buckingham Palace Road and Victoria Street their other boundaries. The eastern segment may be called the Victoria triangle, the southern Pimlico.

A good part of the marshy land, reclaimed and developed as PIMLICO, belongs to the Grosvenor Estate and was, to a great extent, built up by Cubitt, working here on a humbler scale than in Belgravia. The neatest assessment of the relative standings of Belgravia and Pimlico can be found in chapter XL of Trollope's novel, The Small House at Allington; the newly betrothed Lady Alexandrina is warned against the intentions of her future husband, who wishes to take a reasonably sized house in Pimlico - 'For heaven's sake, my dear, don't let him take you anywhere beyond Eccleston Square!' Belgravia was for the aristocracy, but an up-and-coming young man, from the professional classes, who could aspire to the hand of an earl's daughter, might fairly contemplate Pimlico. In the end, Mr. Crosbie and Lady Alexandrina take a house off the Bayswater Road, just north of Hyde Park.

Today, Pimlico has an atmosphere all of its own, an atmosphere as piquant, and perhaps as raffish, as its name, which is said to derive from that of a drink,

the recipe of which has been lost for centuries. The respectable, middle-class dwellings have become small hotels or lodging-houses or flats, and the stucco is no longer painted its original cream or white, but has been washed over with sage green or magenta or dark brown, according to the owner's whim. The best way of exploring Pimlico is to wander across it, at random and at leisure, admiring the brilliant urban vistas which Cubitt created by setting his grid of streets at an angle of, roughly, 45 degrees to the river and then cutting across the grid with main thoroughfares such as Lupus Street and Warwick Way, the latter following the line of the much older Willow Walk. The bisections resulted in unexpected oblique and acute angles at the road junctions – the meeting of Vauxhall Bridge Road and Tachbrook Street is a good example. At each of these corners, Cubitt took care to set an unusually strong façade, often curved and frequently that of a public house, to act as a linchpin for the streets radiating from it.

There are two pleasant, if unexceptional, churches by the younger Thomas Cundy, St. Gabriel's in Warwick Square, and St. Saviour's in St. George's Square, in which also stands Pimlico School, designed by Sir Hubert Bennett in 1967, and best described by its local appellation, 'The Glass School'. The curriculum here gives special attention to music and to drama, and the plan of the building is designed to further these activities. Across Grosvenor Road, in Pimlico Gardens beside the Thames, is a statue by John Gibson to William Huskisson, a worthy but unfortunate politician who was crushed to death by Stephenson's Rocket in 1830. Gibson insisted on attiring his subject in a toga, for the sculptor felt a strong aversion to the representation of a frock-coat and trousers, in which the poor gentleman would have been apparelled when attending the disastrous opening of the Manchester and Liverpool Railway.

There are three interesting twentieth-century experiments in mass housing in Pimlico - Dolphin Square, Churchill Gardens, and the Lillington Street Estate. Dolphin Square was a private venture, a huge complex of 1,250 flats covering seven and a half acres, designed by Gordon Jeeves in 1937. The flats have their own restaurant, garage, and shopping facilities, as well as a central garden; they are built of dark red brick with stone dressings and are comfortable if dull. They face directly onto the river and beside them, to the east, Westminster City Council cleared a site of 33 acres just after the war. On it was built Churchill Gardens, designed by A. J. F. Powell and J. H. Moya, which accommodates some 5,000 people in 1,680 dwellings of various sizes, contained in blocks of flats ranging from three to 11 storeys. Post-war materials and resources were very limited, but the architects gave much time and attention to the project. The number of playgrounds is almost certainly inadequate, but those provided have imaginative equipment. The third development, the Lillington Street Estate planned for Westminster City Council in the 1960s by John Darbourne of Messrs. Darbourne and Darke, lies beside Vauxhall Bridge Road. There are no tower blocks, only flats and maisonettes set around courtyards, which communicate with each other like alleyways or lokes in a Norfolk village. The materials used are an aggressively dark red brick combined dramatically with a dark grey slate roof; it remains to be seen how they will mellow.

Behind the estate, in Thorndike Street, is the church of St. James-the-Less, designed by G. E. Street in 1860-61 and built in red and black brick, with a tower separated from the main body of the church. It is seldom open, for fear of vandalism, but the interior is worth visiting for there is a fresco above the altar by G. F. Watts, a fine pulpit heavily carved by T. Earp, and stained glass by Bell and Clayton. The railings around the church are topped by metal arum lilies, almost as delicate as the flowers they represent, so that when St. James was consecrated in that impoverished neighbourhood, the London News declared that it seemed like 'a lilv among weeds'.

In the VICTORIA triangle, Victoria Street runs almost due east from the station. It was cut through closely packed slum property between 1845 and 1851, the intention being to provide the newly developed districts with better communication with Westminster. On its northern side, where Watney Mann's Stag Brewery functioned till 1959 – ale was being brewed on the site by 1641 - a new, windswept office development was designed by Trehearne and Norman, Preston and Partners. Towards Westminster is New Scotland Yard, the Norman Shaw building on the Embankment having at last proved too small; the Victoria Street building, by Max Gordon of Chapman Taylor and Partners, was erected in polished grey granite and glass in 1962-6. Beside the Building in a small park is a memorial to the Women's Suffrage Movement; a huge bronze scroll, the work of Edwin Russell, curves upwards and was unveiled in 1974. Just behind it at number 55 Broadway is the headquarters of London Transport, designed in 1927-9 by Charles Holden and adorned with two large groups, Day and Night, by Epstein, and eight smaller reliefs by Eric Gill (east side of north and south wings, north side of west wing), Henry Moore (north side of east wing), A. Wyon (south side of west wing), E. Aumonier (west side of north wing), A. H. Gerrard (west side of south wing) and F. Rabinovitch (south side of east wing); when installed, these were considered outrageously revolutionary. Nearby are the Army and Navy Stores, established in 1871 and recently rebuilt.

Tucked away behind Victoria Street are some of the earliest blocks of flats to be built in London – Morpeth Terrace, Ashley Gardens, and Artillery Mansions – their façades forbidding but comfortable enough inside. In Regency Place is the little Roman Catholic church of the Sacred Heart, built in the 1960s by H. G. Clacy for a sisterhood, with excellent stained-glass windows by Arthur Fleischmann. Across the way from it stands the Grey Coat Hospital, established as a school for boys and girls in 1698; since 1874, it has provided education for girls only. In 1955, many of the classrooms were rebuilt and the old façade, with figures of a charity school boy and girl, was restored and repainted.

Just behind Victoria Street, at the west end and nearest to the station, stands Westminster Cathedral. The Roman Catholic hierarchy was restored in England in 1850, but it was not till 1894 that Cardinal Vaughan, the third Archbishop of Westminster, felt it was time to build a cathedral. Ten years earlier, Tothill Fields Prison had been demolished and fortunately the diocese had acquired the site. The architect chosen was John Francis Bentley; he had been born in Yorkshire in 1839 and had been converted to Catholicism in his early twenties. He had begun to train as an engineer, but had turned to architecture and had studied under Henry Clutton, Previously, he had worked in the Gothic manner, but the proximity of the new building to Westminster Abbey made it essential to choose some other style, lest the cathedral seem like a poor relation beside the older building. Cardinal Vaughan would have been happy with an Italianate basilica but Bentley travelled abroad and, turning towards primitive Christianity, determined on the Byzantine style, as it was then understood. The original setting was hemmed in and crowded, so Bentley gave his cathedral a strong façade of red brick dressed with white stone and a great arched portal. He had first planned twin towers but, persuaded by Cardinal Vaughan, he decided to signal the presence of the cathedral among the buildings pressed around it by means of a slender campanile soaring 284 feet into the air - almost as high as the campanile at Siena cathedral, which was in part his inspiration. Set above the first bay on the north side, the square tower is banded in alternate stripes of red brick and white stone – a distinctive and unforgettable marking. A clever disposition of the pinnacles at the corners links the shape naturally to the octagonal lantern capped by a small dome. This beacon has become one of London's most conspicuous and easily recognized landmarks; in spite of the tower blocks which have began to besiege it, the prospect from the viewing platform in the lantern (reached by a lift) is remarkable.

The exterior is impressive, but the true importance of Westminster Cathedral is its interior. The building is vast – 360 feet long (342 inside) by 156 feet wide (149 feet inside), the nave rising 117 feet with four brick domes, admitting a shadowy light, set along its length. The aisles are lined with a series of little chapels. It was the architect's intention, and the work is slowly being carried out, to cover all the walls and
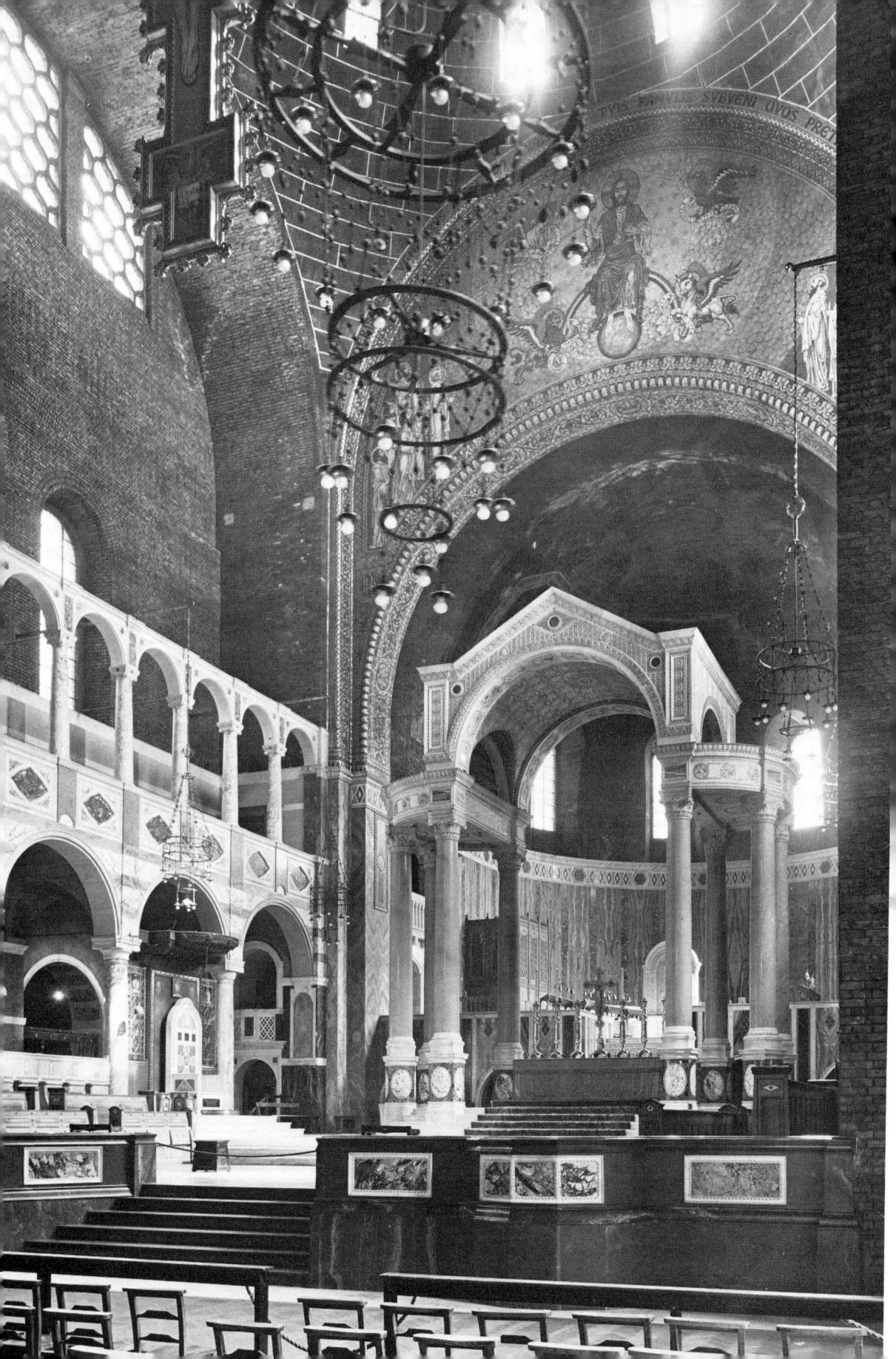

180 WESTMINSTER

pillars and ceilings with marbles and mosaics, as at Ravenna or St. Mark's in Venice. Over 100 different varieties of natural marble have been used from all parts of the world; by comparison, the man-made mosaics seem fussy, over-detailed and, sometimes, flatly sentimental.

At the south-west corner is the Baptistry, its walls as yet unadorned. In it stands the enormous marble font designed by Bentley. A screen separates the Baptistry from the first chapel and above it is a mosaic representing the four rivers of Paradise, Tigris, Euphrates, Gehon, and Phison, which symbolize the waters of baptism. Beyond is the Chapel of St. Gregory and Augustine, its inspiration the early conversion of England. The mosaics on the walls show other early English saints, King Edmund, the Venerable Bede, Oswald of Northumbria, Wilfrid of York, and Cuthbert of Lindisfarne. The designs for this chapel, by Bentley, were executed after his death.

The next two chapels are dedicated to St. Patrick and the saints of Ireland, and to St. Andrew and the Scottish saints. St. Patrick's chapel is entered, not through a grille, but through a white marble screen, pierced with the shamrock, by means of which he expounded the doctrine of the Trinity to the pagan Irish, and with oak leaves, for St. Bridget. The altar, designed by J. A. Marshall, is of black fossil marble from Ireland, and the reredos is of the same stone, set with mother-of-pearl shamrocks. Above it stands a figure of St. Patrick robed as a bishop, the work of Arthur Pollen. Along the south wall is a blind arcade with columns of marble from Cork, and on the west a mosaic by Boris Anrep, representing Oliver Plunket, Archbishop of Armagh (d.1681), the last man to be executed for the Catholic faith in England. In St. Andrew's chapel, Greek and Scottish design and materials stand side by side, for Andrew was the patron saint of Constantinople and of all things Orthodox, as well as being Scotland's own saint. The money to appoint the chapel was given by the fourth Marquess of Bute, and the designs were by R. Schultz Weir, a distinguished Byzantine specialist. Scottish granites were used to equip it, alongside marbles from Greece, one of the most spectacular, on the back wall, from Skyros, where Rupert Brooke lies buried. The sculptures are by Stanley Lee; the mosaics tell the story of the wanderings of St. Andrew's relics. The superb ebony and ivory stalls, made by Ernest Gimson about 1912, are particularly important; their elongated, though not attenuated, line owes much to Charles Rennie Mackintosh and is characteristic of the style of the early twentiethcentury renaissance in Scottish design.

The easternmost chapel on the south aisle is dedicated to St. Paul. The floor, the work of Edward Hutton, is a scholarly reconstruction of Cosmati work, the patterned marble work for which medieval Italian craftsmen were famous (see also p. 100). The mosaics in the vault and apse were the work of Justin Vulliamy, who was advised by Boris Anrep; they give

the effect of the canopy of a tent, since St. Paul, before his conversion, was a tent-maker.

In the south transept is a fifteenth-century English alabaster figure of the Virgin and Child known as 'Our Lady of Westminster'. Nearby is the pulpit, inlaid with coloured marbles and adorned with figures of the four Evangelists, made in Rome in 1899 by C. A. Leonori and presented to the cathedral in 1934 by Cardinal Bourne to commemorate the 30 years he had served there. On a pier to the left is a bronze panel of St. Thérèse of Liseux by Giacomo Manzu. The Lady Chapel is the most richly decorated in the whole building, with a large, somewhat sentimental mosaic of Our Lady holding the Child. designed by Anning Bell and executed by Miss Martin, who also did much work in the Chapel of Holy Souls. The mosaics on the vault were executed in 1931-2 by Gilbert Pownell. The iconography of the scheme is elaborate, and lays particular emphasis on Our Lady as patroness of London, the Tower, Tower Bridge, and a Thames warehouse being shown beside her.

The Sanctuary is the focal point of the whole building. The altar is made of Cornish granite; to its left is the Archbishop of Westminster's throne or *cathedra*, more or less copied from the papal throne in the Lateran Basilica, and above it, in the dome, are twelve small windows from which light spills downwards. Behind the altar is a relief of Christ by Lindsay Clarke, above it a mosaic canopy or baldacchino, supported on eight columns of golden marble from Verona, and before it hangs a great rood by Christian Symons. From here it is possible to appreciate the unity of Bentley's design, which encompassed every detail down to the elegant electric light fittings.

In the north aisle, parallel with the Lady Chapel, are the Chapels of the Blessed Sacrament and of the Sacred Heart, with mosaics by Boris Anrep. A small Chantry Chapel in the north transept, dedicated to

New Victoria Cinema

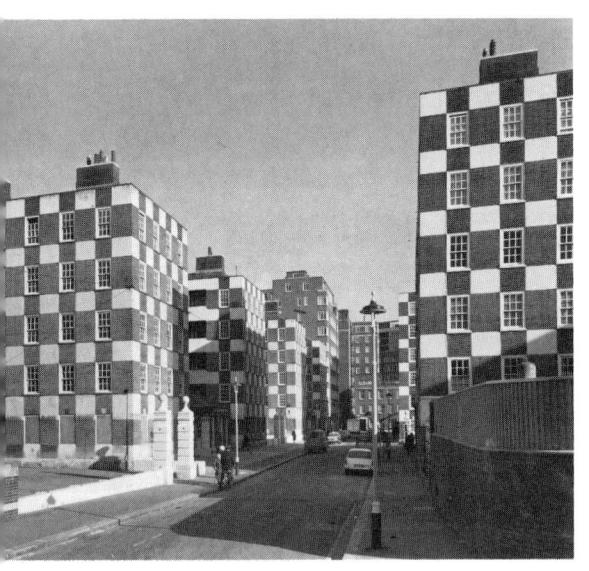

Page Street housing, Sir Edwin Lutvens, 1929-30

St. Thomas à Becket, contains a monument to Cardinal Vaughan; designed by A. I. Marshall, the effigy is by J. Adams-Acton. Along the north aisle are three chapels, dedicated to St. Joseph, to St. George, and to Holy Souls. Above the altar in St. George's is a relief by Eric Gill, representing Christ reigning from the Cross, with St. John Fisher and Sir Thomas More beside Him. The altar steps are hewn from the quarries which provided marble for the Parthenon. Just inside the chapel, in a glass shrine, lies the body of the Blessed John Southworth who was martyred for his faith in 1654. Bentley had completed the decoration scheme for the Chapel of Holy Souls just before his own death. The mosaics by Christian Symons represent Our Lady and St. Joseph interceding with an enthroned Christ for the souls of the dead; they are inlaid on a silver background to give the effect of mourning.

Around the main walls are the 14 Stations of the Cross by Eric Gill; the carving is in relief so shallow that they seem to be line drawings rather than sculpture. Recent rebuilding has been kind to the cathedral. Demolition in Victoria Street revealed the eastern façade and the new buildings, designed by Elsom, Pack, and Roberts, are cunningly arranged in stepped glass boxes to provide a gauzy frame for the great mass of the cathedral.

Nearby is Vincent Square, the only surviving morsel of what were once Tothill Fields, called after a headmaster of Westminster School and still used by the boys for their sports-ground. On its north-eastern side are the halls of the Royal Horticultural Society in which the monthly flower shows are held. Beyond it are early nineteenth-century houses with smaller ones as neighbours in Mansel Street.

Beside the river, on Millbank, stands the Tate Gallery, built on the site of an early nineteenthcentury prison, the Penitentiary. This was demolished in 1890 and the Gallery, designed by Sidney J. R. Smith, was opened in 1897, a gift to the nation from the sugar magnate, Sir Henry Tate. The Gallery has a twofold purpose. It houses both the National Collection of Historic British Art, and the National Collection of Modern Art, both British and foreign. The line of demarkation between its holdings and those of the National Gallery is a little vague: basically, the National Gallery has a token representation of eighteenth- and early nineteenthcentury British masterpieces (see p. 119), but covers European art up to 1914. Thus, many of the most important Impressionist and post-Impressionist paintings were transferred in 1954 under the National Gallery and Tate Gallery Act, and the date will. presumably, be revised as time passes.

The earliest picture in the Tate is John Bettes's Man in a Black Cap, painted in 1545. All the main British schools are well represented, the holdings in the works of Hogarth, Gainsborough, Stubbs, Reynolds, Constable, Blake, the Pre-Raphaelite group, and water-colour painters such as Cozens, Cotman, and Girtin, being particularly impressive. The Tate also holds the greater part of Turner's bequest to the nation of the mass of his works in his studio at his death. A new gallery, paid for by the Clore Foundation and built to an unusual design by James Sterling, opened in 1987, so that at last we are able to see Turner's work as he meant it to be viewed.

The Modern Collection includes paintings, sculpture, prints, and drawings by British and foreign artists from the mid-nineteenth century to the present day. Some Impressionist work is here, and Picasso, van Gogh, Matisse, Sickert, Salvador Dali, Francis Bacon, L. S. Lowry, Warhol, Lichtenstein, and David Hockney are all well represented. Sculpture from Rodin to Henry Moore and Barbara Hepworth, and on to the even more abstract recent work of Anthony Caro, is here too. The Tate is a brave gallery, brave enough to buy works too advanced to be easily assessed; our children, or grandchildren, may well be grateful for the courage of its

Frequent special exhibitions are mounted here: the Gallery's publications and its own shop also deserve attention. The excellent Restaurant was adorned by Rex Whistler with an enchanting mural, The Pursuit of Rare Meats, which provides the wittiest and most attractive setting of any gallery eating-place. The recently decorated cafeteria, though less expensive, is equally stylish in a more streamlined way.

St. Marylebone

The former Metropolitan Borough of St. Marylebone became a part of the City of Westminster in 1965. Populous and prosperous Oxford Street was its southern boundary; its western, which it shared with Paddington, was the Edgware Road. Its northern and eastern limits were less well defined, its neighbours being Hampstead and St. Pancras, which are now parts of Camden. Covering an area of 1.500 acres with a population of about 65,000, accidents of topography and history have divided St. Marylebone into three distinct entities - Marylebone proper, Regent's Park and St. John's Wood. The eastern two-thirds of the parish formed the manor of Tyburn which, taking its name from a forked tributary of the Thames, belonged to the Abbess of Barking throughout the Middle Ages and was appropriated by Henry VIII at the Reformation. 1 The southern third contained the village of Tyburn and was farmland, while to the north lav undisturbed forest. Here, a roughly circular area was fenced off to provide the king with a large hunting park. In 1611, James I sold off the southern village portion, which passed from family to family till in 1719 Edward Harley. Earl of Oxford and Mortimer, whose manuscript library was eventually to provide part of the foundation collection of the British Museum, decided to develop the land, in emulation of those estates which were growing up so profitably in Mayfair. The nub of the development was Cavendish Square; around it, a girdiron pattern of streets spread out, criss-crossing their way over the fields, every street being given the name of a member of the Earl's family or of one of their titles or estates. In 1741, the land passed to the Earl's daughter, Margaret, who married William Bentinck, the second Duke of Portland.

Before the end of the century it was built up solidly and with remarkable homogeneity; the only easily recognizable relicts of Marylebone's agricultural past are the meanderings of Marylebone High Street, which follow the line of the Tyburn and the village street which once ran heside it.²

Cavendish Square, still elegant with noble proportions, is a good starting point for an exploration of St. Marvlebone; if it is entered from Oxford Street by way of Holles Street, in which Byron was born, one may observe, high on the wall of Messrs. John Lewis's building, an aery winged sculpture by Barbara Hepworth. Only on its northern side does the square retain a hint of its original character for there stands a noble pair of houses, probably designed by Samuel Tufnell in the late eighteenth century. Until recently, these houses were occupied by the Convent of the Holy Child Jesus and were used as a school; a bridge, designed most sensitively by Louis Osman, was built to link them and to it was fixed a tender statue by Epstein of the Virgin and Child. In Vere Street, off the south-west corner of the square, stands St. Peter's church, designed in 1721–4 by James Gibbs, as a gracious chapel-of-ease for the Duke's new estate. A rectangular brick box with a big stone portico, the interior, as Sir John Summerson points out, is 'a miniature forecast of St. Martin-in-the-Fields, exquisitely carried out'. The east window has glass by Burne-Jones. Northwards, Henrietta House, a block of offices, covers the site formerly occupied by Georgian town houses; the first-floor drawingroom from number 11, with elegant plaster work and a painted ceiling, probably designed by James Gibbs, has been re-erected in the Victoria and Albert Museum.

To the east of Cavendish Square is Portland Place,

2 Stand at either end of Wigmore Street and look towards its centre; the dip in the road as it slopes down and up the banks of the now culverted Tyburn is unmistakable.

¹ The name slowly changed to Marylebone after 1400 when the site of the parish church moved northwards and the dedication was taken from St. John and was given to Our Lady. Marylebone signifies St. Mary's church by the bourne or stream. The earliest manuscript reference I have found to it is in an inquisition post mortem of 1462. The western half of the borough was the manor of Lilleston which became Lisson Green. Its story, though fascinating to the local historian, has no place here but the amateur of London should visit the recently sprung-up Church Street Market, good for bygones and local colour, and should search for the entrance on the eastern side of Lisson Grove which leads to a section of the towpath beside the Regent's Canal (see also p. 193).

running from north to south, laid out from 1774 onwards as a speculation by the Adam brothers. In its day, it was the widest street in London and its noble proportions remain, though, since 1864 when the Langham Hotel was built, developers have been permitted to destroy many of the original buildings. James Adam, less well known than his elder brother, though scarcely less able, designed the houses, planning each section between cross streets as a unit in its own right. The best remaining section is on the east side, between New Cavendish Street and Weymouth Street; numbers 46 and 48 are particularly attractive.

At the northern end is the Royal Institute of British Architects (see also p. 143). Founded in 1835, the present headquarters were built in 1932–4 by Grey Wornum. Flat-roofed, outspokenly twentieth-century in appearance, and owing much to Scandinavian example, the building is a good neighbour to its companions, for it retains the height and proportions established by Adam's original houses. The huge bronze doors and the statues which top the pillars were by James Woodford, the decorative figures around the library by B. Copnall; inside, a grand spiral staircase signals the way upwards.

A series of conventional statues stand in Portland Place: Edward Augustus, Duke of Kent (by S. Gahagan, set up in 1827), a bronze bust of the surgeon, Lord Lister (Thomas Brock, 1924), and an equestrian statue of Field-Marshal Sir George White (John Tweed, 1922), while in Langham Place the bronze figure of the philanthropist Quintin Hogg (George Frampton, 1906), with two children by his knee, reminds us of the Polytechnic, founded in 1839, which he acquired in 1882 as a social and educational centre. Today it prepares students for London University external degrees and provides a wealth of sporting and recreational activities; its headquarters are in Upper Regent Street.

Turning out of Portland Place into Duchess Street, the sphinx-adorned town house of the connoisseur Thomas Hope can still be seen, and nearby, at 13 Mansfield Street, a blue plaque declares that the architects, John Loughborough Pearson and Sir Edwin Lutyens, lived there at successive times.

Twentieth-century rebuilding has dealt less happily with the southern end of the street than with the northern. Nash turned his thoroughfare through 180 degrees in order to skirt the boundary wall of Langham House (now long since vanished) and disguised the awkwardness by building All Souls church there in 1822-4 to provide a focal point. The church itself is a brick box set at angles to the roadway, but attention is fixed on the circular portico of sturdy Corinthian pillars with a plump little spire on top. Architectural purists have expressed disapproval ever since it was built, but to the open mind the effect is piquant and agreeable. In the porch, gazing down Regent Street, nestles a bust of Nash by Cecil Thomas after Behnes, set up in 1956; inside is an altar painting by Richard Westall, of

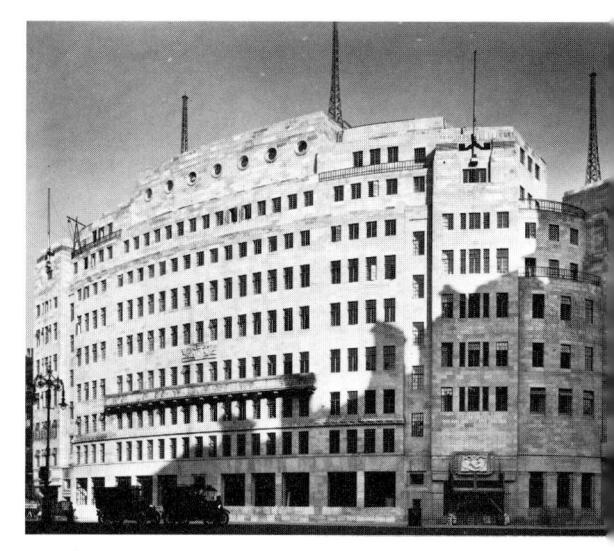

Broadcasting House, Portland Place

Christ crowned with thorns. The recent complete rebuilding of the interior, apart from transforming the entrance and nave, has dug into Nash's foundations and created a spectacular new crypt, incorporating the original double arches of brickwork used in the church's construction 150 years ago. The little church dominated both street junction and skyline till the British Broadcasting Company built its extension to Broadcasting House directly behind Nash's church and, by providing the spire with a stone backdrop, robbed it of the sharp silhouette on which its effectiveness largely depended. The original BBC building was a more gracious companion. Built in 1931 to plans by Val Myers, and not particularly attractive in itself, its battleship bulk is adorned and glorified by Eric Gill's sculpture, which includes Prospero and Ariel, standing above the main doorway.

The streets to the east of Portland Place are less inviting. In Margaret Street stands Butterfield's All Saints (1849–59). Some people consider it the ugliest church in London, and of its interior Eastlake wrote with resignation 'There is evidence that the secret of knowing where to stop in decorative work had still to be acquired.' On a cramped site and built of dark, aggressively patterned brick, the church is set back behind a tiny courtyard. Its tall, thin tower, and needle-pointed slate spire, Germanic in their line and intensity, soar up triumphantly, dominating the buildings crowded around it. It is one of the more important churches of its period. The altar-piece is by William Dyce, repainted by Ninian Comper.

The interest of the eastern side of the borough lies in its associations, rather than its appearance today. The streets which cover it – Newman Street, Rathbone Place, Berners Street, Cleveland Street, and their neighbours – were built in the 1760s or soon

184

after and the artists and sculptors of the day, many of whom were to become Academicians, made their homes there, while the colourmen and framemakers who supplied them settled nearby. By the early nineteenth century the artists had begun to move away, though the colourmen (Rowney's, Winsor and Newton's) and the framemakers (Bourlet's), are still in the neighbourhood and have been joined by a kindred trade, the wallpaper manufacturers (Cole's, Sanderson's).

Westwards of Cavendish Square lie three important institutions: the Wallace Collection at Hertford House in Manchester Square, and the Courtauld Institute and the Heinz Gallery in Portman Square. The Wallace Collection, bequeathed to the nation in 1897 and opened in 1901, was the creation of five generations of the Seymour-Conway family - the first to fourth Marquesses of Hertford, and Sir Richard Wallace, the natural son of the fourth Marquess; it is accommodated in the Wallaces' town house, which Thomas B. Ambler adapted and extended. The first and second Marquesses possessed a number of excellent family portraits, notably by Reynolds, Morland, Hoppner, and Downman, while George III presented a portrait of himself by Allan Ramsay to the first Marquess and the second purchased Romney's painting of Mrs. Robinson ('Perdita') and Reynolds's bewitching Nellie O'Brien, her eyes half veiled by the shade of her straw hat. The third Marquess bought chiefly Dutch cabinet pictures, but he also purchased Titian's Perseus and Andromeda, two portraits by Van Dyck and two views of Venice by Canaletto, and was given by the Prince Regent a full-length portrait of Mrs. Robinson, painted this time by Gainsborough. The peculiar strength of the collection lies, however, in its wealth of eighteenth-century French paintings, sculptures, furniture, porcelain, and objets d'art, for both the fourth Marquess and Sir Richard spent much of their lives in France and Lady Wallace was French. The fourth Marquess (1800-70) retired from public life at the early age of twenty-six and, settling in the Château de Bagatelle in the Bois de Boulogne, devoted the rest of his life to his collection. Post-Revolutionary France had little use for canvasses painted to delight Louis XV and his courtiers but Lord Hertford's earliest recorded purchase was of Fragonard's Schoolmistress. Thereafter he began to assemble works by Watteau, among them the magical Champs Elysées, the Music Party, and the haunting and slightly sinister Gilles and his Family, and Pater, Lancret, Nattier, Greuze, and Le Brun, as well as several by Boucher, including two large and sensual canvasses, The Rising and Setting of the Sun, which had belonged to Madame de Pompadour. He

also acquired Fragonard's enticingly improper painting, The Swing, and to them he added some of the finest examples of the French cabinet-maker's art, opulent, ornamented commodes and escritoires by Boulle, Cressent, and Riesener, as well as porcelain and bibelots as enchanting as the four enamelled plaques of a perpetual calendar, made in 1741 by A. N. Martinière. The magnificent iron balustrade round the stair-well was made between 1733 and 1741 for Louis XV's Cabinet de Médailles in the Palais Mazarin, now the Bibliothèque Nationale, in Paris, and on the half-landing are three busts by Coysevox of Louis XIV himself, of Condé, and of Turenne, the two great commanders looking like heroic reincarnations of ancient Gaulish warriors. To these treasures he added paintings by his contemporaries, Delacroix, Isabey, Géricault, Meissonier, Corot, and Prud'hon. Lord Hertford's own inclination was essentially for sweet, harmonious works - 'I only like pleasing pictures', he wrote - but his taste was as discriminating as his wealth was boundless, so that even the native-born student of French art must cross the Channel to view the riches here, and as much French as English is to be heard in the galleries.

The Marquess also acquired four excellent works by Philippe de Champaigne, one of them a portrait of a vastly good-humoured Echevin of Paris, nine paintings by Rubens, including the radiant Rainbow Landscape, two by Velazquez, eight by Murillo, five Rembrandts, among them the haunting late portrait of his son Titus, a study by Rembrandt's pupil, Flinck, of a negro archer, Franz Hals's Laughing Cavalier, whose face is sardonic rather than amused. several works by Guardi, a number of superb English portraits by Reynolds, Gainsborough, Hoppner, and Lawrence, a large and representative group of oils and watercolours by Bonington, as well as paintings by Wilkie, Landseer, Stanfield, and Westall. Nor did he neglect miniatures, and among the cases in Gallery XI are a self-portrait by Hans Holbein, signed and dated 1534, and an unusual double portrait of two redoubtable ladies, Georgiana, Duchess of Devonshire, and Lady Elizabeth Foster, by J. U. Guérin.

Sir Richard Wallace bought paintings with more restraint than his father had done, but he acquired quantities of fine maiolica and, by purchasing the entirety of the Comte de Nieuwerkerke's collection of European armour as well as the pick of Sir Samuel Meyrick's, he made the armoury at Hertford House second in London only to that in the Tower. He also purchased such unusual, miscellaneous objects as the seventh-century Bell of Mura from Ireland (which was reputed to have descended from heaven ringing loudly) and the Horn of St. Hubert, made about 1468 as a gift to Charles the Bold of Burgundy. Like Apsley House, the Wallace Collection is a comparatively unfrequented museum, yet there are very few galleries in all the world where so many and such varied masterpieces are assembled. The main rooms have recently been redecorated and the walls hung,

¹ For example – Berners Street: Sir William Chambers (number 53), John Opie (number 6); Buckingham Street (now Cleveland Street): John Flaxman (number 7); Mortimer Street: Joseph Nollekens (number 9), John Russell (number 7); Newman Street: John Bacon (number 17), Benjamin West (number 14).

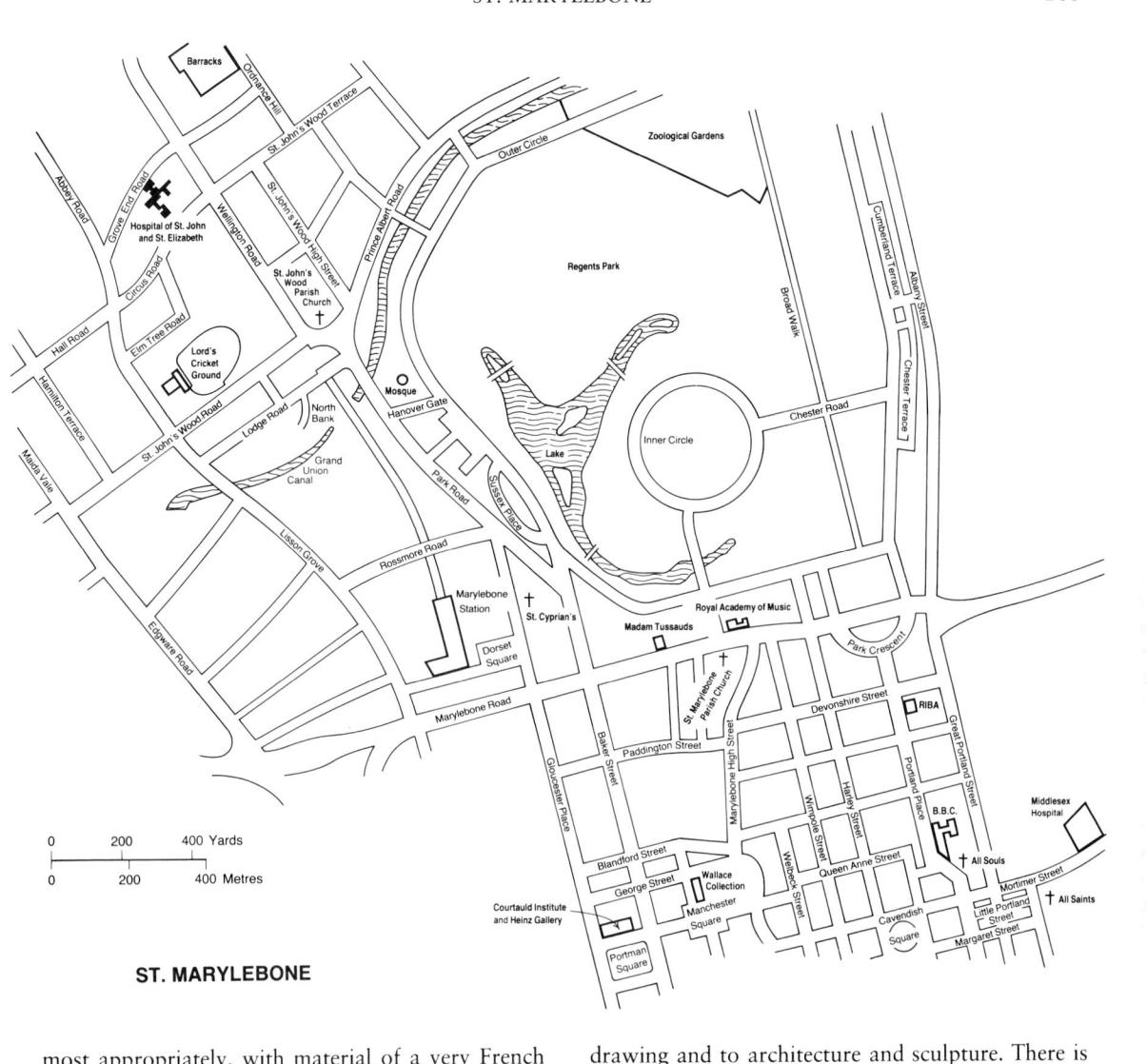

most appropriately, with material of a very French shade of blue.

Home House, 20 Portman Square, was the house of Samuel Courtauld and is the home of the Institute which he founded in 1931, for the study of the history of art, though the Courtauld Gallery is now housed in Woburn Square (see p. 217). The mansion, completed in 1776, was built by Robert Adam for the wealthy, elderly widow of the eighth Earl of Home; its rooms are adorned with stucco and inlaid woodwork, and with paintings by Angelica Kauffmann and Zucchi. At present, Home House houses the Institute's four libraries, which serve its own students and accredited scholars. The general library is here, and so are the Witt and Conway Collections, composed of drawings, engravings, photographs, and cuttings relating, respectively, to painting and

Round the corner, at 22 Portman Square, is the Heinz Gallery, founded in 1971 to accommodate the RIBA's remarkable collection of architectural drawings. Changing exhibitions are housed on the ground floor; scholars and students may use the collection.

Northwards from Cavendish Square, where Romney had his studio, run Harley Street, Wimpole Street, and Devonshire Place. The Portland Estate was laid out with regularity but without uniformity; nineteenth- and twentieth-century insertions and expansions have attentively observed the original proportions. Medical name plates line the door lintels today, but the streets have other associations. Allan Ramsay lived at 67 Harley Street; it was from 50

also a slide collection. The Courtauld has begun to publish its archives, while its journal, issued jointly with the Warburg Institute, is revered internationally.

¹ Eventually, the libraries will be reunited with the collection of paintings in premises in Somerset House.

Montague Mews South, George Street

Wimpole Street that Elizabeth Barrett eloped with Robert Browning, while number 67 was a 'dark house' to Tennyson, for it had been the home of his dear, dead friend, Arthur Hallam, for whom he wrote *In Memoriam*. In Queen Anne Street Turner had lived at number 23 and Fuseli at number 72 before he moved to Berners Street.

The Marylebone Road, laid out in 1757 as London's first bypass, marks approximately the northern limit of the Portland (now Howard de Walden) Estate, and the parish church, built in 1817 to the designs of Thomas Hardwick, stands where the Marylebone High Street joins the broad thoroughfare. Two earlier churches had stood on a nearby site, facing the High Street; a paved garden marks the place. Sir Francis Bacon was married in the earlier church (1400-1740) and Hogarth chose it as the setting for Tom Rakewell's marriage with the Old Lady. Charles Wesley was organist at the second parish church and in its churchyard were laid James Gibbs (d.1764), Allan Ramsay (d.1764), John Rysbrack (d.1770), and George Stubbs (d.1806). Byron and Horatia, Nelson's adored daughter by Lady Hamilton, were both baptized there, and Sheridan was married there. The present church is a large, cruciform building with an imposing Corinthian portico; its bell tower is topped with a cupola, the supports of which are gilded carvatids cast in artificial stone by Charles Rossi. A small separate room has been dedicated in memory of the Brownings.

Almost opposite is the Royal Academy of Music, founded in 1822, which has occupied this building since 1911. Student performances are sometimes open to the public. Madame Tussaud's Waxworks and Planetarium also stand in the Marylebone road. The Waxworks are important historically, including, as they do, life – or death – masks of Madame du

Barry (as the Sleeping Beauty, modelled in 1765 by Madame Tussaud's uncle), Louis XVI, Marie Antoinette, Robespierre, George III, George IV, Byron, Voltaire, and Benjamin Franklin, all by Madame herself. The collection is a three-dimensional international portrait gallery. The recently reconstructed tableau of the lower gunroom of the *Victory* at the Battle of Trafalgar is astonishing, and the Chamber of Horrors contains several sinister relics of an older London, including the door of the condemned cell at Newgate Prison and the bell which tolled to summon the condemned to execution. The lectures at the Planetarium, with its equipment designed in the Zeiss laboratory at Oberkocken in West Germany, are valuable educational experiences.

Also in the Marylebone Road, but on the western side of Baker Street is the former St. Marylebone Central Library, now one of Westminster City Libraries. This building and the present Westminster Council House next door to it (originally St. Marylebone Town Hall) were both designed by Sir Edwin Cooper in 1939 and 1914 respectively. The library contains a collection of water colours and drawings, including works by Robert Marris, William Capon, and Thomas Hosmer Shepherd. The Ashbridge Collection relating to the history and topography of the area is here, and for several years the library has made discriminating purchases of contemporary works of local topographical interest.

Two churches and two schools nearby deserve attention. The churches are St. Mary's, Wyndham Place, designed by Sir Robert Smirke in 1823, and St. Cyprian's, Clarence Gate, designed by Sir Ninian Comper and consecrated in 1903; the schools are Marylebone Grammar School in the Marylebone Road and the Francis Holland School in Clarence Gate. St. Mary's, a fine town church with a semicircular portico and slender west tower topped with a small cupola, is remarkable chiefly for the elegance of its setting, for the crescent of Wyndham Place cradles it and echoes the arc of the portico. St. Marylebone Grammar School, found in 1831, still flourishes in the building designed for it by E. Habershon, with a small octagonal chapter-house to one side of the main building. St. Cyprian's lies in Glentworth Street, built of brick and so cramped by adjacent blocks of flats that it can scarcely be seen, but its lofty, uncluttered interior, seven bays long, is painted white and filled with clear, cold light. The screen supporting the rood and the font with a tall cover are the most remarkable furnishings. Francis Holland School beside it, founded in 1878, is accommodated in a triangular building of 1915 by H. T. Hare, which makes remarkably good use of a difficult site.

York Gate, directly opposite the parish church, provides one of the main entrances into Regent's Park. Henry VIII's hunting preserve (see p. 182) was disturbed during the Commonwealth period, and was subsequently let out as farming land. The leases

expired in 1811 and John Nash, architect and friend of the Prince of Wales, later George IV, was commissioned to lay out the estate, the prize development of early nineteenth-century London, linking it by means of a new street, Regent Street, with Westminster and the Houses of Parliament. The design was beset with every sort of problem but somehow, almost unbelievably, Nash accomplished it, creating a near ideal English landscape, a rus in urbe, which, almost equally incredibly, has survived more or less intact to the present day and is now being restored to its pristine sparkle and condition, as the wedding-cake stucco of the terraces is repaired and repainted and the interiors of the houses adapted to modern needs. The Park has influenced suburban development ever since and vet Nash did no more than take the customary constituents of other London estates - tall terraced houses massed behind a unifying facade and, disregarding the gridiron plans of those estates, adapt and bend the terraces to the shape of the park. Even as Wood's Crescent and Circus nestle into the hillside at Bath, so do Nash's eccentric Inner and

Outer Circles exploit the terrain to the full. Therein lay his genius, in his quickness to adapt the accepted so as to make the most of an unexpected opportunity. Nash's full scheme, which included a small palace for the Prince Regent as well as 56 villas, each secluded in its own grounds and invisible to the others in the park, was, perhaps happily, never completely achieved but enough was accomplished and remains unspoilt today to leave the spectator marvelling.

Regent's Park is best entered along the sweeping curve of Park Crescent (Nash himself, 1819–21). The first major terrace westward around the Inner Circle is York Terrace (Nash, 1822), planned as one long façade towards the Park, but divided by York Gate, with its vista towards the parish church. Here one may make a detour to explore the Inner Circle, beside which stand the modern buildings of Bedford College and two of the original villas, the Holme (Decimus Burton) and St. John's Lodge (John Raffield). The gardens of the latter are open to the public, and between the two but within the core of

St. Cyprian's, Glentworth Street

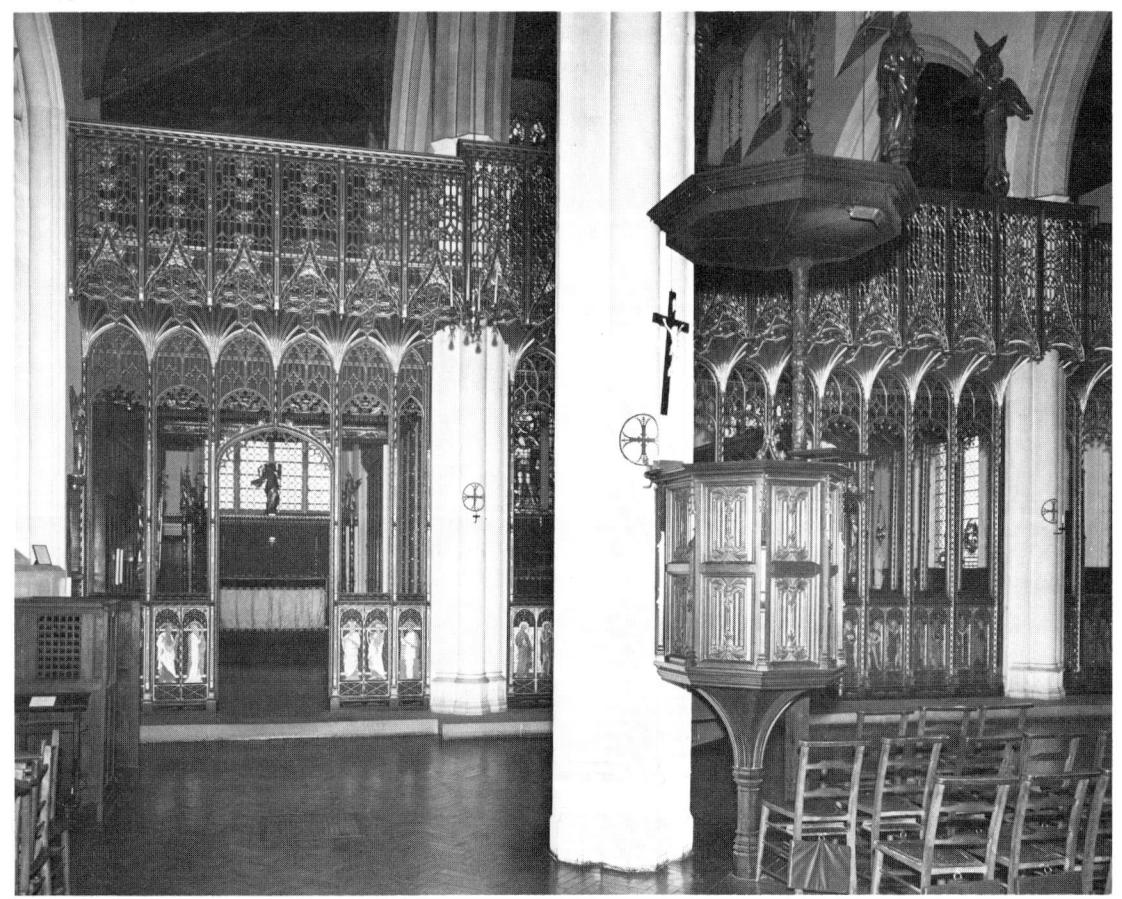

the Inner Circle is the Open Air Theatre at which any summer visitor to London should attend a performance. The heart of the Inner Circle is Queen Mary's Rose Garden, in which stands the Triton Fountain by William McMillan.

On the Outer Circle is the Lake, on which a seemingly endless variety of ducks paddle to and fro, to the delight of smaller Londoners and visitors, and Cornwall and Clarence Terraces, the latter designed by Decimus Burton in 1823, and Sussex Place, with its small cupolas, where Nash seems to have been thinking of the Pavilion, which he had once built for the Prince Regent at Brighton. Beyond is Hanover Terrace, which he designed in a restrained, classical mood, with the capital's newest and most exotic building beside it, the London Mosque, all white save for the gilded dome and minaret which gleam above the trees. How Nash would have delighted to see such a building in his Park! The place of worship, where shoes must be removed before entering, is a great square open space, empty of all furnishings that might distract the mind from the contemplation of God. The only decoration is the vibrant blue mosaic around the interior of the dome. The architect responsible is Sir Frederick Gibberd.

The Outer Circle then sweeps round to the entrance to the Gardens of the Zoological Society of London. Founded in 1824, the Society leased land in the Park and, with Decimus Burton as architect, began to lay out its gardens, which were opened to the Fellows and to the public in April 1828. Burton's camel and giraffe houses are still there, as is his clock tower. The Society has always had an instinct for picking the right architect; the penguin pool by Tecton (1935), the aviary by Lord Snowdon, and the elephant house by Sir Hugh Casson and F. A. Stengelhofen may all be admired for their own merits, though the delight of watching the animals and birds may perhaps make it hard to concentrate on the buildings.

The north-eastern entrance to the Park is at Gloucester Gate, behind which lie the remains of Park Village, planned by Nash as a group of elegant cottages and reminiscent of Blaise Hamlet, which he had laid out years before in Gloucestershire. Back in the Outer Circle, we come to St. Katharine's Church (Ambrose Poynter, 1828), the only brick building in the Park, its stark angularity unsoftened by stucco, which is occupied today by the Danish Church in London. 1 Beyond the church is Cumberland Terrace, Nash's most grandiloquent façade, with a pediment full of sculpture by George Bubb. This was intended to provide the eastern prospect to a small palace in the heart of the park, which was never built; the terrace must be considered as Nash's grandest achievement, and since James Thomson, a careful man, was the architect on site, the details are realized

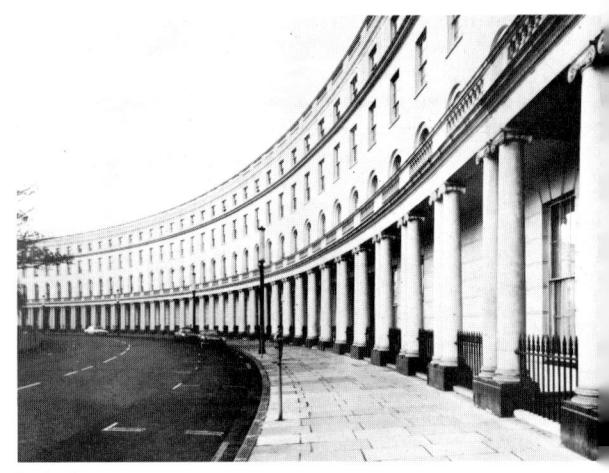

Park Crescent

with precision. Beyond is Clarence Terrace, which Nash planned and James Burton built, with graceful archways to link two houses which stand like pavilions in front of the main building. Cambridge Terrace was built in 1825, but Cambridge Gate not till 1876-80, for the site was originally occupied by the Colosseum, which housed a wonderful panorama of London; never over-successful as a place of entertainment, it was eventually demolished. Beside it stands the T-shaped Royal College of Physicians with its half-sunken lecture threatre beside it, built in 1964 to designs by Sir Denys Lasdun and, in spite of its complete modernity, entirely at home within the Park, largely because it is conceived on the same scale as the terraces. The College, founded in 1518 in Thomas Linacre's own house in Knightrider Street, near St. Paul's, received letters patent from Henry VIII. Though much of its original library perished in the Great Fire of London, the Marquis of Dorchester, on his death-bed in 1680, gave to the College his own collection of books, described by a contemporary as one of the finest in the land. To this, succeeding generations have added, and the College has collected portraits and busts of eminent physicians from the seventeenth century onwards - that of Baldwin Hamey by Edward Pierce (1680) is outstanding. After the Great Fire, Robert Hooke built new premises in the City for the College; the panelling of the Censors' Room has been preserved and has travelled with the College, first to their later building in Trafalgar Square (now Canada House) and then to Regent's Park.

North of Regent's Park lies St. John's Wood. Originally forest land and taking its name from the Knights of St. John of Jerusalem, who owned it before the Reformation, it became agricultural land by the seventeenth century and was developed once Regent's Park had been laid out. In spite of the depredations of subsequent generations, it still re-

¹ Behind the arcade to the south of the church is a full life-size replica of the Jelling stone, bearing the earliest Scandinavian representation of Christ.

tains much of its original elegance and charm. The parish church, by Thomas Hardwick, with a good portico and original pews, stands at the junction of Wellington Road, Prince Albert Road, and Park Road, and looks out at a huge statue of St. George killing the dragon, the work of Charles Hartwell. Beside it is Lord's Cricket Ground. The Marylebone Cricket Club, founded in 1787, called its premises after Thomas Lord, who maintained its first ground, which Dorset Square now covers. The club possesses a small art gallery, opened in 1953. In addition to a wealth of cricketing souvenirs and relics, fit objects of veneration by different generations, it possesses several important paintings which might easily go unlocated by the historian. These unexpected treasures include a Flemish painting of David and Bathsheba with a game of tennis going on in the background, another by Pietro Fabris of a game of pallone, a portrait by one of the Sablet brothers of Thomas Hope playing cricket, painted while the future connoisseur was making the Grand Tour and

12 Park Village West

staying in Amsterdam, and other important works by Francis Hayman, Thomas Hudson, Robert James, John Ritchie, and Henry Garland.

St. John's Wood, though torn apart by the Great Central Railway (later the LNER) at the end of the last century, and further ravaged in this by bombing and rebuilding, still has a wealth of small architectural joys. Much of the land was acquired in 1732 by the Eyre family, who still hold part of it; development began early in the nineteenth century when the laving out of Regent's Park made obvious its potentialities. It was on this estate that pairs of semidetached villas, in contrast with massed lines of terraces, first made their appearance; before the end of the nineteenth century this construction was to become the hallmark of every small development with any pretensions to gentility. The determined pedestrian who walks the length of the High Street and the smaller roads adjacent to it, followed by Hamilton Terrace, Carlton Hill, Clifton Hill, and Maida Vale, will see and learn a great deal. The key note was the cottage orné, expanded into twin residences, and in these pleasant dwellings those artists who were able to afford them during the second half of the nineteenth century made their homes, even as their predecessors had done in and around Newman Street.1 Landseer lived at 1 St. John's Wood Road, Frith in Clifton Hill, Tissot built a colonnade to his house in Grove End Road, a mansion later occupied by Alma-Tadema - though the house has been converted into flats the colonnade is still there, just a little shabby. Opposite, John MacWhirter had a magnificent studio at 1 Abbey Road, while Thomas Shotter Boys and Onslow Ford² both lived in Acacia Road and the St. John's Wood clique - David Wynfield, Henry Stacey Marks, Philip Calderon, John Hodgson, William Yeames, George Leslie, and George Storey – occupied houses nearby and met at Hodgson's home in Hill Road. Their work is, slowly, once again beginning to be appreciated and brought out from the store-rooms of art galleries; another decade may well see a revival of what must be called the St. John's Wood school of artists.

¹ Gordon Mackenzie's *Marylebone* (1972) is worth reading. 2 A memorial to him stands at the intersection of Grove End Road and Abbey Road, just by Tissot's and MacWhirtre's houses. On it is a medallion portrait of the sculptor by A. C. Lucchesi and a figure of a seated woman holding a lyre with broken strings, a copy of the figure which he himself designed for the Shelley memorial in Oxford. The whole was designed by J. Simpson and unveiled in

Paddington

The former Metropolitan Borough of Paddington became, in 1965, a part of the City of Westminster, in company with its sister borough, St. Marylebone. Covering an area of 1,350 acres, with a population of about 100,000, Paddington stretches from the Bayswater Road northwards to Maida Vale and West Kilburn, its southern and eastern boundaries (Bayswater and Edgware Roads) following the line of the Roman roads to Silchester and St. Albans. Church land before the Conquest, Paddington remained church property despite the vicissitudes of the Reformation, so that, even today and in spite of recent sales, a good part still belongs to the Church Commissioners, who have recently been responsible for an interesting development, the Fresh Water Estate beside the Edgware Road.

On what was farm land until the first quarter of the nineteenth century, an elegant estate known as Tyburnia began to be laid out in the south-eastern corner in 1827. The centre of the parish had already, by 1801, been girdled by the canal flowing from Paddington Basin to Uxbridge, and the development of the area was stimulated by the arrival of the Great Western Railway in 1832-8. The Ladbroke Grove Estate (see pp. 299, 301) began to be laid out in the 1840s, and by that time houses were being built in Paddington north of the canal, along Warwick Avenue, Clifton Gardens, and Maida Vale. Still primarily residential, despite its bisection by canal and railway, the housing in Paddington ranges from expensive town houses and flats in Bayswater, through elegant and unusual early, middle, and late Victorian residences along Maida Vale, to artisans' dwellings embowered with acanthus mouldings beside modern council housing estates in Kilburn.

For the purposes of exploration, Paddington falls into three zones, southern, central, and northern; our perambulation begins at the south-eastern corner.

A metal triangle let into the road surface marks the spot where Tyburn gallows stood and where, from 1196 till 1783, public executions took place. Criminals of all sorts perished here; brutal murderers and petty thieves, driven to larceny by their poverty, mounted the steps of the Triple Tree. Catholics and Protestants suffered here alike during the sixteenth century, and at the eastern end of Bayswater Road a sisterhood of Benedictine nuns, established here in 1903, offers prayers daily for those who were martyred; their church, built in 1963, is open to the public. It was at Tyburn that the exhumed bodies of Cromwell, Ireton, and Bradshaw were exposed at the Restoration, and the gallows was not removed to Newgate till 1783, when fashionable development was well established in Marylebone. The name, however, remained, and in spite of its sinister associations, provided a designation, Tyburnia, for the pretty estate which Samuel Pepys Cockerell, an architect who lived in the vicinity, planned for the Bishop of London's estate in 1827. He died in that year and George Gutch took his place, with George Ledward designing the houses. The area laid out was roughly triangular, with Tyburn as the apex, the Bayswater and Edgware Roads as the sides, and Praed Street as the base. Across these acres, an intricate pattern of streets and squares and crescents was laid out, the whole design adding up to something far more impressive than the sum of its constituent parts. The hallmark of Tyburnia was the square porch, which led the way into almost every one of the tall, white-stuccoed houses - 1 Hyde Park Gate is a particularly magnificent example with fantastic plasterwork garlands festooning its walls with their abundance. The main streets were set at right angles to each other, parallel to Praed Street or the Edgware Road, but joining the Bayswater Road at angles acute or oblique, thereby creating unusual urban vistas for which the builders almost always found significant focal points (cf. Victoria, p 177).

The two churches on the estate are not, in their own right, impressive but their settings lend them a dignity with which to outstrip other, better buildings. St. John the Evangelist in Hyde Park

¹ James Brooks's magnificent church of All Hallows in Shirlock Road, Gospel Oak, is a good example. Built in 1889 and immediately cramped in by insignificant property, its buttressed dignity remains hidden, unsuspected, and unadmired.

PADDINGTON 191

Crescent was the pivot for the first part of Cockerell's scheme. Begun by him in 1826, it was completed in 1831 by Charles Fowler, but was much altered in 1895. A little vellow brick box with a large west window, the interior has recently been redecorated, with happy results; it is worth searching out the building simply to admire the great cross designed by Michael Caddy, suspended over the entrance to the chancel. St. James's, at the south-west end of Sussex Gardens, has a spectacular site, of which G. E. Street took proper advantage in 1881. A smaller church by John Goldicutt and George Gutch had been built on the site in 1841-3; Street retained its apsidal chancel but, disregarding theologically correct orientation, he turned the building round, making the old chancel into a west chapel, and giving his church a tall, Early English tower and spire which close the vista along the line of Sussex Gardens. The old chancel is now the baptistery and in 1952 a new window was inserted, its lower lights showing Paddington Station, Lord Baden-Powell, who was baptized here, the church itself in war-time - it was badly damaged -Peter Pan's statue nearby in Kensington Gardens. and Sir Alexander Fleming, the discoverer of penicillin, at work in his laboratory in St. Mary's Hospital in Praed Street. Inevitably, there was a good deal of bomb damage in this area; small, expensive houses now fill in the gaps or replace out-of-date property. These houses are the direct descendants of those which Cockerell planned and Gutch and Ledward

The western end of the Bayswater Road was developed independently of Tyburnia, and it is worth walking the full length of that windswept thoroughfare, from Marble Arch to Notting Hill Gate, to observe how the rhythm of building changes. Though blocks of flats have now replaced houses, Lancaster Gate retains its original, spacious proportions, ranged on either side of where Christ Church (H. and F. Francis, 1855; demolished 1978) once stood. Number 100 Bayswater Road was the home of the dramatist, Sir James Barrie, creator of Peter Pan; very occasionally, it is opened to the public.

Beyond Queensway is Orme Square, laid out by Edward Orme in 1816 when Tsar Alexander was visiting England after the conclusion of the wars against Napoleon, so the streets around bear such names as St. Petersburg Place and Moscow Road. In the latter stands St. Sophia, London's Greek Orthodox cathedral, an inscribed stone from St. Mary the Virgin, built in 1667 where Charing Cross Road now runs, set in the front porch. St. Sophia was built in 1877–9, of brick and in the shape of a Greek cross, the central dome lined with mosaics; the plans were by John Oldrid Scott and the church became a cathedral in 1922. All are welcome here, and it is worth attending a service to listen to the chanting.

In the centre of the southern part of the borough is the railway station, which is what the name of **Paddington** signifies to most people. At first, the Great Western Railway had no London terminus and it was at a temporary building near to Bishop's

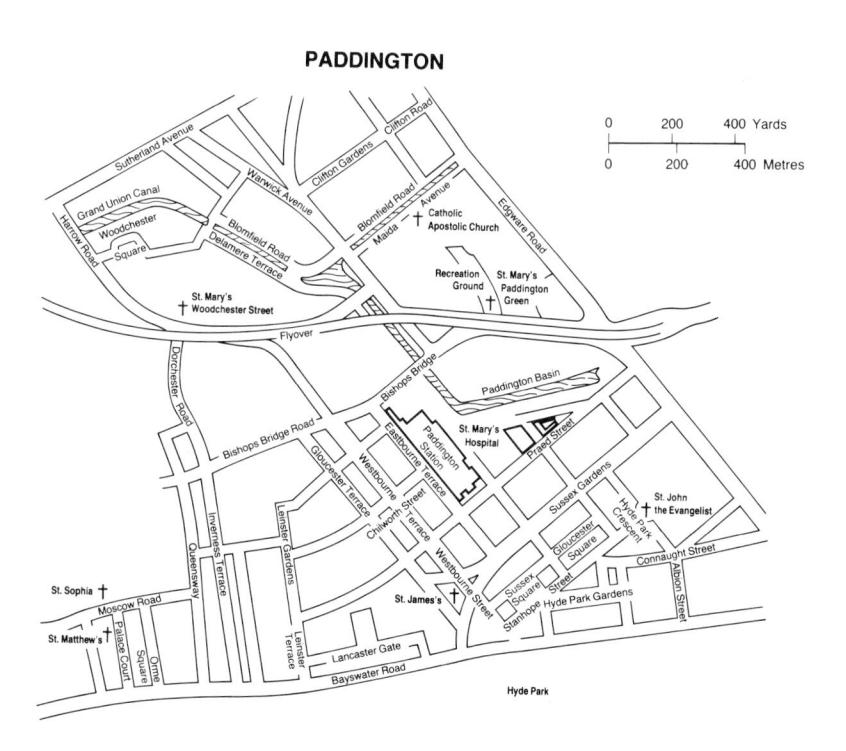

Bridge that Queen Victoria alighted on 13 June 1842, having travelled the 17 miles from Slough in 23 minutes, with Brunel himself on the foot-plate to make sure that nothing went awry. In making that short journey, the Queen gave royal approval to the new and revolutionary means of transport, so that it became socially acceptable. A proper terminus was built to designs by Brunel and his friend, Matthew Digby Wyatt, which opened in 1854 and has changed very little since then. Three great glass and steel arches span 240 feet of station and the platforms are 700 feet long. High on the wall of number 1 departure platform is the iron balcony of Brunel's office, from which he used to survey activity below. A study of William Frith's The Railway Station, now at Royal Holloway College in Egham in Surrey, shows us what Paddington was like in 1861. On the south side of the station is the Great Western Hotel, designed by Philip Hardwick. It was Brunel's ambition that a traveller might enter its portals and be conveyed from it to New York exclusively in transport owned by the company.

To the north of the station lies Westway, its flyover, opened in 1970, swooping and dipping across the heart of the parish. Beside it on a narrow strip of grass – all that is now left of Paddington Green – sits St. Mary's church, composed and steadfast when confronted by so much of what is ugliest in twentieth-century development. A church has stood

St. Mary Magdalene, Woodchester Street

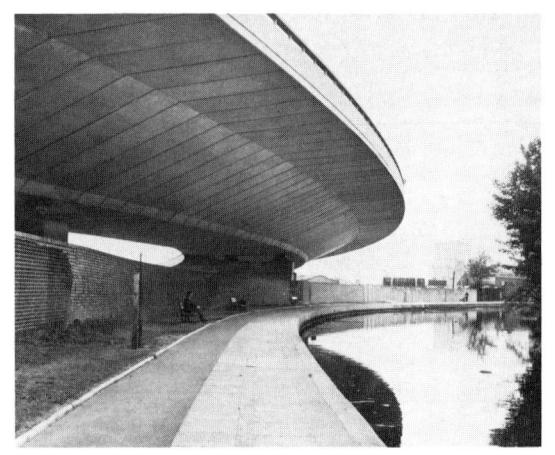

Westway flyover from the canal path

here at least since 1222, the original dedication being to St. Nicholas. The first St. Mary's was built in 1688 - William Hogarth's runaway marriage to Jane, Sir James Thornhill's daughter, was celebrated there in 1729 – and the present church in 1791. Designed by James Plaw, it is built of yellow brick in the shape of a Greek cross, the square centre spanned by a shallow, delicate dome. In the churchyard lie the sculptors John Bushnell and Thomas Banks, the tragic artist Benjamin Robert Havdon, who killed himself because his work was unappreciated, and Mrs. Siddons, who shares her resting-place with Patty Wilkinson, her dresser and constant companion for 40 years. A statue by Chavalliaud of the great actress, its pose modelled on Sir Joshua Reynolds's painting of her as the Tragic Muse, broods in the churchyard, contemplating the traffic rushing past. Inside, St. Mary's is one of the most exciting churches in London. Money in compensation for church land lost in building Westway was spent on the church itself and the architects, Raymond Erith and Quinlan Terry, have restored the church to the freshness it had in Plaw's day, retaining the galleries round three sides and altering very little, but repaving the floor with black, white, and brown Melrose marble for the centre aisle and with elongated hexagons of alternate Portland and York stone for the ambulatory. The cohesion and imaginativeness of these improvements literally have to be seen to be believed. There are several late eighteenth-century monuments, the best being by the elder John Bacon to Francis Aust (d.1794), and there is another in memory of the sculptor, Joseph Nollekens.

Paddington Canal starts just south of the Green and crosses the borough from east to west. Opened in 1801 and running to Uxbridge 14 miles away, in 1805 it was linked with the Grand Junction (later Grand Union) Canal to the Midlands.

Today, the streets around Paddington Basin form one of London's most piquant areas. Trips from the

PADDINGTON 193

Leinster Square

Basin to Camden Lock may be undertaken daily in the summer months on the Jason, the Jenny Wren, and other barges. Beside the Basin stands John Loughborough Pearson's now disused Catholic Apostolic church, begun in 1891 and built throughout of red brick in the Early English manner. Robert Browning lived by the canal from 1862 till 1887 at 19 Warwick Crescent; it is said that the luxuriant and elegiac willows that mourn over the island in the centre of the Basin were planted on his suggestion. During the 1950s, an inspired estate agent described the neighbourhood as 'Little Venice' and the apt name clung to it.

The adventurous and active may make as protracted a walk as they please along the towpath by the Canal (see also p. 182) from which they may observe, on the northern bank, some exceptionally good flats, built by Westminster City Council, overlooking the water, while on the south, now surrounded by another successful council development, stands Street's church, St. Mary Magdalen, built in

1868–78, with a deeply curved chancel and a tall round tower and spire, which look as if they had come from North Germany and were a little bewildered at finding themselves in London. The steep slope of the canal bank has meant that the nave lacks its aisle on that side but the asymmetrical interior possesses remarkably fine acoustics; there is an excellent John Compton organ of 1933 and the St. Mary Magdalen Church Music Society is justly celebrated. In the crypt is a chapel constructed in 1895, [Sir] Ninian Comper's first major work.

The walk along the towpath continues within the shadow of the motorway flyover and suddenly the structure, so repulsive as one crosses it, reveals its beauty as its curves travel, sinuously and purposefully, westwards, towards the ridge above Uxbridge which may be glimpsed, momentarily, between the piers which support the massive roadway. Keeping firmly to the footpath and crossing first under the Harrow Road and then under the Great Western Road, one is rewarded, beyond Ladbroke Grove, by

The canal at Paddington

an ex-urban landscape, not quite the country as yet but most certainly not of the town, and quintessentially Middlesex in character. The remains of Kensal Green gas works are here for those interested in industrial archaeology, and the Victorian angels in Kensal Green Cemetery on the north bank seem to people a village churchyard.

To the north of the Basin across the last section of Paddington are the broad roads – Blomfield Road, Clifton Gardens, Randolph Road – and the dramatically sited St. Saviour in Warwick Avenue. A church, built here in 1855–6 by J. Little, was demolished in 1974 and has been replaced by another designed by Messrs. Biscoe and Stanton, as dramatically sited as the older building. Bombing and replacement have marred the smooth rhythm of portico and balcony in

the streets around, but Lanark Road, a row of modest houses built about 1850, has retained an intact and unblemished southern side.

The borough boundaries have been redrawn to include St. Augustine's church and the interesting new housing development around it in Kilburn (see p. 206). The amateur of London should make a detour or expedition to view what remains of Queen's Park, an area of 75 acres laid out in 1875 by the Artisans, Workers and General Dwelling Company to provide more than 2,000 tiny Gothick houses, each with the Company's entwined monogram in plasterwork above the door and, on Fifth Avenue, the addition of little towers, fit for a French château but built to a scale smaller than that of the Petit Trianon.

NORTH OF THE RIVER

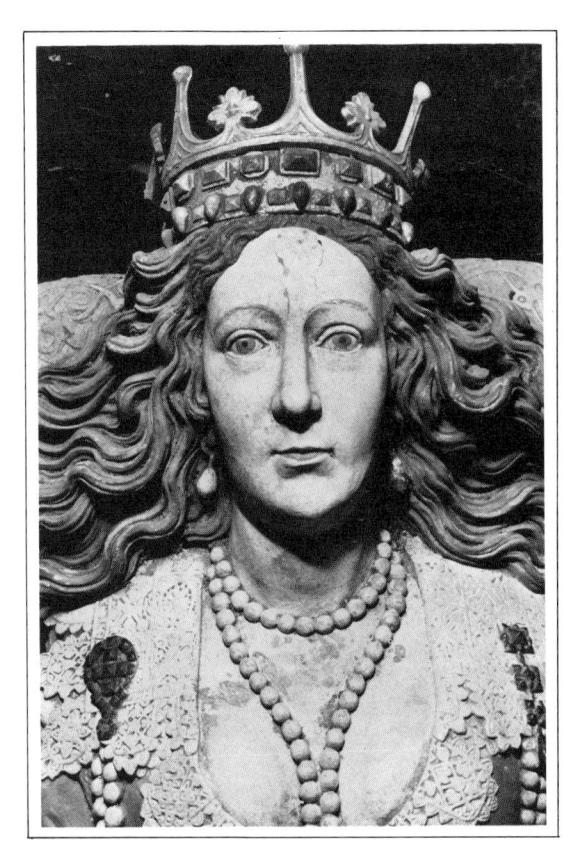

Alice, Countess of Derby (see p. 280)

Barking and Dagenham

The London borough of Barking Dagenham lies to the north-east of the City, and was, till 1965, a part of Essex. Its southern boundary is the north bank of the Thames, and through it runs the River Roding, emptying itself into the main stream at Barking Creek. Covering nearly 9,000 acres with a population of about 150,000, the riverside strip, once completely marshland, now accommodates both some waterside wild life and much heavy industry, the most important factory being Ford's Motor Works at Dagenham. Once heavily forested, the area north of Ripple Road is now closely built up save for four parks, Barking, Mayesbrook, Parsloes, and Valence. the two last names recalling former manors.

The chief monument is the remains of Barking Abbey, to which most of the land in the entire modern borough once belonged. This, the senior convent in all England, was founded about AD 666 by St. Erkenwald for his sister, St. Ethelburga, the first abbess. Probably pillaged by the Danes in the ninth century, it was restored by Alfred's son, Edward the Elder, and was confirmed in all its possessions by William the Conqueror. At the Reformation, the buildings were destroyed to enlarge Greenwich Palace and to build a new royal residence at Dartford; only the Curfew Gate remains, now serving as an entrance to St. Margaret's, the parish church. In its upper room is a fine stone rood, of early thirteenth-century workmanship. The site of the convent was excavated in 1911, and grey stones now mark out the foundations of the main buildings. In 1975, the 20 acres containing the convent and church were declared a conservation area.

The flint and ragstone parish church has a thirteenth-century chancel; the octagonal pillars in the north aisle are of the same date and the eastern chapel on that side may be older still. The nave was lengthened and the tower added in the fifteenth century. The nave still has its original roof but the chancel was given a stucco vault in 1772. There is a stone from a Saxon cross, a fragment of the black marble gravestone of a Norman bishop, Maurice,

and another gravestone, that of the first vicar, Martinus, who died in 1328. It bears his portrait, deeply incised into the stone, a forerunner of the brasses which adorn so many English monuments. Besides these, there are four brasses, three of them from the fifteenth century and the fourth commemorating John Tedcastell (d.1596) who is shown with his wife, four sons, and five babies in swaddling clothes, who presumably died in infancy. An elaborately moulded white marble sarcophagus, the tomb of William Pownsett (d.1553), was the work of Nicholas Bellin of Modena, who was 'image graver' to Henry VIII and to all his three children. Sir Charles Montagu (d.1625) has a particularly fine monument which shows him in full armour, seated in a tent guarded by soldiers. There are busts of Francis Fuller (d.1636), John Bennett (d.1706), Sir Orlando Humphreys (d.1737), and John Bamber (d.1753), this last possibly by Roubiliac, and a weeping putto mourns for Sir Crisp Gascoyne (d.1761), the first Lord Mayor to take up residence in the Mansion House. There is a seventeenth-century font, its cover gaily painted with butterflies, birds, and flowers, a fine eighteenth-century pulpit, an organ case by Byfield and Green, some excellent modern embroidery in the kneelers, and a modern carved screen, set across the entrance to the south chapel as a memorial to the local fishermen, for Barking was once an active fishing port. The figure of Captain Cook, who was married in this church, is carved on it, and so is Elizabeth Fry, the prison reformer, for she spent many summers, as a young woman, in a cottage near Dagenham, and was interred in the Friends' Burial Ground in Barking.

Some two miles east of the parish church is Eastbury House, a small but remarkably complete manor house which belongs to the National Trust but is on lease to the Borough Council. Built by a rich merchant, Clement Sysley, soon after he acquired the estate in 1556, it rises through three storeys and is of red brick, decorated with black diapering. The roof is set about with gables and on the south side is an enclosed courtyard, in the north-west corner of which is the survivor of a pair of spiral staircases, made of oak, the stair and newel post carefully dowelled together. It winds up to a trap door, through which one can scramble onto the lead-covered roof and survey the flat Essex marshes for miles. Inside, the Great Hall has been sub-divided,

but some panelling remains and there are several original fireplaces. On the first floor is a chamber with painted walls. Pairs of fat, flat, barley-sugarstick Corinthian pillars separate primitive *trompe l'oeil* round-leaded windows, through which ships in full sail can be seen, and, a trim, prim orchard in early spring, its bare boughs just about to burst into leaf. The work dates from the late sixteenth or early seventeenth centuries, and is of remarkable quality. In a gallery on the second floor of the east wing are paintings of jaunty figures dancing along.

DAGENHAM, Barking's sister borough, has an interesting parish church, dedicated to St. Peter and St. Paul, with a chancel built in the thirteenth century. The tower collapsed in 1800, so that the nave had to be rebuilt. It was completed five years later with an agreeable tower with curly battlements and a small classical portico. Old materials were used wherever possible in the reconstruction. Inside is a splendid altar tomb belonging to Sir Thomas Urswyck (d.1479), Baron of the Exchequer and friend of Edward IV. The brass shows him in judge's

robes and his wife has a butterfly headdress. A memorial to another judge, Sir Richard Alibon (1635–88), has a bust of the dead man which has been attributed to Van Nost. He was the first Roman Catholic to become a judge since the Reformation. Visitors to the church will also see the Old Vicarage, built in 1665, and the Cross Keys Inn, a fine fifteenth-century timber-framed house with two tall gables.

Of the various substantial estates which made up Dagenham from the Middle Ages onwards, only one house of any importance remains. This is Valence House, which was acquired by Dagenham Council in 1928 and serves today as a local history museum. There was a house here by the middle of the thirteenth century, for a document from the end of that century describes the dwelling as ruinous, but the present mansion dates from the end of the sixteenth. It is a wooden-framed, lath and plaster building, with a west wing added to it during the eighteenth century. The panelling of two rooms has been preserved and restored, and around the house are hung the impressive collection of 48 portraits of the Fanshawe

Ford Motor Works, Dagenham

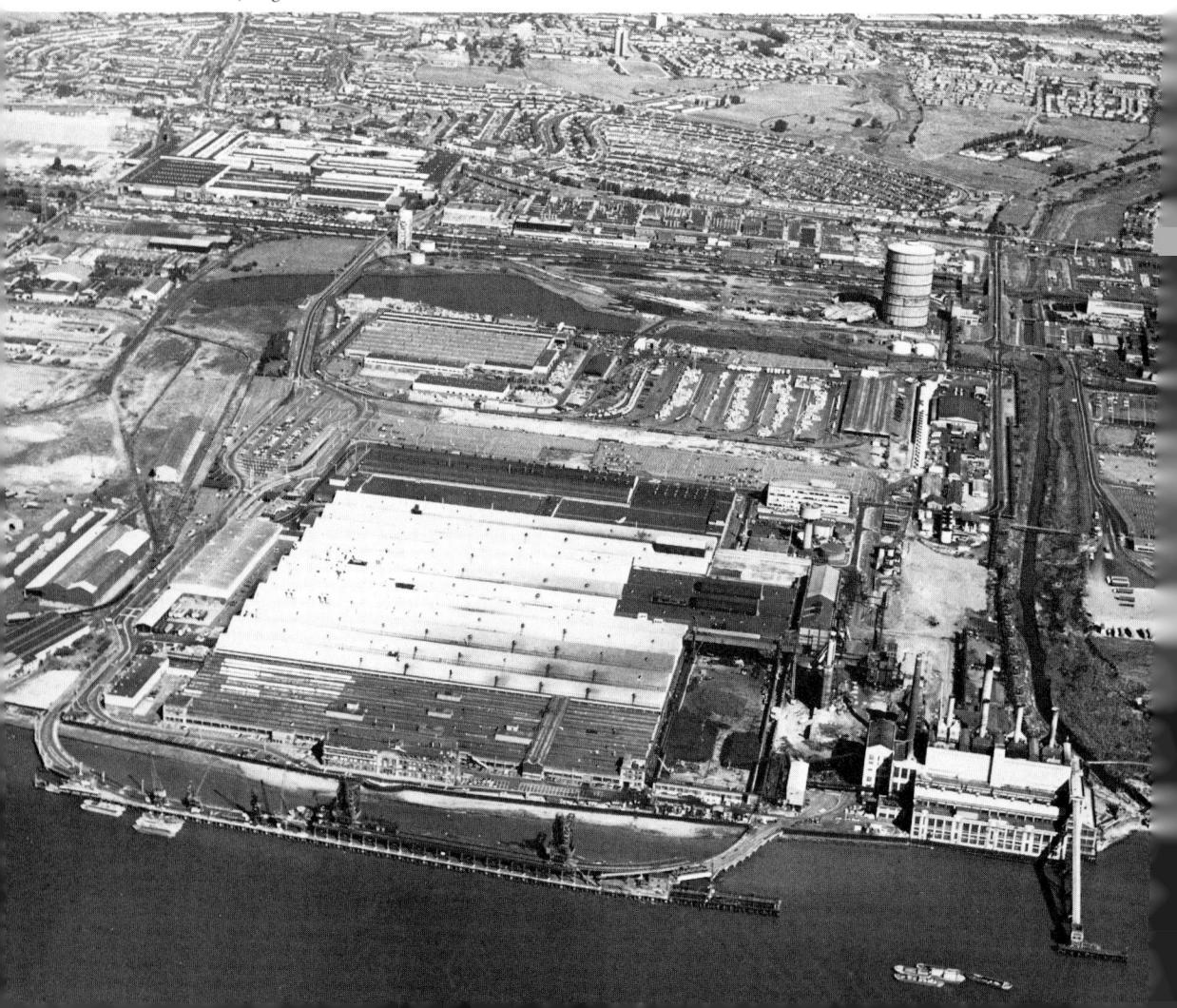

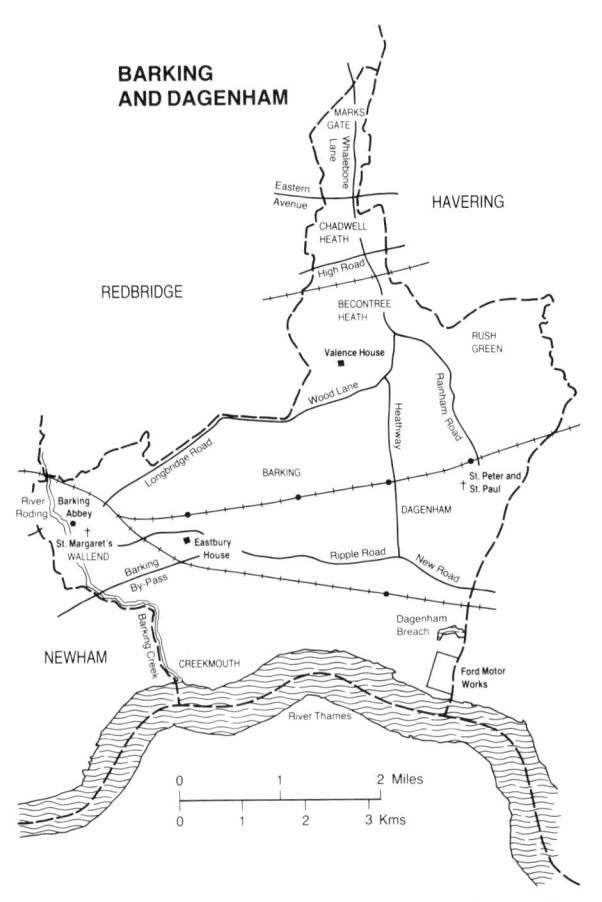

family, who for 300 years occupied the neighbouring but now demolished manor house of Parsloes. They include works by Lely, William Dobson, Kneller, Cornelis Jansen, and Jonathan Richardson. Among the portraits is one of Lady Ann Fanshawe, who wrote memoirs of her life during the Civil War and later in Spain and Portugal when her husband was ambassador there. Of the other rooms, one is devoted to maps of the area, another to the history of Hainault Forest, of which some 1108 acres still remain, though the greater part of this primeval woodland was felled in 1853 when the Commissioners for Land Revenue sold the timber and men worked by torchlight in order to hasten the destruction, hacking down the majestic trees, grubbing up their roots, and ploughing the land for agriculture. A

Eastbury House, Barking

third room, the Long Gallery, houses a museum. Among the exhibits are a replica of a carved wooden figure fashioned during the late Bronze Age¹, some fine flint artefacts, and a Roman coffin with pottery grave goods. There are a number of finds from a Saxon burial on the site of Gerpins Farm, though the most important discovery, a glass drinking horn, is now in the British Museum. A newly-laid-out River Room includes exhibits from HMS *Thunderer*, the last warship to be built on the Thames; she was launched at Canning Town in 1911 and equipped with armour at a specially built jetty in Dagenham Dock.

The Becontree Housing Estate, one of the largest ever to be laid out, is also part of the borough. In 1921, the London County Council bought up 3,000 acres of land in Barking, Dagenham, and Ilford and began to develop them according to the plans of their architect, G. Topham Forrest. More than 27,000 houses and cottages were built, the layout and façades resembling an adulterated version of the designs which inspired Welwyn Garden City and the Hampstead Garden Suburb. But, in spite of comparative monotony, the estate has great virtues, for the houses are on a human scale, with neighbourly porches, and roses flourish in the soil.

¹ The original is now in Colchester Castle.

Barnet, lying to the north-north-west of London, contains the former boroughs of Hendon and Finchlev and the former urban district of Barnet; these include the villages of Totteridge, Monken Hadley, Mill Hill, and Edgware. The borough covers an area of approximately 35 square miles and has a population of about 295,000. Through it run the Mutton Brook, the Dollis Brook, and the Brent, and there is high ground at Barnet, Hendon, and Mill Hill. In spite of steady urbanization from the end of the nineteenth century onwards, the original village centres remain distinct and the whole borough benefits from the sense of spaciousness provided by the open land in the northern half.

Barnet Hill is the highest point between London and York on the Great North Road; on its summit stands the parish church of St. John the Baptist, dominating the former village of Chipping (or High) Barnet. Probably founded in the thirteenth century, it was rebuilt soon after 1420 at the expense of John Beauchamp, a prosperous local maltster. The medieval church was restored and enlarged by William Butterfield in 1875, the old chancel being removed and the tower rebuilt with distinctive bands of chequer-work around the upper part. The original nave and north aisle were retained, but to them a new nave and south aisle were added with cheerfully lop-sided results. In the choir vestry an imp grins down from a roof boss, and mason's marks are visible on an arch of the old tower. The carved woodwork in the pulpit, pew ends, and font cover was designed by J. C. Traylen of Stamford for the nineteenth-century restoration, while Butterfield designed an elaborate reredos. Memorials to the Ravenscrofts were removed to the south aisle: an alabaster figure of Thomas Ravenscroft (d.1630) lies under a canopy with unexpectedly Gothic detailing; James Ravenscroft and his wife, whose bequests financed Butterfield's restoration, are represented by marble busts.

West of the church stands a red-brick hall, originally built for Queen Elizabeth Grammar School, founded in 1573. The whipping-post is still in position though the school has moved, and the old building, now companionably surrounded by new lecture rooms, is part of Barnet College. Nearby, four groups of almshouses - Jesus Hospital (founded in 1679 by James Ravenscroft for six poor women), the Leathersellers' Almshouses (founded in the City in 1544, moved to Barnet in 1837, and rebuilt in 1964 by Louis de Soissons), a third built in 1873 but supported on revenue from land left by Eleanor Palmer in 1558, and a fourth established under the will of John Barrett who died in 1728. In Wood Street, just behind the church, is Barnet Museum,

housing a collection of bygones.

Eastwards, along the Great North Road, is an open green with a grey stone obelisk set up in 1740 by Sir Jeremy Sambrook. It commemorates the Battle of Barnet, fought in a heavy mist on Easter Sunday, 14 April 1471, which finally set Edward IV on the throne. Further along the same road is Hadley Green with several attractive Georgian houses. A plaque reminds us that David Livingstone lived here till he set out for Africa in 1858. The nearby Wilbraham Almshouses, built of purplish brick, were founded in 1612. The parish church is dedicated to St. Mary the Virgin. Built of flint and ironstone with stone dressings, it has altered very little since 1494; this, the date of its completion, is set in Arabic numerals above the doorway of the west tower, half-eights being used to represent the two fours, thus -1898 – while the bird's wing and the quatrefoil are probably the badge of Sir Thomas Lovell, who had local connections. The copper cresset which tops the embattled tower was set up in the eighteenth century and is not an Armada beacon; it was last lit for the wedding of the Prince and Princess of Wales in 1981. Inside, there are a nave, chancel, two aisles, and two chapels, one on either side of the altar; squints are cut through the dividing buttresses so that mass could be celebrated simultaneously at all three altars. The church possesses a large collection of small fifteenth- to seventeenth-century brasses, showing groups of members from four local families, Grenes, Turnours, Goodyeres, and Gales, and there is a fine monument by Nicholas Stone to Sir Roger and Lady Wilbraham, who founded the almshouses on the green. Busts of the pair are set in niches; beneath them kneel tiny effigies of their three daughters, their long hair unbound. Henry Carow (d.1620) and his mother have another fine memorial set on the wall to

the left of the altar. A remarkable painting of the young man is set into a tablet and round it are carved figures of Boyhood (a child blowing bubbles), Manhood, Father Time, and Death, represented as a skeleton. St. Mary's possesses an unusually fine collection of communion plate, the earliest items, two gilt cups, dating from 1562 and 1586; the greater part of it has been sent for safekeeping to the British Museum.

Nearer to London, TOTTERIDGE lies to the southwest of Chipping Barnet, with eighteenth- and large early nineteenth-century houses strung out along the lane which runs from east to west. Their gardens are spacious and there is open land beyond on either side. St. Andrew's church stands at the eastern end of Totteridge Lane. An early foundation, originally dedicated to St. Etheldreda, it was rebuilt in brick in 1790, though the weather-boarded bellturret and weather-vane, dated 1706, were transferred from the older church. Outside the west door stands an enormous yew tree, which experts judge to be more than a thousand years old. Inside, there is an aisleless nave with a small apse added in 1867, with a wooden-ribbed half-dome for the chancel. The fine seventeenth-century pulpit comes from Hatfield church. There are several small wall tablets, including one by the younger John Bacon to John Puget (d.1805).

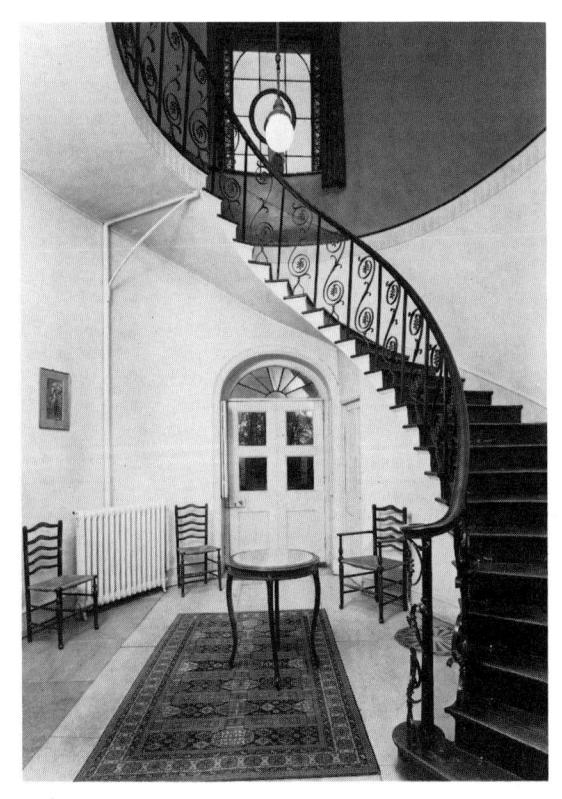

Holcombe House, Mill Hill

The houses westward, on either side of Totteridge Lane, are interesting. A mixed collection, of varying periods and styles, they include some excellent Georgian buildings (The Old House, The Manor House, Denham Park Farm) and some comfortable late Victorian additions (The Croft by Collcutt, 1895, Loxwood and Ellern Mede by Norman Shaw, 1877). Totteridge Lane becomes Highwood Hill, which doubles back on itself at a right angle to The Ridgeway, running the length of the spur of high land along which MILL HILL stretches itself. The old village has both architectural merit and open views across Hertfordshire to the east. Travelling from west to east, there are a number of important buildings. Holcombe House, now a convent school, was built in 1775 for John William Anderson, later Lord Mayor of London, by John Johnson, who became Surveyor to the County of Essex. The front is of three bays, the lower part rusticated, while coupled pilasters divide the first-floor windows and a neat parapet edges the roof line. Inside, the drawing-room has a pretty ceiling with inset ovals painted with the muses in the style of Angelica Kauffmann. On the slope of the hill, below Holcombe House, is St. Joseph's Missionary College, founded by Cardinal Vaughan and built by Messres. Goldie and Child between 1866 and 1871. Beside the chapel, a campanile rises, some hundred feet high and topped with a huge gilded bronze statue of St. Joseph. Back on the ridge, there is Belmont, now a boys' preparatory school, built in 1765 for Sir Charles Flower. Beside it is the neat little box of St. Paul's church (1829-36), built at the instigation of William Wilberforce, with dramatic glass in the east window painted by Charles Muss, and opposite is Mill Hill School, founded in 1807 for the sons of Nonconformist parents. The main building – 1807 by William Tite, with a good portico – occupies the site of Ridgeway House, the home of the Quaker merchant and botanist, Peter Collinson (1694-1768), who created a garden here from which some trees still remain. Beyond the school, by the village pond, are the modern Angel Cottages, designed by Richard Seifert during the 1960s, which won an award from the Civic Trust. Near them is Rosebank. a seventeenth-century weather-boarded dwelling. once used as a Quaker meeting-house, and at the eastern end of the Ridgeway is Littleberries, now enlarged into the Convent of St. Vincent de Paul, but basically a late seventeenth-century mansion. Beyond it is the copper-roofed mass of the Medical Research Council's Laboratories, a huge, thin rectangle with flattened apsidal ends, designed by Ayrton in 1950, and providing an unmistakable landmark for miles around. The Ridgeway becomes Milespit Hill, and on its slopes are the Nicoll Almshouses, tiny, singlestorey dwellings, founded in 1696, restored at intervals and in use ever since.

Modern Mill Hill is separated from the old village by more than a mile of distance and by the traffic of the M1 and of Hendon Way. Among solid, inter-war suburban development, John Keble Church stands in Dean's Lane. It was designed by D. F. Martin-Smith and was completed in 1936. The square, uncompromising, yellow brick exterior hardly suggests the unusual arrangements within, which were considered revolutionary when the church was built, as was the unconventional dedication. There is no division between nave and chancel and holy communion is celebrated in the midst of the congregation.

EDGWARE lies to the west of the newer part of Mill Hill. The Edgware Road follows the line of the Roman highway, Watling Street, leading to St. Albans, and, where the ground rises sharply for Brockley Hill, there were extensive pottery works in a village called Sulloniacae. Specimens of the buff-coloured earthenware that was made there can be seen in the Musesum of London. William Sharpe, the antiquarian who was secretary to the Duke of Chandos in the early eighteenth century, set up an obelisk as a reminder that the Romans were once there; it is still to be seen from the road, standing in a corner of the grounds of the National Orthopaedic Hospital. Back in the village, the parish church is dedicated to St. Margaret; though the ragstone and rubble

fifteenth-century tower is still intact, the chancel and nave had to be rebuilt in 1845, and the aisles were added in 1928. On the wall of the present chancel is a tiny chrisom brass in memory of Anthony Childe who died in 1599/1600, aged three weeks.

The village is cleft by the Edgware Road, as it always has been. Few lath and plaster cottages remain, though one which serves as a gift shop is in good repair. Formerly the village smith, William Powell, worked here; local tradition, without written evidence, claims him as Handel's Harmonious Blacksmith. The legend tells that the composer, who was staying with the Duke of Chandos at Canons (see p. 264), took shelter in the forge during a storm, and was so delighted with the proprietor's tunefulness that he composed a tribute to the smith.

HENDON lies to the south, its village centre still clearly distinct in spite of much development throughout the present century. The parish church, dedicated to **St. Mary** and perched on the hill-top, is probably of pre-Conquest foundation. The present building dates from the thirteenth century, with a battlemented tower some two hundred years younger. There is a square Norman font, carved with

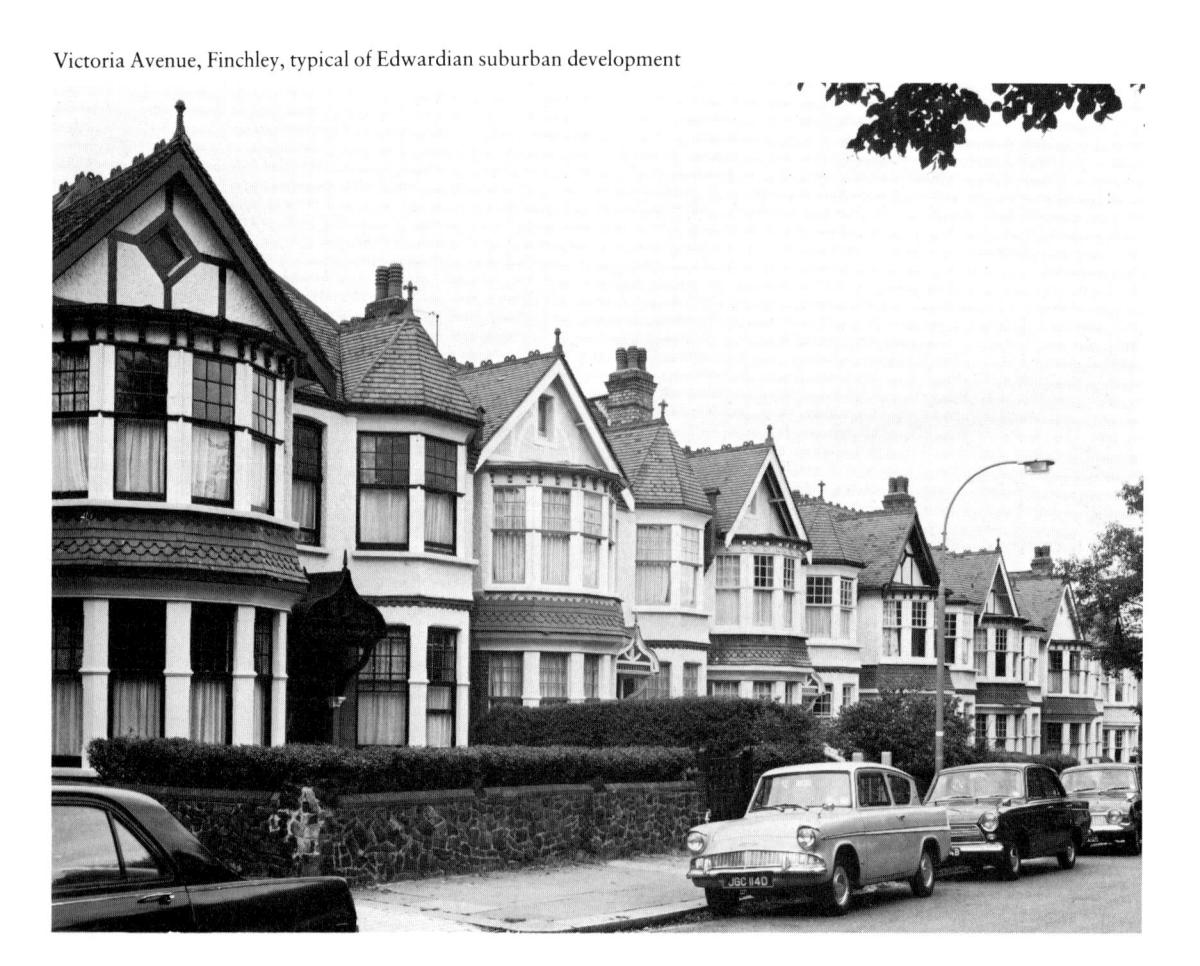

203

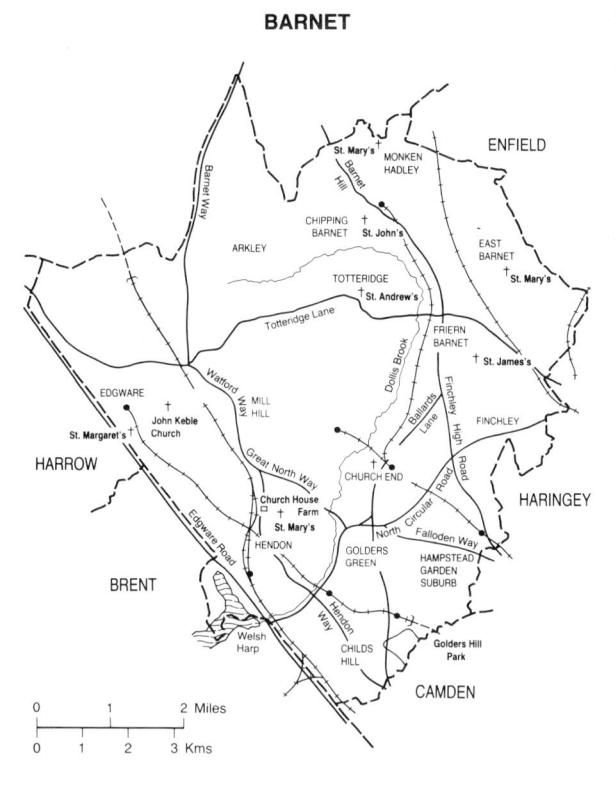

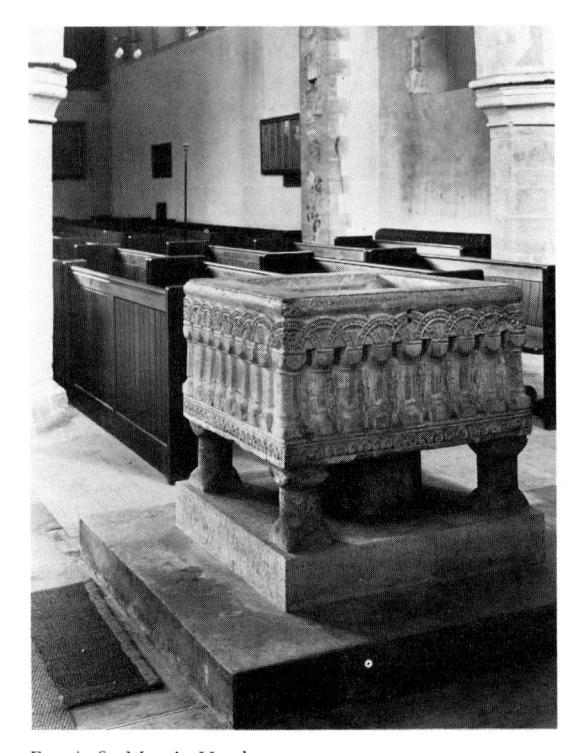

Font in St. Mary's, Hendon

intersecting arcades, one of the finest to be seen in Middlesex. To the thirteenth-century chancel and south arcade and the fifteenth-century north arcade were added a new chancel, nave, and south aisle in 1915. The addition was designed by Temple Moore with exceptionally happy results. There are traces of early wall paintings, and a brass to a child. John Downer, who died in 1515. The tomb-chest of Sir Jeremy Whichcot (d.1677) has superlatively finely cut lettering; there is a life-sized marble effigy of Sir Henry Rawlinson (d.1703), once Commissioner of the Great Seal to Oueen Anne. Cherubs cluster round the memorial to Edmund Fowler (d.1714). Bishop of Gloucester, and there is a small panel by Flaxman to Charles Colmore (d.1795). Sir Stamford Raffles, who persuaded the East India Company to acquire Singapore and who helped to found the Zoological Society of London, is buried near the chancel, and in the churchvard lie Abraham Raimbach, the engraver. Thomas Woolner, the sculptor, his mallet and modelling tools carved on his low tomb, and Emily Patmore, to whom her husband, the poet Coventry Patmore, addressed The Angel in the House.

Church Farm Museum lies a few paces down the hill. A mid-seventeenth-century building, it belonged for almost a whole century till 1780 to a family called Kempe. In 1944 it was purchased by the Borough Council and ten years later was opened as a local museum. The rooms are arranged as they would have been in the eighteenth or early nineteenth centuries; there is a capacious kitchen range with kettles and a mechanical spit, and a fine dining-room table at which to seat family and guests. Upstairs, the rooms have been converted into small galleries for local exhibitions and the house is open daily. The old farmhouse has a rare, intimate, domestic charm, and behind it the fields of Sunny Hill Park are still green and open.

Hendon Aerodrome once occupied the plain below the hill along Watford Way. Opened by Claude Grahame-White as London Aerodrome in 1910, it was from here that the first United Kingdom aerial postal delivery was made in 1911. Until 1939, annual air displays took place here. The airfield has been built over in the last few years, but the RAF Museum, which opened there in 1972, provides a permanent reminder of its former use. One of the original hangars serves as the main hall, and in it one can survey the whole development of aviation. The earliest craft is a monoplane, similar to the one used by Blériot for the first Channel crossing in 1909, and there are aircraft from both the First and Second World Wars. The collection and its display are constantly being expanded and developed. The adjacent Battle of Britain Museum (opened in 1978) holds more aircraft and has displays that seem uncannily evocative to anyone over fifty. On the far side of the former aerodrome is Colindale where the British Library Newspaper Collection provides an endless source of information for historians.

FINCHLEY lies a little to the north-west of Hendon. An area developed on either side of the First World War, the houses – even the small ones – have retained an Edwardian spaciousness. Its parish church, also dedicated to St. Mary, stands in Church End at the top of Gravel Hill. Excavations in 1872 revealed Saxon foundations; some of the stones were hewn in the twelfth century, but most of the old masonry is from the fifteenth century. Two extra south aisles were added in the nineteenth and twentieth centuries. Severely damaged during the Second World War, the church has been restored skilfully. Inside, set into the west wall, is a good brass of a nameless lady wearing a tall headdress; on the north wall is a tiny figure of Joan Prate whose husband Richard died in 1487, though his brass and the figures of their children are missing. There are other small seventeenth-century brasses to members of the Skudemore, Luke, and Whyte families, and a long and unusual inscription in memory of Thomas Sanny, who died in 1509, which contains his will. Alexander Kinge (d.1616) and his wife kneel opposite each other across a prayer-desk on a small, gaily coloured monument.

Opposite the church is a school, Christ's College; the building, designed by Edward Roberts in 1860, has a most distinctive tower with a copper spire. Returning towards London by the Regent's Park Road, we pass, at its junction with the North Circular Road, a statue of a naked woman holding aloft a sword. She is *La Délivrance* by Emile Guillaume, presented to the borough by Lord Rothermere to commemorate the Battle of the Marne. Beyond lies Temple Fortune, its name a reminder that the Knights Templar, whose badge, a lamb bearing a flag, is still a part of Hendon's arms, once held land here, and nearby is Golders Green on the boundary of the borough and its neighbour Camden, with HAMPSTEAD GARDEN SUBURB just to the north.

The Suburb was the most satisfying, both architecturally and socially, of all London's early twentieth-century developments. It was the brainchild of a remarkable woman, Dame Henrietta Barnett, the wife of Canon Samuel Barnett, who was vicar of St. Jude's in Whitechapel and the founder of Toynbee Hall in the East End. The poverty and misery which she had seen there had given her strong views on what a community should be, so, when she heard of the proposed extension of the Northern line underground to Golders Green, she was determined that at least a part of the inevitable housing development should be in accordance with her belief that all classes should live together in surroundings as beautiful and well-planned as possible, in tree-lined streets with woods and open spaces available to all. She formed the Hampstead Garden Trust, raised money, purchased 243 acres of land from Eton College, and appointed her architects, Barry Parker and (Sir) Raymond Unwin; the latter made his home in Hampstead Way at Wyldes, a seventeenth-cen-

Angel Cottages, Mill Hill

Waterlow Court, Hampstead Garden Suburb

tury, weather-boarded former farm house, which had been visited by John Linnell, William Blake, and Charles Dickens at various times. Parker and Unwin had already collaborated in the building of Letchworth Garden City; they now improved upon their earlier work.

The first sod was cut on 2 May 1907 and the foundation stones of two cottages, numbers 140 and 142 in Hampstead Way, were laid on 5 June. The basic plan, with its great variety in type and style of house – sixteenth-century village architecture mingles happily with William and Mary manor houses, both styles well flavoured by the Arts and Crafts movement – and of streets – wandering or straight, with secluded closes, all of them tree-lined – was the work of Parker and Unwin, but the buildings on Central Square, the heart of the Suburb, were entrusted to Sir Edwin Lutyens. There stand the parish church of St. Jude, the Free Church for Nonconformist worshippers, and an Institute for adult educa-

BARNET 205

tion which also accommodates the Henrietta Barnett School for Girls. St. Jude's church is one of Lutvens's most characteristic achievements. Built of brick, its main external feature is the huge, steeply pitched, tiled roof, reminiscent of a great medieval tithe barn. the eaves of which hang so low that they can almost be touched, while the central bell-tower, with its spire like an over-sharpened pencil, points heavenward. The silhouettes of all three buildings in the Square can best be perceived and appreciated from the upper slopes of the Heath Extension, between the Suburb and Hampstead. Inside, the church is both domed and tunnel vaulted, but the curious confusion which this combination creates goes unnoticed since the walls and ceilings are covered with frescoes by Walter P. Starmer, representing scenes from the life of Our Lord, from His parables, and from the Old Testament, while the walls of the Lady Chapel are peopled with a host of famous women of all periods and countries. The Free Church, with a dome instead of a spire, has a more intimate interior, and the fourth side of the Square is left open save for a small memorial, also by Lutvens, to Dame Henrietta, who lived nearby at 1 South Square. The beautifully proportioned Vicarage and Manse, with their hipped roofs, sit companionably beside their respective chur-

The main criticism which can be levelled against the planning of the Suburb is the lifelessness of this central area. All shops have been excluded from it; there is not a single public house in the whole Suburb. The shops are all on the outskirts, in the Market Place along the Lyttleton Road, and at Temple Fortune, and the residents' community centre is at Fellowship House in Willifield Way. Walking through the suburb, it is possible to appreciate both the architectural felicities and the deeper underlying assumptions about what a community should be and how it should live. A good walk could start at the top of Hampstead Way, going along the Heath Extension, passing Waterlow Court by Baillie Scott. There are all sorts of small delights, such as the stucco panels of playful cherubs above the doorways of numbers 87–89 Hampstead Way (by Matthew Dawson), and the pair of dissimilar windows, one round and one lozenge-shaped, above the panels, or the flavour of Charles Rennie Mackintosh's Edinburgh which distinguishes Lawrence Dale's triangular house at the junction of Hampstead Way and Willifield Way, or the plasterwork pitcher which ornaments the front of 46 Hampstead Way, built by T. M. Wilson for himself. The intersection of Hampstead Way and Meadway is marked by four houses. 6-10 Meadway, designed by Baillie Scott, Down the hill in Meadway is a single house with a magnificent Tudor oriel window: this and the distinctive crescent. Meadway Gate, are all by Edwin and James Palser. Beyond Meadway Gate, towards Golders Green, is the North London Crematorium, its main building designed by Sir Ernest George and its grounds and gardens laid out by Gertrude Jekyll: in them stands the Phillipson Mausoleum by Sir Edwin Lutvens, Up the hill, numbers 7-13 Meadway, all with white gables, are by Michael Bunney, who built number 13 for himself. From Meadway, Heathgate, lined with flowering cherry trees, leads up to Central Square. Beyond, on the west side of Erskine Hill, the houses are by Lutyens, who planned each pair to look like a five-bay manor house,1 and nearby, Temple Fortune Hill, with groups of cottages on either side, reioins Hampstead Way, which leads round to the shops of Temple Fortune, set in groups with steeply pitched, almost medieval roofs designed by Arthur Penty, serving as guardians at the entrance to the Suburb. Besides the architects already mentioned, Courtenay Crickner, G. L. Sutcliffe, Geoffrey Lucas, Herbert Welch, and J. C. S. Soutar built houses here, and, until the First World War, the sympathy between members of the team was so close that observers were reminded of the unity of the medieval guild. Later developments, though less inspired, were still good, and the Hampstead Garden Suburb has become an internationally known example of humane urban development.

¹ He went out to build New Delhi before the work on Erskine Hill was completed; his colleague, G. L. Sutcliffe, did the eastern side.

The borough of Brent lies to the north-west of London and is composed of the former boroughs of Willesden and Wembley. The river Brent, flowing from the north-east towards the south, which was once the dividing line between the two, now gives a name to the united boroughs. Its northern course has been dammed to form the Welsh Harp Reservoir. Willesden and the other former village centres of Neasden, Harlesden, and Kilburn, which surround it, are all low-lying but there is high ground to the north around Kingsbury at Barn Hill, Sudbury Hill, and Preston Hill. Brent covers nearly 11.000 acres and has a population of about 250,000. Closely built-up, save on the higher ground, there is a good deal of industry and a wealth of small, late nineteenthcentury domestic architecture.

WILLESDEN remained a rural area until the third quarter of the last century. A railway station opened near Harlesden in 1842 but Willesden Junction with its tangle of railway lines did not come into being till 1866, and it was not till the Metropolitan Railway came to Willesden Green in 1880 that the population began to increase rapidly. Row upon row of small houses were built, their bay windows embowered with acanthus leaf mouldings, the even line of their slate-clad roofs punctuated by the spires and bell turrets of the churches and Nonconformist chapels which ministered to the spiritual needs of their occupants. The places of worship are too numerous even to be listed, but there are four buildings which should be described, for Willesden can boast two important churches, one medieval and one magnificently Victorian, an early eighteenth-century stable-block now turned into a museum, and an 1820s country retreat, the grounds of which now form a public park.

The parish church, dedicated to St. Mary, stands at the corner of Neasden Lane and Willesden High Road. It is of ragstone rubble and flint, with a nave, chancel, and south aisle and a low tower at the south-west corner with a sundial of 1732 set on it. The south aisle seems to have undergone very little restoration since it was built in the thirteenth

century; the chancel was restored and the tower added about 1400. The heavy south door is particularly impressive, and it is worth studying the contrast between the pillars of the south aisle and those under the tower; they sum up the differences between the architecture of the thirteenth and fourteenth centuries. The font is Norman, a tall, square bowl on a stalwart central shaft which is set about with four more delicate subsidiary shafts. The communion table is Elizabethan, with comfortable bulbous legs, and set in the nave floor is a long slab of marble which may well have been the medieval altar. Six brasses remain from those early days; they are for Dr. William Lichfield (d.1517) who wears cassock, surplice, and cope, Margaret Roberts (c.1504) with a neat kennel head-dress, Bartholomew Willesden and his wife Margaret (d.1492), Jane Barne and her daughter (d.1609), both of whom have elaborately quilted petticoats, an unknown lady with her six children (c.1550), and Edmund Roberts with his two wives, Frances and Faith, and their nine children. Edmund has an approving epitaph in two verses which ends:

> So like a lambe he went away And left good land unto his son Who long may live the poore do pray Good house to keep as he hath don.

In the churchyard outside lies Charles Reade the novelist, who is best known for *The Cloister and the Hearth*, and near him lies his friend, Laura Seymour, whose epitaph reads: 'Her face was sunshine, her voice was melody, and her heart was sympathy.'

St. Augustine's, Kilburn, which stands in Oxford Road just off the Edgware Road, was one of the triumphs of the Catholic Revival in the Church of England. Designed by John Loughborough Pearson, it was consecrated in 1880, though the tower and spire, which rise to 254 feet, were not completed for another 18 years. Built of russet-coloured bricks, it is cruciform in shape, and is modelled on the churches of thirteenth-century England. The nave is seven bays long and the chancel three, their width being 28 feet, but the brick vaulting soars 55 feet above the floor,

¹ The church itself stands in Westminster, but it has always been known as St. Augustine's, Kilburn, and the parish lies mostly within the boundaries of Brent.

Wembley Stadium, Wembley

so that the spectator feels as if he were in a deep, narrow defile. This emphasis on the vertical is, as it were, pegged down by the galleries running all round the church above the shallow aisles, which continue behind the altar to form an ambulatory. The galleries help to carry the buttresses needed to support the rib-vaulting; these buttresses, inspired by the Cathedral at Albi in southern France, are pierced by tunnel-like openings through which one may creep. The windows are tall lancets, save for a rose window at the west end; they are filled with glass by Clayton and Bell. The galleries act as bridges over the transepts; in the southern arm is a chapel dedicated to St. Michael, in the northern a Lady Chapel. The chancel is separated from the nave by a rood screen and there is an elaborate reredos behind the altar. 1 Unfortunately but unavoidably, the church is often kept locked, but the dramatic effect of the interior makes it worth while asking for the key.2

The Grange, an early eighteenth-century stableblock with Gothick window mouldings inserted about 1807, was opened by the borough council as a local museum in 1977. It stands in the middle of a roundabout at the junction of Neasden, Dudden Hill, and Dollis Hill Lanes, and can be reached by a footbridge. The miscellaneous collection of a Wembley antiquarian, G. T. Barham, provided a nucleus and to it have been added local artefacts and documentary material, as well as a fine collection of topographical prints, sketches, drawings, maps, and photographs. Many of the works were by local amateur painters; the majority of the donors have been local too. Nearby is Gladstone Park (easiest access by Dollis Hill Lane) in which stands Dollis Hill House, once the home of Lord and Lady Aberdeen, with whom Gladstone often stayed. The attractive grounds give views across to Harrow and there is a formal walled garden. In the Park stands a group of statues by Fred Kormis; unveiled in 1968, they form a memorial to those who suffered in German prisoner-of-war camps.

WEMBLEY, which was an agricultural area till the early 1920s, is chiefly remarkable for its **Stadium**. This was designed by J. M. Simpson and was built in 1923 as part of the accommodation needed for the

¹ Two other nearby churches, St. Gabriel Archangel in Chichele Road (1897–1902 by Philip Day though the saddlebacked tower was by the Rev. C. F. G. Turner) and St. Andrew's, in Willesden High Road (1886–7 by James Brooks) have spectacular Flemishstyle high altars.

² Viscount Rothermere gave the church four paintings, by Filippino Lippi, Crivelli, Palmezzano, and Titian. After one had been stolen the rest were sold to forestall further thefts.

British Empire Exhibition, held in 1924–5 and still remembered. The Cup Final is played there each year and for a few hours Wembley is the most important spot in London. Near to the Stadium is the Empire Pool, designed in 1934 by Sir Owen Williams. The vast roof with its span of 240 feet is supported outside by extraordinary hanging buttresses of concrete. In addition to these twentieth-century buildings, the Underground stations at Alperton and Sudbury, both designed by Charles Holden in the 1930s, are worth noticing. Wembley Town Hall (now Brent Town Hall) stands in Forty Lane. Dignified, sensible as well as sensitive, it was designed by Clifford Strange in 1935–40.

Since Wembley belonged for centuries to the parish of Harrow, it only gained its own parish church in 1846 when Sir George Gilbert Scott built a small, rustic place of worship in the High Road, but near its northern extremity, in Kingsbury, stand three churches which are all of interest. There are two parish churches, old and new, both dedicated to St. Andrew, which stand at the far end of Church Lane. The old church is very small; despite three Victorian restorations which destroyed the rood screen and the south porch, its walls are of thirteenth-century Norman work and it has been claimed, though not proved, that they incorporate Saxon materials, while

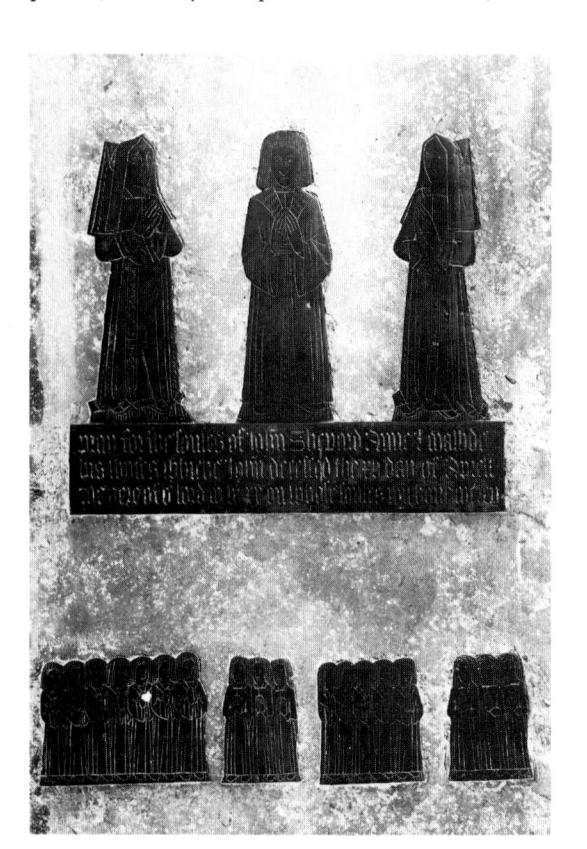

John Shepard's memorial in old St. Andrew's Kingsbury

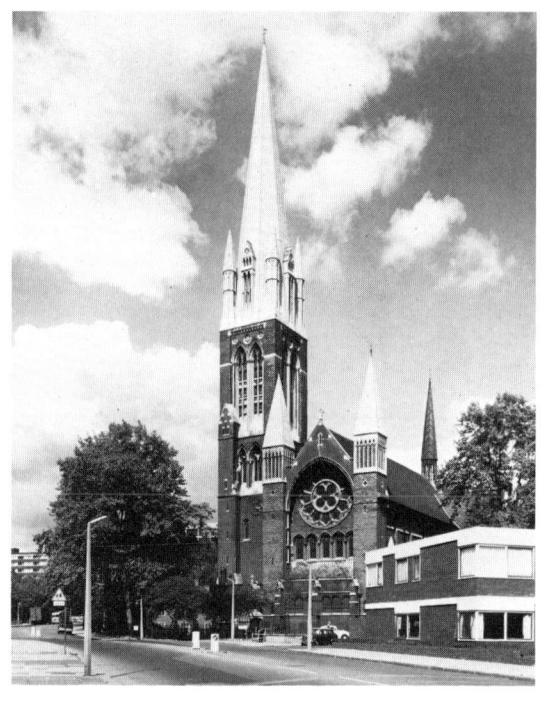

St. Augustine's, Kilburn

there are morsels of Roman hypocaust flues in the chancel walls. One of the western corners rests on a sarsen stone brought southwards by the glaciers and another on a fragment of a thirteenth-century coffin lid. Inside, the church has chancel and nave but no aisles; the trussed-rafter roof is probably fifteenthcentury. There is a thirteenth-century font, an excellent brass to John Shepard (d.1530) and his two wives, Anne and Mawde, who between them bore him 18 children, an inscription to Thomas Scudamore, who served Oueen Elizabeth and James I for 47 years, and a floor slab to John Bul who died in 1621 and was keeper of the King's falcons. There is a fine black oak lectern carved in the shape of an angel with supporting wings, which came from a destroyed City church, and the Lord's Prayer, Creed and Ten Commandments are incised on stone tablets, instead of being painted as is more often the case. Scratch dials can just be seen on the arch of the south door and on the low window beside it. In the bell-turret, rebuilt in 1870, hang three bells, the earliest cast about 1550 by Peter of Weston, the later ones by James Butler in 1604 and Samuel Newton in 1708.

Interesting as the little church is, the newer St. Andrew's is equally worthy of exploration. It was originally built, by Dawkes and Hamilton, in Wells Street, St. Marylebone, in 1847, and was moved to Kingsbury, stone by stone, between 1931 and 1934. A confident re-creation of the Perpendicular style, it is a monument to early Victorian Anglo-Catholicism. The tower and spire rise from the north-west

BRENT 209

corner, and inside is a nave, five bays long, with chancel and north and south aisles. The decorations and fittings of the interior are arresting. A painted effigy of the first vicar, James Murray (d.1862), lies in a niche in the wall; alert dogs, seated on either side of the arch, guard the dead man. The work, by William Burges, is conscientiously and successfully medieval, reminiscent of Rahere's tomb in St. Bartholomew the Great. Murray's successor, Benjamin Webb, was the editor of The Ecclesiologist and he summoned several of the leading artists and architects of the Anglo-Catholic movement to adorn the interior. Chief of them was George E. Street, who designed the remarkable metal chancel screen and pulpit and the magnificent reredos of alabaster and Caen stone, which was carved by James Redfern. Street also designed the font, Pearson the font cover, Butterfield the lectern, and Burges was probably responsible for the litany desk. The original east window, designed by Pugin for the first vicar, was shattered by a flying bomb; the modern replacement is by Goddard and Gibbs. The wooden gallery, which runs across the west end, was painted by Alfred Bell, and there are two Victorian brasses, to Vicesimus Knox (d.1855) and Frederick Nicholl (1814–1893) who is depicted bewhiskered as he lived.

The third church, dedicated to Holy Innocents, was built in 1883–4 by William Butterfield on the Kingsbury Road. It is a small building, constructed from bricks with Butterfield's characteristic patternings and a quaint polygonal west turret. Very properly for such a dedication, particular emphasis is laid on the baptistery, which stands at the west end, separated from the main building, in an attractive and ingeniously designed cloister.

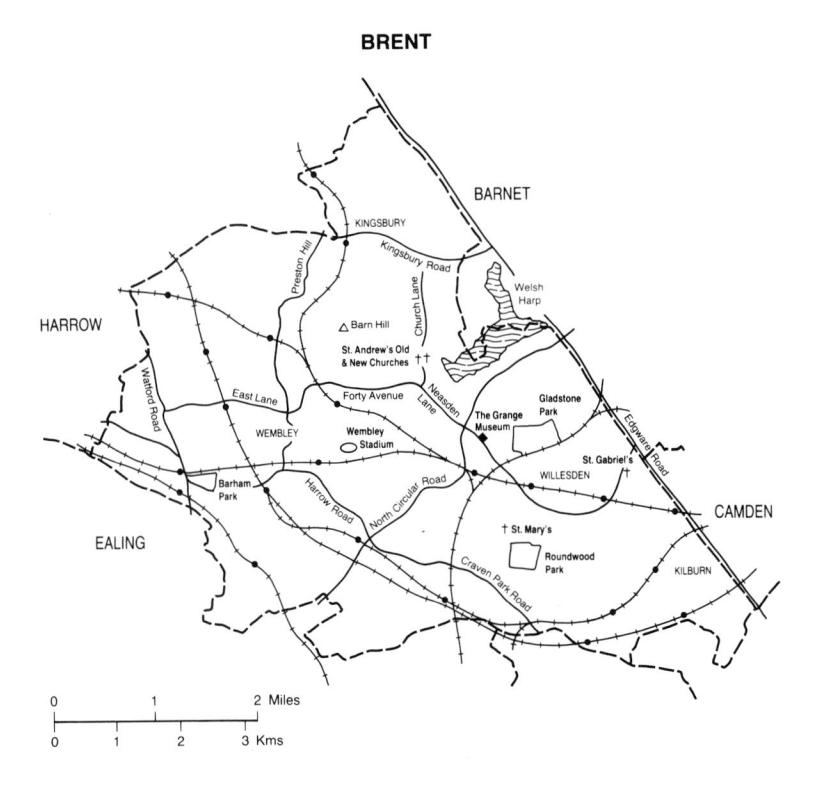

Camden

Camden lies to the north-west of London and is composed of the former boroughs of Holborn, Hampstead, and St. Pancras, its modern name being derived from the title of Charles Pratt, Marguess of Camden (1719-94), whose family estates occupied the heart of the area. Eightand-a-half square miles housed, in 1981, a population of 172,000. Within Camden's boundaries contrasts, both geographical and architectural, are to be found. Once Covent Garden was laid out (see p. 130), the urbanization of Holborn was inevitable; the level plain, on which those three temples to industrialization, the stations of Euston, St. Pancras, and King's Cross, were built, rises sharply to the heights of Hampstead and Highgate; the orderly squares of Bloomsbury, around which cluster a fair proportion of the capital's museums as well as much of the University of London, give way northwards to the windswept spaces of Hampstead Heath, and the Inns of Court in Holborn contrast with the close-packed railway property of Camden and Kentish Towns.

HOLBORN

Throughout the Middle Ages, much of HOLBORN was Church land. At the Reformation, the manor of Bloomsbury, which derives its name from the Blemund family who held lands there in the fourteenth century, was granted to Thomas Wriothesley, Lord Chancellor and later Earl of Southampton. By 1640 the fourth earl wished to build for himself a mansion where Bedford Place runs today, but he was unable to carry out his plans till the later years of the Commonwealth. A private gentleman, William Newton, was more successful, for in 1638 he had obtained permission to build thirty-two houses around Lincoln's Inn Fields, although the members of the Inn protested at the development. One of the original houses survives, now divided into numbers 59-60, possibly designed by Inigo Jones. The house beside it, now numbers 57-58, is, as it were, an architectural grandchild; built by Henry Joynes in 1730, its features dutifully resemble those of the building by the greater architect. On the north-west corner stands Newcastle House, almost entirely rebuilt by Lutyens, but still retaining the appearance of the dwelling begun there in 1685 by Captain Winde, which Wren may have been responsible for finishing ten years later.

By 1660, the Earl of Southampton had built his mansion and had laid out before it, as John Evelyn noted, 'a noble square or Piazza, a little Towne'. None of the original houses survives in Bloomsbury Square, but it is worth remembering that building leases were employed for the first time in its development. When he died in 1667, the estate passed to his daughter, Lady Rachel, who married Lord William Russell, second son of the Earl of Bedford, and Southampton House became known as Bedford House. Beside it, Montague House was built as a residence for Lady Rachel's younger sister, Lady Elizabeth, who married Ralph Montague. Since one development encourages another, and since the Great Fire left Londoners in desperate need of housing, further building in Holborn was inevitable. In 1684, Dr. Nicholas Barbon began to build Red Lion Square, although the members of Grav's Inn literally fought with his workmen to try to prevent it, and in 1693 Sir Thomas Neale, the Master of the Mint, laid out a strange knot of streets known as Seven Dials, for they radiate like a star from a central point where Neale set up a column with a sundial (see p. 134).

While these developments were still only projected, Lincoln's Inn Fields, where in 1586 Anthony Babington and his fellow conspirators had suffered for their plot against the life of Queen Elizabeth, was also the place of execution for Lord William Russell, who was found guilty of complicity in the Rye House Plot against the life of Charles II. He was probably guiltless but on 21 July 1683, his head was struck off, almost within sight of his own house, and his body was carried into Lindsey House to be placed in its coffin. On the accession of William and Mary, his innocence was proclaimed and his father was created a duke. Two generations passed before Lord William's grandson began to develop the Bloomsbury estate. In 1776, Bedford Square was laid out by the builders, William Scott and Robert Crewe; the designer was possibly Thomas Leverton, who completed number 13 for himself and lived there until his death in 1824. The square remains virtually intact, each of its sides treated as a unit with houses three bays wide, the centres emphasized by setting pediments above the middle three, five, or six bays, which are divided from each other by Corinthian pilasters while the façades are faced with stucco. Bearded keystones and blocks of rusticated Coade stone, alternating with brickwork, accent the entrances - an early example of this characteristic London ornamentation - and above the doorways are a variety of graceful fanlights. The Hon. Henry Cavendish, the natural philosopher, lived at number 11, on the corner with Montague Place. Russell Square - its large central garden landscaped by Repton - Tavistock, Torrinton, Woburn, and Gordon Squares soon followed, and other, lesser, landowners and speculators laid out land around the perimeter of the Bedford Estate. A number of attractive houses still stand in and around Great Ormond Street, in which numbers 40 and 41 have doorways worth particular attention.

Meanwhile, Sir Hans Sloane, the physician, who lived at numbers 3 and 4 Bloomsbury Place, had died in 1753, leaving his remarkable collection to the nation, and Montague House was purchased to accommodate the specimens. The British Museum opened there in January 1759 and its presence attracted other learned institutions, and the scholars likely to frequent them, to the area. The foundation stone of University College was laid in Gower Street in 1827, and Bedford College for Women opened at

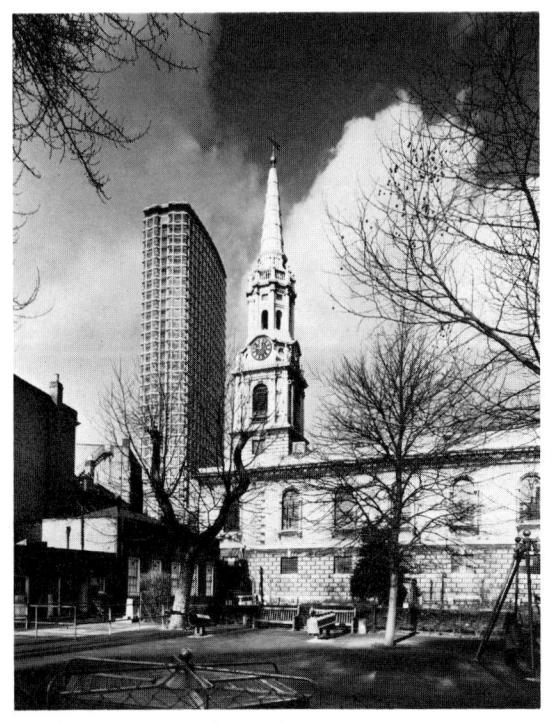

St. Giles-in-the-Fields, flanked by Centre Point

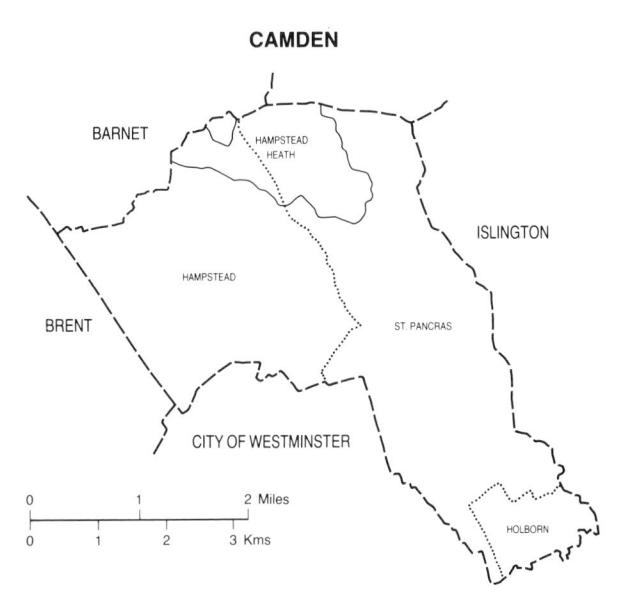

47 Bedford Square in 1849. William Morris and Edward Burne-Jones lived at 17 Red Lion Square from 1856 till 1859, and in 1904 Vanessa, Thoby, Virginia, and Adrian Stephen, the brothers and sisters who were the core of that band of intellectuals, artists, and writers which became known as the Bloomsbury Group, moved to 46 Gordon Square. In 1927, with the aid of a generous gift from the Rockefeller Foundation, the University of London bought land from the Duke of Bedford along Malet Street and there erected its administrative centre, the Senate House. Around this, other academic institutions have clustered, but the buildings provided for them in recent years have been poor replacements for the eighteenth-century squares they have eroded.

A perambulation of the borough may begin in the south-west corner, where the church of St. Andrew stands beside Holborn Viaduct¹. Probably of pre-Conquest foundation, the medieval church escaped the fire of 1666 but, being dilapidated, was rebuilt by Wren between 1684 and 1690. He retained the fifteenth-century tower, which was refaced with stone in 1703, a top stage and pinnacles being added. During the Second World War, St. Andrew's was severely bombed but was restored by Seely and Paget, the rededication taking place in 1960. This was Wren's largest parish church; seven bays long, with nave and aisles, it is today a guild church (see p. 26) and is often used for exhibitions. The original furnishings were destroyed, but an east window is now filled with glass by Brian Thomas, and the font (1804), pulpit (1752), and organ from the Foundling

¹ Properly speaking, St. Andrew's lies within the City, but its description fits best here, with the rest of Holborn.

Hospital (see p. 220) have come here. This is as it should be, for under the tower, in a small chapel, is the tomb of Captain Thomas Coram, the founder of the Hospital. A marble cherub weeps for the man who befriended so many children. The organ is of particular importance, for it was given to the Hospital by Handel in 1750. Figures of two Charity School children stand above the entrance.

In the churchyard, now laid out as a paved garden, is a stone slab carved with scores of tiny figures scrambling from their tombs for the Last Judgement; it came from the burying ground of the workhouse in Shoe Lane where Chatterton was interred after his suicide. Benjamin Disraeli was baptized in this church. Here Lucy Apsley, whose *Memoirs* tell us so much about the Civil War, was married to John Hutchinson in 1638, and Hazlitt wedded Sarah Stoddart with Charles and Mary Lamb as best man and bridesmaid.

Opposite the church, in the middle of Holborn Circus, stands a spritely bronze equestrian statue, set high on a pedestal, of the Prince Consort; he courteously doffs a cocked hat, as if saluting the City. The figure is the work of Charles Bacon, son of the better

known John Bacon.

On the far side of the Circus is Elv Place, its tall houses, built for the most part about 1770, shut off from the main thoroughfare by iron gates. This was the site of the Bishop of Ely's London residence, where John of Gaunt took refuge after his town house at the Savoy had been sacked by Wat Tyler's rebels, and where he died in 1399. The mansion and its gatehouse, which Queen Elizabeth bestowed on Sir Christopher Hatton (hence Hatton Garden nearby), have vanished, but its chapel, completed about 1300 with an undercroft which is about half a century older still, remains and is today St. Etheldreda's church. In 1874, when almost derelict, it was purchased by the Fathers of Charity and so became the first pre-Reformation church to be used again for Roman Catholic services. It is remarkable for the exceptional size and the elaborate tracery of its east and west windows, now filled with brilliant modern glass by Joseph Nuttgens and Charles Blakeman, depicting those who suffered for their faith at Tyburn. In spite of heavy bomb damage, the fine chestnut roof has been made good again; further restoration is planned for the crypt area.

Westwards along High Holborn is the astonishing rubicund façade of the Prudential Insurance building (1890–1906) by Alfred Waterhouse, towering up like a cathedral raised to commerce. It is confronted by an equally astonishing survival, the street façade of **Staple Inn**. Originally a meeting-place for merchants dealing in England's staple export, wool, by the fifteenth century it had become an Inn of Court. A Hall with a hammerbeam roof was built in 1580–1 and the long gabled façade to Holborn was added a few years later. Today, it is the most impressive example of half-timbered work left in London. Over

the years, others besides lawyers came to live there, among them Dr. Johnson, who had rooms in the Inn while he was writing *Rasselas* in 1759, working at great speed in order to raise the money to pay his mother's funeral expenses. In 1886 the buildings were taken over and restored by the Institute of Actuaries, and a further restoration, which almost amounted to a rebuilding, had to be carried out in 1952 after a flying bomb had fallen in the garden behind the hall in 1944. The architect was Sir Edward Maufe. The Holborn buildings, with their oriel windows and overhanging upper storeys, still stand firm.

A short detour northwards, up the Grav's Inn Road, leads to Gray's Inn itself, one of the four Inns of Court, the others being Lincoln's Inn, and the Inner and Middle Temples, which have the exclusive right to call trained men and women to the English bar. The Inns grew up during the thirteenth century and their members are known as benchers, barristers. or students, according to their degree of seniority and learning. An essential condition of being a member of an Inn is to keep 'terms' or 'commons', that is, to dine a certain number of times in hall with the other members. Each Inn has, therefore, a Great Hall, as well as a Chapel (the Temple Church serves the Inner and Middle Temples) and a Library. It is usually possible for the public to enter the precincts but for admission to the Halls, it is advisable to make application in writing or to ask at the Porter's Lodge. Gray's Inn was established during the fourteenth century in the Manor of Portpoole which had formerly been the house of the de Grey (sic) family. Three generations of the family had been celebrated as lawyers since Walter de Grey had been Chancellor to King John at the beginning of the thirteenth century. The Hall was built between 1556 and 1560 with fine panelling and a remarkable screen, and it was here that Shakespeare's Comedy of Errors was performed for the first time in 1594. The Hall,

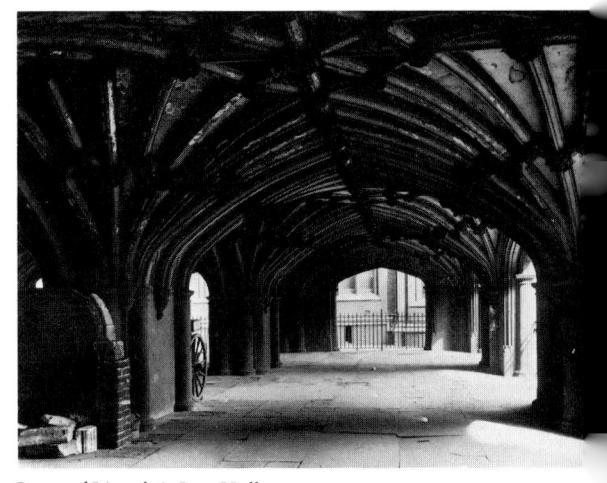

Crypt of Lincoln's Inn, Holborn

CAMDEN 213

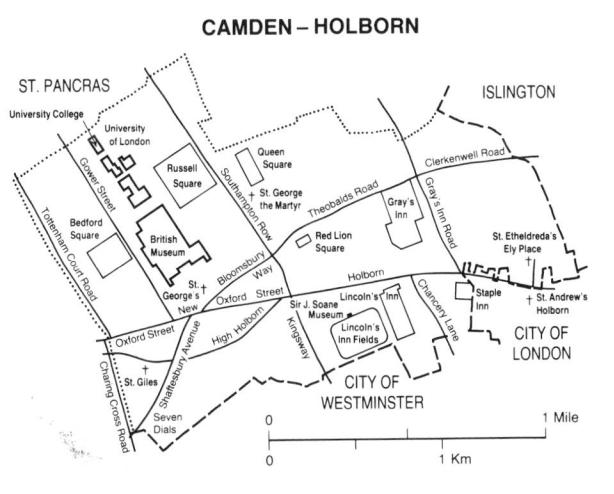

Chapel, and Library were severely bombed in 1941 and 30,000 books were lost. All three have been rebuilt and in the Great Hall the hammerbeam roof with its fine central lantern has been restored, while the screen was saved and has been reinstated. Of oak, constructed in five bays separated from each other by Ionic columns, each bay has an arch, two of them serving as entrance to and exit from the kitchens, which originally lay behind the screen, its purpose being to separate the company from the bustle of food preparation. A screen such as this, or the even more magnificent example in the Middle Temple Hall (see p. 31), is of great importance in the history of English architecture for, in the classical capitals and in the strapwork which ornaments the doors, it shows that new style, from Italy and from France, being applied to a customary piece of furnishing. The Hall and other buildings are set in extensive gardens, said to have been laid out by Sir Francis Bacon who, with Lord Cecil, Sir Francis Walsingham, and Sir Philip Sidney, was a member of the Inn. His statue stands in South Square and the gardens are open to the public on weekdays in August and September.

Returning to High Holborn, another detour southwards runs along Chancery Lane, passing the Patent Office (now part of the scientific division of the British Library), with its wonderful library of scientific and technical literature, and the London Silver Vaults, where cutlery and silverware are displayed and sold, until the Public Record Office is reached. It was established in 1838 by an Act of Parliament which sought to gather together, in one safe and convenient place, all the official records of England since the Norman Conquest. A building was designed by Sir James Pennethorne and was completed in 1856; other buildings have subsequently been added and a supplementary Record Office and Read-

ing Room have been constructed at Kew in order to relieve the overcrowding of the Chancery Lane building (see p. 405). A small museum stands on the site of the Rolls Chapel, founded in 1232, one arch of which was incorporated into the later building. In it are displayed Domesday Book, Magna Carta, and royal signatures from that of the Black Prince (1370) to that of our present Queen. The displays are changed from time to time but Shakespeare's will. the anonymous letter warning Lord Mounteagle of the Gunpowder Plot, communiqués of Marlborough's battles, Wellington's despatch after Waterloo, and a letter from George Washington to George III addressing the monarch as his 'great and good friend', are usually to be seen, besides a wealth of literary and political autographs. A monument to Dr. Yonge (d.1516) used to stand in the Rolls Chapel. A recumbent terracotta effigy of the doctor lies on a limestone sarcophagus under a limestone arch. It is an extraordinary work to be found at such an early date in England and may even be by Torrigiani who was over here at the time. From the lunette, Christ's face, a cherub on either side of Him, looks down tenderly on the dead man, whose serene visage confirms his religious faith. Two other monuments, to Richard Alington (d.1561) and to Lord Bruce of Kinloss (d.1611) are also in the museum.

On the west side of Chancery Lane are the precincts of Lincoln's Inn, which was in existence by 1292 and takes its name either from the title of Henry Lacy, Earl of Lincoln (d.1311) or from Thomas de Lincoln, King's Sergeant in the early fourteenth century. The lawyers first occupied property on the east side of Chancery Lane but moved to the present site early in the fifteenth century. The gatehouse on Chancery Lane was built in 1518, possibly by Sir Thomas Lovell, whose arms are displayed above the entrance in company with those of Henry VIII and the Earl of Lincoln. The Hall was built between 1490 and 1520. It has a fine early seventeenth-century screen and houses Hogarth's huge historical painting, Paul before Felix, of which Leigh Hunt wrote: 'It seems hard upon a great man to exhibit a specimen of what he could not do.' This Hall was used by the Court of Chancery from 1737 and is therefore the one referred to so often by Dickens in Bleak House. The Chapel was built 1620–3 and has been ascribed to Inigo Jones, though John Clarke is more likely to have been responsible. It has an open undercroft in which students still 'walk and talk and confer for their learnings'. Above, in the chapel itself, there is a fine tunnel vault painted a rich deep red, windows with Perpendicular tracery, and an elaborately carved early eighteenth-century hexagonal pulpit. In the south window is glass by Bernard van Linge. The buildings in New Square were added about 1690 by Henry Serle, the Stone Buildings 1774-80 by Sir Robert Taylor, and the New Hall and Library in 1843 by Philip Hardwick and P. C. Hardwick. In the Hall is a large mural by

¹ In fact, half the building is in Westminster and half in the City, but its description fits best with the rest of Chancery Lane and so is given here.

G. F. Watts entitled *Justice – a Hemicycle of Law-givers*, executed between 1853 and 1859 and representing 33 of the great lawgivers, including Ina of Wessex and Alfred the Great – Holman Hunt sat as the model for Ina. The Library, founded in 1497, is the oldest in London and contains a remarkable collection of some 70,000 books concerned with law. It is closed to the public. Sir Thomas More and John Donne were members of the Inn, and so were seven prime ministers, Walpole, the younger Pitt, Addington, Spencer Perceval, Canning, Melbourne, and Asquith. This was the only Inn to escape severe damage during the Second World War.

To the west of the Inn lie Lincoln's Inn Fields (see p. 210). On the south side of the square (and actually in Westminster) is the hall of the Royal College of Surgeons, which was founded in 1745 when the Company of Surgeons was separated from that of the Barbers, with whom they had been joined since 1540. The present building was erected in 1835–7 by Sir Charles Barry; it sustained serious bomb damage and has been partially reconstructed inside, though Barry's façade has been retained. It houses the Hunterian Museum, the anatomical and physiological collections of Dr. John Hunter (1728–93), which may be visited by doctors and other suitably qualified persons. The College also possesses Holbein's cartoon or huge preliminary drawing for his painting of Henry VIII granting a charter to the Company of Barber-Surgeons in 1540; the completed panel is in the Company's hall on London Wall; the cartoon may be seen provided application is made in advance in writing. On the north side of the Fields is the Sir John Soane Museum, perhaps the most extraordinary museum in London. In 1792, Sir John Soane purchased 12 Lincoln's Inn Fields. He lived there till his death in 1837, acquiring, over the years, numbers 13 and 14, and converting the three into a single dwelling, which both exemplified his unique and very personal style of architecture and housed his collection of paintings and antiquities. Time has dealt harshly with his works; his most important London buildings - the Law Courts in Westminster, the Scale Regia and the Library in the old House of Lords, the Bank of England, the Privy Council Rooms in Whitehall - have all been demolished, burnt down, or altered by other, lesser men. But his own house remains, its rooms ingenious, picturesque, always unexpected and utterly personal, willed on his death to the nation and preserved undisturbed, as he left it. His most characteristic device was a shallow ceiling dome, as in the breakfast-room, sprung from piers detached from the main walls which had windows high up to serve as a clerestory. The dining-room looks out on to the Monument Court, an inner courtvard, and the two areas are so related that they seem to be one. Soane collected everything - paintings, drawings, books, sculpture, porcelain, and antiquities of every description and period. Among the latter, the most impressive single item is the alabaster sarcophagus of Seti I, discovered in the Valley of the Kings in Egypt in 1813, which was rejected by the British Museum and was acquired by Soane for £2,000. He had so many paintings that he had to devise ingenious shutters, which fold back into the wall, in order to hang them all. Among them are two series by Hogarth, eight paintings of *The Rake's Progress* and four of *The Election*.

High Holborn continues westwards and becomes New Oxford Street. Close to it lie two important churches, St. George's Bloomsbury and St. Giles-inthe-Fields. St. Giles's church stands beside the High Street, just off the Circus, both of which have taken its name. It was founded at the very beginning of the twelfth century, when Matilda, Henry I's sensible and practical wife, established a leper hospital in the open fields to the north-west of London, which she dedicated to Giles, the patron saint of those unfortunates. The hospital chapel also served as the parish church and continued to do so after the Reformation. It was rebuilt in 1630, in part through the generosity of Alicia, Duchess Dudley, daughter-in-law of Robert Dudley, Earl of Leicester, whom Charles I created a duchess in her own right as a tribute to her good works. It was in the parish of St. Giles that the terrible 1665 outbreak of plague began; the rector, Henry Morse, laboured throughout that dreadful time to cheer and support his parishioners.

In 1731 it was found necessary to rebuild the church again and this time the architect was Henry Flitcroft. As his model he took Gibbs's recently completed St. Martin-in-the-Fields, but he failed to emulate his prototype's graciousness. He omitted Gibbs's portico, though he retained the pediment and under it boldly inscribed his own name: H. Flitcroft Architect. The steeple he followed closely, with coupled columns at the bell stage, though he introduced some nice detail of his own around the clock faces. Above is an octagonal lantern surmounted by a

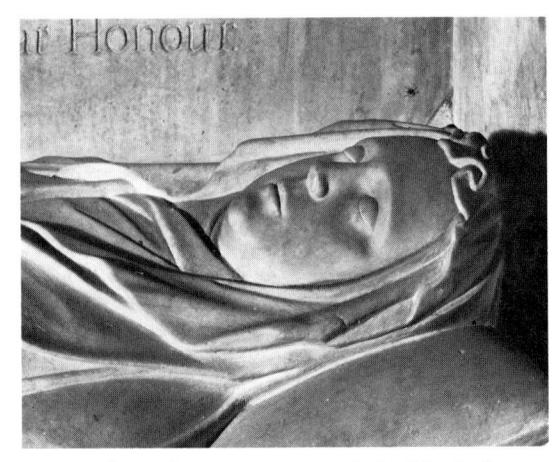

Memorial to Lady Frances Kniveton in St. Giles-in-the-Fields, Holborn
CAMDEN 215

thin spire, girdled at intervals with curiously plump bands of stone. Inside there is a nave with aisles and. above, a barrel vault richly decorated with plasterwork: the interior was redecorated in 1952-3 in Tuscan red, French grey, pale blue, and gold with sumptuous results. Four antique chandeliers, the earliest of them wrought about 1680, were then installed. The pulpit comes from the seventeenthcentury church, having been set up in 1676, and the font was designed in 1810 by Sir John Soane and is prettily ornamented with honevsuckle and a Greek key pattern. The white pulpit in the north aisle is that used regularly for 50 years by Wesley when he preached in West Street chapel in the parish. The old church boasted a Father Schmidt organ made in 1671, and though the instrument has had to be rebuilt several times since then, the diapasons are still in use. On either side of the altar hang paintings of Moses and Aaron by Francisco Vieira the younger, Court Painter to the King of Portugal, who visited England in 1798-1800. In the Gallery are the Royal Arms of George I, and the church also possesses a peal of eight bells, two of them dating from 1635 and two others from 1685, which are rung regularly.

There are several interesting funeral monuments. among them one to George Chapman, whose translation of Homer inspired Keats's sonnet; the monument, which is said to have been designed by Inigo Iones, is shaped like a Roman altar. Joshua Marshall carved a recumbent, shrouded effigy for Lady Frances Kniveton, Duchess Dudley's daughter, some time before 1645, and Andrew Marvell, the poet, and Richard Penderell, who aided Charles II's escape from the Parliamentarian forces after the battle of Worcester, are buried here. Byron's daughter, Allegra, and Shelley's children, William and Clara, were baptized here, as was John Flaxman the sculptor. In 1930 the Royal Academy set up a memorial to him, a cast of his own monument to Baring in Micheldever church in Surrey. Wenceslas Hollar was married here, and so were Caius Gabriel Cibber and David Garrick, Sir Roger L'Estrange has a well-cut tablet and there is a small memorial to Luke Hansard, printer to the House of Commons. George Calvert, first Lord Baltimore, whose son landed in Chesapeake Bay in June 1632 and became first Proprietory of Maryland, is buried here. Near the church door is Flitcroft's original wooden model for it, and set in the tympanum of an entrance arch on the west side of the churchvard is a detailed and alarming Resurrection of the Dead, carved about 1687. The tower block, Centre Point (R. Seifert and Partners, 1963-7, 35 storeys and 365 feet high) dwarfs and, from some aspects, masks the steeple of St. Giles.

Northwards, at the corner of New Oxford Street and Bloomsbury Way, is the church of St. George's, Bloomsbury. This daughter church of St. Giles was built between 1724 and 1731 to designs by Nicholas Hawksmoor. It was one of the 12 churches

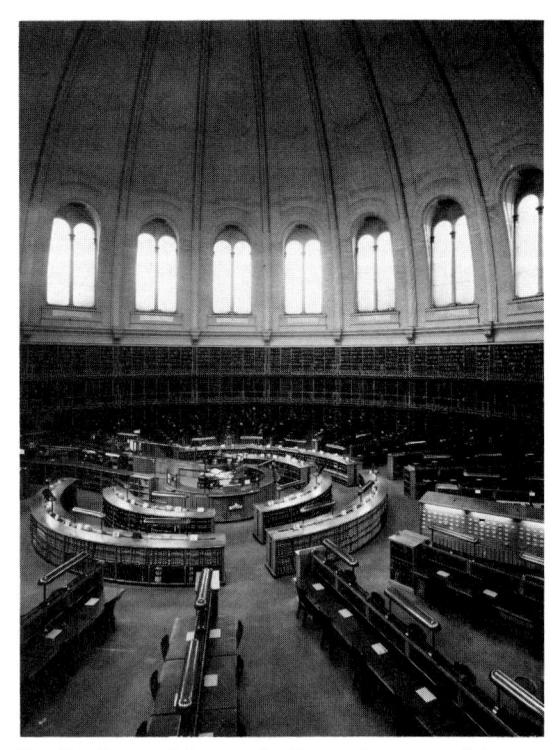

Reading Room of the British Library, Great Russell Street

actually built under the Act passed in 1711 to provide for the building of 50 new churches, to serve the growing needs of eighteenth-century London. 1 St. George's has a noble portico, six huge Corinthian columns wide, two rows deep, the roof above them richly coffered. The tower stands to the north of the church and for a steeple has a stepped pyramid resembling the tomb of Mausolus at Halicarnassus. On top of it is perched a loval statue of George I representing St. George. The tower, steeple, and statue are shown in the background of Hogarth's engraving, Gin Lane. The interior has been altered considerably since Hawksmoor's day. Since the site was cramped and awkward, Hawksmoor gave the church a square centre and contrived to eke out the land to allow an apse to the east, so that the altar might be correctly orientated. Later generations have moved the magnificent reredos, which was part of the original furnishings and did not come from Bedford House, as has often been said, to the north side, where it sits between coupled columns under a broad arch. The plasterwork of the ceiling and apse

¹ These are the churches that were built by Nicholas Hawsmoor: St. Alphege, Greenwich; St. Anne's, Limehouse; Christchurch, Spitalfields; St. George-in-the East, Stepney; St. George's, Bloomsbury; St. Mary, Woolnoth; the Tower of St. Michael's, Cornhill: by James Gibbs: St. Mary le Strand; the steeple of St. Clement Danes: by John James: St. George's, Hanover Square; probably St. Luke's, Old Street; possibly St. John's, Horsley Down: by Thomas Archer: St. John's, Smith Square; St. Paul's, Deptford.

is especially noteworthy; it was by Isaac Mansfield. In the chapel under the tower is a large monument to Charles Grant (d.1823) by Samuel Manning, an unusually exciting piece of work by this sculptor.

Behind St. George's church, in Great Russell Street, is the British Museum, the most important of all the great museums in England. When Sir Hans Sloane, the physician, died in 1753, he left his library, manuscripts, and collections, which were concerned chiefly with botany and natural history, to the nation in return for £20,000, a sum far less than the true worth. The money was raised by a lottery, Montague House was purchased and adapted to provide accommodation, and the Museum opened on 15 January 1759. To the Sloane collections were added the manuscript collections of Sir Robert Cotton and of Robert and Edward Harley, and George II presented the Museum with the Royal Library of books collected by the Kings and Queens of England since Tudor times. In 1782, Sir William Hamilton's collection of Greek vases and antiquities was purchased and, under the Treaty of Alexandria, after Nelson's victory at the Battle of the Nile, the Rosetta Stone and much Egyptian sculpture were ceded to England and were placed in the Museum. In 1816, the sculptures from the Parthenon in Athens, which Lord Elgin had brought to England, were purchased, and during the 1830s and 1840s, archaeological expeditions were sent out to Greece and to the East to conduct excavations. They returned with such important sculptures as the Nereid Monument, the Assyrian reliefs, the remains of the tomb of Mausolus and the Demeter from Cnidus. At his accession in 1820, George IV presented his father's library to the Museum, and it became obvious that a new building was needed. Sir Robert Smirke was chosen as architect, work began in 1823, and during the next 30 years, a new and magnificent building was erected around a central courtyard. The entrance is up a broad flight of steps and through a great portico of Ionic columns, which support a pediment filled with sculpture by Westmacott. Almost at once, it became necessary to roof in the central courtyard to form the Reading Room where Anthony Panizzi, an Italian political refugee and scholar who was later knighted, was organizing an incomparable library. In the early 1880s the natural history collections were removed to South Kensington (see p. 303), and in 1907 Edward VII laid the foundation stone for the large gallery which was erected on the north side of

University College, Gower Street

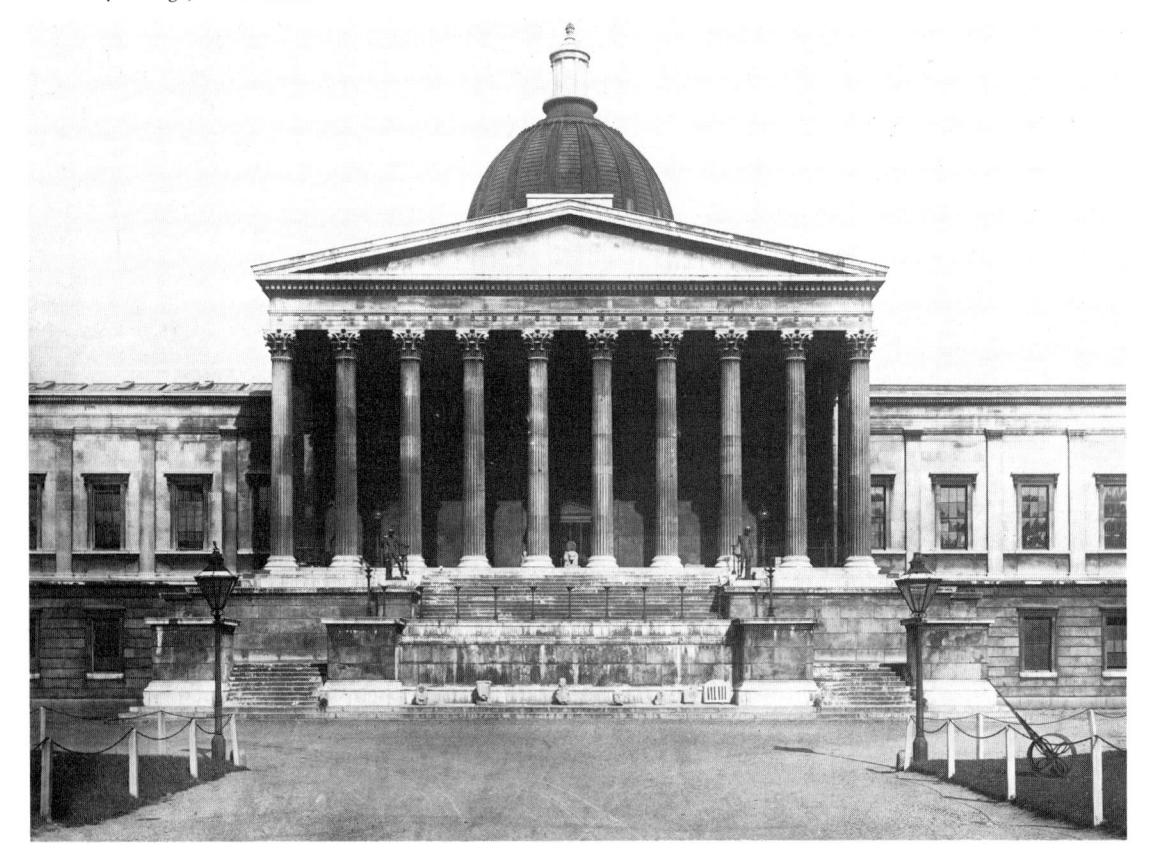

CAMDEN 217

the museum and which bears his name. At its entrance stand huge stone lions designed by Alfred Stevens. In 1939, a new gallery to house the Parthenon sculptures was given by Lord Duveen, though their arrangement could not be completed till 1962 owing to the Second World War. In 1970 the Ethnographical Department moved to Burlington Gardens to become the Museum of Mankind (see p. 157).

In 1973 an administrative distinction was made between the Museum and the Library, with its wonderful adjunct, the Map Room, and the eight million books will one day be transferred to a new building. The British Museum consists of the Departments of Greek and Roman, Western Asiatic, and Oriental Antiquities, Prints and Drawings, Coins and Medals, Egyptology, and English and Medieval Antiquities, this last being of particular interest to all students of London.

We cannot comprehend fully the early society of the capital without examining the pre-Roman gold torques found at Ipswich and Snettisham, the Roman silverware found buried at Mildenhall in Suffolk, or the incomparable Anglo-Saxon grave goods from Sutton Hoo.

It would be easy to spend a lifetime exploring the variety of riches displayed within the Museum, but part of its charm is that one can walk through all the galleries within the space of one long morning or afternoon to gain a general impression, and then return later to study more carefully the artefacts that

appeal most strongly.

The North Door of the Museum opens onto Montague Place, facing the side of Senate House. London was the last of the major European capitals to found a university. Indeed, some of the constituent colleges existed before the parent body was created, but a charter was granted in 1836, though it was not until the Bloomsbury site was acquired in 1927 that it was possible to plan a purpose-built administrative centre. The Senate House, a tall, blunt, white skyscraper designed by Charles Holden, dominates the whole area. In addition to the administrative offices, it houses the central library and Institute of Historical Research, and around its base cluster the School of Hygiene and Tropical Medicine, Birkbeck College, the Students' Union, and the Institutes of Education and Oriental and African Studies. The site is still being developed and other buildings, by Denys Lasdun, are in progress.

At the northern end of Malet Street, in Byng Place turning out of Torrington Place, is the church of Christ the King, built by Raphael Brandon in 1853 for the Catholic Apostolic Church, a sect founded in 1832 by Edward Irving and originally known as the Irvingites. It is enormous, carried out in Bath stone on the scale of a well-grown cathedral, 212 feet long and 77 feet across the transepts. A 300-foot spire was planned but never built. Today, the church is used by the students of London University. The entrance is

by a long arcaded cloister, and behind the altar is a thin, tripartite, stone screen, part of the original furnishings, pierced in the Decorated manner.

Close by, at 53 Gordon Square, is the Percival David Foundation for Chinese art. In 1951, Sir Percival David presented to the University his library devoted to Chinese art and culture and his collection of some 1,500 examples of Chinese ceramics of the Sung, Yuan, Ming, and Ch'ing dynasties, ranging from the tenth to the eighteenth centuries. A year later, a second gift of Chinese porcelain was made by the Hon. Mountstuart Elphinstone. The collection is so beautiful that it delights all who come here. The Foundation is open, free of charge. The Library may be used by scholars and students, provided application has been made first, in writing.

Opposite the entrance to the Percival David Foundation, in Woburn Square, are the Warburg Institute, devoted to the study of the history of art, and the Courtauld Institute Galleries. The Courtauld Institute of Art was founded in 1931 by Samuel Courtauld at the suggestion of Viscount Lee of Fareham, and to it both men bequeathed their remarkable collections of paintings, their intention being to provide London University with the equivalent of the Ashmolean and Fitzwilliam Museums in Oxford and Cambridge. Both men died in 1947. To their collection were added bequests of works of art from Roger Fry (1933), old master drawings from Sir Robert Witt (1952), early Italian paintings acquired by Thomas Gambier-Parry (1966), English landscape water-colours from William Spooner (1967), and in 1978, the incomparable collection of Count Antoine Seilern, containing, among other treasures, 23 drawings and 32 paintings by Rubens, 12 paintings and over 30 drawings by Giambattista Tiepolo, the earliest Netherlandish panel painting, The Entombment by the Master of Flémalle, and six sheets of drawings by Michaelangelo.

A changing display of paintings and drawings is arranged in eight comparatively small rooms, and is shown with china, sculpture, ivories, furniture, and carpets from the various bequests so that the atmosphere is intimate and welcoming. The Lee Collection includes works by Rubens, Velazquez, Botticelli, Bellini, Cranach, and Goya, besides Hans Eworth's enigmatical portrait of Sir John Luttrell and Beechey's kindly one of Queen Charlotte, while Courtauld amassed superlative Impressionist and Post-Impressionist paintings. Degas, Sisley, Manet, Pissarro, Renoir, Cézanne, Monet, Seurat, Dufy, Boudin, Vuillard, van Gogh, Gauguin - they are all here, each of them represented by one or more major works. If one lacked time or strength to visit more than one London gallery, the Courtauld would be the one to choose. It is small, beautifully arranged, and every painting in it is important.¹

¹ The teaching section of the Courtauld Institute is in Portman Square (see p. 185); both Institute and Gallery are to be reunited in Somerset House.

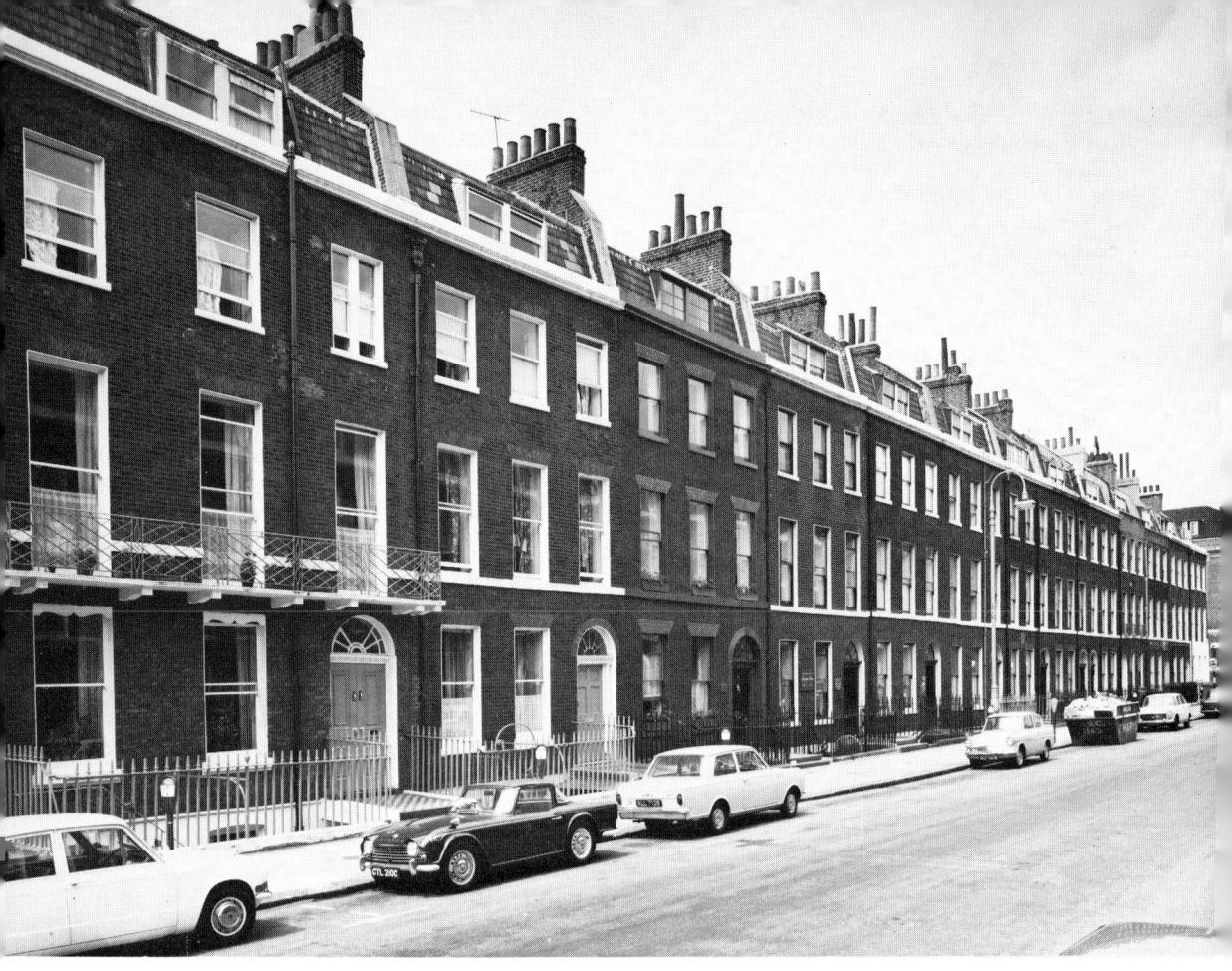

Doughty Street, Holborn

Nearby, in Upper Woburn Place, is the Jewish Museum. Founded in 1932 to demonstrate to the Anglo-Jewish community the richness of their cultural heritage, the collection consists chiefly of ritual objects, and includes superb silverwork, embroidery, manuscripts, and ceramics. Pride of place goes to an Ark, in which the scrolls of the law are kept, which stands 10 feet high, made in Venice in the sixteenth century from walnut, its surface elaborately carved, gilded, and painted.

Just to the north, its façade turned towards Gower Street, is University College, the foundation of which in 1826 led to the establishment, ten years later, of the University of London. It was the first English institution for higher education which did not demand religious qualifications for entry. The building, begun in 1827, was designed by William Wilkins, with a fine portico, ten Corinthian columns wide, approached by a broad flight of steps on which students sun themselves in summer. A dome rises behind the portico, and in 1869–81 a north wing was added by Hayter Lewis, to house the Bartlett School of Architecture and the Slade School of Art, which has been able to boast of such principals as Sir Henry

Tonks and Sir William Coldstream. The College possesses a good collection of modern paintings as well as all the models and casts left in John Flaxman's studio at his death, which his sister-in-law, Maria Denman, herself a sculptress, bequeathed to the College. The Department of Egyptology hopes, one day, to be able to equip a new museum to display the remarkable collection of ancient artefacts excavated by Sir Flinders Petrie. Made up from small items, most of them related to everyday life, this is the finest teaching collection of ancient Egyptian archaeological material possessed by any university in the world.

ST. PANCRAS

The former borough of ST. PANCRAS, a long, narrow strip of land, runs almost from Oxford Street in the south, virtually due north, to Highgate four miles away. Surveyed from east to west, it is never more than a mile wide. Church land, for the most part, until the Reformation, it was then divided into a number of estates and its development from farm

land to its present congested, built-up condition took place over a long period. An isolated village had occupied the northern height at Highgate by the very early Middle Ages, and there was another village around St. Pancras Old Church, but the Euston Road was marked out across fields and the layout of the southern portion did not begin in earnest till the middle of the eighteenth century. It was not until after the middle of the next century, with the coming of the railways, that a rash of comparatively small houses ate up the green fields towards Hampstead and Highgate. Today, Highgate remains a village and the open lands at Parliament Hill and at Kenwood have been joined with Hampstead Heath and have thus been made immune from building development. A steady but piecemeal redevelopment is going on in the rest of the borough as the older houses decay and the needs of the railways contract.

St. Pancras New Church stands at the junction of Upper Woburn Place and Euston Road. The Old Church had become too inconvenient and insignificant for the type of parishioner who had come to live in the well-proportioned houses that James Burton was building around what is today Cartwright Gardens, and who were going to patronize the pretty, bow-fronted shops which still display their goods in Woburn Walk, and so a competition was held in 1818 and was won by William Inwood and his son. Henry William Inwood. This was at the very height of the enthusiastic revival of interest in Greek architecture, promoted, to a great extent, by Lord Elgin's display of the marbles which he had salvaged from the Parthenon (see p. 216). On winning the competition, the younger Inwood travelled to Greece where he made detailed drawings of the Erechtheum and the Tower of the Winds in order to perfect his designs. The church was completed in 1822, having cost well over £70,000 for the building alone, without taking into account the price of the land. It is a rectangular building, faced in stone and entered through a portico of six huge Ionic pillars which support a pediment. Above this rises a steeple in two diminishing octagonal stages, its design clearly based on that of the Tower of the Winds in Athens. Along the north and south sides are rows of gigantic Grecian maidens, copied from the caryatids which support the portico of the Erechtheum in Athens, and cast in terracotta over an iron core by Charles Rossi. Pugin disapproved violently of a Christian church being modelled on pagan temples but the douce, self-possessed carvatids have delighted generations of parishioners and passers-by. The interior is more conventional; galleries, supported on lotus pillars, run round three sides, while the apse at the east end is set about with Ionic columns. Other critics rebuked the Inwoods for having copied their models too faithfully, saying that this, the first neo-Greek church to be built in London, was nothing save a medley of plagiarisms, but an examination of the huge pulpit, carved from the Fairlop Oak in Hainault forest, which had blown down a few years earlier, shows how sure and how independent a command the architects had of the style. They received another commission to build All Saints on the corner of Camden Street and Pratt Street, which retains its fine portico, though the interior has been altered, for it is now used for the Greek Orthodox community in this part of London.

To the south-west of the church, within easy walking distance, are two interesting small museums, Dickens House at 48 Doughty Street and the Thomas Coram Foundation for Children at 40 Brunswick Square. Charles Dickens moved to Doughty Street in March 1837 and remained at number 48 till December 1839. During his residence, he wrote part of Pickwick Papers, Oliver Twist, Nicholas Nickleby, and began Barnaby Rudge. It was here that his seventeen-year-old sister-in-law, Mary Hogarth, died, suddenly and unexpectedly, a tragedy which so distressed Dickens that he was unable to write for

CAMDEN - ST. PANCRAS

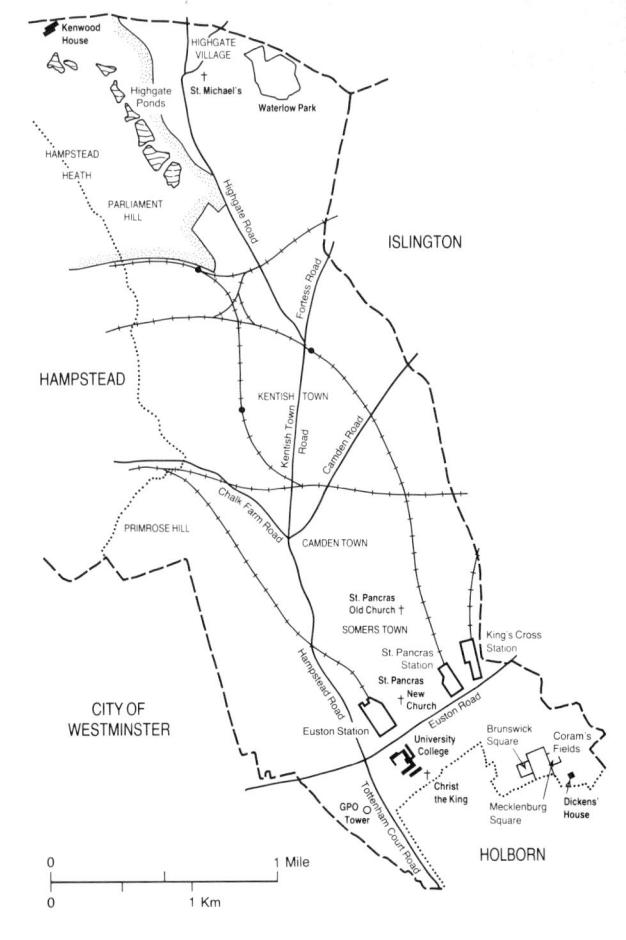

two months afterwards. The house was acquired by the Dickens Fellowship in 1925 and since then has been filled with a remarkable collection of Dickensiana. First editions of his work are here, some manuscripts, many letters, the velvet-covered desk which he used for public readings, and the backdrop, painted by Clarkson Stanfield, for an amateur performance of Wilkie Collins's melodrama, *The Lighthouse*, which Dickens produced. The Dickens collection of the late Comte Alain de Suzannet is displayed in the upper rooms and, in one of the rooms in the basement, a kitchen like that of the Manor Farm, Dingley Dell, where Mr. Pickwick spent Christmas, has been reconstructed.

Unlikely as it may seem, the granting of a charter on 17 October 1739 by George II to a benevolent and determined shipwright, Thomas Coram, that he might establish 'A Hospital for the Maintenance of Education of Exposed and Deserted Children', was an event of great importance in the history of British art. Coram first took a house in Hatton Garden to receive the foundlings, and when that proved too small, he raised money by public appeal and bought 56 acres of Lamb's Conduit Fields from Lord Salisbury. A Hospital was built on part of the land, the architect, Theodore Jacobsen, giving his services free of charge. More land was reserved for playing fields and the rest was laid out about the turn of the century by James Burton, following designs by Samuel Pepys Cockerell, who took the Hospital as the pivot of his scheme and set it in the midst of a related group of squares. Brunswick and Mecklenburgh Squares, which survive, have each one open side and thus enjoy uninterrupted views across the Hospital grounds. In 1926, the Hospital was removed to Berkhamsted and the original building was demolished, its site being laid out as a children's playground, which adults may enter only if they are escorted by a child. Since 1954, the Hospital has carried out its good work through foster homes.

Jacobsen was not the only person to help Coram's foundation freely. William Hogarth, with the aid of Joseph Highmore, Richard Wilson, and Samuel Wale, painted the walls of the Court Room, and he presented the Hospital with a portrait of its founder. which he always vowed gave him more pleasure to paint than any other of his works. When no buyer came to purchase his March of the Guards to Finchley, he offered it as a prize in a lottery; 167 tickets remained unsold, so he gave them to the Hospital, which most happily won the painting. He also persuaded Gainsborough, Highmore, Sir Joshua Reynolds, Allan Ramsay, Francis Hayman, Thomas Hudson, and Richard Wilson to become governors of the Hospital and to exhibit their paintings there. These exhibitions were so successful that they were one of the factors which led to the foundation of the Royal Academy. It was not only the artists who supported the Hospital; Handel gave to it his fair copy of The Messiah, which it still possesses, and an organ which is today installed in St. Andrew's, Holborn, where Thomas Coram was buried (see p. 212).

Over the years, the Hospital acquired a remarkable collection of paintings and sculptures. Works by Reynolds, Gainsborough, West, Ramsay, Hudson, Roubiliac, Rysbrack, Bacon, Shackleton, and Millais are here, besides some fine furniture, and the pathetic tokens which mothers, made desperate by poverty, left with their children in the hope of being able to reclaim them one day. When the foundation's new headquarters was built in 1954, it was found possible to dismantle the Court Room, with its paintings by Hogarth and his friends, and to rebuild it exactly within the new premises.

In the Euston Road are three railway termini of Euston, King's Cross, and St. Pancras. The coming of the railways transformed English society in less than a generation. The railway stations epitomize the confidence their builders felt in their technological skills; the hotels so often attached to them demonstrate the new opulence demanded by those who had made fortunes from the extraordinary development of British industry. Along the lines of the New (Euston) Road, still London's northern boundary at the beginning of the nineteenth century, stand the three termini, doorways to the three iron roads by which men might enter or escape from the metropolis. What the turmoil of their building meant to the local resident can be learnt from chapter VI of Dombey and Son - Dickens was living in Doughty Street while the London to Birmingham Railway was being built. The three stations differ considerably from each other.

The first section of the London to Birmingham Railway opened on 20 July 1837, one month after the accession of Queen Victoria. Euston Station. planned by Robert Stephenson with platform sheds by Charles Fox, was unostentatious to the point of humility, but before the entrance stood a great Doric archway designed by Philip Hardwick. Stone-faced, towering into the air, the name EUSTON proudly cut in letters of gold just below the pediment, that arch symbolized just what the railway meant to its creators. Hardwick added a Great Hall, also neo-Grecian, in 1846-9 and a Boardroom reached by a Grand Staircase, which Watts offered, in vain, to adorn with a fresco. In 1947 the railways were nationalized, Euston Station was rebuilt to designs by Moorcroft, and, despite passionate protests, Hardwick's Doric arch was demolished, along with the other buildings. The new station, opened in 1968, is spacious, dignified, and functions well, but it is no substitute for what has been destroyed. Baron Marochetti's statue of Robert Stephenson has been set up in front of the station, and the marble group by John Thomas of Britannia accompanied by the Goddess of Arts and Sciences and by Mercury, has been installed in the buffet. The Round House, which Stephenson designed to stable the locomotives, still stands in

CAMDEN 221

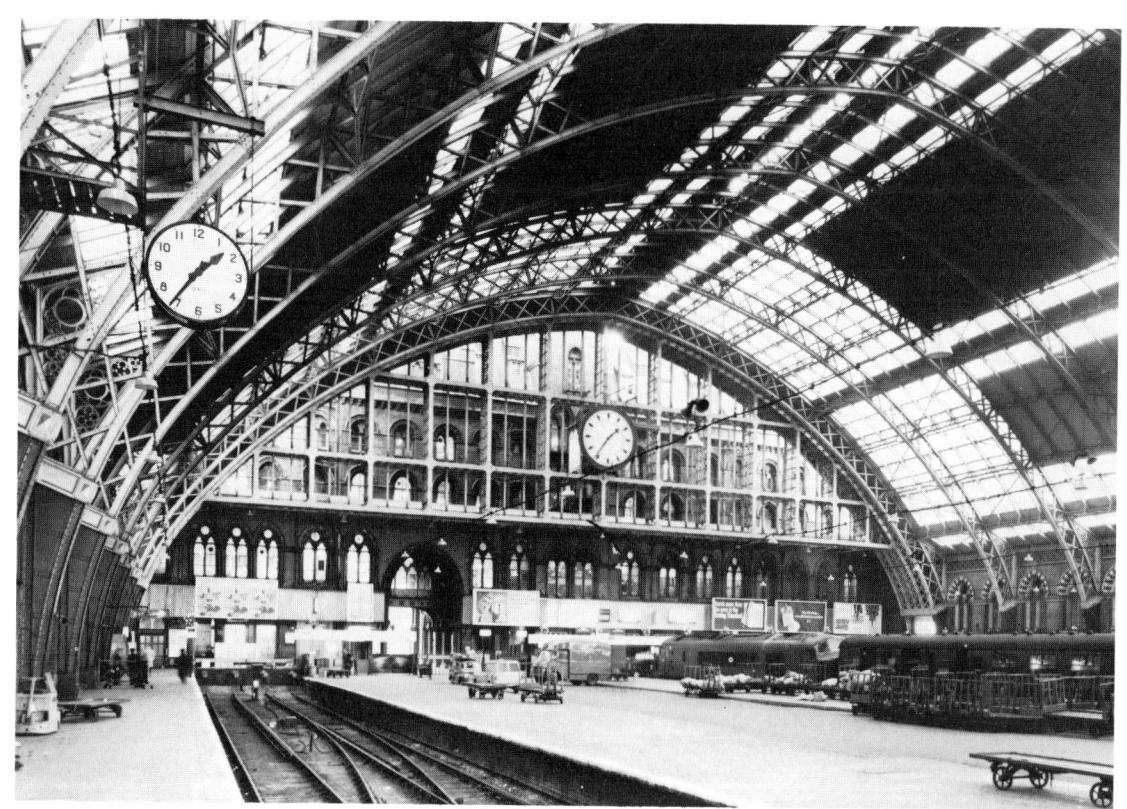

St. Pancras Station, Euston Road

Chalk Farm Road. It serves today as a theatre. Nearby in Camden Lock, a lively market, specializing in crafts, clothing, and bric-à-brac, has recently opened at weekends.

King's Cross, opened 25 years later in 1852. was very different. The designer, Lewis Cubitt, the younger brother of Thomas Cubitt the builder, said that he intended his station 'to depend for its effect on the largeness of some of its features, its fitness for its purpose, and its characteristic expression of that purpose', and he achieved his ambition. It consists simply of two huge, arched train-sheds, each one 71 feet wide; their façades, outlined in brick, one for arrivals, the other for departures, summarize the whole purpose of any railway station. From King's Cross – the name derives from a statue of George IV which used to stand at a nearby cross-roads - the Flying Scotsman, most romantic of all trains, leaves for Edinburgh at 10 a.m. each morning, and from here the longest non-stop run in Britain, 268 miles from London to Newcastle on the way to Aberdeen, is undertaken daily. Between the train-sheds, an Italianate clock-tower rises 120 feet into the air; the clock which it bears aloft came from the Great Exhibition of 1851. Cubitt's station is plain, functional, unromantic, and purposeful - the epitome of what a station should be.

St. Pancras was built in yet another manner. The station itself, designed by H. Barlow and opened in 1868, was as strict and disciplined an exercise as Cubitt's, one vast train-shed, 249 feet wide, spanned by a single pointed arch, made of glass and iron without supporting pillars. The iron ribs rise directly from brick springers at platform level, the maker's name – Butterley of Derby – stamped proudly at the base of each.

The railway hotel, which was completed ten years later and provides the facade to the Euston Road, is another matter; it was designed by Sir Gilbert Scott and is frankly breathtaking. A huge Gothic castle, containing 500 rooms and the grandest of grand staircases, it fairly seethes with vitality. The legend that Scott made use of his rejected Gothic designs for the Foreign Office in Whitehall (see p. 116) is a nice piece of fiction; what is true is that he had been at particular pains to study Gothic principles and details and to meditate upon their application to a large modern secular building. He now put those studies to good use. The difficulties of the site - its curious, cramped, triangular shape, and the 20 feet it stands above road level, owing to the gradient needed to lift the railway over the Regent's Canal - he turned to advantage, sweeping his façade around the corner. and giving it an approach up a long, stately double

ramp, the angles of which he filled with curving steps. Since the railway served the Midlands, wherever possible he employed Midland firms and used Midland materials - bricks from Nottingham, stone from Ketton in Rutland, and slates from Leicestershire. The building is practical too; the spire and tower which give the station its fairytale skyline, best seen by sunrise or sunset from Pentonville Hill, serve to house the water tank and the clock. St. Pancras fulfils all Pugin's requirements, the use of undisguised raw materials, a readiness to allow each separate part of a building to declare its own function, and a willingness to lay bare its construction and only then to adorn it. It is in these adornments – the decoration of the cast-iron bridges (made by Skidmore of Coventry) which carry the first-floor corridors across the entrance arches, the railway staff, porter, signalman, engine-driver, and engineer, carved on the capitals of the booking office, and the tracery of the ground and first-floor windows - that Scott showed his delight in his creation which, he admitted, was probably too good for its purpose.

The old village centre of St. Pancras lies a few hundred yards to the north of the Euston Road. Nothing is left, save St. Pancras Old Church, and there a thorough restoration, amounting to a rebuilding, by Alexander H. Gough in 1848, means that of the old structure there remains one thirteenth-century lancet window and two monuments, one to Philadelphia Woolaston, who died in childbirth in 1616 – an unknown sculptor has portrayed her, holding her baby – and another to Samuel Cooper, the seventeenth-century minaturist. The churchyard is a proper place of pilgrimage. It was laid out as a public garden in 1877 through the generosity of Baroness Burdett Coutts. Most of the tombstones were taken down and arranged in a strange, starlike formation around the base of an ash tree and the good baroness set up a granite monument of exceptional ugliness, with the names of the more famous people who rest here, but Sir John Soane's own memorial was left undisturbed. He lies with his beloved wife and his eldest son, beneath a white marble stele sheltered in a stone aedicule; around the summit a snake wreaths itself, devouring its own tail - the symbol of eternity - and putti, with extinguished, downturned torches, weep about the base.

Northwards up the Hampstead Road, at the junction with Crowndale Road and Eversholt Street, there is a statue of Richard Cobden, the Corn Law reformer, apparently engaged in genial contemplation of the traffic, standing near the site of the Old Bedford Theatre, often painted by Sickert. This is Camden Town, an area of London laid out around the middle of the last century, consisting chiefly of terraces of moderately-sized houses, their uniformity saved from monotony by such touches of imagination as the arc of Mornington Crescent, occupied by residents neither rich nor desperately poor, and associated with that band of painters formed in 1911

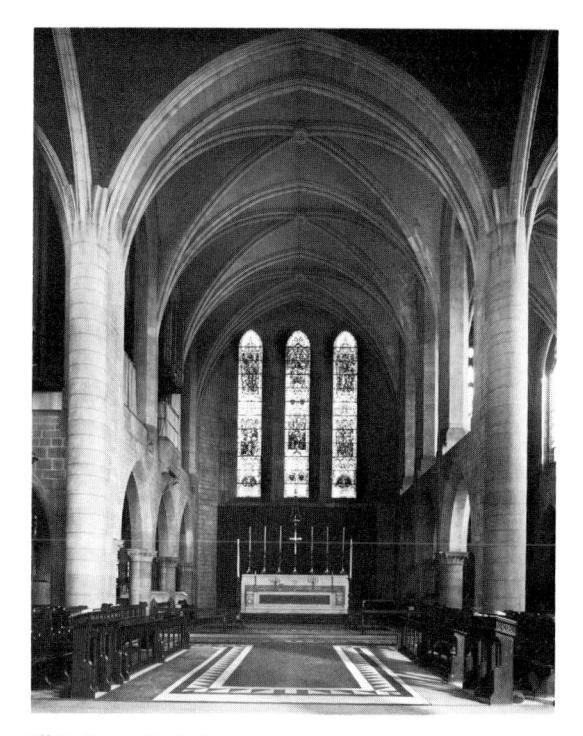

All Hallows, Shirlock Street, Gospel Oak

and known as the Camden Town Group. Its most important members were Walter Richard Sickert, Frederick Spencer Gore, Harold Gilman, and Charles Ginner. Many of their paintings depict the façades and interiors of the houses and shops in this neighbourhood, while its aspect some 60 years earlier was recorded by James Frederick King in an excellent series of panoramas now in the possession of Camden Public Libraries. Still going northwards, through Kentish Town and up the Highgate Road, Grove Terrace has not changed much since it was built in the mid-eighteenth century. A detour leads to the church of All Hallows in Shirlock Street, Built in 1889 to designs by James Brooks, with a chancel added in 1913 by Sir Giles Gilbert Scott, it has a remarkable and very handsome exterior characterized by a series of buttresses.

On the hilltop is HIGHGATE village, still retaining an uncommon number of eighteenth-century houses – and indeed some even earlier – arranged not in the usual formal pattern but in a more random manner. Recent excavations have revealed a number of Roman kilns, dating from the first century AD, in Highgate Woods. The name comes from the medieval toll gate, erected across the Old North Road when it reached the Bishop of London's estate on the summit of the hill; the approximate position of the barrier is indicated today by the Gatehouse public house. By the sixteenth century, a considerable village had grown up, where Sir Roger Cholmley founded a school in 1565, which is still flourishing

223 **CAMDEN**

today. Sir William Cornwallis had a mansion here, wherein he probably received Oueen Elizabeth on her progresses through Highgate in 1589, 1593, and 1594, and which he sold in 1610 to Thomas Howard, Earl of Arundel and art collector, whose antique marbles are now in the Ashmolean in Oxford It was in this house that Sir Francis Bacon died on 9 April 1626, having caught a chill stuffing a chicken with snow to see whether refrigeration would preserve the carcass. That house is gone but there is still a good deal to see in Highgate. The church, dedicated to St. Michael and built by Lewis Vulliamy in 1831-2, with a chancel added by Street 50 years later, is a small, neat, brick box with a spire. Here Coleridge lies buried, his body having been removed from the churchyard of the former Highgate Chapel in 1961, and here there is also a fine east window, designed by Evie Hone and inserted in 1954. Behind the church, the Hill falls away steeply and on its slopes is Highgate Cemetery, which can be reached by way of Swain's Lane. The old part, where Michael Faraday, Mrs. Henry Wood, and Christina Rossetti are buried, is at present open only occasionally, but the newer part is a place of pilgrimage, for Karl Marx was buried here in 1883 and an enormous bust of him was set up in 1956. George Eliot and Herbert Spencer also lie here.

Opposite the church stands an exceptionally pretty public house, the Flask, and a fine terrace of houses, The Grove, built during the late seventeenth and early eighteenth centuries. Samuel Taylor Coleridge, the poet and philsopher, lived at number 3 with his friends, Dr. and Mrs. Gilman, from 1819 till his death in 1834. The brickwork of these houses is handsome and the gardens of some of them are usually opened to the public in summer in aid of charity. Below the church, down West Hill, is a row of eighteenth-century houses, Holly Terrace, shut off from the outer world behind high iron gates, and beyond it is the Holly Lodge Estate, laid out across the site of Holly Lodge, the home of Baroness Burdett Coutts, the grand-daughter of the banker, Thomas Coutts, who spent her fortune and her life in the service of the people of London, and whom Oueen Victoria created a baroness in her own right.

To the east of this church, on the summit of the hill, there is a delightful medley of houses around Pond Square, and opposite the square in South Grove stand the Literary and Scientific Institute, founded in 1839 with white, stuccoed walls, and the Old Hall which replaced the Earl of Arundel's house in 1691. At the end of South Grove, in the High Street, are some pleasant eighteenth-century houses used today as shops.

Further down Highgate Hill, on the southern slope, is Waterlow Park, in which stands an early seventeenth-century mansion, once the country residence of John Maitland, Duke of Lauderdale. It later became the home of the philanthropist, Sir Sidney Waterlow, who in 1891 opened its grounds to the public 'to be a garden for those who are gardenless'. Today, the park is maintained by Camden Borough Council and is one of the most attractive in London. with a small aviary and some excellent herbaceous borders, and Lauderdale House has been restored after a recent fire. Opposite the entrance to the Park stands Cromwell House which, despite its name, has no connection with the Lord Protector, but is of exceptional architectural interest (see also p. 256). It demonstrates the taste of the merchant class in contrast with Inigo Iones's classical inspiration which the court favoured. Ireton House, and Lyndale House next to it, were built about a century later. Further down the hill, towards Holloway, is St. Joseph's church, its two copper domes, one large, one small, providing a landmark for miles around, and further on still, at the junction with Archway Road, a stone cat, carved by Jonathan Kenworthy and Tony Southwall, sits on the payement on the spot where tradition asserts that Richard Whittington heard the bells of the City calling to him to turn back to London Town where he would find fame and fortune. The legend cannot be proved or disproved, but Whittington left money in his will to found almshouses, which stood where the Archway Road runs today until the end of the last century, when they were removed to Felbridge in Surrey and their place taken by the Whittington Hospital, so it is fair to presume that this slope of the hill had a special significance for London's most celebrated lord

Returning to the summit and taking the road westwards to Hampstead, we come to Kenwood. A house had stood on the site since 1616, but in 1754 the estate was purchased by William Murray, Attorney-General, and later Lord Chief Justice and Earl of Mansfield. Ten years later, he called in a fellow Scot, Robert Adam, to rebuild the house for him. On his death in 1793, the property passed to his nephew, who added wings, designed by George Saunders, to the mansion. In 1922, the sixth earl sold 120 acres of the estate for public use and in 1925, Lord Iveagh purchased from him the house and the remaining grounds. He furnished the house and installed in it his remarkable collection of paintings, leaving everything - house, land, and paintings - to the London County Council, as it was then, on his death in 1927. This princely generosity has secured for London what is perhaps the most beautiful among the smaller museums and art galleries. The principal rooms are the entrance hall, with a panel in the ceiling painted by Angelica Kauffmann, the domed inner hall, the Library and the Orangery. The Library is one of the most magnificent rooms Adam ever created. It is a large apartment with apsidal ends, its tunnelvaulted ceiling decorated by Antonio Zucchi, its walls a deep, rich rose colour, picked out in gold. It was here that Zucchi and Angelica Kauffmann fell in love with each other and one cannot imagine a more idyllic setting. The main living rooms, modest in size and

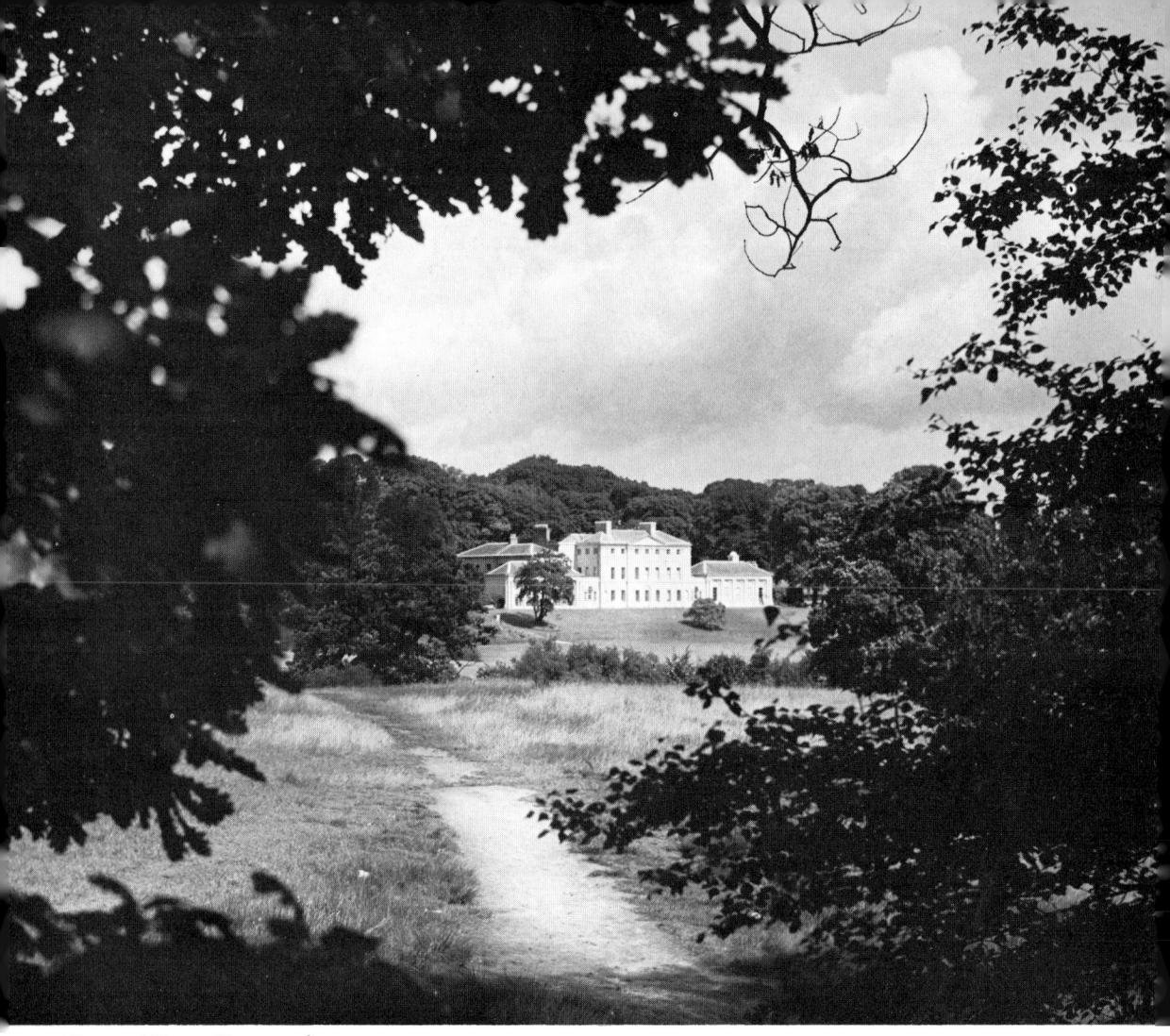

Kenwood House, Hampstead

of comfortable proportions, all face south, looking across the terrace and the grounds to a lake spanned by a white, mock bridge. On any visit to Kenwood, it is essential to walk to the edge of the lake and then to look back towards the house, disposed, serene and benign, along its terrace.

Lord Iveagh's collection of paintings was modest in size but superb in quality. Paintings by English artists – Reynolds, Gainsborough, Romney, Turner, Morland – form the basis, including Gainsborough's wonderful portrait of Mary, Countess Howe, clad in a shimmering pink dress, her expression slightly disdainful. Besides these, there is a late self-portrait by Rembrandt, a cool Vermeer, *The Guitar Player*, a confident, self-possessed *Portrait of a Gentleman* by Franz Hals, and an exquisite study by Van Dyck of Lady Goodwin. A painting of Old London Bridge, executed in 1639 by Claude de Jongh, should not be missed, and Kenwood recently acquired another important work, George Stubbs's magnificent paint-

ing of the racehorse, Whistlejacket. The original furniture left the house long ago, but suitable pieces are being acquired; the 'Icon' Suite, which James Stuart designed for Spencer House beside Green Park, is on loan there at present from the Victoria and Albert Museum.

Concerts are given, both in the grounds beside the lake and in the Orangery, during the summer. In the Coach House refreshments may be obtained. The gardens to the west of the house have received careful and skilful attention in recent years. Sculpture is sometimes displayed here, and, in 1968, Dr. Johnson's summer house was brought from Streatham where it had stood in the grounds of the Thrales' house, and was set up safely here to add a new delight. On the terrace to the east of the house stands a gaily painted gypsy caravan, made about 1905 and formerly the property of the Buckland family, who have long been associated with the fairs on Hampstead Heath.

HAMPSTEAD

On leaving Kenwood, the road (Hampstead Lane) runs westwards till it narrows, slowing the traffic, cramped in between a restored toll-gate and the Spaniard's Inn. It is uncertain how this eighteenthcentury hostelry came by its name – possibly it refers to the nationality of a past innkeeper, possibly to a visit from a Spanish diplomat – but it is worth buying a drink and consuming it in the parlour on the first floor where there is some good panelling. Just beyond the inn, there is a small group of late eighteenth-century weather-boarded houses, still kept in good repair. Spaniards Road, raised as if it were a causeway, due to the excavation of sand for building purposes in the middle of the last century and for sandbags at the start of the Second World War, leads to the Whitestone Pond, besides which a flagpole stands, marking the summit of Hampstead Hill, 443 feet high.

To the south-east, in spite of the tall blocks of flats and offices which have been built in recent years, an extraordinary prospect opens across London to the hills of Surrey beyond. The dome of St. Paul's is clearly visible, and in the opposite direction can be seen the ridge of high land along which Mill Hill extends. All around is the open heathland of Hampstead, 825 acres of it, much painted by Constable, beloved by Londoners, especially local residents. When the qualities of a chalybeate spring were recognized about 1698, the hilltop village began to develop into a small but lively spa within convenient reach of London, and buildings spread up the southern slope of the hill. A dry fountain head in Well Walk and the name of Flask Walk are testimony to the former importance of the spring. In 1780, an

CAMDEN-HAMPSTEAD

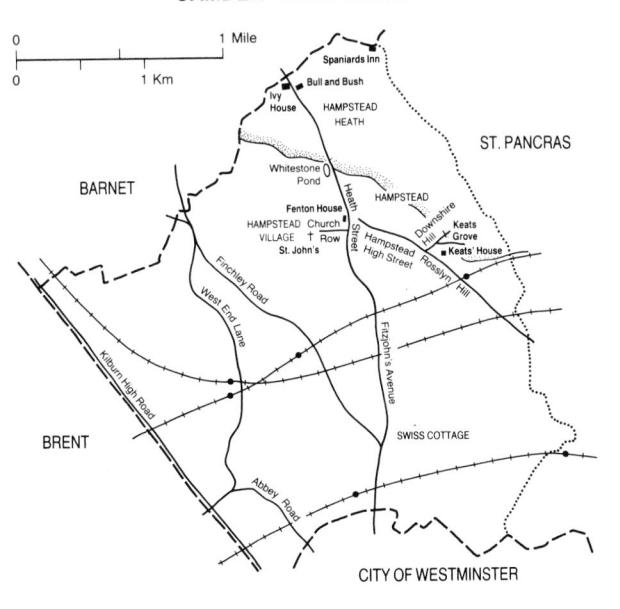

assembly room, now demolished, was built, and in 1829 the Lord of the Manor, Sir Thomas Maryon Wilson, decided to develop the heathland into a profitable estate. The residents, however, thought otherwise and defended their open countryside, taking legal action in the courts and the House of Commons. The struggle continued till Sir Thomas's death in 1869; his brother proved more amenable and 240 acres were sold to the Metropolitan Board of Works in 1871, to be preserved forever as an open space. Successive generations have enlarged the protected area and local residents are still vigilant. There are fewer wild flowers on the Heath than there were in the 1590s when John Gerard, the herbalist, found orchids growing there but one can still find sorrel and buttercups, celandine and daisies, and wander at will there for the whole day, picking wild blackberries in autumn or inhaling the hawthorn in spring. Three fairs are held on the Heath each year, at Easter, at Whitsun (Spring Bank Holiday), and on the August Bank Holiday, and there are still donkeys on which children may ride, as there were in Dickens's day.

To explore the village – for, in spite of a certain self-consciousness, Hampstead is still a village – it is best to go first down Heath Street, the spine of the area. On either side of the main thoroughfare is a labyrinth of tiny streets, alleyways and courts, connected, since the slope of the hill is steep, by flights of steps. The difficulty of representing the terrain accurately is sufficient to defeat most map-makers. Many eighteenth- and early nineteenth-century facades remain unaltered, for the sharp gradient of the hill acts as a brake on redevelopment. Always look up at the first-floor level; ground floor facades change first. acquiring plate glass, sprouting imposing door-casings, or puffing out themselves – and their owners – with bow windows, but the upper storeys usually continue to tell the truth about the original building. Away to the south of Heath Street lie Hampstead Square and Squire's Mount, both built in the eighteenth century, the former composed of self-assured mansions, the latter of contented cottages, now protected by the National Trust. Below the Square is Cannon Place wherein Cannon Lodge opens its grounds occasionally in the summer, and New End leads to Burgh House, built for the eighteenthcentury musicologist, the Reverend Allotson de Burgh, and now open and held in trust by local residents. The road is crossed by Well Walk, where Constable spent the last years of his life at number 40, and by Flask Walk, a part of which has recently been declared a pedestrian precinct, thus enabling the explorer to study the houses without danger. On the upper side of Heath Street, a narrow road humps its way up the hill; this is the Mount, and here Ford Madox Brown painted Work¹ in the 1860s; the

1 Now in Manchester City Art Gallery. Caroline House was not called after the consort of either George II or George IV, but was named for the daughter of the present owner.

houses in the background, Caroline House and Holly Cottage, which were old when Brown looked at them, have not changed at all. Up the steps from Golden Yard we reach the Hollybush Inn. Further down the hill is the King's Well shopping precinct, an enclave of small boutiques which have replaced older, shabbier property.

Hampstead tube station nearby is the deepest underground in London. The High Street lies down the hill to the left, but going straight ahead along Heath Street, we come to Church Row, in which two terraces of houses, built about 1720, their brick richly brown and nicely diapered, confront each other across a central arcade of lime trees, their pavements pebbled with a variety of coal-hole covers. At the end of the row stands St. John's church, consecrated in 1745 and probably built by John Sanderson, possibly to designs by Henry Flitcroft. It is of yellowish brick with a stalwart, battlemented tower and minute spire. The churchyard is entered through iron gates which came from

Canons (see p. 264). The interior was much altered by F. P. Cockerell in 1872 when a reredos by Sir T. G. Jackson and an intricate ceiling decoration executed by Alfred Bell were inserted.

Among the many small monuments, there is one by the younger John Bacon with two allegorical figures, in memory of the Hon. Frances Erskine, and there is also a bust of John Keats by Anne Whitney of Boston, which was presented in 1894. In the churchyard are buried Constable, George du Maurier, Henry Tout, the historian, and Norman Shaw, the architect, whose own house stands nearby at 6 Ellerdale Road and who designed another for Kate Greenaway at 39 Frognal. Along the side of the northern half of the churchyard runs Holly Place with St. Mary's church, built in 1816, one of the first Roman Catholic places of worship to be erected after the Reformation. Inside, its founder, the Abbé Morell, lies in a tomb chest designed by W. Wardell, his effigy stretched upon it, attended by angels, as it would have been executed in the fourteenth century.

West Heath, Hampstead Heath

The continuation of Heath Street, Fitzjohn's Avenue, leads past a series of the opulent, late nineteenth-century houses which clutter the lower slopes of the Hill, as far as Swiss Cottage where a new civic centre will, one day, be built. So far, the Public Library, designed by Sir Basil Spence, and opened in 1964, has been completed; other buildings are contemplated. On the south side of the library stands a figure of Sigmund Freud, the founder of psycho-analysis, who spent the last two years of his life nearby at 20 Maresfield Gardens (see p. 228). The upper hall of the library frequently houses temporary exhibitions, and the Borough Council maintains an arts centre in the old public library in Arkwright Road.

Returning to the top of the hill and crossing to West Heath Road, we find a number of large, wealthy mansions, designed in a hotch-potch of styles ranging from the fantasticated Tudor of Sarum Chase (built 1932 by Vyvyan Salisbury for his uncle, Frank Salisbury, and an interesting sidelight on the economics of portrait painting) to the stark modernity of number 9, but all of them revelling in their uninterrupted vision of the silver birch trees which lace the West Heath. Closer to the village lies Hampstead Grove in which stands Fenton House, built in 1693, plain and dignified with a deeply sloping roof; it now belongs to the National Trust and is open daily excepting Tuesday. On its south side stand iron entrance gates, contemporary with the house but as

Fenton House, Hampstead

Perrin's Court, Hampstead

elaborate and scrolly as the mansion itself is unadorned. The walled garden is scrupulously tended and its herbaceous border is an example to all horticulturalists. Displayed inside are Lady Binning's collection of porcelain and Major George Henry Benton-Fletcher's collection of early keyboard instruments. Among the harpsichords, spinets, clavichords, and pianos is one early harpsichord of 1612 on which Handel played. The instruments do not stand silent for accredited students are allowed to practise on them. Just below the entrance gates is a weatherboarded house where George Romney lived, and opposite Fenton House is George du Maurier's home. Beyond the northern end of the garden is Admiral's House, a tall, white house which Constable painted. Sir George Gilbert Scott lived in it from 1856 to 1864, and John Galsworthy, the novelist and playwright, lived in the cottage next door.

Turning to the northern slope of the hill, the North End Road runs past the Paddock, which was added to the Heath in 1925, past the site of Pitt House, destroyed by bombs in the Second World War, where the elder Chatham lived, and past the entrance to the Hill Garden. This was once the grounds of Lord Leverhulme's house (now the annex to the Manor House Hospital) and was acquired as an open space in 1963. The road runs through a deep cutting at the end of which stands the Bull and Bush public house, built in the early nineteenth century, with a small segmental pediment, immortalized in music hall

St. John's, Downshire Hill

song, and still thriving. Behind it lies Wildwood, beloved by children and perhaps the least frequented part of the Heath. On the edge of the wood, facing on to Hampstead Way, is Wyldes Farm (see p. 204). The agricultural land which its owners tended is now the Heath Extension.

In the North End Road is the entrance to Golders Hill Park, with undulating slopes for children to roll down, ducks to feed, and some unusual flowerbeds. A few yards further down the road is **Ivy House**, in which the great ballerina, Anna Pavlova, lived from 1912 till her death in 1931. Today, it houses a College of Speech and Drama, but a small museum with relics of the legendary dancer is open on Saturday afternoons.

The most conspicuous church upon the eastern side of the hill is Teulon's bluff and uncompromising St. Stephen's on Rosslyn Hill, built in 1876 of indigo brick with a huge rose window and a heavy square tower, but East Heath Road passes the Vale of Health, with a score of small, picturesque early nineteenth-century houses, which once provided lodgings for Leigh Hunt and his family and for D. H. Lawrence, clustering around a willow-hung pond. At the foot of the hill lie Hampstead Ponds, where on the banks doggedly hopeful local fishermen keep vigil

at weekends. Downshire Hill, a pretty street with a number of well preserved early nineteenth-century houses, runs westwards and, where it joins Keats Grove, there stands St. John's church, built in 1818, possibly to designs by S. P. Cockerell, faced in stucco with a porch and cupola. Nearby in Keats Grove stands a white house wherein the poet spent the two most prolifically creative years, 1818-1820, of his short life; his Ode to a Nightingale was penned in the garden here. Originally the little house was divided into two even smaller dwellings, known as Wentworth Place; in one Keats lived with his friend, Charles Armitage Brown, while the other was occupied by a widowed lady, Mrs. Brawne, to whose daughter, Fanny, Keats became engaged. Desperately ill with consumption, he left Hampstead on 13 September 1820 to travel to Italy for his health; he died in Rome in the following February. In 1838 the two houses were converted into one for an actress, Eliza Chester, and in 1925 they were purchased as a memorial to the poet who had once lived happily there. The house has recently (1974) been completely restored by Camden Borough Council and is equipped, as far as is possible, with furniture which once belonged to the poet and his friends. Some of his letters and notebooks are here, Joseph Severn's portrait of him on his deathbed hangs on the wall, and in the little museum is the almandine engagement ring which he gave to Fanny Brawne and which she wore till her dying day, despite her subsequent marriage, besides many other small relics. It is an exceptionally attractive and well-furnished example of a small, early nineteenth-century house.

Freud Museum, 20 Maresfield Gardens, NW3. It was here that Sigmund Freud, the pioneer of psychoanalysis, found a refuge during the last years of his life when he escaped from Nazi Germany. He brought with him his library, his pictures, his collection of antiquities, and the famous couch - colourfully spread with a Kurdistan carpet – on which his patients had reclined. After his death in September 1939 his daughter, Anna Freud, kept his study and library intact; the rooms remain a place of extraordinary and almost mystical power. In July 1986, the house was opened to the public as a museum; the building itself (c.1920, by Albert Hastilow and James Tomblin, with a balcony and conservatory added in 1938 by Ernst Freud) is well worth a visit, as a substantial middleclass residence of the period, with a half-landing to the staircase full of sunlight where Anna Freud's plants still flourish.

Ealing lies due west of the main body of London. The Uxbridge Road, a section of the original highway between London and Oxford. crosses it from east to west, and Western Avenue, cut through in the 1930s, runs roughly parallel to the north of the older highway. When the Great Western Railway was built, a station was opened at Ealing in 1838, and thereafter the borough grew rapidly. Inevitably, the surrounding villages of Acton, Perivale, Southall, Greenford, Hanwell, and Northolt all developed at the same time; the last three have retained their old village centres. The borough covers an area of nearly 20 square miles, and has a population of almost 295,000. There is high ground in the north, on Hanger Hill and on Horsenden Hill, from which some astonishing views across open country can still be obtained. The Brent continues its southern course through the borough to cross the Grand Union Canal just south-west of Hanwell. The local authorities have been particularly vigilant in their maintenance of open spaces; more than 1,500 acres have remained providing in all 127 parks.

EALING itself is a most dignified residential area, with much substantial property. During the eighteenth century, the residence of Princess Amelia, George III's daughter, at Gunnersbury House (see p. 230), and of the Duke of Kent, Queen Victoria's father, at Castle Hill House, gave it considerable prestige; by 1900 it was known as the 'Queen of Suburbs' and in 1901 it became the first Middlesex borough. The modern centre lies along Ealing Broadway, which punctuates two stretches of the Uxbridge Road. In it stands the Town Hall, still the main municipal centre, built in 1888 by Charles Jones, who was Borough Surveyor from 1863 till 1913; the Town Hall has a tower, a spire, and twin archways for an entrance, for all the world as if a small medieval castle had come to rest in the Broadway. Near to it is the church of Christ the Saviour, built in 1852 to designs by Sir George Gilbert Scott, who gave it an ambitious spire. In 1903-8, G. F. Bodley adorned the nave walls with paintings of angels, and designed a screen, which was carved by Rattee and

Kett of Cambridge.

The older part of Ealing lies to the south of the Broadway. The High Street changes its name first to Ealing Green and then to St. Mary's Road, leading to the old parish church, dedicated to St. Mary, Local belief holds that there was a church here in Saxon times, but the first written reference to 'the church at Xelling' dates from 1130. By the beginning of the eighteenth century, it was in ruins and a new church was built in 1739, a neat rectangular brick box with a square west tower. The five medieval bells were recast and, with additional metal, were made into a peal of eight. In 1866, the church was again rebuilt, this time to designs by S. S. Teulon, who set up a large, coarse, brick building with a hefty tower and bare interior. From the older churches, there remain a number of seventeenth- and eighteenth-century tablets and memorials, and one fine brass to a local merchant, Richard Amondesham, who died about 1490 and who is shown in company with his wife, Kateryn, their three sons and their six daughters. In the churchvard are buried John Horne Tooke, the radical politician, and Sarah Trimmer, who founded a Sunday school at Brentford, wrote many children's books, and was a friend of Dr. Johnson.

Northwards from the church, towards Ealing Green, are a number of attractive Georgian cottages and early nineteenth-century houses and, on the west side of the Green, there lie two open spaces, Lammas Park and Walpole Park. In 1770, the younger George Dance built a house, Pitshanger Manor, in the latter for his father-in-law, Thomas Gurnell. This dwelling John Soane acquired and rebuilt in 1800, save for the two best rooms in the south wing. To the new mansion he gave an imposing façade, its centre marked with four great Ionic pillars linked by an emphatic entablature supporting terracotta figures, the whole neatly finished with an elegant balustrade. The interior he decorated with a panache and vivacity which had in part left him by 1811 when he built his last home in Lincoln's Inn Fields (see p. 214); the Breakfast Room, with its strangely shaped recesses and darkly painted panels, is particularly memorable. In 1844, Pitshanger Manor became the home of the unmarried daughters of Spencer Percival, the Prime Minister who had been murdered in the lobby of the House of Commons on 11 May 1812 by a bankrupt merchant, John Bellingham, who had been driven insane by his misfortunes. In 1900, the house was

bought by the borough to serve as a public library, but in 1986 it became a museum with Soane's startling decorations brilliantly restored. As a bonus, it also houses an impressive loan display of Martinware pottery which includes a huge and amazing fireplace.

Ealing possesses three churches, all of considerable architectural distinction. The most important is St. Benedict's abbey, in Charlbury Grove, the first Roman Catholic abbey to be founded in England since the Reformation. It was designed by Charles and Edward Walters, father and son, in 1899 and is all of golden stone with a great west window and a broad flight of steps leading up to the west entrance. Though heavily damaged during the Second World War, it has now been successfully restored by Kerr Bate. Inside, there is a dramatic mosaic of the martyrdom of St. Boniface, and an excellent school for boys is attached to the abbey. Then there is St. Peter's church in Mount Park Road, which was planned by J. D. Sedding in 1893 and was completed after his death by his pupil, H. Wilson. It is a surprising building, in which a traditional fourteenth-century Gothic style has been linked with flowing Art Nouveau lines in the tracery of the windows. Buttresses, not mullions, separate the three lights of the noble west window, and the interior is extraordinarily spacious. The rectory, which stands beside the church, has St. Peter's keys and fishes carved over the doorway. Finally, on the Hanger Hill Estate, there is the Church of the Ascension, designed by Lord Mottistone and Paul Paget, a plain, astringent, and quietly satisfactory building.

On the outskirts of Ealing is Gunnersbury Park.

Early in the nineteenth century, Princess Amelia's house was replaced by two villas which became the property of the Rothschild family. In 1925, they were transformed into an excellent small local museum, which now houses the Sadler Collection of early flint instruments, as well as costume, carriages, and much fascinating nineteenth-century domestic equipment including linen presses and goffering irons.

North-east of Ealing and out of sight of the traffic which thunders along the North Circular Road is TWYFORD, today consisting chiefly of inter-war houses, but for many years the smallest village in Middlesex, and the possessor of an interesting church. The sixteenth-century parish church, St. Mary's, was partly or wholly rebuilt in 1808 – the west porch and pinnacles were certainly added then – but all the monuments were retained. To the old building a new one, designed by N. F. Cachemaille-Day, was added in 1958, the two churches so linked together that one fine east window by A. E. Buss serves to light them both. The new church has an impressive, rather stark tower, over the doorway of which stands a figure of Our Lady, eight feet high and made of concrete; it is the work of Kathleen Parbury. The west wall is broken by 50 small stained-glass windows which shed an extraordinary light within. The earliest monument is to Adriana Gifford (d.1601) who is shown in the company of her four sons and four daughters, and there are others to a father and son, Robert (d.1639) and Walter (d.1660) Movle. Robert, severe and circumspect, wears his hat, even in church, as he was entitled to do, since he was one of the chief clerks of the Court

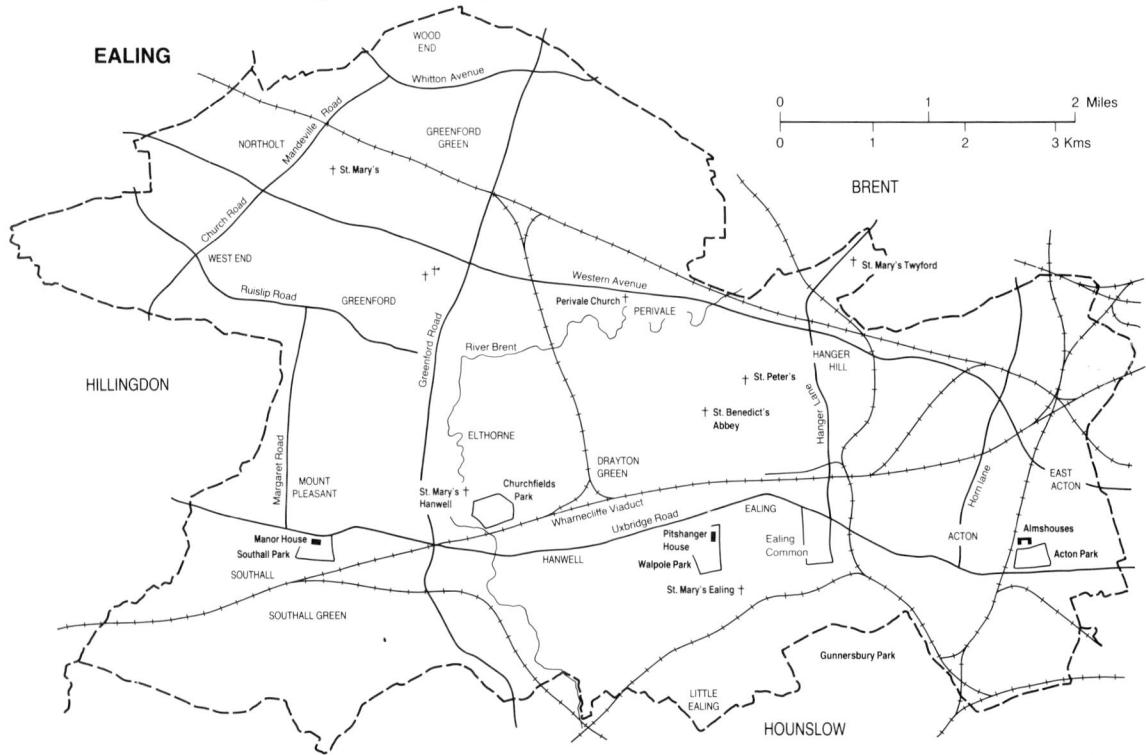

EALING 231

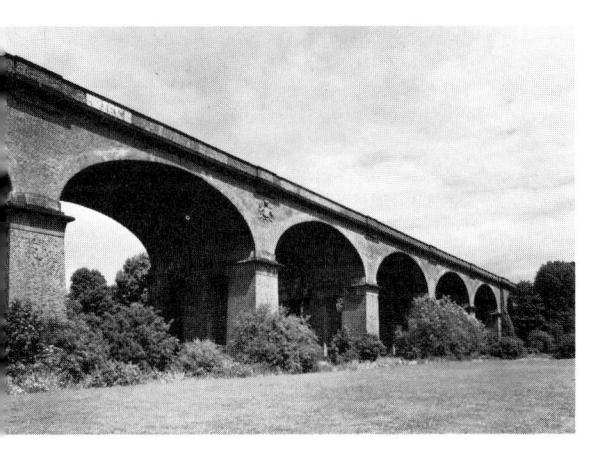

Wharncliffe Viaduct, Hanwell

of Common Pleas: Walter, a freer, far more Baroque figure, has a fashionable curled wig. He died, aged only 31, of grief at the death of his 'little sonne', whose grave is by the sacristy door between the old and new churches. Another father, Fabian Philips (d.1690) who wrote a defence of Charles I, lies here with two sons, one who died in infancy, and another, Andrew, who lived to become a man and whose widow described him on his monument as the 'best of husbands'. The church stands in the grounds of Twyford Abbey, a building now belonging to a nursing order, the Alexian Brotherhood, but with no medieval monastic claims, for it was built about 1808 by P. Atkinson for Thomas Willan, a man of substance, who had once farmed most of the land in Marylebone which Nash laid out as Regent's Park.

ACTON lies in the easternmost corner of the borough, and the greater part of its acres is given over to factories. Indeed, this area has an old industrial tradition, for in 1885 a Stone Age workshop was found where Creffield Road runs today and some 600 worked flints, collected on the site, are now in the British Museum. It was here, on Turnham Green, that the stubborn resistance of the Parliamentary trained bands persuaded the Royalist forces to withdraw after the battle of Brentford in 1642. Throughout the seventeenth and eighteenth centuries, Acton became a favourite place of residence for those who preferred to live a little distance from the metropolis. The Nonconformist divine, Richard Baxter, and his life-long friend, Sir Matthew Hale, Chief Baron of the Exchequer, made their homes here; Henry Fielding, the novelist and reforming magistrate, took a house where Fordhook Avenue now runs and left it desperately ill from overworking, only to set sail for the warmer climate of Portugal, where he died. His house was later occupied by Lady Byron.

Very little remains of the old village. The parish church, St. Mary's, was rebuilt, most unattractively, with an oafish tower, in 1865 by Messrs. Francis,

though a number of small seventeenth- and eighteenth-century memorials were retained to grace its walls, including one to the actress. Elizabeth Barry (d.1713). The Priory Constitutional Club, which stands just to the south-east of the church, occupies a building which, though extensively altered, probably still contains the central early sixteenth-century hall of Berrymead Priory, which stood here before the Reformation. On the south side of the High Street. the George and Dragon Hotel occupies a seventeenth-century, partly timber-framed, building. An obelisk in Acton Park reminds us of the young Earl of Derwentwater, who once had a house here but who lost his head in 1716 for his part in the Old Pretender's Rebellion. On the edge of the park are the Goldsmiths' Company's Almshouses, most attractively built in 1811 and enlarged, with equal elegance, in 1956. One fine eighteenth-century house remains. The Elms in Twyford Crescent: it was built for Sir Joseph Ayloffe, the antiquarian, and is occupied today by Twyford School.

The most interesting building in Acton is modern. It is the Roman Catholic church dedicated to St. Aidan, Designed in 1961 by A. I. Newton, light, open, airy, and very modern, it stands in Old Oak Common Lane. Its most important possession is the great Crucifixion by Graham Sutherland, which hangs on the east wall behind the altar; painted almost entirely in red and black, save for Christ's livid, tormented body, it recalls the suffering expressed in Grunewald's great altarpiece at Isenheim. There is no east window: instead, the north and south walls of the chancel are filled with vivid slab glass set in concrete, depicting English saints and martyrs. The windows were designed by Pierre Fourmaintreaux. and were executed at the Whitefriars Glass works at Harrow. The same artist was responsible for the stained-glass panels in the porch, and the perspex panels there are the work of Arthur Fleischmann, who also designed the Stations of the Cross which are set as a frieze around the south and north aisles, with a continuous mosaic background to give them unity. The side chapels have triptychs of the Sacred Heart and Our Lady by Roy de Maistre; formal and hieratic, with gilt backgrounds, they have a strong Byzantine quality. The huge Portland stone figure of St. Aidan set on the tower wall is by Kathleen Parbury, as is the delicate limewood figure of St. Thérèse of Lisieux in the nave; there are also figures of St Joseph, St. Anthony of Padua, and St. Gerard Majella by George Campbell, P. Lindsay Clark, and Arthur J. J. Ayres. This last stands in the the Children's Room, while in the church hall is an enormous painting by Carel Weight of Christ Preaching to the People which the artist presented as a token of his sympathy with the ecumenical movement.

HANWELL lies to the south-west of Ealing, just north of the Uxbridge Road, its dominating feature the dramatic viaduct. The village green still exists, more or less intact, with the parish church beside it, dedicated to St. Marv. This, built in 1841, was one of Sir George Gilbert Scott's earliest attempts, prim and neat with a tall spire and octagonal pillars within. The nave walls are decorated with paintings by William Frederick Yeames, and one elegant memorial has been retained from the earlier churches which stood on the site: it is to Margaret Emma Orde (d.1806) and was the work of P. M. van Gelder. The philanthropist, Jonas Hanway, is buried in the crypt and Gainsborough's daughter lies here too. There are several fascinating cottages in Church Road and to the south is Wharncliffe Viaduct, one of the rare examples of a man-made construction which improves the natural landscape. Brunel designed it in 1838 to carry the Great Western Railway across the Brent, and the viaduct bears the name and the arms of the chairman of the company, Lord Wharncliffe; the view from it is so fine that Queen Victoria always instructed her engine-driver to cross it slowly so that she might have time to appreciate the prospect. South of St. Mary's, in Boston Road, stands another church dedicated to St. Thomas; it was designed by Edward Maufe, the architect of Guildford Cathedral; it contains sculpture by Eric Gill, and the reredos and organ from the now demolished church of St. Thomas which used to stand in Portman Square, St. Marvlebone.

PERIVALE lies to the north of Hanwell, on the edge of Western Avenue. The village centre has been obliterated by the great thoroughfare, but a little

West door of St. Mary's, Perivale

church remains, dedicated to St. Mary the Virgin. The body of the church, built of ragstone rubble and flint, dates from the thirteenth century, but the low tower is of white weather-boarding - most unusual for Middlesex. The west door dates from the fifteenth century and the roof is of the same period. constructed with king-posts and chamfered tyebeams. The octagonal font is equally early, but has a fine mid-seventeenth-century cover with a pine-cone finial, given by a parishioner, Simon Coston. There is one brass, to Simon Myllet (d.1505) who is shown with his two wives, Alice and Joan, and the 15 children they bore him, and several later monuments. including one carved by Richard Westmacott in memory of Ellen Nicholas, who died young in 1815. On the opposite side of the busy main road stands the Hoover Factory, designed in 1932-8 by Wallis. Gilbert and Partners.

In the south-western corner of the borough lie SOUTHALL and NORWOOD, mid-nineteenth-century building for the most part but able to boast respectively a sixteenth-century manor house and a church, parts of which date from the twelfth century. The house was built in 1587 by Richard Awsiter and has remained almost unaltered save for the addition of a wing in the eighteenth century. It is timberframed, the uprights or standards set closely together; there is a broad fireplace in the main hall and some interesting carving on the panelling. In 1970, it was carefully restored by the Borough Council and is today occupied by the local Chamber of Commerce. Before the Awsiters acquired the manor and built the house, the land was held by the Shoredyches and the Chesemans, one of whom, Robert, one of Henry VIII's gentlemen, was painted by Holbein; the miniature can be seen in the Victoria and Albert Museum. All these families, and the Merricks, who rivalled the Awsiters in local importance, were buried in St. Mary's Church, which stands beside the village green near to a fine eighteenth-century house, The Grange. The walls are of twelfth- and thirteenth-century workmanship, but were refaced with gaudy multi-coloured bricks mixed with flints in 1864, though the original surface can still be seen on the north wall and the thirteenthand fourteenth-century windows in the south wall are intact. The roof was renewed by Archbishop Chichele in 1439 and is still sound; the octagonal font with quatrefoil adornment is of roughly the same date. There are two brasses in the north wall of the chancel showing Matthew Hunsley (d.1618) and Francis Awsiter (d.1624), and an elaborate monument to Edward Cheseman and his son Robert (d.1556) above which hang a helm and sword, possibly connected with the family. The glass here is of particular interest, for in the south-east window of the nave we are shown Our Lady with the Child, who holds a toy windmill; it is of late sixteenth- or early seventeenth-century European workmanship, and there are more roundels set in the west window.

EALING 233

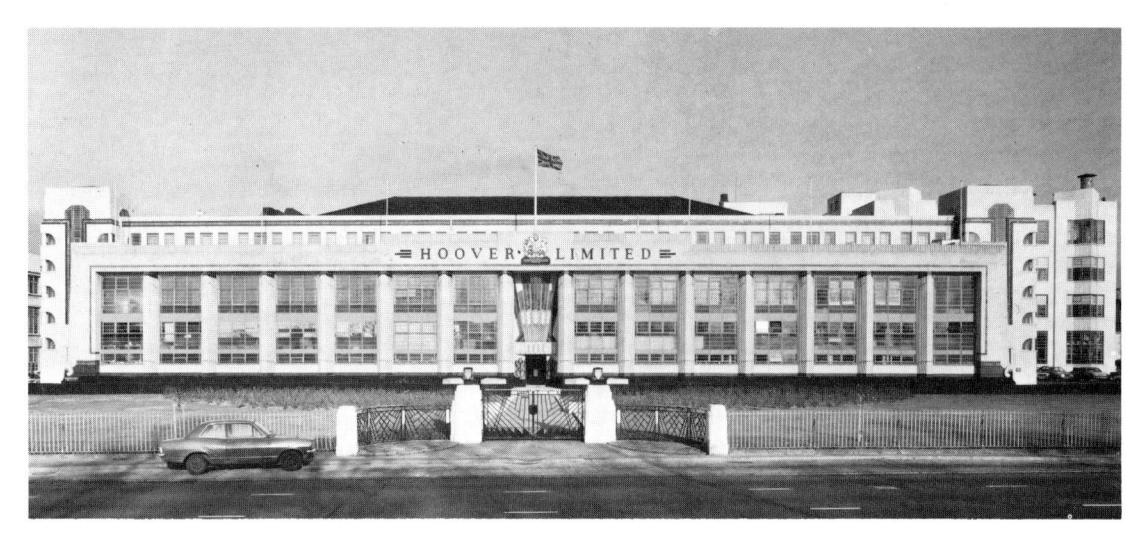

Hoover Factory, Perivale

In the early nineteenth century, Norwood became known for its brick-making, and the bricks for Buckingham Palace came from here.

North of Southall, now an attractive and well laid-out suburb, is GREENFORD, which Norden described in 1593 as 'a very fertile place of corn'. Two parish churches, an old and a new, both dedicated to Holy Cross, stand side by side. The older building dates from the late fifteenth or early sixteenth century, though the chancel was altered and possibly shortened in the seventeenth. The walls are of flint rubble with stone dressings but the west tower is of weather-boarding, like Perivale. Once again, it is the glass which deserves especial attention, since it dates from the sixteenth century and is said to come from King's College, Cambridge, the arms of which institution appear in the south-east and south-west windows. There is more heraldic glass - the arms of Henry VIII and Katherine of Aragon may be seen in the east window, and those of Eton College in the south-west – and there are many other fragments, several of them showing pretty devices such as a windmill, roses, the moon, a stag, and the head of a bearded saint. There are brasses to past rectors, one, un-named, dating from about 1450, another to an unknown lady in a butterfly head dress (c.1480) and a third to Thomas Symons who died in 1521, and two monuments, one showing Michael Gardiner, a rector who died in 1630, kneeling opposite his wife, and another to Simon Coston (d.1637) whose widow Bridget holds a baby boy, her five daughters, Frances, Mary, Jane, Anne, and Philadelphia, all kneeling behind her, while their late father, his cheek resting on his hand, looks down on them wistfully from a niche at the back of the monument. It is signed by Humphrey Moyer. The eldest daughter, Frances, gave the round font with its baluster stem to the church in the following year.

The modern church was begun in 1939 to the designs of Sir Albert Richardson. The interior is like that of a huge medieval barn with an open timber roof and stalwart posts to form the aisles. Though not entirely successful, since the pin-jointing of the beams makes the woodwork look like scaffolding rather than cruck construction, the church is an interesting experiment. The churchyard in which the two buildings stand is exceptionally well kept.

NORTHOLT lies in the westernmost corner of the borough. Domesday Book tells us that this village once belonged to Ansgar, the portreeve of London, who fought beside Harold at Hastings and who, despite his wounds, returned to London to negotiate the capital's peace with William the Conqueror. To-day, Northolt itself is built over with row upon row of little twentieth-century houses, and there is a small aerodrome, where Neville Chamberlain landed after he had negotiated the Munich Agreement with Hitler in 1938. Happily the village green has remained undisturbed and the village church, dedicated to St. Mary, stands beside it. It is a plain little building, made of flint and rubble, its nave dating from the thirteenth century, its brick chancel and bell tower from the sixteenth. The octagonal font was a gift from Sir Nicholas Brembre and bears his arms as Lord Mayor of London. He was Richard II's staunch supporter, for he stood beside the boy-king when he faced Wat Tyler at Smithfield in 1481 and lost his head on the block for his loyalty in 1488, when his monarch attempted, and failed, to establish absolute rule. There are three brasses set in the floor of the nave; they are to Henry Rowdell (d.1452), to Isaiah Bures, the rector (d.1610), and to Susan Gyfforde (d.1560) who is shown with her husband John and their 12 children. A tablet reminds us that Grownow Owen (1723–1769), the Welsh poet, was curate here for two years.

Enfield

ENFIELD is the most northerly of all the new London boroughs. It unites the former boroughs of Enfield, Edmonton, and Southgate, thus virtually reconstituting the medieval Hundred of Edmonton. Its 20,000 acres house a population of about 261,000, unusually low for an area so near to the capital. The northwestern corner is still almost completely rural, being either farmland or protected countryside. The extensive parks here - White Webbs, Forty Hill, and Trent Park - are the remains of Enfield Chase, a royal hunting ground from Saxon to Stuart times. To the east where the River Lea flows from north to south, providing a natural boundary between Middlesex and Essex, there is a good deal of industrial and commercial development, some of it (see pp. 235-6) of great interest to the industrial archaeologist. The Cambridge and Hertford Roads run more or less parallel with the line of the river but, in spite of all this bustle, there is an unexpected amount of wild life to be observed in the area.

ENFIELD TOWN, busy, bustling, and predominantly early twentieth-century, lies to the east of the Cambridge Road and is concentrated around the parish church dedicated to St. Andrew. It is a substantial building, such as one would expect to find in a country market town. The oldest part is the thirteenth-century chancel, while the ragstone and flint rubble nave and west tower date from the late fourteenth century. The north and south aisles were rebuilt and widened about a century later, and the south aisle was again rebuilt, this time in brick, in 1824. The interior is spacious and well lit with a fine, portly organ case of 1752 sitting proudly in the west gallery. The fourteenth-century north and south arcades are five bays long with quatrefoiled piers and a sixteenth-century clerestory above. The chancel arch was widened in 1779 when a painting of the Doom was removed, to be replaced with a Crucifixion in 1923 by Powell's of Highgate - the exchange seems a poor one artistically.

Though of no great architectural significance, St.

Andrew's possesses some important monuments, the most imposing of them being that of Joyce, Lady Tiptoft (d.1446) which stands between the chancel and the north chapel. It is an altar-tomb of painted stone, with four lozenge-shaped panels on each side enclosing coats of arms. Above the tomb is an elaborate canopy, and a magnificent brass of the lady - one of the finest in the London area - is set in its lid. On the north wall of the chancel is a tablet of black marble and alabaster with figures of Faith, Hope, and Charity; it was carved by Nicholas Stone in memory of Martha Palmere, who died in 1617 and whose character was such 'that her whole life was a communion daye'. On the opposite wall of the chancel, John Watt (d.1701) has a pretty marble cartouche, the inscription surrounded by fruit and

The pride of the church stands in the north chapel a huge three-storeyed alabaster and marble monument to Sir Nicholas Raynton, Lord Mayor of London (d.1646), and Rebecca his wife, who lived nearby and are buried there in company with their nephew and niece, another Nicholas and Rebecca. The younger couple kneel on the lowest stage, their sons and daughters behind them and an altar between them, at the foot of which is a cradle containing the effigy of a swaddled infant. Above them lies Lady Raynton, studying a little book containing the Ten Commandments, and above her Sir Nicholas reclines, wearing his mayoral chain of office and grasping the hilt of his broken sword. The monument terminates in a magnificent be-swagged pediment, broken by a cartouche with the family coat of arms. The north chapel also contains a nice tablet to Robert Deicrowe (d.1586), his mother Joan, and Robert Wheler, his master, while in the south chapel are two small wall monuments with kneeling figures, one to Dorothy Middlemore (d.1610) and the other to Francis Evington, alderman of London (d.1614). The same chapel contains a brass to William Smith (d.1592) and his wife Jone (sic) who wears a broad hooped skirt. In the corner of the chapel is a fine monument to Thomas Stringer (d.1706) which Pevsner suggests may be by Francis Bird. A bust of the dead man is sheltered by a canopy in the form of a tent, the whole being set on a marble pedestal on which is cut an eloquently phrased epitaph. There are sixteenth-century fragments of ENFIELD 235

glass in the north-east window of the north chapel and in the third window of the south aisle, and early seventeenth-century bread-shelves with neat little Tuscan columns in the north chapel.

The church stands in an attractive churchyard, set back behind the market place, in which an open weekly market has been held since 1632. It still continues, brisk and lively, each Saturday, though the present market house, an open building with pitched roof supported on eight pillars, was only constructed in 1904 to celebrate the coronation of Edward VII. Enfield Manor House, built in the late sixteenth century and the property of the crown through the Duchy of Lancaster, used to stand on the south side of the market place till it was demolished, partly in 1792 and completely in 1928. Some of its panelling, a superb fireplace, and one fine ceiling were saved and installed in a wing of an otherwise modern house in Gentleman's Row. This fascinating street lies, tucked away, to the west of the church. Numbers 9 to 23 are all old, built for the most part in the early eighteenth century. Number 11 is weatherboarded and jetties out across the pavement, while number 17 provided a temporary refuge for Charles Lamb and his poor deranged sister, Mary, in 1827. At the end of the Row, a series of bridges lead to and fro across the meanderings of the New River (see also p. 296) till an attractive early nineteenth-century public house, the Crown and Compass, with its pleasant garden, is reached. A wide arc of alleyways

Enfield West (now Oakwood) underground station

leads back to the churchyard, passing on the way Enfield Grammar School. The name of a celebrated eighteenth-century naturalist, who was also headmaster, is preserved in Uvedale Cottage, a timber-framed dwelling which nestles beside the original school building, established in 1555 upon a chantry foundation at least half a century older and still, though much restored, put to good use.

Another Enfield academy has now vanished. This was the school run by John Clarke, father of Charles Cowden Clarke, which John Keats attended from 1803 till 1811. The building had begun as a private house in the 1670s when it was constructed by Edward Helder, a bricklayer who had also worked for Wren; in 1849 it became the terminus of the railway to Enfield and was demolished in 1872, but the façade of the upper central storey was saved and is now in the Victoria and Albert Museum.

The road running northwards from the church changes its name as it goes, from Silver Street to Baker Street and then to Forty Hill. On the east side stand two pretty early eighteenth-century cottages, Worcester Lodge and Elsynge Cottage. It was near here that Elsynge Hall stood, where the future Elizabeth I spent much of her childhood and where she and her brother, Edward VI, wept in each other's arms at the news of the death of their aweinspiring father. Elsynge Hall has gone, demolished in the 1650s. It stood directly to the north of the fine new house, Forty Hall, which Sir Nicholas Raynton built for himself between 1629 and 1636, and which serves today as a museum with displays of archaeological and local material, and frequent loan exhibitions. The house is of brick with stone dressings, six bays wide and three storeys high, with a stylish cornice set beneath the eaves of the roof. Tradition ascribes the design to Inigo Jones, but there is no documentary evidence for this belief. Inside, the main features are the intricately patterned plasterwork ceilings, the handsome fireplaces, and the screen, adorned with shell motifs, across the main hall. A portrait of Sir Nicholas, possibly by William Dobson, hangs in the Raynton Room.

Further up the hill, to the north, is Myddelton House, built in 1818, where Sir Hugh Myddelton is traditionally but inaccurately said to have resided two centuries earlier when engineering the New River to carry fresh water from Amwell Springs in Hertfordshire through Enfield to Islington. Nearby is Capel House, built in the eighteenth century and used today as an agricultural college. The road leads across the county border into Hertfordshire where it soon reaches Theobalds, which James I preferred to Enfield Chase as a hunting preserve, and where Wren's Temple Bar still stands, boarded up for protection against vandals, waiting hopefully to be returned one day to a fitting site in the metropolis.

The eastern side of the borough is a sharp contrast to the rural north. The river Lea has always served as a means of transport – the stone for Waltham Abbey

in Essex may well have been carried on it. In 1767, a series of locks was built along it so that the river could be used as a canal, carrying bulk cargoes of grain from Hertfordshire and Essex, gunpowder from the mills at Waltham Abbey, and rifles from the Small Arms Factory at Enfield Lock, established in 1804 and still a security area. 'Brown Bess' muskets were manufactured from 1816 onwards, and from 1854 the armaments factory was expanded to produce the Enfield rifle. By 1900, 2,000 men were producing 60,000 rifles annually; output increased during two world wars. Another weapon, the Bren light machine-gun, took part of its name from Enfield and part from the equally famous ordnance factory at Brno in Czechoslovakia. The industrial archaeologist will make an expedition there, and to Ponders End, where a group of early nineteenthcentury flour-mills still stand, and to Pickett's Lock. The whole area is now part of a great rehabilitation scheme, the creation of the Lea Valley Regional Park. The plan was first put forward by Sir Patrick Abercrombie; the Park Authority, which has its headquarters at Myddelton House, is steadily redeeming some 25 miles of river valley running through land controlled by 18 different local authorities, from its condition earlier this century as an industrial slum, and transforming it once again into an area of varied natural beauty.

Gentleman's Row, Enfield

Forty Hall, Enfield

EDMONTON, unlike Enfield, grew up directly upon the main roads to Cambridge and to Waltham Abbey, that great and wonderful Norman church where the body of Harold, last King of the English, lies, and which was, until the Reformation, one of the most important monastic houses near to London. Comparatively little remains of old Edmonton though Cowper's ballad of John Gilpin's luckless ride to the Bell Inn there, to celebrate his wedding anniversary, has conferred undying literary fame upon it. The inn has now vanished and so has the twelfth-century church which must once have stood in Church Street. Fragments of carved mouldings from its arches are set in the west wall of the present building which is dedicated to All Saints. Its chancel, vestry, nave, north aisle, and west tower were all built in the fifteenth century; the north aisle was refaced with brick in 1772 and the south aisle was added in 1889. The fifteenth-century east window remains intact though much restored and the heavy door into the vestry is of the same date. The roofs are of particular interest. Those to the vestry and nave are of the fifteenth century; the nave has chamfered tie-beams and the wall-posts rest on stone corbels which were once adorned with angels holding shields. The beams above the north vestry are a century later, and the north aisle was roofed in the seventeenth century with sixteen flat panels arranged in alternate cross and lozenge patterns.

There are several brasses, now set in the west wall; we can see Edward (d.1616) and Mary Nowell with their three sons and one daughter, John Asplyn and Godfrey Askew, who stand on either side of Elizabeth, the wife they both married (c.1500), and Nicholas and Elizabeth Boone (d.1523), as well as two other figures and a group of children who are now nameless, besides the indents for several others. John Kirton, who died about 1530, has a fine though somewhat battered monument, and there is an impressive one to George Huxley (d.1627) which stands in the chancel. Charles Lamb spent the last year of his life in Bay Cottage near to the church; he

ENFIELD 237

and his sister, whom he loved and cared for so devotedly, lie in one grave in the churchyard.

Until 1940, Edmonton could boast of two sixteenth-century houses, but in that year one of them Pymme's, was burnt down. It stood in Pymme's Park off Silver Street, where the remains of its walled rose-garden may be seen. Salisbury House is still standing, however, on the south side of Bury Street: timber-framed, it was built about 1600 and the two upper storeys project above the ground floor on all sides. Inside, several of the rooms still retain their panelling, and in one there is a fine overmantel to the fireplace. It is today used as an arts centre and is well maintained by the borough. A modern building nearby deserves mention; it is the public library at the junction of Bush Hill and Ridge Avenue. Constructed largely of glass, with butterfly roofs, it was designed by T. A. Wilkinson, Borough Architect, and Brian van Breda

SOUTHGATE, today consisting largely of superior 1930s housing, occupies the south-western corner of the borough and was what its name implies, the southern entrance to Enfield Chase. There is a large, remarkably unspoilt village green at the northern end of Cannon Hill, and the parish church, Christ Church, stands on the south side of Waterfall Road. It was founded in 1615 as a chapel of ease because of the distance to Edmonton, but the old building was demolished in 1862 and the present church was built

to designs by Sir George Gilbert Scott. The old sanctus bell, dated 1616, was hung in the tower along with a peal of ten modern bells. The present building is pleasant but unremarkable enough, save for the stained-glass windows which shed a luscious light into the interior. They were executed by William Morris's company, the west window of the south aisle with St. James and St. Jude having been designed by Rossetti in 1865, while those in the north aisle, displaying the Christian virtues, were by Burne-Iones and date from 1865, 1866, 1885, and 1898. In a little garden of remembrance, laid out in 1934 just beside the church, stands the giant Minchenden Oak, its girth over 27 feet. It is probably more than 800 years old and is a last survivor of the forest of Middlesex.

The houses near to the Green are worth attention. The Olde Cherry Tree Inn is there, and Arnoside, Old House, and Essex House, all in Waterfall Road, date from the eighteenth century. On the corner of the Green is Southgate House, now used as offices. Formerly known as Arnos Grove, it was built about 1719 for James Colebrook and to it Sir Robert Taylor made additions, exquisitely decorated in the Adam style, about 1777. The original staircase hall remains, decorated with paintings executed about 1723 by Lanscroon, a pupil of Verrio. The present occupants have treated the building with proper respect.

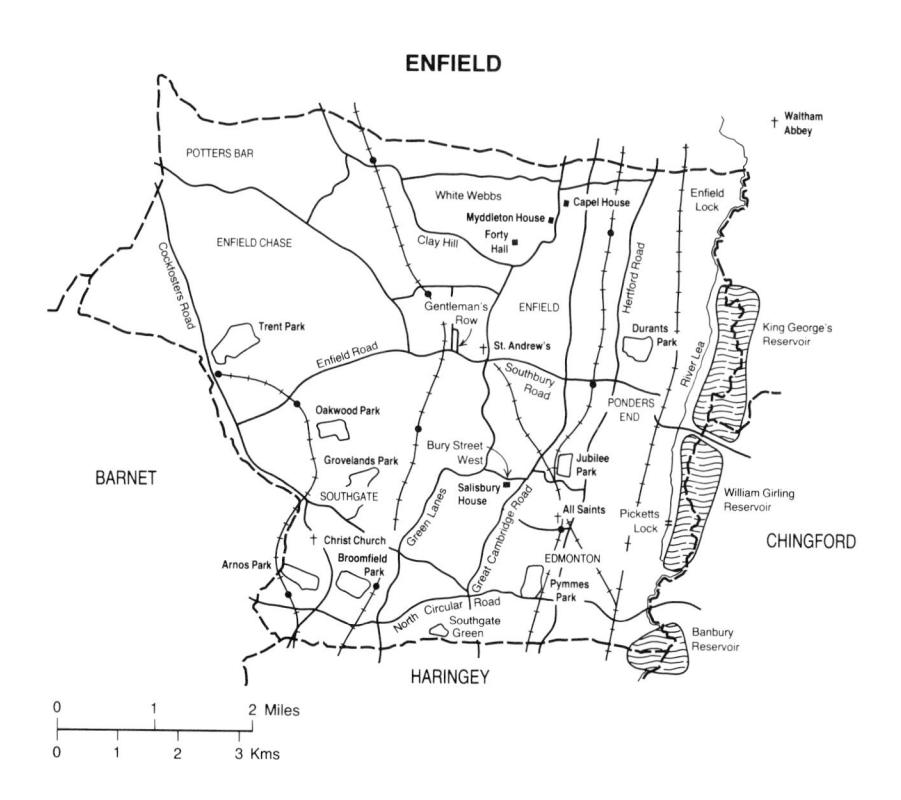

Southgate underground station

South of the Green, where Cannon Hill joins Alderman's Hill, is Broomfield Park in which stands Broomfield Lodge, built in the seventeenth century and now a good local museum with loan exhibitions, a magnificent Victorian nursery and, to the delight of all youthful visitors, a glass beehive which is connected, by means of a small glass tunnel, with the park. The hall of the house is decorated with pleasant mythological scenes, formerly attributed to Sir James Thornhill but now believed to have been executed by Lanscroon when he was working nearby. Northwards is Grovelands Park, which may be approached from Bourne Hill. In it stands a house with an Ionic portico and colonnade, built by John Nash in 1798 and, until 1976, used as a nursing home; most of the grounds are open to the public. Still further north is

Trent Park, which is more properly a part of Enfield. A house was built here for the physician, Sir Richard Jebb, who successfully attended the Duke of Gloucester when he was ill at Trent in the Italian Tyrol. The house was refaced about 1926 for Sir Philip Sassoon, using bricks from William Kent's Devonshire House in Piccadilly, which had just been demolished. Today, it belongs to the Greater London Council and is used as a training college for teachers. The grounds were laid out by Humphry Repton and are still beautiful, two centuries later. Parts of them are open to the public.

In Southgate and the country to the north, three tube stations, Arnos Grove, Southgate, and Cockfosters, built during the 1930s by Charles Holden, are all outstandingly good.

Hackney

Strangely shaped, like a leg-of-mutton sleeve, Hackney lies to the north-east of London. A narrow cuff of land, Shoreditch, in which there is much light industry and commercial development, touches the City boundary and the new administrative area swells out voluminously with the former boroughs of Hackney and Stoke Newington to the north. The River Lea provides part of its eastern boundary and the open, low-lying land at Hackney Marshes is being incorporated into the Lea Valley Development Scheme (see p. 236). To the north, at Stamford Hill, from which James I had his first sight of the capital he had ridden south to claim, is high land where the Hackney Brook, now culverted, flows. The borough covers an area of nearly 5,000 acres and has a population of about 194,000.

SHOREDITCH, a tiny, densely populated area, its urban character intensified by its proximity to the City of London, is made up from the two former villages of Haggeston and Hoxton. It can boast of its parish church, St. Leonard's, a museum, the Geffrye Museum, and a host of literary associations, for it was here, safely outside the City boundary and beyond the authority of the city fathers, that James Burbage established England's first theatre in 1576. With magnificent simplicity, he named it The Theatre. An elegant and informative tablet has been set up to mark the site on the corner of Curtain Road and New Inn Yard. Within a few months of its opening, the Theatre was joined by a second place of entertainment, the Curtain. Built, almost certainly, where Hewett Street runs today, it took its name from the curtain wall of Holywell Priory rather than from the stage accessory, and remained in existence till at least 1627. Burbage's company performed successfully for 22 years till, in 1598, when the ground lease was about to expire, his sons, Richard and Cuthbert, pulled down the wooden building and carted the materials across to Bankside where they rebuilt them as the Globe, a fresh site being leased by them and by five members of the company, one of whom was William Shakespeare. Dickens joins Shakespeare in Shoreditch's memories, for it was at

Windsor Terrace, City Road, that Mr. Micawber resided. The terrace has long since been rebuilt but an adjacent street has been named after that unforgettable character, as perpetually hopeful as he was eternally insolvent.

The parish church, dedicated to St. Leonard, stands on the east side of the High Street. Of twelfth-century foundation, it was rebuilt by the elder George Dance between 1736 and 1740. A large, stalwart, red-brick building entered through a Portland stone, Tuscan-pillared portico, it is remarkable chiefly for its steeple, 192 feet high, terminating in an elongated stone cupola with a slender lantern and tiny spire on top. In it hang the 13 bells which, in the nursery rhyme, ring out the wistful couplet:

When I grow rich, Say the bells of Shoreditch.

Inside is a fine contemporary pulpit, Ionic pillars supporting the sounding board, and on the west gallery is set a clock with an exquisitely carved surround, though bombs shattered the 1634 glass of the east window.

Several monuments have been retained from the old church, including a fine tomb chest, now in the crypt, to John Huniiades (d.1696), and a wall-tablet to Elizabeth Benson who died in 1710, on which two terrifying skeletons rive a young oak tree apart by tugging at drapery hung from its branches. A modern tablet records that in the churchyard lie James, Cuthbert, and Richard Burbage in company with Will Somers, Henry VIII's jester, and Richard Tarleton, the clown of Burbage's company, as well as their fellow players, Richard Cowley, William Sly, Nicholas Wilkinson, and poor Gabriel Spencer whom Ben Jonson killed in a duel. Fortunatus Green, son of the playwright, Robert, who called Shakespeare 'an upstart crow', lies here too, and so does Sir Philip Sidney's only child, Elizabeth, who was the Queen's godchild, and who became Countess of Rutland. The whipping post and stocks are still in the churchyard, protected under a thatched roof.

The Geffrye Museum lies in the Kingsland Road, about a mile north of the church. The buildings were originally a group of 14 almshouses, founded about 1715 out in the fields beyond the hugger-mugger of the city. They were established under the will of Sir Robert Geffrye, Lord Mayor of London and Master

of the Ironmongers' Company, who had died in 1704. By 1908, the green fields had all vanished and the Ironmongers rebuilt the almshouses at Mottingham in Kent. They took with them the statue of Sir Robert which had stood over the entrance, the old buildings were acquired by the London County Council, and a replica of the statue refilled the empty niche. The almshouses became a museum of furniture, arranged in period rooms, beginning in Elizabethan times and continuing to the present day, so that they also provide a panorama of English domestic life. Shop-fronts and doorways from all over London have found refuge here. There is a firstclass reconstruction of a carpenter's shop from Narrow Street, Limehouse, and the Stuart Room with a fine plastered ceiling, which was originally the Master's Parlour in the Pewterers' Hall. Children are welcome, and facilities are provided for school parties.

Nearby, the massive red brick edifice of **St.** Columba's church, designed by James Brooks and consecrated in 1869, which has been closed for several years, is to be reopened and restored by the Christ Apostolic Church of Nigeria. To the North, on the corner of De Beauvoir Road and Downham Street, is the newly-built public library. The archives and local history department contains about 200 water-colours, including work by Varley, Prout, and Thomas Hosmer Shepherd.

To the north-east is HACKNEY, which includes the former villages of Dalston, Hackney Wick, Clapton, and Kingsland. Till 150 years ago, this was completely rural and there are still large open areas at London Fields, Hackney Downs, and Hackney

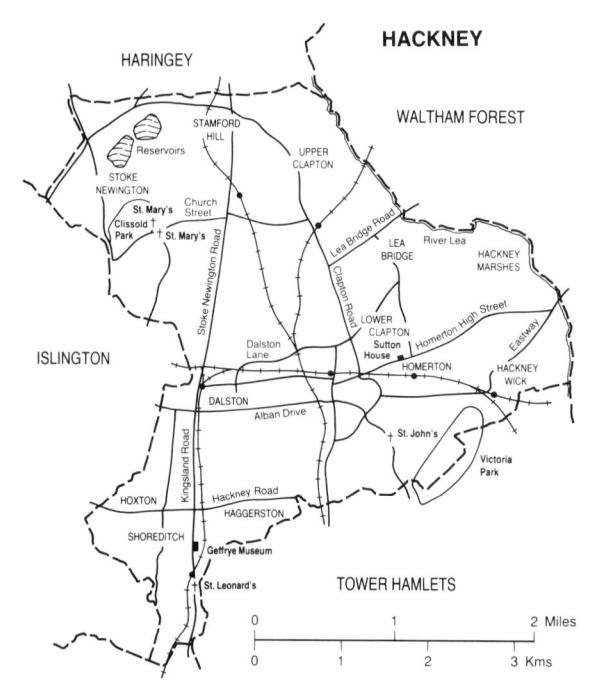

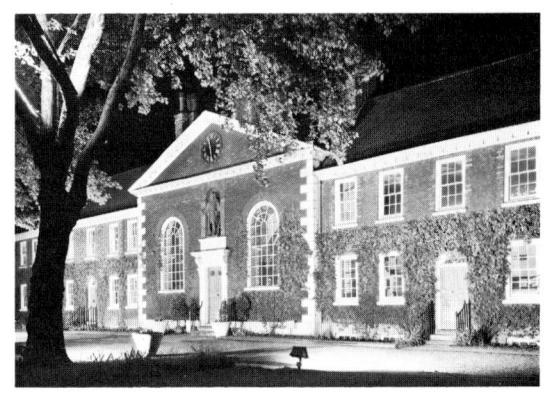

Geffrye Museum, Shoreditch

Marshes, and in Victoria Park (see pp. 319–20). The eighteenth-century parish church, dedicated to St. John, stands in a spacious churchyard opposite the junction of Mare Street and Dalston Lane. The foundation dates from the thirteenth century. In the churchyard stand the remains of an older building, the fifteenth-century tower of the former parish church, St. Augustine's. St. John's was designed by James Spiller in the shape of a Greek cross and was built between 1792 and 1797, the steeple being added in 1812.

Several monuments were brought across from the old church and arranged in two chapels on either side of the entrance. They include a brass to Arthur Dericote (d.1462) and his four wives, Marie, Eme, Margaret, and Jone, and an indent, John Lymsey's (d.1545), with figures four-and-a-half feet high. Christopher Urswyck, Dean of Windsor and Rector of Hackney (d.1522) who performed the marriage ceremony between Henry VII and Elizabeth of York, their union ending the long Wars of the Roses, lies under a delicate canopy in an altar tomb which also serves as an Easter sepulchre, and another, reconstructed, tomb-chest supports an effigy of Lucye, Lady Latimer (d.1583); she wears a ruff and a dainty French cap and her hands are tightly pressed together in prayer. Henry Banister (d.1628) kneels opposite his smartly dressed wife, Anne, on a small wallmonument, and David Doulben, Bishop of Bangor (d.1633), looks down from another. Thomas (d.1649) and Susann Wood have an exceptionally pretty tablet; they are shown against a draped curtain, their eight children, one of whom, Thomas, became Bishop of Lichfield, grouped about them. The fine bronze war memorial to the 800 men of Hackney who lost their lives in the First World War is the work of Richard Goulden. In the churchyard outside, part of which is now a rose-garden, is a memorial to a blind man, Fred George, with an inscription in Braille which reads: One thing I know: whereas I was blind, now I do see.

To the east of the church, in Homerton High Street, stands St. John's or Sutton House. H-shaped HACKNEY 241

in plan, it was built in the first half of the sixteenth century from dark red bricks; the interior still retains several rooms lined with fine linen-fold panelling. It was the home of Thomas Sutton, Master of the Ordnance to Queen Elizabeth, who commanded his own ship against the Armada and had the good fortune to capture a Spanish galleon with a rich cargo. He married Elizabeth, widow of John Dudley, and through her became lord of the manor at Stoke Newington, whither he retired, having become the richest commoner in England. He purchased the Charterhouse from the Howard family and founded there a school for boys and a home for elderly men, both of which still flourish (see pp. 293-4). Later occupants were Sir Thomas Picton, who fell at Waterloo, and Dr. Burnett, the grammarian; today the house is the property of the National Trust and is used for offices.

War damage has robbed Hackney of a second Elizabethan mansion, **Brooke House**, which had been a home to Margaret, Lady Lennox, mother of Mary Queen of Scots' luckless husband, Henry Darnley, and Edward de Vere, the poet Earl of Oxford, Lyly's employer and Spenser's patron. Evelyn and Pepys were both visitors; Evelyn approved of the garden – 'one of the neatest and most celebrated in England', he wrote – while Pepys so coveted the oranges he saw growing there that he

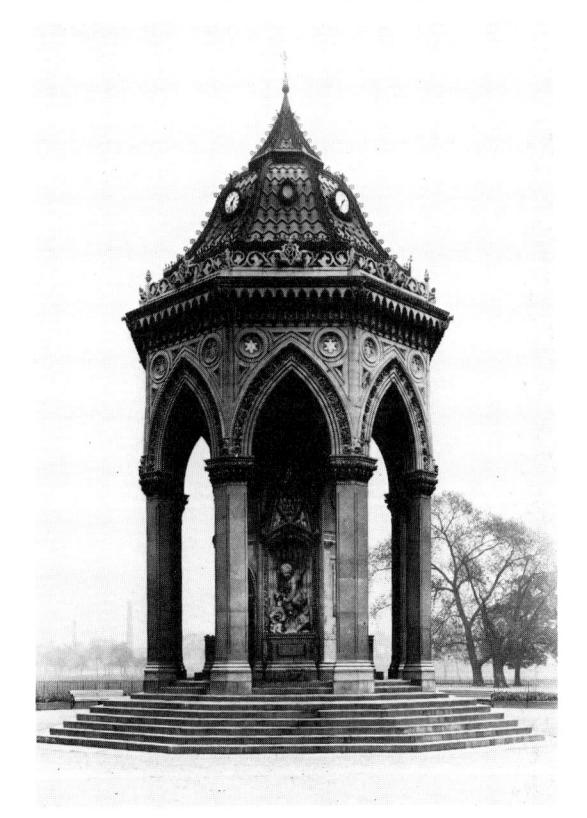

Victoria Park fountain, Hackney

'pulled off a little one by stealth and eat it'. The ruins, on the corner of Upper Clapton Road and Brooke Road, were demolished in 1954 and Brooke House School stands on the site.

Hackney has several interesting Victorian churches. One of the oldest is St. John of Jerusalem. designed by Hakewill and built in 1845-8 on an island site in Church Crescent, Scrupulously Gothic in design and detail, it has a tall west tower and a broad entrance porch like a French cathedral. St. Mark's, Dalston, in St. Mark's Rise, Sandringham Road, was known as 'the cathedral of East London': of enormous size, it was designed by the younger Chester Cheston, of whose work virtually nothing else is known, and was consecrated in 1870. Out on the flat marshes, along Eastway, is St. Marv-of-Eton, designed by Bodley in 1890 as the centre of the Eton Mission and completed in 1912 by Cecil Hare, Of red brick with Bath stone dressing, the broad nave has a painted waggon roof and over the high altar is a painting of the Assumption of Our Lady with Henry VI kneeling before her, his foundation, Eton College, in the left foreground with the Mission buildings to the right. Finally, in Castlewood Road to the extreme north stands the Church of the Good Shepherd, built in 1896 for the Agapemonites, the followers of John Hugh Smyth Pigott, Designed by I. Morris, with four huge symbols of the Evangelists, sculpted by Arthur George Walker, set about the tower, it has a fine stained-glass window by Walter Crane, depicting the rising of the Sun of Righteous-

Northwards is STOKE NEWINGTON. Scarcely a hundred years ago, this was a rural area. The population, which had been a bare 2,000 in 1820. more than doubled itself, from 17,500 to 37,500, in the ten years between 1870 and 1880; today, it has shrunk again. Early development was concentrated on the western side, with clusters of houses about the church and around Newington Green. Throughout the eighteenth and nineteenth centuries, the parish had a strong Nonconformist bias, Newington Green Chapel being built as early as 1708. Today, two parish churches, both dedicated to St. Mary, stand opposite each other on either side of the western end of Church Street. In the old church, the nave and south porch date from the late fifteenth century, but the whole building was refurbished by William Patten in 1563 when his arms were set above the entrance. The south aisle and its arcade are of red Tudor brick. In 1829, a timber spire was set on top of the brick tower, intensifying the appealing, villagelike appearance of the little building. Inside, John Dudley (d.1581) kneels opposite his wife Elizabeth and their six-year-old daughter; Elizabeth survived him for more than 20 years, becoming the wife of Thomas Sutton, but she chose to lie beside her first love. Thomas Banks carved a graceful figure leaning over an urn in memory of Joseph (d.1793) and Sarah Hurlock, and an exquisite small marble figure of a

reclining woman with a child is set under the tower as a memorial to Alexander Chalmers (d.1927). Up in the tower is a clock given to the church in 1723 by the Reverend John Millington, rector at that time. The new church, designed in 1858 by Sir George Gilbert Scott, is an imposing building with a tall spire in the Early English manner. Wreaths of vine-leaves, carved so that each morsel of stone stands clear of the mass, drape the pillars, and a richly coloured stained-glass window by W. D. Carter Shapland, E. J. Dillworth, and A. S. Burcombe has been set in the main window of the north transept as a parochial reparation for the late Victorian mosaics damaged by shrapnel in the Second World War. The old church and the new make good companions.

To the west of the churches is Clissold Park in which Clissold House, designed about 1790 by J. Woods, still stands, today the property of the Borough Council. A part of the gardens is occupied by a small zoo. To the north are the reservoirs into which Sir Hugh Myddelton's New River now empties its waters (see p. 235); the pumping station in Green Lanes is a fantastic folly, designed by Chadwell Mylne in 1854–6.

Further north is Woodberry Down, on which now stands a comprehensive school designed by Professor Robert Matthew. To the east of the churches is Abney Park Cemetery, laid out in 1840 in the grounds of Abney House. To Pugin's distress, the cemetery was given Egyptian lodges to its entrance; these, and the Gothic chapel planned in the form of a Greek cross, were designed by Professor William Hosking. Inside stands a statue to Isaac Watts, the hymn writer, and General William Booth, the founder of the Salvation Army, and his wife Catherine are buried here. Stoke Newington also possesses one of Butterfield's most characteristic churches, St. Matthias in Matthias Road. A lowering, towering building, it was designed in 1850; severely damaged in the Second World War, it has recently been restored.

Scattered throughout the parish are a number of good eighteenth- and nineteenth-century houses, all in various states of repair and adaptation to twentieth-century needs. Two groups deserve particular attention. On the west side of Newington Green is a quartet of houses, numbers 52-55, one of which bears a label dated 1658. They are of brick, with pilasters, also of brick, running between the first and second storeys; the ground floors have, inevitably, been gouged out to provide modern shop-fronts, but, even in their present condition, they could be preserved as one of the very few examples of midseventeenth-century building left in the environs of London. Adjacent to them, on the north side, is Olympic House at number 35, which is about a hundred years later; a built-out nineteenth-century shop-front obscures the façade. North of the Green is Albion Road, begun about 1830 as a speculation by Thomas Cubitt and still with many small, attractive villas, but the most arresting relics are in Church

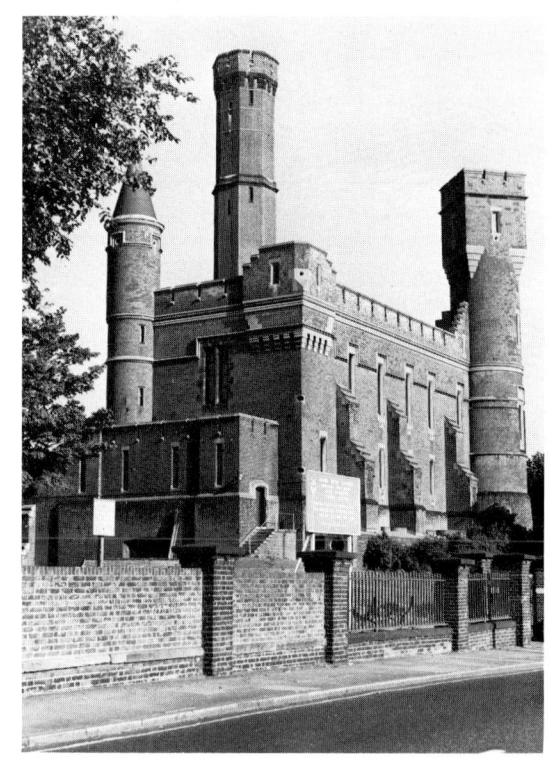

Stoke Newington pumping station

Street, where several of the shabbiest houses have delightful cherubs' heads perched on their lintels. At number 135 we find mid-eighteenth-century Bilney Lodge sitting composedly beside a small hat factory, while the greatest treasures are at numbers 169 and 171, the latter built in 1714 and bearing the name of Sisters' Place in memory of the four Bridge sisters who inherited it in 1813. It must be one of the prettiest dwelling houses in London.

Opposite this house, just south of the church, is the public library, where Daniel Defoe's tomb-stone from Bunhill Fields is preserved; the great writer went to school at Newington Green where the name of a schoolfellow, Timothy Cruso, provided the idea for the title of Defoe's best-known work, Robinson Crusoe. Around the corner of the main building is the entrance to the local municipal art gallery which houses the Chalmers Bequest. Dr. Chalmers, whose memorial is in the old church (see above), left his own collection to the borough, with a sum of money to add to it. Though little known, the collection is far from negligible. There are a number of Dutch genre paintings, an exquisite Roelandt Savery, several seascapes including one by Dominic Serres, a fine view of London from Denmark Hill by Nasmyth, and two good portraits by the younger John Renton of the elder and younger Loddiges, the nurserymen, whose garden was in Hackney.

Hammersmith and Fulham

The 1965 union of the boroughs of Hammersmith and Fulham to form the present London borough was, in fact, a reunion since, from before the Conquest, the two villages were part of the Bishop of London's manor of Fulham. Hammersmith, which gave its name to the larger administrative unit, was created a separate parish only in 1834, the boundaries of the borough being identical with those of the parish. It is a long, narrow strip of land, the northern tip reaching as far as Brent, while the Thames cradles it to the south and southwest. A population of nearly 150,000 inhabits an area of about 4,000 acres. Scrubs Lane, Wood Lane, Shepherd's Bush Road, and Fulham Palace Road - names which preserve an image of earlier aspects of the territory - run from north to south and provide a spinal cord, while half a dozen main roads cross the borough from west to east. Today, Hammersmith is a crowded, urban area, architecturally undistinguished. From the fifteenth century till the very middle of the nineteenth, Hammersmith and Fulham were London's market garden; blessed with fertile soil and an abundance of water, more than half the acreage of both parishes was, till 1850, agricultural land. Then the railways and the people came. In 1801, there were perhaps 10,000 inhabitants; by 1901 there were 249,000, and 30 years later almost another 100.000 had been crammed in somewhere. The houses built for them were of no great beauty though the excellence of the soil meant that even the humblest gardens were – and are – colourful and fragrant. In spite of this gloomy preamble, there is a great deal to see and admire in Fulham and Hammersmith, for between them they have a Bishop's palace and a riverside walk from Hammersmith Bridge to Chiswick Church, which was once described as 'the most civilised two miles in England'.1

At the very beginning of the eighth century, Tyrhtilus, Bishop of Hereford, made a grant of land 'in a place which is called Fulanham' to Waldhere, Bishop of London. Since the Middle Ages, although bishops have had other abodes more conveniently situated in the capital, Fulham has always been a principal residence. The influence of such continuity of ownership and the regular presence of so important a prelate can hardly be overestimated.

To the south of the borough of FULHAM lies the Bishop's Palace, in a park beside the river, close to Putney Bridge. Nothing remains of the medieval manor house, but Richard Fitzjames, Bishop of London 1506-22, built a quadrangle, two storeys high, with a Great Hall at the northern end of the eastern range, and with living apartments and domestic offices around the other sides. The entrance to the courtvard is from the west, in the centre is a large well, and the walls are of red brick diapered with black. It was in the Great Hall that Bishop Bonner tortured Thomas Tomkins's hand with a candle to warn him of the cruelty of the flames which were to consume the steadfast man at Smithfield. Today, the windows are bright with a quantity of sixteenth- and seventeenth-century heraldic glass and across the Hall is set a screen brought from Doctors' Commons in the City.

To the old building, Bishop Terrick, who held the see from 1764 to 1777, added an eastern quadrangle in the Gothick manner; Bishop Howley instructed S. P. Cockerell to give it a plainer eastern façade in 1814–15, so the castellation was removed though some pointed windows remain. This part of the building does not look like a palace at all but like the nicest, friendliest kind of country vicarage. To the south of the two quadrangles, Butterfield added a chapel in 1867, built of blatantly unsympathetic, harshly coloured bricks.

The gardens around the palace are at least as important as the building itself. They were first laid out by Grindal, who held the see at the beginning of Queen Elizabeth's reign; he laid the emphasis on trees, for which the grounds have been famous ever since, by planting a vine and a tamarisk. Bishop

Compton, who was tutor to the future queens, Mary and Anne, added tulip trees, ilex, black American walnut, cork and Virginian oak. Bishop Howley and Bishop Blomfield in the nineteenth century, and Bishop Mandell Creighton, who died in the palace in 1901, continued the tradition, so that people come from all over the world to study the trees in the palace gardens. In 1959, the Men of Trees planted a dawn redwood (Metasequoia glyptostroboides) which, till Chinese botanists recognized one in Szechuan in the 1940s, had been thought to have become extinct in fossil times. Until 1924, when it was filled in, the gardens were surrounded by a moat, thought to have been dug by the Danes about 880; on it used to float large water-lilies known as bishop's wigs. The Bishop of London ceased to reside here only in 1973 and today the building is leased to the Borough Council; its future is uncertain.

The land between the palace grounds and the river became a public park as early as 1893. An open-air theatre, designed by E. A. H. Macdonald, was opened there in 1960. A splendid view of the Thames and its southern bank may be obtained from these gardens, and from their southern tip Putney Bridge, designed in 1886 by Sir Joseph Bazalgette, spans the river, with the fifteenth-century tower of Putney parish church on the further bank. This is the starting point of the Oxford and Cambridge Boat Race, begun in 1829, which has been rowed annually, save in times of national trouble, over the four-and-a-half mile course to Mortlake ever since 1845. Fulham parish church, dedicated to All Saints, stands near the northern end of the bridge. The four-storeyed west tower was completed in 1440 though the rest was completely rebuilt by Sir Arthur Blomfield, son of Bishop Blomfield, in 1881. A number of monuments from the sixteenth to the nineteenth centuries were transferred to Blomfield's church, among them two of more than local importance. They are to Margaret Legh (d.1605) and to John Mordaunt, Viscount Mordaunt of Avalon, who lived and died (1675) at Peterborough House near Parsons Green, where he had a garden which Evelyn visited and admired. The sculpture is by John Bushnell and Francis Bird; a life-sized figure of this passionate and tumultuous supporter of the Stuarts stands, draped in a cloak which resembles a toga, a baton clasped in his right hand, in an attitude of imperious command. The lady's memorial is very different. Another complete though not life-sized figure, she sits, one hand on her breast, the other supporting a baby swaddled into a pathetic little bundle, on which her eyes dwell lovingly; another, even smaller, swaddled effigy is propped beside her.

Around the walls are set a host of other small memorials. A brass (c.1529) shows a half-figure of

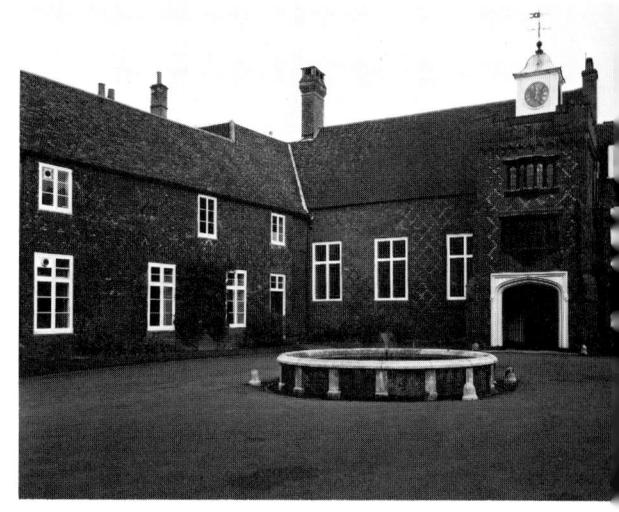

Bishop's Palace, Fulham

Margaret Saunders, later Hornbolt, in her shroud and supported by angels; Sir William Butts (d.1545) who was physician to Henry VIII, has a little alabaster and black marble tablet, while William (d.1626) and Jane (d.1610) Payne have small kneeling figures. Katherine Hart (d.1605) has a kneeling effigy, which is surrounded by tiny figures of her four children. Thomas Smith (d.1609) has a pedimented wall monument, Dorothy Clarke (d.1695) has an imposing urn, and Elizabeth Limpany has a marble cartouche with wooden pilasters on either side and a pediment with a flaming urn and cherubs above, carved in the manner of Grinling Gibbons. There is a restrained tablet to Elizabeth Hatsell (d.1694) carved by P. M. van Gelder, and a neat one to Sir John Beckett by Bedford. There is a sturdy, octagonal font presented by Thomas Hyll in 1622, and an organ case in which fragments of an old pulpit have been incorporated. The churchyard, with avenues of yew and holly trees, is one of the best kept in the London

Behind the parish church, the Powell Almshouses, founded in 1680 and rebuilt in 1869, eighteenthcentury Egmont Lodge, and a charming group of modern houses, Steeple Close, produce a harmony without a jarring note. Near to them, at the junction of the New King's Road and Burlington Road, stood the Fulham Pottery, founded about 1671 by John Dwight. In addition to domestic utensils, he produced a fine portrait bust of Prince Rupert, now in the British Museum and a half-effigy of his little daughter Lydia, modelled after her death, her tiny hands clutching a bunch of flowers (now in the Victoria and Albert Museum). Dwight's descendants managed the firm till 1859; in 1864 it was purchased by Charles Irvine Conyngham Bailey and between 1873 and 1877, the Martin Brothers used to fire their pottery here. The premises, save for one small kiln on

¹ Sir Arthur also built St. Matthew's church in Wandsworth Bridge Road (1893–5) and St. Clement's in Fulham Palace Road, a church enriched by its possession of the font with its delicately carved cover from Wren's St. Matthew's in Friday Street.

the corner of Burlington Road, were demolished in 1975. The site has been excavated by the Fulham Society and it is hoped the remaining kiln may become part of a small museum one day.

The bight of the river embraces the rest of Fulham. The casual visitor may see little distinction between one street and another, but the residents know that the original hamlets of Fulham Town, Walham Green, Parsons Green, North End, and Sands End are still living realities. Following the river bank, we come to a large green park in which stands Hurlingham House, built about 1760 for Dr. William Cadogan, much enlarged towards the end of the same century, and in use today as the Hurlingham Club, a famous sports centre. The eastern border of the river's curve is the property of the North Thames Gas Company; their headquarters, Watson House, designed during the 1950s by E. R. Collister, is a distinguished building, adorned with mural panels by John Piper. The company controlled other property in the hinterland of the borough, which included Sandford Manor House, an estate mentioned in a roll call of Edward I's reign. The present building probably dates from the middle of the seventeenth century and tradition, unsubstantiated by written evidence, has always associated it with Nell Gwynn and Charles II. The land here has recently changed hands and is being developed with the old house preserved as a focal point.

Four other Fulham churches should be mentioned, as well as two houses which time or overzealous redevelopment have removed from the borough. St. Dionis' church on Parson's Green was the work of that prolific architect, Ewan Christian; today it houses the font and pulpit from Wren's St. Dionis Backchurch in the City, while in St. Andrew's hangs a bell from St. Martin Outwich, said to be the only one to survive the Great Fire, with the inscription 'Thomas Bartlet made me 1623'. In Rylston Road, St. Thomas's Roman Catholic church, designed by Augustus Pugin, may be found. Restrained and correct, with a determined spire, it is the burial place of Warrington Taylor, William Morris's trustworthy business manager, who died young of consumption, and of Joseph Hansom, the designer of the 'Patent Safety Cab'. St. Etheldreda's in Fulham Palace Road was first built in 1897 but, after severe bomb damage in 1940, was rebuilt by Guy Biscoe. There is an impressive bell-tower and the semi-circular baptistry glows with the stained glass of Carter-Shapland.

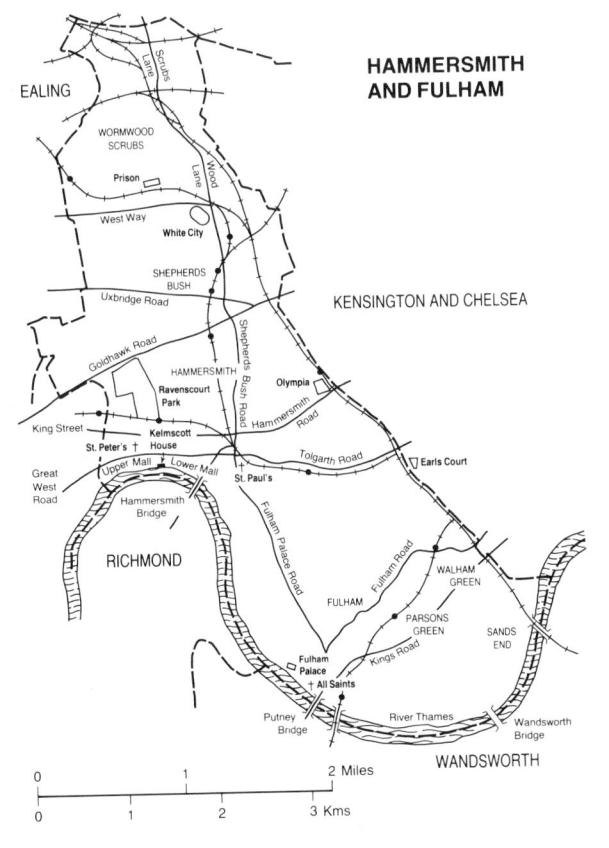

Font cover in St. Dionis', Fulham

One of the lost houses was Fulham House in the High Street, where the Sharp family lived. Granville Sharp, the philanthropist, nursed a sick slave, Jonathan Strong, back to health and refused to hand him over to his master, who claimed him two years later. Sharp fought the case through every court in the country till Lord Mansfield's ruling established that no man could be a slave in England. His elder brother, William, a surgeon at Guy's Hospital, owned an elegant boat on which he entertained George III and Oueen Charlotte, while he and his whole family, who were all accomplished musicians, delighted their royal visitors with a concert. Zoffany painted one such musical merry-making and the family owns the painting still (though it is at present on loan to the National Portrait Gallery). The house was demolished in 1842.

The Grange at North End is a more recent loss, for it was pulled down in 1957 among a storm of local protest. Built about 1714, part of it was rented in 1739 by Samuel Richardson as a country retreat and it was here that he wrote his novels, Pamela, Clarissa, and Sir Charles Grandison. In 1867, Sir Edward Burne-Iones, the Pre-Raphaelite painter, came to live there. Ruskin and William Morris were among his visitors, and his little nephew, Rudyard Kipling, thought the house and garden, with beds of lilies-of-the-valley some 20 feet long, was a very paradise. The artist died there in 1898; a housing estate has stamped out the lilies now. 26 of his paintings, sketches, and drawings are now in the possession of the Borough Council as part of the Cecil French Bequest, which they received in 1954.

Today's average Londoner is more likely to associate HAMMERSMITH with its flyover along which cars race, their occupants intent on their destinations and scarcely aware that their wheels are level with the pinnacles at the top of the tower of St. Paul's, the parish church. A chapel-of-ease was built here in 1631, out of consideration for the long, muddy walk needed to reach All Saints' in Fulham. It became a parish in its own right in 1834 and a new church was built in 1883 by J. P. Sedding and Hugh Roumieu Gough, its tall, impersonal Gothic structure replacing the homelier chapel, which was of a size far better suited to the scanty congregations of the present day. Red Mansfield stone, an unusual material, was used throughout, with Bath stone for the dressings and the arcades, and polished Belgian granite for the columns of the nave. The late seventeenth-century font from the old church was retained, and the exquisitely carved octagonal pulpit comes from Wren's church of All Hallows in Thames Street. The eight bells from the old church, one of the sweetest-mouthed rings in England, were moved to the new building; four of them date from 1639 and a fifth from 1657. A number of memorials came too, of which three are of particular interest. The earliest is that of Sir Nicholas Crisp (d.1665), Charles I's ever-faithful supporter, who had built himself a fine house beside the river.

and had given three of the church bells to the parish. The memorial is in the form of a pillar with a broken pedestal on which is set a bust of Charles I, probably by Le Sueur. James and Sarah Smith (d.1667 and 1680) have an imposing black and white marble wall monument, with a bust of the worthy alderman, flanked by small figures of mourning women, perched on top of it. The third memorial is more recent, being to W. Tierney Clark, the engineer who designed London's first suspension bridge for Hammersmith in 1827; his airy structure, which has been replaced by Sir Joseph Bazalgette's more robust creation, is represented on the memorial.

On leaving the church the bus station may be seen in Queen Caroline Street, built in 1913 and incorporating the garden front of Bradmore House. This mansion, which Pevsner thinks must have been designed by Thomas Archer, was an addition to a still older property; a good water-colour by H. Palmer in the Geffrye Museum records its appearance in its heyday, and the museum possesses and has re-erected the panelling from one room. Nearby, in King Street, a phoenix has risen from the ashes. Hammersmith's own Lyric Theatre had been built in 1895 to designs by Frank Matcham with luxuriant plasterwork decoration; it knew its greatest success under the direction of Nigel Playfair, whose production of Gay's Beggar's Opera opened on 5 June 1920 and ran for 1,463 performances – three-and-a-half years. More recently, the Lyric fell on hard times, was closed in 1965 and was demolished in 1972, but the plasterwork of the interior was saved, stored. and incorporated into the Lyric Theatre, designed by Derek Woolland, which opened in 1979. A second theatre, the Riverside, is an interesting example of sharply modern design; unusual productions, often avant-garde, are shown here.

Beside the river, the Upper and Lower Malls extend to west and to east. Formerly, the Malls were separated by Hammersmith Creek, spanned by the now vanished High Bridge, where a branch of the Stamford Brook ran down to the Thames. War damage obliterated what was left of the picturesque old buildings which crowded here, and the creek has been filled in, though as late as 1921 boats of up to 200 tons were able to unload there. For a two-mile stretch, there is hardly a building that jars. Herons still nest on the eyot, and coots, wagtails, and diving ducks are to be seen. It is best to visit the river on a fine day, and to explore Chiswick Mall as well (see p. 285). Occasionally, the gardens of some of the houses are opened to the public in aid of the National Gardens Scheme.

Beginning at Hammersmith Bridge, numbers 6–11 Lower Mall are all delightful and then comes Westcott House, built in the early eighteenth century, now owned by the Borough Council and used for local society meetings. Beyond it lies a strip of grass, called Furnivall Gardens, after F. J. Furnivall (1825–

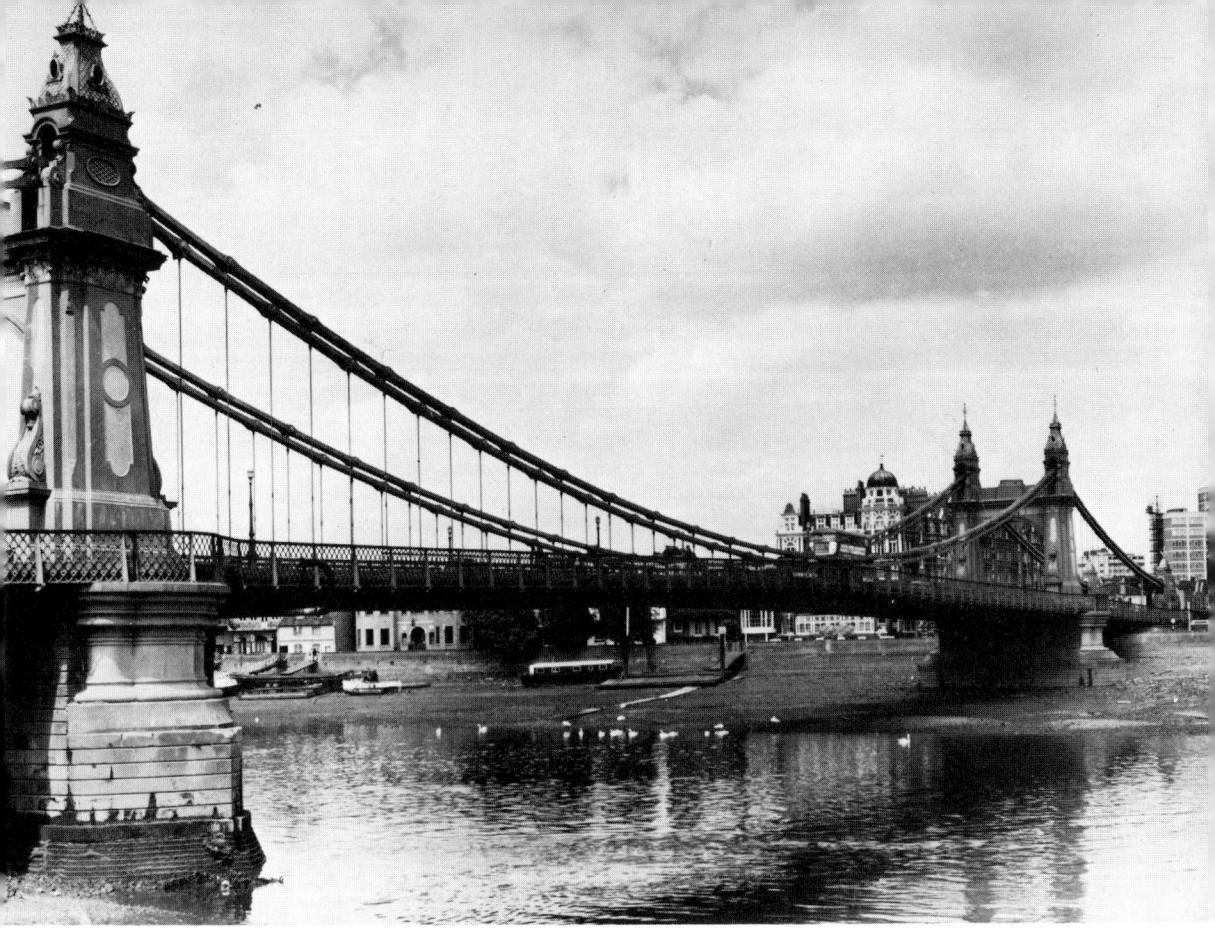

Hammersmith Bridge

1910), a distinguished scholar who established a rowing club for those who would otherwise have had little opportunity for sport. Beyond the green is Sussex House, built in 1762, five bays wide with an elegant porch to the doorway and a pretty iron balcony above. Perhaps during the course of building, a part of the house was divided off and called The Cottage; in this smaller portion, William Morris set up the Kelmscott Press, while the whole building was later used by Sir Emery Walker for his engraving work. Close to the riverside is another double building dating from about 1750. In one half, The Seasons, T. J. Cobden-Sanderson, the master bookbinder lived and worked and, from 1900, carried on the Doves Press and Bindery in partnership with Sir Emery, whilst the other half is the Dove Inn. A little further eastwards, we come to number 26. Kelmscott House, where William Morris made his home from 1878 till his death in 1896. He gave it the same name as his beloved manor house in Oxfordshire and delighted to think that the Thames linked his two

domains. Sixty years earlier, this had been the home of Sir Francis Ronalds, who invented the electric telegraph in 1816, laying down some eight miles of cables in his garden in order to perfect his experiments. Portions of the installation are preserved in the Science Museum and in Hammersmith Public Library. After Morris's death, George Macdonald, that writer of eerie fairy stories which fascinate grown-ups as much as children, came to live here.

At this point, Rivercourt Road runs through to the Mall and two large bastions, protruding from the embankment, mark the site of the house in which Catherine of Braganza, Charles II's Portuguese wife, lived in her widowhood; the house was rebuilt about 1808 and now, with several other properties to the east, belongs to Latymer School, which was established in the parish as early as 1624. A little further on, we come to a fascinating piece of industrial archaeology, the pumping station and other buildings of the West Middlesex Water Company. Much of the building was designed by W. Tierney Clark. On either side of the works are attractive public houses, the Old Ship Inn and the Black Lion. The Mall ends with the 16 houses of Hammersmith Terrace, built before 1755 with their main aspect towards the river. The artist Philippe de

¹ It is often claimed that the poet, James Thomson, wrote the winter sequence of his poem, *The Seasons*, here, but the house is scarcely old enough, and the story probably arises from another James Thomson having been licensee here.

Loutherbourg occupied numbers 7 and 8, where he painted scenery for Garrick and Sheridan, Sir Emery Walker lived at number 7 for a while, and Sir Alan P. Herbert, the yachtsman and writer, lived and died at number 12. Chiswick Mall is reached by way of Western Terrace, and the riverside walk may be continued for another mile as far as St. Nicholas' church.

Opposite the Mall, on the far side of the Great West Road, the church of St. Peter stands rock-fast despite the roar of the traffic which races past it. Built by Edward Lapidge between 1827 and 1829, it is a pretty little brick box with an Ionic portico and a plastered cupola on top of its west tower. Inside, there is a good organ case at the west end and some interesting murals, executed in 1931–3 by Winifred Elizabeth Beatrice Hardman and Mrs. A. D. Cohen on either side of the altar. The pleasant streets around the church were laid out about 1825–30.

On Brook Green, in the centre of the borough, is **St. Paul's School for Girls**, where Holst taught music for many years; its elder brother, St. Paul's School for Boys, moved south across the river to Barnes in 1968.

In the northern part of Hammersmith are two huge exhibition centres, Olympia and White City. The former opened in 1886; its Grand Hall was starkly refronted in 1930 by Joseph Emberton. Many exhibitions are held here annually in its 500,000 feet of display space, drawing crowds to Hammersmith. The White City, opened by Imre Kiralfy, now houses the B.B.C. Television Centre, while the Stadium, built in 1908 to accommodate the Olympic Games, is still put to good use. The traffic of Westway almost isolates the northern section of the borough but for those who can contrive to pause, the church of St. Katherine's on its north side is worth attention. Built in 1923, and rebuilt after bombing in 1940, it was erected from funds provided by the sale of St. Catherine Coleman church in the City, a plain, uncluttered brick building, in contrast to the Gothic

Princess Victoria public house, off the Uxbridge Road, Hammersmith

churches elsewhere in the borough. Northwards again, Wormwood Scrubs Prison, designed in 1874 by the penal reformer, Sir Edward Du Cane, broods upon the bleak open space onto which it looks, and beyond it, on the far side of the Grand Union Canal, is St. Mary's Roman Catholic Cemetery, where Cardinal Wiseman was first buried – he now lies in Westminster Cathedral – and where Anthony Panizzi, the Italian political refugee who became Principal Librarian of the British Museum, and Francis Babington Tussaud, the grandson of the originator of the waxworks exhibition, now rest.

Hampton Court and Hampton

Hampton Court and the adjacent village of Hampton lie in the southernmost corner of the borough of Richmond (see p. 397), cradled by a loop of the River Thames. The palace is of such importance, both in the history of England and of English architecture, that it deserves a chapter to itself.

The history of the building of Hampton Court falls into three distinct phases, the main works having been executed for Cardinal Wolsey, for Henry VIII, and for the joint monarchs, William III and Mary II. By 1515, Thomas Wolsey, the son of an Ipswich butcher, had become, through sheer natural ability and hard work, Archbishop of York and Lord Chancellor of England, besides having been created a Cardinal by the Pope. From the Knights of St. John of Jerusalem, he leased the manor of Hampton Court, and began to build the most magnificent house in England. The site was chosen for its salubrity and beauty, and for the easy communication with Westminster afforded by the Thames. With John Lebons, who also worked on Cardinal College (later Christ Church) in Oxford, as his master mason, the Cardinal built a great gatehouse with two broad courtyards connected by an inner gatehouse. The material used was warm red brick, enlivened with darker diaperings, and with freestone dressings. A moat was excavated and an excellent sanitation system was installed. Around the courtvards were disposed luxuriously furnished apartments, sufficient to accommodate the French ambassador and all his retinue when he came to England in 1527 with some 280 courtiers; to the north lay the kitchens, cellars, and service buildings, with the chapel beyond. The buildings differed little, save in scale and magnificence, from other great houses in England, but as adornments for the courtyards Wolsey commissioned eight terracotta medallions from the Italian Giovanni da Maiano, at a cost of £2.6s.0d. each. Each medallion bore the head of a Roman emperor. surrounded by an intricate border; save for Henry VII's tomb in Westminster Abbey, they were the earliest examples of the new art of the Italian Renaissance to be seen in England (see also p. 290).

Eventually, the King felt himself overshadowed by the Cardinal. In the hope of appeasing his sovereign's

jealousy, Wolsey presented Hampton Court to the King, but it was in vain. In 1529 he was stripped of all his offices, and he died the following year. Henry took possession and set about enlarging the house, with John Molton as his master mason. He demolished Wolsey's comparatively modest Great Hall and replaced it with another, more imposing, edifice. 97 feet long by 40 feet wide and 60 feet high, lit by five windows on either side and by a lofty one at each end under the tall, chamfered-off gables; the hall was spanned by a hammerbeam roof, its braces, pendants, and corbels intricately carved, the workmanship showing an awareness of the new, more ordered classical ornamentation. The carving was the work of Richard Rydge of London who was paid £3.3s.4d for each of the 'pendauntes standing under the hammerbeam'. So anxious was the King that the work should be completed swiftly that hundreds of candles were installed and the carpenters worked by night as well as by day. The chapel he refurbished, giving it a timber fan-vault; the base of each pendant was embattled and over the parapets lean angels, those in the centre holding palms and sceptres, those to the sides playing on pipes. Three stone tablets, carved with the royal arms, were set up on either side of the main gateway and on the outer face of the inner gate, while the Cardinal's arms, on the inner side, were defaced (they have now been restored). This inner gate is always known as Anne Boleyn's for, as in the Great Hall, her initial is entwined with Henry's on the vaulting and her personal emblem, the falcon, is often repeated, though the work had scarcely been completed before the unhappy lady's head had been struck off and her place taken by her own lady-in-waiting, Jane Seymour, whose initials replaced those of her mistress elsewhere in the palace.

On the inner side of the gateway, in 1540, Henry installed a great astronomical clock, probably designed by Nicholas Cratzer, the Bavarian scientist who had become a Fellow of Corpus Christi College at Oxford, and certainly executed by Nicholas Oursian; since the clock was constructed before the discoveries of Galileo and Copernicus, the sun is made to revolve round the earth. This gatehouse is now topped by a pretty eighteenth-century cupola in which hangs the clock bell, cast in 1480 and presumably the last relic of the establishment which the

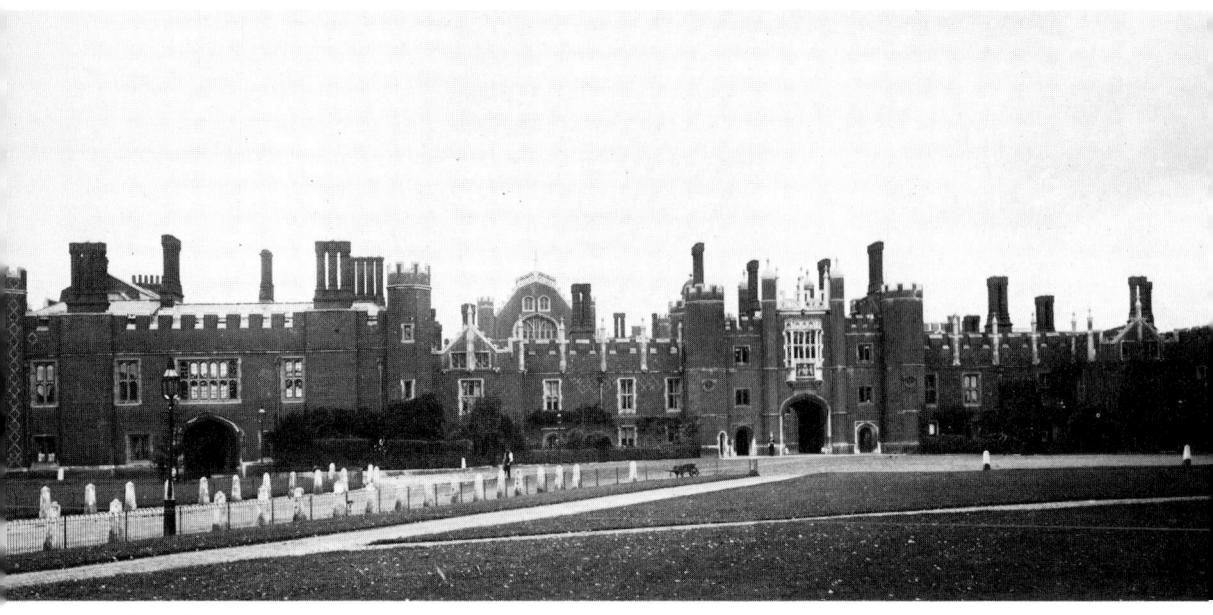

West front of Hampton Court

Knights of St. John once had here. To the south-east of the Clock Court, as it is now known, the King built two ranges of state apartments, his own looking south towards the river, and his Queen's looking eastwards across the Home Park. At their beauties we can only guess, for they have been replaced by Wren's Fountain Court. Additional kitchens and cellarage were needed to provide for the whole court; wings for extra accommodation were added to the west front, and Henry built a Tennis Court and a Tilt Yard, for he delighted in all sports and his contemporaries declared that to see him driving the ball was the 'prettiest thing in the world'.

Queen Jane bore Henry his longed-for son, the future Edward VI, at Hampton Court, and died there herself less than two weeks later of puerperal fever. It was also at Hampton Court that Henry learnt of the faithlessness of his fifth queen, Katherine Howard; slipping away from her guards, she ran to the Chapel in an attempt to plead with him while he prayed there, but she was dragged away screaming before she could enter the royal pew. Henry must have heard her cries but he ignored her; her ghost is said to walk the Gallery.

All Henry's children, Edward, Mary, and Elizabeth, lived regularly at Hampton, and it was there in 1604 that James I convened a gathering of divines to settle religious differences. The controversies remained unsettled but the preparation of the Authorized Version of the Bible in English was undertaken. Charles I spent his honeymoon here with Henrietta Maria of France; Mytens's radiant portrait shows the young royal couple holding a laurel wreath, both clad in ivory satin, the Queen's dress trimmed with

coral ribbons. Charles I's pride was his collection of paintings; many of the best were hung at Hampton. The palace also served as the unfortunate monarch's prison during the Civil War; in 1647 he escaped from it through 'the room called Paradise', only to be recaptured and executed some fourteen months later. A certain amount of damage was done to the Royal Chapel during the Commonwealth period, but for the most part the palace escaped unscathed, for Parliament decreed that it should be reserved for the personal use of Cromwell, the Lord Protector.

After the Restoration, Charles II turned his best attentions to the gardens. Having spent much of his exile in France, he knew and admired the work of André Mollet and his more famous pupil, André le Nôtre, who had laid out the grounds at Versailles. Charles's resources could not match those of Louis, but with John Rose as his gardener he did his best, planting a great semicircle of trees before the east front of the palace, from which there radiate out three double avenues of lime trees, forming a gigantic goose-foot, with the ornamental Long Water running down the middle of the central avenue and seeming to stretch beyond the horizon.

His brother and successor, James II, was hardly on the throne long enough to make many changes to any royal property, but William and Mary made their principal residences at Kensington and at Hampton Court, since in those places the purity of the air helped to lessen William's asthma. Plans were being made to demolish the entire palace and build another that would rival Versailles, but economy, reinforced tragically by Mary's death in 1694, intervened, and only the Tudor State Apartments were replaced by
more up-to-date accommodation around the Fountain Court. The new buildings were undertaken by Sir Christopher Wren, supported by a team of craftsmen which included Grinling Gibbons for the woodwork and some of the stone carving, and two smiths, Jean Tijou and Huntingdon Shaw, one French, the other English, for the ironwork. The felicitous jumble of gatehouses and towers which had made up the Tudor east front was replaced by the colder grandeur of Wren's dignified, symmetrical façade, with its four rows of windows, modest apertures to the ground floor, lofty ones for the piano nobile, small portholes above and square windows to the attics. This eastern front stretches for 23 bays, the central seven projecting very slightly and the middle three a little more. Attached pilasters separate these windows and a somewhat over-restrained pediment sits primly above the centre, kept firmly in its place by the sturdy stone balustrade which runs the length of the whole building. William was a hard-pressed man, ailing but always courageous; the façade of his palace was staid and sedate, the antithesis of the magnificence and splendour for which Wolsey strove and Henry planned and no rival at all to Versailles; this palace was built for a gentleman who was a 'great delighter' in gardens, and the miracle is that the two dissimilar halves of Hampton Court somehow contrive to blend together. It was when riding in the park here that William's horse stumbled over a mole hill, as it was said, and threw him, causing bruising and injuries which brought about his death soon after.

Anne completed the work begun by her sister and brother-in-law; later, Vanbrugh was called in to provide decoration for some of the other state rooms, and William Kent to complete the Queen's staircase and remodel the E-range of Clock Court, now containing the Cumberland Suite. George II was the last monarch to reside at Hampton Court, and after his death the private rooms were converted into accommodation for people of note; Dr. Johnson applied in vain in 1776. Today, there are still some 'grace and favour' residences for distinguished servants of the crown and their families. In 1838, the young and public-spirited Queen Victoria opened the State Apartments to everyone, and Hampton Court became the Londoner's favourite all-day excursion.

Originally, any important dignitary visiting Hampton Court would have approached by water, and the most interesting view of the palace is still to be obtained from the river. Visitors today come by road, entering from the west through the Trophy Gates topped by a lion and a unicorn and built for William III. Charles II filled in Wolsey's moat, which was re-excavated in 1910; a splendid new company of Queen's Beasts stand on either side of the bridge crossing it. Through the gateway is the expanse of the Base Court, from which Anne Boleyn's Gateway leads to the Clock Court, with the entrance to the State Apartments in its south-east corner under an Ionic colonnade designed by Wren. The State Apart-

ments are reached by the King's Staircase, completed about 1700, the ironwork of its balustrade designed by Jean Tijou and the walls and ceiling painted by Antonio Verrio; overhead, the gods feast jovially, while on the walls below Romulus, with his motherly she-wolf, invites the shades of the Roman emperors to join the banquet though Nemesis, clad in scarlet and floating through the air with a fiery sword, threatens the wrong-doers among them while Hercules commends the young Alexander to the favourable attention of the deities. The scene is taken from Julian the Apostate's Satire on the Caesars, and it is not too fanciful to see the excluded rulers as the later members of the Stuart dynasty and Alexander as William III - we know that Hercules was his favourite mythological hero. At the head of the staircase is the King's Guard-chamber, its walls covered with weapons originally arranged in elaborate, almost abstract, patterns by Harris, William III's gunsmith. Nearby are some of the surviving sixteenth-century apartments, the Wolsey Rooms lined with panelling, some plain, some linenfold, and one room with a ceiling patterned all over with thin timber and papier mâché ribs which form lozenges and stars.

The State Apartments were designed in two sequences, one for the King, the other for the Queen. We traverse the King's side in the correct order, the Guard-chamber leading to the Presence Chambers, the Audience Chamber, and the Drawing Room, beyond which lie the Bedchamber and Closets; the Queen's side is viewed in reverse order. These rooms of ceremony lay round the outer side of Wren's building, looking towards the river and gardens, while the private rooms and corridors for communication ran round the inner side of Fountain Court.

For the King's first Presence Chamber, the oak door-cases and the limewood garlands of fruit and flowers were carved in Grinling Gibbons's workshop. The chair of state, with its canopy embroidered in silver with the arms of William III, stands opposite a painting by Kneller of that monarch on horseback, still hanging in the position for which it was painted. Beyond in the Audience Chamber, which looks across the Privy Garden, are two superb mirrors made for William III, and the King's Drawing Room has an overmantel elaborately carved by Grinling Gibbons, framing a portrait of Isabella, Archduchess of Austria, by Franz Pourbus. The King's Bedchamber follows, with its state bed and a ceiling painted by Verrio with Endymion sleeping, woodenly, in the arms of Morpheus, watched by Diana and an assortment of bucolic Cupids. The Dressing Room and Writing Closet complete the sequence of apartments; in the latter, above the chimneypiece, a mirror is so set and angled that the entire sequence of preceding rooms is reflected. These smaller apartments were private, to be entered only by the monarch's most intimate friends and attendants.

The south-east corner of the building is occupied by Queen Mary's Closet, so called because, although the poor lady died of smallpox at Kensington before she could use it, the walls were once hung with needlework wrought by herself and her ladies.

Along the east side of the building runs the Queen's Gallery, with a marble fireplace by John van Nost and a cornice carved by Gibbons. The tapestries were made in 1662 by Charles le Brun at the Gobelins works. Against the walls of the gracious, 80-foot-long chamber are superb blue and white china pagodas and vases designed especially for William and Mary to display tulips and hyacinths indoors. William was devoted to bulbs and had some 30,000 of them planted around the palace gardens in the winter of 1699. In the Queen's Bedchamber beyond the Gallery the ceiling was painted by Sir James Thornhill with Leucothoë restraining Apollo from entering his chariot, while above the fire-place is a tender painting by Lely of Queen Anne as a child, holding a small bird. The Queen's Drawing Room beyond commands the most magnificent view of any in the palace, for its looks out directly over the Long Water. From here we can appreciate the grandeur of the overall design of the grounds. The walls of the room were painted by Verrio for Queen Anne in 1705, two years before his death and burial in Hampton Church nearby. On the ceiling the Queen appears as Justice and on the wall opposite the windows she is shown receiving the homage of the four quarters of the globe. On the north wall her

The chapel, Hampton Court

husband, Prince George of Denmark, gestures to the British fleet of which he was Lord High Admiral, while on the south wall seahorses race over the waves, drawing Cupid in his chariot towards the shores of England, the fleet riding at anchor in the background. These grand paintings are both pompous and pathetic.

At the northern end of the east range is the Public Dining Room decorated as a Music or Dancing Room by Vanbrugh for George II when he was Prince of Wales, and so called because, as King, George sometimes fulfilled the traditional custom of dining in public. The three rooms beyond form the Prince of Wales's Suite. Decorated chiefly by Vanbrugh, these rooms were used by George II and Queen Caroline before their accession to the throne, and then by their son, Frederick, and his wife, Augusta, the parents of George III. The Bedchamber now contains Queen Charlotte's bed, designed for Buckingham House at a cost of £14,000, all hung with embroidered ivory satin. From these rooms, the Prince of Wales's Staircase leads down; around its landing hang a set of tapestries woven at Mortlake and Hatton Garden, probably designed by William van der Velde and woven by Francis and Thomas Poyntz, representing the inconclusive engagement between the Dutch and English fleets at the Battle of Solebay off the Suffolk coast in 1672. The elaborate borders are classically conventional; the main scenes are extraordinary, very pale, almost luminous, more like Impressionist paintings than tapestries. Wraithlike ships form ethereal lines of battle that seem as taut and strong as steel rope.

We now return along the inner side of the Fountain Court through the Queen's Chapel, lit from sky-lights set in a fine plasterwork cupola since it lacks outside windows, to the Queen's private apartments, used by George II and Queen Caroline. In several of the smaller rooms, shelved overmantels have been set cornerwise, built especially to display Mary II's collection of china. The Cartoon Gallery runs the length of the south range. Wren completed it in 1699 to house seven of Raphael's cartoons, painted in 1515-6 for Pope Leo X as designs for tapestries which still hang in the Vatican. Charles I bought them and, after his execution, Parliament did not sell them, as they disposed of most of the rest of his wonderful collection. Queen Victoria deposited the paintings in the Victoria and Albert Museum, where they can be seen today, and around the walls at Hampton Court hang seven seventeenth-century tapestries, copied from the original cartoons, which Baron Emile d'Erlanger presented to the Crown in 1905.

Along the west side of the courtyard runs the Communication Gallery, on its walls the portraits which Lely painted of the ladies of Charles II's court, known as the Windsor Beauties, and at the end of the gallery a door leads through two lobbies to what is known as Wolsey's Closet, the one remaining room

Hampton Court gardens

that still gives some idea of the brilliance that characterized the Tudor palace. The lower walls are covered with nineteenth-century linen-fold panelling and above it are sixteenth-century panels depicting scenes from the Passion of Christ, which recent restoration has shown to have been painted over late medieval work. Above, Wolsey's motto, 'Dominus mihi adjutor' (the Lord is my helper) is repeated time and again, and the ceiling is a glorious golden coverlet, divided into octagons and squares by narrow blue lines and richly studded with Tudor roses and with badges. Next to this apartment, the survival of which warns us how much was lost when the Tudor palace was replaced by Wren's more orderly building, is the Cumberland Suite, consisting of two state rooms and a bedroom, designed by Kent in 1732 for George II and occupied by his son, the Duke known as 'Butcher' Cumberland for his part in suppressing the 1745 Jacobite rising. The larger of the state rooms has a bed alcove, with a handsome screen of Corinthian pillars supporting a gently curved pediment.

By this time, we have in effect made a double circle around the Fountain Court and have reached the Queen's Staircase in the north-west corner. Once again, the superb balustrade was designed by Tijou. On the west wall is a huge allegorical painting by Honthorst, signed and dated 1628, with Apollo

presenting the liberal arts and sciences to Jupiter and Juno. A careful examination reveals that the artist has portrayed Charles I and his Queen as Jupiter and Juno, that Apollo is represented by the Duke of Buckingham, and that the various attendants have been given the faces of the Countess of Carlisle and other ladies of the Court. This large work crystallizes the charade which this most tragic of English monarchs played out so often in the masques which Ben Jonson wrote for him and which Inigo Jones devised. The other walls and the ceiling have decorations by Kent.

On the first-floor level, there are also the Queen's Guard and Presence Chambers, decorated during the reign of George I, beyond which the Haunted Gallery (see p. 250) leads to the Royal Pew at the back of the Chapel. It was customary for the head of a large household to worship in a place apart, and the galleried pew affords today's visitors an excellent view of the breath-taking Tudor ceiling. Below are the handsome black and white marble floor and the superb carving of Grinling Gibbons's reredos. The easternmost window on the south side is blocked, its aperture filled with a trompe l'oeil painting of a pleasant architectural scene by Thornhill. Back in the Haunted Gallery, the windows look into the Round Kitchen Court as the corridor leads round the northern side and into the Great Watching Chamber where the King's Guard stood on duty. The walls are hung with seven late medieval tapestries, all of them purchased by Cardinal Wolsey for his use at Hampton Court; four represent the Seven Deadly Sins and the others depict scenes from Petrarch's poem, I Trionfi, showing the triumphs of Death over Chastity, Fame over Death, and Time over Fame. After nearly five centuries, the colours are still surprisingly vivid and the details are all still there. Next door is the Horn Room, so called from the hunting trophies which were once stored here, but properly the serving place for the Great Hall, which is entered from the Watching Chamber. Its walls are hung with tapestries telling the story of Abraham, which Henry VIII purchased about 1540. At the lower end, an oak screen, carved with less sophistication than the decorated roof, supports the Minstrels' Gallery and conceals the staircase leading to the Great Kitchens.

Beneath the Great Hall and Watching Chamber are the Beer Cellar and the King's Wine Cellar, and in the northern range of buildings is the kitchen, 37 feet long and 27 feet wide, the size of the cooking ranges indicating what a feat of organization and sheer physical strength it must have been to cook for a household of some 500 people.

On the east front a herbaceous border runs the whole length of the Broad Walk. The influence of that dedicated gardener, Gertrude Jekyll, may be discerned in the planting both of these borders and of the Privy Garden.

Each generation has had a hand in the making of the gardens at Hampton Court. Wolsey, Henry VIII, Charles I and Charles II, William and Mary, were all enthusiastic gardeners, and they were served by professionals such as John Rose, George London, and Henry Wise, and were able to call upon Wren, William Talman, and Daniel Marot for designs. To the south of the Fountain Court, the Privy Garden stretches as far as the Thames. At the river end, Tijou's spectacular ironwork panels form a screen. Beyond is the Pond Garden, bedded out brilliantly according to the seasons, with the Knot Garden, designed in 1924 by Ernest Law, the historian of Hampton Court, facing it on the palace side.

William III's little Banqueting House nestles between the gardens and the river. It took the place of the Tudor Water Gallery and was completed about 1701, almost certainly to designs by Wren. A single storey high, it has woodwork from Grinling Gibbons's workshop, and a Banqueting Room painted all over by Antonio Verrio and his assistant Antonio Montingo. Minerva, attended by the arts and sciences, dominates the ceiling, a bust of William III borne proudly by the figure of Sculpture; Jupiter and Juno occupy the overmantel, and mythological scenes in pinkish-grey chiaroscuro crowd the walls. On the south side of the garden is the Great Vine, planted from a slip taken from a black Hamburgh vine at Valentines near Ilford in Essex in 1769, and now of prodigious dimensions. When last measured, the girth of the stem was seven feet, one inch at ground level, and each year it bears hundreds of bunches of grapes. It grows beside the Orangery, built for William III, which today houses not fruit but Mantegna's nine huge paintings of The Triumph of Caesar, still breath-taking in their impact, which Charles I bought from the Duke of Mantua; even Parliament, so sternly anxious to sell the collection of 'the late Charles Stuart', realized the importance of these works and retained them for the state.

Returning along the Broad Walk, the inscription on the south front - Gulielmus et Maria R(ex) R(egina) F(ecerunt) - is visible, lead statues of Mars and Hercules standing beneath it. The Broad Walk looks out over the main garden with its three avenues - giant clipped yews, which Virginia Woolf called 'black pyramids' - near to the house and a single fountain, the sole survivor of the thirteen which William III installed. Beyond, the Long Water stretches away for three-quarters of a mile, and a canal, originally dug for Charles II, divides the gardens from the Home Park. At the northern end of the buildings is the Tennis Court, built for Henry VIII, refurbished for Charles II, and still in use, the oldest court in the world where the game of real or royal tennis is still played, and one of the very few to which the public is admitted. At the far end of the walk is the Flower Pot Gate, the putti with largesse of fruit and flowers carved by van Nost. To the west are the Wilderness, where Henry VIII had his orchard and which now glows golden with daffodils in springtime, and the Lion Gates, wrought by Tijou and

intended by Wren to form the main approach from the north to a completely rebuilt, far more formal, palace. Just inside the Gates is the Maze, laid out by Wise for William III; its intricacies still baffle and delight today's wanderers. The rose-gardens behind it used to be Henry VIII's tilt-yard. Around it were five towers from which spectators might enjoy the sport; four of them were demolished in the seventeenth century and the ground used as a kitchen garden. In 1924, the remaining tower was refurbished and became a tea-room surrounded by lawns and flower-beds.

At the time of writing (1983), the paintings at Hampton Court are being rehung; a new Renaissance Gallery is to be opened in the Base Court, where panel paintings are to be displayed. These will include *The Meeting of Henry VIII and the Emperor Maximilian, Henry VIII's Embarkation for France*, and his meeting with François I on *The Field of the Cloth of Gold*, and a portrait of the aging King and his three children, the future monarchs Edward VI, Mary I, and Elizabeth I.

The Lion Gate leads to Bushy Park. Covering 1,100 acres, it has, from the first, been part of the palace grounds. When William III and Wren were planning the rebuilding, an avenue was laid out for a mile across the park, widening out a third of the way along its length to form a great circle around the Diana¹ Fountain, topped by a delicate figure of the goddess wrought by Francesco Fanelli for Charles I which, unfortunately, is rendered insignificant in this setting. The trees are the true glory of the park some 274 chestnuts, flanked on either side by a double file of limes which perfume the air in summer. 'Chestnut Sunday' is in mid-May, when the pink and white candles of blossom light up the dark leaves. Deer, some red, some fallow, wander freely and across the western side of the park runs the Longford River, a watercourse cut by Charles I to draw supplies from the Colne. Beside it, 100 acres have been laid out as a woodland garden with vivid azaleas and many unusual water-loving plants. 82 species of bird have been recorded here in a single year recently, including some comparative rarities near London such as the green sandpiper, the oystercatcher, and the hooded crow, while herons and kingfishers are frequent visitors. On the north side of the Park, near Teddington Gate, is Bushy House, now the residence of the Director of the National Physical Laboratory. It was built for Lord Halifax, Ranger of the Park to George II; William IV lived there while he was still Duke of Clarence.

On the south side of Hampton Green, where a noisy fair takes place three times a year, is a fine group of houses. Close to the bridge, which was rebuilt in 1933 to Sir Edwin Lutyens's designs, with an excitingly abrupt arc, is the Mitre Hotel, very

¹ Or Venus or Arethusa - the lady's identity is uncertain.

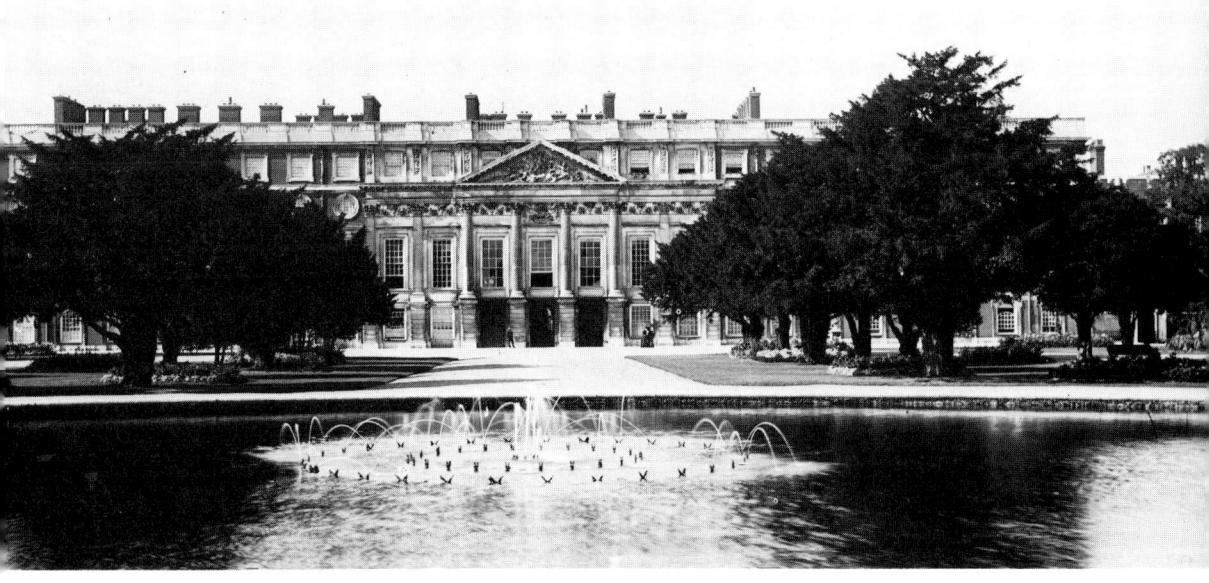

East front of Hampton Court

early nineteenth-century, and nearby is Old Court House which Oueen Anne leased to Wren and which he remodelled to suit himself, followed by Faraday House where the great scientist lived from 1858 to 1867. Then comes the Royal Mews with a noble sixteenth-century barn, still in use, which looks across the Green to Hampton Court House, built in 1757 by Lord Halifax for his mistress, Anna Maria Falkner, who sang Arne's songs so enchantingly. A grotto, lined with shells and ammonites, was built in the garden, though it has now crumbled to decay. In 1883, the house was bought as a marriage gift for Augusta Twining, the daughter of the tea merchant, and her husband, Auguste de Wette. The couple were accomplished musicians and built on a concert room. In 1945, the house was bought by the Borough Council as a home for old ladies, and the music room became the Hampton Court Theatre, open to the public and well worth visiting. On the eastern, adjacent side of the Green, is Craven House, a fine example of early eighteenth-century domestic architecture.

Westwards along Hampton Court Road is Garrick's Villa, where the great actor came to live in 1754. A house had stood here since the middle of the previous century, but Robert Adam gave it a new façade with a wooden portico, and enlarged and altered the interior. Across the main road, beside the river, Garrick built a small temple to house Roubiliac's statue of Shakespeare (now in the British Museum); Zoffany painted it in 1762 and it is still there today, as graceful as ever (see p. 407). The villa has recently been well converted into flats.

Nearby is the parish church, dedicated to St. Mary. Founded at least by the fourteenth century, it has

been rebuilt at intervals; the present structure, dating from 1830-1, was designed by Edward Lapidge, with a slender west tower with four neat pinnacles. The interior is plain enough, save for the richly decorated chancel which Sir Arthur Blomfield added in 1888. The monuments include the tomb, awkwardly placed in the vestibule, of Sibel Penn, Edward VI's nurse, with a life-sized effigy with an exceptional severity of line. Within the church is a marble monument to Susanna Thomas, which shows the young lady reading to her mother; it was designed by Thomas Archer and carved by Sir Henry William Powell - Jerome K. Ierome makes friendly mention of it in chapter 7 of Three Men in a Boat, Huntingdon Shaw, the smith who worked at Hampton Court and who died in 1710, had a monument here, part of which may still be seen on the south wall; the architect, Thomas Ripley (d.1758), Thomas Rosoman, proprietor of Sadler's Wells (d.1782), and John Beard, the celebrated singer (d.1782) all lie here, as does Antonio Verrio, who adorned the walls of Hampton Court with his murals. In the vestibule is an interesting little tablet by Bedford, showing a coastguard mourning for Captain Ellick (d.1853) who had been their comptroller-general, and around the west door, which is surmounted by the royal arms, is a mural painted in 1952-3 by the Reverend Geoffrey M. Fraser, showing Hampton residents, past and present, among them Cardinal Wolsey, Henry VIII, and Anne Boleyn. On leaving the church, the colossal mausoleum of John Greg (d.1795) of Dominica and his widow, Catherine, who died 'full of years and benevolence' in 1819, can be seen. Penn Place, close by the church, is where Sibel Penn is said to have lived.

Haringey

The new London Borough of Haringey, which lies to the north of the City, is made up from the former boroughs of Hornsey, Wood Green, and Tottenham. Of all the names invented or recalled from the past to identify the new administrative units, Haringey has chosen the most interesting, though no one is quite certain of its meaning. Dr. Madge, after listing 160 variant forms of the name, decided that it most probably derived from Heringeshege, meaning 'the enclosure of Hering', which later became 'Hornsey', a part of the modern borough. A chieftain of that name is mentioned in the Anglo-Saxon Chronicle for AD 603, so we can be reasonably certain that the name is Saxon. The borough covers an area of almost 12 square miles and has a population of some 230,000. On the western side are the heights of Highgate, Muswell Hill, and Alexandra Park, while to the east, the River Lea and Tottenham Marshes form the boundary. The predominant character of the area is a mass of small, friendly, turn-of-the-century, suburban housing with some light industry on the eastern side towards Tottenham.

HORNSEY has some interesting architecture, both ancient and modern. The parish church of St. Mary's stood at the junction of the High Street and Church Lane but at present the site lies empty, half churchyard, half garden, save for an isolated west tower built before 1500. The medieval church was demolished in 1927, a new one, designed by James Brooks, having been built a little to the east. A few years ago, the ground on which it stood was found to be unsafe and it too was demolished in 1969. It now seems as if the parish will be united with that of St. George's, Hornsey, and as if the monuments from St. Mary's will be removed to safety in that church. There are three of particular interest. The oldest is a chrisom brass showing the swaddled figure of little John Skevington, who died about 1520, and the most impressive is the large, late sixteenth-century incised

slab which shows George Rey and his two wives; their clothing is represented with unusual clarity and detail. Francis Musters, who died in adolescence in 1680, is shown kneeling in scholar's robes; his book is propped against a skull and cherubs hold a crown above his head. In the churchyard lies Samuel Rogers (1763-1855) who combined the occupations of banker, poet, and collector, and was besides a good and generous friend. At Wordsworth's death, he was

offered the laureateship but declined it.

The Town Hall and Central Library stand beside the Broadway, about half a mile south of St. Mary's tower. Unlike much civic architecture, they are worth seeking out. The Town Hall was built in 1934-5 to designs by R. H. Uren; the buildings are set around two sides of a square with a tower separating the two wings. The nearby Clock Tower was built in memory of Henry Reader Williams, JP. The Central Library was designed by F. Ley and G. Jarvis and was opened in 1965. Beside the west wall, a bronze sculpture by T. E. Huxley-Jones is set in a pool and surrounded by water sprays, and the main window on the staircase is filled with glass engraved by F. J. Mitchell, representing Hornsey both past and present.

The south-west corner of the borough borders on Highgate (see pp. 222-4), and within Hornsey's boundaries lies one of the finest seventeenth-century houses left in London. This is Cromwell House which stands, with Ireton House beside it, on the Bank above Highgate High Street and was built in the second quarter of the century for the Sprignells, a wealthy merchant family. It has a fine staircase which runs right up to the second floor with a panelled handrail instead of the more usual balusters; a cupola on the roof gives light to the stairwell. Seven bays wide, the façade is of brick with brick decorations to the windows. Ireton House, built perhaps fifty years later, is almost as handsome.

On the other side of the slope, in North Hill, stand two blocks of flats, Highpoint 1 and 2, designed in 1936 and 1938 by B. Lubetkin, a founder member of the Tecton group, stylish examples of architecture of that period. On the north-west side of the Hill is Archway Road. It was built to avoid the long, hard pull up from the City to the Great North Road at a time when every turn of a wheel meant a strain on the horses dragging the vehicle. The project was first put forward in 1810 but was not completed satisfacHARINGEY 257

torily till Telford redesigned the drainage in 1829. A viaduct was built to carry Hornsey Lane across the road, and from it Hans Christian Andersen, who was visiting Charles Dickens, looked out one evening and 'saw the great world metropolis mapped out in fire below him'. The same astonishing prospect is still visible today.

The north-west of the borough is occupied by Muswell Hill, a name derived from the Moss Well which existed till 1898 where Muswell Road now runs. Along the top of the ridge, a spacious late Victorian shopping centre was laid out where Fortis Green Road joins Muswell Hill Broadway, with St. James's church (founded 1842; present church 1898 by J. S. Alder), its spire a landmark for miles around, as a pivot. The two thoroughfares are linked by Queen's Avenue, lined on either side with balconied houses which look as if they should be gazing out to sea across some leisurely Edwardian esplanade, instead of being part of a London suburb. Nearby stood the Methodist Church in Colney Hatch Lane, with stained glass designed by Nora Yoxall and Elsie Whitford and dedicated in 1937. Their inspiration was the relevance of Christianity to modern life, and they showed groups of students, a father helping his son with a toy train, children at Sunday school and labourers with their barrows, as well as scenes from the life of Christ. The use of masses of colour rather than single painted lines was particularly suited to the medium. The church was demolished in 1982; the glass is safe and will be used again.

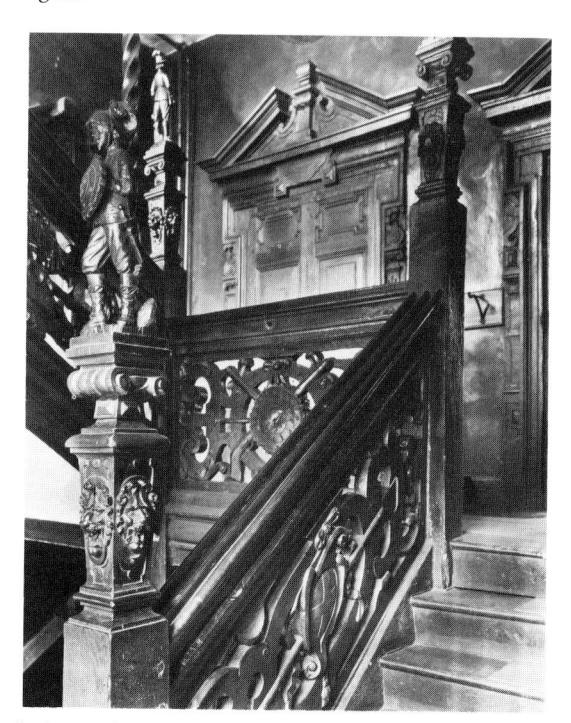

Staircase of Cromwell House, Hornsey

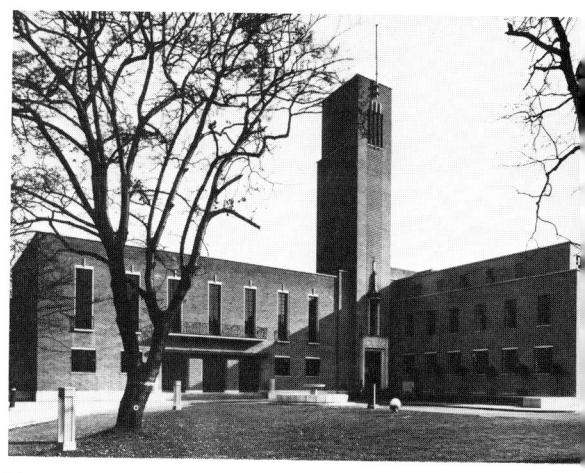

Hornsey Town Hall

The view eastwards from the top of Muswell Hill is one of the saddest in north London. Where the fields of Middlesex once stretched down to the Lea Valley and the 'lovely river' in which Izaac Walton fished, the plain is now filled with what seems to be dingy, ill-assorted housing and a row of giant cooling towers in the distance but, going down the hill, passing on the way the library of the Moravian Brethren and observing their church, a Victorian building with an atmosphere of utter peace, which lies at the foot in Priory Road, a turning into Alexandra Park is reached, from the heights of which the prospect across London broadens and the whole seems to acquire a purpose and a confidence.

By this time, we have come, imperceptibly, over the border into WOOD GREEN in which, until recently, Alexandra Palace was the most important building. The park was laid out in 1863 with a race track and the Palace, named as a compliment to the Princess of Wales and intended to be a north London counterpart of the Crystal Palace at Sydenham, was built ten years later to the designs of J. Johnson. A month later, it was burnt down and had to be rebuilt. A huge organ by Willis was installed in the main hall. In 1936 it became England's first television centre; later, it passed into the care of the GLC. Fire destroyed the building for a second time in the summer of 1980 and the shell stands desolate at present, though the ruins are now owned by Haringey Council who have great plans for the site. Wood Green also possesses Haringey's Civic Centre, built in 1958 by Sir John Brown and Henson. The building is large, glassy, and characterless, a poor companion for the Town Hall erected a generation earlier. Nearby, an enormous shopping centre has recently opened.

To the east of Haringey lies TOTTENHAM, closepacked housing with some light industry, but in it stand a cross, a church, and a castle, three structures of exceptional interest. The cross stands in the High Road. It was *not* built in memory of Queen Eleanor (see p. 122) but was a wayside or, possibly, a market cross, set up in the Middle Ages. About 1600 it was rebuilt in brick and then in 1809 the brick core was encased in Gothick stucco with many small embellishments. Subsequent restorations have, at least, ensured that it is still standing.

The church, dedicated to All Hallows, may well be of pre-Conquest foundation, though the first recorded reference to it is in a charter given by King David of Scotland to the Canons of Holy Trinity, London. This document, usually dated at about 1128, grants the church to the canons. Of the present building, the oldest part remaining is the tower, dating from the early fourteenth century, with an embattled upper storey added in the eighteenth. The chancel, nave, and arcades were all built later in the fourteenth century. About 1500 a rather grand south porch was added, with an upper room which later served as a school house for the entire village. The south aisle was built and faint scratches which once were a mass dial can still be distinguished. Considerable restoration work was carried out at the end of the seventeenth century and again at the beginning of the nineteenth. In 1875, William Butterfield set a disastrous hand to the enlargement of the old building. The chancel and nave were combined and a new chancel built, extending the church considerably to the east. A north aisle was added, as well as chapels like dwarf transepts to both north and south aisles, the nave roof was raised and a clerestory inserted, and the fifteenth-century font was smashed to pieces.

Today, All Hallows is a mixture. The glass at the west end of the north aisle is important; it is from France, fine late sixteenth- or early seventeenthcentury work, and shows Mark, Matthew, and Luke seated under canopies, with David, Isaiah, and Jeremiah below them.' There are two brasses, one to Elizabeth Burroughs (d.1616) and the other to Margaret Irby (d.1640), both of whom are shown with three children. Well-carved busts of Sir Robert Barkham and his wife Mary (d.1644) are set on her memorial, and their twelve children kneel beneath them; the seven daughters living at their mother's death have had to be squeezed in together with their arms linked, and two babies who died in infancy are shown in swaddling clothes, their cheeks resting on skulls. A neat double monument with two pairs of kneeling figures shows Richard Kandeler (d.1602) and his wife Elizabeth, as well as their daughter Anne and her husband Sir Ferdinando Haybourne, while

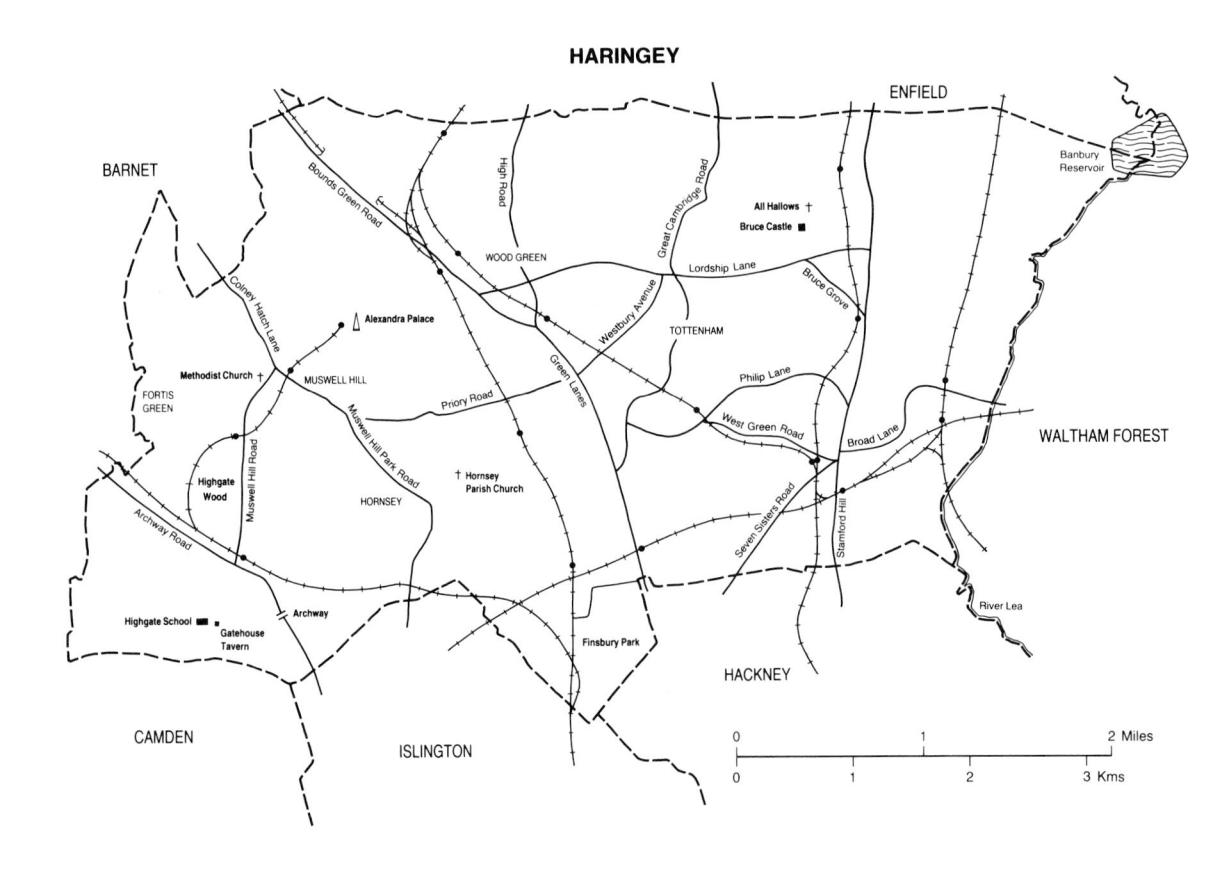

HARINGEY 259

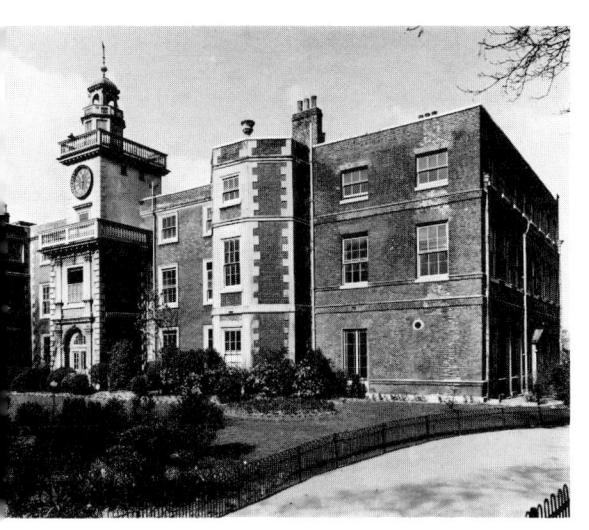

Bruce Castle, Tottenham

another small kneeling pair commemorate Sir John Melton and his lady. William Bedwell, who was Vicar from 1607 till 1632, was buried before the altar though Butterfield's enlargements disturbed his grave. A great oriental scholar, he was one of the translators of the Authorized Version of the Bible as well as being the first Englishman to translate the Koran; a mathematician besides, he also found time to write an account of his own parish, one of the first serious attempts at local history. In the churchyard, Margaret Lydia Samuel was buried; she was the daughter of the poet James Hogg, known as the 'Ettrick Shepherd'.

After the First World War, a memorial chapel was made in the north aisle; in it is a copy of the Perugino *Madonna and Child* which hangs in the National Gallery. In the tower hangs a fine peal of eight bells. Five of them were there, 'a pleasant tunable ring', in 1631; they were recast in 1696 and a sixth was added, to be joined by the two trebles in 1881. A single bell hangs with them. Made in France in 1663, it was the garrison bell of Quebec which was sounded in alarm when General Wolfe attacked on a September night in 1759.

Near to the church stands The Priory, now the vicarage. It was built about 1620 by Joseph Fenton, a rich barber-surgeon of London whose name is set in

the plasterwork of the ceiling. Some magnificent fireplaces remain too, and some panelling; when the house was refronted and the south wing rebuilt early in the eighteenth century, the alterations and additions were gracious. A fine eighteenth-century gateway has been brought here from the former vicarage.

The history of the castle goes back a long way too. The manor of Tottenham belonged at the Conquest to Waltheof, Earl of Northumberland, who married the Conqueror's niece, Judith. Their daughter married a Scottish nobleman and by the middle of the thirteenth century there was a manor house here, the property of Robert de Bruis. When his descendant Robert the Bruce, declared himself King of Scotland in 1306, Edward I, understandably enough, confiscated the estate near to London, but the association and the name remained. Bruce Castle was granted to Sir William Compton in 1514, who replaced the old dwelling with an E-shaped mansion which was considerably enlarged by Lord Coleraine in 1684 and was altered yet again by the Townsend family in the eighteenth century. At some point, probably towards the end of the sixteenth century. possibly when Queen Elizabeth came to Tottenham in 1578, a curious tower was built in the grounds; its purpose is as uncertain as its origins. In 1827, Bruce Castle was purchased by Rowland Hill and a school was opened there; its founder, later Sir Rowland. invented the adhesive stamp and established the scheme of penny post in 1840. The school flourished. under other management, till 1891, when the castle and the grounds were purchased by the borough.

It has now become a lively municipal museum. The display is divided into three sections. First, there are changing exhibitions on various aspects of local history, using paintings, photographs, and other material including a complete run of Court Rolls from 1318 to 1732. Secondly, there is the largest collection in the country, outside the archives of the Post Office, concerned with postal history. Numbers of Victorian pillar boxes are on view and there is a handsome collection of early mail-coach prints and lithographs in the permanent display. Finally, space on the first floor is devoted to the history of the Middlesex Regiment, first raised in 1755 and since 1967 absorbed into the Queen's Regiment, which won its sobriquet, the Diehards, most bitterly against the French at the battle of Albuera during the Peninsular War in 1811.

Harrow

The borough of Harrow lies to the north-west of London, the only one of the new administrative units to retain its pre-1965 boundaries intact. In fact, those boundaries have altered very little since Domesday Survey was made. They include Pinner and the two Stanmores, both Great and Little, enclosing an area of 20 square miles with a population of some 196,000. Harrow, with Hampstead and Highgate, is one of the three main heights to the north-west of London, and there is also high ground at Stanmore. Retaining two distinct (and one half-submerged) village centres, Harrow lies, in spirit if not in administration, outside the London orbit, belonging far more, despite miles of small, red-brick, inter-war housing around south and west Harrow and Rayners Lane, to the Hertfordshire countryside just beyond its northern boundary.

HARROW-ON-THE-HILL must be considered as a whole. Because of the steepness of the Hill, and Harrow School's ownership of a good proportion of the land, changes have come about slowly, and, where there has been rebuilding or the insertion of something new, the plans chosen have been in harmony with those of their neighbours. The Hill, rising to 406 feet, and still, for the most part, green on the southern, western, and eastern slopes, provides the surrounding built-up area with a focal point and an oasis. The name of Harrow derives from hearg, a pagan shrine, and there may well once have been one on the windy hilltop.

Today a church, dedicated to St. Mary, crowns the summit, its sharp spire visible for miles around. Defoe in his *Tour through England and Wales* (1724–6) tells the tale that Charles II, tired of theologians' squabblings, declared that 'if there were e'er a visible church upon earth, he believ'd this was one' and even today, in spite of all the streets and houses that have been crowded into what was once Middlesex, we may agree with that monarch. Land in Harrow was granted to the Church by Offa, King of Mercia, in 767 and we know that, after the Conquest, Lanfranc founded a church there which Anselm, his great successor in the archbishopric of

Canterbury, consecrated in 1094. Nothing remains of it, nor of any pre-Conquest buildings which may have preceded it, but the base of the present tower dates from about 1130-40. The south wall of the chancel, with five slender lancet windows adorned with traces of painting on their splays, dates from the late twelfth century, while the nave and aisles are early, and the transepts late, thirteenth; in the north wall of the south transept is a recess which may be the remains of a piscina. Between 1437 and 1467 when John Byrkhede was rector, a clerestory was inserted, a new tie-beam roof was constructed, and the south porch was built. The plaster above the arches still holds the marks of the beams for the original roof. The wall-posts of the present roof have figures, possibly representing the apostles, set in niches, each tie-beam is trimmed with brattishing and has a carved boss, and at the centre of each bay, with feet at an angle to the wall, is a figure holding a musical instrument. The roof of the north transept is of similar construction. By the beginning of the nineteenth century, the church needed restoration and Sir George Gilbert Scott was called in, with heavy-handed results. He reconstructed most of the walls, except the south wall of the chancel, encasing the exterior with flints, save for the tower to which he added battlements.

The fittings within the church are of great interest and there are no less than thirteen brasses though some are incomplete. The late twelfth-century font is magnificent, with a circular bowl carved with a sort of egg and dart motif and a spirally fluted stem. The north door of the church dates from the late fifteenth century, and the pulpit was given in 1708 by Tanner Arnold Esq.; the hexagonal, much enriched frame is supported on six elaborately carved brackets. Sir Edmund Flambard has the earliest brass (c.1370), with another for his son, Sir John, about twenty years later. John Byrkhede, during whose incumbency the fine new roof was raised, is shown wearing his cope with ten saints about him, while George Aynsworth, who died in 1488, is shown with his three wives and the fourteen children they bore him. The most important brass is that of John Lyon

¹ There are six twelfth-century fonts in Middlesex, at Harrow, Hendon, Finchley, Harmondsworth, Willesden, and Hayes. The remarkable font at West Drayton should be added.

HARROW 261

(d.1592) who is shown with his wife, though the figure of their little son, Zachary, is missing. Left childless, they used their wealth to establish 'a free grammar schoole in this parish to have continuance for ever'. The nineteenth century added its tribute to Lyon, for a small memorial carved by John Flaxman. showing a teacher with three boys, was set up. A pair of kneeling figures commemorate William Gerard (d.1609) and his wife, and there is a plaque by Westmacott to Joseph Drury, who was headmaster at Harrow when Byron was a schoolboy; so successful a pedagogue was he that the numbers in the school rose from 139 to 345. The poet's little daughter, Allegra, whom Claire Clairmont bore him, was buried beneath the church porch in 1822, but there is nothing to mark her resting-place. In the churchyard is the flat tombstone of John Peachev on which the poet used to sit during his schooldays here.

John Lyon's foundation stands beside the church. A school was already in existence at Harrow, established in all probability in pre-Reformation times and certainly by Oueen Mary's reign. In February 1572 Lyon secured a charter from Queen Elizabeth, enabling him to reconstitute the school and to endow it with his landed property. After his death in 1592 and that of his wife in 1608, a red-brick school-house was built in 1615, which still crowns the hill today. The school remained comparatively small till the middle of the eighteenth century when, under a series of effective headmasters, it increased in size and scholarship. Among its pupils, Harrow has numbered seven prime ministers - Spencer Perceval, Viscount Goderich, Sir Robert Peel, the Earl of Aberdeen, Lord Palmerston, Stanley Baldwin, and Sir. Winston Churchill, as well as the incomparable orator and politician, Charles James Fox. Churchmen like Cardinal Manning and Archbishop Davidson, soldiers such as Lord Gort and Lord Alexander, philanthropists like Sydney Herbert and the seventh Earl of Shaftesbury, and poets and writers such as Sheridan, Byron, Trollope, Galsworthy and Trevelvan, have all been schoolbovs here.

The school buildings provide a visible history of the development of educational architecture through four centuries. The Fourth Form Room inside the original building is still equipped as it was in the middle of the seventeenth century when the boys began to carve their names on the panelling. From about 1800, the school started to take over the larger private dwellings on the hill for use by the 'Houses' into which the school is divided. Then accommodation was specially built; C. R. Cockerell enlarged the original building, matching his additions so that they can scarcely be distinguished, Sir George Gilbert Scott built the Chapel and Vaughan Library in the 1850s and 1860s, in 1872 William Burges modelled the Speech Room on the plan of a Greek theatre, and Sir Herbert Baker designed the War Memorial Building, within which is the Alexander Fitch Room. Equipped in memory of an Old Harrovian who fell at

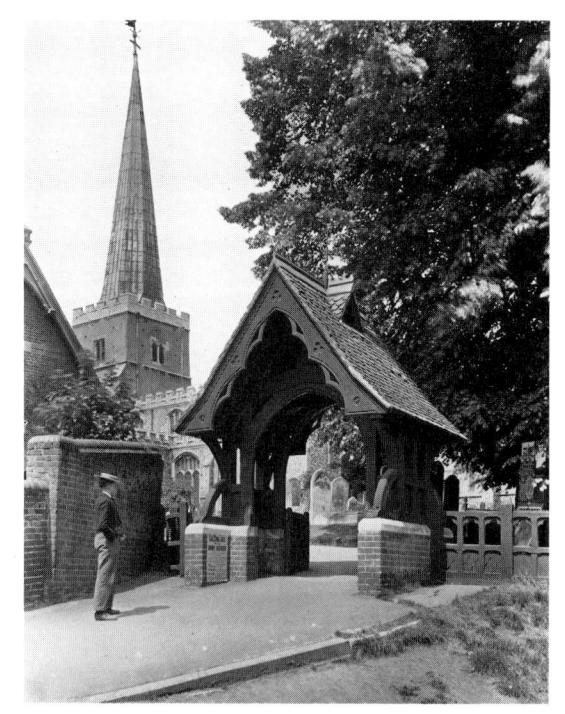

St. Mary's, Harrow-on-the-Hill

Jeancourt in September 1918, it is lined with Tudor panelling from Brooke House which once stood in Hackney (see p. 241), and around the rooms and up the staircase hangs the school's collection of paintings and watercolours, among them works by J. M. W. Turner, David Cox, Copley Fielding, Thomas Girtin, John Varley, and De Wint. Impressive new science laboratories have just been completed and a Dining Hall has been built.

The whole High Street, from the school to the King's Head public house (partly sixteenth-century), is worth attention. Views across London and Middlesex can be seen, while from one point in the churchyard, clearly marked by a brass plate set in the wall, thirteen counties can be surveyed on a fine day.

Once off the Hill, two churches are worth seeking out. They are the Catholic church of Our Lady and St. Thomas of Canterbury¹ in Roxborough Park, which possesses some good stained glass (c.1950) by Joseph Nuttgens, and St. Alban's church in Church Drive, North Harrow, which was designed in 1936 by A. W. Kenyon. Brick-built with a fine square tower, its interior is so simple and unadorned that it seems almost stark; of its period and style, it is an interesting and characteristic example.

WEALDSTONE lies to the north. The Stone, which may have been brought south by the glaciers or may have been dragged here for religious pur-

 $^{1\,}$ St. Thomas à Becket stayed at his manor in Harrow in December 1170, just before his martyrdom.

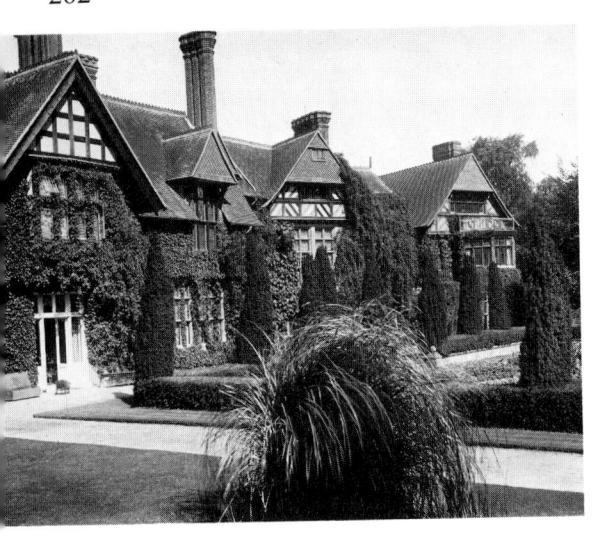

Grim's Dyke, Stanmore

poses, is today set in concrete outside the Red Lion Hotel. Turning westwards, into Headstone Drive, we reach the Kodak Factory where an excellent small museum, devoted to photography and photographic equipment, is housed in the oldest surviving building on the site (1891) and is open daily, free of charge. The Whitefriars Glass Factory in Tudor Road, which closed in 1980, could trace its descent from a seventeenth-century glassworks on the site of the Carmelite monastery off Fleet Street, and was responsible for much fine stained glass. In a small recreation ground off Headstone Lane stands a fourteenthcentury manor house, with additions made during the next three centuries, all surrounded by a moat and today providing a residence for the park keeper, while on the other side of the moat is a tithe barn built about 1530.

A mile further to the west is PINNER. Much of it consists of red-brick, 1930s, superior, architectdesigned housing, but the High Street itself may fairly be considered as a typical, timeless, English village street. Its focal point is the grey flint and freestone fifteenth-century west tower of the church of St. John the Baptist, standing on a little knoll at the far end of the street. The body of the church was consecrated in 1321, while the plan and parts of the north-east wall may well be earlier. The windows have remained unaltered, save for the insertion of a fine east window in the fifteenth century; the font is of the same date and plump twisted altar rails, fashioned in the seventeenth century, were rescued from Chestnut Cottage and re-installed in 1902. The whole building was most sympathetically restored by Pearson in 1880. One little brass to Anne Bedingfeld who died in 1581 in babyhood - she is shown in her swaddling clothes - is kept in the vestry; it must have been cut from an older brass for a few words in Flemish are visible on the back. Christopher Clitherow (d.1685) is remem-

bered by a festooned marble urn, and tablets commemorate Henry James Pye (d.1813), one of the least successful poets ever to have held the laureateship, and the wife of John Holwell, Governor of Bengal. This gentleman was one of the 23 survivors of the 146 men and women incarcerated in the Black Hole of Calcutta one stifling summer night in 1756. Out in the churchyard, a curious obelisk with what appears to be a coffin stuck through it, marks the burial place of the parents of John Claudius Loudon, the horticulturalist; the projection is, however, only a bizarre decoration.

The houses lining the High Street are at one with the church. Half-timbered or of Georgian brick, many have their dates set above the door, the two public houses, the Victory (1580) and the Queen's Head (Queen Anne), being particularly attractive. Once a year, originally St. John's Day in June though now the Wednesday after Spring Bank Holiday, the High Street and adjacent Bridge Street are closed to traffic and the fair, which has been held here ever since 1336, takes place. Originally a cattle and hiring fair, it is now devoted solely to pleasure, and an astonishing number of roundabouts, big wheels, hoop-la stalls and coconut-shies can be seen.

In Paines Lane and Moss Lane are a number of fourteenth- to sixteenth-century cottages, still making excellent dwellings for their twentieth-century owners. The architecture of the present century is well represented by St. Luke's Roman Catholic church in Love Lane, and by St. Anselm's at Hatch End. The former was designed by F. X. Velarde and completed in 1957, with an interior of a glorious spaciousness and three fine sculptures by David John: the latter was designed by F. E. Jones in 1895–1905 and has stained glass by Louis Davis and

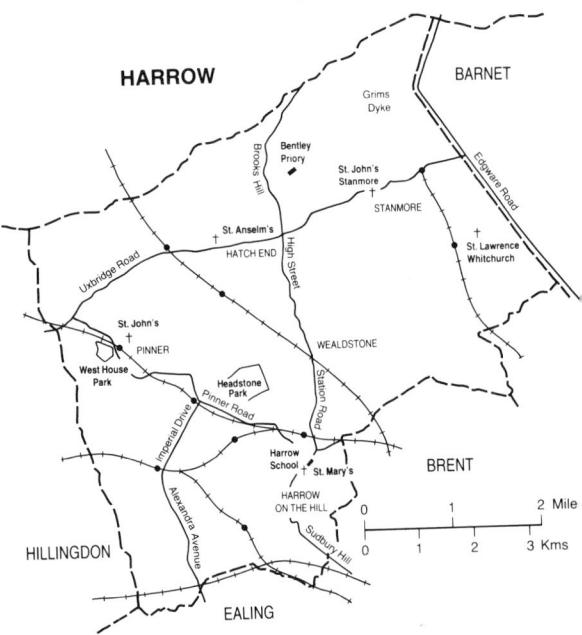

HARROW 263

a handsome rood-screen. Mrs. Beeton lived near to the church, at 2 Chandos Villas.

STANMORE, ostensibly successful stock-broker's villa country, lies to the north-east. Stretching across the golf course there is Grim's Dyke, an earthwork some five miles long, consisting of a rampart and a ditch and probably of fifth- to sixth-century – that is, post-Roman – origin. The best view of it may be obtained at the junction of Oxhey Lane and Old Redding (another road), while permission to walk it should be sought from the secretary of Grim's Dyke Golf Club. This earthwork gave its name to a house built by Norman Shaw in 1870 for the painter Frederick Goodall RA, which afterwards became the home of Sir William Schwenk Gilbert, who wrote the Savoy operas and lived there from 1890 till his death in 1911 on a summer's day in his own garden after rescuing a guest from the lake. The house, in Old Redding, is today used as a restaurant.

Bentley Priory is set on the heights of Stanmore Common. There is no trace now of the monastic building which once stood here, but in 1766 an army contractor, James Duberly, built a house which in 1790 was enlarged by Sir John Soane for the Marquis of Abercorn. A fine circular room with a dome,

known as the Rotunda, still exists in good condition, and the grounds were laid out in terraces, with a view across to Harrow church. Queen Adelaide, William IV's kindly wife, died there in 1849; the walls and ceiling of her sitting room were prettily painted with posies of flowers. Later, Sir John Kelk, the contractor for the Albert Memorial, made his home there. In 1936 the house became the headquarters of RAF Fighter Command and it was from here that the Battle of Britain was controlled. The house is still Air Force property; though damaged by fire in 1979, it has since been restored.

Two churches, both dedicated to St. John, stand in a single churchyard at Great Stanmore. The medieval church which stood on another site a little distant, fell into disrepair by the seventeenth century and a new one, of fine dark red brick with a square tower and a south porch for which Nicholas Stone, the king's own mason, may have been responsible, was built in 1632 at the expense of Sir John Wolstenholme and was consecrated by William Laud, then Bishop of London, later Archbishop of Canterbury. By the middle of the last century, this building too was thought to be unsafe, so the roof was removed and it was left to become the picturesque,

Fourth Form Room, Harrow School

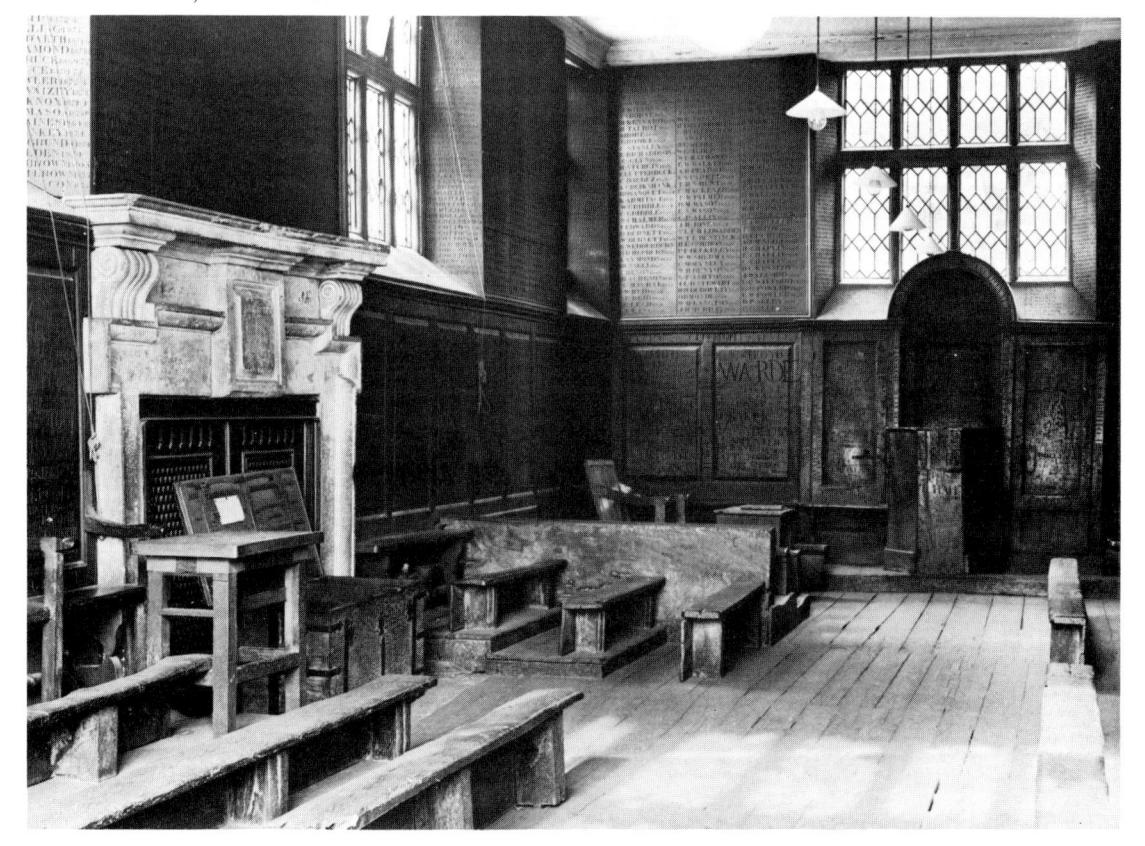

ivy-clad ruin which it is today. A third church was built, this time to the designs of Henry Clutton, in 1850. Of no great architectural importance, though pleasant and welcoming enough, it is worth visiting for the fine monuments, many of which came from the older St. John's, and for two stained-glass windows, one of which, the large east window by Thomas Willement, was given by Queen Adelaide, while the other, in the south wall, set there to the memory of Robert and Ellen Hollond, is by William Morris. Eight bells, two of them presented by Sir John Wolstenholme, hang in the tower.

Of the monuments, there are five in particular which are of importance. The earliest is to John (d.1605) and Barbara (d.1615) Burnell, who are shown kneeling opposite each other, a prayer-desk between them; beneath them kneel their four sons and four daughters; three of them hold skulls to signify that they predeceased their parents. The monument is kept in perfect repair by the Clothworkers' Company of which Burnell was a member. The church's benefactor, Sir John Wolstenholme, who had also financed Henry Hudson's attempts to find the north-west passage, died in 1639. Nicholas Stone carved his life-sized marble effigy, and was also responsible for the font, a neat, hexagonal bowl with the Wolstenholme crest and arms. Sir John's grandson, another John, whose father hazarded much in his support of Charles I, though the family recouped their losses after the Restoration, has a remarkable

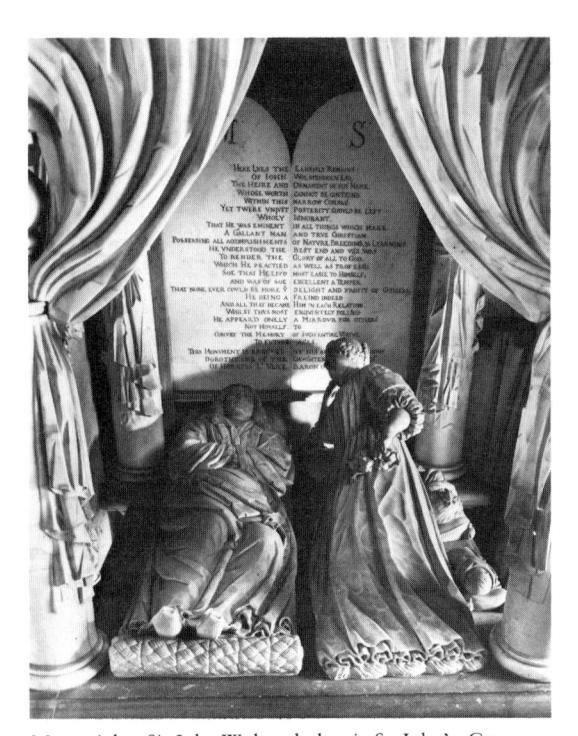

Memorial to Sir John Wolstenholme in St. John's, Great Stanmore

monument too, so large that it is kept in the tower room since there is no place for it in the church. A canopy like that of a four-poster bed shelters an effigy of the dying man; his wife reclines beside him, wiping his brow with a marble handkerchief, while two swaddled infants who died too soon lie beside her. In the north-west corner of the church is an exquisite white marble monument, carved by John Bacon in memory of John Dalton, the son of the rector of Stanmore, who died in 1785 aged 37; the composition, a life-sized lady mourning beside a flower-wreathed urn, is conventional enough, but the execution is superb. On the base, two cherubs float towards each other; sketches for this portion of the monument are in the library of the Royal Academy, Finally, another life-sized effigy commemorates George Gordon, fourth Earl of Aberdeen, who lived at Bentley Priory and died in 1875. It is the work of Sir Edgar Boehm. Stanmore provides a neat set of illustrations to two-and-a-half centuries of British sculpture. In the churchyard outside, a large white marble angel indicates Sir William Gilbert's grave, while the resting-place of William Hart (d.1683), the eldest son of Shakespeare's sister, is unmarked.

On the easternmost boundary of the borough, in Whitchurch Lane, is Canons Park. This covers a part of the site whereon James Brydges, Duke of Chandos, built a mansion. Having been paymaster-general under Marlborough in the wars against France, he retired with a fortune and spent between £200,000 and £300,000 on his villa, which Pope lampooned cruelly in his Epistle to Burlington. The Duke's temper was far from easy and he changed his architect frequently, employing, at different times, John James, William Talman, James Gibbs, John Price, and Edward Shepherd. The house was completed in 1725; the Duke died in 1744, having run through most of his money. Three years later, his son was forced to sell the estate piecemeal, the breakup value of the house realizing a mere £11,000. Fragments of that mansion found their way all over England. The gates are at Hampstead parish church, and some of the railings at New College, Oxford; the staircase went first to Chesterfield House and then to the Odeon Cinema at Broadstairs where it was bombed; the portico went to Wanstead and then to Hendon Hall; the statue of George II is in Golden Square; the altar, font, and pulpit from the private chapel are in Fawley Church, Buckinghamshire, and the wall paintings by Bellucci in Great Witley church, Worcestershire; the organ, on which Handel must have played while he was employed by the duke, is at Holy Trinity, Gosport, in Hampshire. A cabinetmaker called Hallett constructed a modest country house from some of the remaining materials of the Duke's dwelling, and this today, with additions by C. E. Mallows in 1910, is used by North London Collegiate School. Three avenues of trees ran across the grounds, to Edgware, to Stanmore, and to HARROW 265

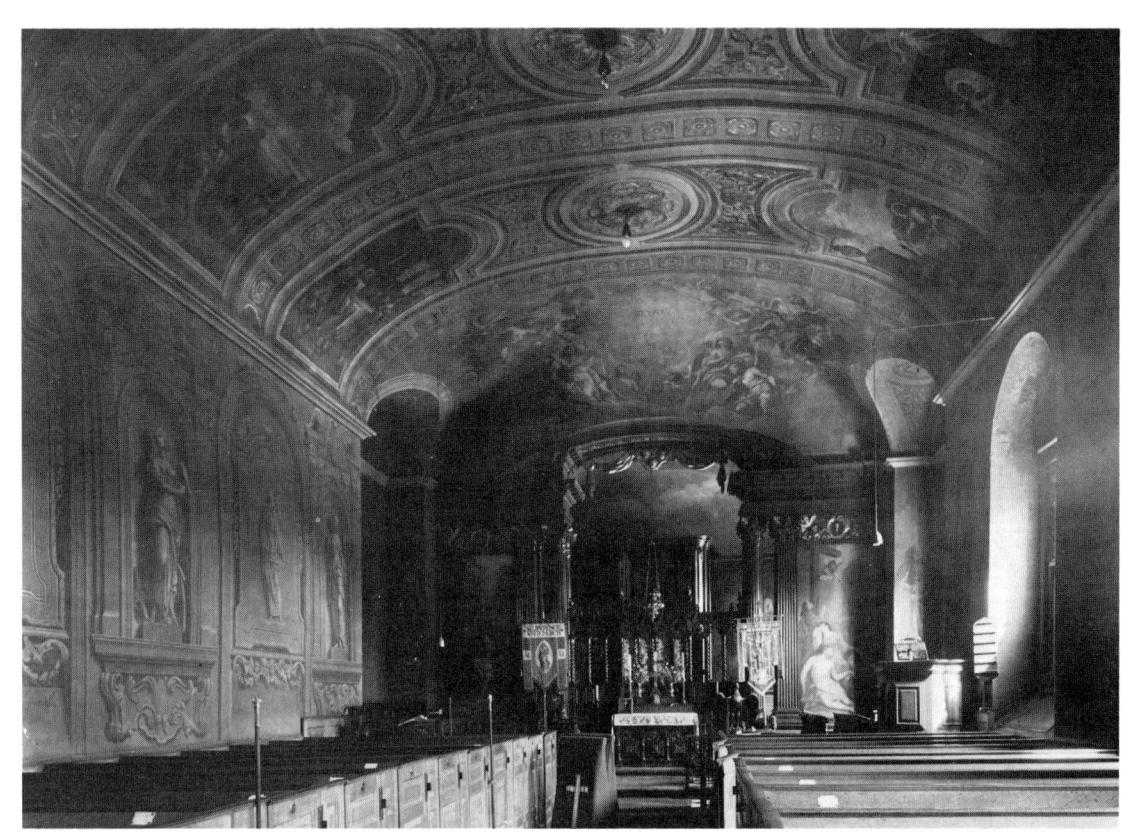

St. Lawrence, Whitchurch

Whitchurch (Little Stanmore); of the three, nothing remains save a few isolated trees to mark where the last one ran. Parts of the old garden walls still stand, enclosing the George V Memorial Garden opened by the municipality in 1937, with vivid herbaceous borders and two small summer-houses, one of which probably dates from Chandos's day. The rest of the land has been built over.

What has survived, more or less intact, is the little parish church of St. Lawrence, Whitchurch. The Duke demolished the medieval building, with the exception of the sixteenth-century tower, and rebuilt the church in brick with dignified stone dressings to the round-headed windows and with Tuscan pillars at the angles of the south porch. Inside, the church is unique, for there is no other similar early Georgian interior anywhere near London. All the walls and the vaulted roof are covered with grisaille paintings by Louis Laguerre, while the altar is flanked by a coloured Nativity and a Pietà by Bellucci, who was also responsible for the copy of Raphael's Transfiguration on the domed ceiling of the Duke's pew. This is in the west gallery, as if it were a box in a theatre, looking towards the altar set between coupled Corinthian pillars joined by a hollow carved and gilded pediment, and resembling nothing so much as a proscenium arch; the altar, inevitably, takes the place of the stage. Behind it is a neat organ by Gerald Smith, on which Handel must surely have played sometimes; on either side of it are paintings by Verrio of Moses receiving the Law and of the Sermon on the Mount. The original box pews and altar rails are still in place, and the carved frieze at the east end, between the pillars and the walls, is superb. The whole church is, gradually and expertly, being restored. On the north side of the building is the Chandos mausoleum, its walls and ceiling covered with more grisaille paintings. In it stands an impressive monument to the Duke and his two wives; he is attired as a Roman, the ladies kneel meekly, like virtues, on either side of him. We do not know who executed the sculpture; Grinling Gibbons and Andries Carpentière have both been suggested. The whole building is a silent but eloquent witness to what one man, possessed of some taste and much money and determined to demonstrate his possession of both, could achieve in the early eighteenth century.

Havering

Havering, the second largest of the new boroughs, lies in the extreme north-eastern corner of the Greater London area and was formerly in Essex. It is composed of the borough of Romford and the urban district of Hornchurch, but it would be more accurate to describe their union as a reunion since, from 1465 till 1892, these 46 square miles, which to-day have a population of about 240,000, were the Royal Liberty of Havering-atte-Bower, which now gives an ancient name to the new administrative unit. There is high land and open country with splendid views in the north at Havering itself, but the centre of the borough, at Romford, Hornchurch and Utminster, is closely built up. The eastern side, at Cranham and North Ockendon, is open again, and there is marshy ground to the south at Wennington and Rainham where the Ingrebourne River which, in its upper reaches, is called the Rom, at last flows into the Thames at Rainham Creek.

HAVERING-ATTE-BOWER lies in the north-western corner. Edward the Confessor had a hunting lodge here and it said that the very name of the place is derived from the legend of a ring which the pious king bestowed upon a beggar who later revealed himself as St. John. A small palace was built there early in the Middle Ages and was an occasional place of residence from Henry II's time till the seventeenth century. There Edward III invested his grandson, the future Richard II, as his successor, and that unfortunate monarch's widow, the young Isabella of France, retired there, as did Henry IV's widow, Joan of Navarre. Of Havering's medieval magnificence little remains. The palace was sold off during the Commonwealth period and demolished; near to the site, John Baynes, serjeant-at-law, built Bower House in 1729. A carved stone above the fireplace bears the arms of Edward III and an inscription below declares that Baynes's architect was Henry Flitcroft; this was probably the young man's first independent commission. The grounds were laid out by Charles Bridgeman, who may well have given advice on the siting of the house, and the stairwell was decorated by Sir James Thornhill with murals of the *Judgement of Paris*, the *Drunkenness of Silenus*, and *Vulcan at his Anvil*; the paintings are still preserved though they have been boarded over for protection. The house is at present used by the Ford Motor Corporation.

The twelfth-century font of Purbeck marble from the palace chapel is to be found in the parish church of St. John, a flint building designed in 1878 by Basil Champneys, which replaced an older church. On the Green nearby stand the village stocks and whipping post, set up about 1700, replaced at intervals, but no longer in use.

To the east is NOAK HILL, windswept and open. The church here, dedicated to **St. Thomas**, was built in 1841–2 by William Blore. Pleasant enough architecturally, it is worth visiting for the fragments of French, Belgian, and English sixteenth- and seventeenth-century glass in the windows, among them the badge of Queen Jane Seymour, Henry VIII's third wife, and for a carved wooden panel showing Christ bearing the cross. Its provenance is uncertain but it would seem to be seventeenth-century and may have come from a Florentine church or monastery.

GREAT WARLEY lies eastwards, through open country on the borders of Essex.1 The parish, mentioned in Domesday Book and with registers running back to 1538, is old enough, but the present parish church, St. Mary's, was dedicated only in 1904, when Evelyn Heseltine built it as a memorial to his brother, Arthur. His architect was Harrison Townsend and Sir William Reynolds-Stephens² designed the decoration of the interior. The result is a perfectly conceived and perfectly decorated Art Nouveau temple. Every detail was carried out with exquisite craftsmanship, while the choice of materials and colours is breath-taking. The apse is sheathed in palest green marble and as reredos a figure of Christ, made of copper with oxidized silver, tramples on a black copper serpent representing death. The walls of the nave and the waggon-vaulted roof are decorated with bands of aluminium adorned with eastern lilies and the rose of Sharon, and the same symbolism of tree and flower is continued in the rood screen, with its base of deep green marble from which spring

¹ Part of the parish is, in fact, in Brentwood and not in London. 2 His best-known work is the bronze statue in the Tate Gallery representing Queen Elizabeth playing chess with Philip of Spain with ships for chessmen.

brass trees, their interlaced branches bright with flowers of red glass and mother-of-pearl, while among the foliage nestle silver angels.

On the western side of the borough, ROMFORD, a busy town, has enjoyed the right to hold its own market ever since 1247. Originally, it was primarily for cattle, but the trade in livestock ceased in 1958 and a general market is now held on Wednesdays, Fridays, and Saturdays. The broad, central market-place has a continental atmosphere as if it might belong equally well to some Dutch or north German town.

The parish church, dedicated with proper local pride to St. Edward the Confessor, stands at the main crossroads. Though the foundation dates from the fourteenth century, the present building was erected only in 1850. Its architect was John Johnson, its most noteworthy feature its dominating 162-foot spire, and it was built partly with stone from Nash's Quadrant in Regent Street, which was being demolished at the time. It houses several monuments from the old church, three of them of particular importance. Throughout the fifteenth and sixteenth centuries, the senior local family were the Cookes, the fourth generation of which produced Sir Anthony, who became tutor to the young Edward VI; he was knighted at his pupil's coronation. His large alabaster monument is divided into three bays by Corinthian columns; Sir Anthony (d.1576), wearing armour, kneels at a prayer-desk opposite his wife, clad in cloak and ruff. His two sons, also in armour, kneel behind him, and their four daughters are behind Lady Cooke; the young ladies all married exceptionally well, Mildred to Lord Burghley, Ann to Sir Anthony Bacon, thus becoming the mother of Sir Francis, Elizabeth to Lord Russell, and Katherine to Sir Henry Killigrew. The balanced proportions and serenity of the carving show how well both the sculptor and the family commissioning the work had absorbed the lesson of Italy. Sir George Hervey, Lieutenant of the Tower, has a smaller, more conventional, memorial, showing him and his wife with their five sons and six daughters; one of their girls married George Carew and became the mother of the future Earl of Totnes who, in filial love, raised to her a monument on which her effigy reclines stiffly, propped up on a rigid elbow.

Church House, which stands beside St. Edward's, is far older than its neighbour. Built in the fifteenth century, its upper floor jetties out. Originally, it housed a chantry priest, but after the Reformation served as the Cock and Bell Inn till it at last became church property again. The Golden Lion, at the south-west corner of North Street, has stood there since the sixteenth century, though the nineteenth century remodelled its façade. Visitors to Romford may care to remember that the now-vanished manor house here was the birthplace of Francis Quarles, the poet, in 1592.

The centre of the borough has been completely built up during the twentieth century, with HORN-

The stables, Bower House, Havering-atte-Bower

CHURCH on the western side, and Upminster to the east. In the former, the most important building is the parish church, dedicated to St. Andrew and with a horned bull's head above its eastern gable instead of a cross. The reason for this unique adornment is uncertain. Though a church may have stood here before the Conquest, and though to the twelfth century Hornchurch was the mother-church for the whole Liberty, serving Havering, Romford, and the surrounding countryside as well as its own village, there is no written record of the church before 1158, when Henry II granted twenty-five acres of land there to the monastery of St. Nicholas and St. Bernard at Montjoux in Savoy. Some of the brethren came over and built a priory and a church here; the tomb of one of the priors, Boniface de Harte of Aosta, can still be seen in the chancel. For nearly two-and-a-half centuries, the monks maintained their establishment, and then, in 1390, Richard II confiscated the lands of alien priories. William of Wykeham, Bishop of Winchester, purchased the property and bestowed it upon New College which he had just founded at Oxford; the living is still in the gift of the College though Hornchurch now belongs to the diocese of Chelmsford.

Of the monks' first church, nothing remains, though the chancel with its sedilia, piscina, and squint, and the north and south arcades date from their second building erected in the thirteenth century. When the church became the property of New College, the north and south aisles were rebuilt (the south aisle has needed a second rebuilding in modern times); towards the end of the fifteenth century the north and south chapels, the west tower with embattled parapet and turrets, and the north porch were added. Thomas Scargill left ten marks in his will of 1476 towards the building of the steeple and the copper-clad spire is still a landmark to shipping coming up the Thames. The lofty flat-pitched roof of the nave was freed from its plaster ceiling in 1957 and was found to be painted with a chequer-board pattern with golden stars in the rectangles; the timbers are adorned with small, grotesque heads.

There are numerous brasses or indents of brasses. now set in the chancel and the north chapel. William Ayloffe and his wife Audrey lie near to the chancel in an altar tomb, rich with quatrefoil mouldings, and there are small wall monuments with kneeling figures to Richard Blackstone (d.1638), to Francis Rame (d.1617), and to Humphrey Pve (d.1625) who was letter-writer to James I. Thomas Witherings, postmaster-general to Charles I and a superbly efficient organizer, who lived at Nelmes, a nearby mansion, and who died on his way to church here in 1651, has a small black tablet with a skeleton carved upon it, and there is another plaque to Sir Francis Prujean, the physician (d.1666). John Flaxman carved a medallion with two angels in memory of Richard Spencer (d.1784). Joseph Fry, son of the prison reformer, Elizabeth, lies here and in the churchyard stands a memorial, designed by Sir Charles Nicholson in 1921, to those who died in the First World War.

Though they were originally two different communities, today the buildings of Hornchurch and UPMINSTER merge into each other. The parish church, dedicated to **St. Laurence**, has an impressive early thirteenth-century west tower, the first floor of which is supported on massive posts and beams. The third storey, containing the bell chamber, was added later; in it are three bells, the largest of them hung there in 1602 to celebrate Queen Elizabeth's visit to

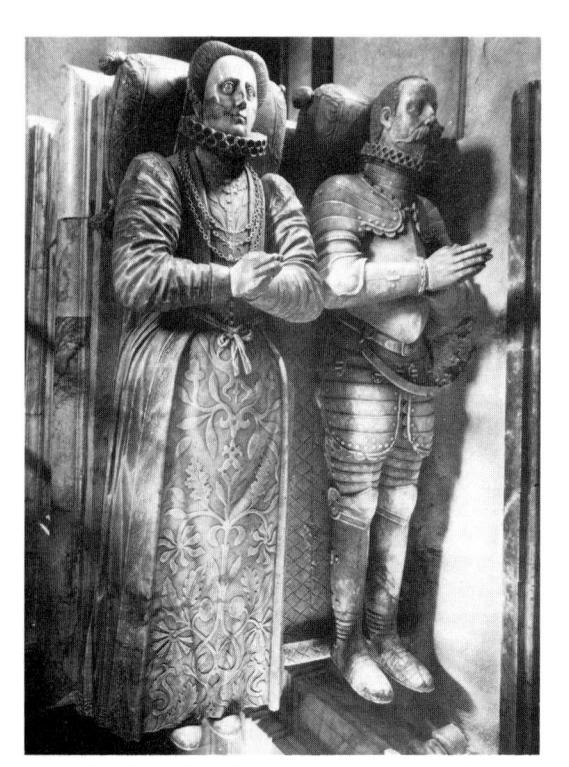

Poyntz family tombs in St. Mary Magdalene, North Ockendon

Windmill, St. Mary's Lane, Upminster

Upminster, the second with the inscription: 'Robert Mot made mee 1583', and the third cast by John Kebyll in the late fifteenth century and inscribed: 'Sancte Gabriel Ora Pro Nobis'. On top of the tower is a pretty broached and shingled spire, said to have been erected while Dr. William Derham was rector here between 1689 and 1735 and to have been used by him as an observation post when he was calculating the speed of sound from guns fired at Woolwich Arsenal. Inside the church, the north arcade was constructed in the early fourteenth century, but most of the rest, save possibly for the core of the walls, dates from the rebuildings of 1771 and 1862. The oak screen across the entrance to the Lady Chapel is of the mid-fifteenth century and the font, which came from the chapel of Upminster Hall, is a little later. In the chapel there is a window dated 1630 but with fragments of earlier glass; the morsels include a partridge, butterflies, a family walking together in a garden, a swaddled baby, and two men armed with arquebuses, the earliest form of hand-gun. There are a number of brasses, now set in the wall of the north aisle, which include Gerard D'Ewes (d.1591) clad in full armour, and a medieval brass with an abbot which was re-used for Nicholas Wayte (d.1545) and his wife Ellen. A later one, to Grace Latham who died in 1626, shows her wearing an elaborate dress with a wide collar.

HAVERING 269

Upminster's most unusual building stands just to the west of the church, in St Mary's Lane. It is a late eighteenth-century, four-sailed smock mill, now maintained in good repair by the Borough Council and open to the public on application in writing. The windshaft came from a much older mill, and the spur wheel and loading device are most ingenious. Not far away, in Hall Lane, stands the fifteenth-century tithe barn which, though less impressive than the barns at Harmondsworth or Ruislip, is still a remarkable building. It has recently been opened as a folk, local history, and agricultural museum. Another mile to the north-east lies Great Tomkyns, a timber-framed yeoman's house, built in the fifteenth century and still in private ownership.

To the south-east of Upminster lies CRANHAM, remaining essentially a village. The medieval parish church, All Saints, was rebuilt in 1874 and, though trim and pretty enough, is of no great architectural significance, but it is a place of pilgrimage for many Americans. In its churchvard lies buried General George Oglethorpe, founder of the state of Georgia, who spent the last 30 years of his life on his wife's estate in Cranham. He was a man of exceptional courage, far-sightedness, and generosity of character, and Dr. Johnson declared, unfortunately without results: 'I know of no man whose life would be more interesting; if I were furnished with material, I would be glad to write it.' Many of the furnishings in the little church have been presented by the National Society of Colonial Dames.

NORTH OCKENDON, not yet town but no longer truly country, lies in the easternmost corner of the borough. The most important building is the church, St. Mary Magdalene. Lying a fair distance from any main road and approached along an avenue of trees, it is a secluded, brooding building. Constructed of ragstone and flint rubble with dressings of Reigate stone, the chancel and nave date from about 1170, the north aisle was added about 1240, the north chapel about 1300, and the west tower was built towards the end of the fifteenth century. No two pillars in the nave are carved alike and in the east window of the north chapel are set fragments of medieval glass - a beautiful thirteenthcentury saint (possibly St. Helen?) and an equally lovely fourteenth-century St. Mary Magdalen holding her pot of costly ointment. In the west window of the tower are seven fourteenth-century coats of arms. There are five seventeenth-century bells and among the Communion plate is a paten of 1561 and a chalice of 1646, now on loan to the Victoria and Albert Museum. There are several brasses and fragments of brasses, the most interesting being of Thomasyn Badley (d.1532), and of William Poyntz and his wife Elizabeth (d.1502) who are shown with their six sons and six daughters. The Poyntz family was the leading local family for three centuries; and it is their tombs that make the most impressive show in the little church. Sir Gabriel Poyntz has the finest

of all. His full-length effigy, clad in armour, lies beside his wife, Etheldreda, who is represented in a magnificent dress with quilted petticoat and three finely-wrought chains about her neck. The sheltering tester above them juts straight out from the wall, instead of being supported by pillars as one would expect. Before he died in 1607, Sir Gabriel had set up, around the walls of the north chapel, eight small monuments, each with a pair of kneeling figures, to himself, to his son, and to their direct ancestors, going back to Pointz Fitz Pointz and his wife Allionora of Edward III's time. Two later generations added to the series. What is particularly fascinating about these monuments of family pride and piety is that a conscious attempt has been made to give each generation the correct costume for its period. A bust of Sir Thomas Poyntz (d.1709), his hand gracefully disposed against his breast, looks down bashfully from a high wall-monument. Before leaving the church, the seventeenth-century pulpit, adorned with cheerful, florid carving, and the solid treads of the stout fifteenth-century staircase to the first floor of the tower are worth attention.

Ockendon Hall was demolished after being bombed in the Second World War, but a mile to the west of the church is **Stubbers**, a curiously named manor house, built in the late sixteenth century and

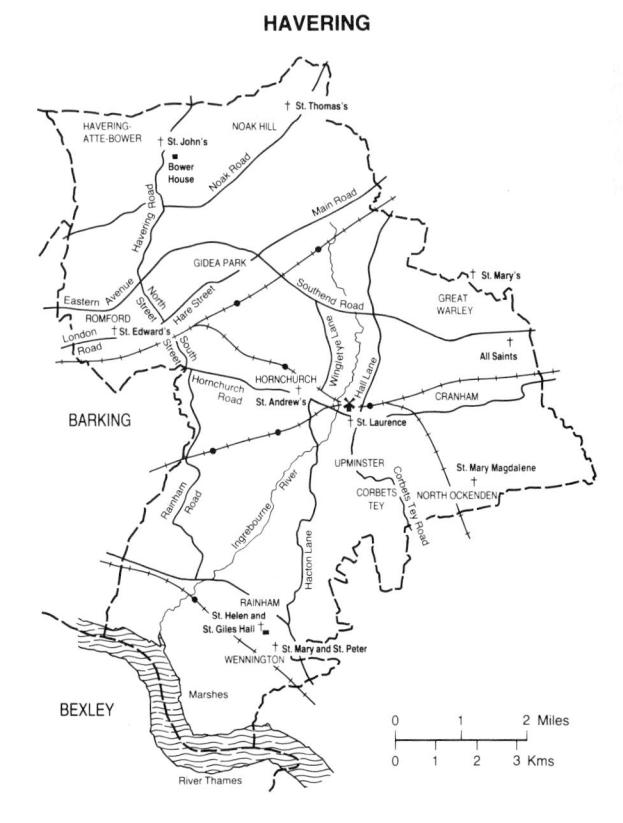

given a new, more imposing façade towards the end of the eighteenth. It was once the home of the botanist, William Coys, who planted a yucca in the grounds which flowered in 1604, and with the help of John Goodyer made an early list of English garden flowers. Coys was buried in the parish church, and today the house and estate are used as an outdoor pursuits centre.

On the way southwards towards the Thames is Corbets Tey, where stands Harwood Hall, built in 1790 by Sir James Esdaile, and High House, a strange, elongated building of about 1700 of a riveting visual quality.

Though its buildings are increasing rapidly, WENNINGTON is still a small village and its church, dedicated to St. Mary and St. Peter, stands among fields. The chancel, nave, and south aisle were built in the thirteenth century but a doorway from an earlier, twelfth-century building has been re-set in the south wall during nineteenth-century renovation. A north aisle was added at the beginning of the fourteenth century, and the three-storeved west tower at the end. There is a thirteenth-century piscina in the chancel and the roof above it is of the fourteenth century. The church possesses a thirteenth-century chest for its documents and other valuables, a font of the same period, and some interesting seventeenthcentury furnishings, in particular the carved font cover and the pulpit with its hour-glass stand for timing the length of the sermon. There is a single monument on the south wall of the north aisle, to a former parson, Henry Bust, and to his son, another Henry, who died within a year of each other, in 1624 and 1625; the bereaved wife and mother, Margaret, set up the small effigies.

RAINHAM, formerly a village but now swollen with much new building and with industry, sits low on the marshes above the Thames and contains three treasures, the parish church dedicated to St. Helen and St. Giles, Rainham Hall, and the new Roman Catholic church dedicated to Our Lady of Salette. It was here that two glass Saxon drinking horns, now in the British Museum, were dug up in 1937. Our Lady of La Salette was designed by Messrs. Burles, Newton and Partners; the artistry and craftsmanship employed about the interior puts this church into the same class as St. Aidan's at Acton, or the Immaculate Heart of Mary at Hayes. The parish church is that rarity, a virtually unaltered Norman building, save for the Tudor brickwork embattling the upper part of the tower. The doorway into the north side of the chancel has an arch with two bands of chevrons and with grotesque faces and leaves carved on the shafts of the door jambs, while the south doorway has the remains of a twelfth-century hinge. The chancel and the nave are almost equal in size, and the arch which separates them is one of the loveliest in London,

St. Mary and St. Peter, Wennington

beautifully proportioned and carved with chevrons. The screen across it, though much restored, is of the late fifteenth century, and a few treads of the stairway up to the rood-loft can still be seen on the north wall with beside them a graffito of a ship, scratched here five hundred years ago. On either side of the arch are remains of squints. Square piers with scalloped ornament support round arches, and in the south aisle is masonry from what was a pillar piscina. There is a circular twelfth-century font and a locker of uncertain date on the south wall of the chancel, while traces of thirteenth- and fourteenth-century wall paintings still decorate both chancel and nave. There are remains of four brasses, all incomplete, which include a woman in a butterfly head-dress of about 1480 and a civilian in a fur-lined robe with his wife of about 1500, while in the tower hang three seventeenth-century bells. Charles Churchill, poet and satirist, became curate here in 1756 but it would seem that he had little in common with his parishioners, for of his preaching he wrote:

Sleep at my bidding crept from pew to pew.

Happily, he soon succeeded his father in the living of St. John's Westminster.

Rainham Hall, which stands in the Broadway close to the parish church, was built in 1729, of warm red brick with stone dressings. The doorway is handsomely carved with Corinthian columns and the wrought-iron gates at the entrance are contemporary with the house. Inside are a fine hall and staircase. The house has belonged to the National Trust since 1949 but is still in private occupation, though it is occasionally opened on prior application to the resident.

Hillingdon

Hillingdon lies in the north-west corner of the Greater London area. To it belong the former borough of Uxbridge and the three urban districts of Haves and Harlington, Ruislip and Northwood, and Yiewsley and West Drayton, which include the villages of Hillingdon, Harefield, Eastcote, Ickenham, Cowley, and Harmondsworth. It is the third largest of the new boroughs, with the counties of Hertfordshire and Buckinghamshire bordering it to the north, west, and south. To the east lie Harrow and Ealing, but within Hillingdon's boundaries, there is what can properly be called open country. Crossed by the Bath Road, the M4, the Grand Union Canal, the Uxbridge Road, and Western Avenue, the communications from east to west are excellent; travelling from north to south, it is wise to be equipped with a good map. Hillingdon can reasonably claim to possess a more exciting collection of churches than any other London borough, and in St. Mary's church, Harefield, it has one of exceptional importance.

Anyone arriving in London by air knows the borough of Hillingdon, since Heathrow Airport fills the plain which spreads across the southern tip of the borough. The visitor is unlikely to be aware of the architectural, antiquarian, and rural delights which lie only a few miles to the north, and the breathless journey eastwards towards London will do nothing to promote a desire to explore the countryside near the airport. This is a pity, for even the airport itself conceals or contains much of interest. Fairey Aviation Company built the Great West Aerodrome there in 1929 and used it for experimental flying. In 1944 it became Heathrow RAF Station, and in 1946 was developed into London's principal airport. Before the main runway was laid down, the opportunity was taken to examine an Iron Age site, and the excavations revealed a temple, consisting of an inner chamber surrounded by a colonnade.

Harmondsworth and Harlington are to the north on the far side of the Bath Road. HARLINGTON has been sliced in two by the M4 motorway, and the church of St. Peter and St. Paul is separated from its parish. It is a fascinating building to which the generations have added from the twelfth to the nineteenth centuries. Built of flint rubble and ironstone, the nave was constructed in the middle of the twelfth century, the chancel was built in 1340 with a trussed rafter roof probably of the same century; the west tower was added in the late fifteenth and the pretty timber and brick south porch in the early sixteenth century. In 1880, a north aisle was built, incorporating sixteenth-century work. The visitor should note especially the Norman south door, the best in Middlesex, the equally early font, and the Easter sepulchre. The doorway, its carvings well preserved by the sheltering porch, should be studied in detail. The round-headed arch has four orders and a label enriched with linked roundels; the innermost order is plain and runs down to the door jambs while around it sweep semicircles, the first with chevrons, the second with beakhead ornaments with cats' masks, and the third with battlement motifs. The two middle orders rest on shafts and spring from carved capitals.

Inside, the square, shallow font is carved around with arcading. There are two brasses, one showing the rector, John Monemouthe, who died in 1419, wearing his mass-vestments, and the other with Gregory Lovell (d.1545) and his wife Anne. It was his family's canopied altar-tomb against the north wall of the chancel which was privileged to serve as an Easter sepulchre, the crucifix being laid there on Good Friday to signify Christ's death and burial, and then being replaced above the altar on Easter Sunday. In the south wall of the nave is set a fourteenthcentury bracket carved with beautiful foliage, and nearby is the memorial to John Bennett, Lord Ossulstone (d.1686), with three handsome busts of him and of his two wives. R. C. Lucas carved the two life-sized effigies of the Count de Salis and his wife: he was the sculptor who undertook the restoration of Leonardo da Vinci's Flora in the Berlin Museum. Outside in the churchyard stands the Harlington vew. which is thought to be more than a thousand years old; it fell in 1959 but the stump is still putting forth new growth.

In spite of the main roads which ring it round, and the considerable amount of pleasant domestic expansion which has taken place in the last forty years, I HARMONDSWORTH has remained an unspoiled and complete village. It is centred around a little square with two excellent public houses, the Crown and the Five Bells. In 1937, the Royal Commission on Historical Monuments was able to list, besides The Grange built in 1675 and Harmondsworth Hall of seventeenth- and eighteenth-century construction, some 26 houses or cottages with their main structures completed before 1715, the majority of which are still tranquilly and firmly in their places.

The church, dedicated to St. Mary, was built between the twelfth and sixteenth centuries, possibly on the site of a still older building. Entering from the churchyard, in which Richard Cox, who perfected the Orange Pippin apple which bears his name, lies buried, we see first the south-west tower, built about 1500, of three stages, the lowest of flint rubble and the two higher levels of brick. The parapet is embattled, and on the top is perched a merry little cupola. Within the tower hang six bells, numbers 2, 3, 5, and 6 having been cast by Bryan Eldridge in 1658. The porch, with a scratch dial beside it, shelters the south door which, like the south aisle within, is of the twelfth century. This doorway ranks second only to Harlington for richness of carving. It is of three orders, the first adorned with a medley of rosettes, the second with fierce beaked heads, and the third with bands of chevrons; the first and third run from threshold to arch, the second rests on little pillars with capitals. The plain, square, Purbeck marble font was made about 1200. The sturdy, squat pillars of the south aisle date from the late twelfth century and have scalloped capitals; those of the north aisle, built perhaps a century later, have taller and more graceful arches. The chancel was enlarged in the fifteenth century; it has both a piscina and sedilia. The different sections of the church exhibit a variety of roofs; the chancel is almost entirely modern, the nave has four bays of fifteenth-century timber-work with modern king-posts; the aisles are of the same century though, whereas the north aisle has tie and collar beams, the south has a pent roof, while the north chapel has an early sixteenth-century hammer-beam roof with carved pendants. The solid pews were made in the early sixteenth century and must have been hewn out in a saw-pit.

Just to the west of the church stands a huge tithe barn, the best in Middlesex and one of the finest in England. 190 feet long, 36 feet wide, and 36 feet high, it is divided into a nave with two aisles, as if it were a church, by massive beams set in stone bases. The roof has king-post trusses with curved braces below the tie-beams. The timbers are without decoration; their own purposefulness gives them dignity. The barn was probably built some time after 1391, when William of Wykeham bought the manor

of Harmondsworth and settled it on Winchester College. It is still in use today as a farm building.

WEST DRAYTON lies almost due north of Harmondsworth, on the far side of the M4. It possesses a magnificent village green, beside which stands a long stretch of rich red brick wall with the twin towers and oaken doors that once provided the gatehouse to the manor. All these, and the long-vanished mansion, were built by Sir William Paget, Secretary of State to Henry VIII. After the King's death, he supported the Duke of Somerset and lost office when the Lord Protector was beheaded in 1552. Escaping with only a brief imprisonment in the Tower, he retired to his country seat where he was buried in 1563. His grandson, who sailed with Essex to Cadiz, and his great-grandson, who lost his fortune in the service of Charles I, lie beside him. The old house was pulled

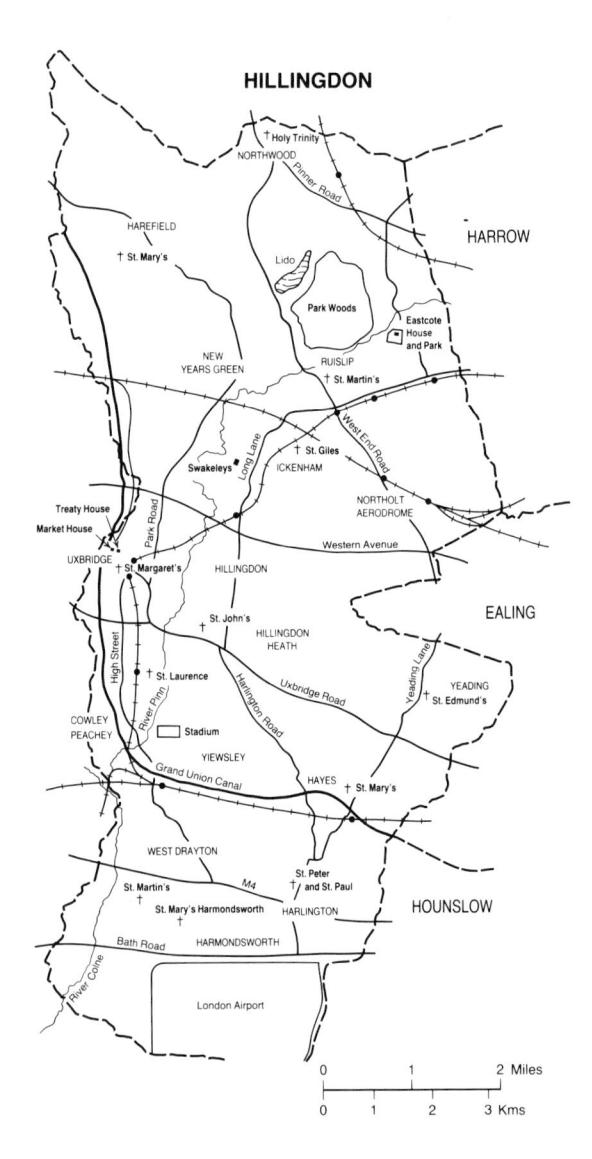

¹ Penguin Books settled in Harmondsworth in 1937.

HILLINGDON 273

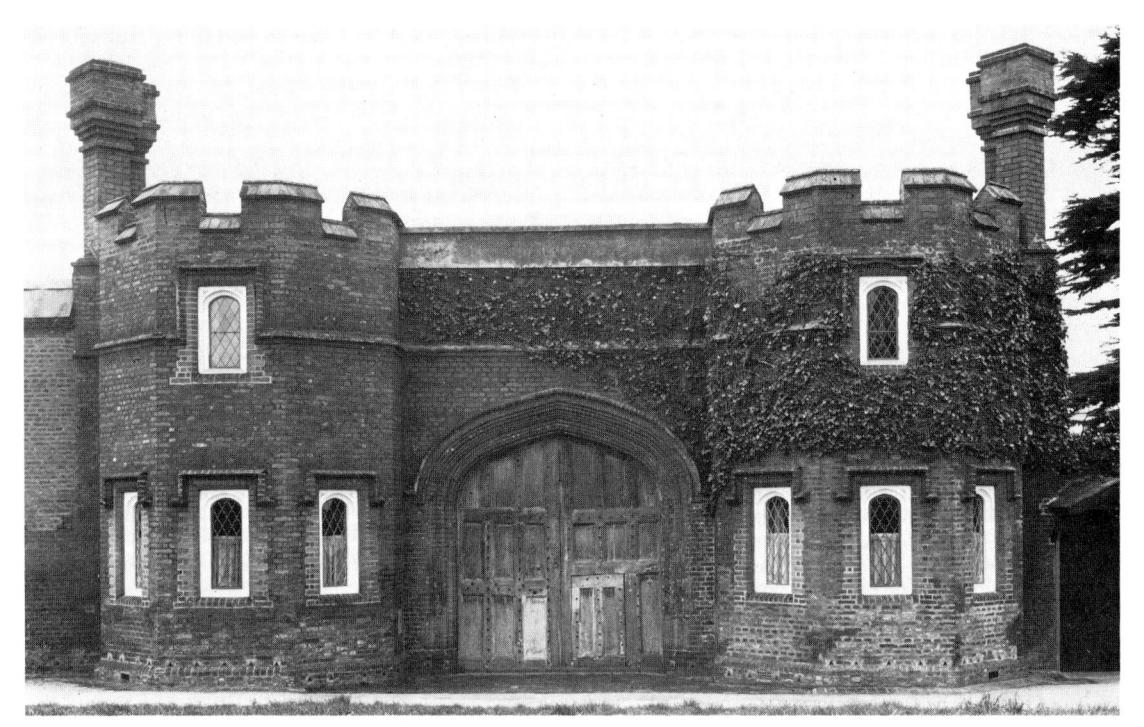

Gate-house to the now demolished manor house, West Drayton

down in 1750, save for the gateway, which today provides two comfortable cottages. The Fysh Coppinger family (who later changed their name to De Burgh), on acquiring the manor in 1786, built themselves a fine new house, Drayton Hall, where they entertained the Emperor Napoleon III after the Franco-Prussian War of 1870–71. The family died out in 1939 and the house is now used as council offices.

The grey of the church walls, of flint with freestone dressings, makes a most agreeable contrast with the warmth of the Tudor brickwork. Dedicated to St. Martin, it was largely rebuilt in the middle of the fifteenth century, though the piscina in the chancel may well be of thirteenth-century workmanship, and there may also be some early work in the west tower. The nave with its aisles forms an almost perfect square; the chancel is exceptionally long. All the roofs are of fifteenth-century construction and the church possesses an extraordinary font of the same date. The octagonal bowl has elaborate carvings on each of its sides, while hooded men, like jesters, peer out from underneath; around the base crouch four sinister figures, half-human, half-bestial. The clock in the tower probably dates from the early sixteenth century. There are several brasses, including one to James Good, a doctor of medicine, who died in 1581 and is shown with his wife and their eleven children, another of a nameless man in civilian dress of about 1520, and a third to Margaret Burnell (d.1529) who is shown wearing a fine kennel head-dress and a girdle with a clasp like a flower. There are three monuments to members of the De Burgh family by the elder and younger John Bacons, and another by an unknown sculptor to Rupert Billingsley (d.1720), with a superb carving of his three-masted ship, the Royal George. The north window, in memory of Mrs. Mercer, is by Burne-Jones, and the church plate includes a beautiful chalice and paten of 1507.

The whole village is worth exploring. It was between West Drayton and Langley, on 28 December 1837, that Brunel made the trial runs for the Great Western Railway, which opened the following year. The great engineer's name has been given, most appropriately, to the technological university which, founded in 1957, moved in 1968 to a 170-acre site just outside Uxbridge, where it is accommodated in buildings designed by Richard Sheppard and Partners.

To the east lies COWLEY, in which stands the smallest parish church in Middlesex. Dedicated to St. Laurence, the flint rubble walls of the nave were built in the twelfth century and the chancel was rebuilt about a hundred years later. The chancel arch was taken down about 1500, and in 1780 the bell turret was rebuilt. St. Laurence's has one brass, to Walter Pope (d.1505) and his wives, Johane and Alys, though only one wife remains. A modern screen incorporates fragments of fifteenth-century tracery and sixteenth-century poppy-head pew ends. There is a miniature double gallery, almost as if the little

church were a theatre. The churchyard has the melancholy distinction of being the burial place of William Dodd, a clever clergyman who foolishly tried to obtain preferment by bribery and, when disgraced and bankrupted, tried to better his fortunes by forgery. Convicted, he was hanged at Tyburn on 27 June 1777, though Dr. Johnson wore a speech for him to use in his defence. His brother, who was rector at Cowley, gave the poor body a decent burial.

HAYES lies on the western side of the borough. Once rustic – its very name comes from 'hesa', meaning a hedge or undergrowth – there is now much light industry here and housing from each decade of the twentieth century. When the foundations for the EMI factory were being dug, an Egyptian statue, now in the British Museum, of a priest holding the shrine of a god in his hand, was found. The Heinz factory (1965 by Skidmore, Owings and Merrill of the United States and Mathews, Ryan and Simpson of England) is an exciting example of modern architecture, and a remarkable collection of modern paintings hangs on its walls.

The village centre is exceptionally well preserved. The church, St. Mary's, faces the manor house, which was built between the sixteenth and eighteenth centuries and is now cherished by the Borough Council. Beside the church stands Hayes Court, with a large, hexagonal, eighteenth-century dovecote in its

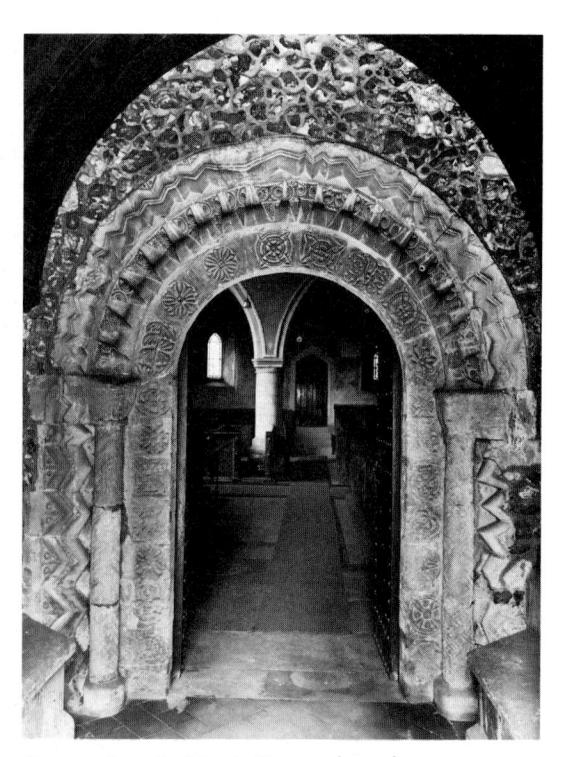

Norman door, St. Mary's, Harmondsworth

Sir Edward Carr's monument in St. John the Baptist, Hillingdon \triangleright

grounds. The church is approached through an early sixteenth-century timber-framed lych-gate. Built of flint and rubble with stone dressings, the chancel with piscina and sedilia and the north arcade date from the thirteenth century, the north aisle and the west tower from the fifteenth, and the south aisle with its arcade and porch from the sixteenth. In spite of Sir George Gilbert Scott's restoration of 1873, St. Mary's is remarkable for its roofs, for its brasses and monuments, and for its fittings and wall paintings. The chancel has a most graceful fifteenth-century elliptical waggon-roof, which provides the perfect complement to the tracery of the east window. Above the nave is a sixteenth-century roof of the trussed rafter type, with panels secured by moulded ribs with bosses at the intersections; these are carved with the Instruments of the Passion and Tudor badges. Above the north aisle is a fifteenth-century flat-pitched roof with tie-beams and curved braces, which rests on briskly carved stone corbels, while the roof of the south aisle dates from the sixteenth century and is also flat-pitched with tie-beams.

The earliest Middlesex brass is here, to Robert Levee who died about 1370; he was in holy orders and is shown in half-effigy wearing mass vestments. Other brasses show Walter Green (d.1456) wearing armour, and Thomas Higate (d.1576) who appears with his wife and their nine children; these brasses are set in altar tombs. Sir Edward Fenner, judge of the King's Bench who died in 1612, has a magnificent monument; a life-sized effigy, clad in legal robes, lies on an altar tomb; Corinthian capitals hold a canopy above him from which two small allegorical figures look down benignly on the stiff figure below. A wall monument of another Edward Fenner (d.1615) makes a shell-shaped niche for a half-figure in marble of the gentleman who poses stiffly, a baton in one hand, the other resting on his helmet. On the east wall of the chancel is a small, thirteenth-century locker, and the font dates from the late twelfth century; its round bowl is adorned with acanthus leaf carvings and it rests on a broad base and eight pillars. The west columns of the north arcade were painted with red and white chequer-work in the thirteenth or fourteenth century, while the east wall of the aisle was decorated with black foliage, probably in the sixteenth century. On the north wall is a large painting, executed about 1500, of St. Christopher wading across the river with the Christ child on his shoulders; he leans on a staff and his cloak billows out behind him; in the water swim crabs, eels, and a small mermaid, on the banks a little boy in red is fishing, and the hermit of the legend looks on approvingly. Among the rectors of Hayes were Henry Gold, who suffered at Tyburn in 1534 for his support of Elizabeth Barton, the 'Holy Maid of Kent', and Patrick Young, an eminent Greek scholar, who became librarian to James I and to Charles I.

There are two modern churches in or near to Hayes which are worth visiting. St. Edmund of

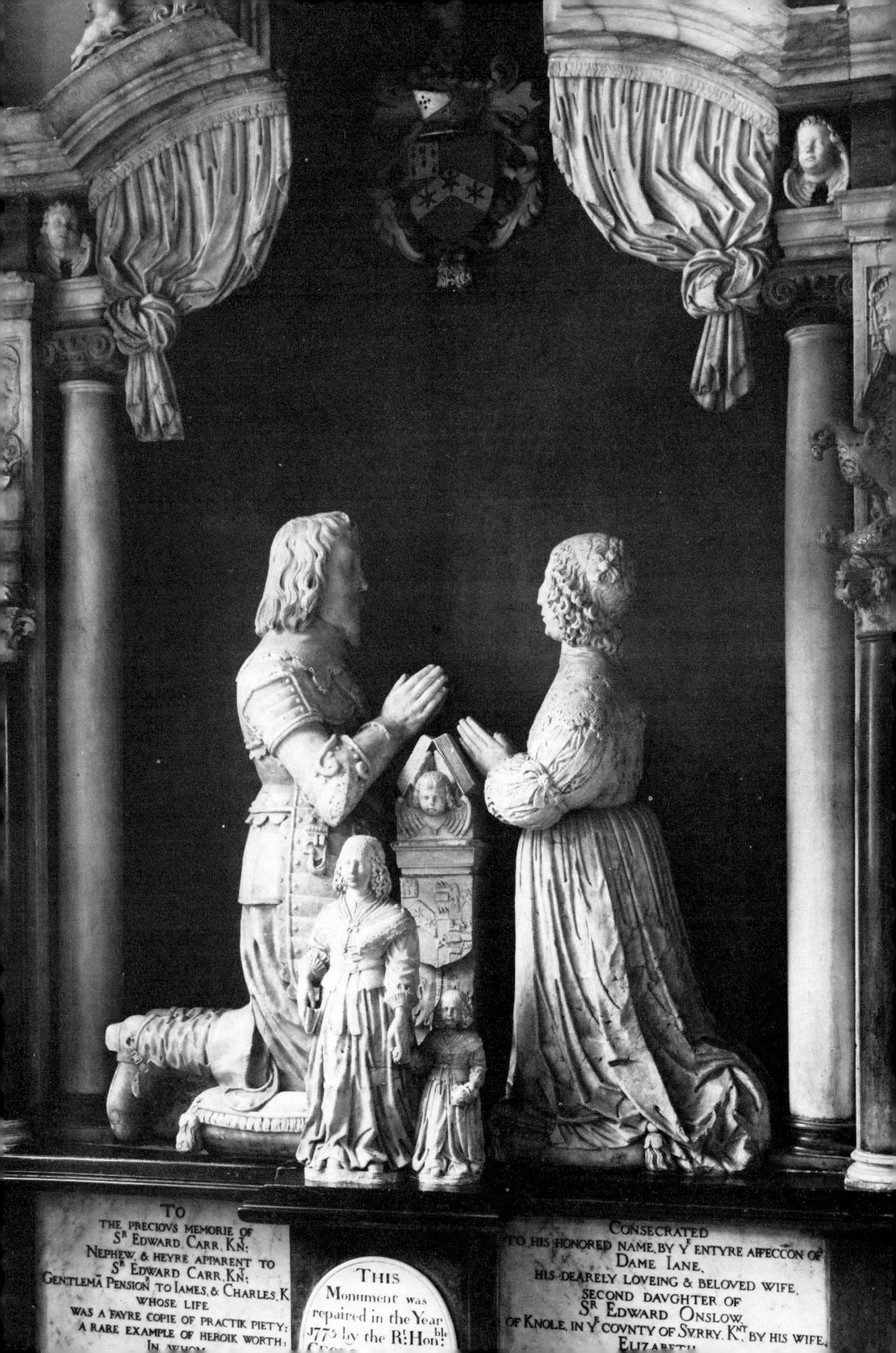

Canterbury stands in Yeading Lane. Consecrated in 1961, its architect was Anthony Lewis; it contains some impressive sculpture by Robert Dawson and vivid, abstract, stained glass by Lawrence Lee. The curtains to the Lady Chapel were designed by Heather Child and were embroidered by the ladies of the parish. The Immaculate Heart of Mary is in Botwell Lane and is the church of the Claretian Fathers. Designed by Burles and Newton and consecrated in 1967, it has as an altarpiece an arresting and controversial painting of the Madonna and Child by Pietro Annigoni and in one of the side chapels hangs a Crucifixion by Roy de Maistre. The 14 Stations of the Cross are excellently carved on

perspex by K. Fleischmann. HILLINGDON, which stands approximately in the centre of the borough, has given its name to the whole area. The church, dedicated to St. John the Baptist, is set, somewhat isolated, on the crest of Hillingdon Hill, on the south side of the Uxbridge Road. The traffic streams past, separating the church from the manor house and such other older buildings as remain. The eastern portions, the chancel, transepts, and chapels, were all rebuilt in 1848 by Sir George Gilbert Scott, but the 1260 chancel arch remains, springing from filleted shafts (that on the north side is modern) with stiff-leaf carving on the capitals. The nave and the aisles were built in the middle of the fourteenth century, and the tower was rebuilt in brick, which contrasts pleasantly with the flint rubble of the main building. The aisle roofs are of the fifteenth century, and that on the north side is supported on corbels carved with male busts. The brasses deserve notice, the most impressive of them being to John, Lord L'Estrange (d.1479) and his wife Iacquette, who was aunt to the little princes who died in the Tower. The tall figures stand under an elaborate incised canopy and between them is a tiny figure of their only daughter; the only other brass in Middlesex of comparable quality is Lady Tiptoft's in Enfield church. There are other brasses for Drew Saunders (d.1579), John Attlee (d.1599), Henry Stanley (d.1528), and for a group of nine children whose names are lost. Sir Edward Carr's monument stands in the chancel; marble figures of himself and his wife kneel opposite each other, their poses fixed and old-fashioned for such a date; a canopy, on which virtues recline, shields them, but their little daughters, Jane and Philadelphia, book and posy of flowers in hand, step off the memorial into the church to face a new generation. A large white marble monument recalls Henry Paget, Earl of Uxbridge (d.1743), representing him in Roman attire. Thomas Lane has a pleasant medallion of conventional design by the elder John Bacon and in the north aisle is a handsome monument to John Mist, who died worth £50,000, having been, during the reigns of George I and George II, 'Paviour to the Royal Palaces, Paviour to the Royal Works, slater, cartaker, thatcher, scavenger, foundation digger etc.

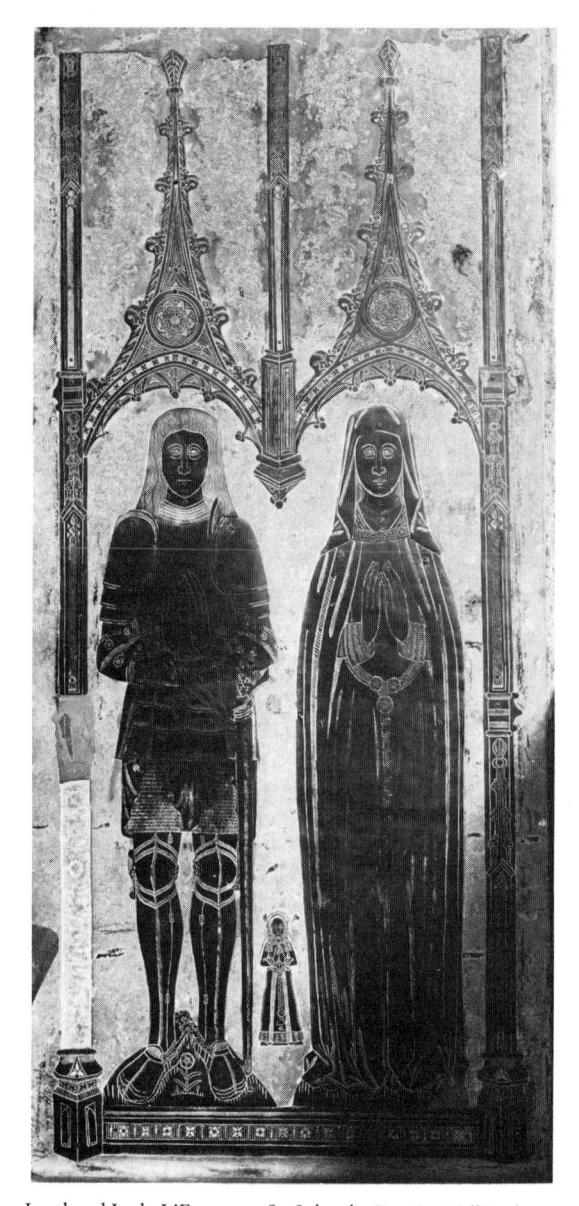

Lord and Lady L'Estrange, St. John the Baptist, Hillingdon

He was a great undertaker and a slave to business. He finished the great drain in Pall Mall and since the new road in Hyde Park.' The modern glass won first prize from the British Society of Modern Glass Painters in 1955; it was designed by A. E. Buss and executed by Messrs. Goddard and Gibbs. In the churchyard outside lies John Rich, who introduced pantomime into England and produced John Gay's Beggar's Opera, of which it was said that it made Gay rich and Rich gay. Immediately to the east of the churchyard is a considerable earthwork, but little is known of its origins.

For those who dare cross the Uxbridge Road in the

teeth of the traffic, Vine Lane has three houses of considerable interest. The oldest is The Cedars, built c.1580 and enlarged gracefully by later centuries. In the seventeenth century it belonged to Samuel Reynardson, the botanist, who in 1683 planted the magnificent tree from which the house takes its name, and later to Major-General John Russell, whose mother was Oliver Cromwell's fourth daughter; when he died in 1735, he was buried in Hillingdon churchyard. A little further on is Hillingdon Court, once the home of the Barons Hillingdon but now a Roman Catholic convent, and beyond it is Hillingdon House, now the property of the RAF, built about 1840 for the Cox family, bankers and army agents, on the site of an older house, which was once the property of the Duke of Schomberg, William III's Dutch commander, who was killed in Ireland at the Battle of the Boyne in 1690.

UXBRIDGE, the principal town in the borough, grew up as a market town and coaching centre. An enormous new civic centre, built to designs by Robert Matthew, Johnson-Marshall and Partners, has recently been completed; the mass of the multigabled building is reminiscent of a medieval, redroofed Italian hill-town. The public library, housed near the centre, possesses an interesting collection of lead firemarks and of carpenter's tools. A compact core in the High Street and Windsor Street, with shops resembling those in a Beatrix Potter illustration, has been declared a conservation area and a pedestrian precinct. Particularly attractive are the Market House of 1788, the Old Bank House and The Cedars in the High Street, the Friends' Meeting House off Belmont Road (meetings started 1662, built 1716, rebuilt 1883), and a public house, the Three Tuns, in the High Street, dating from the late fifteenth century. When walking in Uxbridge High Street, it is best to keep one's eyes fixed, not on the shop windows, but at first-floor and roof level, for neighbouring buildings are of sharply differing periods and the medley is delightful.

St. Margaret's church, built of flint with freestone dressings, stands in the centre of the town. The nave and narrow north aisle were built early in the fifteenth century, the plump south aisle was rebuilt perhaps 40 years later, and the chancel was rebuilt and lengthened about the same time. The fourteenth-century north tower, which gives the building a distinctive character, was largely rebuilt in 1820 and a vestry was added 60 years later. Inside, there is an alabaster monument to Dame Leonora Bennet (d.1638); clad in her finest dress, the lady's effigy lies on a tomb chest into which a grill has been inserted to show the bones within. The font is fifteenth-century and so is the hammerbeam roof with heads of kings and queens carved on the brackets.

The Treaty House stands on the south-west side of the High Street, a short half-mile north-west of the church. Built of brick with a tiled roof and a curved gable at one end, the façade on the road was rebuilt and stuccoed in the eighteenth century. In January 1646 it was still a private house, the home of Sir Edward Carr, who lies in Hillingdon church, and it was in 'this good house at the end of the town', as Clarendon describes it, that representatives from the royalist and parliamentary parties met for three weeks, trying to argue rather than fight out their disagreements. A 'fair room in the middle of the house was handsomely dressed up for the Commissioners, who never went through each other's quar-

Robert Clayton's monument in St. Giles', Ickenham

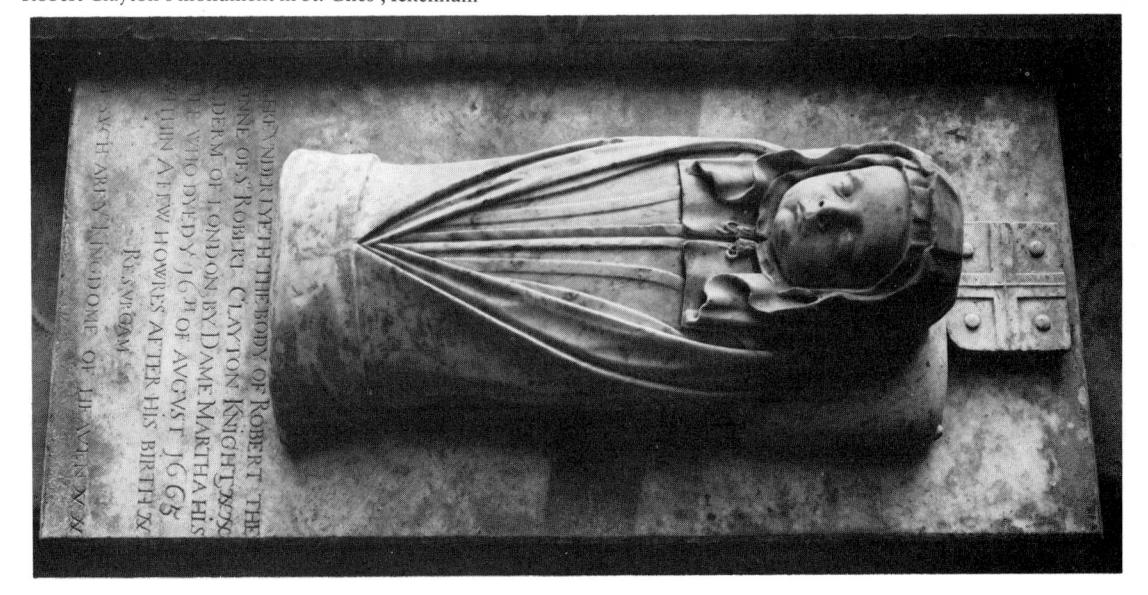

ters nor met but in the great room', wrote Clarendon, remembering it all when he himself was in exile. There was no settlement and the war dragged to its bitter end. The panelling from the two chambers used for the Commissioners was stripped out in 1929 and was used to line walls in the Empire State Building in New York, till in 1955 it returned to this country as a gift to Queen Elizabeth and was reinstalled in its proper place in Uxbridge. Since the mansion is now a public house, the rooms may be seen by the simple and agreeable expedient of buying a drink there.

ICKENHAM, a mile to the north-east of Ux-bridge, has retained its village centre, church, green, Home Farm, pond, pump, and inn, in spite of new shops nearby and increased traffic. Its most important monuments are the church, dedicated to **St. Giles**, and the seventeenth-century mansion, Swakeleys, though the **Manor Farm** (sixteenth to eighteenth centuries) which lies about a mile to the south of the church should not be forgotten; it is still occupied by a descendant of the family which held the manor in medieval times.

The nave and chancel of the church, of flint rubble and brick, with freestone for dressings, were built in the second half of the fourteenth century, the nave being the earlier of the two. In 1575–80, William Say added a north aisle fully as large as the rest of the church so that, architecturally, the building seems disjointed. The wooden bell turret was added about this time; in it hang three bells and a sanctus, the tenor cast in 1589 by Robert Mott, the second about 1600 by Philip Wightman, the treble about 1510 by Thomas Bullisdon, and the sanctus in 1711. Between 1640 and 1650, the Harrington family, who held Swakeleys at the time, built a mortuary chapel on the north-west corner, with upright niches to hold the coffins; this is now used as a chapel dedicated to St. John, and there is nothing else like it in the county. The fitments and details of the interior are so interesting that the lack of proportion seems only an added charm. The chancel retains its piscina and there are traces of medieval painting, while in the south-east window of the nave are fragments of fourteenth-century glass. Chancel and nave have trussed-rafter roofs, that in the chancel dating from the fourteenth, that in the nave from the fifteenth, century. The communion table in St. John's chapel is seventeenth-century, and there is a wooden font of about 1720.

The church possesses some exceptionally good registers ('Buryengs' from 1539 and 'Crystenyngs' from 1538, now in the Middlesex Record Office) and some fine plate, including a flagon given by Sir Robert Vyner of Swakeleys in 1683. There are three fine brasses to members of the Say and Shoreditch families, who held the manor from 1370 till the end of the eighteenth century; the earliest, c.1545, lacks an inscription, but William Say (d.1582) and his wife Isabel are shown with their sixteen children, and

Edmund Shoreditch (d.1584) and his wife, Ellen Say, are there with two sons and a daughter. There are two monuments of exceptional importance. The earlier is to Robert Clayton who died, a few hours old, on 16 August 1665. The marble effigy, two feet long, shows the little body swaddled and shrouded but the face, with closed lids and slightly puckered mouth, is bare; carved with consummate skill, this is the finest effigy of a baby anywhere in England. Sir Robert and Lady Clayton had no other children and their lands passed to a nephew. The second monument also speaks of parental loss, a loss perhaps even more bitter; a tablet carved by Thomas Banks shows a young man reading a book, his right arm resting on a coffin. He was John George Clarke, a young barrister who ruptured an artery at the age of twenty-four in 1820; his parents had taken the place of the Says in local eminence. The bust of the Earl of Essex came from Swakeleys, but now stands in a niche opposite the south entrance. The fine woodwork of the pews was carved by Clifford Robert Davie in 1926-8.

Swakeleys lies half a mile south-west of the parish church. It was built of brick with stone or plaster dressings, between 1629 and 1638, for Sir Edmund Wright, Lord Mayor of London. It is H-shaped in plan, with the cross-wings at the north and south ends. The west front has a welcoming porch with a statue in a niche above it, and the wings have curved gables with top pediments. The mansion suggests a builder who was aware of the new ideas that Inigo Jones had brought back from Italy to the English court, but was not quite sure of how he should use them, so he did his best, with delightful results. During the Civil War, the house was the property of Sir James Harrington and Pepys tells us that he was responsible for the carved screen across the great hall; he presumably commissioned the busts of Fairfax (still in the house) and Essex (now in the church). He may also have had the superb, very simple, deeply coffered, plaster ceiling set above the first-floor saloon. In 1665, Sir Robert Vyner, goldsmith and later Lord Mayor of London, bought Swakeleys; in 1666, when sheriff, he laboured so hard against the fire that his own goods were all lost, though when Pepys visited him at Swakeleys in September 1665, he described how Sir Robert lived 'no man in England in greater plenty, and commands both King and Council with the credit he gives them'. About this date, the staircase walls were painted with stilted and ungainly classical scenes - the death of Dido, the founding of Lavinium by Aeneas, Juno with Iris beside her - the artist probably being Robert Streater, Sergeant Painter to Charles II. In the grounds stands a square dovecote, built at the same

¹ Sir Robert (d.1707) and Lady Clayton lie at Bletchingly in Surrey under a superb monument carved by Richard Crutcher. The baby lies between his parents, his seventeenth-century biggin replaced by a Queen Anne fontange; the memory of him can never have left them.

HILLINGDON 279

Manor Farm library, Ruislip

time as the house – a reliable comment on the diet of the period. Swakeleys is at present the London Postal Region Sports Club; it may be visited by appointment.

Another mile and a half to the north-east is RUISLIP, an old core with a prosperous twentieth-century casing. The Metropolitan Railway reached it in 1904, but from the beginning the inevitable development was planned and controlled. The surrounding countryside is picturesque and wooded, with a former feeder of the Grand Union Canal now used as Ruislip Lido, with a model railway beside its banks.

Within a generation of the Conquest, Ernulf de Hesdin built a motte-and-bailey castle here; he gave the manor to the Abbey of Bec in Normandy when he himself had to slip away on crusade, since he was suspected of conspiracy against William Rufus. The Manor Farm lies within the bailey. A timber-framed building of about 1500, with later additions, it is today the property of the Borough Council. To it belonged two magnificent timber barns; one is still used for agricultural purposes but the other has been converted into the most exciting public library in Middlesex, where readers may change their books beneath a roof constructed c.1600. Immediately outside it is a bowling green. The former post office has a sixteenth-century chimney-stack, and buildings of similar antiquity are to be found all along the High Street, while near the church are ten timber-framed sixteenth-century almshouses.

The church, dedicated to St. Martin, is large, over 100 feet long, and built of flint rubble with stone dressings. Approached from the High Street, the first sight is the parapetted south-west fifteenth-century tower. The nave, south arcade, and chancel arch date from the thirteenth century, the chancel with its roof and the south aisle from the fifteenth, and the north

aisle and south chapel from about 1500. The roof of the north aisle has foliage and a grotesque face carved on the spandrels and ornamental bosses at the intersections. The fittings and monuments are varied and interesting, the earliest being the somewhat worn square font from the late twelfth century. Slipware tiles are in the chancel, decorated with fleur-de-lys, leaves, and heraldic ornaments, and paintings of about 1500 on the walls of the nave and north aisle; a crowned Madonna, St. Michael, St. Lawrence, and the Seven Deadly Sins being spewed forth by seven dragons can still be distinguished. The door to the rood-loft staircase is of the late fifteenth century, and two more on the north side of the church are of the sixteenth century: there are two later sixteenthcentury chests and a chalice of 1595 beside a copy of Bishop Jewel's Apology, published in 1611, and still in its original leather binding tooled with royal badges. The hexagonal pulpit is Jacobean and in 1697 Jeremiah Bright gave the church an elegantly carved bread cupboard.

There are two good brasses, to John (d.1593) and Bregget Hawtrey (kept in the vestry) and to Ralph Hawtrey (d.1574), his wife and their twelve children, besides fragments of several others. A later Ralph Hawtrey (d.1638) and his wife have an elaborate marble tablet carved by John and Matthias Christmas, who were master carvers to Charles I. Opposite is another memorial to their daughter, Mary, who, as Lady Bankes, twice defended Corfe Castle against the parliamentary forces, successfully in 1643 but with less good fortune in 1645, when she and her garrison were forced to surrender through starvation.

On the north-eastern side of the borough is EAST-COTE, where there is a pleasant parish church dedicated to St. Laurence and built in 1932-3 by Sir William Nicholson, and where an unusually large number of sixteenth- to eighteenth-century houses and farm buildings are to be found in the High Road, Field End Road, Joel Street, and Catlins Lane. NORTHWOOD, mainly 1930s suburban housing, has a comfortable, substantial village church. Holv Trinity, built in 1854 by S. S. Teulon with none of his later eccentricities. Inside, there is one window by Burne-Jones and another by Sir Ninian Comper, some good modern carving on the clergy stalls by Alan Durst, and an impressive high altar, dedicated in 1962 in memory of a young flying officer, Michael Harper, who was killed in an accident. Outside in the churchyard is a huge cross of Russian marble sent by the Tsar in memory of Sir Robert Morier (d.1826), who had been ambassador to Russia.

HAREFIELD, still predominantly rural, lies in the north-western corner of Hillingdon, almost out into the open countryside. The village clusters around a broad green, beside which stands the partly seventeenth-century King's Arms, and a long hill leads down to **St. Mary's** church, passing on the way a row of brick almshouses built in 1600 at the expense of

Alice, Countess of Derby. The church is of flint with limestone for dressings, with some brickwork in the tower, and with flint and stone chequer-work and the remains of a mass dial in the south wall. Three distinct roofs cap the little building which, though attractive and quaint rather than impressive architecturally, must be considered as being of national rather than local importance for the astonishing collection of memorials which it houses and for its atmosphere, which epitomizes everything implied by the two words, 'village church'. The west wall of the nave may be of twelfth-century workmanship, and we can be reasonably certain that the chancel is of the thirteenth; the south aisle was added during the fourteenth and the west tower and north aisle during the fifteenth century. The octagonal font is early sixteenth-century, with a wooden cover made possibly a century later. Fragments of sixteenthcentury glass are set in the east window of the north chapel, and the furniture around the altar deserves special attention. The reredos is a magnificently carved panel, on top of which perch two kneeling angels supporting Commandment boards of frosted glass. They were probably made in Flanders in the seventeenth century and were presented by a parishioner in the nineteenth. The sumptuous altar rails and the heavy chairs which stand nearby were part of the same gift. The Georgian pulpit has four neat compartments, one for the preacher, a reading desk and a pew for the parish clerk, and a pew for the

The wealth of monuments in the little church is such that they are probably best described according to the families which they commemorate rather than by their positions about the building. Some twenty of them are to members of the Newdigate¹ family who. save for one break, held the manor from soon after 1500 till the middle of the present century, and others are to their relations by marriage such as John (d.1533) and Barbara Crugge (née Newdegate), whose palimpsest brass is in the vestry with a skeleton on the reverse side, or Charles Parker (d. 1795) for whom the younger John Bacon carved a Tree of Life. There are seven brasses in all, the earliest of them to Editha Newdegate (d.1444), but since John (d.1528) and Amphilisia (d.1544) Newdegate are shown with seventeen children, and their son John (d.1545) and his wife Anne with thirteen offspring, there are more than fifty graven portraits. Several generations of Ashbys, who held the nearby property of Breakspears,2 are commemorated, three of them with brasses.3 The most impressive of their monuments is to Sir Robert Ashby (d.1617) who is shown kneeling at a desk opposite his wife, their five sons below them, while a bust on the north wall represents William Ashby, who in 1744 set up a tablet in memory of his gamekeeper with a verse on it which can still be read on the outer wall. Newdigate monuments throng the chancel and chapels. Sir John (d.1610) has an alabaster memorial by William

White with an unusual epitaph in verse, and Sir Richard, Chief Justice at the Restoration (d.1678). has a plaque with fine marble pillars carved by William Stanton of Holborn, Grinling Gibbons himself executed one of his rare works in stone in memory of Mary, wife of the second baronet; her life-sized effigy reclines gracefully on the north side of the altar. Their son, another Richard (d.1727) is commemorated by a bust by Rysbrack, and three elegant white marble urns are inscribed with the names of three Newdigate ladies, Elizabeth, the mother, and Sophia and Hester, the two wives of Sir Roger Newdigate, who established the Newdigate Prize for Poetry at Oxford University, which he represented in Parliament for thirty years; Sophia's urn was probably carved by Richard Haywards and Hester's by the younger John Bacon.

The finest monument of all in Harefield church is that to Alice, the widowed Countess of Derby (see p. 13), who on her second marriage, to Sir Thomas Egerton, bought the manor in 1601 and lived there till her death in 1637. She entertained Queen Elizabeth there for three rainy days in the summer of 1602, and in 1635 her grand-daughters acted for her Arcades, a masque⁴ written by a young poet, John Milton, who lived nearby at Horton in Buckinghamshire, with music composed by his friend, Henry Lawes, who was a member of the Countess's household. The monument is by Maximilian Colt, who carved Queen Elizabeth's effigy; it shows the Countess lying full-length, clad in a crimson gown, her golden hair, freed from its coronet, spread over the pillow which supports her head. Figures of her three daughters, Anne, Frances, and Elizabeth, kneel in niches in the base of the tomb; their long hair is unbound for mourning. Above the Countess four pillars support a canopy, of which the stone curtains seem to billow in an invisible breeze. This is sculpture of a quality which one would expect to find in Westminster Abbey, not in an obscure village church, but the Countess clearly loved Harefield, which she knew and ruled for so long, and desired to rest at last in a familiar place.

In the churchyard at Harefield, 110 Australian soldiers, who died at an improvised hospital in Harefield Park during the First World War after the Gallipoli landing, lie buried. An obelisk and an archway were raised beside the graves and a chapel was dedicated to the men who lie there. Each year, a special service is held on Anzac Day (25 April) which is attended by relatives from Australia and by most

of the inhabitants of Harefield.

¹ The spelling varies, appearing as Newdegate on the earlier tombs and Newdigate on the later ones.

² It is often claimed that Nicholas Breakspear, the only English pope, came from this family.

³ George and Margaret Ashby (d.1474); George (d.1514) and Rose; William and Jane (d.1537).

⁴ The masque was such a success that Milton wrote *Comus*, which the grand-children performed at Ludlow where Sir Thomas Egerton was Keeper.

Hounslow

Hounslow, the most westerly of all London's riverside boroughs, is the product of the union between the former municipal boroughs of Brentford and Chiswick, and Heston and Isleworth, and the urban district of Feltham, which included the villages of Bedfont and Hanworth. Covering an area of 23 square miles, it has a population of some 203,000. The main road to the west of England has bisected it since Roman times; being thus accessible, Hounslow contains, on its eastern side, three aristocratic residences, all now periodically open to the public, and all of real significance in the history of English architecture. On the western margin lies a scatter of former villages which, despite recent enlargements and the noisy invasion of London Airbort, still retain at least parts of their older centres.

The student of English architecture goes to CHIS-WICK to visit a tiny villa, Chiswick House, designed and built by Richard Boyle, third Earl of Burlington (1694–1753), to a strictly formal, classical pattern. Having succeeded to his title at the age of ten, the young Earl made two visits to Italy, in 1714-15 and again in 1719. Inspired by what he saw, he studied Leoni's translation of Palladio's Four Books of Architecture and Colen Campbell's Vitruvius Britannicus, with its illustrations of English buildings based on Roman models, and determined to build a reconstruction of an antique villa. His grand-father had bought an estate, with a rambling early seventeenthcentury mansion, at Chiswick. The older house was therefore available to provide the everyday domestic functions and so leave Lord Burlington, freed from practical considerations, to build his villa as a temple to the arts, to house his library and paintings and entertain his friends and protégés, among them the philosophical Bishop Berkeley, such writers as Pope, Swift, Gay, and Thomson, the composer Handel himself, and architects, painters, and sculptors such as Campbell, Kent, Guelfi and Rysbrack. Of these, William Kent, Burlington's friend and protégé, was responsible for much of the interior decoration of the villa and for the laying-out of the garden.

Work was begun in 1725 and was completed

within four years. Burlington based his design on Palladio's Villa Capra near Vicenza, though he also drew on other villas built by Palladio's pupil, Scamozzi. But the young lord was a gifted architect in his own right and Chiswick House is not a copy of an Italian original; dignified but spirited, four-square and two storeys high, it sits behind its courtyard like a demure little sphinx, the double staircase that adorns the façade resembling a pair of neatly folded paws. It was to prove one of the most influential buildings in the history of British architecture. Within, the rooms are arranged like a small labyrinth of beautifully proportioned, inter-connecting boxes around an octagonal core.

Today Burlington's conception may be appreciated more clearly than at any time since the late eighteeth century. The old house, to which the villa had been an appendage, was demolished in 1788; the fifth Duke of Devonshire, whose mother was Henrietta Boyle, Burlington's only child and heiress, made the little villa the centre of his residence, enlarging it with wings designed by James Wyatt. In 1892, the eighth Duke removed his art treasures to Chatsworth and let the estate as a private lunatic asylum. In 1928, the threat of building development led the Middlesex County Council to purchase both house and grounds; after the Second World War, the wings were found to be so decayed that they were demolished, thus restoring the diminutive villa, which Lord Hervey described as being 'too small to live in and too big to hang on one's watch', as closely as possible to Burlington's original conception.

Chiswick House is best approached from the intersection of Burlington Lane with Great Chertsey Road; two magnificent gate-piers lead into a square courtyard, enclosed by a box hedge and set about with terms or classical busts on pedestals; from here, the remarkable unity and completeness of Lord Burlington's façade may be appreciated. An elaborate double staircase leads the eye upwards to the six Corinthian pillars, which form the portico and support the pediment above which the dome rises, its lunette windows filtering light down into the salon below. Every detail has been thought out and balanced with the utmost nicety; the trim balustrade supports elegant urns, while Rysbrack's two statues of Palladio and Inigo Jones, one behind each arm of

the staircase, against the rusticated wing-walls which terminate the façade, add a touch of bravura which only heightens the classical restraint of the rest of the building. Entering at the lower floor, originally intended to house the Earl's library and to be his private domain, we pass through the lobby into the octagonal hall; here, we may study the comprehensive exhibition on the history and architecture of the building and its gardens. A modern corridor leads through to the Summer Parlour where there are three grisaille paintings of classical statues, executed for Alexander Pope and bequeathed by him to Lord Bathurst. Back in the main building, stairs descend to the wine cellar below the octagonal hall, and a spiral staircase leads upwards to Lord Burlington's public apartments. To the left are the Red and Blue Velvet Rooms and the Red Closet. In the former, two carved marble chimney-pieces are surmounted by paintings by Sebastiano Ricci (Diana and Endymion, Venus and Cupid). Kent's nine-panelled ceiling has Mercury in the central compartment looking down on allegorical figures of Painting, Architecture, and Sculpture while the surrounding sections form an elaborate border with Roman heads, putti, and the signs of the Zodiac. The Blue Velvet Room is the most sumptuous of all. Above each of its three doors is a portrait - Inigo Jones by Dobson, Alexander Pope by Kent, and an unknown man - while the cerulean ceiling rests on eight pairs of heavy console brackets,

its centre filled with a square panel, painted, presumably by Kent, with a figure of Architecture reclining comfortably on a cloud. The Red Closet is comparatively plain but its window looks out onto the courtyard and the pattern made by the almost abstract relationship of the staircase and balustrade. On the other side of the Red Velvet Room is the octagonal domed Saloon which fills the centre of the building. The dome is lined with rows of eight-sided panels which diminish as they reach the crown; walls and dome have been restored to their original colour, an astonishing rich burnt gold. Around the walls hang eight paintings, four historical - Charles I and his family, probably a contemporary copy of the Van Dyck in the royal collection; the Moroccan Ambassador by Kneller; Louis XIII and Anne of Austria, both by Ferdinand Elle – and four allegorical – Liberality and Modesty by Guido Reni; the Rape of Proserpine by Anthonie Schoonjans; Apollo and Daphne and the Judgement of Paris, both probably by Danielo Volterra.

On the far side of the Saloon is the Green Velvet Room, which also has two fireplaces with overmantels by Ricci representing a cherub (the flowers were painted by Baptiste) and Bacchus and Ariadne. Beyond is the Bedchamber where Charles James Fox, one of the most lovable, eloquent, and incorrigible of men, died in 1806. The chimney-piece is comparatively plain; above it, a lead-backed original mirror

HOUNSLOW

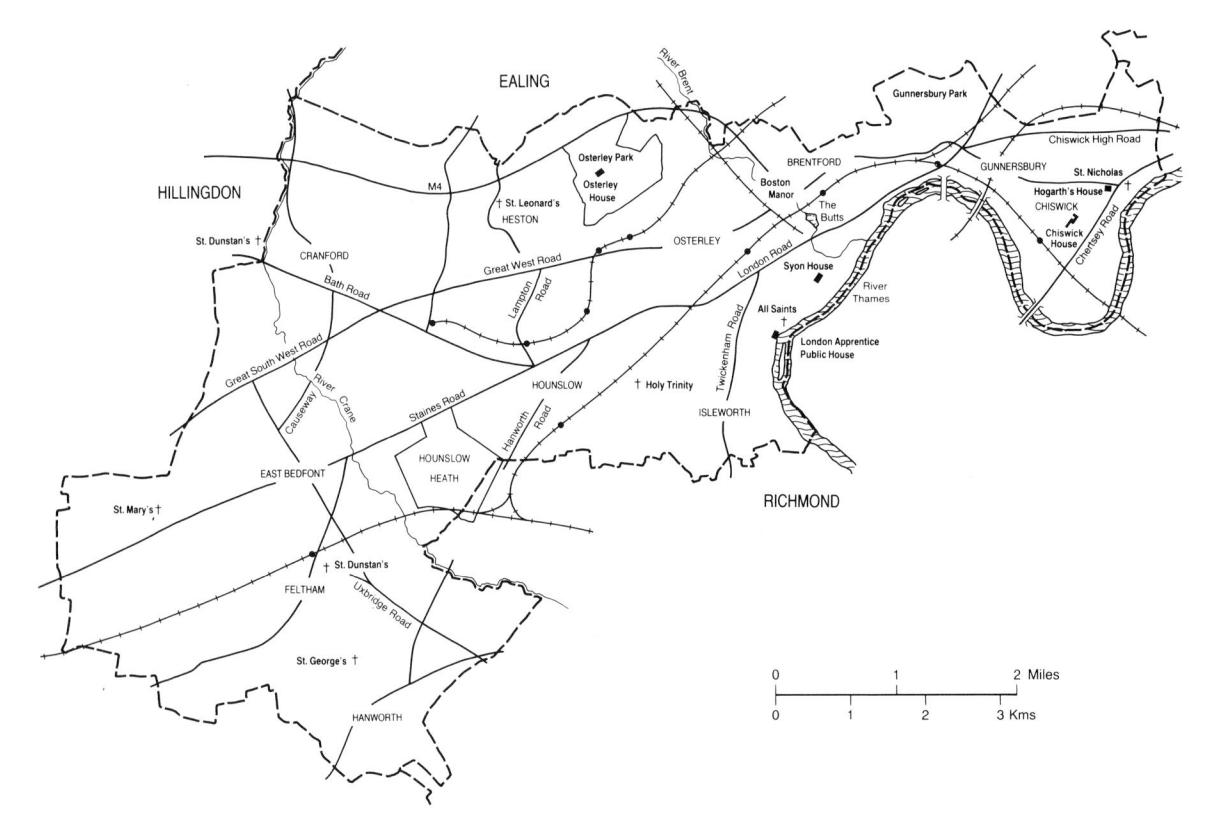

HOUNSLOW 283

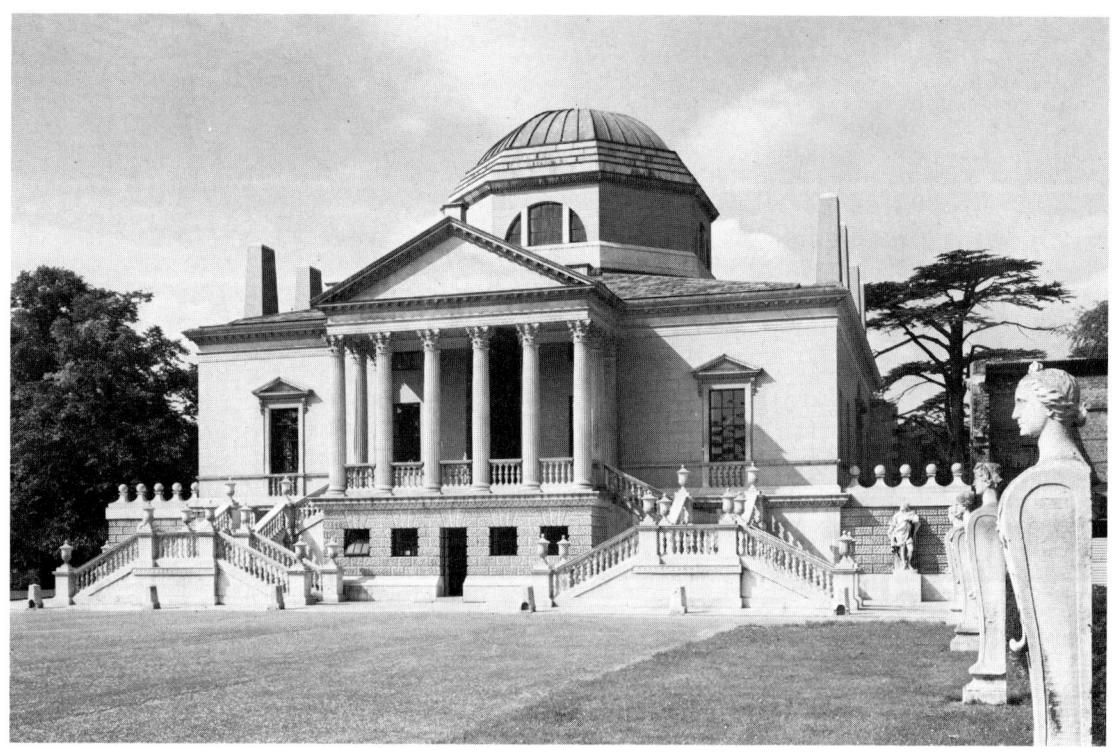

Chiswick House, Chiswick

gives a ghostly reflection and is surmounted with a portrait of the Earl of Cumberland. Above the elaborately decorated doorways, fish-tailed cherubs support roundels with portraits of Pope by Kent and of Lady Burlington and Lady Thanet, both by Aikman.

The north-western side of the house, overlooking the gardens, is given over to the Gallery. Though its actual dimensions are small – a mere 60 feet in length - yet by dividing it into three sections, a circle, an apsed rectangle, and an octagon, linked each to each by archways, Burlington achieved a vista with all the force of the grand manner. Did Soane remember this apartment when he designed the Dulwich Picture Gallery? In the apses at either end of the central section are niches for statues – Mercury and Venus, Apollo and a muse; Apollo was here in the Earl's day, the others are modern copies. Once again, Kent painted the eight outer panels of the ceiling while an Italian landscape, called the Defence of Smyrna, is set in the centre. From the north-western corner runs the upper storey of the Link Building with two rows of Corinthian columns, reminiscent of the Baths of Constatine, and with magnificent views of the gardens from its windows.

The gardens are as important as the house. It was on these acres that the whole classic concept of landscape gardening was first displayed; their proximity to London reinforced their influence. Im-

mediately to the north-west of the villa, a short, broad avenue with sphinxes, vases, and busts scattered between the trees leads to three longer, more slender alleyways which radiate out from each other: so far, the setting is as formal as any admired by the previous generation, but between the three avenues, little pathways wind capriciously in and out of the bushes, and the rest of the grounds are not governed by any overall geometrical scheme. To the south of the villa is a temple and beyond a meandering river with a cascade and a classical bridge, and further south still, an obelisk also surrounded with radiating paths; to the north is a gateway on which other paths converge. Immediately to the north is the Inigo Jones gateway, which originally stood outside Beaufort House in Chelsea and which Sir Hans Sloane gave to Lord Burlington in 1736. Pope wrote a verse for it:

> I was brought from Chelsea last year Batter'd with wind and weather; Inigo Jones put me together; Sir Hans Sloane let me alone; Burlington brought me hither.

The archway must have been one of the Earl's dearest possessions, for Jones was enshrined, along with Vitruvius and Palladio, in his own personal pantheon. Beyond the archway are the Deer House and Doric Column and just to the north of these a handsome conservatory, which the Duke of Devon-

shire had built in the nineteenth century with, in all probability, Paxton as his designer. Before it, a broad semicircle of flowers beds demonstrates the more formal planting of Victorian times.

The house visited there is still much to see in Chiswick. At the roundabout which marks the iunction of Hogarth Lane and Burlington Lane with the Great West Road, set back behind its own garden wall, is William Hogarth's house. This 'little country box beside the Thames' may have been built for the artist who lived here with his wife, his widowed mother-in-law, and his sister, from 1749 till the night before his death in 1764. A century later it had fallen into decay from which it was rescued, in 1902, by Colonel Shipway, who bought it, restored it, lined its walls with a remarkable collection of Hogarth's engravings and presented it to the Middlesex County Council¹ as a museum dedicated to one of the most forceful and socially conscious of all English artists. The house - of brick, three storeys and an attic high. six windows wide with a weather-boarded oriel window projecting above the front door - is unpretentious and sparsely furnished, but the irregular internal arrangements are interesting, and a mulberry tree which the artist planted still, indomitably, produces fruit each summer.

St. Nicholas' church lies towards the river, down Church Street. Probably of thirteenth-century foundation, the tower was rebuilt when William Bordall was vicar from 1416 till 1435. This alone survives from the old church, the rest of the fabric having been ground up and used for mortar in 1882 when I. L. Pearson designed a new building. It shelters Sir Thomas Chaloner's alabaster monument (d.1615); he is shown kneeling opposite his wife under a semicircular canopy from which bearded servants draw aside the curtains. Thomas Bentley (d.1780), Josiah Wedgwood's partner, has a tablet by the younger Scheemakers, and Lord Burlington is kept company in death by his friends and architects, Colen Campbell and William Kent, and by his bricklayer, Richard Wright. Cromwell's daughter, Mary, Lady Fauconberg, is buried here, though no monument marks her resting-place. A tall pedestal with an urn upon it and an epitaph by Garrick indicates Hogarth's grave, and it was to be near Hogarth that J. M. Whistler chose to be buried at Chiswick in 1903. Ugo Foscolo, poet of the Italian Risorgimento, was buried here in 1827, though his body was removed to Florence in 1871, and Chiswick is also the resting-place of Charles Holland, the actor (d.1769) for whom Garrick also wrote an epitaph, and Philippe de Loutherbourg, the artist and scene-painter, who died in 1812.

Chiswick Mall runs north-eastwards along the loop of the river towards Hammersmith. An agreeable morning or afternoon may be spent walking along the arc of the river as far as Hammersmith Bridge, Chiswick Mall is one of the prettiest stretches. of riverside development to be found along the Thames. The finest house of all is Walpole House. where Barbara Villiers, Countess of Castlemaine, Charles II's mistress, died in 1709. The facade is of the first quarter of the eighteenth century. Woodroffe House, Bedford House, Evneham House, Morton House, Strawberry House, to which a pretty porch with delicate columns has been added. Thames View. and Lingard House are all handsome, eighteenthcentury work, and the insertions and additions of the nineteenth and twentieth centuries are of as high a standard as the earlier buildings. Several of the gardens here are open to the public on one or two Sundays during the summer months. The Fox and Hounds public house on the corner of Mawson Row was once the home of Pope's parents, and here the poet lived with them from 1716 till he moved to Twickenham (see p. 407) in 1719.

The quarter-mile of river-bank immediately to the east of Kew Bridge is known as STRAND-ON-THE-GREEN. Building began here with a row of fishermen's cottages and there is still nothing, save a narrow, often tide-flooded pathway, to separate the present houses from the Thames. The houses range from the very grand – number 1 Strand-on-the-Green House and Zoffany House, where the painter lived from 1780 till 1810, having made an adequate fortune on his travels to India - through nineteenthcentury cottages to rather good, smart, modern terrace development, and include a row of almshouses, established in 1704, renovated every few generations and still in use. What all the houses have in common is an awareness of the proximity of the water to which the raised doorsteps, first-floor entrances, and flood-boards bear witness. The main pier of the railway bridge serves as a boat-house, working barges moor on the shore, and the iron railings are fashioned like twisted cables. The view is completed by the graceful line of Kew Bridge and by the cheerful irregularity of the tree-covered evot or island in the Thames.

Back on the main road is BRENTFORD, rich in industrial archaeology and in historical associations, as might be expected in what was once the county town of Middlesex. It is an old place; centuries of habitation have masked and obliterated the past but tradition has always avowed that it was here that Julius Caesar first crossed the Thames. Wooden stakes found driven into the river bed were alleged to have been defences against his legionaries. It is more probable that they were for fishing traps (one can still be seen in Syon House), but this stretch of river bank was inhabited well before London existed. The collection of the local antiquary, Thomas Layton, containing many objects retrieved from the Thames, is

¹ Since 1965, the house has been the responsibility of the London Borough of Hounslow.

now in the Museum of London. In 1642, the Battle of Brentford was fought here between Charles I's men and the parliamentary forces. This was the King's nearest approach to his capital, and it ended the next day in a sullen, bloodless confrontation on Turnham Green, when the royalists realised that they could not hope to force the resistance of the London trained bands, and so turned back to the King's headquarters at Oxford. Throughout the eighteenth century the parliamentary elections for Middlesex took place here, with extraordinary scenes and disturbances in 1768 and 1769 when John Wilkes was the member returned. The High Street today is shabby but it could be as agreeable as any of its riverside neighbours. It possesses, moreover, two unusual attractions which are open at the weekends; they are the Kew Bridge Pumping Station and the Musical Museum.

The Pumping Station on the corner of Kew Bridge Road and Green Dragon Lane houses the five Cornish beam engines, built between 1820 and 1871, which until 1944 supplied west London with water. When electric pumps took over the work, it was decided to preserve the old machinery and to convert the station into a museum devoted to London's water supply. As such, it has been open to the public at weekends since November 1975. The main building contains the 90-inch and 100-inch engines, built in 1845 and 1869. The main beams, each over 30 feet long, were made as single castings, a task that would be difficult even today. Such was the engineers' confidence in their machines that the strictly functional house was built around them, without provision for bringing in replacement parts, which in fact had never been required. The gigantic main shafts follow the Doric order, while the casing of the oldest engine on the site, made by Boulton and Watt in 1820, originally for Chelsea Pumping Station and now in the East Engine House, has an iron casing that is a free interpretation of the Tuscan order. The sheer thrust and power of these machines is heroic.

A few hundred yards westwards up the High Street is the Musical Museum. It is housed in what was St. George's Church, designed in 1887 by Sir Arthur Blomfield, with a piquant octagonal tower added in 1913. It consists of the remarkable collection founded by Frank Holland, containing hundreds of pianos and automatic instruments and some 30,000 music rolls. It is open on Saturday and Sunday afternoons in summer.

Brentford's churches are having a difficult time at present. The parish church, dedicated to **St. Lawrence**, which stands at the western end of the High Street, was declared redundant in 1976 and closed. Its late fifteenth-century ragstone tower is wedded to a nave built from yellow brick in 1764. It houses a good octagonal font of about 1500, a fourteenth-

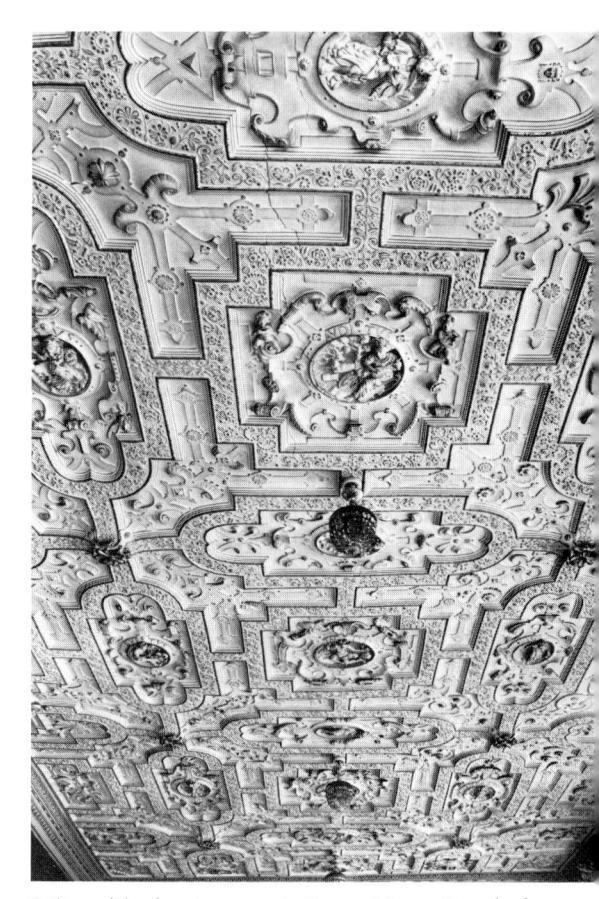

Ceiling of the drawing room in Boston Manor, Brentford

century carving of the Berkeley arms, and a brass to Henry Redman, the King's master mason, who died in 1528, having been responsible for Wolsey's palace at Hampton Court. Among a number of good monuments, there is a charming one by Flaxman to W. H. Ewin (d.1804), and Thomas Hardwick the architect lies in the churchyard in company with William Noy (d.1634), the lawyer who found the precedent for Charles I's levy of ship-money, which led to the Civil War. There is some hope that the church may be reopened as a local arts and drama centre. At present St. Paul's, built in 1867 of grey stone with a broached spire, serves as a parish church and houses a large painting of the Last Supper, which Zoffany executed as an altar-piece for Kew but which the vestry rejected, since he had slyly included a portrait of a local worthy, against whom he bore a grudge, as Judas Iscariot. Close by the church, on the western side of Halfacre are the Butts, a large open square where once the parliamentary elections were held, but which serves today as a car park. Around three sides are grouped fine, very early eighteenth-century houses, Beaufort House being probably the oldest.

Brentford's final surprise is a seventeenth-century

¹ His library, maps, and collection of drawings are housed in Chiswick Town Hall.
HOUNSLOW

mansion, Boston Manor, Built in 1623 by Lady Mary Reade, it was extended and embellished by a later owner, James Clitherow, in 1670; his family, whose memorials are in St Lawrence's church, held it till 1924, when it was sold to Brentford Urban District Council. In 1963 it was well restored and the main rooms on the first floor are open to the public on Saturday afternoons from May till September. The house is of red brick with stone quoins, three storevs high and six bays wide: the attic gables over each pair of windows suggest that it was the work of a local builder, for the right-hand gable window is off centre. The wall of the main staircase has trompe l'oeil painting to match the balustrade on the other side, and the glory of the house is the ceiling of the first-floor Drawing Room, the early date of which is proclaimed by the initials 'M.R.' for Lady Mary, Set in the cartouches among the elaborate plaster strapwork are figures of the Senses, the Elements, of Peace and Plenty and War, of Faith, Hope, and Charity: their medieval stiffness contrasts touchingly with the luxuriance of the Renaissance decoration around them. In the overmantel is set a painting of the Sacrifice of Isaac after Abraham de Bruyn. The grounds of the house are now a public park; the magnificent cedars must have been planted by one of the first Clitherows to own the estate.

The curve of the river goes round to the compact village of ISLEWORTH, near which Syon and Osterley both stand. Syon was founded in 1415¹ by Henry V as a convent of Brigettine nuns, Osterley was completed by 1576 for Sir Thomas Gresham, one of the most successful of all the Elizabethan merchant princes, and both houses were remodelled by Robert Adam at the very height of his powers. Both can be visited in a single expedition in company with Chiswick.

At the Reformation, Syon passed first to the Duke of Somerset and then, following his execution, to the Duke of Northumberland. His daughter-in-law was Lady Jane Grey, and it was here that she unwillingly accepted the crown for a brief nine days on the death of Edward VI, her young life ending on the scaffold in 1554. Thereafter, the estate passed to the Percy family and the house probably assumed much the shape which it presents today, a block some 140 feet square, with a turret at each corner. The central courtyard is open; an arcade was added to the east side soon after 1632, traditionally to the designs of Inigo Jones.

In the mid-eighteenth century, the estate became the property of Sir Hugh Smithson, later Duke of Northumberland, who engaged Robert Adam to transform the interior of the old house. These are the rooms which are open to the public today; they represent the formal aspect of mid-eighteenth-century aristocratic life at its most opulent and elegant. The double cube of the entrance hall, cool, lofty, 287

Still on the south side is the Red Drawing Room, which takes its name from the Spitalfields silk wallhanging, still glowing after two centuries; the floor is covered with a rich carpet which Adam designed and Thomas Moore of Moorfields wove as his masterpiece in 1769, and the deeply coved ceiling is bedizened with small octagonal panels of red, green, and gold. The Great Gallery, 136 feet long and 14 feet wide, runs the whole length of the east front. Triumphantly accepting the challenge of such proportions, Adam decorated it in soft greens and mauves 'in a style to afford variety and amusement' to the ladies who would use it, dividing up the long walls with fireplaces and bookcases of different shapes and setting Michelangelo Pergolesi to paint the 62 pilasters at a charge of 'three guineas a piece'. Below the cornice is a series of medallion portraits, some of them scarcely authentic, of the earls of Northumberland. The great house can be left by way of the Oak Passage, lined with thirteen enriched oak panels, carved soon after 1600, some with the initials H. P. and the Percy badges and motto. Besides these hang a painting on glass by John Martin of Belshazzar's Feast, a map of Isleworth Hundred and the manor of Syon executed with intriguing details in 1635 by Moses Glover, and one of the stakes drawn from the bed of the Thames (see p. 285).

The house once visited, there are still the gardens to be seen at Syon. Protector Somerset's tenure was brief but he encouraged his physician, Dr. William Turner, the 'father of English botany' and the author of Names of Herbes, which he wrote in 1548 at Syon and dedicated to the Protector, to plant out a systematic collection here. Two of the mulberry trees, among the first to be imported into England, still flourish in the present Duke's private garden on the north side. A later owner, Henry Percy, the 9th Earl of Northumberland, built the two white pepperpot lodges on the west lawn. The gardens owe the present layout to the changes made between 1767

airy, dove-coloured, like some Olympian dairy, has a black and white marble floor, exquisite plasterwork by Joseph Rose, and an apse at the north end to enshrine a fine copy of the Apollo Belvedere. Opposite him, raised on a half-landing, the Dying Gaul sinks down, his life ebbing; this copy of the antique statue was cast in Rome by Valadier at a cost of £300. The stairs behind him lead up to the Anteroom, the rich colours - carmine, blue, and gold - of its scagliola floor, its twelve fine verde antico pillars topped with golden figures. The vivid blue and gold plasterwork of trophies and frieze contrast breathtakingly with the restraint of the entrance hall. Beyond is the Dining Room, its walls hollowed out with aedicules, which shelter classical figures; the carved panel above the fireplace represents the Three Graces. In each of these apartments, it is worth noticing Adam's characteristic use of columns to form a screen which, simultaneously and tantalizingly, both divides and unites the space around it.

¹ Upriver at St Margaret's, moved to the Syon site in 1431.

and 1773, when the 1st Duke called in Lancelot 'Capability' Brown to do for the surroundings what Adam had done for the house. The main features were a meandering lake, 400 feet long and 20 feet broad, a green sward known as Flora's Lawn, which stretches out around a Doric column topped by a figure of the goddess, and a woodland area.

To these the 3rd Duke added the Great Conservatory, built between 1820 and 1827 to the designs of Charles Fowler. Fashioned from Bath stone and gun-metal, the internal pillars are of intricately traceried cast iron. The building stretches out for some 382 feet and at its centre soars 65 feet upwards into its resolutely bulbous dome. It was this conservatory that provided Paxton with the model first for his great greenhouse at Chatsworth and later for the Crystal Palace itself. Today, one wing of the Conservatory houses an aviary and another part is devoted to an aquarium, while throughout are special cases in which exotic moths fan their crepuscular wings. A few years ago, an excellent garden centre opened at Syon, so the enthusiast can come away with a practical reminder of the great house and its gardens. Younger visitors will be interested in the exhibition of toys, which includes a rocking-horse said to have belonged to Charles I, as well as some most desirable doll's houses. The way out leads to the magnificent gateway and screen on the road; Walpole grumbled at it, calling it 'all lace and embroidery' but we may rejoice in it today. The main arch is topped by the Percy lion and another noble beast, made from Coade stone, which used to surmount the gateway to old Northumberland House near Trafalgar Square (see p. 137), now adorns the river front. No-one should leave the vicinity of the great house without visiting Syon Lodge, an eighteenth-century dwelling which accommodates the stock of Mr. Crowther, a dealer who specializes in antique garden ornaments and who has the imagination to display them in appropriate settings.

Back by the Thames the visitor may obtain refreshment at the London Apprentice, one of the most picturesque of all the public houses along the river. The low rooms are snug enough in winter and in summer one may sit on the terrace, looking at the river with small craft on it and the tree-covered eyot which parts the flow of the water. To landward, the eye rests on a pleasing mixture of houses, some of them eighteenth-century, and on All Saints church with its projecting sundial, a memorial to Mrs. Susanna Lawes (d.1707), which on a fine day indicates simultaneously the time in Isleworth, Jamaica (where the lady had lived), Jerusalem, and Moscow. The old church, a lovable jumble of a building constructed through several centuries, was burnt out by vandals in 1943 but the fifteenth-century tower, with its fine peal of ten bells, still stands and Michael Blee, architect for the rebuilding, was inspired to use the eighteenth-century walls to form a courtyard

through which a fountain, symbolizing the waters of baptism, flows. The new church has a strange roof like four inverted pyramids carried on columns, giving almost the effect of vaulting; on the river side. the circular Joshua Chapel is called after a child who died at the age of two. The famous brass to Margaret Dely (d.1561), the Nun of Syon, was lost in the fire but several others, including an unknown man in armour (d. c.1450), remain, while the monuments to Sir Orlando Gee (d.1705) whose bust Francis Bird carved, magnificently swathed in draperies, and to Anne Tolson (d.1750) are now restored and installed in little galleries at the west end. Sir Theodore de Vaux (d.1694), physician to Charles II, lies here, and so does John Busch, who settled in Isleworth after having been gardener to the Czarina of Russia, while Peter Oliver, the miniaturist and son of the more famous Isaac, worshipped here.

Attentive map-readers will discover Mill Plat with its row of single-storey almshouses, established in 1664 by Sir Thomas Ingram, each doorway equipped with a flood-board lest the river become too pressing, and at number 158 Twickenham Road a tablet records that Vincent van Gogh lived there while teaching in England in 1876. A quarter of a mile away, Gumley House, a fine eighteenth-century mansion, now serves as a convent, modern wings having been added to it.

Osterley House and its park lie a couple of miles to the north. Sir Thomas Gresham entertained Queen Elizabeth in his new house here in 1578. In plan, it is not unlike Syon, being built about a central courtyard with turrets at the corners. It is of warm red brick and the same materials were used for the stable block, which stands to the north of the main building and may incorporate portions of an earlier manor house. Gresham died childless and the estate passed through various hands, its owners including Sir Edward Coke, Elizabeth's attorney-general, and the parliamentary general, Sir William Waller. In 1710, it was purchased by Sir Francis Child, founder of the banking family, passing by marriage to the Villiers, Earls of Jersey, who presented it to the National Trust in 1949. It was Sir Francis's grandsons, Francis, who died untimely in 1763, and Robert, who decided to remodel the old house. During the 1750s, Francis possibly called in Sir William Chambers, but pressure of business may have forced him to relinquish the commission, and Robert Adam, newly returned from Italy, took it up in 1761. He transformed the old building by setting a double screen of pillars, approached by a flight of steps, across the east front, so that entrance to the house is gained through this portico and across the courtyard – a handsome and arresting approach but most inconvenient in wet weather. Like their neighbours at Syon, however, the Childs instructed Adam to concentrate his attention, not on the façade but on a series of sumptuous state rooms in which they might entertain. The architect was working on the two commisHOUNSLOW 289

sions at the same time and it is instructive to compare the results.

The entrance hall is on the far side of the courtyard. It faces east-north-east and is a cool, restrained room, rectangular save for an apse at each end. Plasterwork trophies, similar to those at Syon but here painted white and grey, panel the inner wall. Beyond the hall is the Gallery, sited to catch every moment of sunlight. As long as that at Syon but broader, the better balanced proportions of Osterley give a greater unity and result in a room well suited for entertaining a large company. A fine collection of paintings used to hang here, but they were removed by the last owner and the paintings at present on the walls have come from the Victoria and Albert Museum; they are intended to convey the general appearance of the Gallery in the eighteenth century. The furniture is worth attention, for Adam bestowed the same care on a keyhole casing as on a main façade and his designs were executed by John Linnell, an exceptionally fine craftsman. In the Gallery, the carved girandoles and pier-glasses are especially elegant. Beyond, in the North Wing, is the Eating Room, arranged formally with the chairs set around the walls and without a table, as it would have been when the Childs lived here; at either end is a large painting by Zucchi, with smaller scenes by the same artist over the doorways and a landscape by Cipriani above the chimney-piece. Then comes the Great Staircase which used to have Rubens's Apotheosis of a Hero as its ceiling, but this, after being removed by the last owner, has since perished in a fire.

The severe dignity of the stairway, which was probably designed by Chambers, is offset by three magnificent lamps, designed by Adam and almost certainly made in Birmingham by Matthew Boulton, James Watt's partner. We then come to the magnificently furnished Library, its walls inset with paintings by Zucchi and Cipriani and a ceiling of which Adam was proud. In the opposite wing, the Drawing Room, Walpole declared, was 'worthy of Eve before the Fall'. His Eve must have been a most sophisticated lady, for this apartment, its walls hung today with a modern reproduction of the original 'pea green Silk Damask', its floor covered with one of Moore's superb carpets, and its ceiling resplendent with green, red, and gold panels massed around a central motif of gilt ostrich feathers radiating from a sunflower - perhaps a reference to the Child family emblem, the marigold - is the epitome of a grand public room and has none of the innocence of the Garden of Eden. The Tapestry Room, which served as an antechamber to the State Bedroom, was planned around a set of wall-hangings designed for it by Jacques Neilson at the Gobelins works in Paris. The loves of the gods are depicted; Aurora and Cephalus, Venus and Vulcan, and Cupid and Psyche are all framed in golden medallions against a rich pink background. In the room beyond is the State Bed, one of Adam's most ambitious pieces of furniture, its

valance adorned with the Child crest and topped with a dome which Walpole, with some justification, described as being 'too theatric'. This room opens into the Etruscan Dressing Room, painted with spidery decorations which were not in fact Etruscan at all but were inspired by the Greek vases which Sir William Hamilton and other gentlemen were avidly collecting. Walpole was outraged at the result, declaring it unworthy of the house that these walls should be 'painted all over like Wedgwood's ware with black and yellow small grotesques'. The grounds surrounding the mansion, though agreeable and ample, are of no particular design, and Osterley will be remembered for its decoration and for its retention of most of its original furniture in pristine condition.

The centre of HOUNSLOW remains to be explored. At a casual glance, it might have been designed expressly as a place of transit. Being on the main road to Bath, the long narrow main street was amplified suddenly in the first half of the eighteenth century, its numerous inns providing refreshment for travellers and relays of horses, and declined as sharply a century later with the advent of the railways. From the end of the nineteenth century onwards, it grew again as an ordinary suburb and sprawls out today on either side of an undistinguished main street.

One tenuous link with the Middle Ages is perpetuated in the dedication of the parish church, Holy Trinity, which stands in the High Street on a corner of the site once occupied by the English headquarters of the Trinitarian friars, who established themselves here in 1211, having been founded some fifteen years earlier for the express purpose of raising money to free Christian captives from the Turks. The building was destroyed by arson in 1943 and a new church was built to the designs of Lt.-Col. W. E. Cross. It is entered under an archway pierced through the tower which stands, 95 feet high, separated from the main building. In the inner wall of the arch is set a stone from the old church, thought to have been part of the sixteenth-century memorial to Lord Windsor. Set high on the tower are two fibre-glass angels sculpted by Wilfred Dudeney, while a figure of Christ by the same artist dominates the interior. The church, with a roof of interlacing concrete ribs, is exceptionally light with an extraordinary feeling of space, and the stained glass by H. P. Thomas in the east window shows to great advantage. The crypt is used today as a parish meeting-place; in it are two small kneeling figures of a knight and his lady, carved about 1540 and therefore early for this type of monument, and on the stairs leading down to the crypt is a handsome bust of Whitelocke Bulstrode (d.1724), a distinguished lawyer and a member of a noted Hounslow family.

Beyond the town centre lies HOUNSLOW HEATH, traditionally a place for military musters and a haunt for footpads which once gained it an ill

reputation. Extending originally for more than 4,000 acres, it has now shrunk to the size of a public park and may indeed some day become one. It was on the Heath in 1784 that General William Roy set up the base line for the first triangle with which the Ordnance Survey of England began. Sunken cannon in King's Arbour (now London Airport North) and in Roy's Grove at Hampton mark the ends of the line.

By this time, the thickly built-up area of Greater London has given way to low-lying countryside most apt for the creation of Heathrow Airport just over the borough boundary in Hillingdon (see p. 271). The feel of the place alters almost imperceptibly and the traveller realizes that these conurbations of late nineteenth- and early twentieth-century housing were till recently villages in an agricultural landscape. Five of them remain to be explored, Hanworth, Feltham, East Bedfont, Cranford, and Heston.

Nearest to Hounslow, in the extreme south of the borough, is HANWORTH, the parish church dedicated to St. George standing in the middle of the village. The medieval church was entirely rebuilt by James Wyatt in 1812, but his trim design was overwhelmed in 1865, when Teulon enlarged the chancel and added a tower, porches, and a north chapel. From the old church, some seventeenthcentury glass remains, inserted into the window of the north chapel; the fragments include a pair of six-winged seraphim. Immediately to the south of the church stood a hunting lodge, once the resort of Henry VIII and the residence of Katherine Parr. Extended considerably in 1629 by Lord Cottington, it was burnt down in 1797 and a block of flats, Tudor Court, stands in its place. Some of the old walls remain and set in the entrance courtyard are two terracotta roundels, representing a Roman emperor and Minerva; they are companions to those modelled by Giovanni da Maiano at Hampton Court (see p. 249). The building now known as Hanworth House stands some distance along the main street; basically about 1700, eighteenth-century additions have been made on the west side and modern ones on the east.

At FELTHAM there is little of interest apart from St. Dunstan's church. An earlier building was pulled down in 1802 and was replaced by a neat little brick box with a low tower and shingled spire; to it, in 1853, aisles were given with delightful round-headed Norman windows with chevron mouldings. Inside, the original pews have, very recently, been removed, but the wooden gallery, supported on trim Doric columns, is still there, its commemorative inscriptions, painted in an elegant flowing script, quite unsmirched. William Wynne Rylands, the last man but one to be hanged at Tyburn, lies in the churchyard; he was engraver to George III, but used his skill to forge East India Company bonds, and so was executed in 1783. Church House, which stands beside St. Dunstan's, seems to have a seventeenthcentury core, though it received a new façade in the eighteenth century.

A mile and a a half to the west, is EAST BED-FONT, with St. Mary's church set back most picturesquely behind a spacious village green. The chancel and nave, forming a long, narrow building, were erected about the middle of the twelfth century. In the fifteenth, the chancel was extended eastwards and windows of both dates can be seen in the walls. A north transept was added in 1829 and in 1865 the nave was enlarged westwards and a south tower and porch were added. The Norman south doorway, protected by the Victorian porch, has well-preserved zig-zag and trefoil mouldings to the double order of the archway; inside, the chancel arch - the only Norman one left in Middlesex - has zig-zag decoration too. In the angle between it and the north wall is a recess with two thirteenth-century wall paintings executed in red line against a dark red background. In one, Christ, enshrined in an elaborate panel, reveals His wounds, while below Him angels sound the Last Trump, calling the dead to rise again, and in the other is the Crucifixion, Our Lady and St. John mourning beside the dead Christ. Worn and faded though they are, their strong, determined line still holds its power. In the chancel are brasses to Matthew Page and his mother, Isabel, who died within a year of each other, in 1632 and 1631, and an unusual achievement of arms as a memorial to William Weldish, who died in 1640. In the nave hangs a small wooden panel, carved in Flanders about 1530, showing the Crucifixion with a busy host of figures crowded around the three crosses. East of the church stands the stylish eighteenth-century Burlington House and nearby are Pates Manor Farm, dating

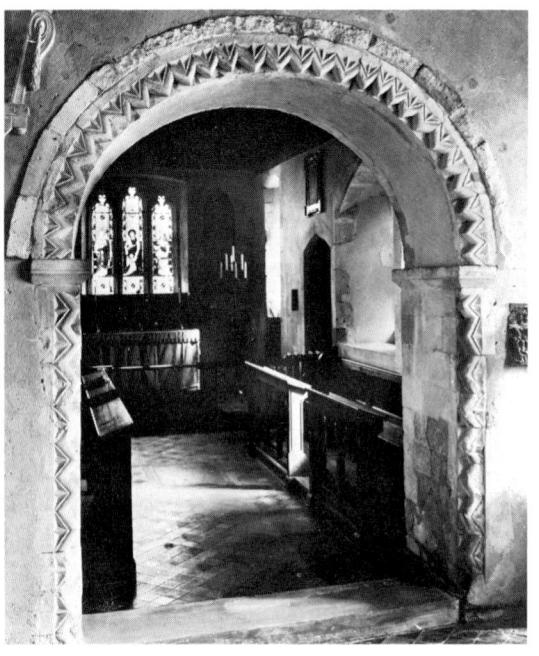

St. Mary's, East Bedfont

HOUNSLOW 291

from the sixteenth century, and Fawns, an attractive seventeenth-century house, almost hidden by trees.

Just over the county boundary is STANWELL. Of pre-Conquest foundation, the body of the church was built about 1260 from flint and stone rubble, the chancel, which is almost as long as the nave, was extended about 1330, and later in the same century the upper stages of the tower were added with chequer-work - rare in Middlesex - to the second stage. The shingled spire - recently well restored was added in the fifteenth century; engagingly, it leans six feet out of plumb. Though the south aisle has lost its old roof, some of the carved corbels have been retained; a queen, two kings, a bishop, a knight. a man, a woman, and a pilgrim with his cockle shell for the shrine of St. James of Compostela, may be identified. At the east end of the south wall, a thirteenth-century pillar piscina, used to wash the sacred vessals after eucharist, has recently been uncovered, and there is another later one in the south aisle. On the south side of the chancel is elaborate fourteenth-century wall-arcading. The orientation of the chancel is three degrees north of east, so that the sun rises to shine through the centre of the east window on Lady Day, the church being dedicated to St. Mary the Virgin. There is one good brass set in the chancel floor with a vestmented half-figure of Richard de Thorpe, who was rector here in 1408.

The pride of the church, however, is the multicoloured marble monument to Thomas, Lord Knyvett, and his wife Elizabeth, who both died in 1622. Carved by Nicholas Stone, at a cost of £215. the couple kneel opposite each other, Lord Knyvett clad in his robes as a peer of the realm, stone curtains drawn up on either side of them and knotted around Corinthian columns; the base is enriched with garlands of flowers and a magnificent coat of arms and crest surmount the whole. Lord Knyvett, who was concerned in the apprehension of the Gunpowder Plot conspirators, left money to found the local free school which still thrives in its original building, and the remarkably unspoiled village retains an appreciable number of Georgian and early nineteenth-century houses and cottages around its triangular green. The miniaturist Nicholas Hilliard was granted the nearby manor of Poyle for 21 years from 1587 by Queen Elizabeth.

Back over the Greater London boundary and eastwards is CRANFORD. The church now stands in a public park, formerly the grounds of Cranford House, which today is almost concealed by the overhead roadway of the M4. Domesday Book records that there was a church here in 1086 and the manor was later the property of the Knights Templar. When that order was dissolved, the church was rededicated to **St. Dunstan** and served the parish. Of the early building, there is very little left, though traces of a pre-Reformation fresco of the Blessed Virgin may still be discerned on the east wall, and one of the three bells in the tower was probably cast

about 1380 by William Burford. The chancel and the lower part of the west tower are fifteenth-century, though the nave was rebuilt in 1716, having been much damaged by fire six years earlier. There are two remarkable funeral monuments and several others. less spectacular but equally interesting. The most arresting of all is to Sir Roger Aston, who died in 1612. Carved by Nicholas Cure, the King's Mason, at a cost of £180, it shows the knight kneeling opposite his two well-dressed wives, four equally elegant daughters behind them, while a fifth lies by her father, wrapped in swaddling clothes. Above the group, a tripartite canopy rises, its centre arched and coffered. Across the seventeenth-century black and white marble chancel floor is another memorial, a tomb-chest with a shrouded figure of Elizabeth. widow of Sir Thomas Berkeley, who died in 1635. Carved by younger Nicholas Stone in Bernini's studio in Rome, the draped figure seems to melt. ghostlike, into the slab on which it lies. There is a wall tablet to Thomas Fuller, chaplain to Charles II, rector at Cranford, and author of The Worthies of England, a collection of short biographies. Another tablet commemorates Sir Charles Scarborough, Charles II's physician, and there are larger, more florid memorials to two local landowners, William Smythe (d.1720) and Pelsant Reeves (d.1727). There is a slender early eighteenth-century marble font, and the twentieth century has made its contribution with the altar and tester above it, designed and painted by Martin Travers.

Still travelling east, we come to HESTON, with trim inter-war and more recent suburban houses. Very little remains of the village surrounded by fields which once grew the best wheat in all England, but the parish church, dedicated to St. Leonard, is worth visiting, though only the tower, its gargoyles and doorway, and the stoup for holy water, remain from the fifteenth-century building, the rest having been rebuilt in 1866-7 by Thomas Bellamy who, however. used old materials to reconstruct the lych-gate and west porch. Inside, there is an interesting brass to Constance, wife of Mordecai Bownell, vicar of Heston, who died in childbed in 1581; the poor lady is shown with clasped hands and a swaddled child on the counterpane beside her. Besides wall tablets. there is a fine memorial to Robert Child of Osterley Park (d.1782), designed by Robert Adam and carved by Peter Mathias van Gelder, with delicately wrought candelabra on either side of a pyramid. Sir Joseph Banks, the naturalist and explorer, is buried here. St. Leonard's most important furnishing is the font cover, carved about 1500 from wood with a traceried base, an ogee-shaped cap, and a tapering spire. Set on one side when the church was rebuilt, it was rediscovered in 1908 and has since been restored. In the beautifully tended churchyard lie Private Frederick John White, the last man to be flogged to death in the British army, and Mrs. Mary Brock, nurse to Queen Victoria.

Islington

The London Borough of Islington lies due north of the City and is composed of the former metropolitan boroughs of Finsbury and Islington. It is a long, thin strip of land, covering almost 4,000 acres, with a population of about 172,000; there is high ground to the north at Islington, at Highbury, at Crouch Hill, and up the slopes of Highgate Hill. Open countryside till the end of the eighteenth century, the fields here provided Londoners first with archery grounds, dairy produce, and a playground in which to wander at holiday times and then, from the nineteenth century to the present day, with land on which to build with a certain elegance.

FINSBURY, formerly the smallest of the London boroughs save for Holborn, has a distinctive character, lying so near the City and yet without the walls. Today, closely built over a with a good deal of light industry, it preserves a certain independence of the metropolis, as if still set apart by bleak Moorfields, where the apprentices used to skate in winter, as the monk Fitz-Stephen, writing in 1174, tells us. Here the homeless citizens camped out through the September nights after the Fire of London. Within Finsbury's boundaries stood three important medieval religious establishments; of two of them, a surprising number of the buildings remain and are still in use.

The earliest of the three was the house of St. Mary Clerkenwell, a convent of Benedictine nuns founded early in the twelfth century by Jordan de Briset and his wife Muriel. The buildings have vanished and the site is now occupied by the parish church of St. James, but the Clerks' Well, which gave its name to the district and which derived its title from being the meeting place of the Company of Parish Clerks, who gathered there to perform mystery plays, can still be seen. Long forgotten, its site was rediscovered in 1924. The well chamber, consisting partly of late medieval stonework and partly of small Tudor bricks, lies beneath 14/16 Farringdon Road, and may be glimpsed through a carefully incorporated window. Jordan de Briset was also a benefactor to the

Knights of the Hospital of St. John of Jerusalem, for about 1144 he gave them five acres of land near to the well on which to build a church and priory intended to serve especially as a hospice for those on their way to the Holy Land. The church was circular, in tribute to the Church of the Holy Sepulchre in Jerusalem; the curve of its walls can still be traced, marked out with cobblestones in St. John's Square, but the round nave was pulled down after being much damaged by Wat Tyler's followers in 1381, and the chancel was enlarged to serve as the main church. After the Dissolution of the Monasteries, the nave and the steeple were torn down by Protector Somerset and were carted away to build his new mansion in the Strand, but the chancel remained and was put to various uses till, in 1721-3, it was repaired, an eighteenth-century roof was set on the twelfth-century walls, the tracery of the fifteenthcentury windows was restored, and for the next two centuries, St John's served as a parish church. It so happened that the Order of St. John was revived in England in 1831 and before the end of the century became associated with the nursing and ambulance work for which it is responsible today. In 1873, the Order secured possession of the Gatehouse, the only surviving fragment of the Hospital's domestic buildings, and in 1931 took over the church, which was no longer needed for parochial purposes. The building suffered much in the air raids of 1941 but was restored most successfully by Lord Mottistone. It is a church which rejoices in an extraordinary purity of light. The walls are whitewashed and unadorned, while outside the south-east window is a tree, the leaves of which in summer give an aqueous translucency to the interior. On the altar stand two wings of the Weston Triptych, which was painted in Flanders for the Priory in 1480, possibly in the workshops of Rogier van der Weyden; stolen at the Reformation, it was recognized in Dorset and purchased for the church again in 1932. On the outer sides of the panels are the Trinity and St. John the Baptist, on the inner sides the presentations of the Virgin and Child; the whereabouts of the central panel is still untraced. The crypt below the church is one of the finest examples of twelfth-century architecture in London. The roof has stone-ribbed, quadripartite vaulting and against the north wall stands the tomb of Dom Juan Ruiz de Vergara ISLINGTON 293

(d.1575), Proctor of the Langue of Castile, which was brought here from Valladolid in 1915. A full-length figure of the knight lies on the tomb, his handsome face serene in death, his hand on his sword, a sleeping page curled at his feet. The quality of the carving is superb. Nearby is another effigy, that of the Grand Prior, Sir William Westall, who died in 1540, his heart being broken by the suppression of his Order; the unknown English mason who carved it strove to represent the transience of life and the harshness of death. This is a *memento mori*; the emaciated corpse lies with shroud folded back, cheeks sunken, and ribs showing.

The Gatehouse is no less interesting. It was the south entrance to the Priory precinct and was built in 1504 by the Prior, Sir Thomas Docwra. After the Dissolution, it was put to a variety of uses, among them serving to house the printing works of the Gentleman's Magazine, for which Dr. Johnson used to write. Built of Kentish ragstone, it straddles the roadway and those who pass under the arch should look upwards to where the vaulting forms the square star of the Order. The two square towers are four storeys high and house the offices, library, museum, and archive repository of the Order; besides portraits, silver, and furniture the library possesses the illuminated Rhodes Missal, made in 1504 for the Altar at Rhodes on the orders of the French Grand Prior. A Chapter Hall and other offices were added by John Oldrid Scott, but it is the winding staircases and small, panelled rooms of the old Gatehouse which are of the greatest interest to the visitor. They are open to the public on Tuesdays, Fridays, and Saturdays.

Before leaving Clerkenwell for the Charterhouse, the third of the religious foundations in the area, time should be found to visit St. James's church. Set back from the corner of Clerkenwell Green, it provides the focal point for one of the prettiest corners of London. Built in 1788-92 by James Carr, a local man, it is of brick with a square stone tower and obelisk spire. In the belfry hangs a peal of eight bells, installed in 1791 and recast in 1928. The most notable feature of the interior is the curved west end; in the gallery stands an organ in a 'handsome case of Spanish mahogany', built in 1792 by George Pike England and rebuilt in 1978 by Noel Mander. Its tone is of an extraordinary warmth and mellowness. The church retains its original communion table and rails; the table is of mahogany decorated with plumes of feathers and a dove, the emblem of the Holy Ghost. The spirited stained glass in the east window is by Heaton, Butter, and Bavne; it was installed in 1863. There is a brass to John Bell, Bishop of Worcester, who lived in retirement in the parish, dying there in 1556, a large armorial tablet to Elizabeth, Dowager Countess of Exeter, recording with pride her illustrious lineage and the marriages she managed for her three daughters, and a wall tablet to Sir William Wood, leader of the Finsbury Archers, who died in

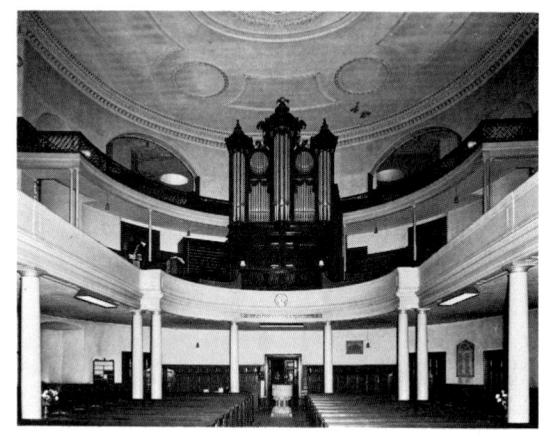

St. James's, Finsbury

1691. A painted board records the names of those who perished in the flames at Smithfield for the Protestant faith. In the porch are memorials to Gilbert Burnet, Bishop of Salisbury (d.1741), who was famous for his preaching and writing, to Henry Penton (d.1714), who developed the area known as Pentonville, and Thomas Crosse (d.1712) and his wife, who are represented by rather unprepossessing busts which Mrs. Esdaile ascribes to Roubiliac. The royal arms of George III above the west door are of Coade stone and were set up in 1792.

At the west end of the irregularly shaped Green stands Middlesex Sessions House, designed in 1774 by John Carter and built in 1779–82 by a Mr. Rogers; it is today used as offices. All around the Green is a warren of small streets and shops, for this was essentially a craftsman's corner of London where, in particular, watches and jewellery were – and still are – made. The Clerkenwell Green Association of Craftsmen is a most active group with headquarters at 27 Old Street. Town planners of the 1980s could look with profiit at the economical and practical gracefulness of the houses in and around Sekforde Street.

A little to the south-east is Charterhouse Square and the Charterhouse itself. The story of this great institution begins with the Black Death in 1348. when the graveyards of London were choked with corpses, so Sir Walter Manny, a soldier as practical in everyday life as he was brave in war, leased 13 acres of land from St. Bartholomew's Hospital to serve as a cemetery. He built a chapel there so that masses could be said for the souls of the dead. In 1371, his piety prompted him to found a Carthusian monastery; the chapel became the monks' church and, when Sir Walter died in the following year, he was laid beneath the high altar. The Carthusians are among the most severe of all the monastic orders. They do not live as a brotherhood but each monk has his own tiny, separate cell, in which he prays, eats, and sleeps; many of the more usual monastic build-

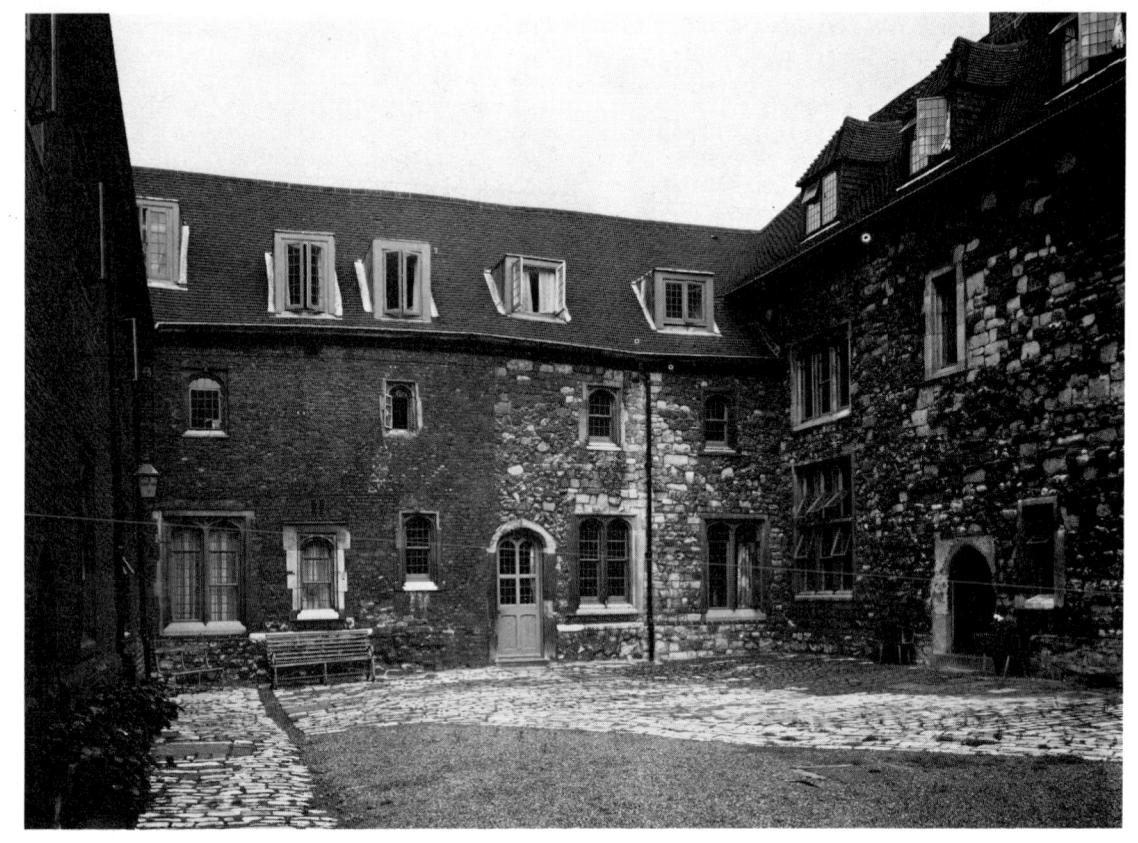

Wash House Court, Charterhouse

ings are therefore not required. A Great Cloister surrounded by 24 cells was planned by Henry Yevele, the King's Mason, for the first Prior, John Luscombe, and was built over the next 40 years; the doorways to three of the cells can still be seen.

Sir Thomas More lived in or near the Charterhouse for four years, wondering whether he should become a monk. He turned back to the world but, had he joined the brethren, he would undoubtedly have suffered the same fate as Prior John Houghton and his two companions1 who, for their refusal to acknowledge Henry VIII as head of the Church, endured a crueller death, hanging, drawing, and quartering, than that meted out to the Lord Chancellor. A more compliant prior surrendered the Charterhouse to Henry's commissioners and the buildings were later granted to Sir Edward North, Chancellor of the Court of Augmentations, who tore down the monks' church and built himself a Great Hall with a hammerbeam roof and a comparatively restrained screen at the west end - a domestic version of the magnificent screens in the Inns of Court. In 1565 he sold the property to the Duke of Norfolk, who over

the next seven years added to the buildings and beautified them. When he was executed in 1571 for his part in the Ridolfi Plot to put Mary, Queen of Scots, on the throne, his family were permitted to retain the property, which his younger son, the Earl of Suffolk, sold in 1611 to Thomas Sutton (see also pp. 240–1) who, being childless, intended to use his great wealth to found a hospital or almshouse for 80 impoverished gentlemen pensioners and a school for 40 boys.

Similar foundations were not unusual in Tudor England, but the scale of Sutton's bounty was unparalleled; Fuller described it as 'the Masterpiece of English Protestant Charity'. Few alterations were needed but a fine chapel was added in which Sutton himself was buried under a magnificent alabaster and black marble monument, with a life-sized effigy by Nicholas Johnson (or Janson) and Nicholas Stone; it cost £400 and is adorned with allegorical figures and a bas-relief, showing the pensioners and boys listening attentively to a sermon. The 'Surveyor or contriver of buildings', Francis Carter, planned the chapel; he had worked under and with Inigo Jones, and it was his son Edward who succeeded Jones as surveyor-general in 1643. The woodwork of the curved

¹ Ten other Carthusians died on the scaffold or in prison.

ISLINGTON

screen and organ gallery is outstanding, and the pew heads were carved by James Ryder at a shilling each; the pulpit was made by Edward Mayes and Thomas Herring, with ornaments by Francis Blunt.

The school moved to Godalming in 1872, its place being taken by Merchant Taylors' School, for whose boys new buildings were erected. They too left London and the whole complex was severely damaged by incendiaries on 10-11 May 1941. Its restoration by Lord Mottistone and Paul Paget was one of the most scholarly and felicitous achievements of its kind in post-war London. The work was of a standard and skill that would not have disgraced the original craftsmen, while the archaeological opportunities afforded by the bombing were of immense value. In the Charterhouse, we have fragments of a great medieval monastery and the sole surviving example of the many noble mansions that must once have ringed the City of London round, preserved with its subsidiary courtyards and outbuildings, Wash House Court still standing as well as the Great Hall. The Charterhouse is open, on application to the Master, on certain Wednesday afternoons between April and June. It is essentially a private place, existing to fulfil the function for which Thomas

ISLINGTON

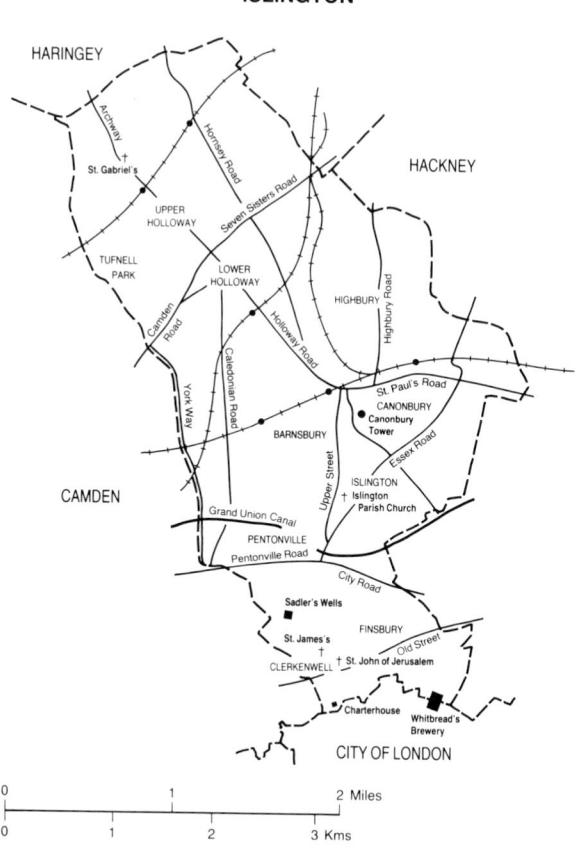

Sutton intended it three and a half centuries ago, to provide a home for gentlemen who would otherwise lack a proper one.

295

On leaving the Charterhouse, one should notice the gateway, its medieval arch crowned with two storeys of eighteenth-century house which now provide the Master's Residence. A few other eighteenthcentury houses still stand around Charterhouse Square and eastwards, in Chiswell Street, is Whitbread's brewery, which each year lends its drayhorses to pull the Lord Mayor's coach in the November procession. The brewery also erected a building, designed by Roderick Gradidge of Wolfe, Ollins and Partners, to house the Overlord Embroidery, now on display in Portsmouth. It was commissioned in 1968 by Lord Dulverton as a record of the Normandy invasion, beginning on 6 June 1944, which brought about the defeat of Germany and the end of the Second World War. Designed by Sandra Lawrence and worked by twenty members of the Royal School of Needlework, the 34 panels, measuring in all 272 feet, took five years to complete; it is a modern counterpart of the Bayeux Tapestry which records that other, cross-Channel invasion in 1066.

Nearby, between Bunhill Street and the City Road, are the headquarters and ground of the Honourable Artillery Company, Britain's oldest regiment, able to trace its descent back to the companies of archers formed in Edward III's reign. Henry VIII granted the Company a charter in 1537 and it took over its present ground in 1641. Armoury House was built in 1735, though the embattled gateway was not added till Queen Victoria's reign. The Great Vellum Book is kept here, with the signatures of all the members from 1611 to 1682, among them those of Milton, Pepys, and Wren. The Company has the right to march through London with drums beating, colours flying, and bayonets fixed, and it is their privilege to fire royal salutes from the Tower Battery. There is a small but interesting museum which may be visited on written application.

Just to the north lie Bunhill Fields, their name a corruption of Bonehill, for this was once a prehistoric burial ground. It served later generations in the same way for from 1665 till 1852 it was London's principal Nonconformist cemetery, some 120,000 burials being crammed into it during that period. John Bunyan, Daniel Defoe, William Blake, Isaac Watts, the hymn-writer, and Susannah Wesley, the formidable mother of Charles and John, all lie here. Opposite stands Wesley's Chapel and beside it the house in which he lived from 1779 till his death in 1791. The chapel, built of brick, five bays wide with a trim pediment and sturdy Doric pillars to the porch, is still as Wesley described it in his journal perfectly neat but not fine'. The pillars which support the galleries are now of French jasper but originally they were masts from men-of-war, presented by George III; some of these masts, plastered over and fluted, may be seen in the vestibule. Wes-

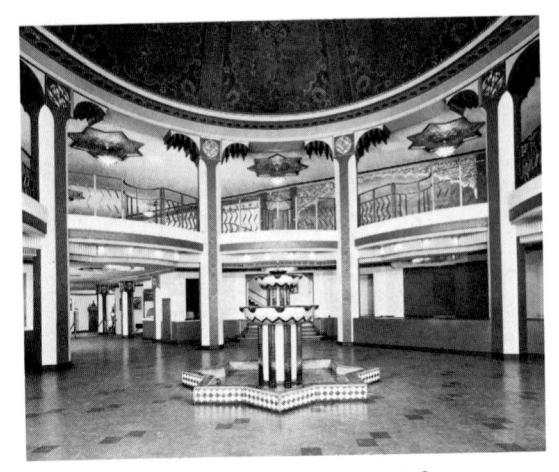

Rainbow Theatre (formerly Astoria Cinema), Seven Sisters Road, Islington

ley's description of the chapel could equally well be applied to his own dwelling, which has changed little since his death. The furniture, so intimately associated with the great preacher, is particularly interesting; like much of the work produced at this period, it is of great simplicity and beauty.

Northwards, beyond Finsbury, lies ISLINGTON. The area between the Clerkenwell and Pentonville Roads was laid out stylishly in the early nineteenth century in a number of small estates by adventurous builders, Thomas Cubitt among them, who had his yard behind Ampton Street off the Gray's Inn Road. Six squares — Northampton, Lloyd, Claremont, Myddelton, Wilmington, and Granville — were set out, all of them attractive, especially Lloyd Square. Northampton Square, with its six radiating streets, now accommodates the headquarters of the City University, formally the Northampton Polytechnic.

Along Rosebery Avenue there are three buildings or groups of buildings which deserve attention. Most appropriately, the Metropolitan Water Board has its headquarters here, for it was to Islington that Sir Hugh Myddelton brought the waters of the Amwell Springs in Hertfordshire in 1613, the distance covered being some 38 miles - an achievement which must be given a place in any history of English engineering. The Water House of the New River Company was built here in 1693 and when it was demolished in 1919-20, the Oak Room was preserved intact and was reconstructed within the new building. It has magnificently panelled and carved walls wrought possibly by Grinling Gibbons himself, and a plasterwork ceiling of almost unbelievable complexity with a portrait of William III set in the centre; the room may be visited provided application is made in writing.

On the opposite side of Rosebery Avenue is a block of flats by B. Lubetkin and the Tecton group which are really imaginative and exciting, and on the

corner with Arlington Way stands Sadler's Wells theatre, built in 1931 to designs by Frank Matcham. Under a trap-door at the back of the stalls is the well which gives its name to the theatre. In the Middle Ages, it belonged to Clerkenwell Priory and was alleged to have miraculous powers, but after the Reformation its existence was forgotten, till Thomas Sadler rediscovered it in 1683. He advertised the medicinal properties of the waters, and provided entertainments for those who came to drink them. A regular theatre was established in 1765 by Thomas Rosoman, where Edmund Kean appeared in his youth, and at which the clown, Joseph Grimaldi, performed. Between 1884 and 1862, Samuel Phelps produced 34 of Shakespeare's plays, but thereafter the theatre fell into disrepute till Lilian Baylis reopened it in 1931 as the 'Old Vic' of North London. There is an excellent Sadler's Wells collection at Finsbury Public Library in St. John's Street. Near to the theatre, at 40 Northampton Road, the Greater London Council's archives, prints and drawings, and photographic collections, a rich resource for historical research, are housed in newly adapted premises.

Pentonville Road, laid out in 1773 by Thomas Penton, runs directly uphill from King's Cross Station. In it stands St. James's church (1787 by Aaron Hurst) where Grimaldi lies buried and where, above the vestry door, is set a fragment of the Pilgrim Rock, on which the weary but intrepid voyagers on the Mayflower first set foot in 1620. Once to the north of it, we are in Islington proper. The Angel, one of the last of London's galleried inns stood here, till it was demolished in 1819. The borough extends as far north as Highgate and Crouch Hill but the two main centres of interest lie along the line of the High Street and around Canonbury Square and Highbury.

St. Mary's church stands in Upper Street. Built in 1751-4, on the site of a medieval foundation from which two excellent brasses to members of the Fowler family have been preserved, it was designed by Launcelot Dowbiggin, an otherwise unknown architect, who lies buried here. The nave was completely shattered by a high explosive bomb on 9 September 1940, but the tower and spire remained standing and were incorporated into the new church which Seely and Paget designed and Dove Brothers built. It was consecrated in 1956. Unusually for these architects, the interior seems clinical and uninviting, but there are interesting murals by Brian Thomas. Thomas Osborne, the impertinent bookseller whom Dr. Johnson knocked down, is buried in the churchyard. The east side of the churchyard opens into Dagmar Passage where, in a former temperance hall, the Little Angel Puppet Theatre has made a home. Founded in 1961, it has become a place of wonder and enchantment for children of all ages, for the performances of the resident company are of a standard which has made them known throughout the world.

A statue of Sir Hugh Myddelton by John Thomas

ISLINGTON 297

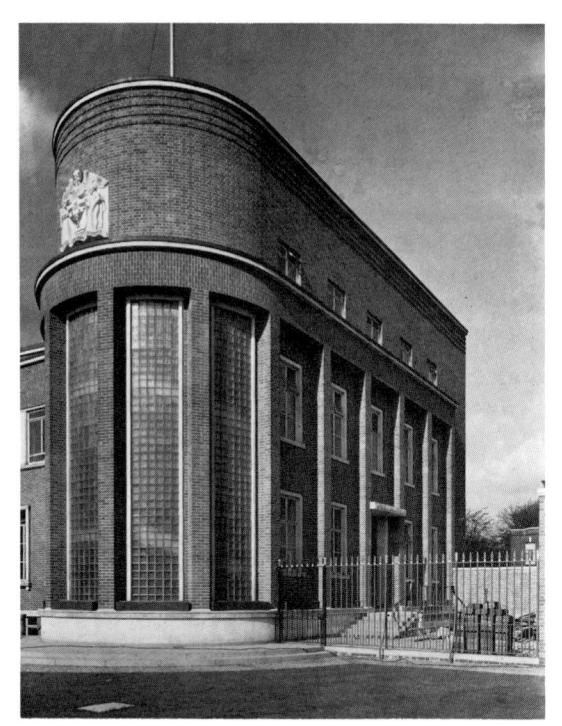

Metropolitan Water Board headquarters, Roseberry Avenue

stands at the junction of Islington Green and Upper Street, and on the east side of the High Street, in a network of alleyways, there has grown up, since 1960, a congregation of small antique shops and, on Fridays and Saturdays, a market which is a worthy successor to the Caledonian Market, which used to flourish before the Second World War. The painter Walter Richard Sickert used to declare that the Caledonian Market was his idea of Heaven and he would certainly have delighted in Camden Passage. Sickert lived or rented studios at a number of Islington addresses, and the Reference Library in the Holloway Road possesses a number of his works, as well as some by his grand-father, father, and brother, and his wife Therèse Lessore, who was a considerable artist in her own right. The library also has an excellent collection of topographical paintings and drawings, including works by Thomas Hosmer Shepherd and by Geoffrey S. Fletcher. In Duncan Terrace Charles and Mary Lamb lived at number 64 (formerly Colebrook Cottage) from 1823 to 1827. Behind it a thin, boulder bestrewn public garden follows the line of the last meanderings of the New River.

Upper Street, passing some excellent mid-eighteenth-century doorways in Cross Street, leads to Highbury Corner, beyond which lie Highbury Crescent and Place. They were designed between 1774 and 1779 by James Spiller, an architect of great orginality but difficult temper, who lived at number

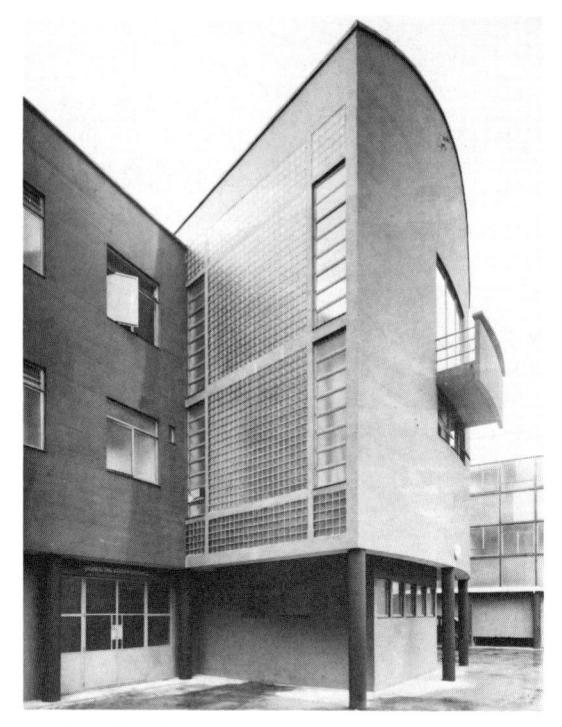

Finsbury Health Centre, Pine Street (B. Lubetkin, Tecton, 1938)

39 Highbury Place. Just to the south-west is Canonbury Square, laid out c.1820 by Leroux, when the area was being developed as a second but in no way inferior Bloomsbury. In the north-east corner of the Square stands Canonbury House, a relic of the days when Islington was open fields among which a rich man might build a country house for his delight and relaxation. Originally the property of the prior and canons of St. Bartholomew's (hence Canonbury), the mansion was built by Sir John Spencer, Lord Mayor of London in 1593, towards the end of the century. After the Civil War, the ranges of buildings were divided into apartments and were let; Oliver Goldsmith, Washington Irving, Ephraim Chambers, the compiler of the first encyclopaedia, and the poet Christopher Smart all lodged here. At the northwestern corner of the property stood a tower which has been well preserved and put to a happy use, for it houses the Tower Theatre Company, the best amateur theatrical company in London or even in England. By joining the club, or by written application to the secretary, it is possible to visit the three panelled Elizabethan rooms attached to the tower. one of which possesses a decorated plaster ceiling. To the south of the tower are the enchantingly pretty Alwyne Villas, built about 1830, among which still stand two polygonal Elizabethan summer-houses. While exploring this fascinating area, it is worth noticing the amount of spruce, well-heeled, new building going on wherever space can be found.

-The Royal Borough of-Kensington and Chelsea

The Royal Borough of Kensington and Chelsea covers an area of four-and-a-half square miles and has a population of 143,000. Within its boundaries are some of the grandest houses and the prettiest mews cottages, as well as some of the shabbier terraces, to be found in London. The southern half, Chelsea, extends to the banks of the Thames; this watery boundary seems to give the whole area a dreamlike quality. To the east lies Westminster, to the west Hammersmith, and Kensington extends as far north as the newly created borough of Brent, situated in what used to be Middlesex. Kensington was declared a Royal Borough in 1901, by the express wish of Queen Victoria who was born in Kensington Palace; its title was confirmed in 1964 at the reorganization of the London boroughs. The royal associations of the area run back to a much earlier period, to 1689 when William III bought a country house there from the Earl of Nottingham and instructed Sir Christopher Wren to turn it into a modest palace (see p. 171). Around the palace, along Church Street, Kensington High Street, and up Campden Hill, lies an area christened 'the Old Court Suburb' by Leigh Hunt in 1851, and later known as 'The Dukeries', owing to the number of noble families who made their homes here.1

St. Mary Abbots church stands at the corner of Kensington High Street and Church Street. The present church was built in 1869–72 by Sir George Gilbert Scott as a replacement for a much earlier building. The unusual name is derived from the presentation of land in Kensington, on which the church still stands, to the abbots of Abingdon in Oxfordshire by Godfrey de Vere, son of the Earl of Oxford, in about 1100. The present church is remarkable chiefly for its spire, the highest in London, which soars up for 254 feet and is modelled on that of St. Mary Redcliffe in Bristol. The mysterious

winding, vaulted cloister, added in 1889–93 by Micklethwaite and Somers Clarke, leads to the entrance. Inside are a few memorials from the older church, the most interesting of them being that of Edward, Earl of Warwick and Holland, who was Addison's step-son and who died in 1721. He is represented in Roman costume, leaning upon an urn; the sculpture has been ascribed to Guelfi.

A little further along the High Street, set back behind the main façade of shops in Phillimore Walk, stands the new Town Hall and Central Library which houses an excellent local studies collection. A tew hundred yards beyond is an astonishing building, the Commonwealth Institute, which has taken over the duties of the former Imperial Institute. The present building was designed by Robert Matthew, Johnson-Marshall and Partners and was built between 1960 and 1962. The exterior is remarkable for its hyperbolic paraboloid roof, which suggests that a pagoda has drifted down from outer space to settle comfortably in Kensington. Inside, the gentle but purposeful sweep of a curved ramp leads the visitor from one discovery to another about the life, natural history, landscapes, cities, and arts and manufactures of all the countries that make up the British Commonwealth. This is one of the best museums in London to which to take children; the variety of the exhibits and the directness with which they are displayed make an instant appeal to the

Behind the Institute, Holland Park spreads out, its greenness jewelled with flower-beds and peacocks which strut and flaunt their tails in spring and summer. The Park was once the grounds of Holland House, built in 1605–7 for Sir Walter Cope, whose daughter married the first Earl of Holland. Only fragments of the building, the arcaded south-east front and the east wing, now rebuilt as a youth hostel, survived the bombing of the Second World War, but they should be treated with respect, for there is no vestige of any other mansion of this date and scale left in central London. Holland House enjoyed a long heyday as a centre of political and literary society, for the third Earl's widow married Joseph Addison, the statesman and essayist, and, in 1768, the property passed to the Fox family. Charles James Fox spent his childhood here, and his nephew, the third Baron Holland, entertained brilliantly,

¹ Those who wish to know more of the history of Kensington and Chelsea should read William Gaunt's excellent study of the two areas, *Kensington and Chelsea* (revised edition, 1975), and Thea Holme's interesting book *Chelsea*, 1972.

numbering among his guests Talleyrand, Madame de Staël, Ugo Foscolo, Sir Walter Scott, Wordsworth, Thomas Moore, Fenimore Cooper, and his neighbour, the historian Lord Macaulay, who lived in Holly Lodge on Campden Hill. Visitors to Holland House should notice the gate piers, carved in 1629 by Nicholas Stone to designs by Inigo Jones, and the Dutch garden laid out in 1812 by Bonaiuti, the Hollands' librarian. The pavilion beside it serves as a restaurant, plays and ballets are performed in the courtyard under the auspices of the Greater London Council, and exhibitions of sculpture are sometimes held in the park, with paintings in the former Ice House.

In the late nineteenth century, this corner of Kensington was the quarter chosen by some of the more successful artists. G. F. Watts lived at 6 Melbury Road, with Marcus Stone at number 8 and Luke Fildes at number 11 as neighbours in houses designed by Norman Shaw. Fildes painted many works of passionate social protest, among them Oueueing for Admission to the Casual Wards (Royal Holloway College) and The Doctor (Tate Gallery). Sir William Thornycroft had his studio at number 2, Holman Hunt lived at number 18, and number 9, 'a model residence of the fifteenth century', was designed by William Burges, the architect of Brisbane and Cork cathedrals and of Castel Coch, Cardiff, for himself. But the most important mansion of all was that of Frederic Leighton, President of the Royal

Linley Sambourne House, 18 Stafford Terrace

Academy, who was created Lord Leighton a month before his death, the only English artist ever to be made a peer. In 1855 the first painting he exhibited at the Academy, Cimabue's Madonna, was bought by Oueen Victoria for £600, and from then his professional success was assured. The house, 12 Holland Park Road, he designed for himself, with the aid of an architect friend, George Aitchison, and with the intention of providing a good studio and an unusual setting in which to entertain his many friends. The top floor was a studio-gallery with excellent clear light, and on the ground floor is the Arab Hall, a small fountain playing in the centre, the walls lined with blue antique tiles from Damascus, Cairo, and Rhodes, their numbers made up with others created by William de Morgan. Around the walls runs a frieze by Walter Crane, inspired by the tiles, and the capitals of the marble pillars were carved by Sir Edgar Boehm, Queen's Sculptor, and by Randolph Caldecott. After the painter's death the house became a museum to his memory and is now in the care of the Borough Council. This is one of the most unusual and completely peaceful houses to visit in London.

Not far away, at 18 Stafford Terrace, is Linley Sambourne House. It was the home of Linley Sambourne, the *Punch* artist and political cartoonist, from 1874 till his death in 1910; thereafter, it remained in the possession of his family till it was presented to the nation in 1980. The Greater London Council and the Victorian Society are now responsible for the house. The decoration, wallpapers, arrangement of pictures, and disposition of furniture have survived, virtually unchanged, since the 1890s; to walk through its front door is to step back a century, into the home and atmosphere of an artistic and cultured family.

On the southern side of Kensington High Street lies Edwardes Square, laid out in 1811-19 on a miniature scale, with a small Tuscan temple as a summer-house in the middle of the central garden. Leigh Hunt spent eleven of his more prosperous years there, and his son, Thornton, always remembered the architectural characteristics of the square -'Such aristocratic size and verdure in the ground plot', he wrote, 'with so plebian a smallness in the tenements.' The diminutive scale of the houses makes them all the more convenient – and valuable – today. At the other end of the High Street in Gloucester Road stands St. Stephen's church (1865 by J. Peacock) with its elaborate reredos by Bodley and Garner, where T. S. Eliot worshipped and was a churchwarden for 25 years.

Going northwards across the borough is Ladbroke Grove, an estate belonging to F. W. Ladbroke and his descendants and laid out chiefly during the 1850s, though plans had been prepared earlier by Thomas Allason. Close to the summit of Notting Hill, in the centre of the estate, stands St. John's church, designed in 1844–45 by J. H. Stevens and G. Alex-

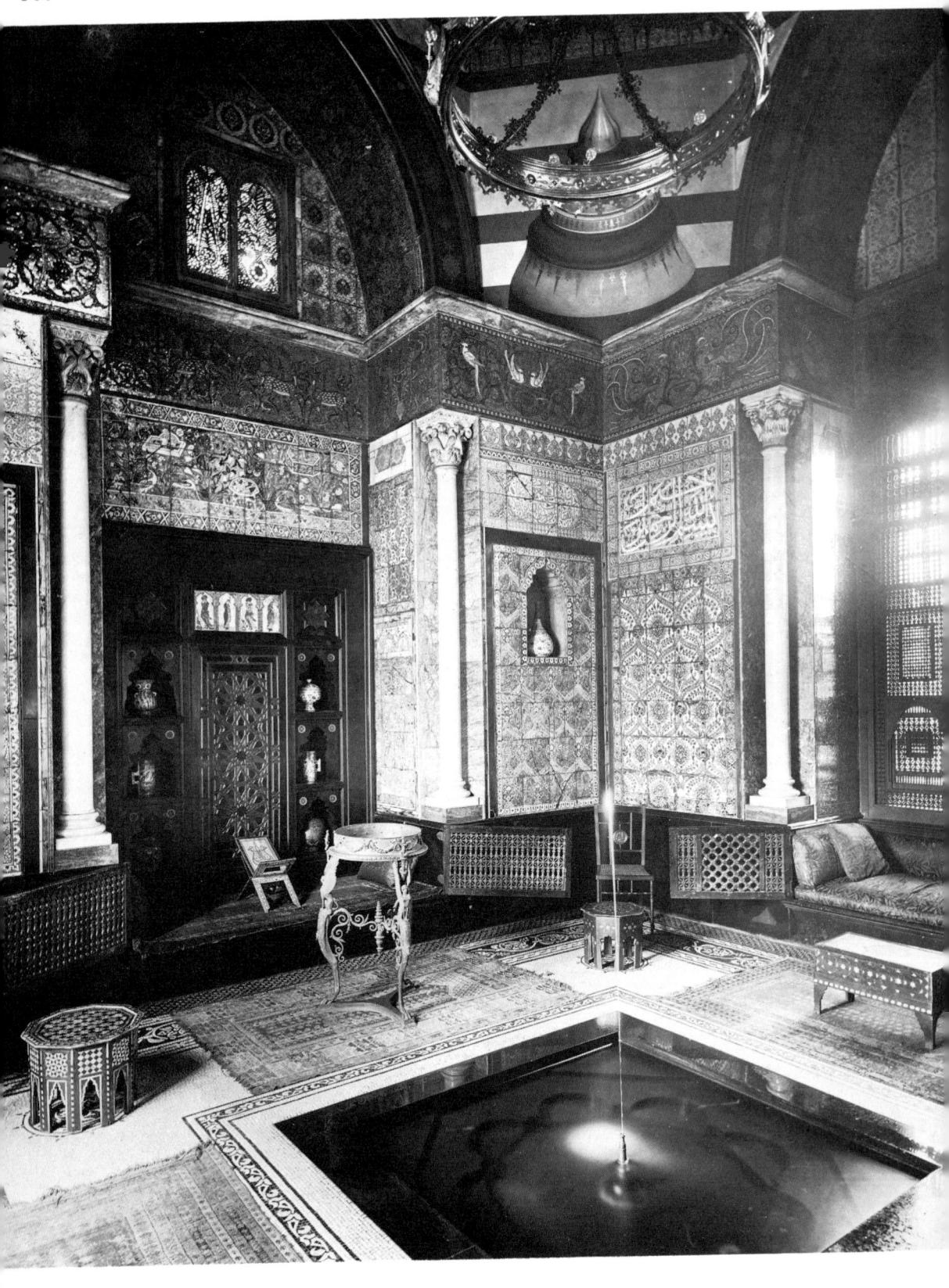

ander. Its spire is a landmark for miles around, and inside is an unusual sculptured reredos designed by Sir Aston Webb and Emmeline Halse about 1890. The streets and crescents, radiating from the central axis of Ladbroke Grove, follow the unusually varied contours of the hill; the houses, many of them designed by Thomas Allom, still have gardens filled with acacias and lilacs. On the eastern side of the hill run Pembridge Road and Pembridge Villas, where William Frith had a house and painted *Derby Day* and *Paddington Station*, though a garage now covers the site of his studio. Turning out of Pembridge Road is the Portobello Road, where a vegetable and fruit market is held throughout the week, to be reinforced on Fridays and Saturdays by an antiques market.

Northwards again, beyond the main line from Paddington Station and across the Grand Union Canal, lies All Souls' Cemetery in Kensal Green, one of the seven 'hygienic' cemeteries opened around London between 1832 and 1841; the others were at Norwood, Highgate, Abney Park, Brompton, Nunhead, and Tower Hamlets. Princess Sophia (d.1848), George III's daughter, and her brother, the Duke of Sussex, who had been born in Kensington Palace in 1773, chose to be buried here when he died in 1843 and this royal approval helped to make the new cemeteries generally accepted. Thackeray, Wilkie Collins, Anthony Trollope, and John Murray, Byron's publisher, all keep the Duke company, and so do Leigh Hunt and the poet Francis Thompson with Sir Robert Smirke, the architect, and the two great engineers, father and son, Sir Marc Isambard and Isambard Kingdom Brunel, as well as the tightrope walker, Blondin. The cemetery was laid out by J. W. Griffiths, with separate little temples for the established church and for the Nonconformists. Walking here, one glimpses the full Victorian panoply of death among the mausoleums, sometimes forbidding, sometimes almost domestic, and often adorned with impressive sculpture - the martial caryatids on General Sir William Casewell's family tomb are remarkable.

To the millions who visit London, and to Londoners themselves, Kensington means especially the Museums area. When the Great Exhibition closed (see p. 170), Prince Albert and his committee found they had made a profit of over £186,000. With it, they bought 87 acres of land in South Kensington on which to build a group of institutions, all intended to 'extend the influence of Science and Art upon Productive Industry', according to Prince Albert's ideal. A detailed history of the site and the buildings upon it may be found in volume 38 of the Survey of London. Listed briefly, they were the Royal Albert Hall, the Natural History Museum, the Royal College of Organists, the Royal College of Music, the Royal School of Needlework (Fairfax B. Wade, 1903,

later demolished and removed to Kensington Gore), the Science Museum, the Imperial Institute (T. E. Collcutt, 1894, demolished save for the tower), Imperial College, which was formed in 1907 by the amalgamation of the Royal School of Mines with the Royal College of Science and City and Guilds College (older buildings by Sir Aston Webb and M. Webb and others still in progress), the Geological Museum, the Royal College of Art, and the Victoria and Albert Museum.

An exploration of the area might begin on the northern boundary, with the Albert Hall, designed by Captain Francis Fowke and Lieutenant-Colonel Henry Scott, 1867–71. This enormous brick elliptical cylinder is covered with a roof of glass and iron, and decorated with a frieze representing the triumph of the arts and sciences. Its main axis measures 300 feet and it is capable of sheltering some 8,000 people. Meetings and performances of all sorts are held here; the most important artistically are the Promenade Concerts, founded in 1895 by Sir Henry Wood and given in the Albert Hall since 1941.

Directly behind the Albert Hall, flanked by flights of steps, is a modest memorial to the Prince¹ and the Great Exhibition. Designed by Joseph Durham with the assistance of Sydney Smirke, it consists of an obelisk surmounted by a statue of the Prince; it was said that the attitude of his right arm was determined by the Queen herself, who had declared that this was her husband's habitual stance. To the west of the Albert Hall stands the Royal College of Art (H. T.

Cadbury-Browne with Sir Hugh Casson, 1960-4), the dark mass of its brickwork sombre beside the terracotta rotunda and against the vivid greens of Kensington Gardens, but inside is colour and bustle. Each summer, the students exhibit their works and the public is welcome to enter and examine; displays are often avant-garde, and are always worth seeing. Behind this fortress of the arts stands the Royal College of Organists, designed in 1874-5 by Sir Henry Cole's eldest son, Lieutenant H. H. Cole, who gave his services free. The façade is one of the most piquant in London. It was intended to contrast with the Albert Hall, so terracotta and brickwork were eschewed and the building was designed in 'the old English style of the fifteenth century' though the windows have a distinctly Venetian flavour. The whole facade was covered with plaster panels of sgraffito-work designed by F. W. Moody and executed by his students at the National Art Training School. The results are astonishing and endearing.

Still behind the Albert Hall but facing Prince Consort Road is Holy Trinity church, designed in 1901-7 by G. F. Bodley as 'a town Church in the style and manner of the 14th century'. The woodwork of the interior, executed by Rattee and Kett of Cambridge, is superb, the remarkable reredos providing a focal point for the whole building. In the ritual north aisle (the limitations of the site meant that the church was orientated in an unorthodox way), stands a monument to the architect designed in the Jacobean manner by his pupil E. P. Warren. A bust of Bodley by the younger T. Murphy is sheltered in an aediculated niche fashioned by L. A. Turner from alabaster and red and black marble. Beside the church, hemming it in, is the Imperial College Students' Union building.

Westwards, along Kensington Road, is Hyde Park Gate. The fine, tall houses here were built under lease from the Great Exhibition Commissioners as a means of raising money for the institutional buildings. Numbers 27 and 28 were built for two artists, Richard Redgrave and Charles West Cope, in 1841; in 1945, Sir Winston Churchill acquired number 27, to which number 28 was later added and the two houses were thrown into one. Save for the years 1951–55 when he was Prime Minister, the great statesman lived here till his death in 1965.

To the east of the Albert Hall is a huge block of flats, Albert Hall Mansions, designed by Norman Shaw in 1879; enormous though these flats seem by modern standards, they indicated that a new style of living was about to replace the more spacious habits of the earlier nineteenth century. Beyond the mansions is Lowther Lodge, also designed by Shaw in 1873, and now occupied by the Royal Geographical Society. In niches on the walls stand good bronze statues of David Livingstone and Shackleton by T. B. Huxley-Jones and Sargeant Jagger. The Society has a magnificent map collection, which is open to accredited members of the public, and its own small

museum with relics of great explorers from Livingstone, to the present day – Sir John Hunt's diary of his successful expedition to Mount Everest is here.

A little further eastwards, on the far side of Exhibition Road, is Prince's Gate with the Royal School of Needlework at number 25. Founded in 1872, its work is sent all over the world. English embroidery was famous before the Conquest; the fruits of the present renaissance in church embroidery are specially commissioned for churches in this country and overseas. Occasional exhibitions are held and a shop is open on weekdays.

Southwards down Exhibition Road, Prince Consort Road runs to the west and in it stands the Royal College of Music (Sir A. W. Blomfield, 1894). A charming marble figure of Queen Alexandra, clad in a mortar-board and clutching a roll of music, stands in the porch. The College houses the Donaldson collection of musical instruments which may be seen by appointment during term time on Mondays and Wednesdays. The oldest instrument is a clavicytherium made about 1480, and there are many other treasures, such as an Italian harpsichord made in 1531 by Alessandro Trasuntino and Haydn's clavichord made by John Bohak in 1794. The College also possesses a collection of more than 100 portraits of musicians, and some 3,000 engravings and photographs, which may been seen daily in term time by appointment with the keeper. Lively concerts are given by the students.

The buildings of Imperial College fill the western side of Exhibition Road until, about halfway down, we reach the Science Museum (Sir Richard Allison, 1914), the first of that scholarly triumvirate of institutions which present scientific knowledge to us. The exhibits are, however, so seductively and instructively arranged, and there are so many personal relics of great scientists, that even a totally nonscientific visitor can spend a whole day here pleasantly as well as profitably. In the entrance hall are busts of Newton and Einstein, the latter the astonishing bronze by Epstein which seems to tingle with energy, while to the left, by the staircase, a Foucault pendulum rotates serenely, demonstrating dispassionately that the earth moves about its axis. The ground floor is devoted to the development of motive power. Monumental beam engines, devised by Thomas Newcomen in 1791 and by Matthew Boulton and James Watt in 1788, loom up like megaliths. There is a reconstruction of Watt's garret workshop from his house in Staffordshire and sections devoted to rail and road transport. Exhibits include the oldest locomotive in existence, the 'Puffing Billy' of 1813, Stephenson's Rocket of 1828, and magnificent automobiles such as the 1888 Benz, which in 1956 was still able to accomplish the 56 miles of the London to Brighton rally, and a 1904 Rolls Royce which is still in good running order. A million-volt electrical impulse generator is demonstrated twice daily with a crack which can be heard throughout the building. On the lower ground floor is a section devoted to mining, with a full-scale working model of a mine, and a gallery full of dioramas depicting the development of transport and especially intended for children, though most parents find it interesting too. Tools and machinery are displayed on the first floor; Maudslay's screw-cutting lathe of 1800 is here, and in the section on clocks are the original works of the Wells Cathedral clock, driven by weights, made in 1392 and still working. On this floor there is a Star Dome, and a lecture on astronomy is given daily. On the second floor we find photography, atomic physics, chemistry, marine engineering – a full-scale model of a ship's bridge with radar equipment is a particularly popular exhibit – and a sociable computer terminal which will play games with the visitor. On the third floor are magnetism and electricity, George III's superb collection of scientific instruments, including such intricate masterpieces as the orrery made in 1733 by T. Wright, and a whole gallery, arranged with superlative showmanship, devoted to aeronautics. There is a reconstruction of the frail contraption in which the Wright brothers made the first powered flight in 1903, the Vickers 'Vimy' aircraft in which John Alcock and Arthur Whitten Brown made the first crossing of the Atlantic by air in June 1919, and the Whittle Turbo-Jet Aero-Engine which powered the first jet flight in May 1941. The lighter machines are suspended so that they hover like dragonflies, and the whole gallery is one of the most exhilarating in any London museum.

Next door is the Geological Museum (Sir Richard Allison, 1929–33), founded in 1837 in Jermyn Street. The staid entrance to the building gives no warning of the excitements within. A large portion of the ground floor is filled with a newly arranged and instructive exhibition, 'The Story of the Earth', and the rest of the entrance hall is crammed with cases containing a collection of gem stones. The precious stones - diamonds, rubies, emeralds, sapphires - are breath-taking, but the semi-precious stones – onyx, agate, blue john, opal, chalcedony, and peridot – are the more beautiful. Upstairs on the first floor is a display of the regional geology of Great Britain, which contains some remarkable fossils, and the second floor is concerned with economic mineralogy, with a display of the stones and materials chiefly used in the building of London. There is an excellent library which is open to the public.

The Natural History Museum (Alfred Waterhouse 1873–91) sits at right angles to Exhibition Road, presenting a front 675 feet broad to the Cromwell Road. The genesis of the collections was Sir Hans Sloane's 'noble cabinet' from which the British Museum sprang (see p. 216) – a part of it is still the subject of a special display; within a century of its opening in 1757, it was suggested that the natural history section deserved a home of its own. A first plan was devised by Captain Fowke; after his death, fresh designs in the Romanesque manner, popular at

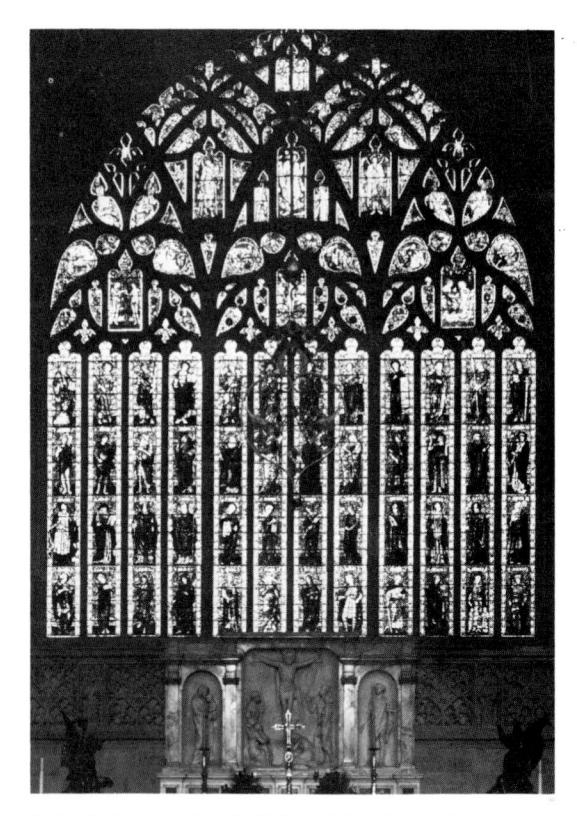

Stained glass window in Holy Trinity, Sloane Street (see p. 309)

the time in Germany, were prepared in 1868 by Alfred Waterhouse, and the museum opened in April 1881. The whole façade is banded in horizontal stripes of buff and sombre blue terracotta. The entrance is approached up a gentle ramp, and through a recessed and arched doorway, flanked on either side by towers 192 feet high. Every available surface is carved with animals and plants, extinct species adorning the west and living species the east wing. Beside such abundant vitality, the new annexe, designed by G. E. H. Pearce and R. I. Greatorex continues to hold its own; though less exuberantly conceived, it has great dignity. Inside, each of the five departments - Zoology, Entomology, Palaeontology, Mineralogy, and Botany – into which the museum is divided, is able to display a treasure house. The sheer beauty of the exhibits is not always recognized. At the time of writing, a general reorganization is under way. The museum provides a particularly good service to children who, on Saturdays and during the school holidays, may borrow paper and coloured pencils to draw the exhibits, or may follow a nature trail from one gallery to another.

Opposite the Natural History Museum, at number 7 Cromwell Place, is the imposing stucco-fronted house in which Sir John Millais lived and worked from 1862 to 1879, and further westwards along the

Cromwell Road, at the corner with Queen's Gate, is Baden-Powell House, the Scouts' headquarters, with an international hostel, where historical records of the movement and mementoes of Lord Baden-Powell are kept. Westwards again, at 37 Harrington Gardens, is the Society of Genealogists (closed on Mondays) with a library which includes an unparalleled set of transcripts of parish registers, which may be consulted by non-members on payment of a fee. Number 39 was the home of W. S. Gilbert; built for him about 1881 by George and Peto, the terracotta decorations recall the Savoy operas.

The Victoria and Albert Museum is the last of the series of national institutions. The collections housed here are of an importance comparable with those in the British Museum, while the building itself is a labyrinth. The Museum had its beginnings in the Department of Ornamental Art in the Museum of Manufactures which opened at Marlborough House in 1852 as a direct result of the Great Exhibition. In 1856, it moved to South Kensington, housed at first in a glass and iron building designed by Sir Thomas Cubitt and known affectionately as the 'Brompton Boilers' (see p. 322). From then on, the collections and the buildings expanded inexorably. At the end of the century, it was decided to provide separate accommodation for the scientific collections and to enlarge the South Kensington Museum, limiting its scope to the fine and applied arts. Additional galleries were designed by Sir Aston Webb, the foundation stone was laid by Queen Victoria in 1899 - her last important public engagement - and the building was declared open by Edward VII in 1909. The façade is of dull terracotta, the roofline culminating in an octagonal cupola, crowned by a lantern adorned with flying buttresses and reminiscent of Edinburgh Cathedral or of the steeple of St. Dunstan's-in-the-East.

The museum is too large, and its collections too rich, to be covered in one - or indeed in many - day's exploration. The departments include: Architectural Details, Arms and Armour, the Art of the Book, Bronzes, Calligraphy, Carpets, Clocks, Costumes, Cutlery, Drawings, Embroideries, Enamels, Engravings, Fabrics, Furniture, Glass, Gold and Silversmiths' Work, Ironwork, Ivories, Jewellery, Lace, Lithographs, Manuscripts, Metalwork, Miniatures, Musical Instruments, Oil Paintings, Posters, Pottery and Porcelain, Prints, Sculpture, Stained Glass, Tapestries, Theatre Art, Vestments, Watches, Watercolours, and Woodwork. These categories are further divided into Primary and Departmental or Study Collections. The Primary Collections draw together objects of all sorts to illustrate Early Medieval, Gothic and Renaissance Art, Indian, Islamic and Far Eastern Art, Continental Furniture and Decorative Arts to 1825, English Furniture and Decorative Arts from 1500 to 1860, Portrait Miniatures, Costumes, and Paintings, both oil and water-colour. These collections are arranged on the ground and upper ground floors and may, with reasonable diligence and a comfortable pair of shoes, be fairly examined in a single day, provide one does not allow oneself to be enticed away from a steady perambulation. The Study Collections on the upper floors are no less worthy of attention – for example, in Textiles one can find the exquisite panels of embroidery worked by Louisa Peysel in 1911–13 which demonstrate with beautiful precision how each stitch should be worked, the names alone – tête-de-boeuf, herringbone, ribbed spider, Algerian eye, wheatear, chevron and trellis couching – weaving a spell over the spectator.

There are, however, certain treasures which no one visiting the museum should miss. It is hard to know which to mention first, but perhaps it should be the seven great cartoons which Raphael painted for Pope Leo X in 1515–16 and which were sent to Brussels to serve as designs for tapestries, being cut into pieces there for the convenience of the weavers. That purpose fulfilled, they passed from hand to hand till Charles I, at that time still a prince but already a connoisseur, heard of them and purchased them for £700 in 1623. They were at first used as designs in the Mortlake Tapestry Factory which James I had founded some four years earlier. Unlike the King, they survived the Civil War, and William III commissioned an artist, Henry Cooke, to piece them together as best as he could and to mount them on canvas. They were hung at Hampton Court and in Buckingham Palace till, in 1865, Queen Victoria decided that, since the Prince Consort had wished it, a greater public should be allowed to see them, and she therefore sent them on loan to South Kensington. Successive monarchs have graciously renewed the loan. Then there are the sculptures, a wax model by Michelangelo, A Slave, which was a preliminary model for one of the figures intended for the tomb of Pope Julius II, a marble group, Samson and a Philistine, by Giovanni Bologna, the magnificent Neptune and a Triton by Bernini, and the subtle and touching Ascension, carved in low relief by Donatello. The display of miniatures is astonishing, the most important being those by Holbein (Anne of Cleves, Mrs. Pemberton), by Nicholas Hilliard (Young Man by a Rose Tree, Unknown Man against a Background of Flames, and, probably, the portrait of Queen Elizabeth set in the Armada Iewel), and by Samuel Cooper (James II when Duke of York).

The museum also possesses nearly 400 paintings, both oils and water-colours, by John Constable, given by his daughter Isabella in 1888; they include the finished paintings Salisbury Cathedral and Dedham Mill, and studies for The Hay Wain and The Leaping Horse. The well arranged Dress Collection is filled with a mouth-watering display of finery, ranging from the early seventeenth century to the present day, an Elysium in which one may window-shop forever without being tempted to squander one's resources.

Then there are the galleries containing English furniture and the appropriate decorative arts, including such items as the Great Bed of Ware, large enough to hold four couples in comfort, and mentioned by Shakespeare in a joke in Twelfth Night. A lime-wood carving, copied from Tintoretto's Crucifixion and set in a frame of flowers fashioned so skilfully that they seem to move, is by Grinling Gibbons and is said to be the piece on which he was engaged when John Evelyn looked through the cottage window at Deptford and realized that a genius was at work there. In these galleries, the Music Room from Norfolk House (see pp. 141–2) and the Glass Drawing Room from Northumberland House (see p. 137) have been reconstructed. Though sadly reduced from their original estate, they still retain the ghostly essence of their former magnificence. These one-time glories may be reinforced by a study of the humbler domestic architectural details salvaged from scores of houses and at present displayed in Room 48 adjacent to the Raphael Cartoons. Here is the almost complete façade of Sir Paul Pindar's house from Bishopsgate, set up about 1600 and ornamented

most sumptuously; here are carved doorways from Great Ormond Street, Great Queen Street, Carey Street, and Adelphi Terrace; here are fireplaces and cupboards and other fragments saved from the destruction which has obliterated the houses of which they were once parts.

The Museum also contains the National Art Library, to which admission may be gained by written application, and the National Art Slide Library (ask for the special leaflet). It organizes a remarkable series of lectures on all aspects of the arts, both fine and applied, given by distinguished visitors and by the staff of the museum. Temporary loan exhibitions are frequently arranged; for these, catalogues, which are often abiding works of scholarship, are usually published.

A new extension, sponsored by the Conran Foundation, opened in 1982 in the old boilerhouse yard of the museum. Known as the 'Boilerhouse Project', a new gallery has been created to house temporary exhibitions concerned with design, both industrial and as applied to the objects that surround us in everyday life.

Natural History Museum, South Kensington

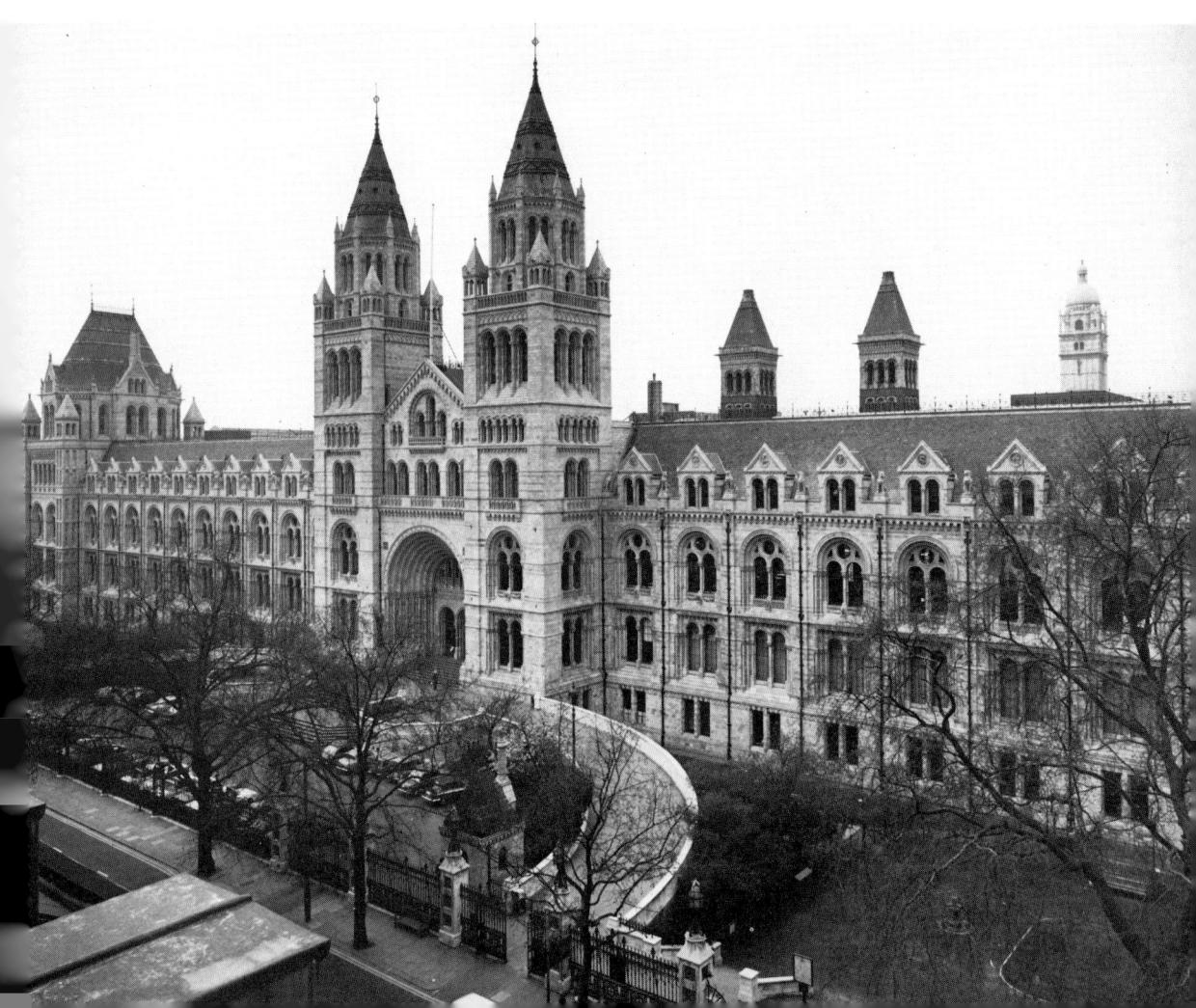

In 1983, the Henry Cole wing with its dramatic Great North Staircase opened with the Constable Collection – over 100 oil paintings given by the artist's daughter as well as many watercolours and drawings – housed on the sixth floor; the roof-top views across London are almost as exciting as the paintings. Below is the Print Room, the miniature collection, European and British painting, watercolours, panoramas, photographs, and space for temporary exhibitions.

Opposite the main entrance of the Victoria and Albert museum, a new Islamic Cultural Centre has been built. Eastwards in Brompton Road stands the Brompton Oratory, beside a statue by Chavalliaud of Cardinal Newman, who in 1848 introduced into England the Order founded by St. Philip Neri in 1575. The present church was designed by Herbert Gribble and built between 1880 and 1884. Constructed from gleaming Portland stone, the Oratory looks as if a sixteenth-century north Italian church had been spirited across Europe and set down in Kensington. The two-storey façade, with coupled pillars for the portico and a well proportioned pediment, would look perfectly at home in Florence or Milan. Gribble died at the early age of 47 and the dome was completed in 1895-6 by George Sherrin.

The interior is even more fervently Italianate. The nave, 51 feet wide, is broader than that of St. Paul's Cathedral, and on each side are four small chapels. Gribble's original designs, which included an elaborate baldacchino over the High Altar, were never carried out, but sumptuous mosaic decorations were added during the 1930s by C. T. G. Formilli. Chief among its treasures, the Oratory possesses twelve more than life-sized statues of the Apostles by Giuseppe Mazzuoli (1644-1725) which, having lined the nave of Siena Cathedral for two centuries, were cast out by the authorities there, to be rescued from a Genoese warehouse and installed in London. The altar of the Lady Chapel was built in 1693 by Franciso Corbarelli, with his sons Domenico and Antonio, for the Dominican church in Brescia, north Italy, and was saved when the church was pulled down in 1885. In St. Wilfrid's Chapel, the high altar came from the cathedral of St. Servatius at Maastricht in Holland, and there is a smaller altar, dedicated to the English Martyrs, with a triptych painted by Rex Whistler, showing St. Thomas More and St. John Fisher. In St. Patrick's chapel hang two wooden panels showing the Circumcision and the Presentation of Christ; they are attributed to the sixteenthcentury Flemish painter, Franz Floris. The singing of

Michelin factory, Fulham Road (François Espinasse, 1910/11)

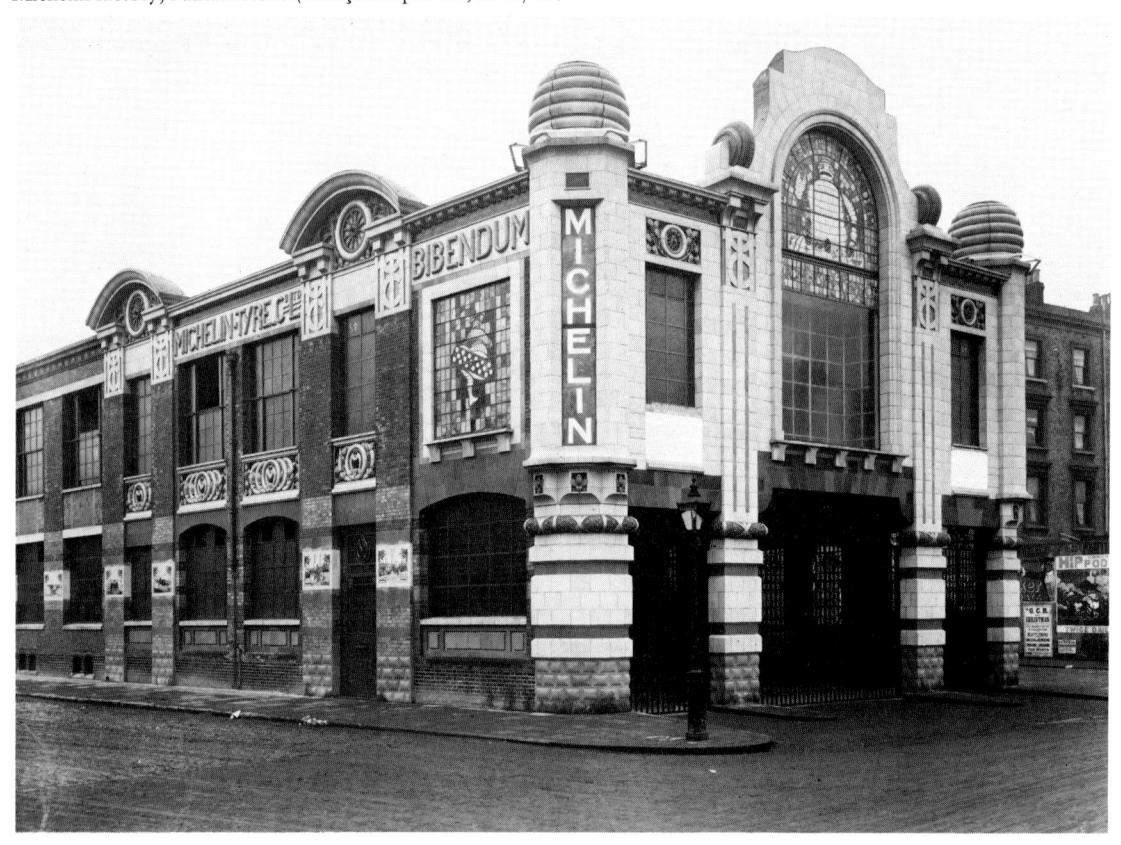

the choir is of an extraordinarily high standard and people come from all over London to delight in the beauty of the services.

Although, strictly speaking, a description of the shopping facilities of Kensington¹ is outside the scope of this book, yet they are so characteristic of part of the Royal Borough that readers may wish to allow themselves time to examine the boutiques which crowd together in Beauchamp Place and Walton Street - one can always excuse such frivolity by studying the neat scale of the houses and mews cottages. And it is essential to go to Harrods. Founded in 1849, in smaller premises, the present building, fashioned from dull terracotta brick, Kensington's own livery, was designed in 1901-5 by Stevens and Munt. Harrods can provide you with almost anything, and can care for you from the cradle to the grave. In the Food Halls, the walls are covered with Art Nouveau tiles, depicting the culinary delights which may be purchased there. Opposite Harrods, in Montpelier Square and Trevor Square, are enchanting doll's houses of dwellings, always, it seems, inhabited by beings as trim and smart as their own front doors.

Before leaving Kensington we should mention two more churches and a cemetery. Behind Harrods in Pont Street stands St. Columba's, Church of Scotland. The church, built in 1884, was shattered by bombs on 10 May 1941; a new church, designed by Sir Edward Maufe, was dedicated in December 1955. It is a striking building of white stone with a tall, ogee-capped corner tower. The interior too is starkly white. Over the entrances are sculptures by Vernon Hill of St. Columba and of angels, and the glass in the rose window is by Moira Forsyth. In the centre of the borough is an ellipse of houses, The Boltons, in the centre of which stands St. Mary's church, designed in 1850 in the shape of a Greek cross by George Godwin, with a fine east window by Margaret Kay which was installed in 1954. Finally, Brompton cemetery lies in the south-western corner of the borough. Inspired by the same hygienic reformation which created Kensal Green, it was consecrated in 1840, having been laid out to designs by Benjamin Band. His plans were never completely realized, but the domed octagonal Anglican chapel is a fine structure. Sir Henry Cole, Prince Albert's friend and the first Director of the South Kensington Museum, lies here, and near him his son-in-law, Captain Francis Fowke, who designed the Albert Hall.

The triangle of land between the Fulham Road and the Thames was formerly the borough of CHELSEA. The tiny riverside hamlet became a place of importance when Sir Thomas More, scholar, diplomat, and Chancellor of England, built a country house here within easy reach by river of his demanding duties at

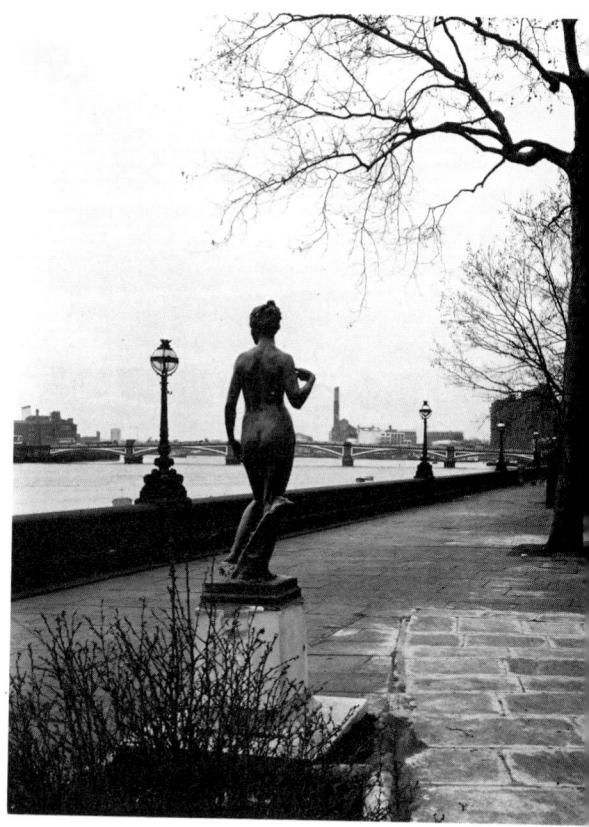

Chelsea Embankment

Westminster. He attended service regularly at the little parish church of All Saints, which, though virtually reconstructed after bomb damage in 1941, is still standing, its chancel dating from the thirteenth century and its nave from the seventeenth. More's two wives lie here, Jane, the mother of his children, his chara uxorcula, his dear little wife, and Alice who, despite her sharp tongue, brought up the motherless infants tenderly; the epitaph which Sir Thomas wrote for them is still intact, but his own body rests in the Chapel of St. Peter in the Tower. where it was laid after he went to the scaffold rather than acknowledge his earthly ruler, Henry VIII, as Head of the Church. Tradition ascribes the design of the two Renaissance capitals dated 1528 to Holbein, who spent many happy months with the Chancellor's family at Chelsea; the drawings he made of that good company are now in the royal collection at Windsor, and his enormous group portrait of them is in the National Portrait Gallery.

There are several other interesting monuments in the little church – Thomas Hungerford (d.1581) and Thomas Lawrence (d.1593) appear, with their wives and children, as small kneeling figures on wall plaques, Sir Arthur Gorges (d.1625) has a good brass, and the Duchess of Northumberland a magnificent one with all her thirteen children about her. There

¹ The ward boundaries have recently been changed; politically, Harrods is now in Chelsea.

are life-sized effigies of Gregory, Lord Dacre (d.1594) and his wife, and a figure of Sara Colville (d.1631) rises from its shroud, hands and eyes raised to heaven; the work was probably inspired by Nicholas Stone's memorial to John Donne in St. Paul's Cathedral. Richard Jervoise (d.1563) has a freestanding classical triumphal arch, and the busts of Sir Robert Stanley (d.1632) and his two infants, Ferdinando and Henrietta, are carved with such life that Sir Robert's eves seem to follow the visitor around the church. Lady Chevne is commemorated by a life-sized recumbent figure carved by Pietro Bernini, able son of the great sculptor. Henry James, the American novelist who so loved England that he chose to make one of his homes in Chelsea, is buried here too. Outside in the churchyard lie little Elizabeth Smollett, from whose death her father, the writer, never really recovered, and Sir Hans Sloane, the doctor whose collection provided the nucleus of the British Museum, with an urn by Joseph Wilton to mark his resting-place. In 1970 a statue of Sir Thomas More, by L. Cubitt Bevis, was set up between the churchyard and the river. The fascinating hassocks in the church were designed and worked by members of the congregation, each one with a portrait or symbol in memory of a famous resident.

More's house was demolished in 1740 by Sir Hans Sloane, and nothing remains of it save a later gateway which Lord Burlington set up in his gardens at Chiswick (see p. 283), but an extraordinary coincidence has placed in a corner of what was once his garden a fifteenth-century building which More once owned, probably as an investment. This is Crosby Hall, built in 1466 in Bishopsgate for Sir John Crosby, Lord Mayor of London. The Duke of Gloucester was in residence there when he was offered the crown and became Richard III. The mansion stood there through the centuries, being put to ever more humble uses. In 1908, the Chartered Bank of India, Australia and China bought the site and most generously re-erected the old building in Chelsea, where it serves as the headquarters of the Federation of University Women. The doors to the main hall are usually open on Saturday and Sunday afternoons so that passers-by may admire the superb timber roof and the noble proportions of the chamber - tangible evidence of how handsomely a merchant prince could live in fifteenth-century London.

Ever since More's day, Chelsea has been an area beloved of scholars, writers, artists, and others of distinction. With the current edition of the Greater London Council's list of commemorative tablets in hand, one can explore Chelsea, seeking out houses that have sheltered the great. The changing light from the river here has made Cheyne Walk dear to artists. Turner's house at the western end has been rebuilt, though the new edifice bears his name, while

William de Morgan, painter, potter, and novelist, lived and died at 127 Old Church Street, as did his wife Evelyn, who was also an artist. A visionary of another kind, Captain Robert Falcon Scott, lived at 56 Oakley Street and Leigh Hunt, the writer, and his unruly family filled 22 Upper Cheyne Row for a while. Surprisingly enough, considering the difference in the temperaments of the two men, the feckless author was on cordial terms with his more circumspect neighbour, Thomas Carlyle, who, with his wife Jane, lived at number 5 (now number 24) Cheyne Row from 1834 for the rest of their lives. The house, its furnishings almost unchanged, is now the property of the National Trust and is open to the public daily, save on Mondays and Tuesdays and during December. Carlyle's desk is here, cloistered in the sound-proof attic he had built to escape the crowing of the local cockerels. The chair from which Jane Carlyle rose to greet Leigh Hunt is undisturbed; he went home from that meeting to write a poem:

Jenny kissed me when we met,
Jumping from the chair she sat in.
Time, you thief, who loves to get
Sweets into your list, put that in!
Say I'm weary, say I'm sad,
Say that health and wealth have miss'd me,
Say I'm growing old, but add,
Jenny kiss'd me.

East of Cheyne Walk, at the western end of the Chelsea Embankment, is the Physic Garden formerly owned by the Society of Apothecaries. Established in 1673 and still flourishing, it is open to the public only twice a week, but it is easy to peer through the railings to see the multiplicity of plants and in their midst Rysbrack's statue of Sir Hans Sloane, who presented the Apothecaries with the freehold of the land. It was from here that cotton seed was sent out to America to establish the cotton plantations.

Ranelagh Gardens, the pleasure haunt of eighteenth-century London, lay eastwards of the Apothecaries' enclosure. The grounds were contiguous with those of the Royal Hospital, established in 1682 by Charles II in imitation of the Hôtel des Invalides

Philip Wilson Steer lived at number 109, Whistler at number 96, and Rossetti at number 16, with the poet Swinburne to keep him company; a fountain in his memory, designed by Sedding, stands in the garden opposite. Mrs. Gaskell, the novelist, was born at number 93, and Mary Ann Evans, better known as George Eliot, died at number 4. The great engineers, Sir Marc Isambard Brunel and his son, Isambard Kingdom Brunel, lived at number 98, a dwelling which was once a part of Lindsey House. Built in the 1670s, Lindsev House became the home of the Moravian Brethren in the 1750s. In 1775, it was divided into numbers 95-100 Cheyne Walk. In the early years of this century, numbers 99 and 100 were the home of Sir Hugh Lane, collector and founder of the Dublin Art Gallery.

¹ Known familiary as the 'Blue Plaques' List', this little pamphlet is indispensable to the student of London.

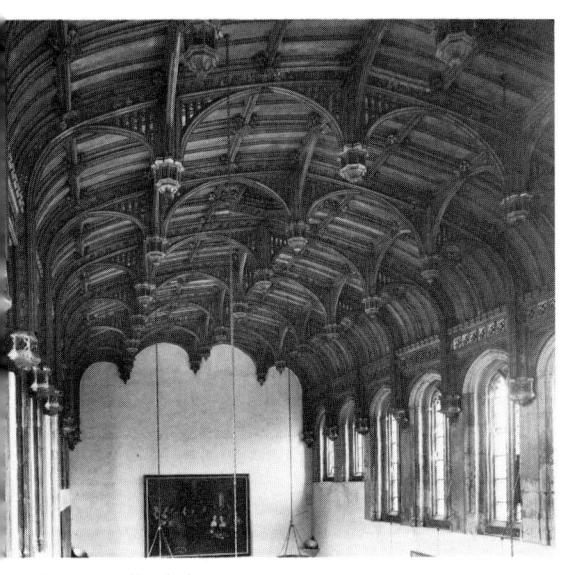

Crosby Hall, Chelsea

which Louis XIV had founded in Paris. Sir Stephen Fox, the Paymaster-General, provided finances from his own pocket, John Evelyn advised on the organization, and Sir Christopher Wren was chosen as architect. He planned the buildings around three courtyards - Light Horse Court, Figure Court, and College Court – and provided open colonnades where men who had grown old or been maimed in their country's service could sit at ease in all weathers to watch the Thames and the world go by. The upper floors of the living quarters around the Figure Court are reached by staircases with the shallowest of steps, to be gentle to crippled limbs - Wren never neglected practical details. To the Council Chamber, the Chapel, and the Great Hall he gave dignity without ostentation, employing his best craftsmen on the work. William Cleere and Sir Charles Hopson were his joiners, John Grove and Henry Margetts his plasterers, William Emmett and William Morgan his carvers. The overmantel of military trophies in the Council Chamber is especially impressive. In this room hang a portrait group of Charles I and his family by Van Dyck, and portraits of Charles II, Catherine of Braganza, James, Duke of York, and Richard Jones, Earl of Ranelagh, by Lely. In the chapel, the half-dome of the apse was painted by Sebastiano Ricci and his nephew Marco with a fresco of Christ Rising from the Tomb. The case of the original Renatus Harris organ still commands the gallery at the west end, though the instrument itself was renewed in 1934 by John Compton. Visitors may attend morning service in the Chapel at 11.00 a.m. when the 450 in-pensioners wear their scarlet coats and tricorn hats, a modernized version of the service dress of Marlborough's day.

The pensioners still eat in the Great Hall, its brickwork by Morris Emmett and its stonework by Thomas Hill. 115 feet long, 37 feet high, and 38 feet wide, it is an impressive chamber. There is a large mural, begun by Verrio and completed by Henry Cooke, of Charles II on horseback, surrounded by allegorical figures with the Hospital buildings in the background, and a number of other royal portraits by J. B. Clostermann, Sir Godfrey Kneller, and Allan Ramsay. At meal times the pensioners are served before the officers of the Hospital, to show respect for their past service. It was in this Hall that Wellington's body lay in state in 1852, and there are relics of the great soldier in the little museum, where an astonishing display of medals won by past inmates may be seen; the museum, Hall, and Chapel are open daily from 10-12 a.m. and 2-5 p.m. though the Council Chamber may be seen on Sunday afternoons only. Each year on Oak Apple Day (29 May), Grinling Gibbons's statue of Charles II is wreathed in greenery in memory of his escape after the Battle of Worcester by hiding in Boscobel Oak, and a parade is held in the founder's honour. And, early each summer, the Chelsea Flower Show is held in the grounds of the Hospital.

Beside the Hospital stands the National Army Museum, which opened in 1971. It tells the history of the British army from Henry VII's reign until the outbreak of the First World War, when the story is taken up by the Imperial War Museum. The buildings were designed by William Holford and Partners; the displays are still being developed but include an excellent parade of uniforms and some fine paintings.

Royal Hospital Road is not far from the King's Road, laid out in the seventeenth century to provide an easy means of communication between Whitehall and Hampton Court, and from the 1950s onwards considered to be the heart of 'swinging London'. At its eastern, townside end is Sloane Square with the Royal Court Theatre. The present structure – there had been an earlier playhouse - was designed by Walter Emden and W. R. Crewe in 1888; since 1956, with the advent of the English Stage Company, an impressive number of new plays have been presented. Just northwards in Sloane Street is John Dando Sedding's masterpiece, Holy Trinity. Built in 1888-90, a church 'by living men for living men', it is an epitome of the architectural and decorative inventiveness of the day. The ironwork (altar grille and rails, the railings outside) was designed by Sedding's best pupil, Henry Wilson, and executed by Nelson Dawson. Holy Trinity's great glory are its huge windows with 48 panels of richly stained glass designed by Burne-Jones and executed in the William Morris workshops. The organ, by J. W. Walker and Sons, is magnificent.

Newham

The London borough of Newham, which lies some five miles to the east of the City, was created from the union of West Ham and East Ham, morsels of Barking and North Woolwich being added to them. Its almost 9,000 acres with a population of about 225,000 were formerly in Essex; its western and eastern boundaries are the River Lea and the River Roding. Marshy, low-lying land along the river frontage with the Thames provided a perfect terrain for the Royal Docks – the Royal Victoria (completed 1855, the first dock to be equipped with hydraulic machinery and to have a direct communication with the railway system). the Royal Albert (completed 1880, the first large public undertaking to be lit throughout by electric light), and the George V Dock (opened in 1921 and large enough to admit the Mauretania when she came up the Thames in 1939) which together formed the largest area of enclosed dock water in the world. With the change to container transport (see p. 317), all three docks were closed and the area awaits redevelopment; it seems likely that a STOL (short take-off and landing) airport will be opened between the Albert and George V Docks. In the mean time, a classic industrial waterside landscape remains almost petrified, waiting to see what will come next.

Approaching from the west, the entrance to Newham is over the sharp ellipse of **Bow Bridge**, a congested labyrinth of flyovers and underpasses on either side of it. This is the direct successor of that bridge, the first stone one in Essex, which was built across the Lea early in the twelfth century at the command of Mathilda, Henry I's practical and efficient wife. A second was built in 1839 and the present structure in 1967. On the eastern bank of the Lea are the close-packed streets of STRATFORD, which takes its name from the Cistercian Abbey of Stratford Langthorne, founded about 1135 by Walter de Mountfichet. Near the flyover, approached by a footpath, is **Three Mills Centre**. The monks built a mill here and the industry which they established survived the

Reformation. One mill was demolished in Edward VI's reign, when the Lea was made navigable and compensation was paid to the owners – the first such case on record. Today, there remain the 1817 Clock Mill, magnificently restored for Messrs. Charrington with its wheels still in position, and the House Mill, built in 1776 but at present derelict. Its sluice, across which gates penned up the tidal waters of the Lea, is still easily distinguishable. Nearby in Abbey Lane is Abbey Mills Pumping Station, built in 1864 to serve Bazalgette's Northern Outfall Sewer. Crowned with a dome like that of an Eastern Orthodox church and containing much bravely convoluted ornamental ironwork, the building may be visited on written application to the Thames Water Authority. Enthusiasts for Victorian architecture and engineering should be aware that West Ham Pumping Station in Abbey Road, E.15, which may also be visited provided written application is made in advance, retains its twin beam engines. There are magnificent Victorian gas-works nearby, and in Angel Lane is the Victorian Theatre Royal, built in 1884, refurbished most attractively in 1953 by John Bury, and for some years the home of Theatre Workshop, a company which, under the masterful direction of Joan Littlewood, gave the English theatre a new sense of purpose.

The parish church of Stratford, dedicated to St. John and designed in 1834 by Blore, stands in Broadway. Around the tall landmark of its spire is a martyr's crown, for it was here that eleven men and two women were burnt to death on 27 June 1556 for their adherence to the Protestant faith. The old parish church, dedicated to All Saints, lies just a little behind to the south-east, at the junction of Church Street and Portway. Its gradual enlargement epitomizes the development of the whole neighbourhood. A church stood here by 1180, as portions of ragstone and flint rubble wall with blocked clerestory windows testify. Later building of about 1240 set up five bays of the north and south arcades; by this time, the church probably had transepts, which were pulled down and their materials reused about 1400, when the church was extended eastwards, the imposing west tower was added, and the chancel was given a new arch. The south chapel was added late in the fifteenth century, and the north chapel about 1550 when red bricks with dark blue diapering added NEWHAM 311

colour to the patchwork of the exterior. Sir George Gilbert Scott designed a new reredos in 1866, when a general refurbishing and mild restoration took place. Today, the church is entered under a long brick and timber south porch in which are set fragments of window tracery from Stratford Langthorne Abbey, while a stone, carved with a skull and set in the north wall inside the tower, is said to come from the same source. The nave roof dates from the fifteenth century, that of the chancel from about 1500, and that of the north chapel from the mid-sixteenth; the font was present in 1707, and a pair of royal beasts, probably of William IV's reign, ramp with spirit against the south wall.

There is one good brass, to Thomas Staples (d.1592) who kneels with four of his women-folk around him, but the church, apart from being a fascinating architectural jigsaw puzzle, should be outstandingly visited for its good monuments.1 Set high on the south wall of the chancel are two small monuments to John (d.1613) and Francis Faldo (d.1632), and in the north chapel Captain Robert Rooke (d.1630) kneels, clad in armour, his two wives, three sons, and four daughters to keep him company. Nearby stand two large and remarkable works. The earlier is to Sir Thomas Foote (d.1688), Lord Mayor of London, and his wife Elizabeth (d.1667); their life-sized, slightly stiff figures stand in round-headed niches, set on a sarcophagus base, a pediment above, and a panel with a lengthy inscription between them. Sir Thomas wears his chain of office proudly. The second is to James Cooper (d.1743) and his wife who stand close together, engaged in agreeable domestic conversation; the unknown sculptor carved with amazing vitality. The south chapel harbours two more monuments, the earlier to William Fawcit (d.1631) who reclines on his elbow, kept company by kneeling figures of his widow and her second husband, William Toppesfield. The later one, carved by Edward Stanton, tells of an all too familiar eighteenth-century tragedy; the seven Buckeridge children predeceased their parents. Nicholas and Eleanor (d.1724 and 1727) kneel on either side of an obelisk surmounted by a life-sized figure of their daughter Elizabeth, while around her are busts of the other little ones.2

In the Romford Road, less than half a mile to the north of All Saints church, is an imposing trio of institutions, the Public Library, the College of Technology, and the Passmore Edwards Museum, all housed in a single group of buildings, designed with almost overwhelming vitality in 1896–8 by Gibson and Russell. A bust of John Passmore Edwards stands in the hall of the museum; above the entrance is a bronze relief on which a delightful Art Nouveau

Theatre Royal, Stratford

Abbey Mills Pumping Station, Stratford

damsel reclines, presumably representing Fame and supporting a medallion portrait of the philanthropist. When it was opened in 1900, this was the only purpose-built museum in Essex and so is of considerable interest to the student of Victorian institutional architecture. The functions of the museum were clearly laid down on its establishment; it was to be 'a centre of information and study of Biology, Zoology, Geology, Topography, Meteorology and Ethnology and kindred studies with particular reference to Essex and of the prehistory, antiquities and industries of Essex'. The impressive Natural History Gallery contains a large pond in which swim local fish, there are loan exhibitions of local artists, and galleries are devoted to the history of Essex, in which the displays of palaeolithic material from the Lea Valley and the collection of Bow porcelain are especially good. The nineteenth-century exhibits, housed in the Rotunda Gallery which deserves to be seen for its own sake, illustrate the growth of population, as well as the agriculture, industry, transport, and obsolete crafts of the county.

¹ It is, unavoidably, often locked; a preliminary letter or telephone call is essential.

² One stone baby has recently been stolen.

Eastwards, at the southern end of the High Street, is EAST HAM parish church, dedicated to St. Mary Magdalene. Set in a wide churchyard, the view blocked by the bleak hump of the Northern Outfall Sewer, it is a surprising building to find in such a close-packed neighbourhood, for it is substantially an unspoiled Norman church. The apse, chancel, and nave were all constructed in the first half of the twelfth century and when the western tower, consisting of three humble storeys, was added early in the sixteenth, the Norman west door with its arch of three moulded orders was not destroyed but became the inner door to the nave. A single bell, cast about 1380, hangs in the tower; an inscription, cut in Lombardic lettering, says: 'Dulcis Sisto Melis Vocor Campana Gabrielis' ('I am of sweet honey; I am called the bell of Gabriel.'). There is no arch to separate the nave from the chancel. Along the north wall of the latter is an intersecting blind arcade, hacked about during the centuries but still in comparatively good repair. At the eastern end is a blocked archway with a little hatch, the remains of an aperture into an anchorite's cell. A plain round arch leads into the apse with its two round-headed twelfth-century windows and a third altered to a lancet in the thirteenth; the easternmost window is filled with glowing modern fibre-glass, a successful

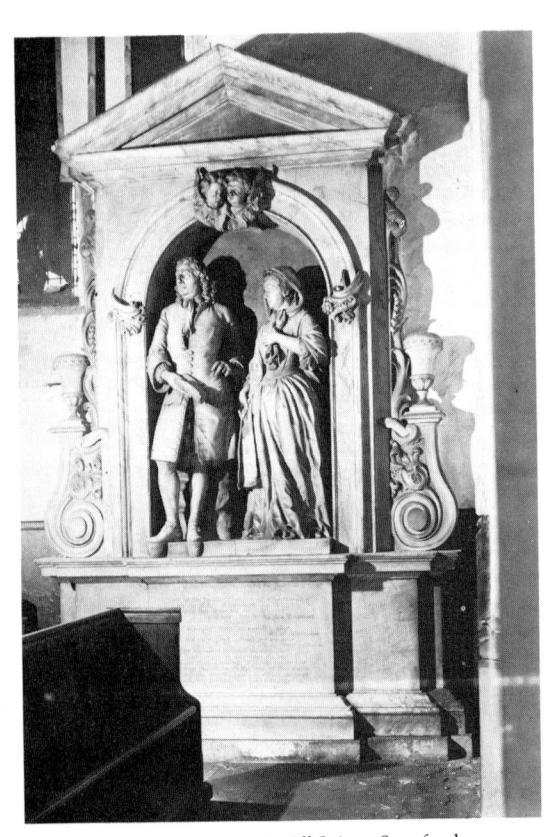

James Cooper's monument in All Saints, Stratford

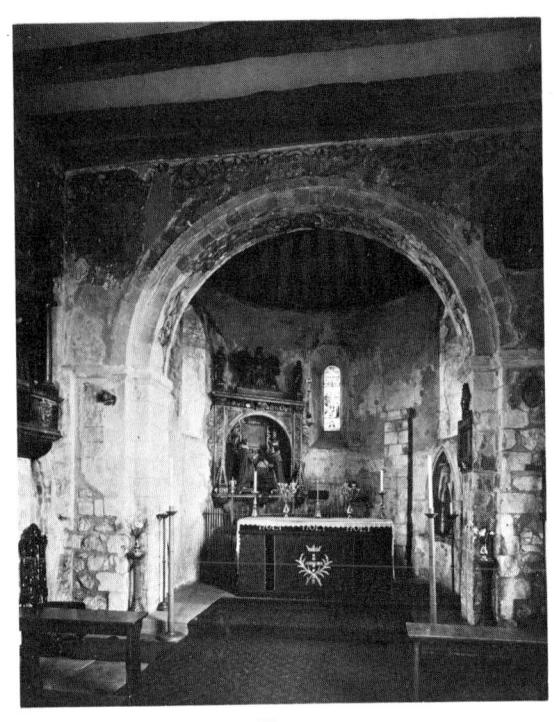

St. Mary Magdalene, East Ham

union of old and new. On the southern side is a thirteenth-century piscina; traces of wall-paintings linger above the archway. The roof was panelled till 1931; repairs then carried out revealed an intact Norman roof structure, the timbers pegged together.

Hester Neve (d.1610) and Elizabeth Heigham (d.1622) are shown on their brasses, and a relative of Elizabeth's, Sir Richard Heigham, presented the little church with a round marble font, its bowl set on a baluster pedestal, in 1639. A monument with small figures to Giles Bream (d.1621) is on the north wall of the chancel, while into the north-eastern side of the apse is crammed the altar tomb of Edmund and Jane Neville. He claimed to be the seventh Earl of Westmoreland, but since his father had forfeited his title for his part in the 1569 attempt to set Mary Queen of Scots on the throne of England and since not even her son, James I and VI, would restore it, his wife had to be content with a countess's coronet set on the brows of her effigy instead of the one she aspired to wear in life. Somewhere among the nineand-a-half acres of churchyard lies William Stukeley (d.1765), secretary of the Society of Antiquaries, which he helped to found. It is planned, when funds permit, to turn the churchyard into a nature reserve, for there is much wild life in this area.

The third of Newham's Norman churches lies at LITTLE ILFORD, in Church Road, Manor Park. Dedicated to St. Mary, the nave and possibly the lower part of the chancel walls are of the twelfth century and what are believed to be two of the

NEWHAM 313

original oak beams are still in position at the west end. The chancel was altered in the late sixteenth century, and in 1724 the eastern part of the tiny church – the whole building is barely 50 feet long – was rebuilt and the bell-turret, south porch, and Lethieullier Chapel were added. The Lethieulliers had come from Brabant and settled in Essex in the seventeenth century; the chapel contains monuments to several generations of the family. Two of them became sheriffs of London, while a later scion, Smart Lethieullier (d.1760), was the first antiquary to recognize the importance of the remains of Barking Abbey (see p. 197). In the window of their chapel are fragments of late fifteenth-century glass - Tudor roses and a small panel showing the Deposition - and the chimney for their much-needed fireplace is still in position.

In the body of the church is a monument with kneeling figures to William Waldegrave (d.1610) and his wife, with their three sons and four daughters, and there are brasses to Thomas (d.1517), the schoolboy son of Sir John Heron, Henry VIII's treasurer, who is represented with his ink-horn and pen-case, and to a brother and sister, William and Anne Hyde. William (d.1614) died in babyhood and is shown in swaddling bands; Anne (d.1630) lived to young adolescence and wears a dress with a fine lace collar. A lad, scarcely more than a child, lies in Manor Park Cemetery. He was Jack Cornwell, who, at the age of sixteen, when aboard HMS Chester at the Battle of Jutland in May 1916, received mortal wounds but would not leave his post in the gun turret. He was awarded the Victoria Cross, one of the youngest heroes ever to receive that honour.

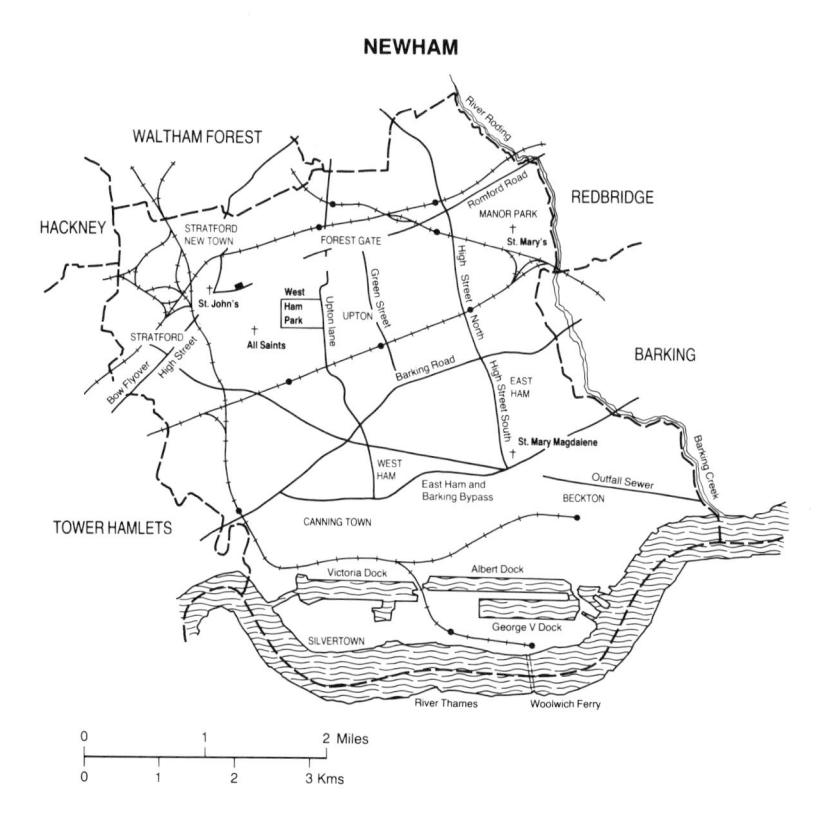

Redbridge

The London Borough of Redbridge lies to the north-east of the Greater London area and is composed of the former boroughs of Ilford, and of Woodford and Wanstead, with the addition of small parts of Dagenham and Chigwell. Covering an area of nearly 22 square miles with a population of about 225,000, all this land lay formerly in the county of Essex. The borough's new, fanciful name is derived from the Red Bridge¹ over the River Roding, which appears on John Rocque's map of 1746 but may well have been built in the previous century. A more modern structure fulfils the same function at the same spot, where today Eastern Avenue crosses the river. Redbridge is flat countryside, a full third of its acres to the north-east still being farmland. Wanstead and Woodford, on the western border, are mentioned in Domesday Book; Ilford, lying just to the south of the centre of the borough, is old too. Villages until the late seventeenth century, they became places of country retreat for gentlemen and successful merchants, but remained undeveloped till the railway came in the middle of the nineteenth century, bringing with it industry, while attendant small housing spread out across the fields and ploughland. Each of the three townships retains, or has erected, some buildings of interest.

WOODFORD is in the north-western corner of the borough. It retains an uncommon number of good Georgian domestic buildings and much of the more modern housing is of a substantial character. The parish church, dedicated to St. Mary, was unfortunately burnt down in 1969; a new one, designed by John Philips, was completed in 1972. The former building, erected in 1817 by Charles Bacon, took the place of a still earlier church from which the tower (c.1708) was retained. This tower is still intact and has been incorporated into the new church, which is otherwise architecturally undistinguished. The funeral monuments were all rescued from the flames and have been reinstated. They include a small tablet with kneeling figures to Rowland Elrington (d.1595)

and his wife Agnes, and a conventional tablet by the elder John Bacon to Charles Foulis (d.1783). In the churchyard, Sir Thomas Rowe, Queen Elizabeth's much-travelled ambassador who brought home with him the Codex Alexandrinus, now in the British Museum, as well as 29 other manuscripts for the Bodleian Library, lies in an unmarked grave; a tall marble column with an urn signals the restingplace of the Godfrey family. The column was raised to the design and at the cost of Sir Robert Taylor, to whom the Godfreys had proved benefactors in time of trouble. Another urn marks the tomb of William Morris's father, who came to live at Woodford Hall in 1840 when the future artist, craftsman, and social reformer was six years old. A parish hall has been built in the grounds of their former mansion.

Beside the church stands the vicarage, built in the first half of the eighteenth century and happily unscathed in the fire; it is today used as a Crown Court. To the north, up the High Road, is the Green, dominated by a bronze statue by David McFall of Sir Winston Churchill, MP for Wanstead and Woodford from 1924 till 1964. Northwards again, on the borders with Waltham Forest, is Highams, built in 1768 for Sir Anthony Bacon by William Newton, with grounds laid out by Humphry Repton in 1793, now used as Woodford County School for Girls. To the east, in Chigwell Road, is Broadmead Baptist Church, designed by Denis Hull and built between 1964 and 1969. It has an aluminium flèche and a most imaginative use has been made of timber, both internally and externally. A curved wall guides the congregation and visitors towards the entrance; it is of concrete, sculpted all over by the architect himself, telling the story of the creation of the world and of Christ's Crucifixion and Resurrection. A most original design has resulted in a building of great beauty.

At Woodford Bridge in Manor Road is Dr. Barnardo's, where many homeless children have found comfort and succour since he began his work in the poverty-stricken quarters of London in 1870.² Some 60 acres here were laid out, from 1910 onwards,

¹ The bridge was of red brick and was for vehicles. There was a white wooden foot-bridge just to the north.

² There is a second Dr. Barnardo's at Woodford in Barkingside, a little further eastwards still, where the good doctor was buried under a memorial by Sir George Frampton.

REDBRIDGE 315

with small reassuring houses designed by W. A. Pite and a chapel by Walter Godfrey was built here in 1929. Gwynne House, designed in 1816 by J. B. Papworth, is still standing among the smaller dwellings.

Prosperous WANSTEAD lies almost due south of Woodford. Here Sir Richard Rich, whose very name proclaimed the wealth that he derived from former monastic property, rebuilt for himself a mansion which was later enlarged by the Earl of Leicester. In 1667, Sir Josiah Child, chairman of the East India Company, bought the estate and his son, Sir Richard, destroyed the old house and built a new Wanstead House in its place, designed in 1715 by Colen Campbell. This, in its turn, disappeared, along with the family's fortune, and was demolished in 1824, but not before it had had a lasting influence on the development of English architecture. Studiously classical with a serene façade and a noble portico, it became a seminal work for the next generation of architects.1 The interior was equally magnificent; about 1729, Hogarth painted Sir Richard and his wife, their guests assembled around them in the sumptuously decorated main salon.2 Though the house is lost, part of the stables remain, in use at present as a golf club, while part of the grounds have escaped being built over and are today a remarkable public park.

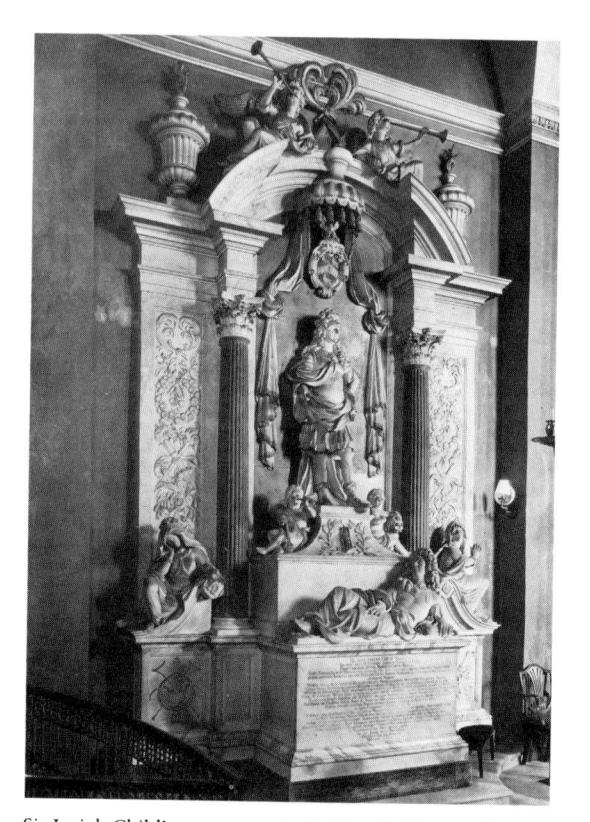

Sir Josiah Child's monument in St. Mary's, Wanstead

One relic of the Child family remains in the parish church, where Sir Josiah's monument seems to dominate the whole building. Evelyn described him as a 'sudden monied man'; he was intent on cutting a figure after death as he had in life. The marble monument, which Mrs. Esdaile ascribes to John Nost or Van Ost, stands some 20 feet high. Upon the base, which bears a long and hyperbolic inscription, lies the effigy of Barnard Child who predeceased his father. Sir Josiah's figure, clad in Roman armour and full-bottomed wig, stands on a pedestal in the centre, a small baldacchino and a coat of arms above his head. On top of the segmental pediment, cherubs sound blasts on Fame's trumpets, while, at the base of the flanking Corinthian columns, mourning women crouch in attitudes of grief and despair. Like Wanstead House, the monument was one of the showpieces of its period and still, today, it is one of the more remarkable works of sculpture in the London area.

St. Mary's church itself, built in 1790 by Thomas Hardwick, provides a worthy setting for Sir Josiah's monument. Ashlar-faced throughout, it has a lofty porch supported on pairs of Doric pillars, and a high

¹ Sir John Summerson, Architecture in Britain, 1530–1830, pp. 320ff, names Flitcroft's Wentworth Woodhouse and James Paine's Nostell Priory, both in Yorkshire, as well as the elder John Wood's Prior Park near Bath, as Wanstead's direct progeny. Nearer London, James Thornhill imitated the portico at Moor Park where it can still be seen.

² That painting is now in the Philadelphia Museum of Art. The joyous romp of Hogarth's *Wedding Dance* (at present on view at the Tate Gallery, but the property of the South London Art Gallery) which Ronald Paulson has shown to be part of a lost series, was for many years known as *The Wanstead Assembly* and it is possible that the elegant room in which the dancers frolic was inspired by an apartment in the great house.

bell-turret above. Inside, everything – walls, galleries, high box pews – is painted white. The elegant pulpit has two graceful palm-trees to support the sounding-board above the preacher's head, and the superb marquetry table, which serves as the altar, may well have come from Wanstead House when the contents were sold.

Though ILFORD was built chiefly in the 1930s and 1950s, the scanty remains of an Iron Age settlement, Uphall Camp, are still to be seen. When clay was being dug for brick-making in 1834, the bones of mammoths and elephants were discovered, which may be seen today in the Natural History Museum. Closed gates shut off the bustle and traffic of Ilford High Road from the Hospital and Chapel of St. Mary and St. Thomas of Canterbury. Founded about 1140 by Adeliza, Abbess of Barking, as a leper-house, it became an almshouse after the Reformation, and continues to fulfil the same function today. The chancel and nave of the chapel were rebuilt in the fourteenth century and this part of the fabric remains, though the south aisle, chapel, vestry, and north porch were added in the nineteenth. Against the south wall of the chancel are the remains of the tomb of John Smythe, a former chaplain, who died in 1475; his effigy, wearing mass vestments, lies under a canopy; the carving of the pillars shows a masterly command of classical ornament - not the sort of work one would expect to find in a small township in Essex at that date. The back of the tomb has been reset at the west end of the south aisle. In the windows of the church are medallions of sixteenth- and seventeenth-century Flemish glass, one of them showing the Visitation and another with the inscription 'Van der Balck 1550'. There are also panels with the arms of John Gresham, and his badge, a golden grasshopper.

The parish church, St. Mary's, erected in 1831 to designs by James Savage, is also in the High Road; built of yellow brick, it has a narrow west tower. The centre of Ilford is being redeveloped very fast, but one older building remains, Valentines, a mansion built in 1696–7, with spacious grounds which serve today as a public park, while council offices occupy the house. It was from a vine in the conservatory here that a cutting, taken in 1769, grew into the Great Vine at Hampton Court; the parent plant was cut down by an over-zealous gardener in 1875.

Ilford has endeavoured bravely and with considerable success to promote good modern architecture. St. Andrew's church in the Drive was designed in 1924 by Sir Herbert Baker, with sculpture by Sir Charles Wheeler and glass by Carl Parsons. Newbury Park has a dramatic tube station with a parabolic canopy, designed in 1937 by Oliver Hill, though not built until after the Second World War in 1949.

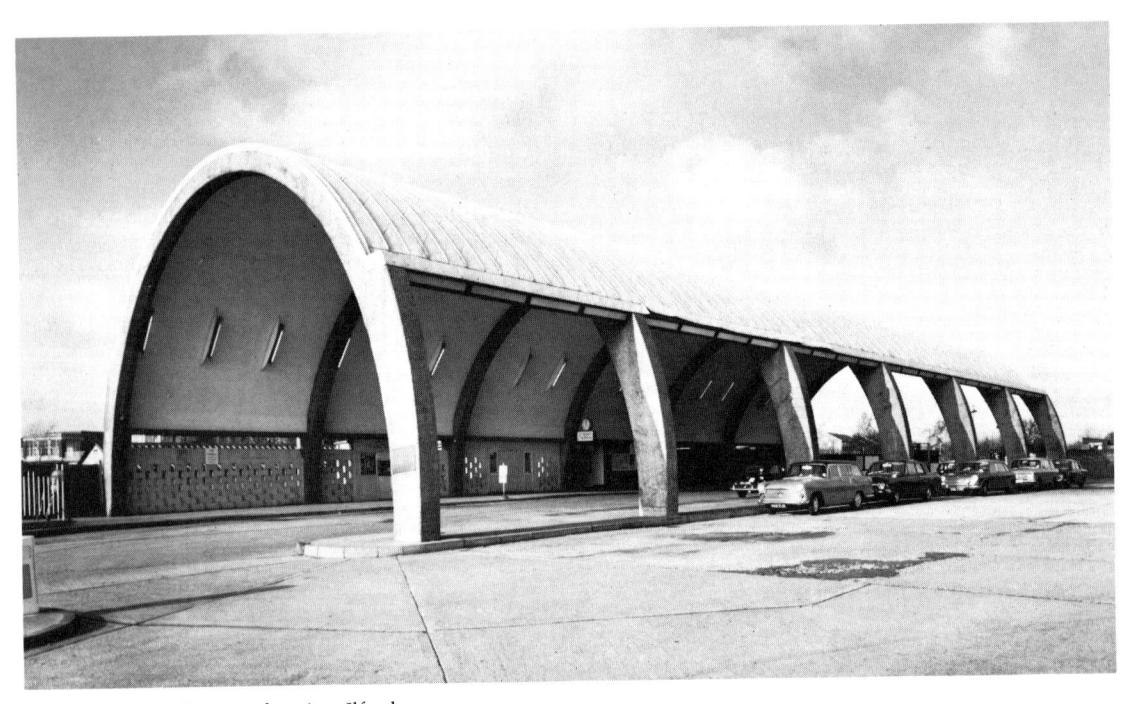

Newbury Park underground station, Ilford

Tower Hamlets

The London Borough of Tower Hamlets consists of the former metropolitan boroughs of Stepney, Poplar, and Bethnal Green, a union which effectively reconstitutes the enormous area of the Bishop of London's medieval manor of Stepney. It stretches from the city walls eastward to the River Lea, once the boundary between London and Essex, and takes its present name from the huddled clusters of dwellings, for the safety of which the Constable of the Tower of London was once responsible. Its eight square miles, with a population of about 146,000, contains London's East End where. since the Middle Ages, foreigners coming to the great city tended to settle, and where those trades, such as tanning, bleaching, and vinegar making, which were unfit to practise within the City walls, could be exercised without restriction.

During the sixteenth century, expansion of trade with Russia, Turkey, the East Indies, and the New World reached such proportions that by 1661 the East India Company had to set up a small wet dock at Blackwall for refitting its fleet of vessels. In 1696, the royal assent was given to a bill for providing a wet dock at Rotherhithe, thus creating the nucleus for the Surrey Docks. Trade continued to increase. By the end of the eighteenth century, as many as 1,775 ships might be moored in the Upper Pool in a space scarcely adequate for 545. In 1796, a parliamentary committee was set up to consider the problem, with the result that a series of docks was rapidly provided - West India Dock (1802), London Docks (1805), East India Docks (1806), St. Katharine Dock (1828), Victoria Dock (1855), Millwall (1868), Royal Albert (1880), and Tilbury (1886), and in 1909 the Port of London Authority was established to control the 90 miles of tidal water from Teddington to the Thames estuary. The sudden change to container delivery in the 1960s has closed them all for general cargo work; St. Katharine's and East India Docks shut in 1968, London Docks and Regent's Canal Dock in 1969, Surrey Commercial Docks in 1970, West India and Millwall Docks in 1980, and the Royal Docks in 1983. A new pattern of life has yet to be worked out here.

Stepney and its neighbour, Poplar, are areas more difficult to describe than to explore. Listed in print, the haphazard scatter of hamlets – Whitechapel, Spitalfields, Mile End, Ratcliffe, Bromley-by-Bow, Old Ford, Limehouse, Wapping, and Shadwell with Millwall and Blackwall on the Isle of Dogs – seems confusing, as alien as the poetic designations given to the obscurely sighted physical features of the moon. When explored, the names reveal themselves as distinct and characterful enclaves.

Overcrowded even today, shabby but full of life, STEPNEY lies just outside the City boundary, the late seventeenth-century Hoops and Grapes, which is being extensively refurbished, surviving, miraculously, in Aldgate High Street. Whitechapel's name commemorates the white stone walls of the thirteenth-century church of St. Mary Matfelon. Frequently rebuilt through the centuries, a bomb shattered the Victorian Gothic fabric and the ruins were demolished in 1952. The boundary between the City and Stepney runs down the centre of Middlesex Street, better known by its old name of Petticoat Lane, where a thriving, vociferous street market still flourishes, selling almost everything but specializing in clothing. Travelling west-north-west, Whitechapel High Street and Road in turn becomes Mile End Road and Bow Road.

Just off the High Street, in Commercial Street, is Toynbee Hall, founded in 1884 as the first university settlement by Canon Samuel Barnett, with the declared intention of bringing 'the West End into the East'; the work continues vigorously a century later. Here, the young, the old, anyone lonely or in trouble, can find help and companionship. The Curtain Theatre is only one of the many stimulating recreational activities provided. It was Canon Barnett who founded the Whitechapel Art Gallery in the

High Street. Designed by Charles Harrison Townsend in 1897 and opened in 1901, the façade is that of an Art Nouveau castle – a large, recessed entrance porch placed asymmetrically with two curious, spiky turrets above, a bastion determined to defend the East End's right to enjoy works of art. There is no permanent collection, but special exhibitions are

regularly arranged. Opposite is the London Hospital, founded in Featherstone Street in 1740. The original building on this site was begun in 1751 by Boulton Mainwaring and to that three-storeyed structure, 23 bays long, succeeding generations have added as their needs dictated, so that now a grimy jumble of buildings present themselves to the gaze of the architectural historian. Tucked away behind the hospital is a young cathedral of a church, St. Philip's, Newark Street. Founded as a chapel in 1819, it was rebuilt to designs by Arthur Cawston and reconsecrated in 1892. The nave is of such a height that it can accommodate a triforium as well as a clerestory and the double aisles meet to form an ambulatory leading to the Lady Chapel behind the high altar. A new floor designed by S. E. Dykes-Bower was laid in the sanctuary in 1940; the same architect also designed the crucifix and candlesticks on the high altar.

Trinity Almshouses stand on the northern side of the road. Opened in 1695 by Trinity House Corporation, and built to the designs of William Ogbourne, the chapel and two rows of low dwellings, ranged on

HACKNEY

HACKNEY

Wictoria

BETHNAL

GREEN ROMAN BOW

SPARA Gallery

WHITECHAPEL

Commercial Road

LIMEHOUSE

Fast India

Docks

SIEDNET

Tower

Bridge

SOUTHWARK

DEPTFORD

2 Miles

GREENWICH

GREENWICH

RIVER Thames

GREENWICH

GREENWICH

GREENWICH

RIVER Thames

GREENWICH

either side of a garden, were shattered by bombs. The London County Council (now the GLC) purchased the ruins in 1954 and restored them as a rehabilitation centre for the physically handicapped. Early eighteenth-century panelling from Bradmore House in Hammersmith has been fitted neatly into the chapel, and the gardens are so tended as to delight all who pass by. Almost opposite the Almshouses is the Whitechapel Bell Foundry at 32–4 Whitechapel Road. The firm has occupied these premises only since 1738, but it can trace its history back through fully four centuries, for Robert Mot was casting bells on the north side of the Whitechapel Road by 1570. The house, shop, and foundry are among the most remarkable industrial buildings in London.

Stepney Green lies south of the Mile End Road, and leads to the parish church, St. Dunstan and All Saints. St. Dunstan was Bishop of London from 959 to 960, and the church was probably founded or rebuilt during his episcopate; the original dedication was to All Saints but the bishop's name was added after his canonization in 1029. Only the rood stone remains from the tenth-century church; of the present building, the oldest part is the thirteenth-century chancel with its unusual (though much restored) sedilia, while the body of the church was rebuilt again some two centuries later. Additions, mostly now vanished, were made during the seventeenth and eighteenth centuries, the nineteenth 'renovated' the fabric zealously, and the twentieth restored it lovingly after a severe fire in 1901 and a V1 rocket in the churchyard in 1945. St. Dunstan's now stands, with its beautifully proportioned west tower and battlemented nave roof, surrounded by seven acres of churchyard, looking like a country church rather than the centre of one of London's most crowded parishes. The broad nave and aisles, seven bays long, are lit by the great east window filled with modern glass by Hugh Easton; the figure of Christ, crucified but triumphant, stretches His arms above the bombtorn roofs of Stepney. On the wall beneath, behind the altar, is the Saxon rood stone; Our Lady and St. John stand sorrowing beside the cross, the worn modelling of their robes still holding something of the original fluidity of line; flowers and leaves form a border. On the north wall of the chancel is a little fourteenth-century carving of the Annunciation; though much worn, the two figures still express tenderness and grace. A recessed tomb-chest with lacelike tracery holds Sir Henry Colet (d.1510) twice Lord Mayor of London, whose only surviving son, John, was rector here before he became Dean of St. Paul's and founder of St. Paul's School. Sir Thomas Spert (d.1541), the founder of Trinity House, had a memorial raised to him in 1622, and there are alabaster figures of Robert Clarke (d.1610) and his daughter, Frances, of Elizabeth (d.1620), widow of Richard Statute, and of her daughter Clare and son-in-law, Captain Michael Merriall. From the middle of the south wall, a staircase winds upwards,

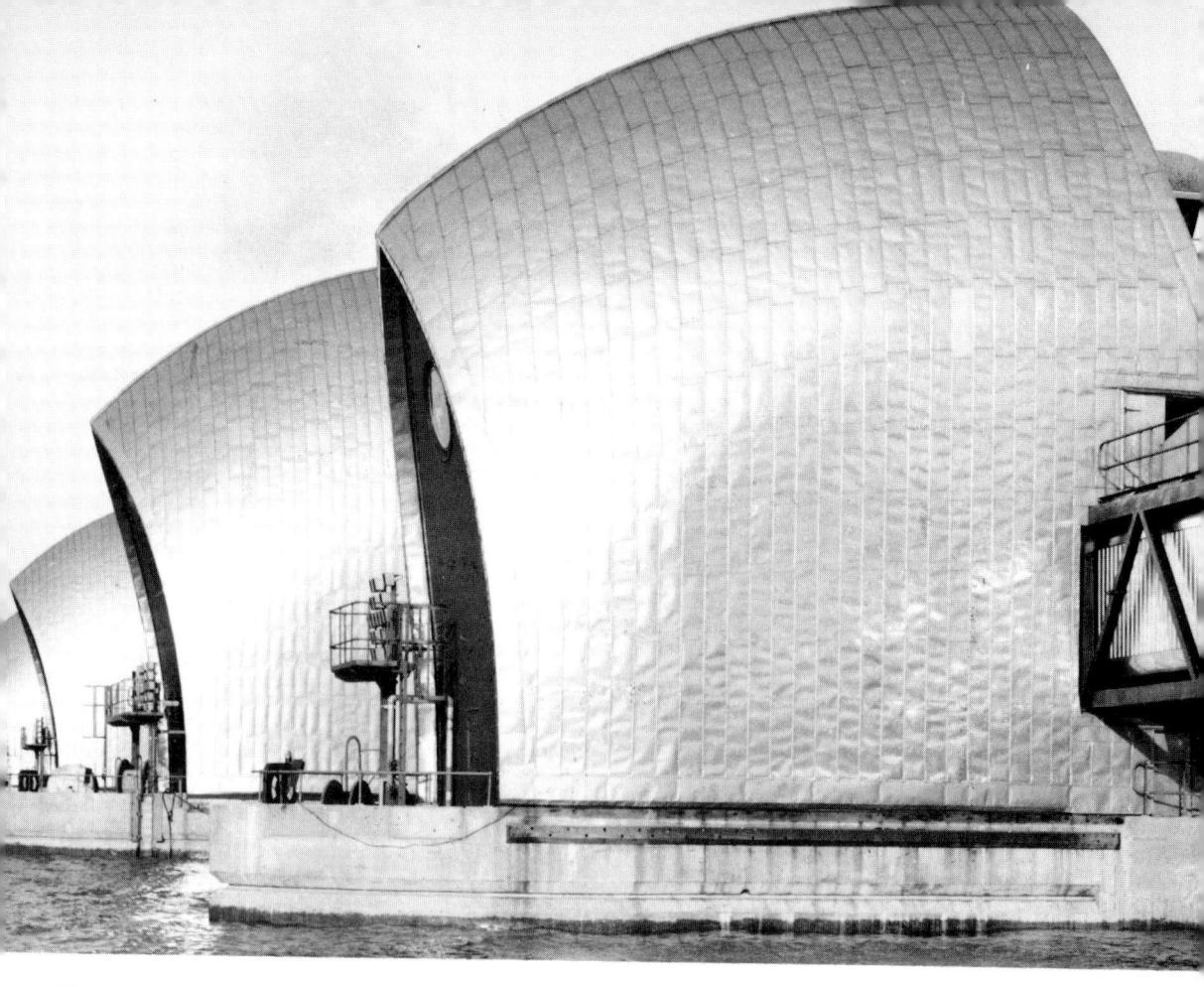

The Thames Barrier (see p. 372)

leading to nowhere nowadays but once providing access to the rood loft.

The Mile End Road continues westward, passing Queen Mary College. Part of its premises are the old People's Palace, which Queen Victoria opened in 1887 to provide civilized entertainment for the inhabitants of East London; the first Sunday afternoon concert had an audience of 3,000. St. Benet's church, rebuilt by Playne and Lacey after bombing, serves the college as a chapel, and behind the main buildings lies the Jewish burial ground which Cromwell permitted the Jews to buy when he allowed them to return to England, from whence they had been banished in 1278. In this spot lies Benjamin D'Israeli, whose grandson and namesake became Prime Minister.

When almost at the River Lea, the road divides to form an island site for a small church, St. Mary's. Built in 1311 as a chapel of ease to Stepney, succeeding generations have repaired and added to the ragstone walls; the stout west tower must date from the fifteenth century. In the week, the church is usually shut — the noise of the traffic alone would make a service hard to hear in spite of double glazing

– but it is often open on a Sunday when the fine seventeenth-century communion table, the fifteenth-century font, and the wall tablets, particularly those of Grace Amcottes (d.1551) and James Walker (d.1712) with busts, *putti*, swags of flowers, and draperies, are worth seeing. Nearby, in Burdett Road on Bow Common, stands St. Paul's church, built in 1958–60 by Robert McGuire and Keith Murray, an exciting, strictly functional modern building lit by a soaring lantern.

Victorian redevelopment destroyed James I's small and convenient palace at Bromley, though the panelling of one fine room was saved and is today in the Victoria and Albert Museum. It was this vandalism that roused C. R. Ashbee, one of the originators of the Arts and Crafts movement, who had his workshops close by at 401 Mile End Road, to publish in 1900 a survey of the historic buildings remaining in the parish, an undertaking which resulted in the establishment of the *Survey of London*, still in progress.

A detour northwards leads into the Old Ford area of Poplar to visit Victoria Park. Laid out during the good Queen's reign, part of the money to finance it

came from the sale of crown property, Stafford (now Lancaster) House. Its 217 acres were laid out by James Pennethorne, John Nash's adopted son and pupil; the intention, which in part succeeded, was to make it into a Regent's Park for East London. In it stand two stone alcoves, brought from Old London Bridge (demolished 1831).

SPITALFIELDS, often shabby but still preserving many interesting houses, lies due north of Whitechapel. Though adjacent to the City, there was little development here during the Middle Ages, the one important institution being the Augustinian Priory or Hospital of St. Mary Spital, on the east side of Bishopsgate, founded soon after 1197 by Walter and Rosia Bruno, which eventually gave its name to the whole area. When development came after the Reformation, it was at first concentrated within the precinct of the former priory, and, since the main axis of the buildings ran north and south while through traffic between London and Essex travelled west to east, this corner outside the walls remained somewhat isolated, attractive therefore to Roman Catholic recusants and later to a variety of national groups who, arriving in this country as refugees, brought with them their own forms of worship. When the fields around the former hospital were developed, it was along individual lines, not typical

Saxon rood stone in St. Dunstan and All Saints, Stepney

of the rest of East London. By 1537-8 the 'tessell grounds'1 in the southern part of the precinct had been leased by the 'Fraternyte or Guylde of Artillary of Longebowes, crossebowes and handegonnes' as a practice ground – a cluster of warlike street names, Artillery Lane, Fort Street, Gun Street, are an echo of its former usage – but purposeful development began in the 1650s and 1660s till, by 1674, the Hearth Tax Returns show 1,336 houses in Spitalfields of which 140, probably newly built, stood empty. The house where Susannah Annersley, Wesley's mother, was born in 1669 still stands, in good repair, in Spital Yard. A market, which flourishes today under the control of the City Corporation, was established in 1682, and the name of the brewer, Joseph Truman, appears in a ground lease of 1683. The number of inhabitants increased sharply after 1685, when Louis XIV revoked the Edict of Nantes by which, in 1598, Henry IV had granted freedom of worship to the French Protestants. 30,000 Huguenots crossed to England; many who were silk-wavers settled in Spitalfields, bringing a new prosperity to the trade and to the district. By 1700, there were seven French churches in the area and more substantial houses were in demand. Spital Square has almost vanished. but early eighteenth-century houses remain in Fournier Street, in Artillery Lane, and in Elder Street. In some the attic rooms were used as workshops; wide windows, inserted into the garrets to admit the maximum amount of daylight, can still be seen in Fournier Street; the floor joists were packed with silk waste to deaden the sound of the looms. The increase in London's population, coupled with a lack of churches, roused the government's anxiety; in May 1711 an act was passed, authorizing the building of 50 new churches. In fact, only 12 were built (see pp. 19, 215); of these, six were the work of Nicholas Hawksmoor, from 1711 to 1733 one of the surveyors appointed under the Act. Three of the creations of this strange genius were needed in Stepney; one of them, Christ Church (foundation stone laid 1714, consecrated 1729), the most unusual edifice of all, was built in Spitalfields.

It stands on the east side of Commercial Street, just to the south-east of Spitalfields Market. For Christ Church, Hawksmoor took as his motif the outline of a Venetian window — a triple opening, the central space tall and arched, with slightly lower rectangles on either side — and adapted it to provide a novel portico which commands the long vista down Brushfield Street. Four massive pillars support a broken entablature, the two halves of which are linked by a tall, narrow round-headed arch like heavy eyebrows with a furrowed brow above. Behind the portico are three doorways, the central one loftier than its companions. A square west tower, broad as the portico but so shallow as to seem fragile when viewed from the side, rises above the entrance, its

¹ Teasels were used in the preparation of the surface of cloth.

two tiers of windows arranged so as to repeat the Venetian rhythm. A small, square, upper stage has a semicircular lunette and above this rises a broached spire, its flanks now bare but originally adorned with fantastic crockets. At the eastern end is an exquisitely proportioned Venetian window, its central aperture echoed by the tall narrow windows on the north and south sides. The interior, a spacious basilica with giant Corinthian columns, lofty enough to accommodate two tiers of galleries, has been closed, save for the annual festival and an occasional concert, for some years for lack of repairs. When at last restoration comes, as surely it must, London will regain one of the noblest and most awe-inspiring of all her churches.

The streets immediately around Christ Church should be explored too. Fournier Street, with eighteenth-century façades and a wealth of imaginative doorways, has at its eastern end the former French chapel (built in 1743) which for many years subsequently served the local Jewish population as the

Great Synagogue but is now a mosque. Brick Lane is lined with the buildings of Messrs, Truman's Black Eagle Brewery; the Director's House, built in 1740 on the western side, is now linked to a modern, glass-fronted brewery designed by Ove Arup, while the purposeful façades of the Vat House and stables (1837) fill the eastern side of the street. Nearby, at the corner of Folgate Street and Commercial Street, is the shell of the first Peabody building to be erected in London, designed by H. H. Darbishire in 1864 at the expense of George Peabody 'to ameliorate the condition of the poor and needy of this great metropolis and to promote their comfort and happiness'. Elder Street, where Mark Gertler, who was born at 15 Gun Street, lived at number 32, has some well-preserved houses still; number 36 has an excellent doorway. The dog-leg of Artillery Lane runs to the south of the market; in it, at numbers 56 and 58, are two handsome shop-fronts. Built in the early eighteenth century, the façade of number 56 was inserted about 1756-7; Doric three-quarter columns divide it into

Petticoat Lane market

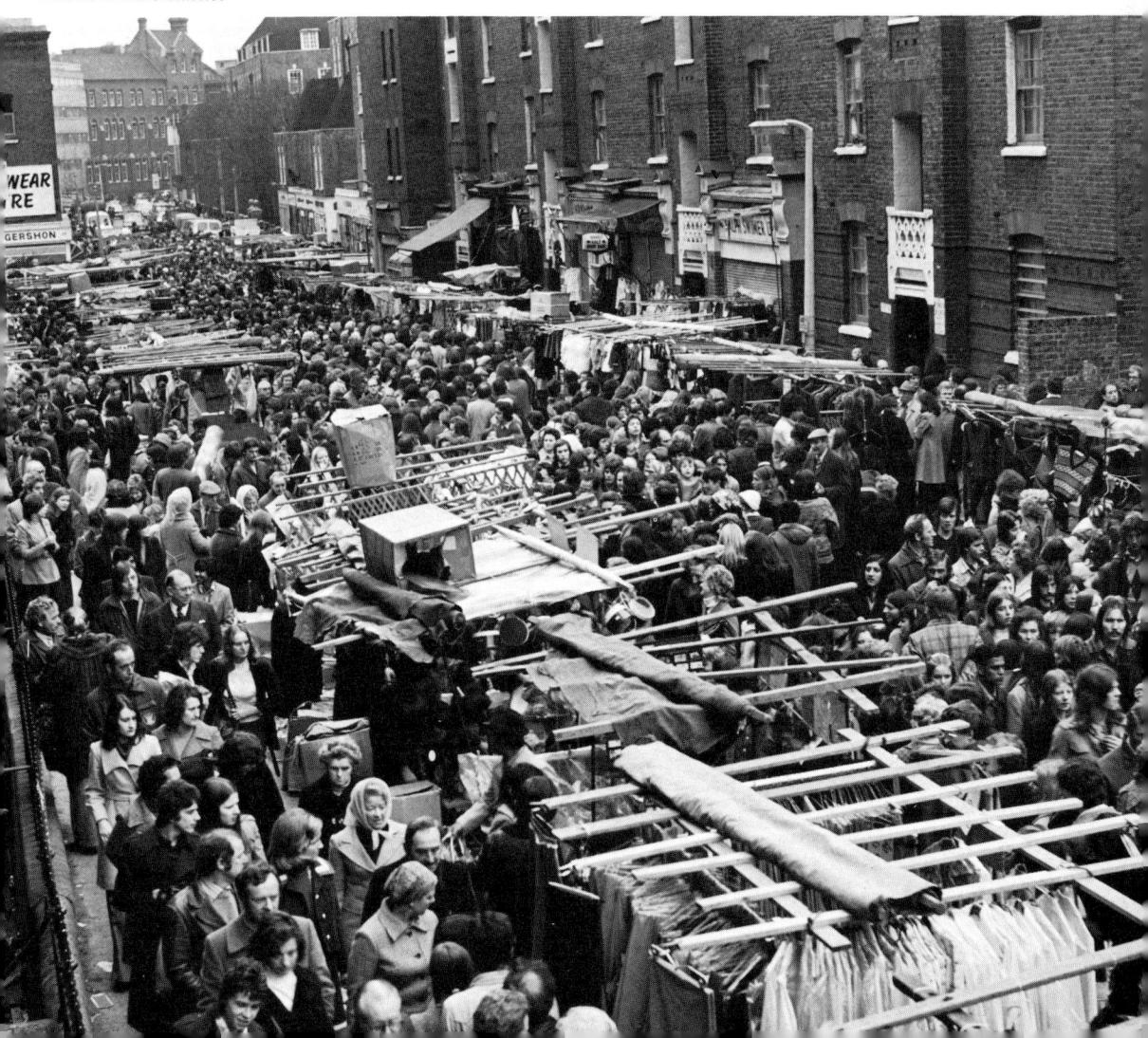

three bays of differing widths, an oval cartouche with a rococo frame marks the doorway of the shop, while an Aurora mask with draperies sits above the entrance to the domestic premises, which have splendid Chinoiserie decorations. Number 58's façade dates only from the early nineteenth century, though its first-floor room has now been reassembled in the Geffrye Museum.

BETHNAL GREEN lies to the north-west of Spitalfields. This corner of the borough, being more remote from the City and removed a little to the north from the direct traffic into Essex over Bow Bridge, was built over later than the rest, but in the end with the cruellest overcrowding of all. Figures speak more plainly than words. In 1700, Bethnal Green was a pleasant, country place; the four main establishments were Aldgate House belonging to Lord Wentworth, Kirby Castle, built in Tudor times and only demolished in 1921, to which Pepys hastily removed his possessions for fear of the Great Fire, the Bishop of London's manor house, and Netteswell House, built before 1660 and still standing. 50 years later, the population was still well under 15,000 but it then increased to 82,000, and by 1901 it had swollen into a close-packed mass of 130,000, living in wretched surroundings, beset by misery, dirt, disease, and crime. The urban reformers rightly began their work here. Between 1860 and 1862, Miss Burdett-Coutts - Queen Victoria had not yet made this benevolent and stout-hearted lady a peeress in her own right - commissioned Henry Darbishire to build several blocks of 'improved dwellings for the working classes'. In spite of decorative Gothick detail, they were very grim. Realizing that those whom she sought to defend were constantly cheated by dishonest traders, she bought and demolished one of the worst slums. Nova Scotia Gardens, and there in 1869 Darbishire built Columbia Market, a vast cathedral-like hall where good quality food was to be sold at a fair price. But even here, human corruption undermined idealism; the LCC demolished the market in 1960 and its site was built over. It was just to the south of the market, in the 1890s, that the LCC began its own work of slum clearance with the Boundary Estate. This was the area around Nichols Street, described so appallingly in Arthur Morrison's novel, A Child of the Jago. Inspired by social reform of the sort that William Morris advocated, the LCC attempted to build homes for human beings, not dwellings for some separate species classified as 'the working classes'. Arnold Circus was the centre of the estate and from it streets radiate out, planned with a good attempt at imaginative grouping of buildings.

The parish church, **St. Matthew's**, lies just south of Bethnal Green Road. Built in 1743–6 by George Dance and remodelled internally in 1859–61 by Knightly, it preserves a stalwart and purposeful presence. All around it, redevelopment is in progress. At the junction with Cambridge Heath Road is the

Fournier Street, Spitalfields

portico and west tower of St. John's church, built by Soane in 1825–8, its interior unfortunately recast in 1871 by S. S. Teulon, whose individuality was as strong as Soane's had been; his schemes assorted uncomfortably with the earlier architect's work.

Nearby is Bethnal Green Museum. Opened in 1877, its building is part of the iron structure, known affectionately as 'the Brompton Boilers', which Major-General Scott erected in 1856 for the South Kensington Museum, the forerunner of the Victoria and Albert, of which Bethnal Green is a branch; the museum and the greenhouse at Kew are the most important surviving examples of the prefabricated iron and glass construction used by Paxton for the Great Exhibition Building of 1851. The external mosaic frieze was designed by F. W. Moody to show, on the north side, man engaged in the arts and sciences, and on the south side, busy with agricultural occupations; it was executed by the students at the National Art Training School, now the Royal College of Art. In the forecourt stands The Eagle Slaver by John Bell, one of the triumphs of the 1851 Exhibition; inside, galleries run around a huge, open hall. Bethnal Green is first a museum of childhood; everything that the young could desire is here – doll's houses (the earliest made in Nuremberg in 1673 and the largest in Dorset in 1760), dolls, some still pristine, others battered with too much loving, rocking-horses, card games, toys of every description, including some marvellous Victorian optical devices, model theatres, and picture bricks. Secondly, the museum has a good collection of costumes and textiles, with a special emphasis on the work of the Spitalfields silk weavers. English life and landscape are illustrated by the collection of watercolours, many of them by Thomas Rowlandson, which Joshua Dixon, a poor boy from the East End
who made a fortune in America, bequeathed to the museum, which also houses London's chief collection of European sculpture and the decorative arts from Napoleon's day till the turn of the present century, when Art Nouveau was the prevailing style. Rodin generously gave many of his smaller sculptures to the museum, and it is worth penetrating to the topmost galleries where the works of less well-known artists and craftsmen may be found. Jules Dalou's first model for his figure of *Motherhood* is here; the finished work, cast in bronze, stands behind the Royal Exchange.

By now, we have reached the former borough of POPLAR. The **Isle of Dogs**, once busy with the West India and Millwall Docks, stands silent, awaiting redevelopment. It is hoped that with the cooperation of the London Docklands Development Corporation, a new Docklands Museum, an off-shoot of the Museum of London, may before long be established in the north-west corner of the West India Docks in Poplar.³ It should provide a heart for the East London which must develop here, and there could be few prouder displays than one concentrating on London's history as a port and as an industrial centre, the 'workshop of the world'.

There are unexpected architectural delights here too. At the corner of Greenbank and Scandrett Street stands the tower – all that was left after bombing – of St. John's church; erected in 1790, the ruin is still imposing, its height topped with a swelling cupola. Along Wapping Pierhead, off Wapping High Street, stand dignified houses designed in 1811 by Daniel Alexander, Surveyor to the London Dock Company, as accommodation for the Company's employees, and nearby, in Wapping Wall, is the Prospect of Whitby public house, built about the turn of the eighteenth century, with a breath-taking view of the Thames from its terrace; the name commemorates a Mr. Prospect who owned that part of Whitby which supplied sea-coal to London. There is another excellent hostelry, the Grapes, in Narrow Street, and more elegantly purposeful houses around Limehouse Basin, then, as the road edges round the blunt thumb-tip of the Isle of Dogs, we are in Cubitt Town, laid out in the mid-nineteenth century as accommodation for dock workers. William Cubitt, brother of the better-known Thomas, designed Christ Church in 1852. The brick building was sited so as to command, imperiously, both the approach roads, its asymmetrical spire pointing, firmly, heavenwards. At this point it is vital to gain the waterfront and to look across to Greenwich, for the noble buildings of the Royal Naval College with the Queen's House and the Royal Observatory beyond them are seen to their best advantage from across the water. A foot tunnel runs from the Isle of Dogs to Greenwich and it is possible to walk under the Thames to this riverside paradise (see p. 363). Northwards along Preston's Road is a small turning called Coldharbour – suggestive nomenclature – in which stands yet another public house, the Gun, with a terrace which commands the riverside. Nearby, around Castalia Square, is one of the best and most humanely proportioned pieces of post-war redevelopment to be found in London. Shops and flats face onto a court-yard from which vehicles are barred, and the residents have clearly responded to the architect's vision by taking a pride in their surroundings.

On the eastern side of the borough the perimeter road joins the main artery of East India Dock Road, to the north of which lies Lansbury, an amorphous housing estate planned by the London County Council as a part of the Festival of Britain celebrations in 1951, now looking rather sadly down at heel. Beside or near to the main road stand four churches, all of them worth attention. The most ambitious, externally, is All Saints, designed by Charles Hollis in 1817–20, and built in smooth Portland stone with a giant Ionic portico, above which rises a tower supporting a steeple that might have been designed by Wren a century earlier. Near to it, in a little park, stands St. Matthias' church. Originally built in 1654

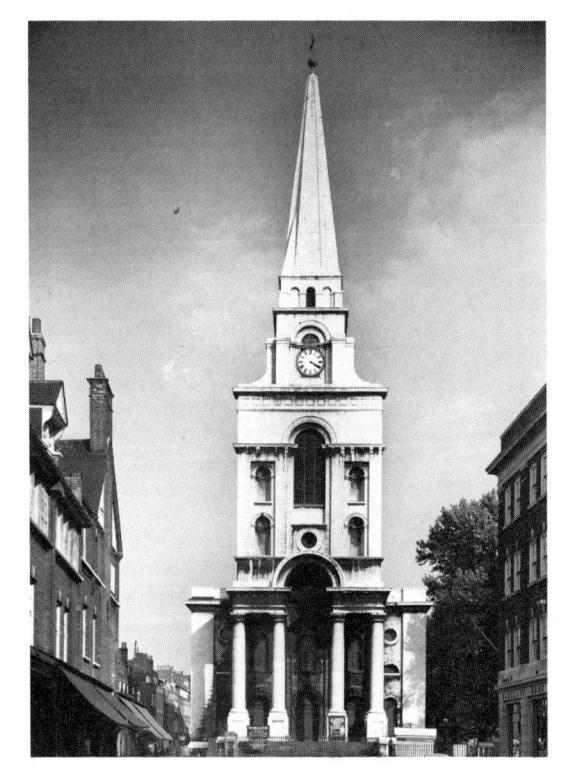

Christ Church, Spitalfields

¹ His larger works have returned to the parent museum, the Victoria and Albert; they stand, welcomingly, at the entrance to the new extension.

² He came to England as a political refugee in 1870 and became chief instructor at the South Kensington Art Schools.

³ I am most grateful to Chris Elmers of the Museum of London for this information.

Lansbury Market Place, Bethnal Green

as a chapel by the East India Company, it was substantially reconstructed in 1776 with the masts of ships used as columns along the nave. Flaxman carved a memorial here to the Shakespearian scholar, George Steevens, whom he portrayed in a comfortable chair, gazing fondly at a bust of the dramatist. In the third quarter of the century, Victorian improvers encased the little chapel in a strait-jacket of ragstone, added a cruelly ugly bell-turret, and obscured the windows with singularly unfortunate glass. The vicarage, happily, remained unspoiled.

Trinity Church, with a united assembly of Presbyterians and Congregationalists, stands on the opposite side of the road. It is a new building, an earlier edifice having been bombed, and was designed most successfully with a tower and lantern by Cecil C. Handisyde and D. Rogers Stark. Before the church stands a massive and imposing statue by Sydney Sharpley entitled *The Docker*, and inside there is some gracefully engraved glass. Just behind in Upper North Street stands the Roman Catholic church of St. Mary and St. Joseph, designed by Adrian Gilbert Scott in 1954 in the shape of a Greek cross with an enormous central lantern. Above the altar is a canopy and the pulpit is a little gallery by itself.

Back on the western side of the borough, the bulge of land lying between Commercial Road and the river comprises the waterside districts known as WAPPING, SHADWELL, RATCLIFFE, and LIME-HOUSE. Across the centre, parallel with each other from west to east, run Cable Street and the Highway; south of them, off East Smithfield, lies St. Katharine's Dock. The name comes from the Royal Hospital of St. Katharine, founded in 1148 by Matilda, Stephen's Queen, in memory of her sons,

Eustace and William, who died in babyhood. Eleanor, Edward I's Queen, confirmed the foundation in 1273, and Philippa of Hainault, Edward III's wife, established a chantry renowned for its choir. This patronage, extended down the centuries to the Hospital by generations of royal ladies, preserved it at the Reformation, but in 1825 commercial expansion succeeded, where religious zeal had failed, in obtaining its closure. The foundation was removed to Regent's Park where it continued, in curtailed form, till its recent rebirth. The site was excavated for St. Katharine's Docks which opened in 1828; Telford was the engineer and Hardwick the architect, though these early buildings have now all gone. In spite of bombing, the dock functioned till 1968 when it was closed and Messrs. Taylor Woodrow began to develop the site. The old dock has been retained as a marina where a number of historic craft, belonging for the most part to the Marine Trust's historic ship collection and including the Old Nore lightship, are now moored. A timber-framed brewery warehouse, built in the second half of the eighteenth century and thus pre-dating the dock, has been freed from a brick casing, moved to a more convenient site, and furbished up to become the Dickens Inn. The Ivory House, designed in 1854 by George Aitchison in a restrained Renaissance style with a sheltering arcade, originally guarded the more valuable cargoes; its ground floor has been converted into small shops, with offices and flats above. Two huge new blocks, the World Trade Centre and the Tower Hotel, have been erected.

Northwards, Wellclose Square and Swedenborg Square lie almost side by side. It was said that the Scandinavians warmed their hands at the Fire of London, so vast was the quantity of timber needed for the rebuilding. The merchants dealing with imports and sales settled over here, building themselves substantial houses. The Danes had their church in Wellclose Square and the Swedes in Swedenborg, called after the mystic Count Swedenborg who was buried there, while for a time Solander, the botanist, was pastor there. Both churches have gone but the Danes have built a new one at 649 Commercial Road. Designed by Holge Jensen and consecrated in 1950, it is built of dark red, very small, bricks, and it sits on the corner with Yorkshire Place so unobtrusively that it would be hard to find save for the bright flag of Denmark which flutters from the low tower. Inside, since the church is also a mission to Danish seamen, there is a club room, with an immense copper-cowled fireplace, and the church, small but lofty, is panelled with timber. Two statues, of St. Peter and St. Paul, carved by Caius Cibber who settled in London about 1660, are here; two more are in the Danish Church in Regent's Park (see p. 188) and the figures of Raving and Melancholy Madness, which he carved for Bedlam Hospital, are in the Museum of London.

The shell of an eighteenth-century church, Hawksmoor's St. George-in-the-East (1715–23), stands beside the Highway; gutted by incendiaries in May 1941, a new church has been built within the shelter of the old walls. Hawksmoor's church was planned as a Greek cross within a square, with a shallow apse at the east end, while to the west, the broad tower seems to smash its way through its own pediment and to soar upwards to the octagonal lantern, its angles reinforced by buttresses, each one topped with a Roman altar. On the north and south sides, the second and sixth bays project to support ogee-capped turrets like four neat pepper-pots. Within this Baroque framework, Arthur Bailey built a smaller, modern church which was rededicated on 26 April 1964. Hawksmoor's tower was left free-standing with a small courtyard between it and the new church, the west end of which is almost entirely of glass so that the interior is filled with a strong light. It is a plain interior, save for the five glass mosaics which were set in the walls of Hawksmoor's apse in 1880. Beneath the church is a large parish hall. The Whitechapel Bell Foundry cast a new peal of bells for St. George's.

St. Paul's church in the Highway was designed in 1817–21 by John Walters, a gifted architect who died very young. The west tower, topped by a circular stage and an obelisk, recalls Wren's City churches. Beside it is King Edward's Memorial Garden in which an inscribed stone recalls that it was from this reach of the Thames that Sir Hugh Willoughby, Richard Chancellor, William Borough, and Sir Martin Frobisher set out during the sixteenth century on their voyages of discovery and exploration in 'tall ships of the city of London', as Hakluyt wrote. Just beyond the park, Cable Street and the

Highway are linked by Butcher's Row, on the east side of which lies the churchyard of St. James's church. The church was destroyed by bombs, but the Georgian vicarage remains, and is today the Royal Foundation of St. Katharine. Revived after the Second World War under the patronage of Queen Mary and Queen Elizabeth the Queen Mother, the Foundation carries on the work of prayer, as the medieval Hospital did, undertakes much active social work in the immediate neighbourhood, and provides a centre for study and retreat. A chapel designed by Messrs. Enthoven has been built, in which the immaculately preserved medieval stalls have been reinstated; the carving of the misericords is as fine as on those in Westminster Abbey and there are contemporary statues of Edward III and Philippa of Hainault. Permission to visit should be sought from

Cable Street and the Highway merge in the Commercial Road which soon joins the East India Dock Road. At their junction stands the third of East London's Hawksmoor churches, St. Anne's Limehouse (1712-30). Another astonishing Baroque performance, its dominating feature, as usual, is the west tower, this time with an apse instead of a portico for an entrance and a tower that bulks more substantially than those of its sisters by reason of the pilasters attached to the corners of its lower stages and the buttresses which stand free on the diagonals of the eight-sided lantern topped by four minute pepper-pots. Two dumpy turrets mark the east end. The north and south sides are very plain, stone-faced, with seven tall, thin, round-headed windows. On the north side lies a sunless churchvard; in it stands a memorial to those who died in the First World War. with a large, insipid figure of Christ standing on a pedestal, in which is set a bas-relief of terrifying vividness, representing the barren, shattered landscape of trench warfare. The interior of St. Anne's is planned as a Greek cross within a rectangle, the corners being marked out with Corinthian pillars. The chancel is a shallow recess, separated from the nave by a broad, depressed arch like the proscenium arch of a theatre, and lit by an east window flanked by pairs of richly carved pillars. The stained glass of this window, by Clutterbuck, represents the Crucifixion and is dark and foreboding, filling the church with an eerie light when there is a thunderstorm. Hawksmoor was like no other architect. Dutiful in his service to Wren, self-effacing in the provision of technical knowledge with which he supported Vanbrugh's more flamboyant genius, his own creativity was most clearly expressed in his London churches. The proximity of these three in Stepney, Christ Church, St. George-in-the-East, and St. Anne's, reinforces the individual effect of each; despite the injuries of war and time, they remain, louring, indomitable, aspiring, unmistakably a legacy from one of Europe's greatest and most surprising architects.

The Tower of London

The Tower of London gives its name to the borough of Tower Hamlets in which it stands. Since it is the most important secular medieval building in London, and since it is a place of extraordinary delight, quite at variance with its grim history, both to Londoners and to visitors, it seems best to give the fortress and its environs a chapter to themselves.

Stand on the summit of Tower Hill, in Trinity Gardens, and look towards the river. The Tower of London fills the whole foreground and, seen from a little distance, the crowds of tourists which throng it, summer and winter, may be ignored and a proper attention given to the line of the outer defences beyond the moat, with their rhythm of bastions alternating with stretches of wall, which wrap themselves around the core of the citadel, the White Tower, the Conqueror's own stronghold. Perhaps the finest and most important example of early medieval military architecture left in England, the Tower is the supreme symbol of the feudal system, a visible demonstration of the might and authority of medieval monarchy. This was the king's last fastness, his treasury, his arsenal, and his secure prison.

William was accepted by the citizens of London as king in December 1066, two months after the Battle of Hastings. He promptly granted them a mollifying charter, confirming all their rights and privileges, but early in the next year a temporary earthwork was constructed in the extreme south-east corner of the city, where the considerable remains of the Roman defences formed an acute angle by the river. The choice of terrain, though lacking any particular natural advantages, was strategically sound; the Tower commands the river, up which an attack might come as it had done in 1015 when the Vikings destroyed London Bridge, and it controls the Bridge itself which would, almost inevitably, be the target of any attack from the south. The Conqueror needed to protect his newly-won capital as well as to overawe its 'vast and fierce populace'. In 1078, a monk, Gundulf, came from the abbey of Bec in Normandy to hold the Bishopric of Rochester and to plan and supervise the building of a more permanent stronghold. Stone was imported from Caen for dressing the massive ragstone walls, 90 feet high and 15 feet thick at the base. The keep, which appears to be square, is of irregular shape for the sides are of different lengths - 118 feet on the south, and 107 feet on the west and three of the corners, from which rise ogeecapped turrets of various shapes, are not right angles. At least from the time of Henry III, the walls were whitewashed, thus giving the citadel its name - the White Tower. Work on it was more or less completed by 1097. It was the White Tower that was held in pledge for the completion of Magna Carta, and it was here, during the long wars with France and with Scotland, that David and James I, Kings of Scotland, John, King of France, Charles, Duc de Blois, and John de Vienne with his twelve brave burgesses from Calais, were all lodged. It was in the Tower in 1399, where he had once taken refuge from Wat Tyler's mob, that Richard II signed away his crown to his cousin, Bolingbroke, the future Henry IV, and it was here that that monarch's son installed the poet duke, Charles of Orleans, whom he had taken prisoner at Agincourt in 1415. A book of his lyrics, illustrated in England in the Flemish style for Henry VII or for his son, Prince Arthur, and now in the British Museum (MS Royal 16. F. ii), shows on folio 73 the captive duke sitting in a perfectly recognizable, sparkling white Tower, writing home at the end of his 25 years' imprisonment. In the background of this first real view of London, St. Paul's Cathedral, the churches of the City, and London Bridge are clearly depicted.

The White Tower is a noble example, exceeded in size only by Colchester Castle, of that familiar medieval fortification, the hall-keep. No building of comparable strength had been raised in England since the Roman occupation, yet this nonpareil of a fortress, well able to withstand the fiercest of attacks by the armies of the day, cradled within its walls chambers fit for the abode of a king and his family. Several royal children were born within the Tower; the effigy of one of them, Edward III's little daughter, Blanche de la Tour, may be seen in Westminster Abbey. This accommodation naturally included a chapel, dedicated to St. John, for the king's devotions. Virtually unaltered since it was completed soon after 1080, this chapel, $55\frac{1}{2}$ feet long by 31 feet broad, is the oldest complete church building in London and one of the most important examples of Norman work to be found anywhere in the country.

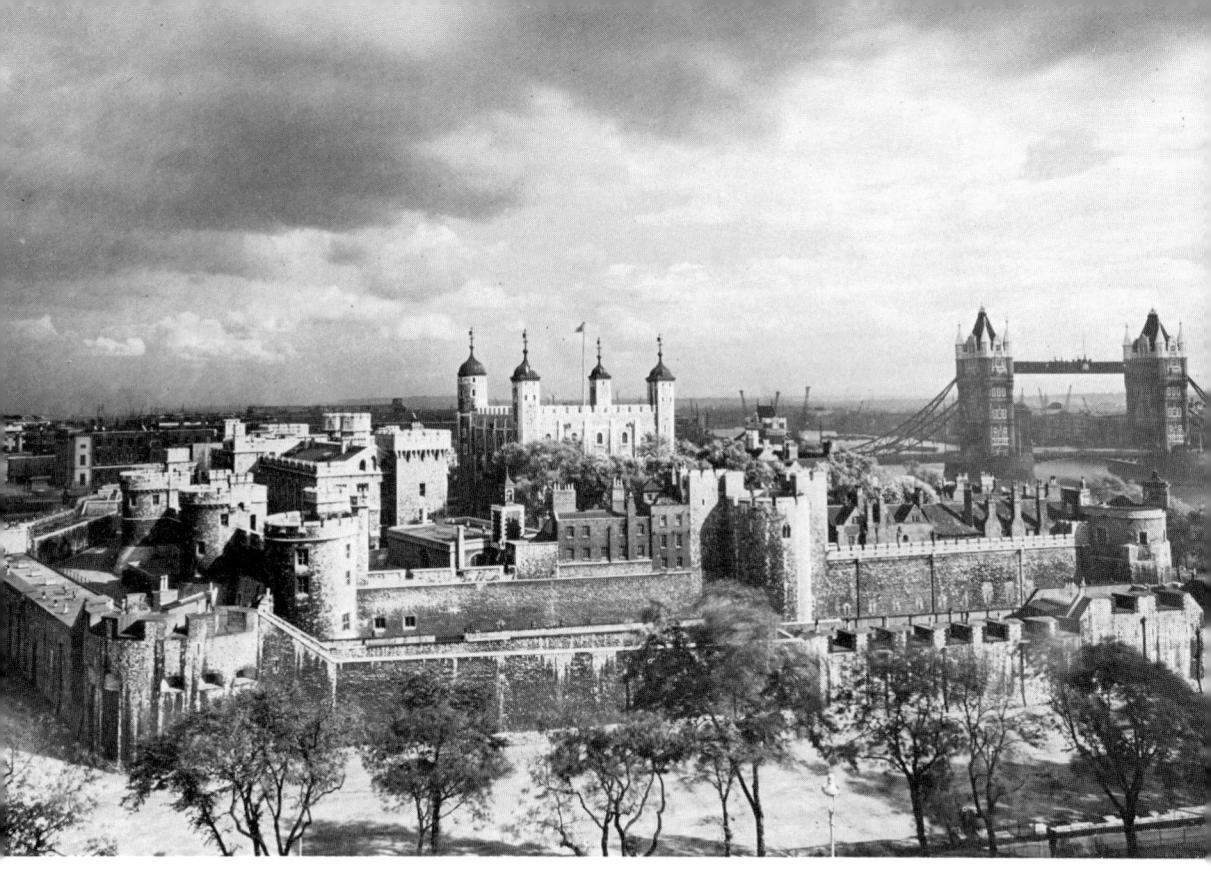

Tower of London

The nave and the sanctuary are undivided, but all around runs an arcade of massive cylindrical pillars, their bulk supporting a continuous gallery and the heavy tunnel vault, while they divide the groinvaulted aisles from the nave and form an ambulatory behind the altar. All these pillars, save one, have identically carved square capitals, an impressive Tshaped cross on each side with the corners chamfered away and grooved. The sole exception, on the south side of the altar at the east end, is wreathed with a slender chaplet of spiky foliage, as if the mason who carved the stones was determined to bring some hint of the green woods into this implacably brooding chapel, the still centre of so much petrified history. It was here that Henry VI's body was brought after his murder, that Elizabeth of York, Henry VII's Queen, lay in state, surrounded by 800 candles, after her death in childbed, that Lady Jane Grey prayed on the night before her execution, and that Mary Tudor was betrothed, by proxy, to Philip of Spain, a trothplighting as unhappy for the poor lady and for England as those earlier, bitter events.

Today, the White Tower houses the Royal Armouries. A Line of Kings was set up as early as Charles II's reign and has been on view, in different locations, almost ever since; it can claim to be the oldest museum display in England. The wooden figures and the horses on which the armour was

shown were carved by some of the leading sculptors and craftsmen of the day, Grinling Gibbons among them - he was paid £40 in 1685 for a likeness of Charles I and for a horse – and examples can still be seen in the galleries. Recent restoration has seen the principal entrance to the White Tower returned to where the Conqueror and Gundulf intended it. In the Armouries, weapons and equipment for sport and for tournament are on view, while above, on the level occupied in part by the Chapel of St. John, are European arms and armour from the Viking period to the fifteenth century. The visitor should note especially a magnificent harness for horse and man made in Germany during the late fourteenth century. the decorated 'Lion' armour made in France about 1540 and, among the equipment used by ordinary soldiers, two longbow staves, salvaged from the wreck of the Mary Rose which sank in 1545, examples of what was once our national weapon. The topmost floor, which was probably inserted in 1603-5, houses the Royal Armour Gallery, with four suits worn by Henry VIII, his increasing corpulence made manifest, as well as much other fine work from the Royal Armouries at Greenwich. Among the weapons is a unique series of gun shields. In the adjacent gallery are the Stuart royal armours, including an engraved gilt harness made for Charles I and a smaller, beautifully decorated suit, made for Charles

II when he was about fourteen. In a case opposite is a buff leather coat, said to be the one worn by Colonel Hacker, who officiated at Charles I's execution. The staircase from this gallery leads down to the basement where mortars and cannon are displayed.

Though under blockade in 1141 during the wars between Matilda and Stephen and again in 1191 when Richard I was absent on crusade and the London populace, led by the King's brother, Prince John, besieged William Longchamp, Richard's regent, and forced him to surrender the fortress, the White Tower was never called upon to withstand a sustained attack or siege by experienced troops. However, the troubles of Henry III's minority and long reign induced him, and later his warlike son the future Edward I, to rebuild the outer defences on a more impressive scale, incorporating the most advanced theories of the period in military architecture. The White Tower and Inmost Ward were encircled by two concentric lines of defence, first a wall with 13 towers set at intervals and beyond the Outer Ward a second wall with six towers facing the river and two semicircular bastions to the north-east and north-west. Around these, a moat, now partly filled, was dug. By 1307, the year of Edward's death, the defences were virtually complete.

The main entrance is from Tower Hill. The Lion Tower, once the home of the menagerie which used to delight the kings of England from Edward I's day till 1834, when the last inmates left to join the London Zoo, was demolished; its place is now taken by offices and a tourist shop. Passing under Middle Tower, a causeway crosses the moat to reach Byward Tower, where in 1953 a wall-painting was uncovered, showing Our Lady with saints against a background of the leopards of England and the fleur-de-lys of France. The roof-beams too were painted. Permission to view may be obtained from the Governor of the Tower, if sought in advance. The yeoman warders, popularly known as Beefeaters, are one of the great delights of the Tower; their blue undress uniform, granted to them by Queen Victoria in 1858, is handsome enough, but their scarlet and gold state uniform, the fashion of which dates from 1552, is spectacular.

As we have said, there are 13 towers set about the wall of the Inner Ward. Beginning in the south-west corner with the Bell Tower and travelling clockwise, we will examine them one by one. It was in the Bell Tower that John Fisher, Bishop of Rochester, and Sir Thomas More were lodged before being led out to die on Tower Hill for their refusal to recognise Henry VIII as head of the Church of England. Henry's own daughter, Princess Elizabeth, spent some months here in close confinement during the reign of her elder sister, and here the Duke of Monmouth, Charles II's illegitimate son, was imprisoned before being executed for his rebellion against his uncle, James II. To the north lies the Beauchamp Tower, which is usually open to the public. Here are to be

found some of the inscriptions which prisoners have carved on the walls of the Tower, a number of them having been brought here from other parts of the fortress. The most heart-rending, and perhaps the best known, is the single name, 'IANE' which has always been said to refer to Lady Jane Grey, Oueen of England for nine brief days, whose husband, Lord Guildford Dudley, was imprisoned here prior to his execution. His four brothers were also confined here at intervals and the eldest. John, who died in 1554. carved their crest, a bear and a lion holding a ragged staff, surrounded by flowers symbolizing brothers' names - roses for Ambrose, oak leaves for Robert (robur - an oak; this hardy gentleman survived to become Queen Elizabeth's trusted courtier, the Earl of Leicester), gillyflowers for poor Guildford, and honevsuckle for Henry.

Around the northern wall are set the Devereux Tower, where Robert Devereux, Earl of Essex, was lodged prior to his execution in 1601, which his Queen was so loath to exact, the Flint Tower, and the Bowyer Tower, where tradition has it that the Duke of Clarence was drowned in a butt of malmsey wine in 1478, and in which a small display on torture and executions has been opened, the block and axe being among the more sinister exhibits. Then come the Brick Tower and the Martin Tower where the regalia were housed from 1669 to 1841, and from which Colonel Blood tried, unsuccessfully, to steal them, only to be rewarded, rather curiously, with a pension by Charles II. Along the east wall stand the Constable, Broad Arrow, and Salt Towers: the latter contains numerous inscriptions carved by prisoners therein. All the towers along the inner, eastern defence, together with their connecting curtain walls, were opened to the public during 1983. Turning westwards along the south wall, we come to the Lanthorn Tower, followed by the Wakefield and Bloody Towers. On the first floor of the Wakefield, there is a fine vaulted room with an oratory recessed in the south-east wall; tradition holds that the saintly but ineffectual monarch, Henry VI, was stabbed to death here after Edward IV's victory at the Battle of Barnet (see p. 200). On 21 May, the anniversary of his death, representatives from Eton College and King's College, Cambridge lav lilies and white roses on the spot where their founder fell. His death was most horribly avenged when Edward's two young sons, Edward V and the Duke of York, were murdered next door in the Bloody Tower. We do not know whether the children were slaughtered on the orders of their uncle, Richard III, or his successor, Henry VII, but in 1674 two childish skeletons were found buried under a staircase on the south side of the White Tower; Charles II ordered that they should be interred in Westminster Abbey where they rest to-day, in Innocents' Corner (see p. 104). Other prisoners in the Bloody Tower were Thomas Cranmer, Archbishop of Canterbury, and Sir Walter Raleigh, who spent 12 long years there - the rooms

have recently been refurnished as they would have been in Raleigh's time, very plainly but quite comfortably, and a copy of The Historie of the World, which Raleigh wrote during his incarceration, is displayed. Archbishop Laud was lodged here and it was from a window in this tower that he blessed the Earl of Strafford on his way to the scaffold on Tower Hill whither he himself, a martyr for the Church of England beside many who had laid down their lives for the Catholic Church, made a last walk on 10 January 1644. The cruel and blood-thirsty Judge Jeffreys died here, delirious, in 1689. In this tower too there is a serviceable portcullis. Facing the Bloody Tower, on the river side of the defences, is St. Thomas's Tower with its enormous Traitors' Gate beneath; this was built as the principal water entrance into the Tower during the 1280s when the outer defences were erected. It was by this entrance that Princess Elizabeth came on Palm Sunday in the spring of 1544 on the orders of her sister, and could hardly be persuaded to land for, she declared, she was no traitor.

The archway under the Bloody Tower leads directly into the Inner Ward. In the centre stands the White

Tower, and in the sheltered south-western corner of the walls is the Queen's House. Rebuilt in 1540, it probably incorporates the remains of the medieval Constable's House; its gables are adorned with fanciful barge-boarding. The south range contained a spacious hall some two storeys in height but a floor was inserted in 1607 and the upper floor, in which the Gunpowder Plot conspirators were interrogated, became the Council Chamber. Anne Bolevn and Katharine Howard spent the last days of their lives here, and so did Lady Jane Grey who, watching from the window, saw her young husband walking to the scaffold on Tower Hill and then his headless body carried back on a cart, while on the green before the house, another scaffold was being prepared for her own execution later in the same day. It was probably through this front door that a more fortunate prisoner, the Jacobite Lord Nithsdale, slipped away to safety on the night before his execution, clad in the woman's dress and cloak which his resourceful and determined wife had smuggled in to him. Rudolf Hess, the Deputy Führer, spent four days here in May 1941 after a parachute landing in Scotland. The house is not open to the public.

Chapel of St. John, Tower of London

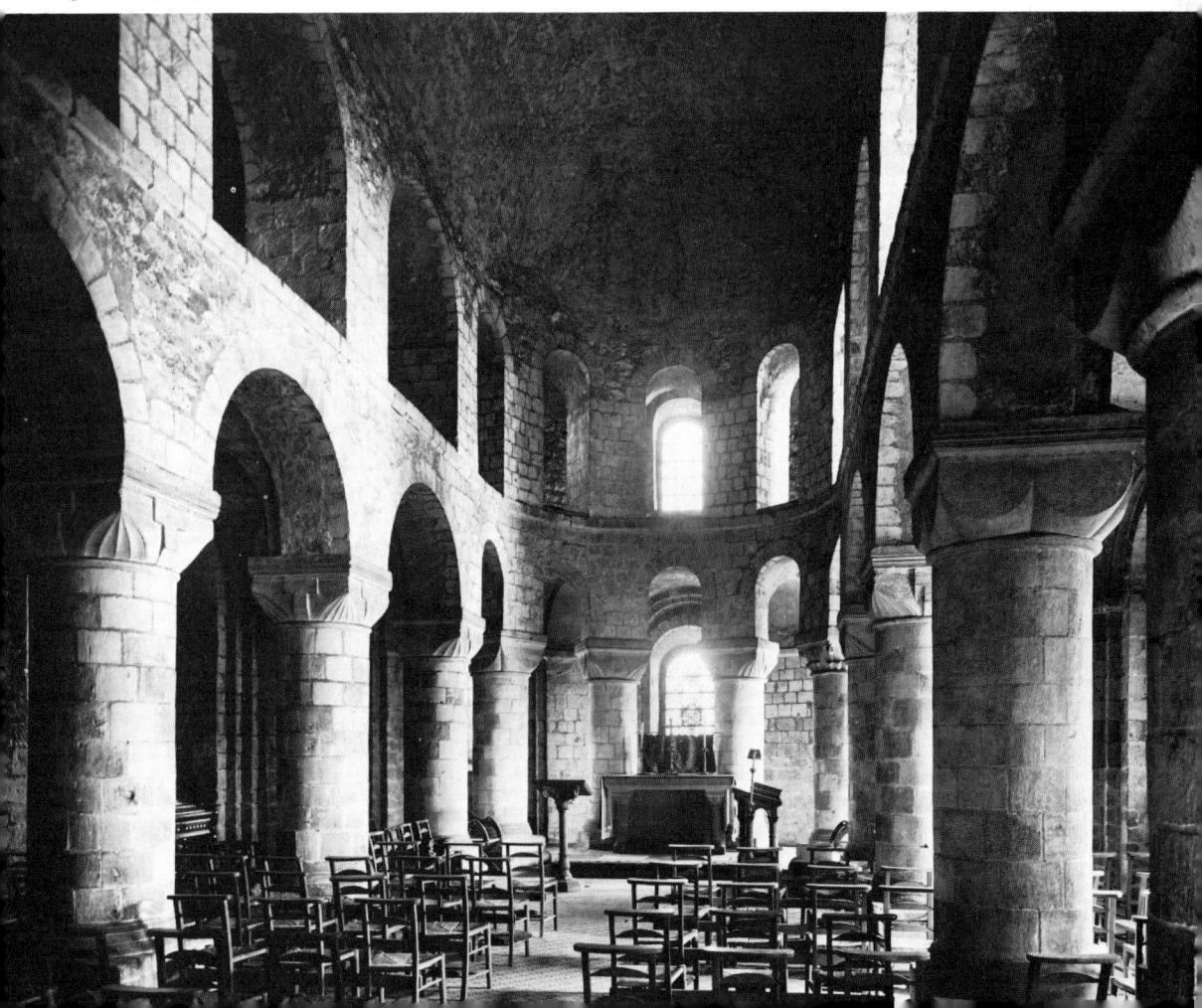

The windows of the Queen's House look onto the site of the scaffold on Tower Green, on which seven royal or noble heads have fallen. They belonged to William, Lord Hastings (June 1483), Anne Boleyn, Henry VIII's second wife (19 May 1536), Margaret, Countess of Salisbury, the last of the Plantagenets (27 May 1541), Katharine Howard, Henry VIII's fifth wife, and her lady-in-waiting, Iane, Vicountess Rochford (13 February 1542), Lady Jane Grey (12 February 1554), and Robert Devereux, Earl of Essex (25 February 1601). All seven were buried in the chapel of St. Peter ad Vincula, Today, chain and cobblestones mark the site of the block, and ravens, the last representatives of the royal menagerie, strut about the site, the gruesome cusp of their beaks cocked for titbits, expectantly eveing the crowds of tourists who, eager to hear of past sufferings, hang on the words of the veoman warder who lectures to them.

The Chapel of St. Peter ad Vincula fills the northwestern corner of the Inner Ward. Evidently this was a parish church before it was engulfed by Henry III's expansion of the defences in the mid-thirteenth century, though what remains today dates largely from after a severe fire in 1512. It is a plain, unpresumptuous building, with a modest west tower topped with a pretty bell-turret. The interior consists of a nave and north aisle, both radiant with light through the wide windows, though of it Macaulay wrote: 'In truth, there is no sadder spot on earth' for here, in Stow's words, lie 'two dukes between two queens, to wit, the Duke of Somerset and the Duke of Northumberland, between Queen Anne and Queen Katharine, all four beheaded'. In death they keep brave company; Fisher and More lie here, Anne Bolevn's dear brother, Lord Rochford, is near her, Lord Guildford Dudley and Lady Jane Grey close by, and the Scottish lords, Tullibardine, who died in captivity, Kilmarnock, Balmerino, and Lovat, who went to the scaffold, support each other in death as they did in life. Simon Fraser, Lord Lovat, was the last man to die by the axe in England. All these were interred without ceremony, but there are monuments for those who died in the course of nature and were buried here because, in life, their duties associated them with the Tower. Sir Richard Cholmondeley prepared a fine tomb-chest in his life time, with effigies of himself and his wife, Elizabeth, but their bodies never lay there since, before he died in 1554, Sir Richard had fallen from the king's favour. The sixteenth-century font was hidden in the empty tomb during Stuart times and was not found till this century when it was once again put in its proper place. Sir Richard Blount, Lieutenant of the Tower (d.1564), and Sir Michael, his son, who held the same office (d.1592) appear with their families on a marble and alabaster wall monument. The two generations kneel in four arched bays, separated and flanked by Corinthian columns, with delicately carved masks on the keystones and garlands festooned in the spandrels. George Payler, Master Survevor of the Ordnance (d.1651) shares his monument with his wife, Maria, and their three small children. Busts of the parents rest in oval niches, two swaddled babies and a little girl recline in niches between them. Captain Valentine Pyne, Master Gunner of England (d.1677), has a tablet with a cannon in place of supporting columns. The grandest tomb of all is that of John Holland, Earl of Exeter (d.1447), who was originally buried in St. Katharine's Hospital. The Earl's alabaster effigy is kept company by figures of his first and third wives. The organ which was originally made in 1676 by 'Father' Schmidt for the Chapel Royal, Whitehall, still retains some of its original pipes. Parties are allowed to enter the church under the supervision of the yeoman warder, but it is better to attend service here on a Sunday when the little church fulfils its proper function. All worshippers are permitted to enter the Tower free of charge.

Along the northern wall of the precinct run the Waterloo Barracks, designed by Antonio Salvin in 1845. In 1967 the western end of the range was converted to provide a new Jewel House in which the regalia and plate used at the coronation of the kings and queens of England are kept, ready for use and available for the inspection and admiration of the public. Much of the plate, and especially that made for George IV's coronation banquet, seems ostentatious. The achievements of six centuries of medieval craftsmanship were briskly melted down, broken with hammers, or sold off by Oliver Cromwell, who found it as difficult to control the finances of the country as his predecessor, Charles I, had done, so that, when Charles II was restored to his father's throne, there was no regalia and a new crown, called to this day St. Edward's crown for it was the lineal descendant of the diadem worn by the Confessor, had to be made for his coronation. Only two ancient pieces remain, the anointing spoon, possibly made for the coronation of John in 1199, and the ampulla, fashioned like an eagle, which holds the oil for the anointing and was probably made during Henry IV's reign (1399-1413); both objects needed repair before they could be used for Charles II. The Imperial State Crown was made for Queen Victoria's coronation in 1834; in it are set an ancient ruby, said to have been given by Pedro the Cruel to the Black Prince after the Battle of Navarette in 1367 and later worn by Henry V in the coronet surrounding his helm at Agincourt, the Stuart Sapphire which James II took with him at his deposition, the second largest of the 'Stars of Africa', cut from the Cullinan diamond and, in the topmost cross, an ancient sapphire, thought to have been taken from the Confessor's ring when his tomb was opened in the twelfth century. The Indian diamond, the Koh-i-Noor, is set in the crown made for Queen Elizabeth the Queen Mother in 1937. The five swords of state, the sceptres, in one of which is set the largest of the 'Stars of Africa', the

orb, and the 'ring of kingly dignity' which is placed on the third finger of the monarch's right hand, are here too.

Along the eastern side of the Inner Ward stand the Royal Fusiliers' Museum, the Hospital Block, and the New Armouries. Opposite the junction of the two latter, beside the curve of the White Tower's wall which contains the apse of St. John's Chapel, is a small section of the Roman city wall and the foundation of a later Roman bastion beneath the remains of the twelfth-century Wardrobe Tower. The position and construction of the wall should be related to those other sections of the defences to be seen outside the Tower precinct in Wakefield Gardens and Cooper's Row.

No description of the Tower is complete without some mention of a curious ceremony, to which the public, if they apply in writing to the governor, may be admitted each evening. This is the Ceremony of the Keys, the nightly locking-up of the Tower, and its manner of performance has not changed for almost 700 years. It begins at 9.53 p.m. (21.53 hours) precisely and ends at ten o'clock with the great outer gates safely locked by the chief warder, the Queen's Keys saluted by the soldiers and guards, and the Last Post sounded. Picturesque enough to please the most romantic, the ceremony is both reassuring and moving. The visitor should also look at Tower Wharf from whence Royal salutes are fired by members of Honourable Artillery Company anniversaries of the birth, accession, and coronation of the sovereign, at the birth of a royal infant, and on other suitable occasions.

Before leaving the vicinity of the Tower, the summit of Tower Hill and the buildings around it in Trinity Square may be explored. The hill top is crowned with the curve of the war memorial to the 36,000 dead of the mercantile marine in the two World Wars. Designed by Sir Edward Maufe, with sculptures by Charles Wheeler, the wall and garden seem cold and impersonal even when stained with the scarlet of the Armistice Day poppies, reminders of the countless individual sacrifices which receive tribute here. In one chilly corner, a paved square marks the site of the scaffold where, through the centuries, more than 125 people were executed. An inscribed stone is set there, 'to commemorate the tragic history and in many cases the martyrdom of those who, for the sake of their faith, country or ideals, staked their lives and lost'. Wallflowers perfume the spot now but it is still a dreadful place.

Just to the east of Trinity Square Gardens are Wakefield Gardens, laid out around one of the most impressive stretches of Roman wall. In it is set a reconstructed replica of a tombstone (the surviving original fragments are in the British Museum) set up in memory of Julius Classicianus by his sorrowing widow, Julia Pacata. He was that procurator who, after Boadicea's uprising, appealed to Rome that

Suetonius' vengeance on the rebels might be restrained. The ruthless general was recalled to Rome and Classicianus remained to control the province, dying at last in the city which he had cherished.

On the north side of Trinity Gardens are the former Port of London Authority headquarters (Sir Edwin Cooper, 1912-22) though the Authority has moved its premises to St. Katherine's Dock. Beside it stands Trinity House, its elegant façade contrasting with the elephantine bonhomie of Cooper's building. Trinity House had its origins in an early fifteenthcentury fraternity of seamen and pilots; its objectives were, and are, the safeguarding of navigation and the relief of poor mariners. Henry VIII granted it a charter in 1514, the corporation's first lighthouse was built in 1680, and its good work still continues today. The present building was designed in 1792-4 by Samuel Wyatt; though almost destroyed in the Second World War, his façade was reconstructed by Sir Albert Richardson. Admission to the building is permitted on Saturday mornings, application having been made previously in writing. In the entrance hall stand two interesting lead statues, the earlier of Captain Maples by Jasper Latham (1683), the later of Captain Sandes by Scheemakers (1746).

To the east of Tower Hill stood the Royal Mint, which moved to this building in 1811 after having coined money in the Tower since before 1300. The building, rather sombre with a portico of six Tuscan columns, was planned by James Johnson and completed after his death by Sir Robert Smirke. The Mint has left London for Llantrisant in Wales; there is some possibility that the building may one day be opened as a numismatic museum. To the south of it. spanning the river effortlessly, is Tower Bridge. Designed by Sir Horace Jones and Sir Wolfe Barry, and opened on 30 June 1894, the middle section of the roadway can be raised to permit large vessels to enter and leave the Pool of London. The silhouette of its beginnacled twin towers - 'steel skeletons clothed with stone', as their architect wrote - festooned with chains for the lifting bridge between them, provide a symbol of sufficient power and distinction to signify London throughout the world. On 30 June 1982, a museum on four different levels was opened inside the bridge. Imaginative displays tell the history and explain the mechanism; the working drawings by George Stevenson, the assistant architect, are exquisite. At the foot of the bridge, on the south side. the original boilers, steam and hydraulic engines, and accumulators can be seen, the giant spanners needed for maintainance beside them. Animated diagrams, a video film, a model, and reconstructed mechanisms explain the engineering. The upper part of the bridge has been made into two enclosed glass walkways, providing panoramic views up and down the river and across London; the prospects are, genuinely, breath-taking and the opportunity for photographers unequalled.

Waltham Forest

The London Borough of Waltham Forest lies to the north-north-east of the London area and consists of the boroughs of Chingford, Walthamstow, and Leyton, all of them formerly in Essex. Its $15\frac{1}{2}$ square miles, with a population of some 215,000, form a long, thin rectangle running from high ground in the north at Pole Hill, Chingford, to the low-lying marshes of Levton. Along the western boundary stretches a chain of reservoirs; when they were dug, in 1869 and 1900, a crannog or Iron Age pile dwelling was found where the Maynard Reservoir now is, and the Lockwood Reservoir vielded an oaken Bronze Age canoe, now in the British Museum. Along the eastern side lies Epping Forest, the substantial remains of Waltham Forest, which now lends its ancient name to the new borough. Extending for nearly 12 miles, from Wanstead Flats by the Thames to Epping in the north, these nine square miles of former royal forest are the responsibility of the Corporation of London and are by far the largest open space controlled by a public body. Protected by the Epping Forest Act of 1878, Oueen Victoria was able, on 6 May 1882, to proclaim it 'an open space for the enjoyment of the people for ever'.

In the extreme north of the borough CHINGFORD sits on its hill, looking out across the Lea Valley. There are two parish churches, one old, dedicated to All Saints, and one new, under the protection of St. Peter and St. Paul. Documentary evidence shows that the old church was established by 1181 but of Norman masonry nothing remains save, possibly, the lower courses of the north wall. Most of the church was rebuilt in ragstone about 1270-80, the tower being added about 1400 and the chancel needing a second rebuilding about 1460. A brick porch was added early in the sixteenth century. Over the years, the population of Chingford shifted so that, when the new parish church was built a mile to the north-east in 1844 by Lewis Vulliamy, the old one was allowed to decay and to become overgrown with vegetation so that it was known as the 'Green Church' and was a favourite subject for local artists and for such better-known men as the Pre-Raphaelite painter, Arthur Hughes. He set his Home from Sea (now in the Ashmolean Museum, Oxford) in Chingford churchyard; the young sailor lies sobbing on his mother's grave, watched sympathetically by his sister, with the old church in the background. An energetic and remarkably successful restoration was undertaken in 1928-9, financed by Miss Boothby-Heathcote, the daughter of the former rector, with C. C. Winmill as architect. The foliated thirteenthcentury stone cross, now set under the tower arch, originally adorned the exterior, and imaginative use has been made throughout of the old carved stones. The most interesting monument is to Mary Leigh, who died in childbed in 1602 and is shown with a swaddled infant in her arms; near to her are small effigies of her relations by marriage, Sir Robert Leigh (d.1612) and Margaret Leigh (d.1624). In the churchyard, the following dramatic verse was, till recently, legible on the tombstone of Anne Ungley (d.1771):

This life's a city full of crooked streets,
And death's the market place where all must meet.
If life were merchandise which all could buy
None but the rich would live; none but the
poor would die.

Three bells, of 1626, 1657, and 1835, have been restored to the tower, after a long sojourn in the belfry of the newer parish church.

St. Peter and St. Paul, standing beside Chingford Green, still retains the twelfth-century Purbeck marble font, its sides carved with a shallow, blind arcade. Vulliamy's church was enlarged in 1903 by Sir Reginald Blomfield. There is an unusual altar frontal in the St. Elizabeth Chapel, embroidered in 1969 by Mrs. Joyce Williams, and the ladies of the parish have worked kneelers to go with it.

Half a mile due north of the church is the top of Pole Hill, on which is set an obelisk, erected in 1824 by the Reverend John Pound, Astronomer Royal, to mark the true north when sighted from Greenwich Observatory. 60 years later, the meridian was adjusted and the true north now lies 19 feet to the east of the obelisk.

Less than a mile eastwards, in Ranger's Road, is a most unexpected building known as Queen Elizabeth's Hunting Lodge. It is indeed a three-storey standing from which the progress of the hunt might be viewed, but it was completed in 1543, in Henry VIII's reign. Timber-framed and L-shaped, a broad staircase spirals round a square newel-post to the top floor where visitors may see the carpentry of the open roof structure, with its arched braces, collar beams, queen posts, and purlins. The building is today in the care of the Corporation of London and serves as a small museum. The displays are chiefly devoted to the natural history of the area. William Morris knew the lodge from his boyhood and wrote of 'the impression of romance it made upon me'. It still makes a similar impression.

The small enclave around St. Mary's church in WALTHAMSTOW is so quiet and so comparatively unspoilt that it is almost a shock to come to it at the top of Church Hill after the noise and bustle of the shops - early nineteenth-century, clumsily adapted, cheek by jowl with 1930s Art Deco façades - which line Hoe Street, while Walthamstow High Street is one of the longest in Britain. The church was founded early in the twelfth century but all that is left of the medieval building are the remains of round columns in the north and south arcades, which are probably of the thirteenth century. The north chapel and aisle and the west tower were built c.1535 at the expense of Sir George Monoux, a merchant and local benefactor, who founded the excellent school which bears his name to this day. Money under the will of Robert Thorn, who founded Bristol Grammar School, covered the cost of the south aisle and chapel; the south porch was probably added at the same time. The church was drastically restored in the early nineteenth century and was encased in a straitjacket of Roman cement which successfully conceals the work of earlier craftsmen. Sir George Monoux's brass has been reset in the north pillar of the chancel arch; he kneels opposite his wife, Dame Ann, scrolls issuing from their mouths with the legends: 'O Lorde shew thy mercy unto us' and 'O Lorde give to us thy salvation'. Thomas Hale's brass lies in the north aisle but only an indent shows where his wife, who died in 1588, used to stand beside him. Among a wealth of good, small memorials, there are three of real artistic importance, to Lady Stanley (d.1630), to Sir Thomas and Lady Merry, and to Sigismund Trafford (d.1723). Four of Lady Stanley's seven daughters were buried with her in Walthamstow church and their busts appear in the corners of the monument, while their mother kneels, life-sized, grandly dressed, with an elaborate coif on her head, in the centre. The sculptor of this impressive work is unidentified, but we know that Nicholas Stone executed the Merry monument for £50 in 1633, after Lady Mary Merry's death in the previous year. Sir Thomas did not die till 1654 and so, for the last 20 years of his life, he must have contemplated his own memorial each Sunday. Busts of the husband and wife are framed in oval niches and there are relief portraits of two sons and

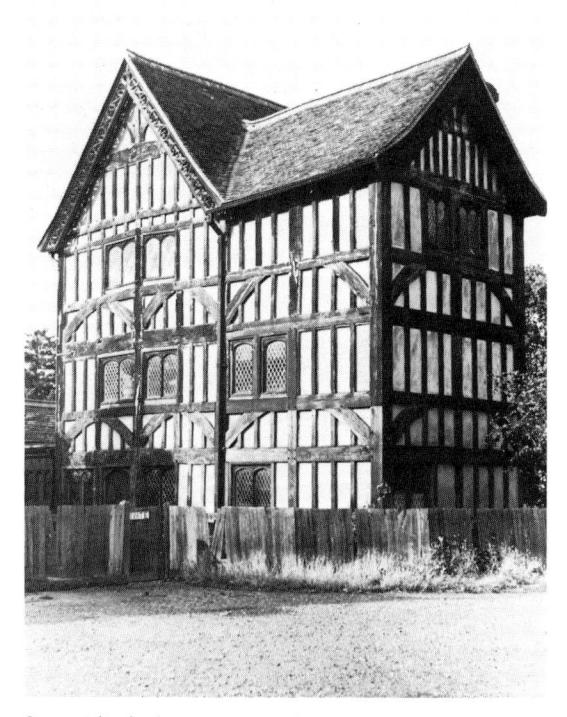

Queen Elizabeth's Hunting Lodge, Chingford

two daughters below the inscription. The individuality of the portraits suggests that they were executed from life; the sons appear to have had very different temperaments, the daughters look purposeful ladies. Sigismund Trafford's memorial was also erected many years before his death; an unknown sculptor has portrayed him, in company with his wife and infant daughter, life-sized and in classical garb.

Other buildings in the vicinity of the church deserve careful attention. The Ancient House, a fifteenth-century, timber-framed building, stands to the south of St. Mary's, on the corner of Church Lane and Orford Road. By the end of the nineteenth century, the open hall with its kingpost roof had been divided into four shops. It is today in private ownership but every passer-by is free to observe and to enjoy the sight of the sturdy timbering and the well-pitched gables. Sir George Monoux's almshouses stand to the north of the churchyard and to the south-west, facing on to Church Path, is another row of tiny dwellings founded in 1795 by Mrs. Mary Squires and intended 'for the use of six decayed tradesmen's widows of this parish and no other'; they are still occupied. Walthamstow has two unusual school buildings, the National School in Vestry Road, built in 1819, in use till 1928, and today the property of the National Spiritualist Church, and St. Mary's Infants' School, built in 1828, the oldest infants' school in the country, but unfortunately closed in 1978.

On the corner of Vestry Road stands Vestry House, plain but elegant, built in 1730 to accommodate the inmates of the workhouse, enlarged and adapted at intervals during the next two centuries, and since 1931 in service as the local museum. A series of well-constructed dioramas illustrates the development of Walthamstow and in the garden, the older letter-boxes, milestones, and sign posts, as well as the village pump, have found a refuge. Walthamstow's archives, which include the Court Rolls of the five manors and the Vestry Minutes and Rate Books from the early eighteenth century onwards, are housed here, but the most important exhibit is the Bremer Car, which was built in Walthamstow between 1892 and 1895 and is claimed to be the first British car with an internal combustion engine. It was undoubtedly well built for it was able to complete the London to Brighton rally in 1965. One of the galleries is furnished with panelling taken from Essex Hall (demolished in 1932) which, having been

WALTHAM FOREST

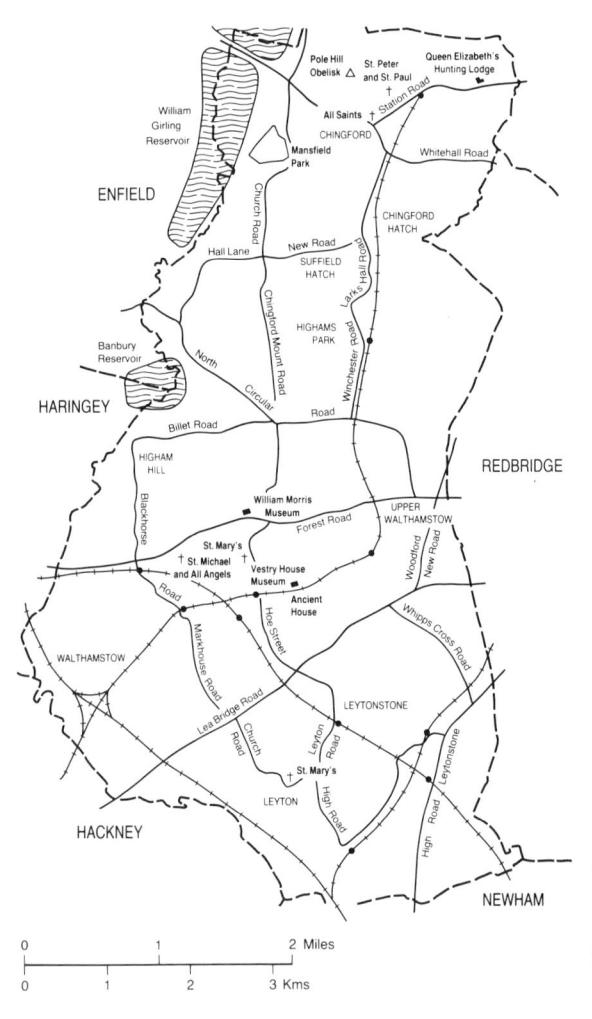

built early in the seventeenth century, became a school about 1801, numbering among its pupils the young Benjamin Disraeli, Florence Nightingale's father, and Samuel Lister, the future pioneer of antiseptic medicine. Outside the Vestry House stands a huge carved capital from the Post Office in St. Martin's-le-Grand, built in 1824–9 to designs by Sir Robert Smirke and demolished in 1913 to make way for the present, far less magnificent building; the capital, presented to the borough by an enthusiastic local builder, has an air of glorious incongruity.

Half a mile to the north-west in Forest Road stands Water House. Built about the middle of the eighteenth century, with ample three-bay bow windows on either side of the front door, it was, from 1848 to 1856 the boyhood home of William Morris, artist, master craftsman, poet, social reformer, and shrewd man of business. It was from this house that the young Morris explored the Essex marshlands and roamed in Epping Forest. Later, Edward Lloyd, the publisher, lived here and it was his family who presented the house and its broad gardens to Walthamstow Borough Council in 1898. In 1950 it was at last opened as the William Morris Gallery and Brangwyn Gift. The collection is made up of Morris items - paintings, drawings, furniture, textiles, wallpapers, printed books, especially from his own Kelmscott Press, and personal possessions – and of works presented in 1936 by Sir Frank Brangwyn. In the 1870s, the young Brangwyn's abilities had been recognized by A. H. Mackmurdo, the founder of the Century Guild and an established architect. He introduced the young artist to Morris, who employed him for several years till Brangwyn's career was established. As a memorial to Morris, Brangwyn presented Walthamstow with a collection of British and Continental paintings, including works by Burne-Jones, Rossetti, and other members of the Pre-Raphaelite Brotherhood, by Lucien Pissarro and by Walter Crane, as well as a large number of his own achievements, besides ceramics by William de Morgan and the Martin Brothers. Additional works have been acquired over the years, as well as much fascinating material relating to Mackmurdo's Century Guild and to the Arts and Crafts movement in England. Whole rooms are furnished in the William Morris style.

A little to the east of Water House but still in Forest Road is the Civic Centre, begun in 1937 by P. D. Hepworth in the Swedish style of a decade earlier, with a thin central portico and three neat rows of windows. It is flanked on the right by an Assembly Hall with a broader portico and the words 'Fellowship is life and the lack of fellowship is death'

¹ Before abandoning the history of Walthamstow, it is worth remembering that Salisbury Hall, the home of that Countess whom Henry VIII had butchered, was here; Roger Ascham, tutor to Lady Jane Grey and to Queen Elizabeth, lived there from 1557 till his death in 1568, during which time he wrote *The Scholemaster*, which his widow published in 1570. The house was demolished in 1952.

Water House, Walthamstow

carved as a frieze above it; law courts should have stood to the left, but intervening war prevented their construction.

A short walk from Water House, at the junction of Palmerston and Northcote Roads, stands the church of St. Michael and All Angels. Designed by James Maltby Bignell and consecrated in 1885, the russet brick building makes manifest the teachings of the Ecclesiological Society. The church is lofty and impressive, but its main interest lies in its fittings, in its glass by John Hardman and Son of Birmingham and in its spectacular triple-tiered reredos by Messrs. Hardman, with woodwork and statues from the Oberammergau workshop of Sebastian Zwincke.

The southern third of the borough is occupied by LEYTON. Once again, the most important building is the church, dedicated to **St. Mary the Virgin**. Though Domesday Book tells us that there were two priests in Leyton in 1086 so that, therefore, there was most probably a church as well, today the oldest part of the structure is the north-west tower, built of brick in 1658 – one of the few examples of church building during the Commonwealth period. The north aisle, also of brick, was added at this date and the chancel was enlarged in 1693. The south aisle was added in 1822 and the chancel enlarged yet again in 1932. Happily, this piecemeal growth has resulted in an unified and well proportioned interior, distinguished

for its unusual collection of funeral monuments, both large and small. There are two brasses, one to Ursula Gaspev who died in girlhood - her hair, unbound, hangs loose below her waist - in 1493, and another to Elizabeth Wood (d.1620) who is shown with her husband Tobias, and their seven sons and five daughters. Among the carved monuments, pride of place goes to those commemorating three generations of the Hickes family, now placed in the chapel under the tower. Effigies of Sir Michael Hickes (d.1612) and his wife, Dame Elizabeth, lie toe to toe on a long, panelled, stone plinth, the outer compartments of which are filled with elaborate escutcheons. He is clad in armour, though, as Lord Burghley's secretary, he was essentially a man of peace; she wears a widow's garb; both figures are propped uncomfortably on their elbows. Their attitude and the semicircular arches, filled with their epitaphs, behind them led Mrs. Esdaile to ascribe the work to William Wright of Holborn. On the opposite wall, a single large monument displays figures of Sir Michael's son and grandson, kept company by the latter's wife, Lady Marthagnes. The elder Sir William, clad in contemporary dress, reclines in the centre, his arm outstretched, his hand still grasping the staff which he carried as Warden of Waltham Forest. The younger Sir William wears an unusually elaborate fullbottomed wig and the armour of a Roman centurian; his wife's attire is also classical. Mrs. Esdaile suggests that the monument was designed by Grinling Gib-

¹ I am indebted to Julian Litten for information about the church.

Assembly Hall, Walthamstow

bons but carved by a lesser hand; a careful study suggests that two sculptors were at work, the more able being responsible for the recumbent figure of the elder Sir William.

The smaller monuments are too numerous to describe in full or even to list completely. An unusual number of them are signed by the sculptors and the following may be noted: Newdigate Owsley (d.1714) by Samuel Tufnell; Sir John Strange (d.1754) by Sir Henry Cheere; Samuel Bosanquet (d.1765) by Joseph Pasco; Sir John Story (d.1786) by John Hickey; William Bosanquet (d.1813) and the children of the Hillersden family (latest death in 1807) by John Flaxman, the latter a touching and beautiful work. The lettering on the tablet to Charles Goring, 2nd Earl of Norwich (d.1670) is stylish and there are plainly cut inscriptions to members of the Bowyer and Dawkes families, two related groups of eighteenth-century printers. The church can also rejoice that the antiquary, John Strype, was vicar here from 1669 till his death in 1737; he died at 94, lamenting that he still had so much work to do, and his memorial slab lies at the foot of the chancel steps. Against the north wall of the chancel is the medieval housling or communion bench and, in a glass-fronted recess, is an hour-glass with four glasses which can measure the separate quarters of the hour. It was made in Munich in 1693 and was presented to the church by a vicar who passed a long and happy ministry here in the last century. In the tower hang six bells and a clock-bell; the fifth bell was made in 1694 by William Wightman and the sixth, cast in the fourteenth century, is inscribed in Lombardic capitals: Domine exaudi oracionem meum et clamor meus ad te veniat.1 The clock-bell is said to be seventeenthcentury; the clock, made by William Addis in 1768, came from the Great House which used to stand in Leyton High Road; it was set in the church tower when the cupola was erected in 1806.

A little further northwards along Church Road is the engaging 'Gothick' façade of Etloe House, built in 1760 and used, from 1858 till 1866, by Cardinal Wiseman as a rural retreat, when Leyton was still part of the Essex countryside.

¹ O Lord hear my prayer and my cry shall come unto Thee.

SOUTH OF THE RIVER

Lady Lumley (see p. 422)

Bexley

The River Thames is a great barrier, separating North from South London. Sometimes, it seems as if the inhabitants of either bank consider the opposite shore as unknown, alien territory. The boroughs around the southern perimeter of the Greater London area, which were formerly in Kent and Surrey, are less closely related to, and influenced by, the metropolis than are their counterparts in the north which were previously in Middlesex or Essex. The outer southern boroughs have an uneasy relationship with London; in spite of some industry and twentieth-century housing, they look towards the countryside, not the town.

Bexley is the easternmost of the riverside boroughs on the south bank. Originally a scatter of Kentish villages which, even today, retain their village cores, the centre of the borough was largely built over in the early part of the present century and between the wars. It can, however, boast of an impressive collection of churches, a sixteenth-century mansion still in constant use, and William Morris's Red House, built for him by Philip Webb, one of the seminal achievements of modern architecture. Its northern riverside marshland is now being reclaimed for Thamesmead, one of the largest of London's modern municipal housing estates.

In 1965, the former boroughs of Bexley and Erith joined Crayford and parts of Sidcup and Chislehurst to form a new administrative unit of about 15,000 acres with a population of nearly 220,000; the whole area lay formerly in Kent. It is of irregular shape with good communications from west to east, for the main roads strive to link London with the Kentish coast, though the connections between the northern and southern extremities are more devious. The geographic centre is Bexleyheath, but the historic centre, which gives its name to the whole area, is Bexley.

BEXLEY lies in the south-east of the borough. The High Street eases itself round a right angle, spans the

river Cray, and is crossed by a railway bridge on an embankment. The parish church, dedicated to St. Mary the Virgin, stands at the apex of the angle. There was a church here before the Conquest, though the earliest surviving fabric of the low, flint building is found in the late twelfth-century walls of the tower, with three lancet windows, and in the south wall of the nave. The chancel was extended in the thirteenth century, when a north aisle, fully as broad as the nave, was added and then continued eastwards, in its turn, in the fourteenth century. The whole building was restored, sympathetically, by Basil Champneys in 1882–3; the five pre-Reformation mass dials remain undisturbed on the south wall of the chancel, though now they lack their pointers. and the basic structure of the unusual 'candle-snuffer' belfry is still that erected in the Middle Ages. Three sedilia remain in the south wall of the chancel. with a piscina beyond them. Champneys set a pleasing iron screen across the chancel arch where the rood loft must once have been, and in the east window is glass given in the last century by Oxford University in memory of William Camden, the antiquary, who was lord of the manor here and who, before his death in 1623, endowed a chair of ancient history at Pembroke College from the Bexley lands. The font bears the date 1684 on the rim of the bowl. when it was 'sett up at ye Charge of ye Parish', but the stem is medieval.

There are two brasses, one of which, with a hunting horn and a coat of arms encircled in its baldric, may well be unique; the inscription is lacking, but from the blazon it seems that it is in memory of Henry Castilayn, a wealthy land-holder who died in 1407. The other shows Thomas Sparrow alias Lamendby - the name is found elsewhere in the borough - wearing a long robe with fur facings; he died in 1513. Other monuments commemorate successive dynasties at Hall Place, the local manor house; Sir John Champneis (d.1556) and his wife Meriel can be seen, gaily painted, kneeling opposite each other on a memorial erected by their son Justinian in 1590, while Sir Robert Austen (d.1666), who bought the estate from the Champneis, has an elaborate architectural monument with an inscription set between twisted pillars. Lady Mary Gerard-Cosein, who died cruelly young at 28 in 1683, has a marble wall-tablet over the south door, carved to

look like a cloth or shroud borne by two cherubs, and John Styleman of Danson (d.1734) who endowed almshouses which still stand in the High Street, has a large pyramid, the work of I. Annis, to which cartouches of arms are attached. Both the Wesley brothers visited the church in the 1730s, and the Reverend George Whitefield preached here in 1737. In 1951, the whole little building was carefully and thoroughly renovated and the Victorian plaster ceiling was taken down, revealing the medieval rooftimbers. The eighteenth-century lych-gate has been moved to the south-east corner of the churchyard, and by the north wall is a large piece of sandstone containing fossil shells, set there in memory of Catherina Thorpe (d.1778), wife of John Thorpe, the antiquary, who lived beside the church in High Street House. The early seventeenth-century wall running round the churchyard is probably the oldest brickwork in the village.

The Manor House, screened by trees, lies east of the church, and to the north is High Street House, built by John Thorpe in 1761, with a welcoming flight of shallow steps leading up to the front door. Opposite is Cray House, also of the eighteenth century, and then beside the Cray is the Mill, erected in the eighteenth century, burnt out in 1966, and now rebuilt so that outwardly there is little change, though it is used as a restaurant. The public library on the corner of Bourne Road and Albert Road was designed in 1912 by Edward Maufe. Around the bend of the High Street are Styleman's twelve Almshouses, erected under the terms of his will in 1755, each designed to shelter a poor family and still used. Here the High Street becomes Park Hill Road. St. John's church, built in 1882 by G. Low, has a north-east tower, which makes a good visual point for the immediate neighbourhood.

Half a mile away to the east, in Bourne Road, beside a modern flyover and a roundabout, is the stone and flint chequerwork façade of Hall Place, a sixteenth-century mansion which has survived into the twentieth century, still fulfilling a useful purpose. Sir John Champneis, having served as Lord Mayor of London in 1534, some three years later built a hall, availing himself of good stone from the local monastic houses that were being closed. His son Justinian lightened the hall by the insertion of a second tall bay window and added two wings to the north, sheltered by the rising ground beyond. The next generation sold the estate in 1649 to Robert Austen who, throughout the turmoil of the Civil War, quietly doubled the size of the mansion, building in red brick around three sides of an inner courtvard, and then, after he had been made a baronet and Sheriff of Kent in 1660, adorning a first-floor room with a magnificent plaster ceiling. Hall Place changed hands many times till, in 1935, it was acquired by the borough council; in 1965, it was thoroughly restored and became a local history and arts centre, open to the public. The Great Hall now houses exhibitions and,

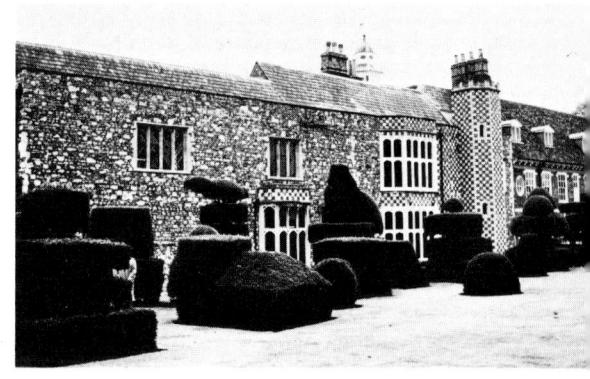

Hall Place, Bexley

for the time being, provides a refuge for the organ, made in 1766 by George England, from the mansion at Danson Park (see p. 342). Up in the gallery, a portion of the original walling has been left exposed, and fragments of carved and painted stone, pillaged from some former monastic building, can be distinguished. In the gardens, which slope gracefully down to the Cray, the municipal gardeners are attempting to restore the elaborate topiary work.

NORTH CRAY lies to the south of Bexley, and here the countryside is still open. Loring Hall, where Viscount Castlereagh lived from 1811 till 1822 and where he took his life, is close to the parish church, dedicated to St. James. Of pre-Conquest foundation, the medieval church was rebuilt in 1850-52 by Edwin Nash, and the chancel was enlarged in 1871. The font, however, is old – almost certainly thirteenth-century - and the carved pulpit is dated 1637. The woodwork of the reredos and choir stalls is remarkable; how it came to this quiet place is unknown, but it is fifteenth- or sixteenth-century work and probably of Flemish origin. The style is like Dürer's, and the scenes represented are the Epiphany and the Flight into Egypt, while on the stalls we see again the Magi and the Shepherds as well as the Visitation and the Circumcision. Behind the choir stalls hangs a medieval carving of the Seven Corporal Works of Mercy. There are two charming seventeenth-century memorials, to William (d.1636) and Helen (d.1652) Wiffin, and to Elizabeth Buggin (d.1659), which both use architectural adornments – pediments, columns - with rustic over-enthusiasm, a graceful memorial to Lady Ellenborough, Castlereagh's sister (d.1819), by Chantrey, with a kneeling woman laying a wreath of flowers, and a strange tablet in the chancel to Alice Morris (d.1894) by J. Nelson MacBean, on which a woman in Grecian draperies seems to float out of the marble, her arms completely free-standing; the style is that of an earlier century. Around the churchyard runs the wall of North Cray Place, demolished in 1966; the grounds, landscaped by 'Capability' Brown, have been retained as a park.

BEXLEY 341

An observant local antiquary recently recognized a complete and well preserved timber hall-house of about 1400 beneath modern weatherboarding. The building was rescued just as it was about to be demolished for road-widening, and is to be re-erected at the Weald and Downland Open Air Museum at Singleton in Sussex.

FOOT'S CRAY lies half a mile to the south-west. It probably owes its curious name to a certain Godwin Fot, who was a tenant here in the time of Edward the Confessor. The church, dedicated to All Saints, may well be of pre-Conquest foundation, but the present structure belongs to the fourteenth century, though the font, with a square bowl and a pedestal with four corner shafts, has waterleaf mouldings which date it to the late twelfth century. About 1863, the little flint building was extensively restored by Hakewill, who did, however, take care to replace the timber porch on the west side, while Lord Waring presented the church with a trim octagonal shingled spire to commemorate Edward VII's coronation. Inside, one lancet and two Perpendicular windows remain undisturbed in the nave, and the broad arch into the north aisle is intact; a choir of exuberant Victorian angels carols round the chancel arch and the rood-loft stairs have been adapted to give access to the nineteenth-century alabaster pulpit. In the nave hang large, spirited panels of Moses and

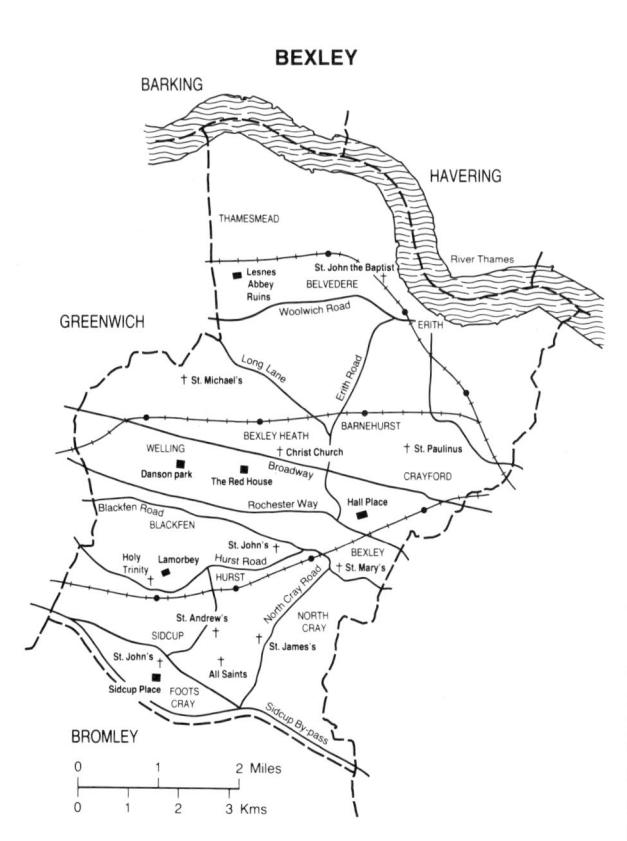

Aaron, said to have been painted by a Mr. Taplock in 1709, presumably as parts of an altar-piece, and against the far wall of the north aisle, in a low arched recess, is an effigy of a once-elegant fourteenth-century lady. The figure is much worn, and of a knight who kept her company, and who is believed to have been Sir Simon de Vaughan, only the helmed head remains; before it became shabby it must have been a fine sculpture.

Behind the church, green meadows spread out, with factories prowling up to the hawthorn boundaries; this was once the estate of Foots Cray Place, but the Villa Rotunda, built in 1754 for a wealthy merchant, Bouchier Cleve, in imitation of Lord Westmorland's villa at Mereworth, was burnt down in 1950, and only the parkland remains. Just south of All Saints, where Church Road joins the High Street, stands a group of eighteenth-century cottages and the Old House, constructed in the early nineteenth century; near them is a row of Tudor cottages, adapted from a single timber-framed hallhouse, now restored and used as an architect's office, with the weather-boarded Seven Stars Inn, which has refreshed the community since the seventeenth century, opposite them. To the north of the church, in Maylands Drive, is St. Andrew's church, built in 1964 by Braddock, Martin-Smith and Lipley. Octagonal in plan, the sharp slope of the hill makes it possible for the parish room to occupy the ground floor, while the church itself fills the roof and is entered on its own level. A tall flèche arises from the angular, spiky roof, with an east gable filled with pale, tinted glass, so that the services are celebrated against a backdrop of light.

The southern tip of the borough is filled by SIDCUP, which began as a hamlet on the Maidstone Road - the Black Horse Inn, with a seventeenthcentury core and an ironwork balustrade fashioned like a fruit-laden vine, marks the centre. All around is small modern housing, for Sidcup became a London dormitory suburb when the Dartford Loop Line was electrified in 1926, but Church Road still leads from the tavern in the High Street past St. John's church to the Green, beside which stand the Manor House and Sidcup Place, both now borough council offices. The Manor House, built about 1790 from warm red brick, has a porch formed from four delicate little pillars, while local tradition alleges that Sidcup Place was built about 1743 by an 'officer of Engineers' in the shape of a star fort, with angle bastions at the cardinal points of the compass. Such an origin, with Victorian additions, would account for the piquant building in use today. A fine central staircase and an eighteenth-century marble fireplace with graceful nymphs remain in position; the grounds, now a public park, stretch away to the south-east to join those around Queen Mary's Hospital. Nearby, Frognal House, built in the mid-seventeenth century but given a handsome, regular brick façade in 1719, was restored in 1981 for office use.

On the Green, Place Cottage has some early timbering and Cluny Cottage a façade onto which a nineteenth-century owner crowded every architectural detail he knew. Near to them, **St. John's** parish church began as a simple building of 1841–4, but was replaced by the present large edifice in 1892–1901, chiefly to the designs of George Fellows-Prynne. The drab brick exterior is unlovely, with a fat, squat tower and sloping roofs over the aisles, but the interior is more rewarding. Strong and spare, the four tall west windows are nobly proportioned, and the pulpit and canopy above the altar are of seventeenth-century Flemish woodcarving.

Sidcup Station lies northwards, at the foot of the hill, surrounded by small, late nineteenth-century property, the roofs adorned with sharp finials and barge-boarding, and the upper windows sporting thick eyebrows of curved chevron ornament. Holy Trinity, on the corner of Hurst Road and Halfway Street, was designed by Ewan Christian in 1879 and restored in 1949. It is a low building with ragstone laid up the walls like crazy paving and an unpretentious, peaceful interior. Beside it stands Holy Trinity School, a one-storey building with a playground filled with large-scale concrete toys, such as a steam engine. Nearby, in Burnt Oak Lane, is Lamorbey, its name a corruption of the Lamendby found in Bexley parish church. Built in 1744-8 for an East India merchant, William Steel, the house was enlarged in the 1830s by Neill Malcolm, who was probably also responsible for the Jacobean exterior with tall, mullioned bay windows and plasterwork fleur-de-lys decoration on every available surface. The house is used today as an adult education centre, the gardens and lake are cared for, and the Barn Theatre occupies an outhouse. North Oxford architecture came to Sidcup at the Hollies, a group of houses erected about 1901 on the site of an older building, as homes for orphans and children in care.

The centre of the borough is BEXLEY HEATH, which remained more or less open till the railway reached it in 1895. In the Broadway stands Christchurch, erected in 1872-7 to noble designs by William Knight of Nottingham, of whose work little else is known. Built of creamy gold stone, it is in the early French Gothic style, interpreted by a nineteenthcentury architect with dignity and without sentimentality. Cruciform in shape, there is a fine rose window in each transept. To the south-west, Danson Park stands on a hilltop, with grounds originally laid out by Lancelot ('Capability') Brown and still well maintained by the borough council. Sir Robert Taylor planned the mansion for Alderman Boyd, and it was built between 1759 and 1762. The villa is almost star-shaped, the three centre windows on the south, east, and west sides being set forward in half-hexagonal bays, while the main entrance to the north projects grandly, presenting Corinthian columns, a broad balcony, an elegant urn, and a medallion, with a portrait of a girl wreathed with

flowers, to the gaze of those ascending the steps to the front door. Inside, an elliptical stair-case fills the centre of the house and the three main rooms were decorated, about 1770, by Sir William Chambers; they still retain their marble fireplaces and inset paintings, probably by Charles Pavillon, but the organ has found refuge in Hall Place, for Danson Park has stood empty for the last ten years. It is one of the most exquisite houses near London and should be restored and used.

Nearby, in Red House Lane, stands the Red House, built in 1860 for William Morris and his young wife, Jane Burden, by their friend, Philip Webb - a landmark in English architecture. Then, the plain brick house stood in the countryside, embowered amongst Kentish cherry orchards. Today, the orchards have vanished, other, smaller, red-brick houses cover the countryside, and the characteristics which seemed unique have become the stock-in-trade of a later generation, but it is still possible to imagine something of the shock and the delight that the Red House gave Morris and his friends more than a century ago. It is an L-shaped building with a steeply pitched roof, an abundance of gables, tall, tapering chimneys, and an arched, northfacing porch. In the angle of the house is a garden well, and on the west side is a curious oriel window, its brick support rising from the ground like the elongated stem of some gigantic tulip. A heavy front door leads into the hall, in which stands a cupboard painted by Burne-Jones with scenes from the Nibelungenlied. To the left is a smaller hallway with two stained-glass panels by Burne-Jones and tiny animals and flowers picked out by Morris, and to the right is a dining-room with a massive sideboard, too large to be removed from its original position. The staircase, with an angularity which looks forward to Charles Rennie Mackintosh, leads sharply out of the hall. The plasterwork of the ceilings is pricked out in simple, almost abstract, patterns, quite unlike the designs we associate with the Pre-Raphaelites, and painted in bold, acid colours. Originally, Morris and his friends covered the stairwell with Arthurian scenes, but, as in their decoration of the library of the Oxford Union, they were ignorant of the proper preparation of the ground, and their efforts have crumbled away.

On the first floor, the main apartments are the drawing-room and Morris's studio, which has been refurnished. In the former is the huge settle which was Morris's first essay in furniture making. A minstrels' gallery was added to the drawing-room for amateur theatricals and to give access to the roof loft. On either side of it are Arthurian scenes by Burne-Jones, which have been preserved, for they were glassed over soon after completion; they contain portraits of Morris and his bride. The function of the oriel window, which seemed so unusual from the outside, becomes clear – it has a window seat and is for sewing and reading, for it faces due west and an

BEXLEY 343

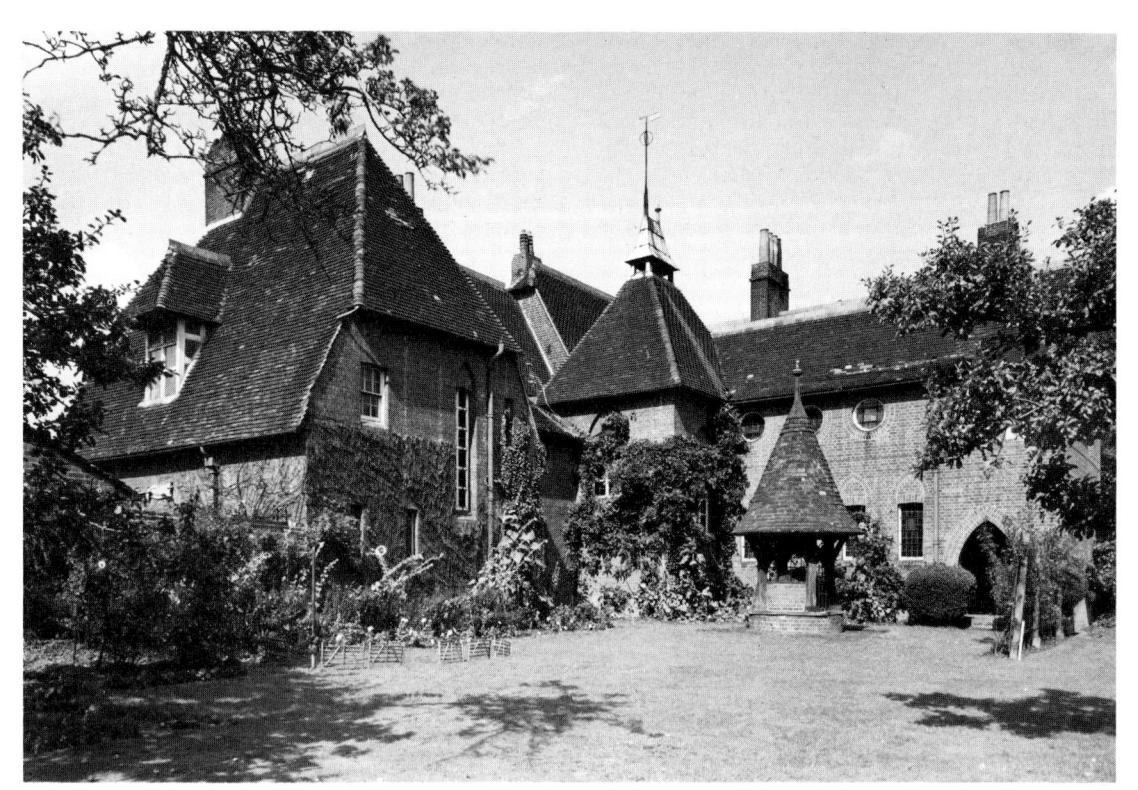

The Red House, Bexley Heath

industrious needlewoman or student can catch the last of the light here. The unadorned lines of the fireplace, with its massive brick hood, point forward to the forms of the twentieth century; above it is the tag, Ars Longa Vita Brevis, in Morris's unmistakable script. The essence, the conundrum, of the Red House is contained in that fireplace; Morris and his friends looked back to the Middle Ages, seeking a remedy for the ills of their own time, but they built and adorned the Red House with a spare simplicity which gave the twentieth century its diagram for the future. The present owner admits visitors on one week-end in each month, provided application in writing has been made well in advance. The Red House may be visited in conjunction with Frank Dickinson's home at Carshalton (see p. 425), so as to compare Morris's inspiration with his disciple's interpretation a generation later.

In the north-western quarter of the borough are WELLING and EAST WICKHAM, where the medieval church of **St. Michael**, once a chapel of ease to St. Nicholas at Plumstead, stands at the north end of Upper Wickham Lane. The tiny building, constructed from a mixture of flints and ragstone, dates from the early twelfth century, though it was much rebuilt in the nineteenth, when a little square bellcote and spire were perched on the west end of the roof. Large figures, painted in the thirteenth century, still

decorate the walls. The old church is used today by the local Greek Orthodox community, and the Anglican congregation meets in a slightly larger building of 1932, to which three ancient bells and two interesting brasses have been removed. The earlier of the two shows half effigies of John de Bladigdone (d.1325) and his wife surrounded by a curvy frame; it is thought to be the earliest surviving brass to show a man in civil dress as opposed to armour. The second shows William Payne (d.1568) and two of his wives; this stalwart gentleman is proudly wearing the uniform of a yeoman of the guard. The organ is set aloft in an exceptionally graceful west gallery and there is a good roof of open timberwork. The headstones have been levelled in the large churchyard, save for one lonely cherub guarding a single tomb.

On the eastern side of the borough is CRAYFORD, where Hengist defeated the Britons, who fled to London in 457. The parish church in Perry Street has a form as unusual as its dedication to St. Augustine's companion, St. Paulinus. Of pre-Conquest foundation, it was rebuilt about 1100; in the north-west corner we can see blocks of tufa, that characteristic Norman building stone. About 1190, a south aisle was added and then, early in the four-teenth century, there was more building and a general rearrangement. The church is almost unique in

England, for it has twin naves with the chancel sited neatly between them, so that the piers of the arcade obscure the altar. In spite of the liturgical difficulties, succeeding generations have accepted the inconvenience, even after a serious fire of 1628 which destroyed all the early memorials, save that to Blanche Marler, who died in 1608. The fire spared the fifteenth-century tower and the early volumes of parish registers escaped too, though a new pulpit had to be made in 1630.

St. Paulinus contains a number of interesting monuments and one remarkable one in the north chapel to William Draper (d.1650) and his wife Mary (d.1652), who are represented by life-sized alabaster recumbent effigies, apparelled as strict Puritans. Their son and daughter kneel on either side, and beneath, easy to overlook, is a tiny figure of a swaddled babe. The student of costume may be grateful that adherence to their beliefs did not restrain them from the vanity of commemoration after death. The monument is unsigned but it has been suggested that Thomas Stanton was the sculptor. In the south chapel, added during the fifteenth century. is a monument to Lady Shovel (d.1732), widow of Admiral Sir Cloudesley, the Norfolk shoemaker's apprentice who ran away to sea and from cabin boy rose to be Admiral of the Fleet and Member of Parliament for Rochester. It was in this connection – Crayford is in the diocese of Rochester – that he bore the cost of restoring St. Paulinus in 1700, only seven years before his own death by shipwreck off the Scilly Isles. He lies in Westminster Abbey, but Dame Elizabeth chose to be buried near her home, and her son-in-law, Robert Mansel, who predeceased her in 1723, has a tablet here too. At the west end of the north aisle is a pretty Victorian tablet to William Tucker (d.1851), with a cherub and a wreath of flowers, like a prim version of a seventeenth-century memorial, and vivid modern glass by Hugh Easton fills six of the windows. In the churchyard lies Thomas Desaguliers, once chief at Woolwich Arsenal, the earliest scientific maker of cannon and one of the first to experiment with rockets.

To the north, towards the Thames, a massive seventeenth-century brick barn, still in agricultural use, remains among modern housing at Howbery Grange on Slade Green. At the river's edge, we are in ERITH, its High Street still a strand giving access to the wharfs, while Riverside Gardens provides local residents with a promenade from which to watch the shipping on the Thames. It was from this lonely stretch of marshland that Lord Clarendon set out to pass the rest of his life in exile on the Continent, writing his History of the Rebellion and Civil Wars, and it was here that Alexander Selkirk, whose shipwreck and adventures provided Defoe with the in-

spiration for *Robinson Crusoe*, landed in 1709, after his long sojourn on the island of Juan Fernandez.

At the north end of the town is the parish church, dedicated to St. John the Baptist. In spite of heavy restoration about 1877 by Habershon and Pite, much Norman work remains in the chancel, and the rest of the building, including the west tower, dates from the thirteenth century. The south doorway, with Purbeck marble shafts and waterleaf capitals, is well preserved and the spacious interior, with a nave and two aisles, has shallow Norman arcading running round the chancel wall. There are half a dozen brasses, all of them interesting - Roger Sencler (d.1425) in civilian dress, large figures of John Ailemer (d.1435) and his wife, Emma Wode (d.1471) in a tall peaked head-dress, John Milner (d.1511) and Edward Hawte (d.1537) in armour beside his wife, while the inscription to Anne Harman (d.1574) is a palimpsest on a Flemish brass, first engraved at the beginning of that century. The church possesses three important monuments, the earliest to Elizabeth, Countess of Shrewsbury (d.1568) whose life-sized effigy, superbly carved, lies on a tall tombchest with Doric columns, strapwork panels, and heraldic lozenges. Francis Vanacker has a two-part memorial, the inscription carved on an elegant tablet with a tomb-chest beneath, its top a slab of plain black marble, though the sides are beautifully carved with laurel wreaths, fruit, and flowers and the heads of three cloud-borne cherubs. Chantrey sculpted the third memorial, a large tablet on which a woman, in bold relief, kneels by a pedestal supporting two urns, which bear the names and dates of Lord Eardley and his son, who both died in 1824. The sundial, on a buttress of the south wall, was the gift in 1643 of Nicholas Stone, possibly the sculptor of that name.

Beyond Erith lie the marshes, which are even now being drained and covered by THAMESMEAD, a new Greater London Council estate, which, when completed, will spread over some 1,700 acres and will house about 45,000 people. It should, more properly, be described as a new town on the south bank of the Thames. The marshiness of the terrain has made it a problematical site, and all buildings have needed piled foundations. Work began in 1967, but it is still too soon to judge the scheme as a whole. It is not intended to be a dormitory suburb but a complete community with churches, schools, shops, businesses, and recreational facilities; an ecumenical centre, the Church of the Cross, has been completed and is serving the social as well as religious needs of the community. One-room flats, suitable for the elderly, are being provided, as well as family houses with gardens, conscious efforts are being made to preserve the wildlife of the area, and the GLC Architects' Department is busy landscaping; road schemes deliberately separate vehicles from pedestrians and bicycles. Because of the danger of floods, which have always threatened these marshes, a river wall is being constructed, with views over the

¹ Caythorpe in Lincolnshire and Hannington in Northamptonshire are also distinguished by this uncomfortable arrangement. St. Helen's Bishopsgate has ordered matters better.

BEXLEY 345

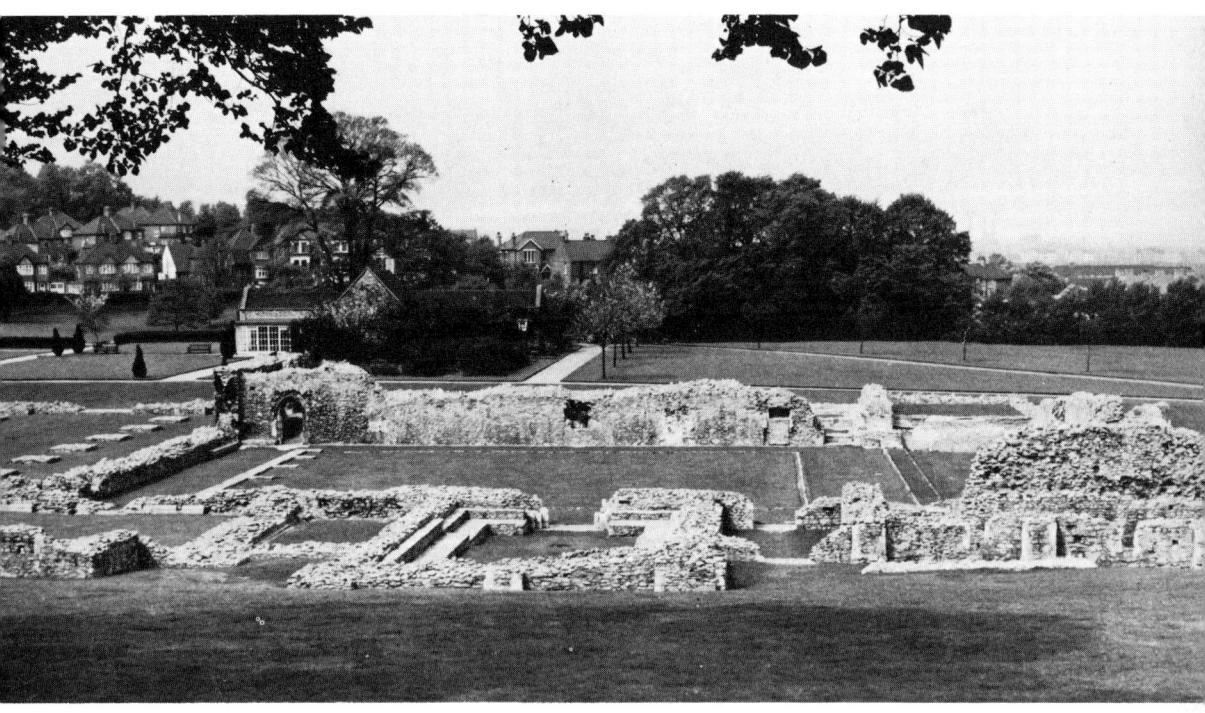

Lesnes Abbey, Thamesmead

Thames and a three-and-a-quarter-mile walk beside it, well planted with shrubs and trees. Almost equally dramatic is the bridge spanning the road and railway and leading, like an aerial green grass-clad ribbon stretched between white buildings, from Thamesmead itself to the slopes of Abbey Woods. It is as yet too soon to decide whether we should applaud the venture or condemn it for having produced an estate so large that it both overwhelms the individual denizen and annihilates all sense of community.

Within sight of the new town, the skeletal foundations of the abbey which gives its name to the area are laid out clearly for all to see beneath the hillside. This was Lesnes Abbey, an Augustinian house founded in 1178 by Richard de Luci, Chief Justiciar to Henry II, and dedicated to Our Lady and St. Thomas à Becket, in whose martyrdom, a bare eight years earlier, de Luci had been implicated. During the following year, the founder took up residence in the Abbey and soon after died and was buried there. The family continued the association with their foundation; the heart of Roesia of Dover, Richard's great-great-grand-daughter, was buried beneath the altar, and a recumbent, headless effigy of another nameless de Luci who, from his armour, must have died about 1320, was recovered during excavations and is now in the Victoria and Albert Museum. The house was small and not particularly wealthy, as much of the income went into the work of draining and maintaining the river wall along the south bank of the Thames - the convent at Barking had to deal with a similar problem along the north bank. Nevertheless, a seemly cruciform church was built, with the chapter house and dormitory beyond the north transept and the cloister and refectory along the north aisle of the nave, since this arrangement accorded best with the slope of the land. The little monastery was suppressed before the Reformation, being dissolved in February 1525. Its estates were granted first to Cardinal College (Christchurch) Oxford, and then, after Wolsey's fall, to Sir William Brereton who, being accused of an illicit association with Henry's second queen, Anne Boleyn, lost his head. After several changes of ownership, the site of Lesnes Abbey passed into the hands of Christ's Hospital, until 1930 when it was sold to the London County Council. The site was excavated and laid out in 1951, and those who wish to learn the arrangement of a simple monastery cannot do better than to take the train to Abbey Wood and study the outline, limned in stone and turf, on the hillside. The closeness of the link between the Abbey ruins and Thamesmead, between the old building and the new community, between the past and the present, demonstrates one of the essential qualities of London.

Bromley

Bromley is the largest of all London's 32 boroughs. It fills the south-eastern corner of the conurbation, its 59 square miles housing a population of about 300,000, made up from the former boroughs of Bromley and Beckenham, the former urban districts of Orbington and Penge, and the southern part of Chislehurst and Sidcup. The whole area formerly lay in Kent and, though the north-western corner is closely packed with residents who travel daily into London, while the Cray Valley to the north-east is crammed with light industry. vet the southern half has remained a loosely linked collection of Kentish villages, some of them grown recently, almost overnight, into towns and others still little more than hamlets. Bromley is a most instructive borough, for it combines stretches of true farmland and a remarkable selection of small medieval parish churches with a complete range of suburban development of all qualities, besides some excellent unfettered modern churches and public buildings. Save for the Cray valley, it lies chiefly on high ground, with a main line of communication in the road to Tunbridge Wells and the south coast.

BROMLEY lies in the north-west, giving its name to the whole borough. Until the middle of the last century it was a sprawling village, houses straggling along a central spine of highway, its northern end known as the London Road, its southern as the High Street, and their junction as the Market Place. It is a place of baffling one-way traffic circuits, best explored on foot, starting at the Market Place, crowded since 1933 with melancholy neo-Tudor shops, so that the Thursday market, held since 1205, has had to move northwards to Station Road. Medhurst's store has engulfed number 47 High Street, where H. G. Wells was born in 1866, and to the east is Dunne's, London's best furniture shop, established before 1712 and occupying an enticing split-level building designed between 1954 and 1957 by Bertram Carter.

Church Road turns westward out of the High Street and leads to St. Peter and St. Paul. Of thirteenth-century foundation, the fine fourteenth-century tower remains, but the rest of the church, which had been rebuilt in 1792, was destroyed by bombs in 1941. A new church, differently orientated from the old, was designed by J. Harold Gibbons and was consecrated in 1957. The old tower was restored and inside it is a fourteenth-century door with a wellcarved band of blank tracery still in place across the top. The new church is large, a modern interpretation of the true Gothic exemplar of the tower, executed, because of the difficulty of the times, in comparatively cheap materials. The Norman font stands on a modern base and an ambulatory has been added on the north side. On its walls are brasses to Richard Thornhill and his two wives; he gave £100 towards the preparations against the Spanish Armada of 1588. A number of gravestones stand under shelter here, among them one to Elizabeth, Samuel Johnson's beloved wife 'Tetty' (d.1752) with a Latin inscription by the Doctor describing her as 'beautiful, cultured, ingenious and pious', and another to Zachary Pearce, Bishop of Rochester (d.1774).

To the south the gardens of Church House make a public park; their terracing has been retained, and a small amphitheatre for concerts has been laid out at the foot of the hillside beside a lake. On their eastern side are two rugged new civic buildings, the Churchill Theatre and the Public Library, both designed by Aneurin John and built 1970–75. In spite of an austere façade, the theatre has a proper red-plush interior and a foyer with seats overlooking the gardens.

The Town Hall lies to the east of the Market Place. A first building was erected in Tweedy Road in 1906 to designs by R. Frank Atkinson. Of red brick with white stone for the details and embellishments, it is an Edwardian neo-Wren structure, with a domed circular porch providing a properly pompous entrance for mayors and civic dignitaries. An addition was needed in 1939, which C. Cowles Voysey, with greater restraint and severity, provided round the corner in Widmore Road. To the south, in Rochester Avenue, stands what was, from the tenth century to 1845, the residence of the bishops of Rochester. In the grounds, throughout the Middle Ages, St. Blaise's Well dispensed health-giving waters - the well-head is still marked though now it seems dry. The medieval palace was pulled down and replaced in 1775 by a solid red-brick edifice, with a BROMLEY 347

pediment to the main entrance; the Victorians added a colonnade on the south or garden side. In the hall are two semicircular eighteenth-century carvings of *putti* engaged in agricultural pursuits. **Stockwell College**, founded in 1861 for the training of teachers, moved to the palace in 1935, and modern additions were erected, the best being the Music School by Ashley-Smith, with unusual canted slit windows, but the College closed recently and the buildings are now used by Bromley Council.

The southern end of the High Street has recently been rebuilt as a modern shopping area with a pedestrian shopping precinct. The Mall, planned in 1967-9 by the Owen Luder Partnership, stands on the east side opposite the Army and Navy Stores, by Elsom, Pack and Roberts (1968-80) with a striking dark brick cladding. On the northern side of the Market Place are older shops, of about 1900, with elaborately ornate gables. Where the High Street becomes the London Road stands Bromley College. founded in 1666 under the will of John Warner. Bishop of Rochester, to provide housing for 'twenty poore widowes of orthodox and loyall clergymen' and still fulfilling its original purpose, though since 1976 retired married couples have been admitted as well as widows. The original 20 buildings are grouped around a quadrangle with a bold entrance and their design, similar to Morden College (see p. 369), has been atributed to Sir Christopher Wren. A sheltering arcade runs round the quadrangle, and its pillars, according to tradition, come from Sir Thomas Gresham's Royal Exchange building, devastated in the Great Fire of 1666. A new quadrangle was added in 1794–1805, partly under the will of Bishop Zachary Pearce, whose tombstone stands in the parish church. The original chapel was rebuilt in 1863 by Waring and Blake; the stained glass, by O'Connor, depicts the women of the Old and New Testaments, from Eve to Our Lady, and above the stalls hang portraits of the founder and the benefactor, Bishop Warner and Bishop Pearce.

On the outskirts of Bromley are two impressive eighteenth-century buildings and one interesting modern one. In London Lane stands Plaistow Lodge. built soon after 1777 for Peter Thellusson, the eccentric Huguenot millionaire. The architect is unknown, but may well have been Thomas Leverton. The house, its facade unimpaired though the interior has been adapted, now serves as Ouernmore Secondary School. A mile to the east is Sundridge Park. its grounds now a golf course. The house and grounds were planned jointly by John Nash and Humphry Repton, while some of the interiors were designed by Samuel Wyatt. The staircase is one of the handsomest in southern England. The Technical College and the Ravensbourne College of Art and Design lie on the west side of Bromley Common, off Rookery Lane. Designed in 1957-62 by George, Trew and Dunn, the buildings are executed in a severely plain modern idiom.

Bromley College

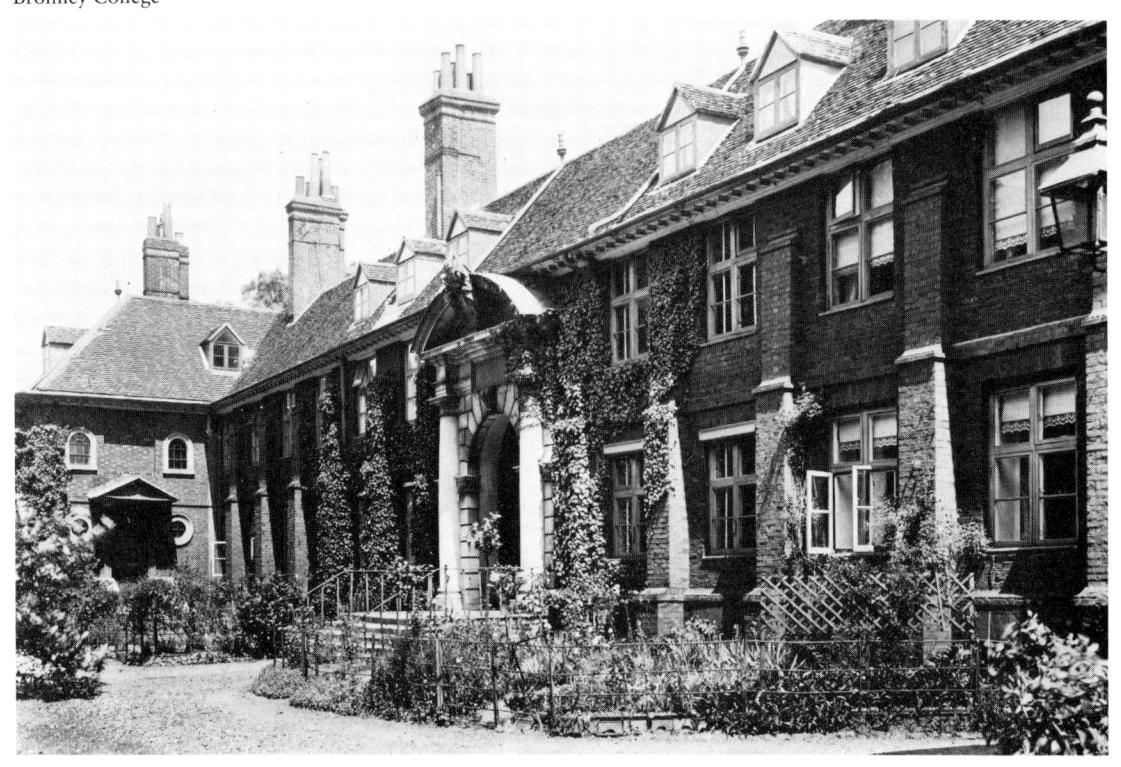

BECKENHAM lies due west of Bromley. It is essentially a residential area and among the low buildings the robust, pinnacled tower of **St. George's** parish church stands out impressively. The thirteenth-century lych-gate is claimed to be the oldest in England, but the medieval church was replaced by a spacious, confident building, planned by a local architect, W. Gibbs Bartlett, in 1885, though it was nearly 20 years before the tower was completed. The nave rises to a clerestory and there is a big rose window at the west end. There is some spirited modern glass by Thomas Freeth and the altar rails, made up from linked, gilded circles, are elegant.

The monuments, saved from the old church, provide a miniature illustrated history of English funeral sculpture. It begins with Sir Humphrey Style's tombchest of 1552, a brass above it showing that gentleman, clad in armour covered by a tabard, with his two wives, Bridget and Katherine, beside him. Nearby is another brass, for Margaret Damsell (d.1563); all the faces are unusually animated for the medium, and suggest that they are attempts at portraits. Generations of the Burrell family, who from 1688 till 1820 owned large estates in Beckenham, are commemorated, the three most interesting memorials

being an exquisitely carved tablet, with flowers that are almost free-standing, to Peter Burrell (d.1718), a lamentable one with an undersized cherub and an oversized urn to another Peter (d.1756), and a delicate relief to Amy (d.1790) by John Hickey, showing a seated lady being greeted by an old man and another woman with two children; the scene may have a classical or a family significance. John Flaxman carved the memorial for Frances, Lady Hoare (d.1800), showing her family in contemporary dress, weeping for her, and the severe profile relief of Catherine Vansittart (d.1810) may be by Chantrey. The medallion for William, Lord Auckland (d.1814) was probably carved some years after the nobleman's death by Henry Weekes.

The sinuous High Street leads past a cheerful eighteenth-century public house, dedicated, like the church, to St. George, till we come to the junction with Village Way, where stands the Roman Catholic church of St. Edmund. Built in 1937 by J. O'Hanlon Hughes, it is one of the more exciting twentieth-century churches near London. Of pale brown brick, it has a lofty, square, east tower with four tall narrow windows and a parapet, with minute pediments set about a low copper pyramid for a steeple. Within,

Beckenham Place (see p. 388)

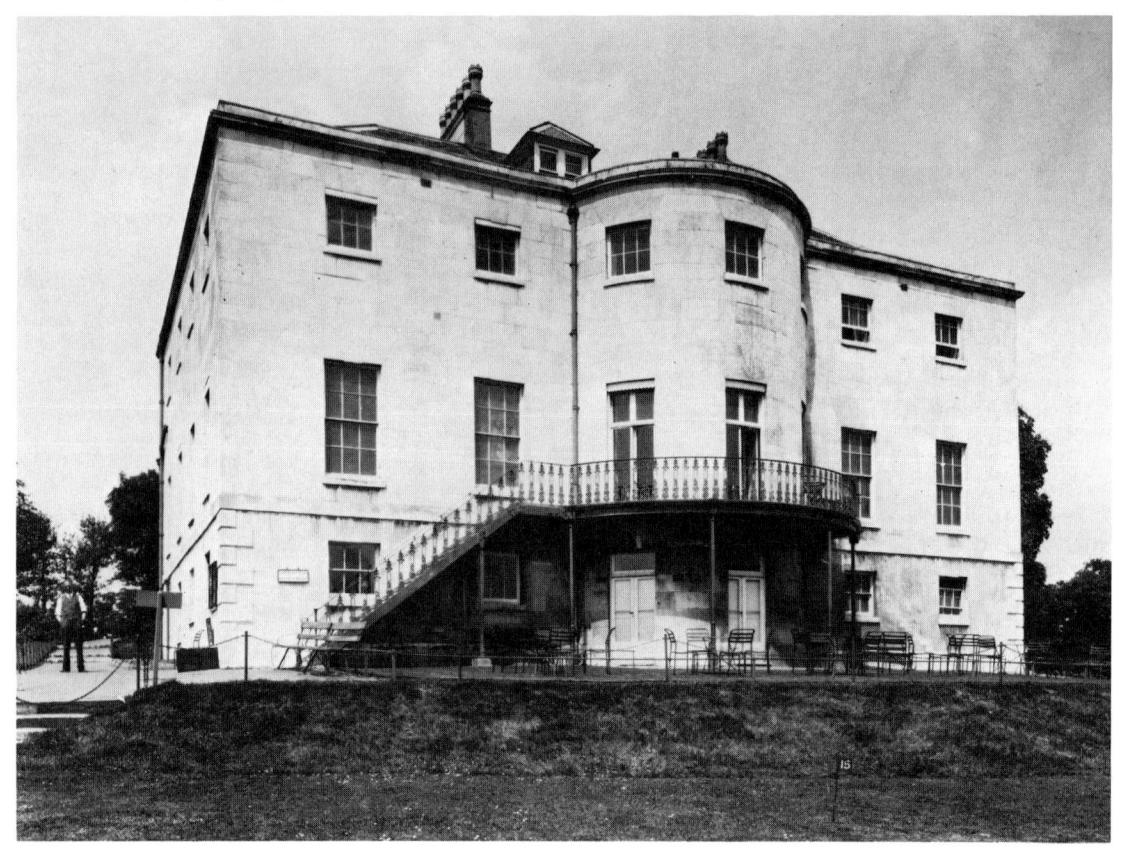

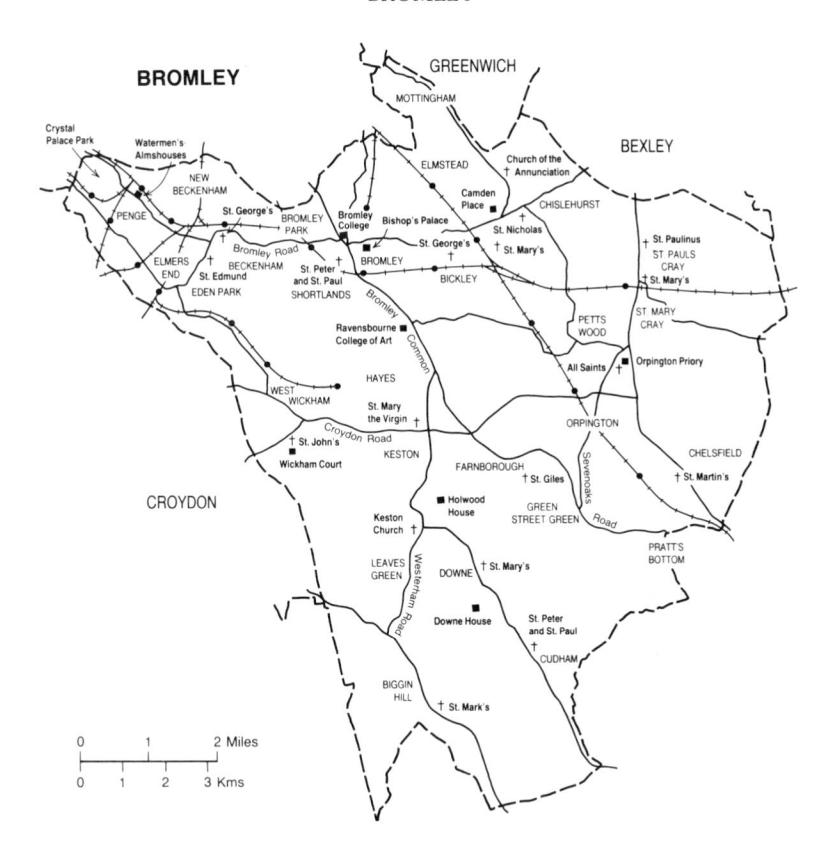

the tower windows shed an unearthly light on the altar, and round the underside of the roof runs an iron frieze of diagonal crosses silhouetted starkly against dark space. The new church hall, recently designed by Frances Weal, is also adventurous and effective.

In PENGE, to the east, the Free Watermen's and Lightermen's Almshouses in the High Street are a most remarkable group of buildings. Designed in 1840–41 by George Porter, in the Tudor style, they lie around three sides of a quadrangle, with an impressive gatehouse. Close by them, in St. John's Road, is King William's Naval Asylum, founded in 1847 to shelter the widows of twelve naval officers. Still in the Tudor manner, but interpreted with greater subtlety and delicacy, they were designed by Philip Hardwick and paid for by Queen Adelaide, herself a sailor's widow, in memory of William IV.

Up a steep road are the remains of the Crystal Palace. When the Great Exhibition of 1851 closed in Hyde Park (see p. 169) Paxton's building was reerected three years later on this hilltop site, and a gigantic head of the architect, sculpted by W. F. Woodington, was set up on a pedestal. In 1854, a million and a quarter Londoners came to see the Palace; the railway station, built to cope with them, is a cavernous vault. With the Palace went the prehistoric monsters, the brain children of Professor

D. T. Ansted, which B. Waterhouse Hawkins fashioned in 1854 under the supervision of Professor R. Owen. These terrifying beasts are set about a small island in the lake, and in 1961 were joined by a noble gorilla made by David Gwynne. In 1936, the Crystal Palace caught fire, and now nothing remains except a few of the arcades which once adorned the terraced gardens. Between 1956 and 1964 the National Sports Centre, designed by the LCC Architect's Department, was built on the lower slopes; open to all on payment of a modest fee, the complex of buildings is straightforward and sensibly designed.

On the eastern side of Bromley is BICKLEY, largely made up of prosperous and comfortably imaginative Edwardian housing. The best guide to the area is Pevsner's West Kent in The Buildings of England series, where the achievements of Norman Shaw's pupil, Ernest Newton, and his contemporaries are described in enthusiastic and fascinating detail. The apse windows of the Victorian Decorated parish church of St. George (F. Barnes, 1863–5) have recently been blacked out, as have all save single lights of those in the aisles, so that the building is now dark and sinister.

CHISLEHURST fills the north-easternmost corner of the borough. It is a confusing place to explore, for, though there is a broad and purposeful High Street, the most interesting buildings are scattered around

the Common, which remains resolutely rural in spite of the main roads that cut it into triangles. There are three churches, the parish church, St. Nicholas, on the Common, the Church of the Annunciation in the High Street, and St. Mary's in Hawkswood Lane.

St. Nicholas is of pre-Conquest foundation, though a small opening turned in flint in the west wall is all that remains of the Saxon church. In 1424, Thomas Walsingham bought the nearby manor of Scadbury and his son rebuilt the parish church – the indent of his wife's brass, showing her in a butterfly head-dress, can still be seen, though the brass has gone. That for Alan Porter, Rector of Chislehurst from 1446 to 1482 during the rebuilding, is safe. In spite of two lengthenings of the chancel in 1849 and 1896, the addition of the south aisle in 1849, and the rebuilding of the broached, shingled spire after a fire in 1857, the fifteenth-century flint building remains substantially intact, with its graceful arcades and the original screens in place across the chancel and the north chapel. The font is Norman and, besides the brasses, there is a varied collection of monuments. Sir

Edmund Walsingham (d.1549) has a tomb-chest with elaborate tracery on the side panels; tablets for other, later Walsinghams are grouped around it. There are several well carved memorials; a tablet to Sir Richard Betenson (d.1679) rests on a Tuscan pillar with a palm-scroll on either side, as if the Adam brothers had been at work a century before they were born, and Lord Thomas Bertie (d.1749) is commemorated by an exquisitely carved relief of a naval battle, for which Cheere's design has recently been discovered. Chantrey signed a large monument to William Selwyn (d.1817), which shows his son and two daughters mourning him, and there is a life-sized effigy of Earl Sydney (d.1890), wearing his Garter robes, begun by Sir Edgar Boehm and completed by Alfred Gilbert. The broad churchyard encloses fine vew trees, while close by on the Common, the lines of the village cockpit can still be traced.

The Church of the Annunciation in the High Street is the first Anglican church to be so dedicated since the Reformation. Designed by James Brooks between 1868 and 1870, it is of ragstone with a lofty

Monsters in Crystal Palace Park, Penge

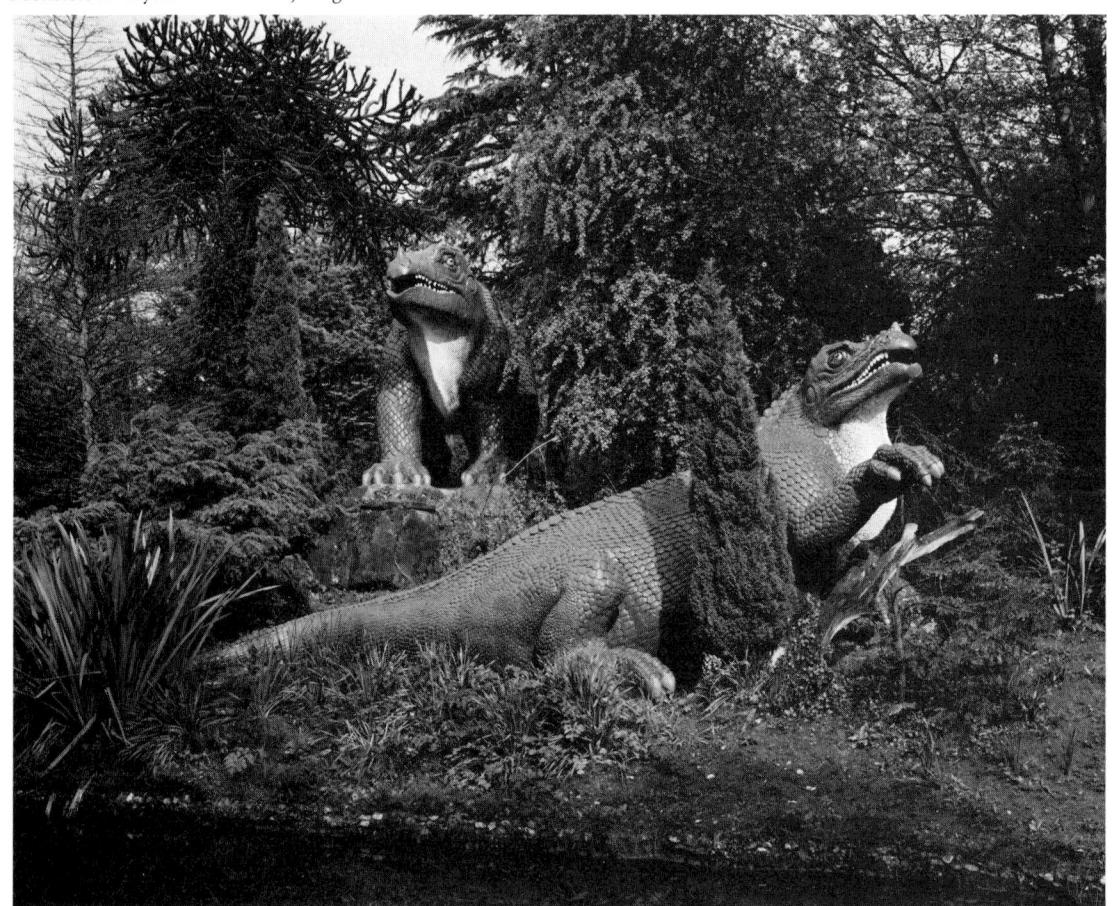

chancel and clerestory nave, which contrast with the low aisles. In the darkly glittering chancel there is a mosaic by Salviati, a reredos designed by Brooks and executed by Westlake, and paintings by Westlake with parallel scenes from the Old and New Testaments. The font and pulpit, no doubt designed by the architect, are fine stalwart pieces of Victorian masonry and woodwork, and there is a great west window made up from 19 smaller circles.

Chislehurst retains an air of distinction from its imperial associations, for here Napoleon III made his home in exile after 1871. He lived at Camden Place on the north-west side of the Common, in a house built about 1717 by Robert Weston from curiously coloured red and yellow brick with giant pilasters. The interior was remodelled during the 1780s by the vounger George Dance for the Lord Chief Justice Camden, and in 1807 the same architect, working for Camden's successor, Thomas Bonar, added pavilions on either side. He gave the south-facing drawing-room a bow-fronted window, decorated with curious Ionic pillars supporting spheres, and designed an exquisite ceiling for the breakfast-room, with motifs and garlands as fine as those of the Adam brothers but more robust. The gilded French woodwork in the south pavilion and the murals in another sitting-room were inserted during the late nineteenth century. When Napoleon III died in 1873, he was at first buried in the small Catholic church of St. Mary's in Hawkeswood Lane, designed in 1854 by W. W. Wardell, to which the Empress Eugénie added a mortuary chapel, with a sculpture of Christ in the tomb placed in a recess. The widowed Empress remained at Camden Place till the Prince Imperial met his tragic death, when serving with the British forces in South Africa during the Zulu Wars. He was temporarily buried in the south aisle of St. Mary's; a life-sized effigy in uniform marks the place, and his fellow officers erected a massive Celtic cross on Chislehurst Common. In 1880 the inconsolable Empress moved to Farnborough in Hampshire, where her husband and son were reburied. Camden Place was bought by the builder William Willett who, with the versatile architect, Ernest Newton, developed the estate for prosperous London merchants and professional men. Willett, when riding through Petts' Wood, conceived the idea of advancing the clock by an hour throughout the summertime, so that his more sluggish compatriots might enjoy the beauties of the early morning without the effort of rising early; a stone pillar with an inscription stands in the 77-acre wood, now owned by the National Trust, to commemorate his inspiration.

To the south-east of Chislehurst lies the Cray valley, now industralized and overcrowded. This has always been a populated area – carefully wrought Stone Age axes have been found in St. Mary Cray, there was a Bronze Age encampment at St. Paul's Cray, and an Iron Age settlement at Keston. The remains of three Roman villas have been uncovered

at Orpington, with a pagan Saxon cemetery beside one of them at the foot of Poverest Road, and just over the London boundary, at Lullingstone in Kent, is another handsome villa, scientifically excavated and open to the public.

ST. PAUL'S CRAY has what should be a valued possession in its church, dedicated to St. Paulinus. The Saxons must have built a place of worship here – a morsel of wall remains in the north-east corner of the present building, with Roman tiles set in it, and some of the windows may be of equal antiquity. Most of the building was erected about 1200, with a low west tower and a south aisle; the arcade between nave and aisle has circular piers, with heads and acanthus leaves carved on some of the capitals. similar to those wrought in Canterbury Cathedral about 1175-80. The little building was heavily restored in 1856-61, and a south chapel was added in 1863; the Victorian architect gave his capitals acanthus leaves and small heads too – compare the vigour of the early carvings with the more accomplished but flaccid Victorian work. In the late 1970s, the church was restored again and now serves the community as an old people's day centre.

Half a mile away in ST. MARY CRAY is another village church, dedicated to Our Lady, huddled under the railway viaduct, heavily restored by the Victorians, but still unmistakably thirteenth-century, with a west tower and shingled spire. The south arcade and the chancel arch are a century later, and the wooden medieval screens to the chapel and tower have survived the centuries. There are several interesting brasses - Richard Albery (d.1508) who married thrice, Richard Manning (d.1604) and his wife, and Philadelphia (d.1747) and Benjamin G. Greenwood (d.1773); this latter pair, as Mrs. Esdaile tells us, the last spontaneously engraved brasses before the Oxford Movement consciously revived the style. There is one small hanging monument to Margaret Crewes (d.1602), with kneeling figures. Opposite the church, numbers 7-9 in the High Street are a row of cottages, disguised by modern trappings, which must date back at least to the sixteenth century.

The River Cray rises to the south, its source probably the village pond in ORPINGTON. The village here outgrew itself in the 1920s and 1930s and has continued to expand since 1950. The east side of the long High Street is being developed as a shopping precinct, the **Walnuts**, called after the trees for which the countryside was noted.

Eastwards, on the crest of Church Hill, stands All Saints. There was a church here in the eleventh century, though, after a drastic restoration in 1874, nothing remains of the Saxon long-and-short work once visible in the south-east corner of the nave. The chancel arch, the north tower, which sits over the transept, and the west doorway with dog-tooth carvings, all date from the late twelfth or early thirteenth centuries, while the porch, which shelters

一般の 大田 といれ

his elegantly canopied tomb, was constructed when Nicholas de Ystele (d.1370) was rector. A chantry, known as the Rufford chapel, with a handsome four-light window, was added to the north side of the chancel during the fifteenth century. The thirteenthcentury font has a cover carved 200 years later, and on the north side of the chancel there is a brass showing Thomas Wilkynson, (d.1511) once rector here, in his eucharistic robes. The twentieth-century increase of population made an enlargement essential. In 1957, the south wall of the nave was pulled down, and a wonderfully light, large church, designed by Geddes Hyslop and built in a limply sub-Gothic style, was added. A sixteenth-century manor house, Bark Hall, was demolished to make space, and the old church now serves as a narthex to the new building. As reredos, there is a triptych by Brian Thomas, painted in 1959; the central panel depicts Christ in Majesty, shouldering the Cross, and to the sides are the patron saints of Orpington's daughter churches, with views of All Saints and of Rochester Cathedral. This enlargement revealed an unexpected legacy from the earliest church to stand here – a magnificent Saxon sundial with runic letters and an Anglo-Saxon inscription describing its function of 'counting and holding the time to him who knows how to seek out how'. It is now set, unfortunately upside down, in the western pier of the arcade separating the old church from the new.

Near the church stands Orpington Priory, still in use after 700 years. Never a monastic establishment, it was built before 1270, as a hostelry for the priors of Christ Church in Canterbury, to whom the manor belonged, and as a rectory for All Saints. The buildings, enlarged in 1393 and in 1471, remained, fairly intact, till taken over by Orpington Council. The Priory itself has become a museum, the outbuildings, with a lofty central entrance through which a laden hay-cart could pass, were restored as offices in 1974-5, and a modern public library was designed with discretion by Lord Mottistone in 1961. In the museum are displays on the prehistoric, Roman, and Saxon communities which have flourished and waned here. The ancient roof timbers and an Elizabethan plasterwork ceiling have been preserved,

and the grounds are a public park.

To the south-east lies CHELSFIELD, its parish church dedicated to St. Martin of Tours and isolated from modern development in the parish by the bypass. The twelfth-century chancel and nave were extended in the thirteenth century, when three tall, handsome, lancet windows were cut in the east wall. Before the end of the century, a low tower, now capped by a broached, shingled spire, and a small south aisle had been added. Across the Early English tower arch is a carved oaken screen, which probably once served to separate the nave from the chancel. The modern pulpit, designed by George Rose and carved by S. Chapman, bears a figure of St. Martin. At either side of the altar stands a tomb-chest, each

for a past rector, that to the north for Robert de Brun (d.1417), with indents which once held a tiny brass crucifix with flanking figures of Our Lady and St. John, its companion to the south for a member of the Smith family, which supplied the parish with three parsons in the seventeenth century. Other brasses in the chancel are to William Robroke, a priest, who died in 1420, to an unknown lady of about 1480, accompanied by her eleven children, the sons separated from the daughters by a symbolic tree of life, and to Alice Bray, shown with her four sons, who died in 1510 and bequeathed land to the church for the renewal of bell ropes – the field is still known as Bell Rope Field. In the south aisle is a small monument with kneeling figures of Peter Collett (d.1607), Alderman of London, his wife, and children, and another tiny figure nearby for his grandson, Peter Havman, who died in infancy. Beside the church stands Court Lodge, a graceful secluded eighteenthcentury mansion.

FARNBOROUGH lies due west of Chelsfield. The parish church, dedicated to St. Giles the Abbot, was blown down in a storm in 1639 and was rebuilt, from flint, with brick facings to the windows and a crown-post roof like that of a great barn. The chancel and nave are undivided, there is a west gallery with a small new organ, and a low west tower. Thomas Brome, who died in 1673, has a handsome architectural tablet signed by Jasper Latham, and Thomas Young (d.1829), 'Phenomenon Young', who was the first to decipher the hieroglyphs on the Rosetta Stone and who established the undulatory theory of light, has a plainer one, while on the north wall hangs a large brass plaque with elongated figures of Christ and the Apostles, fashioned by Elsie March in 1939. The font dates from the thirteenth or early fourteenth century, and the fair in honour of the patron saint, which the village has held since before 1292, is still celebrated, though now in July and not on St. Giles's Day (1st September). Dendrologists visiting the neighbourhood should explore High Elms Park. Sir John Lubbock, astronomer and mathematician (d.1865), lived here; his house was burnt down in 1967, but a remarkable collection of unusual trees remains in the grounds. Sir John was the father of the naturalist, Lord Avebury, who was responsible for the introduction of Bank Holidays.

DOWNE lies almost due south of Farnborough. The pretty village centre is unusually well preserved, with charming flint cottages and one handsome eighteenth-century house, Petleys, a name which occurs again on the tiny brass in the church to Thomas Petle (d.c.1420). Dedicated to St. Mary the Virgin, the medieval church has two magnificent brasses to Jacob Verzelini (d.1606) and his wife; the Venetian glassmaker became lord of the manor in this pleasant Kentish village and is commemorated in all his finery. One lancet window remains in the south wall, the east window is filled with a vivid

BROMLEY 353

modern Crucifixion by Evie Hone, and the tiny window on the south side of the chancel is filled with blue glass painted with the signs of the zodiac in thanksgiving for the safe return of Robin Knox-Johnstone from his single-handed voyage round the world, accomplished between 14 June 1968 and 22 April 1969.

A sundial has been set on the south wall of the low west tower in memory of the village's most celebrated inhabitant, the scientist Charles Darwin, who lived nearby in Down House from 1842 till his death there, 40 years later. The house, built in the latter half of the eighteenth century, was purchased as a national memorial in 1927 and now, under the aegis of the Royal College of Surgeons, is open. Through the generosity of Darwin's descendants, the rooms have been arranged and furnished as far as possible as they were in his lifetime. The notebooks he kept during his voyage on the Beagle are to be seen, as well as his telescope, barometer, and other scientific instruments. There are portraits of Darwin and Huxley by the Hon. John Collier, another of Erasmus Darwin, Charles's grandfather, by Joseph Wright of Derby, and three more by the same artist. The gardens are well maintained, and the 'Sand Walk', round which the great scientist used to pace daily, is still there.

CUDHAM lies south-south-east from Downe. The

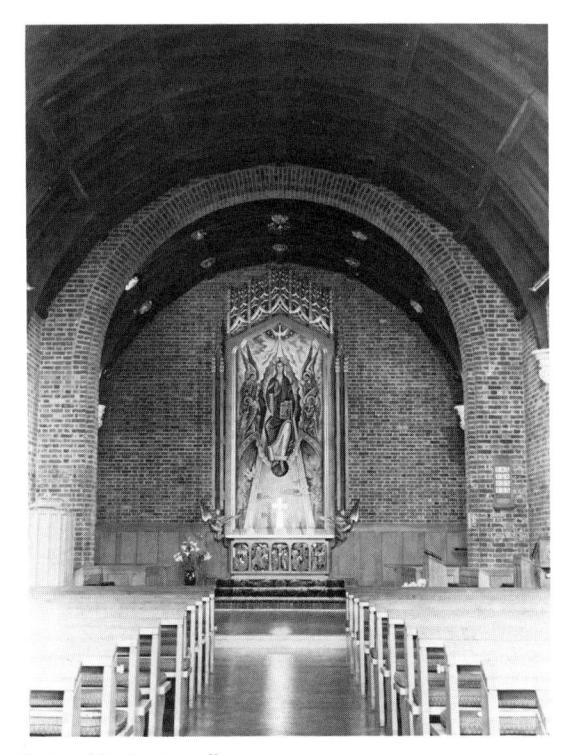

St. Mark's, Biggin Hill

flint parish church, dedicated to St. Peter and St. Paul, is perched on a rural hilltop. There was a church here before the Conquest and the base of the south tower is probably of that period. The two giant yew trees in the churchyard, one of them 30 feet in circumference, may be equally ancient. The narrow, lofty, Saxo-Norman nave retains two lancet windows and leads to a thirteenth-century chancel; the chancel and tower arches are adjacent to each other. locked together by an internal buttress. In the fourteenth century, a plump, short, north aisle with a low side window (see p. 395) was added to the nave, and a south chapel, dedicated to St. Katherine, to the chancel. The octagonal font is of the fifteenth century, as is the tomb-chest in the chancel, which may have served as an Easter sepulchre. There is a nice brass, kept carefully covered, of Alys Waleys (d.1503) with her six sons and three daughters; her husband Walter lies in the church porch. In the tower hangs a peal of ten bells, the oldest of them cast in 1490 by Thomas Bolledon, while two others were the work of John Hodson in 1661. There are three piscinas in the chancel, the south chapel, and the north aisle, all of them set in the east walls, which is unusual.

To the south-west lies BIGGIN HILL, the southernmost point of the borough. It takes its name from John Byggin, who held land here in the sixteenth century. The aerodrome, now used for private flying only, holds wartime memories, symbolized by the Spitfire and Hurricane standing sentinel outside the path to the Memorial Chapel, with its fine glass by Hugh Easton. The parish church is dedicated to St. Mark and has an extraordinary history. From 1904 the only church was a temporary iron shack, inelegant but adequate to serve a population of 200. By 1951, the population had risen to 4,000 and a larger church was needed. In that year, the Reverend Vivian Symons became perpetual curate of Biggin Hill and, with his own hands, assisted by a band of volunteers, he demolished the redundant church of All Saints, North Peckham. The 125,000 bricks were cleaned by the women of the parish and a new church, consecrated in 1959, was built, to the design of R. Gilbert Scott. The rectangle of the campanile, crowned by a lacy parapet, and the firm triangle of the church loom like abstract geometrical shapes. Under the steeply pitched roof is the open timber-work from the old church. The aisle walls are brick piers with massive clear windows between them, the glass engraved by the Vicar himself, using a dentist's drill, with scenes from a fifteenth-century German Biblia Pauperum. He also carved the roof corbels and made the plate and altar cross, as well as the extraordinary font for the Memorial Chapel at the aerodrome. Behind the altar, Roland Pym painted a huge mural, 24 feet high, of Christ in Majesty. St. Mark's is an act of faith made manifest in brick and stone, timber and

To the north, KESTON has a hill-fort and a

post-mill of 1716 on the open Common. The tiny flint parish church, its dedication forgotten long ago, stands in the Westerham Road, miles from the village. Recent excavations have revealed the foundations of what may have been a Roman building, but the present edifice is of Norman and Early English workmanship, with a surprisingly large peal of seven bells lodged in its stone bell-cote. Inside there is a painting of Aaron, cut from an eighteenth-century altar-piece, one window, representing Love, by William Morris and Company, and other glass by James Blackford (1952). The top of a seventeenth-century altar, inlaid with a cross boutonée and inscribed The Keston Marke In Hoc Signo Vinces, has been built into the present altar. Mrs. Humphrey Craik (d.1887), best remembered for that excellent novel John Halifax, Gentleman, was buried in the little churchyard.

North again is HAYES, with a flint thirteenthcentury parish church dedicated to St. Mary the Virgin and heavily restored by Sir Gilbert and I. Oldrid Scott in 1856 and 1878. The dramatic reredos shows the risen Christ, surrounded by angels; there are three brasses to priests, John Osteler (d.c.1460), John Andrew (d.1479), and John Heygge (d.1523), and a tablet carved with cherubs' heads and a skull to Anne Cleaver (d.1737). On the north wall are the profiles, in low relief, of the elder and the younger William Pitt, the only father and son who both became Prime Minister. The younger man lived nearby at Holwood from 1785 till 1803; Sir John Soane enlarged the house for him, Repton replanned the gardens. Tradition declares that it was here, when visiting the Prime Minister, that William Wilberforce resolved to accomplish the abolition of slavery. Early in the nineteenth century, Soane's structure was burnt down and a new house was built between 1823 and 1826 by Decimus Burton. 15 bays wide, with a curved Ionic portico to the garden front, and with superb views across Kent, the house is today the headquarters of Seismograph Ltd., who open the gardens twice a year in aid of charity, when it is possible to see the earthworks of a massive Iron Age fort, as well as a recently excavated late medieval tile kiln.

At WEST WICKHAM, the parish church and manor house are noteworthy. Sir Henry Hevdon, who married Anne Boleyn's great-aunt, was responsible for both. He 'buildid a right fair Manor Place, and a fair Chirche', and they still stand looking out over the Kentish countryside to the north. There was a church here before the Conquest and some fragment of the building may be encased in the massive pillar which links the present chancel and chapel; despite some restoration, St. John the Baptist remains essentially a late fifteenth-century structure. The delicate rood screen, with linenfold panelling and ornamented shafts, is intact, and there are patterned tiles, probably of the fourteenth century. set in the chancel. Two former rectors are shown on their brasses, wearing their mass vestments; they were William de Thorp (d.1407) and John Stockton (d.1515). Sir Walter de Huntingfield has a thirteenthcentury marble tombstone with a long cross on it, while the alabaster tomb-chest of Sir Samuel Lennard (d.1618) serves as an altar in the Lady Chapel, which retains its early sixteenth-century Flemish glass, with figures of Our Lady, St. Anne, St. Christopher, St. Dorothy, and St. Catherine, in spite of threats which the Reformation and Civil War must have posed. The east window shows Sir Henry Heydon as a skeleton, kneeling on tiles of a pattern similar to those before the altar. A wall memorial bears a tiny figure of Margaret Hobbes (d.1608), seated stiffly, her stillborn baby below her. In the low tower hang six bells, two cast by Brian Eldridge in 1640 and another by John Hodson in 1669. The architect, J. D. Sedding, spent the last three years of his life in the village and designed the pulpit and organ loft.

Wickham Court looks like a pocket-sized castle, almost square, with octagonal corner turrets, all of red brick save for stone dressings. It seems unlikely that there was ever a gatehouse or moat, but the house is stalwart enough to make any would-be marauder, even during the troubled reign of Richard III, think twice before attempting an assault. During the present century, the mansion has served as a hotel and a training college for teachers; at present, it is a college for students from abroad.

Croydon

The Borough of Croydon lies due south of the city, its boundary at Coulsdon marking the southern limit of the Greater London area. It is the fifth largest of London's 32 boroughs, with $33\frac{1}{2}$ square miles of housing and the densest population of any - nearly 350,000 people. with an exceptionally high proportion of children among them. Consisting of the former county borough of Croydon and the urban district of Coulsdon and Purley, the whole area centres on the town of Croydon, the largest in Surrey, to which it formerly belonged. Croydon, an extraordinary and sometimes uneasy mixture of old and new, pursues an existence largely independent of the capital, for its industries and commerce provide employment for most of the local residents. In spite - or because - of this concentration, some 3,000 acres remain as open land, as public parks, golf courses, countryside, heath and woodland. We deal first with Croydon itself, and then travel anticlockwise around the borough, beginning with Coulsdon, Purley, and Woodcote in the south, moving eastwards through Sanderstead. Selsdon, Addington, and Shirley to Norbury and South and Upper Norwood in the north.

CROYDON lies on the London side of a gap in the North Downs through which the Roman road to Portslade ran. Here the Saxons made a settlement and the manor became the property of the Archbishop of Canterbury. Since Croydon, less than ten miles from Lambeth, was the penultimate stage on the journey between Canterbury and London, an archiepiscopal palace was built here, which several prelates preferred above their other residences. Their comings and goings, their reception of royal and noble guests, conferred dignity upon, and brought trade to, the little town; Croydon became a place of consequence, increasing in size and importance, till by the mid-seventeenth century it was one of the principal towns in Surrey. During the eighteenth and early nineteenth centuries, it became a coaching centre and in 1803 was the destination of the Surrey Iron Railway - the earliest public railway in the

world - first running from Wandsworth to Croydon and then extended southwards to Merstham in 1805. A railway station opened in West Croydon in 1839, and another at East Croydon in 1841; throughout the century Croydon continued to expand. Then, in 1954, it was decided to undertake a wholescale commercial redevelopment of the town centre, providing a fresh location for many offices being moved out of London. Over the next 20 years, Croydon rebuilt itself, so that today it resembles a miniature Manhattan with about 50 tower blocks. The borough guide describes the new town centre as 'the most consistently modern-looking area in the whole of England'. Some may feel that Croydon has torn its heart out, or at least inflicted upon itself a heart transplant from which it has scarcely recovered. The scale is overwhelming, the results sometimes frightening – and often exhilarating.

The High Street bisects the town, its continuations in the appropriate directions being North End and South End. The new development lies chiefly to the east, while the older part is divided again by the Croydon Flyover, running from south-west to northeast. The parish church, the largest in Surrey, is dedicated to St. John the Baptist. Amost certainly, there was a church here before the Conquest, but the medieval church was probably begun at the expense of Archbishop Courtney in the late fourteenth century, to be completed early in the fifteenth when Chicheley was primate (1414-43). That church vanished, save for the two-storey porch, the core of the tower, and parts of the outer walls, in a disastrous accidental fire in 1867. Sir Gilbert Scott, who then lived in Croydon, rebuilt it faithfully, in the Perpendicular style and on the old foundations. though extending it eastwards by some 18 feet, thus increasing its five bays to six. The tower he embellished with massive pinnacles, and in it now hang 13 bells – the old ones melted in the heat of the flames. The nave is lofty, with a clerestory, and there is an open timber-work roof. The chancel, with its waggon-shaped wooden roof, has on its north side a mural, painted about 1885, of the Feeding of the Five Thousand. Fragments remain from the old church – a double piscina, a fine fifteenth-century brass lectern shaped like an eagle with outspread wings, tomb recesses and memorials, an aumbry, and a seventeenth-century Bible box. There are several brasses and morsels of brasses – the earliest an inscription to Giles Seymour (d.1390), one to a priest, Gabriel Sylvester (d.1512) who had been Master of Clare College Cambridge, another to Elys Davy, who in 1447 founded almshouses which still exist, a fragment showing the seven daughters of Thomas Heron (d.1544), and in the north aisle there is a nineteenthcentury tablet to John Singleton Copley, RA, the distinguished American painter (1737–1815). In the south of St. Nicholas's Chapel, there is a finely carved, nameless tomb, which, from the coat of arms, commemorates Hugh Warham, a brother of a sixteenth-century archbishop, and next to it, fire damage restored by public subscription, is Archbishop Whitgift's tomb. He loved Croydon, founding there a grammar school and a hospital or almshouse, both of which still flourish. His painted alabaster effigy lies in prayer under an archway, watched over by allegorical figures and cherubs. Near him, at the east end of the south aisle, is Archbishop Sheldon's memorial, carved by Jaspar Latham. This prelate, who gave Wren's Sheldonian Theatre to Oxford, reclines, quizzical and comfortable, resting against a marble pillow on a tomb-chest,

its sides adorned with charnel-house scenes. His funeral banner, framed, is nearby. Four other archbishops rest in Croydon – Edmund Grindall (1519–83), William Wake (1657–1737), John Potter (1674–1747) and Thomas Herring (1693–1757).

Their Palace, which gave dignity to the parish church, remains, substantially intact and in use today as a girls' school run by the Sisters of the Church, an Anglican community of nuns, on whom the Duke of Newcastle bestowed the building in 1887. During the spring and summer school holidays, it is occasionally open to the public. The oldest apartment is the twelfth-century undercroft, its roof partly supported by a massive octagonal post and T-beam; around an archway are traces of a fourteenth-century painting. The Great Hall, measuring 50 by 38 feet, was built by Archbishop Courtney about 1390 and then rebuilt, in stone, with a magnificent Spanish chestnut arched braced roof, by Stafford between 1443 and 1452; the carved angels on the roof-corbels hold aloft his arms and those of later prelates. In it stands an interesting sculpture, two angels, one now headless, supporting the royal arms of Henry VI, while beneath, a cherub holds up a scroll reading D'ne

Aerial view of Croydon, showing modern tower block development

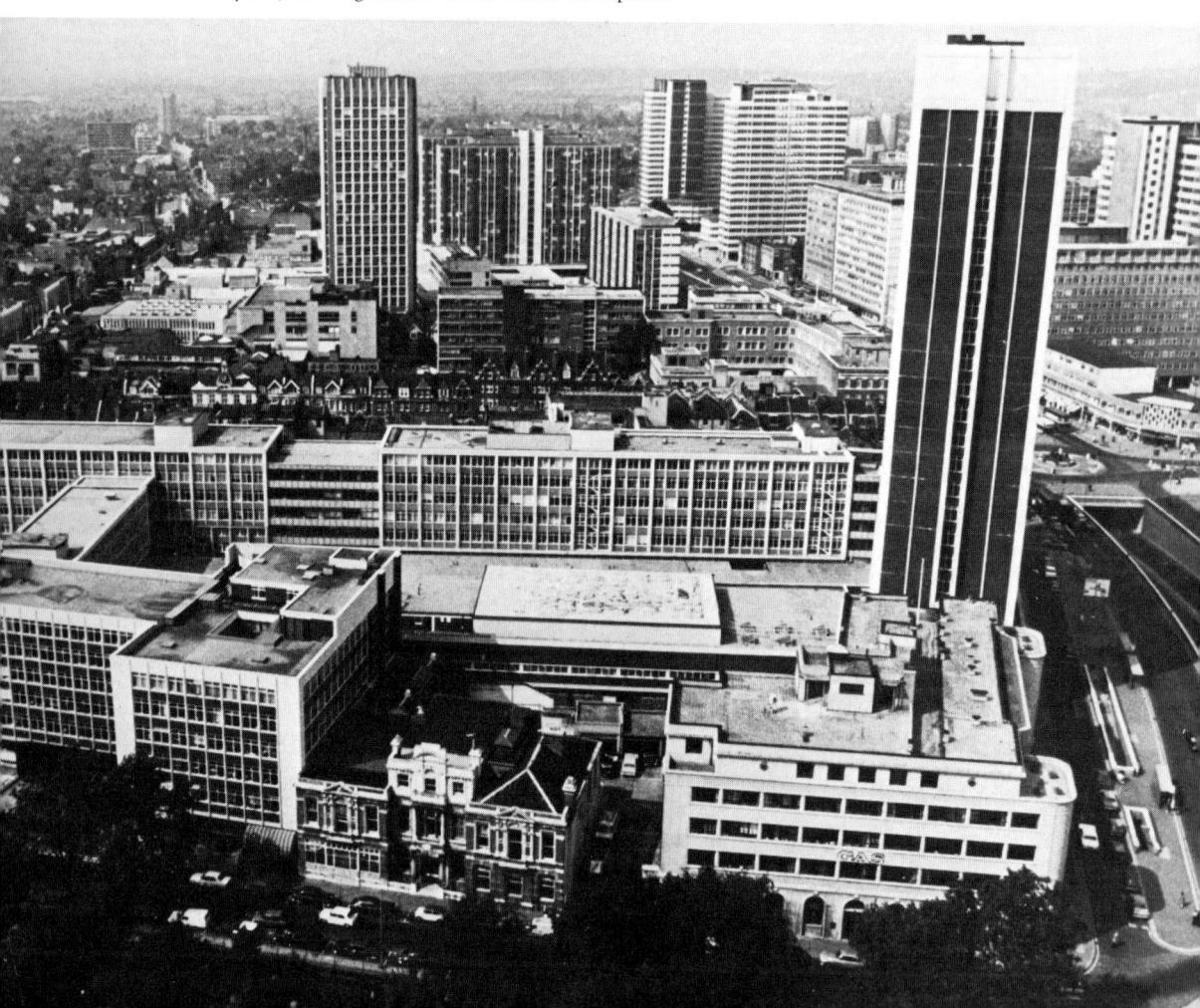

357

CROYDON

salvum fac regem. Beyond the Hall, a dining chamber built by Archbishop Morton in the late fifteenth century has been partitioned into classrooms. A seventeenth-century staircase leads to the Great Parlour or Guardroom, built by Archbishop Arundel soon after 1400. Once again, the corbels display coats of arms, though one has an angel with a lute and another a shield with the instruments of Our Lord's Passion. The Gallery has now been blocked off as a classroom, but across the blind arch have been set the altar rails, which Archbishop Laud had made for the Chapel. An oriel window, its stonework renewed soon after 1900, looks into the South Courtvard. It was in this apartment that the young Earl of Rothesay, later James I of Scotland, spent much of his six years of captivity at Croydon. On the upper floor are Oueen Elizabeth's Bed-chamber – she stayed six times at Croydon - the Long Gallery where she conferred the Great Seal of England upon Sir Christopher Hatton when she made him Lord Chancellor, and the Chapel, probably built by Archbishop Bouchier about 1460-80 on the site of an older place of worship. Measuring 70 by 24 feet. it is of brick with seven tall lancet windows at the east end. The panelled ceiling is of the seventeenth century, and the carved finials to the pews bear the arms of Archbishops Laud and Juxon. At the west end is a screen, possibly installed by Archbishop Morton, with vine leaves and grapes carved along its length, and behind it a gallery-pew bearing Laud's arms and probably carved by his joiner, Adam Black.

Near the Palace are Elvs Davy's almshouses, founded in 1447, rebuilt in 1875 and 1887, red-brick dolls' houses round a miniature courtvard, a refronted seventeenth-century public house, the Rose and Crown, and the premises of Reeves, the auctioneers, which range from an early eighteenthcentury house to a row of shops built a hundred years later, with an astonishing roof-line. In Church Street, its curve followed by the track of the Surrey Iron Railway (see p. 355) the first-floor windows proclaim that several eighteenth-century properties are now in use as twentieth-century supermarkets. The road crosses Surrey Street, redolent of fresh fruit and vegetables, in which a daily street market is held. as it has been since Archbishop Kilwardby obtained its charter for Croydon in 1246. In it stands Ye Dog and Bull public house, an early eighteenth-century building, which claims to have held a licence since 1431, and opposite, in an alleyway, is a remnant of the market's earlier existence, the pavement arcade of Butcher's Row, where meat is still sold. On the west side of Surrey Street, in Waterworks Yard, is a castellated pumping station, re-erected here in 1851, having previously served as the Engine House of the Atmospheric Railway, which ran between Forest Hill and West Croydon from 1845 to 1847. Under good conditions, it was possible to obtain a speed of 70 m.p.h., but mechanical failures occurred so often that the line closed.

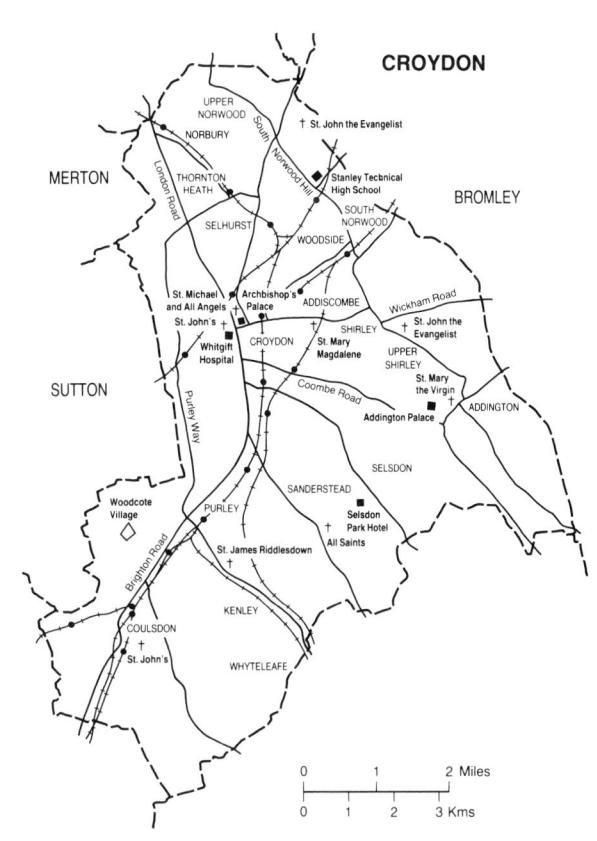

Crown Hill leads steeply out of Surrey Street into the High Street, facing the outer wall of the Whitgift Hospital, the Archbishop's initials – I W for Iohannes Whitgift – picked out in dark bricks against a red background. Completed in 1599 at a cost of over £2,700 - the Archbishop's surveyor would accept only the best quality bricks - the little enclave still provides accommodation for elderly Croydonians. The original furniture, with the addition of Whitgift's travelling chest, is still in the Audience Chamber, and in the Chapel, with its severe backless pews, hangs a portrait of the town's benefactor. The Ten Commandments are set out on a board, with Moses and Aaron standing to attention on either side. Over the entrance of the little quadrangle is a sixteenth-century clock with only one hand and irregular dial spacing; the clock still keeps good time, though it requires practise to read it.

The bustle and at least the ground-floor façades of the High Street belong to the twentieth century, but almost underneath the arches of the Flyover stands **Wrencote**, a magnificent early eighteenth-century house, not built by the great architect. Its recessed doorway is approached by four shallow, curved steps and around the cornice runs a frieze with five large grotesque plaques. Next to the Palace, this is the handsomest building in Croydon; today it is used as offices. In **South End**, among much recent building, the Parks Department has restored number 19,

another eighteenth-century dwelling, where local history publications are sold, and number 46, now an antique shop, is a timbered building of the late sixteenth or early seventeenth century, its tie beam and queen-post roof fully exposed in the front upstairs showroom. On the west side of the High Street lies Laud Street, with pretty eighteenth- and early nineteenth-century cottages, Queen Street, the oldest complete street in Croydon, and the brick-built Providence Chapel of 1847 in West Street, with its neatly decorated pediment. Further westwards lies the Waldrons, now a conservation area. During the 1850s, 34 houses were built to restrained original designs, number 19 having its own tower. Over half remain, set out around the east side of a sinuous crescent. Beyond them, Duppa's Hill, now a recreation ground, rises up; from its summit, the most impressive prospect of the towers of new-built Croydon may be obtained.

The tower blocks cluster on the eastern side of the High Street, and in their midst the confident magnificence of the Town Hall and Public Library in Katherine Street (1892–6 by the younger Charles Henman) provides a red-brick foil to the glassy modernity all around. The imposing clock tower of the Town Hall and the recessed, pedimented porch of the Library epitomize the robust self-confidence and strength of the late Victorian period. Behind them, other council offices are accommodated in Taberner House (1968, 252 feet high, designed by A. F. Holt, the Borough Engineer), called after a former town clerk, a nineteen-storey splayed block, tapering at each end, set on a three-storey podium, and sheltering the Mayor's ceremonial suite.

Beyond the Town Hall, a sunken park occupies the site of what was once Croydon Central Station, and beyond Park Lane and the underpass are the Fairfield Halls and Croydon Technical College and College of Art, all designed by Robert Atkinson and Partners. Fairfield Halls, which also accommodate the Ashcroft Theatre and Arnheim Gallery, are well planned, with a façade of orthodox and uninspired modernity; the Colleges, equally well ordered internally, have a façade so hesitant and pedestrian that it is hard to distinguish the main entrance when approaching the building. An interesting abstract statue by Roger Harmer, a former student at the College of Art, sits on the lawn between the buildings. By contrast, the furthest eastern outpost of the tower blocks, N.L.A. Tower at the junction of George Street and Addiscombe Road, beside East Croydon Station, is quirkily original. Octagonal, its sides a series of alternately projecting and recessed balconies, it rises 270 feet into the air and was built between 1968 and 1970 to designs by R. Seifert and Partners.

Back in the High Street, an extraordinary jumble of façades lines North End. In many cases, the ground floor has been gutted and modernized, but at first-floor level are relicts from the early nineteenth century, fragments of mid-Victorian Gothic and late-

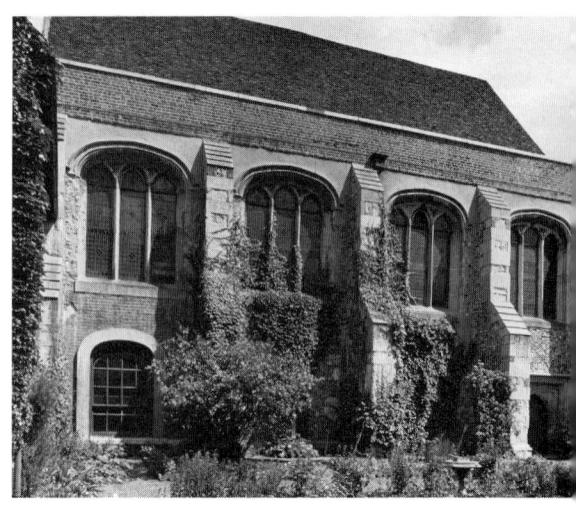

Archbishop's Palace, Croydon

Victorian Moorish, which must once have been their architects' and owners' prides. The Whitgift Centre, a shopping precinct, has replaced the Grammar School, which the Archbishop founded. It was planned by Fitzroy Robinson and Partners between 1965 and 1969; shops line the two-level precinct, from which traffic is excluded, so that purchases can be made in relative peace. A well proportioned central spiral ramp, providing access for perambulators and wheelchairs, gives an airy, insouciant feeling to the whole complex.

At the northern end, in Poplar Walk, is J. L. Pearson's noble church of St. Michael and All Angels, built in 1871. Large and built of brick, the massive south tower was never completed. The interior is extraordinarily satisfying. Lofty and brickvaulted throughout, with stone ribs to the vaults, the altar is cradled in an apse ringed about with seven sharply pointed arches, while a narrow ambulatory, yielding dazzling cross-views of the building, runs behind. The Lady Chapel is a tiny church in its own right, with nave and aisles marked out by delicate, slender piers, very French in feeling. G. T. Bodley designed the pulpit and organ case, Temple Moore the choir stalls, Sir Ninian Comper was responsible for the furnishings of the Lady Chapel, and William Lawson carved the Stations of the Cross.

On the eastern side of Croydon, in Canning Road, is the church of St. Mary Magdalene, built in 1868 by Buckton Lamb. A forbidding façade with a stocky north-east tower does nothing to prepare the visitor for the excitement within. The church is as broad as it is long, the high altar set in an apse, enshrined behind bold brass rails, and raised several feet above the nave. The timber roof centres upon a shallow lantern, around which groups of beams brace themselves in almost individual clusters. Lamb was an eccentric architect, but, within the last ten years, his church has come into its own. The high altar has
CROYDON 359

been retained, but the altar for regular parish use has been brought down into the centre of the nave under the lantern, the light of which is augmented by a starkly modern, wholly successful, electric lighting fitment. The pews have been rearranged to embrace and encircle the altar on three sides, and the whole church has come alive as a meaningful, vital place of worship. The architect responsible for the rearrangement was George Pace.

It is too soon to pass judgement on the new Croydon created by the past generation; such an upheaval will scarcely have been assimilated when the twenty-first century has begun, but one small, hopeful sign is the quality and rapid sale of local history publications, both those provided by the borough council, and those issued by Living History Publications from 294 High Street. A population so healthily interested in its own past is not going to settle for an unworthy future.

COULSDON, still largely open countryside, lies in the southern tip of the borough. There is some excellent long-distance walking to be had here, across Farthing Down where the lynchets or earth banks which marked out the Celtic field boundaries can still be seen, and where a line of Saxon barrows is clearly visible in winter, and through Happy Valley, a protected reserve celebrated for its spring flowers, its wild orchids, and varied wild life, to Coulsdon Common, with the mid-eighteenth-century Fox public house. The land here is maintained as a public open space by the Corporation of the City of London.

Architecturally, the most interesting part of Coulsdon lies around Bradmore Green where, beside the pond, stands eighteenth-century Bradmore Farm with The Barn, dating from the sixteenth century, near it. On the eastern side is St. John's church, built in the late thirteenth century with a low fifteenthcentury tower, in which hangs a peal of five bells, the oldest in regular use in Surrey, cast in 1675 by John Hodson. In 1958, a big extension, twice the size of the original building, was added to the south side by I. S. Comper. It is a fine, light church, with a clerestory to the nave and a fanciful baldacchino, modelled on one in Gerona Cathedral, over the altar; a more impressive south window, behind the altar, might be an improvement. The old church has remained comparatively undisturbed, its most beautiful features the lofty blank arcading on the chancel walls, with a handsome, trefoil-arched sedilia and piscina on the south side, and a blocked thirteenth-century doorway, once used by the priests when entering the chancel directly. Opposite is a Coade stone memorial to Mrs. Elizabeth Howard (d.1802) with three small cherubs' heads, and in the north aisle, now partitioned off as a vestry, is an alabaster monument to Grace Rowed (d.1631) and Thomas Wood, with a small figure of a woman standing on a skull, and two slate panels with the names of the deceased in acrostic verses.

PURLEY, to the north of Coulsdon, was little more than a name till a railway station opened there in 1879; afterwards, it became an architecturally unexciting residential area. There is, however, J. E. Newberry's fine church, St. James Riddlesdown, built betweeen 1915 and 1931 in St. James' Road, with recently acquired dramatic stained glass by Martin Travers in the main windows, while along the side aisles are scenes from the life of Joan of Arc – unusual in an Anglican church. On its western edge is Woodcote Village, laid out between 1901 and 1920 by William Webb, who planned the gardens before beginning the houses. There is an impeccably smooth village green and an avenue of sombre Lombardy poplars, the Promenade de Verdun, was planted in soil brought from France as a war memorial.

SANDERSTEAD lies to the east, its development confined to a ribbon along the Limpsfield road by Kingswood, laid out chequerwise in formal shooting rides, and by the expanse of Selsdon Park Golf Course, with the remains of Selsdon Court as its club house. The parish church, dedicated to All Saints, is a low, flint, thirteenth-century building with a fourteenth-century tower and an over-restored chancel of a century later. On either side of the east window is a spidery, elongated, fourteenth-century figure, St.

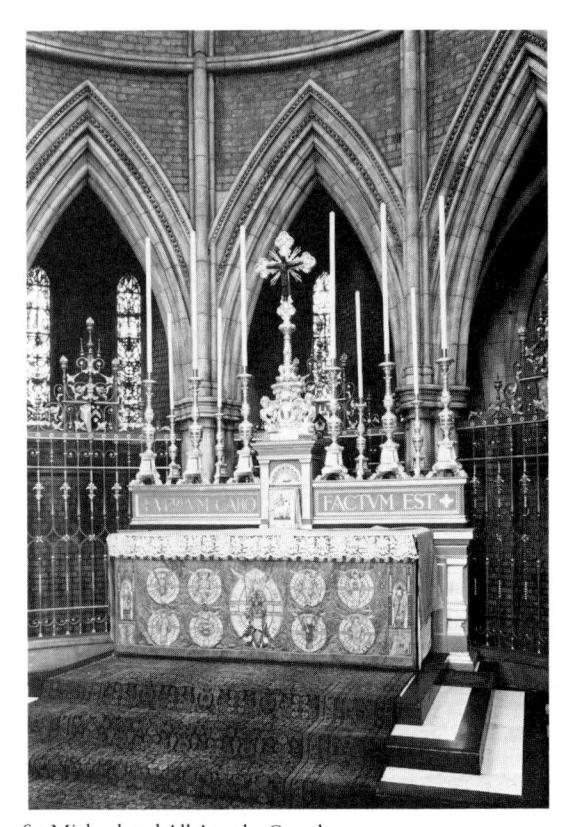

St. Michael and All Angels, Croydon

Edmund with his arrows to the north, an archbishop to the south, and on the chancel arch are painted the royal arms of Charles I. John Atwodde (d.1525) and his wife can be seen on their brass, and John Ownsted (d.1600), Master of the Horse to Elizabeth I, is commemorated by a small, brightly painted, kneeling figure. A life-sized shrouded effigy, the cloth drawn back to reveal the face, commemorates Lady Mary Audley (d.1655); the carving is rough in places, but expressive. There are several engraved floor slabs to members of the Mellish family and a nameless early eighteenth-century memorial, with the wigged bust of a young man and a poem lauding the dead youth's virtues and abilities, is thought to commemorate a son of Henry Mellish. The church has recently been enlarged to the north, and an impressive porphyry font has been installed; a small west gallery supports a graceful modern organ.

A quarter of a mile away, along the Selsdon Road, is Selsdon Park Hotel, occupying an early nineteenth-century building designed by its owner, George A. Smith MP, which embodied now unrecognizable fragments of a medieval establishment. After 1925, the house became a hotel, with not entirely sympathetic enlargements by Hugh Macintosh. A small folly, designed as a tower, stands in front of the main building, and the grounds are laid out most graciously, with a long terrace, impressive cedar trees, and a view across to the National Trust bird sanctuary in Selsdon Wood.

ADDINGTON lies on the easternmost edge of the borough. In it stands Addington Palace, the official archiepiscopal residence from 1808 to 1896. The house, erected in 1773-9 by Robert Mylne for Barlow Trecothick, Lord Mayor of London and Member of Parliament, is a three-storeyed building, seven bays wide with wings and end pavilions, and an interior filled with the clearest light, for the window glass is of superb quality. In 1897, Archbishop Temple decided to live primarily at Canterbury and the house was remodelled internally for F. A. English, a South African millionaire, by Norman Shaw, at the enormous cost of £70,000, though the architect retained much of Mylne's quiet elegance. In 1951, the Palace became the property of the borough council who leased it to the Royal School of Church Music; a conservatory was changed into a chapel by Stephen Dykes Bower and furnished with the choir stalls from Wren's St. Sepulchre in Holborn. The grounds, laid out by Capability Brown, have become Addington Palace Golf Course.

Inevitably, the presence of the Archbishop at the Palace increased the importance of the hitherto humble parish church, dedicated to St. Mary the Virgin. Its chancel and nave had been built about 1080, with three narrow lancets, one high in the east wall, the other two, later blocked up, in the north and south. Half a century later, three more lancets, slightly broader this time, were introduced, cut in a row behind the altar – a most unusual feature. The low

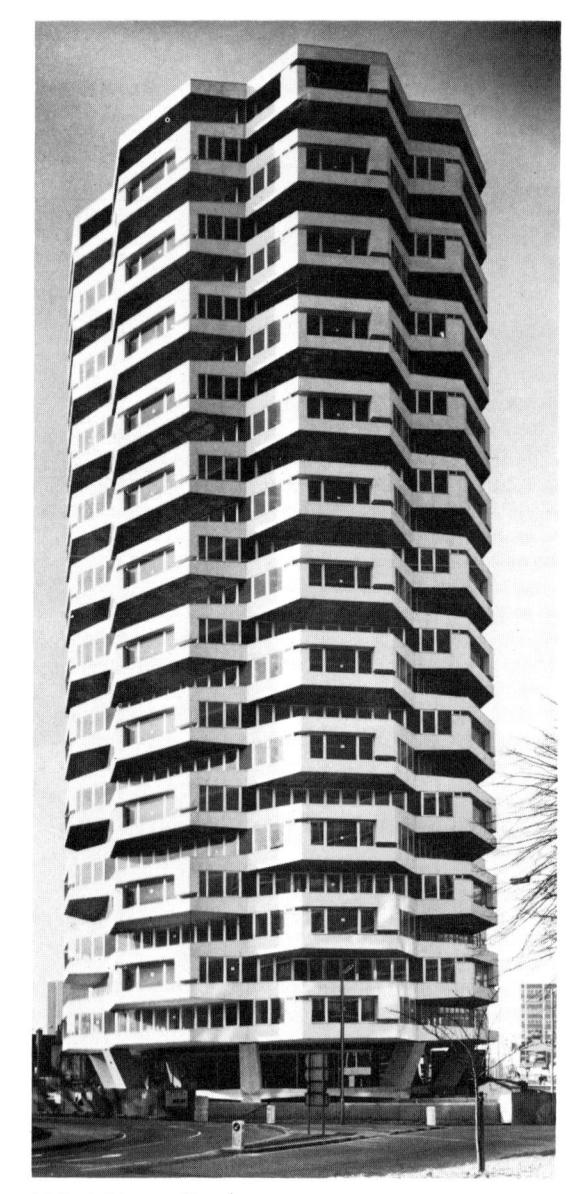

N. L. A. Tower, Croydon

south arcade, with alternating round and octagonal piers, dates from the thirteenth century, the north arcade from an extension of 1876. At the end of the nineteenth century, a marble reredos, with statuettes of Archbishops Cranmer, Theodore, Benson, and Laud, was installed, and the walls and splays of the ancient lancets were painted with patterns of a bemusing, dazzling intricacy. In the chancel floor are set figured brasses to John Leigh (d.1509) and his wife, and to Thomas Hatteclyff (d.1540), 'sumtyme on of ye foure masters of ye howsholde' to Henry VIII. On the north wall of the chancel is an alabaster and black marble memorial to three generations of

CROYDON 361

the Leigh family. Sir Francis Leigh (d.1612) erected it and he and his wife are represented by stiffly recumbent, life-sized effigies, while his parents and grandparents, Sir Oliph and Lady Leigh, and Nicholas Leigh and his wife, appear as smaller kneeling figures in niches above. There is some attempt to convey the changes in women's clothing over the period. Elizabeth Lovell and her daughter, Lady Sarah Leigh (both died in 1691), have a tablet with well carved bunches of flowers, and on the south wall are two urns, one portly, the work of Wilton, raised by Barlow Trecothick to his first wife, Grizzel (d.1769), and the other more graceful, to the gentleman himself (1775), set up by his second wife, Anne. In the churchyard, are several wooden 'bedstead' tomb markers; popular in the nineteenth century for reasons of economy, they are now becoming rare.

Addington Hills rise up to the west of the Palace park, and from a viewing platform, some 470 feet up, erected at the expense of Lieutenant-Colonel Basil Monk to commemorate Croydon's millenary year in 1960, it is possible, on a fine day, to see over the towers of Croydon to Epping Forest, to St. Mary's church on Harrow Hill, 19½ miles away, to Amersham, 32½ miles away, and to Windsor, 25 miles distant. The expanse of heath and birchwood around provides the residents of New Addington, a large council estate, with a wonderful recreational area. At the foot of the hills runs Coombe Lane, with Coombe Lodge, an estate once the property of William Harvey's brother-in-law, and now housing the Parks Department Central Nursery, which is sometimes open to the public, and Coombe House, an elegant mid-eighteenth-century house, built of red brick with a trim pediment above the door. It is now St. Margaret's School for spastic children, and both house and grounds are open each summer for a fête.

SHIRLEY lies on the northern side of the Addington Hills, cradled between them and the golf course. The Trinity School of John Whitgift moved here in 1965, having been ousted from its ancient site at North End in Croydon. John Ruskin's School is nearby, with a well preserved mid-nineteenth-century tower-mill in its grounds. It takes its name from the burial of John Ruskin's parents in the churchyard of St. John the Evangelist, a flint and stone village church carefully designed by Sir Gilbert Scott in 1855, with a small bell-turret and spire. The church is less remarkable than the collection of Victorian monuments in the churchyard. A past vicar, the Reverend William Wilks, was Secretary of

the Royal Horticultural Society and was probably responsible for the variety of trees planted around the little building. It was he who propagated that delicate flower, the Shirley poppy.

NORBURY with SOUTH and UPPER NOR-WOOD occupy the northern tip of the borough. Sir Arthur Conan Doyle, the creator of Sherlock Holmes, lived for many years at 12 Tennison Road in South Norwood. The whole area is closely built up now, but it is worth noticing Norbury Hall in Craignish Avenue, now an old people's home, but built in the early nineteenth century with a pretty trellis-work veranda, and Norwood Grove, on the slope of Gibson Hill, its grounds now a public park. The stuccoed mansion, its glass conservatory boasting a pair of miniature glass onion domes clearly inspired by those at Brighton, is now council property and available for local meetings.

At South Norwood, the main crossroads is marked by an iron clock-tower, erected in 1907 to celebrate the golden wedding of Mr. and Mrs. Stanley. Mr. Stanley had designed and financed the construction of the Stanley Hall and the Stanley Technical High School for Boys, two glorious, spontaneous, unself-conscious, Art Nouveau buildings, their roof-lines decorated with flower pots sprouting stiff iron daffodils and tulips and the staircases effulgent with the glow from the sea-green Doulton balusters which line them. A statue of a smith outside the school bears the motto Labor Omnia Vincit. Norwood should cherish these buildings; the confidence and sincerity which inspired them speak from every curiously angular line.

Three-quarters of a mile away, in Auckland Road in Upper Norwood, stands John Loughborough Pearson's noblest London church, St. John the Evangelist, consecrated in 1887. All of bright red brick, a cloistered porch and two asymmetrical turrets mark the west end; their angularity would have been better balanced had the huge tower which Pearson planned ever been realized. The original pews have gone, and the spaciousness of the uncluttered interior shows to better advantage than it did before. Every section of the roof is brick-vaulted and the clerestory fills the whole building with a silvery light. This interior is as simple as Pearson's other masterpiece at St. Augustine's, Kilburn, is complicated, and makes a direct impact, where St. Michael's church in Croydon persuades with subtlety and delicacy. This borough is fortunate to possess two churches by this remarkable architect.

Greenwich

The London Borough of Greenwich is composed of the former boroughs of Woolwich and Greenwich. It lies to the south-east of the City with nearly nine miles of riverside boundary, the longest possessed by any London borough, and its 12,000 acres house some 215,000 people. It is a place of rare beauty. A line of former villages - Greenwich, Charlton, Woolwich, Plumstead - string out along the Thames; inland, the ground rises sharply to Shooter's Hill and then stretches away to Eltham in the south. In spite of the usual spread of late nineteenthand early, inter-war, and current twentiethcentury housing, much of the borough is parkland, with Greenwich Park as the most remarkable open space. Here, Le Nôtre's dramatic terracing can still be recognized beneath the overgrowth of centuries. And architecturally, the borough is rich. Whereas at Hampton Court the visitor has a single magnificent edifice on which to concentrate, Greenwich provides a pattern book of buildings by all the best English architects, from Inigo Jones onwards, with such extraordinary additional sights as the Cutty Sark and the Gipsy Moth IV in dry dock, while an exploration of the other corners of the borough – Blackheath, Charlton, Woolwich, Plumstead, and Eltham - only enlarges the architectural anthology.

GREENWICH lies beside the Thames, just north of Roman Watling Street, the alignment of which may still be followed, through 12 straight miles, over Shooter's Hill, through Crayford to Swanscombe Park. A morsel of the red tesserae-covered floor of what may have been a native, pre-Roman temple may be seen, preserved and enclosed, among the trees near Maze Hill Gate in Greenwich Park. It was here that the Danes murdered Archbishop Alphege in 1012, and the parish church, dedicated to that stubbornly heroic saint, marks the spot where he is believed to have been struck down. About 1428, Humphrey Duke of Gloucester, brother to Henry V, whose library provided the nucleus of the Bodleian at Oxford, built himself a mansion, which he called

Bella Court, beside the Thames and enclosed a park around it by royal licence in 1433. Between 1500 and 1510, the house was rebuilt and renamed Placentia. Here, when the Tudor dynasty had united the warring houses of Lancaster and York, Henry VIII was born and here he wedded Katharine of Aragon and later Anne of Cleves; Greenwich claims too that it was here, where the Dover Road ran through the Park, that Sir Walter Raleigh, sacrificing his cloak that she might cross dry-shod, found fortune at the court of Elizabeth I.

James I gave Greenwich to his Queen, Anne of Denmark, and she commissioned Inigo Jones to build for her a small palace, so sited that one half faced Placentia while the other stood in the park, with a bridge, straddling the Dover Road, to join the two. Begun in 1616, it was the first royal commission for a building planned in the new Palladian style. It might be possible to claim this as the prettiest house in all England, but its charm is founded on the discipline of classical architecture which Jones had studied in Italy 'sollid, Proporsionable according to the rulles, masculine and unaffected' - and the little building has a gravity and serene dignity which go beyond mere prettiness. The Queen died before the work was finished, but the house was completed in 1635 for Henrietta Maria, Charles I's fascinating French wife: she called it her 'House of Delight', and returned to it in her widowhood, after the tragedy of the Civil War. The ravages of that struggle and the passage of time had so dilapidated the main palace that Charles II had the old buildings demolished and commissioned John Webb, Inigo Jones's nephew-in-law and pupil, first to enlarge the Queen's House by turning its H-shape into a square, by adding two more bridges across the roadway, and then to design a new establishment for him. The foundation stone was laid in 1664 and the western range, at right angles to the river, was built with a sober, well proportioned, main façade facing east onto a courtyard. The Park was laid out formally, probably to plans prepared by André le Nôtre, who designed the gardens at Versailles, with avenues of trees and a series of terraces like giant grassy steps. The work on the palace stopped through lack of money in 1669, but in 1675 Charles II ordered Duke Humphrey's tower which, from the height of Greenwich Hill, had commanded the river approaches to London, to be pulled down and GREENWICH 363

replaced by **Flamsteed House**, the first Royal Observatory, with a distinctive roofline which still tops the hill.

When William and Mary took over the throne. they decided to make Hampton Court their chief residence, and in 1694 Wren was instructed to complete the buildings at Greenwich as a hospital for seamen, on the lines of Charles II's military foundation at Chelsea. The original plans, which would have obscured the Oueen's House from the river, were revised by Mary herself, and the work was carried out after her untimely death. The King William Building, with its magnificent dining-hall, was completed about 1704, though the west facade, designed by Vanbrugh, was added in 1728; the two western ranges, named for Queen Mary and her sister. Oueen Anne, though begun in 1699, were not finished till the middle of the next century, by which time there were plenty of pensioners in residence. Hawksmoor and Vanbrugh both worked on the plans, and Vanbrugh was Surveyor to the Royal Hospital from 1717 till 1726; Colen Campbell and Thomas Ripley completed the Queen Anne building in 1740, and Ripley worked alone on the Queen Mary block till 1750. All in all, the four blocks, with Wren's twin domes raised above to frame the Oueen's House, and the almost matching facades of the two riverside ranges, with their coupled pillars supporting uncluttered pediments, provide an epitome of seventeenth- and eighteenth-century English architecture. All is well disposed space and good proportions: there is no meanness anywhere.

The best way to approach Greenwich is on a fine summer's day by river steamer, boarded at Westminster, Charing Cross, or Tower Pier. From the water the group of buildings can be appreciated as a whole, stretching away up the hill, with Flamsteed House to close the vista on the southern height. London can be proud of this prospect, one of the finest in western Europe. For those who come in winter or who do not care to travel by water, the same view can be obtained from Island Gardens in Tower Hamlets, on the north bank of the river, via the underwater footway tunnel; two neat little terracotta temples, one on either bank, mark the entrance.

Once disembarked at Greenwich Pier, the explorer's attention is drawn by two vessels, no longer storm-tossed but cradled in dry dock, the *Cutty Sark* and the frail *Gipsy Moth IV*. The former, taking her name from the abbreviated garment in Burns's poem, *Tam o' Shanter*, was built by Scott and Linton. Every graceful, urgent line in her speaks of speed, for she was built as a tea-clipper on the China run, though she was baulked of much service in those seas by the opening of the Suez Canal just a week before her launching at Dumbarton on 22 November 1863. From 1877 to 1895 she carried wool on the Australian run and, under Captain Richard Woodget, was never beaten home by any other ship. Then she was sold to the Portuguese, but in 1922 Captain Wilfred

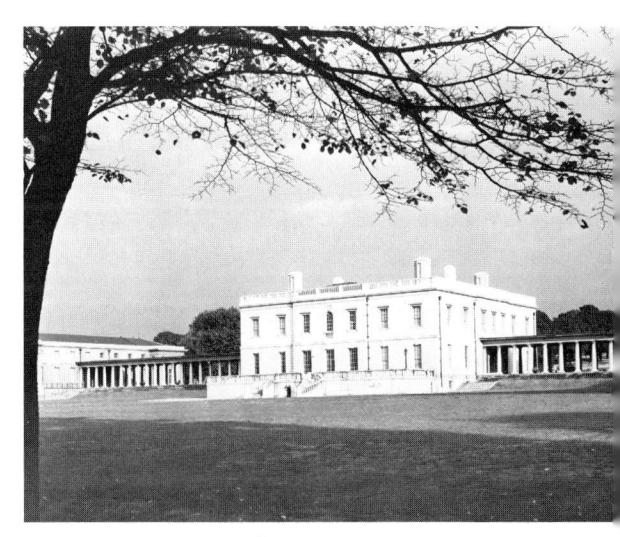

Queen's House, Greenwich

Dowman bought her, re-rigged her, and maintained her at Falmouth. The last surviving clipper, she was offered to the National Maritime Museum as a gift in 1949, and five years later was berthed at Greenwich. It is possible to wander all over her decks, to marvel at the ten miles of intricate ropes which make up the rigging, and at the spare dignity maintained below decks where the wool bales were stowed. In the upper hold, an exhibition describes the construction of the ship and tells her history; in the lower is a handsome display of painted figure-heads, which adorned the prows of nineteenth-century sailing ships. The bulk of the clipper emphasizes the frailty of Gipsy Moth IV, in which Sir Francis Chichester sailed single-handed around the world in 226 days in 1966–7. Both vessels are open to visitors throughout the year.

Eastward lie the four ranges of what is now the Royal Naval College for by 1869 so many inmates of the hospital had become out-pensioners that the College was moved here from Portsmouth. Save on Thursdays, Good Friday, and over Christmas, the Painted Hall and Chapel are open to the public, free of charge, each afternoon. The dining-hall, designed by Wren with Hawksmoor's assistance, was completed in 1704; from 1707 to 1722, Sir James Thornhill covered the walls and ceiling with the most spectacular display of heroic allegorical painting ever achieved by an Englishman. He was paid at the rate of £1 per square yard for the grisaille panels and trophies on the walls, with £3 for each yard of the roof, where he depicted the Triumph of Peace and Liberty. In the central panel, Apollo urges his chariot through the heavens, while below him, shaded by a canopy, sit William and Mary, rejoicing in the success of the bloodless revolution which had given them the throne. Peace, kneeling, offers them an olive branch, and William confers the scarlet Cap of

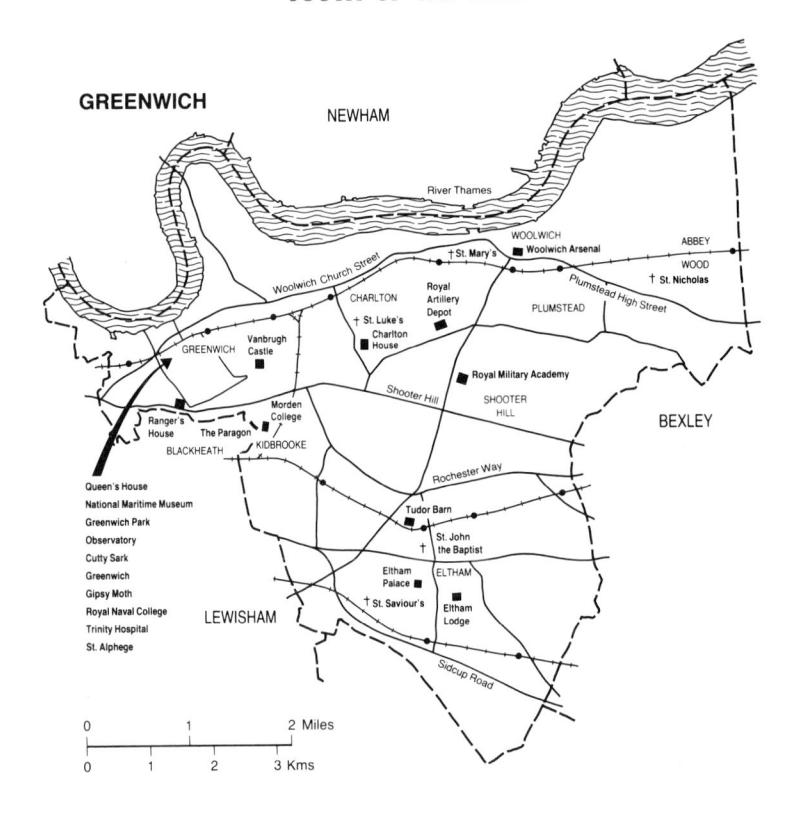

Liberty on Europe, while trampling Louis XIV, the personification of Arbitrary Power, underfoot. Around them dance the Signs of the Zodiac, while the Seasons watch the merriment. John Worsley, one of the first and oldest pensioners, sat as the model for Winter; having served 70 years at sea, he was still lively enough at 96 to need correction for drunkenness and swearing. In the extreme south-east corner we can recognise Flamsteed, the first Astronomer Royal, with his assistant Thomas Weston, and the 'great mural arch or tube', the telescope that Newton had used; Flamsteed holds a paper predicting an eclipse of the sun on 22 April 1715. On the roof of the Upper Hall, portraits of Queen Anne and her consort, George of Denmark, are saluted by the Virtues and acclaimed by the four Continents -Australia was scarcely known - while on the west wall is depicted the return of the golden age of peace and prosperity under the benign rule of the Hanoverian dynasty. Thornhill included his own portrait in the scene; he stands to the right of the daïs on which George I sits with his family around him, pointing to the new sovereign, his brushes, maulstick, and palette beside him. The men who worked on this Hall must have loved it; Hawksmoor presented the Hospital with six silver salt cellars and Thornhill gave six silver rat-tailed spoons, which are still set out on ceremonial occasions. It was in this Hall that Nelson's body lay in state in 1805, after his death at Trafalgar.

The heroic decorations of the Hall find a sharp contrast in the exquisite neo-Grecian adornment of the Chapel. After a disastrous fire in 1779, James Stuart's plans were executed by William Newton and Robert Mylne. Throughout, delicate pastel colours, like those beloved of the Adam brothers, are used, with magnificent mahogany woodwork, fine, crisp plasterwork, and Coade stone decorations. In the Vestibule stand figures of Faith, Hope, Charity, and Humility, designed by Benjamin West and executed in Coade stone: the frieze was the work of John Bacon. Inside, the shallow blue vault is encrusted with delicate plasterwork, and the galleries carried on slender cantilevered brackets. The altar-piece, showing St. Paul's shipwreck, was executed by West for a fee of £1,200; it has a sumptuous gold frame, carved by Richard Lawrence at 50 shillings for each square foot. The angels flanking it are by Bacon, and the dorsal is of material used at the coronation of Queen Elizabeth II. The handsome oak and mahogany pulpit, carved by Lawrence and Arrow and adorned with Coade stone medallions, was once the top of a three-decker structure. In the galleries, the paintings between the windows were designed by West and executed by Biagio Rebecca who, with De Bruyn, Cotton, and Milburne, was also responsible for the paintings on copper plates in the lunettes above the lower windows. The organ was installed in 1787 by Samuel Green, in a handsome case made by William Newton, and in the marble floor is set a GREENWICH 365

representation of a mariner's compass with the Navy's crest, a fouled anchor, pointing to show the north. In the courtyard beyond the chapel stands a statue, probably by Rysbrack, of George II as a warrior.

When the Tudor palace was replaced by the Royal Hospital, the Queen's House first became the residence of the Ranger of Greenwich Park, and the road beneath it was diverted to run as it does today. Later, it provided accommodation for the staff of the Royal Hospital School for seamen's children. Flanking colonnades were built to provide covered playgrounds in wet weather and a means of communication with outlying buildings. In 1933 the school moved to Suffolk and its place was taken by the newly formed National Maritime Museum. At once, the Office of Works (now the Department of the Environment) set about restoring the Queen's House to its former perfection, so that today its structure is much as Inigo Jones conceived it two-and-a-half centuries ago, nine bays wide, two storeys high, with a neat balustrade round the top, a sheltering loggia to the first floor on the southern side, and a double staircase giving a graceful approach from the north. Every detail is of perfect symmetry and proportion; this forerunner of the Trianon must have presented an extraordinary contrast to the rambling Tudor palace. Inside, we enter first the double cube of the Great

Carved keystone from the Tudor palace at Greenwich

Hall, the divisions of its plaster ceiling reflected in the design of the black and white marble floor which Gabriel Stacy laid, with Nicholas Stone, the King's Master Mason, to supervise him. The paintings by Orazio Gentileschi, which once filled the ceiling compartments, are now in Marlborough House, for Queen Anne gave them to Sarah Churchill (see p. 141). In the adjacent rooms are Tudor and Stuart portraits and sea paintings. A white marble spiral staircase, cantilevered out from the side walls without visible support – the first of its kind in England – leads upwards to the gallery; it is known as the 'Tulip Stair', from the wrought ironwork of the balustrade, though the motif is more likely to have been intended as a fleur-de-lys – a compliment to the French princess who used it. Around the gallery, which retains its original woodwork, the Museum authorities have hung with splendid effect a series of paintings by Matteo Perez de Aleccio of the Siege of Malta in 1565. From it we can enter the Queen's Drawing Room, with a portrait of Henrietta Maria by Van Dyck and another of Charles I by Mytens. The delicate carved work of the decorated ceiling has survived intact. On the opposite side of the gallery is the Queen's Bedroom which, apart from the Hall, is the finest and best preserved room in the house. The original central ceiling panel vanished during the Commonwealth, but another was inserted during the succeeding century, while the grotesques which fill the cove are the original decoration. The museum authorities have furnished the room as it might have been in Henrietta Maria's day, with a replica of a state bed modelled on an early seventeenth-century one at Knole.

Beyond the bedroom, through the North-East Cabinet, is the King's Privy Chamber, added by Webb for Charles II, with a plasterwork ceiling wrought by John Groves, one of Wren's leading craftsmen in the rebuilding of City churches. The rooms on the south side of the house now display the Museum's holdings of material connected with the development of the English Navy under James II, when he was still Duke of York, and under Samuel Pepys, and also on the wars with Holland in the 1670s. Lely's portraits of the admirals are here, and so is a single Mortlake tapestry from the set depicting the Battle of Sole Bay in 1672, the others being at Hampton Court (see p. 252). The East Bridge Room, added to serve as Catherine of Braganza's Presence Chamber, has another fine ceiling by John Groves, and in the Middle Bridge Room, part of the original structure, though much altered when windows were inserted in the nineteenth century, are housed the ship-models of c.1660-70, from which the Navy Board determined the designs of future craft. Back in the gallery, the South Stairs lead down to the Orangery, where there stands a marble bust of Inigo Jones with a long table, designed for the game of shove-halfpenny or shovel-board, to which Henry VIII was addicted. The room to the east houses the

Barbarini Collection of early astronomical instruments, while that on the west was probably used by William van der Velde as his studio – the National Maritime Museum possesses some 1,450 marine paintings by this artist and his sons.

Though the Museum has brought together its chief treasures in the Queen's House, the collections are still large enough to fill the two main buildings at either end of the colonnade. The principal entrance is in the East Wing, where the displays are devoted to the nineteenth and twentieth centuries, with particular emphasis on migration to the United States and Canada; on the small wooden ships which once transported goods around the coasts of Britain; on the nineteenth-century dockyards along the Thames; on the twentieth-century development of the Navy; and, in the Arctic Gallery, on the attempts to find the North-West Passage. There is an excellent Children's Centre, and the Lecture Theatre is here.

The West Wing is larger and was increased still further by the addition, in 1972, of the Neptune Hall, which, seen for the first time, provides even a

seasoned museum visitor with a sharp shock for, towering up to the girders which span the roof, is the funnel of the riveted steel steam paddle-tug, the Reliant, reconstructed here almost completely, with her unique side-lever engines running, and access for visitors to the decks, the stokehold, the master's cabin, and the crew's forecastle. Near the Reliant is the cockleshell of an Irish coracle, primitive in design but still in use for fishing. Around the walls is a display on the development of wooden boats from prehistory to the Vikings, through medieval cogs and hulks, to the last days of wooden ship-building; nearby are early marine diesel and petrol engines, with material on the supporting services of shipping - lighthouses, tugs, pilotage, lifeboats, and dredgers. There are some magnificent figure-heads and, in the Barge House is the State Barge built in 1731-2 for Frederick, Prince of Wales, constructed at John Hall's boat-yard opposite Whitehall, with a fantastically decorated hull, designed by William Kent and carved by James Richards, who had succeeded Grinling Gibbons as Master Carver to the Crown. The

Aerial view of Greenwich

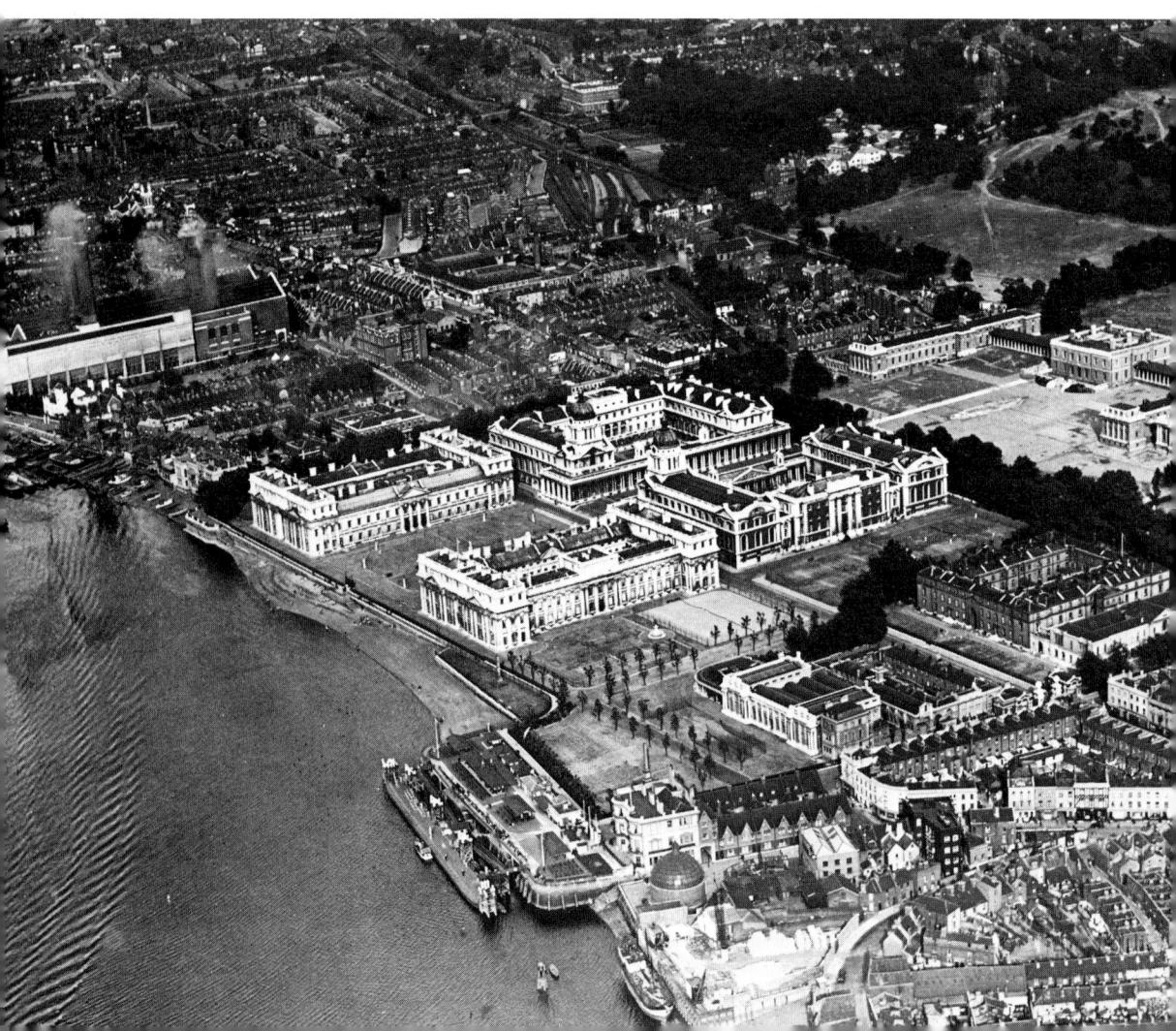

GREENWICH 367

vessel was still in use by the royal family in 1849. Upstairs is the Navigation Room, with four marine chronometers made by John Harrison between 1736 and 1764, which demonstrated that a timepiece could be made sufficiently accurate to determine a ship's longitude at sea. The museum is rich in paintings. Canaletto's magical prospect of Greenwich, a view scarcely changed even today, is here, with Hogarth's portrait of Captain Sir Alexander Schomberg, Samuel Scott's awe-inspiring representations of the use of fire-boats at Ouebec in July 1759, and John Cleveley's rustically lyrical Launching of a Sixth-Rater at Orford in the second half of the eighteenth century. Fresh displays on the lives and achievements of Cook and Nelson have recently been arranged. Being outside central London, the National Maritime Museum is seldom overcrowded.

On the height above the Museum is the Old Royal Observatory, established in 1675 by Charles II who, wrote John Flamsteed, the first Astronomer Royal, 'said the work must be carried out in royal fashion. He certainly did not want his ship-owners and sailors to be deprived of any help that the Heavens could supply, whereby navigation could be made safer.' Wren built Flamsteed House, 'for the observer's habitation a little for pompe'; successive generations have added to it. Above the eastern turret, the Lords Commissioners of the Admiralty raised, in 1833, a pole and time-ball which falls daily at 1 p.m., precisely. The Royal Observatory moved to Herstmonceux in Sussex in 1948, in search of cleaner air and clearer skies, and Flamsteed House became part of the National Maritime Museum. In the Octagon Room and the galleries around are displayed a wealth of astronomical instruments, maps, charts, and models; the astrolabe collection in the Esmond Halley Gallery is one of the most important in existence. Greenwich Meridian, the Prime Meridian of the world, runs through Airy's Transit Circle Room and across the courtyard, so children - and adults - may stand with a foot in each hemisphere. The South Building of 1891-8 has become the Museum's Planetarium, which school parties and members of the public may visit by prior arrangement. Just to the east of the Observatory is Tait Mackenzie's brooding statue of James Wolfe, captor of Quebec, whose parents lived in Macartney House, at the top of Croom Hill above the park, and who was buried in the parish church.

In spite of modern development and traffic, the village centre of Greenwich has obdurately maintained itself intact, with the walk along the riverside as its most obvious attraction. Beyond the Royal Naval College is the Trafalgar Tavern, built by Joseph Kay in 1837, with iron balconies resembling the galleries of a man-of-war, overlooking the river, where the Liberal Party held its ministerial whitebait dinners at the close of each parliamentary session till 1883. Behind the Trafalgar runs Crane Street, a narrow footway in which stands the Yacht Tavern,

the headquarters of the Curlew Rowing Club, the oldest on the Thames tideway, and beyond is the curious frontage of Trinity Hospital. Founded in 1613 by Henry Howard, Earl of Northampton, for the maintenance of 21 poor local men, it still fulfils its original purpose, under the administration of the Mercers' Company. The battlemented façade with its low tower and the chapel were rebuilt in the early nineteenth century but the living accommodation around the courtyard, the south staircase to the upper floor, and the superb lock to the Treasury door, have changed little since the seventeenth century. In the chapel is the Earl's tomb, removed here piously in 1696 by the Company, when it became derelict in Dover Castle. A figure of the Earl, possibly carved by Nicholas Stone, kneels stiffly; the canopy which once sheltered him has gone, though the four demure little Cardinal Virtues which supported it now stand outside in the courtyard. Sixteenth-century Flemish glass, representing the Crucifixion, the Agony in the Garden, and the Ascension, is set in the east window.

Turning inland, Maze Hill leads up the east side of Greenwich Park. Half-way up, on the corner with Vanbrugh Park, is Vanbrugh Castle, England's earliest example of deliberate medievalizing, built by Sir John when he was Surveyor to the Royal Hospital, and where he lived from 1719 till his death in 1726. Nearby, at 90 Mycenae Road, is Woodlands, built in 1774 by George Gibson as a country house for John Julius Angerstein, the marine insurance underwriter whose collection of paintings provided the nucleus of the National Gallery. A charming, unassuming house, with a portico on the east front – the original entrance was here - and bay windows, a frieze, and decorative medallions on the north, it was the first house in this country since Roman times to have a central heating system. Having been used as a convent from 1923 to 1967, it was purchased by Greenwich Borough Council, restored as nearly as possible to Gibson's original plans, and opened in 1972 as a local history centre and art gallery, both of which functions it fulfils admirably.1

King William's Walk marks the western boundary of the Royal Naval College and the Museum, and beyond is the old town, with the winding alleyway and fascinating shops of Turpin Lane and the brightly painted façades of Stockwell Street. Beside them lies the Market, laid out in 1831 by Joseph Kay and still in use. The centre of the town is St. Alphege's church. The medieval building saw the baptism of Henry VIII in 1491 and the marriage of his sister Mary, by proxy to the King of France, in 1514. From 1444 till 1454 it had as vicar John Morton, later to become a Cardinal and Chancellor of the realm (see also p. 381), while Thomas Tallis,

¹ Alan Glencross's exemplary pamphlet, *The Buildings of Greenwich*, may be purchased here. Woodlands is at present closed on Wednesdays and Fridays.

the father of English church music, was buried beneath the chancel of the old church in 1585; the keyboard of the sixteenth-century organ, on which he must have played, is preserved in the nave. The medieval structure collapsed in November 1710 in a great gale, and a new St. Alphege's was built in 1711-14 by Nicholas Hawksmoor, with a tower, which may be the old one encased, by John James in 1730. It is an imposing building, with a projecting bay on either side of the entrance to give emphasis, a shallow portico to the east front, and Doric pilasters separating the windows on the north and south sides. Wren would have approved of the west tower, with coupled pillars marking the corners, a clock-face on each side above, and a circular lantern with a narrow flèche. The interior was gutted by bombs in 1941, but was restored as closely as possible by 1953, under the direction of Sir Albert Richardson. The shallow apse has been repainted and, thogh only a couple of the capitals carved by Grinling Gibbons to support the galleries survived, new ones have been fashioned. New stained glass is by Francis Spear; the east window shows Christ in glory, and along the side aisles are representations of historical personages connected with the church.

Further to the west, in the High Road, is the Town Hall of the former metropolitan borough of Greenwich, designed by Culpin and Son, and built in 1939 from plain red brick on simple Dutch lines with a tower. The railway station is a quiet Italianate building of 1840 (re-erected 1878) by George Smith. Oueen Elizabeth's Almshouses were built around three sides of a courtvard in 1819, but they were established in 1576 - the first such foundation after the Reformation - by William Lambarde. Beyond lies Deptford with its parish church, St. Nicholas (see p. 386). In the centre of Greenwich is the Theatre, opened in 1969, with a modern auditorium, designed by Brian Meeking, within the shell of a Victorian music hall. Excellent productions are shown here and the upper floors above the fover serve as a gallery for local artists. Opposite it, in Burney Street, is a well preserved terrace of early nineteenth-century houses and beside it Croom's Hill runs southwards, parallel with Maze Hill on the opposite side of Greenwich Park. Numbers 6-12 are a terrace, with the date 1721 on a rain-water head; the Poet Laureate, Cecil Day Lewis, lived at number 6 till his death in 1972. Elegant, late Georgian Gloucester Circus, which never became more than a crescent, turns off the hill and confronts a harshly unsympathetic row of twentieth-century housing.

Up the hill is the Roman Catholic church, Our Lady Star of the Sea, built in 1851 by W. W. Wardell, a friend of A. W. N. Pugin, who may have been responsible for the decoration of the interior, with its sedilia and open stone rood-screen. The founder, Richard Michael North (d.1860) has a handsome tomb and there is some striking Art Nouveau glass. Nearby is the former Presbytery (now called Heath-

Charlton House

gate and serving as the sixth-form house of the nearby Ursuline convent school) which must date from the first half of the seventeenth century, and, close to it, Mays Court, a fine terrace of 1760, and The Grange, with foundations that may well antedate the Reformation; in its garden, but overlooking the road and Park, is a gazebo probably designed by Wren's friend, Robert Hooke, in 1672. Both men were Fellows of the Royal Society.

Croom's Hill leads to the wind-swept top of BLACKHEATH, with its magnificent views over London. A detailed account of Blackheath is given under Lewisham (see p. 390), but its finest buildings - the Ranger's House, Macartney House, Morden College, and the Paragon - stand on the Greenwich side of the boundary. Ranger's House was built in the 1680s, probably as a speculative venture, by Andrew Snape, the King's Sergeant Farrier; it was rebuilt some 40 years later by Admiral Hosier, and was enlarged with a gallery on the south side by the witty diplomat Philip, 4th Earl of Chesterfield, whose letters to his natural son, published posthumously, are still read today. A wing was added to the north side in the 1790s and in 1814 the house became the residence of the Ranger of Greenwich Park, Princess Sophia Matilda. A later occupant was General Sir Garnet Wolseley, the army reformer, who led the expeditionary force to relieve General Gordon at Khartoum in 1885. In 1959-60, the house was restored and redecorated, and in 1974 became an art gallery, where the magnificent Suffolk Collection of family portraits is displayed. These paintings, the most important series of seventeenth-century portraits to survive intact, include William Larkin's seven breath-taking full-length representations of ladies of the Suffolk family, as well as portraits by Mytens, Cornelius Johnson, Kneller, Thomas Hudson, and Catherine Read. Behind the house are rose gardens and before it a perfumed avenue of young lime trees was planted to celebrate the Queen's Silver Jubilee (1977); concerts are often given here.

GREENWICH 369

On the Croom's Hill side of the Ranger's House is Macartney House, built about 1684 and described by General Edward Wolfe, father of the more famous James, as 'the prettiest situated house in England'.

On the eastern side of Blackheath lies the Paragon, built by Michael Searle, 1794-1807. This crescent of seven pairs of four-storey houses, with mansard roofs and Coade stone decorations to the façades, are connected with each other by colonnades. They were well restored between 1946 and 1958 by Bernard Brown and are now converted into flats. Behind them lies Morden College, founded in 1695 by Sir John Morden as a refuge for 'poor, honest, sober and discrete merchants who shall have lost their estates by accidents and perils of the seas, or by any other accidents'. The College, built round four sides of a quadrangle, with an imposing entrance surmounted by statues of Sir John and Lady Morden, was possibly designed by Wren and was built by his best mason, Edward Strong. Opposite the entrance arch. at right angles to the eastern range, is the chapel, with high box pews and fine woodwork, and in the east window are three figures of sixteenth- or early seventeenth-century German or Flemish glass. Around the inner quadrangle runs an open colonnade with Doric columns, providing shelter for those wishing to take the air even in unclement weather. The College is a remarkably fine example of seventeenth-century domestic architecture and the modern buildings which have been erected to continue its good work are in the same excellent tradition.

Beyond Blackheath lies CHARLTON, which still retains both its manor house and its parish church. The house was built between 1607 and 1612 as a 'nest for his old age' by Adam Newton, Dean of Durham and tutor to Prince Henry, Charles I's gifted but short-lived elder brother. The handsome mansion, its red brick offset by white stone dressings, may have been designed by John Thorpe. Three storeys high, in the shape of an H, the centre of the main façade is marked by an elaborate porch. The pattern of the balustrade to the terrace is repeated in the parapet around the roof. At each end of the garden front is a square, ogee-topped tower, and in the garden grows a mulberry tree, said to have been planted in 1608. A small garden pavilion, firmly attributed by local tradition to the design of Inigo Iones, has prosaically been converted into a public lavatory. Today, the house is owned by the borough council and used as a community centre, so it is easy of access. The Hall, with its gallery and flat strapwork ceiling, was one of the first in England to be set at right angles to the entrance; it was no longer the main living apartment but a place of passage. Above it is the Grand Salon, with striking ceiling pendants and a magnificent marble fireplace with figures of Vulcan and Venus. From it, the White Room, with panels above the fireplace showing the Triumph of Christ and the Triumph of Death astride a pale horse, leads to the Long Gallery, which runs right through the North Wing for 70 feet, with a strapwork ceiling and a plaster frieze with curly foliage, dogs' heads, and masks. The gardens close to the house are well maintained and part of the more distant grounds serves as a public park.

Beside the house is the parish church, dedicated to St. Luke and built of brick about 1630, on the site of a medieval foundation, by the trustees of Sir Adam Newton. During the same century the tower was given its brickwork crenellations, and a north aisle was added, resulting in a curiously portly interior; finally the chancel and vestry were built in 1840 and 1873. There is a fine marble font with scallop shells round its base and a graceful wooden cover, and the imposing box pew for the squire is still there. Edward Wilkinson (d.1561), once Master-Cook to Queen Elizabeth, has a stone tablet carved with his achievement of arms; Nicholas Stone was responsible for the black and white canopied altar tomb of Sir Adam and Lady Newton. Grace, Countess of Armagh, has an equally dignified standing memorial, with angels flanking the pillars of the canopy, while Brigadier Michael Richards, Surveyor-General of the Ordnance to George I (d.1721), is commemorated by a handsome near life-sized statue, and there is an excellent, very simple, bust by Chantrey to Spencer Perceval (d.1812), our only Prime Minister to have been assassinated. The clergy of St. Luke's have patronized modern embroiderers, and there are some magnificent vestments to be seen at the services here. Opposite the church, behind Charlton House, is the Bugle Inn, with three seventeenth-century cottages for its core, though succeeding generations have built over the early structure.

Further east is WOOLWICH, originally a small fishing village but chosen in 1513 by Henry VIII as a suitable place for a royal dockyard. Here the Great Harry, the Henry Grace à Dieu, was built, and the tradition was carried on in the next century, when Phineas Pett and his son Peter, who lie in Deptford churchyard, built the Sovereign of the Seas in 1635-7. Ordnance stores joined the Dockyard and in 1716 the Royal Arsenal moved here from Moorfields. The entrance to it, built in 1829 with a superstructure of 1891, still stands off Beresford Square, with earlier buildings behind it, designed by Vanbrugh, for the Royal Brass Foundry and Model Room. All this area is to be redeveloped. Understandably enough, Woolwich became an important military centre, and the concentration of establishments here continues to this day.

The Royal Military Academy, founded in 1741 for 'instructing the gentlemen belonging to the train of artillery', was originally housed in Vanbrugh's Model Room, and was later accommodated in a magnificent building by James Wyatt, completed in 1808. Its north front, 720 feet long and constructed of yellow brick, with a central block inspired by the White Tower at the Tower of London, overlooks a parade ground. When the Academy was amalga-

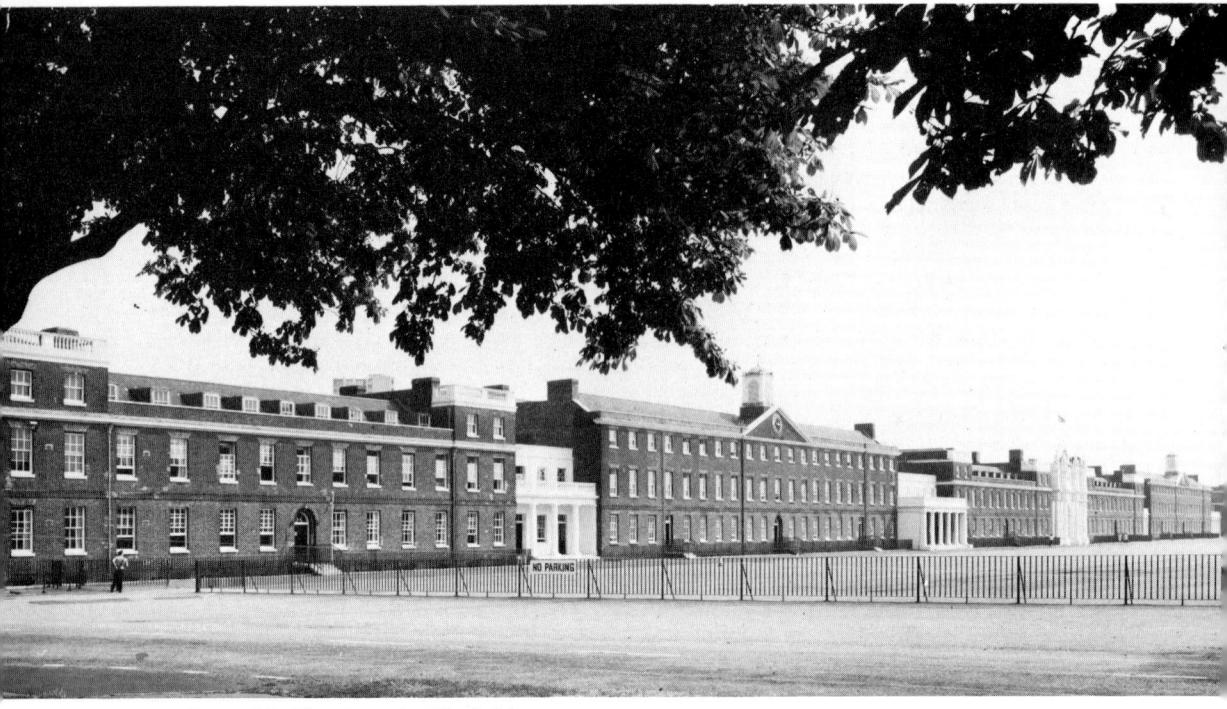

Parade Ground, Royal Artillery Barracks, Woolwich

mated with the Royal Military College at Sandhurst in 1945, space was given within the buildings to the Royal Artillery Museum. Open daily, the displays tell the story of the regiment, concentrating on its human side, on personal relics, and on extraordinary displays of courage shown by its members. The artistic quality of the exhibits is very high; it is worth remembering that, till photography was introduced, an officer needed to be able to record an area in water-colour — William Congrave's sketch-books are exquisite.

The Royal Military Academy lies on the south-east side of Woowich Common and the Royal Artillery Barracks on the north. The Barracks, built between 1776 and 1802, were conceived on a scale of such grandeur that they seem scarcely English. The façade, spreading out on either side of a low triumphal arch, runs for some 1,080 feet - one of the longest in Europe; the parade-ground in front of it is vast. Before the main entrance is a bronze figure of Liberty by John Bell (1860), a memorial to those who fell in the Crimean War, but the quarters behind the façade, once laid out on the Roman grid pattern and able to accommodate about 4,000 men, have been completely redeveloped during the past 30 years. The Mess is still there, however, with its glittering chandeliers and its truly astonishing collection of silver, presented by the officers through the generations.

On the western side of the Common is the Rotunda, a circular building which began its existence as a tent, devised by John Nash in 1814, set up in St. James's Park for the celebrations when the allied

sovereigns visited London, at what they hoped was the end of the Napoleonic Wars. In 1819 it was re-erected in Woolwich to house 'the military curiosities usually preserved in the Repository of the Royal Artillery'. Three years later, it was decided to make the structure permanent; a polygonal yellow brick wall was built, with a concave copper roof which conveys, quite uncannily, the line and feeling of the original canvas, which can still be seen on exhibition inside. A very small cupola marks the apex. Inside, the exhibits demonstrate the development of artillery from the fourteenth century to the present day; they include a bombard very probably used at the Battle of Crecy in 1346 and a brass nine-pounder gun used at Waterloo. The Museum is open daily, free of charge.

In much-rebuilt Woolwich town itself, the most important buildings are St. Mary's church and the two Town Halls. The flamboyant building in Wellington Street, designed in 1906 by Sir A. Brunwell Thomas, is of red brick with stone dressings, and sports an asymmetrical tower and a grandiose entrance hall, with brightly painted domes and a staircase at the far end, which divides to enshrine a marble statue of Queen Victoria by Frank Pomeroy. The old Town Hall of 1842, nearby in Calderwood Street, is plainer and humbler, with a repose which the Edwardian building lacks; it has a classical façade with pilasters and an unadorned pediment. The present St. Mary's church, though of older foundation, was built between 1732 and 1738, with

a large chancel added in 1894. Standing on the summit of Church Hill, its plain square tower serves as a landmark to craft on the river. The interior, grave and spacious, has galleries which, since 1961, have been used as offices for parochial and social work. At the east end of the south aisle is a memorial. with stone draperies surmounted by a flaming lamp and parted to reveal mourning cherubs, a coat of arms, and an inscription to Daniel Wiseman, 'Clerk of the Cheque of His Majesty's Yard at Deptford', who died in 1739. In the churchyard a sarcophagus (now in the brass foundry in the Arsenal for safekeeping) marked the grave of the inventor and engineer Henry Maudslay (1771-1831), and a sad lion guards an urn in memory of Tom Cribb, the prize-fighter, Champion of All England, who spent his last few penniless years at Woolwich. The church, which for its naval associations has the right to fly the Royal Ensign instead of St. George's Cross, overlooks Woolwich Free Ferry, designed to carry both man and vehicle swiftly across the Thames, while two terracotta tempietti mark the entrances to a foot tunnel.

PLUMSTEAD lies a mile to the east, high on the Common. The most remarkable building here is the Old Mill Inn, an eighteenth-century mill which, on ceasing to grind in 1842, became a beer-shop and still flourishes, encapsulated in a later building. Down in the High Street at the foot of the escarpment are two other eighteenth-century taverns, the Plume of Feathers and the Volunteer, which was once the parsonage. Beside them stands the public library with a small local museum on its upper floor; the collection is particularly rich in minor Roman and medieval metalwork and deserves more spacious premises.

Opposite is St. Nicholas's church, founded in the twelfth century, with parts of the south and west walls surviving from the original building. The thirteenth century added a transept, and the fifteenth a north aisle, while the tower was built in 1664 – a rare date for church building. Some rebuilding of the north aisle was needed in 1820, with further restorations in 1870, 1905-11, and 1959, after war damage. Today, St. Nicholas is a large, airy church with a graceful fifteenth-century arcade to the south aisle, and mason's marks on the capital of the first freestanding pier. In the east wall of the south transept are traces of what must once have been a squint, and a scarcely used thirteenth-century chisel was found, walled up by mistake and now treasured in the Science Museum. A small enamelled angel, which must once have decorated the cover of a missal, can be seen in the local museum. The glowing reredos, baldacchino, font, choir and clergy stalls were all the work of Stephen Dykes Bower in the early years of the present century.

Towards the Thames, Plumstead Marshes are now reclaimed land, rapidly being covered by Thamesmead (see p. 344).

Southwards lies Shooter's Hill, with its two towers - a large, regrettably ugly water-tower of 1910 and the more graceful folly of Severndroog Castle, now almost hidden by the trees of Castle Wood, but erected in 1784 by Lady James of Eltham to celebrate her late husband's exploits against the Malabar pirates, who had their stronghold at Severndroog off the coast of Goa. There is still much woodland here and open grassland around Avery Hill, surrounding the teachers' training college built as a private mansion in 1889 by T. W. Cutler for Colonel North. There are good modern additions to meet institutional needs, and a conservatory that antedates the house by some seven years. This conservatory, recently restored and superbly stocked with an immense variety of plants, is open to the public and is one of the finest in England.

ELTHAM can boast of a medieval palace. The establishment was begun about 1300, possibly on the site of an older house, by Bishop Bek of Durham, and he gave the half-finished building to Edward, the first Prince of Wales, in 1305. Tradition asserts that it was at a gathering here in 1347 that Edward III established the Order of the Garter. Foreign monarchs, such as John II of France in 1364 and the Emperor of Byzantium in 1400, were entertained here; Geoffrey Chaucer, when Richard II's Clerk of Works, was robbed of £20 at Eltham, but the French historian, Froissart, paid a more successful visit in 1395. In 1450, the buildings were struck by lightning but by 1479 a new Great Hall was nearly complete. Henry VI added royal apartments, which impressed Erasmus when he came in 1500, and Wolsey was made Lord Chancellor of England here. The palace continued to be used, at intervals, by the later Tudors and early Stuarts, but fell into disrepair during the Commonwealth. The Great Hall became a barn; the rest was pulled down for building materials. In 1933, Samuel Courtauld obtained a lease from the Crown. restored the Hall and had a house added for himself by Seely and Paget. Nowadays, the house is the headquarters of the Institute of Army Education, but the Hall is normally open to the public on Thursdays and Sundays, while recent excavations have revealed the plan of the medieval and Tudor buildings. The approach is through an outer courtyard, over a fifteenth-century bridge and across an inner court. The Hall is of ashlar and ragstone with a tiled roof. Buttresses divide the main walls, with two pairs of cinquefoil-headed windows set high between them, while at the west end are lierne-vaulted bays, made almost transparent with double-height oriel windows. The whole interior, 101 feet long by 36 feet wide, is filled with an extraordinarily clear light. At the upper end of the Hall, flanked by the bays, is a dais, and, at the lower, a screen and minstrels' gallery have been reconstructed. The glory of Eltham is its hammer-beam roof, 55 feet up. Well finished, but without decorative carvings, the spare nobility of the structure is worth close study. Outside the Palace

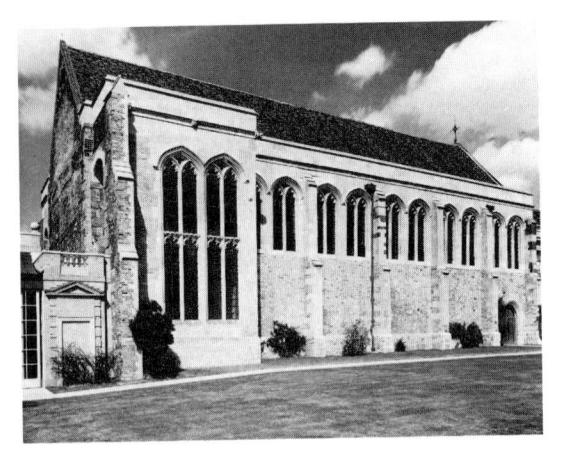

Eltham Palace

wall is the half-timbered façade of the mid-fifteenthand early sixteenth-century Lord Chancellors's Lodging, where Wolsey may have stayed.

To the east of the Palace lies the Royal Blackheath Golf Club with its Club House, Eltham Lodge, constructed between 1663 and 1665 by Hugh May for the banker and supporter of Charles II, Sir John Shaw. Built of brick and seven bays wide, four stone pilasters with Corinthian columns mark the three central bays and reach upwards to join the modillioned cornice and pediment, with its coat of arms. Inside, there is a Great Staircase, the balustrade superbly carved with acanthus scrolls, and some magnificent plasterwork ceilings. This is one of the most important houses of its period left anywhere near London. Just to the south is a public garden. The water of the Tarn once provided ice for the company in the great house; the brick ice house has been preserved.

To the south-west, in Middle Park Avenue, surrounded by unpromising houses of the 1930s, is St. Saviour's church, designed in 1933 by N. F. Cachemaille-Day and Welch and Lander. All of brick, it has a squat, square tower and a bold, expressive outline. The interior, with a high nave and tunnel-like aisles, is of brick too, right down to the impressive pulpit. The tall thin windows are filled with vibrantly blue glass, and a peaceful, contemplative Christ looks down from the reredos. Altogether, this church is an important twentieth-century achievement, and deserves to be better known.

From it the main thoroughfare, Court Road, leads due north to the crossroads which form the centre of Eltham. Rural until the inter-war years, the outline of the former village can still be traced. At the crossroads stands the parish church, dedicated to St. John the Baptist. There was a church here by the twelfth

century, but of that building, which was used for 700 years, nothing remains; the present St. John's, designed by Sir Arthur Blomfield in 1885, is a plain building, with a square tower and spire over the main entrance to the south-west. The interior is spacious with a beautifully proportioned chancel arch and a number of small but still interesting memorial tablets; that recording the tragic mortality among the family of the seventeenth-century Dr. Richard Owen is perhaps the most interesting. In the churchyard lies Thomas Doggett (d.1721), the actor-manager who married Owen's grand-daughter and instituted a race for single scullers, still rowed annually in July or August, against the tide, all the way from London Bridge to Chelsea. The contestants are watermen in their first year out of apprenticeship. The winner receives a scarlet livery with a silver shoulder badge and holders sometimes take part in the Lord Mayor's ceremonials.

Just to the north of the village centre is another astonishing survival - a Tudor barn which has become municipal property. Until his death in 1577, the estate was the property of William Roper who, in 1521, had married Sir Thomas More's favourite daughter, Margaret, and it is possible that the Chancellor may have visited the young couple here. The Barn may well have been built before Margaret's death in 1544, though the house in which she lived was demolished in the early eighteenth century. Another mansion, Well Hall, was built in its place, which E. Nesbitt made her home from 1899 till 1922, describing it in her novel The Red House and in her more famous book for children, The Wouldbegoods. In 1931, the estate was bought by Woolwich Borough Council; the house was demolished, the gardens became a richly planted public park and the Barn, with a small stained-glass window inserted showing Margaret Roper as she appears in Holbein's portrait of the More family (National Portrait Gallery), continues its useful existence as an art gallery and restaurant.

The threat of a surge tide flooding London has increased over the years; in 1974, the Greater London Council began work on the Thames Barrier. With Rendel. Palmer and Tritton as consulting engineers, a defence of movable gates was designed and sited at Woolwich. Its most striking feature are the hoods which shelter the machinery operating the rocker beams. Shaped like primitive helmets, the wooden frames of Iroko hardwood and European pine are protected with a quilted outer covering of strips of stainless steel, reminiscent of the armour worn by a Samurai warrior. A pleasant riverside walk has been laid out from which to view this marvel of engineering and a small exhibition explains the fascinating technicalities. Besides protecting the city, the Barrier gives the Thames another silhouette as distinctive as that of Tower Bridge.

Kingston upon Thames

The Royal Borough of Kingston upon Thames lies in the south-west of the Greater London area. The present administrative unit was made up by uniting Kingston with the former boroughs of Surbiton, and Malden and Coombe; the whole area lay formerly in Surrey. Over 9,000 acres house a population of approximately 132,000. A long, thin, knifeshaped sliver of land, it stretches from Richmond Park in the north through the closely built-up townships of Kingston, Surbiton, and Malden, into the open countryside of Ashstead Common and Forest. The Thames provides three miles of the western boundary, while the eastern limit, adjoining Merton, Sutton, and Epsom, is marked out by the Beverley Brook and Hogsmill River. It is one of only four Royal Boroughs in the whole of England and Wales, the others being Windsor, Kensington and Chelsea, and Caernarvon.

KINGSTON itself can claim great antiquity. The name means 'the King's enclosure' and it was here that seven Anglo-Saxon rulers were acclaimed, the first coronation being that of Edward the Elder, Alfred the Great's son, in 900, followed by Athelstan (925), Edmund (940), Eldred (946), Edwy (956), Edward the Martyr (975), and Ethelred II, the Unready (979). After the Conquest, Kingston's economic importance rested largely on its bridge, in existence by 1193, and the first to span the Thames above London Bridge, till Putney Bridge was built in 1729 and Westminster Bridge in 1750. Its social significance rested on its proximity to the royal palaces of Nonsuch, Hampton, and Oatlands, and on its market.

On visiting Kingston, the first impression is of a maelstrom of traffic sweeping around every corner. In addition to a complicated one-way system, Kingston lies on the main route to Portsmouth, and heavy lorries constantly rush through it. In spite of this, and in spite of several baleful shop-and-office tower blocks which oppress the centre of the town, Kingston has the best preserved medieval street plans in the whole Greater London area. For those perspicacious enough to look above ground-floor

level, there remains to be recognized an impressive amount of good vernacular architecture, from the fifteenth century onwards. It is essential to explore the heart of Kingston on foot and at leisure; the past has left sufficient beauty and the present imparts sufficient liveliness to reward such an effort.

At the centre is All Saints' church. A large edifice, restored by Pearson in 1887, its commanding bulk and central tower, which dominates the marketplace, give no hint of the jigsaw puzzle the centuries have created within. A church stood on the site before the Conquest; as far as we can tell, a first building, dedicated to All Hallows, was destroyed by the Danes and replaced by another, St. Mary's, just to the south of the present All Saints'. It was presumably within those walls that the seven Saxon coronations took place; the old building collapsed in 1729 and All Saints' only Saxon relic is a stone fragment, displayed at the east end, carved with an intricate interlacing pattern on its two outside edges, which may have been part of the shaft of a cross. Some panels, which perhaps came from the chapel, painted during the fifteenth century with portraits of the Saxon monarchs, are at present in the keeping of the Society of Antiquaries. A large Norman church was built under the supervision of Gilbert the Knight. who gave the living of Kingston to his priory at Merton (see p. 391); the west portal was uncovered in 1858 but was destroyed. The oldest remaining parts of the structure are the four massive crux arches supporting the tower, which were built during the second half of the thirteenth century. About 1400, the nave was pulled down and widened; the octagonal pillars to the four bays remain from this extension. In the middle of the fifteenth century, the chancel was given its present beautiful waggon-shaped roof and an extension was made to the north to accommodate a chantry chapel. With its unusually wide transepts, All Saints' seems exceptionally spacious – an imposing church for the inhabitants of a busy country market town with royal connections, since Kingston must never be considered as only a London suburb.

On entering All Saints', attention is drawn to the massive pillars which mark the crossing; the high altar, designed by John Comper in 1951, stands beneath it. To the south-east is St. James's Chapel, with a fifteenth-century niche in the wall that may once have served as an Easter sepulchre. The chapel,

which retains its original open timbered roof, was founded by William Skerne, of Down Hall, Kingston. A stone slab, with fine memorial brasses three feet three inches high, shows a member of his family, Robert Skerne (d.1437), with his wife Joanna, who was a daughter of Edward III by Alice Perrers. Opposite it lies Jansen's figure of Sir Anthony Benn, Recorder of London (d.1618), wearing his official robes. At the east end of the south transept is a dark corner known as the Parson's Chancel or vicars' burying-place; in its east wall is a window with tracery which may have come from the Saxon chapel. On one of the fourteenth-century pillars is a muchrestored painting of St. Blaise. There is a small brass to John Hertcombe (d.1488) and his wife, and memorials to two Henry Davidsons who died in 1781 and 1827; the earlier tablet, carved by Regnart, shows a mournful lady standing beside an urn, and the latter bears a figure of the dead man sitting in a Grecian chair and also contemplating an urn. Also at the east end is the fluted marble font with the date 1669, and in the north transept is a monument by John Flaxman, who carved an unusually lively cherub in memory of Philip Meadows (d.1795). John Heyton, Sergeant of the Larder to Mary I and Elizabeth I, has his memorial in the nave and in the south transept is a life-sized seated figure by Chantrey of Louisa Theodosia, Countess of Liverpool (d.1825). The peal of 12 bells hanging in the tower is the third lightest in the world. New glass was inserted in the windows of the north aisle in 1955, with scenes commemorating Kingston's Saxon coronations and links with Merton Priory, and new inner glass doors were set to the west entrance to permit the interior to be seen from the market-place, so emphasizing the close relationship between everyday life and the place of prayer.

The river, with Kingston Bridge, lies west of the church. The present stone structure, designed by Edward Lapidge, was opened in 1828 and doubled in width in 1914. On the Middlesex side, the approach is marked by handsome iron posts and rails, cast locally in Harris's Iron Foundry, and a dark bronze plaque, set in a niche on the parapet, gives a brief history. 50 yards downstream on the Surrey side, at the end of Bridge Street, are situated the recently excavated (1972–1982) remains of the medieval structure, and, a little to the north, is Turk's Boatyard, controlled since 1740 by six generations of the same family and still producing most water-

worthy craft.

Beyond the Yard lies Canbury Gardens, its name a corruption of Canonbury, for part of Kingston once belonged to the canons of Merton. The Gardens include a handsome municipal promenade, constructed since 1889 over desolate swampy ground, where formerly osiers were grown for basket-making. Inland, south of the bridge, is Thames Street, running parallel with the river, with number 1, a merchant's house, dating from about 1575, though

in the detached kitchen block at the back of the main building a tile-built oven was discovered, of a type becoming obsolete by 1500. Nearby, in complete contrast, Millets (until recently British Home Stores) occupies a former restaurant, built in 1901 and a magnificently exuberant example of late Victorian Renaissance architecture, once the observer looks above the first-floor windows.

The heart of the town is the Market, which may well have flourished since Saxon times, though there is no written reference to it before the thirteenth century. In 1543, Leland described it as the 'beste market toune in all Southerey'; Charles I granted it a patent in 1628, so that no other market could be established for seven miles around; this supremacy holds good today. The Market is funnel-shaped; in the centre stands what is now the Market House, built in 1838 to designs by the elder Charles Henman as the Guildhall and replacing a sixteenth-century

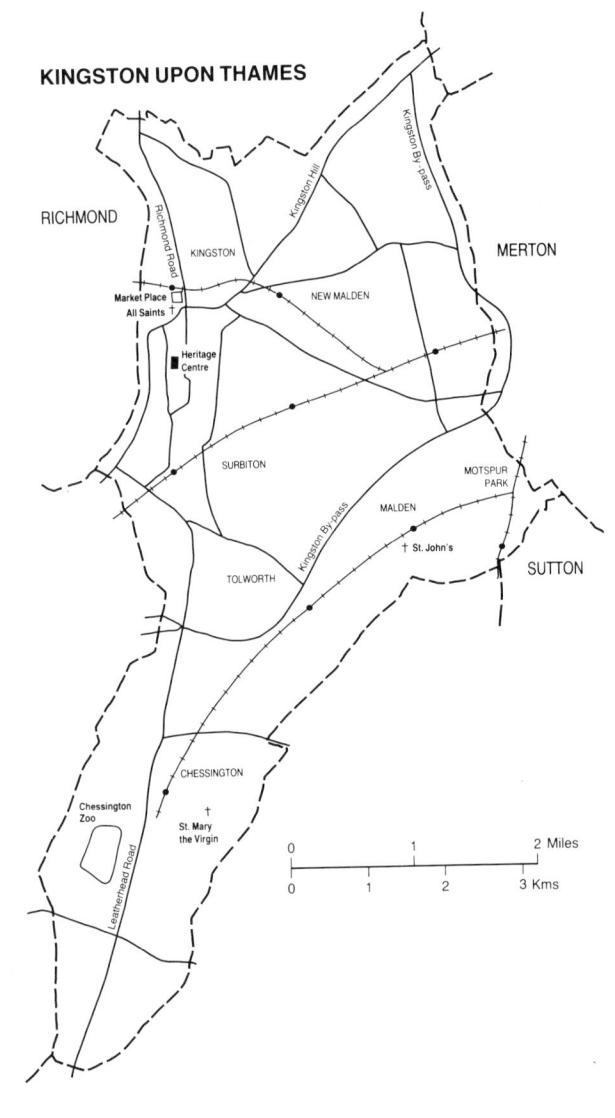

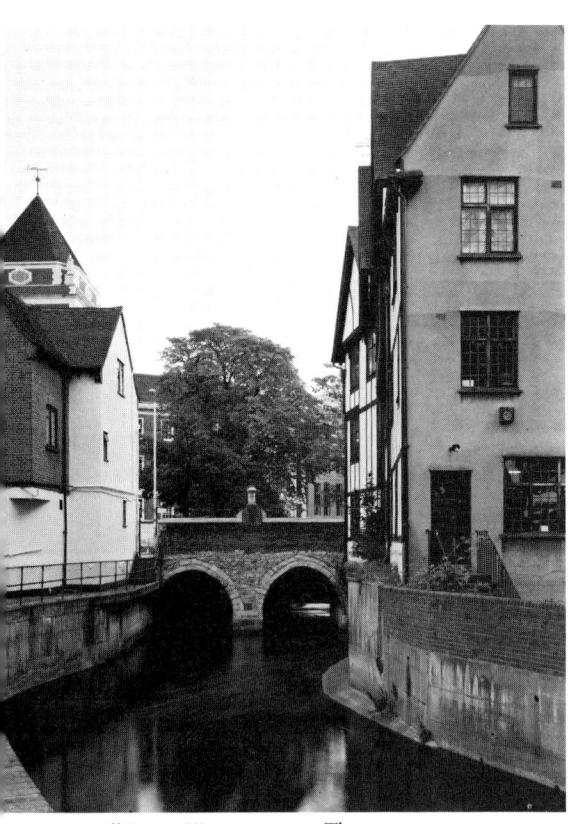

Hogsmill River, Kingston-upon-Thames

edifice. A new Guildhall was opened in the High Street in 1935 and the older building was devoted to the needs of the market. Italianate, with four square towers, neat little pediments along every available scrap of roof-line and beswagged with balconies, it sports, at first-floor level, a gilded statue of Queen Anne, sculpted by Francis Bird in 1706, while a little in front of the building stands the Shrubsole Memorial, executed in 1882 by Francis Williamson. The statue is a pretty ornament of a young mother, bearing an urn on her shoulder, and leading a small child by the hand; the gentleman commemorated was Henry Shrubsole, a local banker and draper, who was Mayor of Kingston from 1877 to 1879. The northern side of the Market is filled chiefly with the astonishing façade of Boots, designed in 1909, with amplifications in 1929, by Dr. William Finny, seven times Mayor of Kingston. It is flamboyantly and determinedly Tudor, adorned with gables, halftimbering, statues, painted plasterwork, and stained glass. Beside it, a humble adjunct to the main premises, is number 14, built about 1570; on the walls of the upper floor there was some exceptionally fine eighteenth-century wallpaper, now preserved in the Kingston and the Victoria and Albert Museums. Along the west side are two public houses, the Griffin Hotel, with an early nineteenth-century facade and a claim to have sold refreshments since the fourteenth century, and the Druid's Head, with an unpretentious exterior and a superb late seventeenth- or early eighteenth-century room on the first floor, with panelling and elaborate plasterwork. Beside them, a department store is built around a seventeenthcentury oak staircase, which remains from when the premises were the Castle Hotel. Opposite, at number 41, is an elegant Georgian building; its ground floor is modern shop premises but the upper part of its facade remains intact. Harrow Passage leads through to the Apple Market, taking its name from a former public house which was converted into shops in 1920. A pseudo-antique façade was built on, but the upper floors of what is now Shell's Bakery retain beams dating from about 1530, showing that this is the oldest surviving domestic building in Kingston.

Roughly parallel with the east side of the market place is Eden Street, in which stands the United Reformed Church, built in 1855 and an immaculate example of Victorian Doric architecture, while Church Street turns out of the north-eastern corner of the Market Place. Three small shops, numbers 6, 8, and 8a, reveal in their upper storeys that they were once part of a single mid-sixteenth-century building, which served as an inn, with its own brew-house in the back premises. Nearby, the Old Crown Inn presents a façade of about 1720, but the interiors of the upper floors are of the early seventeenth century, while the back of the old building can be seen clearly from Union Street, in which stands the Watch House. built in 1825 to accommodate the town's night watchman, though now a sandwich shop. Church Street leads through into Clarence Street and Bentall's, one of the best department stores in South London. The store's Wood Street frontage recalls Wren's facade at Hampton Court. Littlewood's store, at numbers 69-71 Clarence Street, is thought to cover the site of a house, in the garden of which Nipper, the dog who was the trade mark of His Master's Voice record company, was buried under a mulberry tree.

The High Street leads away to the south of the Market Place. In it stands the Guildhall, built in 1935 by Maurice Webb, with a portly façade spreading out on either side of a clumsy tower. Inside, sixteenth-century panelling, saved from the original Guildhall, has been enshrined. In the fore-court, protected by railings, is the Coronation Stone, on which the seven Saxon Kings are reputed to have been acclaimed. Around its base are set seven silver pennies, given by the British Museum in 1850, one for each of the kings crowned here. Immediately beside the stone, a bridge crosses the Hogsmill river. There is nothing remarkable to be seen from the roadway but on the western side of the street a gate and a few steps lead down beside the water, and the three semicircular arches of the Clattern Bridge, built about 1175 and still well able to carry a quarter of the roadway, are clearly visible. On the further bank, where the police station now stands, were the foundations of a late twelfth- or early thirteenth-century building, small but of some dignity, known locally as King John's Palace; a portion of a carved pillar, now standing outside the public library in the Fairfield, was unearthed here. Number 17 High Street is a pretty eighteenth-century house, with bay windows on either side of the pillared porch and a Venetian window above. Picton House (now restored as Amari House), on the opposite side of the road, is a fine eighteenth-century property, once the residence of Caesar Picton, a coloured man who rose to be one of Kingston's wealthiest and most respected citizens. A little further still, at numbers 35-41, three small shops have been made out of a sixteenth-century open-hall, timber-framed dwelling. Number 41 is at present an excellent pizzeria and from its windows the Thames can be seen, flowing parallel with the High Street but elsewhere hidden by buildings and outhouses.

The Fairfield lies to the east of the Market. Its green, open expanse is now a municipal park, soon to include a new swimming pool. On its northern edge are the Public Library and the Museum and Heritage Centre. The latter contains a collection of local paintings and prints, archaeological exhibits, including a Roman altar and bones, swords and brooches from the graves at Mitcham, some seventeenth-century stained glass, an excellent set of municipal weights and measures, and Eadweard Muybridge's photographic equipment. Born in Kingston, he became Director of Photographic Surveys to the United States Government. A pioneer of cinematography, he invented an apparatus, the zoopraxiscope, which gave the illusion of movement by means of a rotating glass disc. Dying in Kingston in 1904, he bequeathed his invention and equipment to his birthplace. Just to the north, the London Road runs parallel with the Fairfield, and in it stand the Cleave Almshouses, built in 1669 by William Cleave and still in use. The centre of the long row of little houses is very grand, the doorway being emphasized by rugged rustication, while above are three graceful elliptical windows and the founder's coat of arms, carved by Joshua Marshall. Beyond them is the Lovekyn Chapel, probably the only separate chantry chapel to survive the Reformation. Founded in 1309 by Edward Lovekyn, and re-established a generation later by his son John, it was given in 1561 to the Grammar School which Queen Elizabeth bestowed on Kingston and has remained in use as school premises ever since. Just beyond is Vine House, with a fine entrance; built about the middle of the eighteenth century, it was recently restored.

With the coming of the railway in 1838, SURBI-TON was established as a separate, wealthy suburb of large Victorian and Edwardian houses. Many of Surbiton's dignified residences have gone, or have been converted into offices, but development at this period has left both Kingston and Surbiton with a

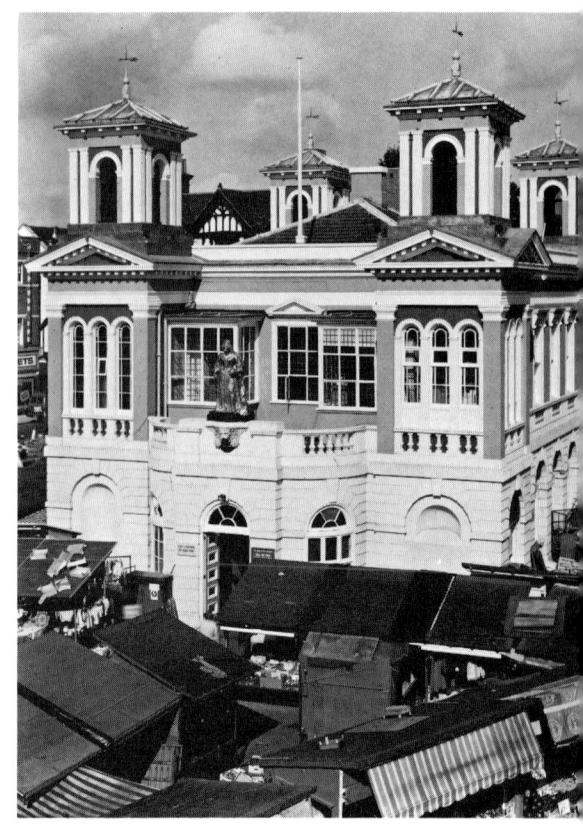

Market Place, Kingston-upon-Thames

wealth of late Victorian churches, some of them important subjects of study for the connoisseur. In Kingston, the basilica of St. Raphael's (1846–7 by Charles Parker, in the Portsmouth Road) presents its Italianate, square tower to the river, providing craft with a distinctive landmark, while at Surbiton St. Matthew's (1874–5 by C. L. Luck, St. Matthew's Avenue) has a superb tower and spire, rising 170 feet in the air. In London Road is St. Peter's, designed in 1842 by Sir Gilbert Scott in yellow brick and in the Romanesque style. The most unusual church is St. Andrew's in Maple Road, Surbiton, designed in 1871 by Sir Arthur Blomfield and constructed from startling yellow and red brick, with an almost detached tower. Inside, there is an extraordinary sense of space, the nave being exceptionally wide and the body of the church open right into the chancel. Its mother church is St. Mark's, first consecrated in 1845, and practically rebuilt in 1854 by P. C. Hardwicke. Only the tower of the nineteenth-century church remains, the rest having been destroyed by fire-bombs in 1940. A new building, designed by Romilly Craze, was consecrated in 1960 and is remarkable chiefly for its fine glass, the statues by Christine Hall and Anthony Southwell, and some exceptionally good modern embroidery.

COOMBE, the district to the north-east of Kingston, has an interesting history. The springs here yield water which Cardinal Wolsey had piped across the Thames to supply Hampton Court three miles away; some of the conduit houses still remain, though now on private property and more or less out of sight. Warren Road was developed at the end of the last and throughout the present century as an exclusive residential quarter; Victorian, Edwardian, and mid-twentieth-century interpretations of Tudor architecture may be compared, while Coombe Wood House, a genuine pre-Reformation building, has been transported bodily from Essex.

Those who have travelled as far as Kingston should not fail to explore the southern tip of the borough. On its eastern side, in Church Road at OLD MALDEN is St. John's, a good church for demonstrating building materials to children. The medieval chancel is of flint, but the body of the church was rebuilt about 1627 at the expense of John Goode, who is commemorated by a well carved tablet beside what was then the high altar. The material used was brick, laid English bond and jointed together with unusually broad bands of mortar pointing. There is a low west tower with a simple parapet. In 1875, increase of population necessitated a new, broader nave and chancel, which T. G. Jackson designed and which reduced the old church to the status of a chapel and south aisle. Though humble, this is a fascinating interior. The main church is consciously medieval, apart from the striking pulpit with its high relief modelling of New Testament scenes, while the older church is simply and purposefully itself, intended for everyday worship. Beside it stands the red-brick manor house, and half a mile away, beside the Plough Inn which, despite its exterior, has a pre-Reformation core, the village duck-pond still supports its proper popula-

To reach CHESSINGTON, in the southern tip of the borough, take the Hook Road, passing on the way the startling red brick of St. Paul's church (1881 by Carpenter and Ingelow) with the glass of the east window designed by Seddon and executed by S. Belham & Co., where Harry Hawker, the aircraft test pilot, lies buried. The church of St. Mary the Virgin lies at the eastern end of Garrison Road, off the main Leatherhead Road, and is an unspoiled medieval village church at the heart of a midtwentieth-century housing estate. The chancel and north wall are part of the original thirteenth-century structure and retain three narrow lancet windows set in rounded arches, while broader lancets were probably cut about 1230. On the south wall of the chancel hangs a small delicate alabaster, made about 1370 and representing the Annunciation, and beneath it are traces of sedilia. Opposite, the Priest's Doorway supports a wooden door, reputed to have come from Winchester Cathedral, which was the gift of a parishioner. The beautifully proportioned east window probably dates from the seventeenth century. The church was well restored in the midnineteenth century, when the bell-cote was replaced by a broached spirelet; a peal of eight bells presented in 1894 now hangs in the turret. The timber roofs were then reconstructed but old timbers were reused. An angel with wings outspread to support the Bible serves as a lectern; it was carved in 1898. At the west end of the north wall is a tablet commemorating Samuel Crisp of Chessington Hall; the epitaph was composed by the musicologist, Dr. Charles Burney, father of the novelist and diarist, Fanny Burney. The young lady was staying with the Crisps when news came of the success of her novel, Evelina, and she ran out into the garden to dance round the mulberry tree. In the west window, there have recently been set six medallions of glass from the Grosvenor Thomas Collection, four of them sixteenth-century Flemish and two seventeenth-century Dutch, and the church is the owner of the Pekynge Chalice, a tiny Elizabethan communion cup 33 inches high and hallmarked for 1568, which is at present in the keeping of the Victoria and Albert Museum.

A little further south one returns to the twentieth century, and Chessington Zoo, a sizeable menagerie rich in gaudy flamingoes, opens its gates.

Lambeth

The former metropolitan borough of Lambeth has been enlarged by the acquisition of Clapham and Streatham from Wandsworth to form the present London borough. Densely built up, for the most part with small, late Victorian and twentieth-century housing and with light industry, it is still an area well worth exploring. The borough is shaped like a long, narrow trapezium with roughly parallel west and east sides and the sharp north-south bend of the Thames as its riverside boundary. The land rises from a bare 12 feet above water level beside the Thames through 50 feet in the centre at Brixton and 150 at West Norwood on the eastern boundary, to some 379 feet in the south on the heights of Streatham Common. For the purpose of exploration, Lambeth divides itself into four distinct areas - the South Bank, with all the development that has taken place there in the past generation, an older core in Lambeth and Kennington, and the two country villages of Clapham and Streatham, which were overtaken and almost submerged by the flood-tide of late Victorian London. The majority of visitors will venture no further than the South Bank though the dedicated student of London will not neglect the other three areas.

That stretch of the river frontage which lies between Waterloo and Westminster Bridges and is today known as the SOUTH BANK has undergone an astonishing change over the past 30 years. The village centre of Lambeth lay half a mile away, dependent upon the Archbishop's Palace, and the marshy land beside the river escaped the busy development of Southwark, being occupied chiefly by market gardens, tenter grounds, and vinegar yards. About 1769, an important enterprise, Mrs. Coade's Artificial Stone Manufactory (see also p. 382), was established here, to be joined by Lambeth Water Works (1785), the Lion Brewery (1836), and a miscellaneous collection of wharfs and factories. The Albert Embankment ended at Westminster Bridge; the new building for St. Thomas's Hospital was opened by Queen Victoria in 1871, but it was not until the beginning of the present century that this westward-facing reach of the river began to be developed systematically.

In 1906, the London County Council (now the Greater London Council) purchased land on which to build a new administrative headquarters, County Hall, with the 29-year-old Ralph Knott as architect. The foundation stone was laid in 1912, and while the footings were being dug, an ancient ferry boat, now in the Museum of London, was discovered some 20 feet down. The main building was completed in 1922, its most impressive architectural feature being a neo-Renaissance colonnaded crescent facing the river, adorned with large groups of decorative sculpture by Ernest Cole. Knott, who died in 1929, never saw his designs completed, and so much additional office accommodation has proliferated since then that it is easy to overlook the strength and graciousness of this original vision, which is best appreciated from the vantage point of a boat, on the river. The Greater London History Library, with its impressive collection on the history and topography of London, may be used by serious students. The GLC also possesses remarkable collections of topographical paintings and engravings, and of maps. Its archives, to which, since the 1965 reorganization of London boundaries those of the Middlesex Record Office have been added, are of national importance; they are now housed in separate accommodation in Northampton Road, Islington (see p. 296). The GLC is responsible for the publication of The Survey of London; as its volumes issue from the press with unhurried majesty, we should all give thanks that, here at least, a civic authority is prepared to uphold scrupulous scholarship and dignity of presentation.

The Second World War left much of Lambeth in ruins, but even while the bombs were falling, the County of London Plan (1943) was being drawn up by Sir Patrick Abercrombie and J. H. Forshaw. They declared that it was:

One of the great anomalies of the capital that, while the river from Westminster eastwards is lined on the north side with magnificent buildings and possesses a spacious and attractive embankment road, the corresponding south bank, except St. Thomas Hospital and County

Hall, should present a depressing semi-derelict appearance, lacking any sense of that dignity and order appropriate to its location in the centre of London and fronting onto the great waterway... Cleared of its encumbrances, equipped with a continuous strip of grass and a wide esplanade, this area might well include a great cultural centre embracing, among other features, a modern theatre, a large concert hall, and the headquarters of various organizations.

When the War ended, the Government decided that in 1951, a century after the Great Exhibition, to the success of which London owes so much of its cultural development (see p. 169), a Festival of Britain should be held to celebrate this country's re-emergence from the years of struggle. The site chosen for the main exhibition was this stretch of Lambeth riverside. Derelict buildings were demolished, temporary ones erected; the Festival cheerful, touching, funny, a little awkward, slightly self-conscious, and wholly admirable - was held and became part of London's folklore. The site remained, empty save for the sole permanent building, the Royal Festival Hall. Designed for the LCC at a cost of £2,000,000 by Robert Matthew and J. L. Martin, it opened on 3 May 1951, though the building was not completed till 1965. Designed with the express intention of being as perfect as possible acoustically, the result is a large, impersonal auditorium, seating 3,000, in which every note can be distinguished with an icy clarity. The organ, designed by Ralph Downes, displays its pipes functionally and uncompromisingly, producing a tone of exceptional purity. The Royal Festival Hall is the antithesis of the Albert Hall, a brilliantly successful auditorium without humanity. The exterior is not especially memorable but the delight of the Hall lies in its fovers and staircases, which wind aerily away, apparently spiralling into space, for the auditorium is raised on pillars and the whole ground floor is one enormous concourse, huge and yet friendly, a lovable area, unlike the hall above it. Nearby, the Queen Elizabeth Hall (G. Horsfall, 1967, seating for 1,100) and the Purcell Room (1967, seating for 372) have been added for recitals and chamber concerts. Besides the main building, a riverside walk was freshly laid out to celebrate Queen Elizabeth's Silver Jubilee in 1977.

Inevitably, the Festival Hall attracted other buildings of a similar purpose to the site, so that the South Bank is now the most obvious single spot in London to which to direct anyone interested in the state of modern architecture in Britain. The National Film Theatre (1956, by J. L. Martin; members only but easy to join) nestles under the arches of Waterloo Bridge, dispensing delight to all those who love and revere the cinema as an art form in its own right. The Hayward Gallery (1968, by Hubert Bennett) has an exterior of quite frightening ugliness and is forbiddingly difficult of access; its outward form gives no

hint of the spacious, adaptable interior which has housed so many magnificent temporary exhibitions for the Arts Council.

Then there is the National Theatre, designed by Sir Denys Lasdun. The idea of a national theatre was first suggested in 1848, but it was not until 1903 that a determined effort to procure such an institution was begun by Harley Granville-Barker and William Archer; the foundation stone was at last laid by Her Majesty Queen Elizabeth the Queen Mother in 1951, and the first public performance in the new building was given on 16 March 1976. The building, standing on the Southwark side of Westminster Bridge, is enormous; seen from the Victoria Embankment

LAMBETH

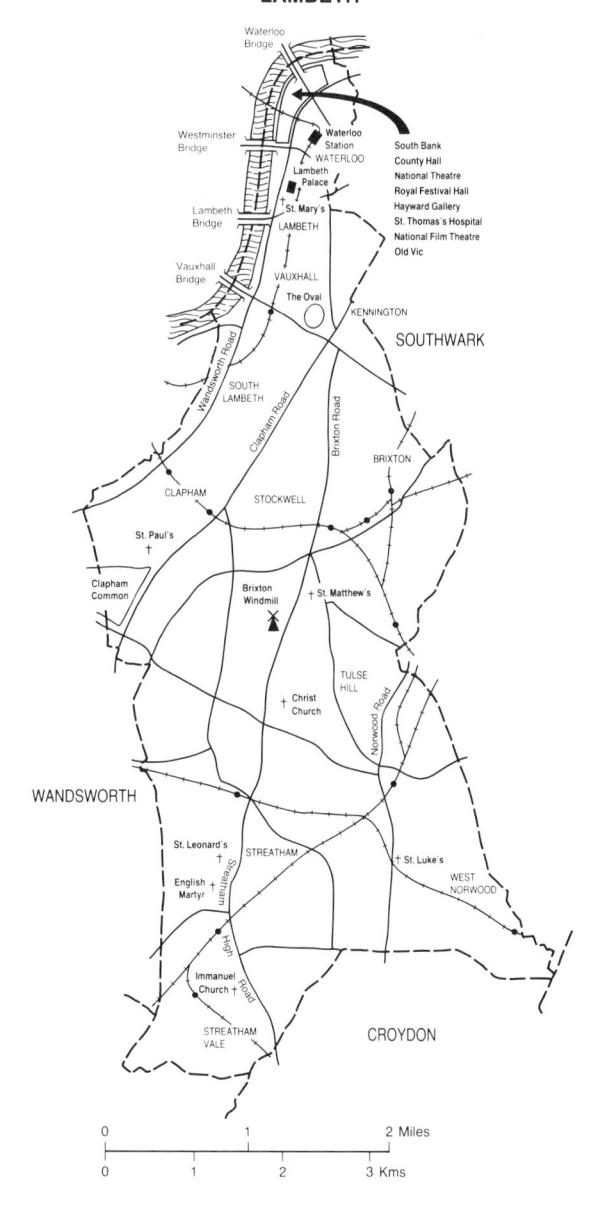

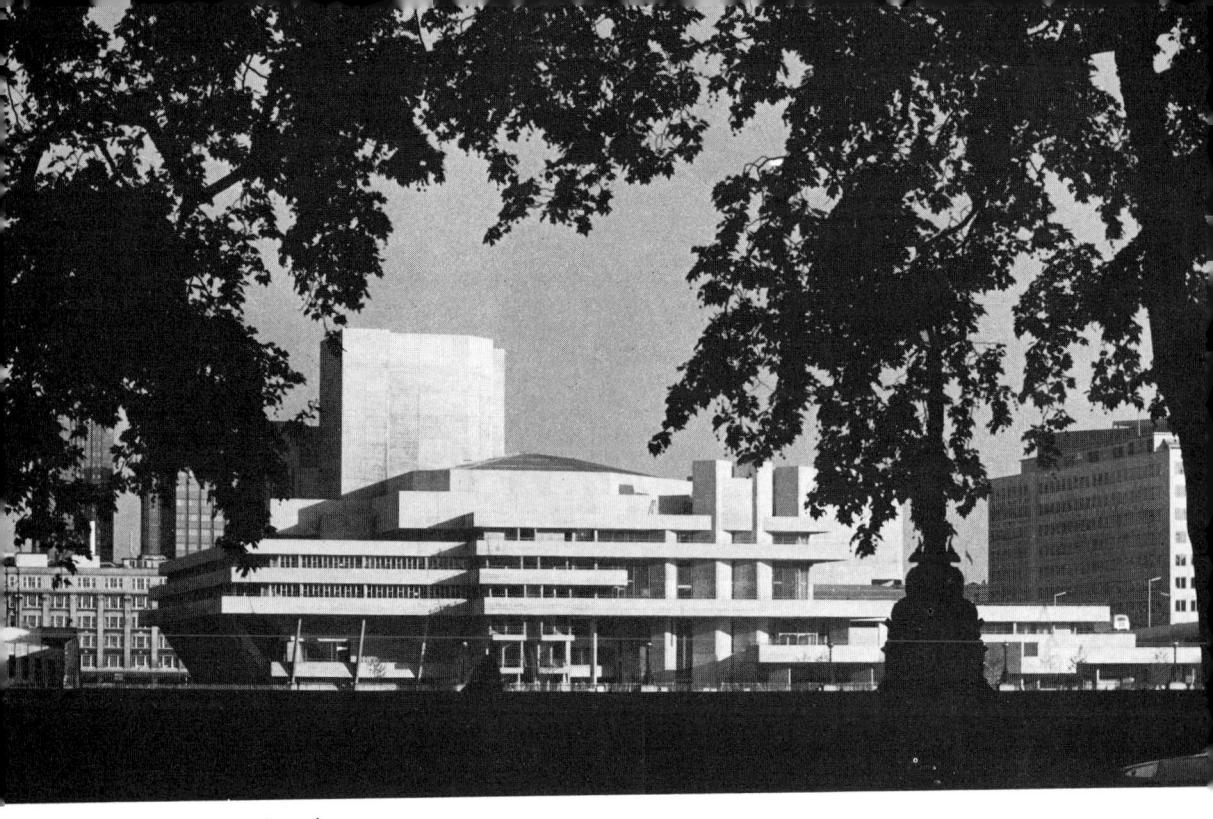

National Theatre, South Bank

across the river, it resembles a minor, irregular pyramid or the inner keep of a medieval castle. Within its walls is a whole small world, devoted to the theatre. There are three auditoriums - the Olivier (called after the actor who was chosen as the theatre's first director), a vast open-stage arena said by those who work in it to be the most exciting theatre in the world, the Lyttelton (called after the theatre's first chairman) with a conventional proscenium-arch stage, and the Cottesloe (called after a former chairman of the Arts Council), a tiny theatre for experimental productions. There are also workshops for scenery and costumes, rehearsal rooms large enough to permit the cast to work on a full set right from the start - a luxury unknown anywhere else in the world - and a vast foyer or concourse, with refreshment bars and bookstalls, where small, free entertainments are staged and where the wanderer can simply sit and think or talk or look at the river, which provides a permanent backdrop more spectacular than any ever devised within the theatre. The express purpose of this foyer is to draw the man in the street into the theatre and then to assure him that 'all the world's a stage'. The National Theatre is too new an achievement for anyone to judge it fairly yet; all we can say is that London now has one of the most exciting theatres in the world. The Maugham collection of theatrical portraits is scattered about the building.

Among so many public buildings dedicated to the arts, the Shell Centre stands up for commerce. It does

stand up indeed, 25 storeys into the air. Designed by Sir Howard Robertson, the façade is adorned with sculpured shells, and in a courtyard stands a fountain by Franta Belsky, made of great bronze shells piled up on top of each other, water spilling down in small cascades. Around the pool at its base are cobblestones in which ammonites have been set. Another fountain, of engagingly irregular geometrical shape, has recently been built in the new courtyard of St. Thomas's Hospital.

New and exciting buildings for St. Thomas's Hospital have been under construction for the past generation. Designed by Eugene Rosenberg, the architect has given more than bricks and concrete to the new complex, for he has persuaded his friends, and in particular Victor Pasmore, to present to the hospital examples of print-making; the hospital authorities have used their resources to enlarge the collection. Such an alliance of medicine and art is reminiscent of the support Hogarth gave to St. Bartholomew's Hospital and to the Founding Hospital. St. Thomas's, which was formerly in Southwark (see p. 413), brought with itself to Lambeth four statues of cripples by an unknown sculptor, another of Edward VI carved in 1682, another of the same monarch, this time in bronze by Scheemakers, and a marble figure of Sir Robert Clayton, President of the Hospital 1692-1707, which Grinling Gibbons sculpted in 1701-2.

Lambeth also provides, across the river, a comprehensive view of the façades of the Houses of Parlia-

LAMBETH 381

ment and of Somerset House, while away to the north-east are the dome of St. Paul's and the wedding-cake tiers of St. Bride's steeple. If time and the river currents have necessitated the replacement of Rennie's Waterloo Bridge (opened 1817) which Canova described as 'the finest bridge in all Europe'. the present structure (opened 1945), by Sir Giles Gilbert Scott, crosses the Thames gracefully in five shallow spans. When walking here, among so much that is new, it is still worth noticing some of the smaller, older details, especially along the Albert Embankment beyond Westminster Bridge, on which stands a huge, white, Coade stone lion, once the proud mascot of the Lion Brewery. The elegant lamp-posts, entwined with dolphins, were designed by G. Vulliamy and modelled by C. Mabey, and some substantial iron seats remain, adorned with friendly swans offering their folded wings as armrests.

Inland is Waterloo, London's most efficiently planned railway station, with its vast passenger concourse. It opened in 1848 as the terminus of the London and South Western Railway, and was given its present grand facade by I. R. Scott between 1907 and 1922; unfortunately, it is so sited that it is almost always ignored. Near to it stands St. John's church, one of the four so-called 'Waterloo' churches dedicated to each of the evangelists, which were built after the Napoleonic wars to provide for the growing population of Lambeth. The designs of all four were inspired by the revived interest in classical Greek architecture. St. John's, completed in 1824, was the work of Francis Bedford, who gave it a tall thin steeple, 'straddled a-cock-horse', as James Elmes put it, above a delicately proportioned Doric portico. Pillars, topped with honeysuckle motifs, mark the entrances. Much damaged by bombs, it was swiftly restored after the war to serve as the Festival of Britain church.

A couple of hundred yards further down the Waterloo Road, on the corner of the Cut, stands the Old Vic, probably London's best loved theatre. It opened as the Royal Coburg in 1818 but became the Royal Victoria in 1833, under which name it enjoyed, or rather endured, a usually seedy and shabby existance as a music-hall. In 1880, Emma Cons, the social reformer, reopened it as the Royal Victoria Coffee Music Hall, and gathered around her a theatrical and opera company. After her death in 1912, her niece, Lilian Baylis, succeeded to the management and added Shakespeare to the repertoire, building up a remarkable and versatile company. From 1963 till the new building was ready, the National Theatre Company performed at the Old Vic.

The curve of the river goes south to LAMBETH. At the southern end of the bridge, screened by a high wall, is Lambeth Palace, the London residence of the Archbishops of Canterbury and one of the few considerable medieval domestic buildings left in the capital. That portion of the Palace in which the

Archbishop resides and has his offices was rebuilt in 1829 in a neo-Tudor manner by Edward Blore, but the older buildings, lying beside the river, remained and are partially visible from the Embankment. The most imposing is the great gatehouse, built of rosy red brick by John Morton, who was both Archbishop and Cardinal as well as Henry VIII's devoted minister, a man most subtle in devising new taxes, and in whose household the young Thomas More received his early training. Massive twin towers flank a double entrance, a broad gateway for carriages, a narrower one for foot-travellers. Within the grounds, the eye is drawn to the high-pitched roof and neat hexagonal lantern of the Great Hall. built in 1663 by Archbishop Juxon, after the Palace had suffered much damage during the Commonwealth period. Pepys described it as 'a new, oldfashioned Hall' - a fair judgement, for the buttressed walls, tall, pointed, three-light windows, and hammer-beam roof were all deliberately kept in the Gothic manner, though the stone and wood-carvings, such as the cherubs supporting Juxon's arms over the doorway and the Negroes' heads, the Archbishop's heraldic device, over the fireplace, were executed in the classical manner, which was to be the hallmark of the churches that Wren would be called upon to build a few years later. Just beyond the Hall is the low tower, which Laud had built in 1635, and the greater bulk of the Water or Lollards' Tower, built during 1434-5; no strong evidence has been found to contradict the tradition that Wyclif's heretical followers were imprisoned here. On the first floor of the tower is the Post Room, in which an exceptionally well preserved, three-ordered, thirteenth-century archway with twin, trefoil-headed entrances leads into the chapel. This, lying at right angles to the river, was built between 1225 and 1228, towards the end of the long episcopate of Stephen Langton. It was here that Wyclif faced his second trial for heresy in 1378, and that Matthew Parker was consecrated as the first truly Anglican Archbishop. Through the generations, the Chapel has been refurbished frequently, as well as suffering severe damage during the Civil and Second World Wars, but the basic thirteenth-century fabric is all there - four bays of meticulously plain vaulting, four sets of triple lancet windows, and the great east window, filling the whole chamber with a strange, watery radiance. The fine screen, with square panels at its base and oval cartouches above, which Laud installed, has been restored from its bomb-damaged condition and now stands in the Post Room. 1 Beneath the Chapel is the crypt or undercroft, scarcely altered since it was constructed soon after 1207, when Langton became Archbishop. Within the Palace, the Guard Room, though mostly rebuilt, has a roof of fourteenth-century timbers.

¹ So called from the great central post which used to support the ceiling. Alas, after the war it succumbed to dry rot and had to be removed.

Of necessity, the Palace is seldom open to visitors, though parties are occasionally admitted, but a substantial part of the gardens which lie behind the complex of buildings were opened as a park for the public in 1900 and may be entered easily from Park Street and Carlisle Street. The library too is open sometimes for exhibitions and welcomes accredited students and scholars. Lambeth Palace can boast of being the oldest public library in the country, for it was founded in 1610 by Archbishop Bancroft, and has been preserved and enriched through the centuries, in spite of the Civil War and later ravages. There are about 1,250 manuscripts, among the earliest being the ninth-century Macdurnan Gospels and a tenth-century text of Aldhelmus's De Viginitate, with wonderful Anglo-Saxon drawings. For the twelfth and thirteenth centuries, there are the illuminations of the Lambeth Bible and the Lambeth Apocalypse, and the fifteenth-century history of England, the St. Albans Chronicle, is no less exquisitely illustrated. The Archbishops' registers of their official acts are here, running in an almost unbroken sequence from Pecham (1279–92) to the present day, and with them a wealth of documents and papers essential to any student of English history. To the original collections, some 8,732 volumes that had belonged to Archbishops Abbot and Bancroft, a modern working library has been added. The printed books include a particularly fine Gutenberg New Testament and over a hundred other incunabula, among them six Caxtons. Cranmer's own copy of Henry VIII's Assertion - the volume that won him and his successors the title of Defender of the Faith - is here, as well as Edward VI's Latin grammar and Queen Elizabeth's own prayer book.

Beside the Palace, its grey stone contrasting demurely with the rubicund brickwork of Morton's tower, is the former parish church of St. Mary's. The late medieval west tower remains intact, save for a nineteenth-century top storey, but the body was rebuilt in 1851-2 by P. C. Hardwick, who followed medieval precedent so carefully that the casual observer would scarcely be aware that centuries separate the two parts of the building. Archbishops Bancroft – still close to his beloved library - and Tenison lie here, and so does Elias Ashmole, the antiquary and collector to whose zeal we owe the Ashmolean Museum in Oxford, as well as John Boughton, the eighteenth-century pugilist. In the churchyard are three interesting tombs, that of the Tradescant family and those of William Sealy and Captain Bligh. The Tradescants were great collectors too, and owned a botanical garden and museum known as the Ark nearby in south Lambeth - Tradescant and Walberswick Roads cover the site; after the death of the younger John Tradescant, his collection was acquired by Elias Ashmole and eventually provided the nucleus around which the Ashmolean Museum in Oxford has developed. Tradescant lies beneath a curious sarcophagus, its sides adorned with ruined

St. Mary's, Lambeth, and the gateway to Lambeth Palace

temples and crocodiles who push their snouts up through primeval mud. Sealy was the partner of his aunt, Eleanor Coade, in her Artificial Stone Manufactory which gave employment to many as yet unknown sculptors, Bacon and Rossi among them, and produced wares so resilient that the classical heads on their key-stones still smile down from such eighteenth-century houses as remain in London. Very properly, Sealy's tomb is of that redoubtable material, which also covers the harsh-hearted Captain Bligh, whose severity aboard the Bounty drove her men to mutiny in 1789; in later life, the captain attained the rank of Vice-Admiral. The church was declared redundant and closed in 1972 but five years later it was acquired by the newly-established Tradescant Trust as a Museum of Garden History; George Tinworth's Doulton terracotta reredos is safe inside and the shabby churchyard is being redeemed by the hands of diligent volunteers and transformed into a botanic garden which would have delighted the Tradescants' hearts.

Lambeth Walk, famous both for the song and for the tenacious stoicism of its inhabitants during the Blitz, has been rebuilt as a pedestrian shopping precinct, with flats above the shops; the idea is excellent, the manner of execution lamentable. Angry, dark red, brick balconies glower at each other in sullen, brutal confrontation; the inhabitants sensibly try to minimize the architect's mistakes with windowboxes. Nearby, just off Black Prince Road, the quadrangle of flats and the terraces of cottages built for the Duchy of Cornwall just before the First World War by Louis de Soissons show how aesthetically satisfying massed housing can be, provided it is humanely kept to a proper human scale. There are several charmingly imaginative touches, such as the weather-boarding to the bay-windows of the flats and the neat little urns which enliven the fanlights over the cottage doors. The eastern end of Black Prince Road runs into the Kennington Road, which turned from a cart track to a main throughfare when Westminster

LAMBETH 383

Bridge was opened in 1750. In it stand some fine late eighteenth- and early nineteenth-century terraces, and adjacent, in Kennington Lane, is the porticoed façade of the former Licensed Victuallers' School, which was built in 1836 to designs by Henry Rose. When the school moved out of London in 1921, the building was put to other uses and is now called Imperial Court. Just to the east lies Cleaver Square, set about with trim houses, built just before and just after 1800.

Kennington Lane runs beside the former site of Vauxhall Gardens where, by 1660, Londoners were disporting themselves, and where they continued to take their recreation till the Gardens closed on 25 July 1859; a short detour leads to the present Vauxhall Park, once the site of the house of the blind Postmaster-General, Henry Fawcett, who died there in 1884.

Southwards is the Oval, the home of Surrey County Cricket Club, opened as a cricket ground in 1844 on the site of a market garden. Nearby stands St. Mark's, Kennington, built in 1824 by D. R. Roper and A. B. Clayton, with a robust portico supporting an attenuated, starved-looking tower and spire. Inside, the galleries have been enclosed, thereby robbing the church of much of its light. Still heading south, it is worth noticing Stockwell Terrace (1843 by John Notley), Surridge Court Shopping Arcade (1960) beside Stockwell Station, and the Dolby Laboratories in the Clapham Road (1970), all good, forthright buildings. Only a short detour is needed to reach the Minet Library in Knatchbull Road, passing on the way the imaginative and effective efforts that the borough is making to preserve the late eighteenth-century terraces which line the Brixton Road, by converting them into flats for present-day families. Their treatment of the smaller houses in Lough-

Lambeth Palace Library

borough Road and Minet Road is particularly sympathetic. The Library, which opened in 1890, houses the Archives Department of the Lambeth Public Library system, with rate-books and vestry-books going back, albeit with gaps, to 1504, and with special collections on the history and topography of Surrey, to which county Lambeth belonged until 1888. The collection includes material on Doulton's Pottery, which flourished near Lambeth Bridge from 1815 till 1956.

CLAPHAM, which deserves at least a full day's exploration to itself, lies beyond. When Rocque drew his indispensable survey of London's environs in 1746, Clapham consisted of St. Paul's church standing on a little knoll, the broad common with the Old Town, as the village came proudly to call it, spread out in a curve on the north-east corner, a cluster of cottages along what is today the main Clapham Road but which was then known as Babilon, and fields and market gardens all around. Change did not come for almost a century, when the railways arrived and Thomas Cubitt began to lay out Clapham Park. Within 50 years, the closely packed Victorian streets which make up Clapham today were constructed. The Common, however, remained, threatened, surrounded, but still inviolate, and the student of architecture can spend several happy hours wandering round the perimeter, contemplating in particular the houses on the North Side, where William Hewer, Samuel Pepys's clerk and friend, bought a house built in 1663 by Sir Denis Gauden, and where Pepys came to live too, to be tended, lovingly, in his old age, in 'your Paradisian Clapham' as John Evelyn called the village. That mansion was demolished in 1754 and several others were built on the site, the most handsome of them being The Elms, where Sir Charles Barry made his home and died at last in 1860. Before Hewer's house was pulled down, it had been joined by several attractive short terraces of tall houses which are still standing, sleek and well preserved. and there is Gilmore House, built in 1760, with niches in which sit busts of Shakespeare and Milton. In such a harmonious setting, two blocks, Cedar Terrace and Thornton Terrace, designed in 1860 in the French style with mansard roofs by James Knowles, shoulder their way disturbingly with gruesome self-assertiveness. In the north-east corner of the common is Holy Trinity Church, a neat little brick chapel with a restrained portico and hexagonal bell-turret designed in 1776 by Kenton Couse. A stone's throw from the church are the last remaining morsels of the Polygon, built in 1792, of which the most piquant is number 1, at present a grocer's but once an oil-merchant's shop, as the large jars set into the façade at first-floor level testify. Opposite the shop, at numbers 39, 41, and 43 Old Town, are three beautifully proportioned, very early eighteenth-century façades with fine door-cases. From 1876 to 1896, number 43 was the home of John Francis Bentley, the architect of Westminster Cathedral.

The old parish church lies a little to the north of the Common, at the far end of Rectory Grove. A church dedicated to the Holy Trinity was here by the beginning of the thirteenth century, but the present building, dedicated to St. Paul, and designed by J. Edmonds, took its place in 1815. A plain little stock-brick box with a west pediment, it was enlarged with a fanciful neo-Norman chancel and transepts, which Blomfield added in 1875. Within the last few years, the two halves have been separated, the old nave now providing a parish church of just the right size, while Blomfield's augmentations have become an unusual but useful parish hall. It is worth gaining access to the church for the sake of the sculpture. The earliest memorial is a brass to William Tableer (d.1401) but the most important are the five figures from the tomb of Sir Richard Atkins (d.1689), whose family had been lords of the manor throughout the previous century and were to continue to hold that honour for another hundred years. He is represented in armour, his wife, Dame Rebecca, lying beside him, while their three children, Henry, Annabella, and Rebecca, who predeceased their parents, sit or stand. Henry is clad in Roman armour, and eight-year-old Rebecca holds a skull. The architectural surrounding, against which the figures were originally displayed, has gone, but the figures themselves are of exceptionally fine quality; the work is usually, and convincingly, attributed to William Stanton. There is also a tiny, neat, kneeling figure, a fragment of Bartholomew Clarke's monument (d.1589), and a large, imposing cartouche with a portrait medallion to William Hewer, Pepys's clerk and friend. J. B. Wilson (d.1835) has a large, unsigned memorial, on which an allegorical figure bends mournfully over an urn adorned with a portrait medallion, and there are several imposing sarcophagi in the churchyard, which stare defiantly across at the high-rise flats pushing upwards between them and London. The sculptors, John and Henry Cheere, lie here too.

On the south side of Clapham Common is Crescent Grove, built soon after 1820 by Francis Child, the houses arranged as if around the sector of a circle, a terrace arching itself about the curve, pairs of semi-detached houses across the chord, and a communal garden with daffodils in the middle. To the west lay Clapham Park, developed from the 1830s onwards by Thomas Cubitt, who chose to make his own home in Cavendish House on the South Side of the Common; the pleasant villas have been demolished and their sites re-developed with smaller property. Further down the South Side is the Henry Thornton School, its name a reminder of the influential, deeply religious families, who made their homes around the Common and were known as the Clapham Sect. Their most famous member was the philanthropist William Wilberforce, by whose efforts slavery was abolished in this country, but the mainstay of the group were three generations of the Thornton family, who provided other members with hospitality and encouragement; their story was told by their great-nephew, the novelist E. M. Forster, in his book *Marianne Thornton: a domestic biography* (1956).

Leaving the Common by way of Cavendish Road (called after Henry Cavendish, the scientist) and Poynders Road, we pass a successful modern parade of shops on the corner of Clarence Avenue, and reach an elevation, the northern slope of which is known as Brixton Hill and the southern as Streatham Hill. Its summit is commanded by Christ Church, built in 1842 to the designs of J. W. Wild, who had studied under Basevi. Its style is one seldom found in England, though much admired in Germany at that time, being a reconstruction of a Byzantine basilica. Built of yellow brick, it has a noble west entrance and a tall tower, 113 feet high. Inside, the ceiling of the apse and the tops of the piers were decorated by Owen Jones, who was Wild's close friend, and around the apse walls are mosaics made by craftsmen who came over from Italy. In the Chapel of Our Lady and St. George in the north aisle are two stainedglass windows, designed by Walter Crane - a rare example of his work in this medium.

STREATHAM lies in the extreme south of the borough. Its name is always associated with the hospitable ménage of Henry and Hester Thrale, where Samuel Johnson found a second home from 1765 till 1782. Their mansion, Streatham Place, lav on the western side of what is today called Tooting Bec Common, so that modern boundary lines would apportion it to Wandsworth, but it is more proper to speak of the family here for it is in the parish church, St. Leonard's, that Mr. Thrale, his small son, his eldest daughter, and his mother-in-law were buried. The low west tower was constructed late in the fifteenth or early in the sixteenth century; the rest of the church was rebuilt at intervals since 1831, till in 1974 it was gutted by fire. The opportunity to reconstruct the church in a manner well suited to the needs of the twentieth century, while retaining all that was attractive and survived the flames, has been well taken. Happily, it has been possible to restore the monuments. Sir John Ward rests beneath the canopy of another early tomb, and the tablets to the Thrale family, with Johnson's Latin epitaphs, have been pieced together; that of Sophia Hoare, Henry Thrale's daughter, is adorned with a small relief by Flaxman. Much work remains to be done on the memorials of John Massingberd (d.1653) and his wife, who kneel opposite each other, and on a large monument with a black marble urn to the Howlands, who were lords of the manor in the seventeenth century, but a bust of Thomas Hobbes survives, as do two seventeenth-century tablets with unusual epitaphs. The earlier is to Edmund Tilney, 'Maister of the Revells' to Queen Elizabeth and James I; the inscription sets out his pedigree and connections in quite astonishing detail. The other, set up by William

LAMBETH 385

Lynne, commemorates his wife, Rebecca, who died on August 1653, and declares roundly:

Were Solomon on earth he would confesse I founde a wife in whome was happinesse... Should I ten thousande yeares enjoy my life I could not praise enough soe good a wife.

The wall-paintings with which William Dyce adorned the nave have vanished but his memorial brass has been preserved and is soon to be set up on the wall of the south aisle. St. Leonard's has as neighbour the Roman Catholic Church of the English Martyrs (1892, by Purdie); the two companionable spires provide an eye-catching landmark.

It was not until the very end of the last century and the beginning of the present one that the hillsides of Streatham were built over. In Convers Road, at the foot of Mitcham Lane, is an astonishing Italianate pumping station and away to the south lies Streatham Common, with Immanuel church (1865) by Benjamin Ferrey) on its east side. Immanuel can boast of a nobly parapetted upper storey to its tower and a good modern church hall at its side, while the open expanse of the Rookery at the top of the Common provides a splendid wilderness in which to walk. Crown Lane follows the crest of the ridge, passing on the way St. Michael's Convent, an Italianate villa which was once the Park Hill, the home of Sir Henry Tate, to whose munificence we owe the Tate Gallery. Northwards again, down Knight's Hill, stands South London College.

At the foot of the hill is another of Bedford's churches, St. Luke's, once again with a slender steeple perched above the portico. Here, however, the ground falls away steeply below the church and the drama of the setting lends the façade a majesty which more conventional surroundings would deny it. To the east lies West Norwood Cemetery, a vast necropolis opened in 1837 to meet London's urgent need for more hygienic burial than the overcrowded churchyards of the city could afford. The Church of England and Nonconformist¹ Mortuary Chapel, possibly designed by John Oldrid Scott, was erected in memory of Augustus Ralli, who had died of rheumatic fever while a pupil at Eton. Beside the chapel stands the Ralli family memorial, designed by G. E. Street. Up Tulse Hill is the imposing façade of Silwood Hall (1856-7, architect unknown), now occupied by the St. Martin-in-the-Fields High School for Girls, and on the eastern slopes of the hill lies

Brockwell Park, once the grounds of Brockwell Hall, which still stands at the top of a small but steep incline, surveying its own demesne. It was built between 1811 and 1813 by D. R. Roper for the wealthy glass manufacturer, John Blades, with a porticoed entrance front to the north-west, which catches the evening sun, and a central bow to the south-east front with pretty iron-work. The imposing interior, for which J. B. Papworth designed the original decorations and furniture, is now melancholy and a little slatternly; it serves as a public tearoom.

In BRIXTON is the fourth, and finest, of the 'Waterloo' churches. St. Matthew's was designed by C. F. Porden and was consecrated in 1824. The architect took advantage of the spacious island site on which the church stands. He gave it a grave and nobly proportioned Doric western portico, and at the east end set a two-storey tower surmounted by an octagonal lantern, reminiscent of the Tower of the Winds in Athens. The interior is at present being altered and modernized to accommodate the needs of the local inhabitants; it is too soon to judge the results but the action is right, and those responsible are to be congratulated on the respect with which they have treated Porden's dignified exterior. In the churchyard stands a memorial, designed by R. Day, and erected in 1825 by Henry Budd, in memory of his father, Richard. It is as if three Roman altars of diminishing size had been piled on top of each other, and stone palmettes set on the summit. The sides are adorned with serpents devouring their own tails symbols of eternity – and with winged globes, the Egyption hieroglyph for the Almighty Creator. It is a rare joy as one drives up the Brixton Road to be greeted by this strange stele, with the noble bulk of St. Matthew's behind it.

A few hundred yards away, in Blenheim Gardens, stands a relic of London's rural past, Brixton Windmill. Built in 1816, its tower is of stock brick. Though the sails were removed in 1862, it was equipped with machinery and the mill remained in use till 1934. In 1957, the LCC purchased it, installed the machinery from the derelict tower-mill at Burgh-le-Marsh in Lincolnshire, replaced the missing sails and set all in working order again. The interior may be inspected on application to the attendant. It is only a low building — no greater height was needed for the sails to catch the wind when the fields lay open around it — and waits invisible, screened by the houses all around, till the explorer reaches the edge of the little park in which it now stands.

¹ The latter was severely damaged in the Second World War but has since been restored to the designs of Alwyn Underdown.

Lewisham

The London Borough of Lewisham covers the large area of approximately 13 square miles; it is shaped like an irregular, five-pointed star and has been formed by the union of Deptford with old Lewisham so that the new administration is responsible for meeting the needs of some 270,000 people. Today, the general impression of the borough is of a mass of small and medium-sized housing, built from the midnineteenth century onwards, but a careful examination reveals more exciting matter.

A medieval core at Ladywell and older centres at Deptford and Blackheath are worth exploring in detail, and there are also a good and unusual museum, the Horniman, a huge, but human, Greater London Council estate, two eighteenth-century mansions, now the property of the borough, but in full use, besides as impressive a collection of municipal parks as may be found in any London borough.

If the five points of the star are Deptford, Sydenham, Beckenham, South Lee, and Blackheath, we will begin in the north, at Deptford on the river margin, and travel widdershins around Lewisham. The local planning authorities have shown themselves particularly imaginative and efficient, both in the redevelopment of decrepit areas, and in the conservation and rehabilitation of the architecturally impressive parts of the borough.

DEPTFORD was a small riverside village till Henry VIII founded the Royal Naval Dockyards there in 1513. From then onwards it grew rapidly till, by the end of the seventeenth century, John Evelyn, the diarist, recorded that it was 'neare as big as Bristoll'. It was at Deptford that Drake moored the Golden Hind in 1581 after 'compassing the world', and Queen Elizabeth came aboard to dine with her captain and to confer a knighthood upon him.¹ The dockyards continued to function, save for a brief closure between 1830 and 1844, till 1869 when the last ship, a wooden corvette, the Druid, was launched.

Of medieval Deptford virtually nothing remains save for the fifteenth-century ragstone tower of the parish church, dedicated to St. Nicholas and standing on the corner of Deptford Green and Stowage Lane.² The body of the church was rebuilt in 1697 in warm red brick, with stone dressings and jolly Dutch gables over the entrances, but it was gutted by bombs during the Second World War. Happily, the exceptionally fine furnishings had already been removed, and have now been reinstated in the restored building. Originally four bays long with north and south aisles and a shallow chancel, the altar has been moved westwards to provide space for a parish hall within the building, so that though this truncation mars the proportions, it has created a church of suitable size for a present-day congregation.

St. Nicholas's chief glory is the huge reredos, thought to have been carved by Grinling Gibbons, who, though a native of Holland, lived in Deptford in young manhood; all garlanded with fruit and flowers, it is further adorned with portraits of Moses and Aaron, and with an oval of glass set high in the semicircular pediment and painted by William Price with the Adoration of the Shepherds. The hexagonal pulpit, richly carved about 1620, is worth noticing, as are Sir Godfrey Kneller's portrait of Queen Anne, and an animated and macabre carving of Ezekiel's vision in the Valley of Dry Bones, which used to hang over the doorway of the little brick charnel house in the churchyard. The funeral monuments have suffered much damage, but the visitor should remember that the playwright Christopher Marlowe was buried here, having been stabbed to death in a drunken brawl in Deptford, and that a number of John Evelyn's family rest here: his father-in-law, Sir Richard Browne, his five-year-old son, another Richard, 'for which I go even mourning to the grave', and his daughter Mary, beautiful and witty, who 'danced with the most grace that ever I saw in my life', but who died at the age of 19. Peter Pett (d. 1652), one of three generations of master ship-

¹ Though the Queen ordered that the ship should be preserved forever, nothing remains save a chair in the Bodleian Library at Oxford and a table in the Hall of the Middle Temple (see p. 31) carved from her timbers.

² Owing to some quirk of the borough boundaries, St. Nicholas stands in Greenwich, but must be described in relationship to Deptford.

387

builders, lies here, and so do several generations of the Shish family who provided Charles II with three master shipwrights, Jonas and his sons, John and Thomas, at Woolwich and at Deptford.

Nothing remains of John Evelyn's riverside house, Says Court, which he inherited from his father-in-law and which Peter the Great of Russia rented from him in 1698, nor of the gardens with their holly hedges, which he laid out himself. It was through his perspicacity that the genius of Grinling Gibbons was first recognized. When walking in Deptford, Evelyn looked into a poor cottage and saw a young man at work, carving a relief panel after Tintoretto's painting of the Crucifixion. Recognizing the extraordinary quality of the work (at present on loan to the Victoria and Albert Museum), he recommended Gibbons to the King and to Wren, with happy results for the young man, for the adornment of London's post-Fire churches, and for the development of English woodwork and sculpture.

A second church, St. Paul's, was built between 1712 and 1730 to designs by Thomas Archer, and stands just to the east of Deptford High Street. Like few other churches in England, St Paul's is a perfect Baroque building. A semicircular portico of Tuscan pillars, approached by a wide sweep of steps, softens the relationship with the west tower and delicate steeple, while the north and south façades are given unusual dignity by the addition of double staircases,

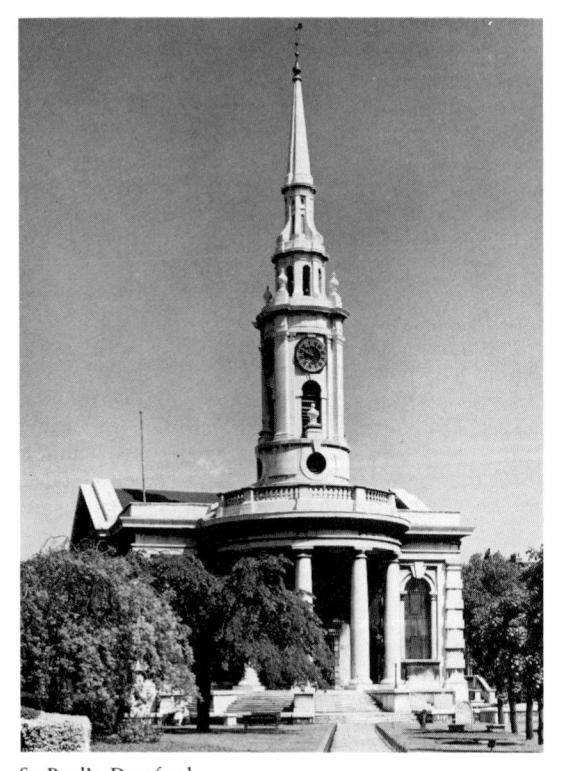

St. Paul's, Deptford

such as those which lead to Palladio's villas or. nearer home, to the house which Lord Burlington built for himself at Chiswick (see p. 281). At the eastern end, a Venetian window bends itself sinuously around the apse. The interior is in the form of a Greek cross, with giant Corinthian pillars to mark the crossing. The plasterwork of the flat ceilings is sumptuous, and the pulpit is generously carved. The chief memorials are to Matthew ffinch and to Mary Finch, who both died in 1745 and who each have an urn, his portly, hers more graceful with rococo decorations. Vice-Admiral James Sayer (d.1776) is commemorated by a bust by Nollekens. Dr Charles Burney (d.1817), brother of Fanny Burney, the novelist, and a classical scholar and bibliophile whose library was purchased for the British Museum, was rector of Deptford for ten years, and appears in profile on a medallion, which leans against an obelisk.

In the High Street by the church, though there is nothing of special architectural importance, the massed diversity of shop façades, built and altered at any time between the eighteenth century and the present day, makes a pleasing whole. Once, Deptford High Street looked dowdy and more than a little decrepit, but in 1971 the Borough Council began to give the whole thoroughfare a face-lift, with the spruce and agreeable results that can be seen today. Bolder redevelopment is going on at the north end, around Albury Street, which was built at the very beginning of the eighteenth century; traditionally, these houses, with their door-cases elaborately carved with cherubs and grotesque masks, were the homes of those sea-captains who set out from Deptford on their long voyages. They are being preserved and restored, while around them a whole new estate is being built; it will be interesting to see, in half a generation's time, how the old and the new have blended. Some of the new council housing in Adolphus Street is good, while Tanner's Hill is being converted, imaginatively, into a pedestrian precinct, with seventeenth-century shops at numbers 19-31. On the foreshore beside the river, where the Pepys Estate covers the site of the Royal Victualling Yard, which used to provision the fleet, one of the original office buildings, erected around 1790, now serves, most satisfactorily, as a public library.

To the south, towards NEW CROSS, is Goldsmith's College, now part of London University, in Lewisham Way. Designed by John Shaw in 1843, and occupied originally by the Royal Naval School, it is a restrained but imposing building, with the South-East London Technical Institute, built in 1927 by F. R. Hiorns, as a good and unselfconscious companion beside it.

The Horniman Museum stands in the London road. Frederick John Horniman, chairman of his family's firm of tea importers, built up, throughout his life, a remarkable and wide-ranging collection, devoted chiefly to ethnography and natural history.

This he opened, in 1890, in his own home, to the public and then in 1901 he rehoused it in a new museum built at his own expense and 'dedicated to the public for ever for their recreation, instruction and enjoyment'. As architect, he chose Harrison Townsend, who had already designed the Whitechapel Art Gallery and the Bishopsgate Institute. A bold and original Art Nouveau building was the result, its facade, decorated with a mosaic by Anning Bell, set back behind a dominating tower. Inside, the collection covers animal evolution, from the fossil footprints of the iguanadon that strolled through the mud at Swanage in Dorset centuries ago, to a lively and most active glass bee-hive. The museum also holds material on the majority of the world's peoples. There is some fine Indian sculpture, and a number of magnificent Benin bronzes. There are magic and ritual objects from many countries, including some exquisite Polish Easter and Christmas decorations. One of the most interesting displays demonstrates early methods of hafting axes, collected together from all over the world.

In 1947, the Carse Collection of musical instruments was presented by Adam Carse in memory of his son; the Horniman now possesses some 5,000 instruments of all ages and from all parts of the world. There is also a textile collection, though this is, for the most part, available only on request, to

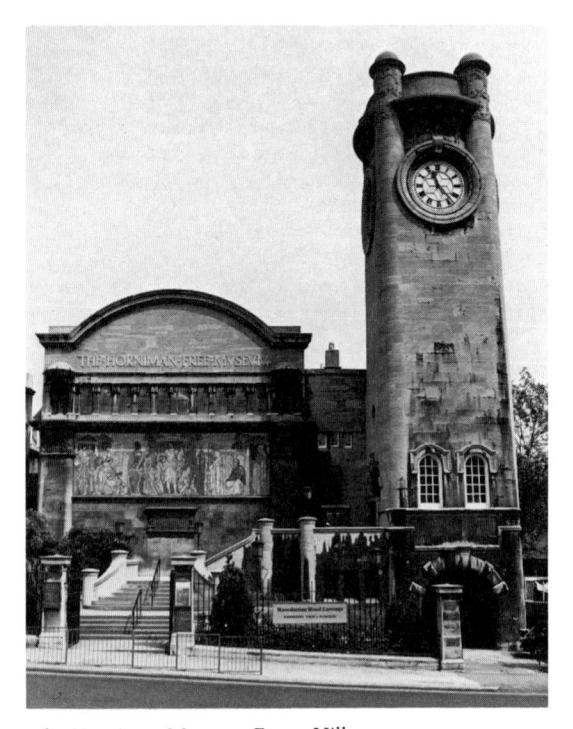

The Horniman Museum, Forest Hill

protect the materials from fading. In 1969, an Education Centre was opened, with facilities for formal and informal instruction, based on objects in the collection. The gardens were once the grounds of Mr. Horniman's house; they command remarkable views across South London into Kent and Surrey, and are planted with an unusual variety of flowers.

To the south lies SYDENHAM, on a pleasant hillside, laid out prosperously in a variety of styles from the early nineteenth century onwards, with one exceptionally well planned GLC estate at Hillcrest, and an unusual municipal garden at Sydenham Wells Park. The waters here are impregnated with iron and mineral salts, so that a spa grew up and George III came to take the waters. The health-giving flow is now converted into pools and streamlets which give much variety to the park and make it possible to grow several unusual plants which prefer damp conditions. Lewisham Council has bought Mortimer Brown's sculpture, Shepherd Boy, to grace the spot and child visitors will be diverted by the flamingoes and the large rabbit warren.

Eastwards towards BECKENHAM is Bell Green, where the spidery filigree of a group of enormous gas-holders has a grace of its own, and where the small Livesey Memorial Hall is an interesting example of Art Nouveau design. The southern tip of the borough is occupied by Beckenham Place Park. The fine stone house, with four huge Ionic columns1 topped by a pediment, forming a porch to shelter arriving guests, was built about 1774 for John Cator; the architect is unknown. The grounds are used as a municipal golf course, which at least protects them from being built over; the decorations of the house have lost their pristine attraction, but the proportions of what must once have been the drawing-room have remained unspoiled, and its sweeping semicircular window, sited so as to trap the sun throughout the day, still looks out over the estate as it merges into the deep verdure of the Kentish countryside. It has recently been agreed that the Mander and Mitchenson Theatrical Collection will be installed here - a splendid use for a fine building (see p. 348).

The south-eastern corner of the borough is occupied chiefly by the huge GLC estate of **Downham**, consisting of some 7,000 houses built during the 1920s and 1930s, to designs by G. Topham Forrest and E. P. Wheeler. In spite of its extent, a human scale has been preserved throughout, with great variety in the design of the houses, so that the individuality of each family has been preserved, in a way that is impossible in the massed housing provided by tall tower blocks in Bromley Road.

Nearby is **St. John's** church. The old chapel, with a cupola and Tuscan pillars forming a porch, is now used as the parish hall and a new church has been

¹ They came from Wricklemarsh, Sir Gregory Page's seat at Blackheath.

LEWISHAM 389

built to designs by Sir Charles Nicholson. In it are monuments by Robert William Sievier from the old church to John (d.1834) and Elizabeth Forster, and Cecil Thomas's recumbent bronze figure of a dead soldier, a memorial to Alfred Forster, who was killed in the last weeks of the First World War, is here too. Justly, this statue became famous and several copies of it were made; one of them lies in All-Hallows-bythe Tower. The Forster Memorial Park in Whitefoot Lane is a further token of the family's long association with Lewisham.

LEE lies northwards where, around the former Green, there are still standing several eighteenth-century houses, now turned into shops, while the former Manor House in Manor Lane, throughout the nineteenth century the home of the Baring family, now houses the public library, its gardens having become a public park. There are excellent natura! history guides to each of the public parks of Lewisham.

Beside the Manor House stands Pentland House, built some three-quarters of a century earlier, and in the High Street stand Boone's Almshouses, founded in 1683 and rebuilt in 1876 as the Merchant Taylors' Almshouses, though the old chapel was left intact. Of red brick with rusticated stone quoins, it has a hipped roof on top of which perches a tiny timber cupola, and on three sides there are small, well proportioned pediments, while a modillioned cornice runs round the eaves of the building. The doorway, small but imposing, is flanked by round-headed windows, and oval windows are set in three of the sides. Inside, there is some good plasterwork. The chapel is at present little used, but it is a treasure which Lewisham should restore and cherish.

The parish church, dedicated to St. Margaret, stands at the junction of elegant Lee Terrace and Belmont Hill. Built in 1841 to designs by John Brown, it has an imposing west tower, tall, coupled, lancet windows and aisles as high as the lofty nave, separated from each other by delicate quatrefoil piers. The walls and wooden vault are painted in sombre hues and an iron screen, its metal beaten out almost to filigree, divides the chancel from the body of the church. There are three attractive brasses, now set in the north aisle, one to Nicholas Ansley (d.1593) who was Sergeant of the Cellar to Queen Elizabeth and who kneels in full armour, another to his wife, Isabel (d.1582), who is shown wearing an elegant French cap, and a third, the earliest, to Elizabeth Couhyll (d.1513); this gentlewoman has a pedimental head-dress and a long girdle. All three came from an earlier St. Margaret's, the ruined west tower of which still stands, ivy grown, in the churchyard on the opposite side of the road. Around it are a number of picturesque urns and sarcophagi; Sir Esmond Halley and John Pond, both Astronomers Royal, lie here, and there is a large, recently restored monument to Daniel Boone, who founded the almshouses in the High Street.

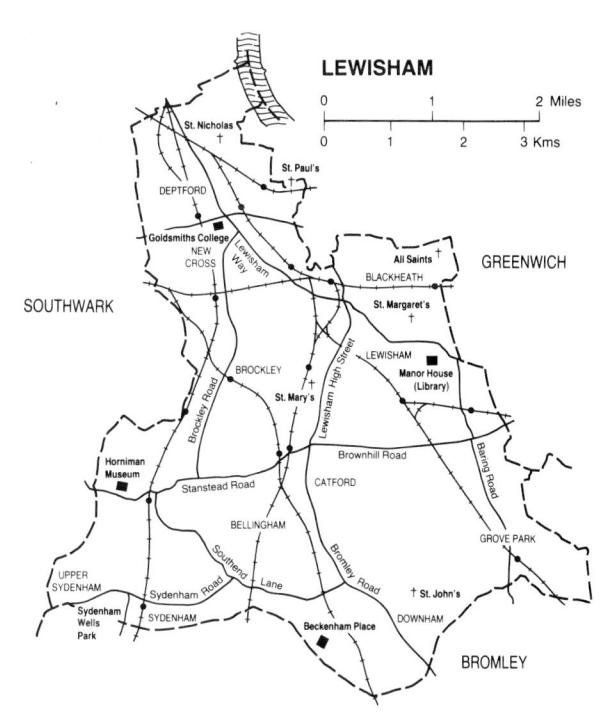

In LEWISHAM, the heart of the borough is the parish church, dedicated to St. Mary. Though of pre-Conquest foundation, nothing remains of the earlier buildings which must have stood on the site, nor of the medieval church which replaced them, save for the base of the tower, built about 1500. The present church was erected between 1774 and 1777 by John Gibson, who gave St. Mary's two attractive features – an upper storey to the tower, wreathed with graceful swags of neoclassical garlands, and a main entrance on the south side emphasized by a four-column portico topped by a pediment. The interior, altered and extended by Sir Arthur Blomfield about 1880, is unprepossessing, save for the old tower arch, but there are a number of funeral monuments, among them four of importance. High on the west wall are mounted two reliefs: Anne (d.1787) and Margaret Petrie (d.1791). The earlier work is by Vanpook of Brussels and the later by Thomas Banks; each shows the lady commemorated dying upon her couch, surrounded by children and supporting Virtues, and both are sincere and touching achievements. Between these two is a large tablet by E. H. Baily to John Thackeray (d.1851) with a portrait medallion unveiled by an angel and another allegorical figure seated below, while on the wall of the north aisle is a sad memorial to Mary Lushington, who died at the age of 28 in 1797. Her heart-broken mother commissioned the work from John Flaxman, who carved two figures, clinging together in grief, severely stylized and vet almost abstract in their line. On the western wall a bust of

Sir Henry Watson Parker (d.1881) is set in a niche. There are a number of agreeable late Victorian stained-glass windows. In the churchyard is buried Thomas Dermody, a wayward Irish poet who died in 1802 at the age of 27.

The Vicarage, a comfortable house built about 1692, stands on the corner of Lewisham High Street and Ladywell Road. It is a good example of the substantial but modest domestic architecture of the period, five bays wide with a modillioned eavescornice, a fine pedimented hood to the doorway, and solid wooden frames to the windows. Our Lady's Well, renowned in the Middle Ages and then again as a curative spa in the eighteenth century, has disappeared, though its coping stones are set round a flower-bed outside the Ladywell Sports Centre in Ladywell Road.

Northwards along Lewisham High Street, is the Roman Catholic church of St. Saviour, Built of dark brick in 1909 to designs by I. Kelly, a tall campanile was added to it 20 years later, and is now a landmark even in this crowded, built-up area; a Calvary is set over the porch and the ornate decoration of the interior was clearly inspired by that of Westminster Cathedral. At the junction of the High Street with Loampit Hill is St. Stephen's church, built in 1865 to designs by Sir George Gilbert Scott. The west end, with a double archway for entrance and a graceful rose-window above, is well worth a second glance; only a sharply realistic roundel, carved with the stoning of the first martyr, set above the doorway gives an unwelcoming air to the church. Beside it runs the Ravensbourne, a small river neatly culverted and giving a curiously rural air to the busy thoroughfare.

The easternmost corner of the borough is BLACK-HEATH. The Heath itself is a broad green open space, 267 acres in extent, crossed from west to east by the main Dover Road, which follows much the same route as the Roman Watling Street. Some 125 feet above sea level, commanding views across Greater London and into Kent, Surrey, and Essex may be obtained from Point Hill in the north-western corner.

A convenient rendezvous for those planning insurrection or invasion and intending to march on London, the Heath has seen the encampments of the Danes in 1011, when they murdered Archbishop Alphege at Greenwich, of Wat Tyler in 1381, of Jack Cade in 1449–50, of Henry VI's supporter, Thomas Falconberg, in 1452 and 1471, and of Lord Audley and his Cornishmen in 1497, while, more happily, the Heath served as a meeting-place for Richard II

and his young bride, Isabella of France, for Henry IV and Manuel Palaeologus, Emperor of Constantinople, in 1400, for Henry V with the jubilant citizens of London after Agincourt in 1415, for Henry VIII and his fourth, level-headed bride, Anne of Cleves, in 1540, and for Charles II with the Lord Mayor and Aldermen at his Restoration on 29 May 1660. Though the most important buildings, the Ranger's House, the Paragon, and Morden College, all lie over the boundary in Greenwich (see pp. 368–9), almost the whole of the greensward and a number of fine houses lie within Lewisham.

High on the Heath stands All Saints church, built there by Benjamin Ferrey in 1859. Since the architecture of Blackheath belongs essentially to the eighteenth-century manner, All Saints, built of rugged Kentish ragstone, and firmly in the Victorian Gothic tradition, seems to brace itself against the winds, convinced of the righteousness of its own nonconformity. Its asymmetrical south spire stands up in lofty defiance, and, in spite of its incongruity, All Saints holds its exposed position well. The visitor arriving by train can notice at once the spacious self-assurance, so characteristic of places fashionable in the eighteenth century, with which the shopping area has been laid out; Tranquil Vale, Montpelier Vale, and Royal Parade are worth exploring.

On the northern side of the Heath is Eliot Place, in which stands **Heathfield House**, with bow windows on either side of a Tuscan colonnade, and in Pagoda Gardens stands **Pagoda House**, built in the second half of the eighteenth century, inspired by the drawings which the young William Chambers brought back from his travels in the East.

A little to the west, on land that was once part of the Earl of Dartmouth's estate, is Dartmouth Row, with Spencer and Percival Houses, built originally as one house about 1690, of fine red brick with stone dressings, spirited key-stones, and a magnificent staircase inside, while several of the houses opposite, notably number 32, still have very early glass in their windows. The neighbouring streets are attractive, while on the eastern side of the Heath, across the boundary in Blackheath Park, built where Sir Gregory Page's magnificent Palladian mansion, Wricklemarsh, designed by John James, 1 stood from 1721 till it was pulled down in 1787, are two interesting houses, known jointly as The Gables, by Sir Aston Webb (1895), as well as one of the best modern houses to be found in the London area, number 8a, designed by Patrick Gwynn.

¹ See also note on p. 388.

Merton

Merton lies to the south-west of the Greater London area, beyond Wandsworth and away from the Thames, though the river Wandle, after marking a stretch of the north-eastern boundary, flows through the borough, providing, as it were, a spine for the whole. Covering nearly 9,400 acres with a population of some 166,000, this entire London borough formerly lay in Surrey and is made up of Merton and Morden, and the boroughs of Mitcham and of Wimbledon. The Roman Stane Street ran across it, heading to Chichester and the coast, and, during the Middle Ages, Merton Priory was of national importance. Today, save for Wimbledon and Mitcham Commons and a good number of parks, it is a closely built-up area, developed from the late nineteenth century onward. The four village centres remain, however, and the rest is leavened with sufficient unexpected survivals and imaginative modern buildings to make an exploration rewarding.

MERTON, which gives its name to the whole new borough, lies roughly in the centre and is primarily residential. In 1114, the manor was granted to Gilbert the Knight, who came to live there and in 1117 founded a house of Augustinian canons, which he himself subsequently entered. The king bestowed the whole estate on the priory and a chapter-house was built, of such size and dignity that when, in 1217, a peace conference was needed to end the civil war following the death of King John, in which the Dauphin of France had joined with an army, it was held there. In 1236, the Great Council, forerunner of Parliament, also met in the chapter-house and the Statute of Merton was promulgated, in which the barons declared Nolumus leges Angliae mutare -'We do not wish to change the laws of England'; this edict held first place in the statute book till its repeal in 1948. Thomas à Becket was educated here and it was Walter of Merton who in 1264 founded Merton College in the University of Oxford, from which the English collegiate system derives. The priory was dissolved in 1538, and cartloads of its stones were dragged away to provide building material for Nonsuch Palace, four miles to the south.

By 1742 William Halfhide had set up a calico mill beside the river Wandle on the site of the priory, and early in the nineteenth century Edmund Littler established a block-printing business there, which was continued by his family till Liberty's acquired it in 1904; until 1972, their fabrics, which have become part of the English decorative tradition, were printed there. In 1881, William Morris bought seven acres of meadow land with a group of old weather-boarded mills and established in them his workshops. In company with Philip Webb, William de Morgan, and Edward Burne-Jones, he manufactured textiles, carpets, embroideries, stained glass, tiles, and furniture there, to his own exacting standards of design and workmanship. The factory flourished till 1939; the influence of its work lives on today. Of the priory itself, nothing remains above ground save for a few odd stretches of wall, now in the protection of the National Trust, and the site of the high altar, fenced off and maintained with proper piety by the Borough Council; a slightly battered stone figure of a paschal lamb rests on the modern paving.

Nelson made his home in Merton, with Sir William and Lady Hamilton, from 1801 till he set out to meet his death at Trafalgar in 1805; he was happy here and his pew is still preserved in the parish church. When he went to join the fleet at Portsmouth, he wrote in his diary: 'At half past 10 drove from dear, dear Merton, where I left all that I hold dear in this world to go and serve my King and Country.' Lady Hamilton stayed on till she fell into debt. The estate, its boundaries marked today by Merton, Quicks, and Haydons Roads, was sold 'in lots adequate for detached villas' in 1823 and Nelson's house was demolished.

The parish church, dedicated to St. Mary the Virgin, lies at the junction of Church Path and Church Road. There was a wooden chapel here before the Conquest, and Gilbert the Norman built a new stone church in 1115, before he founded the priory; much of its framework, one window at the west end of the north wall, and the north door with its ironwork remain today. Early in the next century, the chancel was lengthened – four lancet windows, the blind arcading, and the priest's door leading to the vestry remain unaltered – and the west door with two, now crumbling, stone heads was inserted 100 years later still. About 1400, the fine, three-light,

east window, filled today with pleasant modern glass, was inserted, the nave roof, its main timbers dating from the previous century, was put in order, and in the chancel a chestnut hammer-beam roof. both delicate and strong, installed. During the fifteenth century, the north porch, with its open-work panels and barge-boarding was added, and the plain, low roof acquired a perky little spire early in the sixteenth, which had to be rebuilt 200 years later. At the Reformation, all but one of the medieval bells were lost, though later generations have added four more; in 1856 and 1866 the south and north aisles were constructed, and in 1889 the chancel was given an alabaster and marble dado, designed by Ewan Christian, which now seems an aberration. In the vestibule rests a contemporary copy of Van Dyck's Christ Falling under the Cross, and above it hang six funeral hatchments, Nelson's and Sir William Hamilton's side by side among them, as well as Sir Isaac Smith's, who sailed with Cook to Australia and was the first member of the crew to leap ashore. The stained-glass windows in the south aisle were designed by Burne-Jones and came from the nearby Morris workshops. Sir Gregory Lovell (d.1597), 'cofferer' or treasurer to Oueen Elizabeth, has a handsome memorial in the chancel, showing him kneeling opposite his two wives, with the eight children they bore him kneeling below. In the north aisle is a memorial, with the figure of a crouching woman, carved by R. J. Wyatt, which Mrs. Cook erected to her cousins, the Smiths, with whom she spent some of the 54 years of her widowhood, after the slaughter of the circumnavigator in Hawaii in 1779. In the churchyard is an imposing table-tomb

for William Rutlish (d.1687), 'Inbroiderer' to Charles II, and, opposite the west door, stands an archway of about 1175 with zig-zag mouldings, brought here in 1935 from the site of the priory. It is believed that it led into the guest house; if so, today's vicars enter their demesne beneath a portal through which saints, kings, queens, archbishops, and nobles have passed.

The area around the church was developed from 1867 onwards by John Innes, an enterprising speculator and horticulturalist, with H. G. Quartermain as his architect. The width of the streets, the pleasing variety in the style of house, the deliberate planting of trees, all became exemplars to later developers of garden suburbs. The handsome Vicarage and St. Mary's House are particularly impressive. Nearby, in the Kingston Road, is Dorset House, a lovely survivor from the eighteenth century.

MITCHAM lies to the south-west and is as old a settlement as Merton. The name is Anglo-Saxon and in the early years of this century more than 200 bodies were excavated from a Saxon cemetery beside Ravensbury Park; the numerous weapons and brooches discovered there are now in the Museum of Archaeology and Ethnology in Cambridge, in Kingston Museum, and in the Museum of London. The village developed originally around the church, dedicated to St. Peter and St. Paul, about the three Greens - Upper, Lower, and Cricket - and along the London Road. Here a number of interesting buildings are to be found, and the Common still lies open, though dissected by the main road, but otherwise the area is covered with small, undistinguished dwellings. There is one peculiarity, however - the number of foot-

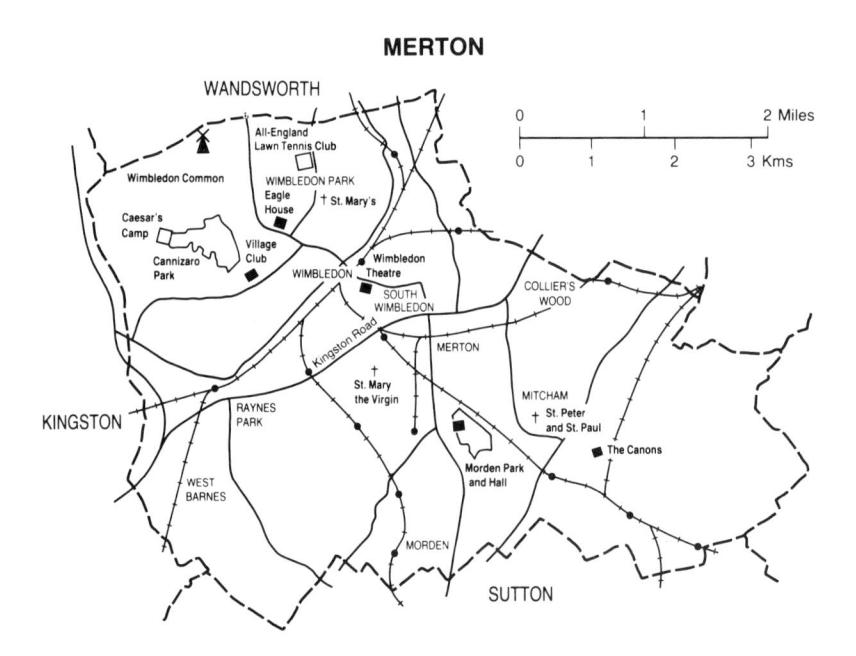

MERTON 393

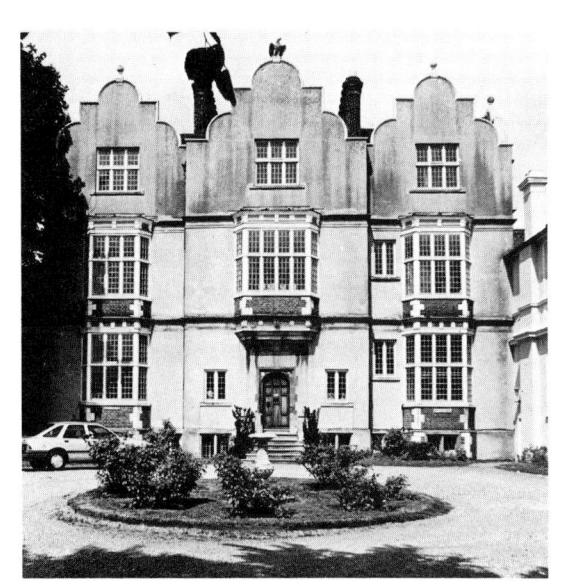

Eagle House, Wimbledon

paths that run to and fro across it, linking up with each other, as if the rural community which existed till the beginning of this century were still there in hiding, signalling its existence to children with the curiosity and adults with the imagination to seek it out, while the name of Lavender Avenue speaks of the scented bushes, which once flourished in the light soil. There was a parish church here by the middle of the thirteenth century; later generations added to it, though of the medieval building nothing remains save the battlemented north-west tower, primly encased in stucco when the present church was erected in 1819-22 by the local builder, John Chart, to the designs of George Smith. A narrow church, with carefully copied Perpendicular details and a constricting chancel arch, the nave has tierceron and lierne vaulting, brittle but charming, picked out in bright colours. At the west end, a well carved memorial shows the profiles of Sir Ambrose (d.1713) and Lady Crowley (d.1727); the epitaph tells of his 'Indefatigable Industry and Application to Business' and of his 'Unblemished Probity', and lists their children with details of their satisfactory marriages. culminating with the triumphant announcement that the youngest daughter married into the nobility.

Upper Green lies due west of the church and is graced by a clock erected in honour of Queen Victoria's 1897 Jubilee, its four faces set high on a metal post festooned with spindly loops and curves. Close to it, in the London Road, is Eagle House, built in 1705 for Fernando Mendes, who had been physician to Catherine of Braganza, Charles II's Queen. Five bays wide, with a basement, two main floors and an attic, it has a modillioned cornice and a neat pediment, with a trim balustrade and a cupola on the roof. Today it is used as an adult education centre.

Lower Green, a little to the south-west, has on its perimeter the former Vestry Hall (1887, by R. M. Chart) built like a French château, small but aware of its own dignity, and the National School House, constructed in 1788 by a local builder, Oxtoby, and given a central clock and bell-cote a generation later. Nearby is the White Hart, an eighteenth-century inn, with a sixteenth-century timber-framed building as its neighbour at 346-8 London Road, a later facade concealing the early work. Then there are Elm Lodge (1808) with a pretty porch, which was for a short time the residence of the painter, Sir William Nicholson, and Mitcham Lodge, very early nineteenthcentury, now used by the borough council. On the third Green, to the south, cricket was being played before 1720 so that, save for Hambledon in Kent. this is the oldest village cricket green in the world. On its south-west side lie the one-storeved brick Tate Almshouses, built in 1829 to designs by J. C. Buckley, and opposite them is a modern welcoming Methodist church with a zig-zag roof-line, and a massive obelisk, erected in 1822, with an inscription, now wearing faint:-

In grateful recollection of the goodness of GOD through whose favour water has been provided for this neighbourhood.

Just behind it, in Madeira Road, lies The Canons, a fine mid-seventeenth-century building, once the manor house of Mitcham and now used as borough council offices. In the grounds, a sixteenth-century dovecote, inhabited by ivory fan-tailed pigeons, keeps company amicably with a very modern, well designed leisure centre, and the gardens are sheltered by walls built through the centuries as they were needed. Across the Common, around a loop of roadway, is Mitcham Garden Village, the half-timbered and brick houses, looking like illustrations by Arthur Rackham, built between 1929 and 1932 by Chart and Reading.

MORDEN lies to the south, beyond the St. Helier Estate, built during the 1930s for the London County Council. Here, rows of houses, each street called after a British abbey, were designed by G. Topham Forrest on a human scale with pleasant detail. What remains of the old village centre stands at the top of Stonecot Hill, with the main roads leading away to London or to Epsom and its racecourse where the old grandstand, it is said, was built with the stones of the old priory, once Nonsuch Palace had, in its turn, been torn down (see p. 421).

At the summit of the hill, over which Stane Street used to run, stands St. Lawrence's church, still a rural place of worship in spite of the traffic which rushes past it. Of eleventh-century foundation, it is of warm red brick and dates from 1636, though the old footings and medieval doors were reused. Few churches were built during Charles I's reign, so St. Lawrence's is of particular interest. There is a low, embattled, west tower and a small south porch.

West Place, Wimbledon

Inside, the nave and chancel are as one, the altar fenced off by rails set up in 1720, when the pulpit, which retains its original stair and inlaid soundingboard, was presented by Mrs. Elizabeth Gardiner. The roof, which may contain reused medieval timbers, has tie-beams and king-posts; the four-light east window is Perpendicular and may well have come from the older building. The glass is an appealing jumble of the seventeenth and nineteenth centuries. A small silver model of the church, presented to a particularly beloved curate in 1835, is now treasured by the parish. There are no monuments of importance but a friendly collection of tablets; Sir Peter Leheup's, with a dignified bust, is the most distinguished, and John Roland (d.1702) has a curly, rococo plaque. The church stands on the edge of the grounds of Morden Park, built by 1770 and the finest eighteenth-century house in the area. Five bays wide, with recessed round-headed windows to the ground floor, an imposing pedimented doorway, and a fascinating staircase within, which doubles back on itself, it is today used by the local Arts and Recreation Department. A stone's throw away is the Old School House, erected in 1731 largely at the expense of the beneficent Mrs. Elizabeth Gardiner, who gave the church its pulpit.

A second venerable residence of local importance is Morden Hall, standing in its own grounds a mile to the north-east. The late seventeenth-century house was stuccoed over about 1840 and is at present used by the borough council, though both the house and its park, with imposing iron gates and an avenue of

slightly ragged trees, are now the property of the National Trust, which also owns Ravensbury Park and Watermeads, thus providing much-needed open space in a crowded area. All three are treated as nature reserves and a variety of species of birds and animals may be observed, from kestrels to familiar grey squirrels. The Wandle runs through the Park and by its banks stands a deserted weather-boarded snuff-mill, which once produced the staple manufacture of the village. A number of weather-boarded buildings are to be seen throughout the streets of the borough, isolated among twentieth-century development but still in good repair.

The history of WIMBLEDON goes back further than that of the other villages. Its hilltop position accounts for the construction here of an Iron Age fort, known today as Caesar's Camp, though certainly of pre-Roman origin.1 Roughly circular, the fortifications enclose some seven acres; the outline of its ditch and rampart, once surmounted by a wooden palisade, can still be traced on the course of the Royal Wimbledon Golf Club. The small village, which developed during the Middle Ages, acquired a new importance when William Cecil, later Queen Elizabeth's Lord Burghley, chose to live in retirement here during the reign of Mary Tudor; his son Thomas, later Earl of Exeter, so loved the place that in 1588 he built here one of the finest houses in all England. His architect may well have been Robert

¹ Camden knew it as Bensbury in the early seventeenth century and 100 years later it was called the Rounds.
MERTON 395

Smythson; the terraced gardens were planned to take advantage of the hillside site. His son, Robert, built a family chapel onto the parish church but the male line failed at the fourth generation and Charles I purchased the mansion for his Queen, Henrietta Maria, for whom Inigo Jones built on a new wing. The house was demolished by a later generation.

The village, despite recent expansions, still commands its hilltop and is a fascinating amalgamation of old and new. The most handsome edifice, Eagle House, was built by Robert Bell, a founder of the East India Company, about 1613, and still retains an unaltered facade, with three shaped gables and fine plasterwork ceilings to the main rooms, though it is now used as offices. Almost opposite stands Claremont, a friendly, L-shaped, late seventeenthcentury house. The group of small shops beside the Green is delightful, with a little weather-boarding, a beautiful cast-iron balustrade around an early nineteenth-century dairy, and farther down the High Street is a clock tower, erected in 1890 and full of its own dignity and importance. Exploration along the side streets, such as Lancaster Gardens, reveals groups of early nineteenth-century cottages, of which Walnut Tree Close is perhaps the best example, and an eighteenth-century dovecote in the garden of a house in Church Road. In 1964, the village decided to give itself a face-lift; the resulting improvements were recognized by the bestowal of a Civic Trust award in 1968.

The Ridgway, a modern road following the line of a pre-Roman track, runs to the south-west of the High Street. At its upper end is the Village Club where meetings are held and where the John Evelyn Museum is housed. Though the diarist had no connection with the village beyond visiting Wimbledon House, his name was given to this local amenity society because its founders felt that Evelyn's love of trees and desire to preserve the best of the past and use it to advantage in the present, represent aims that the twentieth century should foster too. The remarkable little local history museum is open on Saturday afternoons. Paintings, maps, photographs, archaeological material ranging from Neolithic flint tools found on the Common to equipment from longvanished cottage industries are all preserved here, besides a herbarium of local plants and a substantial collection of materials relating to the natural history of Wimbledon. The title deeds of Nelson's estate at Merton are the Society's most valued possession, and their range of local publications is impressive. To the south, in the Broadway at the foot of Wimbledon Hill, is Wimbledon Theatre, opened in 1910, with a jolly green cupola and a reputation for putting on excellent pantomimes at Christmas, and Polka, a recently founded children's theatre with its own museum and toys, which include the 30,000 puppets in the Lancaster Collection.

The parish church is on the high ground, though St. Mary's lies a good half-mile from the village

centre. The reason for this isolation is uncertain. but we do know, from Domesday Book, that there was a church here before the Conquest. At the end of the thirteenth century, a stone church was built, which survives substantially as the present chancel. Between 1626 and 1630, the Cecil family added a mortuary chapel to the south side, in the centre of which stands a large, black, marble tomb for Sir Edward Cecil, Lord Burghley's grandson. Some of the original heraldic glass is still in the windows, and two suits of armour, one for a horseman, the other for a pikeman, stand in the corners. The church was enlarged in 1788 by John Johnson, and was virtually rebuilt in 1843 by Scott and Moffat, with the future Sir Gilbert in charge of the work. Though some rebuilding was carried out in the chancel, the excellent low side window in the south wall was left undisturbed; these windows probably accommodated persons kneeling outside the church - this would once have been an outside wall - to make confession. Otherwise the result was a Victorian Perpendicular church, with a spire soaring up for 196 feet. In the tower hangs a good peal of eight bells, of which number 6 was cast by Robert Mot of Whitechapel in the 1570s and number 7, dedicated to St. Bartholomew, by William Culverden in London about 1520. The clock was the gift of John Murray, Byron's publisher, who was buried in the churchyard here. He is kept company by Arnold Toynbee (1852-83), the economist and philanthropist, in whose memory Toynbee Hall was established (see p. 317), by Sir Theodore Janssen, the financier who was ruined by the collapse of the South Sea Company in 1720, and by members of the Wilberforce family. There is an unusual Art Nouveau pulpit, and some subtly coloured modern glass in the east window. In the porch is a memorial to James Parry (d.1821) who is shown gazing at a bust of Charles James Fox; Sir Joseph Bazalgette, the great engineer who gave London its drainage system, has a tablet in the nave.

Just beyond the churchyard wall is the Old Rectory, part of which dates from 1500, while a sixteenth-century walk of fig trees still flourishes in the garden. A pleasant new parish room, one storey high, has been built beside the church. Nearby, in Arthur Road, is Well House, now a residence but originally constructed over a well, sunk 563 feet deep in 1798, to provide water for Earl Spencer's household. All around are imposing late Victorian and Edwardian houses, and on the northern slope of the hill is the All England Lawn Tennis Club, where the game has been played seriously since 1877, and where the outcome of the championships in June is a matter of national importance. There is a small museum, open daily, devoted to tennis, its history, and its exponents.

Wimbledon Common remains to be explored. It is still very much a common – rough grass and bracken, contrasting sharply with the smooth turf which

Windmill, Wimbledon Common

covers that other open hilltop at Blackheath. The Iron Age fort has already been mentioned; those suitably shod may tramp half a mile to view what is known as Caesar's Well, a natural spring which must have supplied the occupants of the camp. Of more recent habitations, the best are to be found around the south-eastern corner of the Common, among them South Lodge, late eighteenth-century, and Laurison Cottages, once the staff quarters of Laurison House, now demolished, where William Wilberforce, the reformer, lived for a time. Turning aside down Woodhayes Road, there is Southside House, built in 1687, with its cupola, and Gothic Lodge of about 1761, with pretty pointed windows, where Captain Marryat, sailor and writer, once lived. These houses face Crooked Billet, a sharply angled road with two good taverns. Continuing up West Side, Barclays Bank have refurbished a fine late eighteenthcentury house, further north are Cannizaro and The Kier, and the cottages of West Place blend unobtrusively into the bracken. Cannizaro, built about 1901 with considerable magnificence, occupies the site of

an earlier house destroyed by fire, but once the home of the statesman, Henry Melville, Viscount Dundas; it took its name from the title of an Italian nobleman. In 1948, it became the property of the borough council and the grounds were opened as a public park. The gardens here had been well tended and stocked for generations, and there is a fine display of azaleas and bulbs in late spring and early summer.

On the northern edge of the Common stands the Windmill, a lonely survivor of the many that once punctuated London's skyline. Wimbledon's is most unusual in that it is believed to be the only hollow-post flour-mill remaining in this country, though the type is common enough in Holland. Built in 1817 by a local carpenter, Charles March, it was converted into cottages in the 1860s, and it was here that Lord Baden-Powell began writing his *Scouting for Boys* in 1907. It was restored in the 1890s and again in the 1950s, and is now open on Saturday and Sunday afternoons from March till October, with exhibits relating to the technology and history of windmills.

Richmond upon Thames

The London Borough of Richmond upon Thames was formed in 1965 by the union of the former metropolitan borough of Twickenham, which lies on the Middlesex bank of the Thames, with the boroughs of Richmond and Barnes on the Surrey side. Kew and Petersham were part of the borough of Richmond, Mortlake of Barnes, while Twickenham contained Teddington and Hampton, with the royal palace of Hampton Court, to which is devoted a separate chapter (see p. 249). Covering an area of nearly 14,000 acres, of which two-fifths are open space, with a population of some 167,000, Richmond has a fair claim to be the most picturesque London borough. It is the sole possessor of territory on both sides of the Thames. 21 miles of river meander through it in an engaging – and sometimes confusing – series of loops, and those with the energy and stamina may walk, on the Surrey side, along the towpath from Hammersmith Bridge to the Kingston boundary or, on the Middlesex side, from Twickenham Bridge to the waterfront opposite Eel Pie Island and then, starting again at Kingston Bridge, follow the curve of the river round to Hampton Court.

A proper exploration of RICHMOND'S beauties depends on making a circuit of the Green, an expedition to the riverside, an attentive ascent of the Hill, and a careful contemplation of the view from its summit. A brief account of Richmond's association with the English crown is, however, necessary. As early as 1125, Henry I stayed in his manor at Sheen, as it was called then, and Edward III built a sizeable palace there, where Geoffrey Chaucer served in his capacity of Yeoman of the King's Chamber, and where the monarch died in 1377. His grandson, Richard II, with his bride, Anne of Bohemia, preferred it to their other palaces but when the Queen died there on Whit Sunday in 1394, the King forsook the place. Elizabeth Woodville, Edward IV's consort, made it her chief residence, and when it was damaged by fire in 1499, Henry VII, usually a parsimonious monarch, rebuilt it with 'glittering magnificence' and renamed it Richmond, calling it after his own earldom, and dying there at last on 21 April 1509. Henry VIII spent much time there in the early part of his reign, and later, after their divorce, he granted it to the Princess Anne of Cleves, one of his more fortunate wives. All his children, Edward VI, Mary, and Elizabeth, lived in the palace, which was recorded in its splendid heyday in 1562 by Anthony van den Wyngaerde; his panoramic view may be seen in the Ashmolean Museum in Oxford. Elizabeth died there on the morning of 24 March 1603, and during the reign of her successor, James I, the palace was granted first to Henry, Prince of Wales, and at his early death to his younger brother, the future Charles I. Prince Henry built himself a gallery there to house his collection of paintings, which his brother augmented so royally. During the Commonwealth, the palace fell into decay; later, William and Mary preferred to reside at Hampton Court and the early Hanoverians favoured Kew, but even without its royal residents. Richmond continued to be a place frequented by the nobility and the more successful members of the professional classes, and remains so to this day.

An exploration should begin with a circuit of the Green, the largest and least spoiled near London. The court jousted there and later cricket was a favourite sport, as the name of the public house, the Cricketers, implies. The sole incongruous building – and even this adds piquancy to the harmony of the others - stands in the easternmost corner and is the **Theatre** on the Green, built in 1899 by Frank Matcham, triumphantly florid with plenty of terracotta ornamentation and viridian copper cupolas at the corners of the façade. Greenside, along the south-eastern edge, is a fascinating jumble of houses, dating from the seventeenth to the nineteenth centuries, most of them constructed from a rich dark brown local brick. Number 1, which has a seventeenteenth-century core, was from 1760 till 1800 the property of Solomon Brown, Sir William Chambers's bricklayer, who was responsible for the erection of his local commissions, including the royal undertakings at Kew. Number 21, entered in the Rates Book by 1721, was from 1815 till 1826 the home of Stephen Peter Rigaud, the astronomer and mathematician, and for the next ten years that of his uncle, the Reverend Stephen Demainbray, who for 58 years was Astronomer at the Royal Observatory at Kew. A number of alleyways, Brewer's Lane, Golden Court and Paved Court, turn out of Greenside and they are all worth exploring. On the corner with King Street, covering the site once occupied by the monastery of Observant Friars, stand Oak House, built about 1760 with a fine interior, possibly by Sir Robert Taylor, Old Palace Place, built about 1700, and Old Friars, with the date 1687 on a rainwater head.

Beyond Friars Lane, we come to the site of Richmond Palace, ravaged during the Commonwealth period; on part of it now stand Tudor Lodge and Tudor Place, both with early nineteenth-century façades, and Maids of Honour Row beyond them. Erected about 1724 on the orders of the future George II, to provide accommodation for the ladies attending upon the Princess of Wales when she was in residence in Richmond Lodge (demolished about 1772), these four houses, three storeys high and five bays wide, have plain but beautifully proportioned façades, with Roman pilasters to the doorways and exceptionally delicate inwork gateways. In 1744, number 4 became the home of John James Heidigger, manager of the King's Theatre in the Haymarket, who had the hall decorated with landscapes by Antonio Jolli, his scene painter.

The last remains of the Tudor palace are Old Palace, built of dark red brick with indigo diapering, and the Gate House, with Henry VII's arms set high

above the entry. Tradition alleges that it was from a window, possibly in this building, possibly in the now-vanished Middle Gateway, that a ring was dropped to the waiting Sir Robert Carey to tell him that Elizabeth, England's greatest monarch, was dead and that he should ride north to proclaim to James VI of Scotland that he was also James I of England. Beyond are Old Court House and Wentworth House, originally with façades like those of Maids of Honour Row though refronted in the early nineteenth century, and Garrick Close, which stands almost on the site of Richmond's own Theatre Royal, where Kean played to so much applause. The northwest side is filled with Pembroke Villas, ten semidetached houses built about 1840 on the site of Lord Fitzwilliam's mansion, where he built up the great collection of antiques and works of art which now forms the basis of the Fitzwilliam Museum in Cambridge. Along the north-east side runs Portland Terrace, prim, staid houses built in 1968-9 by Manning, Clamp and Partners.

Old Palace Yard lies through the gateway. On the left is the Wardrobe, reconstructed in the eighteenth century with a thrifty use of such Tudor walling as was still standing, and converted into three houses about 1955. On the south side of the yard is Trumpeter's House, built in 1708, with its imposing porticoed main façade turned towards the river. Along Old Palace Lane, with its terrace of early

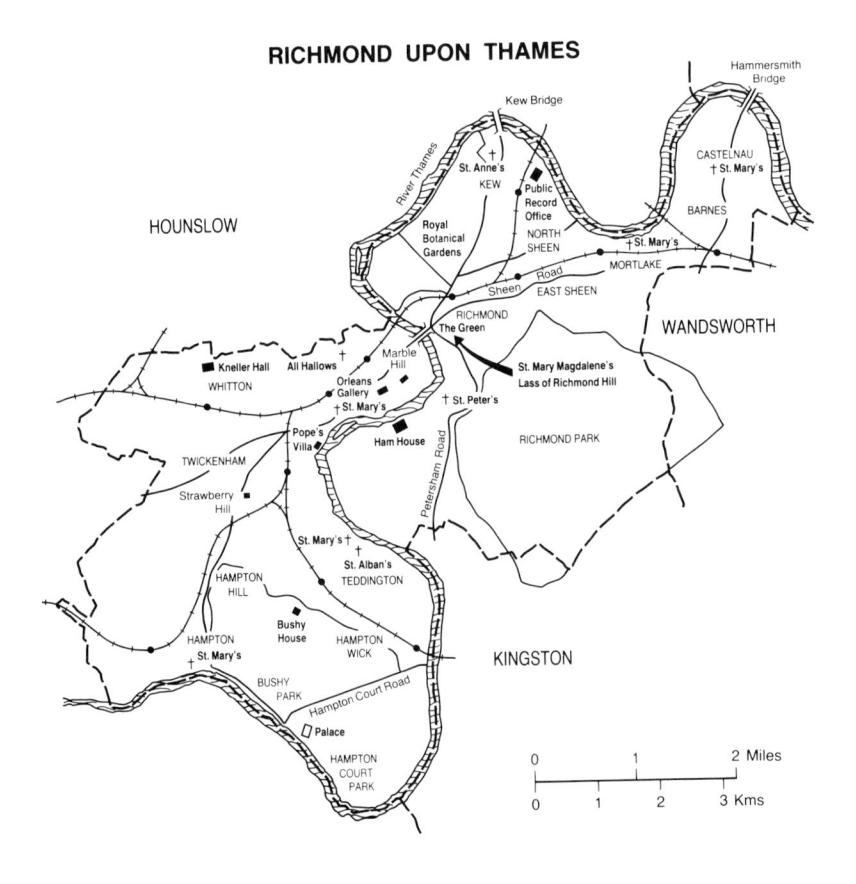

RICHMOND 399

nineteenth-century cottages and a miniature public house, the White Swan, is the river with Twickenham Bridge (1933, Maxwell Ayrton) to our right and Cholmondely Walk following the water's edge, beside which stands Asgill House, built about 1760 for Sir Charles Asgill, a discriminating merchant and Lord Mayor of London, by Sir Robert Taylor, architect and founder under his will of the Taylorian Institution in Oxford. It is the smallest villa Taylor designed. Ingeniously planned, with an octagonal room which may follow some of the palace foundations, the roof has deep, sheltering eaves, and the stonework to the ground floor is grooved and incised. The view across the river towards the eyot, its banks covered with boat-yards, is of no great distinction - being possessed of the handsomest green and the finest view near London, Richmond has modestly relinquished the palm for waterside beauty to Chiswick, to Isleworth, and to Strand-on-the-Green but St. Helena Terrace set high above the bank has great charm, and Richmond Bridge is the loveliest of those that span this section of the Thames. Built between 1774 and 1777, the principal architect was James Paine, with Kenton Couse responsible for the engineering; constructed from Portland stone, it spans the river in five graceful elliptical arches.

The town, despite the tangle of traffic and oneway streets, still has considerable character. The church is dedicated to St. Mary Magdalene. The low, battlemented, flint and stone tower was constructed about 1500, the body of the church was rebuilt in 1750 from yellow and red brick, and the chancel was enlarged in 1904 to designs by G. F. Bodley. This compound of the centuries stands in its churchyard, engagingly set back from the traffic by the pedestrian precincts of Church Walk and Church Court. Inside, the most impressive feature is the west arch, contemporary with the tower above, in which hang eight bells, cast between 1680 and 1761. There is an imposing late seventeenth-century hexagonal oak pulpit and a delicate eighteenth-century font. Around the walls hangs an anthology of minor but still appealing funeral sculptures. There is a family group incised on Robert Cotton's brass; he was Groom of the Privy Chamber to Mary Tudor and Officer of the Wardrobe to her sister, Elizabeth, and is shown with his wife, Grace, and their four sons and four daughters. John Bentley (d.1660), his wife, and his daughter are represented by three lifelike busts. Henry, Viscount Brouncker (d.1687) and Lady Sophia Chaworth (d.1689) both have pedimented tablets, Randolph Greenaway (d.1754) has one with rococo decorations and there is a plainer one for the poet, Iames Thomson (d.1748) who wrote some celebrated lines on the view from Richmond Hill. Two impersonal Flaxmans commemorate Robert Delafosse (d.1819) and the Hon. Barbara Lowther (d.1805), while a despairing lady, carved by the younger John Bacon, mourns Major Bean who fell in 1815. Draped curtains part on a tablet by

James Loft to reveal a medallion profile of Edmund Kean, the actor (d.1833), and in the churchyard are two notable memorials, a sarcophagus and an obelisk ascribed to Scheemakers, to Sir Matthew Decker and his son-in-law Viscount Fitzwilliam, and a tablet with a weeping woman and an urn by E. W. Wyon to Mrs. Barbara Hofland (d.1844), author of many children's books and wife of the painter, Thomas Hofland.

Just to the east of the church, in Paradise Road, stands **Hogarth House**, built in 1748 and occupied from 1915 till 1924 by Leonard and Virginia Woolf, who issued the first publications of the Hogarth Press from here; among the works produced were Virginia Woolf's own *Kew Gardens*, T. S. Eliot's *The Waste Land*, and Robert Graves's *The Feather Bed*.

The ascent of Richmond Hill now begins. For the first part of the climb, the landward side has a number of agreeable shops, some of them built in the eighteenth century, the rest later, but all filled with desirable wares. Ormond Road has many of its original houses, dwellings built when royalty spent time in the vicinity of Richmond and Kew. In the Vineyard stands St. Elizabeth's Roman Catholic Church, built in 1824 with a Baroque west front and pretty Wedgwood-style decorations to the interior, and beyond it are Newark House, very grand, of about 1750, with an elaborate doorcase with a broken pediment, and three sets of almshouses, Michel's (c.1811), Bishop Duppa's, established 'Deo et Carolo' in 1667 but rebuilt in 1850 in a pseudo-Jacobean style by Thomas Little, and Queen Elizabeth's, founded in 1600, reconstructed in 1767 and renovated recently. Vineyard Passage turns out of the main street and runs beside a churchyard where Thomas Cundy, the architect, lies buried, and nearby, in Halford Road, we may note Halford House, with a pretty, delicate porch, and Vine Row, with a carved date, 1700.

By this time the slope lies open, the great houses which once covered it now demolished and the whole laid out as Terrace Gardens, open to the public since 1887. In them stands a Coade figure of Father Thames by John Bacon, and a sturdy Aphrodite by Allan Howes (1952). On the eastern side, the houses – Georgian and later – look out across a prospect unrivalled in the neighbourhood of London. The Hill drops away and in the valley, with Petersham Meadows on one side and the banks tree-lined on the other, the Thames winds, its waters still as silver now as they were when Sir Walter Scott described the scene in The Heart of Midlothian. Artists as diverse as Turner and Oscar Kokoschka have been moved to paint the view from Richmond Hill.

At the summit, on the eastern side, a heterogeneous terrace of eighteenth- and early nineteenth-century houses has been converted into an hotel and near them, in Queen's Road, is a new public house continuing an old and honourable name, the Lass of Richmond Hill. On the hill side stand The Wick,

with three beautiful oval rooms, built by Robert Mylne for Lady St. Aubyn in 1775, and Wick House, built a few years earlier by Sir William Chambers for Sir Joshua Reynolds. Beyond them, on the very summit, is the Star and Garter Home, built on the site of the famous tavern where Dickens loved to celebrate family anniversaries and the publication of his novels. Now providing a home for disabled and incurable servicemen, the present structure was built in 1921–4 by Sir Edwin Cooper from bright red brick, contrasting sharply with the stone which faces the lower floors and trims the windows.

This is the entrance to Richmond Park. Its 2,000 acres were first enclosed in 1637 by Charles I as a hunting park, though the public was usually allowed to maintain a right of way. The wall is now pierced with six gates for cars and ten for pedestrians but cars may only circle the perimeter; Pen Ponds in the centre or the botanical riches of the Isabella Plantation can be reached only on foot. Some of the oak trees must date back at least to the Middle Ages; the herds of deer, both red and fallow, roam freely. During the summer, they live off the land, but it is a rare sight in winter to watch them following the truck which brings a supply of fodder early each afternoon. In the south-eastern quarter of the Park stands White Lodge, built in 1727-9 by the Earl of Pembroke, with Roger Morris as his assistant; the debt it owes Lord Burlington's villa at Chiswick is immediately obvious; the wings were added later. The future Queen Mary, George V's consort, spent her girlhood and young womanhood here, and it was here that her eldest son, later Edward VIII, was born. It is now the home of the Royal Ballet School and so is not open to the general public who may, however, obtain refreshments at Pembroke Lodge, once the residence of Lord John Russell. From the high ground nearby, a view across to St. Paul's Cathedral is visible through a ride in Sidmouth Wood. In the south-west corner, close to Kingston Gate, is the mound of a once-useful ice house, and on it stands the Thatched Lodge, a summer-house still decorated with paintings in the manner of Angelica Kauffman.

On the western side of the Park, cradled by a loop of the river, is PETERSHAM, in which stands Ham House. The village itself is strung out along the Petersham Road, eighteenth-century houses and prosperous Victorian residences interspersed with stylish 1960s Span developments. The old parish church, dedicated to St. Peter, lies beside a footpath, off the main road. An appealing little building, it has a late thirteenth-century chancel with one blocked lancet window, visible from the outside. In 1505 the nave was rebuilt in brick, and about a century later the west tower and transepts were added, the south transept being enlarged in 1840 so that the little church is considerably longer on its north-south axis than on its east-west. The upper part of the tower, in which hangs one bell cast in 1620 by Bryan Eldridge of Chertsey, was rebuilt about 1790, when the pretty

octagonal lantern with its ogee cupola was added. The interior is unusual in that it retains its Georgian box-pews. The slender font was carved about 1740 and the pulpit, which retains its candle-holders, was made in 1796 by a local carpenter, John Long, who probably at the same time made the vicar's desk from part of the older pulpit which he must have dismantled. Against the broad, shallow chancel arch are set the royal arms of George III, and within the chancel is the monument, erected in 1624, of George Cole and his wife who, handsomely dressed, rest recumbent under a coffered arch, their little grandson kneeling beneath them. The Duchess of Lauderdale (d.1698) lies in a vault beneath the chancel, where she had been married to the Duke 26 years earlier, and in the churchyard lie Mary and Agnes Berry, two sisters whose companionship delighted their neighbour, Horace Walpole, and Mary Burdekin, a pastrycook said to have been responsible for creating the first Maid of Honour tartlet, a delicious confection with an almond and orange filling. In the southeastern corner of the churchyard is Captain George Vancouver's grave. Having completed his survey of the Pacific coast of North America, he returned to Petersham, broken in health, to write up his journals, a task completed after his death in 1798 by his brother John. Each year, on a Sunday early in May, a service is held by the graveside and wreaths are laid in memory of an indomitable man.

Beyond the church, in the Petersham Road, are four fine eighteenth-century houses, Petersham House, Renton Lodge, Rutland Lodge, and Montrose House, and there are others along River Lane. Sudbrook Lane turns out of the main road and leads to **Sudbrook Park**, built in 1726 for the Duke of Argyll and Greenwich by James Gibbs, with a portico of giant Corinthian pillars and a magnificently Baroque cube room as the main apartment on the ground floor; it is used today by the Sudbrook Golf Club.

The main attraction in Petersham is Ham House, since 1948 the property of the National Trust and administered by the Victoria and Albert Museum, An H-shaped, brick mansion was built here in 1610 by Sir Thomas Vavasour, Knight Marshal to James I; its carcase survives, though succeeding generations have altered the interior. By 1626 it was the residence and in 1637 became the property of William Murray, Earl of Dysart, who, in his youth, had served as whipping boy for the future Charles I and through these painful duties became the monarch's intimate friend. Dving without a male heir, he left Ham House to his eldest daughter, Elizabeth, who was also permitted to bear the title of Countess of Dysart in her own right and to transmit it to the children whom she bore her first husband, Sir Lyonel Tollemache. After his death, she married in 1672 John Maitland, Earl and later Duke of Lauderdale, whose vaunting ambition matched her own. Needing a more imposing mansion in

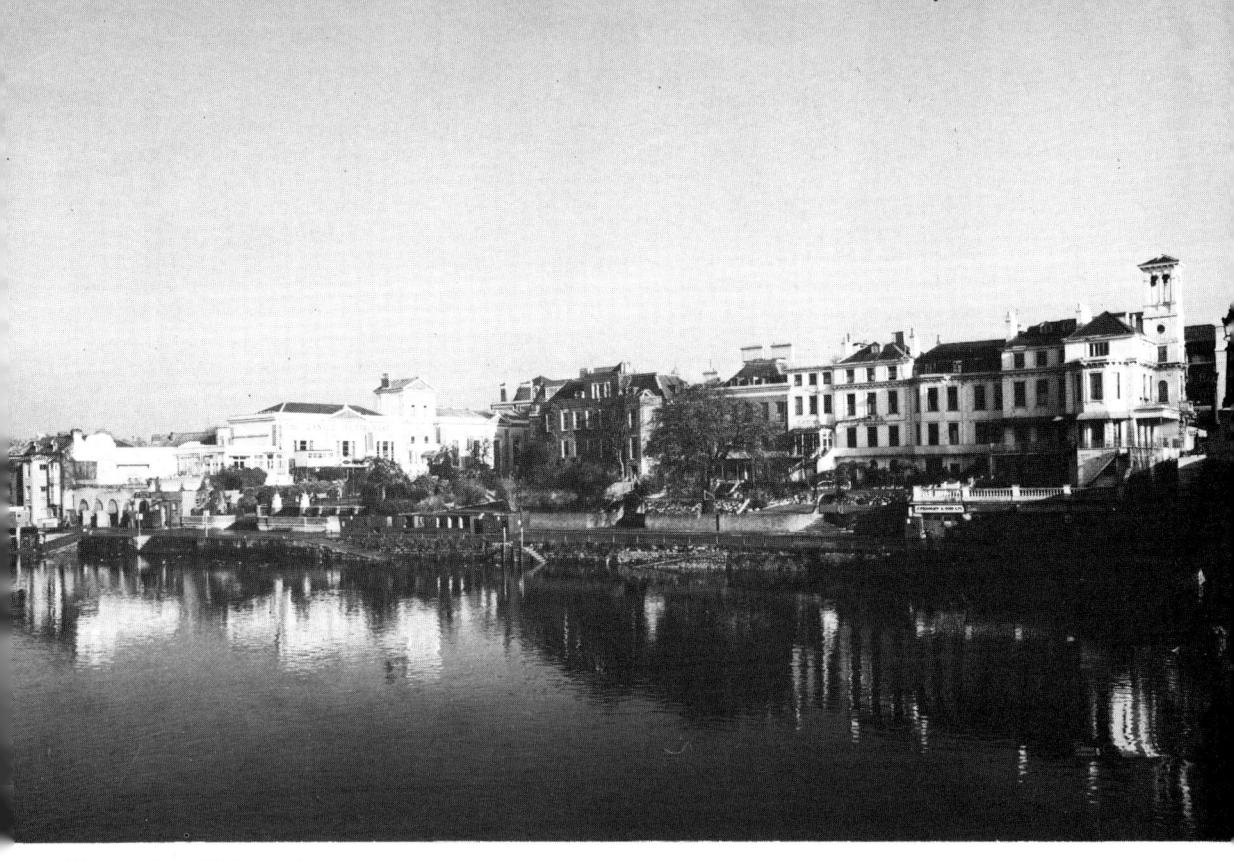

The riverside at Richmond

which to entertain, they enlarged the old house by adding a new suite of rooms along the south front: William Samwell was their architect. Though all the apartments were comparatively small, they were furnished with a luxury and ostentation that aroused comment even in a society determined to react as extravagantly as possible against the austerity and restraint of the Commonwealth period. The Duchess's successors were less ambitious than she had been and by extraordinary chance the appointments of the house remained largely undisturbed for nearly three centuries; many of the items listed in the inventories of 1679 and 1683 still stand in the rooms for which they were intended, and more can be learnt about the manner of aristocratic life in the seventeenth century from Ham House than from any other near London. The upholstery and textiles have survived unusually well and, even where they have perished, sufficient has remained for accurate modern reproductions to be woven; it has also been possible to discern the original plan of the formal gardens and to replant them afresh. This refurbishing was carried out as the National Trust's contribution to European Architectural Heritage Year in 1975.

The north entrance front is approached through a terraced garden in which stands a Coade stone figure of the River, a twin to the one on Richmond Terrace.

This facade would, by and large, have been familiar to Sir Thomas Vavasour, its centre set back behind wings which advance in two stages and terminate in bays. The Lauderdales adorned it with lead busts set in oval niches along the line of the firstfloor windows, and the windows themselves were altered from casements to sashes, one of the earliest instances of this type of window in England; some were even double-glazed. The main entrance, through a doorway with Corinthian pilasters and a metope frieze, leads into the Great Hall which contains a fireplace surmounted by two figures, believed to represent the first Earl of Dysart and his wife, clad as Mars and Minerva and possibly sculpted by Francesco Fanelli, Beyond lie the apartments which the Lauderdales added and which constituted their domestic suite, those on the first floor being reserved for state occasions. The Marble Dining Room comes first, its black and white floor covered with fine parquetry about the middle of the eighteenth century. The elaborate carvings on the panelling were executed by John Bullimore and the walls were hung with gilded leather, which still survives in position. Above the doors are inset paintings of boys playing, copied from those by Polidoro Caldara which Charles I acquired in 1637 and which are now at Hampton Court. To the west lie the Duke's Dressing Room and Closet and the Duchess's Bedchamber, its ceiling painted by Verrio and with four sea pieces by the younger Willem van der Velde set above the doorways. Opposite the fireplace hangs an unusual painting, a conversation piece with small stilted figures, executed by Joan Carlile about 1648 and therefore very early for such a composition, showing Elizabeth Dysart with her first husband, Sir Lyonel Tollemache, and her sister, Lady Maynard.

At the eastern end of the building are the Withdrawing Room, the Yellow Bedchamber, the White Closet, and the Duchess's Private Closet. The first of these now contains furniture covered in Spitalfield silk and made for the fourth Earl of Dysart about 1730, while the hangings in the Bedchamber are of modern reconstruction. There are two inset paintings of birds by Francis Barlow (1626-1702) who was well known for his representations of field sports. The exquisite little White Closet has a ceiling by Verrio and over the fireplace a painting of Ham House from the south, attributed to Henry Danckaerts, which shows the Lauderdales walking proudly in their newly laid out garden, while their servitors bow low and their friends smile approvingly. The 'six arme chayres Japand, with black cane bottomes', on which the Duchess must have sat to drink tea, have not survived, but there is a magnificent scriptor or writing cabinet. Beyond, in the Private Closet, Verrio painted Time, Death, and Eternity on the ceiling, and the spaces over the fireplace and the door were adorned by William Gowe Ferguson with classical

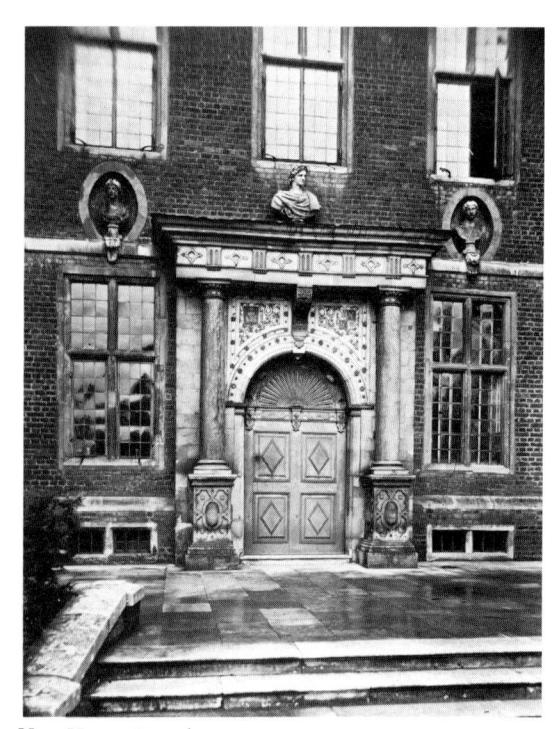

Ham House, Petersham

ruins. The chapel is set on the North Front with its furniture carved by Henry Harlow in 1673–4, the original altar cloth still in place. In the inner hall the armchairs retain their mid-eighteenth-century woollen cut-velvet upholstery – a rare escape from the moth! On the walls hang an enormous painting of the Battle of Lepanto attributed to Cornelius Vroom and a very good double portrait by Cornelius Johnson of the Duke of Hamilton and the Earl (later Duke) of Lauderdale.

From the Inner Hall, the Great Staircase leads upwards. This staircase, with its carved balustrade, was inserted about 1637 by the Earl of Dysart, whose architectural tastes were progressive. Instead of balusters or strapwork, there are pierced and carved panels of military trophies with baskets of fruit to adorn the newel posts, while the ceiling above was plastered by Joseph Kinsman in the Italian manner which Inigo Jones had just introduced into England, demonstrating it for the first time in the Queen's House in Greenwich. At the head of the stairs are the Bedroom and Dressing Room originally occupied by Lady Maynard, the Duchess's sister, with four inset paintings by Dirck van den Bergen and two copies of family portraits by Reynolds and Hoppner made by John Constable, who stayed here several times, while the 'Room over the Chapel' is now set aside for a display of costume and the rare domestic textiles in which Ham is so rich. The room next door is arranged as a cabinet of miniatures; its treasures include Hilliard's portrait of Queen Elizabeth, Isaac Oliver's A Man Seen Against a Background of Flames, an unknown lady by Samuel Cooper, and Charles II in his youth by David des Granges, as well as a lock of hair cut from Robert Devereux's head on the morning of his execution, 25 January 1601.

The Round Gallery was originally the first in the sequence of State Rooms which culminated in the Queen's Bedchamber. This then served as the 'Great Dining Room' and the garlanded ceiling was Kinsman's work, but, early in the eighteenth century, the floor was cut away to form a well into the Great Hall below. A pretty balustrade was installed as safeguard and paintings were hung around the walls; all are of high quality and two in particular should be noticed. They are both by Lely, the first showing Elizabeth Dysart in her youth and the second portraying her as Duchess of Lauderdale; it seems almost impossible that the ethereal, virginal creature can have become the bold woman who sits beside her porcine spouse with his 'Saracen fiery face', but on a second examination one realizes that the eyes are the same.

Beyond is the North Drawing Room, its plaster ceiling and frieze made by Kinsman, the walls hung with Mortlake tapestries and four, now damaged, paintings by Francis Cleyne set on the walls. On the floor is a Persian carpet, which the Lauderdales would have kept rolled up and brought out only on state occasions, and the dolphin-carved chairs retain

RICHMOND 403

their original silk covers and so are objects of the utmost rarity. The twisted columns flanking the fireplace are copied from those in Raphael's painting of the Healing of the Lame Man at the Temple, which Charles I had just acquired. The Green Closet turns out of the Drawing Room; the ceiling and frieze of this tiny, elegant apartment were painted by Francis Cleyne working in tempora on paper - it is astonishing that the work has survived. Beyond is the Long Gallery, part of the original house and built for large gatherings or for brisk exercise, since it lacks a fireplace, but redecorated entirely in 1639 by Lord Dysart, who installed the panelling. Around the walls the Lauderdales hung 'Two and Twenty pictures in Carvd Guilt Frames' representing their relations and their contemporaries; most of them are by Lely with two interesting exceptions - a good copy of Van Dyck's self-portrait, wearing the gold chain which Charles I had given him and holding a sunflower, and a sensitive portrait of William Russell, first colonel of what is now the Grenadier Guards, by John Michael Wright, the excellent Scottish artist.

On the western side of the house is the Library with its closet, and we then turn back along the south front and enter the Ante-chamber to the Oueen's Bedroom. The walls retain their original hangings of 'blew Damusk' though these have faded to a soft brown while their embroidered velvet surrounds still retain their vivid colouring. The room is furnished with the lacquered and japanned ware which became so popular in Charles II's reign, and the paintings on the walls are all by Dirck van den Bergen. Beyond is the Queen's Bedchamber, prepared for a visit from Catherine of Braganza, Charles II's consort, but converted to a Drawing Room about 1740. From its earlier use there remain the ceiling with delicate plasterwork, probably by Henry Wells, the elaborate parquetry of the floor by Henry Harlow and the '6 festons and a crown over ye chimney' carved by John Bullimore; the eighteenth century hung the walls with four fine tapestries executed in silk and wool by the English weaver Bradshaw, their subjects based on figures and motifs from paintings by Watteau and Pater. Above the fireplace hangs a fine copy of the now-lost Andrea del Sarto's Virgin and Child with St. John (the Pinti Madonna). To the Queen's Closet, only those most intimate with the monarch or with the Lauderdales would have been admitted. The walls are still hung with their original brocaded satin, the small painting of Ganymede and the Eagle set in the ceiling is probably by Verrio, and the three landscapes inset on the walls are by Thomas Wyck. Around the fireplace and on the window sill are panels of imitation marble or scagliola, perhaps the earliest example of this form of decoration in England. The 'sleeping chayre', with its feet carved like sea-horses and its adjustable back, still has its original silk upholstery, and in an alcove hangs a painting, already here in 1679, after Van Dyck of Henrietta Maria, Charles I's devoted queen.

Visitors to the House should allow time to walk in the gardens, now freshly planted out in their formal seventeenth-century pattern, and to see and hear the slide lecture given in the Demonstration Room off the Great Hall.

In the northern part of the borough the river, flowing west to east, winds itself into two broad loops, like the humps on a camel's back, with Kew to the west, Mortlake in the hollow, and Barnes to the east.

KEW GREEN, an elegant triangle bisected by the main road, is remarkably handsome, St. Anne's church standing in its centre and its perimeter set about by fine houses and chestnut trees. The site for the parish church was given by Queen Anne, who also contributed £100 towards the erection, between 1710 and 1714, of a neat little brick box which was thereafter altered and enlarged. John Kirby, Gainsborough's friend, lengthened it and built the north aisle in 1770, Sir Jeffrey Wyatville gave the west end its portico and balcony in 1836, then a polygonal wooden bell-turret was added, and in 1884 the south aisle was built and the east end received its curious octagonal cupola which catches the eve as one crosses Kew Bridge from the Hounslow bank. The white interior has wooden Tuscan columns and the crossing is marked with pink scagliola pillars. Thomas Gainsborough was buried in St. Anne's, and so were John Kirby, the architect who was Queen Charlotte's drawing master, Jeremiah Meyer, her miniature painter, Francis Bauer, George III's botanical artist, John Zoffany, who lived nearby at Strand-on-the-Green, and Sir William and Sir Joseph Hooker, successive directors of the Botanic Garden. The church is surrounded by its own little garden.

Most of the houses on the Green are Georgian, the best of them being the Herbarium, which belongs to the Royal Botanic Garden and contains one of the largest collections of dried plants in the world. The entrance to the Garden is at the apex of the Green through an imposing pair of gates designed by Decimus Burton in 1848; the lion and the unicorn which originally adorned the piers have been moved and now crouch above secondary gateways on the Kew Road.

The Botanic Garden originated in the royal family's enthusiasm for horticulture. About 1722 George II acquired Ormonde Lodge, now demolished, which stood in the Old Deer Park near the Observatory, and his son Frederick, with whom he was constantly at loggerheads, lived on the adjacent Kew estate, now covered by the Gardens. Frederick died in 1751 and in 1759 his widow, Princess Augusta, started a small botanic garden on nine acres of land south of where the Orangery stands today. After her death her son, George III, enlarged the garden by the amalgamation of the two estates. At first Lord Bute and later Sir Joseph Banks acted as unofficial directors, William Aiton was head gar-

dener, and Sir William Chambers was architect. He designed a number of delightful conceits, of which the Orangery, the Pagoda, the Ruined Arch, and the Temples of Bellona, Arethusa, and Aeolus still remain. In 1841, the Gardens were taken over by the state, their area was increased to some 300 acres, the Palm House was built and the Lake excavated. From the main gates a path leads past the Aroid House, which Nash designed for Buckingham Palace and which was moved here on the orders of William IV, to the Broad Walk, passing Chambers's graceful, classical Orangery, now a museum and book stall, and the Filmy Fern House. The Walk leads to the Pond, the remains of an ornamental water which was an earlier feature of the gardens. In its centre stands a figure of Hercules, sculpted by Basio and cast by Crozatier in 1826 for George IV, while on the far side two Chinese guardian lions keep watch. Beside the Pond stands the Palm House, designed in 1844 by Decimus Burton and built from glass and iron under the supervision of Richard Turner, a civil engineer; its noble proportions are matched by its exotic contents. On a terrace before it stand the Queen's Beasts, stone figures of the heraldic animals wrought by James Woodford for the Queen's coronation in 1953; they were presented by an anonymous benefactor in 1956. Behind the Palm House is the Rose Garden, and on the far side of the Pond is the General Museum with displays on botany, on the work and history of Kew, and on botanical art.

All through the gardens there are unparalleled combinations of architectural fantasy and natural delights which change with the seasons. Past the Palm House is the Flagstaff, a single spar of Douglas fir presented by British Columbia, and standing some 225 feet high, and the Marianne North Gallery, containing botanical paintings executed all over the world by this redoubtable Victorian lady, who presented her collection to the Gardens in 1882. Nearby is the Temperate House, designed in 1862 in glass and iron by Decimus Burton; the central building with its elegant flanking octagons and extended wings was restored to pristine glory in 1980 and was reopened by Her Majesty the Queen in 1982. The structure gives some idea of what the Crystal Palace must have looked like.

In the south-eastern corner of the Gardens is the Pagoda. Chambers drew upon memories of the voyage which he had made as a young man to Canton. To keep it company, there stands on a nearby mound a replica of a famous Japanese gateway, the Chokushi-Mon, which was brought to England for the Anglo-Japanese Exhibition of 1912 and was afterwards presented to Kew; appropriately enough, Japanese azaleas have been planted on the slopes of the hillock. Beside the southern boundary of the Gardens is the Queen's Cottage, built about 1772 as a thatched summer-house to shelter Queen Charlotte when she wished to take tea out of doors; the wall-decorations were designed and probably

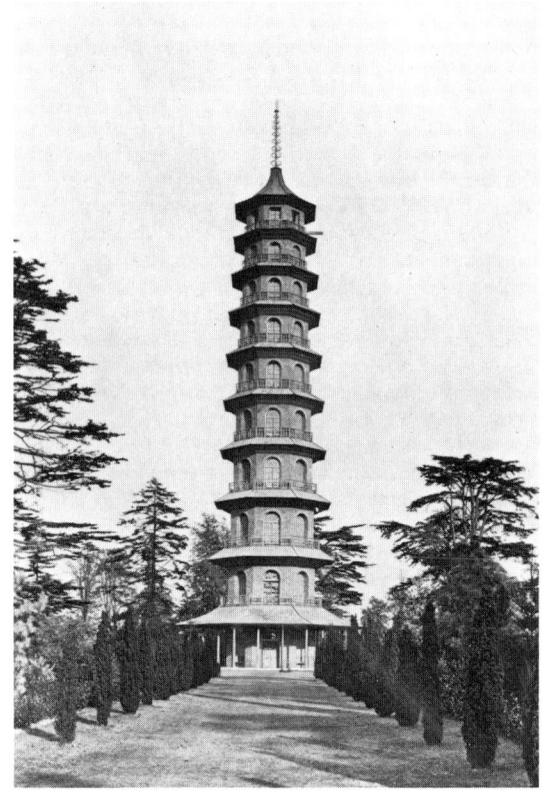

The pagoda, Kew Gardens

executed by Princess Elizabeth, her third daughter, who had considerable talent. Queen Victoria presented the cottage to the nation and it is open on summer week-ends to the public; in the springtime, the surrounding woodland is bright with bluebells. From the riverside, there is a magnificent view across to Syon House in Isleworth.

At the northern end of the Gardens grow the lilacs of which Alfred Noves sang, and there is Kew Palace, also known as the Dutch House, the smallest of all England's royal residences, being only 70 feet long and 50 feet deep. It was built in 1631 of red brick, Flemish-bonded, with three moulded gables back and front, by Samuel Fortrey, a prosperous London merchant of Dutch descent; his initials, entwined with those of his wife, Catherine, are set above the entrance. From 1727 onwards, it was leased by the Crown and was used by members of the royal family, in particular some of George III's large brood of children. The King resided there for a while during his periods of illness after 1802, and the double wedding of the Dukes of Clarence and Kent - the latter's union produced Queen Victoria – was celebrated in the drawing-room on 11 July 1818, the wedding party, which included the Prince Regent, driving round the estate afterwards to take tea in the Queen's Cottage. The decoration of the rooms has

RICHMOND 405

been changed very little; their daintiness and intimacy emphasizes how much George III and Queen Charlotte preferred a simple, natural existence to the grandeur of court. The muslin hangings of the Queen's bedroom are particularly charming. Worth special notice are the paintings of exotic birds by the Hungarian artist, Jakob Bogdany, some fine portraits by Allan Ramsay, an unusual painting by Zoffany of Absalom, and needlework pictures by Miss Knowles and Miss Mary Linwood, which George III and his family collected. A small exhibition of playthings - a silver filigree rattle used by each royal baby from George IV to Queen Victoria's children, alphabetical counters with capital letters and appropriate pictures - and of personal objects relating to George III, illustrate the day-to-day life of any well-to-do but not especially pretentious eighteenth-century family. The little palace is open daily during the summer months but is closed in the winter.

Behind Kew Palace, a formal garden has recently been laid out in the manner of the early seventeenth century and planted with popular garden flowers of the period, which include many sweet-smelling herbs and shrubs — rosemary, southernwood, bergamot, box, lavender, and thyme. In spring, the tulips and John Tradescant's double daffodil create anew a seventeenth-century joy in which the twentieth century may share. A fine well-head from Bulstrode Park in Buckinghamshire, five terms similar to those at Chiswick, a pleached alley of hornbeams, and an artificial mound topped by a wrought-iron trelliswork rotunda, are additional delights in this tiny garden.

Across the Old Deer Park, just south of the Botanic Gardens, is George III's Observatory, built to Sir William Chambers's designs and completed in time for the King to watch the transit of Venus there on 3 June 1769. The three obelisks in the park were set up so that the transit instruments could be corrected against them. The Observatory is now under the control of the Meteorological Office and still gives good service providing weather reports.

Near Kew Bridge is the fine new Public Records Office building in Ruskin Avenue. Of uncompromisingly modern design, it is a remarkably well equip-

ped research centre.

The church of St. Philip and All Saints in Atwood Avenue, North Sheen, contains timbers and a stone plinth from a late medieval barn at Stonehall Farm, Hurst Green, Oxted, Surrey, which were re-erected here in 1928–9. The huge, cruciform building retains a rustic atmosphere.

MORTLAKE, attractive and prosperous, lies to the east, beside the southern loop of the river. Here James I established a tapestry works in 1619, with Prince Charles as an enthusiastic and active patron. 50 Flemish weavers and their families settled here, and were soon producing the finest tapestry in Europe. From 1623 onwards, Francis Cleyne was their designer. The most important series produced was based on Raphael's Acts of the Apostles; Prince Charles bought the cartoons, now in the Victoria and Albert Museum, expressly to serve as designs for the tapestries. The factory limped on through the Civil War, enjoyed a brief revival at the Restoration, but had closed down by 1703 when Queen Anne granted the use of the buildings 'for other purpose than tapestry weaving'. Mortlake work may best be seen at Hampton Court (see p. 252), but a panel of it is let into the back of the priest's chair in St. Mary's, the parish church which stands opposite the site of the factory. Nothing remains of the medieval building, save for the octagonal armorial font given to it by Cardinal Bouchier, who was Archbishop of Canterbury between 1474 and 1486; the stone base of the tower – a patchwork of the centuries – dates from 1543, the brick upper storey was added in 1694, and a wooden bell-turret tops the whole. The rest was rebuilt 1885–1905, the chancel in the Early English manner to designs by Sir Arthur Blomfield. A peal of eight bells hangs in the tower, the earliest dated 1694; they were the first in England to ring for the birth of the future Edward VIII, nearby at White Lodge in Richmond Park. In the churchyard stands a curious stone arch, erected in 1865 from old materials when the tower doorway had to be renewed. Inside there are some good monuments - one by William Kidwell in memory of Francis Coventry (d.1699) and another by Westmacott to Ursula, Viscountess Sidmouth (d.1811) - three fine fifteenthand sixteenth-century iron-bound chests, and several patriarchal sixteenth-century chairs. John Dee, the Elizabethan alchemist and astrologer, is said to have been buried in the chancel of the old church, though his grave is unmarked. An unusual feature of St. Mary's is the brick Vestry House, built onto the north side about 1660; its upper room is still in active use as a parish hall.

A path runs through the churchyard and leads into North Worple Way in which stands St. Osmund's Roman Catholic church, with the astonishing tomb of Sir Richard Burton, the explorer, philologist, and translator, in the churchyard. Made in the form of a huge stone Arab tent, a window cut in the roof enables the visitor to see the small altar inside and the gilded coffins of Sir Richard and his wife, Isabella. J. F. Bentley, the architect of Westminster Cathedral, lies in a more conventional grave. Otherwise, Mortlake is famous chiefly for being the finishing point of the University Boat Race and for Watney's brewery, the high walls of which dominate everything else

along the riverside.

The river bends sharply northwards along The Terrace, with charming houses built chiefly in the eighteenth and early nineteenth centuries; Gustav Holst lived at number 10, and number 7 has a plump bow window and iron balcony. This road and its continuation lead to BARNES, and its many substantial nineteenth-century residences. Once again the

parish church is dedicated to **St. Mary**. There was a church here by the early thirteenth century but of this building, said to have been consecrated by Archbishop Lanfranc, the only remaining morsel is the east end of the south aisle, originally the chancel, where faint traces of a painted frieze were uncovered in 1956, and where three lancets with a vesica window above them are still set. There is a comfortable sixteenth-century red-brick tower, but the rest of the building is Victorian. There is one small brass, showing two young members of the Wylde family which died virgyns' in 1508. On either side of the church are fine early eighteenth-century brick houses, The Homestead and Strawberry House; the whole group retains an unusual charm.

Twickenham and Teddington on the north bank deserve at least a day's careful exploration. To millions, the name of TWICKENHAM means the headquarters of the Rugby Football Union, on whose ground matches have been played since 1907. A spread of late nineteenth- and twentieth-century suburban streets and houses covers the hinterland, but, upstream from Richmond Bridge, one can still see why, throughout the eighteenth century, this reach of the river was regarded as an earthly paradise within easy reach of London. Marble Hill was built in 1724-9 for Henrietta Howard, Countess of Suffolk, George II's sensible and dignified mistress. The first plan was probably sketched by Colen Campbell, but the final design was by the Earl of Pembroke, with Roger Morris as the builder. Executed in a chaste Palladian manner, Marble Hill is five bays wide and three storeys high, its three central bays projecting slightly, with four giant Ionic pilasters running from a rusticated lower storey to a shallow pediment. A double string-course runs between the ground and first floor, and the low pitched roof has an elaborate modillioned cornice. Inside, a magnificent mahogany staircase leads to the Great Room on the first floor, its superb proportions modelled on Inigo Jones's Single Cube Room at Wilton, Lord Pembroke's family seat. The carved decorations are probably by James Richards, Grinling Gibbons's successor. Several of the rooms - the Hall, Lady Suffolk's Bedchamber, and the Breakfast Parlour - are engagingly sub-divided by columns or small arcades. In 1734, Lady Suffolk was able to retire from court and to enjoy her country property, where she was visited by a host of friends, including the composer John Gay and her neighbour, the poet Alexander Pope, with whose advice she planned the grounds, relying on the professional gardener, Charles Bridgeman, for the execution of the scheme. In her old age, the young Horace Walpole, who had purchased Strawberry Hill nearby, came over often to gossip. After her death in 1767 the house passed through numerous hands till in 1902 the estate was purchased by the London County Council to prevent its commercial development. The house has recently been restored with remarkable care and taste by the Greater London Council and is open daily, save on Fridays, to the public.

To the west, Marble Hill Park is bounded by Montpelier Row, a handsome terrace built about 1720, in which Alfred, Lord Tennyson, and Walter de la Mare once lived. Just bevond is Orleans Park, in which stands the Octagon Room, by James Gibbs. Nothing is left of the villa which John James built for James Johnston, Secretary of State for Scotland, in 1710. The Octagon was not part of the original design but was added in 1720 for the reception of Caroline of Anspach, George II's consort, 32 feet across and 34 feet high, with a door or round-headed window in each wall and a lunette above, the walls and ceiling are elaborately decorated with stucco executed by Giuseppe Artari and Giovanni Bagutti whom Gibbs described as 'the best fret-workers that ever came to England'. From 1814 to 1817, Louis Philippe, Duc d'Orléans, who ruled as King of the French from 1830 to 1848, rented the house to which his name became attached. The body of the house was demolished in 1926 but the Octagon remained intact and was bequeathed to the borough by the Hon. Mrs. Ionides, on condition that it was used as a public art gallery. She also bequeathed her own collection of some 400 topographical paintings and drawings of Richmond and Twickenham, which includes works by Leonard Knyff, William Marlow, Anthony Devis, and Peter de Wint.

The waterside path called Riverside may be followed past Sion Road, where the corner house bears the date 1721, and behind which there is some interesting vernacular development in Sion Cottages and Redknap's Cottages, dated respectively 1852 and 1854, as far as York House, now used as council offices, but built about the middle of the seventeenth century on the site of York's Farm. For a short while, it was probably the property of Lord Clarendon, author of the History of the Great Rebellion, fatherin-law of James II and grandfather of Queen Mary and Queen Anne. The house was enlarged by later generations and was the home of several interesting and important people, including Anne Damer, the sculptress, to whom Walpole left his beloved Strawberry Hill, the Comte de Paris, the diarist Sir Mountstuart Elphinstone Grant Duff, and the Indian merchant prince, Sir Ratan Tata, who installed in the gardens, now open to the public, an Italianate fountain, in the waters of which eight marble nymphs disport themselves.

The parish church, dedicated to St. Mary, stands just west of York House. In 1896, William of Wykeham settled the living on the College of St. Mary which he had just founded at Winchester and he may have rebuilt the little church – certainly, the stone west tower would appear to date from the late fourteenth century. On the night of 9 April 1713 the nave fell down but, led by Sir Godfrey Kneller who lived nearby and was churchwarden, money was raised for the rebuilding, which was undertaken to

RICHMOND 407

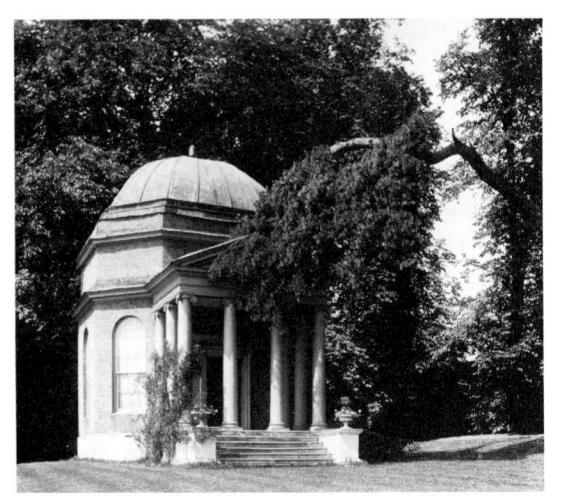

The temple, Garrick's Villa, Hampton Court Road (see p. 255)

designs by John James, who must have been working half a mile away for Secretary Johnston at the time. He built the church broadside on to the river with all the emphasis on the north and south façades which present themselves to the village and to the water. Of the five bays of the nave, he caused the three central sections to project slightly, separated the round-headed windows from each other with giant Tuscan pilasters, and set above them a pediment with a lunette window. For material, he chose a glowing red brick which contrasts dramatically with the grey stone of the tower, in which hangs a fine peal of eight bells, the earliest of them having survived the Reformation, and the rest dating from 1669 to 1722.

The recently repainted interior has retained its original reredos and altar rails, and around the walls and in the galleries is a wealth of sculpture in the funeral monuments. There is a brass to Richard Burton (d.1443), who was cook to Henry VI, and two remarkably life-like baked clay busts represent Francis Poulton (d.1642) and his wife; his hand rests on a skull, showing that he was already dead, and the epitaph tells that 'shee yett liveth but desireth with him to bee dissolved and to be with Christ'. On the north wall of the sanctuary hangs a tablet, possibly by Bird, to members of the Humble family (c.1686), and nearby stands a pedestal and urn possibly carved by Bushnell to Matthew Harvie (d.1693), for whose wife, also buried here, Dryden wrote the long and tender epitaph. Under the tower are large memorials, in the style of Grinling Gibbons, to members of the Ashe and Berkeley families; Sir William Berkeley was Governor of Virginia during 1676, when the colony was in a state of insurrection. Up in the north gallery is Pope's loving tribute to his parents, with the words 'et sibi' ('and to himself') added after his own death. Beside it is the grander, but still restrained, memorial which Bishop Warburton raised to the poet, with a

medallion portrait by Prince Hoare and a pithy verse by Pope himself. Another memorial, finely carved by Rysbrack, commemorates Admiral Sir Chaloner Ogle (d.1750) and across in the south gallery are two tablets, one, to Nathaniel Piggott, with an epitaph by Pope, and the other, in memory of George and Anne Gostling, carved by the younger John Bacon, with a gracefully draped woman resting against an urn and delicate poppy-heads drooping on either side of the inscription. Sir John Suckling the poet (1609) and Batty Langley the builder (1696) were baptized here, Francis Chantrey the sculptor was married here, and Sir Godfrey Kneller buried here. In the trim churchyard, there are tablets on the east outer wall to Mary Beach, Pope's nurse and servant for 38 years, to Kitty Clive, the generous-hearted actress, and to Thomas Twining, founder of the firm of tea mer-

The river frontage below the church and the banks of Eel Pie Island in the middle of the Thames are a purposeful jumble of boat-houses; the borough council is striving to improve their appearance. The island may be reached by an unsightly bridge and then a ferry, if it is running, will bear the traveller over the second arm of the river to Petersham, close to the gates of Ham House.

On the outskirts of Twickenham, Cross Deep, with its one fine eighteenth-century house, leads to where Radnor Garden, its banks decked with willow trees, projects into the Thames and provides a waterside bowling green. Beside it is St. Catherine's Convent School for Girls, standing on the site once occupied by Pope's villa. He lived here from 1719 till his death in 1744 and lavished his best attentions on his gardens, in which he constructed a grotto which may be visited on Saturday mornings, provided written application is made. The walls were once bright with minerals which his friends gave to him; these have long since gone but the place is still curiously evocative.

A little further on, in Waldegrave Road, is St. Mary's Training College, which occupies Strawberry Hill, Horace Walpole's famous house. He brought a cottage here in 1747 and spent the next 30 years turning it into a Gothick castle, with the advice and assistance of his friends. Every detail was inspired by some famous building - the bookcases were copied from the side doors of the screen of Old St. Paul's, the roof of the gallery from the vaulting of Henry VII's Chapel in Westminster Abbey, the chimneypiece in the Holbein chamber from Archbishop Wareham's tomb at Canterbury. The results were astonishing and far-reaching. St. Mary's College has preserved the fabric with scrupulous care and admits visitors, provided application has been made in advance in writing, on Wednesday and Saturday afternoons.

TEDDINGTON is chiefly an architecturally unaesthetic suburb, built mostly in the late nineteenth and twentieth centuries. The highest tidal point on

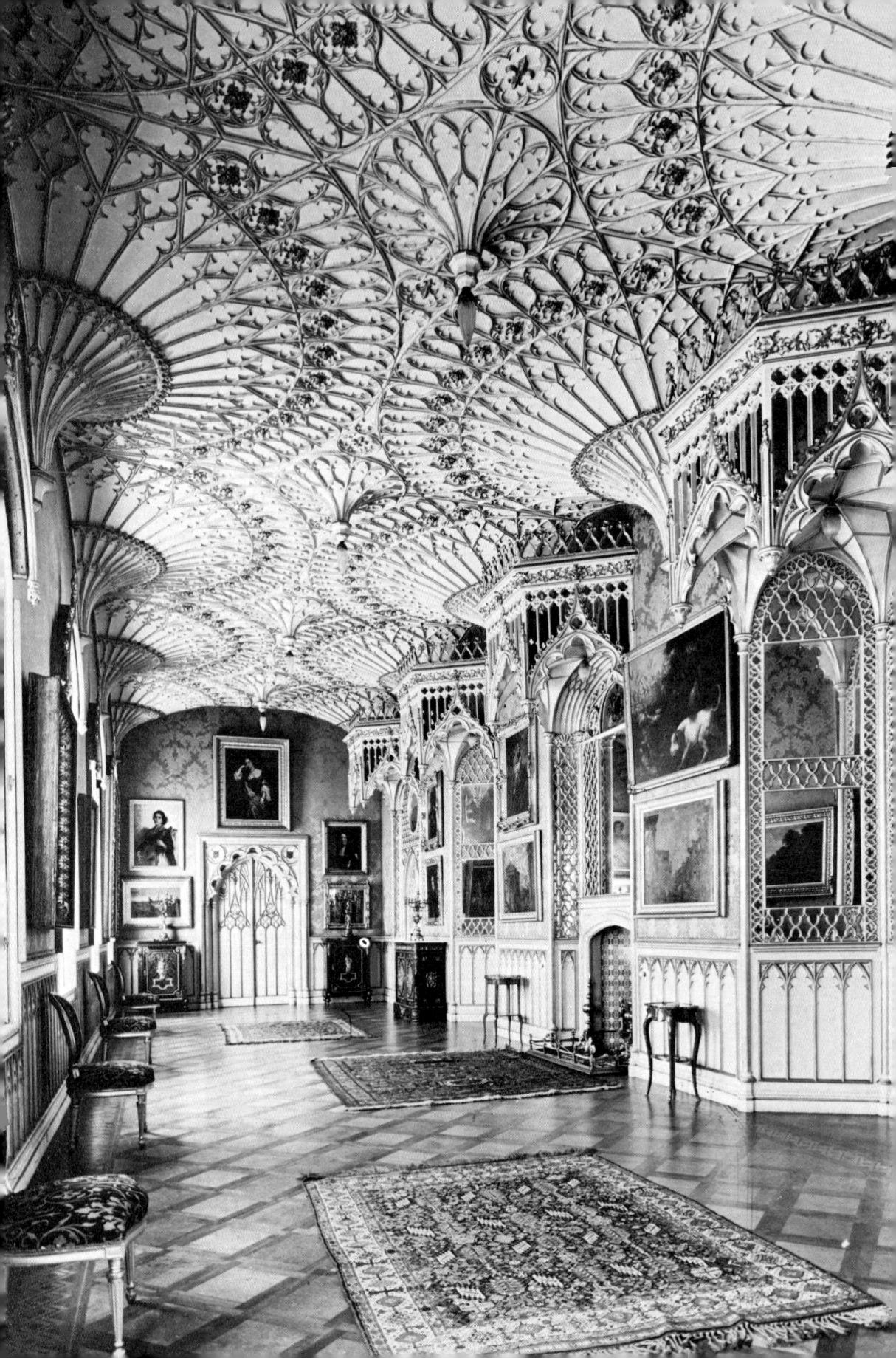

RICHMOND 409

the Thames, it possesses two parish churches, St. Mary's and St. Alban's. The latter was designed by W. Niven and was begun in 1888. Built of grey stone with buttresses and a green copper roof, a landmark for miles around, it was never completed, for this 'cathedral of the Thames valley' was too ambitious for twentieth-century needs; it is now closed and its future undecided. St. Mary's, which stands modestly on the opposite side of the road, is once again the parish church. It is a small building, its nave constructed in 1753, though the south aisle is of patterned sixteenth-century brickwork and the chancel is Victorian. The low brick tower is wrapped thickly in ivv. Inside. there is a small brass to John Goodvere (d.1508) and his wife Thomasyne who wears a tall kennel head-dress, and an elaborate architectural monument to Sir Orlando Bridgeman, who sat in judgement upon the regicides who had executed Charles I. He had as chaplain the visionary poet, Thomas Traherne, who often preached in this church and who now lies in a humble grave. He keeps good company, for in St. Mary's were also buried Margaret Woffington, the enchanting actress who first played Polly in John Gay's Beggar's Opera, Stephen Hales, the inventor and physiologist, who was vicar here from 1709 till his death in 1761, and John Walter, the merchant who launched The Daily Universal Register, which became The Times. Richard Dodderidge Blackmore, the novelist, who is best remembered for Lorna Doone, lies in Teddington Cemetery. The excellent glass in the south windows war set there about 1870-80. Sir Richard Westmacott's delicate little monument to W. T. Stratton shows a woman kneeling at an altar overhung with willow boughs.

In the western corner of the borough members of the Royal Military School of Music practise magnificent fanfares and flourishes of trumpets in Kneller Hall. Charles II's court painter built himself a country house here between 1709 and 1711, but his home has disappeared inside a huge neo-Jacobean mansion with turrets, which George Mair designed in 1848. It is worth writing to enquire when public concerts are being given, for the standard of performance is very high.

Nearby in Chertsev Road, stands All Hallows, designed by Robert Atkinson, completed in 1940, and the proud possessor of the tower and furnishings of All Hallows. Lombard Street. When it was decided to demolish the City church, its tower, 104 feet high. was taken down carefully, stone by stone, and was brought, with its ten bells (cast in 1726) to stand serenely beside the bypass - a sight to arouse the curiosity of the attentive passing motorist. Atkinson's church, to which the tower is attached by a long narthex or covered cloister, is a remarkable achievement, completely modern vet in harmony with the older fabric: its coffered roof is particularly successful. The visitor's eve is held by the superb carving of the tripartite pedimented reredos and the pulpit with its huge tester - carving of a quality equalled only by that in St. Mary Abchurch (see p. 72), which we know for certain came from Grinling Gibbons's own chisel. It was from this pulpit that Wesley preached his first extempore sermon. The font, decorated delicately with garlands and cherubs' heads, the royal arms, hanging in the tower for lack of space, and the organ case are all unusually handsome. There is a bread cupboard for the distribution of an old charity, a spritely pair of royal beasts, and two early nineteenth-century sword-rests. The organ itself was first built by Renatus Harris in 1708, as a single-manual instrument of nine stops. Though rebuilt and enlarged at intervals, it has retained its original case, and is so true an instrument that it is often chosen to make recordings of early English keyboard music.

Along the walls of the narthex are ranged a number of memorials from the old church, including those of the six Vardon infants who died between 1768 and 1779, and of Samuel Lea Child who passed away in 1830, having been 'a respectable inhabitant' of the parish. There is one grand monument by William Stanton to Edward Tyson (d.1708), which shows a bust of the famous surgeon sheltered under a small circular canopy, and near it stands an old gateway, which used to mark the entrance to the church from Lombard Street, carved gruesomely with skulls, hour-glasses, and bones, and surmounted by figures of Death and of Father Time with his scythe.

Southwark

The London Borough of Southwark is composed of the former metropolitan boroughs of Southwark, Bermondsey, and Camberwell. Shaped roughly like an isosceles triangle, with five miles of riverside as its base, it stretches southwards to an apex, six miles away at Dulwich. Its 7,000 acres accommodated, in 1976, a population of nearly 225,000. Lowlying and, formerly, marshy beside the Thames, the land rises steadily towards Dulwich, where the highest point is reached at Crystal Palace. The broader, northern half is densely built up with much commerce and some light industry, in contrast to the southern tip of the borough where Dulwich Wood and golf club spread out and the roads become fewer, wider, and leafier.

SOUTHWARK, lying at the south end of London Bridge, has a longer known history than any part of London other than the City itself. There must have been a considerable Roman settlement here; a fragment of tessellated pavement may be seen in the south transept of Southwark Cathedral, and many objects, including a trident, once part of a military standard, and a wine-jug inscribed Londoni ad Fanum Isidis ('London, at the shrine of Isis') have been retrieved and are now in the Museum of London. An exploration of the borough may begin at the southern foot of London Bridge.

The first building to visit is Southwark Cathedral which, with Lambeth Palace, is one of the two most important medieval buildings in South London. Tradition claims that a sisterhood founded a church here in 606, which they dedicated to St. Mary Overie (meaning either 'over the river' or 'on the bank'). In 852, St. Swithun established an order of priests, who in 1106 were joined by the Augustinian canons, when the building of a substantial stone church was begun. A house was built nearby for the Bishop of Winchester who, until 1877, was responsible for the spiritual welfare of what is today the diocese of Southwark, and by 1173 the monks had founded a hospital which in that year was dedicated to St. Thomas à Becket; their good work is still continued, though the hospital has moved to Lambeth and is now dedicated to St. Thomas the Apostle. In 1206, the stone church

was destroyed by fire, so that only a part of the walls of the north transept and the jambs of a doorway in the north aisle remain today. In its place, London's first Gothic church arose, though its building was not completed for many generations. Of that church, the choir with its north and south aisles, and the ambulatory with its particularly fine vaulting remain, while a fragment of wall arcading at the west end of the nave is of the same date. The south transept was completed about 1420, at the expense of Cardinal Beaufort, whose arms are set on the east wall of the south transept; when the vault of the nave collapsed in 1469 it was restored in oak. The burly tower, which rises above the crossing at the centre of the church, was completed in 1520, and the magnificent altar screen was installed at the same time. In 1830, the roof of the nave was declared unsafe and the whole nave was pulled down, to be replaced by a flimsy neo-Gothic structure, which was in turn rebuilt by Sir Arthur Blomfield in 1890-7. Considering the confused and chequered history of the building, it presents a remarkably unified and harmonious appearance today.

With the Reformation, the great church was given a new dedication to St. Saviour, but when a separate diocese of Southwark was created in 1905, the old name was revived and it is now the Cathedral Church of St. Saviour and St. Mary Overie. The main entrance today is at the west end of the south aisle, near to which stands the font with an elaborate cover, designed at the end of the last century by G. F. Bodley. High on the west wall between the windows are set figures of David and of two angels with trumpets, formerly a part of the late seventeenthcentury organ. Below them, in the north-western corner, are those bosses remaining from the fifteenth-century oak roof; some are carved with flowers and foliage and others more elaborately, among them a pelican drawing blood from her breast to feed her young and the Devil gulping down Judas Iscariot. In the north aisle is the tomb of the poet, John Gower, who passed his last years within the precincts of the church. His effigy lies under a canopy, the head resting on three volumes, which are inscribed with the titles of his principal poetical

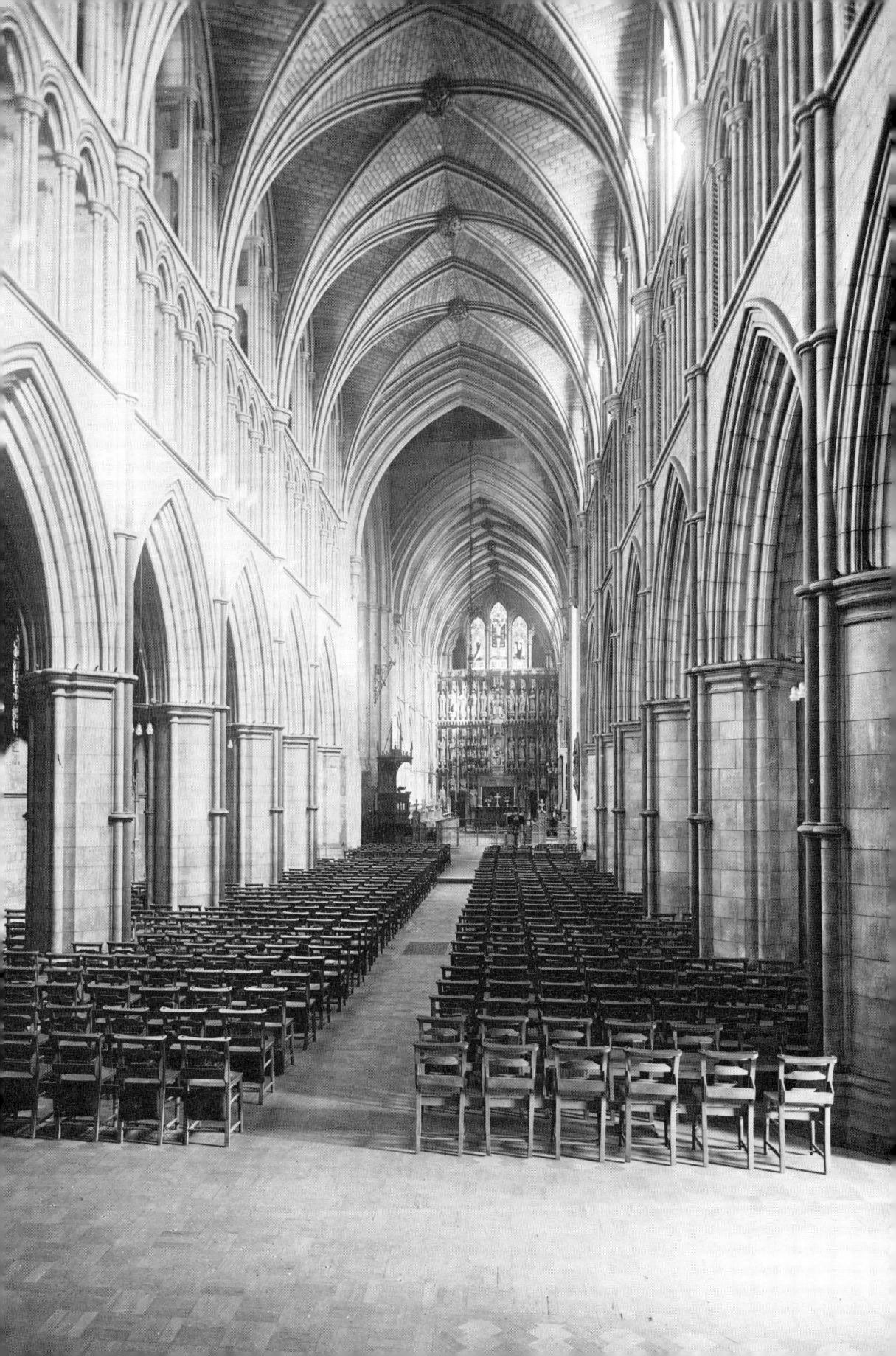

works, of which the *Confessio Amantis*, the *Lover's Confession*, written in English, is still read. In the north transept is a monument to the physician, Lionel Lockyer (d.1672), and a fine bust to Richard Blisse (d.1703); nearby stands a magnificent chest, probably given to the church about 1588, its front an architectural composition in miniature.

On the west wall of this transept is a remarkable memorial to Joyce Austin, later Lady Clarke (d.1626) by an unknown sculptor; a personification of Agriculture stands above garnered sheaths of corn, and harvesters with pitchforks and rakes sit mourning on either side, the whole being an allegory on the text of St. John's Gospel, chapter 12. v. 24: 'Except a corn of wheat fall into the ground...'

A curiously stilted thirteenth-century arch leads into the north choir aisle, out of which the Harvard Chapel opens. John Harvard was baptized in St. Saviour's in 1607; he emigrated to Massachusetts and, dying early, left his books and property in Southwark to one of the colleges, which has become Harvard University. This chapel to his memory, where American visitors are especially welcome, was set aside and furnished in 1907. In the north choir aisle lies one of the comparatively few surviving wooden funeral figures in the country, an oaken crusader carved about 1270, the details of his armour and surcoat still retaining a remarkable crispness. Beside him are stern-faced effigies of John Trehearne (d.1618) and his wife, and opposite is the monument of Alderman Humble (early seventeenth century) with his wives, Margaret and Isabel; the latter's effigy suggests that throughout life she was deeply interested in smart clothes. The high altar is shut off from the retro-choir by means of the tall screen, which Bishop Fox installed about 1520: much restored, figures representing saints, clerics, and kings associated with the Cathedral, designed by Oldrid Scott and carved by Farmer and Bridley and by Nicholls, were set in its niches during the early years of the present century, while its lower storey was painted and gilded by Sir Ninian Comper in 1929-30. On the south side of the sanctuary are two tombs, one for Bishop Talbot, the first Bishop of Southwark (d.1934) and the other of Lancelot Andrewes, Bishop of Winchester (1555–1636), author of a book of devotions, Preces Privatae, and one whom, if the Church of England admitted saints, would be canonized. Against the south wall of the south transept stands a carved Jacobean communion table, with lusciously twisted legs and tiny cherubs' heads, and from here, under the crossing tower, can be seen the magnificent candelabrum, presented in 1680, and a curious carved chair, the back of which is hinged so that it may be lowered to form a table-top. At the entrance to the south aisle of the nave is a monument executed in 1912 by H. V. McCarthy to William Shakespeare, which shows a reclining figure of the dramatist, with the buildings of Southwark carved in low relief behind him. Shakespeare, of course, rests in Stratford, not Southwark, but his brother Edmund was buried in the church, and so were his fellow-dramatists, Philip Massinger and John Fletcher, though their graves are unmarked. The organ, built in 1897 by T. C. Lewis and reconstructed in 1952, is regularly used for lunch-time recitals.

Immediately to the west of London Bridge, within a couple of hundred yards of the Cathedral, but so hidden away that it requires determination to find them, are the remains of the Bishop of Winchester's Palace, built into the end of a warehouse in Clink Street, the name of which recalls the security of the

SOUTHWARK

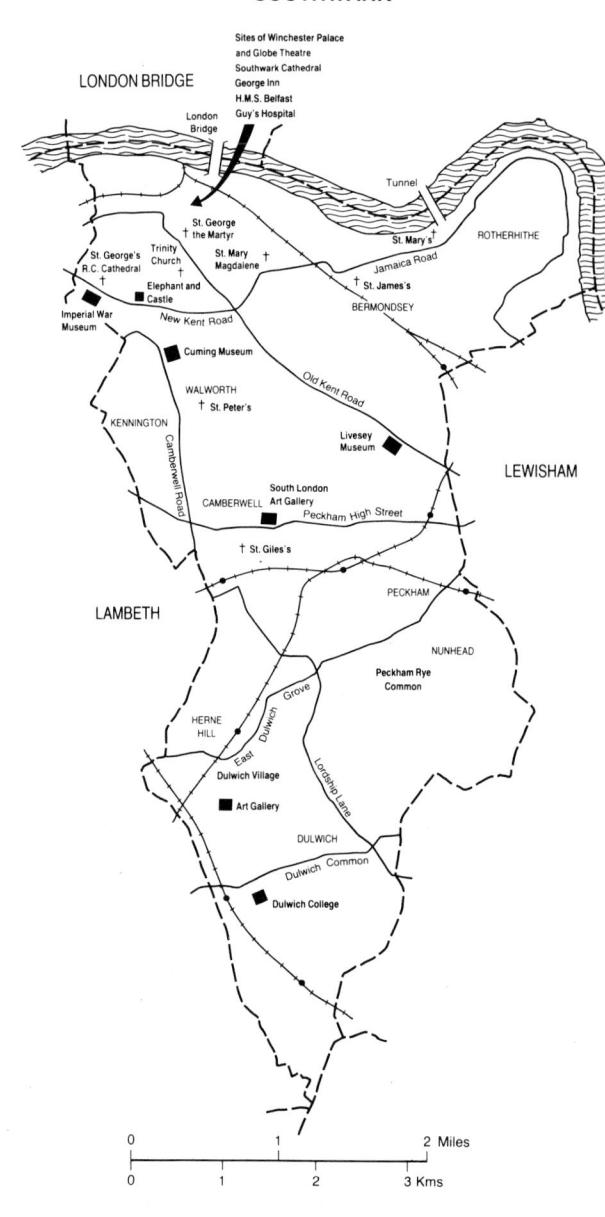

Bishop's own prison, the Clink. A section of the south wall and the west gable of the fourteenthcentury Great Hall rise from twelfth-century footings. The main chamber was on the first floor and would have been entered by the door in the south wall, while at the western end is a triple service door, now bricked up, which once led to the kitchens, and above, high in the gable, its tracery still precise and delicate, is a great rose-window. A new development is being planned for this section of the waterfront. The site of the palace will be excavated and the remaining walls and window tracery displayed to better advantage, Victorian warehouses will be refurbished and new offices built, and a dock will be constructed to cradle Captain Scott's Discovery, in which he made his first polar expedition. The ship, which is at present undergoing refitting in St. Katharine's Dock near the Tower, will once again be open to the public.

Bankside follows the river's margin and at its eastern edge is the Anchor public house, which has dispensed good entertainment since the late eighteenth century. Beside it is a raised terrace, a pleasant place on which to spend a summer's evening. Nearby are number 1 Cardinal's Wharf, where Wren is said to have lived while busy with St. Paul's, though the tradition is without documentary confirmation, and the Beargarden Museum, established in 1972 by the film director, Sam Wanamaker, with exhibitions to recall the Southwark of Shakespeare's day. Plans have recently been launched to build, at the junction of Bankside and Emerson Street, a theatrical centre, with a reconstruction of the Globe Theatre, erected here in 1599 by Richard Burbage and his company of actors, William Shakespeare among them; it is hoped that the centre may be built by the late 1980s.

The most obvious nearby landmark is the tall. no longer smoky, chimney of Bankside Power Station, built just after the Second World War to designs by Sir Giles Gilbert Scott, and just inland a long wall beside Park Street marks the boundary of Courage's Brewery, the successor on the site of the brewery once owned by John Thrale, Dr. Johnson's friend and supporter. Westwards on the Lambeth side of Blackfriars Road, stands Christ Church, established in 1671, bombed in 1941, and rebuilt to designs by R. Paxton Watson and Harry Costin. Christ Church is the headquarters of the South London Industrial Mission; appropriately, the stained-glass windows in the church, the work of Frederick Cole, represent the industries and occupations of South Londoners instead of the saints and Bible scenes which one would expect; the results, though subdued in colour, are remarkably successful. Nearby, in Hopton Street, stand the brick cottages of the Hopton Almshouses, grouped around a square with a trimly pedimented Committee Room at the centre of the main block. Founded in 1752, they continue their good work today.

As Hopton Street bends towards the Thames, it

reaches the Bankside Gallery, newly built to attractive designs by the Fitzroy Robinson Partnership, under the direction of G. T. West, and opened to the public in 1980. It is the headquarters of the Royal Society of Painters in Water-Colour (founded 1804) and of the Royal Society of Painter-Etchers and Engravers (founded 1880). Frequent and interesting exhibitions are organized, some of members' work, some historical, and some of work by foreign artists.

Back near the foot of London Bridge is Borough Market, where fruit and vegetables are sold wholesale, Tuesdays and Fridays being the busiest days. Owned today by the borough council, it is the descendant of the Market of the Household held, from the thirteenth century onwards, at first on London Bridge itself and later in Borough High Street. Just off the High Street, which roughly follows the line of the Roman Stane Street, stands the George Inn, London's last galleried hostelry, today the property of the National Trust. Built late in the seventeenth century around a courtyard, only the southern side now remains, but plays are sometimes given here in summer, staged much as they were in Shakespeare's day. This is a good area for inns and their associations; in Newcomen Street stands the King's Arms, using as its sign a royal coat of arms which once adorned the southern gatehouse of Old London Bridge. It was the sale of the now demolished Queen's Head which provided the money for the foundation of Harvard University, while Talbot Yard marks the site of the Tabard Inn. from which Geoffrey Chaucer and his companions set out joyously on their pilgrimage to Canterbury one April morning in 1388. In King's Head Yard, another tavern still has a robust, late seventeenth-century figure of Henry VIII as its sign.

Out of the High Street turns St. Thomas's Street, the bulk of London Bridge Station lying along its northern side. Though Euston was London's first main-line terminus, it was from London Bridge that the first passenger services ran. The official opening was on 14 December 1836, when four separate trains, bearing the Lord Mayor, City Aldermen, Sheriffs, Directors, and the band of the Welsh Guards playing loudly, travelled in procession over the two miles to Deptford. Closely contemporary, the old station and Rennie's London Bridge have both vanished in the past decade, the bridge to a new site in America but the station beyond recall.

On the same side of the street stands St. Thomas's church, used today as the Chapter House of Southwark Cathedral. The Hospital and parish church were rebuilt between 1693 and 1708, at a time when Sir Christopher Wren was a hospital governor. The loft of the church was used by the hospital apothecary for drying and storing the stock of herbs, from which the medicines were made. When an additional operating theatre for woman was needed in 1821, half of the herb garret was adapted and equipped; the hospital left Southwark in 1865, the entrance to

Rennie's Wharf, Hopton Street

the theatre was blocked up, St. Thomas's ceased to serve the parish and became the Chapter House, and the theatre was relocated only in 1956. Since then, it has been restored as a museum, the only surviving example in England of a nineteenth-century operating room. The instruments displayed, and the box of sawdust ready to soak up the blood, are grim. Beside the Chapter House is a fine eighteenth-century building, the Provost's Office. As we pass, we may remember that it was among the buildings of St. Thomas's Hospital that the glaziers making the glass for King's College Chapel in Cambridge had their factory, and that James Nycolson's Press, which printed Bishop Coverdale's Bible, the first complete text in English, stood here too.

On the south side of the road is Guy's Hospital, founded in 1722 by Thomas Guy who, though born in poverty in Bermondsey, made a fortune which he devoted to this good work. The original buildings, set out around two large courtyards, still survive, save for the wartime destruction of the Committee Room. In the forecourt stands a bronze statue of the

founder by Scheemakers, and the centre of the main block was embellished by Jupp in 1774, with a pediment and six Ionic columns. Two statues by the elder John Bacon stand in niches, another of his works fills the pediment, and in the chapel, on the southern side of the forecourt, is the same artist's memorial to Guy. The subject aroused Bacon's profoundest sympathies; he carved a life-sized figure of Guy, his face both strong and tender, raising up a pitifully sick man with pinched lips and emaciated cheeks, the pair of them set against a low-relief background of the hospital buildings. In the inner courtyard of the hospital, one of the alcoves from Old London Bridge has found a refuge, and the visitor may remember that John Keats was a medical student here.

The line of the Thames goes east towards ROTHERHITHE, which, even today, is still very much an isolated community, separated from the rest of London. From Tooley Street – its name a corruption of that of the belligerent saint, Olave of Norway, who pulled down London Bridge in 1015 (see p. 84)

- HMS Belfast may be boarded. She is the last surviving warship from World War II and is now moored in the Thames as a floating museum.

The way to Rotherhithe passes Cherry Garden Pier, now desolate, where Turner sat to paint The Fighting Téméraire as she was towed to her last mooring, and the Angel Inn, a late seventeenth- or early eighteenth-century building with a weatherboarded frontage towards the river. Off Jamaica Street in Thurland Road is Savage's Greek Revival church, St. James's, built 1827-9. The deep Ionic portico shelters immensely tall west doors, and around the chancel is an enormous painting of the Assumption of the Virgin by John Woods (1844). As the Thames bends northwards the sharp green spire of St. Olaf's, the Norwegian church, comes into sight. It was built of red brick in 1927 to designs by J. L. O. Dahl. It is followed by the square tower of St. Mary's, the parish church of Rotherhithe. It was from this parish that the captain and first mate of the Mayflower came, the ship that bore the Pilgrim Fathers safely to America, and it is in St. Mary's churchyard that her captain, Christopher Jones, lies buried. The present church, brick with stone quoining and built on the site of an earlier edifice, was begun in 1714, though the west tower with a frill of parapet and neat cupola and spire, and possibly the chancel as well, were not completed till 1747. Inside, there is the fine wood-carving of the late seventeenthcentury reredos and a painting of Charles I, said to have been presented to the church by his son after the Restoration. There are several interesting memorials, the two most remarkable both to men associated with the sea, Captain Anthony Wood (d.1625) has a proud merchant ship in full sail carved on his, and Joseph Wade (d.1743), King's Carver in the shipvards at Deptford and Woolwich, is remembered by an elegant asymmetrical rococo cartouche, bordered with cherubs' heads, skulls, foliage, and shells. All the fittings are good and the organ, by Byfield, was installed in 1764.

Opposite the church is Peter Hill's School, established in 1797 in an earlier school building, with two charming figures of pupils in niches on a level with the first-floor windows; beside the school and adjacent to the churchyard is a watch-house. Around the corner from the church is an old inn, renamed the Mayflower in memory of the ship which cast her moorings one autumn morning in September 1620 to sail with the tide on the long voyage to America. Nearby are the engine house and ventilation shaft of the entrance to the Thames Tunnel, which the two Brunels, father and son, built under the river from Rotherhithe to Wapping between 1825 and 1843. Their skill and incredible perseverance against watery odds made the building of this tunnel into one of the great sagas of enginering history. It is still watertight and is used daily by the East London section of the Metropolitan Underground Line. The engine house was restored and became a museum in 1980; it

is open at weekends in the summer months. Beside the Thames Tunnel, the launching ramps for Brunel's **Great Eastern** are just visible across the river on the Isle of Dogs and nearby, Hope Sufferance Wharf has been restored by the Industrial Buildings Preservation Trust and converted into small workshops for craftsmen.

Rotherhithe Street – the longest street in London – sweeps in a great loop around the Surrey Commercial Docks. The development of the area began with the Greenland Dock in 1700, and the docks remained active till their closure in 1970; the land is to be redeveloped. At the junction of Abbey Street and Tower Bridge Road, there is a green open space, in which stands St. Mary Magdalene church, next to the site once occupied by Bermondsey Abbey. Founded in 1082 by a wealthy merchant, Aylwin Childs, and throughout the Middle Ages one of the most important religious houses in England, two Queens of England, Katherine de Valois, Henry V's widow, and Elizabeth Woodville, Edward IV's widow, ended their days here. Nothing remains of the once-beautiful buildings save a morsel of the Gatehouse at number 7 Grange Walk. One of a group of seventeenth-century houses which have been stuccoed over, its walls incorporate medieval stonework, and, on the outside, the hinges where the gate once hung are still visible. St. Mary Magdalene church was largely rebuilt in 1680, though the base of its west tower is of the fifteenth century. The interior resembles Wren's St. Martin's, Ludgate, though no one would suspect this from the outside; it was remodelled about 1830 and given a lovable if unacademic Gothic Revival façade. The church was lengthened in 1883, but the galleried interior retains its seventeenth-century fittings - carved reredos, paintings of Moses and Aaron, pulpit, organ-case, panelling, and two fine brass candelabra dated 1699 and 1703. In the chancel, William Castell (d.1681) has a dignified tablet, and in the vestibule are kept three intricately carved twelfth-century capitals, which must have come from the Abbev.

Just by the church, in Bermondsey Square, an antiques market is held each Friday morning, for the former Caledonian Market moved here in 1950.

Back in Borough High Street stands the well sited church of St. George the Martyr. Founded in 1122, it was rebuilt in 1736 by John Price. Hogarth included the tower of the earlier church in his engraving of Southwark Fair (1733). The body of the church is of warm red brick with which the white Portland stone of the tower makes a bright contrast. The edge of the roof is outlined with a balustrade, and the two tiers of windows to the north and south recall the design of Wren's St. James's in Piccadilly. Inside, the shallow plaster ceiling of the nave was decorated with Italianate angels by Basil Champneys in 1897, and there are low box pews. Two late seventeenth-century paintings of Moses and Aaron found a home here when St. Michael's in Wood Street was de-

molished, and on the west gallery a magnificent Stuart royal arms is displayed. The pulpit and communion rails are also impressive. This is the church that was so significant in the life of Charles Dickens's heroine, Little Dorrit. Those who wish to follow her steps further should seek out Angel Place, where fragments of the walls of the Marshalsea Prison for Debtors, which closed in 1849, still stand. Less than a quarter of a mile southwards from St. George's, in Trinity Church Square, self-consciously wellgroomed, is Francis Bedford's church, built in 1823-4. It has on its north side a portico of six giant Corinthian columns surmounted by a tall square tower, with an octagonal upper storey modelled on the Tower of the Winds in Athens. In front of the church stands an astonishing stone statue, eight feet high, said to have come from Westminster Hall and to have been one of the series of kings commissioned by Richard II in the 1390s. It is known locally as King Alfred, but whichever monarch it represents, and however weather-beaten it may be, it still retains a rugged dignity.

Borough Road leads to St. George's Circus on the extreme western side of Southwark. The land here lay open till the middle of the eighteenth century; Gerard, the herbalist, searched for water violets here, and it was here on 2 June 1780 that the Gordon Rioters assembled to demand the repeal of the Catholic Relief Act. After Westminster Bridge had been built in 1750 and Blackfriars in 1769, the Circus and the roads radiating from it were laid out by the elder George Dance as London's first specially designed traffic junction. In the centre of the circus there used to stand an obelisk with four iron lamps, which in 1905 was moved to the grounds of what is today the Imperial War Museum. This imposing building was erected in 1815, to designs by James Lewis, to house Bethlem Hospital, founded in the thirteenth century in the City to care for those who were out of their wits. The building was enlarged and given a copper-sheathed dome in 1844-6 by Sidney Smirke. In 1926 the hospital moved out to Kent and Viscount Rothermere purchased the property, laid out the grounds as a memorial park to his mother, Geraldine Mary Harmsworth, and presented the building to the nation. Since 1936, it has housed the Imperial War Museum.

Founded in 1920 as a tribute and memorial to those who died in the First World War, the Museum's scope has been extended, tragically, to cover the history of the Second, and of the Korean War. Every kind of relic is here – field guns, ships' guns, tanks, aeroplanes,¹ uniforms worn and medals won, all are displayed. Special exhibitions are frequently arranged, to the great delight of schoolboys and their fathers, but it is probably less generally

Just to the north of the Museum is St. George's Roman Catholic cathedral, designed in 1848 by Pugin, the largest and finest Catholic church to be built in England since the Reformation. Much damaged by incendiary bombs, it was restored and reopened in 1958.

From the Circus, St. George's Road and London Road lead south-west to the Elephant and Castle, that 'ganglion of roads' as Dickens called it in *Bleak House*. Modern redevelopment has done nothing to make this tangle of thoroughfares less Gordian. The inn which gave its name to the complex has vanished, but its impressive sign, a huge pachyderm with a castle on its back, has been resurrected in front of the new shopping centre. The only old building to survive is the Metropolitan Tabernacle, built in 1861 so that congregations of up to 6,000 people could throng to hear the sermons of the famous Baptist preacher, Charles Haddon Spurgeon. In spite of a serious fire in 1898, and heavy bombing in 1941, the

Part of the carved organ-case, St. Mary Magdalene, Rotherhithe

realized that the museum also houses a remarkable collection of works of art, about 9,000 paintings and drawings executed by the official war artists. These include works by Stanley Spencer, Paul and John Nash, Wyndham Lewis, C. W. Nevinson, Graham Sutherland, and the famous series by Henry Moore of studies of people sheltering in tube stations during air raids.

¹ The reserve collection, of aeroplanes too large to be housed in London, is at Duxford in Cambridgeshire. (See p. 203 for Royal Air Force Museum at Hendon.)

portico of six giant Corinthian columns still steadfastly confronts the swirl of modern traffic. A nearby high-rise block houses the London College of Printing.

From the Elephant and Castle, the main roads -Newington Butts which becomes Kennington Park Road, Walworth Road, and the Old Kent Road - run southwards, speeding towards the coast, the Channel, and the continent. It is here that the traveller first realizes what graciously broad roads South London enjoys, planned far more consistently on a boulevard scale than any on the more crowded north bank of the Thames. A little green garden on the west side of Newington Butts marks the site of Old St. Marv's Church, where Pepys's parents were married and where Faraday was baptized. In 1878, a new church was built a few hundred yards away southwards, but it was bombed save for its tower, and a third parish church was built on the site.

Along the Walworth Road, there is much to observe and to approve, such as the crazily endearing buildings of the former Town Hall of Southwark (Gothic red brick, 1866, by Jarvis) and the public library (Tudor Classical, 1893, by l'Anson). Inside the latter is the Cuming Museum. This sprang from the gift, in 1782, of an old coin and three fossils to a five-year-old child, Richard Cuming. He grew up to be a man of reasonable substance and he continued to collect almost anything collectable, but with an especial interest in the natural sciences. He married and begot a son who shared his father's enthusiasms, especially archaeology, ethnography, and local history. When that son died in 1902, leaving the entire collection to the borough, it represented 120 years of diligent and intelligent acquisition. The collection was cocooned for a generation but in 1959 the Cuming Museum was reopened to the public. It is now the research centre for archaeology in this area. where there is much to be discovered, the uncovering of the foundations of the Black Prince's palace at Kennington by the local excavation committee being one of the undertakings. The museum itself is an extraordinary mixture - fragments of Roman pottery, old inn signs, an enchanting hand-propelled milk-cart, the pump from the yard of the Marshalsea Prison, the gravestone of two cruel murderers, Mr. and Mrs. Manning, whose execution Dickens witnessed with horror, a necklace of oak-apples to promote good health, and two terracotta reliefs of The Mocking of Christ and The Jews Brickmaking in Egypt by George Tinworth, one of the designers at Doulton's factory, as well as a model for a proposed memorial to Shakespeare by the same sculptor. Children throng the gallery and delight in the medley. The building also houses the Southwark collection of archives, some of them dating from the seventeenth century, and of local history material.

Opposite the library is a fine terrace of late eighteenth-century houses at 140-52 Walworth Road and the nearby streets deserve exploration. There is an excellent Tuesday to Saturday general market in East Street, and in Liverpool Grove stands St. Peter's church, designed in 1825 by Sir John Soane, with four giant Ionic pillars to its portico, a crisp entablature with a neat balcony above, and a tall thin tower topped by an elongated cupola of such distinction that it holds its own among the high-rise buildings which encircle it in ambush. Inside, there is a white marble font, and three vivid east windows by Clare Dawson. A few terraces of older houses have remained around the church, maintaining a proper scale and proportion, while nearby the terrace known as Surrey Square is still almost intact, an elegant fan-shaped artificial stone pediment emphasizing its centre. The architect was Micheal Searles, who lived in the White House at 155 Old Kent Road¹ and who also designed the Paragon at Blackheath (see p. 369). Public housing on the Aylesbury Estate is among the most cruelly ugly and antisocial in London.

Southwark's other southern artery is the Old Kent Road. Beyond the recently constructed flyover, at the junction with Peckham Park Road, stands the North Peckham Civic Centre, its walls bright with Adam Kossowski's mosaic, symbolizing the past of the road from the Roman legionary to the Pearly Kings and Queens of today. A little beyond, at number 682 Old Kent Road, is the Livesey Museum. This opened as a library in 1890, and was bombed and rebuilt to open as a Museum in 1974. It has no permanent collection but arranges two or three main exhibitions a year on themes related to local or to social history. A courtyard at the back of the building has been developed by the architects, Myles and Dierdre Dove, as an open exhibition area, and in it have been set such splendid local relics as a model of the graceful façade of Edginton's shop² – 'Tentmakers since Trafalgar' – mosaics of Chaucer's pilgrims executed in 1907 by Thomas A. Cook, and a huge bell, cast in 1856, which once summoned the children to St. Alban's School, Walworth. The Museum is not open to the public during school holidays as the staff are then occupied with special activities for children.

CAMBERWELL is the centre of the borough, its Green, alas, now a prim municipal open space and not the rural Elysium that inspired Mendelssohn to write his Spring Song. In Church Street stands St. Giles, a young cathedral of a building, with a massive tower and spire and unusually spacious transepts. It was designed by the youthful George Gilbert Scott and built in 1841-44, after a fire had destroyed the small, twelfth-century stone church, which had replaced a wooden pre-Conquest one. Inside are preserved the fourteenth-century sedilia and piscina and several brasses, including one to John Bowyer

2 Formerly at 105 Old Kent Road, and now at Woburn, Bedford-

¹ Later the offices of the Rolls Estate. John Rolls, who started life as a cow-keeper, made a fortune from here which helped his greatgrandson to produce the Rolls-Royce motor car.

(d.1570) which shows him with his wife, eight sons, and three daughters. Samuel Sebastian Wesley was organist here and designed the recently restored organ, and from 1785 till 1811, the vicar was George Sandby, uncle of the water-colour artists, Thomas and Paul, some of whose paintings are in the South London Art Gallery. In the west window are fragments of thirteenth-century German glass from Trier, and the east window is filled with vivid glass designed by John Ruskin and Edward Oldfield, who were friends and who both lived nearby, on Herne Hill and on Champion Hill respectively. Behind the church, there are some attractive late Georgian houses in Camberwell Grove and in Grove Lane.

The road continues eastwards, changing its name to Peckham Road. On its north side stands the Town Hall (1934 by Culpin and Bowers and the less said about it the better), with beside it the Camberwell School of Arts and Crafts and the Passmore Edwards South London Art Gallery (Maurice Adams) with lively carvatids. This, the oldest municipally owned gallery in London, had its origins in the efforts of William Rossiter who, in 1868, began to exhibit paintings in his shop in Camberwell Road. Public reaction was so enthusiastic that, with the encouragement of Lord Leighton, G. F. Watts, and Sir Henry Irving, the present permanent art gallery was built and opened to the public in 1891, becoming the property of Camberwell Vestry and later of the successive borough councils. Works by leading nineteenth-century artists - Leighton, Watts, Ford Madox Brown, Val Prinsep, and John Collier - were purchased, besides drawings by John Ruskin, while a Hogarth sketch in oils, a study for his Masked Ball at Wanstead Assembly, was presented by an early trustee. To this substantial nucleus, a council resolution, passed in 1953 to celebrate the coronation of Queen Elizabeth II, provided the resources to buy contemporary British works of art (paintings by John Piper, Alan Reynolds, Duncan Grant, John Tunnard, and Christopher Wood) and twentieth-century original prints, among them works by William Gear, Patrick Heron, Graham Sutherland, and Michael Ayrton. The Gallery also possesses a comprehensive collection of topographical paintings of local subjects. Unfortunately, owing to acute restrictions on space, only selections from this excellent collection can be shown at any time. Temporary exhibitions are arranged here at intervals.

PECKHAM lies south along Rye Lane and Peckham Rye. The Common and Park are still open, though the oak tree, in the branches of which the young William Blake saw a host of angels, has gone.

At the extreme southern tip of the borough is DULWICH, a village with a long recorded history, for King Edgar granted the manor here to one of his thanes in 967, and throughout the Middle Ages it belonged to Bermondsey Abbey. At the Reformation, Henry VIII sold it to the Calton family and they in turn disposed of it in 1605 to the actor-manager,

Edward Alleyn, who had played the protagonists in Marlowe's tragedies, Dr. Faustus, The lew of Malta, and Tamburlaine. Alleyn made a fortune and with it he founded 'The College of God's Gift in Dulwich' which was to be an almshouse for 'six poor brothers and six poor sisters' and a school for 'twelve poor scholars'. Suitable buildings were erected by John Benson, the east wing of which is still in use as an almshouse. The school long ago outgrew its premises and moved to new buildings, ornately Italian, designed by Charles Barry, son of the architect of the Houses of Parliament. The College Chapel is still in daily use; Alleyn's body lies there and at the end of each service the congregation gives 'humble and hearty thanks' for the memory of his good works. The font, designed by James Gibbs and wrought by van Spangen, was the gift of James Hume, Fellow of the College from 1706 till 1728; around its copper cover is a Greek palindrome² which means in translation: 'Wash away sin, not the visage only.'

At the beginning of the nineteenth century, the College received a bequest which made it the controller of the oldest public art gallery in England and of one of the finest collections of paintings in the country. A connoisseur and art dealer, Noel Desenfans, was commissioned to collect paintings for King Stanislas of Poland. When that monarch abdicated in 1795, Desenfans was left with the pictures on his hands. In vain he tried to persuade the government of the day to purchase them for the foundation of a national collection. When he died, he left them to his widow and to his closest friend, Sir Francis Bourgeois, landscape painter to George Bourgeois bequeathed the paintings to Dulwich College and Margaret Desenfans provided the money for a gallery, designed by Sir John Soane, to house them: it was also to be a mausoleum for the ashes of the three founders. The gallery opened in 1817, 21 years before the National Gallery.

The building itself is as remarkable as the collection it shelters. The mausoleum, in no way morbid, sits at the heart of the museum, a still centre, kept warm by the life all around it. The rhythm of the square lantern and shallow dome above it were re-echoed, a few years later, in the aedicule which Soane set above the ashes of his beloved wife in Old St. Pancras Churchyard. The paintings Desenfans had assembled form an impressive representative collection of European art; Raphael, Piero di Cosimo, Claude, Poussin, Rembrandt, Rubens, Van Dyck, Veronese, Dolci, Tiepolo, Canaletto, Murillo, Watteau, Hogarth, Reynolds, and Gainsborough all are here and each is represented by at least one important work. Every visitor will have his or her favourite work, whether it is Rembrandt's Girl at a Window, Watteau's radiant Les Plaisirs du Bal, or Hogarth's sedate Fishing Party. With the collection,

¹ At present on loan to the Tate Gallery.

² The same inscription encircles the font in St. Martin's Ludgate.

SOUTHWARK 419

Alleyn's family portraits are also exhibited and so are the paintings from the Cartwright Bequest, which include a self-portrait of Richard Burbage, Shakespeare's partner and Alleyn's rival. When the College organist, Ozias Linley, died in 1831, he too bequeathed his collection, which included Gainsborough's painting of the Linley sisters, one of whom married the dramatist Sheridan, and a studio version of Reynolds's awe-inspiring portrait of Mrs. Siddons as the Tragic Muse. Children who visit the gallery with their parents may well decide that their favourite is a prim, over-hatted portrait of Queen Victoria at the age of four, painted by Samuel Denning, who at that time was Keeper. The Gallery is open daily, save on Mondays, free of charge.

After the Picture Gallery come the attractions of **Dulwich Village** itself, an agreeable street with hardly a building in it that discountenances its neighbours. Numbers 60 and 62 were built in 1767, and numbers 97–105 and the row of small shops were all built before the end of the eighteenth century. Their neighbours are comfortably Edwardian or restrainedly modern. The parish church, **St. Barnabas** in Calton Avenue, was not built till 1894, to designs by Oliver and Leeson. It is large, with Perpendicular

detail and a robust, pinnacled, Norfolk-type tower, all of deep red brick. Somehow, the incongruity of the form with its building material is endearing, and inside there is good stained glass of 1922, by E. B. Powell, in the east window.

Dulwich Park and its azaleas are worth a visit, and the municipal authorities have taken over two interesting local houses, Belair in Gallery Road and Kingswood off Kingswood Drive. The former, built in 1785, resembles the work of Robert Adam or Henry Holland; by the end of the Second World War, it had fallen into decay but Southwark has restored the exterior, preserved the fine central staircase, and adapted the rest of the interior for recreational facilities. The Southwark Festival takes place each summer in the grounds. Kingswood was built in 1812 but was enlarged for L. J. Johnson, who made a fortune out of Boyril, and who spent £10,000 on his highly idiosyncratic Victorian baronial mansion. After the war, the Council turned it into a public library and community centre; adults may select their volumes in what once served as the Great Hall, and the Jacobean Room and the Golden Room now provide magnificent settings for wedding receptions and for meetings of local societies.

Lorrimore Square, Kennington

The London Borough of Sutton lies due south of Westminster and on the perimeter of the Greater London mass. A medley of twentiethcentury suburban development, with houses both large and small, it retains, or attempts to retain, despite the recent rebuilding of the centre of Sutton, a firmly rural character. It is made up from the former boroughs of Sutton and Cheam, and Beddington and Wallington, which in 1965 were united with Carshalton to form an administrative area of nearly 11,000 acres with a population of about 170,000. The River Wandle flows through on its way to the Thames and across the centre, from west to east, lies a bed of Thanet sand, percolated by springs of clear water, which determined the original pattern of settlement, for upon it the villages grew up, spaced out neatly along a local equator. The network of lanes which linked them was augmented in 1755 by a turnpike road running from Croydon to Ewell; the construction of the main London-Brighton road before the end of the nineteenth century gave pre-eminence to Sutton, which now lends its name to the whole borough.

In spite of its main roads, SUTTON remained a country village till after the coming of the railway in 1847 and, despite a rapid increase in population, it is only since 1965 that it has torn its heart out to make way for massive new civic and commercial buildings. Its centre remains the junction of the High Street, running north and south, with the Cheam and Carshalton Roads leading west and east. The crossing is marked by the signboard of the Cock Inn, demolished in 1961 but once a posting-stage for coaches. The north-west quarter is now almost filled with the newly built Civic Centre, Liberal Arts College, and the Public Library; its foyer houses the Europa Gallery, where temporary exhibitions are arranged. Of the old village, very little remains, Sutton having rebuilt itself so thoroughly in the past half-generation.

The parish church, dedicated to St. Nicholas, lies just off the High Street. Though a church has stood here since Saxon times, the present building dates

only from 1864, when it was rebuilt, to designs by Edwin Nash, in dark flint with a wooden-tiled roof, a comfortable broached spire, and a stalwart pinnacled west tower. In the churchvard stands the Gibson Mausoleum, 12 feet square and first tenanted in 1777. The interior is inspected annually by the rector, parish clerk, and churchwardens, and a brief sermon is preached afterwards. Inside the church, hidden from view behind the organ, is a memorial to Dorothy, Lady Brownlow (d.1699), wife of Sir William Brownlow, which was brought from the old church. The sculptor, who was probably William Stanton, has shown the lady reclining, surrounded by her three sorrowing children, while cherubs flutter above, holding trumpets. It was to the initiative of a former rector of Sutton that America owes the introduction of the printing press. The Reverend José Glover bought one and set out for the New World: he did not survive the voyage but his partner, Stephen Daye, went on to become the first printer in New England.

In the Cheam and Carshalton Roads stand two impressive churches, the United Reformed Methodist Trinity Church and the Baptist Church. The former, designed in 1907 by Gordon and Gunton, is of grey stone, its massive tower topped by a lantern crown like Edinburgh Cathedral or St. Dunstan's-in-the-East, while the latter, designed by Cachemaille Day in 1934, has a nave enshrined by seven curiously shaped arches, tapering like candle flames, and the form of the windows repeats the motif. The stained glass in the east window is filled with figures and scenes from Bunyan's Pilgrim's Progress, while the window on the adjacent wall, with glass by Marion Grant, is a war memorial dedicated in 1949; future generations are going to find the mid-twentieth-century apparel of the figures particularly interesting.

A mile away to the south, near Belmont on the Brighton Road, is Sutton Lodge, built in 1782 and once a farm, which now serves as an old people's day centre, while, closer to the town in Christchurch Park, is Christ Church, designed in 1888 by Newman and Jacques. It is a vast building, constructed from the very reddest of red brick, with a splendid interior of cathedral-like proportions. The font is set in a narthex and between the vast nave and the chancel is a rood screen of singular magnificence; in the altar-

SUTTON 421

Whitehall, Cheam

piece of the Lady Chapel, Christian subjects are re-interpreted in wafting, wavering, Art Nouveau lines. When passing through Sutton, it is worth watching out for milestones. In a place unrepentantly committed to the twentieth century, there are an unusual number; those in the High Street, on Rose Hill, and on the Brighton Road, near Ventnor Road, are comparatively easy to sight.

CHEAM, prosperous with well spaced streets, lies to the west of Sutton. Once again, the centre is a crossroads, here set about with magpie-timbered shops of the 1930s, doing their best to show their relationship with the astonishing morsels of vernacular architecture which Cheam cherishes. Its wealth of antiquity is best displayed in the Malden Road and the Broadway, to the south end of which the Old Cottage was removed in 1922. Built about 1500, its oaken timbers were prised apart and pegged together again, though the rye-dough walling which filled the gaps between them had shrunken, so that it had to be replaced by concrete.

Parkside turns out of the Broadway; in 1923, a thirteenth-century pottery kiln, excavated there, was removed intact to the Science Museum and the pots discovered were distributed between the British Museum, the Victoria and Albert, and the Guildford Museums. On the south side of the next turning, Park Lane, stands a stepped row of seventeenth-century weather-boarded cottages; the modern building, Elizabeth House, which faces them is tactfully weather-boarded too.

On the corner of Park Lane and the Malden Road stands Whitehall, Cheam's chief treasure. Built about 1500, it is one of the earliest surviving houses to have been constructed with two storeys throughout. About the middle of the sixteenth century, the distinctive porch, jutting out over the front door, was added; the original timbering was masked with weather-boarding in the late eighteenth century to counteract the shrinkage of the rye-dough, or mixture of straw and plaster, which covered the lathes

between the main timbers. Whitehall provided the original premises for Cheam School, which the Reverend George Aldrich founded about 1645, and which still flourishes, though now in Berkshire. Among its pupils, the school has numbered Lord Randolph Churchill, Prince Philip, Duke of Edinburgh, and Charles, Prince of Wales. In 1970, Whitehall became the property of the London Borough of Sutton and was restored with exceptional care and felicity as a centre for exhibitions, lectures, and recitals. Just beyond it, at right angles to the road, is the Rectory, built in the sixteenth century with an engaging medley of later additions.

The western side of Cheam lies open to the greenery of Cheam Park, and beyond is the expanse of Nonsuch Park. Here, from 1538 onwards, Henry VIII built his last palace, Nonsuch, levelling the whole village of Cuddington to make space for it. Of this lovely edifice, which 'no equal has in art or fame', nothing remains, for Charles II gave it to the wanton Barbara Villiers, Countess of Castlemaine. and she sold it for its demolition value. Even its exact position was forgotten, till excavations in 1959 revealed its foundations. These had to be covered over again, but three pillars mark the site and numerous fragments of carved stone and gilded slate. besides glassware and pottery, may be seen in the Museum of London and at Bourne Hall Museum in Ewell. The buildings of the home farm attached to the Palace remained in use till the twentieth century, and then, when progress and road widening called for them to be swept away, they sustained a curious and triumphant resurrection by providing building materials for St. Alban's church, half a mile northeast of Cheam, on the corner of Gander Green Lane and Elmbrook Road. The architects were Charles Marshall, the Cheam local historian, and Edward Swan, who had been responsible for a similar reconstruction at North Sheen (see p. 405); the result, long and low, very simple, with exposed timbers for the roof and a cheerful rusticity throughout, deserves to be better known.

The parish church, dedicated to St. Dunstan, stands on high ground in the centre of the village, set back from the Malden Road. It can be reached by Park Road, in which a fair is held each 15 May, as it has been since 1259, and in which stands Bay Cottage, a three-bay, eighteenth-century brick house. and the Old Red Lion, which has been dispensing beer since the sixteenth century. Beside St. Dunstan's stands the old Farm House, formerly Church Cottage, a late sixteenth-century timber-framed building now used as offices. Opposite it stands Cheam Library, a long low building which won a Civic Trust award in 1962; in the car-park behind are fragments of the walls of West Cheam Manor, built from square-cut slabs of chalk, for the escarpment of the Surrey Downs begins nearby. The present church was designed in 1862-4 by T. H. Pownall and is a pleasant though not particularly inspired building.

In the churchyard stands the Lumley Chapel, beautiful in itself and containing some remarkable funeral sculpture. The flint structure was originally the chancel of the old St. Dunstan's, and so was in existence by the beginning of the thirteenth century; in the north wall are the outlines of two blocked-up, round-headed windows, and in the south the shape of a sealed archway which must once have led into a south chapel or aisle. About 1550 John, Lord Lumley, the scholarly bibliophile whose books are now part of the Royal Library in the British Museum, married Iane FitzAlan, daughter of the Earl of Arundel, who at that time was the owner of Nonsuch Palace, which he later bequeathed to the young couple. The bride was as learned as her husband. She died in 1577, having borne three short-lived children. In 1592 – the date is given on the plasterwork of the ceiling - Lumley decided to transform the chancel of the church into a memorial for them. A new barrelvault was raised, with intersecting ribs and moulded pendants, and with a frieze of foliage and fruit around the walls. A magnificent alabaster table-tomb was intalled, with elaborate coats of arms at either end. Along the side are figures of the children, Charles, Thomas, and Mary, in high relief, modelled against a shallower background reputed to represent a room in Nonsuch Palace, with an open doorway revealing an obelisk, which we know to have stood in the garden there. The lattice-work of the windows is gilded and the whole scene seems dappled with sunlight. Above the tomb, a panel shows Lady

Lumley kneeling, her skirt arranged in a neat pile of pleats, a golden pomander hanging from her waist. Behind her, curly sunlit clouds swirl, as they do in the lower panel, though the corner to the lady's right seems to be incomplete. The figures are stiff and a little clumsy, but there is a desperate attempt in the whole work to capture something once lovely and beloved, and to fix a joyous moment for all time in stone. Lord Lumley remarried in 1582, his bride being Elizabeth Darcy, daughter of Lord Darcy of Chiche; they were both buried in St. Dunstan's. For himself, Lord Lumley (d.1609) chose a sober memorial, reaching from floor to ceiling, with Corinthian columns flanking a long inscription in elegant Latin – he had been a founder member of the original Society of Antiquaries and Lord High Steward of Oxford University – all set about with coats of arms, tracing his ancestors and their marriages back through eight generations. The Lumley emblem, the green popinjay, is perched everywhere. His second wife outlived him, dving in 1616, but her tomb was probably prepared in her lifetime. She is represented by a life-sized figure, wrapped in a fur robe and wearing a particularly pretty French hood; if the face is a true representation, she must have been a very beautiful

The Lumley tombs are not the only treasures here. There are a number of brasses, the most important being that of Thomas Fromond (d.1542) and his wife Elizabeth, who are shown with their six sons. It is a palimpsest brass and on the back we can see frag-

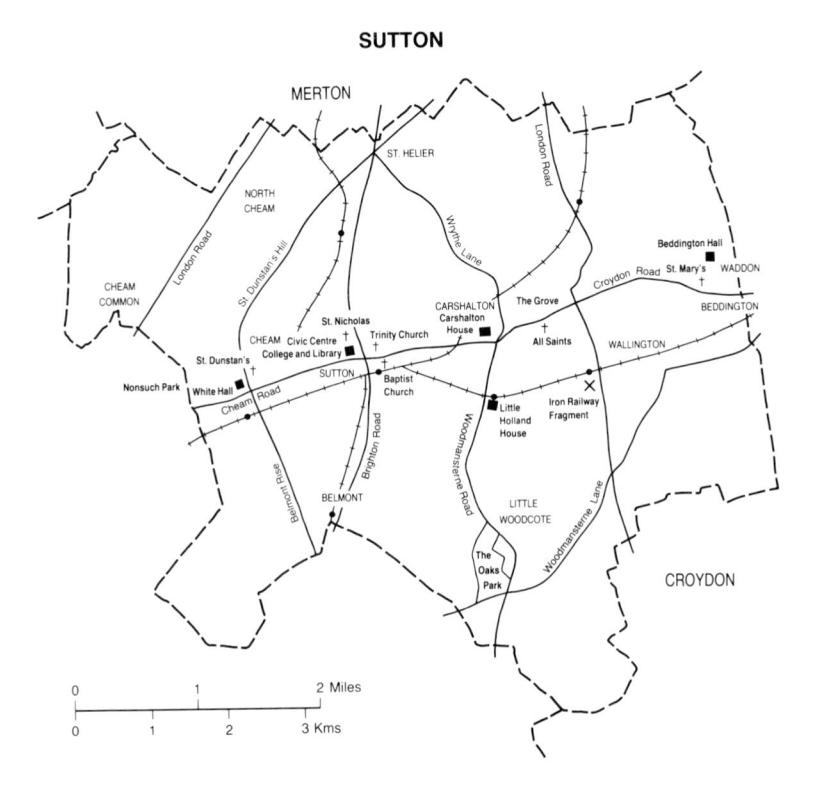

SUTTON 423

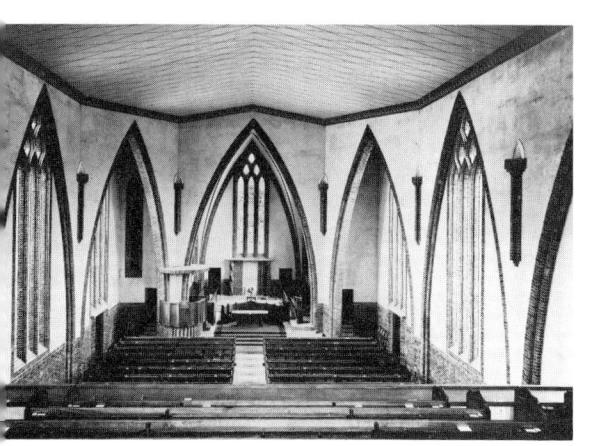

Baptist Church, Sutton

ments of earlier incisions – a lady, a shrouded figure, a chalice holding the host, and a demon in flight. There is an unnamed civilian of about 1360, John Crompton and his wife Joanna, who died in 1450 and 1458, William Wodeward who died a year later, and a tiny brass of a nameless man in armour who died about 1480. A long inscription commemorates Edmund Barret (d.1631), Sergeant of the Wine Cellar to Charles I, who was 'happie in two wedlocks & both were fruitful unto him', Dorothy bearing him three sons, the eldest of whom became Clerk of the Wardrobe to the monarch, and a daughter, and Ruth three sons and two daughters. John Pybus (d.1789), the first Englishman to be received in an official capacity by the King of Ceylon, has an urn, and there are scores of other small memorials and inscriptions to members of local families. The little chapel is kept locked but is readily opened if prior application is made; it is immaculately tended by the ladies of the village. In the churchyard, Charles Mayo, once headmaster of Cheam School, lies in a tomb designed many years after his death by Sir Charles Barry; with him lies one of his pupils, Henry Thomas, fourth Earl of Carrick, who died in 1846 and shares a grave with his beloved tutor.

CARSHALTON occupies the geographical centre of the borough. Even today, the ponds are the most arresting feature of the village, which remains, to a good extent, unspoiled. These ponds provide the source for one of the upper branches of the Wandle, which flows from Croydon, through Sutton and Merton, to join the Thames at Wandsworth. In 1831, its banks held 90 mills, which provided power for the production of hemp, iron, flour, and paper; they ground logwood for dyes, powered peppermint and lavender distilleries - herbs grew abundantly in the fields nearby - and drove silk-printing and felt-making machinery. One of the mill-wheels and several millstones may be seen in the public gardens of The Grove, a nineteenth-century mansion now in use as borough council offices.

The parish church, dedicated to All Saints and raised on a slight elevation above the south side of the High Street, lies broadside on to the Ponds. Domesday Book records that there was a church here in 1086, and it may be that the base of the present tower contains Saxon work. The building then consisted of a chancel, a central tower, and a nave, to which were added a north aisle about 1150 and a south about 1200; blocked lancet windows may just be discerned in the outer wall. The church was enlarged about the mid-eighteenth century and, save for the old chancel which now serves as a Lady Chapel, was substantially rebuilt between 1893 and 1914 by Sir Arthur Blomfield and his nephew, Sir Reginald. From 1931 onwards, Sir Ninian Comper redecorated the interior, giving it a new altar, rood screen, organ loft, and reredos for the Lady Chapel; covered in gold leaf, the figures and surfaces glow like the shrines of Byzantium, refulgent and breathtaking.

The most interesting monuments are in the old chancel, the north aisle of which is filled with the table-tomb of Nicholas Gaynesford (d.1498), which may also have served as an Easter sepulchre. In its lid are set brasses of himself and his family, his sons' occupations - soldier, priest, civilian - being distinguished by their apparel. Set in the floor and covered over for protection are fragments of other brasses, Walter Gaynesford (d.1493), who must have been a chaplain, holding a chalice with the Host, and Thomas and Elizabeth Ellenbridge under a canopy. surmounted by a tiny roundel of Our Lady of Pity, holding the dead body of Christ. William Quelche (d.1654), a former rector, has a tablet inscribed with a curious verse in Latin and English, and William Kidwell carved a scrolly memorial for Henry and Alice Herringman (d.1703) with putti and a skull, while their daughter, Elizabeth Byne, has another tablet, telling us that she died in childbirth in 1687 at the age of 19. In the body of the church, the monument to Sir William and Lady Scawen holds pride of place; she died first, in 1700, and cherubs weep for 'so dutyful a Wife, and so good a Woman', while he, who had been Governor of the Bank of England, is represented by a life-sized reclining effigy. His neighbour, Sir John Fellowes (d.1724), has a plain fluted sarcophagus with a tall obelisk, Rysbrack carved a stylish tablet for John Bradyll (d.1753), and Sir George Amyand (d.1766) has a tall, restrained urn. A brother and sister, Michael and Susanna Shepley, each have a small tablet, his carved by E. J. Physick, with a woman (Susanna herself?) kneeling by the dead man.

Besides the church is a sixteenth-century shop, now a wine bar, but formerly a butcher's, which had sold meat for at least 300 years. Below the church is a well, known as Anne Boleyn's well, and slightly westwards, beside the Wandle, is a stone set up by Ruskin in memory of his mother, who grew up here. Nearby is the Greyhound, a pretty eighteenth-cen-

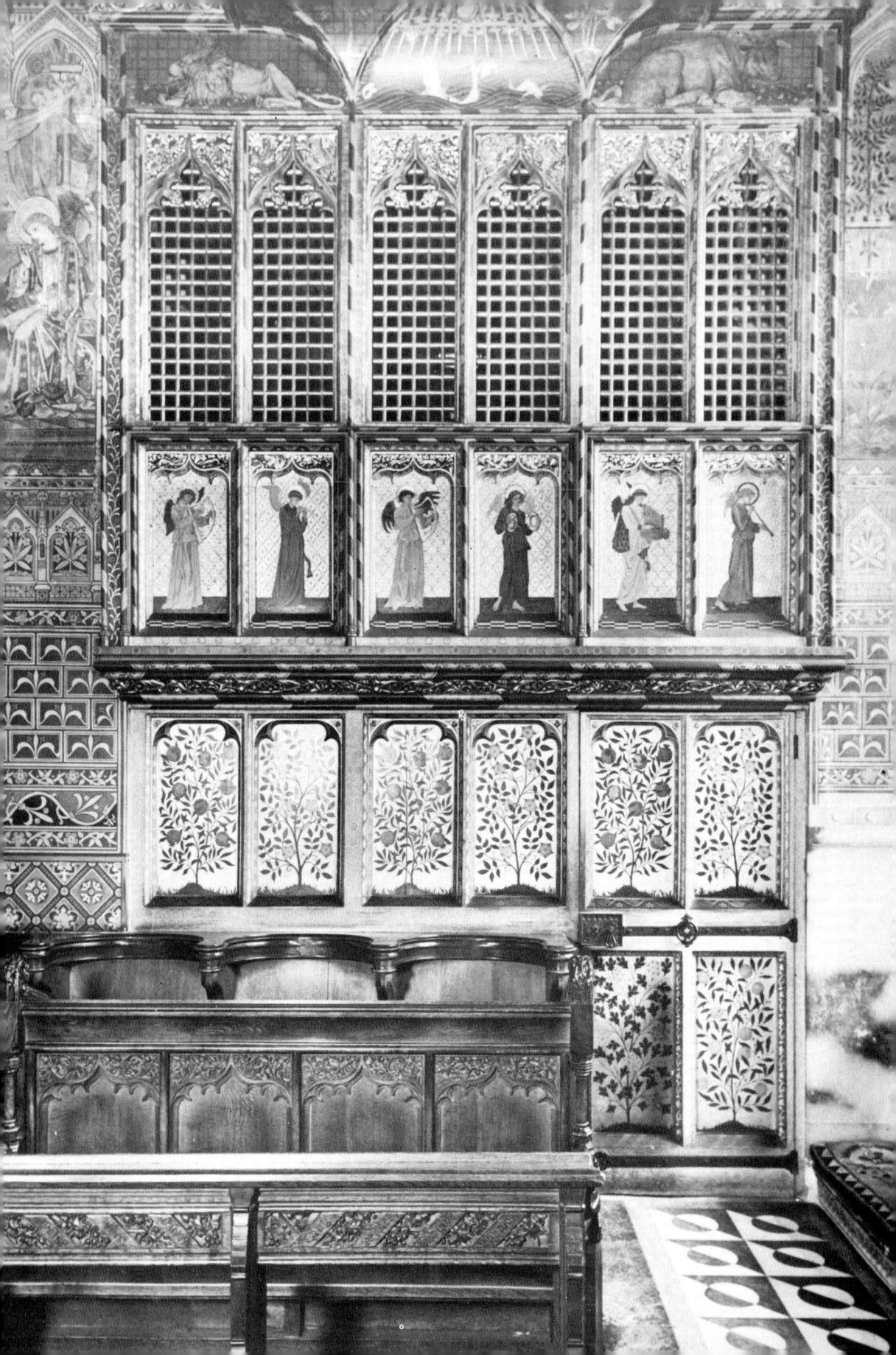

SUTTON

425

tury inn with curved gables, and on the far side of the main street runs Festival Walk, linking North and West Streets and containing the Old Rectory, a fine eighteenth-century house, with the tallest London plane tree beside it, reaching 123 feet into the air

with a girth of 20 feet 11 inches.

Beside West Street, which contains at its southern end some charming weather-boarded cottages, lies Carshalton House, built about 1714 for Edward Carleton who, on being declared bankrupt, sold it to Dr. John Radcliffe, the physician unable to attend Queen Anne on her death-bed because of his own severe, soon to be fatal, illness. The Camera, Infirmary, Science Library, and new Hospital at Oxford are all called after this learned man. The house, two storeys and an attic high, is a solid rectangular block. nine bays wide on its main aspects, seven on the others. The pedimented entrances are dignified but not elaborate. From 1848 onwards, the house served as a school, and in 1893 became St. Philomena's Convent where the Daughters of the Cross still continue the work of education; the school has recently become comprehensive. Of the original interiors the Drawing Room, with a superb chandelier and an alcove separated by delicate Ionic columns, the Oak Room with a fine carved surround to the chimney piece, the panelled Library, and the Painted Parlour remain, more or less intact. The Parlour walls are covered with landscapes, apparently part of the original decorations; some sentimental rustic scenes were added about 1900. The grounds were laid out, possibly by Charles Bridgeman, about 1719-20, with cunningly placed avenues - now rather threadbare - and a lake, now dry, on the far side of which stands a water-tower of a design so sombre and so brooding that it may even have been planned by Vanbrugh himself.

The village should have possessed another great mansion, Carshalton Park. Thomas Scawen succeeded to the old manor house but, finding it insufficiently grand, commissioned Giacomo Leoni to design a medium-sized palace for him during the 1720s. Portland stone was brought to the site and carved there, and a brick grotto was constructed, but Mr. Scawen's resources were insufficient to carry through his design. The stone was carted off to build other houses, and part of the estate became, in 1913, a municipal park, with the grotto and the dry bed of the canal as unusual ornaments. The handsome iron gates intended for the mansion now provide an unexpected entrance to New York State College of Agriculture and Technology on Long Island.

Carshalton still has yet another house of real importance. Little Holland House, called after the house in Kensington where G. F. Watts lived for many years, is not a stately residence, but the home

that one man, a strange yet practical dreamer, built and adorned almost entirely with his own hands as a tribute to one woman, his beloved wife. It was the house of the artist and craftsman. Frank Reginald Dickinson, who, though born in poverty, developed an extraordinary range of skills in arts and crafts. later working for Doulton's, the china manufacturers. On becoming engaged, he determined to build a house of which Ruskin and Morris would have approved. In 1902, he bought a plot of land, now 40 Beeches Avenue, out in the country at Carshalton and, with the aid of his brother, a bricklayer and a labourer, began to build a house there to his own designs. In March 1904 he and his bride, Florence Mariott, spent their honeymoon labouring on the house, which was still little more than a shell. During the rest of their married lives - Dickinson died in 1961, his widow is still alive - they worked on the interior. Condemning all forms of mechanical production, Dickinson carved the main beams, setting out his creed:- 'Serve Humanity, the Gods we know not', for all to see across the living-room. He panelled the walls and built the cupboards, made the furniture, the rugs, lamps, bowls, silverware, and curtains, beat copper for the fireplace surrounds. planted the garden, and painted a frieze around the main bedroom and pictures to hang on the walls. His style, based on what was most genuine in the Arts and Crafts movement, was a restrained Art Nouveau, a domesticated version of Charles Rennie Mackintosh's manner. The hopes and beliefs behind his work were similar to those which inspired the creators of London's garden suburbs. The house, its contents still intact, came up for sale in 1972 and was purchased by the Borough of Sutton. Many people dream of such total domestic creativity; Dickinson realized his dreams, accomplishing Ruskin's ideal -'We will make some small piece of English land beautiful, peaceful and fruitful.'

Half a mile to the south of Carshalton, where the ground begins to rise as it reaches up to the long hills of the Surrey downs, is a huge open space, the Oaks Park. The house that once stood here. The Oaks, was built by 1770 for Lord Derby; two Epsom horseraces were called after the nobleman and his mansion, in which his son-in-law, General John Burgoyne, who surrendered to the American forces at Saratoga in the War of Independence, lived for a while. The house was demolished in 1957-60, but

the grounds remain open.

To the west, WALLINGTON grew up, almost overnight, after a railway halt was established there in 1847. Of the village, the Duke's Head Inn remains at the junction of Manor and Croydon Roads. overlooking what was formerly Wallington Green, and there are some pleasant white early nineteenthcentury houses nearby, but a parish church was not needed till 1867 when Holy Trinity was designed by Habershon and Brook. The Wandle, flowing in from Croydon, runs under the London Road at the foot of

Butter Hill, with the charming eighteenth-century Bridge House beside it. Opposite, adjoining Beddington Park, The Grange, built about 1878, stood still till it was destroyed by fire in 1960. A restaurant now occupies the site but the gardens, reclaimed from marshland and laid out by the first owner's father, are still looked after by the Borough Council.

Wallington possesses one remarkable relic of industrial archaeology – a re-laid fragment of the metal track and stone sleepers of the Surrey Iron Railway, built to transport minerals and manufactures, not people. It was incorporated under an act of 1801, began operations by 1803, and closed in 1846. This, the first public railway in the world, ran between Wandsworth and Croydon, with a later extension to Merstham and a branch line across Mitcham Common to Hackbridge. The steam-engine had still to be invented so horses provided the locomotive power; the rails were grooved to hold the wheels steady, for the flanged wheel had not yet been developed.

BEDDINGTON, with all the greenery of its park, is one of the unexpected excitements that delight the heart of the explorer of the metropolis. The Romans appreciated the area – the bath-house of a villa is being excavated there at present. Standing beside the green expanse of **Beddington Park** are the village church and the manor house which, despite a mock Tudor façade given it in the nineteenth century, still cherishes its sixteenth-century Great Hall. Both buildings are still in use.

There was a church, probably of wood, here before the Conquest, and the foundations of the stone Norman building which succeeded it are still in use. The fabric of St. Mary's was largely rebuilt towards the end of the fourteenth century, when Nicholas Carew, who died in 1391, left £20.0s.0d towards the work; the south porch was constructed in the fifteenth century and the Carew Chapel added to the east end of the south aisle in 1520. The fifteenth-century square flint tower was necessarily restored early in the nineteenth century and a noble peal of bells was hung in it in 1869 - the fame of Beddington's ringers runs throughout England. A north aisle was added in 1852, a good deal of restoration work was carried out in 1867-9, and the outer walls, of flint and brick with stone dressings, have been patched up through the generations. Inside the church, we notice first the twelfth-century font, with blind arcading carved on its sides. The pulpit, made in 1611 with linenfold panelling probably taken from the manor house, is still in position. The painting of the walls and roof of the chancel dates from the Victorian restoration; the elaborate decorations around the organ were by Bell and Clayton, while the organ-case was made and painted in the Morris Workshops in Merton – it is bright with flowers, foliage, and angels. Among the choir stalls are nine of the fourteenth century with misericords. A nineteenth-century copy of a Flemish Last Judgement hangs at the west end of the north aisle.

A delicate wooden parclose screen separates the chancel from the Carew Chapel. Sir Richard Carew (d. 1520) who built the chapel, has a plain canopied table-tomb, with brasses of himself and his wife inlaid in the surface; these brasses were once enamelled and their eyes still look towards each other. Sir Francis (d.1611), uncle of Elizabeth Throckmorton, Sir Walter Raleigh's wife, is represented by a life-sized alabaster effigy, recumbent with his head upon a rolled-up mat, with smaller figures of the nephew whom he adopted as his heir and the next generation of seven young Carews kneeling beneath. Other brasses are set in the chancel floor and are covered over for protection. The earliest is to Philippa Carew, who died in maidenhood in 1414, and who is shown with her seven brothers and six sisters, the whole brood keeping company in death. Nicholas Carew (d.1432) and his wife Isabel are represented by fine figures, four feet seven inches high, under a cusped canopy, and the only interlopers in this family company are Sir Roger Elynbrigge (d.1437), Sheriff of Surrey and Sussex, who is shown in full armour with his hands clasped in prayer, and two sisters, Katherine Berecroft and Elizabeth Barton, who both died in 1507. An ancient stone coffin, probably of Roman origin, stands in the church.

The Carews, whom we have mentioned so often, were lords of the manor from 1352 till 1859. It was Sir Nicholas who rebuilt the Great Hall, which survives, though the rest of the house was rebuilt both in the early eighteenth and mid-nineteenth centuries. Today, the manor is used as a school and day centre, so the Great Hall continues its proper function of accommodating large gatherings. It is a magnificent chamber, 60 feet long and 32 feet broad, with a sturdy hammer-beam roof, an exceptionally large achievement of the arms of Sir Nicholas Carew (d.1727) and a curious trophy of Elizabethan armour and military engines. The original iron gates have gone to America and replicas stand in their place; in the grounds are the remains of a late seventeenthcentury orangery and an octagonal dovecote. John Evelyn tells us that orange trees were here first grown in England. When Charles Hallowell Carew dissipated the family fortunes in 1859, the Rector of Beddington bought up all the parkland around the manor to save it from the developer, so that succeeding generations might still enjoy the open greenery of Beddington Park.

Wandsworth

The London Borough of Wandsworth has been formed from the union of the Metropolitan Boroughs of Battersea and Wandsworth though the latter has relinquished Clapham and Streatham to the Borough of Lambeth (see pp. 383–5). Its 9,000 acres accommodate one of the closest packed populations of any of London's 32 boroughs — nearly 290,000 people. The present administrative unit is more readily understood if it is considered as an amalgamation of five villages — Battersea, Wandsworth, Tooting, Putney, and Roehampton.

The river crossing at BATTERSEA is clearly of ancient usage, for it was from this part of the Thames that the magnificently decorated Iron Age shield, which is today one of the treasures of the British Museum, was recovered in 1857. A church stood here, its village clustered about it, before the Conquest. Within sight of Chelsea but separated from it by the river, isolated from Lambeth by the marshes to the east, the hamlet developed an independent and distinctive character which it has never lost and. though modern redevelopment has left little more than the ghost of the original village, that ghost is sturdy and dauntless and unlikely to be diminished further in the future. Throughout the Middle Ages, the manor was the property of Westminster Abbey which, in 1379, sent its chief mason, Henry Yevele, to the little church to supervise the enlargement of the east window; the outline of that window was followed faithfully in the later building. After the Reformation, the manor passed eventually to the St. John family, who were responsible for the building of the mansion known today as Battersea House and of the local school. In 1771, Earl Spencer acquired the estate, built a river wall, partially drained the marshes, and in 1776 constructed the first wooden Battersea Bridge, the silhouette of which, grown shaky and precarious, Turner and Whistler delighted to paint. Once linked with Chelsea, substantial houses were built and Battersea began to develop into a fashionable suburb, a character which it relinquished by the end of the nineteenth century but which it is now, slowly, beginning to regain.

The local vestrymen decided that the medieval

church needed a more imposing replacement. Joseph Dixon was appointed architect and built the present **St. Mary's**, almost exactly upon the foundations of the old, at the very edge of the river-bank. It is of dark red brick with stone quoins, a square tower with an octagonal lantern and stumpy, copper-clad spire, and a neat porch of four Tuscan pillars supporting a pediment. Behind this porch, at the west end of the church, is the vestry with a window looking out onto the Thames, from which Turner used to gaze at the river, absorbed by the play of light upon the water, the sunsets, and the shifting clouds. The chair in which he sat is now treasured in the chancel of the church.

The body of the church is plain and rectangular, with galleries running round three sides, supported by columns; the ceiling is of plaster with an elegant central rosette. The east window is filled with heraldic glass transferred from the older church, painted by Bernard von Linge and set there by the orders of Sir John St. John in 1631. The emphasis is on the St. John family's royal and noble connections and portraits of Henry VII, his grandmother, Margaret Beaufort, and his granddaughter, Queen Elizabeth I, are surmounted by full achievements of arms for the Stuart and St. John families, while numerous small shields form borders. The two flanking circular dove and lamb windows were painted by James Pearson in 1796. The lectern once belonged to Holman Hunt and the unusual wineglass-shaped pulpit was originally the upper level of a three-decker structure.

St. Mary's chief prides are her funeral monuments and her bells. There is a full peal of eight which are rung regularly, numbers 3, 4, 5, and 6 being of pre-Reformation date, though they were re-cast by Robert Mot in 1603 and by Brian Elderidge in 1653. Among the many small tablets which line aisles and galleries, there are seven particularly important monuments. The earliest is to Sir Oliver St. John (d. 1630) on which busts, carved by Nicholas Stone, of the deceased knight and his wife, Joan, stand on small pedestals between columns and under a heavy segmental pediment – an unexpectedly classical composition for so early a date. Beside it is a memorial to Henry St. John, Viscount Bolingbroke, and his second wife, Mary Clara des Champs de Marcilly, Marchioness de Villette (d. 1750), with an elabo-

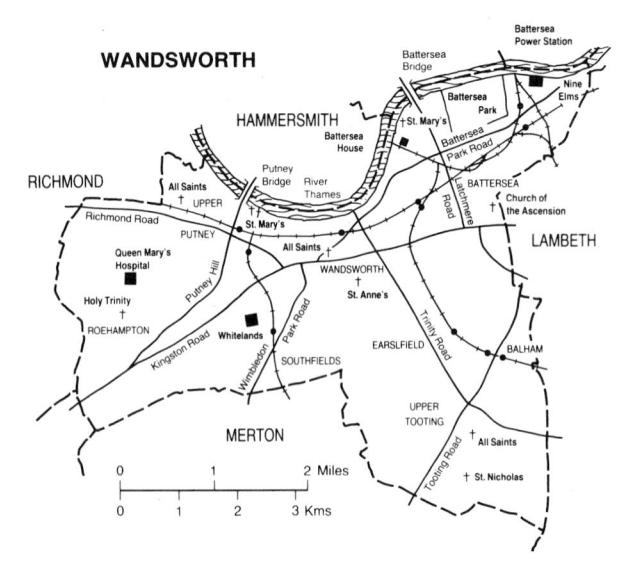

rately draped urn, a long inscription - the Marchioness was 'the honor of her own sex, the delight and admiration of ours' – and delicate profile portraits, carved by Roubiliac, of the couple. At the altar end of the same gallery is a sumptuously carved tablet to Sir John Fleet (d. 1712), who for 13 years had been Member of Parliament for the City of London, as well as Lord Mayor in 1693. His son-in-law and grandson, both called John Bull (d. 1713 and 1729), have a similar monument, surely from the same workshop, which now hangs on the south staircase. In the south gallery is a memorial to Holles St. John (d. 1738), Bolingbroke's half-brother, a pyramidshaped tablet with a sarcophagus and urn, carved by Peter Scheemakers, without inspiration, and another monument to John Camden (d. 1780) and his daughter Elizabeth Nield (d. 1791), for whom a gracefully draped lady mourns over an urn. This work is signed by Coade of Lambeth (see p. 382) but the signature must relate to the artificial stone in which it is cast, for the design is surely by the elder John Bacon. The seventh monument is to Sir Edward Wynter (d. 1685) with a grandiloquent epitaph to record his prowess:-

Alone, unarm'd, a Tygre he opprest And crushed to death ye Monster of a Beast. Thrice twenty mounted Moors he overthrew Singly on foot, some wounded, some he slew, Dispersed ye rest: what more cou'd Sampson do? True to his Friends, a Terrour to his Foes, Here, now, in peace his honou'd bones repose.

A small bas-relief represents the exploits.

William Curtis, the botanist and author of Flora Londiniensis, who died in 1799, lies in the churchyard, his gravestone recently restored by the Royal Horticultural Society, and Benedict Arnold, one of George Washington's generals, who defected

to the British side, was buried in the crypt with his wife and daughter. The church registers are almost complete from 1559 and in the marriage register is the entry for William Blake's wedding to Catherine Boucher on 18 August 1782. Of the churches outside the better known quarters of London, perhaps because it sits directly on the river-bank, Battersea is one of the most attractive of all.

To the north of the church, Mayhew's flour mill, with its warm, homely smell, occupies the site of the former manor house, which was partially demolished in 1778, though the panelling of the Cedar Room, in which Pope used to write on his visits to Bolingbroke, remained in position till it crossed the Atlantic to Philadelphia in the 1950s. To the south stands the Old Swan Inn which, paradoxically, was built only a few years ago, of white weather-boarding, to an unusual but effective design by R. Wilson Smith. There is a fine view of the river from its windows. Another public house is the Dutch-gabled Raven, which was a century old when the vestry met there to decide upon the rebuilding of the old church.

Nearby, in Vicarage Crescent, are three exceptionally interesting houses, the most important of them being Battersea House, which Sir Walter St. John built about 1699 as a dower house for his wife in their old age and where she lived in widowhood. Nine bays wide, with a hipped roof and pedimented entrance, tradition has always ascribed its design to Wren and, though research now makes this seem doubtful, its sensible, unadorned style resembles that used for Marlborough House and for St. Paul's Deanery. In 1931, Battersea House was in danger of demolition, but it was saved by Charles Stirling and his wife, the writer A. M. W. Stirling. She was the sister of Evelyn de Morgan, a distinguished painter and the wife of William de Morgan, the novelist and potter. Mrs. Stirling bequeathed to the nation her magnificent collection of the de Morgans' paintings and ceramics:1 Wandsworth Borough Council has become the owner of Battersea House and it is hoped that both house and collection will eventually be on view, by appointment, to the public. As neighbours, Battersea House has the school which Sir Walter St. John founded and which today serves as a sixth-form college, the original panelling still immaculate in the hall, stairway, and first-floor apartments, while another late seventeenth-century mansion, now known as St. Mary's House, is today used as architects' offices. It was once the home of Dr. Edward Wilson, who died with Captain Scott in the Antarctic. Explorer, scientist, and philanthropist, he was also a remarkable artist whose work is little known; the main collections are to be found in the Scott Polar Research Institute in Cambridge, the Royal Geographical Society, and the Natural History Museum.

¹ Part of the collection is on loan to the National Trust and is on view at Cragside, Northumbria.

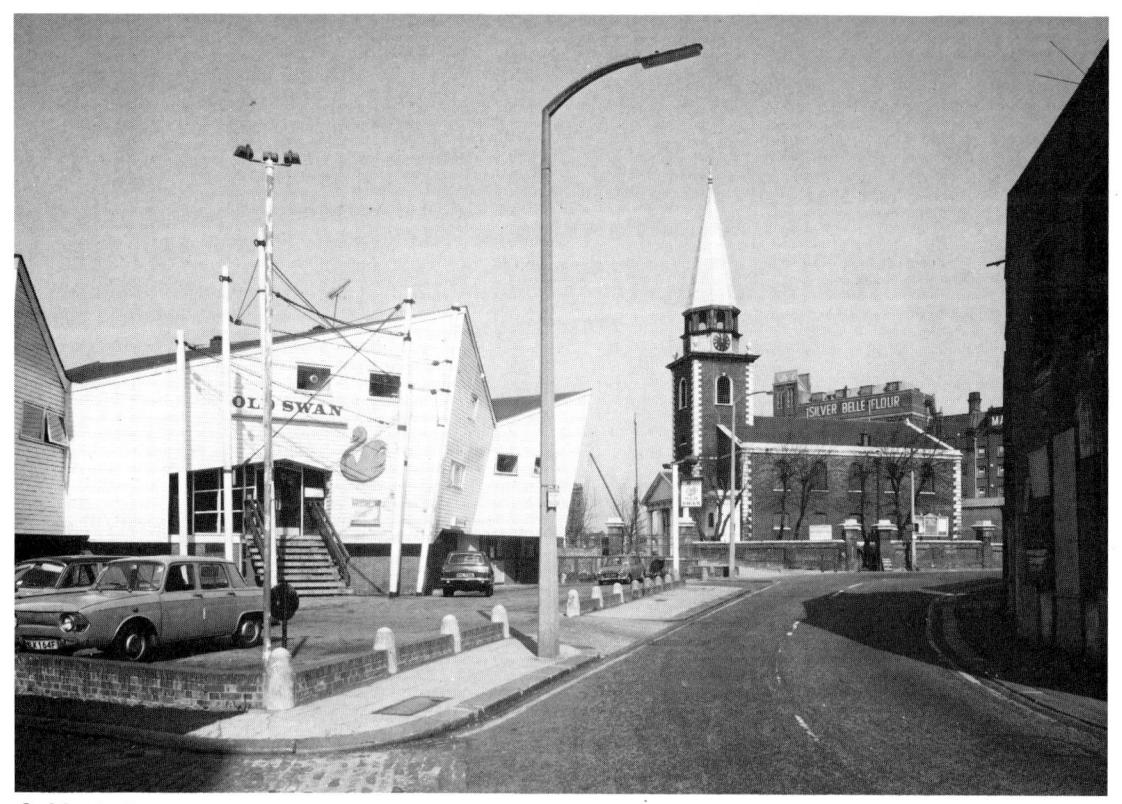

St. Mary's, Battersea

To the east of the old village centre lies Battersea Park, 200 acres of marsh and waste land which, at the instigation of Thomas Cubitt, were laid out as a public park in 1853, to designs by Sir James Pennethorne. The flat terrain was given a drive around the perimeter and a great lake in the centre, beside which stands a sculpture by Barbara Hepworth, Single Form, wrought in 1961-2 as a memorial to Dag Hammerskjold. Open-air exhibitions of sculpture are often held in the Park in the summer, where the natural setting displays large works to better advantage than any gallery can hope to do. Beyond the gardens is Battersea Power Station, built in 1932-4 by Sir Giles Gilbert Scott. Its massive, lumbering silhouette, rearing up its chimneys as if, for all the world. it was trying to be an industrial imitation of Archer's St. John's church at Westminster, has become one of London's landmarks, endearing and of great integrity. Beyond it, at Nine Elms, is the new Covent Garden, London's main fruit and vegetable market. Efficiently and hygienically laid out, it lacks the character and ebullience of the old setting.

Turning west, along Battersea Park Road is the **Dogs' Home** at number 4, where most of London's lost dogs are eventually brought and where they may be retrieved (visitors are admitted; a donation is expected). On Lavender Hill – its name a reminder of

the sweet-scented flowers which once grew in the market-gardens here - is the Church of the Ascension, begun in 1873 to designs by James Brooks and completed ten years later by Micklethwaite. Of red brick pierced by lancet windows, with a lofty waggon-roof, lean-to aisles, and a narrow ambulatory, it is worth entering for the Rood screen designed in 1914 by George Wallace and for the stained glass by C. E. Kempe and W. E. Tower, executed at intervals between 1881 and 1904. Nearby is York Road, crossing the site where, in the Middle Ages, the Archbishop of York owned a small manor. The old house passed, about 1750, into the hands of Stephen Theodore Janssen, who set up an enamel works where many small trinkets were prettily decorated. Transfer printing was employed successfully here for the first time, but despite becoming Lord Mayor of London in 1754, Janssen was declared bankrupt two years later and the little factory was closed down, leaving behind it a tradition of fine workmanship which may best be admired in the Victoria and Albert Museum, where the many enamels collected by Lady Charlotte Schreiber are now housed.

Lavender Hill runs on, past Clapham Junction, busiest in all the world, through which more than 2,500 trains pass every 24 hours, and then, as the thoroughfare changes its name to East Hill, it passes

a tiny triangle of land filled with the graves of those Huguenots who came to England in 1685 and establishing themselves in Wandsworth, introduced hatting and dyeing manufactures to the neighbourhood. Among the tombs, on which the inscriptions have now grown faint, stands a memorial listing the names of some of the families which lie here. Looking northwards across the river, one may see how much industry has congregated in this part of London. Among the factories on the river bank are Price's Patent Candle Works, established there in 1843, pungently redolent of hot wax, and the Morgan Crucible Company, which has flourished here since 1856.

At the foot of the hill is the High Street in WANDSWORTH, under which the River Wandle still flows, its passage now marked only by a slight

hump where the road bridge is. The municipal buildings, erected in 1935–7 to designs by E. A. Hunt, provide an awe-inspiring display of civic pride and pomposity. Nearby is Book House, the head-quarters of the National Book League. Of the original village there is scarcely anything left, save for All Saints' Church and one stylish terrace in Wandsworth Plain, where six early eighteenth-century houses sport Corinthian pilasters to their front doors and a brick pediment in the centre of the row. The rest is late nineteenth- and twentieth-century urban compaction, featureless unless known intimately as home territory.

All Saints' church is a happy mingling of building lovingly executed down the centuries. The tower went up in 1630, the body of the church was rebuilt in 1779–80 and then altered in 1841, and the tower

Battersea Power Station

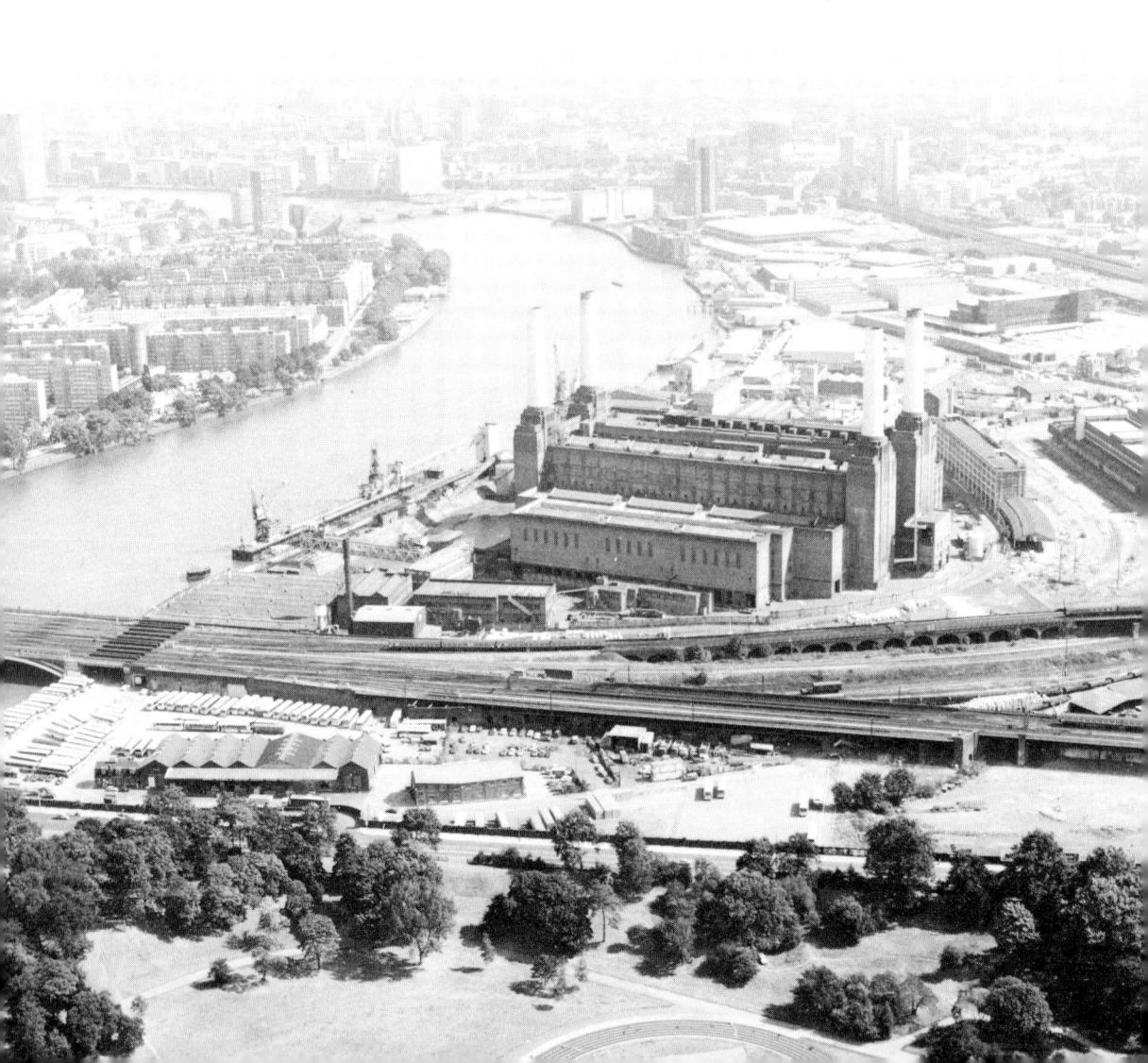
top, damaged during the Second World War, has just been restored. The entrance is on the south side. under a neat little porch with slim, prim pillars. The body of the church is rectangular and tunnel-vaulted on columns, with galleries around three sides, and the altar is recessed in a shallow apse. All Saints' has just undergone a thorough and most successful redecoration. On the north wall of the chancel there is one brass, to Nicholas Maudyt (d.1420), who was sergeant-at-arms to Henry V and whose headless body is shown in full plate-armour, and beside him two wall-monuments, to Henry Smith (d.1627) and to Susanna Powel (d.1630). These two benefactors of Wandsworth are both shown kneeling at prayerdesks, each of them in a niche, his flanked with Ionic columns, hers with Corinthian. There is a small tablet by Scheemakers to Samuel Palmer, who died in 1738 and who, in life, had been a Fellow of the Royal Society and Treasurer of St. Bartholomew's Hospital. At the west end of the church, there is a curious churchwarden's pew, large enough to hold a small fixed table and presumably intended to accommodate a vestry committee meeting.

Through Wandsworth High Street and just off West Hill is Whitelands, built in 1930 by Sir Giles Gilbert Scott to house a teachers' training college, which had been founded nearly a century earlier, in 1841, in Chelsea. It is an imposing and serious building with carefully thought out and well executed detail, such as the brick balustrading to the garden façade. The chapel was specially planned to accommodate the furnishings from the original building, in particular a gesso-work reredos painted a rich dull bronze, and stained-glass windows, designed by Burne-Jones and filled with a multitude of female saints, their names - Dorothy, Ursula, Cecilia - as sweet as the colours of their robes are rich. Ruskin took a great interest in the college, presenting it with a selection of engravings and water-colours, including a few of his own works, and instituting the election of a May Queen, chosen annually by the students, a ceremony which continues to this day, each Queen still being presented with a gold cross, as Ruskin had suggested.

To the south-east of the centre of Wandsworth, in St. Ann's Hill, stands St. Anne's church, built there in 1824 to designs by Sir Robert Smirke. Ungainly and oddly proportioned, it has a giant portico, above which a tall circular tower rises. Nearby, at the junction of Earlsfield Road and Windmill Road stands a weather-boarded, now sail-less windmill. Trinity Roads runs south-east beside the remains of Wandsworth Common, now bisected by the railway but still a green oasis, leading to TOOTING, chiefly close-packed rows of houses but with two churches of considerable importance.

The first is the parish church, dedicated to St. Nicholas and standing at the corner of Church Lane and Mitcham Road. Designed in 1833 by Thomas Witlam Atkinson, it is built of dark brick, with a

Alton West housing estate, Roehampton

gaunt and impressive tower some 99 feet high. It took the place of a much earlier church with a round Saxon tower, which was demolished, apparently without a thought, when Atkinson's church was completed. A representation of the little building appears in the stained glass of the east window. A number of memorials were brought from it and re-erected in the present St. Nicholas. They include a bell, Big Tom, cast in 1705 by Matthew Baddeley, a brass to Elizabeth (d.1582) and to William Fitzwilliam (d.1597), and a large cartouche, now high on the wall of the vestibule under the tower, to Lady Bateman (d.1709), aflutter with carved drapery, a flaming urn, two seated cherubs, and a choir of cherubs' heads. Mrs. Esdaile ascribes the monument to Francis Bird. Beside it hang the funeral helm and gilded sword of some other member of the family.

Half a mile to the south, on the corner of Franciscan Road and Brudenell Road, is All Saints church, designed by Temple Moore and built in 1905–6. Like all this architect's work, the church is spacious, plain, and sympathetic. Of brick, with an entrance under the square tower on the north side, there is an ambulatory and broad double aisles, with wooden vaulting set at right angles to the vaulting of the nave. The font, pulpit, organ-case, and memorial to the founder, Lord Charles Brudenall-Bruce, were designed by Sir Walter Tapper, but the other furnishings were brought from Italy by the first vicar, Canon John Stephens, who was an enthusiast. They are, for the most part, of the Renaissance period, and

include ironwork from a church near Lake Como, massive candlesticks from Florence, and a magnificent altar-piece and clergy stalls from Bologna. Behind the altar hangs a fine copy by Raoul Maria of Velazquez' *Christ on the Cross*, the original of which is in the Prado in Madrid. The accoustics in All Saints are of a rare quality and the church is often used for concerts and recordings.

PUTNEY lies on the western side of the borough, a certain riverside insouciance lingering among the late nineteenth-century semi-detached villas. A bridge was first built across the river here in 1729 by the King's Carpenter, but was replaced by the present structure in 1884 by Bazalgette. Since 1829, it has served as the starting-point for the annual Oxford and Cambridge University Boat Race. At its foot stands St. Mary's, the parish church, its square, early fifteenth-century tower with a small turret keeping company with that of Fulham church on the opposite bank. The body of the church was rebuilt in 1836 by Lapidge but a little fan-vaulted chantry chapel, built by Bishop West just before the Reformation, was reprieved, though it was moved to the north side of the chancel. In 1973, the church was gutted by a fire which happily spared both tower and chapel. These will be retained when St. Mary's is rebuilt. While it lay derelict, vandals stole the brasses, and it is not yet certain how far it will be possible to restore the monuments, which included exceptionally fine tablets to Katherine Palmer (d.1613) and to Richard Lussher (d.1615), the latter adorned with a maze of ribbon-work decoration. Putney High Street, leading away from the bridge, is broad, undistinguished architecturally, but friendly and with a good deal of character.

Away to the west of the High Street, on the bright edge of Barnes Common, is another church, also dedicated to All Saints, built in 1874 to designs by G. E. Street. Unpretentious and essentially a village rather than a suburban church, it has a friendly interior and a vault painted with small flowers, but what makes it worth a long journey is its glass. The windows all came from Morris's workshops and several were designed by Burne-Jones himself. In each light is a single figure – Our Lady, Pax, Caritas, St. Agnes, Isaiah, Moses, David, and a host of others – painted in the richest colours; since the church stands isolated, free from any surrounding buildings, the glass glows with every change of light.

ROEHAMPTON, still green and open, lies to the south. Roehampton was once a place that a nobleman might choose for his country seat, and an unusual number of the houses have remained on one side or the other of Roehampton Lane, today, for the most part, put to institutional uses. The most impor-

tant is Roehampton House, built in 1710 for Thomas Cary by Thomas Archer. The magnificent seven-bay brick central block was linked by graduated arcades to pavilions, and the front entrance was approached up a broad double flight of steps with an elaborate wrought-iron hand-rail. The walls and ceiling of the main salon were painted by Sir James Thornhill with The Feast of the Gods but, owing to war damage, the painting was lost. Today, the house serves, nobly, as Queen Mary's Hospital and the pavilions have necessarily been replaced by modern wings, but the steps, hand-rail, and many fine fireplaces are still there, and the Hospital is opened annually for a garden party. Roehampton Grove, which today houses the Froebel Institute, was built in 1777 by James Wyatt and Robert Adam for Sir Joshua Vanneck, afterwards Baron Huntingfield; the house has been well preserved and the gardens are still glorious. Bessborough House, built about 1750 by Sir William Chambers for the 2nd Earl of Bessborough, has become a Jesuit training college, Manresa House. Elm Grove, which James Spiller designed about 1797 for Benjamin Goldsmid, is now part of the Convent of the Sacred Heart. Mount Claire, built about 1772 by an unknown architect for George Clive, is now the property of the Greater London Council.

The old village centre, with an unusually large complement of excellent public houses, is at the southern end of Roehampton Lane. The enormous Alton Estate (1956–61, LCC Housing Division), originally praised to the skies, nowadays admired more temperately, has virtually obliterated everything on a human scale, but if one looks carefully, the village is still there, its centre a public fountain set up in 1882. Under a funereal canopy, two jolly bronze cherubs, sculpted by Henry Dasson, disport themselves; on close examination, the face of one bears a surprising resemblance to the infant Queen Victoria.

Medfield Street, a row of pretty, late nineteenth-century cottages, runs up to the edge of Putney Heath and on a corner of that Heath stands Holy Trinity church, designed in 1898 by George Fellowes Prynne. Built of Corsham stone, with a lofty waggon-roof, the most remarkable features are the elaborate reredos, busy with marble figures of Our Lord and His disciples, and the stone chancel screen which soars up to the roof, its upper part filled with tracery, so that it is like a window empty of glass through which men may walk to reach the altar.

To the south again, over the Portsmouth and Kingston Roads, is the greater part of Putney Heath, covered with thickets of birch and beech, its limits merging with those of the 1,000 acres of Wimbledon Common.

Institutions open to the Public

Although details are correct at the time of going to press, readers are advised to check details of opening times etc. before making a visit

Fleet Street

DR JOHNSON'S HOUSE 17 Gough Square EC4 3DE 01-353-3745 Mon-Sat 11-17.30 (17.00 Oct-Apr) Charge under review

NEWSPAPERS — write to editor

ST. BRIDE PRINTING LIBRARY St. Bride Institute, St. Bride Lane Fleet Street EC4Y 8EE 01-353-4660 Mon-Fri 9.30-17.30 Free

St. Bride's Crypt Museum St. Bride's church Fleet Street EC4Y 8AU 01-353-1301 Daily 9-17.00 Free

INNER TEMPLE HALL The Temple EC4 Mon-Fri 10-11.30 & 14.30-16.00 (during legal terms)

MIDDLE TEMPLE HALL Middle Temple Lane EC4 Mon-Fri 10-12.00 and 15-16.30

TEMPLE CHURCH The Temple EC4 Daily 10-16.00

St. Paul's

St. Paul's Cathedral Crypt Ludgate Hill EC4M 8AE 01-248-2705 Mon-Fri 10-15.15 (16.15 in summer) Adult 70p, child 30p

Newgate to Smithfield

THE OLD BAILEY EC4 7BS Open when courts are sitting Free

CITY WALL
Basement of the Post Office,
Giltspur Street, EC1
Apply to Postmaster-General

National Postal Museum King Edward Building King Edward Street EC1 1LP 01-432-3851 Mon-Thur 10-16.30, Fri 10-16.00 Free

ST.BARTHOLOMEW'S HOSPITAL West Smithfield EC1 Apply to archivist for permission to visit Great Hall and Staircase

Blackfriars Bridge to Southwark Bridge

COMPANY HALLS Usually open once or twice a year Ask at City Information Office

The Guildhall and its Neighbourhood

GUILDHALL King Street EC2

> Reference Library Mon-Sat 9.30-17.00 Free

Clock Museum Mon-Fri 9.30-17.00 Free

Art Gallery Mon-Sat 10-17.00 Usually free

Great Hall
Daily 10-17.00 (closed
Sun Oct-Apr)
Free

CHARTERED INSURANCE INSTITUTE MUSEUM 20 Aldermanbury EC2V 7HY 01-606-3835 Free

GOLDSMITHS' HALL Foster Lane Cheapside EC2V 6BN Open c. 6 days a year Ask at City Information Office

The Barbican, Aldersgate to Bishopsgate

MUSEUM OF LONDON London Wall EC2Y 5HN 01-600-3699 ext. 240 Tue-Sat 10-18.00, Sun 14-18.00

ROMAN FORT Fore Street EC2 Weekdays 12.30-14.00 Free

BARBICAN ART GALLERY
Barbican EC2Y 8DS
01-638-4141
Tue-Sat 12-21.00,
Sun and Bank Holidays 12-18.00
Closed between exhibitions
Charge varies with exhibition

Around the Bank

BANK OF ENGLAND MUSEUM Threadneedle Street EC2 Written application only

STOCK EXCHANGE Old Broad Street EC2 Mon-Fri 10-15.00 Free

ROYAL EXCHANGE (Commodities Exchange) Cornhill EC3 Weekdays 10-16.00 Free

ST. PETER'S CORNHILL
EC3
Every December a selection of
medieval mystery plays are performed
by the Players of St. Peter upon
Cornhill
Enquiries to the church

Bishopsgate to Aldgate

PETTICOAT LANE MARKET Middlesex Street E1 Sunday mornings

London Bridge and Riverside

ALL HALLOWS-BY-THE-TOWER Byward Street EC3 5BJ 01-481-2928 Daily 9-17.30 Free

Westminster Abbey

WESTMINSTER ABBEY Broad Sanctuary SW1 Daily 8-18.00, Wed 8-20.00

Royal Chapels, Poets Corner, Transepts and Quire Mon-Fri 9.20-16.00, Wed also 18-20.00, Sat 9.20-14.00 and 16-17.00 Adult £1.20, student 60p, OAP and under 16 10p Free on Wed evening College garden Thur 10-16.00 (Oct-Mar), 10-18.00 (Apr-Sept) Free

Abbey Treasures
Daily 10.30-16.30
Adult 25p, child and OAP 10p

Westminster

HOUSES OF PARLIAMENT Parliament Square SW1

When Houses are not sitting: Sat; Mon-Tue and Thur in August; Thur in Sep; Easter, Spring and Summer Bank Holidays; 10-17.00 During sessions queue at St. Stephen's entrance Lords Mon, Tue, Wed from 14.40, Thur from 15.10 Commons Mon-Thur from 16.15, Fri from 11.30

WESTMINSTER HALL SW1

During recess: Mon-Fri 10-16.00, Sat 10-17.00 In session: Mon-Thur 10-13.30, Sat 10-17.00

JEWEL TOWER Old Palace Yard SW1 Mon-Sat 9.30-18.30 (16.00 Oct-Mar) Adult 15p, child 5p

Westminster Cathedral Ashley Place SW1 Daily 7-20.00

Tower 10.30-dusk Adult 50p, child 30p

Whitehall and Trafalgar Square

BANQUETING HOUSE Whitehall SW1 Tue-Sat, Spring and Summer Bank Holiday 10-17.00, Sun 14-17.00 Adult 50p, child 25p

NATIONAL PORTRAIT GALLERY St. Martin's Place WC2H 0HE 01-930-1552 Mon-Fri 10-17.00, Sat 10-18.00, Sun 14-18.00 Free

HORSE GUARDS Whitehall SW1 Changed 11.00 daily, inspected 16.00

NATIONAL GALLERY Trafalgar Square WC2N 5DN 01-839-3321 Mon-Sat 10-18.00, Sun 14-18.00 Free

The Strand

ROMAN BATH 5 Strand Lane WC2 Weekdays 10-12.30 LAW COURTS Strand WC2 Public admitted when Courts are sitting

Covent Garden

LONDON TRANSPORT MUSEUM Covent Garden WC2E 7BB 01-379-6344 Daily 10-18.00 Adult £1.60, child, OAP & student 80p

BRITISH CRAFTS CENTRE 43 Earlham Street WC2H 9LD 01-836-6993 Tue-Fri 10-17.30, Sat 10-16.00 Free

St. James's

LANCASTER HOUSE Stable Yard, St. James's Palace SW1 Sat, Sun and public holidays 14-18.00 (Easter to mid-Dec) Adult 60p, child 30p

MARLBOROUGH HOUSE AND QUEEN'S CHAPEL Pall Mall SW1 5HV 01-930-9249 Mon-Fri by prior arrangement with Admin. Officer Chapel free, House 5p

20 St. James's Square Apply in writing

CHRISTIE'S AUCTION ROOMS 8 King Street SW1 Sales 5 days a week, early Oct-end July

Institute of Contemporary Arts Nash House, The Mall SW1A 1AA 01-930-3647 Tue-Sun 12-21.00 Charge 40p

CHANGING THE GUARD Buckingham Palace SW1 Alternate days 11.30 (Apr-Sep daily)

QUEEN'S GALLERY Buckingham Palace Road SW1Y 5AH 01-930-4832 ext. 351 Tue-Sat and Bank Holidays 11-17.00, Sun 13-17.00 Adult 75p, child, OAP, student and disabled 30p

ROYAL MEWS Buckingham Palace Road SW1W 0QH 01-930-4832 ext. 249 Wed-Thur 14-16.00 Adult 30p, child, OAP and student 15p

Piccadilly

ROYAL ACADEMY OF ARTS (Burlington House) Piccadilly W1V 0DS 01-734-9052 Daily 10-18.00 Charge varies with exhibition Wellington Museum (Apsley House) 149 Piccadilly W1V 9FA 01-499-5676 Tue-Thur & Sat 10-18.00, Sun 14.30-18.00 Adult £2.00, child, OAP and student £1.00

Mayfair

SOTHEBY'S AUCTION ROOMS 34 New Bond Street W1 Viewing days and auctions open to the public

MUSEUM OF MANKIND 6 Burlington Gardens W1X 2EX 01-437-2224 Mon-Sat 10-17.00, Sun 14.30-18.00 Free

NATIONAL MONUMENTS RECORD Fortress House 23 Savile Row W1X 1AB Mon-Fri 10-17.30 Free

Regent Street and Soho

St. Barnabus-in-Soho 1 Greek Street W1 Wed afternoons, Thur mornings Free

Hyde Park and Kensington Gardens

SERPENTINE GALLERY Kensington Gardens W2 3XA 01-402-6075 Daily 10-18.00 (dusk Nov-Mar) during exhibitions Free

Kensington Palace State Apartments Kensington Gardens W8 4PX 01-937-9561 ext.20 Mon-Sat 9-15.00, Sun 13-15.00 Adult £2.50, child and OAP £1.25

Belgravia, Pimlico, and Victoria

TATE GALLERY Millbank SW1P 4RG 01-821-7128 Mon-Sat 10-18.00, Sun 14-18.00 Free (charge for special exhibitions)

St. Marylebone

WALLACE COLLECTION Hertford House Manchester Square W1M 6BN 01-935-0687 Mon-Sat 10-17.00, Sun 14-1700 Free

HEINZ GALLERY 21 Portman Square W1H 9HF Mon-Fri 11-17.00 and Sat 10-13.00 (during exhibitions) Charge varies with exhibition ROYAL ACADEMY OF MUSIC York Gate, Marylebone Road NW1 Performances occasionally open to the public

MADAME TUSSAUD'S Marylebone Road NW1 5LR 01-935-6861 Daily 10-17.30 (18.00 Apr-Sep) Adult £2.75, child £1.55

LONDON PLANETARIUM Marylebone Road NW1 5LR 01-486-1121 Daily 11-16.30 Adult £1.50, child 95p

LONDON ZOO Regent's Park NW1 4RY 01-722-3333 Daily 9-18.00 (19.00 Sun and Bank Holidays, 10.00-dusk Nov-Feb), aquarium 10.00, children's zoo 10.30 Adult £3.50, student £2.50, child £1.50, OAP £1 Aquarium: adult 30p, child 10p Children's zoo: free

CRICKET MEMORIAL GALLERY Lord's Cricket Grounds NW8 8QN 01-289-1611 Mon-Sat 10.30-17.00 on match days, otherwise by prior arrangement Adult 50p, child and OAP 25p

Barking

Valence House Museum Becontree Avenue, Dagenham Essex RM8 3HT 01-592-2211 Mon-Fri 9.30-12.00 and 14-16.00, by prior arrangement Free

Barnet

BARNET MUSEUM 6 Mount Grace Road, Potters Bar Hertfordshire EN6 1RE Information: Potters Bar 54150 Tue & Thur 14.30-16.30, Sat 10-12.00 & 14.30-16.30 Free

CHURCH FARM HOUSE MUSEUM Greyhound Hill, Hendon NW4 4JR 01-203-0130 Mon & Wed-Sat 10-13.00 & 14-17.30, Tue 10-13.00, Sun 14-17.30 Free

ROYAL AIR FORCE MUSEUM Grahame Park Way Hendon NW9 5LL 01-205-2266 Mon-Sat 10-18.00, Sun 14-18.00 Free

BATTLE OF BRITAIN MUSEUM Grahame Park Way Hendon NW9 5LL 01-205-2266 Mon-Sat 10-18.00, Sun 14-18.00 Adult £1, child, student and OAP 50p

Brent

GRANGE MUSEUM OF LOCAL HISTORY Neasden Lane NW10 1QB 01-452-8311 Mon-Fri 12-17.00 (Wed 20.00), Sat 10-17.00 Free

Camden

Gray's Inn WC1

Hall, Chapel and Library Write to Under Treasurer

Gardens Mon-Fri 12-14.00 May, June, Jul; Mon-Fri 9.30-17.00 Aug, Sep Free

LONDON SILVER VAULTS Chancery House Chancery Lane WC2 Mon-Fri 9-17.30, Sat 9-12.30 Free

PUBLIC RECORD OFFICE MUSEUM Chancery Lane WC2 1LR 01-405-0741 Mon-Fri 13-16.00

SIR JOHN SOANE'S MUSEUM 13 Lincoln's Inn Fields WC2A 3BP 01-405-2107 Tue-Sat 10-17.00 Free

BRITISH MUSEUM Great Russell Street WC1B 3DG 01-636-1555 Mon-Sat 10-17.00, Sun 14.30-18.00 Free

Percival David Foundation for Chinese Art University of London 53 Gordon Square WC1H 0PD 01-387-3909 Mon 14-17.00, Tue-Fri 10.30-17.00, Sat 10.30-13.00 Free

COURTAULD INSTITUTE GALLERIES Woburn Square WC1H 0AA 01-387-0370 Mon-Sat 10-17.00, Sun 14-17.00 Adult £1, child, OAP and student 50p

JEWISH MUSEUM Woburn House Upper Woburn Place WC1H 0EP 01-387-3081 Mon-Thur 12.30-15.00, Sun 10.30-13.00 Free

Petrie Museum of Egyptian Archaeology Department of Egyptology University College London Gower Street WC1E 6BT 01-387-7050 ext. 617 Mon-Fri 10-12.00 & 13.15-17.00 Advisable to telephone in advance Free DICKENS HOUSE MUSEUM AND LIBRARY 48 Doughty Street WC1N 2LF 01-405-2127 Mon-Sat 10-17.00 Adult 75p, student 50p, child 25p

FOUNDLING HOSPITAL ART TREASURES (Thomas Coram Foundation for Children Art Gallery and Museum) 40 Brunswick Square, WC1N 1AZ 01-278-2424 Mon-Fri 10-16.00 Advisable to telephone in advance Adult 30p, child 10p

KENWOOD HOUSE, IVEAGH BEQUEST Hampstead Lane NW3 7JR 01-348-1286

House Daily 10-19.00 (17.00 Oct, Feb, Mar; 16.00 Nov-Jan) Free

Park Daily 8.00-dusk Free

FENTON HOUSE
Windmill Hill NW3 6RT
01-435-3471
Mon-Wed & Sat 11-17.00,
Sun 14-17.00 (Feb, Mar & Nov
Sat-Sun only)
Adult £1.40, child 70p

PAVLOVA MEMORIAL MUSEUM Ivy House North End Rd Golders Green NW11 7HU 01-435-1444 Sat 14-18.00 Free

KEATS HOUSE Wentworth Place, Keats Grove Hampstead NW3 2RR 01-435-2062 Mon-Sat 10-13.00 & 14-18.00, Sun & Bank Holiday Mon 14-17.00 Free

CAMDEN ARTS CENTRE Arkwright Road NW3 6DG 01-435-2643 Mon-Sat 11-18.00 (20.00 Fri), Sun 14-18.00 Free (charge for special exhibitions)

FREUD MUSEUM 20 Maresfield Gardens, NW3 5SX 01-435-2002 Wed-Sun, 12-17.00. Adult £2.00, student and OAP £1.00

Ealing

GUNNERSBURY PARK MUSEUM Gunnersbury Park Pope's Lane W3 8LQ 01-992-1612 Mon-Fri 13-17.00 (16.00 Nov-Feb), Sat & Sun 14-18.00 (16.00 Nov-Feb) Free

Pitshanger Manor Walpole Park, W5 5EQ 01-579-2424 ext. 2683 Tues-Sat 10-17.00. Free

Enfield

FORTY HALL MUSEUM Forty Hill, Enfield EN2 9HA 01-363-8196 Tue-Fri & Bank Holiday Mon 10-18.00 (17.00 Oct-Easter), Sat-Sun 10-20.00 (17.00 Oct-Easter) Free

BROOMFIELD MUSEUM Broomfield Park N13 4HE 01-886-6555 ext. 15 Tue-Sun 10-17.00 (18.00 Tue-Fri and 20.00 Sat-Sun, Easter-Sep) Free

Hackney

GEFFRYE MUSEUM Kingsland Road E2 8EA 01-739-8368 Tue-Sat & Bank Holiday Mon 10-17.00, Sun 14-17.00 Free

Hammersmith and Fulham

RIVERSIDE STUDIOS Crisp Road, Hammersmith W6 9RL 01-741-2251 Mon-Sat 11-23.00 (18.00 Mon), Sun 12-22.30

Hampton Court and Hampton

HAMPTON COURT PALACE East Molesey, Surrey KT8 9AU 01-977-8441 Mon-Sat 9.30-18.00, Sun 11-18.00 (Apr-Sep); Mon-Sat 9.30-17.00, Sun 14-17.00 (Oct-Mar) Adult £2.80, child and OAP £1.40, child under 5 free

Park and Gardens Daily until 21.00 or dusk if earlier Free (Maze 30p, Orangery 10p)

Banqueting House, Tudor Tennis Court, Kitchens & Cellars Apr-Sep Free

Haringey

BRUCE CASTLE MUSEUM Lordship Lane N17 8NU 01-808-8772 Tue-Fri 10-17.00, Sat 10-12.30 and 13.30-17.00 Free

Harrow

KODAK MUSEUM Headstone Drive, Harrow HA1 4TY 01-863-0534 Mon-Fri 9.30-16.30, Sat-Sun & Bank Holidays 14-18.00 Free

Havering

WINDMILL
St. Mary's Lane, Upminster
Apply in writing to the borough
council

Hillingdon

SWAKELEYS HOUSE The Avenue, Ickenham, Middlesex 01-713-9577 Admission by appointment only

Hounslow

CHISWICK HOUSE Burlington Lane, Chiswick W4 2RP 01-994-3299 Daily 9.30-13.00 & 14-18.30 (16.00 Oct 16-Mar 14, and closed Mon and Tue) Adult 50p, child and OAP 25p

HOGARTH'S HOUSE Hogarth Lane, Chiswick W4 2QN 01-994-6757 Mon-Sat 11-18.00 (16.00 Oct-Mar), Sun 14-18.00 (16.00 Oct-Mar) (closed Tue Oct-Mar) Free

LONDON'S LIVING STEAM MUSEUM Green Dragon Lane Brentford TW8 0EF 01-568-4757 Sat-Sun & Bank Holidays 11-17.00 Adult £1, child and OAP 60p

MUSICAL MUSEUM 368 High Street, Brentford TW8 0BD 01-560-8108 Sat-Sun 14-17.00 Apr-Oct Adult 80p, child 50p

Syon House Syon Park, London Road Brentford TW8 8JF 01-560-0884

House

Sun-Thur 12-17.00 Good Friday-Sep, Sun 12-17.00 Oct Adult 75p, child, student & OAP 40p

Gardens Daily 10-18.00 (dusk Oct 26-Feb) Adult 70p, child and OAP 40p

OSTERLEY PARK HOUSE Isleworth TW7 4RB 01-560-3918 Tue-Sun & Bank Holiday Mon 14-18.00 (Apr-Sep), 12-16.00 (Oct-Mar) Adult 50p, child and OAP 20p

Islington

CHARTERHOUSE Charterhouse Square EC1 Wed at 14.55 Apr-Jul Adult 50p, child 25p

HONOURABLE ARTILLERY CO. MUSEUM Armoury House, City Road EC1 Apply in writing

WESLEY'S HOUSE AND MUSEUM 47 City Road EC1Y 1AU 01-253-2262 Mon-Sat 10-16.00, Sun after 11.00 service Adult £1.20, child and OAP 60p

Kensington and Chelsea

LEIGHTON HOUSE 12 Holland Park Road W14 8LZ 01-602-3316 Mon-Sat 11-17.00 Free

LINLEY SAMBOURNE HOUSE 18 Stafford Terrace W8 7BH 01-994-1019 Wed 10-16.00 & Sun 13-16.00, Mar-Oct Charge £1.50

ROYAL COLLEGE OF MUSIC Prince Consort Road South Kensington SW7 2BS 01-589-3643

Department of Portraits Mon-Fri 10-17.00, by prior arrangement Free

Museum of Instruments Mon & Wed 10.30-16.30 during term, by prior arrangement Adult 50p, child and OAP 25p

SCIENCE MUSEUM Exhibition Road SW7 2DD 01-589-3456 ext. 632 Mon-Sat 10-18.00, Sun 14.30-18.00 Free

GEOLOGICAL MUSEUM Exhibition Road SW7 2DE 01-589-3444 Mon-Sat 10-18.00, Sun 14.30-18.00 Free

NATURAL HISTORY MUSEUM Cromwell Road South Kensington SW7 5BD 01-589-6323 Mon-Sat 10-18.00, Sun 13-18.00. Adult £2.00, child £1.00 Mon-Fri, 16.30-18.00 free BADEN-POWELL HOUSE Queen's Gate SW7 5JS 01-584-7030 Daily 9-17.00 Free

VICTORIA AND ALBERT MUSEUM Cromwell Road South Kensington SW7 2RL 01-589-6371 Mon-Thur & Sat 10-17.50, Sun 14.30-17.50 Free

CROSBY HALL Cheyne Walk, Chelsea SW3 5AZ Mon-Sat 10-12.00 & 14-17.00, Sun 14-17.00 Free

CARLYLE'S HOUSE 24 Cheyne Row, SW3 5HL 01-352-7087 Wed-Sat & Bank Holiday Mon 11-17.00 Apr-Oct, Sun 14-17.00 Apr-Oct Adult £1, child 50p

CHELSEA PHYSIC GARDEN 66 Royal Hospital Road SW3 4HS 01-352-5646 Mon-Fri 8-17.00, by prior arrangement Free ROYAL HOSPITAL MUSEUM Royal Hospital Road SW3 4SL 01-730-0161 Mon-Sat 10-12.00 & 14-16.00, Sun 14-16.00 Free

ROYAL COLLEGE OF ART Kensington Gore SW7 2EU 01-584-5020 Mon-Fri 10-18.00 Free

Newham

ABBEY MILLS PUMPING STATION Abbey Lane, E15 Apply in writing

PASSMORE EDWARDS MUSEUM Romford Road, Stratford E15 4LZ 01-519-4296 Mon-Fri 10-18.00 (20.00 Thur), Sat 10-13.00 & 14-17.00 Free

Tower Hamlets

WHITECHAPEL ART GALLERY Whitechapel High Street E17 QXX 01-377-0107 Mon-Fri & Sun 11-17.50 Free, except for special exhibitions

SPITALFIELDS MARKET Commercial Street E1 Early morning

BETHNAL GREEN MUSEUM OF CHILDHOOD Cambridge Heath Road E2 9PA 01-980-2415 Mon-Thur & Sat 10-18.00, Sun 14.30-18.00 Free

HISTORIC SHIP COLLECTION East Basin St. Katharine's Dock E1 9AF 01-481-0043 Daily 10-17.00 (19.00 in summer) Adult £1.50, child 50p

Tower of London

Tower of London Tower Hill EC3 01-709-0765 Mon-Sat 9.30-17.00 (16.00 Nov-Feb), Sun 14-17.00 (Mar-Oct) Adult £4.00, child and OAP £2.00

Jewel House Opening times as above (closed Feb)

Royal Fusiliers Museum Mon-Sat 9.30-17.45 (16.30 Nov-Feb), Sun 14-17.45 (Mar-Oct) Admission 25p

Ceremony of the Keys Apply in writing to the Governor

Tower Bridge SE1 2UP Daily 10-18.30 Apr-Oct, 10-16.45 Nov-Mar (closed Sun Nov-Feb) Adult £2.00, child and OAP £1.00

Waltham Forest

EPPING FOREST MUSEUM (Queen Elizabeth's Hunting Lodge) Rangers Road, Chingford E4 7QH 01-529-6681 Wed-Sun and Bank Holiday Mon 14-18.00 (or dusk, if earlier) Adult 25p, child free

Vestry House Museum Vestry Road, Walthamstow E17 9NH 01-527-5544 Mon-Sat 10-17.30 (17.00 Sat) Free

WILLIAM MORRIS GALLERY (Brangwyn Gift) Lloyd Park, Forest Road E17 4PP 01-527-5544 Telephone for information Free

Bexley

HALL PLACE Bourne Road, Bexley, Kent DA5 1PQ 0322-526574 Mon-Sat 10-17.00 (sunset if earlier), Sun (Apr-Sep) 14-18.00 Free

RED HOUSE Red House Lane, Bexley Heath, Kent One weekend each month; apply in writing only

Bromley

Orpington Museum The Priory, Church Hill Orpington, Kent BR6 OHH Farnborough 31551 Mon & Wed 9-18.00, Tue & Fri 9-20.00, Sat 9-17.00 Free

CHARLES DARWIN MEMORIAL MUSEUM Luxted Road, Downe Orpington, Kent BR6 7JT Farnborough 59119 Tue-Thur, Sat-Sun & Bank Holiday Mon 13-18.00, closed Feb Adult £1.20, child 30p, OAP 60p

Croydon

CROYDON PALACE Old Palace Road, Croydon, Surrey 21-25 Apr, 26-30 May, 13-18 Jul, 20-25 Jul Adult 25p, child 12p

Greenwich

NATIONAL MARITIME MUSEUM Romney Road, Greenwich SE10 9NF 01-858-4422 Building incorporates Queen's House Tue-Fri 10-18.00 (17.00 in winter) Sat 10-18.00, Sun 14-17.30 (17.00 in winter) Adult £1.80, child and OAP 90p

Old Royal Observatory Greenwich Park Times as above Combined ticket with museum Planetarium
Mon, Tue, Thur & Fri at 14.30 and
15.30
Adult 30p, child 15p
Cutty Sark
Greenwich Pier
01-858-3445
Mon-Sat 11-18.00 (17.00 in
winter), Sun 14-30-18.00 (17.00 in
winter)
Adult £1.20, child 60p

Gipsy Moth IV Greenwich Pier Apr-Oct, hours as for Cutty Sark, but closed Fri Adult 20p, child 10p

ROYAL ARTILLERY REGIMENTAL MUSEUM Academy Road, Woolwich SE18 4JJ 01-856-5533 ext. 2523 Mon-Fri 10-12.00 and 14-16.00 Free

WOODLANDS ART GALLERY 90 Mycenae Road Blackheath SE3 7SE 01-858-4631 Mon-Tue and Thur-Sat 10-19.30 (18.00 Sat), Sun 14-18.00 Free

WOODLANDS LOCAL HISTORY CENTRE 90 Mycenae Road Blackheath SE3 7SE 01-858-4631 Mon-Tue and Thur 9-20.00, Sat 9-17.00 Free

RANGER'S HOUSE Chesterfield Walk Blackheath SE10 8QX 01-853-0035 Daily 10-17.00 (16.00 Nov-Jan) Free

MUSEUM OF ARTILLERY (Rotunda) Repository Road SE18 4JJ 01-856-5533 ext. 385 Mon-Fri 12-16.00, Sat-Sun 13-16.00 (17.00 Apr-Oct) Free

ELTHAM PALACE Eltham SE9 Thur & Sun 10-12.15 & 14.15-18.00 (16.00 Oct-Mar) Free

WELL HALL (Tudor Barn Art Gallery) Well Hall Road, Eltham SE9 6SZ 01-850-2340 Mon-Fri & Sun 11-16.30 (20.00 Apr-Aug) Free

Kingston upon Thames

KINGSTON UPON THAMES MUSEUM AND ART GALLERY Fairfield West, Kingston upon Thames, Surrey KT1 2PS 01-546-5386 Mon-Sat 10-17.00 Free CHESSINGTON ZOO Chessington, Surrey KT9 2NE Epsom 27227 Daily 10-17.00 (19.00 summer holiday period, 16.00 in winter) Adult £5.00, child and OAP £4.00

Lambeth

ROYAL FESTIVAL HALL Belvedere Road SE1 01-928-3191 Guided tours available

NATIONAL THEATRE South Bank SE1 01-928-2252 Guided tours available

Hayward Gallery South Bank Belvedere Road SE1 8XZ 01-928-3144 Mon-Thur 10-20.00, Fri-Sat 10-18.00, Sun 12-18.00 Charge varies with exhibition

LAMBETH PALACE Lambeth Road SE1 Apply to the Archbishop's secretary

MUSEUM OF GARDEN HISTORY St. Mary-at-Lambeth Lambeth Palace Road SE1 01-373-4030 Mon-Fri 11.00-15.00, Sun 10.30-17.00 (closed Saturdays and from second Sunday in Dec. to first Sunday in March)

Lewisham

HORNIMAN MUSEUM London Road, Forest Hill SE23 3PQ 01-699-1872 Mon-Sat 10.30-18.00, Sun 14-18.00 Free

Merton

JOHN EVELYN SOCIETY MUSEUM 26 Lingfield Road Wimbledon SW19 4QD 01-946-9529 Sat 14.30-17.00, or by prior arrangement Free

WIMBLEDON LAWN TENNIS MUSEUM Church Road, Wimbledon SW19 5AE 01-946-6131 Tue-Sat 11-17.00, Sun 14-17.00 Adult £1.50, child and OAP 75p

WIMBLEDON WINDMILL MUSEUM Windmill Road Wimbledon Common SW19 5NR Sat, Sun & Bank Holiday Mon 14-17.00 (Apr-Oct) Adult 20p, child 10p

Richmond upon Thames

Ham House Richmond, Surrey TW10 7RS 01-940-1950 Tue-Sun 14-18.00 (Apr-Sep), 12-16.00 (Oct-Mar) Adult £1.80, child, student & OAP 90p

Kew Gardens (Royal Botanic Gardens) Kew, Richmond, Surrey TW9 3AB 01-940-1171 Daily 10-20.00 (16.00 in winter) Admission 50b

Kew Palace Kew, Richmond, Surrey TW9 3AB 01-940-7333 Daily 11-17.30 Apr-Sep) Adult 70p, child and OAP 35p

MARBLE HILL HOUSE Richmond Road Twickenham TW1 2NL 01-892-5115 Mon-Thur & Sat-Sun 10-17.00 (16.00 Nov-Jan) Free

STRAWBERRY HILL Waldegrave Road Twickenham, Middlesex Wed & Sat afternoons with written permission

Southwark

Southwark Cathedral London Bridge SE1

BEAR GARDENS MUSEUM & ARTS CENTRE 1 Bear Gardens, Bankside, Southwark SE1 9ED 01-928-6342 Fri-Sun 10.30-17.30 (Apr-Dec), Bank Holiday Mon 10.30-17.30, Wed & Thur by prior arrangement, Mon-Fri (Feb-Mar) by prior arrangement Adult 50p, child, student & OAP 25p

OLD OPERATING THEATRE Southwark Cathedral Chapter House St. Thomas's Street, SE1 9RZ 01-407-7600 ext. 3149 Mon, Wed and Fri 12.30-16.00 Adult 40p, child and OAP 20p

HMS BELFAST Symons Wharf, Vine Lane, Tooley Street SE1 2JH 01-407-6434 Daily 11-16.30 (17.30 in summer) Adult £3.00, child and OAP £1.50

IMPERIAL WAR MUSEUM Lambeth Road SE1 6HZ 01-735-8922 Mon-Sat 10-17.50, Sun 14-17.50 Free

CUMING MUSEUM 155 Walworth Road SE17 1RS 01-703-3324 Mon-Fri 10-17.30 (19.00 Thur), Sat 10-17.00 Free

LIVESEY MUSEUM 682 Old Kent Road SE15 1JF 01-639-5604 Mon-Sat 10-17.00 Free

SOUTH LONDON ART GALLERY Peckham Road SE5 8UH 01-703-6120 Mon-Sat 10-18.00 and Sun 14-18.00 (during exhibitions) Free

DULWICH PICTURE GALLERY
College Road SE21 7AD
01-693-5254
Tue-Sat 10-13.00 and 14-17.00,
Sun 14-17.00
Adult £1.50, student & OAP 50p, child
free

Sutton

WHITEHALL
Malden Road, Cheam
Surrey SM3 8QD
01-643-1236
Tue-Fri 14-17.30 (Apr-Sep), WedThur 14-17.30 (Oct-Mar), Sat &
Bank Holidays 10-17.30,
Sun 14-17.30
Adult 50p, child 25p

LITTLE HOLLAND HOUSE 40 Beeches Avenue, Carshalton Surrey First Sun of each month Mar-Oct and on Bank Holidays 12-18.00

Wandsworth

BATTERSEA DOGS HOME 4 Battersea Park Road SW8 01-720-7982 Mon-Fri 9.30-16.45 Adult 10p, child 5p

OLD BATTERSEA HOUSE Vicarage Crescent SW11 For admission apply in writing to c/o 21 St Margaret's Crescent, Putney SW15

INDEXES

1. Places of Worship

RC indicates a Roman Catholic church. See also under Chapels in the General Index. Italic numbers refer to pages with illustrations.

All Hallows, Barking-by-the-Tower

12, 90, 389; 91 -, Bread St. 57

-, Gospel Oak 21, 190, 222; 222

— the Great 14, 67, 88 –, Lombard St. 9, 409

—Staining 83

–, Teddington 409

—, Thames St. 246 —, Tottenham 258

on-the-Wall 64; 65 All Saints, Barnes 432

-, Blackheath 390 —, Camden St. 219

-, Carshalton 423

—, Chelsea 16, 307 —, Chingford 332

—, Cranham 269 -, Isleworth 288

-, Edmonton 236

-, Foots Cray 341

-, Fulham 244, 246 -, Kingston 373

-, Margaret St. 183 —, Orpington 351-2

-, North Peckham 353

-, Sanderstead 359 -, Stratford 310; 312

-, Tooting 431 -, Wandsworth 430

Wapping 323 All Souls, Langham Place 161, 183

Baptist Church, Sutton 420; 423 Bevis Marks Synagogue 81, 83; 82 Broad Mead Baptist Church 314 Brompton Oratory (RC) 306

Christ the King 217 Christ the Saviour 229

Christchurch, Bexley Heath 21, 342

-, Blackfriars Rd. 413

-, Brixton/Streatham 384 —, City 41

—, Isle of Dogs 323

—, Lancaster Gate 191 —, Southgate 237 —, Spitalfields 19, 215, 320; 323

Sutton 420

Church of the Annunciation,

Chislehurst 350

Church of the Ascension, Hangar Hill

Church of the Ascension, Wandsworth 429

Church of the Cross, Thamesmead

Church of the English Martyrs (RC)

Church of the Good Shepherd 241

Holy Cross 233

Holy Innocents, Kingsbury 209 Holy Trinity, Clapham 383 —, Gosport, Hants 264

—, Hounslow 289 —, Marylebone 55

—, Minories 55 -, Northwood 279

-, Prince Consort Rd. 302; 303

-, Roehampton 432 —, Sidcup 342

-, Sloane St, 309; 303

—, Wallington 426

Immaculate Conception (RC) 160 Immaculate Heart of Mary, Hayes (RC) 270, 276

Immanuel, Streatham 385

John Keble Church 201

Keston Parish Church (dedication lost) 354

Methodist Church, Muswell Hill 257 Moravian Church 257 Mosques 188, 321

Notre Dame de France (RC) 166

Our Lady, St. Mary Cray 351 Our Lady of Salette (RC) 270 Our Lady Star of the Sea (RC) 368 Our Lady and St. Thomas of Canterbury (RC) 261

Sacred Heart (RC) 178 St. Aidan (RC) 231, 270 St. Albans Abbey 13

—, Cheam 421

-, N. Harrow 261 —, Teddington 409

—, Wood St. 12, 56, 62 St. Alphege 62, 215; 62 —, Greenwich 19, 362, 367 St. Andrew's, Enfield 234

—, Marylands Drive, Foots Cray 341

-, Fulham 245 —, Holborn 211, 220

—, Hornchurch 267 —, Ilford 316

–, Kingsbury (2 churches) 208; 208 –, Surbiton 376

— Undershaft 14, 78; 79

— by-the-Wardrobe 48

-, Totteridge 201 -, Willesden 207

St. Anne's, Blackfriars 47

-, Kew 403

-, Limehouse 19, 215, 325

—, Soho 163, 165

-, Wandsworth 431

St. Anne and St. Agnes 57 St. Anselm's, Hatch End 262

St. Antholin's 60

St. Augustine's, Hackney 240

—, (near St. Paul's) 38 —, Kilburn 21, 194, 206, 361; 208

St. Barnabas, Dulwich 419

St. Bartholomew-the-Great 13, 15, 16, 44-46; 45

St. Bartholomew-the-Less 44; 44 St. Benedict's Abbey (RC) 230

St. Benet's Gracechurch St. 83, 114

Mile End 319

St. Botolph's, Aldersgate 41

-, Aldgate 80

—, Bishopsgate 64 St. Bride's, Fleet St. 12, 27, 33, 90, 92,381

St. Christopher-le-Stocks 57, 67 St. Clement Danes 19, 127, 215

St. Clement's Eastcheap 71

-, Fulham Palace Rd. (note) 244

St. Columba's 307

St. Cyprian's, Clarence Gate 186; 187 St. Catherine Coleman 83, 248

St. Dionis, Parsons Green 245; 245

- Backchurch 245 St. Dunstan's, Cheam 421 plus

Lumley Chapel , Cranford 291

- in-the-East 91, 420

—, Feltham 290 -, Stepney 318

in-the-West 25-6 St. Dunstan and All Saints, Stepney

318; 320 St. Edmund's, Village Way,

Beckenham (RC) 348 of Canterbury 274

-, Lombard St. 70 St. Edward the Confessor 267

St. Elizabeth's, Richmond (RC) 399 St. Ethelburga, Bishopsgate 14, 75;

St. Etheldreda's, Ely Place (RC) 13, 212

, Fulham Palace Rd. 245

St. Gabriel Archangel 207 -, Warwick Square 177

St. George's Beckenham 348 —, Bickley 349

Bloomsbury 19, 156, 214, 215;

-, Whitechapel 81 -, Brentford 286 St. Leonard's, Heston 291 — in-the-East 19, 215, 325 —, Hanworth 290 -, Shoreditch 239 -, Willesden 206 -, Wimbledon 395 Streatham 384 —, Hornsey 256 —, Windsor 14 St. Luke's, Charlton 369 —, Woodford 314 — Woolnoth 19, 70, 78, 215; 72 —, Woolwich 370 —, Wyndham Place 186 St. Mary and St. Joseph (RC) 324 St. Mary and St. Peter 270; 270 Woodford 314 —, Norwood 385 — the Martyr, Southwark 415 — Roman Catholic Cathedral 416 —, Old St. 19, 63, 215 —, Pinner (RC) 262 St. Giles, Camberwell 417 St. Magnus the Martyr 89 —, Cripplegate 14, 62; 62 — the Abbot, Farnborough 352 — in-the-Fields 214; 211, 214 —, Ickenham 278; 277 St. Margaret's, Barking 197 —, Edgware 202 —, Fish St. 89 St. Mary the Virgin, Addington 360 —, Bexley 339 —, Lee 389 -, Chessington 377 —, Lothbury 58, 67 — Pattens 92; 92 St. Helen's, Bishopsgate 13, 14, 16, —, Downe 352-3 -, Great Warley 21 St. Helen and St. Giles, Rainham 9, —, Uxbridge 277 — (Greek Orthodox) 191 -, Westminster 9, 14, 103, 112-3, 121, 125 —, Hadley 200 12,270 St. James's, Clerkenwell 293; 293 -, Hayes 354 —, Garlickhythe 50, 88 — the-Less 178 St. Mark's, Biggin Hill 353; 353 —, Dalston 241 —, Leyton 335 –, Merton 391 —, Kennington 383
—, N. Audley St. 160
—, Surbiton 376
St. Martin of Tours, Chelsfield 352 -, Muswell Hill 257 -, Perivale 232; 232 —, North Cray 340 —, Pentonville Rd. 296 St. Mary Magdalene, Bermondsey 415; 416 -, Piccadilly 144, 149, 415 -, Canning Road 21, 358 —, Riddlesdown 359 -, East Ham 12, 311; 312 St. Martin-in-the-Fields 121, 156, 163, 182, 214; 120 — le-Grand 15, 41 —, Ludgate 9, 39, 415; 42 — Outwich 76, 245 -, Sussex Gardens 191 —, Paddington 193; 192 Thurland Rd. 415 -, Richmond 399 St. John's, Beckenham 388 —, Bethnal Green 322 -, North Ockendon 269; 268 St. Marylebone (RC) 182 —, Ruislip 279 —, West Drayton 273 St. Mary Abchurch 9, 72, 409 St. Matthew's, Bethnal Green 322

—, Brixton, 385

—, Friday St. 49, 244 —, Bexley 340 —, Clerkenwell 292 -, Coulsdon 359 —, Downshire Hill 228; 228 -, Surbiton 376 -, Acton 231 -, Hackney 240 - Aldermanbury 56 Wandsworth Bridge Rd. 244 St. Matthias, Stoke Newington 242

—, Wapping 323

—, Wapping 323 —, Hampstead 227, 264 — Aldermary 60; 59 -, Havering-atte-Bower 266 — Axe 80 —, Horsleydown 19, 215 —, Barnes 406 St. Michael and All Angels, Croydon —, Ladbroke Grove 299 —, Lambeth 381 —, Beddington 426; 425 —, The Boltons 307 21, 358, 361; 359 Walthamstow 334 -, Malden 377 -, Bromley-by-Bow 319 – Bassishaw 49 —, Sidcup 342 —, Smith Square 19, 113, 215, 270, 429; 112 — le-Bow, Cheapside 12, 58, 92; 57 —, Chislehurst 350, 351 —, Chester Square 176 — Cornhill 69, 215 —, East Wickham 343 -, Ealing 229 –, Stanmore 263-4; *264* –, Stratford 310 — of Eton 241 -, Highgate 223 — Paternoster Royal 51, 86 —, Queenshythe 51 —, Wood Street 415 —, Finchley 16, 204 — in-the-Tower 12, 326 –, Hampton Court 255 –, Hanwell 232 —, Wapping 323 — Zachary 56 -, Harefield 14, 16, 271, 279 -, Harmondsworth 272; 274 -, Harrow 141, 260, 361; 261 -, Hayes 274 St. Nicholas, Chislehurst 350 —, Chiswick 285 St. John the Baptist, Barnet 200 —, Croydon 355 — Cole Abbey 49 —, Deptford 368, 386 -, Eltham 372 —, Erith 344 -, Plumstead 371 -, Hendon 12, 14, 202; 203 —, Sutton 420 —, Tooting 431 —, Hillingdon 276; 275, 276 - at-Hill 92 —, Pinner 262 —, West Wickham 354 —, Hornsey 256 —, Ilford 312, 316 St. Olaf's 415 St. John the Evangelist, Hyde Park Crescent 190 -, Islington 296 St. Olave's, Hart Street 14, 81 old Jewry 49, 67
St. Osmund's (RC) 405
St. Pancras churchyard 418
— new church 219 Abbots, Kensington 298 –, Lambeth 382; 382 –, Lewisham 389 -, Norwood 21, 361 -, Shirley 361 St. John of Jerusalem 241 St. John's Wood Parish Church 189 St. Joseph's 223 — Matfelon 317 -, Mortlake 405 -, Newington Butts 417 -, Paddington 192 St, Jude's, Hampstead Garden Suburb —, Putney 432 — Redcliffe, Bristol 298 Whitechapel 204 St. Katharine Cree 78, 80, 130 -, Holly Place (RC) 227 —, Regent's Park 188 -Somerset 52 -, Westway 248
St. Lawrence, Brentford 286
-, Cooley 273 -, Brentford 286 - Overie, Southwark Cathedral 13, —, Chessington 377 410 —, Clapham 384 —, Covent Garden 130-2 —, Deptford 19, 215, 387; 387 — le-Strand 19, 126, 215; 127 —, Stoke Newington 241 —, Teddington 409 , Eastcote 279 —, Hammersmith 246 —, The Highway 325 —, Mill Hill 201 — Jewry 54 —, Morden 13, 393 -, Twickenham 406 –, Twyford 230 -, Pountney 85 , Upminster 268 —, Walthamstow 333 Wilton Crescent 175

—, Wanstead 315; 315

St. Paul's Cray 351

-, Whitchurch 265; 265

St. Paulinus, Crayford 343

St. Peter-le-Cheap 58 —, Cornhill 9, 69-70

—, Eaton Square 176 —, Hammersmith 248 —, Liverpool Grove 417

-, Mount Park Rd. 21, 230

—, Petersham 400 —, Surbiton 376

—, Vere St. 182 — ad Vincula 115, 330

St. Peter and St. Paul, Bromley 346

-, Chingford 332 —, Cudham 12, 353 —, Dagenham 198 —, Harlington 271 , Mitcham 392

St. Philip's, Newark St., Whitechapel

St. Philip and All Saints, North Sheen

St. Raphael 376

St. Saviour, Eltham 372 -, Lewisham (RC) 390 —, St. George's Square 177

—, Warwick Avenue 194 St. Saviour and St. Mary Overie, Southwark Cathedral 410

St. Sepulchre 42, 360

St. Sophia, Moscow Rd. 191 St. Stephen's, Gloucester Rd. 299

-, Lewisham 390 —, Rosslyn Hill 228 — Walbrook 73; 73 St. Swithin's London Stone 75, 86, 90

St. Thomas's, Ealing 232

—, Fulham (RC) 245

—, Portman Square 232

–, Noale Hill 266

—, Southwark 413 St. Vedast's 57

Trinity Church (Presbyterian/ Congregationalist), Poplar 324 -, Southwark 416

United Reformed Church, Kingston 325

United Reformed Methodist Trinity Church, Sutton 420

Westminster Abbey 9, 12, 13, 14, 15, 16, 19, 25, 95-106, 107, 112, 113, 114, 122, 130, 169, 249, 326, 328, 427; 97, 99, 103, 104, 105

2. Funeral Monuments

Barton, Elizabeth 426

This is not an index to burials, only to memorials in churches and cathedrals in London. B indicates a brass. Italic numbers refer to pages with illustrations.

Abercrombie, Sir Ralph 35 Adelmare, Sir Julius Caesar 76 Ailemer, John and wife Emma Wode (B) 344 Alanbrooke, Field-Marshal 36 Albery, Richard (B) 351 Alexander, Field Marshal 36 Alfrey, Johane 76 Alibon, Sir Richard 198 Alington, Richard 213 Amcottes, Grace 319 Amondesham, Richard (B) 229 Amyand, Sir George 423 Andrew, John (B) 354 Andrewes, Lancelot, Bishop of Winchester 412 Anne, Queen to Richard II 101 Anne, Countess of Oxford 102 Ansley, Isabel and Nicholas 389 Armagh, Grace, Countess of, 369
Ashly family 280
Ashby, Sir Robert William 280
Ashe family 407 Askew, Godfrey (B) 236 Asplyn, John (B) 236 Asquith, Henry Herbert, 98 Aston, Sir Roger 291 Atkins, Sir Richard and Dame Rebecca 384 Attlee, John (B) 276 Atwoode, John (B) 360 Auchinleck, Field Marshal 36 Auckland, William, Lord 348 Audley, Lady Mary 360 Auriol, Edward James 26 Aust, Francis 192 Austen, Sir Robert 339, 340 Austin, Joyce, Lady Clarke 412 Awsiter, Francis (B) 232 Ayloffe, William and Audrey 268 Aynsworth, George (B) 260

Bacon, Joan and John (B) 91 Badley, Thomasyn (B) 269 Balthrope, Robert 44 Bamber, John 197 Benalius, Hieronymus 91 Bancroft, Francis 76 Banister, Henry and Anne 240 Bankes, Mary, Lady 279 Barkham, Sir Robert and Lady Mary 258

Barne, Jane 206 Barret, Edmund 422

Bateman, Lady 431 Batson, Susannah 92 Bayning, Andrew and Paul 83 Bazalgette, Sir Joseph 395 Bean, Major 399 Bearsley, Margaret 60 Beaufort, Lady Margaret 104
Beckett, Sir John 244
Bedingfield, Anne (B) 262
Bell, John, Bishop of Worcester (B)
293 Benn, Sir Anthony 374 Bennet, Dame Leonora 277 Bennett, John, Lord Ossulstone 271 -, John 197 Benson, Elizabeth 239 Bentley, John and family 399 -, Thomas 285 Berecroft, Katherine 426 Berkeley families 407 —, Sir William 407 -, Lady Elizabeth 9, 291 Bernard, Alderman Walter 77 Bertie, Lord Thomas 350 Betenson, Sir Richard 350 Billingsley, Rupert 273 Blackstone, Richard 268 Bladigdone, John de (B) 343 Blake, William 36 Blanche of the Tower 102 Blisse, Richard 410 Blount, Sir Richard and Sir Michael 330 Bodley, Lady Anne 44 -, G.F. 302 Bond, Capt. Martin 76 -, Alderman William 76 Bone, Muirhead 36 Boone, Daniel 389 Boone, Nicholas and Elizabeth (B) 236 Bosanquet, Samuel 335 -, William 336 Bownell, Constance 291 Bowyer family 336 Bowyer, John and family (B) 417 Boydell, Alderman John 67 Bradyll, John 423 Bray, Alice (B) 352 Bream, Giles 312 Bridgeman, Sir Orlando 409 Brome, Thomas 352 Bromley, Sir Thomas 101 Brouncker, Henry, Viscount 399 Brownlow, Sir William and Lady Dorothy 420 Bruce, Lord 213 Buckeridge, Nicholas, Eleanor, Elizabeth and children 311

Budd, Henry and Richard 385 Buggin, Elizabeth 340 Bull, John, elder and younger 428 Bulstrode, Whitelocke 289 Bures, Reverend Isaiah (B) 233 Burgess, Capt. 35 Burnell, John and Barbara 264 -, Margaret (B) 273 Burnet, Gilbert, Bishop of Salisbury Burney, Dr. Charles 387 Burrell, Amy, Peter, and Peter 348 Burroughs, Elizabeth (B) 258 Burton, Sir Richard and Lady 405 —, Richard 407 —, Simon (B) 79 Bush, Henry 270 Butts, Sir William 244 Byne, Elizabeth 423 Byng, Alice 79 Byrkhede, John (B) 260

Camden, John 428 Camden, William 98 Campbell, John, Duke of Argyll 100 Cappone, Peter 83 Carew, Sir Francis 426 —, Sir Nicholas 81 -, Nicholas and Isabel 426 —, Philippa (B) 426 —, Sir Richard and Lady (B) 426 —, Lady 267 Carow, Henry 200 Carr, Sir Edward 276; 274 , Jane and Philadelphia 276 Cass, Sir John 81 Castell, William 415 Castilayn, Henry (B) 339 Castilayn, Henry (B) 339
Castlereagh, Viscount 98
Cecil, Sir Edward 395
—, Mildred, Lady Burghley 102
Chalmers, Alexander 241
Chaloner, Sir Thomas 285
Chamberlayne, Sir Robert 46
Champneis, Sir John 339, 340
Chapman, George 215
Chaworth, Lady Sophia 399
Cheseman, Edward and Robert 232
Cheyne, Lady 308 Cheyne, Lady 308 Child, Sir Josiah and Barnard 315 Childe, Anthony (B) 202 Cholmondeley, Sir Richard 330 Clark, W. Tierney 246 Clarke, Bartholomew 384 —, Dorothy 244 -, John George 278 Robert and Frances 318 Clayton, Sir Robert and Lady 277, 278 Clitherow, Sir Christopher 79 -, Christopher 262

Cole, George and family 400 —, Thomas (B) 113 Colet, Sir Henry 318 Collett, Alderman Peter 352 Colmore, Charles 203 Colville, Sara 308 Constable, John 36 Cooke, Sir Anthony and Lady 267 , Edward 46 Cooper, James 311; 312

—, James and wife 9, 311

—, Samuel 222 Copley, John Singleton 356 Cosein, Lady Mary Gerard 339 Coston, Bridget 233 Cotton, Robert and family 399 Couhyll, Elizabeth (B) 389 Coventry, Francis 405 Crewes, Margaret 351 Cribb, Tom 371 Cripps, Sir Stafford 36 Crisp, Sir Nicholas 246 —, Samuel 377 Croke, Alderman John (B) 90 Crompton, John and Joanna (B) 422 Crosby, Sir John 77 Crosse, Thomas and wife 293 Crowley, Sir Ambrose and Lady 393 Crugge, John and Barbara (B) 280

Dacre, Gregory, Lord 308 Dacres, Henry and Elizabeth (B) 26 Dalton, John 264 Damsell, Margaret (B) 348 Darcy, Elizabeth, Lady Lumley 422 -, Lord 81 Davidson, Henry 374 Davy, Elys 356 Daubeny, Giles, Baron 101 Dawkes family 336 Deane, Sir James 83 De Brun, Revd. Robert (B) 352 De Burgh family 273 De la Mare, Walter 36 De Mandeville, Geoffrey 29 De Ros, Robert 29 De Salis, Count 271 De'Sans, Count 271
D'Ewes, Gerardt (B) 268
Decker, Sir Matthew 399
Deicrowe, Robert 234
Delafosse, Robert 399
Delmé, Sir Peter 92
Dely, Margaret (B) 288
Decker Alice Counters of Derby, Alice, Countess of 16, 280; 13 Dericote, Arthur (B) 240 Dick, Sir William Reid 36 Dill, Field-Marshal 36 Disraeli, Benjamin 98 Dodsley, James 150 Donne, John, Dean of St. Paul's 34 Douglas, Gavin, Bishop of St. Andrew's (B) 125 Margaret, Countess of Lennox Doulben, David, Bishop of Bangor 240 Dove, F.L. 46 Dowe, Robert 81 Downer, Robert 81
Downer, John (B) 203
Draper, William 9, 344
Drury, Joseph 261
Dudley, Elizabeth and John 241
—, Lady Mary 113
Dyce, William 385

Eardley, Lord 344 Edward III 101 Edward V 104 Eleanor, Queen to Edward I 101 Eleanor, Duchess of Gloucester (B) 102 Elizabeth I 104 Elizabeth of York, Queen to Henry Ellenborough, Lady 340 Ellenbridge, Elizabeth and Thomas 423 Ellick, Captain 255 Elmore, Bartholomew 80 Elrington, Rowland and Agnes 314 Elynbrigge, Sir Roger 426 Erskine, Frances 226 Evington, Francis 234 Evyngar, Andrew and Ellen (B) 91 Ewin, W.H. 286 Exeter, Elizabeth, Dowager Countess of 293

Faldo, John and Francis 311 Fawcit, William 311 Fellowes, Sir John 423 Fenner, Sir Edward 274 Fetherstone, Cuthbert 26 Finch, Matthew and Mary 387 Finnis, John 91 Fishborne, Richard 58 Fitzwilliam, Viscount 399 William and Elizabeth (B) 431 Flambard, Sir John and Sir Edmund (B) 260 Fleet, Sir John 428 Foote, Sir Thomas and Elizabeth 311 Forster, Alfred 91, 389 Elizabeth 389 Foulis, Charles 314 Fowler family (B) 296 Edmund, Bishop of Gloucester 203 Fox, Charles James 97 Frampton, Sir George 36 Freke, John and Elizabeth 44 Freshwater, Elizabeth 46 Fromond, Thomas and Elizabeth (B) 422 Fuller, Francis 197 —, Thomas 291

Garrick, David 98 Gaspey, Ursula (B) 335 Gaynesford, Nicholas and Walter (B) Gee, Sir Orlando 288 Gerard, William 261 Gifford, Adriana 230 Gilbert, Alfred 36 Gladstone, William 98 Godfrey family 314 Good, James (B) 273 Goode, John 377 Goodman, Gabriel, Dean of Westminster Abbey 102 Goodyere family 200 —, John and Thomasyne 409 Gordon, George, Earl of Aberdeen 264 , General 34 Gorges, Sir Arthur (B) 307 Goring, Charles, Earl of Norwich 336 Gort, Field Marshal 36 Gostling, Anne and George 407

Gales family 200

Grattan, Henry 98 Green, Walter (B) 274 Greenaway, Randolph 399 Greenwood, Benjamin and Philadelphia (B) 351 Greg, John and Catherine 255 Grene family 200 Gower, John 410 Gresham, Sir Thomas 76 Gyfforde, Susan (B) 233

Haddon, Sir Richard (B) 83 Hale, Thomas (B) 333 Halsey, Thomas, Bishop of Leighton in Ireland (B) 129 Hammersley, Sir Hugh 79 Handel, George Frederick 98 Hansard, Luke 215 Harley, Edward, Earl of Oxford 98 Harman, Anne (B) 344 Hart, Katherine 244 Harvie, Matthew and wife 407 Hatsell, Elizabeth 244 Hattecliffe, Thomas 360 Hawte, Edward (B) 344 Hawtrey, Bregget, John, and Ralph (B) 279 Hay, Andrew 35 Haybourne, Sir Ferdinando and Anne Hayman, Peter 352 Heigham, Elizabeth (B) 312 Henley, W.E. 36 Henry III 101 Henry V 101 Henry VIII 103 Heron, Thomas (B) 313 —, Thomas, daughters of 356 Herringman, Alice and Henry 423 Hertcombe and wife (B) 374 Hertcombe and wife (B) 374
Hervey, Sir George 267
Heygge, Revd. John (B) 354
Heyton, John 374
Hewer, William 384
Hickes, Elizabeth, Lady Marthagnes,
Sir Michael, and Sir William 335
Higate, Thomas (B) 274
Hillersden family 336 Hoare, Lady Frances 348 —, Sir Richard 26 Sophia 384 Hobbes, Margaret 354 —, Thomas 384 Hofland, Barbara 399 Hoghton, General 34; 35 Holford, W.G. 36 Holland, Earl of 298 —, John, Earl of Exeter 330 Holwell, John and wife 262 Howard, Elizabeth 359 –, Henry, Earl of Northampton 367 –, John 35 Howland family 384 Humble family 407 , Alderman, Isabel, and Margaret 16,412 Humphreys, Sir Orlando 197 Hungerford, Thomas 307 Huniades, John 239 Hunsley, Matthew (B) 232 Hunting Horn Brass 339 Hunting field, Sir Walter 354 Hurlock, Joseph and Sarah 241 Huxley, George 236 Hyde, William and Anne 313

Irby, Margaret (B) 258 Ironside, Field Marshal 36

James, Roger (B) 91 Jervoise, Richard 308 John of Eltham 102 Johnson, Samuel 35 Johnson, Elizabeth (Tetty) 346 Jones, Sir William 35 Judd, Sir Andrew 77 Judkin, Hobson 26

Kandeler, Richard and Elizabeth 258 Katherine, Princess, Henry III's daughter 102 Kean, Edmund 399 Kelly, Sir Gerald 36 Kinge, Alexander 16, 204 Kirton, John 236 Kirwin, William 76 Kitchener, Lord 34 Kniverton, Lady Frances 215; 214 Knox, Vicesimus (B) 209 Knyvett, Lord Thomas and Lady Elizabeth 291

Lamendby, Thomas 339
Lancaster, Edmund and Aveline, Earland Countess of 100
Landseer, Sir Edwin 36
Lane, Thomas 276
Langham, Simon, Abbot 102
Latham, Grace 268
Latimer, Lady Lucye 240
Lauderdale, Duchess of 400
Lawrence, Thomas 307
Layton, Alexander 26
—, Sir Roger 215
Legh, Gerald 26
—, Margaret 244
Leheup, Sir Peter 394
Leigh, Margaret, Mary, and Sir Robert 332
—, John (B) 360
—, Sir Francis, Nicholas, Sir Oliph, and Lady Sarah 360-61
Leighton. Lord 34

Leighton, Lord 34 Lennard, Sir Samuel 354 L'Estrange, Lord and Lady (B) 9, 276 Levee, Robert (B) 274 Leventhorpe, John 77 Leveson, Nicholas, Dionysia and children 79 Lichfield, Dr. William (B) 206 Limpany, Elizabeth 244 Liverpool, Countess of 374

Lockyer, Lionel 410 Loudon, parents and John Claud 262 Louis Napoleon, Prince Imperial of the French 350

Lovell, Elizabeth 361
—, Sir Gregory and family 392
—, Gregory (B) 271
Lowther, Barbara 399

Lowther, Barbara 399 Lucas, Margaret, Duchess of Newcastle 98 Luke family (B) 204

Lumley tombs 422
—, Jane, Charles, Thomas, and Mary
—, Elizabeth

–, John Lushington, Mary 389 Lussher, Richard 432 Lutyens, Sir Edwin 36 Lymsey, John (B) 240 Lynne, Rebecca and William 385 Lyon, John (B) 260

Manning, Richard (B) 351 Mansel, Robert 344 Marcilly, Mary Clara, Viscountess Bolingbroke 427 Markesby, William and Alice (B) 44 Marler, Blanche 344 Marshall, William, Earl of Pembroke Martin, Richard 31 Mary, Princess, daughter to James I 104 104
Mary, Queen of Scots 104
Massingberd, John and wife 384
Maudyt, Nicholas (B) 431
Maurice, Bishop 197
Mayo, Charles 422
Meadows, Philip 374
Melbourne, Viscounts 34
Mellish family 360
Merriall, Captain Michael 318
Merry, Sir Thomas and Lady 333
Micklethwaite, Sir John 41 Micklethwaite, Sir John 41 Middlemore, Dorothy 234 Mildmay, Sir Walter 46 Milles, Dr. Jeremiah 70 Milner, John (B) 344 Mist, John 276 Mompesson, Richard 113 Mompesson, Richard 113 Monmouthe, John (B) 271 Monoux, Sir George and Dame Ann (B) 333 Montagu, Sir Charles 197 Montgomery, Field Marshal 36 Moore, Sir John 35 More, Sir Thomas 307 Morecroft, William 26 Morecroft, Willam 20 Morley, Thomas (B) 83 Morris, Alice 340 Moyle, Robert and Walter 230 Munnings, Sir Alfred 36 Murray, Revd. James 209 Nicola 125 Musters, Francis 256

Nelson, Horatio, Viscount 17, 36
Neve, Hester (B) 312
Neville, Edmund and Jane 312
Newcastle, Duke of 98
Newdigate, Amphisilia, Anne, Editha, and John (B) 280
—, family, monuments 280
Newton, Sir Adam and Lady 369
Newton, Isaac 98
Nicholas, Ellen 232
Nicoll, Frederick (B) 209
Nield, Elizabeth 428
Nightingale, Lady Elizabeth 98
North, Elizabeth and children 26
Northcliffe, Lord 26
Northumberland, Duchess of (B) 307
Novello, Ivor 36
Nowell, Edward and Mary (B) 236

Myllet, Simon (B) 232

Offley, Sir Thomas and Lady 80 Ogle, Admiral Sir Chaloner 407 Orchardson, Sir William 36 Orde, Margaret Emma 232 Orgene, John and Elleyne 83 Osteler, Revd. John (B) 354 Oteswich, John de 77 Owen, Dr. Richard 372 Ownsted, John 360 Owsley, Newdigate 335

Packington, Dame Anne (B) 41 Page, Matthew and Isabel (B) 290 Paget, Henry, Earl of Uxbridge 276 Paget, Sir James 44 Palmer, Katherine 432 Samuel 431 Palmere, Martha 234 Palmerston, Viscount 98 Parker, Charles 280 -, Sir Henry Watson 390 , Sir Peter 113 Parry, Blanche 113 , James 395 Patience, Joseph 64 Payler, George, Maria, and family 330 Payne, William and Jane 244 , William (B) 343 Peachey, John 261 Pearce, Zachary, Bishop of Rochester 347 Peel, Sir Robert 98 Pemberton, Alderman Hugh (B) 76 Penn, Sibel 255 Pennant, Sir Samuel 88 Penton, Henry 293 Pepys, Elizabeth 83 Percival, Spencer 369 Petrie, Anne and Margaret 389 Philippa of Hainault, Queen to Edward III 101 Philips, Fabian and Andrew 231 Pickering, Sir William 77 Picton, Sir Thomas 36 Piggott, Nathaniel 407
Pitt, William, Lord Chatham 97, 354
—, William, the younger 354
Plowden, Edmund 30, 31 Ponsonby, Sir William 36 Pope, Alexander 407 —, Walter, Johane, and Alys (B) 273 Porter, Revd. Alan 350 Poulton, Francis and wife 407 Powel, Susanna 431 Pownsett, William 197 Poyntz family 269; 268 Prate, Joan (B) 204 Prujeau, Sir Francis 268 Puckering, Sir John and Lady 101 Puget, John 201 Pybus, John 422 Pye, Henry James 262 —, Humphrey 268 Pyne, Captain Valentine 330

Quelche, Revd. William 423

Radclif, Sir John and Lady 83
Raffles, Sir Stamford 46
Rahere 46
Rame, Francis 268
Ravenscroft, James 200
Rawlinson, Sir Henry 203
Rawson, Christopher and wives 91
Raynton, Sir Nicholas and Lady
Rebecca 234
Redman, Henry 286
Reeves, Pelsant 291
Reresby, Gervas 77
Resurrection Brass 91
Rey, George 256
Reynolds, Sir Joshua 36

446 Richard II 101 Richards, Michael 369 Richardson, Lady 41 , Sir Albert 36 Rivers, James 46 Roberts, Edmund, Faith, Frances, and Margaret (B) 206 Robroke, Revd. William 352 Robinson, Alderman John 76 Rochester, Robert 77 Roland, John (B) 394 Romney, Earl of 150 Rooke, Captain Robert 311 Rowdell, Henry (B) 233 Rowed, Grace 359 Roycroft, Thomas 46 Ruiz de Vergara, Dom Juan 292 Rusche, John (B) 91 Rutlish, William 392 St. John family 427 -, Henry, Viscount Bolingbroke 427 Sanny, Thomas (B) 204 Sargent, John Singer 36 Saunders, Drew (B) 276 —, Revd. Isaac 49 —, Margaret (B) 244 Say, William and Isabel (B) 278 Sayer, Vice-Admiral James 387 Scarborough, Sir Charles 291 Scawen, Sir William and Lady 423 Scott, Robert Falcon 36 Seale, John 60 Selden, John 31 Selwyn, William 350 Sencler, Roger (B) 344 Seymour, Giles (B) 356 Shakespeare, William 412 Shaw, Huntingdon 255 Sheffield, John, Duke of Buckingham Sheldon, Gilbert, Archbishop of Canterbury 356 Shepard, John, Anne, and Maude (B) Shepley, Michael and Susanna 423 Shoreditch, Edmund and Ellen 278 Shovel, Lady 344 Shrewsbury, Elizabeth, Countess of Sidmouth, Ursula, Viscountess 405 Sidney, Frances, Countess of Sussex Sievier, Robert William 389 Simpson, Mrs 67 Skerne, Robert and Joanna (B) 374 Skevington, John (B) 256 Skudemore family (B) 204 Slim, Field Marshal 36 Smalpace, Percival and Agnes 46 Smith family 392 —, family 352 -, Elizabeth 42 —, Henry 431

-, James and Sarah 246

Smythe, Revd. John 316

William and Jone (B) 234

Sophia, Princess, daughter to James I

Sparrow, Thomas, alias Lamendby

—, Thomas 244

William 291

339

Spencer, Sir John 77 -, Richard 268 Spert, Sir Thomas 318 Stafford, Lady Dorothy 113 Stainer, Sir John 34 Stanhope, James, Earl 98 Stanley, Arthur, Dean of Westminster Abbey and Lady Augusta 103 -, Henry (B) 276 —, Lady 333 Sir Robert and children 308 Staper, Alderman Richard 77 Staples, Thomas (B) 311 Statute, Richard, Elizabeth, and Clare 318 Steer, Philip Wilson 36 Steevens, George 324 Steward, Alicia 125 Stewart, Robert 113 Stockton, Revd. John (B) 354 Story, Sir John 335 Stow, John 79 Strange, Sir John 335 Stratton, W. 409 Stringer, Thomas 234 Stuart, Ludovic, Duke of Richmond and Lennox 104 Style, Sir Humphrey (B) 348 Styleman, J. 340 Sullivan, Sir Arthur 34 Sutton, Thomas 294 Sydney, Earl 350 Sylvester, Revd. Gabriel 356 Symington, William 81

Symons, Thomas (B) 233

Tableer, William (B) 384 Talbot, Bishop of Winchester 412 Tedcastell, John 197 Thackeray, John 389 Thomas, Henry, Earl of Carrick 422 Thomas, Susanna 255 Thomson, James 399
Thornhill, Richard and wives (B) 346 Thornycroft, Hamo 36 Thorpe, John and Catherine 340 —, Richard de (B) 291 -, Samuel 80 , Revd. William de (B) 354 Thrale family 384 Throckmorton, Sir Nicholas 80 Thynne, Thomas 97 William and wife (B) 91 Tilney, Edmund 384 Tiptoft, Lady Joyce 9, 234, 276 Tolson, Anne 288 Tonge, William (B) 91 Toppesfield, William 311 Townsend, Roger, Lieutenant-Colonel 97 Trafford, Sigismund 333 Trecothick, Barlow and Grizzel 361 Trehearne, John and wife 412 Turner, Dr. William 83 Turnour family 200 Tyson, Edward 409

Ungley, Anne 332 Urswyck, Revd Christopher 240 —, Sir Thomas 198

Valence, Aylmer de, Earl of Pembroke

100

—, William de 102
Vanacker, Francis 344
Vandeput, Sir Peter 92
Van Dun, Cornelius 113
Vansittart, Catherine 348
Vardon children 409
Vaughan, Sir Simon de 341
Vere, Sir Francis, and Horace, 1st
Baron Vere of Tilbury 98
Verzelini, Jacob and wife (B) 352
Villiers, George, Duke of Buckingham
103

—, Sir George and Lady Mary 102

Wade, Joseph 415 Waldegrave, William and family 313 Waleys, Alice, Walter, and family (B) Walker, James 319 Walsingham, Thomas (B) 350 Ward, Sir John 384 Sir Patience 72 Warham, Hugh 356 Washington, George 36 Watson, Charles, Rear-Admiral 98 Watt, John 234
Wavell, Field Marshal 36
Wayte, Nicholas and Ellen (B) 268
Webb, Philip 46 Weldish, William 290 Wellington, Duke of 34, 36 Westall, Sir William 293 Whichcot, Sir Jeremy 203 Whitgift, John, Archbishop of Canterbury 356 Whiting, John and Margaret 46 Whyte family (B) 204 Wiffin, Helen and William 340 Wilbraham, Sir Roger and Lady 200 Wilkinson, Edward 369 Wilkynson, Revd Thomas (B) 352 Willocks, Joseph, Dean of Westminster Abbey 97 Willesden, Bartholomew and Margaret (B) 206 William of Windsor 102 Williams, Thos. (B) 77 Wilson, Field Marshal 36 , J.B. 384 Windsor, Lord 289 Wiseman, Daniel 371 Witherings, Thomas 268 Wode, Emma (B) 344 Wodeward, William (B) 422 Wolstenholme, Sir John 264 Wood, Captain Anthony 415 -, Elizabeth and Tobias (B) 335 —, Thomas 359 —, Thomas, Susann, and children 240 Sir William 293 Woodmason children 70 Woolaston, Philadelphia 222 Wray, Daniel 42 Wylde family (B) 406 Wylliams, Thomas and wife (B) 77

Yonge, Dr 213 Young, Thomas 352 Ystele, Revd Nicholas de 352

Wynter, Sir Edward 428

3. Artists and Craftsmen

A = architect; P = painter,topographical artist, engraver, etc.; S = sculptor

Abercrombie, Sir Patrick (A) 236, 378 Adam, James (A) 183 —, Robert (A) 20, 97, 118, 123, 125, 137, 142, 143, 153, 158, 164, 173, 182, 185, 223, 255, 287, 288, 289, 291, 432 style 237, 364, 419 Adams, Acton J. (S) 181 Holden & Pearson (A) 129 Maurice (A) 418 Addis, William (clockmaker) 336 Aelst, Peter Cocke van (P) 75 Agas, Ralph (cartographer) 15 Aikman, William (P) 283 Aitchison, George, (A) 299, 324 Aiton, William (gardener) 403 Alberie, Master (mason) 105 Alder, J.S. (A) 257 Aleccio, Matteoz Perez de (P) 365 Alexander of Abingdon (S) 100 Alexander, Daniel (A) 323 Alexander, G. (A) 299 Alfune (mason) 62 Alken, Siffrin (woodcarver) 112 Allason, Thomas (A) 299 Allen, Godfrey (A) 27, 34, 63, 72, 74 Allen, Ralph (A) 44 Allison, Sir Richard (A) 301, 303 Allom, Thomas (A) 301 Alma-Tadema, Sir Lawrence (P) 189 Ambler, Thomas B (A) 184 Amigoni, Jacopo (P) 172 Annigoni, Pietro (P) 85, 276 Annis, John (S) 340 Anrep, Boris (mosaicist) 120, 180 Archer, Thomas (A) 19, 113, 132, 215, 246, 255, 387, 429, 432 Archer & Green (A) 136 Armistead, H.H. (S) 100, 170 Armistage, Edward (P) 107 Armshead, Henry Hugh (S) 108, 127 Armstrong-Jones, Anthony, Lord Snowdon (designer) 188 Arrow (carver) 364 Artari, Giuseppe (plasterer) 121, 406 Arup, Ore (A) 321 Ashley-Smith (A) 347 Athey (joiner) 39 Atkinson, Peter (A) 231 Atkinson, R. Frank (A) 346 —, Robert (A) 358, 409 -, Thomas Witlam (A) 431 Aumonier, E. (S) 178 Avis, Joseph (A) 81 Ayres, Arthur J.J. (S) 231

Ayrton, Maxwell (A) 201, 399 Ayrton, Michael (P, S) 38, 42, 418

Bacon, Charles (S) 212, 314 -, Francis (P) 181, 213 -, John, the elder (S) 35, 54, 63, 70, 98, 123, 125, 144, 152, 184, 192, 220, 264, 273, 276, 314, 364, 381, 399, 414, 429 399, 414, 428 John, the younger (S) 35, 60, 80, 144, 201, 226, 273, 280 407 Baddeley, Matthew (bellfounder) 431 Baduti, Giovanni (plasterer) 121, 406
Bailey, Arthur (A) 50, 68, 325
Baily, Edward Hodges (S) 36, 118, 145, 167, 389
Baines, Sir F. (A) 113
Baker, Sir Herbert (A) 67, 119, 129, 261, 316 Band, Benjamin (A) 307 Banks, Sir Edward (builder) 89 , Robert Richardson (A) 151 Thomas (S) 35, 68, 192, 241, 278, -, Th 389 Barbon, Nicholas (builder) 19, 127, 210 Barker, Robert (P) 166 Barlow, Francis (P) 402 —, Henry (engineer) 221 Barnes, F (A) 349 Barrow, Janet (tapestry) 128 Barry, Sir Charles (A) 20, 107, 109, 111, 112, 116, 117, 118, 140, 145, 147, 151, 214, 383, 422 -, Charles, the younger 418 -, E.M. (A) 122, 134 -, James (P) 124 -, Sir Wolfe (engineer) 331 Bartlett, Anthony (bellfounder) 80 —, and James 83 —, W. Gibbs (A) 343 —, Paul (S) 127 -, Thomas (bellfounder) 245 Bartolozzi, I. (engraver) 70 Basevi, George (A) 139, 175, 384 Basio (S) 404 Bate, Kerr (A) 230 Bates, H. (S) 117 Bauer, Francis (P) 403 Bazalgette, Sir Joseph (engineer) 20, 135, 138, 244, 246, 310, 395, 432 Bear, Bennett & Wilkins (A) 58 Beaunève, André de Valenciennes (P) Beazley, Samuel (A) 133 Bedford, Francis (A) 381, 416 —, J. (S) 244, 255 Beechey, Sir William (P) 217 Behnes, William (S) 183

Belham & Co (glass) 377 Bell, Alfred (decorator) 209, 226 -, Anning (mosaicist) 109, 180 —, C. Farrer (glass) 80, 176 —, John (S) 54, 145, 170, 322, 370 Bell & Clayton (glass) 426 Bellamy, Thomas (A) 291 Bellin, Nicholas (S) 197 Bellini, Giovanni (P) 119, 217 Bellucci (P) 264, 265 Belsky, Franta (S) 380 Bennett, Sir Hubert (A) 56, 61, 177 Benson, John (A) 418 , William (A) 171 Bentham, P.G. (S) 78 Bentley, J.F. (A) 81, 178, 383, 405 Bernini, Gianlorenzo (S) 120, 291, 304, 308 Bettes, John (P) 181 Bevis, L. Cubitt (S) 308 Bignell, James Maltby (A) 334 Billerey, Fernand (A) 176 Billing, A. (A) 42 Birch, C.H. (S) 138 Bird, Francis (S) 32, 34, 38, 234, 244, 288, 375, 407, 431 —, Richard (smith) 59 Biscoe, Guy (A) 245 Biscoe & Stanton (A) 194 Black, Adam (joiner) 357 Blackford, James (glass) 354 Blake, William (P) 181 Blakeman, Charles (glass) 212 Blee, Michael (A) 288 Blick, Nicholas (builder) 160 Blomfield, Sir Arthur (A) 28, 83, 127, 176, 244, 255, 286, 302, 372, 376, 384, 389, 405, 410, 423

—, Sir Reginald (A) 136, 138, 150, 332, 423

Blore, Edward (A) 97, 147, 310, 381

—, William (A) 266 Blow, Dettmar (A) 176 Blunt, Francis (woodcarver) 295 Bodley, George Frederick (A) 35, 175, 229, 241, 302, 358, 399, 410 and Garner, Thomas 299 Boehm, Sir Joseph Edgar (S) 25, 34, 98, 137, 169, 264, 299, 350 Bogdàny, Jakob (P) 405 Bolledon, Thomas (bellfounder) 353 Bologna, Giovanni (S) 304 Bone, Muirhead (P) 36 Bonington, Richard Parkes (P) 184 Bonomi, Joseph (A) 157 Borra, Giovanni Baptista (S) 142 Botticelli, Sandro (P) 119, 217 Boucher, François (P) 184 Boudin, Eugène (P) 120, 217 Boulle (cabinet maker) 184

Boulton, Matthew (engineer) 289 - and Watt 286, 303 Bourgeois, Sir Francis (P) 418 Boyle, Richard see Burlington, Lord Boys, Thomas Shotter (P) 189 Braddock & Martin Smith (A) 57 - and Lipsley 341 Bradshaw (weaver) 403 Bramante, Donato (A) 35 Brandon, Raphael (A) 217 Brangwyn, Sir Frank (P) 108, 334 Brazdys, Antonas (S) 56 Breton, Jean-François (S) 97 Brettingham, Matthew (A) 20, 141, 143, 153 Brewer, Cecil (A) 158 Bridgeman, Charles (gardener) 170, 266, 406, 425 Bridges, John (A) 62 Brittan, A. (mosaicist) 34 Brock, Sir Thomas (S) 34, 137, 183 Broker, Nicholas (coppersmith) 101 Brooks, James (A) 21, 190, 207, 222, 256, 350, 429 Brown, Bernard (A) 369 —, Cecil (P, S) 55, 138 -, Ford Madox (P) 225, 418 -, John (A) 389 -, Sir John & Henson (A) 257 -, Lancelot, 'Capability' (gardener) 287, 340, 342, 360 —, Mortimer (S) 388 Solomon (bricklayer) 397 Browne, Sir John (P) 50 —, Robert (P) 39, 79 Brueghel, Jan (P) 153 Brydon, John M. (A) 116 Bubb, James George (S) 54, 188 Bullesdon, Thomas (bellfounder) 44, Bullimore, John (carver) 401, 403 Bunney, Michael (A) 205 Burcombe, A.S. (glass) 242 Burford, William (bellfounder) 291 Burges, Robert (joiner) 47 Burges, William (A) 123, 209, 261, 299 Burke (mosaicist) 147 Burles, Newton and Partners (A) 270, Burlington, Lord (Richard Boyle) (A) 19, 106, 150, 151, 171, 281-5, 308, 387, 400 Burne-Jones, Sir Edward (glass) 182, 211, 237, 246, 273, 279, 334, 342, 391, 392, 431, 432 Burnet & Tait (A) 89 Burton, Decimus (A) 145, 169, 187, 188, 200, 354, 403, 404 , James (builder) 219, 220 Busch, John (gardener) 288 Bushnell, John (S) 40, 83, 192, 244, Buss, A.E. (glass) 230, 276 Butler, James (bellfounder) 208 Butterfield, William (A) 71, 183, 200, 209, 242, 243, 258 Butterley of Derby (ironfounders) 221 Byfield (organ builder) 415 and Green (organbuiders) 197

Cachemaille-Day, N.F. (A) 230, 372, 420 Cadbury-Brown, H.T. (A) 301

Caddy, Michael (designer) 191 Caine, Capt. J. (A) 86 Caldara, Polidoro (P) 401 Caldecott, Randolph (S) 36, 299 Calderon, Philip (P) 189 Campbell, Colen (A) 150, 151, 156, 159, 171, 172, 281, 285, 315, 363, 406 George (S) 231 Canaletto, Antonio (P) 165, 184, 367, Canova, Antonio (S) 153, 168, 381 Capon, William (P) 186 Carew, John Edward (S) 119 Carlile, Joan (P) 402 Carlini, Agostino (S) 125 Caro, Anthony (S) 181 Carpenter & Ingelow (A) 377 Carpentière, Andries (S) 265 Carr, James (A) 293 Carter, Bertram (A) 346 —, Edward (A) 131, 294 –, Francis (A) 294 –, John (A) 293 Casson, Sir Hugh (A) 188, 301 Caux, Isaac de (A) 131 Cave, Nicholas (mason) 125 Cawston, Arthur (A) 318 Ceunot, John (woodcarver) 142 Cézanne, Paul (P) 120, 217 Chamberlain, Powell & Bon (A) 61 Chambers, Sir William (A) 20, 125, 140, 150, 184, 288, 289, 340, 342, 397, 400, 404, 405, 432 Champagne, Philippe de (P) 120, 184 Champneys, Basil (A) 138, 226, 339, 415 Chantrey, Sir William (S) 68, 97, 167, 340, 344, 348, 350, 369, 374, 407 Chapman, S. (carver) 352 Chapman, Taylor & Partners (A) 178 Chardin, Jean Baptiste (P) 120 Chart, John (builder) 393

—, R.M., & Reading (A) 393
Chavalliaud (S) 192, 306 Cheere, Sir Henry (S) 97, 335, 350, 384 Cheston, Chester (A) 241 Child, Francis (A) 384 Child, Heather (embroiderer) 276 Christian, Ewan (A) 245, 342 Christmas, Gerard (mason) 137 John, & Matthias (S) 279 Cibber, Caius Gabriel (S) 35, 89, 163, 215, 325 Cipriani (P) 147, 289 Clacy, H.G. (A) 178 Clapperton, Thomas (S) 162 Clark, Michael (S) 96 Philip & Lindsay (S) 180, 231 Clarke, Chatfield (A) 79

—, G. Somers (A) 9

—, John (A) 213

—, Joseph (A) 164 Claude, Gellée (P) 120, 418 Clausen, Sir George (P) 109 Clay, Charles (clockmaker) 172 Clayton, Alfred B. (A) 383 -, J.R. (glass, mosaic) 100, 147 - and Bell 69, 100, 176, 178 Cleer, W. (joiner) 51, 89, 92, 309 Cleveley, John (P) 367 Cleyne, Francis (P) 402, 403, 405 Clifton, E.N. (A) 58 Clostermann, J.B. (P) 309

Clutterbuck (glass) 325 Clutton, Henry (A) 132, 178, 264 Clyde, Young & Engels (A) 137 Cobden-Sanderson, T.J. (bookbinder) 247 Cockerell, F.P. (A) 226 c, Samuel Pepys (A) 118, 164, 190, 220, 228, 243, 261 Cocteau, Jean (P) 166 Cohen, Mrs A.D. (P) 248 Coldstream, Sir William (P) 218 Cole, Ernest (S) 378 —, Frederick (glass) 413 Collcutt, T.E. (A) 125, 201 and Hamp (A) 123 Colledge, Stephen (woodcarver) 40 Collier, John (A) 353 Collins, Thomas (plasterer) 126 Collister, E.R. (A) 245 Colt, Maximilian (S) 77, 104, 280 Comper, Sir John Ninian (A) 72, 75, 160, 186, 193, 279, 358, 412, 423 —, John (S) 359, 373 Compton, John (organ builder) 193, 309 , Messrs 27, 83 —, Messrs 2/, 83 Congreve, William (P) 370 Constable, John (P) 36, 120, 181, 225, 226, 304, 306, 402 Cook, Thomas A. (mosaicist) 417 Cooke, Henry (P) 304, 309 Cooper, Sir Edwin (A) 78, 186, 331, -, Samuel (miniaturist) 131, 304, 402 Cope, Charles West (P) 107, 108, 302 Copland, Alexander (A) 150 Copnall, B. (S) 183 Corfiato, Prof. (A) 166 Corbarelli, Francisco (A) 306 Cornelius, Peter von (P) 107 Cornellis, Feter von (P. 10) Corot, Jean-Baptiste-Camille (P) 184 Correggio, Antonio (P) 153 Cortona, Pietro Berrettini (A) 126 Costin, Harry (A) 413 Cotman, John Sell (P) 181 Cotton (P) 364 Couse, Kenton (A) 383, 399 Cox, David (P) 261 Coysevox, Antoine (S) 184 Cozens, Alexander (P) 181 Crace, Frederick (decorator) 108 Cranach, Lucas (P) 217 Crane, Walter (P) 241, 299, 334, 384 Cratzer, Nicholas (scientist) 249 Craze, Romilly (A) 376 Cressent (cabinet maker) 184 Crewe, Robert (builder) 210 Crickner, Courtney (A) 205 Christian, Ewan (architect) 392 Crivelli (P) 207 Cross, Lt. Col. W.E. (A) 289 Croxtone, John (mason) 53 Crozatier (S) 404 Cruikshank, George (P) 36 Crunden, John (A) 139 Crutcher, Richard (S) 278 Cubirt, Lewis (A) 221

—, Thomas (builder) 20, 132, 143, 174, 176, 221, 242, 296, 304, 323, 383, 384, 429 —, William (A) 174, 323 Culpin and Bowers (A) 418 and Son 368

Culverden, William (bellfounder) 395 Cundy, Thomas (A) 168, 175, 176, 177, 399 Cure, Cornelius (S) 80, 104 -, Nicholas (S) 291 -, William (S) 104 Cutler, T.W. (A) 371

Dahl, J.L.O. (A) 415 , Michael (P) 150 Dale, Lawrence (A) 205 Dali, Salvador (P) 181 Dalou, Jules (S) 68, 323 Damer, Anne (S) 406 Daniel, Allie (3) 400
Dance, George (the Elder) (A) 20, 41, 64, 72, 81, 229, 239, 322, 416

—, George (the Younger) (A) 40, 44, 53, 64, 73, 145, 158, 350
Daniels, L. H. (A) 321, 322 Darbishire, H.H. (A) 321, 322 Darbourne, John & Darke (A) 178 Dasson, Henry (S) 432 David, Allen (S) 56 Davie, Clifford Robert (woodcarver) 278 Davies, Elider (A) 52 , Roger (woodcarver) 47 Davis, Louis (glass) 262 Dawkes & Hamilton (A) 208 Dawson, Clare (glass) 417

—, Matthew (A) 205

—, Robert (plasterer) 159, 276

Day, Philip (A) 207 , R. (designer) 385 Deane, Beryl (embroiderer) 37 De Bruyn, Abraham (P) 287, 364 De Loutherbourg, Philip (P) 285 De Maistre, Roy (P) 231, 276 De Morgan, Evelyn (P) 308, 428 —, William (P) 299, 308, 334, 391 De Soissons, Louis (A) 200 De Syllas, Leo (A) 38 Degas, Edgar (P) 217 Delacroix, Eugène (P) 120, 184 Denham, Sir John (A) 130, 141 Denison, E.B. (clock designer) 111 Denman, Maria (S) 218 Denning, Samuel (P) 419 Dent, E.J. (clock designer) 111 Des Granges, David (miniaturist) 402 Devis, Arthur (P) 406 Dick, Sir William Reid (S) 28, 34, 36, 112, 136, 159 Dickinson, Frank Reginald (A, P) 425 Dillworth, E.J. (glass) 242 Dixon, Joseph (A) 427 Dobson, William (P) 199, 235, 282 Dolci, Carlo (P) 418 Doman, Charles (S) 162 Donatello (S) 304 Downes, Ralph (organist) 128, 379 Downman, John (P) 184 Dove, Lt. Col. W.W. (builder) 60 — Brothers, 60, 296 -, Myles and Dierdre (A) 417 Dowbiggin, Lancelot (A) 296 Drury, Alfred (S) 40, 68 Duberly, James (builder) 263 Duccio (P) 119 Ducheman, Thomas (smith) 102 Dudeney, Wilfred (S) 289 Dufy, Raoul (P) 217 Dürer, Albrecht (P) 340 Durham, Joseph (S) 151, 166, 301

Durst, Alan (carver) 279 Dyce, William (P) 107, 183, 385 Dykes-Bower, Stephen E. (A) 35, 57, 318, 360, 371

Earp, Thomas (S) 122, 178 Easton, Hugh (glass) 44, 70, 103, 318 Eaton, Messrs. (moulders) 149 Edmonds, J. (A) 384 Edwards, Carl (glass) 30, 128 —, Morton (S) 31 Elcock & Sutcliffe (A) 27 Eldridge, Bryan (bellfounder) 80, 354, 400, 427 Elle, Ferdinand (P) 282 El Greco (P) 120 Ellis & Clarke (A) 27 Elizabeth, Princess, d. of George III (P) 404 Elsheimer, Adam (P) 153 Elsom, Pack and Roberts (A) 181 Emmett, Morris (builder) 49, 309 Emmet, William (S) 30, 39, 72, 309 England, George Duke (organ builder) 293, 340 Enthoven, Messrs (A) 325 Epstein, Sir Jacob (S) 36, 112, 129, 167, 169, 178, 182, 303 Erith, Raymond (A) 192

Erlich, George (S) 38

Espinasse, François (A) 306 Etty, William (P) 70, 123, 164 Evans, Nathaniel (A) 41

Eworth, Hans (P) 217 Eyck, Jan van (P) 119 Fabris, Pietro (P) 189 Fabritius, Carel (P) 119 Fagan, W.B. (S) 113 Faithcraft Studios (glass) 63 Fanelli, Francesco (\$) 254, 401 Farmer & Bridley (\$) 412 Feibusch, Hans (P) 75 Fellows-Prynne, George (A) 342 Ferguson, William Gowe (P) 402 Ferrey, Benjamin (A) 385, 390 Fewkes, George (plasterer) 73 Fielding, Copley (P) 261 Fildes, Luke (P) 299 Finny, Dr. Williams (A) 375 Fitzgerald, Percy (S) 128 Fitzroy, Robinson & Parts (A) 67, 347 Flandes, Juan de (P) 153 Flaxman, John (S) 35, 134, 150, 184, 203, 215, 261, 268, 286, 324, 336, 374, 384, 389, 399 Fleischmann, Arthur (glass) 178, 231, Flémalle, Master of (P) 217 Fletcher, Geoffrey S. (P) 297 Flinck, Govaert (P) 184 Flitcroft, Henry (A) 122, 143, 214, 215, 226, 266, 315 Florence, S.L. (A) 144 Floris, Franz (P) 306 Foley, John Henry (S) 145, 170 Fortana, Giovanni (A) 126 Forbes, V. (P) 109 Ford, Onslow (S) 189 Formilli, C.T.G. (mosaics) 305 Forrest, G. Topham (A) 199, 388, 393

Forshaw, J.H. (A) 22, 378

Forsyth, Moira (S) 307 Fourmaintreaux, Pierre (P) 231 Fowke, Capt. Francis (A) 301, 303, 307 Fowler, Charles (A) 132, 191, 288 , John (decorator) 159 Fox, Charles (A) 220 Fragonard, Jean Honoré (P) 184 Frampton, Sir George (S) 121, 138, 168, 183, 314 Francis, Messrs. (A) 231 Freeth, Thomas (glass) 348 Freud, Ernst (A) 228 Frink, Elizabeth (S) 38 Frith, Richard (builder) 154, 164 William (P) 192, 301 Fuller, John (joiner) 51 Fuseli, Henry (P) 145, 186

Gahagan, Sebastian (S) 35, 183 Gainsborough, Thomas (P) 119, 145, 168, 181, 184, 220, 224, 232, 403, 418, 419 Gambardella, Spiridione (P) 153 Gandy-Deering, J. (A) 160 Gardner, Starkie (smith) 46 Gardier-Brzeska, Henri (P) 121 Garland, Henry (P) 189 Gauguin, Paul (P) 217 Gear, William (P) 418 Geddes, Andrew (P) 51 Gentileschi, Orazio (P) 141, 365 George, Bruce (A) 147 —, Sir Ernest (A) 51, 89, 205 and Peto 304 George, Trew & Dunn (A) 347 Gerbier, Balthazar (A) 122 Géricault, Théodore (P) 184 Gerrard, A.H. (S) 178 Gentler, Mark (P) 321 Gheeraerts, Marcus, the younger (P) 120 Ghiberti, Lorenzo (S) 113 Gibberd, Lorenzo (5) 113 Gibberd, Sir Frederick (A) 129, 188 Gibbons, Grinling (S) 35, 72, 90, 91, 120, 139, 149, 172, 173, 251, 252, 253, 254, 265, 280, 296, 305, 309, 327, 335, 366, 368, 386, 387, 406, 407, 409 J. Harold (A) 346 Gibbs, C. Alexander (glass) 70, 73

—, James (A) 19, 44, 72, 113, 121, 126, 127, 150, 151, 156, 182, 186, 214, 264, 400, 406, 418 Gibson, George (A) 367, 389 —, John (S) 108, 177 — & Russell (A) 311 Gilbert, Alfred (S) 36, 148, 174, 350 John (S) 73 Gill, C. (P) 109 —, C. Lovett (A) 55 Eric (S) 178, 181, 183, 232 Gillray, James (cartoonist) 67, 150 Gilman, Harold (P) 222 Gimson, Ernest (A) 180 Ginner, Charles (P) 222 Giotto (P) 119 Gipkyn, John (P) 152 Girtin, Thomas (P) 181, 261 Glanfield, E.B. (A) 83 Glover, Moses (cartographer) 287 Goddard and Gibbs (glass) 204, 276 Godfrey, Walter H. (A) 30, 315 Godwin, George (A) 307 Goetze, Sigismund (P) 68

Goldicutt, John (A) 191 Goldie & Child (A) 201 Gollins, Melvin & Ward (A) 77 Good, J.H. (A) 56 Goodall, Frederick (P) 263 Goodhart-Rendall (A) 85 Gordon, Max (A) 178 Gordon & Gunton (A) 420 Gore, Frederick Spencer (P) 222 Gotzenberger, J. (A) 147 Gough, Alexander H. (A) 222 -, Hugh Roumieu (A) 246 Gould, James (A) 64 Goulden, Richard (S) 240 Goya, Francisco (P) 120, 153, 217 Gradidge, Roderick (A) 295 Graham, George (clockmaker) 98 Grant, Duncan (P) 418 —, Marion (glass) 420 —, Mary (S) 138 Greatorex, R.I. (A) 303 Green, Samuel (organ builder) 41, 364 Greuze, Jean-Baptiste (P) 184 Grey, William (joiner) 39, 72, 89 Gribble, Herbert (A) 306 Griffin, Thomas (organ builder) 77 Griffith, J.W. (A) 41, 301 Griffiths, W.P. (A) 42 Groves, John (plasterer) 309, 365 Guardi, Francesco (P) 184 Guelfi (P) 281, 298 Guercino (Francesco Barbieri) (P) 140 Guérin, J.U. (P) 184 Guillaume, Emile (S) 204 Gundulf (A) 326, 327 Gunton & Gunton (A) 58 Gutch, George (A) 190, 191 Gwilt, George (A) 92 Gwynn, Patrick (A) 390 Gwynne, David (S) 349

Habershon, E. (A) 186 -, Matthew and Brook (A) 426 and Pite (A) 344 Hakewill, Edward Charles (A) 241 -, Henry (A) 176 -, John Henry (A) 176, 341 Hartwell, Charles (S) 189 Hall, Christine (S) 376 –, E.T. & E.S., (A) 162 —, John (boat builder) 366 —, W. Austen (A) 83, 85 Hallett, John (cabinet maker) 264 Hals, Franz (P) 184, 224 Halse, Emmeline (designer) 301 Handisyde, Cecil C. (A) 324 Hardiman, A.F. (S) 103 Hardman, John (metalwork, glass) 108, 335 Winifred Elizabeth Beatrice (P) 248 —, while the Encaderin Beatifice (1) 2
Hardwick, Philip (A) 44, 57, 147,
176, 192, 213, 349

—, P.C. (A) 213, 326, 382

—, Thomas (A) 131, 186, 190, 286,
315, 324 Hare, Cecil (A) 241 —, H.T. (A) 186 Harlow, George Henry (P) 150 -, Henry (carver) 402, 403 Harmer, Roger (S) 358 Harrington, D.E. (A) 50 Harris, E. Vincent (A) 116 —, (gunsmith) 251 —, Renatus (organ builder) 42, 63,

69, 72, 79, 149, 309 , Thomas (clockmaker) 25 Harrison & Harrison (organ builders) 75,91 -, George (A) 116 -, John (clockmaker) 367 Hatch, F. Brook (S) 138 Hawkins, B. Waterhouse (S) 349 Hawkshaw, John (A) 122 Hawksmoor, Nicholas (A) 19, 69, 70, 96, 143, 156, 167, 171, 215, 320, 325, 363, 364, 368, 380 Haydon, Benjamin Robert (P) 150, 192 Hayman, Frances (P) 189, 220 Haysham, Terence (A) 78 Hayward, John (glass) 60, 88, 164, Haywards, Richard (S) 280 Heaton, Butler & Bayne (glass) 293 Helmle & Corbett (A) 129 Henman, Charles (A) 358, 374 Hennequin de Liège (S) 101 Henry of Reynes (mason) 95, 105 Henning, John (S) 169 , Thomas (woodcarver) 295 Hepworth, Barbara (S) 182, 429 Herbert, William (builder) 129 Herland, Hugh (carpenter) 101, 110 Hickey, John (S) 335, 348 Highmore, Joseph (P) 40, 220 Hill, Oliver (A) 316 —, Thomas (S) 171, 309 —, Vernon (S) 307 —, William (organ builder) 92 Hilliard, Nicholas (miniaturist) 291, 304, 402 Hiorns, F.R. (A) 387 Hoare, Prince (S) 407 Hobbema, Meindert (P) 119 Hodgson, John (P) 189 Hockney, David (P) 181 Hodson, John (bellfounder) 354, 359 Hogarth, William (P) 44, 46, 64, 119, 131, 134, 163, 166, 181, 186, 192, 213, 214, 215, 220, 285, 315, 367, 380, 415, 418 Holbein, Hans (P) 44, 80, 100, 114, 120, 139, 171, 214, 232, 304, 307, Holden, Charles (A) 22, 129, 178, 208, 217, 238 Holford, Sir William (A) 22, 38, 309 Holland, Henry (A) 117, 133, 139, 145, 419 Hollar, Wenceslaus (P) 32, 84, 215 Hollis, Charles (A) 323 Holmes, Benjamin (smith) 158 Holt, A.F. (A) 358 Hone, Evie (glass) 160, 223, 353 Honthorst, Gerard van (P) 253 Hooch, Pieter de (P) 153 Hooke, Robert (A) 89, 188, 368 Hoppner, John (P) 184, 402 Hopper, Humphrey (S) 35 —, Thomas (A) 139 Hopson, Sir Charles (joiner) 309 Horsfall, G. (A) 379 Horslan, G. (A) 379 Horslan, Hopkins H. (P) 107, 108 Horsnaile, Christopher (S) 73 Hosking, William (A) 242 Houdin, Jean (S) 120 Howes, Allan (S) 399 Howson, Joan (glass) 105, 125 Hudson, Thomas (P) 189, 220, 368

Hughes, Arthur (P) 332
—, J.O'Hanlon (A) 348
Hull, Denis (A) 314
Hunt, E.A. (A) 430
—, Holman (P) 36, 214, 299, 427
Hurst, Aaron (A) 296
Hutton, Edward (mosaic) 180
—, John (glass) 145
Huxley-Jones, T.E. (S) 168, 256
Huysmans, James (P) 150
Hynde, John (builder) 154
Hyslop, Geddes (A) 352

l'Anson (A) 417 Ingres, Jean-Auguste Dominique (P) 120 Inwood, Henry William (A) 219 —, William (A) 219 Isabey (P) 184

Jackson, Ernest (P) 150 -, Sir T.G. (A) 68, 377 Jacobsen, Theodore (A) 220 Jagger, C. Sergeant (S) 169 James, John (A) 19, 72, 96, 112, 215, 368, 407 , Robert (P) 189 Jansen, Bernard (mason) 137, 374 Cornelis (P) 199 Jarman, Edward (mason) 57, 68, 86 —, Roger (carpenter) 51 Jarvis, (A) 417 Jeeves, Gordon (A) 177 Jekyll, Gertrude (gardener) 205, 253 Jell, G. Thrale (A) 150 Jensen, Holge (A) 325 John of St. Albans (S) 106 John, Aneurin (A) 346 , David (S) 262 of Gloucester (mason) 95 —, W. Goscombe (S) 34, 117, 137 —, Gwen (P) 121 of Thurke (mason) 101 Johnson, Cornelius (P) 368, 402 —, John (A) 201, 257, 267, 331, 345 — Nicholas (S) 79, 294 Joliffe & Banks, Messrs (building contractors) 89 Jolli, Antonio (P) 398 Jones, Adrian (S) 169 -, Charles (A) 229 -, F.E. Francis (A) 262 -, Glyn (glass) 28 -, Sir Horace (A) 25, 43, 53, 89, 331 -, Inigo (A) 16, 19, 32, 36, 38, 52, 57, 76, 86, 106, 114, 122, 125, 130, 131, 141, 143, 151, 210, 213, 215, 235, 253, 278, 281, 282, 283, 287, 294, 299, 362, 365, 369, 395, 402, 406 Owen (P) 384 Jongh, Claude de (P) 224 onzen, Karin (S) 56 Jopling, Joseph (A) 176 Jordan, Abraham (organ builder) 89 Joy, Bruce (S) 127 Joynes, Henry (A) 210 Jupp, William (A) 86, 414

Kauffman, Angelica (P) 145, 151, 166, 185, 201, 224, 400 Kay, Joseph (A) 367 —, Margaret (glass) 307 Kebyll, John (bellfounder) 268 Kelly, Sir Gerald (P) 36 —, John (A) 163, 390

Kelk, Sir John (builder) 263 Kempe, C.E. (glass) 429 Kempster, Christopher & William (masons) 33, 36, 72 Kendall, Henry Edward (A) 176 Kent, William (A, P) 19, 97, 98, 116, 117, 128, 150-3, 156, 158-60, 171-3, 238, 251, 253, 281-3, 285, 366 Kenworthy, Jonathan (S) 99 Kenyon, A.W. (A) 261 Kidwell, William (S) 405, 423 King, Cecil (A) 55 —, Harold Knox (engineer) 84 —, James Frederick 222 , Laurence (A) 60 Kinsman, Joseph (plasterer) 402 Kirby, John (A) 403 Kirwan, William (S) 26 Kneller, Sir Godfrey (P) 56, 68, 131, 172, 199, 251, 309, 368, 386, 406, 407, 409 Knight, Dame Laura (P) 121 —, William (A) 21, 342 Knightly (A) 322 Knightly (A) 322 Knopple (organ builder) 51 Knott, Ralph (A) 378 Knowles, Sir James (A) 383 -, James (S) 166 John Thomas (A) 176 , Miss (embroiderer) 405 Knyff, Leonard (P) 123, 406 Kokoschka, Oscar (P) 399 Kormis, Fred (S) 207 Kossowski, Adam (mosaics) 417

Labelye, Charles (engineer) 138 Laguerre, Louis (P) 140, 173, 265 Laing, David (A) 89, 91 Lamb, Buckton (A) 21, 358 Lancelot, Nicolas (P) 184 Landseer, Sir Edwin (P) 36, 118, 156, 184, 189 Lane, John (A) 118 Langley, Batty (A) 72, 407 Lanscroon (P) 237 Lapidge, Edward (A) 248, 254, 374, 432 Larkin, William (P) 368 Laroon, Marcellus (P) 131 Lasdun, Sir Denys (A) 122, 147, 188, Latham, Jasper (S) 331, 352, 356 Lawlor, John (S) 108, 170 Lawrence, A.K. (P) 109 —, Richard (carver) 364 -, Sandra (embroiderer) 295 -, Sir Thomas (P) 36, 153, 164 Lawson, William (S) 358 Leaver, James (smith) 127 Lebons, John (mason) 249 Le Brun, Charles (P) 184, 252 Ledward, George (A) 190 Lee, Charles (A) 143 -, Lawrence (glass) 276 -, Stanley (S) 180 Leeke, Ralph (silversmith) 150 Leemput, Remigius van (A) 114 Leighton, Frederick 34, 299, 418 Lely, Sir Peter (P) 131, 199, 252, 309, 365, 402, 403 Lem (bricklayer) 51 Le Nôtre, André (gardener) 131, 250, 362

Leonori, C.A. (S) 180 Leoni, Giacomo (A) 19, 72, 143, 157, 281, 425 Leroux, Jacob (A) 297 Leslie, George (P) 189 Lessore, Therese (P) 297 Le Sueur, Hubert (S) 46, 68, 103, 104, 116 Leverton, Thomas (A) 347 Lewis, Anthony (A) 274 -, Hayter (A) 218 -, James (A) 416 -, T.C. (organ builder) 412 -, Wyndham (P) 416 Ley, F. & Jarvis, G. (A) 256 Lindsay, J. Seymour (craftsman) 103 Lindy, Kenneth & Partners (A) 80 Linge, Bernard von (glass) 213, 427 Lippi, Filippino (P) 207 Little, J. (A) 194 —, Thomas (A) 399 Llewelyn Davies, Weeks Forestier Walker & Partners (A) 67 Lloyd, Andrew (A) 127 Lomax, Simpson J. (A) 28 London, George (gardener) 171, 254 Long, John (carpenter) 400 Lote, Stephen (mason) 101 Lovell, James 142 Loveli, Jaines 1.2 Low, G. (A) 340 Lowky, L.S. (P) 181 Lubetkin, B. (A) 256, 296 Lucas, Geoffrey (A) 205 Lucas, Richard Cockle (S) 271 Lucchesi, A.C. (S) 189 Luck, C.L. (A) 376 Linwood, Mary (embroiderer) 405 Lutyens, Sir Edwin (A) 25, 36, 116. 119, 125, 150, 183, 204, 205, 255

Mabel of Bury St. Edmunds (embroiderer) 95 Mabey, Charles H. (S) 138, 381 Macbean, J. Nelson (S) 340 McCarthy, H.V. (S) 412 McCarthy, H.V. (S) 412 Macdonald, E.A.H. (A) 244 Macdowell, Patrick (S) 170 McFall, David (S) 27, 314 McGill, David (S) 137 McGuire, Robert and Murray, Keith (A) 319 Macintosh, Hugh (A) 360 Mackenzie, A. Marshall (A) 129 —, Tait (S) 367 Mackintosh, Charles Rennie (A) 180, 205, 342, 425 Mackmurdo, Arthur H. (A) 125, 334 Maclise, Daniel (P) 108 McMillan, William (S) 116, 136, 188 McMoran & Whitby (A) 40 Macvicar Anderson (A) 129 MacWhirter, John (P) 189 Maine, Jonathan (woodcarver) 34, 36, 71 Mair, George (A) 409 Mainwaring, Boulton (A) 318 Malcolm, Neill (A) 342 Malissard, G. (S) 176 Mallows, C.E. (A) 264 Mander, Noel (organ builder) 63, 293 Manet, Edouard 120, 217 Manning, Clamp & Partners (A) 398 —, Samuel (S) 49, 216 Mansfield, Isaac (plasterer) 216 Mantegna, Andrea (P) 119, 254

Manzú, Giacomo (S) 180 Maiano, Giovanni da (S) 249, 290 Maratti, Carlo (P) 92 March, Charles (millwright) 396 Marshall, J.A. (A) 180, 181 Margetts, Henry (plasterer) 309 Maria, Raoul (P) 432 Marks, Henry Stacey (P) 189 Marlowe, William (P) 406 Marochetti, Baron (S) 34, 111, 118, 138, 220 Marot, Daniel (designer) 254 Marrable, F. (A) 134 Marris, Robert (P) 186 Marshall, Charles (A) 421 Joshua (S) 104, 116, 215, 376 —, W. Calder (S) 151, 166, 167, 170 Martin, Miss (mosaics) 180 — Brothers (potters) 244, 334 —, John (P) 135, 287 —, Sir Leslie (A) 56, 61, 379 Martin-Smith, F.D. (A) 201 Martinière, A.N. (enameller) 184 Marquand, John (A) 116 Masaccio (P) 119 Massey (joiner) 89 Matcham, Frank (A) 134, 246, 296, Mathews, E.D. Jefferiss (A) 126 Mathews, Ryan & Scrupton (A) 274 Matisse, Henri (P) 181 Matthew, Sir Robert (A) 9, 144, 242, 374 —, Johnson-Marshall & Partners (A) 277, 298 Maufe, Sir Edward (A) 31, 212, 232, 307, 331 May, Hugh (A) 152, 372 Mayes, Edward (woodcarver) 295 Mazzoni, Guido (S) 103 Mazzuoli, Giuseppe (S) 306 Mealand, H.A. (A) 61 Meard, John (carpenter) 164 Mears & Stainbank (bellfounders) 60, Meeking, Brian (A) 368 Meissonnier (P) 184 Meredith, Michael (A) 66 Mewès & Davis (A) 144, 145, 150 Meyer, Jeremiah (miniaturist) 403 Michelangelo (A, P, S) 35, 103, 119, 151, 170, 174, 217, 304 Micklethwaite, J.A. (A) 96, 429 — and Somers Clark 298 Millais, Sir John Everett (P) 36, 220 Milburne (P) 364 Mitchell, F.J. (glass engraver) 256 Moira, Gerald (P) 40 Mollet, André (gardener) 250 Molton, John (mason) 249 Molyneux, Emery (globemaker) 31 Monet, Claude (P) 120, 217 Monnington, Sir Thomas (P) 109 Monturgo, Antonio (P) 254 Moody, F.W. (mosaics) 302, 322 Moorcroft (A) 220 Moore, Francis J. (S) 54 —, Henry (S) 112, 155, 178, 181, 416 —, Temple (A) 203, 358, 431 Thomas (carpet weaver) 287, 289 Morgan, William (carver) 309 Morland, George (P) 184, 224 Morris, J. (A) 241 -, Robert (builder) 406

452 INDEXES

—, Roger (architect) 400

—, William (P) 21, 139, 211, 247, 314, 322, 333, 334, 342, 391, 425

—, William & Co. 237, 244, 246, 264, 354, 392, 426, 432

Mot, Robert (bellfounder) 80, 268, 278, 318, 395, 427

Mottistone, Lord (John Seely) see also Seely and Paget (A) 35, 44, 90, 292, 295, 352

Mountague, William (builder) 64

Mountford, Edward (A) 40

Mowlem, John & Co. (builder) 84

Moyer, Humphrey (S) 233

Munnings, Sir Alfred (P) 36

Murro, Alexander (S) 40, 158

Murillo, Bartolomé (P) 153, 176, 418

Murphy, T. (S) 302

Murray, J.W. (A) 116

—, Thomas (P) 31

Mytens, Daniel (P) 250, 365, 368

Myers, Val (A) 183

Mylne, Chadwell (A) 242

—, Robert (A) 40, 300, 364, 400

Nash, Edwin (A) 340, 420

—, John (A) 9, 20, 118, 129, 139, 144, 145, 147, 148, 161, 163, 167, 174, 183, 187-8, 238, 267, 320, 347, 370, 404

—, John (P) 416

—, Paul (P) 416

Nasmyth, Patrick (P) 242

Nattier, Jean Marc (P) 184

Nauta, Max (stained glass) 68

Neilson, Jacques (tapestries) 289

Nemon, Oscar (S) 54, 109

Nevinson, C.W. (P) 416

New, Keith (stained glass) 50, 74

Newberry, John E. (A) 359

Newman & Jacques (A) 420

Newman, William (woodcarver) 51

Newton, A.J. (A) 231

—, Ernest (A) 350

—, William (A) 314, 364

Nichols (S) 412

Nicholson, A.K., Studios (glass) 63

—, Sir Charles (A) 268, 389

—, Sir William (P) 393

Nimptsch, Uli (S) 109

Nivon, W. (A) 409

Nixon, Samuel (S) 57

Noble, Matthew (S) 112, 137

Nollekens, Joseph (S) 67, 184

Norden, Robert (cartographer) 173

North, Roger (A) 28, 131

Nuttgens, Joseph (glass) 212

Nye, David H. & Partner (A) 56, 64

O'Connor, M. (glass) 347 Odericus (craftsman) 100 Ogbourne, William (A) 318 Oldfield, Edward (glass) 418 Oliver, Isaac (miniaturist) 47, 402 —, Peter (miniaturist) 288 Oliver & Leeson (A) 419 Opie, John (P) 145, 184 Orchard, John (S) 101, 102 Orley, Bernard van (tapestry designer) 106 Osman, Louis (A) 182 Oursian, Nicholas (clockmaker) 249 Owen Luder partnership (A) 347 Oxtoby (builder) 393

Pace, George (A) 359 Paget, Paul see also Seely and Paget (A) 295 Page, Thomas (engineer) 138 Paine, James (A) 117, 315, 399 Palladio, Andrea (A) 19, 151, 281, 283, 362, 387 Pater, Jean Baptiste (P) 184, 403 Palmer, Henry H. (P) 246 Palser, Edwin & Joseph (A) 205 Papworth, John Byonarotti (A) 315, Parbury, Kathleen (S) 230, 231 Parker, Harold (S) 129 -, Barry (A) 204 , Charles (A) 376 Parsons, Carl (glass) 316
Pasco, Joseph (\$) 335
Pasmore, Victor (P) 380
Paterson, George (\$) 342 Pavillon, Charles (P) 342 Paxton, Sir Joseph (A) 169, 170, 285, 288, 349 Peacock, James (A) 299 Pearce, G.E.H. (A) 303 -, Joseph (A) 163 Pearson, James (P) 427 —, John (P) 41 , John Loughborough (A) 21, 96, 112, 183, 193, 206, 209, 285, 358, 361, 373 Pegram, Henry A. (S) 34 Pellequini, Giovanni Antonio (plasterer) 151 Pembroke, Earl of (Henry Herbert) 400, 406 Pennethorne, Sir James (A) 125, 157, 213, 320, 429 Pergolesi, Michelangelo (decorator) 287 Perugino (P) 259 Peruzzi, Baldassare (A) 168 Peter of Colechurch (mason) 84 Peter of Rome (craftsman) 100 Peter of Weston (bellfounder) 208 Peysel, Louisa (embroiderer) 304 Philips, John (A) 314 Phillip, John Bunce (S) 108, 170 Phillips, John (carpenter) 160 Philpot, G. (A) 109 Phipps, John C. (A) 125, 129, 144 Physick, Edward James (S) 423 Pibe, W.A. (A) 314 Picasso, Pablo 181 Pierce, Edward (S) 49, 59, 85, 89, 188 Piero della Francesca (P) 119 Piero di Cosimo (P) 418 Pinker, H. Richard (S) 138 Piper, John (P) 9, 113, 245, 418 Piranesi, Giovanni Battista (A) 125 Pissarro, Camille (P) 217 , Lucien 334 Plaw, James (A) 192 Playne and Lacey (A) 319 Pocock, W.W. (A) 68 Poel, Egbert van der (P) 119 Pollen, Arthur (S) 180 Pomeroy, Frederick William (S) 40, Porden, Charles Ferdinand (A) 385

Porter, George (A) 349 Potter, Thomas (builder) 127 Poulden (joiner) 39 Pourbus, Franz (P) 251 Poussin, Nicolas (P) 120, 418 Powell, A.J. Phillip and Moya, John Hidalgo (A) 61, 177 -, E.B. (glass) 419 -, Sir Henry William (S) 255 Pownall, T.H. (A) 421 Pownell, Gilbert (mosaics) 180 Poynter, Ambrose (A) 109, 188 Poyntz, Frances and Thomas (weavers) 252 Pratt, Sir Roger (A) 152 Prest, Godfrey (coppersmith) 101 Price, John (A) 264, 415 —, Joshua (glass) 44, 97 —, William (P) 386 Prinsep, Val (P) 418 Prosperi, Christopher (S) 113 Proud'hon, Pierre Paul (P) 184 Prout, Samuel (P) 240 Prynne, George Fellows (A) 432 Pugin, Augustus (A) 20, 107, 108, 109, 126, 150, 209, 219, 222, 242, 245, 368, 416 Purdie (A) 385 Pyke, John (clockmaker) 172 Pym, Roland (A) 353

Quartermain, H.G. (A) 392 Quellin, A. (S) 97

Rabinovitch, F. (S) 178 Rackham, Arthur (P) 393 Raffield, John (A) 187 Raggi, Nicholas (S) 112 Railton, William (S) 118 Raimbach, Abraham (S) 203 Ramsay, Allan (P) 184, 185, 186, 220, 309, 405 Raphael (P) 151, 170, 252, 304, 403, 405, 418 Rathbone, Richard (S) 125 Rattee and Kett (carvers) 34, 229, 302 Read, Catherine (P) 368 Rebecca, Biagio (P) 364 Redgrave, Richard (P) 302 Redfern, James (S) 209 Redman, Henry (mason) 112, 266 , Thomas (mason) 112 Regnart, Charles (S) 374 Rembrandt (P) 119, 184, 224, 418 Rennie, George (engineer) 168 , Sir John (engineer) 51, 84, 89, 138, 168, 381, 413 Renoir, Pierre Auguste (P) 120, 217 Renton, John (P) 242 Repton, G.S. (A) 145 —, Humphrey (landscape gardener) 238, 347, 354 Reni, Guido (P) 282 Reynolds, Alan (P) 418 , Sir Joshua (P) 27, 36, 48, 56, 119, 120, 145, 151, 155, 166, 168, 174, 181, 184, 192, 220, 224, 400, 402, 418, 419 Reynolds-Stephens, Sir William (A) 266 Ribera, José (P) 153 Ricci, Sebastiano (P) 151, 152, 282,

Richard of Crundale (S) 101 Richard of Reading (S) 100 Richards, James (S) 173, 366, 406 Richardson, Jonathan (P) 199 Sir Albert (A) 36, 69, 149, 233, 331, 368 Richmond, Thomas (builder) 159 , Sir William (P) 35, 199 Riesener (cabinet maker) 184 Ripley, Thomas (A) 118, 255, 363 Ritchie, Alexander (S) 108 John (P) 189 Robert of Beverley (mason) 95 Robert, Dom (tapesty) 166 Roberts, Edward (A) 204 —, Henry (A) 84 Roberts-Jones, Ivor (S) 112 Robertson, Sir Howard (A) 380 Rocque, John (cartographer) 314 Rodin, Auguste (S) 36, 112, 181, 323 Rogers (builder) 293 W. Gibbs (carver) 69, 92 Romney, George (P) 145, 184, 224, Roper, David Riddal (A) 383, 385 Rose, George (designer) 352 —, Henry (A) 383 -, John (gardener) 250, 254 -, Joseph (plasterer) 287 Rosenauer, Michael (A) 155 Rosenberg, Eugene (A) 380 Rossetti, Dante Gabriel (P) 237, 308, 334 Rossi, Charles (S) 134, 186, 219, 382 Rothenstein, Sir William (P) 109 Roubiliac, Louis François (S) 42, 57, 81, 98, 100, 165, 172, 197, 220, 255, 293, 428 Rovezzana, Benedetto da (S) 36 Rowlandson, Thomas (P) 322 Rubens, Sir Peter Paul (P) 115, 119, 153, 184, 217, 289, 418 Rushworth & Draper (organ builders) 60 Ruskin, John (P) 361, 417 Russell, Edwin (S) 178 John (P) 184 Ryder, James (woodcarver) 295 Rydge, Richard (carpenter) 249 Ryley (S) 70 Rysbrack, Michael (S) 92, 98, 121. 143, 186, 220, 280, 281, 308 365, 407, 423

Saarinen, Eero (A) 159
Salisbury, Vyvyan (A) 227
Sablet (P) 189
Salviati (mosaics) 100, 147, 351
Salvini, Antonio (A) 330
Sambourne, Linley (cartoonist) 299
Sampson, George (A) 67
Samwell, William (A) 401
Sargent, John Singer (P) 36
Sarto, Andrea del (P) 403
Sandby, Paul (P) 418
—, Thomas (P) 418
Sanderson, John 226
Saunders, George (A) 157, 223
Saupique, Professor (A) 166
Savage, James (A) 92, 316, 415
Savery, Roelandt (P) 242
Scamozzi, Vincenzo (A) 281
Schaufelberg, Ernest (A) 129
Scheemakers, Thomas (S) 98, 103,

331, 380, 414, 428 the younger 285 Schmidt, Bernhard, 'Father' (organ builder) 35, 39, 51, 71, 80, 98, 115, 149, 156, 215, 330 Schoonjans, Anthonie (P) 282 Scoles, Joseph John (A) 160 Scott, Adrian Gilbert (A) 324 -, Baillie (A) 205 -, Lady (later Lady Hilton Young) (S) 26, 145 -, Mayor-General (A) 322 , Sir George Gilbert (A) 68, 84, 96, 100, 105, 106, 116, 170, 176, 208, 221, 227, 229, 232, 237, 242, 260, 261, 274, 276, 298, 310, 355, 361, 376, 390, 395, 413, 417 576, 596, 593, 415, 417 —, Sir Giles Gilbert (A) 53, 69, 109, 138, 232, 381, 429, 431 —, Henry (A) 301 —, John Oldrid (A) 191, 293, 385, 412 -, J.R. (A) 381 -, Peter (P) 86 -, R. Gilbert (A) 354 -, Samuel (P) 84, 131, 367 -, William (builder) 210 and Linton (shipbuilders) 363 and Moffat (A) 395 Seares-Wood, H.D. (A) 50 Searle, Michael (A) 369, 417 Sedding, John Dando (A) 21, 230, 246, 308, 354 Seddon (glass) 377 Sedgwick, William (P) 32 Seely and Paget see also Mottistone, Lord and Paget, Paul (A) 92, 230, 295, 296, 371 Seeman, Enoch (P) 31, 172 Seifert, Richard (A) 68, 201, 215, 358 Seth-Smith, W.H. (A) 176 Semper, Gottfried (S) 37 Serle, Henry (A) 213 Serres, Dominic (P) 242 Severn, Joseph (A) 228 Shapland, W.D. Carter (glass) 242, 245 Sharpley, Sidney (S) 324 Shaw, Huntingdon (smith) 251, 255 -, John, the elder (A) 25 -, John, the younger 25, 387 -, Norman (A) 21, 135, 144, 148, 152, 178, 201, 226, 263, 299, 302 Shepherd, Edward (builder) 143, 160, 264 , Thomas Hosmer (P) 186, 240, 297 Sheppard, Richard & Partners 273 Sherrin, George (A) 306 Shrider, Christopher (organ builder) Shute, John (A) 70 Sickert, Walter Richard (P) 121, 181, 222, 297 Simon of Wells (S) 102 Simonds, George (S) 138 Simmons, John (builder) 159 Simpson, J.R. (A) 207 Sims, C. (P) 109 Sisley, Alfred (P) 217 Sisson, Marshall (A) 48, 80, 113 Sittow, Michael (P) 120 Skidmore, Messrs. (builders) 170 Owings and Merrill (A) 274 Smirke, Sidney (A) 124, 139, 151, 301, 416

Sir Robert (A) 31, 41, 90, 124-6, 134, 140, 158, 176, 186, 216, 331, 334, 431 Smith, A. Dunbar (A) 158 —, Sir Francis (engineer) 147 —, John Raphael (P) 131 —, George (A) 368, 393 —, George A. (A) 360 —, Gerald (organ builder) 265 —, J. Osborne (A) 143 -, James (S) 54 -, Nathaniel (S) 125 —, Sidney J.R. (A) 181 —, T.H. & Wimble, W. (A) 80 –, T. Taylor (A) 40 –, R. Wilson (A) 428 Smithson, Alison and Peter (A) 144 Smythson, Robert (A) 395 Snetzler, John (organ builder) 49 Snow, William (P) 72 Snowdon, Lord (Anthony Armstrong-Jones) (A) 188 Solane, Sir John (A) 63, 107, 115, 116, 142, 161, 175, 214, 215, 229, 263, 283, 322, 354, 417, 418 Soloman, Lewis, Kaye & Partners (A) Soutar, J.C.S. (A) 205 Southwell, Anthony (S) 376 Span Group (A) 22 Spear, Francis (glass) 368 —, Ruskin (P) 128 Spence, Sir Basil (A) 170, 227 Spencer, Stanley (P) 415 Spiller, James (A) 133, 240, 297, 432 Sprague, W.G.R. (A) 134 St. Gauden (S) 112 St. Michele, Jean-Baptiste (plasterer) 44 Stacy, Gabriel (stonemason) 365 Stanfield, Clarkson (P) 123, 184, 220 Stanton, Thomas (S) 344 William (S) 280, 384, 409, 420 Stark, D. Rogers (A) 324 Starmer, Walter P. (P) 205 Steell, Sir John (S) 137 Steer, Philip Wilson (P) 36, 308 Stengelhofen, F.A. (A) 188 Stephens, Edward (S) 151 Stephenson, Roberts (engineer) 220 Stevens, Alfred (S) 35, 158, 168, 217 -, J.H. (A) 299 Stevenson, George (A) 331 Steyner, Thomas (S) 26 Stone, E.A. (A) 118 tone, E.A. (A) 118

–, Marcus (P) 299

–, Nicholas (S) 34, 77, 79, 102, 103, 122, 128, 134, 200, 234, 263, 264, 291, 294, 299, 308, 333, 344, 365, 369, 427 , Nicholas, the Younger (S) 291 Stowell, Robert (mason) 112 Storey, George (P) 189 Strang, William (P) 121 Strange, Clifford (A) 208 Streater, Robert (P) 69, 278 Street, George Edmund (A) 127, 178, 191, 209, 223, 432 Strong family (masons) 33 -, Edward 43, 88, 369 Stuart, James, 'Athenian' (A) 143, 144, 147, 224, 364 Stubbs, George (P) 181, 186, 224 Sutcliffe, G.L. (A) 205 -, T.W. (A) 31

Sutherland, Graham (P) 12, 231, 415, 418 Swan, Edward (A) 421 Symondson, Cornelius (smith) 104 Symons, Christian (S) 180 —, Revd. Vivian (A) 22, 353

Tait, Thomas (A) 27, 89 Talman, William (A) 165, 254, 264 Taplock (A) 341 Tapper, Sir Walter (A) 49, 103, 432 Tatchell, Rodney (A) 70, 81 Taylor, Sir Robert (A) Intro, 67, 72, 157, 213, 237, 314, 342 398, 399 Taylor Woodrow (builders) 324 Tecton (A) 188, 256, 296 Telford, Thomas (engineer) 257, 324 Teniers, David (P) 153 Tenison, H.H. Ryan (S) 138 Ternouth, John (S) 118 Terry, Quinlan (A) 192 Teulon, S.S. (A) 228, 229, 279, 290, 322 Thatcher, S.J. (A) 163 Thead, William (S) 36 Theed, William (S) 40, 170 Thomas de Hokyntone (carpenter) — of Leighton Buzzard (smith) 101 -, Brian (glass) 34, 42, 57, 90, 211, 296, 352 -, Sir A. Brunwell (A) 370 —, Cadogan (builder) 154 —, Cecil (S) 90, 183, 389 —, H.P. (glass) 289 —, John (S) 108, 109, 111, 220, 296 Thomson, James (A) 188 Thornhill, Sir James (P) 35, 97, 131, 141, 192, 238, 252, 253, 266, 315, 363, 364, 432 Thorpe, John (A) 369 Thornycroft, Sir Hamo (S) 111, 135, Thomas (S) 40, 128, 135, 170 Tijou, Jean (smith) 34, 36, 79, 173, 251, 253, 254 Tiepolo, Giambattista (P) 217, 418 Timbrell, Benjamin (builder) 143, 180 Tintoretto, Jacopo 305, 387 Tinworth, George (S) 382, 417 Tite, Sir Edward (A) 20, 68 —, William (A) 201 Titian (P) 112, 119, 151, 184, 207 Tissot, James (P) 189 Tompion, Thomas (clockmaker) 173 Tonks, Sir Henry (P) 218 Torel, William (S) 101 Torrigiani, Pietro (S) 103, 104, 213 Tower, W.E. (glass) 429 Townsend, Charles Harrison (A) 21, 66, 266, 317, 388 Tralen, J.C. (woodcarver) 200 Travers, Martin 89, 291, 359 Trehearne & Norman, Preston & Partners (A) 178 Troup & Steele (A) 126 Tufnell, Samuel (A) 182, 335 Tulipani (S) 91 Tunnard, John (P) 418 Turner, Joseph Mallord William (P) 36, 181, 186, 224, 261, 308, 399, 415, 427 -, L.A. (S) 302 -, Revd. C.F.G. (A) 207

—, Richard (engineer) 404 Tweed, John (S) 117, 183

Uccello, Paolo (P) 119 Underdown, Alwyn (A) 385 Unwin, Sir Raymond (A) 204 Uren, R.H. (A) 256

Valadier, Giuseppe (S) 287 Valentia, Franciscus de (P) 173 Van Breda, Brian (A) 237 Van den Bergen, Dirck (P) 402, 403 Van der Velde, William (P) 150, 252, 366, 402 Van der Weyden, Rogier (P) 292 Vandiest, Adrian (P) 134 Van Dyck, Sir Anthony (P) 36, 47, 119, 145, 176, 184, 224, 282, 309, 365, 392, 403, 418 Van Gelder, Peter Mathias (S) 232, 244, 291 Van Gogh, Vincent (P) 120, 181, 217, Van Nost, John (S) 166, 252, 254, Van Pook (S) 389 Van Spangen (S) 418 Vanbrugh, Sir John (A) 19, 74, 140, 144, 171, 251, 252, 363, 367, 369, Vardy, John (A) 20, 117, 147, 157 Varley, John (P) 240, 261 Vasconcellos, Josephena de (S) 34, 46 Velarde, F.X. (A) 262 Velazquez, Diego (P) 120, 153, 184, 217, 432 Vermeer, Jan 119, 153, 224 Veronese Paolo (P) 418 Verrio, Antonio (P) 237, 251, 252, 255, 265, 309, 402, 403 Vertue, Robert (mason) 102 —, William (mason) 102 Vieira, Francisco (P) 215 Vinci, Leonardo da (P) 119, 151, 271 Vivarini, Bartolommeo (P) 103 Vitruvius (A) 73, 283 Volterra, Danielo (P) 282 Voysey, C. Cowles (A) 346 Vroom, Cornelius (A) 402 Vuillard, Edouard (P) 217 Vulliamy, G. (A) 138, 381 -, Justin (A) 180 —, Lewis (A) 157, 168, 223, 332

Wade, Fairfax B. (A) 301
—, Joseph (S) 415
Wainwright and Waring (metalwork) 34
Wale, Samuel (P) 220
Walker, Arthur George (S) 112, 145, 241
—, Leonard (glass) 75
Wallace, George (A) 429
Wallis, Gilbert & Partners (A) 232
Walter of Durham (P) 100
Walters, Charles and Edward (A) 230
Ward & Hughes (glass) 41
Ward, E.M. (P) 109
Wardell, W.W. (A) 226, 268, 350
Ware, Isaac (A) 72, 168
—, Samuel 151
Warhol, Andy (P) 181

Waring & Blake (A) 347 Warren, E.P. (A) 302 Warwick, Sir Norman (designer) 125 Waterhouse, Alfred S. (S) 136, 212, 303 and Ripley 56 Watson, Musgrave Lewthwaite (S) Watteau, Jean Antoine (P) 120, 184, 403,418 Watts, George Frederick (P) 35, 42, 107, 168, 173, 178, 214, 220, 299, 418, 425 Weal, Francis (A) 349 Webb, Christopher (glass) 55, 149 —, Sir Aston (A) 44, 46, 68, 147, 163, 301, 304, 390 —, John (A) 52, 86, 106, 262, 265 —, Maurice (A) 375 —, Philip (A) 21, 342, 391 Webber, Henry (S) 98 Webster, Thomas (A) 157 Weekes, Henry (S) 40, 151, 166, 170, Weight, Carel (P) 231 Weir, R. Schultz (A) 180 Welch, Herbert (A) 205 and Lander (A) 272 Wells, Henry (plasterer) 403 Westall, Richard (P) 183, 184 West, Benjamin (P) 145, 151, 184, 220, 264 Westlake, Nathaniel (P) 351 Westmacott, Richard (5) 35, 97, 145, 169, 216, 232, 261, 405, 409, Richard, the Younger (S) 68 Weston, Robert (A) 350 Wheeler, Sir Charles (S) 67, 69, 119, 129, 316, 331 White, William (S) 280 Whinney, Son, and Austen Hall (A) Whistler, James Abbott McNeill (P) 162, 285, 427 Rex (P) 181, 306 Whitford, Elsie (glass) 257 Whitefriars (glassworks) 34, 57 Whitney, Anne (S) 226 Whiteman, Madge (S) 128 Wightman, Philip (bellfounder) 278 —, William (bellfounder) 336 Wilcox, Jonathan (mason) 149 , Edward (mason) 149 Wild, J.J. (A) 384 Wilkie, Sir David (P) 153, 173, 184 Wilkins, William (A) 119, 174, 218 Willement, Thomas (glass) 264 Willett, William (builder) 350 William of Gloucester (S) 102 — of Ramsay (mason) 32 — of Westminster (P) 100 — of Winchester (tile decorator) 105 Williams, Denise (embroiderer) 46 -, Joyce (embroiderer) 332 -, Sir Owen, and Partners (A) 27, 208 -, Herbert (A) 68 Williamson, Francis (S) 375 —, T.A. (A) 237 Willis, Henry (organ builder) 35, 257 Willmott, Humphrey 73 Wilson, E. (A) 64 —, H. (A) 230

Richard (P) 131, 220

Wilton, Joseph (S) 125, 151, 308, 351

Winde, Captain (A) 210 Winterhalter, F.X. (P) 173 Winmill, C. (A) 332 Wint, Peter de (P) 261, 406 Winter, Eric (S) 81 Wise, Henry (gardener) 171, 254 Witt, John (bricklayer) 157 Witte, Peter de (P) 83 Wolfe, Ollins & Partners (A) 295 Wood, Christopher (P) 418 —, John (A) 19, 187, 315 Woodford, James (S) 183, 404 Woodington, William Frederick (S) 118, 349 Woodman, William (S) 150 Woodroffe (woodcarver) 51 Woods, Derwent (S) 169 —, John (P) 415 , Joseph (A) 242 Woolland, Derek (A) 246 Woolner, Thomas (S) 112, 138, 166, 203 Wornum, Grey (A) 183

Worthington, Sir Herbert (A) 31, 56 Worthington, Sir Herbert (A) 31, 56 Wren, Sir Christopher (A) 9, 18, 19, 22, 25, 27, 30, 31, 32-8, 39, 41, 48-52, 53, 54, 56-8, 60, 62, 67, 69-73, 87-9, 91, 92, 96, 106, 114, 116, 127, 133, 135, 136, 139, 140, 149, 165, 167, 170, 171, 173, 174, 210, 211, 235, 244, 246, 251-4, 295, 298, 309, 323, 325, 363, 365, 367-9, 375, 381, 387, 413, 415, 428 Wright, John Michael (P) 127, 403 — Joseph (P) 353 -, Joseph (P) 353

-, Patience (wax modeller) 106 —, Thomas (instrument maker) 303

William (S) 335

Wyatt, Benjamin (A) 133, 140, 145, 153

-, James (A) 96, 139, 163, 171, 290, 269, 432 —, Matthew Digby (A) 177, 192

-, Richard James (S) 392

—, Samuel 115, 143, 331, 347 —, T.H. (A) 169

Wyatville, Sir Jeffrey (A) 403 Wyck, Thomas (P) 403 Wynfield, David (P) 189 Wyngaerde, Antony van der 84, 397 Wyon, A. (S) 178 -, W., (S) 399

Yeames, William F. (P) 189, 232 Young, Lady Hilton (formerly Lady Scott) (S) 26, 145 -, William (A) 116, 136 Yoxall, Nora (glass) 257 Yveley, Henry (mason) 89, 96, 101, 110, 112, 294, 427 Yxeworth, William (S) 106

Zoffany, Johann (P) 246, 255, 285, 286, 403, 405 Zucchi (P) 185, 224, 289 Zurbaran, Francisco de (P) 120 Zwincke, Sebastian (S) 335

4. General Index

Numbers in italic refer to pages with illustrations.
Aaron 354, 357; see also Moses Abbey Mills Pumping Station 310; 311
Abbey Road 189 Abbey ruins 197, 345
Abbot, Archbishop 382
Abercorn, Marquis of 263 Aberdeen, Earl of 207, 261, 264 Abingdon Place 298
Abingdon Place 298 — St. 112
Abney House 242
— Park Cemetery 242 Acacia Road 189
Achilles, statue 169
Acoustics, unusual 113, 193, 379, 432 Acton 229, 231
Acton 229, 231 — Park 232 Actor 139, 131, 168, 228, 231, 239
Actors 129, 131, 168, 228, 231, 239, 255, 285, 296, 407, 409, 418 Actuaries, Institute of 212 Adam & Eve (on font) 149 Adam St. 123
Actuaries, Institute of 212
Addition 120
Adams, John Quincey 90 Addington, Henry, Viscount
Sidmouth 214
Addington 365, 360-1 — Palace 360
Addison, Joseph 70, 98, 298 Adelaide, Queen to William IV 263,
264, 349
Adelaide St. 129 Adelphi, The 20, 123, 125, 305
Theatre 129
—, Lords of 131, 367
Aerodromes 11, 203, 233, 271, 281,
Admiralty House 118 —, Lords of 131, 367 Aerodromes 11, 203, 233, 271, 281, 289, 310, 353 Aeroplanes 242, 303, 353, 377, 416 Africa, statue of 170; 170
Africa, statue of 1/0; 1/0 Agapemonites 241
Agar St. 129
Agincourt 326, 330, 390 Agnew's 154
Agriculture & Fisheries, Ministry of 116
Air raid shelters 416
Akenside, Mark 122 Akmatova, Anna 120
Albany 150 Albemarle St. 154, 157
Alberta Prince Consort 20, 107, 111, 125, 127, 120, 140, 160, 170, 173
135, 137, 139, 140, 169, 170, 173, 212, 301, 302, 304
Albert Embankment 20, 381
—Hall 301, 379 — Hall Mansions 302
— Memorial 170; 170, 171, 172

```
Albery Theatre 134
Albuera, Battle of 34, 259
Albury St. 387
Alcock, John 303
Alcoves 167, 320, 414
Alderich, Revd. George 421
Aldgate 80
— High St. 317
  -House 322
Aldwych 128, 129, 161
    Theatre 129
Alexander, Tsar 191
    Viscount 261
Alexandra, Queen to Edward VII
   145, 302
   Gate 170
— Palace 257
— Park 256, 257
Alfred, King 12, 127, 197, 214, 373,
All England Lawn Tennis Club 395
All Souls Cemetery 301
Allen, Sir John 73
Alleyn, Edward 63, 64, 418, 419
Allied Assurance Co. 144
Almshouses 200, 201, 231, 239, 244, 279, 288, 293, 316, 318, 333, 340, 347, 349, 356, 357, 367, 368, 369, 376, 389, 393, 399, 413, 418
Alperton 208
Alphege, Saint and archbishop 362.
    390
Alsatia 15
Altar furnishings 90, 183, 353, 432
Altar rails 34, 39, 50, 52, 57, 69, 70,
74, 79, 80, 81, 83, 89, 90, 348,
407
Altars 26, 34, 35, 46, 60, 70, 74, 80, 83, 90, 207, 215, 279, 291, 306, 316, 354
Altars, Roman 12, 385
Alton Estate 432; 431
Alwright, W. 160
Alwyne Villas 297
 Amélia, Princess 229
American Associations 28, 31, 34, 43,
   56, 84, 90, 142, 213, 215, 269, 296, 308, 356, 366, 407, 412, 413, 415, 420, 425, 428
 — Embassy 159
   - Memorial Chapel 34
 Anchor, public house 413
 Anchorites 64, 274, 312
 Andersen, Hans Christian 257
Anderson, John Williams 201
Andrewes, Lancelot, Bishop 63
Andrews, Robert 159
 Angel, public houses 296, 415
     Court 71
 — Cottages 201; 204
```

```
Angels 35, 280, 341, 357, 377, 410,
   415
Angerstein, John Julius 119, 142, 367
Anglo-Saxons 12, 64, 69, 70, 73, 83, 84, 90, 91, 197, 199, 204, 217, 256, 318, 341, 350, 351, 352, 353, 354, 355, 359, 373, 374, 375, 376, 382, 392
Angerstein, John Julius 119, 142, 367
Angus, Earl of 104
Anne, Queen 31, 35, 38, 81, 106, 127, 140, 147, 156, 167, 171, 173, 202, 244, 251, 252, 254, 255, 363,
   364, 365, 375, 386, 403, 405, 406,
   425
   of Austria 282
   of Bohemia, Queen of Richard II
101, 106, 397
  of Cleves, Queen to Henry VIII
100, 305, 365, 390, 397
  of Denmark, Queen to James I 16,
Annesley, Dr. Samuel 63
   - Susannah 320
 Annunciation 106, 318, 377
 Anselm, Archbishop of Canterbury
    260
Ansgar, Portreeve of London 233
Anson, Thomas 143
Amsted, D.T., Professor 349
Antiquaries, Society of 32, 126, 151, 152, 312, 373, 422, 151
 Antiques, markets for 296, 299, 415
Apocalypse 105
Apples 272
 Apprentices 78, 292
 Apsley House 148, 153, 169
 Aquarium 288
Arbuthnot, Mrs 153
Arcades 47, 130, 347, 351
    , shopping 129, 145, 150, 152, 161, 176
   -, unusual 77, 80, 83, 89, 90, 241, 344
Arcading 29, 150, 291, 332, 344, 426
Archer, William 379
 Archery, arrows 124, 184, 292, 293,
    327
 Arches 167, 169, 220, 280, 353
 Architectural detail 305
    - drawings 185
 Archives 44, 296
 Archway Road 223, 256
 Argyll, Duke of 100, 400
 Ark of the Covenant (Echal) 81
     Noah's 149
 Arlington, Lord 147
 Arlington House 150
 Armada, Spanish 32, 47, 76, 113,
    120, 241, 305, 346
```

Armagilus, Saint 103 - Council 143 Bankside 413 Armorial Bearings 241, 290, 291, - and Crafts Movement 81, 158, 204, 319, 334, 425 Gallery 413 293, 376, 426 Armour 56, 70, 197, 232, 274, 288, 311, 335, 344, 348, 389, 395, 426, Arundel, Archbishop of Canterbury 357 253 -, Earl of 16, 223, 422 Armouries 139, 184, 251, 304, 327 Ascham, Roger 43, 334 Armour House 295 Army 309 Asgill, Sir Charles 399 Asgill House 399 - Education, Institute of 371 - and Navy 309 - and Navy Stores 178 Ashbee, C.R. 319 Ashridge Collection 186 Ashburnham House 106, 165 Ashcroft Theatre 358 Arne, Thomas 131, 255 Arnhem Gallery 358 Arnold, Benedict 428 Ashley, Robert 31 Ashley Gardens 178 Ashmole, Elias 52, 382 Ashstead Common and Forest 373 -, Matthew 176 —, Samuel 98 —, Tanner 260 Askew, Anne 53 Asprey's 154 Asquith, Herbert 156, 214 Assembly Hall, Walthamstow 336 Arnos Grove 237 Arquebus 268 Arsenal, Royal 369 Art dealers 155 Astronomical Society 151 405 Art Galleries Astronomy 186, 303, 332, 364, 367, 389, 398, 405 - Hill 206 Agnew's 154 Apsley House 153 Athelstan, King 373 Arkwright Road 227 Arnhewn 358 Athenaeum, The 145; 144 Atmospheric Railway 357 Auctioneers 144, 155, 357 Barnet 200-1 Bankside 413 Auden, W.H. 98 Audley, Lord 390 Audley End 15 Barn 372 Bridgewater 147 - Museum 200 Chalmers 242 Colnaghi's 154 Augmentations, Court of 294 Coram's 220 Courtauld 185, 217 Augusta, Princess of Wales 172, 252, Dulwich 418-9 Augustine, Saint 12, 32, 69 Europa 420 Augustinians 345, 391, 410 Fine Arts 155 Aulus Plautius 11, 12 Greenwich Theatre Gallery 368 Austen, Jane 157 Austin Friars 68 Grosvenor 168 Australia 363, 364, 392 Guildhall 53 Hayward 379 House 129 Heinz 185 Bath 19, 187
— Rd. 271, 289 Australians 280 Authors, Society of 138 Avery Hill 371 Kenwood 233-4 Lansdowne 158 Lord's 189 Aviaries 188, 288 Marlborough 154 Awsiter, Richard 233 Axes 388 , Lord 282 Medici 157 National Gallery 119-20 Aylesbury Estate 417 National Portrait Gallery 120 Ayloffe, Śir Joseph 232 Orleans 406 — Enamels 428 Queen's Gallery 147 **BBC 248** Photographer's 134 Ranger's House 368 Royal Academy 151 Babies 83, 344, 352, 354; see also Children Babington, Anthony 210 Bacchus 78 Serpentine 168 Shakespeare 145 South London 418 Bacon, Sir Anthony 267 -, Sir Francis 76, 92, 121, 122, 186, 213, 223, 267 -, Sir Nicholas 122 Tate 181 Walker 168 Wallace 184 Baden-Powell, Lord 191, 304, 396 Baynes, John 266 Whitechapel 168 Bailey, Charles Irvine Conyngham 244 Art Nouveau 21, 44, 80, 86, 230, 266, 307, 311, 318, 361, 388, 395, 421, 425 Baird, James Logie 164 Baker, Robert 148 Workers Guild 158 Baker St. 186 Arthur, King 103, 118

—, Prince, Henry VII's son 112, 326

—, Prince, Queen Victoria's son 173 Baldacchino 35, 70, 180, 306, 371 Beard, John 255 Baldwin, Stanley 261 Balfour, Arthur 140, 156 Artillery Lane 320, 321 Balmerino, Lord 330 Baltic Exchange 80 Mansions 178 — Museum, Royal 370 Artisans, Workers & General Bancroft, Richard, Archbishop of Canterbury 382 Dwelling Co. 194 Bank of England 53, 67, 214, 423; 69 Bankes, Henry, M.P. 53 Artists' colonies 184 Arts Centres 63-4, 227, 393 Banks, Sir Joseph 291, 403

- Power Station 413 Banqueting House, Hampton Court - House, Whitehall 16, 38, 52, 114, 142, 151; 116 Baptisteries, noteworthy 91, 180, 191, 209, 245
Barberini Collection 366 Barbican 22, 61-4; 66 Barge boarding 329, 342 Barges 57, 81, 193, 366 Barham, G.T. 207 Baring family 389 Bark Hall 352 Barking 75, 90, 197-9, 310, 345 Barking, Abbess of 316 Barking Abbey 197, 182, 313 — and Dagenham, borough of 197-9 Barn 254, 269, 272, 279, 340, 372, Barnardo's Homes, Dr 314 Barnes 397, 403, 405-6 — Common 432 -, Battle of 200, 328 -, borough of 200-205 Barnett, Dame Henrietta 204 Canon Samuel 204, 317 Barracks, 169, 330, 370 Barrett, Élizabeth 186 -, John, Almshouses 200 Barrie, Sir James 168, 191 Barry, Elizabeth 231 Bartlett School of Architecture 218 Barton, Elizabeth 274 Basilica, Roman 11, 78 Basket making 374 Knights of 102 Bathurst, Baron 152 Battersea 427-30
— Bridge 427
— Dogs' Home 429 — House 427, 428 — Park 429 — Power Station 429; 430 Battishill, Jonathan 72 Baxter, Richard 231 Bay Cottage, Cheam 421 Bayeux Tapestry 295 Baylis, Lilian 296, 381 Baynard's Castle 47 Bayswater 100, 191 —, Rd. 2, 22, 190 Beach, Mary 407 Beak St. 165 Beam engines 286, 303 Beargardens Museum 413 Beauchamp, Sir John 48 , John Matthew 200 Beauchamp Place 307 Beaufort, Cardinal 410 -, Lady Margaret 16, 104, 427; 104 Beaufort House 283 Beaumont, Francis 98 —, Sir George 119, 151

Bec, Abbey of 279, 326 Beckenham 347, 386, 388 — Place Park 388; 348 Becket, Thomas à, Saint and Archbishop of Canterbury 180, 261, 391, 410 Beckford, Richard 163 -, William, Lord Mayor 54, 163 —, William, the younger 163 Becontree Housing Estate 9, 199 Beddington 420, 426 — Hall 14, 426 Bede, Venerable 12 Bedfont, East 281, 290 Bedford, Dukes of 132, 137 —, Earls of 16, 19, 130, 132 Bedford Chambers 132 — College 187, 211 — Estate 132, 134 — House 130, 132, 210, 215 — Level 130, 431 — Place 210 -Row 19, 130, 131 - Square 210 Bedlam Hospital 325, 416 Beds 251, 252, 253, 289, 305, 365 'Bedstead' tomb markers 361 Bedwell, Revd. William 259 Beecham family 132 Beeches Avenue, No.40 425 Beehives 238, 386 Beer cellar 253 Beerbohm, Max 158 Beergar's Opera 246, 276, 409 Belfast, H.M.S. 414 Belfry, The 176 Belgrave Square 175 Bell, Robert 395 Bell-turrets 75, 76, 273, 278, 354 Bella Court 362 Bellair, Dulwich 419 Dellair, Dulwich 419
Bellingham, John 40, 230
Bells 42, 43, 44, 59, 69, 80, 81, 83, 128, 208, 214, 229, 237, 239, 245, 246, 249, 259, 264, 268, 269, 270, 272, 278, 288, 293, 312, 332, 334, 343, 353, 354, 359, 374, 377, 395, 399, 400, 405, 407, 426, 427, 431

School 417 School 417 Belmont 201 Benedictines 95, 190, 292 Benin Bronzes 388 Estate 132, 134 Benson, Hugh, Archbishop of Canterbury 360 Bentall's, Messrs 375 Bentley Priory 263 Benton-Fletcher, Major George Henry Bentinck, Margaret and William 182 Berengar, Raymond, Count of Provence 95, 98 Berkeley, Bishop 281 – family 286 — Lady 154 - Lord 151, 152 Berkeley House 151, 152 - Square 158; 159 Bermondsey 410, 414
— Abbey 415, 418
— market 415 Bernard, Dr Francis 42 Berners St. 183, 184, 186 Berry, Agnes & Mary 400 — Bros & Rudd 144

Berrymead Priory 231 Berwick St. 165 Besant, Sir Walter 138 Bessborough House 432 Bethnal Green 140, 317, 322 Museum 19, 322 Beverley Brook 373 Bevis Marks 81; 82 Bexley 339-40 —, borough of 339-45 — Heath 21, 342 Bible 46, 72, 106, 250, 259, 414 — box 356 Bickley 349 Big Ben 107, 111 Biggin Hill 353 Bigod, Roger, Earl of Norfolk 98 Billesdon, Roger 86 Billingsgate 12, 89 Bilney Lodge 242 Binham Priory, Norfolk 96 Binning, Lady 227 Birch, Revd Thomas 92 Birds 167, 254 Birdcage Walk 147 Birkbeck College 217 Bishopsgate 15, 66, 75, 305 Institute 388 Black Death 293 Black Eagle Brewery 321 Black Friars 14, 47

— Bridge 135, 138, 416

Black Prince, The; see Edward, the **Black Prince** - Prince Rd. 382 - Prince's Palace 417 Blackheath 362, 368, 386, 390 Blackmore, Richard Dodderidge 409 Blackstone, Sir William 127 Blackwall Docks 317 Blades, John 385 Blaise, Saint 374 Blake, Robert, Admiral 113 —, William 149, 166, 295, 418, 428 Blanche of Navarre, Duchess of Lancaster 81, 124 de la Tour, Princess 326 Blenheim 140, 173 , Battle of 141 Gardens 385 Bleriot, Louis 203 Bligh, Captain 382 Blitz see Bombing Blomfield, Charles James, Bishop of London 244 Blomfield Rd. 194 Blood, Colonel 328 Bloody Tower 328 Bloomsbury 19, 20, 132, 210 Blow, John 98 Blucher, Field Marshal 108 Blindness 240 Boadicea, Queen of the Iceni 11, 22, 135, 331 Boat Race 244, 405, 432 Boats 81, 246; see also ships Bodleian Library 102, 314 Body-snatchers 128 Boehm, Edward, financier 143 Bohale, John 302 Boleyn, Anne, Queen to Henry VIII 54, 249, 251, 255, 328, 329, 330, 425 Bolton, William 46

Boltons, The 307 Bombing 22, 53, 55, 56, 57, 58, 59, 61, 62, 64, 68, 72, 81, 83, 86, 88, 90, 91, 111, 127, 138, 144, 147, 149, 165, 189, 191, 204, 211, 212, 213, 214, 230, 241, 242, 264, 269, 292, 295, 296, 298, 307, 317, 318, 325, 346, 368, 376, 381, 382, 386 Bonaiuti, Seraphino 299 Bonaparte, Joseph 153 , Napoleon 153 Bonar, Thomas 350 Bond, Sir Thomas 154 Bond St. 139, 154, 155 Bonner, Edmund, Bishop of London 243 Boniface, Saint 230 Boodle's 139 Booksellers 131, 150, 166, 296 Boone's Almshouses, Lee 389 Booth, Catherine 242 —, General William 242 Boothby-Heathcote, Miss 332 Boots, Messrs 375 Bordall, Revd William 285 Borough, William 325 Borough Market 413 Borrow, George 157 Boston Manor 16, 286; 286 Boswell, James 123, 131, 166 Botanists 201, 277, 287, 428 Botolph, Saint 65 Boucher, Catherine, later Mrs Blake Bouchier, Cardinal, Archbishop of Canterbury 357, 405 , Elizabeth 63 Boucicault, Nina 168 Boundary Estate 322 Boughton, John 382 Bourlet's 184 Bourne, Cardinal 180 —, widow 144 Bourne Hall Museum 421 Bow Bridge 310, 322 porcelain 311 Bower House 266; 267 Bowes, Sir Martin 70, 73 Bowes-Lyon, Lady Elizabeth 144 Bowling Greens 279, 407 Bow St. 131 Boxing 111, 371, 382 Boyce, William 69 Boydell, Alderman John 21, 53, 58, 145, 342 Boyle, Henrietta, later Duchess of Devonshire 281 Boyne, Battle of 145, 155, 277 Bradmore Farm 359
— House 246, 318 Bradshaw, John, regicide 190 Braille 240 Bramston, James 127 Brand, Revd John 92 Brangwyn Gift 334 Brawne, Fanny 228 Bread cupboard 72, 235, 279, 409 Breakspear, Nicholas 280 Brembre, Sir Nicholas 233 Bremer Car 334 Bren gun 236 Brent, borough of 206-9 —, River 200, 206, 229, 232, 241 Brentford 11, 281, 285, 287 Brereton, Sir William 345

Brewer St. 161 Brewing 64, 178, 321, 378, 405, 413 Brickwork 49, 52, 57, 61, 85, 139, 140, 177, 178, 180, 183, 232, 238, 241, 242, 249, 261, 263, 272, 325, 335, 340, 348, 351, 353, 357 Bridewell Palace 28 Bridges, 11, 12, 84, 85, 89, 137, 180, 246, 255, 310, 374, 375, 399 Bridgetine Nuns 287 Bridgewater House 147 Brigham, Nicholas 98 Bright, Jeremiah 279 Brighton 188, 362, 420 Briset, Jordan de 292 Bristol 137, 333 Britannia 143, 220 British Broadcasting Corporation 129, 183 - Crafts Centre 134 — Empire Exhibition 208 — and Foreign Bible Society 48, 49 — Library 123, 213, 215, 217 Medical Association 129 - Museum 11, 12, 67, 78, 158, 163, 182, 199, 201, 211, 214, 216-17, 231 Society of Modern Glass Painters 276 - Theatre Museum 133 Broad Walk, Kensington 170 — Walk, Kew 404 Broadway 55, 178 Brock, Mrs Mary 291 Brockley Hill 202 **Brockwell Park 385** Bromley 9, 11, 346-8 —, borough of 346-54 - College 347; 347 - Palace 9, 347 Bromley-by-Bow 317
— Palace 319 Brompton Boilers 301, 322 Cemetery 307 - Oratory 306 - Rd. 306 Brontë family 120 Bronze Age 199, 332 Brook St. 154, 155; 155 Brooke, Rupert 180 Brooke House 241, 261 -School 241 Brooks 139 Broom-pods 119 Broomfield Lodge and Park 238 Brown, Arthur Whitton 303 —, Charles Armitage 228 Browne, Sir Richard 386 Browning, Robert 98, 186, 193 Brown's Hotel 156 Brougham, Lord 157 Bruce, Robert the 259 Bruce Castle 259; 259 Brudenall-Bruce, Lord Charles 431 Brunel, Isambard Kingdom 137, 192, 232, 273, 301, 308, 415 , Sir Mark Isambard 301, 308, 415 **Brunel University 273** Bruno, Rosia and Walter 320 Brunswick Square 219, 220 Bruton St. 155 Bryan, Sir Francis 47 Brydges, James see Chandos, Duke of Buckingham, Duke of 147 Buckingham House 103, 125, 252

— Palace 121, 139, 145, 147, 167, 169, 233, 304 — Palace Rd. 176 — St. 122, 123 -St. (Cleveland) 184 Buckland family 224 Buckle, Richard 133 Bucklersbury House 74 Bugle Inn 369 Builder, The 161 Builder, 1 no 161
Building regulations 2, 15, 16, 130
Bul, John 208
Bull, W.J. 135
Bull and Bush, public house 227
Bulle, William 63
Bullen, Sir Geoffrey 54
Bullen, Sir Geoffrey 54 Bull's Head 267 Bulstrode Park House 49, 405 Bunhill Fields 63, 242, 295 Bunyan, John 63, 295, 420 Burbage, James 48, 239
—, Richard 48, 239, 413, 419
Burdekin, Mary 400 Burden, Jane, later Mrs Morris 342 Burdett-Coutts, Angela, Baroness 222, 223, 322 Burgh, Revd Allotson de 225 Burgh House 225 Burgh-le-Marsh, Lincolnshire 385 Burgoyne, General John 425 Burial Service, use of 103 Burke, Edmund 109, 124, 166 Burlington, Earls of 150, 151, 154, 156; see also Artists' Index , Lady 283 Burlington Arcade 151; 152 — House, 126, 148, 150, 151, 157 -St. 156 Burnett, Dr 244 Burney, Dr Charles 123, 377, 387 —, Fanny 123, 139, 166, 377, 387 Burns, Robert 98, 137, 363 Burton, Sir Richard 405 Busby, Richard 98 Bush house 129 Bushy House and Park 254 Butcher's Row 357 Butcher's shop 425 Bute, Lord 403 —, Marquess of 180 Butler, Elizabeth 173 Butts, The 286 Buxton, Colonel 70 Byng Place 217 Byrkhede, Revd John 260 Byron, Allegra 215, 261 -, Lady 231 -, Lord 98, 150, 157, 169, 182, 186, 261, 301, 395 Byzantine style 178, 384 Byzantium, Emperor of 371 Cabs 245 Cade, Jack 390 Cadiz 117, 272 Cadogan, Dr William 245 Caen Stone 12, 96, 326 Caernavon 373 Caesar, Julius 11, 285 Caesar's Camp 394 — Well 396 Calais, Burghers of 326 Calamy, Revd Edmund 56 Calcutta, Black Hole of 262

Caledonia Club 175 Market 297, 415 Calendar 184 Calico Mill 391 Calthorpe Estate 174 Calton family 418 Calvert, George, 1st Lord Baltimore 215 Camberwell 19, 410, 418 School of Arts & Crafts 418 Town Hall 418 Cambridge 104, 105, 217, 233, 244, 356, 392, 398, 414

— Gate 188 — Rd. 234 -Terrace 188 Camden, Lord 210, 350 —, William 41, 85, 98, 102, 152, 339, 394 Camden, borough of 210-28
— Lock 193, 221
— Passage 297 — Place 350 — public library 222
— St. 219
— Town 222
— Town 6 Group 222 Camel Corps, Imperial 138 Cameron, Archibald, of Lochiel 125 Campanile 163, 178, 201, 353, 390 Campbell-Bannerman, Henry 156 Campden Hill 298, 299 Campion, Edmund 41 Canada 75, 119, 188, 259, 366, 367, 400 Canals 182, 190, 192, 193, 236, 254, 271; 194 Canbury Garden 374 Candelabrum 412, 415; see also chandeliers Candles and candlesticks 86, 90, 400, 430, 432 Canning, George 112, 214 Canning Town 199 Cannizaro 396 Cannon 344 Lodge and Place 225 - St. Station 11, 85 Canonbury 296-7 — Tower 15, 297 Canons, The, Merton 393
—, Stanmore 57, 166, 226, 264, 265
Canterbury 42, 351, 352, 407, 413 Capel House 235 Card Houses 121 Cardinal's Wharf 413 Carey Street 305 Carew Chapel 426 — family 426 Carleton, Edward 425 Carlile, Revd William 92 Carlisle, Countess of 253 Carlos Place 159 Carlton Club 139 — Gardens 145 — Hill 189 - House 119, 145, 148, 161 - House Terrace 121, 145 Carlyle, Jane 308 , Thomas 143, 308 Carmelites 14, 262 Carnaby St. 162 Caroline, Queen to George II 147. 167, 169, 171, 172, 252, 398, 406 Carow, Edith, later Mrs Roosevelt 156

Carpenters Shop 240 - tools 277 Carpets 51, 287, 289, 304, 402 Carr, Sir Edward 277; 275 Carse Collection 388 Carshalton 420, 422, 425 - House and Park 425 Carthusians 293 Cartwright Bequest, Dulwich 418 Gardens 219 Cary, Sir Robert 398 Caryatids 186, 219, 301, 418 Casewell, General Sir William 301 Cass, Sir John 81 Cass Institute 81 Castalia Square 323 Castle Hotel, Kingston 375 Castlereagh, Lord 340
Catherine of Braganza, Queen to
Charles II 125, 247, 309, 365, 393, - de Valois, Queen to Henry V 101, 106, 415 the Great, Empress of Russia 86 Catholic Apostolic Church 193, 217 Revival 206, 209 Cato Street Conspiracy 40, 159 Cator, John 388 Caunt, Benjamin 111 Cavell, Edith 121 Cavendish, Lord George 151—, Hon. Henry 211, 384 Cavendish Rd. 384 -Square 182, 184 – St., New 182 Caxton, William 67, 113 Cecil, Sir Edward 395 -, Thomas, Earl of Exeter 394 -, William, Lord Burghley 102, 213, 335, 394 - French Bequest 246 Cedar Terrace 383 Cedars, The, Uxbridge 276 Ceilings 29, 41, 44, 47, 57, 71, 81, 83, 86, 115, 151, 159, 171, 172, 173, 182, 224, 226, 235, 251, 252, 253, 259, 267, 278, 282, 287, 340, 351, 352, 365, 372, 403
Celtic remains 11, 358
Celly Richard & Robert 83 Cely, Richard & Robert 83 Cemeteries 194, 242, 295, 301, 307, 385, 393 Census 20 Cenotaph 116 Central Square 204, 205 heating 367 Centre Point 215 Century Guild 334 Ceylon, King of 422 Chairs 41, 280, 403, 412, 427 Chalk Farm Rd. 221 Chalmers, Alexander 241, 242 Chalybeare Spring 225 Chamberlain, Neville 233 Chambers, Ephraim 297 Chancel arches 13, 270, 276, 290 Chancellor, E. Beresford 131 , Richard 325 Chancery Lane 213 Chandeliers 39, 47, 49, 57, 70, 81, 86, 88, 215 Chandos, Duke of 143, 166, 202, 263, 264, 265 - House 143 Chantry Chapels 352, 432

Chapels Addington Palace 360 Biggin Hill, Memorial 353 Chapel Royal 42, 139 Charterhouse 294-5 Commonwealth 55 Croydon Palace 357 Dulwich College 418 Fulham Palace 243 Greenwich Hospital 364 Grosvenor chapel 160 Hampton Court 249, 253 Harrow School 261 Lambeth Palace 381 Lincoln's Inn 213 Merchant Taylors' Almshouses 389 Mercers' 58 Morden College 369 Queen's chapel 139, 141 Royal Fusiliers 43 Royal Hospital, Chelsea 309 Royal Military 147 Royal Auxiliary Air Force 46 St. Barnabas-in-Soho 164 St. Faith's 36 St. John's 330 St. Katharine's 325 Whitelands 431 Whitgift 357 Chapter Houses 13, 38, 105, 391, 413 Style 186 Charing Cross 101, 122; 136 Cross Pier 363 Cross Rd. 20, 118, 161, 163, 166, 191 Cross Station 122, 137 Charities 164 Charity Children 28, 178, 212 Fathers of 212 Charles I 16, 31, 40, 47, 79, 80, 98, 103, 106, 109, 111, 115, 116, 119, 122, 126, 130, 131, 134, 139, 141, 369, 374, 393, 395, 397, 400, 401, 403, 405, 409, 415, 422; 43 Charles II 18, 19, 32, 33, 40, 42, 73, 79, 86, 89, 106, 114, 117, 139, 141, 143, 145, 150, 163, 210, 215, 245, 247, 250, 251, 252, 254, 260, 282, 285, 288, 291, 308, 309, 327, 328, 330, 362, 365, 367, 372, 387, 390, 392, 393, 402, 403, 409, 421 390, 392, 393, 402, 403, 409, 421 -, Prince of Wales 421 -, Duke of Blois 326 —the Bold of Burgundy 184 -, Duke of Orleans 326 Edward Stuart 125 Charles St., Mayfair 160 Charles II St. 141, 142 Charlotte, Queen to George III 125, 139, 147, 217, 246, 252, 403, 404, 405 Charlton House 16, 362, 369; 368 Charnel Houses 46, 386 Charrington, Messrs 310 Chartered Insurance Institute 56 Charterhouse 14, 241, 293, 295, 299; 294 — Square 293, 295 Charters 12, 13, 326, 357 Chatham House 143 Chatsworth 281, 288

Chatterton, Thomas 70, 212 Chaucer, Geoffrey 80, 91, 98, 124, 371, 397, 417 Cheam, 420, 421-422 School 421 Cheapside 12, 58 Hoard 57 Cheke, Sir John 56 Chelmsford 267 Chelsea 307-9, 372, 427
— Embankment 20, 308; 307
— Flower Show 309 - Hospital 19, 309, 363 Chemical Society 151 Chequerwork (Flushwork) 200, 290 Cherry Garden Pier 415 Cherubs 35, 91, 92, 212, 242, 254, 264, 282, 340, 343, 344, 354, 412 Chesapeake Bay 215 Cheseman, Robert 232 Chessington 377

— Zoo 377 Chester, Eliza 228 Chester, H.M.S. 313
— Square 174, 176
Chesterfield, Earl of 149, 160, 368
Chesterfield House 264 Chests 75, 270, 405, 412 Cheylesmore, Lord 138 Cheyne Walk 308 Chicago 112 Chichele, Archbishop of Canterbury 232, 355 Chichester, Sir Francis 363 Chigwell 314 Child, Sir Francis 288, 289
—, Sir Josiah 315; 315
—, Richard 315 —, Richard 315 —, Robert 288, 289, 291 Children 26, 30, 69, 76, 77, 79, 83, 90, 91, 102, 104, 105, 173, 197, 202, 222, 230, 232, 233, 234, 236, 240, 241, 244, 256, 257, 258, 260, 261, 262, 264, 267, 269, 273, 274, 276, 278, 279, 280, 291, 307, 308, 311, 313, 330, 332, 342, 344, 352, 353, 384, 400, 409, 422 353, 384, 400, 409, 422 — of the Queen's Revels 48 Children, Special Provision for, in Museums, etc. 298, 303, 322, 366, 388, 395, 405, 417 Childs, Aylwin 415 Chimney stacks 279 China 363 Bank of 86 Chinese art 217, 244, 322 Lions 404 Chingford 15, 332 Chippendale, Thomas 134 Chipping Barnet 200, 201 Chisel 371 Chislehurst 349 Chiswell St. 295 Chiswick 281, 285, 399 -House, 19, 143, 153, 281, 285, 308, 387, 400 - Mall 246, 285 - Town Hall 285 Choirstalls 77, 361 Cholmley, Sir Roger 222 Chopin, Frederick 140 Christ in Majesty 149, 181, 183, 188, 213, 231, 253, 257, 266, 289, 290, 325, 353, 423 Christie, James 144, 150

Christie's Messrs 144, 155, 158 Christina of Denmark, Duchess of Milan 119 Christmas decorations 161 Christopher, Saint 100, 274 Christ's College 204 Chronometers 367 Church Commissioners 190 - Farm Museum 203 — House, Romford 267 — plate 55, 80, 121, 150, 201 — Row, 226 — St., Kensington 298 -Street Market 182 Churchill, Charles, poet & cleric 270 —, Lord Randolph 421 -, Sarah; see Marlborough, Duchess of —, Sir Winston 54, 56, 97, 109, 112, 120, 121, 140, 261, 302, 314 Churchill Gardens 177 Cinema, Empire 379 Cinemas 166 Cinematography 166, 376 Cistercians 310 Citadel, The 117 City Companies Apothecaries 47-8, 308; 49 Armourers 56 Barber Surgeons 214 Brewers 56 Carpenters 68 Chandlers 86 Clothworkers 83, 264 Cutlers 40 Drapers 68 Dyers 86 Fanmakers 66 Fishmongers 84; 85 Girdlers 56 Goldsmiths 57, 231 Grocers 58, 67 Haberdashers 56 Innholders 86 Leathersellers 76 Merchant Taylors 14, 57, 79, 86, 389 Painters 50 Pewterers 56 Saddlers 58 Skinners 86 Stationers 39, 46; 41 Vintners 51-2, 77; 51 Waxchandlers 58, 79 City Corporation 138
— and Guilds College 301
— Rd. 295 - Trained Bands 76 — University 296 — walls 11, 12, 13, 14, 331; 87 Civic Award 77 -centres 257, 277, 417, 420 -Trust Award 201, 395, 421 Civil Service Commission 157 Service Rifles 126 — War 16, 32, 131, 231, 277, 278, 279, 285, 286, 304, 340, 405 Clairmont, Claire 261 Clapham 21, 378, 383-4, 427 Bus Garage 133

— Junction 429

— Sect 384 Clapton 240 Claremont (house) 395
— Square 296

Clarence, Duke of 328, 404

Clarence Gate 186 House 139 -Terrace 188 Clarendon, Lord 152, 277, 344, 406 Clarendon House 152 Claretian Fathers 276 Claridges 155 Clarke, Charles Cowden 235 , John 235 Classicianus, Julius 331 Clattern Bridge 375 Claudius, Emperor 11 Clayton, Sir Robert 380 — Revd 'Tubby' P.B. 90, 91 Cleopatra's Needle 138 Clerkenwell 292-6 Priory 296 Clermont Club 159 Cleave Almshouses 376 William 376 Cleaver Square 383 Cleve, Bouchier 341 Cleveland, John 88 Cleveland Row 147 — St. 183, 184 Clifton Hill 189 Gardens 190, 194 Clink Prison 412 Clissold House and Park 242 Clitherow, Sir Christopher 79 , James 286 —, James 200 Clive, George 432 —, Kitty 407 Clocks 25, 54, 56, 89, 92, 162, 172, 239, 241, 250, 273, 303, 304, 335, 357, 367, 393, 395 Cloisters 44, 53, 104, 105, 111, 217, 298, 409 298, 409 Cloth Fair 43 Trade 69 Trace 67 Clothes 27, 90, 102, 106, 139, 141, 161-3, 240, 268, 277, 280, 304, 322, 343, 344, 348, 361, 412, 422 Clubs 107, 134, 139, 143, 145, 153, 159 Coaches 64, 147, 295 Coaching Inns 289, 355, 420 Coade Stone 66, 86, 137, 145, 186, 211, 288, 293, 359, 364, 369, 378, 381, 382, 401, 428 Coal Exchange 89 Coast Guards 255 Coates, Eric 111 Cobden, Richard 222 Cochrane, C.B. 131 Cock and Bell 267 — Inn 420 — Lane Ghost 43 -Pit 116 350 — Pit Passage 116 Cockayne, William 86 Cockfosters 238 Coffee Houses 78, 80 — Shops 127, 150 Coffin-plates 128 Coins, Anglo-Saxon 375 Coke, Sir Edward 288 Colby, Reginald 154 Colchester 11, 85, 199, 326 Cole, Sir Henry 169, 302, 306, 307 Colebrook, James 237 Colefax and Fowler 155 Coleridge, Samuel Taylor 98, 223 -, William 41

Colet, John, Dean of St. Paul's 318 Coliseum Theatre 134
College of Arms 49; 50
Collier, John 418
Collins, Wilkie 220, 301 Collinson, Peter 201 Colnaghi's 154 Colosseum 188 Columbia Market 322 Commercial Rd. 325
— Union Building 77 Commons 9, 263, 392, 432 —, House of 105, 109, 112, 113 Commonwealth Institute 298 Communion Bench 336 — Plate, etc. 269, 273, 278, 279, 377 Compensation 310 Compton, Bishop 163, 244 -, Sir Francis 163 —, Lord 77 , Sir William 259 Compton St. 163 Condell, Henry 56 Conduit Heads 377 St. 156 Conran Foundation 305 Cons, Emma 381 Conservation areas 197, 358 Conservative Club 139 Conservatories 283, 288, 360, 361, 371 Constantine, Emperor 75 , Arch of 167 Constantinople 180 Convents 75, 76, 83, 182, 197, 201, 277, 287, 288, 292, 324, 356, 415, 425, 432 Conway Collection 185 Cook, Captain 197, 367, 392 Coombe 373, 377 Lodge 361 Cooper, James Fennimore 299 Cooper's Row 331 Cope, Sir Walter 298 Copenhagen, horse 169 Copernicus 249 Coppin, Sir Geo. 170 Coppinger, Fysh, family 273 Coram, Captain 212, 220

— Foundation 219, 220 Corbets Tey 270 Corbett, Elizabeth 113 Corfe Castle 279 Cork, Ireland 180 Cornhill 69 Cornwall, Duchy of 382 — Terrace 188 Cornwallis, Sir William 223 Cornwall, Jack 313 Coronation, Ceremony of 100, 373, 374, 375 - Chair 101 Cosmati work 100, 180 Coston, Frances and Simon 232 Cottages 272, 285, 352, 406, 421 Cottington, Lord 289 Cotton, Sir Robert 216 Cotton 308 Coulsdon 111, 355, 359 County Hall 135, 378, 379 Courage (Postman's Park) 42 Courage's Brewery 413 Court of Arches 58 of Common Pleas 107 — of Justice 111

— Lodge 352 — Rolls 259, 334 Courtauld, Samuel 217, 371 Courtauld Institute and Gallery 121, 185, 217 Courtney, Archbishop 355, 356 Coutts, Angela Burdett, Baroness 222, 223, 322 -, Thomas 223 - Bank 122, 129; 125 Covent Garden 16, 22, 130-8, 141, 164, 210; 133 - Market 132, 429 Coventry Cathedral 113 Coverdale, Miles 89, 414 Cowley, Richard 239 Cowley 271, 273 Cowper, William 236 Cox family 277 Cox, Richard 272 Coys, William 270 Crabbe, George 157 Crafts, British Centre 134; see also Arts and Crafts Craftsmen's Workshops 293, 415 Craig's Court 116 Craik, Mrs Humphrey 354 Cranford 291 - House 291 Cranham 266, 269 Cranmer, Thomas, Archbishop of Canterbury 328, 360, 382 Crannog 332 Craven House 255 -St. 122 Crayford 343-4, 362 Crecy, Battle of 370 Creffield Rd. 231 Creighton, Bishop 244 Crescent Grove 384 Crewe, Marquess of 160 Cricket 189, 383, 392, 393, 397 Crimean War 370 Criminals 15, 43, 134, 190 Cripplegate 9, 62 Cripples, statues of 380 Cromwell, Oliver 16, 55, 63, 101, 103, 109, 111, 113, 131, 134, 190, 250, 277, 319, 330 — Mary (Lady Fauconberg) 285 —, Thomas, Earl of Essex 68 Cromwell House 223, 256; 257 Croom Hill 366, 368, 369 Crosby, Sir John 14, 53, 76, 308 Crosby Hall 14, 77, 308; 309 Cross, John Walter 156 Cross, John Walter 156 Cross Deep 407 — Keys Inn 198 —, True 75, 152, 257, 354 Crosses 332, 351 Crouch Hill 292, 296 Crown, Harmondsworth 272 & Compass 235 — Estate 161 Estate Commissioners 148Jewels 330 Land 116 Crowther, Messrs 288 Croydon 21, 355-9, 361 —, Archbishop's Palace 14, 356, 358 -, borough of 355-61, 356 College of Art 358Technical College 358 Crucifixes 49, 89 Crucifixion 290, 352, 353

Cruso, Timothy 242 Crusoe, Robinson; see Defoe Crypts 28, 36, 46, 53, 54, 58, 72, 83, 90, 121, 127, 183, 292, 381 Crystal Palace 169, 170, 173, 257, 288, 349, 404, 410; 350 Cubitt Town 20, 323 Cuddington 421 Cudham 353 Cumberland, Duke of 253 Earl of 283 Cumberland Suite 251, 253
— Terrace 188 Cuming, Richard 417 Cuming Museum 417 Cup Final 208 Cups 52, 56, 57, 58, 83, 86 Curtain, The 239 Curtis, William 428 Curzon, Sir Nathaniel 154, 160 -St. 160 Cut, The 381 Cutty Sark 362, 363 Customs 80 - House 90; 88

Dagenham 197, 198, 199, 314 Dagmar Passage 296 Daily Express 27; 28 — Telegraph 27 – Universal Register 409 Dalston 240 Dame, Anne 406 Dane, Clement 131 Danes 12, 22, 62, 70, 127, 129, 197, 244, 362, 390; see also Vikings Danish Church 188, 325 Danson Park Mansion 21, 340, 342 Darcy, Elizabeth, Lady Lumley 422 Dare, Virginia 28 Darke, Harold 69 Darnley, Henry 104, 241 Dartford 15, 197 Dartmouth, Earl of 390 Dartmouth Row 390 Darwin, Charles 21, 98, 353 , Erasmus 353 Daughters of the Cross 425 David, figure of 410 -, King of Scotland 258, 326 Davidson, Randall Thomas, Archbishop of Canterbury 261 Davies, Thomas 131 Davis, Blevins 49 , Charles 144 Davy, Ely 356, 357 -, Sir Humphry 123, 157 Daye, Stephen 420 Dean St. 160, 163, 164, 165 Deanery, St. Pauls 49 Death, personification of 60, 98, 239, 268, 280, 409 De Bruis, Robert 259 De Burgh, family 273 De Everdon, Sylvester, Bishop of Carlisle 30 De Grey, Earl 143 —, Walter 212 De Harte, Boniface 267 De la Mare, Walter 406 de Loutherbourg, Philippe 248 De Quincy 164 De Vaux, Sir Theodore 288 De Vere, Edward, Earl of Oxford 241 De Wette, Auguste 255 De Worde, Wynkyn 27 Dee, Dr John 405 Deer 254, 400 Defence, Ministry of 114, 116, 136 Defoe, Daniel 63, 80, 242, 260, 295, 344 Delaune, Gideon 48 Delft 119 Demainbray, Revd Stephen 397 Denham Park Farm 201 Denmark Hill 242 Deptford 9, 371, 386, 413, 415 Derby, Countess of 16, 279; 13 —, Lord 112, 425 Derham, Dr William 268 Dermody, Thomas 390 Derwentwater, Earl of 231 Desaguliers, Thomas 344 Desenfans, Noel 418 Devereux, Robert, Earl of Essex 127, 328, 330, 402 Devereux St. 127 Devonshire, Dukes of 151, 153, 169, 281, 283 Devonshire House 158, 238 Place 185 Diamonds 330 Diana, goddess 57 - Fountain 254 Dickens, Charles 40, 81, 98, 113, 122, 126, 134, 164, 213, 219, 220, 239, 257, 400, 416, 417 Dickens Inn 324 Dickinson, Frank 343 John 31 'Diehards' 259 Dinneville, Jean de 119 Diploma Gallery 151 — Works 151 Discovery, H.M.S. 413 Disraeli, Benjamin, Lord Beaconsfield 98, 112, 156, 212, 319, 334 Distillers Co. 143, 144 Dixon, Joshua 322 Docklands Museum 323 Docks 21, 22, 310, 317, 323 Dockyards 386 Doctors 39, 185, 244, 246, 273, 288, 291, 393, 410, 425 Commons 52 Docwra, Sir Thomas 293 Dodd, Revd William 274 Dodsley, Robert 150 Doggett, Thomas 372 Dogs' Cemetery 167 —, lost 429 Dollis Brook 200 Hill House 207 Dolls' Houses 288, 322 Dolphin Square 177 Domesday Book 213, 233, 260, 266, 291, 314, 335, 395, 423 Donaldson Collection of Musical Instruments 302 Donne, Anne 128 —, John 34, 128, 214, 308 Doorcases 9, 83, 89, 92, 142, 251 Doorways 12, 211, 271, 272, 290, 297, 303, 346, 376, 377 Dorchester, Marquess of 188 Dorset House 168 Dorset House 116, 392 Dorset House 116, 392 -Square 189 Doughty St. 219; 218

Doulton's potteries 361, 382, 383, 417, 425 Dovecotes 274, 393, 395, 426 Dover, Lord 154 Dover Castle, public house 367 — House 117 — St. 156, 157, 159; 158 Dove Inn 247 Doves 51, 91 -Press 247 Dowding, Lord 103 Dowgate Hill 86 Dowman, Capt. Wilfred 363 Downe, Bromley 352-3 - House 353 Downham, G.L.C. estate 388 Downing, Sir George 117 Downing St. 114, 117 Downshire Hill 228 Doyle, Sir Arthur Conan 361 D'Oyly Carte, Richard & Rupert 125 Drainage 276, 345, 427 Drake, Sir Francis 31, 121, 386 Drayton, Michael 98 Drayton Hall 273; 273 Druid, ship 386 Druid's Head, public house 375 Drury Lane 133 Dryden, John 98, 133, 134 Du Barry, Madame 186 Du Cane, Sir Edward 248 Du Maurier, George 226 Duchess St. 183 Duck-pond 377 Dudley, Alicia, Duchess 214, 215 —, Elizabeth 241 -, Guildford 53, 328, 330 -, Robert, Earl of Leicester 214, 315, 328 Duff, Śir Mount Stuart Elphinstone Grant 406 Dugdale, William 32 Duke St. 122 of York's St. 141, 144
of York's Theatre 134
Dulverton, Lord 295 Dulwich 410, 418, 419 – Art Gallery 418-19 – College 418-19 Duncombe, Sir Charles 89 Dunne, Messrs 346 Dunstable, John 74 Dunstan, Saint and Archbishop 95, 103, 318 Duppa's Almshouses 399 — Hill 358 Durham, Bishop of 123 Dutch Church 68 - House 404 Duveen, Lord 217 Duxford, Cambridgeshire 416 Dwight, John, potter 244 - Lydia 244 Dyer, Charles 86 Dyke, John 80 Dysart, Earl of 400, 403

E.M.I. factory 274
Eagle House, Mitcham 393
— House, Wimbledon 395; 393
Ealing 21, 229-30, 271
—, borough of 229-33
Earlham St. 134
Earthworks 263, 276, 354

East Acton Manor House 57 Bedfont 281, 290 - Ham 12, 310, 311-2 — India Company and House 78, 203, 290, 317, 323, 395 India, Devonshire Sports Club 143 - Indies 163, 317 India Street Market 417 Eastbury House 16, 197; 199 Eastcote 271, 279 Easter Sepulchre 76, 240, 271, 353, 373, 423
Eastlake, Sir Charles 183 Eaton Mews North 17 Square 174, 176 Ebury St. 174 **Ecclesiological Society 334** Ecclesiologist 209 Eccleston St. 176 **Economist Buildings 144** Edgar, King 418 Edgington, Messrs 417 Edgware 200,202 — Rd. 182, 190, 202 Edinburgh 91, 205, 221, 304 — Gate 169 Edith, Queen to Edward the Confessor 100 Edmonton 234, 236 Edmund, Saint and King 62, 70, 103, 373 Duke of Lancaster 81 Education, Institute of 217 Edward the Confessor 12, 13, 53, 95, 100, 101, 103, 107, 111, 266, 330, Edward the Elder, King 197, 373 Edward I 13, 54, 100, 101, 122, 245, 259, 328 Edward II 13, 102, 371 Edward III 13, 48, 101, 106, 112, 266, 295, 325, 326, 371, 374, 391 Edward IV 198, 200, 328, 397, 415 Edward V 104, 276, 328 Edward VI 46, 62, 63, 68, 79, 103, 113, 114, 125, 163, 167, 235, 250, 255, 267, 287, 310, 380, 382, 397 Edward VII 125, 216, 235, 304, 341 — Memorial Garden 325 Edward VIII 400, 405 — Augustus, Duke of Kent 183 259, 328 - Augustus, Duke of Kent 183 -, the Black Prince 213, 330 Edwardes Square 299 Edwards, John Passmore 311 Edwy, King 373 Eel Pie Island 397, 407 Egerton, John, Earl of Bridgewater 63 —, Sir Thomas 280 Egremont, Lord 153 Egypt 214 Egyptian Antiquities 216, 218, 274
— Architecture 242
— Hall 73, 150, 170
Egyptology 138, 218
Einstein, Albert 303 Eisenhower, General 141 Eldred, King 373 Eleanor of Castile, Queen to Edward I 101, 122, 258, 324 — of Provence, Queen to Henry III Eleanor Crosses 101, 116, 122 Election, The (Hogarth's) 214 Elections 54, 286 Electricity 125

Elephant and Castle 416 Elephants 40, 316 Elfin Oak 173 Elgin Marbles 216, 219 Eliot, George (Mary Anne Evans) 156, 223, 308 -, Thomas Stearns 70, 89, 98, 120, 299, 399 369, 374, 376, 382, 384, 386, 389, 392, 394, 397, 398, 399, 402, 427 Elizabeth II 67, 84, 129, 146, 278, 364, 368, 379, 404, 418 Queen to George VI 144, 325, 330, 379 of York, Queen to Henry VII 16, 103, 106, 114, 240, 327 Ellerdale Rd. 226 Ellen Mead 201 Ellesmere, Lord 147 Elm Grove 432 Elmers, Chris 323 Elmers, James 381 Elphinstone, Hon. Mountstuart 217 Elsing Spital 62 Elsynge Hall 235 Eltham 362 — Lodge 372 — Palace 14, 15, 371; 372 - Town 372 Ely, Bishop of 157, 212 Ely Cathedral 175 Place, Holborn 13, 212 Embankments 20, 122, 135, 136, 147, 308, 379, 381 Emberton, Joseph 149 Embroidery 37, 43, 44, 52, 69, 71, 85, 92, 95, 125, 128, 150, 197, 251, 276, 295, 302, 304, 308, 332, 369, 376, 392 Emden, Walter 134 Emmanuel College 46 Emigration 366 Empire Cinema 166
— Pool 208 — State Building 278 Enfield 234-5, 236 -, borough of 234-8 - Chase 234, 235, 237 – rifle 236 Engineering 303 English, F.A. 360 English Electric Co. 129

— National Opera 134

— Speaking Union 160 Enthoven, Gabrielle 133 Epitaphs, noteworthy 36, 46, 83, 89, 206, 332, 393, 428, 384, 385 Epping Forest 9, 15, 332, 334, 361 Epsom 8, 373 Erasmus, Desiderius 54, 371 Erith 344 Erkenwald, Saint 15, 32, 75, 90, 197 Erlanger, Emile d', Baron 252 Eros 148; 149 Erskine Hill 205 Esdaile, Sir James 270 , Katherine 293, 315, 335, 351, 431 Essex, Earl of 272, 278

Essex 22, 197, 266, 310, 311, 317, 320, 332, 377 – Hall 334 -St. 127 Ethelburga, Saint 75, 90, 197 Etheldreda, Saint 201, 212 Ethelred, King 20, 84, 373 Ethnography 387 Etloe House 336 Eton College 14, 204, 241, 328, 385 Etruscan Dressing Room 289 Eugenie, Empress 351 Europa Gallery 420 Euston Rd. 219, 220 Estation 20, 210, 220, 413 Evelyn, John 33, 122, 145, 149, 152, 210, 241, 244, 305, 309, 315, 383, 386, 395, 426 —, Mary 386 -, Richard 386 Everest, Mount 302 Ewell 12 Executions 115, 116, 122, 125, 127, 167, 180, 181, 186, 190, 210, 231, 233, 249, 250, 252, 274, 290, 294, 307, 310, 328, 329, 330, 402 Exhibition Rd. 302 Explosions 90, 119 Eyre Estate 189 Eyre, Sir Simon 78

Fabyan, Robert 69 Factories 122, 236, 262, 274 Fairey Aviation Company 271 Fairfax, Thomas, Baron Fairfax 278 Fairfield, Kingston 376 — Halls 358 Fairlop Oak 219 Fairs 43, 224, 225, 254, 262, 352, 421 Faithorne, William 47 Falconberg, Thomas 390 Falcons 208 Falkner, Anna Maria 255 Fanshawe family 198, 199 Fanum House 166 Faraday, Michael 98, 157, 223, 254, Faraday Building 49 - House 254 Fardyce, John 20 Farnborough 9, 352 Farringdon Rd. 292 Farthing Down 11, 359 Fauconberg, Mary, Lady 285 Fawcett, Henry 138, 383 Fawkes, Guy 111 Featherstonehaugh, Sir Matthew 117 Fedorovitch, Sophie 131 Feltham 281, 290 Fenchurch St. Station 81 Fenton House 227; 227 Ferries 371, 378, 407 Festival of Britain 323, 379, 381 Fielding, Henry 52, 131, 231 —, Sir John 131 Finch, Isabella, Lady 158 Finchley 9, 200, 204; 202 Fine Arts Society 155 Finsbury Circus and Square 64
— Place 292, 296 Fire Court 18, 127 -, The Great 18, 27, 30, 31, 33, 43, 48, 53, 56, 64, 68, 75, 88, 89, 90,

127, 188, 211, 245, 322, 324 - Insurance marks 56, 277 Fireplaces 168, 172, 173, 198, 282, 313, 341, 343 Fires 18, 20, 89-90, 114, 115, 133, Fish 50, 89, 112, 285 Fisher, John, Bishop of Winchester 90, 111, 181, 306, 328, 330 Fishermen 198 Fitch, Alexander 261 Fitzalan, Jane, Lady Lumley 422 Fitzailwyn, Henry 13, 68 Fitzjames, Richard, Bishop of London Fitzjohn's Avenue 227 Fitzstephen, William 292 Fitzwilliam, Jane 139 —, Lord 398 Fitzwilliam Museum, Cambridge 398 Five Bells, Harmondsworth 272 Fields 174 — Members 16, 109 Flambeaux 143, 158, 200 Flamingoes 388 Flamstead, John 364, 367 Flamstead House 363, 367 Flanders 280, 290 Flask, The 223

— Walk 225

Flats 178, 193, 256, 289, 296, 302, 321, 322 Fleet Street 25-8, 29, 34, 262; No.17 15, 28-9 Fleming, Sir Alexander 191 Fletcher, Bannister 49 John 412 Flooding 285, 288, 344, 345 Flower, Sir Charles 201 Floyd, John 125 Fly-overs 246, 355, 357 Font covers 42, 49, 51, 57, 78, 91, _ 270, 280, 291, 352 270, 280, 291, 352 Fonteyn, Dame Margot 120 Fonthill Abbey 163 Fonts 12, 34, 39, 46, 49, 50, 51, 52, 55, 63, 67, 69, 70, 74, 78, 79, 80, 89, 91, 92, 128, 149, 180, 186, 197, 202, 206, 215, 232, 233, 244, 246, 258, 260, 261, 264, 266, 268, 270, 271, 273, 274, 277, 278, 279, 280, 286, 291, 312, 319, 330, 332, 339, 340, 341, 346, 350, 352, 353, 339, 340, 341, 346, 350, 352, 353, 360, 369, 371, 374, 399, 400, 405, 409, 410 Football 208 Footpaths 392 Foot's Cray 341 Ford Motor Company 197, 266; 198 Fordhook Avenue 231 Foreign Office 116, 221; 115 Foreigners 78, 163, 320 Forests 182, 237 Forgery 274 Forster, E.M. 384 -, Lady Elizabeth 184 -, William Edward 138 Forster Memorial Park 389 Fort, Roman 12, 56, 62, 64 -St. 320 Fortis Green Road 257 Fortnum & Mason 150 Fortrey, Samuel and Catherine 404 Forty Hall 235; 236 — Hill Park 234

Foscolo, Ugo 285, 299 Fot, Godwin 341 Foubert's Place 162 Foucault pendulum 303 288, 380, 406, 432 Fournier St. 19, 320, 321; 322 Fourth Form Room, Harrow 261 Fox, Bishop 412 Charles James 109, 261, 282, 298, 395

—, Sir Stephen 309

Fox and Hounds 285 Foxe, John 63 Frame makers 184 France 98, 137, 143, 147, 166, 207, 259, 267, 326, 359, 391 Francis Holland School 186 Franciscans 14, 41 François I 57, 254 Franklin, Benjamin 44, 186 Freckenham, Abbot 100 Frederick, Prince of Wales 166, 252, 366, 403

—, Duke of York 117, 139, 145, 150 French Protestant Church 163 Frere, Sir Bartle 137 Fresco 107, 108, 109, 114, 178; see also wall paintings Fresh Water Estate 190 Freud, Sigmund 227, 228 Friends' Burial Ground 197 Meeting House 277 Frith St. 164 Frobisher, Martin 63, 325 Froebel Institute 432 Frognal House 341 Froissart, Jean 371 Fry, Elizabeth 40, 197, 268 —, Joseph 268 —, Roger 217 Fulham 243-6 — Palace 15, 243-4; 244 - Pottery 244 Fuller, Revd Thomas 72, 291, 294 Funeral hatchments 392 Funeral palls 69, 85 Furniture 40, 165, 184, 224, 288, 296, 304, 334, 342, 346, 357, 401, Furnival, F.J. 246 Furs 50 Gaiety Theatre 129 Galilee 249 Galleries, Long 172, 173, 252, 253, 283, 287, 289, 403 Galsworthy, John 227, 261 Gambier-Parry, Thomas 217 Garbo, Greta 120 Garden, Sir Denis 383 Garden History, Museum of 382
— Suburbs 204-5, 392, 393 Gardens 31, 38, 42, 43, 56, 60, 64, 66, 68, 86, 88, 91, 106, 170, 188, 227, 241, 243-4, 250, 253-4, 283, 285, 287, 288, 298-9, 308, 340, 344, 346, 354, 379, 382, 407 Gardening 167 Gardiner, Mrs Elizabeth 394 —, Revd Michael 233

Garibaldi 140

Garnett, Father 53 Garrick, David 27, 98, 120, 123, 131, 133, 166, 215, 248, 255, 285 Garrick Club 134 Garrick's Villa 407 Garter, Order of 371 — Robes 106, 172, 350 Gas holders 388 works 194 Gascoyne, Sir Crisp 72, 197 Gaskell, Elizabeth 308 Gate piers 281, 299 Gatehouse, public house 222 Gatehouses 249, 272, 293, 295, 349, Gateways 46, 283, 288, 404; 29 Gaulle, General de 145 Gaunt, William 298 Gay, John 98, 134, 246, 276, 281, 406, 409 Gayer, Sir John 80 Gayne, Sir Robert 150 Gazebo 368 Geffrye Museum 239, 246, 322; 240 Genealogists, Society of 304 General Credit & Discount Co. 9 Gentleman's Magazine 293 — Row, Enfield 235 Geological Museum 21, 301, 303
— Society 151
George, Saint 103, 112
George 131, 34, 121, 155, 167, 171, 172, 173, 253, 276, 364, 369
George II 103, 117, 147, 152, 166, 171, 251, 252, 253, 264, 276, 364, 398, 403, 406
George III 54, 125, 139, 147, 150, 151, 152, 164, 172, 184, 186, 213, 216, 229, 246, 252, 290, 293, 295, 303, 388, 400, 403, 404, 405, 418
George IV 20, 117, 119, 143, 145, 147, 153, 161, 167, 184, 186, 187, 221, 331, 404, 405
George V 112, 138, 147, 265 Geological Museum 21, 301, 303 George V 112, 138, 147, 265 George V Dock 310 George VI 144, 150 of Denmark, Queen Anne's Consort 252, 364 , Frederick 240 George & Dragon Hotel 231 — Inn 413 - St. 122 Georgia, U.S.A. 269 Gerard, John 149, 225, 415 Ghana 157 Ghosts 43, 250 Gibbons, Christopher 98 -, Orlando 98 —, Stanley, Messrs 129 Gibraltar 91 Gibson Mausoleum 420 Gilbert the Knight 373, 391 —, Sir Humphrey 63 —, Sir William Schwenk 21, 125, 138, 263, 264, 304 Giles, Saint 214 Gilmore House 383 Gilpin, John 236 Gipsy Moth 362, 363 Gladstone, William Ewart 98, 128, 143, 150, 156, 164, 207 Gladstone Park 207 Glass buildings 132, 134, 145, 169, 176, 177, 192, 222, 237, 288, 322,

— drawing room 137 — drinking horn 199, 270 — factory 262 - Heraldic 60, 90, 105, 233, 266, 269

-, noteworthy 9, 28, 30, 34, 36, 41, 42, 44, 49, 55, 57, 60, 63, 68, 69, 70, 73, 74, 75, 76, 79, 80, 88, 97, 113, 156, 164, 176, 212, 213, 223, 230, 232, 233, 237, 241, 242, 245, 257, 258, 262, 264, 266, 269, 270, 273, 276, 278, 280, 289, 290, 293, 304, 307, 312, 313, 316, 318, 324, 325, 342, ??, 353, 354, 367, 368, 369, 372, 376, 377, 384, 390, 392, 394, 395, 409, 413, 414, 418, 419, 427, 429, 432 427, 429, 432 Glastonbury Abbey 32 Glencross, Alan 367 Glentworth St. 186 Globe Theatre 413 Glover, Revd José 420 , Robert 63 Gloucester, Duke of 238 Gloucester Gate 188 Gobelins tapestry works 252, 289 Goderick, Viscount 261 Godwin, E.W. 162 Gold, Revd Henry 274 Golden Hind 31, 386 - Lion, Romford 267 - Lion, St. James's 144 -Square 165, 264 Golders Green 204 - Hill Park 228 Goldsmid, Benjamin 432 Goldsmith, Oliver 166, 297 Goldsmiths' College 387 — Co. Almshouses 231 Golf Clubs 263, 347, 360, 388, 394, Goodall, Frederick 163 Goode, John 377 Thomas 160 Goodwin's Court 134; 123 Goodyer, John 270 Gordon, General 136, 368 Gordon Riots 416 — Square 211, 217 Goring, Lord 147 Gort, Lord 261 Gosfrith the Portreeve 12 Gospel Oak 190 Gosse, Edmund 148 Gough Square, No.17 26; 26 Gower, John 410 Gower St. 211, 218 Graffiti 270 Grafton St. 157 Grahame-White, Claude 203 Grand Union Canal 192, 229, 248, 271, 279, 301 Grange, The, Brent 207 —, The, Croom's Hill 368 –, The, Hammersmith 246 –, The, Wallington 426 – Walk 415 Grant, Baron 166 Granville-Barker, Harley 379 Granville Square 296 Graves, Robert 399 Gray's Inn 16, 210, 212 — Inn Rd. 174, 212 Great Central Railway 189 - Eastern 415

-Exhibition 20, 57, 137, 147, 169, 221, 301, 303, 322, 349, 378 - George St. 118 - Harry 369 - Marlborough St. 162 - Model, St. Paul's 33, 37; 33 North Rd. 200, 256 Ormond St. 211, 305 — Queen St. 16, 134, 205 — Russell St. 216 — Seal 203 — Tomkyns 269 — Warley 21, 266 — West Aerodrome 271 — West Rd. 285 – Western Hotel 192 - Western Railway 190, 191, 229, 232, 273 Western Rd. 194 Greater London Council 21, 122, 132, 238, 257, 296, 299, 372, 378, 406 Greatorex, Thomas 98 Greece: Byron, 169; Parthenon 180 Greek architecture 219 - Christian Community 163 — influences 36, 39, 340 - Orthodox Church 163, 191, 219, 343 — St. 163 vases 216, 289 Green, Fortunatus 239 , Robert 239 Green Belt 22 Park 147, 148, 150, 153, 167 Greenaway, Kate 226 Greenford 229, 233 Greenland Dock 415 Greenwich 362-8 - borough of 362-72 Observatory 332 -Palace 16, 141, 151, 197, 323 Queen's House 16, 141, 365-6 — Theatre 368
Grenadier Guards 403
—, The, public house 174 Gresham, John 316 —, Sir Richard 54 -, Sir Thomas 58, 68, 76, 287, 288, 347 Grey, Lady Jane 43, 53, 90, 287, 327, 328, 329, 330, 334 , Sir Thomas 90 Grey Coat Hospital School 178 Greyfriars 14 Greyhound, The 425 Griefin Hotel 375 Grimaldi, Joseph 296 Grim's Dyke (house) 21, 263; 262 Grindall, Edmund, Archbishop of Canterbury 243, 356 Grisaille painting 35, 265, 282, 363 Grissell & Peto, contractors 108 Grocyn, William 54 Groom Place 176 Grosvenor, Lord 154, 174 , Sir Richard 159, 160 Grosvenor Collection of Glass 377

— Estate 19, 174, 176, 177 — Hotel 176 House 168 — Place 147, 174 — Square 19, 154, 159 Grotto 255, 407, 425 Grove End Rd. 189 –, The, Highgate 223 – Terrace 222

Grovelands 238 Grunewald 231 Guard, Changing of 117, 147 Guildford Museum 421 Guildhall 14, 18, 22, 53-5, 89; 55, 56 —, Kingston 375 -School of Music & Drama 63 Guinness family 96 Gurney House 288 Gun, The, public house 323 -St. 320, 321 Gundulf, Bishop of Rochester 12 Gunnersbury Park 230 Gunnis, Rupert 278 Gunpowder Plot 53, 213, 291, 329 Gurnell, Thomas 229 Guns 118, 169, 236, 268, 327 Gutenberg New Testament 382 Guy, Thomas 414 Guy's Hospital 246, 414 Gwydyr House 116 Gwynne, Nell 121, 133, 245 Gypsies 224

Hacker, Colonel 328 Hackney 240-1, 261 -, borough of 239-42 Marshes 239, 240 Hadley Green 200 Haggerston 239 Hainault Forest 199 Haldimand, George and William 175 Hale, Sir Matthew 231 Hales, Revd Stephen 409 Half-timbering 212, 261 Halfhide, William 391 Halicarnassus 215 Halifax, Lord 254, 255 Halkin Arcade 176 — St. 175 Hall, Sir Benjamin 111 Hall Place, Bexley 340; 340 Hallam, Arthur 186 Halley, Sir Esmond 389 — Gallery 367 Halls 14, 28, 31, 44, 47, 51, 53-4, 90, 107, 110-111, 243, 249, 253, 294, 308, 356, 371, 381, 412-3, 426 Ham House 400-403, 407; 402 Hambledon, Kent 393 Hamey, Baldwin 188 Hamilton, Duke of 402 -, Lady 186, 391 —, Sir William 216, 289, 391 Hamilton Terrace 189 Hammerbeam roofs 14, 31, 110, 212, 213, 249, 272, 277, 294, 308, 371, 372, 381, 392, 426 Hammerskjold, Dag 429 Hammersmith 246-8 — Bridge 243, 246 — and Fulham, Borough of 243-8 — Mall 246-7 -Terrace 247 Hampstead 11, 107, 182, 210, 219, 223-8, 260; 227 -Garden Suburb 22, 199, 204-5 — Heath 9, 11, 205, 210, 219, 224, 225; 226 — Square 225 — Way 204, 205 Hampton 249, 254-5, 289, 397

Bridge 254

Hampton Court 15, 90, 114, 135, 170, 249-55, 304, 362, 363, 365,

373, 377, 397, 401, 405; 250, 252, 253, 255 - Court, House 255 — Court, Theatre 255 — Court, Vine 316 Handel, George Frederick 98, 155, 165, 202, 212, 220, 227, 264, 265, 281 Hangar Hill 229 Hanover Square 154, 155, 159; 155 - St. 154 Terrace 188 Hanoverians 364, 397 Hanseatic Merchants 85 Hansom, Joseph 245 Hanway, Jonas 232 Hanwell 12, 229, 231 Hanworth 15, 281, 289 House 289 Hardy, Thomas 121 Harefield 13, 16, 271, 279 Haringey, borough of 256-9
— Civic Centre 257 Town Hall and Central Library 256 Harleian Collection 98, 123 Harlesden 206 Harley, Robert, Earl of Oxford 98, 123, 182, 216 Harley St. 185 Harlington 12, 271 Harmondsworth 9, 12, 271, 272 Harmsworth, Geraldine Mary 416 Lord 27 Harold, King of the English 12, 95, 233, 236 Harper, Michael 279 Harpsichords 227 Harrington family 278 , Sir James 278 Harrington Gardens 304 — House 116 Harris, Sir James 86 Harris's Iron Foundry 374 Harrods 307 Harrow, borough of 260-5 on-the-Hill 14, 15, 207, 260-1, 271, 361 - Ŕd. 194 -School 261; 263 South 22 -, Soutn 22 - Weald 163, 261-2 Hart, William 264 Harvard, John 412 Harvard Chapel 412 University 412, 413 Harvey, William 361 Harwood Hall 270 Hasted, Edward 10 Hastings, Lord 330 Warren 111 Hastings, Battle of 12, 326 Hatchards 150 Hatfield 15 Church 201 Hatters 144 Hatton, Sir Christopher 212, 357
— Garden 212, 220, 252
Havelock, Sir Henry 119
Havering, borough of 266-70 Havering-atte-Bower 266 Hawker, Henry 377 Hawkins, Sir John 91 Hay Hill 158 Haydn, Joseph 302

—, Middlesex 271, 274-6 Haymarket 9, 141, 144 Theatre 144 Hayward Gallery 379 Hazlett, Sarah 212 —, William 164, 212 Head-dresses 198, 204, 206, 233, 270, 273, 333, 344, 350, 389, 409 Headstone Lane 262 Health Tax Returns 320 Heath St., Hampstead 225 Heather, William 98 Heathfield, Lord 153 Heathfield House 390 Heathgate 203, 368 Heathrow Airport 11, 271, 281, 289 Heidigger, John James 398 Heigham, Sir Richard 312 Heine, Heinrich 122 Heinz Gallery 185 Helder, Edward 235 Helen, Saint 75 Heminge, John 56 Hendon 12, 200, 202-3 Aerodrome 203 - Hall 264 Hengist 343 Henrietta Maria, Queen to Charles I 16, 106, 125, 141, 250, 253, 362, 365, 395, 403 Henrietta Barnett School 205 St. 131 Henry I 13, 100, 310, 397 Henry II 266, 267, 345 Henry III 13, 30, 95, 96, 101, 102, 105, 107, 125, 326, 328, 330 Henry IV 14, 106, 111, 266, 326, 330 Henry V 101, 287, 330, 362, 390, 415, 431 Henry VI 24, 327, 330, 356, 371, Henry VII 14, 15, 16, 49, 96, 102-4, 106, 114, 120, 240, 249, 309, 326, 328, 397, 398, 427 - Chapel 15, 16, 96, 102-4, 111, 249, 407
Henry VIII 15, 43, 44, 46, 47, 50, 57, 69, 79, 81, 104, 106, 107, 108, 112, 113, 114, 119, 120, 121, 125, 139, 167, 182, 186, 188, 197, 213, 214, 232, 235, 239, 244, 249, 250, 251, 253, 254, 266, 272, 286, 290, 294, 295, 307, 313, 327, 328, 330, 331, 333, 362, 365, 367, 369, 381, 382, 386, 397, 413
Henry VIII's wine cellar 15, 114 Henry VIII's wine cellar 15, 114 -, Prince of Wales 28, 369, 397 — Grace à Dieu 369 Thornton School 384 Henson, Leslie 131 Heraclius, Patriarch of Jerusalem 30 Heraldic glass 31, 75, 77, 243 Heraldry 49, 98, 102, 108, 122, 274, Herbaceous borders 190, 253, 265 Herbariums 395, 403 Herbs and Herbals 83, 149, 225, 287, 413, 416 Herbert, Sir A.P. 248 , Sidney 145, 175, 261 Hercules, statue 404 Her Majesty's Theatre 144 Hermit 64, 274, 312

Hayes, Bromley 11, 354
Herrick, Robert 58 Herring, Thomas, Archbishop of Canterbury 356 Herschel, Sir John 98 Hertford, Marquis of 25, 184 Hertford Rd. 234 Hertfordshire 11, 201, 260, 271 Hervey, Lord 281 Hesdin, Ernulf de 279 Heseltine, Evelyn 266 Hess, Rudolf 329 Heston 15, 281, 291 Hewer, William 21, 383, 384 Heydon, Sir Henry 354 High Elms Park 9 Holborn 214 Highams 314 Highbury 292, 296 — Corner 297 Highgate 9, 15, 210, 219, 222, 256, 260, 296 - Cemetery 222 - School 222 Highland dress 153 Highpoint (flats) 256 Highwalks 56 Highway, The 324, 325 Highwaymen 289 High-wood Hill 201 Hill, Sir Rowland 259 Hill Garden 227 Rd. 189 Hillcrest, G.L.C. estate 388 Hillingdon 9, 271, 276-7 —, borough of 271-80 — House 277 Hilton Hotel 154, 168 Hinges 270, 415 His Master's Voice Record Co. 375 Historical Research, Institute of Hitler, Adolf 233 Hobart, Hon. George later Earl of Buckingham 142 Hodges, Nathaniel 74
Hodges, Nathaniel 74
Hogarth, Mary 219
Hogarth House, Richmond 399
— Press 399
Hogarth's House 285
Hogg, James 259
—, Quintin 183
Hogsmill River 373, 375, 275 Hogsmill River 373, 375; 375 Holbein Chamber 407 Holborn 174, 210-18, 292 Viaduct 211 Holcombe House 201; 201 Holford, R.S. 168 Holland, Charles 285 —, Countess of 70 —, Earls of 298 —, Frank 286 Holland 365 House 298 — Park 298 — Park Rd., No.12 299; 300 Holles St. 182 Hollies, The 342 Hollond, Ellen and Robert 264 Holly Lodge Estate 223 - Place 226 Terrace 223 Hollybush Inn 226 Holme, The 187 Holmes, Sherlock 361 —, Thea, 298

Holst, Gustav 405; 248 Holwood 354 Holy Roman Emperor 98 Holy Trinity Christchurch, Aldgate 80, 258 Holywell Priory 239 Home House 185 — Office 116 Homer 170, 215 Homerton High St. 240 Honourable Artillery Company 79, 295, 331 Hooker, Sir Joseph 403 —, Sir William 403 Hoop and Grapes, public house 317 Hoover factory 232; 233 Hope, Thomas 183, 189 Hope Suffrance Wharf 415 Hopton Almshouses 413 Hornchurch 266, 267 Horniman Museum 387; 388 Horney 256, 257; 257 Horse Guards Avenue 116, 136 Guards Barracks 169 - Guards Parade 20, 117, 136, 147; Horses 174, 425 Horsenden Hill 229 Horseferry Rd. 174 Hosier, Admiral 368 Hospitals 15, 19, 43-4, 58, 64, 174, 191, 220, 227, 318 Hotels 125, 129, 155, 156, 221, 254 Houghton, Prior John 294 Houndsditch 81 Hounslow 289 —, borough of 281-91 — Heath 9, 289 Hourglasses 270, 336 Housing Estates Alton 432 Aylesbury 417 Becontree 199 Boundary 322 Downham 388 Hillcrest 388 Lansbury 323 Queen's Park 194 Roehampton 432 St. Helier 393 Thamesmead 344-5 Howard, Sir Ebenezer 63 — family 241 Henrietta, Countess of Suffolk Henry, Earl of Northampton 137, —, Henry, Earl of Surrey 90 —, Katherine, Queen to Henry VIII 250, 329, 330 —, Lord 113 -, Thomas, Earl of Arundel 223 Howbery Grange Barn 344 Howe, Mary, Countess 224 Howland West Dock 19 Howley, Benjamin, Bishop of London 243 Hoxton 239 Herbert, Saint 184 Hudson, Henry 75, 264 W.H. 167 Hudson Bay Company 50 Hugh, Saint 103 Huguenots 19, 163, 320, 430 Hume, David 123

Hunt, Sir John 302 —, Leigh 41, 213, 228, 298, 299, 301, 308 Hunter, John 48, 124, 166, 174, 214 Hunterian Museum 214 Hunting 163, 167, 182, 234, 253, 266, 289, 332 horn brass 339 Huntingdon Collection, U.S.A. 168 Hurlingham Club 245 Huskisson, William, M.P. 177 Hutchinson, John and Lucy 212 Huxley, Thomas 353 Hyde Park 167-170 — Park Corner 135, 169, 174 — Park Crescent 190 Park Gate 190, 302 Hygiene & Tropical Medicine, School of 217 Hyll, Thomas 244 Ice Houses 299, 372, 400 Ickenham 271, 278 Iceni 11 Iconoclasm 15, 103, 122 Icons 26 Ilford 199, 312, 314, 316 Illustrated London News 178 Imperial Camel Corps 138 - Chemical Industries 113 — College 303 - College Student Union 301, 302
- Defence College 176
- Institute 301 — War Museum 309, 416 India 174, 285 — House 129 Indian sculpture 388 Ingram, Sir Thomas 288 Inner Circle 187 Innes, John 392 Innocents' Corner 104, 328 Inns of Court 26, 28, 210, 212 Institute of Contemporary Arts 145 Insurance 56, 78 Ionides, Hon. Mrs 406 Ireland, John 42 Ireland (Eire) 125, 180 — Yard 48 Ireton, Henry 190 Ireton, Henry 190
Ireton House 223, 256
Iron Age 11, 217, 271, 316, 332, 351, 354, 394, 395, 396, 427
Ironwork 34, 101, 102, 103, 104, 127, 158, 160, 176, 184, 251, 254, 285, 361, 371 Irving, Revd Edward 217 —, Sir Henry 129, 133, 418 —, Washington 297 Isabella, Archduchess of Austria 251 — of France, Queen to Richard II 119, 266, 390 Isabella Plantation 400 Islamic Cultural Centre 306 Islamic Cultural Centre 306
Island Gardens, Tower Hamlets 363
Isle of Dogs 20, 317, 323, 415
Isleworth 281, 287, 399
Islington 15, 19, 235, 296-7
—, borough of 292-7
Islip, Abbot 96, 101, 112
Islian merchants 83, 352 Italian merchants 83, 352 Iveagh Bequest 223-4

Humphrey, Duke of Gloucester 362 Hungerford Market 122, 137 Ivory House 324 Ivy House 228

Jacob, Patriarch 101 Jacobites 253, 329 Jacobsen, Theodore 68 lamaica 288 Jamaica 288 James I 16, 29, 32, 40, 76, 79, 80 103, 104, 115, 123, 152, 167, 182, 208, 235, 239, 250, 254, 268, 274, 304, 312, 318, 362, 384, 397, 398, 400, 405 James II 18, 89, 103, 115, 120, 149, 154, 250, 304, 309, 328, 330, 365 James I, King of Scotland 326, 357 —, Henry 28, 308 -, Lady 371 Janssen, Sir Theodore 395, 429 Japan 176, 404 Jason, barge 193 Jebb, Sir Richard 238 Jefferies, Judge 56, 329 Jelling Stone 188 Jenner, Dr 167 Jenny Wren, barge 193 Jermyn, Henry, Earl of St. Albans 141, 149 Jermyn St. 144, 303 Jerome, Jerome K. 255 Jerusalem 28, 30, 43, 288, 292 - Chamber 106 Jesse, Tree of 105 **Jesuits 432** Jewel, John Bishop 279 — Tower, Westminster 107, 112 — House, Tower of London 330 Jewellery 57, 293, 303, 330-1 Jewish Burial Ground 319 - Museum 218 - Symbols 34, 72, 81 Iews 54 Joan of Arc, Saint 359 of Navarre, Queen to Henry IV John, Saint 100, 149, 266 King of England 13, 108, 328, 330, 391 -, King of France 124, 326, 371 of Gaunt, Duke of Lancaster 135, 212 John (Adam) St. 123 — Ruskin's School 361 Johnson, B.H. 154 , Louisa Catherine 90 -, L.J. 419 —, Samuel 20, 26, 43, 123, 128, 131, 150, 212, 224, 229, 251, 269, 274, 295, 296, 346, 384, 413

Johnstone, James 406

Jones, Christopher, Captain 415 -, Inigo, Lt. Col. 52 —, Richard, Earl of Ranelagh 309 Jonson, Ben 63, 98, 114, 239, 253 Joshua Chapel 288 Joynes, Henry 170 Jubilee Gardens 9 Judas Iscariot 286, 410 Judith, Countess of Northumberland 259 Julia Pacata 331 Julius II, Pope 304 Jutland, Battle of 313 Juxon, William, Archbishop of Canterbury 357, 381

Katharine of Aragon, Queen to Henry VIII 47, 79, 112, 362 Katherine, Saint & Martyr 80, 112 Kean, Edmund 296, 398, 399 Keats, John 66, 215, 226, 228, 235. 414. Keats House 228 Kelmscott Press 247 Kempe, farmers 203 Kennington 378, 417 - Lane 382 - Park Rd. 417 Kenelm, Saint 103 Kensal Green Cemetery 301 Gasworks 194 Kensington 18, 107, 169, 170, 298-309 and Chelsea, Royal Borough of 298-309 — Gardens 167, 170 — High Street, 298 - Palace 18, 140, 160, 167, 169, 171-3, 176, 298, 301 South 301, 303 Kent, Duchess of 171, 176 —, Duke of 143, 171, 229, 404 Kentish Town 210, 222 Kenwood 20, 21, 219, 223-4; 224 Keston 353-4 Kew 15, 135, 213, 397, 398, 403-4 — Bridge 285, 403 — Bridge Pumping Station 285 — Gardens 403-4; 404 -Palace 404 Keys, Ceremony of 331 Kilburn 21, 190, 206 Killigrew, Anne 125 —, Sir Henry 267 Kilmarnock, Lord 330 Kilns 222, 224, 354, 421 Kilwardby, Robert, Archbishop of Canterbury 357 King, Gregory 163 King Edward's Memorial Garden 325 John's Palace 376 – Square 163 — St., City 89 — St., Covent Garden 131, 132, 133; 132 — St., St. James's 141, 143, 144 King's Arms 279, 413 College 125, 126 - Cross Station 210, 220, 221, 296 — Head 261 — Head Yard 413 — Reach 138 -Rd. 176, 309 Theatre in the Haymarket 398 Well Shopping precinct 226 Kingly St. 162 Kingsbury 206, 208 Kingsland Rd. 239, 240 Kingston 373-6 - Market 374; 376 - Museum 374, 392 Kingston upon Thames, Royal Borough of 373-7 Kingsway 161 Kingswood, Dulwich 419 Kinnerton St. 176 Kipling Rudyard 98, 123, 246 Kiralfy, Imre 248 Kirby House 322 Kitchener, Lord 117 Kitchens 14, 203, 249, 253, 374

Kneller Hall 409 Knight, Richard Payne 163 Knole 15, 365 Knox-Johnstone, Robin 353 Kodak factory 262 Konigsmarck, Count 97 Koran 259 Korean War 416 Kynaston, Sir Francis 131

Ladbroke, F.W. 299 — Grove 194, 299 - Grove Estate 194, 299 Ladywell 386 Sports Centre 390 Lakes 145, 167, 188, 224, 250, 251, 263, 287, 404, 425 Lamb, Charles 31, 78, 131, 212, 235, 236, 297 —, Mary 131, 212, 235, 237, 297 —, Sir Peniston 150 -, William, Lord Melbourne 41, 43, Lamb's Conduit Fields 220 Lambarde, William 368 Lambeth 9, 355, 381-3, 410, 427 , borough of 378-85 -Bridge 383 - Palace 14, 378, 381-2, 410, 382, 383 — Walk 382 — Water Works 378 Lammas land 166 - Park 229 Lamorbey 342 Lamp posts 381 Lanark Road 194 Lancaster, Aveline, Countess of 100 — Collection 395 —, Duchy of 235 —, Dukes of 125 —Gate 191 — House 140, 147, 320 Lancet, The 123 Land Revenue, Commissions for 199 Landing Steps 114, 122, 135 Lane, Sir Hugh 308 John 150 Lanesborough House 174 Lanfranc, Archbishop of Canterbury Langham, Nathaniel 111 , Simon, Abbot 95 Langham Hotel 183 - House 183 - Place 161, 183 Langton, Archbishop 381 Lansbury Estate 323 - Market Place 324 Lansdowne House 158 Large, Robert 67 Larke, Revd Richard 75 Lass of Richmond Hill 399 Last Judgement 105, 212, 426 Lath and plaster 198, 202 Latvian Congregation 57 Latymer School 247 Laud, William, Archbishop of Canterbury 80, 90, 131, 263, 329, 357, 360, 381 357, 360, 381 Lauderdale, Duchess of 400-2 —, Duke of 223, 400-2 Lauderdale House 223 Laughing Cavalier 184

Laurison Cottages 396 — House 396 Lavender 393, 423, 429 - Hill 429 Law, Ernest 254 Law Courts 127, 214 Lawes, Henry 280 , Mrs Susanna 288 Lawrence, Dame Abigail 77—, D.H. 228 –, Sir John 77 –, T.S. 70 Lawson, Sir Wilfred 137 Layton, Thomas 285 Lea, River 234, 235, 239, 256, 257, 310, 317, 332 — Valley 311 — Valley Park 236 Leadenhall 14, 78 Leasehold System 19 Leather, gilded 401 Leathersellers' Almshouses 200 Lee, Viscount of Fareham 217 Lee, South 386, 389 Leicester, Earl of 315 — House 166 — Square 166 Leigh, Vivien 131 Leighton House 299 Leinster Square 193 Leland, John 374 Le Maire, Sir Peter 68 Lennox, Margaret, Lady 241 Leo X, Pope 252 Lepanto, Battle of 402 Leprosy 139, 214, 316 Lesnes Abbey 345; 345 Letchworth Garden City 204 Lethieullier Chapel 313 Smart 313 Letter boxes 334 Leverhulme, Lord 140, 227 Lewis, Cecil Day 368 –, John, Messrs 182 –, Mary Anne 156 –, 'Monk' 150 Lewisham 389-90 —, borough of 386-90 Leyton 332, 335-6 Liberal Party 367 Liberty, Arthur Lazenby 161 —, Captain Stewart 162 Liberty's, Messrs 161, 170, 391; 165 Libraries Antiquaries 152 British and Foreign Bible Society 49 British Library 123, 213, 215, 217; Newspaper collection 204 City Business 56 College of Arms 49 Courtauld Institute 185 Duke Humphrey's 362 Geological Museum 303 Gray's Inn 212 Guildhall Library 54 Ham House 403 Harleian 98, 106 Harrow School (Vaughan) 261 Kenwood 223 Lambeth Palace 382 Lincoln's Inn 214 London Library 143, 158 Middle Temple 31 Osterley 289 Queen Carolines 147

Royal College of Physicians 188 Royal Library 216 Saint John of Jerusalem 293 Science Museum 303 Victoria and Albert 304-5 Libraries, Public 121, 229, 237, 240, 242, 247, 277, 279, 296, 297, 340, 346, 352, 354, 358, 367, 371, 376, 383, 389, 417, 419, 420, 421 Licensed Victuallers' School 383 Light fittings 180 Lighthouses 331 Lillington Gardens 22 — Estate 177 Limehouse 317, 324 Reach 19 Linacre, Thomas 49, 188 Lincoln, Abraham 112 -, Earl of 213 —, Thomas de 213 Lincoln's Inn 14, 213; 212 — Inn Fields 16, 19, 134, 210, 214, 229 Lindsay House 16, 210, 308 Linenfold panelling 354 Linley, Ozias 49 Linley Sambourne House 299; 299 Linnean Society 151 Lion Brewery 378 and Unicorn 51, 70 Lister, Jane 105 -, Lord 183, 334 Dr Martin 105 Literary & Scientific Institute 223 Litlyngton, Nicholas de, Abbot 97 Litten, Julian 335 Little Angel Puppet Theatre 296 — Holland House 425 Ilford 312 Littleberries 201 Littler, Edmund 391 Liverpool, Walker Gallery 168 Livery halls see City Companies Livesay Memorial hall 388 Livingstone, David 200, 302 Lloyd, Edward, coffee-house keeper 70, 78 –, Edward, publisher 334 –, Marie, 131 -Square 296 — George, David 109 Lloyd's 78, 80 Lobb, Messrs 144 Local History Collections 176, 186, 199, 200, 203, 207, 235, 238, 239, 246, 259, 269, 296, 297, 298, 334, 340, 352, 367, 371, 376, 383, 395, 406, 417 Lock, Messrs 144 Lock Hospital for Women 174 Locker 270, 274 Locks on rivers 236 Loddiges, Conrad and family 242 Lollards Tower 381 London, Bishop of 222, 243, 317, 322 London Airport see Heathrow Apprentice 288
Bridge 11, 12, 84, 89, 138, 224, 320, 326, 372, 373, 410, 412, 413, — Bridge Station 413 -, Chatham & Dover Railway 176 — College of Printing 416 —, Corporation of 170, 332

- County Council 22, 61, 135, 148, 223, 240, 323, 406, 413 - Dock Company 323 Docklands Development Corporation 323 - Fields 240 - Hospital 318 - Library 143, 158 - Museum 61, 140, 171; see also Museum of London and North Eastern Railway 189 School Board 20 -Silver Vaults 213 - and South Western Railway 381 Stone 85 - Symphony Orchestra 64 - Transport 178 — Transport Museum 132 — Wall 39, 47, 56, 61 Londonderry House 168 Longacre 134 Longchamp, William 328 Longford River 254 Lord Chamberlain's Office 139 Lord Mayor's Coach 295 Lord, Thomas 189 Lord's Cricket Ground 189 Lords, House of 108 Loring Hall, Bexley 340 Lorrimore Square 419 Lotteries 123, 216, 220 Louis XIII 282 Louis XIV 140, 163, 184, 250, 309, 320, 364 Louis XV 184 Louis Philippe, King of the French 406 Louvre 119 Lovat, Lord 330 Lovekyn Chapel 376 Lovelace, Richard 27 Lovell, Sir Thomas 200, 213 Lowe, Sir Hudson 160 Lowndes family 174 Square 174 - St. 176 Lowther Arcade 129 Loxwood 201 Lubbock, Sir John 352 Luci, Richard de 345 Lucius, King of Britain 69 Lud, King 39 Ludgate 26, 39 Lumley, John, Lord 422 —, Richard, Earl of Scarborough 154, 155, 159 Lumley Chapel 422; 337 Lupus St. 177 Luscombe, John, Prior 294 Lutine Bell 78 Luttrell, Sir John 217 Lyceum Theatre 129 Lychgates 274, 291, 340, 348 Lynchets 11, 359 Lyly, John 241 Lyndale House 223 Lyon, John 260, 261 Lyric Theatre 246 Lytton, Bulwer 150 Macartney House 366, 368, 369 Macaulay, Thomas 150, 299, 330 Macdonald, George 247 Macdurnan Gospels 382

Mace 73

Mackenzie, Gordon 189 Machine Gun Corps Memorial 169 Madge, S.J. 256 Magna Carta 107, 108, 213, 326 Magnus, Saint 89 Maida Vale 189, 190 Maiden Lane 131 Maids of Honour Row 398 Mail-coaches 259 Maiolica 184 Maitland, John; see Lauderdale, Duke , William 85 Malden, 373, 377 Malet St. 211, 217 Mall, The 139, 145 Hammersmith 246-7 Malplaquet 141 Malta, Siege of 365 Mammoths 316 Manchester 107, 154, 225 and Liverpool Railway 177 Mander & Mitchenson Theatrical Collection 388 Mankind, Museum of 217 Manning, Cardinal 261

—, Mr & Mrs 417

Manny, Sir Walter 293 Manor Farm, Ickenham 278 — Farm, Ruislip 279; 279 — House Hospital 227 Manor houses 197, 201, 259, 261, 269, 273, 274, 340, 341, 354, 389 — Park Cemetery 313 Manresa House 432 Mansel St. 181 Mansfield, Lord 21, 223, 246 Mansfield St. 183 Mansion House 20, 72, 170, 197 Mantua, Duke of 254 Maples, Captain 331 Map Room 217 Maps 302 Marble Arch 22, 167, 169 Hill 406 Marconi, Guiglielmo 129 Maresfield Gardens 227, 228 Margaret St. 183 Marian North Gallery 404 Marina 324 Marine Trust 324 Mariott, Florence later Mrs Dickinson 425 Market gardens 242, 243, 378, 383 — houses 235, 277, 374 Markets 43, 78, 81, 89, 122, 132, 154, 160, 165, 182, 221, 235, 267, 297, 301, 317, 320, 322, 346, 357, 367, 413, 415, 417, 429 Marlborough, Duchess of (Sarah Churchill) 140, 141, 172, 365 —, Duke of (John Churchill) 140, 213, 264, 309 Marlborough Gallery 154 — House 140, 141, 304, 365, 428 - Rd. 140, 145 Marlowe, Christopher 386, 418 Marne, Battle of 204 Marryat, Captain 396 Marshall St. 166 Marshalsea Prison 416 Marshes 197, 241, 256, 266, 310, 332, 344, 345, 378, 427 Martyrs 34, 293, 294, 310, 329, 362 Marvell, Andrew 131, 215

Marx, Karl 223 Mary I 49, 63, 76, 79, 100, 104, 113, 114, 122, 139, 250, 254, 261, 327, 328, 374, 394, 397, 399 ..., 117, 51, 106, 114, 115, 136, 139, 149, 150, 171, 173, 249, 250, 252, 254, 363, 397, 406, Queen of Scots 80, 104, 241, 294, 312 Mary II 19, 51, 106, 114, 115, 136, – Tudor, Henry VIII's sister 367 -, Queen to George V 91, 139, 141, 171, 325 Mary Rose, ship 327 Marylebone see St. Marylebone - Cricket Club 189 — Grammar School 186 - High St. 9, 186 Rd. 186 Masons' marks 200, 371 Masques 16, 114, 253 Mass dials 258, 280, 339 Massachusetts 412 Massinger, Philip 412 Matilda (Maud), Queen to Henry I 80, 100, 214, 310, 324 Empress 328 Matthew Paris 105 Maudslay, Henry 303, 371 Maugham, Somerset, collection of theatrical portraits 380 Maundy Money 104 Mauretania 310 Maurice, Bishop 32 Mausoleum, Chandos 265 , Dulwich 418 Mausolus 215 Maximilian I 254 Maxwell, James Clerk 98 May Day 39, 78, 144 Mayerne, Sir Theodore Turquet de Mayesbrook Park 197 Mayfair 18, 22, 154-60, 163, 166, 182 Mayflower 296, 415 Mayhew's Flour Mill 428 Maynard, Lady 402 Maypole 78, 127 May Queen 431 Mays Court 368 Maze 254 - Hill 367, 368 Meadway 205 Meard St. 164 Mecklenburgh Square 220 Medallions 249, 289 Medals 309 Medfield St. 432 Medhurst's Stores, Bromley 346 Medical Research Council's Laboratories 201 Medici, Ferdinand 130 Lorenzo 119 Medici Gallery 157 Mehemet Ali 138 Melba, Dame Nellie 43 Melbury Rd. 299 Mellitus, Saint 12, 32 Melville, Henry, Viscount Dundas 396 Mendelssohn, Felix 417 Mendes, Fernando 393 Merchant Taylors School 295 Mereworth 341 Meridian, Greenwich 367

Mermaids 176, 274 Merricks family 232 Merton, Walter de 391 Merton, borough of 391-6 — Priory 373, 374, 391 —, Statute of 391 Meteorological Office 405 Metropolitan Board of Works 19, 135, 137, 225 — Museum of Art 158 — Railway 206, 279, 415 Tabernacle 416 - Water Board 296; 297 Meyrick, Sir Samuel 184 Micawber, Mr 239 Michelin factory 306 Michel's Almshouses 399 Middle Temple 28-31, 212, 386; 30 Middlesex 13, 22, 194, 260, 298, 397 — County Council 285 — Record Office 378 — Regiment 259 Sessions House 293 Sheriff of 13 Midland Bank 150 Mile End 317, 319 Miles, Sir Bernard 52 Milespit Hill 201 Milestones 334, 421 Mill, John Stuart 138 Mill Hill 200, 201, 225 — School 201 Mill-Plat Almshouses 288 Millbank 113 Miller Trophy 56 Millington, Revd John 241 Mills 310, 340, 354, 385, 391, 394, 422, 428 Millwall 317, 323 Milton, John 56, 60, 63, 92, 98, 113, 280, 295, 383 Milton Keynes 22 Minet Library 383 Mining 303 Minories 81 Minshall, Elizabeth 60 Mint 331 Mirrors 137, 153, 251, 282 Misericords 102, 325 Mitcham 12, 391, 392-3, 426 Mithraium 12, 74 Mitre Hotel 254 Moats 112, 249, 251, 262, 327 Models 33, 37, 214 Monasteries 14, 43, 68, 80, 81, 106, 231, 235, 236, 239, 258, 263, 267, 289, 292-3, 310, 319, 391, 398 Monck, General 86 Monk, Lt. Col. Basil 361 Monkin Hadley 200 Monmouth, Duke of 163, 328 Monoux, Sir George 333 Montagu, Mrs Elizabeth 123 Montague House 210, 211, 216 — Place 210, 211, 217 - Mews South, George St. 186 Montfort, Simon de, Earl of Leicester Montpelier Row, Twickenham 406 Vale, Blackheath 390 Montrose House 400 Monument, The 89 Moore, Thomas 299 Moorfields 13, 292, 369 Moorgate 64

Moravian Brethren 308 Morden 13, 391, 393-4 — College 347, 368, 369 — Hall 394 Mordaunt, John, Viscount 244 More, Hannah 70, 123 —, Sir Thomas 54, 58, 63, 75, 111, 181, 214, 294, 306, 307, 308, 328, 330, 372, 381 — Chapel, Chelsea 16, 307 Morell, Abbé 226 Morgan, Sir Charles 176 Crucible Company 430 Morier, Sir Robert 279 Morley, Thomas 39, 63 Morpeth Terrace 178 Morrison, Arthur 322 Morse, Revd Henry 214 Mortimer St. 184 Mortlake 397, 403, 405 — tapestries 252, 304, 365, 402, 405 Morton, John, Cardinal 14, 357, 367, Mortuary chapels, 278, 385 Mosaics 35, 67, 78, 180, 191, 230, 351, 384 Moscow Rd. 191 Moses and Aaron 28, 67, 69, 70, 88, 89, 149, 215, 341, 357, 386, 415; see also Aaron Mosques 188, 321 Motcomb St. 176 Moths, exotic 288 Motorcars 303, 334 Motorway 193 Motte-and-bailey castle 279 Motteux, Peter Anthony 80 Mount, The 225 — Claire 432 -St. 160 Mounteagle, Lord 213 Mountfichet, Walter de 310 Mozart, Wolfgang Amadeus 164, 174 Murad, son of Abdullah 117 Murals 40, 44, 68, 75, 342, 343, 351, 353 Murder 97, 101, 103, 104, 159, 229, 239, 328, 362, 386, 417 Murray, Elizabeth; see Lauderdale, Duchess of -, John 157, 301, 395 -, William, Earl of Dysart 400 William see Mansfield, Lord Museums All Hallows Crypt 91 Army 309 Barnet 200 Bethnal Green 322 British Museum 216-17; see also British Museum Church Farm 203 Commonwealth 298 Cuming 417 Dickens 219-20 Docklands 322 Egyptology 218 Forty Hall 235 Garden History 382 Geffrye 239-40 Geological 303 Grange 207 H.M.S. Belfast 414 Honourable Artillery Co. 295 Horniman 387 Imperial War 416

Insurance 56 Jewish 218 Kew Bridge 286 Kew Gardens 404 Kodak 262 Leighton House 299 Linley Sambourne 299 Livesey 417 London 61 Mankind 157 Musical 286 National Army 309 National Maritime 365 National Postal 41 Natural History 303; 305 **Orpington Priory 352** Passmore, Edwards 311 Pavlova's House 228 Percival David 217 Rolls Chapel 213 Rotunda 370 Royal Air Force 203 Royal Artillery 370 Royal Fusiliers 331 Royal Geographical 302 Royal Hospital 309 St. Bride's Crypt 28 St. Thomas's 413-4 Science 303 Tennis 395 Thames Tunnel 415 Theatre Museum 133 Tower Bridge 331 Transport 132 Upminster 269 Valence House 198-9 Vestry House 334 Victoria and Albert 304-6 Windmill 396 Museum of London 12, 22, 53, 61, 74, 202, 285, 378, 392, 421
— of Mankind 157 Music 42-3, 57, 113, 133, 137, 140, 142, 164, 165, 174, 186, 191, 193, 224, 227, 246, 248, 255, 304, 306, 321, 368, 409, 413, 417, 432 Royal School of Church 360 Musical instruments 286, 302, 388 Museum 286 Musicians, Portraits of 302 Muswell Hill 256, 257 Mutton Brook 200 Muybridge, Eadweard 376 Myddleton, Sir Hugh 235, 242, 296 Myddleton House 235 -Square 296 N.L.A. Tower, Croydon 360 Nantes, Edict of 19, 163 Napier, Sir Charles 119 Napoleon I 153, 159, 191 Napoleon III 273, 350 Napoleonic Wars 370 Nassau, Count of 98 National Army Museum 309 Art Collections Fund 104 — Book League 430 Collection of Historic British Art

181

— Film Theatre 379

- Liberal Club 136

Collection of Modern Art 181

151, 181, 259, 367, 418

Gardens Scheme 246

- Gallery 83, 100, 117-21, 142, 145,

— Maritime Museum 365-7 - Orthopaedic Hospital 202 — Physical Laboratory 254 - Provincial Bank 142 - Portrait Gallery 114, 120, 145, 246, 307, 372 - Schools 333, 393 Society of Colonial Dames 269 — Sports Centre 349 —Theatre 135, 379, 381; 380 — Theatre Museum 133 — Trust 126, 147, 197, 225, 227, 241, 270, 288, 308, 350, 360, 391, 394, 400, 401, 413, 428

Natural History Museum 20, 216, 301, 303, 316, 387, 428, 305 Naval & Military Club 153 Navarette, Battle of 330 Naves, double 76, 344 Navy 162, 365 -Board 365 - Office 83 Neal St. 134 Neale, Sir Thomas 134, 210 Neasden 206 Nelson, Horatio, Viscount 35, 36, 54, 102, 108, 119, 145, 216, 364, 367, 391, 395 Nesbitt, E. 372 Netteswell House 322 New End 225 — Oxford St. 20 — River 235, 242, 296 — Victoria Cinema 180 — Year's Eve 118 — York 192, 278 — York State College of Agriculture and Technology 425 Zealand House 9, 144 Newark House, Richmond 399 Newbury Park 316; 316 Newcastle House 210 Newcomer, Richard 303 Newdigate family 280 Prize 280 Newgate Prison 42, 186, 190 Newham, Borough of 310-3 Newington Green 242 Newman St. 183, 184 Newmarket 118 Newton, Revd Adam 369 —, Sir Isaac 98, 127, 166, 303 —, Revd John 70 -, Samuel 208 William 210 Nichol, George and Mary 58 Nichols, John 27 Nicoll Almshouses 201 Nightingale, Florence 145, 175, 334 Nile, Discovery of 168 Nine Elms 132, 429 Nithsdale, Lord 329 Noah Hill 266 Nonconformist Cemetery 295 Church 204, 295 Nonconformity 202, 241 Nonsuch Palace 15, 373, 391, 393, 421, 422 Norbury 355, 361 - Hall 361 Norden, John 233 Norfolk 174, 178 -, Duchess of 142 Duke of 294 — House 20, 141, 142, 305

Palmerston, Lord 112, 116, 153, 261 — Mill Inn 371 Norman Architecture 12, 58, 353. Pan 169 - Pretender 231 Panizzi, Sir Anthony 216, 248
Panelling 26, 40, 48, 49, 57, 225, 235, 251, 253, 261, 278, 297, 318, 334, 354, 426, 428 — Churches 28, 270, 271, 312, 326 — Conquest 243, 259, 260, 373 — gravestone 197 - Red Lion 421 — Swan Inn 428 - Vic 381 Olympia 248 Normandy Landings 1944 295 Olympic Games 248 Open Air Theatre 188 Pankhurst, Mrs 112 North, Colonel 371 Pannemaker, W., weaver 106 Panoramas 166, 188, 222, 306 Pantechnicon 176 -, Sir Edward 294 _, Lord 150 Opera 133 Operating theatre 413-14 Orangeries 170, 223, 224, 254, 365, —, Marianne 404 Papendick, Mrs 139 Richard Michael 368 Parade ground 370 Paragon, The 368, 369, 417 Paris 130, 135, 148, 150, 184 403, 404, 426 North Audley Street 160 Oranges 241
— and lemons 72, 128 — Circular Rd. 204 - Cray 340 Comte de 406 Ordnance Survey 289 — End 245, 246 — London Collegiate School 264 Park Crescent 19, 187, 188; 188 Orford, Earl of 131
Organ cases 35, 42, 57, 70, 71, 72, 121, 149, 156, 160, 197, 234, 244, 264, 265, 293, 330, 354, 379, 409, 410, 412, 415, 417, 426
Organ keyboards 70, 368
Organs 27, 35, 39, 41, 42, 49, 55, 57, 69, 71, 72, 74, 75, 77, 79, 80, 83, 89, 91, 92, 98, 115, 121, 128, 149, 156, 193, 212, 215, 232, 257, 340, 343, 352
Oriental & African Studies, Institute Orford, Earl of 131 — Lane 168 — London Crematorium 205 — Rd. 189 Ockendon 266, 269 — Square 188 — Village 188; 189 Parker, Matthew, Archbishop of - Peckham Civic Centre 417 — Thames Gas Co. 245 - West Passage 366 Canterbury 381
Parks and open spaces 9, 139, 140, 147, 167, 171, 197, 203, 223, 228, 229, 236, 237, 238, 240, 242, 243, 244, 254, 257, 289, 291, 340, 341, 346, 352, 361, 372, 376, 382, 385, 388, 389, 394, 396, 406, 407, 419, 421, 425, 426, 429
Parliament 20, 47, 105, 107-112, 114, 135, 187, 214, 225, 254, 380, 391, 109

Members of 113, 136 Canterbury 381 Northampton 122 — Polytechnic 296 — Rd. 378 -Square 296 Northern Outfall Sewer 310, 311 Northolt 229, 233 Northumberland, Duke of 287, 330 Oriental & African Studies, Institute of 217 wares 161 -, Earl of 287 Orientations, unusual 81, 130, 191, Northumberland Avenue 20, 122, 215, 291, 302 137 — House 20, 137, 288, 305 Northwood 271, 279 Orleans House 406 -, Members of 113, 136 Park 406 — Hill 219 Orme, Edward 191 Norway 83, 84 Square 191 — Square 112 Norwegian Air Force 128 Norwich 118 — St. 114, 116 Parr, Katherine, Queen to Henry VIII Ormonde House 143 -Lodge 403 Norwood 21, 232, 355, 361, 378, Orpington 351-2 385 Parry, Blanche 113 Notting Hill 299 — Hill Gate 191 Priory 352 Osborne, Thomas 296 Osterley 20, 287, 288, 289, 291 Our Lady 91, 180 Parsloes, Manor and Park 197, 199 Parsons Green 244, 245 Nottingham, Earl of 170, 298 Parthenon 169, 181, 216, 219 Novello, Ivor 36 Partridge, Sir Miles 15 Passmore, Edwards, Museum 311 Lady of Pity 423Lady's Well 390 Messrs 165 Noy, William 286 -Edwards South London Art Outer Circle 187 Noyes, Alfred 404 Outram, Sir James 137 Oval, The 383 Gallery 418 Numismatics 331 Patent Office 213 Nursery rhymes 72, 84, 128 Paternoster Lane 86 -, Victorian 238 Overlord Embroidery 295 Pates Manor Farm 290 Owen, Revd Grownow 233 Nycolson, James 414 Oxford 60, 98, 102, 126, 189, 217, 229, 247, 249, 264, 267, 286, 314, 332, 339, 342, 345, 356, 362, 382, 386, 391, 397, 399, 422, 425 Patmore, Coventry and Emily 203 Patten, William 241 Nymphs, marble 406 Paul, Saint 180 Oak Apple Day 309 -, James 69 - apples 417 Paving 68, 72, 192 Circus 161 - Tree 237 Pavlova, Anna 228 Paxton & Whitfield, Messrs 144 — Movement 351 Oaks Park 425 -St. 20, 154, 160, 161, 164, 182, Oatlands 15, 373 Paymaster General's Office 117 Obelisks 164, 168, 169, 200, 202, 231, 262, 280, 283, 332, 393, 416 214, 218 Peabody Buildings 321 Peachey Stone 261 Peacock, James and Mary 86 Pearce, Zachary, Bishop of Rochester P. & O. Building 77, 78; 78 Paddington 107, 182, 190-3 — Canal 191, 192; 194 O'Brien, Nellie 184 Observatories 363, 367, 398, 403, - Green 193 Ockendon Hall 269 Pearly Kings and Queens 417 Pearson, Revd John 72 -Station 191, 301 Octagon Room 406 Pagan worship 260 Odeon Cinema, Broadstairs 264 Page, Sir Gregory 388, 390 Peckham 418 Of Alley 122 Page Street housing 181 Rye 418 Offa, King of Mercia 260 Pedro the Cruel 330 Peel, Sir Robert 112, 261 Paget, Sir William 272 Oglethorpe, George 269 Olave, Saint 81, 84, 414 Old Bailey 40; 43 — Bedford Theatre 222 Pagoda, The 404 — House 390 Pekynge Chalice 377 Palaeologus, Manuel, Emperor 390 Palindromes 39, 418 Pall Mall 139, 141, 144, 145, 151 Pelham, Henry 150 Pelican, Pious 39, 69, 72, 149, 351, — Court House 254 410 - Crown Inn 375 Pallas Athene 145 Pembridge Rd. 301 — Ford 317 Palm House 404 Villas 301 — House, The 201 — Kent Road 417 Palmer, Eleanor, alsmhouses 200 Pembroke, Earl of 138

Pembroke Lodge 400 Villas 398 Penderell, Richard 215 Penge 349 Penicillin 191 Peninsula War 259 Penn, Sibel 255 —, Sir William 90 - William 90 Pennsylvania Museum of Art 158 Pentland House, Lee 389 Penton, Thomas 296 Pentonville Hill 222, 296 - Rd. 296 People's Palace 319 Pepys, Elizabeth 83, 131 -Estate 387 —, Samuel 21, 27, 83, 90, 123, 241, 278, 295, 322, 365, 381, 383, 417 Percival, Spencer 40, 214, 229, 261, 369 Percival David Foundation 217
Percy family 287, 288
—, Henry, Earl of Northumberland —, Henry, 143 — Lion 137, 288 Perivale 229, 232 Perrers, Alice 374 Peter the Great, Tsar 172, 387 — Pan 168, 173, 191 — of Savoy 125 — the Wild Boy 173 — Hill's School 415 Peterborough House 244 Petersham 397, 400-3 House 400 Meadows 399 Petleys, Downe 352 Petrarch 253 Petrie, Sir Flinders 218 Pett, Peter and Phineas 369, 386 Petticoat Lane 81, 317; 321 Petts Wood 351 Pevsner, Sir Nikolaus 85 96, 113, 158, 246, 349
Pews 72, 92, 141, 253, 265, 272, 278, 295, 369, 400, 415, 431 Pewter plate 56 Phelps, Samuel 296 Phidias, statue 151 Philadelphia 428 - Museum of Art 315 Philip, Saint 149 Prince, Duke of Edinburgh 10, 60, 85, 421 —, King of Spain 266, 327 Philippa of Hainault, Queen to Edward III 101, 324, 325 Phillips, Reginald M. 41 Phillipson Mausoleum 205 Phillimore Walk 298 Photographs 120, 145, 185, 296, 305 Photographers Gallery 134 Photography 262, 376 Physic Garden 308 Physicians, Royal College of 40, 49, 119, 188 Pianos 286 Piccadilly 18, 22, 139, 141, 148-53, - Arcade 150 - Circus 148, 161 - Hotel 148

Pickering Place 144

Pickett's Lock 236 Picton, Caesar 376 Sir Thomas 241 Picton House 376 Pigott, John Hugh Smith 241 Pilgrim Rock 296 Fathers 415 Pillars of Hercules, public house 164 Pimlico 20, 174, 177 Gardens 177 — School 177 Pindar, Sir Paul 15, 66, 305 Pinner 9, 260, 262 Pirates 371 Piscinae 30, 77, 270, 272, 273, 274, 278, 291, 312, 339, 353, 355, 359, Pitshanger House 229 Pitt, William, Lord Chatham 54, 106, 143, 149, 227 -, William, the younger 54, 109, 214, 354 Placentia 362 Plague 18, 74, 75, 77, 214 Plaistow Lodge 347 Planetarium 186, 367 Plasterwork 41, 55, 73, 81, 83, 121, 159, 163, 190, 215, 239-40, 246, 259, 287, 289, 296, 297, 309, 350, 352, 364, 365, 372, 375, 387, 401, 403 Plate, Church 55, 80, 121, 150, 201 Plate, City Companies 56, 57, 58, 73, Playhouse Yard 48 Pleasure Gardens 308, 383 Plough Inn 37 Plumstead 362, 371 Plunket, Oliver, Archbishop of Armagh 180 Poets' Corner 98 Point Hill 390 Poitiers, Battle of 135 Pole Hill, 332 Polka, childrens theatre 395 Police 116, 119 Polytechnic 183 Pompadour, Mme de 184 Pompeian decorations 147, 173 Pond, John 389 Ponders End 236 Ponds 228, 351, 422 Poor boxes 40, 60 77 — relief 15, 164 Pope, The 249, 280 Pope, Alexander 113, 264, 281, 282, 283, 285, 406, 407, 428 283, 283, 406, 407, 426 Popham, Sir John 42 Poplar 317, 319, 323 Poppy heads 273, 407 Population 15, 19, 20, 322 Porcelain 48, 153, 160, 173, 184, 217, 227, 252, 304, 311 Porches 53, 69, 83, 90, 310, 341, 353 Port of London Authority 135, 323, 331 Portland, Duke and Duchess of 15, 182 Earl of 116 Estate 186 — Place 161, 182, 183; 183 — Stone 40, 44, 72, 89, 90, 115, 125 Portman Square 185, 232 Portobello Rd. 301 Portugal 153, 215, 231

Post Offices 41, 42, 279, 334 - Master 268 Postage stamps 41, 259 Postmen's Park 42 Potter, Beatrix 277 -, John, Archbishop of Canterbury 356 Pottery, Roman 202 Potteries, Fulham 244 Poultney, Sir John 85 Pound, Revd John 332 Pountney Hill 85 Poverty 321, 322 Powell, William 202 - Almshouses 244 Praed St. 190 Pratt, Charles, Marquess of Camden 210 St. 219 Pre-Raphaelites 158, 334; see also Artists' Index Prehistoric Monsters 349 Pre-history 11, 199, 217, 231, 263, 271, 276, 316, 332, 351, 354, 358, 394, 395, 396, 427 Preston Hill 206 Prevost, William 175 Price's Patent Candle Works 430 Priestley, J.B. 150 —, Joseph 158 Prince Albert Rd. 189 Consort Rd. 302 — Henry's Room 28 — Imperial 351 — of Wales Gate 169 Princess Victoria, public house 248 Printing 28, 44, 420 Prior, Matthew 98 Priory, The, Tottenham 259 Constitutional Club 231 Prisons 28, 40, 43, 178, 181, 248 Privy Chamber 114 - Council Rooms 116, 214 Promenade Concerts 301 Prospect of Whitby, public house 323 Providence Chapel 358 Prudential Insurance building 212 Public Record Office 213, 405 Publishers 150, 157, 165, 272
Pudding Lane 18, 89
Pulpits 55, 57, 60, 67, 77, 83, 88, 149, 201, 213, 214, 246, 279, 280, Pumping stations 242, 247, 286, 310, 357; 242, 311 Pumps 80, 278, 334 Punch 169 Puppets 296, 395 Purcell, Henry 72, 98 - Room 379 Purdeys, Messrs 160 Purley 355, 359 Putney 244, 373, 427, 432 — Bridge 432 Heath 432 Pye Corner 43 Pym, John 113 Pymme's Park 237 Pythagoras, statue 170 Pyx, Chapel of 13, 105, 106 Quadrant, The 148, 161 Quarles, Frances 267 Quartermaine, Leo 131 Quebec 259; see also Canada

Queen Anne St. 186 - Anne's Alcove 167 - Anne's Gate 85, 147 — Caroline St. 246 - Elizabeth Grammar School 200 — Elizabeth Hall 378 Elizabeth's Almshouses 399 Elizabeth's Hunting Lodge 15, 332; 333 Mary College 319
Mary Hospital 432
Mary's Rose Garden 188
St. (City) 89 - St. (Mayfair) 160 Victoria St. 12; 74 Queen's Avenue 257

Beasts 251, 404 — Birthday Salute 117 — Cottage 404 — Gallery 147 — Head, public house 262 – House, Greenwich 16, 52, 151, 323, 362, 365-6, 402; 363 – House, Tower 329 — Park 194 Regiment 259
 Queensberry House, Burlington Gardens 19, 157

Queenshithe 12

Queensway 191 Quixote, Don 80

Quyney, Richard 49 Rabbits 388 Rabelais 80 Radcliffe, Dr John 425 Radnor Garden 407 Rahere 46, 62, 209 Raikes, Robert 137 Railways 176, 177, 189, 191-2, 206, 210, 220, 232, 235, 273, 279, 303, 355, 357, 413, 429
Rainbow Theatre, Islington 296 Rainham 9, 12, 266, 270 — Hall 270 Rake's Progess 186, 214 Raleigh, Carew 134 —, Sir Walter 31, 92, 113, 116, 121, 123, 328, 362, 426
Ralli family 385 Augustus 385 Ralph, James 155 Ramillies, Battle of 141 Randolph Rd. 194 Ranelagh Gardens 308 Ranger's House, Blackheath 368 Raphael cartoons 405 Ratcliffe 317, 324 Rate Books 334, 383 Rathbone Place 183 Raven, The, public house 428 Ravenbury Park 394 Ravensbourne, River 390 — School of Art 347 Ravenscroft Almshouses 200 Rawling, Sir Benjamin 47 Rayners Lane 260 Raynes, Essex 95 Raynton, Sir Nicholas 234, 235 Reade, Charles 206

—, Lady Mary 286 Red House, The 21, 342; 343

– Lion Square 19, 210, 211

Redbridge, borough of 314-16 Redknap's Cottages 406

- Lion Hotel 262

— Lion Inn 142

Reeves, Messrs 357 Reform Club 147 Regalia 330 Regency Place 178 Regent St. 145, 148, 161. 163, 165, 187, 267; 162 Regents Canal 182, 221
— Park 20, 25, 161, 170, 174, 182, 186, 188, 231, 324
Regicides 122, 409
Regiments 70, 125, 259, 295, 369
Registers 51, 266, 278, 428
Registrar-General 126 Reliant 366 Renton Lodge 400 Rerido Lodge 400
Reredos 30, 39, 43, 51, 52, 55, 57, 64, 67, 69, 70, 72, 88, 89, 92, 176, 200, 207, 215, 226, 232, 280, 301, 302, 335, 351, 352, 354, 360, 371, 386, 407, 409, 432 Reservoirs 206, 242, 332 Resurrection 91, 92, 215, 354 Revelstoke, Lord 160 Reynolds, Edward, Bishop of Norwich 55 Rhodes, Cecil 168 Rhodes Missal 293 Rhodesia (Zimbabwe) House 129 Rich, John 134, 276 -, Sir Richard 15, 44, 315 William 27 Richard I 13, 111, 328 Richard II 14, 43, 89, 97, 101, 110, 119, 233, 266, 267, 326, 371, 390, 397, 416 Richard III 14, 49, 308, 328 Richardson, Samuel 27, 40, 246 Richborough, Kent 11 Richmond 15, 135, 249, 397-400, 401 —, borough of 397-400 — Bridge 399, 400 — Hill 399 — Palace 101, 398 — Park 9, 373, 400, 405 Richmond Terrace, Whitehall 116, 136 Ridgeway, The 201 Ridolfi Plot 294 Rifles 236 Rigand, Stephen Peter 397 Rima, statue 167 Ripple Rd. 197 Ritz Hotel 150 Rivers 11, 25, 125, 167, 168, 180, 197, 200, 234, 235-6, 339, 340, 373, 390 Riverside Theatre 246 Rivet, John 116 Robert the Bruce 259 Robert St. 123 Roberts, Lord 117 Robespierre 186 Robinson, Mrs ('Perdita') 184 Roche, Saint 103 Rochester 11, 326 Rochford, Lord and Viscountess 330 Rockefeller Foundation 211 'Rocket', train 177 Rockets 344 Rocking-horses 288, 322 Rococo 142, 163, 164, 321-2, 415 Roding, river 197, 310, 314 Roehampton 116, 427, 432; 431 Roesia, of Dover 345 Rogers, Henry 60 -, John 43 -, Samuel 256

Rolls Estate 417 Office 213 Rolls-Royce 417 Roman Bath, Strand 126 Roman Bath, Strand 126 Roman Remains 11-12, 27, 28, 41, 56, 57, 58, 61, 64, 67, 74, 78, 85-6, 89, 90, 91, 126, 190, 202, 208, 217, 222, 249, 331, 350, 351, 354, 355, 370, 376, 378, 391, 410, 413, 417, 426; 87 Rome 95, 140, 168, 169, 180, 252 Romford, 266, 267 Ronalds, Sir Francis 247 Ronan Point 22 Rood Stone 318 Roods 60, 180, 197 Roof bosses 79, 80, 274 Rookery 385 Rooms re-situated 137, 142, 240, 246, 261, 296, 315, 318, 319, 334, Roosevelt, Theodore 156, 159 Roper, Margaret and William 372 Rose & Crown, public house 357 Rosebery, Lord 156 Rosebery Avenue 296 Rosetta Stone 216, 352 Rosoman, Thomas 255, 296 Rossetti, Christina 223 , Dante Gabriel 162 Rossiter, William 418 Rotherhithe 317, 414, 415 Rothermere, Lord 25, 203, 416 Rothesay, Earl of 357 Rotten Row 169 Rotunda, The 370 Roumanian Church 26 Round House 220 Pond 170, 173 Rousseau, Jean Jacques 123—, Victor 138 Rowe, Sir Thomas 314 Rowing 372 Rowneys, Messrs 184 Roxborough Park 261 Roy, General William 289 Roy's Grove 289 Royal Academy of Art 119, 150, 151, 183, 215, 220, 264 - Academy of Music 186 — Air Force 103, 127, 136, 263, 277 - Air Force Museum 203 - Albert Dock 310 - Albert Hall 301 - Arms 49, 50, 51, 70, 86, 92, 150, 156, 215, 249, 255, 293, 360, 400, 409, 413, 415 — Arsenal 369 — Artillery 169; 370 — Artillery Museum 370 Ballet School 400 Blackheath Golf Club 372 Botanic Garden 403 Brass Foundry and Model Room 369 Coburg Theatre 381 College of Art 301, 322 College of Music 301, 302
College of Organists 301, 302
College of Physicians 40, 52, 119, College of Science 301College of Surgeons 214

- Commission on Historic Monuments 272

Commonwealth Society 122

Courts of Justice, Strand 128

— Engineers 91

Exchange 20, 68, 76, 323, 347Festival Hall 135, 379 — Foundation of St. Katharine 325 — Fusiliers' Memorial 331 — Geographical Society 302, 428 — George, ship 118 — Holloway College 192, 299 - Horticultural Society 181, 361, 428 - Hospital Chelsea 19, 308 — Hospital School 365 — Institution 157 Institute of British Architects 143, 183, 185 Institute of International Affairs 143 - Mews 147 Military Academy 369Military Chapel 147 — Military College, Sandhurst 370 — Military School of Music 409 — Mint 331 Naval College 323, 363; 365 — Naval Dockyards 386 — Naval School 387 Observatory (Greenwich) 323, 363, 367 Observatory (Kew) 398Opera House 133; 134 — Opera House Arcade 145 — Overseas League 150 — Parade 390 — Salutes 295 — School of Church Music 360 - School of Needlework 295, 301, Shakespeare Co. 64Society 55, 126, 145, 151, 368, 431 Society of Arts 123Society of Painters in Water-Colour 413 - Society of Painter-Etchers and Engravers 413 United Services Institution 115 - Victoria Theatre 381 Victoria Coffee Music Hall 381 — Victorian Order 124 — Wardrobe 48 - Wimbledon Golf Club 394 Rugby Football 406 Ruislip 279 Rump Parliament 109 Runes 188 Rupert, Prince 50, 244 Rupert St. 165 Rus, William 69 Ruskin, John 246, 425, 431 Ruskin Avenue 405 Russell, Bernard 120 Edward, Earl of Orford 132 -, Lady Elizabeth 267 —, Francis, Earl of Bedford 130 —, Lord John 400 -, John, Major-General 277 —, Lady Rachel 210 —, Lord William 40, 210 -, William 400

Russell Square 211
— St. 130

Rutland Lodge 400 Rutledge, John 31 Rye-dough walling 421

Rye House Plot 210 Rylands, William Wynne 290

Russia 86, 279, 288, 317 Rutherford, Ernest, Lord 98 Sadler, Thomas 296 Sadler's Wells Theatre 296 St. Albans, Earl of see Jermyn, Henry St. Alban's 190, 202 - House 143 School, Walworth 417 St. Aubyn, Lady 399 St. Barnabas-in-Soho 164; 164 St. Bartholomew's Hospital 293, 297, 380, 431 St. Bride's Institute 28 St. Catherine's Convent School for Girls 407 St. George & the Dragon 189
— St. 155 St. George's Circus 416 — Hospital 174 St. Helier Housing Estate 393 St. James's 139-47, 166 — Palace 70, 121, 139-40, 141, 154; - Park 136, 139, 145-7, 167, 174, 370; 146 Square 141, 143, 149; 143 St. 141, 144 St. John, Sir John 427 -, Oliver 159 -, Sir Walter 428 of Jerusalem, Knights of 28, 188, 249, 292 St. John's House 240
— Lodge 187 Square 292 — Wood 188 — Wood Clique 189 St. Josephus Missionary College 201 St. Katharine, Royal Foundation of 325,330 St. Katharine's Dock 324, 331 Hospital 324 St. Martin's-in-the-Fields High School -Lane 134 -le-Grand Post office 334 — Place 121 — School of Art 163, 166 — St. 121, 166 St. Mary Axe 80 Clerkenwell Convent 292 and St. Thomas of Canterbury, Hospital and Chapel of 316 — Spital, Priory & Hospital 320 — Undercroft 111 St. Mary's Hospital 191 — House 428 — Infant School 333 - Roman Catholic Ceremony 248 Training College 407 St. Marylebone 20, 166, 174, 182-9, 190 — Central Library 186 St. Michael's Convent 385 St. Pancras 182, 210, 218-22 — Station 210, 220, 221; 221 St. Paul's Cathedral 12, 14, 18, 32-8, 39, 73, 125, 130, 152, 171, 225, 306, 326, 381, 400, 407; 34, 35, 36, 37 -Cray 351 — Deanery 428 -School for Girls 248 St. Petersburg Place 191 St. Philomena's Convent 425 St. Stephen's Chapel 13, 105, 107 Hall 109

St. Thérèse of Liseux 180

St. Thomas of Acon, Hospital of 15, St. Thomas's Hospital 378, 380, 410, 413-4 Salamanca 117 Salisbury 107 -, Countess of 330, 334 —, Lord 220 Salisbury Hall 334 —House 237 public house 134 Salt Office 123 Salts 52, 57, 83, 85 Salvation Army 242 Sambrooke, Sir Jeremy 200 Samuel, Margaret Lydia née Hogg 259 Sancroft, William, Dean of St. Paul's 33 Sandbags 225 Sandby, Revd George 418 Sanderstead 355, 359 Sandes, Captain 331 Sandford Manor House 245 Sandhurst 370 Sands End 245 Sanitation 135, 310 Sarum Chase 227 Sassoon, Sir Philip 238 Saunders, Revd Isaac 49 Savile Row 15 Savoy, The 125, 212, 267 — Operas 138, 162, 304 Say, William 278 Sayers, Dorothy 165 Says Court 387 Scaffold 331 Scagliola 403 Scala Regia 107 Scarborough, Earl of see Lumley Scargill, Thomas 267 Scawen, Thomas 425 Schomberg, Sir Alexander 367 —, Duke of 145, 277 Schomberg House 145 Schools Archbishop's 356 Bancroft's 76 Battersea 428 Brooke House 241 Charterhouse 293 Cheam 421 Christ's College 204 Christ's Hospital 41 City of London 28 Cowden Clarke's 235 Dulwich 418 Enfield 235 Greycoats 178 Harrow 261 Henry Thornton 384 Holy Trinity 342 John Ruskin 361 Kingston Grammar School 376 Licensed Victuallers 383 Mill Hill 201 North London Collegiate 264 Pimlico 177 Quernmore 347 Royal Hospital 365 St. Catherine's 407 St. Martin's 385 St. Mary's 333 St. Paul's 248 St. Philomena's 425 Sir John Cass 81 Stanwell 291

Tonbridge 77 Trinity 361 Twyford 231 Westminster 106 Woodford 314 Schreiber, Lady Charlotte 429 Science Museum 20, 247, 301, 303, 371, 421 Scone, Stone of 101 Scotland 80, 101, 115, 116, 122, 180, 259, 326 , Bank of 19, 157 -Yard 116, 135, 178 Scott, Captain Robert Falcon 145, 308, 428 , Sir Walter 299, 399 Scottish Office 117 Scottish Office 117 Scratch dials 208, 272 Screens 9, 31, 51, 53, 55, 58, 67, 69-70, 75, 169, 180, 186, 197, 207, 213, 217, 229, 263, 268, 270, 273, 278, 288, 294, 295, 339, 351, 352, 354, 368, 381, 389, 412, 420, 426, 429, 432 Scudamore, Thomas 208 Sealey, William 382 Sebert, King 95, 102 Secker, Thomas, Archbishop of Canterbury 150 Sedgmoor, Battle of 163 Sedlia 272, 274, 339, 359, 368, 377 Sedley, Catherine, Duchess of Buckingham 103, 106 Seething Lane 81, 83 Sefton, Lord 176 Seilern, Count Antonie 217 Seismograph 354 Selkirk, Alexander 344 Selsdon 355, 359 Park 47 Selve, Georges de 119 Senate House 211, 217 Sequiera, D.A. de 153 Seraphim 289 Serpentine 167, 169 -Gallery 168 Servicemen, disabled 400 Seti I, Pharaoh 214 Seven Deadly Sins 279
— Dials 134, 210 Severndroog Castle 371 Seville Cathedral 32 Sewers 135, 310 Seymour, Algernon, Duke of Somerset 137 Jane, Queen to Henry VIII 114, 249, 250, 266 -, Laura 206 Seymour-Conway family 184 Shadwell 317, 324 Shaftesbury, Lord 140, 148, 261 Shaftesbury Avenue 20, 148, 161, 164, 166 Shakespeare, Edmund 412
—, William 31, 48, 49, 63, 98, 120, 145, 166, 212, 213, 239, 255, 264, 296, 305, 324, 381, 383, 412, 413, 417, 418 Shakespeare Gallery 68, 145 Shamrock 180 Sharp, Granville and William, philanthropists 246 —, William, antiquary 202 Shaw, Sir John 372 -, John 387 Sheen; see Richmond Shelley, Clara and William 215

Mary 176 Shelley Memorial 189 Shell Centre 380 Mex House 125 Shell's Bakery 375 Shells 51, 291 Shepherd's Market 160 Sheppard, Jack 40 Sheraton, Thomas 165 Sheridan, Richard Brinsley 67, 98, 133, 186, 248, 261, 419 Sheriffs 13 Sherlock Holmes, public house 122 Ship builders 386, 387 — building 119, 369, 386 — money 286 Shipping, Lloyd's Register of 78 Ships' figure heads 363, 366 Ships' 91, 162, 252, 270, 273, 295, 324, 327, 363, 365, 369, 386, 415 Shipway, Colonel, benefactor 285 Shirley 355, 361 — Poppy 361 Shish, John, Jonas and Thomas 387 Shirlock Road 190 Shoe Lane 212 Shooters Hill 362, 371 Shop fronts 144, 164, 219, 240, 320-1, 329, 387 Shopping precincts 130, 132, 152, 226, 257, 277, 347, 358, 382, 416 Shops 9, 20, 84, 148, 150, 154, 155, 161-3, 205, 307, 323, 346, 425 Shoreditch 239 Shoredyches family 232 Shove-halfpenny 365 Shovel, Admiral Sir Cloudesley 344 Schrubsole, Henry 375 Shrubsole Memorial 375 Sidcup 341 Siddons, Mrs 168, 192, 419 Sidney, Elizabeth, Countess of Rutland 239 Sir Philip 213 Sidney Sussex College 101 Siena 119, 306 Signposts 334 Silver 50, 52, 68, 69, 73, 85, 86, 217, - Vaults 213; see also Plate Silwood Hall 385 Simpson's Store 149 Singapore 203 Sion College 28 — Cottages 406 Sisters of the Church 356 Place 242 Sitwell, Dame Edith 120 -, Sir Osbert 120 , Sacheverell 278 Skating 292 Skerne, William 374 Skull & Cross Bones 100 Skulls 81, 354, 409 Slade School of Art 218 Slavery 70, 246, 384 Sloane, Sir Hans 211, 216, 283, 303, Sloane St. 174 Sly, William 239 Smallpox 167, 252 Smart, Christopher 297 Smith, Sir Isaac 392 -, Sir James 113 —, Captain John 43, 60 Smith Square 113

Smithfield 43, 243, 292; 44, 45

Duchess of Northumberland 137 —, Sir Hugh, later Duke of Northumberland 137, 287 Smollett, Elizabeth and Tobias 308 Smuts, General 112 Snape, Andrew 368 Snuff Mill 394 Soane Museum 142, 214; 18 Soho 19, 161, 163 Square 163 Solander, Daniel, botanist 325 Solebay, Battle of 252, 365 Somers, Will, jester 239 Somerset, Duke of 125, 272, 287, 292, 330 Lady Henry 138 Somerset House 20, 125, 138, 151, 153, 185, 217, 292, 381; 126 Sophia, Princess 301 - Matilda, Princess 368 Sotheby's, Messrs 155, 168 'Souls, The' 140 South Africa 168 Africa House 119 - Audley St. 159, 160 - Bank 378, 379 -East London Technical Institute 387 Southgate 237; 238 - House 237 South Grove, 223 Kensington 170, 216 London Art Gallery 315, 418London College 385 - London Industrial Mission 413 - Sea Bubble 395 Southall 229, 232 Southampton, Earl of 210 Southampton St. 132 Southey, Robert 98 Southwall, Tony 223 Southwark 11, 13, 15, 19, 138 , borough of 410-19 - Bridge 51 — Cathedral 13, 15, 410-2; 411 - Fair 415 Town Hall 417 Southwood, Lord 150 Southworth, Blessed John 181 Sovereign of the Seas 369 Spain 80, 115, 153, 199, 293 Spaniard's Inn 225 Spanish painting 153 Speakers' Corner 167, 168 Speed, John 63 Speke, J.H. 168 Spencer, Earl 427 -, Gabriel 239 -, Hubert 223 Sir John 297 Spencer House 147, 224 Spenser, Edmund 92, 98, 241 Spiritualist Church 333 Spitalfields 19, 317, 320, 321 — silk 19, 187, 320, 322, 402 Spooner, William 217 Spoons 56 Sprignell family 223 Spurgeon, Charles Haddon 416 Squint or hagioscope 76, 200, 270, 371 Squire's Mount 225 Stadiums 207, 248 Staël, Madame de 299 Stafford, Archbishop 356 —, Margaret 154 —, Marquess of 320

Smithson, Lady Elizabeth, later

Stag Brewery 178 342, 347, 365, 372, 375, 390, 402, Stakes, wooden 285, 287 Stamford Brook 246 - Hill 239 Stane St. 391, 413 Stanley, Arthur Penrhyn, Dean of Westminster 103, 104 -, Lady Augusta 104 -, Edward, Earl of Derby 143 -, Mr and Mrs 361 Stanley Technical High School 361 Stanmore 21, 260, 263-5 Stanwell, 290 Staples Inn 15, 212 Star and Garter Home 400 State Apartments 139, 140, 167, 170, 171, 250, 251, 288

— Papers 105 Stations of the Cross 181, 276 Staves, Beadles 48 Stead, W.T. 138 Stedman, Fairbone 80 Steel, William 342 Steelyard, Hanseatic 85 Stephen, King of England 328 Stephen, Adrian, Thoby, Vanessa and Virginia 211; see also Woolf, Virginia Stephens, Canon John 432 Stephen's Park, Finchley 9 Stephenson, George 177, 303 Stepney 317, 318 Sterling, James 181 Sterne, Laurence 154 Stevenage 22 Stirling, A.M.W. and Charles 428 Stock Exchange 67 Stocks 200, 239 Stockwell College of Further Education 34 Crescent 19 — St. 367 -Terrace 383 Stoke Newington 239, 241; 242 Stone Age 11, 231, 351 Conduit Close 150 Stonehall Farm 405 Stoup, holy water 291 Stow, John 69, 78, 79, 330; 23 Strafford, Earl of 143, 329 Strand 122, 132 — Lane 126 — Theatre 129 -on-the-Green 285, 399; 284 Strapwork 80, 344, 369 Stratford 310 - Langthorne Abbey 310 Stratton, Lady Berkeley of 154 Strawberry Hill 20, 406, 407, 409 Streatham 224, 378, 384-5, 427 — Common 378, 385 Street names 182 – numbering 154 – pattern 12, 373 Strong, Jonathan 246 Strype, Revd John 336 Stuart family 427 , Frances, Duchess of Richmond 106, 143 -, Henry, Lord Darnley 104 -, Matthew, Earl of Lennox 104

Stubbers, Manor House 269 Stucco 161, 174, 187, 190 Stukeley, Revd William 312 Submarine 138 Suckling, Sir John 134, 407 Sudbrook Park 400 Sudbury 208 — Hill 206 Suetonius 331 Suez Canal 363 Suffolk Collection 368 -, Earl of 294 , Lady see Howard, Henrietta Suffrage 178 Sullivan, Arthur 125, 137 Summer houses 167, 170, 176, 265, 297, 404 Summerson, Sir John 84, 182, 315 Sundials 80, 206, 288, 344, 352, 353 Sunny Hill Park 203 Surbiton 373, 376-7 Surgeons, Royal College of 214, 353 Surrey 22, 355, 373, 383, 397 — Commercial Docks 415 County Cricket Club 383 - Iron Railway 355, 357, 426 Steps 126 -Street Market 357 Survey of London 131, 151, 154, 166, 301, 319, 378 Sussex, Duke of 301 - Gardens 191 House 247 Place 188 Sutherland, Duchess of 140 Duke of 140 Sutton, Thomas 240, 241, 294, 295 Sutton 373, 420-1 borough of 420-6 Sutton Hoo 217 House 240 — Lodge 420 Suzannet, Comte Alain de 220 Swain's Lane 223 Swakeleys 278 Swallow St. 161 Swanscombe Park 362 Swedenborg Square 324 Swift, Jonathan, Dean of St. Patrick's, Dublin 174, 281 Swinburne, Algernon Charles 308 Swiss Cottage 227 Swithin, Saint 410 Sword rests 26, 41, 48, 50, 51, 52, 60, 63, 70, 77, 83, 92, 409 Swords 25, 26, 73, 330 Sydenham 170, 257, 386, 388 Wells Park 388 Synagogues 81, 321; 83 Syon 20, 285, 287, 288, 404 Sysley, Clement 197 Tabard Inn 413 Taberner House 358 Tables 31, 51, 52, 278, 293, 316, 319, 365, 412 Tachbrook St. 177 Talbot Yard 413 Tallard, Marshal 141 Talleyrand 299 Tallis, Thomas 367

Tanner's Hill 387

Tassie, William 145

Tata, Śir Ratan 406

Tapestry 52, 106, 128, 139, 166, 252, 253, 289, 304

Tate, Sir Henry 181, 385 Sir Robert 91 Tate, Almshouses 393
— Gallery 119, 181, 266, 365, 418
Tattersall, Richard 174 Tavistock Row 131 — Square 211 Taylor, Warrington 245 Tea-clipper 363 Teddington 397, 406, 409 Telegraph 247 Telephones 49 Television 164, 248, 257 Temperate House 404 Templars 13, 28, 204, 291 Temple, Frederick, Archbishop of Canterbury 360 William, Archbishop of —, William, Alexandra Canterbury 150 Temple Bar 25, 122, 235 — Church 13, 28, 29-31; 29 — Fortune 204 , Iron Age 271 Ten Commandments 357 Tenison, Dr 150 Tennant, Margot 156 Tennis 116, 189, 250, 254, 395 Tennyson, Alfred 98, 186, 406 Tentmaking 417 Terrace, All Hallows 91 – Gardens 399 , Mortlake 405 Terracotta 213, 219, 249, 303, 304, 307, 363, 371 Terrick, Bishop of London 243 Terry, Ellen 131 Textiles 19, 155, 162, 304, 322, 334, 388, 391, 401, 402
Thackeray, William Makepeace 301
Thames 11, 12, 22, 107, 114, 122, 125, 135, 138, 177, 243, 244, 246, 247, 249, 251, 285, 288, 298, 310, 323, 362, 363, 372, 373, 378, 397, 399, 403, 409, 427 - Barrier 372 Tunnel 415 Thamesmead Estate 344, 371 Thanet, Lady 283 Thatched Lodge 400 Theatre, The 239 on the Green 397 - Royal Drury Lane 133, 137 - Royal, Stratford 311 Theatres Adelphi 129 Albery 134 Aldwych 129 Ashcroft 358 Barn 342 Blackfriars 48 Churchill 346 Coliseum 134 Curtain 239 Drury Lane 133 Duke of York's 134 Fulham Open Air 244 Gaiety 129 Globe 239 Greenwich 368 Hampton Court 255 Haymarket 144 Her Majesty's 144 Little Angel 296 Lyceum 129 Lyric 246 Mermaid 52 National 135, 379

Open Air 188 Old Vic 381 Polka 395 Richmond 397, 398 Riverside 246 Round House 221 Royal Court 309 Royal Opera House 134 Sadler's Wells 296 Savoy 129 Strand 129 The Theatre 239 Tower 297 Vaudeville 129 Wimbledon 395 Theatrical Collections 133, 134, 380, 388 Thellusson, Peter 347 Theobalds Park 25, 235 Theodore, Archbishop of Canterbury , King of Corsica 165 Thistlewood, Arthur 40, 159 Thomas, Saint 100

— à Becket, Saint and Archbishop 58, 84, 103, 345 —, Dylan 98 of St. Osyth 46 Thompson, Francis 164, 301 Thomson, James 247, 281 —, Sir Joseph John 98 Thorn, Robert 333 Thorndike St. 178 Thorney Island 95 Thornhill, Jane 192 Thornton family 384 -, Marianne 384 Thornton Terrace 383 Thorpe, Catherine and John 340 Thothmes III 138 Thrale, Henry & Hester 224, 384, 413 Threadneedle St. 67 Three Mills Centre 310 - Tuns 277 Throckmorton, Elizabeth 426 Throne, Archiepiscopal 180 Thunderer, H.M.S. 199 Thynne, Sir George 91 —, Sir John 25 —, Thomas 97 Tide, highest point 409 Tilbury 76 Tiles 105, 109, 175, 279, 299, 307, 354 Tillotson, John, Archbishop of Canterbury 55 Tilt Yard 250, 254 Timber-framed houses 231, 232, 235, 269, 279, 324, 333, 340, 341, 376, 393, 421
Time, Father 60, 409 -/Life Building 155 Times, The 139, 148, 409 Titanic 138 Tithe barn 269, 272 Toc H90 Toll gate (Highgate) 222; (Spaniards) Tollemache, Sir Lyonel 400, 402 Tom Thumb, General 150 Tombes, Henry 79 Tombstones 222 Tomkins, Thomas 243 Tompion, Thomas 98 Tooke, John Horn 229 Tooley St. 414

Tooting 427, 431
— Bec Common 384 Torrington Place 217 Square 211 Tottenham 256, 257 Totteridge 200, 201 Tothill Fields 181 - Fields Prison 178 Tow path 182, 193 Tower Battery 295
— Bridge 180, 326, 328, 331 - Hamlets, borough of 317-25 — Hill 331 - blocks 62, 68, 77, 166, 168, 215, 324, 358, 373, 388 - of London 12, 13, 48, 90, 104, 115, 180, 317, 326-31, 369; 327, 329 - Mill 361 — Pier 363 — Theatre Co. 297 of the Winds, Athens 219, 385, 416 Townsend family 259 Tout, Henry 226 Toynbee, Arnold 395 Toynbee Hall 204, 317 Toys 129, 288, 405 Trade, Board of 116 Tradescant family 382 -, John 405 - Trust 382 Trafalgar, Battle of 188, 364, 391 Square 20, 114, 118, 129, 136, 151, 167, 188; 118
- Tavern 367 Traffic 84 — junction, first 416 Traherne, Revd Thomas 409 Traitor's Gate 329 Tramps 81, 121 Tranquil Vale 390 Transparency 41 Transport 132 Trasuntino, Alessandro 302 Travellers Club 107, 145 Treasury 114, 116 Treaty House 277 Trecothick, Barlow, M.P. 360 Trenchard, Viscount 103, 136 Trent Park 234, 238 Trevelyan, G.M. 261 Trianon, Versailles 365 Trimmer, Sarah 229 Trinitarian Friars 289 Trinity Almshouses 318 - Gardens 326, 331 - Hospital 367 — House 331 — House Corporation 318 School 361 Square 111, 326, 416 Tristram, Professor 100 Trollope, Anthony 177, 261, 301 Trompe l'oeil painting 160, 173, 253, 287 Truman, Joseph 320, 321 Truman's Brewery 321 Trumpeter's House 398 Tube stations 208, 226, 238, 316, 415; 235, 238 Tudor half-timbering 162 Tucker, William 344 Tudor Court 289 Tullibardine, Lord 330 Tunnels under Thames 323, 363, 371, 415

Turenne, Marshall 184 Turkey 80, 117, 317 Turk's Boatyard 374 Turks 289 Turner, Dr William 287 Turnham Green 153, 231, 286 Turpin Lane 367 Tussaud, Babington 248 Tussaud's, Madame 186 Twickenham 9, 285, 397, 406-7
— Bridge 397, 399
Twining, Augusta 407
—, Thomas 127 Twining's Coffee House 127 Twyford 230 - Abbey 231 - School 231 Tyburn Gallows 167, 190, 274, 290 —, River 156, 182 Tyburnia 190 Tyler, Wat 43, 85, 124, 212, 233, 292, 326, 390 Tyndale, William 25, 137; 137 Tyrhtilus, Bishop of Hereford 243 Uniforms 141

Union Club 119
United Reformed Church 375
— Services Club 145
— States; see America
Universal Daily Register 48
University College, London 211, 218; 216
— of London 157, 211, 217-18
— Women, Federation of 308
Unknown Soldier 96
Uphall Camp 316
Upminster 266, 268
— Hall 268
Upper St., Islington 296, 297
Urban V, Pope 102
Uvedale Cottage 235
Uxbridge 192, 271, 277
—, Earl of 157, 276
Uxbridge House 157
— Rd. 229, 271, 276

Vale of Health 228 Valence House 198 Park 197 Valentines 316 Valley of Dry Bones 386 Vanbrugh Castle 367 Vancouver, Captain George 400 John 400 Vandalism 288, 289 Vandedoort, Abraham 134 Vanneck, Sir Joshua, later Baron Huntingfield 432 Vaudeville Theatre 129 Vaughan, Cardinal 178, 180, 201
— Library 261
Vaughan Williams, Ralph 111
Vaulting 53, 60, 102, 111, 292; 103
Vauxhall Bridge Rd. 22, 177, 178 Gardens 383 Vavasour, Sir Thomas 400 Venice 119 'Venice, Little' 193 Verdun, Promenade de 359 Vere St. 182 Verreyden, Cornelius 131 Verney, Sir Edmund 131 Versailles 173, 250, 251 Vestry houses 334, 393, 405 — minutes 334, 383 Viaducts 85, 232

319, 322, 328, 330, 332, 370, 378, 393, 404, 405, 419, 432 Victoria and Albert Museum 20, 121, 123, 133, 137, 142, 160, 165, 168, 182, 224, 232, 235, 244, 252, 269, 289, 301, 304-5, 322-3, 375, 377, 387, 400, 405, 421, 429 Victoria 174, 176-8 - Cross 313 - Embankment 20, 122, 135, 147, 379; 137 -Gate 167 - Park 140, 240, 319; 241 — Square 176; 177 — Station 176 -St. 174, 178, 181 -Tower 107, 111 Victorian brasses 209 Society 299 Victory, figure of 153

—, public house 262
Vienna 135, 141, 173 Vienne, John de 326 Views, noteworthy 261, 358, 361, 399, 404 Vigo St. 157, 161 Vikings 326 Villa Čapra 281 Rotunda 341 Village Club, Wimbledon 395 — greens 237, 272, 278, 279, 290, 291, 389, 392, 425 Villiers family 288 Barbara, Countess of Castlemaine 285, 421 George, Duke of Buckingham 103, 122, 123 Villiers St. 123 Vincent Square 181 Vine, Hamburgh 254, 316 — House 376 — leaves 242, 357 — Row 399 Vinegar Yards 378 Virgin Mary 415 Virtues, Cardinal 367 Vittoria, Battle of 153 Voltaire 186 Vosges, Place de 16, 130 Vyner, Sir Robert 278 Wade, General 156 Wake, William, Archbishop of

Wade, General 156
Wake, William, Archbishop of
Canterbury 150, 356
Wakefield Gardens 331
— Tower 328
Walbrook 11, 73
Waldhere, Bishop of London 243
Waldorf Hotel 129
Waldrons, The 358
Wales, Prince and Princess of 125, 300
Walham Green 245
Walker, Sir Emery 247, 248
Walker, Sir Emery 247, 248
Walker Art Gallery, Liverpool 168
Wall paintings 14, 100, 101, 105, 108, 109, 114, 129, 141, 160, 181, 198, 203, 213, 220, 229, 232, 237, 238, 248, 251, 252, 253, 263, 265, 266, 270, 274, 278, 279, 287, 290, 291, 296, 328, 355, 356, 363, 384, 404, 405, 425, 432

Wallace, Sir William 111 Sir Richard and Lady 184 Wallace Collection 120, 184 Waller, Sir William 288 Wallington 420, 425 Wallpaper 69, 86, 334, 375 Walpole, Horace 20, 123, 130, 141, 151, 158, 165, 288, 289, 400, 406, 407 Sir Robert 117 Walpole House 285 - Park 229 Walsingham, Sir Francis 213 —, Thomas 350 Walter, John 409 Waltham Abbey 13, 112, 235, 236 Cross 122 Forest 322-6 Walthamstow 332, 333-5 Waltheof, Earl of Northumberland 259 Walton, Revd Bryan 72
—, Izaak 26, 257
Walton St. 307
Walworth, Sir William 43, 85; 85 Walworth Rd. 417 Wanamaker, Sam 413 Wandle, river 391, 394, 420, 422, 425, 426, 430 Wandsworth 355, 378, 391, 426, 430-1 -, borough of 427-32 -Common 431 Wanstead 127, 314-15, 332 Hall 264, 315 Wapping 323-4, 415 War Memorials 28, 68, 76, 90, 116, 176, 240, 259, 261, 268, 325, 331, 359, 370, 420 War Office Building 116 Warburg Institute 185, 217 Ward, Seth, Bishop of Salisbury 55 Wardour St. 165 Wardrobe, The, Richmond 398
— Place 49 Tower 331 Ware, Abbot 105 —, Bishop 432 Wareham, Archbishop 407 Warehouses 180 Waring, Lord 341 Warner, John, Bishop of Rochester 347 Wars of the Roses 13, 31, 114, 240, 367 Warwick Avenue 190, 193 - Crescent 193 - Square 177 Washington, George 120, 213, 428 Watches 293 Watch House 375, 415 Water House 334; 335 — supply 156, 169, 296, 377, 393 — towers 371, 425 Waterford glass 96 Watergate 122, 137, 138, 151 Waterleaf lilies 244 mouldings 341, 344 Waterloo Barracks 330 Battle of 143, 153, 159, 213, 241, -Bridge 11, 124, 125, 128, 138, 378, 381; 14 - Churches 381, 383, 385 - Gallery 153 — Place 145

— Station 381

Waterlow, Sir Sidney 9, 223 – Court 205; 204 – Park 9, 233 Watermeads 394 Watermen's Company 138, 372 Waterworks Yard 357 Watford Way 203 Watling St. 202, 362, 390 Watney Mann's Stag Brewery 178 Watney's Brewery 405 Watson House 245 Watt, James 289, 303 Watts, Isaac 242, 295 Waverton St. 160 Wax effigies 106 — Works 29, 186 Wealdstone 261 Weatherboarding 160, 201, 232, 235, 394, 395, 415, 421, 425, 431 Weaving 320 Webb, Revd Benjamin 209 —, Sydney 132 William 359 Wedgwood, Josiah 285 Wedgwood Mews 165 Weights & Measures 112, 376 Well Hall 372 — House 395 Walk 225 Wellclose Square 324 Wellesley, Lord 153 Wellington, Duke of 34, 36, 54, 68. 108, 120, 143, 153, 159, 169, 173, 213, 309 Wellington Arch 169 - Barracks 147 Rd. 189 Wells, H.G. 346 Wells 47, 257, 292, 296, 346 St. 208 Welsh Affairs, Department of 116

— Episcopalians 52 — Guards 413 Harp Reservoir 206 Welwyn Garden City 199 Wembley 206, 207, 208, 209 — Stadium 207; 207 Town Hall 208 Wennington 266, 270 Wentworth, Lord 322 Wesley, Charles 295, 340 -, John 41, 63, 186, 215, 295, 409 -, Samuel 417 Susanna 295, 320 Wesley's Chapel 295 — House 295 West Drayton 271, 272 - Ham 9, 310 — Ham Pumping Station 310 — Heath Rd. 227 — Middlesex Water Co. 247 Norwood Cemetery 385 Place, Wimbledon 394 Westbourne 167 Westcott House 246 Western Avenue 229, 271 Westminster, Duke of 174 , Marquess of 168 —, Marquiss of 160 — Westminster 12, 107-13, 161, 206 — Abbey 9, 12, 13, 14, 15, 16, 19, 25, 95-106, 107, 112, 113, 114, 122, 130, 169, 249, 326, 328, 427, 93, 97, 99, 103, 104, 105 Art Reference Library 121
Bridge 135, 138, 373, 379, 382, 415 Cathedral 178-80, 248, 383, 390, 405; 179

—, City of 95-194 City Council 132, 177 — College, Missouri 56 — Hall 12, 14, 19, 53, 101, 107, 110, 416: 110 , Palace of 107-12, 114: 111 - Panel 102 — Pier 363 — Public Library 176 - School 25, 106, 181 Weston, Thomas 364 Triptych 292 Westway 192; 192 Weybridge 22, 134 Weymouth 183 Whalley, Revd Peter 92 Wharncliffe Viaduct 232; 231 Wheathampstead 11
Whipping post 200, 239, 266
Whispering Gallery 37
Whitbread's Brewery 295 Whitchurch (Little Stanmore) 264 Whitcomb St. 166 White, Private Frederick John 291 -, Sir George 183 Dr Thomas 28 White City Stadium 248

— Hart 393 — Lodge 400, 405 — Webbs Park 234 — Swan 399 — Tower 12, 326, 329 Whitechapel 317-8; 319 — Art Gallery 317 Bell Foundry 80, 83, 128, 318, Whitefriars 14 —glass 231, 262 Whitehall 15, 16, 97, 107, 114-18, 139, 147, 150, 151, 170 - Court 136, 147 — Palace 15, 16, 18, 114-16, 122, 139 — Theatre 118 Cheam 421 Whitelands 431 White's 139 Whitestone Pond 225 Whitfield, Revd George 340 Whittield, Kevd George 340
Whitgift, John, Archbishop of
Canterbury 356, 357, 358
Whitgift Hospital 357
— School 357, 358
Whittington, Richard 59, 78, 86, 88, Whittington Hospital 223 Whittle, Frank 303 Wick House 399 Wickham Court 354 Widdows, John 83 Widow's garb 335 Wig-peg 51 Wigmore St. 182 Wilbraham Almshouses 200 Wilberforce family 395

—, William 70, 354, 384
Wild, Jonathan 40 Wilde, Oscar 40 Wildwood 227 Wilkes, John, M.P. 286 Wilkins, John, Bishop of Chester 55 Wilkinson, Nicholas 239 Patty 192 Wilks, Revd William 361

Willam, Thomas 231 Will on brass 204 Willesden 206 Willett, William 351 William I, the Conqueror 12, 32, 95, 110, 197, 233, 326, 327
William II 12, 107, 110, 279
William II 18, 31, 33, 47, 51, 106, 115, 139, 141, 144, 145, 150, 155, 163, 167, 171, 172, 173, 210, 249, 263, 253, 254, 266, 298 250, 251, 254, 296, 298, 304, 363, William IV 140, 254, 263, 311, 349, 404 William of Sens 170 , son of William the Goldsmith 75 of Wykeham, Bishop of Winchester 151, 267, 272, 406 William Morris Gallery 334 William St. 129 William St. 129
Williamson, Sir James 83
Willifield Way 205
Willoughby, Sir Hugh 325
Willow Walk 177
Wilmington Square 296
Wilson, Dr Edward 428 Erasmus 138 —, Erasinus 136 —, Sir Thomas Maryon 225 Wilton Crescent 174 — Diptych 97, 119 — House 406 Wimbledon, 391, 394-5 — Common 9, 391, 395; 396 — Theatre 395 Wimborne House 150 Wimpole St. 185 Winchester 11, 377, 406 Wind-dial 173
Wind-dial 173
Windmills 232, 233, 269, 385, 396, 431; 268, 396; see also Mills St. 149 Windows, sash 401 Windsor 14, 102, 307, 361, 373 — Beauties 252 Terrace 239 Wine cellars 114, 253 glasses 52 Winslow, Edward 28 Winsor & Newton 184 Wiseman, Cardinal 248, 336 Witchcraft 84 Wither, George 125 Witt, Sir Robert 217 — Collection 185 Woburn 417 Square 185, 211, 217 Walk 219 Woffington, Margaret 409 Wolfe, James, General 259, 367, 369 Wolseley, Sir Garnett 117, 368 Wolsey, Thomas, Cardinal 15, 36, 114, 249, 251, 252, 253, 286, 371, Wolsey's Closet 252 Wolstenholme, Sir John 263 Women's Suffrage Movement 178 Wood, Sir Henry 42, 301 —, Mrs Henry 223 Wood Green 256, 257 -St. 12, 56

- St., Barnet 200

Woodberry Down 242 Woodcarving 9, 26, 28, 39, 51, 67, 70, 71, 73, 74, 77, 89, 91, 92, 118, 131, 137, 142, 149, 163, 172, 200, 249, 251, 254, 266, 279, 290, 295, 302, 304, 305, 309, 335, 340, 347, 351, 364, 403, 415 Woodcock, Katherine, later Woodberry Down 242 Woodcock, Katherine, later
Mrs Milton 56, 113
Woodcote 355, 359
Woodford 314
— County School 314
Woodget, Captain Richard 363 Woodlands 367 Woodville, Elizabeth, Queen to Edward IV 397, 415 Wool 55, 212 Woolf, Leonard 177, 399

—, Virginia 120, 211, 254, 399 Woolgate House 55 Woolsack 108 Woolwich 362, 369-71
— Arsenal 368 North 310 Worcester 105 -, Battle of 309 Bishop of 125 Wordsworth, William 58, 98, 138, 256 Wordsworth, William 38, 76, 136, 23 Workhouse 212, 334 World War I 22, 138, 176, 203, 240, 259, 261, 268, 280, 325, 389, 416 World War II 22, 117, 138, 142, 149, 203, 225, 227, 295, 414, 416 Wormwood Scrubs Prison 248 Worsley, John 364 Wrencote 357 Wricklemarsh 388, 390 Wright, Sir Edmund 278
— Brothers, 303 Wriothesley, Thomas, Earl of Southampton 210 Wulfnoth 70 Wycherley, William 131 Wyclif, John 47, 381 Wyldes 204, 228 Wyndham Place 186 Wynne, Sir Watkin Williams 143

Yacht Tavern 367 Yeading Lane 274 Yeoman of the Guard 343 Yerwood, Sir James 25 Yiewsley 271 York, Archbishop of 114, 122, 249, 429 York 200 — Buildings 122 — Gate 186 — House 122, 137, 151 — Palace 15, 114 — Watergate 122 Young, Edward 92 —, Revd Patrick 274 Ypres 90

Zimbabwe House 129 Zodiac 353 Zoological Society of London 188, 203, 328 Zulu Wars 351 Zwemmers, Messrs 166